American Windsor Chairs

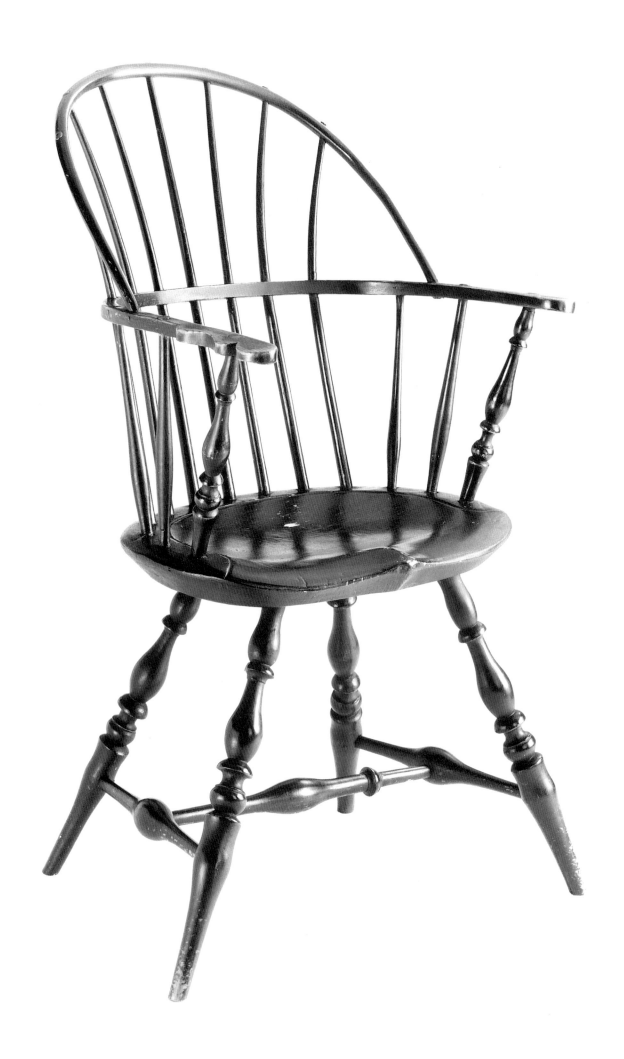

AMERICAN WINDSOR CHAIRS

NANCY GOYNE EVANS

HUDSON HILLS PRESS · NEW YORK

in association with

The Henry Francis du Pont Winterthur Museum

To the memory of
CHARLES F. MONTGOMERY, 1910–1978 *and* BENNO M. FORMAN, 1930–1982

Gladly would he learn, and gladly teach.
—GEOFFREY CHAUCER, *Canterbury Tales*

Published with the assistance of the Getty Grant Program.
Photography funded in part by the National Endowment for the Humanities.

© 1996 by The Henry Francis du Pont Winterthur Museum, Inc.

Published in the United States by Hudson Hills Press, Inc.,
Suite 1308, 230 Fifth Avenue, New York, NY 10001-7704.

Distributed in the United States, its territories and possessions,
Canada, Mexico, and Central and South America by National Book Network.
Distributed in the United Kingdom, Eire, and Europe by Art Books International Ltd.
Exclusive representation in Asia, Australia, and New Zealand by EM International.

EDITOR AND PUBLISHER: Paul Anbinder

CONTENT EDITOR: Gerald W.R. Ward

COPY EDITORS: Catherine Chudzik and Lys Ann Shore

PROOFREADER: Lydia Edwards

INDEXER: Lys Ann Shore

PRODUCTION EDITOR: Susan Randolph

DESIGNER: Howard I. Gralla

COMPOSITION: Trufont Typographers

Manufactured in Japan by Toppan Printing Company

LIBRARY OF CONGRESS CATALOGUING-IN-PUBLICATION DATA

Evans, Nancy Goyne.
American Windsor chairs / Nancy Goyne Evans. — 1st ed. p. cm.
Includes bibliographical references and index.
ISBN 1-55595-112-0 (hardcover : alk. paper)
1. Windsor chairs—United States. I. Title.
NK2715.E92 1996 749′.32′0973—dc20
95-43862 CIP

FRONTISPIECE:
Sack-back Windsor armchair, Rhode Island, probably Providence, 1790–1800 (see fig. 6-40).

Contents

Foreword

To me, a great Windsor armchair conveys a silent but welcome command: "Sit!" The raked back and sculptural seat suggest comfort, the carved knuckles on the arms invite thoughtful caressing, and the splayed legs imply strength. Judging by the number of publications on Windsors that have been issued in recent years and the high prices that great examples command at auction, many people apparently share my appreciation. The next time you have the opportunity to sit in a Windsor chair, indulge yourself—and learn one reason why they have remained so popular for more than two hundred years.

There is more to enjoying Windsor chairs, however, than just the tactile and visual pleasures that they inspire. Knowing more about their history, about significant regional variations, about differences in workmanship and construction among makers, and about the range of forms that make up the heterogeneous group of "stick" chairs (called Windsors because an early rustic version of this seating form was used at Windsor Castle) adds to their fascination. The story of how they came to America, of their use here, and of the remarkable innovations that American chairmakers introduced—creating a recognizable American style—is also told here. The history of Windsor chairs provides insights into how earlier Americans lived, worked, played, and even thought.

This volume serves not only as a guide to the production of Windsor chairs in America but also as a guide to the Winterthur collection, one of the greatest assemblages of eighteenth- and nineteenth-century Windsor chairs anywhere. Windsor chairs and their allied forms fascinated Winterthur's founder, Henry Francis du Pont, who avidly acquired important examples throughout his life.

Nancy Goyne Evans has spent much of her professional life on this project. A rigorous scholar, she has documented objects and uncovered references to produce a comprehensive yet readable view of this fascinating and significant form of American seating furniture. *American Windsor Chairs* is a long-awaited publication, and I think that it is a triumph.

DWIGHT P. LANMON
Director
Henry Francis du Pont Winterthur Museum

Preface and Acknowledgments

American Windsor Chairs grew out of the author's perception that a need existed for a comprehensive study encompassing this branch of the American furniture trade in the preindustrial era. When research began in the 1960s, I expected to complete the project in a few years. Quickly, that myth was exploded as I became aware of the vast amount of material that awaited inspection. It became clear that only a multifaceted investigation would produce all the information necessary to explicate the product, its background and introduction to America, its development, and its assimilation into the cultural fabric of colonial and federal America. Eventually, I examined thousands of chairs and other Windsor forms, making notes on construction techniques and materials when possible. I undertook a concurrent search for written information, using manuscripts, secondary source materials, travel accounts, journals and diaries, city directories, newspapers, land and probate records, unpublished papers, and theses. As the data bank grew, I processed the information for retrieval when the task of interpretation and writing began.

The most expedient way to organize the manuscript was by region, "regional characteristics" having long formed the cornerstone of American furniture studies. As working, migration, and settlement patterns emerged, regional and political divisions frequently became merely artificial boundaries, and the ease of design transmission and the interactive nature of urban and rural chairmaking became more apparent. Subdivisions within the regional sections follow political boundaries—those of colonies before the Revolution, and states after that period. On the local level, the discussion moves from urban to rural areas or considers the work of a series of subregions defined by physical or political boundaries, such as valleys and counties. Ethnicity dominates some discussion, as for example Pennsylvania German chairmaking. I have presented prevailing chair patterns in chronological sequence and noted relationships in style and construction method between regions. Area maps heading chapters and subsections assist the reader in locating named sites of chair production and use.

Since craftsmen were an integral part of society, I address the impact of political and economic conditions, social and technological changes, and geography and climate in shaping environment, culture, working patterns, and activities. I have approached the subject of vernacular-chair making in its many facets without preconceived notions or hypotheses and have let the material speak for itself, providing analyses and comparisons, as appropriate. I introduce aesthetic criteria to assist the reader in distinguishing between urban and rural chairmaking to better cultivate an understanding of the subtleties of design, rather than to establish artificial standards for collecting. Shop accounts, travelers' descriptions of places, people, customs, and events, and craftsmen's personal records provide a sense of prevailing cultures and reveal that most eighteenth- and early nineteenth-century craftsmen were concerned principally about earning a living, maintaining good health, and providing job training for their sons. Accompanying the text is a checklist of these chairmakers and allied artisans, such as turning

specialists who supplied chair stock, identified to date. Only a small number is discussed in the text.

I use period terminology to describe chairmaking products and practices, substituting modern terms only in cases where confusion may occur. All major chair patterns are illustrated and discussed as are many subtypes—the number sufficient to provide springboards for identifying unillustrated patterns and variations.

Figure numbers printed in boldface type within the text identify principal references to the illustrations. Figures not in boldface are cross-references. Identification of the right and left sides of a chair or other Windsor form in the illustrations corresponds to the viewer's right and left.

Of the illustrated chairs in this volume, a number are documented by makers' brands, labels, stencils, or signatures. The captions provide information about the brands that appear on documented chairs, when photographic details are not included. Letter formats are given as closely as possible but do not distinguish between two sizes of upper-case letters. Attributions are based on close similarities of features, usually the turned members, between an unmarked and a documented chair. Except in chairs made prior to the revolutionary war, attributions to specific craftsmen located in urban centers are hazardous at best, since most communities of any size supported several, even dozens, of chairmakers, all producing seating furniture of the same design. By the late eighteenth century, chair-stock suppliers also enjoyed good custom. A single establishment often furnished "chair stuff" to several craftsmen in the same community; some shops provided stock for rural and urban chairmakers working within a radius of fifty miles or more.

Wood identification is by visual inspection, except when microanalysis is specified. Measurements—height, width, and depth—have been taken at points of greatest dimension.

Many people have shared in the creation and production of this book, lending professional assistance, providing leads, sharing information, or making collections accessible. Through the years my colleagues at Winterthur have been an invaluable source of information and expertise; fellows in the Winterthur Program in Early American Culture have passed along relevant material, while occasional student volunteers in the Registrar's Office have assisted in the inevitable task of checking data. Several independent researchers—namely the late William S. Bowers, Milton E. Flower, Wendell Hilt (via Charles F. Montgomery), and the late Charles S. Parsons—were especially generous with their notes. Staff in other institutions have been ever willing to open their collections for research, examination, and photography. The following institutions, in particular, can be cited, although many others provided substantial assistance: American Antiquarian Society, Worcester, Massachusetts; Bennington Museum, Bennington, Vermont; Chester County Historical Society, West Chester, Pennsylvania; Colonial Williamsburg Foundation, Williamsburg, Virginia; Connecticut Historical Society, Hartford; Connecticut State Library, Hartford; Cumberland County Historical Society, Carlisle, Pennsylvania; Fonthill Museum, Bucks County Historical Society, Doylestown, Pennsylvania; Essex Institute, Salem, Massachusetts; Historic Deerfield and the Pocumtuck Valley Memorial Association, Deerfield, Massachusetts; Hitchcock Museum, Riverton, Connecticut; Maine State Musuem, Augusta; Museum of Art, Rhode Island School of Design, Providence; Museum of Early Southern Decorative Arts, Winston-Salem, North Carolina; New York State Historical Association, Cooperstown; Oglebay Institute Mansion Museum, Wheeling, West Virginia; Old Sturbridge Village, Sturbridge, Massachusetts; Shelburne Museum, Shelburne, Vermont; Slater Memorial Museum, Norwich, Connecticut; Society for the Preservation of New England Antiquities, Boston, Massachusetts; Strawbery Banke, Portsmouth, New Hampshire; Williams College Museum of Art, Williamstown, Massachusetts; Yale University Art Gallery, New Haven, Connecticut.

A wide circle of collectors, numbering hundreds of individuals, opened their collections to my inspection; many supplied photographs of key pieces or permitted on-site

photography by Winterthur. Dealers were equally generous, providing access to shop stock and sometimes to their private collections. In particular, I recognize Zeke and Arthur Liverant of Nathan Liverant and Son, Allen Antiques, and Philip H. Bradley Company. Other dealers who were especially helpful include Jerome Blum, Edward F. LaFond, Jr., Carrie and Ray Ruggles, Charlotte and the late Edgar Sittig, Betty Sterling, David A. Schorsch, David Stockwell, and the late I. M. Wiese.

There is a group of people to whom I owe an enormous debt because their contributions to this volume have been little short of extraordinary. First is George Fistrovich, Winterthur photographer, whose artistry and technical accomplishments are explicit in the images that fill this volume. Gerald W.R. Ward guided the work of consolidating the manuscript into a manageable treatise with an unerring sense of direction. Robert F. Trent patiently read the manuscript on several occasions and helped to implement the publication process. Catherine Chudzik and Lys Ann Shore skillfully carried the work to its final copy-edited state. The staff of Winterthur's word processing center has performed a herculean task since the first drafts of the manuscript were submitted many years ago. More recently, members of the Winterthur Publications Office, particularly Catherine E. Hutchins and Susan Randolph, have worked diligently to keep the publication on track. Finally, I thank my good friends Russell Ward Nadeau and Bernard D. Cotton for their many words of encouragement offered in those dark moments known to every author.

<div style="text-align: right;">

NANCY GOYNE EVANS
Hockessin, Delaware
September 1994

</div>

Introduction

American Windsor Chairs is a history of an industry and a description of a craft. The discussion centers in three areas: the origin and early development of Windsor construction from its roots in ancient stick-and-socket furniture to its transmission from England to the American colonies; the adoption of Windsor technology by Philadelphia woodworkers and the dissemination of the craft throughout eastern North America before 1840; and the socioeconomic conditions that established the Windsor as a leading domestic consumer product and a ranking commodity of the overseas furniture trade within the Western Hemisphere.

Introduction of the Windsor to America from England probably occurred between 1726 and 1736 through a Pennsylvania governor appointed by the Penn family, and English chairmaking continued to supply the basic prototypes until the end of the century. From the beginning, American Windsor-chair makers were receptive to secondary influences drawn from both formal and vernacular domestic seating styles, a circumstance that gave their product a distinctly American character. After 1800, European design books heavily influenced American production as formal styles filtered down to the popular level. Although the craft became an industry in both countries, English and American Windsor patterns diverged sharply in the nineteenth century. American chairmakers, freer from tradition and class constraints, continued to innovate, while English craftsmen slowly modified eighteenth-century patterns.

Once established as a new branch of the prerevolutionary Philadelphia furniture trade, the craft of Windsor-chair making spread to Rhode Island and New York City. Rapid expansion marked the federal era, as products and craftsmen followed the coastal and inland paths of commerce. The Windsor craft swept New England and eastern Canada, penetrated the southern tidewater, piedmont, and gulf coast, and traversed mountains and rivers to permeate the booming "West" (Midwest). Raw materials were cheap and abundant, and by 1850 transportation advances, labor specialization, and a national market fostered a factory system ruled by quantity rather than quality production.

Between 1750 and 1850 the American craftsman was frequently subject to conditions and events over which he had little or no control, from political turmoil and economic upheaval to destructive natural forces. Astute artisans, both urban and rural, adapted to changing conditions and capitalized on expanding markets, improved regional communication, and development of new power sources. The success of the Windsor industry may be measured by the popularity of the product. By the 1790s the Windsor had all but driven the modest-priced competition out of the market, and annual production equaled that of *all* other seating furniture combined.

What distinguished the Windsor from other types of seating? The principal construction unit is a shaped and contoured plank drilled with sockets on the upper and lower surfaces to anchor the back and undercarriage. Unlike other seating, the rear legs and upper structure are separate rather than continuous elements. The individual back

members are vertical, horizontal, or curved. Spindles, while a common Windsor component, may be absent in some patterns. Although the Windsor appears light in form, the construction is durable. Seats did not require periodic replacement, and a coat of paint freshened scuffed surfaces. Pattern and ornament ranged from plain to elegant styles, depending upon the consumer's income and requirements.

Early on, American craftsmen recognized the complete adaptability of the Windsor to quantity production. Both turned and hand-shaped components could be made in batches quickly and efficiently to be stockpiled for future use. The interchangeable nature of Windsor parts led to construction economies and permitted shop owners to store prepared materials in bulk for quick framing and quantity sales. By 1800, prepared stock was available from suppliers who specialized in producing chair components.

The commercially viable Windsor was first a seat for the elite and prosperous. During the early federal period the modest price of the side chair promoted its widespread use among the general population. The range of consumers, from John Cooper, New York City laborer, to Thomas Jefferson, president and country gentleman, indicates the Windsor's national appeal, while a brisk overseas trade provides overwhelming evidence of the importance of the product in the international market. The ubiquitous Windsor served in many settings, from formal parlors to rustic cabins and public institutions.

Regional studies are the keys to understanding American Windsor furniture. They provide insights on craft structure; pattern evolution; the roles of geography, technology, and territorial expansion in craft diffusion; the widespread appeal of the Windsor; and its perfect suitability as a major commercial product. This line of investigation also highlights major producers and their work, describes shop and marketing practices, and explores the interaction of craftsmen, workmen, and consumers.

A regional approach also provides the opportunity to compare the furniture of many areas to identify design similarities and pinpoint origins of influence. By looking closely at localized features, it is possible to determine how they evolved and to evaluate their relative standing in local production. The development of frameworks for dating Windsor furniture, particularly in the early years, and for identifying examples by region is the primary goal of this study, complemented by the historical overview. Whereas Pennsylvania German stylistic features are easily recognized, the postwar work of Rhode Island and of the Connecticut–Rhode Island border area is especially difficult to identify because few makers are linked with actual Windsor furniture, and design variations proliferated. Selective visual material and carefully developed criteria enable the reader to follow pattern chronologies and to establish reasonable provenances for unillustrated variants.

Side chairs were the bread and butter of the Windsor trade in federal America; their production greatly exceeded that of armchairs. Orders for specialized furniture, such as settees, children's seating, and rocking chairs, provided additional income for craftsmen. The high point in American Windsor design occurred during the 1790s. Early nineteenth-century work, although innovative, became coarser and relied more on paint and decoration than on the sculptural qualities of the form. By midcentury, design creativity had run its course, and the industry turned to revival styles. A few careful reproductions were made during the centennial period and later. In the early twentieth century, Wallace Nutting collected and publicized antique Windsor seating and then produced idealized copies that instilled a new awareness and interest in the American public. That interest continues today as the antique Windsor market flourishes and many enthusiastic artisans handcraft their own products.

Color Plates

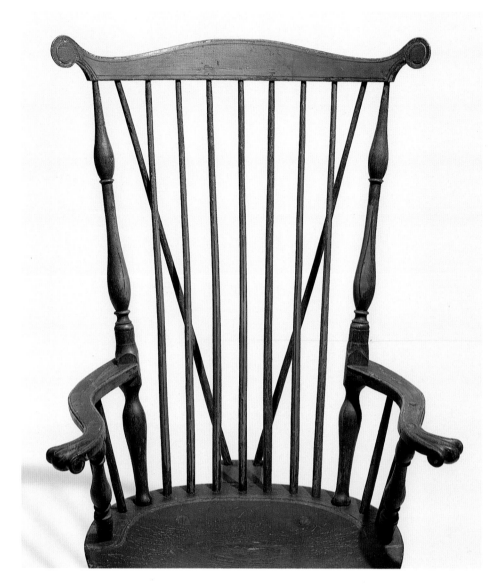

Pl. 1 Detail of right rear leg of figure 3-13. A tricolor painted surface dating from the late nineteenth century.

Pl. 2 Detail of upper structure of figure 6-235. A pencil-accented painted surface dating from the late nineteenth century. Striped decoration was a decorative technique that appeared only after the introduction of simulated bamboo turnings in the late eighteenth century, and it was confined initially to the creases separating the segments.

Pl. 3 Detail of crest of figure 6-230. A gilt-embellished painted surface dating from the late nineteenth century.

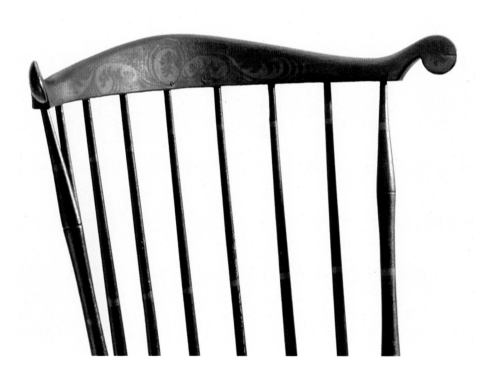

Pl. 4 Detail of seat and lower rail of figure 6-45. A two-color painted surface simulating mottled (tortoiseshell) rosewood dating from the mid to late nineteenth century.

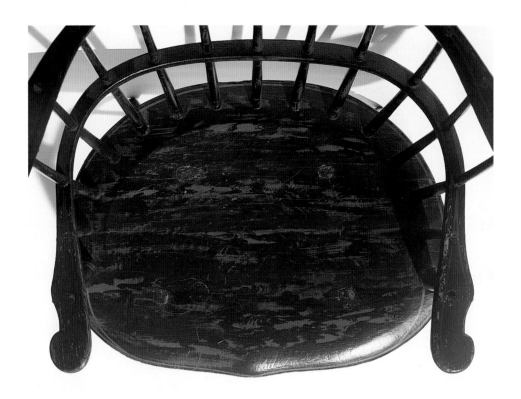

Pl. 5 Detail of left arm post of figure 6-48. An alligatored surface comprising multiple layers of paint and resin dating from the nineteenth and early twentieth centuries. The green visible in chipped areas is the second coat of paint. It probably predates 1815 and is the ubiquitous, eighteenth-century "Windsor green" made with verdigris pigment. The color is dulled due to yellowing of the protective resin coat.

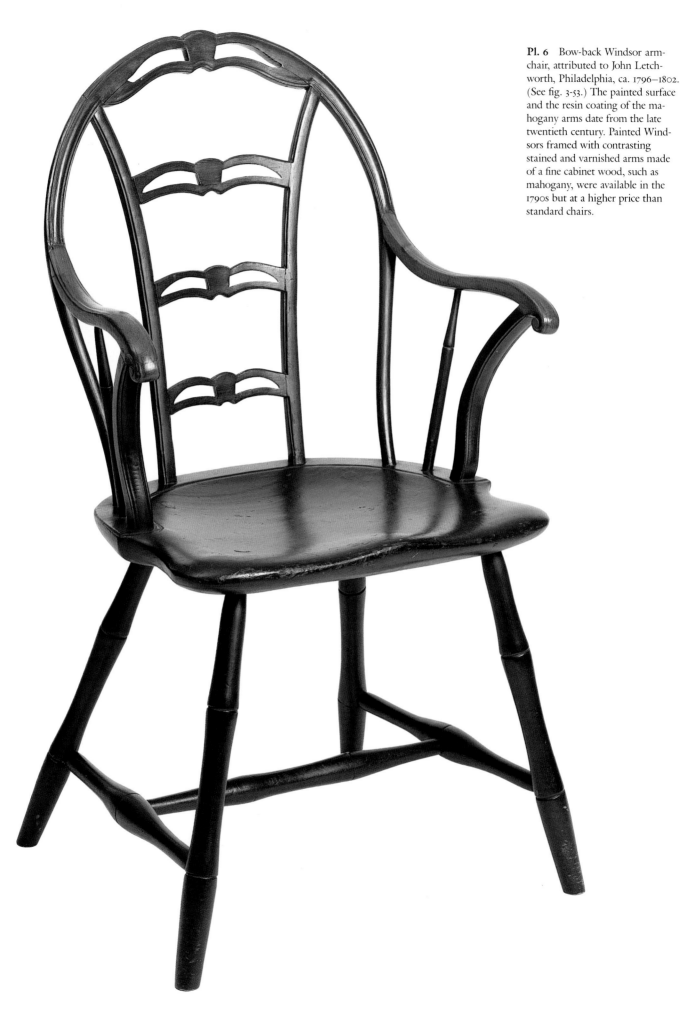

Pl. 6 Bow-back Windsor arm-chair, attributed to John Letchworth, Philadelphia, ca. 1796–1802. (See fig. 3-53.) The painted surface and the resin coating of the mahogany arms date from the late twentieth century. Painted Windsors framed with contrasting stained and varnished arms made of a fine cabinet wood, such as mahogany, were available in the 1790s but at a higher price than standard chairs.

Pl. 7 Bow-back Windsor side chair, Connecticut River valley in Massachusetts, 1798–1808. (See fig. 6-248.) The two-color painted surface probably dates from the early twentieth century, but exemplifies a contrasting paint scheme that was an option in the 1790s.

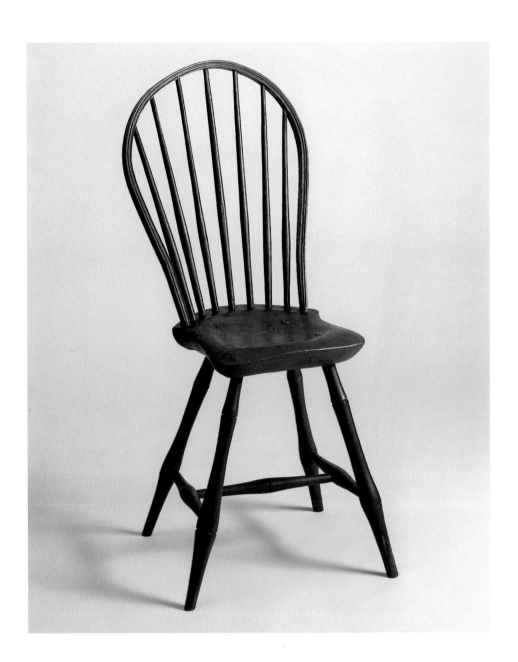

Pl. 8 Detail of left and medial stretchers of figure 6-154. The Prussian blue paint, now darkened by the resin coat and dirt, is original and was never overpainted.

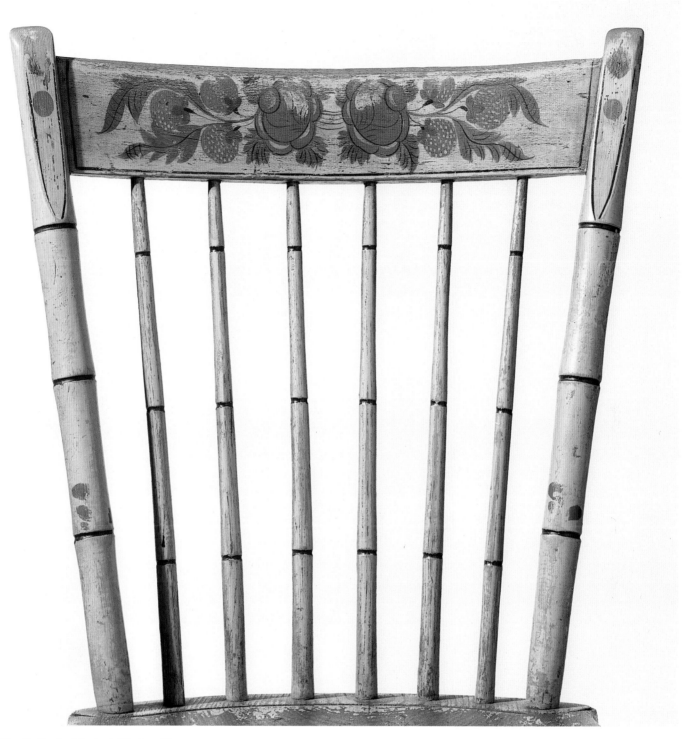

Pl. 9 Detail of back of slat-back Windsor side chair, southeastern central Pennsylvania, 1820–30. Yellow poplar (seat) with maple. H. 35″, (seat) 17¾″, W. (crest) 17½″, (seat) 16¼″, D. (seat) 15⅝″. (Winterthur 93.82.) Original surface paint and decoration.

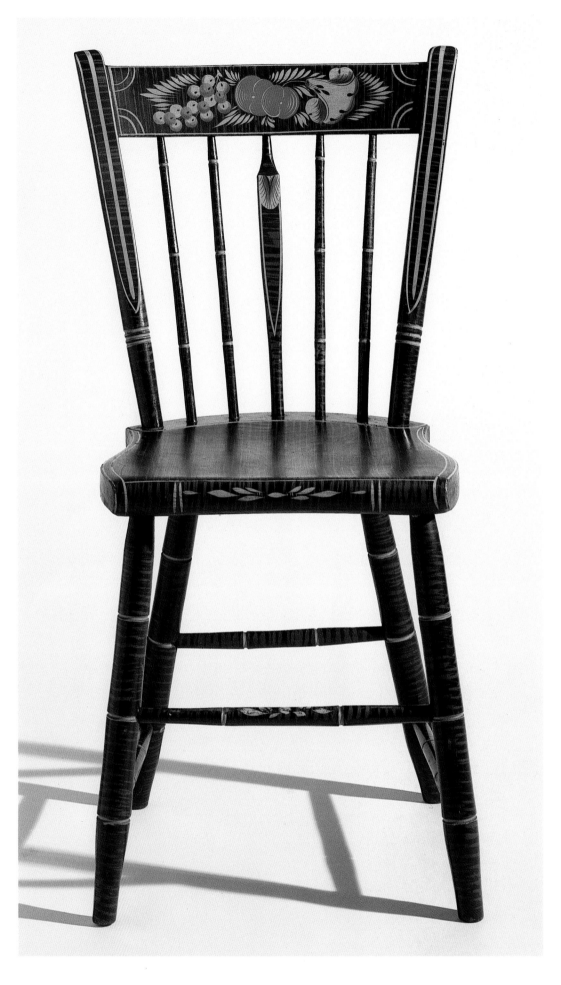

Pl. 10 Slat-back Windsor side chair (one of two), southeastern central Pennsylvania, 1825–35. Yellow poplar (seat) with maple; H. 34¼″, (seat) 17⅞″, W. (crest) 18³⁄₁₆″, (seat) 15½″, D. (seat) 15½″. (Richard S. and Rosemarie B. Machmer collection: Photo, Winterthur.) Original rosewood-grained surface paint and decoration.

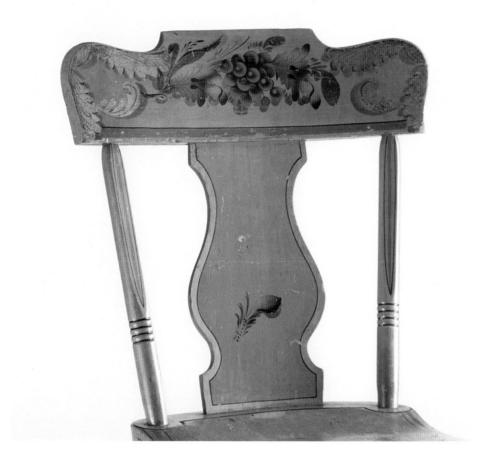

Pl. 11 Detail of back of figure 3-146. Original surface paint and decoration.

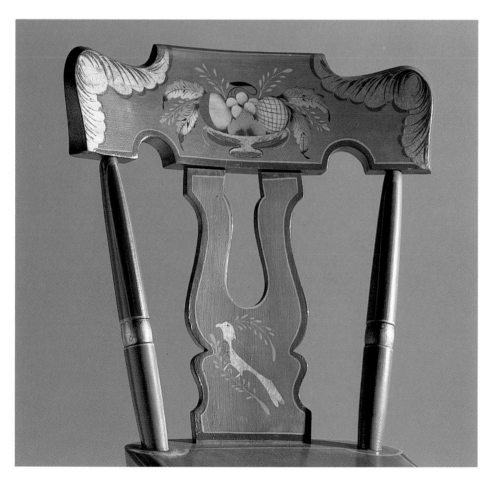

Pl. 12 Detail of back of figure 3-147. Original surface paint and decoration.

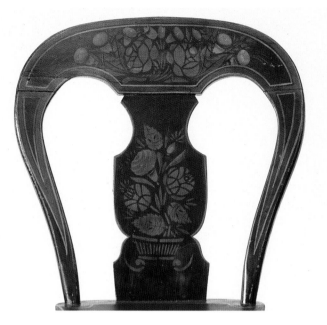

Pl. 13 Detail of back of figure 3-149. Original surface paint and decoration.

Pl. 14 Detail of upper back of figure 3-158. Original surface paint and decoration.

Pl. 15 Detail of a crest in set represented by figure 3-159. Original surface paint and decoration.

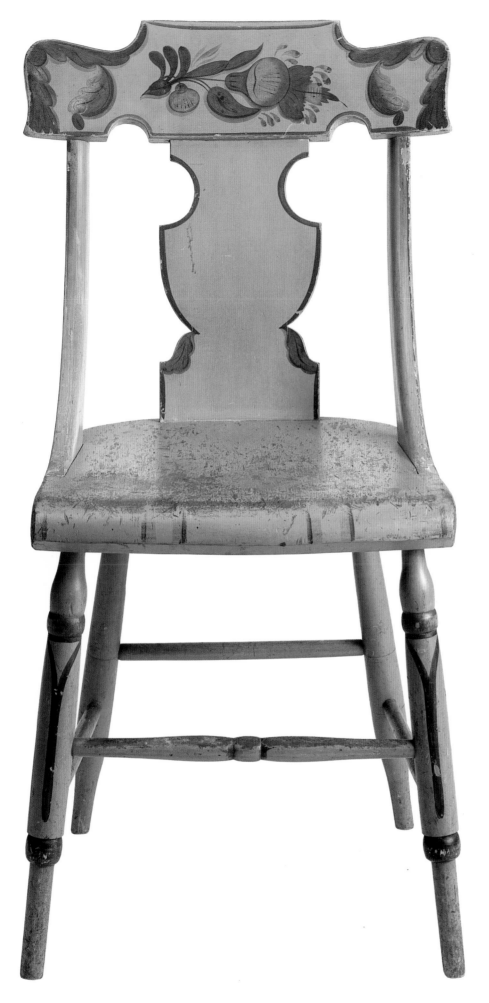

Pl. 16 Tablet-top Windsor side chair, T. Suplee (brand), eastern Pennsylvania, possibly Montgomery Co., 1845–60. Yellow poplar (seat); H. 33⅛″, (seat) 17⅞″, W. (crest) 18¾″, (seat) 16½″, D. (seat) 15⅜″. (Winterthur 92.62.) Original surface paint and decoration.

Pl. 17 Detail of upper back of figure 4-11.
Original surface paint and decoration.

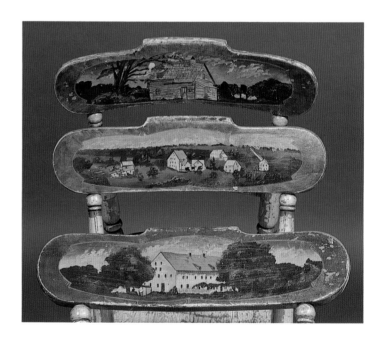

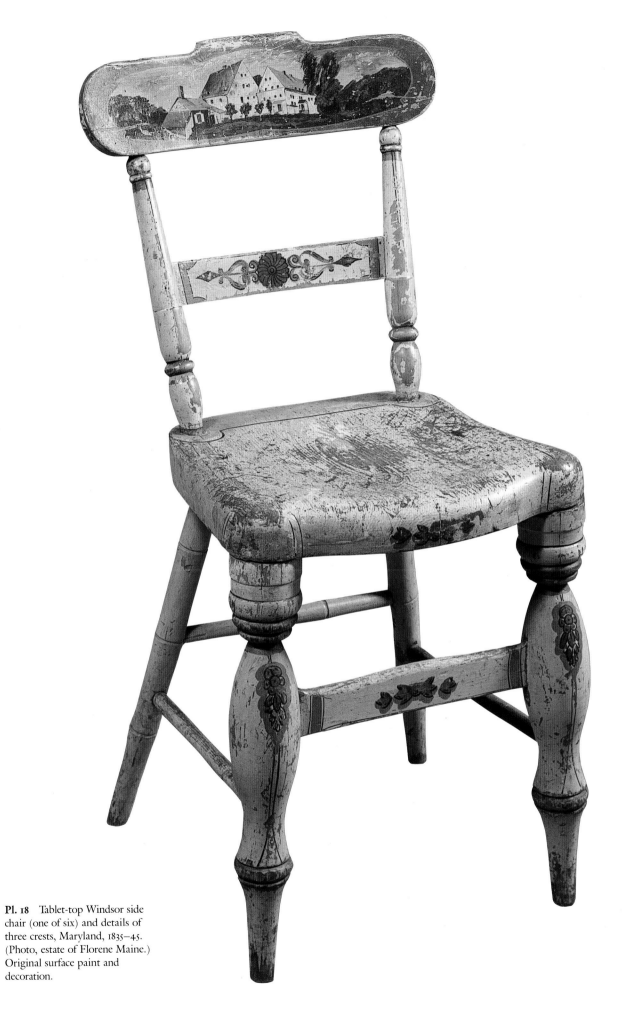

Pl. 18 Tablet-top Windsor side chair (one of six) and details of three crests, Maryland, 1835–45. (Photo, estate of Florene Maine.) Original surface paint and decoration.

Pl. 19 Detail of upper back of figure 5-43. Faded original robin's egg blue surface paint and decoration.

Pl. 20 Fancy slat-back Windsor armchair (one of two), New York, 1814–20. Yellow poplar (seat) with maple (microanalysis); H. 34½″, (seat) 18¼″, W. (crest) 16⅞″, (arms) 19¼″, (seat) 17½″, D. (seat) 16⅞″. (Winterthur 88.2.1.) Original surface paint and decoration.

Pl. 21 Detail of crest of figure 7-23. Original surface paint and decoration.

Pl. 22 Slat-back Windsor side chair (one of two), eastern Massachusetts or southern New Hampshire, 1820–30. H. 34¼″, (seat) 18⅜″, W. (crest) 18½″, (seat) 16½″, D. (seat) 16⅞″. (Steven and Helen Kellogg collection: Photo, Winterthur.) Original surface paint and decoration.

Pl. 23 Detail of upper back of slat-back Windsor side chair (one of two), probably by Thomas Atwood, Bedford, N.H., 1820–25. White pine (seat); H. 33⅞″, (seat) 17⅜″, W. (crest) 17¼″, (seat) 16⅛″, D. (seat) 15⅜″. (Formerly collection of Joshua and Leda Natkin: Photo, Winterthur.) Original surface paint and decoration. This chair and figure 7-78 are closely related in structural design and painted decoration.

Pl. 24 Roll-top Windsor side chair (one of six), possibly by Walter Corey, Portland, Me., 1836–41. H. 33¾″, W. (seat) 15¾″, D. 21″. (Old Sturbridge Village, Sturbridge, Mass.) Original surface paint and decoration.

BACKGROUND HISTORY

AND OVERVIEW

Classical and European Background

Development of Stick Construction and Turnery

A formal history of "Windsor" furniture begins with the ancient cultures, more than 3,000 years before the evolution of a recognizable Windsor design. Evidence of well-defined stools of stick construction occurs in the art of ancient Egypt. Artifacts and wall paintings depicting the daily lives of artisans from tombs of Eighteenth Dynasty (ca. 1570–1320 B.C.) kings and commoners alike document the use of simple, socketed stools made of plank seats drilled or gouged with holes in the bottom surface and fitted with plain, splayed sticks for legs. From the tomb of Tutankhamen (ca. 1370–1352 B.C.) a decorative lunette-shaped seat, or low table, with pierced, carved, and painted top and three curved legs with paw feet represents the high quality and sophistication occasionally achieved in this small wooden form. Such furniture was the exception, however, and the common specimens seen in representations of the craftsman class were low, plank-seat stools with dished tops and three stumpy, splayed legs of straight or curved form (fig. 1-1). Tomb drawings from Thebes (ca. 1460 B.C.) picture artisans seated on low wooden stools, and furniture from workmen's tombs at Deir el-Medina (ca. 1300 B.C.) includes examples made with rush or plank seats.[1]

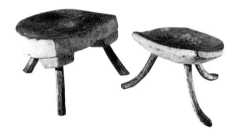

Fig. 1-1 Low stools, Thebes, Egypt (tomb of Kha), Eighteenth Dynasty (ca. 1400 B.C.). Painted wood; H. 14″ (left), 12½″ (right). (Museo Egizio, Turin.)

Evidence of stick construction occurs infrequently in Middle Eastern and Greek cultures, but more certain proof appears with the Roman Empire. Pictorial representations establish the popularity of low, stick benches and worktables for craftsmen and tradesmen. A first-century A.D. wall painting from the Vettii house at Pompeii shows a joiner at his trade, while a second-century relief panel from Rome displays the interior of a butcher's shop equipped with a dressing block raised on stick legs (fig. 1-2).[2]

A dearth of pictorial material from the early Middle Ages obscures the threads of evidence before the eleventh century when illuminated manuscripts depict craftsmen working at low benches. A thirteenth-century German wooden panel details a monk carving a choir stall (fig. 1-3). The relief shows a stool and a workbench with stick supports and a complete range of carver's tools, including chisels, mallet, square, and compass.[3]

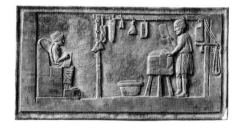

Fig. 1-2 Carved relief panel of butcher's shop, Rome, 125–150 A.D. Marble; H. 15″, W. 40¾″. (Staatliche Kunstsammlungen, Dresden.)

Illustrations of benches, stools, and tables with socketed supports appear more frequently from 1300 to 1500. In Lincolnshire, England, the illuminator of the Louterell Psalter (ca. 1340) drew two three-legged stick tables in a scene of meal preparations for the lord of the manor and his family. A century later a small four-legged stool is represented in a side panel of *The Mérode Triptych* by Flemish painter Robert Campin (Master of Flémalle, ca. 1378–1444) (fig. 1-4). This carefully constructed seat or footrest beneath Saint Joseph's workbench prefigures future utilitarian design in its rectangular form, precise socketing, and tapered cylindrical legs. In the late fifteenth-century painting *Wrath* from his series on the seven deadly sins, Hieronymus Bosch (1450–1516) shows an overturned large, rustic stick table at the left. The tapered, boardlike legs pierce

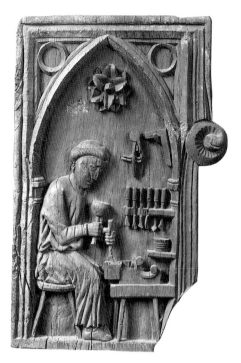

Fig. 1-3 Detail of choir stall, monastery chapel of Pöhlde, District Osterode, Harz, Germany, 1284. Wood; H. 57½″, W. 23⅝″. (Niedersächsische Landesgalerie, Hannover.)

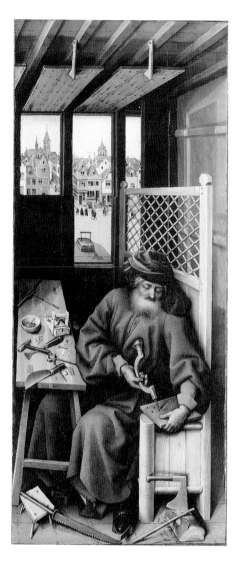

Fig. 1-4 Robert Campin, right panel of *The Mérode Triptych*, Flanders (Belgium), 1425–28. Oil on wood panel; H. 25³⁄₁₆″, W. 24⅞″. (Cloisters Collection, Metropolitan Museum of Art, New York.)

the round top and are strengthened below by a T-style brace secured with nails or wooden pins.[4]

A panel commemorating a 1483 marriage from the Florentine studio of Sandro Botticelli (1445–1510) shows an overturned stick stool with hexagonal top and a sophisticated stick-legged chair, its low U-shaped rail supported on short turned spindles (fig. 1-5). The chair is significant because it introduces socket construction to the plank top by

Fig. 1-5 Studio of Sandro Botticelli, details from *La Historia de Nastagio degli Honesti* (third of four panels), Florence, 1483. Oil on wood panel. (Museo del Prado, Madrid.)

adding a back support. Several early sixteenth-century engravings depict seating with backs socketed directly into the seats, such as *Saint Jerome in His Study* by Albrecht Dürer (1471–1528) (fig. 1-6). The well-known *Ständebuch* written by Hans Sachs (1494–1576) and illustrated in 1568 by Jost Amman (1539–91), describing Nuremberg professions, trades, and social classes in verse and woodcut, has many representations of seats, tables, and shop benches supported on socketed stick legs. Of the forty-seven woodcuts featuring seated figures, twenty-five show stools of this construction.[5]

Genre paintings by Flemish and Dutch masters of the sixteenth and seventeenth centuries provide more examples. Paintings and engravings by the Brueghels and their contemporaries abound with stick forms, which serve as props for the endless activity and frivolity depicted in the scenes. In *Alchemist* (1661), a panel by Adriaen van Ostade (1610–85), a low stool in the foreground introduces the stretcher—a relatively rare feature in stick furniture prior to this time (fig. 1-7). The braces substitute socketed "rounds" for the crudely nailed laths of earlier periods. The addition of stretchers to the stick form increased structural strength; the wide leg splay provided stability on uneven surfaces.

About twenty-five years after Ostade's cottage scene, Englishman Randle Holme completed *Academy of Armory; or, A Storehouse of Armory and Blazon* (1688), a monumental illustrated manuscript accompanied by woodcuts. Holme described two stools of stick construction from a page illustrating household objects as "a countrey stoole . . . being onely a thick peece of wood, with either 3 or 4 peece of wood fastned in it for feet. . . . If these be made long, then they are termed, either a Bench, a Forme, or a Tressell; of some a long seate" and "a round three footed stoole, or a countrey stoole made round with three feete" (fig. 1-8). Holme suggested that seats of stick construction were associated with rural work and use but gave no hint that the next several decades would produce a startling change in the simple, socketed English stool.[6]

The joiners and carpenters who produced the plain furniture were replaced in the transformation by turners. This craft united the techniques of stick construction and turnery that eventually led to the introduction of the Windsor chair. A mid fifteenth-century Flemish drawing portrays the social upheaval and change of the late Renaissance by indiscriminately mixing the turned seats of the privileged with the simple stools of the lower classes, a concept analogous to the unification of turnery and stick construction in the craft practice of one artisan group (fig. 1-9).

Fig. 1-6 Albrecht Dürer, detail of *Saint Jerome in His Study*, Nuremberg, 1514. Engraving; H. 9¹¹⁄₁₆″, W. 7⁷⁄₁₆″. (Metropolitan Museum of Art, New York, Fletcher Fund, 1919.)

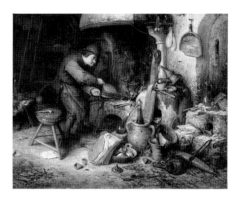

Fig. 1-7 Adriaen van Ostade, detail of *Alchemist*, Haarlem, Netherlands, 1661. Oil on panel; H. 13⅜″, W. 17¹³⁄₁₆″. (National Gallery, London.)

Fig. 1-8 Randle Holme, detail of woodcut engraving showing household objects. H. ¹³⁄₁₆″, W. 1³⁄₁₆″. From *The Academy of Armory; or, A Storehouse of Armory and Blazon* (1688), vol. 2 (London: Roxburghe Club, 1905), bk. 3, chap. 14, p. 15. (Winterthur Library.)

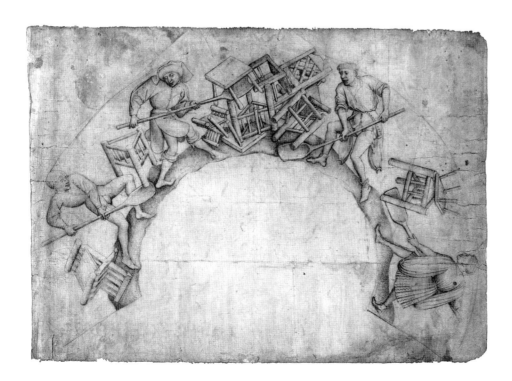

Fig. 1-9 Master of Flamand, school of Rogier van der Weyden, *Men Shoveling Chairs*, Brussels, ca. 1445. Ink and chalk on paper; H. 11¾″, W. 16¾″. (Robert Lehman Collection, Metropolitan Museum of Art, New York.)

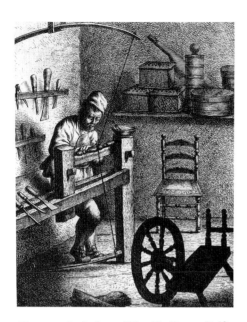

Fig. 1-10 Jan Joris van Vliet, *The Turner*, Delft, Netherlands, ca. 1635. Engraving; H. 8¼″, W. 6⅜″. (Rijksmuseum, Amsterdam.)

Turners traced their craft to ancient Egypt, where woodworkers made turned furniture in the Seventeenth (ca. 1650–1570 B.C.) and Eighteenth dynasties. The lathe was an important woodworking tool throughout the classical period, and many examples of turned seating are represented on terra-cotta, metal, and stonework from the first six centuries B.C. Turned furniture appears in wall paintings in Roman villas buried during the eruption of Mount Vesuvius in A.D. 79. After the decline of the Roman Empire, significant evidence of turned furniture recurs in Renaissance paintings. In *Adoration of the Magi* (ca. 1467) by Flemish painter Justus of Ghent (ca. 1435–ca. 1480), the holy family receives the three wise men in a simple setting containing a low, three-legged stick table with a circular, lathe-turned, dished top. A Dutch engraving of about 1635 delineates a fairly complete view of a turner's shop where the craftsman is surrounded by his pole lathe, hand tools, and products—a slat-back chair and a spinning wheel (fig. 1-10).[7]

Although many records of the London Company of Turners were destroyed in the Great Fire (1666), enough material survives to develop a rough history. In the early fourteenth century a guild of turners was formed. The group strengthened its organization, gained approval of its ordinances by the Court of Aldermen in 1478, and established a guild hall in 1591. The company strictly regulated the craft practices of members from the formative years onward, particularly about taking apprentices, employing foreigners (turners outside the guild), maintaining standards of workmanship, and hawking wares in the streets. The ordinances of 1608 describe the range of contemporary products—measures, shovels, scoops, bowls, wheels, pails, trays, and chairs. Regular production of spinning wheels and chairs (and, undoubtedly, stools) indicates the turners' familiarity with traditional socketed construction.[8]

Two developments in English turnery occurred after the fire. The serial publication of Joseph Moxon's *Mechanick Exercises* between 1678 and 1680 provided a lengthy essay, the "Art of Turning." The literate public was enlightened in the art, skills, techniques, and tools of the trade and provided with directions for various projects. The status of the London furniture industry was also changing at this time. Benno M. Forman has discussed the increasing popularity of the cane chair in the last decades of the seventeenth century. He has shown how the shops of both joiner and turner quickly became active centers in supplying local and foreign demand for cheap to expensive work. The widespread use of cane seating continued into the early eighteenth century until the Windsor chair succeeded it as the turner-chairmaker's staple product.[9]

The English Windsor, 1720 to the 1750s

EMERGENCE OF THE FORM

On the eve of the introduction of the Windsor chair, favorable conditions prevailed in England: the turned chair had soared to popularity; many skilled turners practiced in London, the center of government, commerce, and fashion; and the simple stool of stick construction was an article of daily use. When and where did the Windsor evolve from a stick stool to a turned chair? There are no precise answers, but present evidence provides guidelines to reconstruct a short history. The name *Windsor* as applied to seating sprang full blown into the London market of the 1720s.

The first references to Windsor furniture occurred in landscape gardening writings. Stephen Switzer in *Ichnographia Rustica; or, The Nobleman, Gentleman, and Gardeners' Recreation* (1718), the expanded edition of his 1715 treatise on rural gardening, described "a beautiful Rural Garden" at Dyrham Park, Gloucestershire, near Bath, the property of William Blathwayt, a ranking government official and seasoned traveler. During a walk through this delightful landscape, the visitor ascended from "a pleasant little Garden laid out into Gravel-Walks, Grass-Plats, &c." to a "Mount . . . in the Middle of a Warren [game preserve]; on the Top of which is a large Seat, call'd a *Windsor* Seat, which is

contriv'd to turn round any way, either for the Advantage of the Prospect, or to avoid the Inconveniencies of Wind, the Sun, &c."[10]

At face value the Windsor appears to have emerged as a swivel, or revolving, chair, but further investigation rules out this theory. In 1725 or earlier Daniel Defoe in surveying the "Prospect" from the "lofty Terrace" at Windsor Castle described another such contrivance:

Here also is a small Seat, fit for One, or but Two at the most, with a high Back, and Cover for the Head, which turns so easily, the whole being fix'd on a Pin of Iron, or Brass, of Strength sufficient, that the Persons who sit in it, may turn it from the Winds, and which Way soever the Wind blows, or how hard soever, yet they may sit in a perfect Tranquility, and enjoy a compleat Calm. This is said also, to be Queen *Elizabeth's* own Invention, who, though she delighted in being Abroad in the Air, yet hated to be ruffled with the Wind. It is also an admirable Contrivance for the Person sitting in it, to shelter himself from the Sun.

Three noteworthy points stem from Defoe's statement. The inspiration for the sheltered mechanical seat was of some antiquity, although perhaps not Elizabethan in origin, as claimed. The seat was constructed as an open box with board sides, back, and top—in short, as a narrow, modified settle. And the purpose of the design was to provide shelter from the wind.[11]

These points echo an observation that Celia Fiennes made at the close of the seventeenth century while on a journey through the country. At a private estate near Shrewsbury she described a garden with a large fountain where "at ye four Corners are seates shelter'd behind and on ye top and sides wth boards painted on w[hi]ch you sit secured from the weather." The descriptions by Defoe and Fiennes indicate that the Dyrham "Windsor" seat, designed for "the Inconveniencies of Wind," could not have been of the open-spindle Windsor construction known today. Instead, use of the term appears to have hinged (or pivoted, as it were) upon the mechanical aspect of the seat. Was Windsor Castle the inspirational source for revolving "settle" chairs? Blathwayt was intimately involved in politics until his retirement in the early 1700s; he was a favorite of William III and entertained Queen Anne at his Bath home in 1702. He and other members of the gentry and nobility would have visited Windsor Castle and observed the house and garden furnishings, including the swivel seats on the terrace. (Oddly enough, Fiennes failed to mention such novel chairs on her visits to Windsor.) If these were indeed the first "Windsor" seats, the link between them and the form recognized as a Windsor by the mid 1720s is yet to be established.[12]

Whereas the revolving settle of board construction was probably a product of the joiner-carpenter, the "stick" Windsor almost certainly emerged from turnery, although the earliest examples may have had few, if any, turned elements. Turners used a variety of shaving and smoothing tools, as shown in the London guild records, which list measures, pails, and spinning wheels among their production. Implements required for this work, such as drawknives, spokeshaves, and planes, would have been equally satisfactory for forming the various parts of the Windsor chair, including the sticks.

London apprenticeship records for the first quarter of the eighteenth century indicate that turners constituted a labor force of sufficient size to introduce and popularize a new chair design. In 1710/11 the Commissioners of Stamp Duties established county and city/town registers to account for moneys received upon drawing formal apprenticeship indentures throughout England. The records involved only those craftsmen who entered into apprenticeship bonds, and many were undoubtedly omitted, particularly in the earliest volumes; however, the recorded transactions probably represent a good cross section of activity. The first volume in the metropolitan series (October 1, 1711, to November 15, 1712) contains 2,700 entries. The master's trade is recorded in most instances, and that of the consenting parent appears in more than two-thirds of the listings. Of the total number, 35 entries identify turners, of whom twenty-three were masters and twelve were parents. Thirty-two turners resided in London or its suburbs and one each in Cambridgeshire, Buckinghamshire, and Berkshire. The first county

volume (from about May 1710 to late 1711), containing 3,100 entries, names only four master turners, one residing near London. Neither volume uses the term *chairmaker*.[13]

In the early to mid 1720s the number of metropolitan turners increased to forty; twenty-eight of these men (primarily masters) resided in London or its suburbs, and several masters lived in adjoining counties. Buckinghamshire towns are unlisted, although Reading in neighboring Berkshire was the home of two master turners. Of the four parents who lived in Berkshire, two sent their sons to London for training. The county indentures record only sixteen master turners, none in the London vicinity. The terms *chairmaker* and *turner-joiner* each occur once. The statistics indicate a concentration of turners in London, a few in the surrounding counties, and a sprinkling throughout the country. Additional records confirm that the number of turners in counties adjacent to London was limited.[14]

Published and manuscript inventory studies for London and vicinity prior to 1720 fail to mention Windsor chairs, although they provide a wealth of data concerning other seating and point to corollary activities. Turned chairs were "bottom'd with rushes" and alternatively described as "matted" or "flagen"; a few had "bassen" seats. Joined chairs, framed with mortise and tenon, had lightweight seats of woven cane or stuffed seats covered with leather, serge, turkey work (a loomed cloth with a woolen pile imitating Turkish carpets), needlework, or silk fabrics. In rural areas "joynt stooles" and board-bottom chairs in the wainscot (paneled) style continued in use. Another class of seating best described as rustic includes "wicker chaire," "twige chayre," and "rodded bottom." Pauline Agius cites similar references in Oxford inventories throughout the seventeenth century. This taste for simple chairs made of little-altered natural materials continued into the early eighteenth century when records introduce the "forrest" chair. The name suggests outdoor use in gardens and parks, a function similar to that of the early Windsor. Craftsmen apparently used their material as it came from the woods, rough and unfinished. In 1719 when appraisers drew inventories for the estate of Christopher, Viscount Castlecomer, they listed a forest chair in the hall of his Middlesex residence and twelve more "in the Banquetting house" on the green at his Charlton property in Kent. The "eight forrest Chairs at six shillings each" purchased by the Ingram family in 1720, probably for their Hills Place residence near Horsham, Sussex, required "caredge from Windsor six pence each." Other evidence of forest chairs used in halls occurs in inventories of George Chudleigh's Great George Street residence, Westminster, in 1739 and of William, Lord Abergavenny's Kidbrook House, Sussex, in December 1744. Lord Abergavenny stored additional forest chairs in the barn on his country estate, probably for use in the "Thatched House" and on the "Plantation" where "Three Forrest Elbow Chairs" already supplemented painted settees and four "Back Stools" with arms. The rustic look was simulated in finer materials for indoor use. For the royal establishment at Swinley Lodge, Henry Williams in the 1730s constructed "6 Mohogony Forest Chairs neatly carved with scrolls" at a cost of £24.[15]

Ever since twentieth-century furniture historians first began to discuss Windsor seating, the origin of the term *Windsor* has remained elusive. Many writers have assumed that the town of Windsor, located on the Thames at the gateway to the vast timber resources of the Chiltern Hills, was the logical birthplace of a new furniture form bearing the same name. The hypothesis is somewhat correct, although area records fail to show that inexpensive turned furniture was an article of local commerce. Rather, *The First Hall Book of the Borough of New Windsor, 1653–1725* portrays a castle town whose tradesmen catered to court needs. The services of innkeepers, victuallers, goldsmiths, joiners, upholsterers, and clothiers were in greatest demand; few turners plied their trade.[16]

A nineteenth-century reference sheds light on the mystery. In the 1836 Philadelphia edition of *The Panorama of Professions and Trades*, Edward Hazen noted in "The Chair-Maker": "The Windsor chair seems to have been first used for a rural seat in the grounds about Windsor castle, England; whence its name. It was originally constructed of round wood, with the bark on; but the chair-makers soon began to make them of turned wood,

for the common purposes of house-keeping." If Hazen's information is correct, it explains the origin of the name *Windsor* as applied to stick chairs. The reference circumvents the town altogether and links the furniture with the castle itself. A handy woodsman or carpenter perhaps conceived the idea of capitalizing on the abundant area materials to produce rustic seating for the grounds. Since many chairs so provided still retained bark, these may have been the forest chairs so popular among the nobility and gentry for their country seats beginning in the 1710s. As a royal residence Windsor Castle and its grounds attracted many visitors, who could have noted such chairs and then had their grounds keepers make similar seating for their own estates. The fashion probably spread quickly. Chairs were occasionally procured in Windsor and transported elsewhere at a fair expense, as in the case of the Ingram family seating. At an early date forest chairs intended for hall use were likely turned or made of fine wood by London craftsmen on special commission. The artisans quickly recognized a commercial opportunity and took the initiative, as Hazen indicated.[17]

The new seating rapidly advanced the already substantial demands of London craftsmen for raw materials. About 1725 Defoe described how the forests surrounding the High Wycombe area north of Windsor supplied London with wood. During a stop at Great Marlow, "a Town of very great Embarkation on the Thames . . . for Goods from the neighbouring Towns," he noted: "Here is also brought down a vast Quantity of Beech Wood, which grows in the Woods of *Buckinghamshire* more plentifully than in any other Part of *England*. This is the most useful Wood, for some Uses, that grows, and without which, the City of *London* would be put to more Difficulty, than for any thing of its Kind in the Nation." Defoe observed that timber was used in making felloes for the wheel rims of carts plying London streets; some wood provided billet for the king's palaces and fuel for manufacturing glass. For "Beech Quarters" Defoe described "divers Uses, particularly Chairmakers, and Turnery Wares," adding, "The Quantity of this, brought from hence, is almost incredible, and yet so is the Country overgrown with Beech in those Parts, that it is bought very reasonable, nor is there like to be any Scarcity of it for Time to come." Defoe cited the brisk timber business of the towns of Maidenhead, Henley, and Reading and noted that Berkshire was also "a very well Wooded Country." He added, "all the Bridges on the River between *London* and *Oxford,* are of Timber, for the Conveniency of the Barges." Defoe also described the timber supply and markets around Guildford and Maidstone to the south. In all his observations on country crafts, manufactures, and extensive commercial activity directed toward the London market, Defoe never spoke of a particular trade in Windsors or other chairs along the Thames from Berkshire and Buckinghamshire.[18]

Lumber merchants of London and the surrounding countryside exerted substantial control over the timber trade. A steady supply was critical, and contracts, or indentures, such as the one drawn between Garton Orme and Edmund Sherring in Sussex on January 26, 1720, were typical. For £210, Sherring, a "Timber-Merchant" of Cocking, purchased "All those two hundred and Sixty Beech Timber Trees together with those three hundred Sixty and Six Ash Timber Trees with the Lops and Tops thereunto belonging now standing and growing in or on the two bottoms and Hangers called or known by the severall names of Mail Comb and Deep Comb scituate lying and being in the parish of Eastdean in the County of Sussex aforesaid (All which said Timber Trees . . . are already sett out and marked with the Letters [RO] on the bodys or Stembs of the said Trees)." Orme gave Sherring and his workmen access to the land to cut down and convert timber until March 25, 1722, and permission to dig and set up sawpits and coalpits, provided the holes were filled when the lease expired.[19]

Turners as well as lumber merchants contracted with landowners for timber privileges. A December 2, 1723, agreement of sale between widow Jane Edmonds of Clapham, Surrey, and John Field and Edward Vickery of Berkshire, the latter a turner of Newbury, allowed the men to clear and use the underwood growing in a thicket known as Ridings Coppice in Enborne Parish, Berkshire, until the following July. John Leach, a "citizen and turner" of the parish of Saint Martin-in-the-Fields, London, secured timber

for his craft directly from West Wycombe and Bradenham as early as the 1690s. Before 1701 Leach returned to West Wycombe, apparently his birthplace, where he continued his trade. A contemporary "7 years account of wood felled At West wycomb" from the papers of the Dashwood family lists three kinds of local timber—beech (commonest), ash, and oak. In 1706 Robert Jenkins, a woodmonger of Lambeth, contracted with Sir Francis Dashwood, "Lord of the Manor of West Wycombe," to purchase 500 loads of beech timber on Booker Common, West Wycombe. These references solidify the evidence pointing to London as the place where Windsor seating was first produced. Large quantities of timber flowed into the city and suburbs, where a substantial work force supplied metropolitan and rural demand for a new, inexpensive seating form.[20]

The Windsor chair was introduced in the decade between 1710 and 1720. The cane chair had been in use for nearly fifty years by 1710, and its vogue was waning. Chairmaker-turners probably recognized the need to stimulate the market with a chair that could become as popular as the cane seat. A review of Windsor references from the 1720s lends support to this supposition and suggests that production began only after 1710.[21]

WRITTEN EVIDENCE OF EARLY PRODUCTION

Apart from the indefinite Dyrham Park reference, earliest mention of a Windsor chair dates to August 9, 1724, when Sir John Perceval wrote from Oxford to his brother-in-law, describing a tour through Buckinghamshire. Since this reference is also ambiguous and has caused speculation among modern scholars, it is appropriate to examine details of the traveler's comments, particularly the now-obscure subtleties of language:

Friday morning left Becconsfield; we went half a mile out of our way to see Hall Barn. . . . From the parteere you have terraces and gravelled walks that lead up to and quite thro' the wood, in which several lesser ones cross the principal one, of different breadths, but all well gravelled and for the most part green sodded on the sides. The wood consists of tall beech trees and thick underwood, at least 30 foot high. The narrow winding walks and paths cut in it are innumerable; a woman in full health cannot walk them all, for which reason my wife was *carry'd in a Windsor chair like those at Versailles,* by which means she lost nothing worth seeing.

The italicized phrase is a tantalizing puzzle in semantics. What did Lord Perceval mean by the word *like?* He probably intended it to be interpreted as "in the manner of." No evidence confirms that the Windsor was ever produced in France, where the popular, inexpensive seating form was the common rush-, or straw-, bottomed chair. Considering "carry'd," the *method* of transportation appears to be the focus. A small, open, one-horse riding vehicle, or chair, may be indicated; but, since Lord Perceval described the walkways as "narrow" and "winding," that seems unlikely. Perhaps Lady Perceval sat in a pushchair fitted with wheels or fixed to a low, wheeled platform, such as the garden and invalid vehicles delineated in chairmakers' trade cards later in the century (fig. 1-30). Similar conveyances were used in other gardens of the day. About 1733 Jacques Rigaud (1681–1754) depicted a pair of Windsor chairs mounted on wheeled platforms in the famous gardens of neighboring Stowe (fig. 1-11). Lady Perceval might also have ridden in a sedan chair. In view of the popularity of the Hall Barn gardens with their endless miles of paths, the owner may have provided a jerry-built Windsor chair attached to poles for two men to carry. Of course, Lord Perceval could have confused his terminology, and the conveyance may have been just an ordinary sedan chair. Semienclosed box-shaped portable chairs were in use at Versailles.[22]

Another reference to the Windsor is dated February 24, 1725, when London appraisers in Christ Church parish inventoried Richard Witchele's household furnishings. Since his widow had remarried, Witchele had probably died the previous year or earlier. The inventory is the only one listing a Windsor chair among 500 probate records of the Commissary Court of London dating between 1700 and 1730. The chair stood in the kitchen with other furniture: "one old table, six old wooden chairs, one windsor chair,

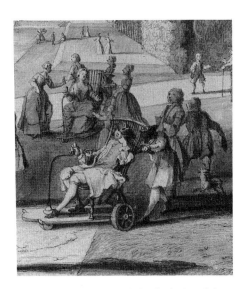

Fig. 1-11 Jacques Rigaud, detail of *View of the Queen's Theatre from the Rotunda*, Stowe, Buckinghamshire, England, 1733/34. Ink and wash drawing on paper; H. 11¹¹⁄₁₆″, W. 19¼″. (Metropolitan Museum of Art, New York, Harris Brisbane Dick Fund, 1942.)

one side board." Elaborate Windsors were part of the library furnishings at Canons, the residence of James Brydges, first duke of Chandos, near Edgware, Middlesex. A 1725 inventory of this splendid "palace" lists "seaven Japan'd Windsor chairs."[23]

In 1726 a London auction house printed two sale catalogues listing household property of the "Honourable Brigadier-General Munden, Deceased." The first, for furnishings in the general's London home near St. James's Square, mentions no Windsors, but a room-by-room inventory of his second "dwelling-house" at Egham, near Staines, lists eleven. The "Wardrobe," a room apparently used for general storage, contained one Windsor. The "Little Hall," a small but tastefully furnished gaming room, housed "Six windsor chairs with three cushions [£]0..10..0," and the "Green-House" had four Windsor chairs. An auction held on February 12, 1728, in Covent Garden disposed of household furnishings from the estate of Thomas Coke, "Vice-Chamberlain to his late Majesty." Sold as a lot for 5s. were "two cane Chairs, a matted Chair, A Windsor Chair, and a Table."[24]

The royal household accounts list mahogany Windsor chairs purchased from joiner Henry Williams between 1729 and 1733. Williams made a "neat" Windsor for the library of Frederick Louis, Prince of Wales, at St. James's Palace where other furniture included "6 doz of the best Beech Chairs wth Matted Seats £36" and "2 Doz of ordinary matted bottom Chairs £9." Two "richly carved" mahogany Windsors at £8.0.0 the pair graced the Blue Room at St. James's. Later in the 1730s Williams received an order for beech chairs and "2 very neat Mohogony Windsor Chairs with Carved Feet" priced at £8.10.0 for Hampton Court Palace. Turner William Crompton's 1735 bill to the Prince of Wales records a "Windsor Chair Civer'd [Covered] with Royal Mat" priced at £0.18.6 and delivered to his "House in St. James Park." Windsors were "covered" with other materials, such as "quilted crimson damask" on one sold at auction in 1733 from Sir William Stanhope's household. The term *covered* implies more than a cushion and probably denotes a case or pad fitted to the chair back for both comfort and protection from drafts.[25]

John Brown's April 1730 newspaper advertisement offering for sale "ALL SORTS OF WINDSOR GARDEN CHAIRS, of all Sizes, painted green or in the Wood" at his shop in St. Paul's Churchyard, is the earliest listing unearthed by furniture historians. The reference to size implies that Brown sold chairs with and without arms and settees of varying length. Some purchasers of chairs "in the wood" probably left their unpainted furniture in gardens to weather to a deep, natural color. The emphasis on garden use pinpoints the Windsor's initial function and closely links its genesis with the English landscape garden. Besides Switzer and Henry Wise, Charles Bridgeman was a leading figure in horticulture and garden design in the 1720s and 1730s. Bridgeman's 1738 estate inventory shows that he was familiar with the Windsor, since one stood in the room of his London house where he designed gardens for the nobility and gentry.[26]

The English landscape garden blended ideas borrowed from Dutch, French, and Italian design with the natural features of the countryside to create formal gardens, promenades, naturalistic rural prospects, wildernesses, and woods. Seats and benches were considered crucial to the total plan. Various writers describe the widespread use of garden seating, which included Windsors. Switzer suggested that at the "Intersections of . . . Walks . . . a Fountain, or a little Garden . . . be set round with little Nitches, Seats, and Benches." At Dyrham Park the owner erected "several seats . . . for Resting" along the ascent of a cascade and planted two small trees "encompass'd with Seats" at the bottom. At Wanstead Palace, Essex, traveler John Macky described a bowling green "incircled with Grotto's and Seats, with antique Statues between each Seat." The mount, or elevated prospect, was an important element of many gardens, and summerhouses or small temples with seats often crowned these low hills. At Beachborough House, Kent, in a domed temple on a rising slope above a pond, a family sat on high-back Windsor chairs and shared the distant view through a telescope (fig. 1-19). Greenhouses, such as the one at Dyrham, sometimes contained cane chairs in the summer, although Windsor furniture served equally well, as noted at General Munden's Egham property.[27]

References from the 1730s show the gradual diffusion of Windsor construction to areas far beyond London. A Chancery Court suit brought against Thomas Jobber, Esq., of Aston, Shropshire, introduced a bill of February 21, 1732/33, for extensive work done by William Cooke, a London upholsterer. One item, "a Windsor Chaire for a pattaren" at 6*s.*, suggests that Jobber intended to have additional chairs made by a local artisan who either was unfamiliar with the latest London design or, more likely in view of the early date, the particulars of Windsor construction.[28]

After the death of William, Lord Byron (1669–1736), a suit brought on behalf of his children against Frances, Lady Byron, and her second husband, Sir Thomas Haye, required appraisers to make a full inventory of the furnishings at Newstead Abbey, Nottinghamshire. The Windsors varied from a single chair in the hall to ten settees in four galleries. Indoor use of Windsor settees is unusual, and gallery locations add still another dimension to the function of this utilitarian form. At this date the term *settee* was usually associated with the long, upholstered seat, while Windsor size was generally expressed as an expanded (double or treble) chair.

		[£ s d]
In the Red Gallery		
4	Double Windsor Chairs	
	One Treble D[itt]o	3.03.00
8	Single Branches [candle arms]	
2	Glass Sconces	1.08.00
80	prints of Several Sorts	8.08.00
In the Great Gallery		
4	Treble Windsor Chairs, 6 Single D[itt]o	4.04.00
2	Arm Chairs and Cushoons	0.15.00
	A Harpesichord wth Leather Cover	5.05.00
	An Elks head A Wooden Bagg Pipe	1.01.00
In the Little Gallery		
12	Cane Chairs 4 Windsor Chairs	2.10.00
4	Arm Chairs and Cushoons	1.10.00
2	Marble slabs wth Iron frames	5.05.00
8	Single Branches 2 Glass Sconces	
	Double Branches	1.06.00
	A Brass Branch wth four Socketts	1.10.00
20	Pictures
In the Blue Gallery		
1	Treble Windsor Chair & Single D[itt]o	3.00.00
12	Single Branches	1.05.00
15	Heads [busts] 2 Lanthorns	1.01.00
2	Black Marble Tables wth	
	mohogany frames	5.00.00

In his study of the English country house, Mark Girouard describes the evolution of the gallery from its initial function as a connecting corridor, to a perambulatory hall, and finally to a room for displaying pictures, combining all functions by the end of the sixteenth century, although furnishings remained sparse. The original ecclesiastical design of Newstead probably explains the presence of four galleries. Beyond these areas, three Windsor chairs stood in "my Lady's Parlour," a room with an equipped hearth, window hangings, a looking glass, five watercolors, two oval tables, and a "Stone Side Board Table" accompanied by 10 "Wood" chairs and a "Leather Easy Chair." This inventory is particularly important since it describes in considerable detail both variety of form and range of use.[29]

Windsor seating was included among the household furnishings of other estates during this period. The 1738 estate records of Mary, dowager duchess of Northumberland, list at Sunbury House (probably at Epsom, now Epsom and Ewell, Surrey) eight

Windsor chairs in the hall, along with a "6 leafed Indian paper screen," a large "Turkey" carpet, and a large marble sideboard. Frances Seymour, countess of Hartford, referred to Windsor seating in a May 21, 1740, letter to Henrietta Louisa Fermor, countess of Pomfret. Lady Hartford described her estate "Richkings" near Colnbrook, Buckinghamshire: "There is one walk that I am extremely partial to; and which is rightly called the Abbey-walk, since it is composed of prodigiously high beech-trees, that form an arch through the whole length, exactly resembling a cloister. At the end is a statue; and about the middle a tolerably large circle, with Windsor chairs round it."[30]

George Bowes of Gibside, Durham County, had acquired directly or through an agent a selection of Windsor seating. His London accounts list a May 13, 1734, payment to John Willis of St. Paul's Churchyard for "1 Windsor Settee wth 4 seats, Two Ditto wth 3 Seats each, and 8 Single chairs at 6 ye Seat £5.8.0," the lot shipped north to the Tyne River aboard the *Thomas and Francis* at an additional expense of £0.2.6. Presumably, the furnishings were installed in the bathhouse at Gibside, the subject of preceding entries in the records. Almost a decade later in 1743, Bowes ordered additional Windsor furniture from London, the purchase again comprising chairs and settees. The green-painted seating may have been placed in the "Gothick Tower" that Bowes had just erected in the park surrounding the house. Both references offer rare insights into the special use of Windsors in this early period.[31]

Just as the 1720s and 1730s can be identified with the introduction and early production of Windsor seating, so the 1740s and 1750s are associated with major changes in the London furniture trades. Innovations in formal design swept the industry, and the market for cheap seating furniture began to grow. William Ellis, author of *The Timber Tree Improved* (1738), alluded to the latter in a chapter on the poplar tree when he commented on the "many Uses this Tree is converted to, especially to the Chair-Turner, who willingly gives five pence per solid foot if it is sound." Two other volumes, *A General Description of All Trades* (1747) and *The London Tradesman* (1747), also refer to craftsmen who produced cheap seating furniture and cite both diversity and specialization within the trade. By the late 1740s, turners consisted of two groups. One worked with fine materials such as boxwood, lignum vitae, and ivory; the other sold "a vast Variety of necessary Household-stuff," thereby engrossing "almost all the Produce of the *real Turners*, and many Trades besides." The *General Description of All Trades* recognized chairmakers as yet another group of craftsmen who produced seating furniture. Chairmaking was a craft in name only since "chairmakers" were drawn from several trades:

Though this Sort of Household Goods [the chair] is generally sold at the Shops of the *Cabinetmakers* for all the better Kinds, and at the *Turners* for the more common, yet there are particular Makers for each. The *Cane-chair-makers* not only make this Sort (now almost out of Use) but the better Sort of matted, Leather-bottomed, and Wooden Chairs, of all which there is great Variety in Goodness, Workmanship, and Price. . . . The white Wooden, Wicker, and ordinary matted Sort, commonly called Kitchen-chairs, and sold by the *Turners* are made by different Hands, but are all inferior Employs. Those covered with Stuffs, Silks, &c. are made and sold by the *Upholsterers*.

In less than three decades London production of Windsor, or "wooden," chairs had shifted from an activity of turners to a diversified business. Customer preference for quality determined the type of craftsman patronized, and this stratification within the chairmaking trade continued into the nineteenth century.[32]

PICTORIAL EVIDENCE

The earliest pictorial representations of Windsor chairs occur in the mid eighteenth century. The images depict three distinct designs, each with a counterpart in surviving furniture. High-back chairs appear first in Rigaud's 1733 perspective drawing of Lord Viscount Cobham's gardens at Stowe, Buckinghamshire (fig. 1-11). *View of the Queen's Theatre from the Rotunda* is one of fifteen drawings commissioned by Bridgeman, designer of the gardens, for a planned publication with engravings, *Views of Stowe*. On

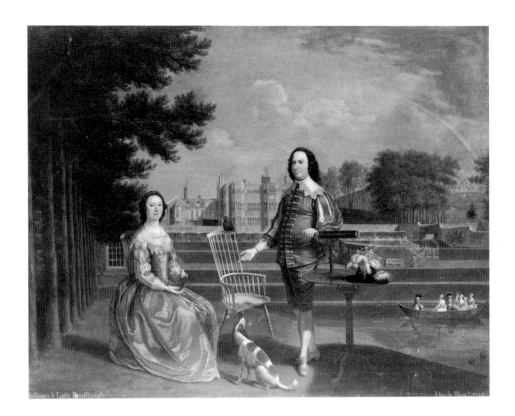

Fig. 1-13 *The Tobacco College of King Frederick William I of Prussia*, Potsdam, Germany, 1737–38. Oil on canvas; H. 51³⁄₁₆″, W. 68⅞″. (Sanssouci, Neues Palais, Potsdam: Photo, Halsey Papers, Winterthur Library.)

the gravel walk the artist carefully drew a man and a woman seated on Windsor chairs mounted on platforms fitted with wheels and tillers. These vehicles call to mind the chair used for Lady Perceval's excursion around the grounds at neighboring Hall Barn. The chairs in the drawing are large and somewhat clumsy, with flat, raillike crests and backs of extreme lateral curve. Turned ornament embellishes the front legs; the rear legs are plain "sticks."[33]

Similar chairs in two later paintings are more refined. In the 1746 portrait of Sir Roger and Lady Bradshaigh on the grounds of Haigh Hall, Lancashire, by Edward Haytley (fl. 1743–61), two high-back chairs are prominent in the foreground, and a settee appears in the middle ground under the double staircase (fig. **1-12**). The chair backs curve gently, and the crests form a peak. Beneath the arms are slat-style posts; the seat has a prominent ridge behind the centered front pommel, and multiple ball turnings partially form the legs. The Haytley painting is the rediscovered original of the Bradshaigh family, of which a copy had been commissioned prior to March 31, 1750. The Windsors in the copy, attributed to Joseph Highmore, differ from the original in several subtle ways, including the substitution of cylindrical posts for the slat supports and plain, flaring sticks for the turned legs. Chairs of related design, but with double-ogee crests, appear in a 1737/38 painting, *Tobacco College of King Frederick William I of Prussia* (fig. **1-13**). Since the Windsor was foreign to northern Germany, these high-back chairs were either imported or constructed from a pattern sent from England. Rulers of German descent also occupied the English throne, and Frederick's wife, Sophia Dorothea II, was George II's sister. One author has summed up the situation: "It is safe to guess that the mutual interchange of courtesies was such as to permit the ruler at Berlin to become acquainted with English Windsor chairs, and to awaken his desire to acquire such comfortable articles for his own use."[34]

Wooden chairs were practical for a smoking room since they lacked fabric-covered parts that absorb the smoke, not to mention being safer in avoiding fire. Englishmen were well aware of the problem even at this early date. Business records of Robert Gillow of Lancaster show that by 1746 his firm produced a corner smoking chair in mahogany with pierced banisters; later accounts indicate that the seats were covered with leather.

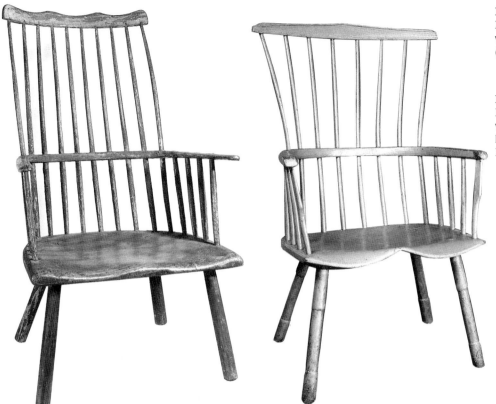

Fig. 1-14 High-back Windsor armchair, England, 1730–50. Elm and maple; H. 41¾″, W. (seat) 24″, D. (seat) 17⅛″; arm posts missing. (Colonial Williamsburg, Williamsburg, Va.)

Fig. 1-15 High-back Windsor armchair, England, 1740–60. Ash, elm, and oak; H. 42½″, W. (seat) 27½″, D. (seat) 16½″; one or both rear legs replaced. (Victoria and Albert Museum, London.)

Thomas Carlyle relates, "George I. at Hanover had his Smoking-room, and select smoking Party on an evening; and even at London . . . smoked nightly, wetting his royal throat with thin beer, in presence of his fat and of his lean Mistress, if there were no other company." How natural, then, for George's son and grandson to introduce sturdy, even elegant, Windsor chairs into St. James's and Hampton Court.[35]

The high-back Windsors in the three pictures are distinctive. Their large D-shaped seats, shaved arm supports, and, for some, plain stick legs are similar to an early English chair possibly from the 1730s (fig. **1-14**). A second, more refined high-back chair probably dates to the following decade (fig. **1-15**). The face of its triangular, architectural crest, which duplicates the profile of the Bradshaigh chairs, is molded along the edge in a modified ogee pattern that is repeated around the upper seat edge. The slat posts also relate to the Bradshaigh chairs. The unusual turned legs emphasize raised and depressed cylindrical sections for ornamental effect.[36]

Before 1750 Arthur Devis (1711–87) had established a prolific career as a painter of individual and family portraits emphasizing interior and exterior country settings. Devis incorporated into his outdoor portraits leisurely activities common to the gentry at their provincial estates—family discussion, reading, sketching, needlework, musical interludes, fishing, kite flying, and flower picking—all within a framework of gardens, terraces, and parkland where Windsor chairs are plentiful. Of a group of sixteen dated paintings depicting Windsor seating, eleven early views were executed between 1749 and 1754. Each scene pictures a fan-back Windsor side chair with stick legs and shaped crest rail with scrolled ends. Some chairs have braced backs; the seats are usually circular, but some are square. A detail from a 1751 garden portrait of the James family provides a glimpse of both the front and the back of a pair of chairs (fig. **1-16**). Except for the crest profile, the design resembles that of a small Windsor dating perhaps to the 1740s in the Bodleian Library, Oxford (fig. **1-17**). This rare type of chair is little known today, and outdoor use may explain its disappearance. This chair may have been part of a furniture suite. A small, two-seated settee in Jesus College, Oxford, bears a crest of identical

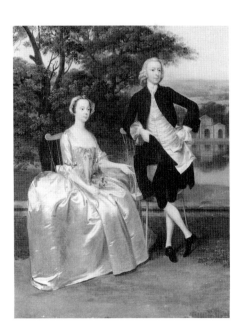

Fig. 1-16 Arthur Devis, detail of *The James Family*, possibly Essex Co., England, 1751. Oil on canvas; H. 38¾″, W. 49″. (Tate Gallery, London.)

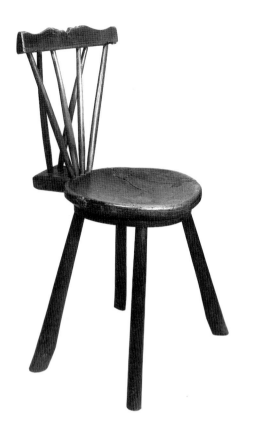

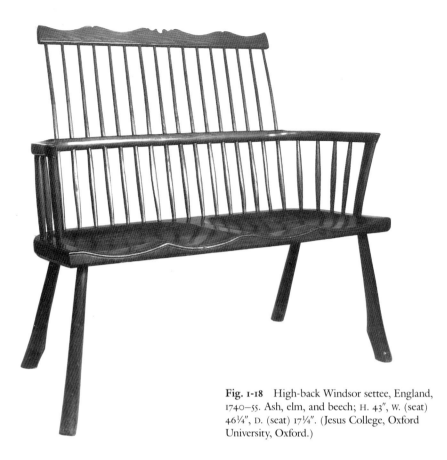

Fig. 1-18 High-back Windsor settee, England, 1740–55. Ash, elm, and beech; H. 43″, W. (seat) 46¼″, D. (seat) 17¼″. (Jesus College, Oxford University, Oxford.)

Fig. 1-17 Fan-back Windsor side chair, England, 1740–55. H. 33¾″, W. (seat) 14½″, D. (seat) 19″; seat reinforced, right front and left rear legs restored. (Bodleian Library, Oxford University, Oxford.)

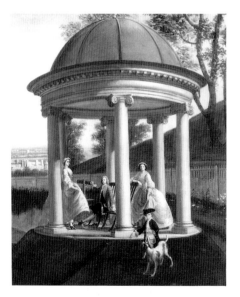

Fig. 1-19 Edward Haytley, detail of *The Drake-Brockman Family of Beachborough*, Folkestone, Kent, England, 1743. Oil on canvas; H. 20¾″, W. 25⅝″. (National Gallery of Victoria, Melbourne, bequest of Everard Studley Miller, 1963.)

pattern and has crude, hocked, stick legs similar to the two remaining original legs on the small chair (fig. 1-18). The simple feet echo the sophisticated hoof supports of high-style furniture produced early in the century. The "double chair" plank of the settee establishes the furniture's early date, since the individual scooped contours of the long seat have not yet given way to the flat surfaces of later years.[37]

Two paintings attributed to Haytley from 1743 and 1744 provide conclusive evidence that the shaped, boardlike crest of the furniture at Oxford predates the scroll-end design seen in the Devis paintings and in seating of the 1750s and 1760s. The first painting is a conversation piece of the Drake-Brockman family on the grounds of Beachborough House near Folkestone, Kent (fig. 1-19). Within a small temple two women stand near a gentleman seated on one of two plain Windsor chairs with flaring sticklike supports and a high back ending in a squared crest. The chairs closely resemble the settee at Oxford. A December 28, 1743, letter of Elizabeth Robinson, a neighbor of the Drake-Brockman family, tells of Haytley's painting a companion scene during his visit to Beachborough. By the following summer the artist was painting in Berkshire at Sandleford Priory, the home of Robinson's daughter and son-in-law, Elizabeth and Edward Montagu. Haytley included similar Windsors in a family portrait on a terrace overlooking a park. Three side chairs, one tipped over, are in full view; the Montagus' son carries another toward the group.[38]

The side chair delineated by Devis, the furniture at Oxford, and the Windsors in the Beachborough and Sandleford paintings represent stages of development from the earliest stick chairs to the finely turned and well-proportioned "Goldsmith" chair (fig. 1-21). Two other Devis portraits, one of Lord Clinton and the other of Lord Fitzgerald, depict Windsors with small turned balusters above the front feet. This refinement of an otherwise unturned stick support forges a real link between the first stick chairs and the more advanced Goldsmith pattern. The portrait of Henry Fiennes Clinton, earl of Lincoln, with his wife and son, painted between 1748 and 1752, suggests a midcentury date for the first appearance of the fully turned leg fashioned with long and short

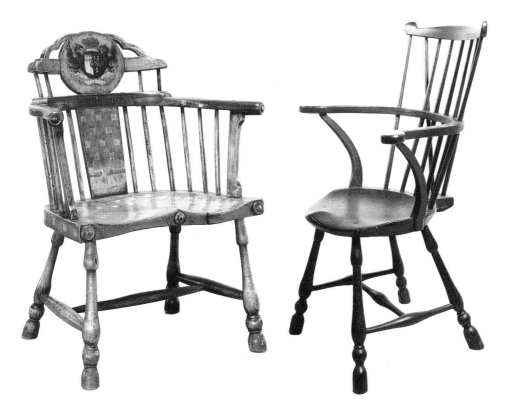

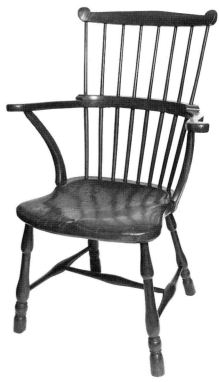

balusters terminating in a "colt's foot" (comprising a ball and round-top cylinder). The colt's-foot baluster leg probably originated in sixteenth-century Continental furniture; a *Ständebuch* woodcut illustrates the workroom of a draftsman whose backless stool has similar turned legs. Four colt's-foot legs braced by stretchers support a low-back chair whose inside back bears the painted arms of Perceval impaling Compton and the date "1756" in roman numerals (fig. **1-20**). The chair, probably part of a set, was apparently decorated for the marriage of Sir John Perceval, second earl of Egmont (1711–70), to Catherine Compton on January 26, 1756. Other painted details include an earl's coronet above the coat of arms, white squares with crosses from the Perceval arms on the seat, splat (or banister), and arm rail, and the name "Enmore" on the back rail. Enmore was Egmont's residence near Bridgwater, Somerset; however, he probably spent little time there because of his active political career in the House of Commons and later the House of Lords. The chair could have been purchased in Somerset, perhaps at Bristol, but likely originated in a London shop and was shipped by sea to Bridgwater. A 1758 engraving of the Studley Royal gardens, Yorkshire, pictures a similar chair in a round temple directly opposite a banquet house.[39]

The best-known colt's-foot chair, which probably dates to the 1750s, is the one Oliver Goldsmith bequeathed at his death in 1774 to his friend William Hawes (fig. **1-21**). The contoured, circular seat further develops the design of the chair at Oxford (fig. **1-17**) and those illustrated in the Devis paintings. The back and support structures are similar to those of a side chair in John Zoffany's (ca. 1733–1810) conversation piece of 1781, *The Ferguson Group*, although the seat shape varies (fig. **1-22**). Since Devis depicts both circular and squared seats in his canvases, the two apparently developed simultaneously. Closely related to the Goldsmith chair is an armchair from about 1760 that introduces a new shield-shaped seat like the compass form of the early Georgian high-style chair (fig. **1-23**). The design is a good compromise between the small circular seat and the large, somewhat awkward, squared bottom. As illustrated, stretchers became a common structural support in the 1750s.[40]

The three colt's-foot chairs introduce another new Windsor feature—a sawed arm rail formed of three pieces of wood that meet at the center back or back corners in lap joints. The new rail, used on formal corner chairs since the second quarter of the century, offered an alternative to the common bent arm. The heavy construction added strength, particularly in the high-back chair, and usually eliminated the need for bracing spindles. In two of the three chairs, the enlarged center back rail ends in short ogee curves (figs. 1-20, 1-23). The arms usually terminate at the front in large, horizontal scrolls. Francis Wheatley's (1747–1801) portrait of Mr. and Mrs. Richardson (1777/78) at their country estate features an armchair with heavy back rail and curved, sawed arm supports. In early work the arm support was often recessed into the sides of the seat as in figures 1-21 and 1-23 rather than into bored or slotted sockets in the plank.[41]

The English Windsor, 1750s to 1800

NEW PATTERNS AND WOODS

Unlike other new features, the addition of splats, or banisters, to Windsor chair backs probably occurred just before midcentury. Chairmakers used solid splats until high-style designs, popularized by Thomas Chippendale, introduced patterns with ornamental pierced openings. Bold and unusual splat profiles are found in a group of high-back Windsor armchairs from the 1750s or perhaps earlier. A typical banister has an inverted crown at the top connected to an elongated heart that joins another, shorter heart and terminates in a stepped pedestal closely related in profile to the crown (fig. **1-24**). A keystone- or urn-shaped element may replace the short heart. The earliest chairs in the group have shaved stick legs, while later ones sometimes have four tapered cylindrical legs, each with a small baluster near the foot. Most chairs, however, have rear legs of the baluster design with cabriole front legs; some chairs have four cabriole legs. Regardless of leg type, almost all the chairs have lathlike arm supports cut along the front in shallow curves, like those of figure 1-20. The curved back of the arm rail often repeats this profile. The seats are large, D-shaped planks contoured on the upper surfaces for comfort. The swelled cylindrical stretchers are sometimes ornamented with arrow-shaped tips or central turnings. The serpentine crest that is standard to this group of chairs has turned-up scroll ends supported on long, narrow laths flanking the spindles. At least one settee exists in this style, its seat consisting of two individually saddled surfaces.[42]

Two of these chairs retain fragments of original printed paper labels fixed to the seat bottoms. The label of figure 1-24 reads in its discernible parts: "RICHARD HEWETT / CHAIR-MAKER / At Slough, in t[he?] . . . [?]ar Windsor / MAKES and s[ells] . . . Forest C[hairs] / and all S[orts]." The label of the second chair, which bears the keystone-shaped variation of the banister and ornamental, turned stretchers, is in even poorer condition. Only the first two printed lines of the legend can be deciphered: "John Pitt, / WHEELWRIGHT and CHAIRMAKER." Remnants of the third line appear similar to the wording of the Hewett label: "At SLOU[GH] . . . [WIN]DSO[R]."[43]

These chairs are extremely important because few well-documented, eighteenth-century English Windsors are known. The design represents a substantial transformation of the high-back style from the earliest forms to a more refined pattern suited to chairs intended for indoor as well as garden use. In addition, Slough, twenty miles west of London and adjacent to the Chiltern Hills, is pinpointed as a small chairmaking center at midcentury. Slough and metropolitan chairmaker-turners may have produced similar furniture, a premise suggesting that many craftsmen in areas surrounding London received their training in the city and then returned home to pursue their trade. This is substantiated in the apprenticeship records of the Commissioners of Stamp Duties and in the career of John Leach, who worked as a turner in the London parish of Saint Martin-in-the-Fields before returning to West Wycombe to continue his trade. Slough is close to Richings, the Colnbrook estate of the countess of Hartford who had

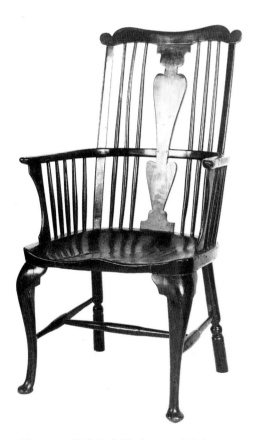

Fig. 1-24 High-back Windsor armchair bearing the label of Richard Hewitt, Slough, Buckinghamshire, England, 1750–60. Ash, beech, and elm; H. 45″, W. 23″, D. 18″. (Thomas Crispin collection.)

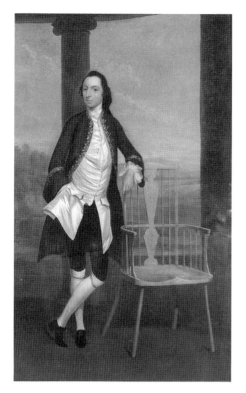

Fig. 1-26 High-back Windsor armchair, England, 1760–70. Ash, fruitwood, and birch; H. 44″, W. 23″, D. 19½″. (Victoria and Albert Museum, London.)

Fig. 1-25 Arthur Devis, detail of *Lascelles Raymond Iremonger*, Thames Valley, England, 1747–49. Oil on canvas; H. 24¼″, W. 16½″. (Private collection: Photo, Paul Mellon Centre for Studies in British Art, London.)

used Windsor chairs in her garden by 1740; and only a short distance beyond Richings was the Egham residence of General Munden, whose estate was dispersed in 1726.

Devis's portrait of Lascelles Raymond Iremonger, featuring a Slough-type chair, also suggests that many chairmakers trained in London and then returned to their neighboring home districts (fig. **1-25**). The chair, an early version of the pattern, has plain, shaved legs without stretchers, slightly modified splat profile, and crest similar to that of fanback chairs in Devis's James family portrait (fig. 1-16) and his works from the late 1740s. The subject of the portrait is identified on the back of the canvas, and the work was probably painted between 1747 and 1749. It is one of twelve Devis portraits that hung originally at Uppark in Sussex (near the Hampshire border). Dated paintings in the group range from 1746 to 1749. The work was either commissioned by Sir Matthew Fetherstonhaugh of Uppark or brought to the house by his wife, Sarah Lethieullier, "daughter of a rich Middlesex merchant." Devis may have painted the canvas in his London studio, in the adjacent countryside, or at Sussex, but not at Slough—a circumstance strongly indicating that the chair pattern originated in London and was then transmitted to surrounding regions.[44]

In the 1760s the Slough-type armchair underwent several modifications. This new streamlined pattern, like the first, combined stick legs with cabriole front supports (fig. **1-26**). Small spurs on the splat just above the arm rail eventually became a shaped medallion at midsplat. The back was narrowed and the seat reduced in width. Scrolls and piercings were added to the upper, and sometimes lower, half of the splat in the early Georgian manner. The arm supports remained curved. The crest, with opposing end scrolls, evolved from the original design. Simple, cutout ogee curves replaced the shoulders near the terminals; the bottom edge was straightened. Side chairs of the updated pattern usually have braced backs. Pierced and unpierced banister variations appear in a few round-top armchairs.[45]

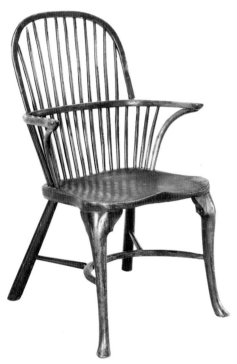

Fig. 1-27 Walter C. Horsley, detail of *Old Time Tuition at Dulwich College*, London, 1828. Oil on canvas; H. 33⅛″, W. 42¼″. (Dulwich College Picture Gallery, London.)

Fig. 1-28 Round-top Windsor armchair, England, 1755–75. Yew, elm, and beech; H. 37½″, W. 19¼″, D. 17¾″. (Colonial Williamsburg, Williamsburg, Va.)

English paintings depicting Windsor furniture rarely show details of household furnishings. An exception is Walter C. Horsley's 1828 *Old Time Tuition at Dulwich College*, picturing a tutor teaching from his bed. At the left, a young pupil studies his lesson in the generous lap of an eighteenth-century round-top ("bow back" in popular British terminology) armchair in which H-plan stretchers join cabriole and stick legs, and a pierced splat ornaments the back (fig. 1-27). The artist has rendered the splat with such meticulous care that the pattern can be recognized as a Slough-type design with a medallion at the arm rail and a heart-shaped vase beneath it (fig. 1-26).

The round-top chair originated in the 1750s. An early example has plain stick legs, a spindle back, and a D-shaped seat. As the form advanced, pierced splats in the upper backs and cross stretchers appeared on a few chairs with turned cylindrical legs. The bracing, unusual in Windsors, also occurs on chairs with cabriole legs. The inspiration was clearly the cross-stretcher design found in many low-back reading or writing chairs made of fine wood. In other contemporary round-top designs, mixed features seem the rule—sawed or bent arm supports, splats or spindles, turned or cabriole legs, H-plan braces or fashionable curved stretchers. Plain designs emphasize curved lines and silhouette (fig. 1-28). A round-top chair is featured in a painting completed between 1769 and 1773 of Sir James Langham, sheriff of Northampton County and later member of Parliament, his wife, and their young child in a park setting. Lady Langham's skirt covers the lower chair front, but a spindle back, bent arm supports, and rear stick legs are visible behind the costume.[46]

The use of fine woods, such as mahogany, in English Windsor furniture has a long history extending from royal household purchases in the 1730s until well into the nineteenth century. The earliest surviving examples from the late 1750s or early 1760s include several low-back mahogany chairs at Ham House, London (fig. 6-12). Appraisers in 1763 listed a "Mohogany Elbow Windsor chair, loose leather Squab" at the shop of William Linnell, "Carver, Cabinett-maker & Upholsterer," when his son John took over the family business in Berkeley Square, London. The 1765 estate inventory of Leak Okeover, Esq., compiled at Okeover Hall, Staffordshire, lists six mahogany chairs valued at £9.9.0. The duke of Cumberland's furnishings at Windsor Great Lodge the same year included a mahogany chair in the butler's pantry. Placement of a Windsor in a service area suggests that the chair was already quite old or in poor condition.[47]

Windsor chairs constructed of yew were made in several designs, some highly ornamental. The masters of Jesus College, Oxford, chose fine wood over cheaper materials when they purchased "18 new Yew-tree chairs @15/-pr chair" for the common room in 1773; the design was unspecified. Gothic-style yew armchairs, adapted from round-top chairs, feature arched or pointed bows above the arm rails (fig. 1-29). Three long splats, pierced to imitate tracery, fill the space between the bow and the seat; shorter versions occur beneath the arms. These decorative silhouettes reflect motifs from midcentury design books. Front cabriole legs, connected by curved stretchers, usually have knee brackets, although some have been lost over the years. Windsor and rustic furniture "in the modern Gothic" style was fashionable by the early 1750s, as indicated in an advertisement of William Partridge of Banbury. Linnell's London workshop contained "a garden Gothick Chair painted" in 1763. Trade cards of chairmakers who worked in London during the last quarter of the century document the continued popularity of this picturesque design for garden furniture (fig. 1-30).[48]

A pierced splat, carved work, and ornamental turning embellish an exceptional yew armchair in a different style (fig. 1-31). The supports, seat, and arm assembly date after 1750. The sweeping C scrolls and forked pedestal of the strapwork splat, which reflect designs disseminated by Chippendale and others at midcentury, are new to the Windsor. William Ince and John Mayhew's patterns for fire grate grills, illustrated in *Universal System of Household Furniture* (1759–62), suggest prototypes for the chair's ornamental spindles. Subtle design features include scrolled and carved arm terminals and openwork leg brackets that echo the splat piercings.[49]

Fig. 1-29 Two Gothic-style Windsor armchairs, England, 1765–1800. Yew and elm; left: H. 41⅜″, W. 24½″, D. 22½″; right: H. 36½″, W. 23½″, D. 24″; (right) knee brackets missing. (Victoria and Albert Museum, London.)

Fig. 1-31 High-back Windsor armchair, England, 1760–75. Yew; H. 40½″, W. 20¼″, D. 17½″. (Colonial Williamsburg, Williamsburg, Va.)

DIFFUSION OF THE FORM BEYOND LONDON

Written sources from midcentury document further the social history of the Windsor. A 1754 London inventory for the late "Rt. Honble Henry Pelham's" house in Arlington Street lists a Windsor in "Mr Robert's Room and Passage." The following year two chairs in "The India Paper Closets, adjoining to the Drawing Room" formed part of the house furnishings of Henry, earl of Grantham, in Albemarle Street, St. James's. These chairs perhaps provided additional seating for the drawing room.[50]

The Windsor continued in favor outside London. In Jackson's *Oxford Journal* of July 13, 1754, Partridge announced that he had "open'd a SHOP near the *White Lion* in *Banbury*" to supply the area "with all Sorts of the most fashionable Furniture in the Cabinet Way" and "Garden Seats, Windsor and Forrest Chairs and Stools in the modern Gothic, and Chinese taste; and all other Things made in Wood that are not to be had in this Part of the Country of any Person but himself." Provincial craftsmen with the requisite skills and knowledge of current design capitalized on the distance between the local consumer and the metropolitan market.[51]

By the late 1750s the Windsor chair had become popular in inns and taverns along main travel routes and in other facilities where people congregated. Tobias Smollett, while imprisoned in 1759, described Windsor furniture in public houses in his *Adventures of Sir Launcelot Greaves*: "It was on the great northern road from York to London . . . that four travellers were . . . driven for shelter into a little public-house on the side of the highway. . . . The kitchen, in which they assembled, was the only room for entertainment in the house, paved with red bricks, remarkably clean, furnished with three or four Windsor chairs, adorned with shining plates of pewter and copper saucepans, nicely scoured." About 1766 the Bodleian Library was enhanced "by the Introduction of Windsor-Chairs, so admirably calculated for Ornament and Repose."[52]

Gillow's Lancaster furniture firm, established about 1728, conducted business for more than thirty years before producing Windsor furniture. Local sales in 1759 and 1760 give information on price and finish: a "large Windsor Chair wth painting" cost 8*s*.; an unpainted one sold for 6*s*. Although most Windsors were painted green, particularly appropriate for their outdoor use, other colors were available. A 1762 inventory of Lord

Fig. 1-30 John Stubbs trade card, London, 1779–98. Engraving; H. 3¼″, W. 5″. (Banks Collection, British Museum, London.)

Waltham's property at New Hall, Essex, describes the seating of the hall, a large dining room, as "three Doz Cherry Tree Hall Chairs Colourd" accompanied by "two Windsor chairs & a Seat D[itt]o painted White."[53]

Windsor production had spread throughout England by the 1770s and gained a substantial foothold in the furniture market. Early use in gardens, gentlemen's smoking rooms, and picture galleries was expanded to include service in domestic quarters, gaming rooms, small parlors, and multipurpose halls. The requirements of public taverns, inns, and libraries for substantial but economical seating encouraged a general demand for single-seat and extended Windsors. Late eighteenth-century documents describe the Windsor's use in daily life. Edwin Lascelles, proprietor of Harewood House in Yorkshire, supplemented furnishings from Chippendale's London workshop with purchases from local artisans. In 1773 John Green supplied him with a dozen Windsor chairs, possibly for use in servants' quarters. In neighboring Ripley, the 1773 estate of Sir John Ingilby included a chair in the study and another on the staircase. In Lincolnshire a 1775 appraisal of the estate of Frederick Augustus Hervey, fourth earl of Bristol and bishop of Derry, located six Windsors in the hall of his Leasingham residence and three more at his office in Sleaford. Across the Wash in the town of Little Walsingham, Norfolk, the moderate household of "Mrs. Williams, deceased" in 1780 included a Windsor chair and mahogany seating covered with horsehair. The 1788 household inventory of William Mayhew, Esq., of Colchester, Essex, described a Windsor chair as part of the furnishings of his "Clerk's Office": "A mahogany Double writing Desk on frame, A black Ink-tray, . . . A 2 light brass Candlestick, . . . A Mahogany Reading Table, A Walnutt-tree Drawing Chair, A Mahogany Stool and Steps, 2 Mahogany Compting House Stools, . . . a Windsor Chair, a large Wainscott case for Writings, . . . 8 Prints fram'd and Glaz'd, . . . a small grate Shovel and Poker."[54]

The west country was the scene of brisk retail activity in Windsor seating by the 1770s. When Bartholomew Sykes of Bristol disposed of furnishings before his move to London in 1772, "boarded Bottom and Windsor Chairs" formed part of the sale lot. In 1785 two Bristol furniture artisans offered their stock-in-trade at public sale. A carver and gilder named Williams in St. James's Churchyard advertised "a general Assortment of Walnut and Windsor Chairs," while a cabinetmaker named Robbins of Bridge Street sold mahogany, "Dressing," and Windsor chairs. As in London, Windsors were produced and sold not only by chairmakers and turners but also by other artisans. The extent of the Bristol market and the opportunities for inland distribution of Windsors from Bristol and elsewhere are indicated in a local directory notice of 1784. Thomas and Edward Easthope, who announced as "Barge-masters for conveying Goods from Bristol to Stratford-upon-Avon, &c," identified the important role of canals and navigable rivers in this trade. Timber merchants across the country also took advantage of this network of waterways to transport the raw materials of the woodworking trades.[55]

LONDON MARKETING AND LATE STYLES

London commodity distribution changed during the last decades of the century when warehouse marketing enabled entrepreneurs to gather goods from many craftsmen and sell them at one location. A wide range of ready-made household furnishings concentrated under one roof allowed customers to make on-the-spot selections. Wilkinson and Son's warehouse in Cheapside offered case furniture, bedsteads and bedding, looking glasses, clocks, stoves, and seating comprising japanned, dyed, Windsor, and neoclassical cabriole chairs. Like other London craftsmen and retailers, the Wilkinsons catered in part to the export trade. On the reverse of a surviving trade card is a 1779 bill for furnishings purchased for shipment to Madeira. In 1792 D. Watson and Son, cabinetmakers and upholsterers on Bridge Street, Westminster, prepared to ship "12 Round top'd Green Painted Elbow Chairs," priced at 7s. each, by winding hay bands around vulnerable surfaces and wrapping the chairs in mats.[56]

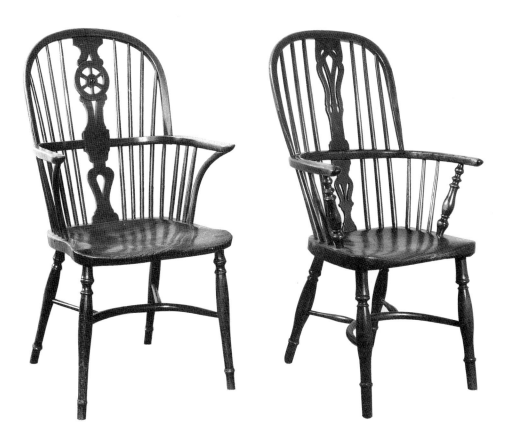

John Stabler has documented a shipment of Windsor furniture from London to Durham County during the last quarter of the eighteenth century. One of a pair of round-top armchairs with pierced splats featuring wheel motifs, known today as "wheel-back" Windsors, is inscribed on the seat bottom: "Mr. Longridge / Gateshead / Durham / 6 Chairs / by the Vulcan Captn R Hawks / or by the first Ship in that Trade" (fig. **1-32**). The chairs, datable between 1779 and 1783, were purchased by Thomas Longridge of Gateshead on the Tyne River. Shipping records reveal that Robert Hawks, captain and part owner of the brig *Vulcan,* traded from the neighboring port of Newcastle to foreign markets, except for the years cited when he made many runs to and from London. When Longridge acquired the chairs, his employer was William Hawks, Robert's brother. Longridge ordered the chairs personally or through a London agent, and it was no coincidence that he preferred that Hawks bring them to Gateshead. With this discovery the wheel-back Windsor can be assigned a date well before the turn of the century. The style was in fashion when Longridge bought the seating, suggesting that chairmakers had developed the splat pattern and distinctive leg turnings at least by the mid 1770s. London was still the center for new design, as it had been for centuries, and innovative Windsor features continued to originate there. As late as 1802, *The London Chair-Makers' and Carvers' Book of Prices for Workmanship,* a volume devoted principally to formal seating furniture, illustrated and described two methods for "FRAMING Windsor elbows," further confirming the continued demand for and salability of this vernacular form in the local market.[57]

In a separate line of study the Longridge chairs are the starting point for a chronology of turned supports made between 1780 and 1860. According to this system, a chair made by Frederick Walker of Rockley in Sherwood Forest dates between 1835 and 1850 (fig. **1-33**). Comparison of the leg turnings with those of the Longridge Windsor illuminates design changes that occurred during the first half of the nineteenth century. The flared collar at the leg top moved downward, compressing the spool-and-ring turning. The long, inverted baluster became shorter and thicker, while the ring near the foot moved slightly upward.[58]

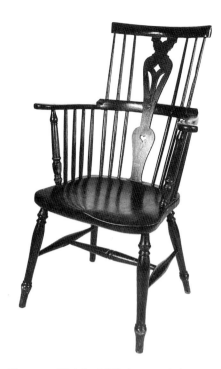

Fig. 1-34 High-back Windsor armchair, England, 1775–84. Walnut; H. 42″, W. 23″. (Royal Ontario Museum, Toronto.)

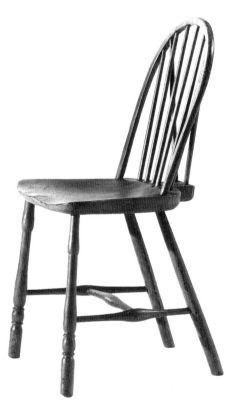

Fig. 1-35 Bow-back Windsor side chair, England, 1760–1800. Elm and beech; H. 34⅛″, W. (seat) 15½″, D. (seat) 17″. (State in Schuylkill collection: Photo, Winterthur.)

The Longridge leg profile appears in a high-back armchair, by tradition a 1784 wedding gift to Christiana Merkley and Jacob Ross from Sir John Johnson, Superintendent General of Indian Affairs in British North America (fig. **1-34**). The chair also incorporates features of two other distinct designs. The splat modifies the pattern used by Hewett at Slough (fig. 1-24) by eliminating the pedestal at the base and extending the short heart-shaped vase to the seat. Although the ring-turned center of the medial stretcher relates to Slough chairs, the heavy, three-piece arm rail with its outward-scrolled terminals recalls the colt's-foot chair of figure 1-23. The Johnson chair represents a transitional pattern that unites various features into a workable design: the leg turnings are of "the latest fashion"; the arm supports, now turned, incorporate a small urn as a new Windsor element; and the splat and the arm rail reflect developments of the 1750s and 1760s.[59]

The bow-back chair is contemporary with the wheel-back and Johnson chairs (fig. **1-35**). Some armchairs within the group have cabriole supports, but the bow-back style is basically a turned-leg chair. This early example retains several features of pre-1775 chairs—colt's-foot legs, H-plan stretchers, squared seat, and braced back. George Romney (1734–1802) delineated a similar chair in a portrait of Sir William Templeton, possibly painted in the 1770s. In a portrait of actor R. Palmer, exhibited at the Royal Academy in 1797, Samuel de Wilde (1747–1832) depicts a pair of side chairs with unusual cross stretchers. Fashion favored the turned supports and curved stretcher of the wheel-back chair, usually accompanied by one or more pierced splats with wheel, three-feather, or looped motifs. Intermixed elements characterized the bow-back style, which continued well into the nineteenth century.[60]

Records from Gillow and Company of Lancaster shed additional light on the furniture industry. At midcentury Windsor seating figured in Gillow's domestic production in only a small way, but by the 1770s it was an export item. A 1790s estimate sketchbook contains measured drawings for several round-back Windsors. A September 11, 1798, drawing of a chair with a bent arm rail and turned stick legs provides an estimate of materials and labor and names John Harrison as the craftsman (fig. **1-36**). The specifications call for mahogany except for the bent arm rail and bow, which required more supple "Cherry Tree" wood. The projected cost was 18s.3d.; the sale price was increased to 22s. Some months later Harrison constructed a chair of identical design, using elm for the seat and cherry for all other parts, at a cost of 9s.6d. In January 1799 Harrison made another plain stick-leg mahogany chair in a round-back pattern. Larger than the previous chair, its sizable squared seat and sawed rail consumed one-third more mahogany; the stretchers and bow required cherry. The estimated cost was 21s.6½d., slightly more than that of the chair sketched in figure 1-36. By 1810 a smaller chair executed in cheaper materials, such as ash and deal (pine), and painted green was only 7s. Such examples illustrate that even a firm designing and making sophisticated furniture for a distinguished clientele also produced ordinary, traditional furniture for a popular market. In 1810 these plain, round-back patterns were more than fifty years behind the times. The dual forces of conservative taste and practical need have traditionally formed a strong foundation for the furniture industry, linking one design era with another to provide a stable economic base.[61]

Lord George Gordon (1751–93), while confined in Newgate Prison during the early 1790s for libel against the state, used a large set of Windsors closely related to the Gillow designs (fig. **1-37**). Wealthy political prisoners in Newgate's "State Side" enjoyed comfortable private quarters and visits from friends. In Richard Newton's (1777–98) drawing from about 1793 Gordon sits at the head of the table surrounded by his friends, mainly print- and booksellers, writers, and solicitors. The men enjoy their pipes and mugs of ale or glasses of wine while engaging in stimulating conversation from the easy comfort of their bow-back armchairs. The artist has faithfully reproduced the smallest details of the setting, even showing one man resting his foot casually on the rung of his companion's chair. Such scenes indicate the widespread use of Windsor seating after a half century of production and development.[62]

Fig. 1-36 Drawing of round-top Windsor armchair, Lancaster, England, September 11, 1798. From Gillow and Co., estimate book, 1798–1803. Ink and pencil on paper; H. 3¾″, W. 2″. (Westminster Public Library, London.)

Fig. 1-37 Richard Newton, *Soulagement en Prison*, London, ca. 1793. Watercolor drawing on paper; H. 14½″, W. 22½″ (sight). (Lewis Walpole Library, Yale University, Farmington, Conn.)

Fig. 1-38 Thomas Malton, Jr., after Georgiana Jane Keate, detail of *Hall's Library at Margate*, published by I. Hall and T. Malton, London, England, 1789. Hand-colored aquatint; H. 14⅞″, W. 21⅝″ (trimmed). (Paul Mellon Collection, Yale Center for British Art, New Haven, Conn.)

Another picture places the Windsor in a circulating library (fig. **1-38**). *Hall's Library at Margate*, a 1789 aquatint by Thomas Malton, Jr. (1748–1804), captured the atmosphere of the popular seaside resort. In the large room, which also served as a promenade, simple board benches supplemented Windsor chairs and settees. Hall's patrons could purchase toys and games, play cards, attend musicales, or borrow books for a small fee.[63]

The English Windsor, 1800 to 1850

The unusual pattern of the Mendlesham armchair, so called because it originated in Mendlesham near Ipswich, Suffolk, varies distinctly from standard Windsor design (fig. **1-39**). This regional expression combines elements of the Windsor and the cheap fancy joined chair in the manner of Sheraton and Hepplewhite. Windsor construction prevails: upper and lower structures socket directly and independently into the seat; the arm structure is similar to that of bow-back chairs; and the leg turnings are standard for the early nineteenth century (figs. 1-32, 1-33, 1-34). In the chair back, however, the spindles and pierced splat derive from Windsor design, while the square frame and crossrails accented by string inlay reflect high-style furniture. The novel addition of large turned beads, or round buttons, and a bent rod, similar to a curved stretcher, emphasizes the fusion of the two chairmaking traditions. The design departs from standard early nineteenth-century chairs, such as those produced in Buckinghamshire.[64]

The Wycombe region of Buckinghamshire is famous for its Windsor-chair industry. L. J. Mayes's pioneer chronicle of chairmaking in the Chiltern Hills describes the early development of this flourishing industry and traces its progress during the nineteenth century. Mayes explores the techniques and working methods of the handcraft tradition and describes the operation and growth of the mass-production system. Limited

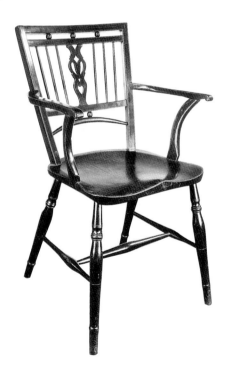

Fig. 1-39 Square-back Windsor armchair, Suffolk, England, 1800–1830. Elm and yew; H. 33″, W. 20¼″, D. 22″. (Victoria and Albert Museum, London.)

woodworking activity occurred in the Wycombe area before the late eighteenth century. Raw materials—beech, ash, and elm—were sent to London at an early date, but farming remained the dominant local occupation. According to Mayes, the transformation from minor craft to well-developed trade took place just before 1800. *Bailey's British Directory,* a document unknown to Mayes at the time, adds strength to his findings. The 1784 directory, which includes the names of eighty-eight High Wycombe residents, lists only three chairmakers, all members of the well-known Treacher family. Of greater significance than the chairmakers, however, are the five men described as carpenter-timber merchants. The business of supplying furniture materials to other areas was clearly still more important than the local chairmaking industry.[65]

During his research Mayes unearthed the highly informative 1798 census of Buckinghamshire men aged fifteen to sixty. The document lists thirty-three chairmakers in the Chepping Wycombe (now High Wycombe) borough, seven more in the surrounding parish, and eighteen in West Wycombe. These fifty-eight men constituted the largest craft aggregate in the area. The local region encompassed by the enumeration may have been larger than that covered in the incomplete *Bailey's Directory,* but the figures still demonstrate a remarkable increase in chairmaking activity in only fourteen years. Mayes shows that production began with individual craftsmen who either worked alone or employed journeymen and took apprentices. Some piecework turnery (called "putting out" work) was done in the surrounding countryside and woodlands. The early market was local, but by 1800 distribution had expanded to many adjacent towns and villages and possibly to London and its suburbs, accessible via wagon or by barge on the Thames. This marketing apparently continued into the first quarter of the nineteenth century when the picture changed with the rise of industrialization. The gradual conversion from hand to machine production drew a new labor force from the countryside into the towns. This substantial migration altered the size and character of many communities and created a new class of consumer: the factory worker. Expansion of the chairmaking trade led to the establishment of the chair factory where specialization and division of labor became commonplace. Mayes describes how employees of chairmaking firms in the 1830s made their rounds through factory towns of the Midlands in wagons piled high with chairs and how they established trade with businessmen and storekeepers in a wide area.[66]

A popular Windsor design of the Wycombe trade was the simple, single-bow chair, sometimes embellished with a pierced back splat. John Claudius Loudon illustrated the style, termed a "kitchen chair," in his 1833 *Encyclopaedia of Cottage, Farm, and Villa Architecture and Furniture* (fig. 1-40). He provides a valuable contemporary description of construction techniques and wood finishes:

A Windsor chair, [is] one of the best kitchen chairs in general use in the midland counties of England. The seat . . . is of elm, somewhat hollowed out; the outer rail of the back is of ash, in one piece, bent to the sort of horseshoe form in the figure, by being previously heated or steamed; its ends are then inserted in two holes bored through the seat, and are wedged firmly in from the under side. An additional support is given to the back, by two round rails [bracing spindles] . . . which are also made fast in two holes, formed in a projecting part of the seat. These chairs are sometimes painted, but more frequently stained with diluted sulphuric acid and logwood; or by repeatedly washing them over with alum water, which has some tartar in it: they should afterwards be washed over several times with an extract of Brazil wood. The colour given will be a sort of red, not unlike that of mahogany; and, by afterwards oiling the chair and rubbing it well, and for a long time, with woollen cloths, the veins and shading of the elm will be rendered conspicuous. Quicklime slacked in urine, and laid on the wood while hot, will also stain it of a red colour; and this is said to be the general practice with the Windsor chair manufacturers in the neighbourhood of London.[67]

The chair delineated by Loudon is similar in style to side chairs in Robert Seymour's illustrations for the first edition of Charles Dickens's *Pickwick Papers* in 1836. A London scene shows club members relaxing on bow-back side chairs around a long table while

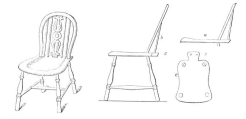

Fig. 1-40 Engraving of bow-back Windsor side chair. From John Claudius Loudon, *An Encyclopaedia of Cottage, Farm, and Villa Architecture and Furniture* (1833; rev. ed., London: Longman, Orme, Brown, Green, and Longman, 1839), pp. 319–20. (Winterthur Library.)

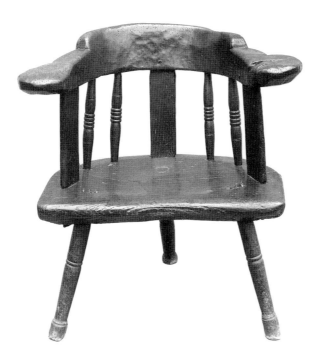

Fig. 1-41 Low-back Windsor armchair, Wales, 1850–80. H. 31¾″, W. 31″, D. 14¾″. (National Museum of Wales, Welsh Folk Museum, St. Fagans, Cardiff.)

listening with mixed emotions to Pickwick. Seymour's use of Windsor chairs follows Dickens's description of the event and is typical of period club furnishings. The London Athenaeum, founded in 1824 and comprising men from the arts, sciences, and literature, purchased Windsor chairs for its service rooms from the furnishing house of Taprell and Holland. Other Windsors were placed in a waiting room of its permanent Pall Mall clubhouse completed in 1830. Use of Windsors by social organizations extended the serviceability discovered by taverners and innkeepers during the previous century. Public institutions also included Windsors among their furnishings.[68]

Discussion of English Windsor furniture would be incomplete without a brief look at crude stick seats from rural areas located beyond the established routes of commerce and travel until recent times (fig. **1-41**). These low-back chairs characterized by thick plank seats, heavy hewn arm rails, flat or cylindrical spindle-laths, and three to five rounded or flattened stick legs have a medieval appearance. Through the century's end these chairs were common in Wales and on the Isle of Man. Despite their venerable quality and apparent evolution from ancient stools of stick construction, such chairs represent local carpenters' and handymen's later interpretations of stylish eighteenth-century Windsor prototypes. Some heavy, clumsy examples seem very old, but their cylindrical members have multiple ring turnings introduced to furniture design only around 1850. Hard wear and exposure to the cottage hearth's heat and smoke for seventy-five years give wood a deceptive ancient quality. With these chairs the story of English Windsor furniture comes full circle; they seem to typify the beginning, when in reality they signify the end.[69]

Continental Forms

The stick chair developed differently on the Continent. A plank-bottomed, board-back seat, known as a sgabello chair, appeared in northern Italy and adjacent areas during the late Renaissance (fig. **1-42**). Shaped panels, front and back, usually form the supports, although splayed sticks occasionally socket into the seat plank. The back forms a vase, banister, or triangle, and rich carving often covers the broad, flat surfaces above and below the seat. Wendel von Olmutz's engraving of the Last Supper of about 1560 depicts a southern German sgabello chair with a rectangular, carved-panel back and stick legs, a type often reinforced beneath the seat with a front-to-back cleat at either side.[70]

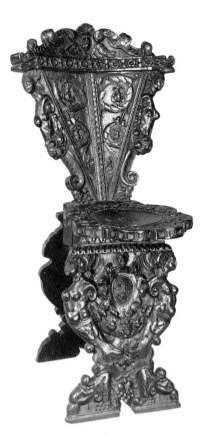

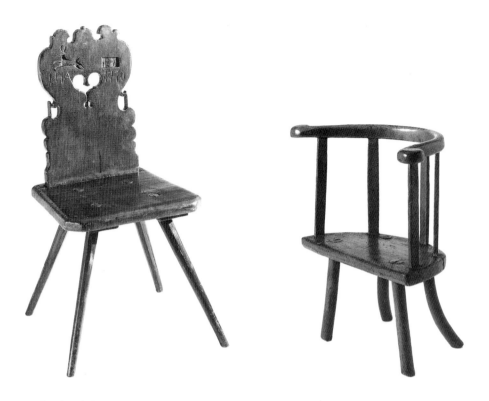

Fig. 1-42 Sgabello chair, probably northern Italy, 1500–1700. Chestnut; H. 42″, W. 21″. (Victoria and Albert Museum, London.)

Fig. 1-43 Board chair, eastern Pennsylvania, 1750–70. Walnut (microanalysis); H. 31½″, W. (seat) 16⅛″, D. (seat) 14½″. (Winterthur 63.827.)

Fig. 1-44 Child's low-back Windsor armchair, central Europe, 1775–1850. European spruce, ash, and white oak (microanalysis); H. 16⅛″, W. (arms) 16″, D. (seat) 7¾″. (Winterthur 64.922.)

By the eighteenth century the southern German sgabello chair had been reduced to a plain plank seat with four tapered, splayed legs and a shaped board back that may feature pierced decoration or simple carving in traditional local styles. The form became a folk craft, and collections from the upper Rhine Valley and Switzerland eastward to Hungary now contain sgabello chairs. Dated examples suggest that they were most popular between 1750 and 1850. German settlers in eastern Pennsylvania acquired related chairs from the 1750s into the nineteenth century (fig. **1-43**). Before 1800 these German seats probably influenced the development, or revival, of a Continental low-back stick chair with an arm rail supported on spindles, laths, or narrow splats (fig. **1-44**). Low-back chairs with turned spindles, such as the one noted in the painting from Botticelli's studio (fig. 1-5), may have been the prototype for this common European seating. A few late nineteenth-century examples even have turned legs. Scandinavian plank chairs developed in a similar way, but a relationship with American seating is unsubstantiated. Nor has a connection been established between Continental and British work in the evolution of the socketed plank-seat chair after 1700. The work of British turners and chairmakers found its way to America, where it inspired the development of Windsor construction during the 1740s and influenced design through the end of the century.

1. This chapter was published almost in its entirety in Nancy Goyne Evans, "A History and Background of English Windsor Furniture," *Furniture History* 15 (1979): 24–53, pls. 68a–95b. Hollis S. Baker, *Furniture in the Ancient World* (London: Connoisseur, 1966), pp. 89–91, 117, 119, 134–35, 139, 142, 298–99. Stick, or socket, construction involves shaping sticks of wood and fitting them into prepared holes in a wooden plank to provide a support structure that raises the plank off the ground or floor.

2. The wall painting is illustrated in Helena Hayward, ed., *World Furniture* (New York: McGraw-Hill Book Co., 1965), facing p. 17.

3. Manuscript pages showing craftsmen appear in Virginia Wylie Egbert, *The Mediaeval Artist at Work* (Princeton, N.J.: Princeton University Press, 1967), pls. 3, 6, 14.

4. Collection of the British Museum, London; illustrated in Eric G. Millar, "The Louterell Psalter," *Old Furniture* 8, no. 28 (September 1929): fig. 5. Bosch's painting *Wrath* is in the Museo del Prado, Madrid.

5. The Botticelli shows a feast celebrating a marriage between members of the Pucci and the Bini families. The figures, grouped around long covered tables set in a coastal pine forest, symbolize actors in "Nastagio degli Honesti" from Giovanni Boccaccio's *Decameron* (1353), a story about a spurned young lover who has a vision that a knight on horseback pursues and kills the maiden he loves (Laurence Binyon, *The Art of Botticelli* [London: Macmillan, 1913], pp. 79–80; Giovanni Boccaccio, *The Decameron*, vol. 3 [New York: AMS Press, 1967], pp. 68–76). Jost Amman and Hans Sachs, *The Book of Trades (Ständebuch)* (1568; reprint, New York: Dover Publications, 1973).

6. Randle Holme, *The Academy of Armory; or, A Storehouse of Armory and Blazon* (1688), vol. 2 (London: Roxburghe Club, 1905), bk. 3, chap. 14, p. 15.

7. Egyptian turned furniture is illustrated in Baker, *Ancient Furniture*, p. 140. Robert S. Woodbury, *History of the Lathe to 1850* (Cleveland, Ohio: Society for the History of Technology, 1961), pp. 38–42. Justus of Ghent's *Adoration of the Magi* is in the Metropolitan Museum of Art, New York.

8. A. C. Stanley-Stone, *The Worshipful Company of Turners of London* (London: Lindley-Jones and Brother, 1925).

9. Benno M. Forman, Introduction, and Joseph Moxon, "The Art of Turning," in Joseph Moxon, *Mechanick Exercises* (1703; reprint, New York: Praeger Publishers, 1970), pp. ix–xxvii and 167–236; Benno M. Forman, *American Seating Furniture, 1630–1730: An Interpretive Catalogue* (New York: W. W. Norton, 1987), pp. 229–41, 248–49.

10. Stephen Switzer, *Ichnographia Rustica; or, The Nobleman, Gentleman, and Gardeners' Recreation*, vol. 3 (London: D. Browne, 1718), p. 125.

11. Daniel Defoe, *A Tour Thro' the Whole Island of Great Britain*, vol. 1 (1725; reprint, London: Peter Davies, 1927), p. 304.

12. Celia Fiennes, *Through England on a Side Saddle in the Time of William and Mary* (London: Field and Tuer, 1888), p. 193. The so-called Windsor seat in the Kensington Garden summerhouse is a modern designation of David Green in *Gardener to Queen Anne* (London: Oxford University Press, 1956), p. 78, and used by later authors. The bench is not of Windsor construction and lacks a pivotal mechanism; the surrounding shelter is enclosed on three sides, eliminating the need for movable protection from the wind.

13. Apprenticeship books, 1710–12, vols. 1, 9, Board of Inland Revenue, Public Record Office, London (hereafter cited as PRO).

14. Apprenticeship books, 1722–25, vols. 41, 48, Board of Inland Revenue, PRO. Quaker records for the "Upperside" of Buckinghamshire between 1669 and 1690 list sixty-three artisans, but only one is a turner. One or two craftsmen probably filled the needs of a large rural area for turned chairs. Hertfordshire records of 1687 contain information about wages for laborers and craftsmen. Surprisingly, no turners are listed, although they may be included with carpenters or joiners or with cartwrights and wheelwrights. The same year in neighboring Berkshire, chairmaker William Parker of Speen tried unsuccessfully to transfer his business to the adjacent borough of Newbury where the market was more lucrative. The town corporation opposed Parker's move because it might have jeopardized the local supply-and-demand balance, suggesting that a craftsman already worked in the area. By 1715, however, conditions had changed, since Edward Vickery, a Reading turner, had relocated in Newbury. See Beatrice Saxon Snell, ed., *The Minute Book of the Monthly Meeting of the Society of Friends for the Upperside of Buckinghamshire, 1669–1690* (Aylesbury, England: Records Branch of the Buckinghamshire Archaeological Society, 1937), p. vi; William Le Hardy, ed., *Hertfordshire County Records: Calendar to the Sessions Books, 1658–1700*, vol. 6 (Hertford, England: Elton Longmore, 1930), pp. 403–4; P. H. Ditchfield and William Page, eds., *The Victoria History of Berkshire*, vol. 4 (London: Archibald Constable and Co., 1906), p. 379; and Quarterly Meeting of Berkshire and Oxford Marriages, 1648–1837, Quaker Records, Berkshire Record Office, Reading, England (hereafter cited as BRO).

15. Probate Inventories of the Commissary Court of London, 1705–49, Guildhall Library, London (hereafter cited as GL); Francis W. Steer, ed., *Farm and Cottage Inventories of Mid-Essex, 1635–1749* (Colchester, England: Wiles and Son, 1950); Wills and Inventories of the Consistory Court of Oxford, 1516–1732, Bodleian Library, Oxford; Pauline Agius, "Late Sixteenth- and Seventeenth-Century Furniture in Oxford," *Furniture History* 7 (1971): 78–79. The ambiguous eighteenth-century term *forest* chairs seems to describe the appearance or the source of the construction materials. In the early 1700s *forest* and *Windsor* were probably synonymous but by midcentury indicated two distinct styles, as seen in William Partridge's 1754 advertisement in *Oxford Journal* listing both types (Robert Wemyss Symonds Collection, Joseph Downs Collection of Manuscripts and Printed Ephemera, Winterthur Library [hereafter cited as DCM]). "Rural" chairs shown in Robert Manwaring's *Cabinet and Chair-Maker's Real Friend and Companion* (London: Robert Pranker, 1765), pls. 24–28, incorporate miniature trees or other rustic curiosities in the back design. The word *hall* also had various meanings in the early eighteenth century, primarily that of a large room for receptions, banquets, or audiences. It also implied a smaller entrance room, vestibule, or passage, although in some cases the area still served as a sitting room (Sir James A. H. Murray et al., eds., *A New English Dictionary* [Oxford, England: Clarendon Press, 1888–1933], s.v. "hall"). Christopher, Viscount Castlecomer, estate records, July 3, 1719, Chancery Masters' Exhibits, C-109, no. 345, PRO; Christopher Gilbert, "The Temple Newsam Furniture Bills," *Furniture History* 3 (1967): 21; George Chudleigh, October 1–2, 1739, and William, Lord Abergavenny, December 1744, estate records, Chancery Masters' Exhibits, C-108, nos. 2 and 4, PRO. Henry Williams bills to the royal household, 1734–40, as transcribed in the Symonds Collection, DCM.

16. Shelagh Bond, ed., *The First Hall Book of the Borough of New Windsor, 1653–1725* (Windsor, England: Royal Borough of New Windsor, 1968), pp. xi–xii. As late as 1784, three upholsterers made up the entire furniture trade at Windsor. *Bailey's British Directory*, vol. 2 (London: J. Andrews, 1784), pp. 477–78.

17. Edward Hazen, *The Panorama of Professions and Trades* (Philadelphia: Uriah Hunt, 1836), p. 227.

18. Defoe, *Tour*, 1:114, 145, 292, 299–301, 313.

19. Garton Orme and Edmund Sherring, indenture, January 26, 1720, Chancery Masters' Exhibits, C-109, no. 317, PRO. Lops (trimmings) and tops were generally used as firewood.

20. Jane Edmonds agreement of sale with John Field and Edward Vickery, December 2, 1723, Reading Monthly Meeting Scrapbook of Marriage Certificates and Other Documents, 1696–1835, Quaker Records, BRO. Murray, *New English Dictionary*, s.v. "underwood," defines it as "small trees or shrubs, coppice-wood or brushwood, growing beneath higher timber trees." Calendar of estate deeds and ancillary papers relating to the Dashwood family, Buckinghamshire Record Office, Aylesbury. Robert W. Symonds came to similar conclusions about the origin of the Windsor chair in his pioneer 1935 article, although he failed to provide a rationale. In "The Windsor Chair," *Apollo* 22, pt. 1, no. 128 (August 1935): 67, 69; pt. 2, no. 131 (November 1935): 261, Symonds pinpoints the London-Buckinghamshire-Berkshire region as the original area of Windsor furniture production and notes that the first craftsmen to market the new form were turners working during the reign of George I (1714–27).

21. Forman, *American Seating Furniture*, pp. 234–37.

22. Lord Perceval is quoted in Alicia Amherst, *A History of Gardening in England* (London: Bernard Quaritch, 1896), pp. 240–42. Graveled walks, as described by Switzer (*Ichnographia Rustica*, 3:71–73), were solid garden ways composed of blended binding gravel; after wet rolling and drying they became "like a Rock," suitable for a wheeled chair. Jean-Baptiste Martin in 1688 showed courtiers conveying Louis XIV through the Versailles grounds in a platform chair equipped with a tiller to turn a small wheel at the front (Nancy Mitford, *The Sun King* [New York: Harper and Row, 1966], p. 140). Two other paintings of Versailles show the sedan chair in use. Martin depicts the courtyards and stables (ca. 1690) from Louis's bedroom (Mitford, *Sun King*, facing p. 96), and Rigaud pictures the chapel (ca. 1710) near the entrance courtyards (Bernard Champigneulle, *Prom-*

enades dans Versailles et ses jardins [Saverne, France: Club des libraires de France, 1961], facing p. 144). The sedan chair was known in England. Fiennes (*Through England,* pp. 13–14, 199) and Dudley Ryder (William Matthews, ed., *The Diary of Dudley Ryder, 1715–1716* [London: Methuen, 1939], p. 241) describe such popular conveyances in Bath. John Macky was carried in a sedan chair from his lodgings in Pall Mall, London, to the local coffee or chocolate houses (*A Journey through England* [1714; 2d rev. ed., London: J. Hooke, 1722], pp. 167–68). An engraving after Charles Bridgeman's view of St. James's Square, Westminster (1727/28), illustrates carriages and a sedan chair (Peter Willis, *Charles Bridgeman and the English Landscape Garden* [London: A. Zwemmer, 1978], pl. 16b). Sedan boxes on wheels were depicted in the Versailles gardens by Martin, as illustrated in Mitford, *Sun King,* facing p. 64, and near the Saint-Cloud cascade by Rigaud, as reproduced in John Dixon Hunt and Peter Willis, eds., *The Genius of the Place* (London: Paul Elek, 1975), pl. 7.

23. Richard Witchele, estate records, February 24, 1725, Probate Inventories of the Commissary Court of London, 1705–49, GL. There are no published London directories for this period to aid in establishing Witchele's identity. Brydges reference, as quoted in Percy Macquoid and Ralph Edwards, *Dictionary of English Furniture,* vol. 1 (1924–27; reprint of 2d rev. ed. by Ralph Edwards, Woodbridge, England: Barra Books, 1983), p. 320.

24. Printed catalogues of the household furnishings of Brigadier General Munden, March 28 and July 18, 1726, Chancery Masters' Exhibits, C-107, no. 287, PRO; printed catalogue of the household furnishings of Thomas Coke, February 12, 1728, Symonds Collection, DCM.

25. Henry Williams bills to the royal household, 1729–40, and William Crompton bill to Frederick, prince of Wales, July 11, 1735, as transcribed in Symonds Collection, DCM; Stanhope reference quoted in Macquoid and Edwards, *Dictionary,* 1:320.

26. Brown advertisement, as quoted in M. Harris and Sons, *The English Chair* (London: By the authors, 1937), p. 173; Bridgeman inventory, as transcribed in Willis, *Charles Bridgeman,* p. 161.

27. French theorist A. J. Dézallier D'Argenville, whose 1709 book was translated into English as *The Theory and Practice of Gardening* by John James in 1712, cites the "Conveniency" that benches and seats "afford in great Gardens, where you can scarce ever have too many" (as quoted in Hunt and Willis, *Genius of the Place,* pp. 125, 130–31). Switzer, *Ichnographia Rustica,* 3:89, 121–22, 124–25; [Macky], *Journey,* p. 23.

28. William Cooke bill to Thomas Jobber, February 21, 1732/33, Chancery Masters' Exhibits, C-108, no. 19, PRO. A 1736 inventory of the Burch and Tyndal upholstery establishment fails to verify Symonds's and Roe's suggestion that early production of Windsor furniture occurred in Shropshire. The list of furnishings excludes Windsors, although appraisers surveyed the contents of three separate buildings and noted many chair types and materials ranging from mahogany and walnut examples to painted, "Oaken," wooden-bottom, and "Twigg Bottom" chairs. Since "wooden" or "wooden bottom" chairs occur in other documents along with "Windsor" chairs, no relationship with Windsors can be drawn from this particular reference (John

Burch and Tyndal, estate records, May 2, 1736, DCM; Symonds, "Windsor Chair," 1:67–68; F. Gordon Roe, *Windsor Chairs* [London: Phoenix House, 1953], pp. 21, 71).

29. William, Lord Byron, estate records, n.d., Chancery Masters' Exhibits, C-108, no. 4, PRO; Mark Girouard, *Life in the English Country House* (New Haven, Conn.: Yale University Press, 1978), pp. 100–101, 247.

30. Mary, dowager duchess of Northumberland, inventory, 1738, Chancery Masters' Exhibits, C-103, no. 170, PRO; *Correspondence between Frances, Countess of Hartford, and Henrietta Louisa, Countess of Pomfret,* vol. 1 (London: Richard Phillips, 1806), p. 273.

31. George Bowes, accounts, Durham Co. Record Office, Durham (reference courtesy of Sarah Medlam); Sarah Medlam, "William Greer at Gibside," *Furniture History* 26 (1990): 142–43, 149–50.

32. William Ellis, *The Timber Tree Improved* (London, 1738), chap. 19, Symonds Collection, DCM; *A General Description of All Trades* (London: T. Waller, 1747), pp. 57–58, 211–12; R. Campbell, *The London Tradesman* (London: T. Gardner, 1747), pp. 243–45.

33. Willis, *Charles Bridgeman,* pp. 113–15.

34. Information on the Haytley painting is from *Sixteenth, Seventeenth, Eighteenth, and Nineteenth Century British Paintings,* November 12, 1980 (London: Sotheby Parke Bernet, 1980), no. 29. John Steegman, "An 18th-Century Painting Identified," *Country Life* 134, no. 3481 (November 21, 1963): 1348–49 (reference courtesy of John Harris); [Homer Eaton Keyes], "The Editor's Attic," *Antiques* 30, no. 1 (July 1936): 8.

35. Gillow Papers, waste book, 1742–54, day-book, 1756–62, and estimate book, 1784–87, Westminster Public Library, London (hereafter cited as WPL) (microfilm, DCM). The popular "smoker's bow," a low-back Windsor chair with a heavy rail, appeared only in the nineteenth century. Thomas Carlyle, *History of Friedrich II of Prussia,* vol. 1 (London: Chapman and Hall, 1858–65), n.p., as quoted in Jerome E. Brooks, *Tobacco: Its History Illustrated by the Books, Manuscripts, and Engravings in the Library of George Arents, Jr.,* vol. 4 (New York: Rosenback Co., 1937–52), pp. 272–74.

36. Mark Haworth-Booth, "The Dating of 18th-Century Windsor Chairs," *Antique Dealer and Collectors Guide* 27, no. 1 (January 1973): fig. 5. See also A. E. Reveirs-Hopkins, "The Windsor Chair in England and Its Ancestors," *Fine Arts* 19, no. 1 (June 1932): 21.

37. An armchair with the same crest as the settee and similar features is illustrated in A. E. Reveirs-Hopkins, "Eighteenth-Century Windsor Chairs," *Old Furniture* 5, no. 18 (November 1928): fig. 4.

38. Beachborough House and Sandleford Priory are illustrated and discussed in John Harris, *The Artist and the Country House* (London: Sotheby Parke Bernet, 1979), figs. 237, 286.

39. Devis's portrait of Henry Fiennes Clinton, earl of Lincoln, is illustrated in *Pictures by Old Masters,* March 31, 1939 (London: Christie's, 1939), no. 14. The date of the painting is based upon the birth and death dates of the small child, possibly George, Lord Clinton (1745–52). The child may be Henry (1750–78), George's brother (Ellen D'Oench, Davison Art Center, Wesleyan University, Middletown, Conn., letter to the author, De-

cember 2, 1980). See also Ellen G. D'Oench, *The Conversation Piece: Arthur Devis and His Contemporaries* (New Haven, Conn.: Yale Center for British Art, 1980), List of Works, no. 34. The other Devis portrait depicting a chair with turned legs is that of James and Emily Fitzgerald, earl and countess of Kildare (m. 1747), illustrated in study photograph, Courtauld Institute of Art, London (hereafter cited as CIA). *Book of Trades (Ständebuch),* p. 24. Information on the Egmont chair and family has been supplied by the Victoria and Albert Museum, London. Sir Leslie Stephen and Sir Sidney Lee, eds., *The Dictionary of National Biography* (1917, 3d printing; reprint, London: Humphrey Milford for Oxford University Press, 1937/38), s.v. "Perceval, John, Second Earl of Egmont (1711–1770)." The Studley Royal engraving is illustrated in Hunt and Willis, *Genius of the Place,* pl. 77.

40. Information on the Goldsmith chair has been supplied by the Victoria and Albert Museum.

41. The Wheatley painting, in the National Gallery of Ireland, is illustrated in Haworth-Booth, "Dating of 18th-Century Windsor Chairs," p. 66.

42. Variant examples are illustrated in Arthur Hayden, *Chats on Cottage and Farmhouse Furniture* (1912; 2d rev. ed. by Cyril G. E. Bunt, London: Ernest Benn, 1950), p. 175, and Symonds, "Windsor Chair," 1:fig. 1; 2:fig. 3. The high-back chair with triangular crest at the Victoria and Albert Museum (fig. 1–15) exhibits a modified lathlike arm support.

43. Thomas Crispin, "Richard Hewett's Windsor Chair," *Antique Collecting* 9, no. 9 (January 1975): 12–13; Richard Britten, "Where Captain Cook Sat," *Country Life* 159, no. 4110 (April 8, 1976): 890. John Stabler, in "Two Labelled Comb-Back Windsor Chairs," *Antique Collecting* 11, no. 12 (April 1977): 12–14, found that John Pitt died in 1759, confirming the stylistic dating of these chairs to the 1750s.

44. D'Oench, *Conversation Piece,* pp. 9–15, 81, 83–85, 89–90 (Iremonger portrait brought to the author's attention by Ellen D'Oench). Robin Fedden and Rosemary Joekes, comps., *National Trust Guide to England, Wales, and Northern Ireland* (New York: Alfred A. Knopf, 1974), pp. 208–10.

45. A similar pierced-splat armchair with hooklike crest terminals is illustrated in *Antiques* 126, no. 3 (September 1984): 445.

46. Related round-top chairs are illustrated in J. D. U. Ward, "A Note on English Windsors," *Antiques* 56, no. 3 (September 1949): 172; Julia W. Torrey, "Some Early Variants of the Windsor Chair," *Antiques* 2, no. 3 (September 1922): 109, fig. 15; Christopher Gilbert, *An Exhibition of Town and Country Furniture* (Leeds, England: Temple Newsam, 1972), fig. 17; G. Bernard Hughes, "Windsor Chairs in Palace and Cottage," *Country Life* 131, no. 3403 (May 24, 1962): 1243, fig. 6. The Langham painting is reproduced in *Calendar of Sales,* November–December 1978 (London: Christie's, 1978). Information about Sir James is from Peter Townsend, ed., *Burke's Genealogical and Heraldic History of the Peerage, Baronetage and Knightage* (103d ed., London: Burke's Peerage, 1958), pp. 1401–2.

47. William Linnell, estate records, February 17, 1763, Chancery Masters' Exhibits, C-107, no. 69, PRO; Helena Hayward, "The Drawings of John Linnell in the Victoria and Albert Museum," *Furniture History* 5 (1969): 1; Leak Okeover, estate records, March 25, 1765, Chancery Masters' Ex-

hibits, C-110, no. 163, PRO; Edward T. Joy, *The Country Life Book of Chairs* (London: Country Life, 1967), p. 57.

48. Jesus College, common room accounts, 1773, Jesus College, Oxford University, Oxford (reference courtesy of Pauline Agius); Partridge advertisement, DCM; Linnell estate records, PRO.

49. Thomas Chippendale, *Director* (3d ed., 1762; reprint, New York: Dover Publications, 1966); William Ince and John Mayhew, *The Universal System of Household Furniture* (1759–62; reprint, Chicago: Quadrangle Books, 1960); Manwaring, *Chair-Maker's Real Friend*.

50. Henry Pelham, estate records, March 1754, Greater London Record Office, London; printed catalogue of the household furnishings of Henry, earl of Grantham, February 24, 1755, British Museum, as reproduced in the Symonds Collection, DCM.

51. Partridge advertisement, DCM.

52. Tobias Smollett, *The Adventures of Sir Launcelot Greaves* (London, 1762); Bodleian Library reference, as quoted in Pauline Agius, *101 Chairs* ([Oxford, England, 1968]), fig. 38.

53. Gillow Papers, daybook; John Luttrell Olmius, November 1762, and Lord Waltham, March 6, 1787, estate records, Chancery Masters' Exhibits, C-107, no. 53 and C-108, no. 6, PRO.

54. Anthea Mullins, "Local Furniture-Makers at Harewood House as Representatives of Provincial Craftsmanship," *Furniture History* 1 (1965): 36; Sir John Ingilby, estate records, June 1773, Chancery Masters' Exhibits, C-105, no. 17, PRO; earl of Bristol, estate records, May 12, 1775, Chancery Masters' Exhibits, C-103, no. 174, PRO. Williams furniture listed in *Norfolk Chronicle* (England), September 16, 1780, as transcribed in Symonds Collection, DCM; William Mayhew, estate records, April 17, 1788, Chancery Masters' Exhibits, C-103, no. 196, PRO.

55. Furniture of Sykes, Williams, and Robbins listed in *Bristol Journal* (England), July 18, 1772, and *Bonner and Middleton's Bristol Journal* (England), January 8 and September 24, 1785, as transcribed in Symonds Collection, DCM. *Sketchley's Bristol Directory* of 1775 lists a city work force of forty-six furniture artisans, including chairmakers but not counting upholsterers, and also names eight furniture brokers. Karin M. Walton, "Eighteenth-Century Cabinet-Making in Bristol," *Furniture History* 12 (1976): 59–63; *Bailey's British Directory*, 2:320; *York Courant* (England), January 24, 1775, as quoted in Symonds Collection, DCM; *Rutland, Lincoln and Stamford Mercury*, March 26, 1790, as transcribed in Symonds Collection, DCM.

56. Wilkinson and Son, trade card and bill to Duff, 1779, and D. Watson and Son bill to James Duff, May 17, 1792, Tradecard Collection, GL.

57. John Stabler, "An Early Pair of Wheelback Windsor Chairs," *Furniture History* 9 (1973): 119–22; *The London Chair-Makers' and Carvers' Book of Prices for Workmanship* (London: T. Sorrell for the Committee of Chair-Manufacturers and Journeymen, 1802), pp. 46–47; pl. 6, nos. 11, 12.

58. John Stabler, "A New Look at the Bow-Back Windsor," *Connoisseur* 187, no. 754 (December 1974): 238–45; Christopher Gilbert, "Windsor Chairs from Rockley," *Antique Finder* 13, no. 2 (February 1974): 18–19.

59. Information on ownership of the Johnson chair supplied by the Royal Ontario Museum, Toronto.

60. The Templeton portrait is illustrated in *Fine Old Paintings at . . . Lehmann Hall, April 5–7, 1933* (Baltimore: Galton, Osborn Co., 1933), no. 400. The Palmer portrait is illustrated in study photograph, CIA.

61. Gillow Papers, estimate books, 1798–1803, 1803–15, WPL (microfilm, DCM).

62. Stephen and Lee, *Dictionary of National Biography*, s.v. "Gordon, Lord George"; Mary Dorothy George, *Catalogue of Political and Personal Satires*, vol. 7 (London: British Museum, 1942), pp. 36–39.

63. The Malton print is illustrated and discussed in J. H. Plumb, *The Pursuit of Happiness: A View of Life in Georgian England* (New Haven: Yale Center for British Art, 1977), fig. 44 and p. 40.

64. The round buttons of the Mendlesham chair copy a feature of inexpensive board-seat framed chairs common to the region. See B. D. Cotton, *Cottage and Farmhouse Furniture in East Anglia* (Lechlade, Gloucestershire: By the author, 1987), pp. 44–48.

65. L. J. Mayes, *The History of Chairmaking in High Wycombe* (London: Routledge and Kegan Paul, 1960); *Bailey's British Directory*, 2:491–93. For additional information on late Wycombe Windsor production and mechanization in chairmaking, see Ivan G. Sparkes, *The Windsor Chair* (Bourne End, Buckinghamshire: Spurbooks, 1975), chaps. 5, 7, 8.

66. Mayes, *History of Chairmaking*, pp. 25–31.

67. John Claudius Loudon, *An Encyclopaedia of Cottage, Farm, and Villa Architecture and Furniture* (1833; rev. ed., London: Longman, Orme, Brown, Green, and Longman, 1839), pp. 319–20.

68. Seymour's *Mr. Pickwick Addresses the Club* is illustrated in Roe, *Windsor Chairs*, frontispiece. Charles Dickens, *The Posthumous Papers of the Pickwick Club* (New York: George Routledge and Sons, n.d.), p. 3; Simon Jervis, "Holland and Sons, and the Furnishing of the Athenaeum," *Furniture History* 6 (1970): 47, 49, 57.

69. Torrey, "Early Variants," pp. 106–8. Other rural stick seats are in the Welsh Folk Museum, St. Fagans, Cardiff. English Windsor chairs with multiple ring turnings are illustrated in Thomas Crispin, "English Windsor Chairs: A Study of Known Makers and Regional Centers," *Furniture History* 14 (1978): pls. 46b, 47a-b, 48b, 51b.

70. The Olmutz engraving is reproduced in Eric Mercer, *Furniture 700–1700* (New York: Meredith Press, 1969), fig. 111.

Profile of the American Windsor Furniture Industry

Transmission of the Windsor to America

The English Windsor chair was introduced to colonial America within a decade of its appearance in the home country. When Patrick Gordon arrived in Philadelphia in 1726 as lieutenant governor under Penn family sponsorship, he probably brought sufficient furnishings to establish a residence befitting his position. His 1736 estate inventory documents a substantial household, including "Five Windsor Chairs" valued at 11s.6d. apiece. These may have been part of Gordon's initial baggage, or he may have ordered them from London after his arrival. Gordon and other wealthy colonists looked to London as the style center of their world and purchased luxury goods and furnishings from that city's artisans and merchants. Other Gordon possessions reveal their English, if not London, origin: silver plate valued at £513; 111 ½ pounds of pewter bought at Jonas Durand's London shop; 20 glass decanters and cruets; many prints and paintings, including portraits of English royalty, family members, and the governor himself.[1]

Gordon's chairs sparked an interest among other Philadelphians to acquire Windsor seating. Shopkeeper Hannah Hodge, a widow who died in 1736, owned one chair, and by the early 1740s at least six other households had Windsors. Because documented Philadelphia production dates from only the mid 1740s, the seating originated in England. Locally, the English Windsor took its place among common and fashionable furniture: board-bottomed chairs; cane seating; chairs with colored leather bottoms, some from Boston; slat- and vase-back, rush-seat chairs with cylindrical or "crookt" (cabriole) legs; and "Compass Seat" Queen Anne-style chairs.[2]

Southern colonial centers were also introduced to the English Windsor at an early date. The 1734 Charleston, South Carolina, inventory of John Lloyd, Esq., lists three "Open" Windsor chairs together valued at £3. Lloyd's will, which identifies brothers Thomas and David, suggests close family ties with Philadelphia, where men of those names were leading attorneys in the early 1700s. Thomas Gadsden's Virginia estate probated in 1741 enumerates Windsor chairs and silver plate. Four years later the estate of James Mathewes of Charleston included one chair, and English Windsors were still marketed in the city as late as the 1760s. The first advertisement for Windsor chairs produced in America appeared in 1745 when Richard Caulton, London "upholster," announced at Williamsburg, the center of Virginia society, "That he doth all Sorts of Upholsterer's Work, after the newest Fashion, with all possible Care and Expedition, at reasonable Rates, either at [patrons'] Houses or at his Lodgings. . . . He likewise makes and mends Easy Chairs, Dressing Chairs, Windsor Chairs, Settes, Pin Cushion Chair Seats, Couches; also covers and stuffs the Banks of Billiard Tables, lines Coaches, Chariots, Chaises and Chairs." Although Caulton's American career was apparently brief, he could have made the two Windsors listed in the 1750 estate of James Wray, a Williamsburg carpenter and "joyner."[3]

Fig. 2-1 Design for chair. From [George] Hepplewhite, *The Cabinet-Maker and Upholsterer's Guide* (2d ed.; London: I. and J. Taylor, 1789), pl. 8. (Winterthur Library.)

Fig. 2-2 Design for chair. From [George] Hepplewhite, *The Cabinet-Maker and Upholsterer's Guide* (3d ed.; London: I. and J. Taylor, 1794), pl. 6. (Winterthur Library.)

Events leading to the establishment of an American Windsor industry followed closely on Caulton's notice. Back in Philadelphia several estate records from 1746 to 1748 list Windsors. Then on August 25, 1748, a local chairmaker advertised in the *Pennsylvania Gazette:* "David Chambers is removed from his house in Walnut-street, to his house in Plumb-street on Society-hill, where he keeps shop, and makes Windsor chairs as formerly." Chambers's notice suggests that he had been producing English-style Windsor seating for several years. The new American craft was on firm footing by 1752 when two sailing vessels on separate voyages from the Delaware River delivered Windsor chairs to Barbados in the Caribbean Sea. Two years later Quaker merchant John Reynell made the earliest recorded purchase of Windsor furniture from a Philadelphia chairmaker.[4]

English Windsor design dominated American production through the end of the century. The first Philadelphia pattern, dating to the mid eighteenth century, imitated the early English chair in breadth, height, and character from seat to crest. Refinements soon followed, and a low-back chair was in the market within a few years. The next patterns interpreted two tall, slim, English Windsors. One new chair substituted the English curved arm support for the turned post; the other borrowed a rear seat extension and bracing spindles.[5]

A second group of English designs, comprising sack- and fan-back chairs, was developed more fully in Philadelphia following the war, although the prototypes date to midcentury. The bow back that dominated the American market late in the century owes less to the English round-back Windsor than to high-style designs published by Thomas Sheraton and George Hepplewhite, as interpreted in American formal seating (figs. **2-1**, 3-55). The prominent waist in the lower back of the Philadelphia chair imitates the incurved rear supports of formal patterns. Around 1800 American production returned to the square back, although the only English Windsor of comparable profile and date was an uncommon one of localized production (fig. 1-39). American chairmakers now drew inspiration for their Windsors almost completely from English design books, formal seating, or fancy chairs (fig. **2-2**).[6]

Early Development and Diffusion

From the beginning of American Windsor production at Philadelphia in the mid 1740s until the Revolution, only a few cabinet- and chairmakers were associated with the craft because of limited demand. Although Windsor construction added a new dimension to the furniture trade, it also called on existing skills: those of the joiner for sawing seats and other flat parts, the turner for preparing the roundwork of the legs, posts, and stretchers, and the carver for embellishing crests with volutes and arms with three-dimensional scrolled terminals. Turnery, in particular, distinguishes the early American Windsor from its English counterpart. The legs and medial stretcher duplicate turnings common to the front posts and stretchers of the Delaware valley slat-back chair. The same elements occur in interior architecture, and evidence linking three Windsor craftsmen with turned staircase work demonstrates further the close ties within the woodworking trades.

Surviving chairs detail the stylistic development of the Philadelphia Windsor. The crest that became a trademark of the American high-back armchair and later the fan-back side chair incorporated design elements from high-style seating, a continuing influence. The serpentine profile of the Chippendale top piece embellished at the ends with Queen Anne volutes led to the refined crest of the high-back Windsor (figs. **2-3**, **2-4**). Parallel refinement marked the development of a small high-back chair, from the English prototype and the first American interpretation through a second stage to the mature product with updated legs and arm posts and a slick, streamlined seat. Other patterns evolved in similar sequences.

From the beginning, chairmakers relied on interchangeable parts and stockpiles of prepared materials for quantity production. By 1775 Philadelphia cabinetmaker Francis Trumble advertised a stock of 1,200 Windsor chairs. Given the modest quarters of a metropolitan shop, the seating was unframed; parts were stored in the shop loft, under the workbench, in a rear shed, or in other accessible places. A single chairmaker was unable to produce that amount of material, particularly when, like Trumble, he also offered a full line of cabinetwork. Where did chairmakers acquire parts in quantity? Part of the answer lies in Trumble's advertisement, which solicited country craftsmen and handymen to supply 40,000 hand-shaved hickory spindles. To produce the necessary turned work, Trumble employed journeymen and apprentices and likely contracted with local turning specialists who jobbed for furniture makers and builders. The practice was already established in the 1740s when rush-bottomed-chair maker Solomon Fussell hired a turning specialist. After the Revolution, subcontracting expanded as the chair-making craft moved toward industrialization.[7]

Philadelphia Windsor chairs were advertised for sale in New York by 1762. Local production probably began only in the early 1770s when John Kelso and Adam Galer migrated from Philadelphia and the native-born Ash brothers, Thomas and William, completed their apprenticeships. Until after the Revolution, the New York product remained a Philadelphia-style chair. The situation was different at Newport, Rhode Island, where local production began by the early 1760s. Newport high- and low-back chairs are an amalgam of Philadelphia and English Windsor design and high-style seating. English influence prevailed in a high-back Windsor of early Connecticut origin. The limited output was perhaps solely the work of Felix Huntington of Norwich, who produced two dozen Windsors, presumably of this Anglo-American design, for a relative in 1779.[8]

Rapid expansion of the craft and diffusion of the product marked the postwar years. Philadelphia, continuing its leadership, developed all but one American pattern in the market before 1800. Around 1789 New York, the second largest metropolitan producer of the period, introduced the continuous-bow Windsor inspired by the French bergère. In Rhode Island, Providence rather than Newport took the lead in developing the vernacular-chair industry, although initial progress was slow due to highly unstable business conditions immediately after the Revolution. The state's fluctuating economy in the 1780s led to the broad proliferation of one-of-a-kind interpretations of Windsor patterns, primarily the high-, sack-, and fan-back styles.

Boston rivaled Providence as a chairmaking center before 1800, although Windsor production began only in the mid 1780s. Boston's output may have been matched by that of New Haven, Connecticut, whose Windsor industry blossomed into a brisk coastal trade late in the century. In neighboring New London County, Connecticut, chair-makers were scattered over a wider region. The quality work produced by Tracy family members in designs equaling metropolitan interpretations demonstrates clearly that talented and enterprising craftsmen could succeed in nonurban locations. In sharp contrast, the highly mannered production of the Pennsylvania Germans in south-central Pennsylvania can only be considered as provincial work. Other small centers of distinction are Nantucket and Northampton, Massachusetts.

Late eighteenth-century regional work was closely interrelated because of the nation's commercial economy and relatively mobile population. Philadelphia was the center for innovation and dissemination of patterns, but within certain areas particular interpretations developed that identify local production. Direct Philadelphia influence remained strong in New York and extended north to Boston where chairmakers faced a formidable challenge from imported Pennsylvania seating. New York and Rhode Island's close commercial ties are manifest in the latter's Windsor seating, and both areas guided the work of coastal New London County. Rhode Island chairmaking also influenced that of neighboring Massachusetts, from Bristol County in the south to Boston and Worcester County in the north and west.

Fig. 2-3 Design for chair. From Thomas Chippendale, *The Gentleman and Cabinet-Maker's Director* (London: By the author, 1754), pl. 12. (Winterthur Library.)

Fig. 2-4 High-back Windsor armchair, Philadelphia, ca. 1765. Yellow poplar (seat) with maple, oak, and hickory; H. 44⅝″, (seat) 17⅛″, W. (crest) 25¾″, (arms) 25⅝″, (seat) 24″, D. (seat) 16″. (Mr. and Mrs. James Palmer Flowers collection: Photo, Winterthur.)

Fig. 2-5 *Windsor from Eton*, attributed to Paul Sandby, England, ca. 1770–75. Watercolor on paper; H. 13″, W. 19⅛″. (Colonial Williamsburg, Williamsburg, Va.)

WINDSOR from ETON.

Early Owners

Throughout its early development in Britain and America, Windsor seating was associated with individuals of substance and the leisured life. The English nobility and gentry used Windsor furniture outdoors in the gardens and parks surrounding their country estates and in their recreational pursuits. The use of Windsor chairs in small boats extends this outdoor function (fig. **2-5**). Symbolically, the boating party fishes in the shadow of Windsor Castle, where the Windsor chair originated as seating furniture in the surrounding grounds. In the 1720s and 1730s the English Windsor came indoors to libraries, smoking and gaming rooms, picture galleries, small parlors, and halls. Elegant examples were occasionally constructed of mahogany or finished with japan.

The American Windsor was primarily an interior furnishing, although it was also used outdoors upon occasion. In the decade following Patrick Gordon's death in 1736, Philadelphia documents identify Windsors with the households of a merchant, a former city mayor, a man of means, and others. In the quarter century before the Revolution, records continue to describe members of the upper classes and prosperous tradesmen as primary users. Intricate turnings and substantial handwork made the labor-intensive early Windsor an expensive product. Surviving accounts and bills of sale price individual items from 10*s*. to 18*s*. The lower figure was twice the cost of rush-bottomed seating, while the top figure represented half the price of a formal walnut chair. The average working man's daily wage at this time was about 5*s*. After the Revolution, the Windsor became the primary seat of the general populace, although it was still used in upper-class homes.⁹

Similar purchase patterns emerged in other areas. The Philadelphia and Boston correspondence of merchants William Barrell and John Andrews from the early 1770s identifies the Windsor as a new commodity in the northern city, where it was popular with the local elite. John Singleton Copley (1738–1815) posed several wealthy sitters in Windsor chairs in his prerevolutionary Boston portraits; in neighboring Worcester, Stephen Salisbury in 1789 sat for Christian Gullager (1762–1826) in his green Windsor. Ownership of such seating was already one mark of a gentleman in Rhode Island. The Redwood Library of Newport, whose membership comprised prosperous Jews, Quakers, and Anglicans, ordered Windsor seating in 1764 to furnish its "Doric temple" designed by Peter Harrison. The Reverend Ezra Stiles, the group's librarian, purchased

similar seating for personal use and sat in a green Windsor in his home library when painted by Samuel King (1748/49–1819) in 1771. Connecticut statesman Roger Sherman may have purchased his low-back Windsor directly from a Philadelphia shop when he attended the 1774 and 1775 sessions of the Continental Congress. Moses Brown, a leading Providence merchant who died in 1836, owned a high-back Philadelphia Windsor that he had likely transported in his own ship seventy years earlier.

Leading Designers

Identifying the craftsmen who introduced and adapted English Windsor design to American production is a speculative effort, although Philadelphia was the center of activity. David Chambers may have constructed the first American high-back Windsors in the mid 1740s. Perhaps five years later Thomas Gilpin began to transform that design to what is today considered the classic form, since his documented and attributable work introduces and refines a volute-shaped crest and exchanges slat-style posts beneath the arms for turned members that are compatible with the leg elements (fig. 2-4). Francis Trumble's late 1750s work manifests his experience as a master cabinetmaker. His arm supports are perfectly proportioned, incorporating features such as ringed balusters and waferlike disks. Another early Philadelphia chair, produced for ceremonial use, was possibly the work of cabinet- and chairmaker Jedidiah Snowden. Although the chair has a high-style carved shell in the crest and volute-accented arms and seat corners, the turned work is of poorer quality than that produced by Trumble.

Late eighteenth-century turned work from master chairmaker Joseph Henzey stands apart from that of his Philadelphia contemporaries (fig. 2-6). Long, shapely balusters, large flaring spools, and slightly bulging rings identify his chairs, even when unmarked. The output of few other craftsmen is as easily recognized when undocumented, since distinguishing features are usually associated with regions or production centers rather than individuals. James C. Tuttle's Salem, Massachusetts, work features short turned balusters tapered sharply at top and bottom. Turned profiles also identify the western Massachusetts furniture of Ansel Goodrich. Several designs of relatively consistent features and proportions characterize the eastern Connecticut production of the Tracy family.

New York City chairmakers produced the continuous-bow chair, the only eighteenth-century Windsor design originating outside Philadelphia (fig. 2-7). Of French rather than English inspiration, this armchair was first made with an oval seat, which was soon replaced by a shield bottom. An American version of the bergère supplied the profile for the high, arched back. Any one of three leading chairmakers in business when the new Windsor was first marketed around 1789 may have originated this design. John Always branded several early oval-seat chairs, the Ash brothers are identified innovators, and Thomas Timpson made both chairs and cabinets. At this date the bow-back chair with mortised arms was the principal armchair in the Philadelphia market, and Rhode Island also produced this pattern in quantity. The New England forward-scroll arm is distinguished from the Philadelphia design by its precise, angular edges and full, rounded terminals. Some northern chairs are further enhanced by tapered feet whose swelled profile derives from either Sheraton and Hepplewhite designs or the elongated feet on many contemporary bedsteads.[10]

Late eighteenth-century craftsmen in two widely separated regions produced Windsor seating with unmistakably localized features. The Pennsylvania Germans of south-central Pennsylvania adopted a system of dual legs with ball-foot front supports and tapered rear feet. Other unusual features include extended arm grips, tall squared bows, and distinctive crest volutes. In southeastern Massachusetts, including Nantucket Island, craftsmen developed a braced, oval-seat, high-back chair. Influenced by Philadelphia work but exaggerated in height and canted back, the design became a tall "easy" chair.

Fig. 2-6 Sack-back Windsor armchair, Joseph Henzey (brand "I·HENZEY"), Philadelphia, 1770–85. Yellow poplar (seat) with maple, oak, and hickory (microanalysis); H. 39 1/16″, W. (arms) 25 1/4″, (seat) 21 1/4″, D. (seat) 16 1/8″. (Winterthur 87.19.)

Fig. 2-7 Continuous-bow Windsor armchair, Thomas Timpson (brand "T. TIMPSON / N-YORK"), New York, 1790–1800. H. 36 7/8″, (seat) 16 7/16″, W. (arms) 21 1/2″, (seat) 17 1/2″, D. (seat) 17 1/4″. (Robinson D. Wright collection: Photo, Winterthur.)

The Tracy craftsmen of eastern Connecticut produced formulaic Windsor turnings. Sack-back armchairs, writing chairs, and an unusual settee employ short, stylish leg balusters of pronounced flare. Another baluster turning, combining a full body with a long, slim neck, was used in the legs of fan-back, continuous-bow, and bow-back chairs. The long post of the fan-back chair with modification became the arm support of the sack-back chair. Throughout the family's work, the influence of Rhode Island design is apparent.

Bamboowork was introduced to the Philadelphia chair market in the mid 1780s. The first interpretations are characterized by segmented legs with pronounced swells and hollows, bulbous medial stretcher knobs, and side stretchers with a large central modeled swell. Identified producers include John B. Ackley, Henzey, John Lambert, and John Letchworth, all prominent names in the trade (except for Lambert, who died young). Philadelphia influenced early Boston bamboowork to the extent that some examples duplicate the early modeling found in Philadelphia chairs. The imaginative Boston team of William Seaver and James Frost also introduced curved and crossed stretchers to some of their Philadelphia-style bamboo chairs.

Early nineteenth-century Windsor seating has its high points. Before the War of 1812 Baltimore chairmakers introduced a large tablet-style crest mounted on top of the back posts, although this feature was uncommon in other areas until the 1820s. Chairs constructed with tablet crests in other regions were referred to as "Baltimore pattern," even though other elements followed local design. Baltimore influence was especially strong in southern Pennsylvania. New York work of the 1810s is outstanding for its painted ornament, which ranges from guilloche and rope borders to stars, trophies, floral and fruit figures, and special subjects. Boston's major design contribution was the narrow, stepped tablet crest adapted from formal federal-style seating, which, in turn, reflected English pattern books. The top piece combined with a tall, contoured back and rockers produced a major design stimulus that led eventually to the Boston rocking chair. The same stepped profile inspired chairmakers in northern New England to produce a variant with a centered tablet and ribbonlike ends. The pattern was especially popular in Portland, Maine, and in southern New Hampshire among the Wilder family chairmakers.

Swift diffusion of design during the first half of the nineteenth century placed most Windsor patterns in eastern and midwestern markets shortly after their initial appearance. Most designers are anonymous, and the main inspiration was the fancy chair. Cross-rod styles, introduced around 1800 in Philadelphia, were reproduced in many areas throughout the East. Cross slats framed between the post tops became popular after the War of 1812 and remained in fashion for several decades, although New York chairmakers had first introduced the feature shortly after 1800. The versatile top piece was combined with plain spindles, various fancy sticks, and midback slats and frets. Variations included low-arched crest profiles, hollow corners, and pierced ends. Rectangular tablet-top seating began in Baltimore and was widely distributed. Round tablets appeared in various markets during the 1830s. The roll-top chair, introduced around 1820 in New York City and southern Connecticut, was the least common early nineteenth-century Windsor; modest production also occurred in Philadelphia and eastern Pennsylvania. The extensive coastal furniture trade opened southern seating to many influences, particularly from Baltimore and Philadelphia. Local southern production followed the prototypes closely. As examples of eastern seating moved west, however, hybrid patterns became common. The dual impact of Baltimore and Philadelphia design left its mark in West Virginia, continued into Ohio, and moved farther west and south along the avenues of commerce.[11]

Expansion of Production and Marketing

The revolutionary war marked a turning point in Windsor-chair making. Limited prewar production was based primarily on customwork, although the coastal and Caribbean seating trade, particularly from Philadelphia, had begun to flourish. Postwar recovery was steady, the major impetus being waterborne commerce, for which the new nation was geographically and entrepreneurially well suited. Agricultural products from the hinterlands and limited manufactures were the main trading commodities. During the 1790s Windsor chair sales exceeded those of all other seating furniture. The Philadelphia chair was marketed so successfully that it appeared quickly on printed commodity lists. Providence and New York chairmakers developed more modest commercial enterprises, while Boston chairmakers enjoyed limited success by 1800. Charleston, South Carolina, a substantial market for northern chairs, was a thriving entrepôt for Windsor distribution throughout the South.

With circulating money in short supply until the early nineteenth century, producers and middlemen encouraged business in various ways. Local exchanges involved skilled services, day labor, manufactured and cottage goods, produce, and sometimes cash; the primary distribution method was direct sales. Consignment and commission merchandise stimulated regional and export business. Middlemen sometimes disposed of seating advantageously at auction, particularly in the South. Auctions were also a good way for craftsmen to distribute examples of their work when starting a business or to dispose of stock when closing out. Peddlers retailed limited amounts of furniture throughout the rural countryside. Aside from word of mouth, the printed advertisement quickly became a chairmaker's best promotional tool, whether a newspaper or directory notice, broadside, or label affixed to the product. Impressed name brands and painted stencils on seat bottoms served a similar function.[12]

The rise of substantial, well-maintained turnpike roads during the 1790s encouraged wider inland distribution. Steamboats appeared early in the nineteenth century and quickly became a common sight on eastern waterways. Freight charges were reasonable, and sailings took place on a regular schedule. The phenomenal economic and territorial growth after the War of 1812 was closely linked to increased use of steamboats on midwestern rivers. The steamboat business was barely established when a canal-building craze hit the country. In 1825 the completion of the Erie Canal, linking the Great Lakes with the Hudson River, was celebrated in New York. Manufacturers could now ship their goods to every known part of the country. By 1840 railroads provided another option for transporting goods and people.

After 1800 chair merchandising continued the upward spiral begun in the 1790s. Waterborne trade out of Philadelphia was particularly successful until English and French depredations on the high seas prompted President Thomas Jefferson's Embargo Act of 1807. The trading restrictions created hardship throughout the country, and soon the United States was again at war with England. Insolvencies among chairmakers were common and continued into the postwar period, when a nationwide recession followed a short business boom. The 1820 Census of Manufactures provides details on economic conditions, including difficulties experienced by chairmakers. Recurring financial crises culminated in the Panic of 1837. Diversification helped to ease these economic problems. Country craftsmen often supported their families during hard times through the homestead farm. Some craftsmen had small retail businesses on the side or had developed another woodworking or craft skill.[13]

As the chairmaking trade expanded after the Revolution, so did interest in protecting home manufactures against a flood of English imports. Craftsmen and manufacturers formed societies to promote domestic industry and establish protective tariffs. These organizations were of limited success until the 1810s when the financial setbacks of the embargo and the war encouraged the shipping community to diversify and invest in manufacturing. Markets broadened substantially during the early nineteenth century when commerce with Central and South America, eastern Atlantic islands such as

Fig. 2-8 *Little Boy in Windsor Chair*, attributed to Sarah Perkins, New England, ca. 1790. Oil on canvas; H. 31¼″, W. 24″. (Montclair Art Museum, Montclair, N. J., Florence O. R. Lang Acquisition Fund.)

Madeira, and the East Indies supplemented trade with the American South and the Caribbean islands. The home market also grew by leaps and bounds as the eastern coastal population increased rapidly. Continuing migrations from southern New England into northern New England, western Massachusetts, and New York State were a mere trickle compared with the westward trek that began early in the century. The Western Reserve and the Northwest Territory were soon dotted with settlements.

Quantity production for a mass market became a reality during the 1790s with Philadelphia leading the way. More bow-back Windsors were constructed than any other chair, the variety of colors equaling the selection available in fancy seating. Ornament was restricted to accenting bamboowork until the nineteenth century when flat surfaces were introduced for painted and stenciled decoration. Structural elements became coarser, and ordinary turned work eventually consisted merely of tapered sticks with painted bamboo rings. The price range was relatively broad, with the more expensive seating elaborately painted, framed with ornamental components, or both. Specialized forms, available before the Revolution, became more prominent after the war, especially settees and children's seating (fig. 2-8). Windsor writing-arm and rocking chairs were introduced around 1790; Windsor stools, from the low cricket to the tall seat, were of limited production until after 1800. By then the Windsor had become a truly ubiquitous seating form, its home use extended to commercial facilities and public institutions.

Industrialization and Mass Production

The foundations for transforming the Windsor craft into an industry were laid before the Revolution. Trumble's stockpiling of interchangeable parts and prepared materials in quantity was a first step in that direction. By the 1810s a few shops specialized in supplying complete sets of chair parts to other establishments for framing, seating (for fancy chairs), and finishing. By the 1820s the development of the furniture wareroom, forerunner of the modern furniture store, created another boon for the American chairmaker. The proprietor, frequently just a retailer, stocked finished goods obtained from various sources for direct sale to consumers without prior order. By then the typical chairmaking structure had changed from the one-room shop of the eighteenth century to a multistoried facility. The Finlay brothers' Baltimore business of this period had four floors, each one consisting of a thirty-foot-long room. David Alling's chair wareroom in Newark, New Jersey, stood near his two-and-one-half-story shop. The technological advances of the 1830s and 1840s that harnessed water and steam to provide power for manufacturing also facilitated the procurement of raw materials and the distribution of products to expanding home and foreign markets.[14]

By midcentury some manufacturers had built large facilities where the work was divided into departments, such as David Dexter's waterpowered complex in rural Jefferson County, New York (fig. 5-60). Lambert Hitchcock's 300-acre property near Farmington, Connecticut, included a two-and-one-half-story factory, a three-story warehouse, and outbuildings. Walter Corey made 300 to 500 chairs a week at his Portland, Maine, factory in 1840 after he replaced horsepower with a steam engine. John Pfaff began using steam at his Cincinnati chair factory a few years later. While both water and steam enhanced quantity production, steam was doubly attractive because the manufacturer could locate his factory anywhere. Coexisting with the large single complex was the small factory town where several chairmaking establishments and a substantial labor force created a manufacturing center. Northern Worcester County, Massachusetts, with its ready source of natural waterpower contained about six such communities.[15]

Many new or improved mechanical devices were introduced to the American chair factory during the 1840s. The circular saw, already in limited use for several decades, became increasingly common. Benjamin Bass, a Boston cabinet- and chairmaker, owned

one before 1819, and Hitchcock installed several in his Connecticut factory. Drilling and mortising machines, first operated by hand or foot lever, were powered by water or steam in many large establishments by 1850. The all-essential lathe was also driven by water or steam, and many facilities were equipped with more than one.[16]

Conversion from a shop or small chairmaking operation to a factory system brought many changes in the work force. Skilled journeymen who had labored for daily or piecework wages were replaced by large numbers of semiskilled workmen who performed repetitive tasks for much lower pay. Women joined the work force as seat weavers, preparing both rush and cane bottoms, and boys helped with odd jobs. The Finlay establishment in Baltimore, with its work force of thirty men, twenty-five women, and thirteen boys, was already becoming a factory after the War of 1812. Introduction of the decorated chair broadened the industry's scope by creating a special demand for ornamental painting and later for stenciling. Steam-powered equipment required the services of mechanics; and quantity production for wide distribution necessitated shipping clerks, packers, and wagon masters. The factory owner, often a businessman rather than a craftsman, produced cheap, coarse, stock patterns for an extensive market. Since volume sales were critical, production costs had to be minimized. Low pay, long working hours, and changing business methods caused considerable unrest and led to increasing activity by nascent labor unions.[17]

A vital element in volume merchandising was advertising. From the 1830s announcements in newspapers and city directories increased. Pictures accompanied many notices, as each manufacturer tried to gain an edge (fig. **2-9**). Abraham McDonough of Philadelphia packed his goods "in the most careful manner, either for land or water carriage, so as to avoid all risk of damage." Samuel Beal of Boston itemized a stock of almost 3,000 chairs in 1830. At Utica, New York, James Hazlet featured the "newly invented PIVOT REVOLVING CHAIR" in 1843. When Phelps, Kingman, and Company of New York City appealed to "those engaged in the Southern and Western Trade" in 1846, they identified substantial domestic markets. Canals, railroads, steamboats, and fast sailing vessels carried Windsor seating throughout the nation and the world. The Windsor furnished homes and provided economical, practical seating for public facilities ranging from resort hotels to county courthouses.[18]

By the 1840s most Windsor patterns in the market were tablet tops with rounded profiles. Variations lingered for several decades; some featured Gothic-style details current in formal seating. Eighteenth-century patterns were revived, although the coarser nineteenth-century interpretations are seldom mistaken for the prototypes. Pennsylvania and Ohio chairmakers produced balloon-back chairs with large vertical splats and back profiles simulating contemporary high-style seating and eighteenth-century bow-back Windsors. Low-back armchairs with high rail caps and sack-back chairs with broad arms were offered as office chairs but served a multitude of other functions. Both patterns were varied by introducing a revolving base. Other new Windsor forms included barber chairs, commode chairs, and wheelchairs as well as multifunctional furniture. However, neither new forms nor revived patterns could stem the tide of competition from other seating, and after the Civil War the Windsor lost considerable ground to chairs with cheap upholstery, plywood seats, and machine-woven cane bottoms.

Fig. **2-9** Joel W. Mason billhead, New York, 1857–58. Engraving; H. 3½″, W. 2¼″ (image). (Winterthur Library.)

Notes

1. Patrick Gordon, estate records, 1736, Philadelphia Register of Wills. Esther Singleton, in *The Furniture of Our Forefathers* (Garden City, N.Y.: Doubleday, Page, 1913), p. 88, states that John Jones, a Philadelphia "gentleman of wealth," possessed three Windsor chairs at his death in 1708, which is an erroneous interpretation of the inventory. The item actually reads "3 bermudas Chairs-old," although the letters are difficult to read (John Jones, estate records, 1708, Philadelphia Register of Wills; microfilm, Joseph Downs Collection of Manuscripts and Printed Ephemera, Winterthur Library [hereafter cited as DCM]).

2. Hannah Hodge (1736), Owen Owen (1741), Elizabeth Carter (1744), Amos Lewis (1744), William Bell (1745), and David Evans (1745), estate records, Philadelphia Register of Wills (some references courtesy of Wendy Kaplan); William Fishbourne, inventory, 1742, Philadelphia, as quoted in Arthur W. Leibundguth, "The Furniture-Making Crafts in Philadelphia, c. 1730–c. 1760" (Master's thesis, University of Delaware, 1964), p. 43; Solomon Fussell, account book, 1738–48, Stephen Collins Papers, Library of Congress, Washington, D.C. (microfilm, DCM); Benno M. Forman, "Delaware Valley 'Crookt Foot' and Slat-Back Chairs," *Winterthur Portfolio* 15, no. 1 (Spring 1980): 41–64; Nancy A. Goyne (Evans), "Francis Trumble of Philadelphia: Windsor Chair and Cabinetmaker," in *Winterthur Portfolio 1*, ed. Milo M. Naeve (Winterthur, Del.: Winterthur Museum, 1964), p. 233.

3. John Lloyd, estate records, 1733–36, Charleston Co., S.C., Surrogate Court; Edwin Wolf II, *Philadelphia: Portrait of an American City* (Harrisburg, Pa.: Stackpole Books, 1975), p. 16; Gadsden estate, as discussed in Singleton, *Furniture of Our Forefathers*, p. 121; James Mathewes, estate records, 1745, Charleston Co., S.C., Surrogate Court. Caulton's advertisement appeared in the *Virginia Gazette* (Williamsburg), November 28 to December 5, 1745. James Wray, estate records, 1750, as excerpted in Mrs. Rutherford Goodwin to Charles C. Wall, June 26, 1962, Research Files, Colonial Williamsburg, Williamsburg, Va.

4. Matilda Oliver (1746), Joseph Richards (1747), and Samuel Coates (1748), estate records, Philadelphia Register of Wills (references courtesy of Arlene Palmer Schwind); Joseph Armitt, estate records, 1747, as quoted in Harrold E. Gillingham, "The Philadelphia Windsor Chair and Its Journeyings," *Pennsylvania Magazine of History and Biography* 55, no. 3 (October 1931): 303; Samuel Powell, estate records, 1749/50, as quoted in Leibundguth, "Furniture-Making Crafts in Philadelphia," p. 43. Chambers's notice appeared in *Pennsylvania Gazette* (Philadelphia), August 25, 1748. Chambers is a shadowy figure. A man with this name lived in Philadelphia in 1743/44 (*Pennsylvania Journal*, Philadelphia, January 26, 1743/44), but in 1752, a David Chambers is identified as a stonecutter (*Pennsylvania Gazette*, January 7, 1752). He appears to have had a brother in New Jersey, Alexander Chambers of Trenton, who is often cited, without proof, as a maker of Windsor chairs (David Chambers, estate records, 1759, Philadelphia Register of Wills). *Charming Polly* and *Hannah* entries, October 4 and December 20, 1752, shipping returns for Barbados, 1728–53, Colonial Office, Public Record Office, London. The Reynell reference is cited in Goyne, "Francis Trumble," p. 229.

5. Nancy Goyne Evans, "Design Sources for Windsor Furniture, Part 1: The Eighteenth Century," *Antiques* 133, no. 1 (January 1988): 282–97.

6. Evans, "Design Sources, Part 1"; and Nancy Goyne Evans, "Design Sources for Windsor Furniture, Part 2: The Early Nineteenth Century," *Antiques* 133, no. 5 (May 1988): 1128–43.

7. Francis Trumble, *Pennsylvania Gazette,* December 27, 1775; see also Goyne, "Francis Trumble," pp. 233, 239. Forman, "Delaware Valley Chairs," p. 45.

8. Thomas and James Franklin, *New-York Gazette,* January 4, 1762, as quoted in Rita Susswein Gottesman, comp., *The Arts and Crafts in New York, 1726–1776* (New York: New-York Historical Society, 1938), p. 123; Perry, Hayes, and Sherbrooke notice in *New-York Mercury,* December 6, 1762.

9. Nancy Goyne Evans, "The Philadelphia Windsor Chair: A Commercial and Design Success Story," in *Shaping a National Culture: The Philadelphia Experience, 1750–1800,* ed. Catherine E. Hutchins (Winterthur, Del.: Winterthur, 1994), pp. 335–75.

10. New York design is also discussed in Evans, "Design Sources, Part 1," pp. 292–93, 296. Thomas Sheraton, *The Cabinet-Maker and Upholsterer's Drawing Book* (1793; reprint, New York: Dover Publications, 1972), pls. 29 (top), 32 (left); appendix pls. 4 (top), 18 (top); [George] Hepplewhite, *The Cabinet-Maker and Upholsterer's Guide* (1794; reprint of 3d ed., New York: Dover Publications, 1969), pls. 24, 26, 27.

11. Evans, "Design Sources, Part 2."

12. Nancy Goyne Evans, "American Painted Seating Furniture: Marketing the Product, 1750–1840," in *Perspectives on American Furniture,* ed. Gerald W. R. Ward (New York: W. W. Norton, 1988), pp. 153–68.

13. Records of the 1820 United States Census of Manufactures, National Archives, Washington, D.C. (microfilm, DCM).

14. The Finlay establishment is described in John Henry Hill, "The Furniture Craftsmen in Baltimore, 1783–1823" (Master's thesis, University of Delaware, 1967), p. 112.

15. Lambert Hitchcock, estate records, 1852, Farmington, Conn., Genealogical Section, Connecticut State Library, Hartford; Earle G. Shettleworth, Jr., and William D. Barry, "Walter Corey's Furniture Manufactory in Portland, Maine," *Antiques* 121, no. 5 (May 1982): 1199–1200; Jane E. Sikes, *The Furniture Makers of Cincinnati, 1790 to 1849* (Cincinnati: By the author, 1976), p. 42.

16. Hitchcock, estate records; Benjamin Ball, estate records, 1819, Suffolk Co., Mass., Registry of Probate (microfilm, DCM).

17. The Finlay work force is reported in the 1820 Census of Manufactures, State of Maryland.

18. Abraham McDonough, advertisement in *Public Ledger* (Philadelphia), March 25, 1836; Samuel Beal, advertisement in *Daily Evening Transcript* (Boston), July 24, 1830; James Hazlet, advertisement in William Richards, comp., *The Utica City Directory for 1843–'44* (Utica, N.Y.: [Robert W.] Roberts and Henry H. Curtiss, 1843), p. 144; Phelps, Kingman, and Co., advertisement in *J. F. Kimball and Co.'s Eastern, Western, and Southern Business Directory* (Cincinnati: J. F. Kimball, 1846), n.p.

Part Two

REGIONAL STUDIES: PRODUCTS AND PRODUCERS

Chair Production
in the Middle Atlantic Region

Locations of Craftsmen and Product Destinations
Pennsylvania, 1740s–1799

NEW YORK

OHIO

NEW JERSEY

Susquehanna River

Delaware River

Allegheny River

Ohio River

Pittsburgh

Monongahela River

Tulpehocken Twp.

Reading

Bethlehem

Jonestown

Berks Co.

Buckingham Twp.

Dauphin Co. Lebanon

Lancaster Co.

Coventry Twp.

Bucks Co.

Harrisburg

Lititz Akron

Lancaster

Germantown

Fallsington

Cumberland Co.

York

Gap

Chester Co.

Philadelphia

Chambersburg

Franklin Co.

Adams Co.

York Co.

Chatham

Vincent Twp.

Hanover

Quarryville

Emmitsburg

Taneytown

West Caln Twp.

Graceham

Carroll Co.

London Grove Twp.

Frederick Co.

Libertytown

Frederick

1 inch = 51.6 miles

MARYLAND

Pennsylvania

Philadelphia from the 1740s to 1800

By the time Philadelphia craftsmen began making Windsor chairs in the late 1740s, the city that William Penn laid out in 1682 had risen to an eminent position in the New World. Peter Kalm noted in 1748: "the Delaware is exceedingly convenient for trade. It is one of the largest rivers: . . . yet its depth is hardly ever less than five or six fathoms. The largest ships therefore can sail right up to the town and anchor in good ground in five fathoms of water on the side of the bridge." Philadelphia was fast becoming "the metropolis of a large business area" that encompassed southeastern Pennsylvania; northern Maryland; the valleys of the Delaware, Susquehanna, and Potomac rivers; and the Chesapeake and Delaware bay areas. As a great commercial center "the streets [were] crowded with people, and the river with vessels." Trade reached ports along the entire eastern coast of North America as well as Britain, Ireland, the Continent, Madeira, Africa, the northern coast of South America, and the West Indies. Philadelphia drew wheat, flour, timber, and other products necessary for trade from the fertile hinterlands of southeastern Pennsylvania and the Delaware Valley.[1]

Philadelphia's general climate of prosperity promoted its rapid growth and development. Thousands of immigrants—individuals of wealth and learning, artisans, laborers, and redemptioners—poured into the city. Most newcomers were British, but many were of German origin. The city's population was about 24,000 in 1775, making it the eighth largest city in the British Empire. By 1770 the seaport already extended two miles along the Delaware River and a half mile inland, including the adjacent Southwark and Northern Liberties sections; over 200 houses were being built annually. Robert Honyman, who visited the city in 1775, found the wooden or brick houses "neat enough . . . but [following] no particular plan of building." Stones paved the main streets, posts shielded pedestrians from traffic, and street lamps guided residents after dark. Private wells and public pumps ensured a water supply. The city also had its disagreeable aspects. Alexander Graydon recalled his boyhood in the early 1760s when Dock Creek, which angled its way to the river, was "a filthy uncovered sewer, bordered . . . by shabby stables and tan-yards."[2]

Interspersed among the city's homes were retail shops, craft establishments, and public buildings. Quays, wharves, warehouses, and counting rooms lined the riverfront. Like many rapidly developed urban communities, Philadelphia had congested areas: "In some parts of it, the intention of the great Founder is said to be departed from; and it is too much cut up and confined into small places by narrow lanes and alleys, not suitable for the heat of the climate, nor proper for the health of the inhabitants." The well-to-do moved out of the city or established summer residences in the country. A traveler in 1774–75 described the rural districts surrounding Philadelphia as "very pleasant and agreeable, [and] finely interspersed with genteel country seats, fields and orchards, for several miles round, and along both rivers."[3]

Philadelphia residents shared the city's prosperity in varying degrees. At the top of the social scale were merchants, whose wealth derived from commerce and land speculation. Out of their ranks came the young men who entered the legal and medical professions. Members of this class became the major patrons and customers of artists and artisans. Many civic-minded individuals, Quakers in particular, contributed their wealth and time to the city's social welfare. Widespread interest in intellectual and philosophical pursuits, sparked by individuals of genius such as Benjamin Franklin, stimulated scientific observation, improvement of educational facilities, and growth of organizations and societies for the promotion of knowledge. By 1750 a rising, prosperous middle class, composed mainly of craftsmen and tradesmen, began to share these interests.

The time was ripe for Philadelphia furniture craftsmen to develop an American counterpart of the English Windsor, which had been introduced to local homes in the late 1720s and 1730s. David Chambers of Society Hill was among the first artisans to produce an *American* Windsor during the mid 1740s, although his product remains unidentified among the dozen or more surviving early chairs. The first Philadelphia Windsors shipped to the West Indies in 1752 heralded the start of a brisk trade that reached many parts of the world within a half century.[4]

EARLY CHAIRS

Manuscripts document the Windsor production of three Philadelphia chairmakers in the 1750s. The first record is a bill dated September 14, 1754, from joiner-chairmaker Jedidiah Snowden to Quaker merchant John Reynell. Snowden constructed "2 Double Windsor Chairs with 6 Legs" (two small settees) and charged his customer a total of £3. In May 1759 the craftsman made "two high back windsor chairs" for Mary Coates at 16s. apiece. Snowden began his career as a furniture maker in the late 1740s. He was debited from January 1749 through February 1753 in the accounts of Joseph Webb, a Philadelphia carpenter, for lumber, carpentry work at his shop and house, and miscellaneous items. In theory, Snowden could have produced Windsor seating five years before he made the settees; he continued as a cabinet- and chairmaker at least until the Revolution.[5]

In chronological order, the second documented craftsman is Thomas Gilpin, whose name appears in Webb's accounts for the years 1752 and 1753 when he purchased boards. Daybook and ledger entries made several years later by Samuel Emlen, executor of Samuel Powel I's estate (d. 1756), refer to Gilpin as a chairmaker. From 1755 to 1761 Gilpin's shop stood on Powel land, and the chairmaker had considerable difficulty paying his ground rent. When Gilpin was still in arrears in 1759 for moneys due in 1755–56, Emlen, realizing that his tenant might default, acquired several articles of furniture and credited the account. The purchase included twelve Windsor chairs presented to the new Pennsylvania Hospital and a stool and bedstead with sacking bottom for Emlen himself. At 16s. apiece the hospital chairs were probably high-backs. On April 1, 1761, debt forced Gilpin to sell Emlen his "work Shop and Appurtenances" for £14 15s. The following year the relocated chairmaker sold six low-back Windsors to Garrett Meade at 15s. apiece. The 1s. differential in the price of high- and low-back Windsors appears small in view of the tall chair's greater size, but extra spindle length and labor costs for carving volutes and bending parts were almost offset by the materials and labor required to construct the more complicated low-back arm rail. Gilpin, and perhaps Snowden, made high-back chairs in two sizes; the 16s. chair probably was the smaller one.[6]

Thomas Gilpin's name also occurs in the 1767 Assessors' Returns for the County of Philadelphia. The document shows that he resided in Dock Ward where he was a joiner, owned a dwelling valued at £14, and again paid ground rent to Emlen. The chairmaker-joiner was one of three Philadelphia residents during the 1750s and 1760s named Thomas Gilpin. Heretofore, Thomas Gilpin I of Philadelphia, Chester County, Pennsylvania, and Wilmington, Delaware, a prosperous man who died in 1766 at age sixty-six leaving

an estate valued at over £900, has been mistakenly identified as the chairmaker. Thomas I was the uncle of Thomas II, a wealthy Philadelphian who is recorded in the 1767 returns as "Thomas Gilpin Mercht," only a column apart from "Thomas Gilpin joiner." The mystery remains, however, for public records and family genealogical materials fail to mention the joiner. It seems likely that Gilpin the woodworker gave up chairmaking during the late 1760s.[7]

Francis Trumble, the third documented Windsor-chair maker, was a colorful, enterprising, and enduring figure. His career as a cabinetmaker began about 1740, although he made Windsor furniture only after the mid to late 1750s. Several documents record Trumble's skill as a joiner; as early as 1741 he produced mahogany "Compass Seat Chairs," now highly prized as Queen Anne-style seating. Cabinetwork was probably his only business in 1754 when he advertised a complete line of furniture. The first evidence of other activity occurs in 1759 when Trumble sold two customers "Windsor Chairs," probably with low backs, at 14s. each. The following summer Quaker merchant Charles Norris credited Trumble with two lots of Windsors at 18s. for high backs and 15s. for low backs. Norris placed four chairs in his Chestnut Street house, conveyed two to his sister Hannah, and may have sent the others to Fairhill, his country estate. Thomas Wharton, also a Philadelphia merchant, paid Trumble 18s. apiece for high-back Windsors in 1761. The 3s. range between Trumble's high- and low-back seating suggests, as in Gilpin's accounts and documented work, that tall seating was available in two sizes. In this context, Trumble's product would be classified as "large."[8]

When Trumble entered the Windsor market in the 1750s after over fifteen years in the furniture business, he recognized the Windsor's potential as a popular seating form. His decision to begin production came at the right moment, for the infant industry was beginning to develop. The 1767 returns show that Trumble, at age fifty-one, was a prosperous Southwark craftsman who owned a house, two acres of land in Moyamensing, and a horse and had the support of an indentured servant and four blacks. Trumble continued chairmaking until his death in 1798.[9]

High-back armchairs were the first Windsors produced by American craftsmen. Although connoisseurs have vacillated between assigning the initial position to the tall or the low chair, two critical points favor the high-back Windsor: (1) there appear to be as many as five tall chairs for every low one; (2) there are no low-back Windsors comparable to the early high-back pattern of figure 3-1. The first reference to Windsor furniture *sold* in Philadelphia describes two small low-back settees made in 1754, but the documentation proves only that the low design was current at that date. The Windsor chairs made in David Chambers's shop in 1748 and those shipped to Barbados in 1752 most likely had high backs, probably of the early pattern illustrated in figure 3-1.

Based on style and circumstantial evidence, the earliest surviving high-back Windsor has a plain rounded-end crest, narrow rounded arm terminals, and slat-shaped posts (fig. **3-1**). Over a dozen of these armchairs are known today. Comparison of the chair with two early English high-back Windsors underscores the Philadelphia Windsor's initial indebtedness to English design (figs. 1-14, 1-15). Prototypes had been in the city for about two decades after their first introduction in Governor Patrick Gordon's household. The Philadelphia chair shares several English features: a large, D-shaped seat with flat-chamfered edges and a saddlelike pommel at the center front; spindles and arm supports elevated on a platform at the perimeter of the seat; a double groove marking the inside edge of the platform; a bent arm rail with narrow, rounded terminals; shaped, slatlike arm supports; and an uncarved crest.[10]

The chair departs from English models in the undercarriage. Philadelphia craftsmen fashioned the turned balusters, rings, spools, cylinders, and ball-like feet that had been part of furniture design since the seventeenth century into a new support. This innovative design was inspired by a well-known form—the Delaware Valley slat-back armchair, which often employs similar elements in the front posts. Craftsmen shortened the long cylindrical section in adapting the design for the Windsor. The short, thick baluster common to these Windsors exhibits a strong seventeenth-century quality, while the

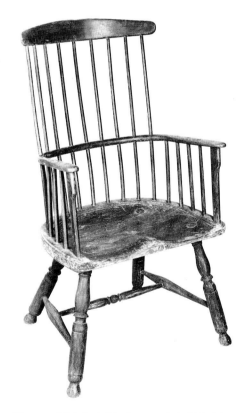

Fig. 3-1 High-back Windsor armchair, Philadelphia, ca. 1748–54. (Photo, George E. Schoellkopf.)

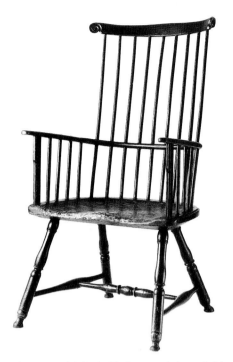

Fig. 3-2 High-back Windsor armchair, probably by Thomas Gilpin, Philadelphia, ca. 1752–56. Yellow poplar (seat); H. 44⅝″, (seat) 17¾″, W. (crest) 23¾″, (arms) 25¼″, (seat) 26″, D. (seat) 17″. (Private collection: Photo, Winterthur.)

Fig. 3-3 High-back Windsor armchair and detail of brand, Thomas Gilpin, Philadelphia, 1754–58. Yellow poplar (seat); H. 45⅛″, (seat) 17½″, W. (crest) 24⅜″, (arms) 28⅞″, (seat) 25″, D. (seat) 16⅛″. (David Stockwell collection.)

American roots of the centered ball-and-ring ornament in the medial stretcher may be traced to the early eighteenth century. Sound construction dictated the use of stretchers. An important characteristic of early American Windsors is the position of the medial brace behind the midpoints of the side stretchers.

Although this pattern represents the earliest American Windsor interpretation, the elements are somewhat incompatible. Slat posts combine more successfully with stick legs, and turned work blends with other round elements. American craftsmen soon recognized the design's inconsistency. A slat-post chair with an ownership history in the Stretch family of Germantown reflects concern with overall design (fig. 3-2). The slat posts remain, but a molded bead finishes the narrow front edges; the slimmer crest terminates in carved volutes. The angular, slim leg balusters echo the elongated elements of the medial stretcher. The center brace is fuller than in the original design. The entire support structure resembles that of a high-back Windsor made by Gilpin (fig. 3-3).

Gilpin probably originated the distinctive high-back design seen in figure 3-3. Of about a dozen known examples, the majority bear his name brand beneath the seat pommel; the others could be marked under many coats of old paint (fig. 3-5). All share two features of the slat-post design—a double groove inside the spindle platform and a back-oriented medial stretcher. Gilpin perhaps led the way in converting the slat to a baluster support beneath the arms. His unique baluster profiles are more angular than those of his contemporaries. Other Gilpin trademarks are the small bead and flaring cap at the arm post tops and the thick, well-delineated ring between the leg cylinder and the foot (fig. 3-3). In early Delaware Valley work, swelled turnings frequently have one or two ornamental lines that were scratched into the wood while the work was still in the lathe. Such lines are visible in the medial stretcher balusters of figure 3-2 and the front legs of figure 3-5. The seat of figure 3-4, viewed from the front, shows how the 2-inch depth of the plank appears lightened by the broad chamfer (fig. 3-5). In figure 3-4 the bent arm rail terminates in circular pads, and the early serpentine crest with carved volutes successfully adapts and unites high-style Queen Anne and Chippendale features. Gilpin's baluster-post chairs fall into two design groups, one slightly earlier than the other (figs. 3-3, 3-4). In early chairs the base ring of the leg cylinder is thick, and the medial stretcher is slim; later chairs reverse these features with a thinner ring and fuller stretcher. The baluster post in later chairs has a long neck, fully rounded body, and necked base; a half-ball rather than a cylinder sockets into the seat.

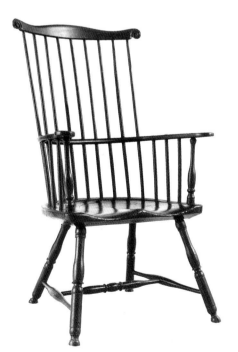

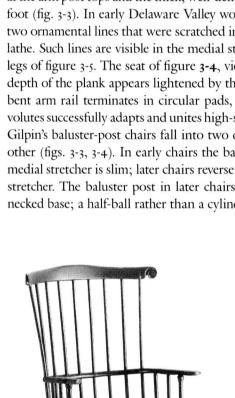

Fig. 3-4 High-back Windsor armchair, Thomas Gilpin (brand "ᴛ·ɢɪʟᴘɪɴ"), Philadelphia, 1756–60. Yellow poplar (seat); H. 40⅝″, (seat) 15¾″, W. (crest) 23½″, (arms) 23¼″, (seat) 21⅛″, D. (seat) 14⅞″. (Private collection: Photo, Winterthur.)

Fig. 3-5 Detail of understructure of figure 3-4. (Photo, Winterthur.)

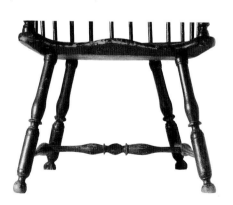

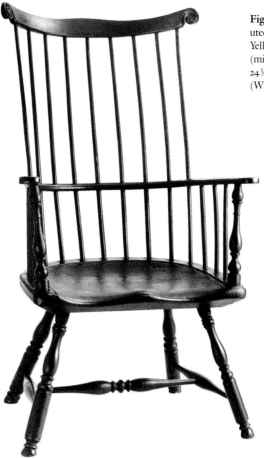

Fig. 3-6 High-back Windsor armchair, attributed to Francis Trumble, Philadelphia, 1755–62. Yellow poplar (seat) with maple, oak, and hickory (microanalysis); H. 44⅞″, (seat) 15⅞″, W. (crest) 24½″, (arms) 26¾″, (seat) 24″, D. (seat) 16¾″. (Winterthur 78.106.)

The short cylinder of Gilpin's first turned arm post is a key feature in dating early round-post work. The high-back armchair with short cylinders in figure **3-6**, like the early Gilpin chair in figure 3-3, is a large form with a tall, slanted back and sloping arm rail that is highest at the front. The two chairs, however, differ in the turned work, which becomes highly sophisticated in figure 3-6. Its creator was a master craftsman who was conversant with both high-style furniture and the best Delaware Valley turned-chair work of the 1740s and 1750s, an artisan who followed Gilpin's lead and branded *one* such chair under the seat pommel with his name "F. TRUMBLE."

Trumble's turned leg and post designs have no exact prototypes among the Philadelphia rush-seat, slat- and vase-back chairs of the Solomon Fussell-William Savery school. Trumble, however, used many individual elements of these chairs and combined them into a new design. Fussell employed a similar, budlike turning at the top of his arm supports, while Savery favored the same long, slender baluster. The ringed baluster neck and squat, vaselike form at the base reflect baroque features popular in the early eighteenth century and ultimately seventeenth-century European furniture design. The ringed baluster had been used in Philadelphia for engaged columns on clock cases and for gateleg tables; the profile of the off-center medial stretcher was adapted from the Delaware Valley slat-back chair. The double groove inside the spindle platform gave way to a single seat channel. For his high-back chairs Trumble charged 2s. over most of his fellow chairmakers, but the price seems more than justified.[11]

Trumble's high-back chair also has connections with architecture since the ringed baluster is basically a stylized Doric column. Trumble's baluster duplicates a staircase turning in the Wright's Ferry Mansion at Columbia, Pennsylvania (fig. **3-7**). The house was built in 1738 for Susannah Wright, a Quaker who had moved from Chester with her family in 1726. The Wright family secured a patent in 1730 for a ferry across the Susquehanna and another for a road to Lancaster, thus encouraging trade with the Delaware Valley. The lady corresponded with Isaac Norris, James Logan, Franklin, and

Fig. 3-7 Staircase balustrade, Wright's Ferry Mansion, Columbia, Pa., ca. 1738. (Photo, Louise Steinman Von Hess Foundation.)

Fig. 3-8 *Edward Hicks,* attributed to Thomas Hicks, Pennsylvania, ca. 1838. Oil on canvas; H. 27¼", W. 22⅛". (Abby Aldrich Rockefeller Folk Art Center, Williamsburg, Va.)

Fig. 3-9 High-back Windsor armchair, Philadelphia, ca. 1760–68. Walnut; H. 43", (seat) 18", W. (seat) 23⅞", D. (seat) 17". (Art Institute of Chicago, gift of Mrs. Christopher Brown, Marshall Field, Mrs. Harold T. Martin, Mrs. H. Alex Vance, and the Mary Waller Langhorne Fund.)

other prominent Philadelphians; the family also visited the city from time to time. Sally Armitt, daughter of cabinetmaker Samuel Armitt and later the wife of James Logan, Jr., was also a friend. Books and glass from Philadelphia arrived at Wright's Ferry, and in return the family sent local crops and native cherry. The staircase balusters were made of cherry, and their varied adaptation to the existing area—doubled in some places and split in others—suggests that they were turned elsewhere, possibly in Philadelphia, then modified for the space on site. In any event, both balustrade and arm posts were part of the same turning tradition.[12]

At least five high-back and two low-back chairs in this early Trumble pattern are known, in addition to a few variant designs. Newtown, Bucks County, artist Edward Hicks (1780–1849) by tradition owned one of the tall Windsors, which he sat in for an 1839 portrait attributed to his nephew Thomas (fig. **3-8**). Visible beneath the artist's right arm is the ringed baluster of the post. Of the variant Windsors, one is a high-back chair converted later to a writing-arm chair. Trumble redesigned some of the turned elements in the chair, although with less success. A subtle change in the crest volute introduces a definite preliminary cut with a carving tool at the rounded lower corners. The volute reveals that two carvers, one more skillful than the other, were at work. Figure 3-6 exhibits a narrow, coiled spiral; the more accomplished technique introduced a gradual transition from high to low areas within the scroll. An unusual feature of the converted writing chair is a barrel-shaped turning centered in each side stretcher, an element linking the chair to a rare cabriole-leg Philadelphia Windsor constructed entirely of walnut (fig. **3-9**). Trumble's skill as a cabinetmaker and the similarity of some turned elements in the walnut chair to his work—the ringed baluster, the post with budlike top and molded cylindrical base, and the central ring of the medial stretcher—suggest that he could have been the maker. Documentation linking American craftsmen with Windsor seating constructed of fine wood and varnished, as in the English tradition, dates only to 1766 when Sheed and White, merchants of Charleston, South Carolina, advertised a new shipment of Philadelphia Windsor furniture including "walnut of the same Construction."[13]

The walnut Windsor has a long history in the Waln family of Philadelphia and appears to be the only survivor of a limited production. The cost would have been substantial, possibly twice the price of a painted Windsor. Most customers preferred to buy plain joined chairs of walnut or mahogany with slip seats for upholstery. While the walnut chair exhibits a variety of broadly related elements—carved volutes, cabriole legs, turnings of several patterns, and a contoured seat—the quality of the work and the balance achieved between the solid and open areas unites the design. The soft rounding of the arms shows the cabinetmaker's touch, and the carved crest volutes are delicate and advanced in design. The use of cabriole supports dictated vertical seat edges without chamfering. A heavy back rail on a high-back Windsor with a D-shaped seat is rare, but the chairmaker handled the feature successfully. If a documented pad-foot joined chair by Trumble were available for comparison, an identification probably could be made.[14]

Following the introduction of Trumble's painted Windsors in the late 1750s, another tall pattern entered the Philadelphia market, accompanied by a low-back counterpart (fig. **3-10**). Gilpin's nearly contemporary baluster-post chair (fig. **3-4**) had hinted at the changes to come. Distinctive features of the Gilpin and the "new" chair are: an arm post baluster of long, attenuated neck, bulbous body, and short, necked base; a medial stretcher turned with balusters duplicating the post and leg profiles; and side stretchers with central bulbous swells similar to that found at the front in Fussell-Savery chairs (fig. 3-59). Since chairmakers produced the design in high- and low-back patterns for several years beginning in the late 1750s, early and late features occur within the group. The early support structure has a slightly hollowed lower leg, and under the arm are waferlike disks above and below the baluster and a half-ball turning at the base of the post. The character and sequence of the elements recalls Pennsylvania fall-leaf tables and board-seat chairs with line-and-berry inlay of a quarter-century earlier. In the first tall examples, arm rails exhibit a definite backward slant, the seat bears only one groove

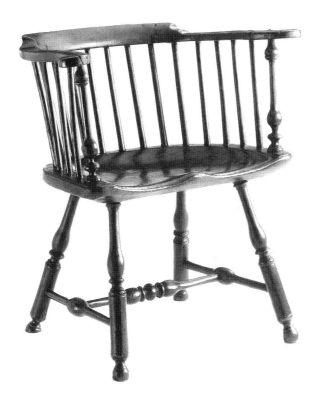

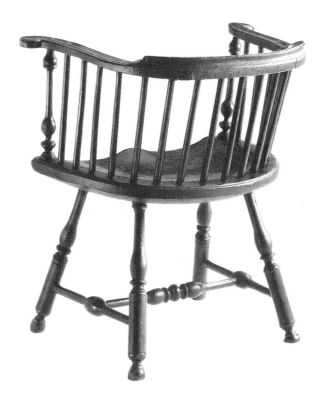

inside the spindles, and the medial stretcher is often almost centered between the front and back legs. The low-back chair in figure 3-10, dating sometime after the design's introduction, has ringlike disks above the completely rounded bases of the arm posts.[15]

The low-back Windsor was in general use in England by midcentury, and related American-made settees were in the Philadelphia market by 1754. The low-back design derives from the corner, or roundabout, chair, which like the Windsor has an arm rail consisting of three pieces of sawed and shaped wood. In Delaware Valley construction the flat, ogee-curved arms terminate at the front in large, circular pads; the arms meet the heavy back rail in a lap joint, or rabbet, at either rear corner. The shallow ends of the back rail extend over the arm tops and form a smooth transition through ogee-shaped tongues. The joints in figure 3-10 are visible both in front and back. Two other features of the Delaware Valley low-back Windsor stand out: the beaded arms, which are pierced by the posts and first four spindles; and the broad, deep channel of the outside back rail. The purely ornamental rail depression creates an interplay of light and shadow that minimizes the heaviness of the back in much the same way that chamfered edges lighten the seat plank without compromising structural strength.

Ball-foot, D-seat Windsor chairs introduced in the 1760s show a more unified design than their predecessors. Figure 3-11, a typical example, features post and leg balusters of oval body and a medial stretcher centered with a single bulbous swell. A collared ring was introduced near each end to minimize the length of the medial brace. The neck

Fig. 3-10 Low-back Windsor armchair (two views), Philadelphia, ca. 1758–65. Yellow poplar (seat) with maple and oak (microanalysis); H. 27¾", (seat) 16¾", W. (arms) 28½", (seat) 24⅝", D. (seat) 17". (Winterthur 64.1526.)

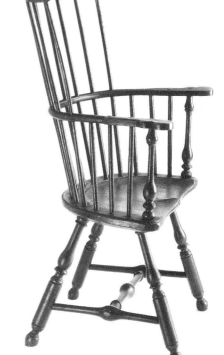

Fig. 3-11 High-back Windsor armchair and detail of arm terminal, southeastern Pennsylvania, ca. 1760–68. Maple (seat) with ash and hickory (microanalysis); H. 43⅜", (seat) 17", W. (crest) 23⅞", (arms) 27", (seat) 24⅝", D. (seat) 15 1/16". (Winterthur 65.3023.)

Fig. 3-12 *Moses Brown* (1738–1836), Rhode Island, 1800–1836. Watercolor on paper; H. 5″, W. 5″. (John Carter Brown Library, Brown University, Providence, R.I.)

below the arm baluster, prominent on earlier chairs, almost disappeared, and a curved rail return augmented the circular arm terminal (fig. 3-11, detail). Pads were cut with the arm rail from one piece of wood or applied separately to the thin strip of bent wood. Large crest volutes were somewhat outdated by the 1760s, replaced by smaller scrolls on slim, double-cut necks (fig. 3-20). Moses Brown, member of a prominent Providence, Rhode Island, mercantile family with many Philadelphia ties, sat in his tall chair for a portrait in the early nineteenth century (fig. 3-12). In old age Brown draped the chair with cloth nailed in place, thus converting it for invalid use. The exaggerated crest proportions in the portrait dramatize the use of carved volutes as a decorative element in early high-back Windsors.[16]

Minor deviation from standard patterns became commoner during the 1760s, and old-style chair parts were occasionally combined with the new. Two typical 1770s elements are large, carved arm terminals and thick, vaselike leg balusters. Occasional leg variations include a cylinder with rounded base above the foot; a short, tapered cylinder between the baluster and the seat; and a collarless baluster. The last-named variation copies a feature of the English colt's-foot leg of the early 1750s (fig. 1-20); the result is an abrupt transition between the baluster and the bulbous element below the seat (fig. 3-13, pl. 1). The same bulbous-stretcher chairs display conical tips in the medial stretcher. The undercarriage of a low-back chair at the Metropolitan Museum of Art is identical to figure 3-13 and appears to be from the same shop, although the arm posts vary in their profiles. In Windsor construction the rounded-face arm rail is commoner than the squared one of figure 3-13. A few high- and low-back chairs mark the end of the D-seat pattern by replacing the lower half of the ball-foot leg with a long, straight or tapered, cylinder, similar to that at the base of some arm supports (fig. 3-13).

More low-back chairs were made in the 1760s than at any other time. One important bulbous-stretcher chair, branded on the seat bottom by Trumble several years after he

Fig. 3-13 High-back Windsor armchair, Philadelphia, ca. 1765–70. Yellow poplar (seat) with maple, oak, and hickory (microanalysis); H. 43⅛″, (seat) 17⅛″, W. (crest) 27″, (arms) 25⅞″, (seat) 24⅜″, D. (seat) 17″. (Winterthur 59.1612.)

Fig. 3-14 Low-back Windsor armchair, Francis Trumble (brand "F·TRUMBLE"), Philadelphia, ca. 1763–68. Yellow poplar (seat); H. 29⅜", (seat) 17½", W. (arms) 28½", (seat) 24⅝", D. (seat) 17⅛". (Amity and Woodbridge Historical Society, Woodbridge, Conn.)

Fig. 3-15 Ralph Earl, *Roger Sherman* (1721–93), New Haven, ca. 1775. Oil on canvas; H. 64⅝", W. 49⅝". (Yale University Art Gallery, New Haven, Conn.)

had introduced his ringed-baluster Windsor, varies the leg baluster profile (fig. **3-14**). The round-chamfered seat edges diverge from the prevailing flat-chamfered technique, placing the chair's date well into the 1760s. Shifting the maker's brand from the pommel to the bottom of the seat was both necessary and convenient, although Trumble still used the same name iron to mark this chair. His later brands differ slightly in letter character and size. Trumble's low-back chair has a long ownership history in the Darling family of New Haven County, Connecticut. The overall design resembles that of the low-back chair depicted in Ralph Earl's (1751–1801) portrait of Connecticut statesman Roger Sherman (fig. **3-15**). Sherman was in Philadelphia in 1774 for the First Continental Congress; he signed the Declaration of Independence two years later and remained a member of the congress until 1784. Just before the Revolution chairmakers introduced the tapered-foot leg to the low-back chair.[17]

Three unusual early chairs demonstrate the strong innovative forces that encouraged Windsor-chair makers to experiment, even though their designs fell outside the mainstream of consumer taste. Earliest is a low-back chair whose feet and stretcher balusters recall Gilpin's late work (fig. **3-16**). The double rings at the base of the arm posts date to the early 1760s, but other turnings deviate substantially from standard work. The pattern

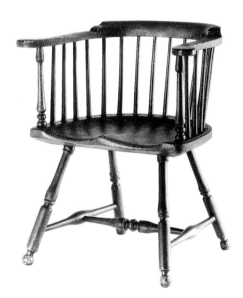

Fig. 3-16 Low-back Windsor armchair, Philadelphia, ca. 1760–65. Yellow poplar (seat) with maple and hickory (microanalysis); H. 30", (seat) 17", W. (arms) 27⅞", (seat) 24¾", D. (seat) 17⅛". (Winterthur 65.2035.)

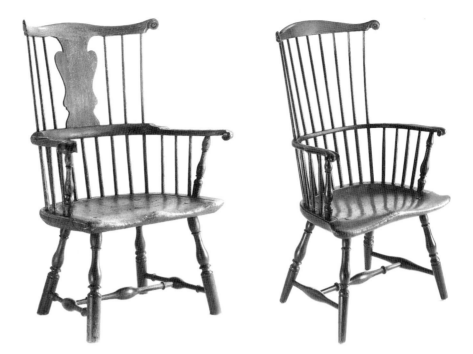

Fig. 3-17 High-back Windsor armchair, Philadelphia, ca. 1767–72. Yellow poplar (seat) with maple, oak, and hickory (microanalysis); H. 46¼″, (seat) 17⅞″, W. (crest) 28⅜″, (arms) 34½″, (seat) 27¾″, D. (seat) 20⅞″. (Winterthur 59.1611.)

Fig. 3-18 High-back Windsor armchair, Philadelphia, ca. 1768–76. Yellow poplar (seat) with maple, oak, and hickory (microanalysis); H. 44⅜″, (seat) 17½″, W. (crest) 25⅟₁₆″, (arms) 28½″, (seat) 26¾″, D. (seat) 17½″. (Winterthur 65.3026.)

was inspired by a commode-seat, roundabout chair with columnar posts attributed to Savery's furniture shop. The arm posts also relate to roundwork in the Pennsylvania William and Mary style.[18]

A late 1760s high-back chair of three-piece rail construction is unique in its enormous size—a Windsor "great" chair—and its vase-shaped splat, or banister (fig. **3-17**). The chair's large size suggests that it could have served a ceremonial function within a public or private organization. The splat profile resembles that of two walnut, high-style Philadelphia chairs at Winterthur. Because of the chair's massive size, all three long stretchers bear collared rings. The chair represents the beginning of a new era in Windsor design. The balusters are short and vaselike, and the bulbous members are sizable. The straight cylinders of the lower legs, a transitional design, lack the ball feet. The carved-scroll arms are an integral part of the pattern; small volutes carved into either side surface repeat the crest scrolls. A slightly later high-back chair also displays transitional features (fig. **3-18**). The seat illustrates a stage of development between the D-shaped and the shield plank and represents strong contemporary English influence (figs. 1-26, 1-29, 1-31). The awkwardly shaped plank dominates the entire chair. The legs are fully converted to long, tapered cylindrical feet.[19]

NEW DIRECTIONS IN HIGH-BACK SEATING

Increased Windsor production during the 1760s indicates that the trade now extended to a broader circle of artisans. About a dozen more craftsmen made Windsor furniture, and several are particularly important. Josiah Sherald's career began about 1758 when he advertised as a turner and rush-bottomed-chair maker. Within four years he had added Windsor chairs to his production, calling himself a "Rush-bottom and Windsor Chair maker" when he applied for a marriage license in June 1762. Sherald advertised in 1765 and in 1767, when he paid estate and head taxes of 27s. Business records of the 1770s suggest that he left the furniture market and went into another line of work.[20]

William Cox came to Philadelphia probably from New Castle, Delaware. He arrived in the early 1760s, since on October 3, 1765, John Shearman, a Philadelphia turner and spinning-wheel maker, advertised that his "young lad" (presumably his apprentice) named William Cox had run away. All was forgiven, however, and Cox completed his service. Cox himself took William Widdifield, a poor boy, as a chairmaking apprentice on March 8, 1768. A lifelong Quaker, Cox was quite successful in his trade, and his customers included prominent Philadelphians John Cadwalader, Esq., and Stephen

Girard. At his death in 1811, Cox owned three properties, including his house and lot in Coombes's (Garden) Alley; in his will he provided generously for the education of poor children.[21]

The early activity of John Pinkerton, who already practiced woodworking when he married Lydia Potts in 1762, probably centered on joinery. The 1767 returns list joinery as Pinkerton's trade and record that he paid a tax of 6s. During the 1770s he produced spinning wheels and chairs, including Windsors, and by the decade's end he made settees for the Pennsylvania State House, Philadelphia. Pinkerton is described as a "Turner and Setteemaker" as late as 1783; he may be the same man listed as an ironmonger in 1784.[22]

Joseph Henzey, like Cox, was a competent, successful Quaker craftsman; both men were a generation younger than Trumble. Henzey was born about 1743 and probably completed his apprenticeship in the mid 1760s. The earliest record of his working career occurs in the 1767 assessment, which indicates that he paid only a 2s. head tax because he was both unmarried and without taxable property. He was either beginning his own business or working as a journeyman. Henzey began to sell Windsor furniture on his own account by 1772, when he married and also took two apprentices. Both boys, Isaac Covert and David Stackhouse, the latter a Bucks County Quaker, later established their own chairmaking businesses. By the early 1790s Henzey was also steward of Pennsylvania Hospital. At Henzey's death in 1796, Quaker cabinetmaker Daniel Trotter provided his coffin.[23]

New developments in Windsor design had occurred in England before 1760. The large high-back chair with its D-shaped seat gradually gave way to smaller armchairs with colt's-foot legs, medium tall backs, and circular or shield planks (figs. 1-21, 1-23). These and side chairs like those depicted in the early 1750s paintings of Arthur Devis greatly influenced American Windsors during the next decade (fig. 1-16). The first American adaptation introduced a small high-back chair with shield-shaped seat and curved, tapered arm supports (fig. 3-19). The understructure, scaled to size, duplicates that of a large, contemporary high-back chair (fig. 3-11). Subtle design and construction changes took place in the London to Philadelphia transfer (fig. 1-23). Behind each circular arm pad is a small pointed projection and a narrow, serpentine sidepiece. The curved supports below the arms pierce both rail and seat with rectangular tenons, and pins at the seat edges secure the lower joints. This construction is stronger than the English practice of butting the support against the seat edge. The flat rear plank edges are chamfered, and the arm posts terminate in a small crook at the lower back corners. Although light and delicate, the design is awkward because large voids occur between the arm supports and the long back spindles, a flaw more apparent in the English models.

English chairmakers remedied this problem by introducing one short spindle behind the post, and the Americans followed suit. Some examples have a bent rail, but the three-piece arm rail with lap joints in the English and Philadelphia fashion produced a stronger chair (fig. 3-20). Other changes included: crest scrolls projecting from slim, double-cut necks; arms forming angular "elbows" as in early Georgian design; arm supports curving more vigorously to balance the arms; seven, instead of six, long back spindles, each thickening below the rail; a broad seat rounding at the back edge; shortened leg balusters; and a medial stretcher terminating in collared arrow-shaped tips.[24]

This improved pattern was soon followed by a related one with baluster posts, two short spindles beneath the arms, and tapered feet (fig. 3-21). The sophisticated design features a considerably refined sweep of the seat and round-edged arms terminating in bold Georgian handgrips with carved knuckles. The thickened lower spindles remain and become a Philadelphia trademark from the mid 1760s into the 1770s. The spindles balance the heavy rail visually and also provide structural stability. The tapered feet and medial stretcher with large knobs carry the improved design into the 1770s. The leg balusters are remarkably similar to those of figures 3-17 and 3-18, reflecting the standardization of the Windsor industry in response to an expanding market.[25]

Fig. 3-19 High-back Windsor armchair, Philadelphia, ca. 1760–68. Yellow poplar (seat) with maple and oak; H. 43½″, (seat) 18″, W. (crest) 21⅝″, (arms) 21¼″, (seat) 16¼″, D. (seat) 18″. (Private collection: Photo, Winterthur.)

Fig. 3-20 High-back Windsor armchair, Philadelphia, ca. 1764–70. H. 40¼″, W. 24¾″, D. 21″. (Milwaukee Art Museum, gift of Paula Uihlein.)

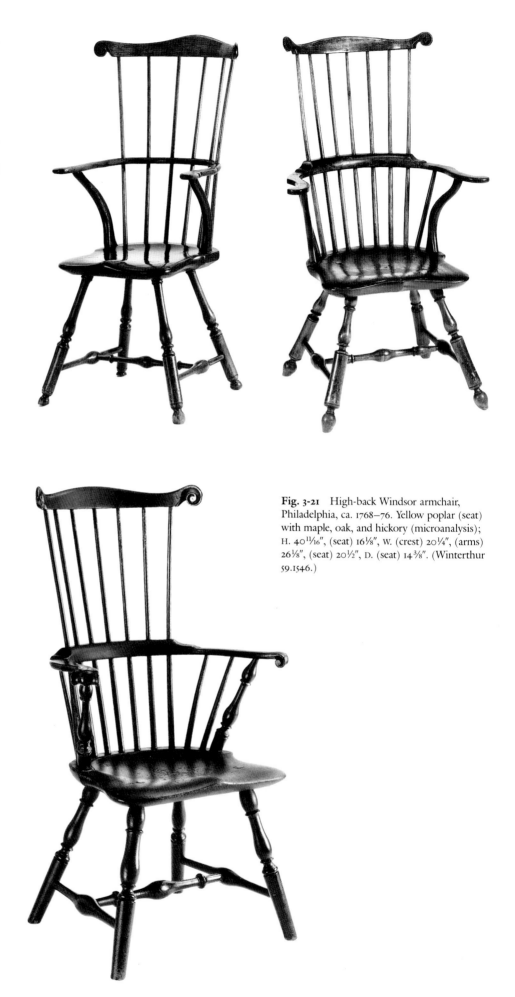

Fig. 3-21 High-back Windsor armchair, Philadelphia, ca. 1768–76. Yellow poplar (seat) with maple, oak, and hickory (microanalysis); H. 40¹¹⁄₁₆″, (seat) 16⅛″, W. (crest) 20¼″, (arms) 26⅛″, (seat) 20½″, D. (seat) 14⅜″. (Winterthur 59.1546.)

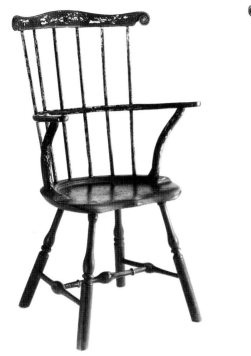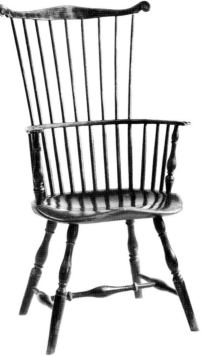

Fig. 3-22 High-back Windsor armchair, southeastern Pennsylvania, ca. 1767–72. Yellow poplar (seat) with maple, oak, and hickory (microanalysis); H. 42⅝″, (seat) 18¼″, W. (crest) 24¾″, (arms) 24⅞″, (seat) 21½″, D. (seat) 15⅝″. (Winterthur 59.1636.)

Fig. 3-23 High-back Windsor armchair, attributed to William Cox, Philadelphia, 1770–85. Yellow poplar (seat); H. 44⅜″, (seat) 17⅞″, W. (crest) 24½″, (arms) 24⅝″, (seat) 21⅞″, D. (seat) 16¾″. (Steven and Helen Kellogg collection: Photo, Winterthur.)

Evolution of the new prerevolutionary Windsor design was more complex than the three examples suggest (figs. 3-19, 3-20, 3-21). At each stage variant designs combined fashionable and outmoded features as the furniture market moved forward at a fast pace. Carved handgrips occasionally accompanied the intermediate seat design, and ball-foot legs socketed into the more refined seats. Between the ball-foot leg and tapered support, the straight cylindrical foot appeared on an unusual chair, which may have originated outside Philadelphia (fig. **3-22**). This chair also amplifies the complexity of mixed patterns. The upper structure approximates an early model in overall design but has plain rounded arm terminals and chamfered posts (fig. 3-19). The unique seat, oval in back and shieldlike in front, has an unusual molded spindle platform whose inner face may imitate the double groove of early D-seat chairs.[26]

About 1770 a tall, considerably refined oval-seat chair, which also drew inspiration from earlier designs, entered the market (fig. **3-23**). Its height and breadth relate to the D-seat Windsor. The refinement of the arm terminals (here damaged), contoured seat, and turned elements owes more to the shield-seat chair. Cox, Henzey, and Trumble made these new chairs: several documented examples from the shops of Cox and Henzey survive, and Trumble's brand appears on one chair. Figure 3-23, which is attributed to Cox based upon two marked examples, represents an early version of the design, since it retains spindles that thicken below the rail (fig. 3-21). Leg balusters of long, oval body and short neck distinguish Cox's work from that of the others, while similar carved crests appear on Henzey and Trumble chairs.

At least five documented oval-seat chairs made by Henzey survive, including a pair of marked armchairs with three-piece sawed rails and mahogany arms (fig. **3-24**). The "2

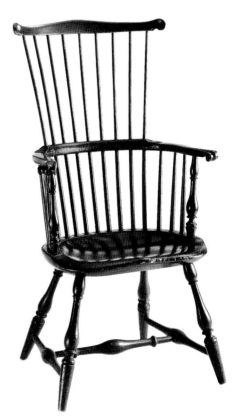

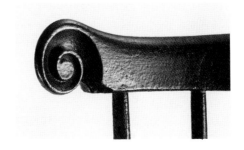

Fig. 3-24 High-back Windsor armchair (one of a pair) and detail of crest terminal, Joseph Henzey (brand "I·HENZEY"), Philadelphia, 1770–85. Mahogany (arms); H. 43⅝″, (seat) 16¾″, W. (crest) 22″, (arms) 24½″, (seat) 21″, D. (seat) 15¾″. (Private collection: Photo, Winterthur.)

Windsor Chairs Mah'y Arms" Trumble sold to Edward Shippen, Esq., in July 1769 were likely of similar form. In other respects Henzey's mahogany-arm Windsors duplicate his bent-rail chairs, most with scrolled arm terminals (fig. **3-25**). Small, carved, wooden blocks affixed to rail ends provide the necessary depth for the broad, flaring three-knuckle scrolls. Henzey's style is fairly easy to recognize: a shallow crest with small volutes (fig. 3-24, detail); elongated baluster turnings with short oval bodies; short tapered feet; and moderate-size spool turnings with well-defined compressed rings similar to those on many Delaware Valley slat-back chairs (fig. **3-26**). Several narrow-back designs have seven spindles (fig. 3-25); other related Windsors have nine-spindle backs, and a large example has eleven spindles. The Henzey brand is typical of those used in Philadelphia during the late eighteenth century (fig. 3-26).[27]

A rare high-back Windsor armchair attributed to Trumble also dates to the revolutionary era (fig. **3-27**). The only known documented example, whose plank is stamped "F.T" in serif letters, is at the Maryland Historical Society. The unmarked chair is virtually identical to the stamped one and, unlike the damaged Maryland chair, retains its carved arm scrolls (fig. 3-27, detail). This Windsor exhibits several general features of other oval-seat work, including the turned profiles and thickened spindles of the Cox chair and the open spacing of Henzey's seven-spindle back.[28]

When Cox, Henzey, and Trumble were producing their tall, oval-seat chairs, other craftsmen were also active. One group of high-back chairs, probably made in several shops, has shorter backs and more widely spaced spindles, a combination that alters the character of the chairs (fig. **3-28**). The slim turnings reflect a type popular in the 1770s. Shouldered spindles appear on some chairs, and the end spindles occasionally flair outward slightly as they meet the crest. The small crest volutes and arm scrolls follow the typical oval-seat Windsor pattern.

A high-back English Windsor (fig. 1-21) similar to the influential shield-seat chair (fig. 1-23) also set in motion creative forces that led city chairmakers to introduce another

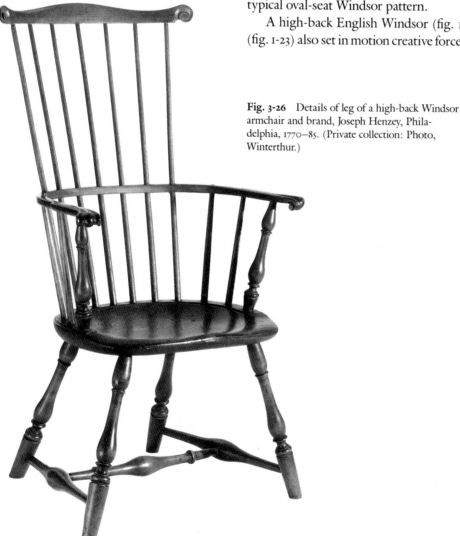

Fig. 3-25 High-back Windsor armchair, Joseph Henzey (brand "I·HENZEY"), Philadelphia, 1770–85. Yellow poplar (seat); H. 42″, (seat) 16″, W. (crest) 22¼″, (arms) 26⅛″, (seat) 21⅛″, D. (seat) 15⅝″. (Private collection: Photo, Winterthur.)

Fig. 3-26 Details of leg of a high-back Windsor armchair and brand, Joseph Henzey, Philadelphia, 1770–85. (Private collection: Photo, Winterthur.)

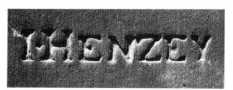

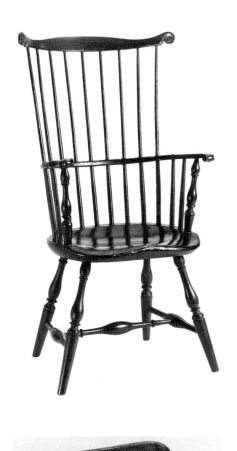

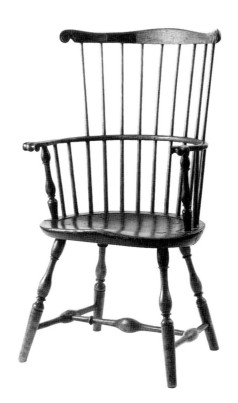

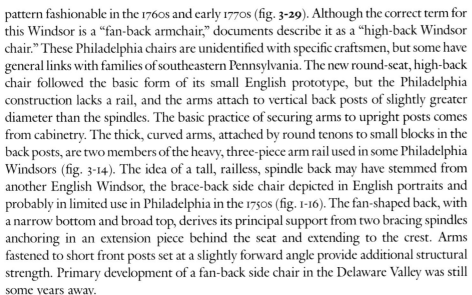

Fig. 3-27 High-back Windsor armchair and detail of arm terminal, attributed to Francis Trumble, Philadelphia, 1770–85. Yellow poplar (seat); H. 45⅜″, (seat) 17⅞″, W. (crest) 24⅞″, (arms) 24⅛″, (seat) 21⅛″, D. (seat) 17⅜″. (Mr. and Mrs. Joseph A. McFalls collection: Photo, Winterthur.)

Fig. 3-28 High-back Windsor armchair, Philadelphia, 1770–85. Yellow poplar (seat) with maple and oak; H. 42⅞″, (seat) 18½″, W. (crest) 24⅞″, (arms) 24½″, (seat) 22¾″, D. (seat) 17″. (Private collection: Photo, Winterthur.)

Fig. 3-29 High fan-back Windsor armchair, Philadelphia, ca. 1764–70. Yellow poplar (seat) with maple, oak, and hickory (microanalysis); H. 39³⁄₁₆″, (seat) 15½″, W. (crest) 21⁵⁄₁₆″, (arms) 25⅞″, (seat) 19″, D. (seat) 17³⁄₁₆″. (Winterthur 59.1634.)

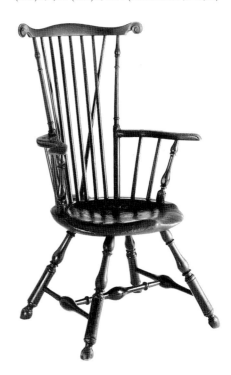

pattern fashionable in the 1760s and early 1770s (fig. 3-29). Although the correct term for this Windsor is a "fan-back armchair," documents describe it as a "high-back Windsor chair." These Philadelphia chairs are unidentified with specific craftsmen, but some have general links with families of southeastern Pennsylvania. The new round-seat, high-back chair followed the basic form of its small English prototype, but the Philadelphia construction lacks a rail, and the arms attach to vertical back posts of slightly greater diameter than the spindles. The basic practice of securing arms to upright posts comes from cabinetry. The thick, curved arms, attached by round tenons to small blocks in the back posts, are two members of the heavy, three-piece arm rail used in some Philadelphia Windsors (fig. 3-14). The idea of a tall, railless, spindle back may have stemmed from another English Windsor, the brace-back side chair depicted in English portraits and probably in limited use in Philadelphia in the 1750s (fig. 1-16). The fan-shaped back, with a narrow bottom and broad top, derives its principal support from two bracing spindles anchoring in an extension piece behind the seat and extending to the crest. Arms fastened to short front posts set at a slightly forward angle provide additional structural strength. Primary development of a fan-back side chair in the Delaware Valley was still some years away.

The small high-back chairs of the Philadelphia area, like their English models, have circular seats cut from wooden planks whose long fibers run diagonally from a front to a back corner (fig. 3-29). The broad, coffin-shaped extension behind the spindles is sawed as a piece with the plank. Most seat edges are rounded, although a few examples have traces of chamfering. A diagonal-grained seat used with a back projection reduced material waste. Craftsmen laid out seats in pairs, interlocking the extension ends, and thereby saved several inches of stock for every two cut (fig. 3-30). Such economy was

Fig. 3-30 Drawing of a seat layout on a plank.

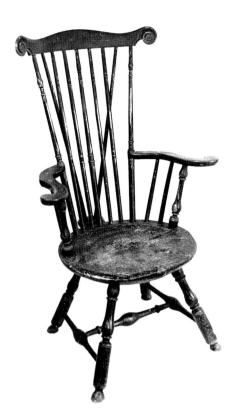

Fig. 3-32 High fan-back Windsor armchair, southeastern Pennsylvania, ca. 1764–70. Yellow poplar (seat); H. 40½″, W. 26½″, D. 23¼″. (Chester County Historical Society, West Chester, Pa.: Photo, Winterthur.)

Fig. 3-33 Detail of seat bottom of figure 3-32. (Photo, Winterthur.)

Fig. 3-31 High fan-back Windsor armchair (one of a pair), Philadelphia, ca. 1764–70. Yellow poplar (seat) with maple and hickory; H. 40¾″. (Nantucket Historical Association, Nantucket, Mass.)

more critical in England than in America where raw material was plentiful. Ball-foot legs and bulbous stretchers provided a support structure for the new chair. The blunt serpentine arms, somewhat unsuccessful in a chair with delicate turned and carved members, stem from 1750s Philadelphia rush-seat, vase-back chairs attributed to Savery (fig. 3-59). Chairmakers soon employed the more sophisticated flat scroll arm of the shield-seat chair, minimizing the arm's extra thickness by chamfering the lower edges (figs. **3-31**, 3-20). The crest rails with their projecting volutes are typical mid 1760s features. The tall back posts are of two designs (figs. 3-29, 3-32). The columnar profile appears to be the earlier of the two (fig. 3-29); an extra, centered post sometimes accompanies this design.[29]

The long-baluster back post provided another design (fig. **3-32**). Some chairs with baluster back posts have unusual archaic crests that may reflect the influence of still other English models. The arms combine blunt ends and chamfered edges. In other respects this chair resembles columnar-post Windsors (figs. 3-29, 3-31). The circular seat shows an unusual nineteenth-century repair of a long split with iron cleats, one on the top surface and two underneath (fig. **3-33**). Also visible under the plank are narrow parallel cuts of the jack plane used to dress the plank in the direction of the long wood fibers before shaping the top surface and edges. Both arm and back posts pierce the seat with circular tenons expanded by cross wedges to form the tight joints typical of Windsor construction. The chair was owned by a Lancaster County branch of the Brinton family. Wallace Nutting illustrated two other chairs with the same crest, indicating that they were "believed to be the property of Ex-Governor Sproul of Pennsylvania," who died in 1928. Nutting also noted that Sproul's wife was born in Lancaster County. The leg turnings, especially from the spool and ring downward, are remarkably similar to those in Lancaster County Windsor work (figs. 3-56, 3-58, 3-61).[30]

The final small high-back chair shared several stylistic features with the contemporary shield-seat Windsor, including comparable arm posts and legs, serpentine arms with scrolled terminals, and medial stretchers with large knobs (figs. **3-34**, 3-21). References to "small" Windsor chairs in Philadelphia area probate records through the 1770s, such as that of Samuel Shoemaker of Arch Street, describe both round and shield seats.

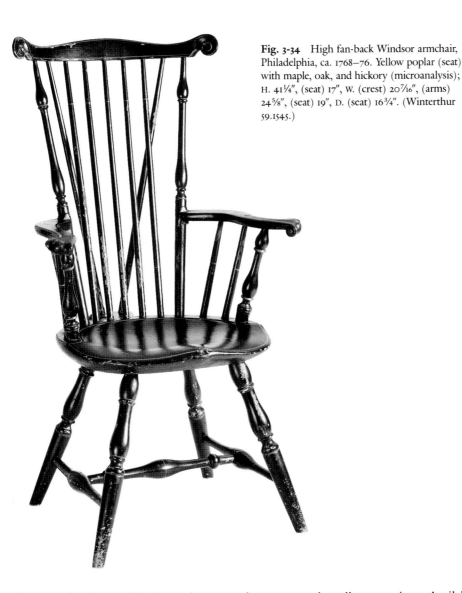

Fig. 3-34 High fan-back Windsor armchair, Philadelphia, ca. 1768–76. Yellow poplar (seat) with maple, oak, and hickory (microanalysis); H. 41¼", (seat) 17", W. (crest) 20⁷⁄₁₆", (arms) 24⅝", (seat) 19", D. (seat) 16¾". (Winterthur 59.1545.)

Fig. 3-35 Sack-back Windsor armchair and detail, Philadelphia or Lancaster Co., Pa., ca. 1760–68. (Private collection: Photos, C. Robert Martin.)

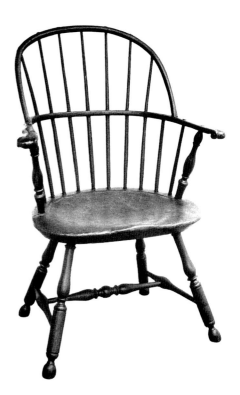

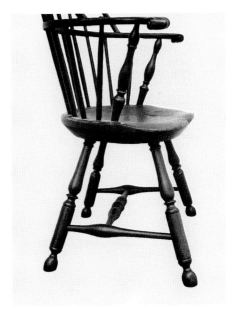

Compared to D-seat Windsors, these must have appeared small to appraisers. Available for over a decade, these high-back chairs furnished many households until they faded from the market by the Revolution's end.[31]

THE SACK-BACK ARMCHAIR

When Andrew Gautier, a New York City dealer, advertised a "large and neat Assortment of Windsor Chairs" for sale in April 1765, he itemized the selection as "High back'd, low back'd, and Sackback'd." This is the earliest reference to the American sack-back armchair, a Windsor pattern that remained popular until the century's end, especially in New England (fig. 3-35). The sack-back armchair entered the Philadelphia furniture market in the early 1760s following its introduction in England, where it was called a "round-top" chair (fig. 1-28). The new design focuses on an oval seat and an arched bow above the arm rail that echoes the back curve. The bow caps the spindle tops, which are cut to different lengths, and confines them within a framework anchored to the arm rail. The early sack-back armchair displays both contemporary and slightly outmoded features. Surviving from early designs are the flat-chamfered seat edges and a back-oriented medial stretcher, whose position balances that of the arm posts. The vigorous turned patterns with their long balusters and ball feet are typical of early 1760s chairs, but several features advance the design to the mid 1760s. The ball foot (worn), ring, and spool are identical to the same elements in a circular-seat chair that has a history in southeastern Pennsylvania (fig. 3-32). The carved arm scrolls are also a feature of the mid 1760s, although the circular, pad-end arm was probably commoner.[32]

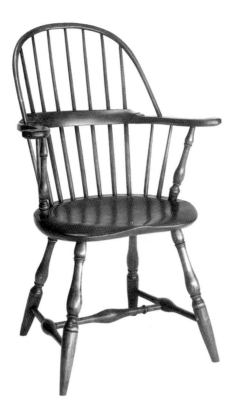

Fig. 3-36 Sack-back Windsor armchair, southeastern Pennsylvania, ca. 1768–76. (Former collection J. Stogdell Stokes.)

Fig. 3-37 Detail of knuckle and flat arm terminals from two sack-back armchairs, Philadelphia, 1770–85. (Private collections: Photos, Winterthur.)

The next sack-back pattern in the market had tapered feet and the heavy, three-piece rail of other contemporary Windsors (fig. **3-36**). The shallow rail joints occur just beneath the shaped ends of the back section. The serpentine arm pattern follows that of several small, round-seat, high-back chairs, complete with chamfered edges (fig. 3-31). The tapered-foot leg combined with a long baluster is unusual in Pennsylvania work; however, a transitional high-back armchair has a similar baluster, and Henzey chose a comparable turning for his work starting in the early 1770s (figs. 3-22, 3-24, 3-25).

The Philadelphia Windsor-chair industry expanded tremendously during the 1770s. As late as December 1775 Trumble advertised a large stock of mahogany cabinetwork and "Twelve hundred Windsor chairs." Although the chairs were unassembled, the parts were ready to be framed on short notice for local sale or exportation. Trumble, who probably employed journeymen and other workers on a regular basis, likely produced all three Windsors popular in the prewar market—the high-, sack-, and low-back types— although the last was on its way out of fashion, except for later use as a writing chair. In his 1770s and 1780s business dealings with merchant Levi Hollingsworth, Trumble called the new chair a "sack-back," "arch top," and "Round top" Windsor. The prices varied from 13s.6d. to 15s. per chair, indicating that the consumer could select particular features, including mahogany arms.[33]

For the sack-back chair, customers could choose between two arm patterns, as Trumble described in 1778, "Round Top Scrol arm Chairs" and "Ditto plain." Philadelphia construction of the carved knuckle varies from that in the state's German regions, to be discussed later in this chapter (fig. **3-37**, top). The bent rail, approximately an inch wide, forms the terminal's inside right face and rounds at the front. Butted to the outside (left) edge is a shaped piece of wood about 7 or 8 inches long, flaring at the front as it rounds forward and often attached with wooden pins driven in from the side edges. The craftsman secured a small block fixed with pins, interior nails, and/or glue to the entire lower front surface of the butted sections and pieced the elements together. In comparison, the plain scroll-tip arm terminal is shaped from the same piece of wood as the rail. Like the knuckle scroll, the plain terminal, a small pad with an outward flare and rounded edges, broadens beyond the first short spindle (fig. 3-37, bottom). Red or white oak proved exceptionally good for bentwork.[34]

Craftsmen made sack-back chairs with seven or nine long back spindles (fig. **3-38**). Other features, including squared bow ends, remained standard, although turnings

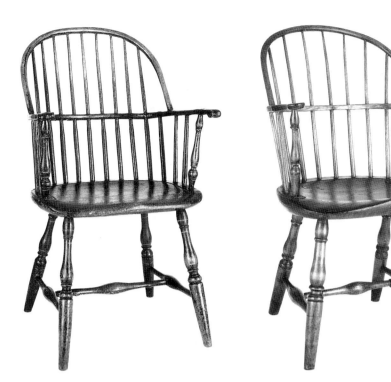

Fig. 3-38 Sack-back Windsor armchairs and details of brands, Francis Trumble, Philadelphia, 1770–85 (*left*) and 1775–90. Yellow poplar (seats) with maple, oak, hickory, walnut (*left*), and ash (*right*) (microanalysis); left: H. 37⅛″, W. (seat) 23″, D. (seat) 16¼″; right: H. 38¼″, W. (seat) 23¼″, D. (seat) 16⅛″. (Independence National Historical Park, Philadelphia: Photos, Winterthur.)

varied within one establishment, as here, and from shop to shop (fig. **3-39**). Trumble's work, in particular, shows considerable diversity in the design of individual elements and probably reflects his employment of journeymen, apprentices, and independent jobbers. The use of thickened lower spindles continued on a limited basis through the revolutionary period (fig. 3-38, left). The typical Philadelphia sack-back Windsor was a compact, solid-looking chair with an overall rectangularity and little leg splay. Henzey's work exhibits about the greatest rake in the undercarriage as found in Philadelphia chairs (fig. 3-39, right).

Sack-back chairs with seven- or nine-spindle backs were contemporary, and Trumble, Henzey, and Cox made both types. Ephraim Evans made nine-spindle chairs in Philadelphia before 1785 when he left the Delaware Valley. A few distinctive features recur in

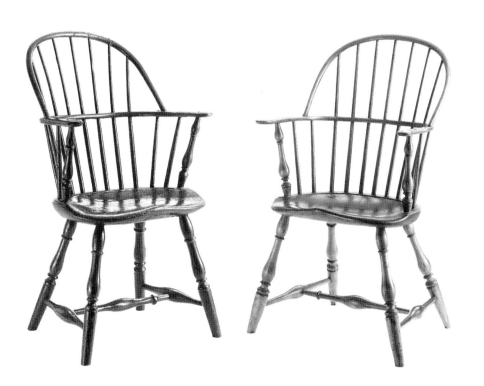

Fig. 3-39 Sack-back Windsor armchairs, William Cox (*left*) and Joseph Henzey (brands "w·cox" and "i·henzey"), Philadelphia, 1775–85 (*left*) and 1775–90. Yellow poplar (seats) with maple and oak; left: H. 37⅝″, (seat) 17½″, W. (arms) 22⅜″, (seat) 20½″, D. (seat) 16″; right: H. 39½″, (seat) 18″, W. (arms) 23⅞″, (seat) 21″, D. (seat) 16⅛″; arm terminals reshaped (*left*). (E. S. Wilkins collection: Photos, Winterthur.)

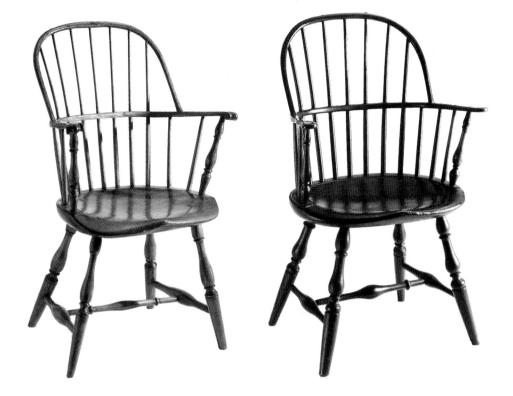

Fig. 3-40 Sack-back Windsor armchairs, James Pentland (*left*) and William Widdifield (brands "I·PENTLAND" and "W·WIDDIFIELD"), Philadelphia, ca. 1791–96 (*left*) and 1780–90. Yellow poplar (seats); left: H. 37⅜″, (seat) 17⅛″, W. (arms) 25½″, D. (seat) 16″; right: H. 37⅜″, (seat) 17½″, W. (arms) 24⅛″, D. (seat) 16″. (Private collections: Photos, Winterthur.)

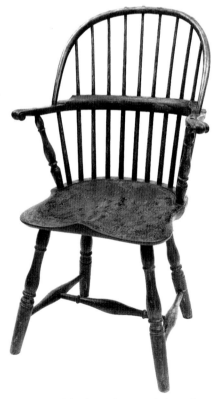

Fig. 3-41 Sack-back Windsor armchair, attributed to Francis Trumble, Philadelphia, 1780–85. Yellow poplar (seat), with mahogany (arm), maple and other woods; H. 37 ¹⁵/₁₆″, (seat) 17⅞″, W. (arms) 23¾″, (seat) 18⁵/₁₆″, D. (seat) 17¹/₁₆″. (Photo, Lynda D. Peters, Inc.)

the work of some chairmakers. The long balusters and thin rings of Henzey's chair legs are particularly consistent (figs. 3-39, right, and 2-6). James Pentland, who later moved to western Pennsylvania, used a thin medial stretcher (fig. **3-40**, left). William Widdifield, who trained with Cox, made a sack-back chair in the 1780s with an unusual rounded cone at the base of the arm posts, duplicating the bulbous element at the leg tops in smaller, inverted form (fig. 3-40, right). Also dating to the 1780s is an unusual sack-back chair with mahogany arms and a shield-shaped seat like those in contemporary Windsor side chairs (fig. **3-41**). Although unmarked, the chair can be firmly attributed to Trumble, since the turned work of the undercarriage duplicates that in his fan-back chair (fig. 3-46). Philadelphia craftsmen continued to make the sack-back chair into the early 1790s, as the work of Pentland and another newcomer, Anthony Steel, attests. At chairmaker John Lambert's death in 1793, chair parts in his shop included "4 Round Top arms bent," each valued at 6*d*. The sack-back chair faded quickly before 1800 as an armchair with simulated bamboo turnings became popular.[35]

The Revolution brought hard times for Philadelphia craftsmen. Steady customers joined the militia, trade came to a standstill, specie was almost unobtainable, and paper currency depreciated daily. Many citizens fled the city; the rest subsisted as best they could. Some furniture craftsmen, such as cabinetmaker David Evans and upholsterer Plunket Fleeson, kept their heads above water because of the demand for military equipment. David Evans, whose daybook is the only complete furniture account to survive, commented frequently on Philadelphia life and events. On September 26, 1777, he noted that "The British Army march'd in this City" and on October 4, 1777, he recorded, "A Very Heavy Battle at Germantown between the British & American Troops it being the 7th Day of ye week." The coffin-making business was brisk and potter's fields were soon filled. After the British left the city, citizens returned and in time life normalized. By 1788 Frenchman Jacques-Pierre Brissot de Warville remarked during a city visit, "The Delaware sees floating, the flags of all nations; . . . Manufactories are rising in the town and in the country." Postwar Philadelphia took on a new look as another generation of merchants and businessmen built their mansions and the newly introduced Lombardy poplar graced gardens and streets. A grand procession held in Philadelphia on July 4, 1788, to mark ratification of the Constitution and to commemorate the Declaration of Independence was both an expression of national pride and a celebration of the city's return to prosperity.[36]

Philadelphia furniture craftsmen had constructed a few fan-back Windsor side chairs in the late 1750s, but the chair was fully developed only after the war (fig. 3-43). The form is first mentioned in Henzey's July 2, 1779, bill to Hollingsworth for "12 windsor Chairs without arms" at the inflated price of £100. Three months later Hollingsworth purchased from Henzey "3 Dozen dining windsor Chairs" and three high-back Windsors "with arms." The price, date, intended `use, and reference to companion armchairs confirm that the dining chairs were fan-back Windsors. Beginning in the last decades of the eighteenth century, craftsmen referred to all Windsor side chairs as "dining chairs." The small size permitted better use of space around the dining table, an important consideration in large households and a family-oriented society.[37]

Trumble first referred to "fan back" chairs in a 1780 bill to merchant Greenberry Dorsey. The price was 11s. per chair, or about 62 percent of the cost of one "Round Top" chair (sack-back Windsor) listed in the same bill. Other references to fan-back chairs during the 1780s involve chairmakers Trumble, Henzey, and Cox. The substantial price range—from 5s. to 12s.6d. per chair—varied according to quality of work and circumstances of sales. Merchants often purchased chairs for exportation and shipped them in bundles of loose parts or assembled but unpainted. In either case, the price was substantially less than that for finished chairs. Some chairs had plain crests; others had carved embellishment, such as "6 scroole top Dineing Chairs" Cox sold to Stephen Girard in 1787. The customer's selection of a chairmaker also made a difference. Zaccheus Collins, a Philadelphia merchant, wrote to Joseph Blake of Boston on June 15, 1795, to explain the delay in his shipment of Windsor chairs and their high cost. The letter offers both a rare insight into the chair industry's inner workings and a testimonial to a leading merchant. Collins, in typical Quaker fashion, went to considerable trouble to provide his client with quality service: "Your chairs which I bespoke [ordered] immediately could not be ready to ship earlier both from the extent of Cox's business & the weather so unfavorable to finishing—They now go pr receipt inclosed by Schooner Hannah Captn Adams & I hope will please you—the prices are such as every body gives him—those you mention are lower than he ever took, which appear'd by his books, at least for many years past—I could however have got Chairs equally good of other workmen whose names are less up, for less money—but you specially ordered Cox's make."[38]

The popularity of the fan-back chair continued into the 1790s, when many new craftsmen joined the trade. John Brientnall Ackley, a third-generation chairmaker, worked as early as 1786, the year he married. He is listed in the second city directory of 1791, which also cites John Wire, who began chairmaking about 1783 when he paid only a head tax. Late in 1793 Wire and fellow craftsman John Letchworth appraised Windsor-chair maker Lambert's estate. Lambert died in the prime of life, and his shop inventory lists many chair parts, tools, and materials along with finished chairs, among them "8 . . . Fan backs Stone Colour @ 6/3." Trumble died five years later at age eighty-two. Letchworth and Thomas Mushett administered his estate, which contained "75 Top Rails" for fan-back chairs. By the mid 1790s the fan-back chair was declining in popularity, but changing fashion had not entirely removed it from the consumer market or daily use in middle-class households. As late as 1813, in a semirural area near Philadelphia, John Lewis Krimmel (1787–1821) pictured a fan-back chair amid the clutter of a room strewn with cloth scraps from a newly completed quilt (fig. 3-42).[39]

A pair of Philadelphia side chairs probably dating before 1760 reveals early experimentation with the fan-back Windsor (fig. 3-43). The unusual design is based directly on an early 1750s English prototype that features a "shovel" seat and braced back (fig. 3-44). Both chair planks compare in shape, rear projection, and edge, but the American seat introduces a centered front pommel. The leg balusters of figure 3-43 are similar to a contemporary local profile (fig. 3-14). Other features, such as the double-baluster medial stretcher and serpentine crest with large, coillike, carved volutes, also reflect prevailing

Fig. 3-42 John Lewis Krimmel, detail of *Quilting Frolic*, southeastern Pennsylvania, ca. May 1813. Oil on canvas; H. 16¼", W. 22 1/16". (Winterthur 53.178.2.)

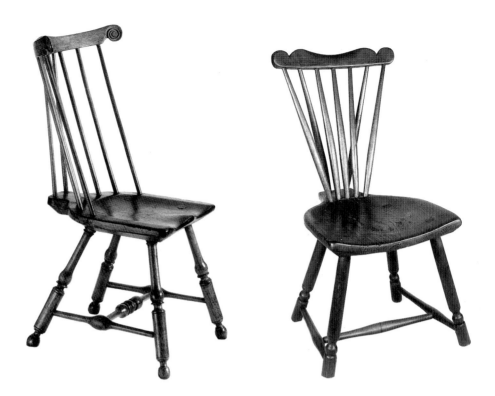

Fig. 3-43 Fan-back Windsor side chair, Philadelphia, ca. 1758–65. Yellow poplar (seat) with maple, oak, and hickory; H. 38⅛″, (seat) 17¼″, W. (crest) 22¾″, (seat) 17¾″, D. (seat and extension) 19¾″. (Private collection: Photo, Winterthur.)

Fig. 3-44 Fan-back Windsor side chair, England, 1745–60. Elm (seat) with beech; H. 32¼″, (seat) 15″, W. (crest) 16¼″, (seat) 15½″, D. (seat with extension) 20¼″. (Former collection J. Stogdell Stokes.)

Windsor design (figs. 3-10, 3-11). Unlike the English model, the American fan-back chair sockets seven spindles to form a raking, lateral curve around the back third of the plank; neither chair has heavy end posts. In overall proportion and stance, the American chair imitates the small, shield-seat, high-back Windsor (fig. 3-19).

Another fan-back chair of tentative design, in a private collection, dates from the mid to late 1760s. The small, squared seat has rounded, sloping sides and a rear wedge-shaped extension. Long, oval balusters and tapered cylindrical feet form the legs. The bulbous medial stretcher ends in large arrow-shaped tips, and the crest terminates in projecting, carved volutes, features also noted in a contemporary high-back armchair (fig. 3-20). The laterally curved, seven-spindle back is taller and more vertical than earlier models but still lacks heavy end posts. In overall proportion and design, the chair is similar to an English fan-back Windsor illustrated in the foreground of a Zoffany painting of about 1781 (fig. 1-22).

In the early 1770s, when the tall, shield- and oval-seat armchairs were in the market, Trumble created the first fully developed American fan-back side chair (fig. **3-45**). He borrowed armchair elements—slim crest, well-modeled shield seat with a groove defining the spindle platform, and fashionable tapered feet—to form a well-balanced design suited to the period's changing tastes. As a craftsman trained before 1750 when heavy, solid construction was customary, Trumble was initially reluctant to eliminate the coffin-shaped seat extension and bracing spindles. The new, turned end posts, visually and structurally integral to the design, were modeled on the long, baluster posts of the circular-seat armchair (fig. 3-34). Inspiration for the ball and double-spool elements of the lower posts came from a turning like that in the medial stretcher of a Gilpin chair (fig. 3-4). Few Windsors with this back structure survive, probably because the Revolution soon disrupted the Philadelphia furniture trade.

After the war, Philadelphia chairmakers further refined the fan-back chair. Trumble eliminated the bracing structure and modified the stretchers and back posts on a chair from around 1780 (fig. **3-46**). Either Henzey or Trumble could have worked out the new post pattern. The updated turning unifies the design by coordinating all the roundwork. The post profile derives from the short post of the armchair; the neck of the baluster has been elongated to achieve the necessary length (fig. 3-27). In this braceless side chair Trumble repeated the low, broad proportions of his earlier version, while other chairmakers favored a slightly taller, narrower back (fig. 3-47).

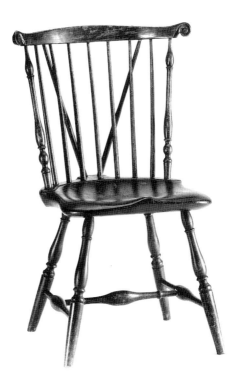

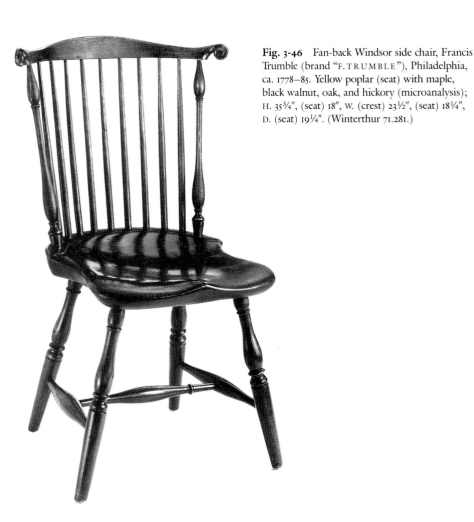

Fig. 3-46 Fan-back Windsor side chair, Francis Trumble (brand "F.TRUMBLE"), Philadelphia, ca. 1778–85. Yellow poplar (seat) with maple, black walnut, oak, and hickory (microanalysis); H. 35¾", (seat) 18", W. (crest) 23½", (seat) 18¼", D. (seat) 19¼". (Winterthur 71.281.)

Fig. 3-45 Fan-back Windsor side chair, Francis Trumble (brand "F.TRUMBLE"), Philadelphia, ca. 1770–76. Yellow poplar (seat); H. 35¾", (seat) 17¾", W. (crest) 22½", (seat) 17¼", D. (seat with extension) 20¾". (Private collection: Photo, Winterthur.)

Henzey's finely proportioned fan-back side chairs may have served as the general model for postrevolutionary production (fig. **3-47**). The turnings duplicate similar elements in his high-back chairs with necessary modifications, such as baluster length in the posts. Henzey's typical long leg baluster is sometimes shortened, and the bulbous parts of some posts are slimmer in profile. Based upon documented production, Henzey

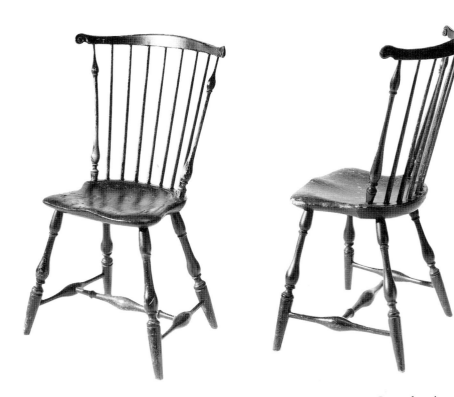

Fig. 3-47 Fan-back Windsor side chairs (pair), Joseph Henzey (brand "I·HENZEY"), Philadelphia, 1780–90. Yellow poplar (seat); left: H. 36⅞", (seat) 17⅝", W. (crest) 23⅜", (seat) 17", D. (seat) 15 ¹⁵⁄₁₆"; right post replaced (right). (Private collection: Photo, Winterthur.)

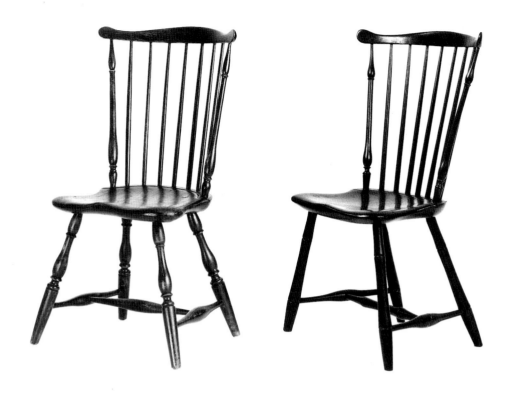

Fig. 3-48 Fan-back Windsor side chair, John Wire (brand "I·WIRE"), Philadelphia, 1780–90. Yellow poplar (seat). (Edgar and Charlotte Sittig collection: Photo, Winterthur.)

Fig. 3-49 Fan-back Windsor side chair, John Brientnall Ackley (brand "I·B·ACKLEY"), Philadelphia, 1790–1800. Yellow poplar (seat); H. 36¼", W. 16½", D. 16". (Independence National Historical Park, Philadelphia: Photo, Winterthur.)

and his customers probably favored the carved, scroll-top crest over the plain one. Henzey produced both seven- and nine-spindle Windsors, the back width of the latter approaching that of Trumble's fan-back chair (fig. 3-46).

Design subtleties vary more in Cox's fan-back work, and he lacked Henzey's distinctive touches. In Cox's chairs the length of the cone-shaped element at the base of the post is twice that in Henzey's work. The longer cone is generally commoner on documented Philadelphia fan-back Windsors. Despite minor design variations that existed from shop to shop, the typical Philadelphia fan-back side chair has several distinct characteristics: the leg baluster, whether medium or long, has an oval body and rather thick neck; the lower spool turning flares into a large mushroom-shaped cap at the top; ornamental rings, when they occur in the medial stretcher, are usually wide in diameter; the front edge of the large seat rounds gently from top and bottom; the back structure is broader than that of most chairs from other areas; and the long balusters in the back posts have fairly consistent elements top and bottom.[40]

Two variations of this typical Philadelphia pattern occur. The first is the rounded cone already noted on Widdifield's sack-back arm supports (fig. 3-40). A cone appears at the base of a back post in a Wire fan-back chair (fig. **3-48**); Widdifield and Pentland also produced fan-back chairs with cone variations. A second departure from standard production introduced a radical new design below the seat. By the early 1790s turned, simulated-bamboo legs and stretchers replaced baluster supports in a few fan-back chairs, such as one by Ackley (fig. **3-49**). Lambert also used simulated bamboo legs on his fan-back chairs. The composite fan-back chair was poorly received in Philadelphia, and few exist today. The bamboo turning was better suited to chairs constructed in the new bow-back pattern.

THE BAMBOO STYLE

Turnings comprising long hollows alternating with swelled, ringed, or cleft joints were common in the ancient world, especially among the Greeks, who found harmony and dignity in the simple profile. The rhythmic sweep of the hollow curves resembles the shape of the bamboo plant, which became popular in England as a material and a decorative form after 1757 when William Chambers illustrated several examples of

Chinese bamboo furniture in his *Designs of Chinese Buildings, Furniture, Dresses, Machines and Utensils*. Direct trade with the Far East also sparked an interest among English furniture craftsmen and their patrons. At the death of William Linnell, cabinetmaker of Berkeley Square, London, several painted, simulated-bamboo chairs with caned or "girt web Bottoms" figured in the 1763 inventory of his large workshop. Four years after taking over his father's business, John Linnell sold "10 Neat Bamboo Chairs with loose seats" to an old family customer, William Drake, Esq., for his Buckinghamshire estate. The fashion disseminated quickly. In the west country, the household goods of the "late Right Rev. Lord Bristol deceased," sold at auction in 1782, contained "a compleat and elegant Set of Green and Gold Bamboo Chairs and Cushions, in perfect Preservation." Thomas Sheraton commented on the bamboo style and its inspiration in his *Cabinet Dictionary* of 1803: "A kind of Indian reed, which in the east is used for chairs. These are, in some degree, imitated in England, by turning beech into the same form, and making chairs of this fashion, painting them to match the colour of the reeds or cane."[41]

The use of wood turned to imitate bamboo quickly found its way from England to America following reestablishment of commercial relations after the Revolution. Samuel Claphamson, "Cabinet and Chair Maker . . . late from London," emigrated to Philadelphia where on January 8, 1785, he advertised "bamboo chairs, fancy chairs, and every article in the above business." Philadelphians also imported all types of fancy furniture directly from London, as, for example, did Henry Hill, Esq., who received a large set of gilt chairs in the ship *Pigou* in 1789. This again had an impact on the city's furniture market. In December 1789, the first recorded reference to Philadelphia Windsor "Bamboo Chairs" occurs in the shipping papers of William Constable, whose agent purchased eight dozen plain, scrolled, bamboo, and common Windsor chairs from Trumble for exportation. In 1790 and 1792 Letchworth sold "Bamboo bow back Windsor Chairs" to a customer. When appraisers itemized Lambert's estate in 1793, they found "600 Turned Bamboo Feet" (legs) in stock.[42]

Lambert is a key figure in pinpointing early Philadelphia use of turned bamboo supports, since the design was obviously in full production at his death. The craftsman apparently began his chairmaking career in Philadelphia about the time the Society of Friends received him into membership on April 4, 1786. An early documented Windsor is a high-back chair of mixed design (fig. 3-50). Lambert took a popular, perhaps slightly outmoded, heavy-rail Windsor and added a shield seat and a new support structure. The legs and stretchers reveal the special characteristics of early bamboowork. The three-sectioned leg is thick, while the "toe" exhibits a slight swell near the base, duplicating half the swelled element centered in the side stretchers. A medial brace with enlarged knobs completes the bracing system. A groove created by a turning tool accents each swelled element of the legs and stretchers. Lambert's brand also appears on a side chair made in the fully converted bow-back pattern with a comparable support structure and a seat made for stuffing.[43]

In the mid 1780s, the new bow-back design was introduced to the Philadelphia market, represented here by the work of Ackley and Henzey (fig. 3-51). Like simulated-bamboo furniture, this pattern was also inspired by English prototypes. A small, braced, bow-back Windsor side chair with front colt's-foot legs was in the English market of the 1770s (fig. 1-35). The design stemmed from the French fauteuil, an open-arm upholstered cabinet chair with a padded backrest frequently elevated above the seat on short, crooked extensions of the back legs. Thomas Chippendale referred to the form, which initially had a squared, cartouche-shaped back, as a "French Chair." During the 1770s Robert Adam introduced an oval-back version, later popularized by Sheraton and George Hepplewhite (fig. 2-1). This profile, resting on incurved supports, forms the waisted arch duplicated in the bent curves of the American bow-back Windsor. The oval-back chair entered the American market only after the Revolution. Initially, Philadelphia craftsmen, and possibly Henzey alone, combined the new back design with baluster legs. Documentation for American bow-back Windsors dates to 1787 when Letchworth made "8 ovel-back Chairs" for Robert Blackwell, although earlier references to "Windsor

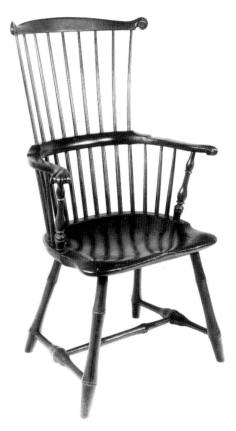

Fig. 3-50 High-back Windsor armchair, John Lambert (brand "I·LAMBERT"), Philadelphia, ca. 1786. Yellow poplar (seat), mahogany (arms). (Photo, Bernard and S. Dean Levy, Inc.)

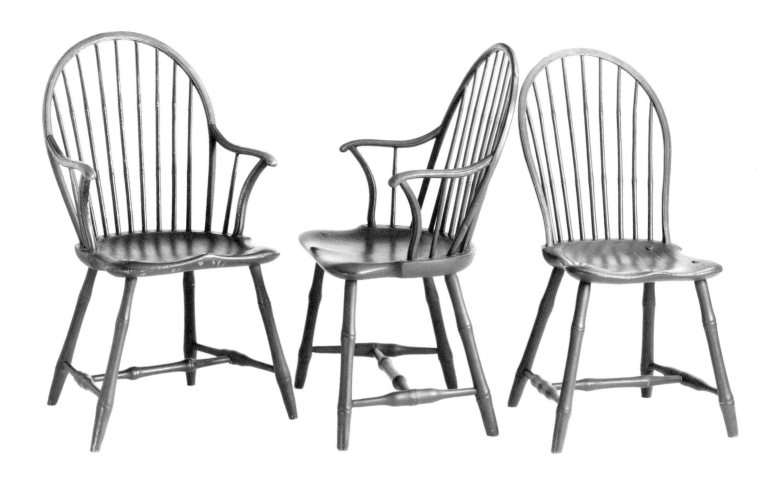

Fig. 3-51 Bow-back Windsor side chair and two armchairs and detail of brand, John B. Ackley (*left*) and Joseph Henzey (brand "I·HENZEY"), Philadelphia, 1785–90. Yellow poplar (seats) with maple, oak, hickory, and ash (arms, *center*) (microanalysis); (*left to right*) H. 37⅜", 37⅝", 36⅞", W. (seats) 19⅞", 20½", 17⅝", D. (seats) 17⅝", 17¾", 16". (Winterthur 63.672, 63.673, 67.1799.)

Chairs" and "Dining Chairs" probably identify bow backs. Philadelphia chairmakers called the new chairs both "oval-backs" and "bow-backs."[44]

The main focus of the oval-back side chair is the bow. In Philadelphia and Delaware Valley chairs, the bent stick forming the bow is U-shaped in cross section and the face is molded with a rounded crown flanked by narrow beads. The bow curves inward near the seat and forms a waist; the lower ends sometimes taper slightly. The spindles are cut to different lengths; each is divided by shallow grooves into three sections with slight swellings at the creases. Lambert's estate appraisers referred to such spindles as "Turn'd Bamboo Sticks." After bamboo-turned supports became commoner, chairmakers introduced a slimmer, less modeled leg. The swelled toe and the slight bulge near the top disappeared from common production. The bulbous side stretchers of earlier patterns remained, but the medial brace reflected the bamboo form.[45]

A bow-back armchair joined the bow-back side chair in the mid 1780s. Both have similar spindles, undercarriages, and seats; the armchair's larger plank provided necessary body room between the arms. The bigger bow has a crowned face only above the mortise-and-tenon joints of the arms. Below, the bow rounds and tapers, usually forming a narrow balloon-shaped profile rather than a waist (fig. 3-51). Short, forward-scrolled arms, called "elbows" in John Lambert's inventory, were hardly new. Boston leather-bottomed chairs, common in the Philadelphia furniture market of the 1730s and 1740s, had larger but similar arms, and Delaware Valley chairmakers like Savery used forward-scrolled arms on vase-back chairs. The initial scroll end was little more than a nub. The sawed, molded arm support duplicates the arm's ogee curve and has similar ornamental grooves along the top and front edges. Fashionable joined seating provided the inspiration for this element (fig. 3-54). A curved C-shaped support was occasionally used; later, a bamboo-turned post was commoner.[46]

While the early bow-back Windsor's exaggerated bamboo turnings were ornamental and striking, they were impractical in Philadelphia's booming postwar market. Domestic and foreign trade expanded by leaps and bounds, and chairmakers needed products they could manufacture quickly and price moderately. Chairmakers simplified the complex bamboo pattern within a short time, perhaps only a matter of months, since none of the eight craftsmen who began making Windsors in the early 1790s appear to have produced bamboo supports of this type (fig. 3-55, left).[47]

Side chairs became the Windsor-chair makers' staple commodity during the 1780s and 1790s, their production greatly exceeding that of armchairs. Mixed sets usually consisted of six side chairs and two armchairs, as noted in a Letchworth bill (fig. 3-52). Socially prominent individuals occasionally ordered many chairs with and without arms to provide adequate seating for their lavish entertainments. General Henry Knox purchased 48 armchairs and 72 side chairs from Cox in 1794 and 1795. By this time, the standard Windsor was, of course, the bow-back chair, a type that merchant Stephen Collins described in 1792 as "the cheapest kind, yet neat and fashionable."[48]

Craftsmen now consciously marked their chairs as a form of advertising, since many were to be exported. Branding was the usual method of identification, with labeling an alternative. Labeling was probably commoner than evidence indicates, but over the years these small papers have fallen off or disintegrated. A label allowed a craftsman to introduce more advertising than was possible with a name brand. A chair, in a private collection, produced by Robert Taylor and Daniel King, business partners in 1799 and 1800, has a brand and a label, although this is rare. On the label, chairmakers listed their shop address and informed ship captains that they produced chairs for exportation.

A special and uncommon innovation in bow-back design occurred near the turn of the century. Family history credits Letchworth with creating the highly ornamental slat-back chair (fig. 3-53, pl. 6). The backs of all known chairs in this pattern conform exactly, except for a pair of chairs of rudimentary pattern marked by Ackley. Letchworth's model was the Philadelphia slat-back, or "pretzel-back," mahogany chair of transitional federal design (fig. 3-54). To construct the ornamental back, the craftsman sawed each slat from a single piece of wood, except the top one, which is a partial slat united with the bow. The vertical slat frame is molded with the same crowned face as the bow, although some bow faces are more elaborate than others. Following the profile of the side chair, the armchair

Fig. 3-52 John Letchworth bill to Jonathan Williams, Philadelphia, 1792. (Dr. Joseph B. Bittenbender collection.)

Fig. 3-53 Bow-back Windsor side chair and armchair, attributed to John Letchworth, Philadelphia, ca. 1796–1802. Yellow poplar (seats) with maple, oak (*left*), hickory (*right*), and mahogany (arms) (microanalysis); left: H. 37⁷⁄₁₆″, W. (seat) 18″, D. (seat) 16⅛″; right: H. 37″, W. (seat) 20½″, D. (seat) 15⅞″. (Winterthur 59.1123, 59.1124.)

Fig. 3-54 Armchair, Philadelphia, 1785–95. Mahogany (microanalysis); H. 38¼″, W. 28⅝″, D. 24⅝″. (Winterthur 59.1486.)

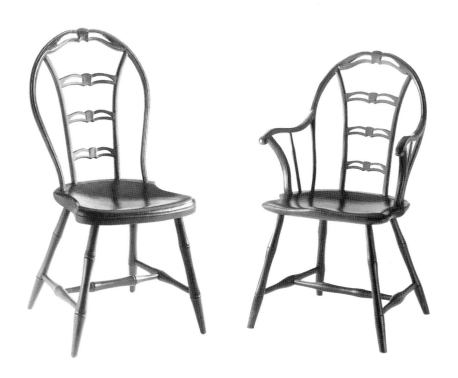

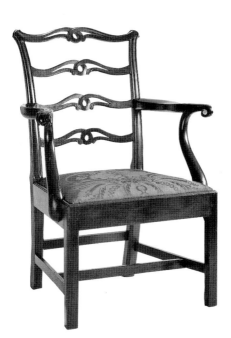

Fig. 3-55 Bow-back Windsor side chairs, Gilbert Gaw (*left*) and William Bowen (brands "G.GAW" and "BOWEN"), Philadelphia, 1798–1802 and 1800–1808. Yellow poplar (seats) with maple, oak, and hickory (microanalysis); left: H. 37⁹⁄₁₆″, W. (seat) 17¼″, D. (seat) 16″; right: H. 38½″, W. (seat) 17¼″, D. (seat) 15¾″. (Winterthur 54.95.2, 69.227.)

bow nips in at the waist. Letchworth produced at least two other back variations: an armchair with a narrow vase splat flanked by three spindles at either side, and a squared slat-back armchair that was introduced after the round back. In place of a bow, the squared armchair has a pierced, modified serpentine top rail supported on plain, molded, upright posts that flare outward, duplicating the lines of the slat frame. Most, if not all, slat-back armchairs have mahogany elbows, and by this date the terminal was a small roll defined on either side surface with the carving tool. The use of mahogany and occasionally black walnut or cherry, common in plain, scrolled-arm, bow-back chairs, was current by 1792, as noted in documents signed by Henzey and by Letchworth (fig. 3-52). Earlier, high-back and sack-back chairs with heavy sawed rails made by Henzey, Lambert, and Trumble employed mahogany arms (figs. 3-24, 3-41, 3-50). Within the slat-back adaptation, general features vary from set to set. In figure 3-53, the legs of the side chair are better defined than those of the armchair. The side chair seat was made for stuffing. The plank lacks the usual groove at the raised spindle platform; a broad groove around the sides and front served as a tacking line for the cover, as old tack holes confirm.[49]

The last bow-back Windsor design appeared at the end of the eighteenth century, and a modified pattern continued into the nineteenth (fig. **3-55**). The focus shifted to the seat, which retained its shield outline but lost the earlier modeled contours. The top surface was formed to a shallow saucer, and the edges became flat or lightly rounded, relieved only by a narrow groove at the top and bottom; the groove around the back platform remained. Gilbert Gaw, who made the H-braced chair, started in business with

his brother Robert in 1793 (fig. 3-55, left). The partnership remained in force until July 1798 when the brothers formed independent businesses. Within a few years the bow-back design underwent more changes. Craftsmen divided the bamboo leg into four instead of three sections and abandoned the H-plan brace for four outside-mounted stretchers in box style (fig. 3-55, right). As late as August 1806 Gilbert Gaw supplied "Ovel back Chairs," probably with box stretchers, to Girard for exportation. The impetus for the transformation came from the outside stretchers of the painted, fancy chair. Two strongholds of the new, competitive seating were Baltimore and New York. In Baltimore, John and Hugh Finlay advertised in 1805: "Cane Seat Chairs . . . of every description and all colors, gilt, ornamented and varnished in a stile not equalled on the continent. . . . Also, A number of sets of new pattern Rush and Windsor Chairs and Settees." A year earlier William Haydon of Philadelphia had placed a notice in a New York City newspaper for "two good workmen" for his fancy-chair business. Challenges to the supremacy of the Windsor as America's most popular seating form were numerous in the nineteenth century.[50]

Pennsylvania from the Mid Eighteenth Century to 1800

THE SOUTHERN SUSQUEHANNA REGION

Chairmakers working within the Pennsylvania German craft tradition produced the most Windsor furniture in Pennsylvania outside Philadelphia during the second half of the eighteenth century. In the German-populated regions of southern Pennsylvania—encompassing Lancaster, York, and Adams counties and parts of Franklin, Cumberland, and Dauphin counties—and Frederick County, Maryland, craftsmen of both German and British origin and descent worked within regional design traditions. Comparative study has made it possible to isolate distinct local patterns and constructional characteristics.

Lancaster, the inland center of German settlement beyond the Delaware Valley, became prominent about midcentury, some twenty years after its establishment as a town and county seat. Thomas Pownall described the small community as "a growing town . . . making money" in 1754. During the third quarter of the century Lancaster became a crossroads town, serving as a market for the productive outlying districts of the county and the region. The town was a stopping point for German and Scotch-Irish immigrants traveling south into Frederick County and Virginia's Shenandoah Valley and for traders bound for western Pennsylvania and beyond. Lancaster enjoyed direct communication with Philadelphia via the Great Wagon Road, which passed through the town before turning southwest toward York and on to Virginia and the Carolinas. Enterprising Philadelphia merchants soon established roots in the center, and mercantile activity, in turn, encouraged craftsmen and shopkeepers to set up small businesses.[51]

The Revolution temporarily halted trade with Philadelphia and the frontier settlements, but after the war the town quickly flourished. European travelers recorded their observations and impressions while journeying through the area at the century's end. Isaac Weld reported that Lancaster now had about 900 houses "built chiefly of brick and stone." François Alexandre Frédéric, duc de La Rochefoucauld Liancourt, observed "broad stone pavements, run in front of the houses, and the streets that are not paved, are at least covered with gravel, and kept clean." In both the town and surrounding countryside, German was the main language. Commerce was prosperous primarily because of the land's productivity. Flour mills sent their product to Philadelphia in wagons that returned with merchandise for regional distribution. La Rochefoucauld Liancourt reported that seventy to eighty wagons frequently passed through Lancaster in a day.[52]

Strong commercial ties between Lancaster and Philadelphia facilitated the transfer of furniture design. Lancaster chairmakers and turners interpreted Philadelphia Wind-

Fig. 3-56 Low-back Windsor armchair (two views; owner brand "GLATZ"), greater Lancaster Co., Pa., region, 1770–80. Yellow poplar (seat) with maple and oak; H. 30½″, (seat) 17⅝″, W. (arms) 27½″, (seat) 24⅞″, D. (seat) 17⅛″. (Private collection: Photo, Winterthur.)

sor patterns within the local ethnic idiom, then distributed their work to towns and countryside where other craftsmen copied or reinterpreted the styles. A study of Lancaster building and furniture trades for the second half of the eighteenth century has found that 85 percent of the woodworking craftsmen were German. Family, religious, and ethnic ties created considerable solidarity among these men, and craftsmen often moved between the city and the surrounding countryside as the job market fluctuated. Lancaster also influenced the town of York, accessible by ferryboat across the Susquehanna. This rich, productive country was again settled largely by people of German origin. Weld noted that York's inhabitants engaged in the same manufactures as Lancaster. In 1809 Joshua Gilpin reported that the community had about 3,000 inhabitants. He likened the town, built chiefly of brick structures around a central courthouse, to an English community because of its compact mixture of old and new buildings, including some "timber frames filled with brick." He also noted the presence "of many genteel & wealthy families." Several years earlier French botanist François André Michaux had noted that most inhabitants were "of German origin, and none speak English."[53]

The first Philadelphia-inspired Windsor made by craftsmen in the greater Lancaster County region was the low-back chair (fig. **3-56**). The basic characteristics suggest that its prototypes date to the 1760s, although the provincial copy likely postdates the decade. The earliest feature is the double vase-and-ring turned medial stretcher; the latest elements are the long, oval balusters of the arm supports and legs. The baluster beneath the arm resembles that of figure 3-13 in more elongated form; the feet of both chairs are also strikingly similar. The D-shaped seat is typical of the prewar period. The arm rail construction follows Philadelphia technique, but the arms are thicker and the heavy back section is taller. The greater rail height required a wider channel on the rear surface and long, double-ogee returns at the points where the back and arms meet. The swelled tips that mark the stretcher ends are characteristic of Pennsylvania German work and lack a Philadelphia counterpart. Such terminals probably also occurred on the front stretchers of regional rush-bottomed chairs. Few Windsor chairs of Pennsylvania German origin are documented. This example bears the brand "GLATZ" on the seat bottom in eighteenth-century-style serif letters, but identification is impossible without other evidence. The brand may be contemporary or a later addition.

A clue to dating the chair comes from a 1784 manuscript illustrated with watercolors of biblical scenes by Ludwig Denig of Lancaster (fig. **3-57**). In this scene King Herod grants a dancing Salome her wish for John the Baptist's head. The figures are in contemporary dress, and Herod and his courtiers sit on low-back Windsor chairs. If the artist's use of this pattern identifies current Windsor work in the Pennsylvania interior, then the chair under discussion reasonably dates in the 1770s.[54]

Fig. 3-57 Ludwig Denig, detail of *John the Baptist . . . Is . . . Beheaded . . . at the Fortress of Macherus*, Lancaster, Pa., 1784. Ink and water-color on paper; H. 8⅞″, W. 6⅞″. (Private collection: Photo, Winterthur.)

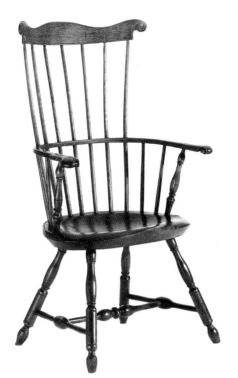

Fig. 3-58 High-back Windsor armchair, greater Lancaster Co., Pa., region, 1775–85. Yellow poplar (seat); H. 43½", (seat) 17⅛", W. (crest) 22½", (arms) 25⅝", (seat) 21⅝", D. (seat) 16½". (Private collection: Photo, Winterthur.)

Fig. 3-60 Detail of arm scroll of figure 3-58. (Photo, Winterthur.)

A high-back chair appears next in chronological order (fig. 3-58). The primary feature is an oval seat with straight-chamfered edges at the back and sides, imitating the earliest known sack-back chair (fig. 3-35). The front edge, however, is chamfered rather than rounded. The modified triangular outline of the oval seat compares to that in a group of regional sack-back chairs. The high-shouldered leg balusters are again similar to the sack-back arm post balusters. Other shared features are the tapered-base arm posts and the foot profiles. The shallow arm scrolls relate to the early 1770s high-back chairs of William Cox and Joseph Henzey. The medial stretcher of the high-back chair, as in the low-back in figure 3-56, is almost centered between the front and back legs rather than set toward the rear, as in the sack-back chair. The Pennsylvania German swelled stretcher tips remain. The side units socket into leg cylinders which, as in the previous low-back chair, are noticeably shorter than those in Philadelphia Windsors. Another distinctive feature is the new, deeper crest delineated at its perimeters with a bead and carved with volutes in partial low relief (fig. 3-70). Inspiration for the bead springs from an earlier Philadelphia vase-back maple chair with serpentine crest rail and cabriole legs (fig. 3-59). One of these maple chairs bears the label of William Savery. The broad outer channel and small, scrolled center of the carved volutes in the high-back chair relate to the same elements in the first Philadelphia fan-back armchairs with circular seats (fig. 3-29). In the Lancaster chair, the surface adjacent to the long, curved edge separating the volute from the body of the crest has been shaved to suggest that the scroll edge is raised. This treatment integrates the bead termination at the volute into the design.

An arm terminal detail of the high-back chair (fig. 3-60) provides another comparison of typical Pennsylvania German work with that of Philadelphia (fig. 3-37, top). In both chairs the end of the bent arm rail forms the inside face of the terminal, rounding at the front and partially carved into a volute on the side. Immediately behind the volute is a wooden pin, and farther back is another. These pins pierce the rail and penetrate a large, shaped, knuckle-end sidepiece fixed to the rail's outside edge; two pins also pierce the attached sidepiece from the outside. Unlike Philadelphia construction, the applied outer piece forms a complete forward knuckle rather than just the top half. Only the lower inside tip of the rail required a tiny, carved block glued on its lower surface to complete the terminal. In figure 3-60 the small block is missing, and so the construction is clearly visible.

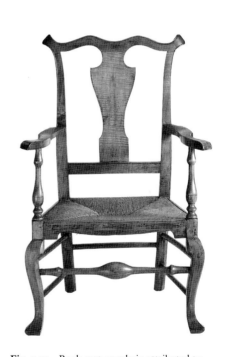

Fig. 3-59 Rush-seat armchair, attributed to William Savery, Philadelphia, ca. 1750. Maple; H. 40⅞", W. 28¹/₁₆", D. 22¼". (Winterthur 67.803.)

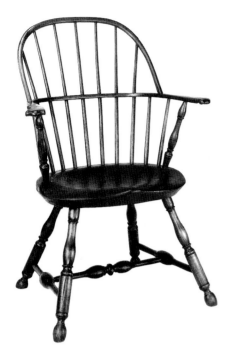

Fig. 3-61 Sack-back Windsor armchair, greater Lancaster Co., Pa., region, 1775–85. (Former collection J. Stogdell Stokes.)

Fig. 3-62 Sack-back Windsor armchair (two views), greater Lancaster Co., Pa., region, 1780–90. Yellow poplar (seat) with maple and hickory (microanalysis); H. 38⁷⁄₁₆″, (seat) 18″, W. (arms) 25¼″, (seat) 21³⁄₁₆″, D. (seat) 15 ¹³⁄₁₆″. (Winterthur 52.237.)

Windsor furniture was used in Lancaster and other southern Pennsylvania counties as early as 1767, when appraisers itemized the personal estate of William Jevon, a well-to-do Lancaster merchant and landowner. A "Highback Windsor chair & cushion" valued at a substantial 15*s.* may have been relatively new, or the high figure may reflect the cushion's worth. In 1778 Mathias Groff sold to Thomas Wharton, Jr., of the Philadelphia family, six Windsor chairs priced at slightly more than 6*s.*4*d.* apiece. In Hanover, York County, William Lorimer, a schoolmaster of Scotch-Irish background, owned two Windsor chairs at his death in 1773, demonstrating that use of the Windsor knew no economic barriers.[55]

A sack-back armchair with a Philadelphia-style bow followed the high-back chair in the market and became the first widely used Windsor pattern in southern Pennsylvania (fig. **3-61**). The high-back chair and the present sack-back Windsor show little variation, suggesting that the seating came from one source. Besides features noted in the high-back Windsor, both chairs display fine, single- and double-incised lines on the fullest diameters of certain turnings, an embellishment popular among regional German chairmakers. Delaware Valley craftsmen had often used scribed lines around the bulbous turnings of rush-bottomed, slat- and vase-back chairs (fig. 3-59). These lines appear here on post balusters and swelled stretcher ends, while the placement of such ornament in other chairs varies, as later examples illustrate. Another common, and most provincial, feature of the high- and sack-back chairs is the long reach of the arms, which extend well beyond the posts. The knuckles are similar, although those of the sack-back chair are small enough to make the addition of a lower block unnecessary. At least four other shops made sack-back chairs of this form, judging by a survey of extant examples.

A sack-back variant from the 1780s features a heavy, pointed-arch bow (fig. **3-62**). The design replaces the double-baluster medial stretcher with a bulbous brace terminating in long, hollow, conelike tips, a form that had originated in Philadelphia more than a decade earlier. The side stretchers swell at the ends, but the leg balusters exhibit a new

Fig. 3-63 Sack-back Windsor armchair, greater Lancaster Co., Pa., region, 1785–1800. Yellow poplar (seat) with maple and oak; H. 35³⁄₁₆″, (seat) 16¼″, W. (arms) 25″, (seat) 21¼″, D. (seat) 16″. (Private collection: Photo, Winterthur.)

profile. The elongated base of the swelled body forms a short neck that replaces the usual spool turning. The arm posts retain the old profile, but such discrepancies between leg and post turnings are common in the area. The primary alteration is the substitution of tapered feet for ball-foot rear legs. This unprecedented union of two support designs in one chair demonstrates the tenacity with which rural craftsmen clung to features long outdated in cosmopolitan centers and the compromises they made to maintain cultural traditions. The ball-foot leg had a long history in both European and American seating, and the dual leg design remained a prominent Windsor feature in parts of southern Pennsylvania through the century's end.

The pointed-bow sack-back chair never became popular and remained localized, but the design may have encouraged other experimentation. The sack-back chair in figure **3-63**, despite the predominance of relatively early features, probably dates in the 1790s, at the end of its stylistic range, since related chairs exist in the bamboo style. The seat, bow, and arms conform to the general regional pattern, and the legs follow the new mode of forming a neck below the baluster. The craftsman altered the character of the turnings, however, particularly in the spherical feet of the heavy front supports. A new treatment of the baluster top introduced a flare in place of the usual well-defined collar, providing turners with still another option. The stretcher design is little known in other seating. Later chairs occasionally employ the same bulbous elements, and similar side stretchers appear on several related bamboo-leg settees. Some southern Pennsylvania turned work has an unusual affinity to New England design. The large, blocked, bulbous turnings of these side stretchers appear in some Rhode Island and Massachusetts work. The sharply tapered back legs that form a toe below the stretchers also appear in coastal New England regions. Several northern areas used flaring or necked balusters; the pronounced spindle swell below the arm rail is a common southeastern New England feature. These similarities seem explicable only in the traditional options available to craftsmen working with wood in the round. Inland Pennsylvania craftsmen, who were slow to assimilate Philadelphia design, would have hardly been conversant with chair production in areas remote from their daily lives. The tapered toe is probably an adaptation of another regional form, the rear leg of the slat-back chair.

Most southern Pennsylvania chairmakers used a rounded or slightly squared arch above the arm rails of their sack-back Windsors. While some chairmakers preferred a necked baluster for this chair, more employed a long baluster with a spool-and-ring turning. In the Lancaster region, and possibly in York County, most craftsmen pro-

Fig. 3-64 Sack-back Windsor armchair with top extension (two views), greater Lancaster Co., Pa., region, 1785–1800. Yellow poplar (seat) with maple and hickory (microanalysis); H. 44⅝″, (seat) 16¾″, W. (crest) 20⁵⁄₁₆″, (arms) 26″, (seat) 21″, D. (seat) 15⅝″. (Winterthur 65.3024.)

duced a standard, regional sack-back armchair during the 1780s, and the number of surviving chairs indicates their popularity. An extraordinary design with a back extension represents the great vision of either the chairmaker or the consumer, since Windsors with top extensions are almost unknown in Pennsylvania (fig. **3-64**). By removing an arc of wood from the center bottom of the high-back crest, the chairmaker achieved both lightness and a delicate rippling effect; his debt to the Delaware Valley slat-back chair is unmistakable. Even without the extension piece, this Windsor seems influenced by the high-back chair in figure 3-58, and at least one transitional pattern forges this link. The large arm scrolls of the present chair nicely balance the other rounded features.[56]

An unusual group of sack-back chairs dates from the end of the eighteenth century (fig. **3-65**). The half dozen or more examples are so similar in design that they undoubtedly came from a small, localized area, possibly the same shop. Features from the arm rail down are familiar: turnings embellished with double-incised lines, swelled stretcher tips, and stylish leg balusters with flared tops and necked bases. An uncommon feature occurs above the arm rail where a tall, squared arch creates a "high-back" chair. The bow provides a critical clue to dating because the groove, or small channel, running around the center of the face, links it directly to the bow-back chair, the first round-back Windsor to use molded ornament on the bow face. The extra back height, while awkward, created a chair for reclining. Another chair of this pattern has small lunette-shaped "wings" containing short spindles attached to the bow face near each upper side. The projections

Fig. 3-65 High sack-back Windsor armchair, greater Lancaster Co., Pa., region, 1790–1805. Yellow poplar (seat); H. 43½". (Mr. and Mrs. Richard Flanders Smith collection.)

Fig. 3-66 High sack-back Windsor armchair, greater Lancaster Co., Pa., region, 1800–1815. (Former collection J. Stogdell Stokes.)

and the chair back provide a framework for a draped cloth. The covering created an "easy" chair that protected invalids and the elderly from drafts.[57]

This unusual sack-back chair has several variants. One substitutes urn-shaped turnings for the standard balusters. A highly ornamental medial stretcher accompanies the urns, and the side stretchers terminate in large swelled ends. This chair probably dates just before 1800, since a new tall-back design with Philadelphia-style bamboowork then became available (fig. 3-66). The bamboo-turned legs are identical to a pattern used in a bow-back side chair by Robert Taylor and Daniel King of Philadelphia. The arms, supported by turnings comparable to those of the legs, terminate in Philadelphia-style bow-back scrolls. The bow face has a crowned surface, and the seat edges round both side and back. On another chair, the legs and side stretchers are turned in the manner of John Lambert's early bamboo, high-back Windsor, with more pronounced swelling of the toes (fig. 3-50). An inscription under the seat indicates that early in the twentieth century the chair was owned in Akron, Pennsylvania, a small community in northern Lancaster County near Ephrata.[58]

The fan-back side chair probably appeared in the southern Pennsylvania market after 1785, and 1790 seems a more reasonable date. In design, the broad, oval seat preceded the shield, and the five-spindle back likely came before the seven-spindle one. An oval-seat five-spindle chair (fig. 3-67) with crisp turnings and precise double-incised banding on the balusters has turned legs like those in the first high sack-back chair (fig. 3-65). The fan-back stretchers vary from the sack-back ones. The ends of the side braces show only a trace of swelling, and the medial support terminates in hollow, conelike tips. The profiles of the rings adjacent to the cones are repeated in the knobs of the back posts. The southern Pennsylvania fan-back post is a rudimentary interpretation of the Philadelphia pattern. The attenuated baluster turning of the rural chair eliminates ornamental terminals, top and bottom, and replaces them with rings for visual definition. A wide seat and the resultant broad, flat back introduce other provincial qualities to the overall design. The awkward grouping, or pinching, of the spindles at the seat and the forward reach of the posts are attempts to increase structural strength. The volute design, a simplification of the earlier high-back pattern, became fairly standard (fig. 3-58). The flat-chamfered seat edge remained a common feature of the fan-back chair, since regional chairmakers were reluctant to depart from tradition.

Pennsylvania 113

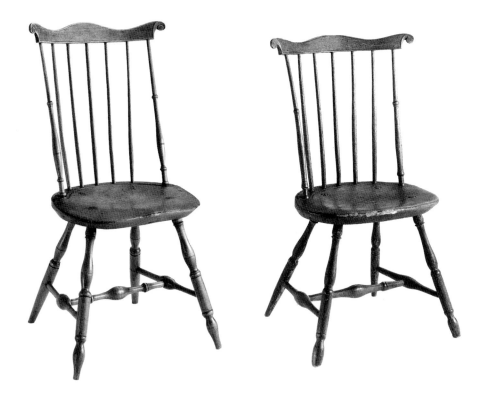

Fig. 3-67 Fan-back Windsor side chair, greater Lancaster Co., Pa., region, 1790–1805. Yellow poplar (seat) with maple and hickory (microanalysis); H. 37″, (seat) 17¼″, W. (crest) 21¼″, (seat) 19³⁄₁₆″, D. (seat) 14⅞″. (Former collection Winterthur.)

Fig. 3-68 Fan-back Windsor side chair, greater Lancaster Co., Pa., region, 1795–1805. Yellow poplar (seat) with maple, hickory, and ash (microanalysis); H. 35¼″, (seat) 16⅝″, W. (crest) 21⁹⁄₁₆″, (seat) 19³⁄₁₆″, D. (seat) 13⅞″. (Winterthur 59.2080.)

Not only did the handling of design elements vary from metropolitan to semirural areas, but the degree of sophistication in nonurban furniture also differed, as demonstrated in figure **3-68**. The chair imitates figure **3-67** element for element, but the craftman's skill with the turning chisel falls short of the mark, and the roundwork has a soft, poorly defined quality. The spindles of both chairs show defects in the wood fibers (hickory or ash) that have caused some sticks to warp, and careless shaving has produced thick and thin sections. The less skillful work of figure 3-68 contrasts greatly with the precise turnings and carved volutes of most regional Windsors. Some seven-spindle fanbacks have characteristics relating them to this group; one has a tradition of family ownership in Lancaster County.

A related fan-back chair substitutes a broad shield for the oval plank and has seven instead of five spindles (fig. **3-69**). The sticks are better formed, although they still vary in diameter. The carved crest volutes are typical of Pennsylvania German craftsmanship (fig. **3-70**). The seat retains the old-style flat-chamfered rear edge. The support structure differs only in its incised balusters and fuller stretcher ends (fig. **3-71**). The many surviving shield-seat chairs indicate their reasonable popularity during the late eighteenth century. One late variation exhibits more flamboyant turnery; the balusters are thicker and more vigorous than those of the previous chairs (fig. **3-72**). Another new feature is the narrower plank with a rounded back edge; the reduced width of the seat produces a more standard back structure. A few privately owned chairs, linked by their Philadelphia-style posts with double-spool-and-ball elements (fig. 3-45), show variable southern Pennsylvania characteristics from oval seats and broad backs to narrow, shield bottoms and compact, tapered backs. Most have leg balusters with bottom necks; some have collared tops.

A final variation of the fan-back chair featured a bamboo-turned undercarriage, although the upper back structure remained the same (fig. **3-73**). The narrow plank still has a chamfered rear edge. The bamboo supports, like those of figure 3-66, follow a Philadelphia pattern dating to the 1790s. By the time Pennsylvania German craftsmen had assimilated this pattern, the metropolitan three-part bamboo leg was replaced by a four-part support with box stretchers.

Until the introduction of the bow-back side chair around 1790, southern Pennsylvania Windsor-chair makers were anonymous. In the late 1780s or early 1790s, Michael

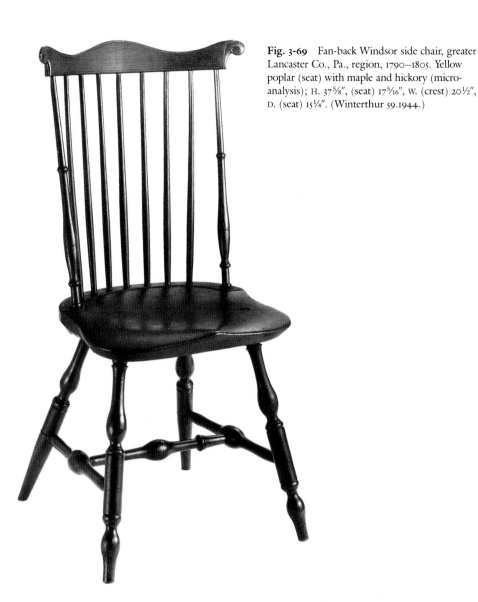

Fig. 3-69 Fan-back Windsor side chair, greater Lancaster Co., Pa., region, 1790–1805. Yellow poplar (seat) with maple and hickory (micro-analysis); H. 37⅝″, (seat) 17⁵⁄₁₆″, W. (crest) 20½″, D. (seat) 15¼″. (Winterthur 59.1944.)

Fig. 3-70 Detail of crest scroll of figure 3-69.

Fig. 3-71 Detail of undercarriage of figure 3-69.

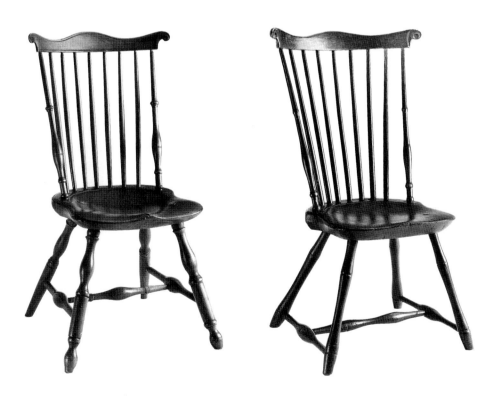

Fig. 3-72 Fan-back Windsor side chair, greater Lancaster Co., Pa., region, 1795–1805. Yellow poplar (seat) with maple and hickory (microanalysis); H. 35⅞″, (seat) 16½″, W. (crest) 20⅛″, (seat) 17⅛″, D. (seat) 16″. (Winterthur 65.2834.)

Fig. 3-73 Fan-back Windsor side chair, greater Lancaster Co., Pa., region, 1800–1815. Yellow poplar (seat); H. 33¾″, (seat) 14⅞″, W. (crest) 21¼″, (seat) 15⅝″, D. (seat) 14¾″. (Private collection: Photo, Winterthur.)

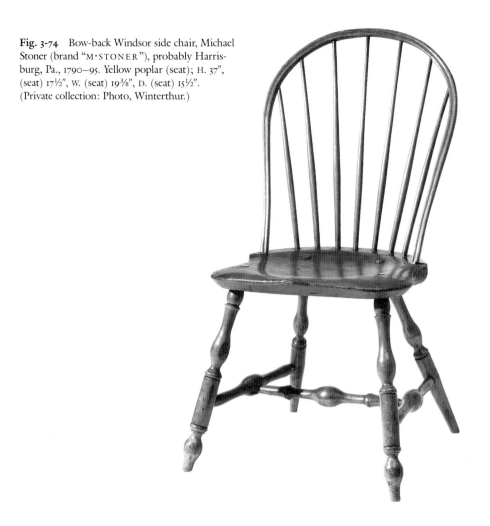

Fig. 3-74 Bow-back Windsor side chair, Michael Stoner (brand "M·STONER"), probably Harrisburg, Pa., 1790–95. Yellow poplar (seat); H. 37″, (seat) 17½″, W. (seat) 19⅜″, D. (seat) 15½″. (Private collection: Photo, Winterthur.)

Stoner established a chairmaking business in Harrisburg. The son of Jacob Steiner of Frederick, Maryland, he was born in 1764 and resided in Harrisburg Township by 1790. Stoner married Elizabeth Trissler in 1791 in the Moravian church at Lancaster. With both Frederick and Lancaster ties, Stoner could have served an apprenticeship in either place, probably as a cabinetmaker. An April 1792 land transaction for a quarter-acre lot in Walnut Street, Harrisburg, perhaps marks the year Stoner opened his own shop. The following July he advertised for an apprentice "to the Windsor chair-making business." When Stoner sold land in Front Street in December 1793, the deed listed him as a chairmaker. Sometime during the next five years the craftsman relocated to Lancaster, where the United States Direct Tax of 1798 lists him as the owner-tenant of a house and separate shop valued at $420. Stoner had probably moved to Lancaster two years earlier. An 1806 mortgage deed, describing his land in Orange Street and giving dimensions similar to those in the direct tax, indicates that he had purchased the property on April 12, 1796. This may have been about the time he took David Trissler, probably his wife's kinsman, as an apprentice. The young man ran away in 1801, and Stoner advertised for his return. The Lancaster borough assessment records refer to Stoner as a joiner or a cabinetmaker from 1799 until his death in 1810. His estate inventory indicates that he also veneered and painted case furniture and made and sold bedsteads, coffins, and patented washing machines. Stoner's household seating included a "Set of black Windsor Chair[s]" and six green side chairs and armchairs.[59]

Stoner practiced chairmaking in Harrisburg for about two to six years. His first documented product is a bow-back side chair (fig. **3-74**) with turnings almost identical to a Lancaster fan-back chair (fig. 3-69). The bow duplicates the front surface molding and the bent waist of the high sack-back Windsor (fig. 3-65). The pinched spindles, which imitate those of fan-back chairs, establish an early 1790s date. Of three branded Stoner

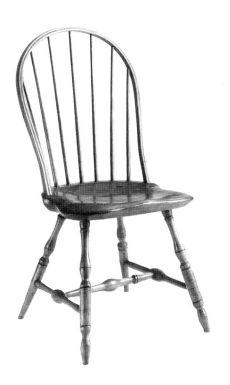

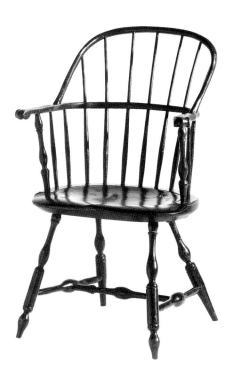

Fig. 3-75 Bow-back Windsor side chair and detail of brand, Michael Stoner, Harrisburg or Lancaster, Pa., 1793–1800. Yellow poplar (seat) with maple and hickory (microanalysis); H. 36⅛", (seat) 16⅞", W. (seat) 19⅜", D. (seat) 15⅝". (Winterthur 78.211.)

Fig. 3-76 Sack-back Windsor armchair, Michael Stoner (brand "M·STONER"), Harrisburg or Lancaster, Pa., 1793–1800. Yellow poplar (seat); H. 36⅛", (seat) 16⅞", W. (arms) 24¼", (seat) 21½", D. 16". (Private collection: Photo, Winterthur.)

bow backs, only this one has pinched spindles. The second, almost identical, side chair, which appears of later design, has slimmer spindles spaced evenly around the back, creating a consistent visual rhythm of solids and voids in the Philadelphia manner (fig. **3-75**). The craftsman must have realized quickly that the pinched placement of the spindles was incompatible with the round-back design. While figure 3-74 appears to be a Harrisburg chair, figure 3-75 could be either of Harrisburg or early Lancaster origin. The third branded bow-back, in the Smithsonian Institution, shares characteristics of both Stoner chairs. The heavy undercarriage turnings resemble those of his first chair, but the unusual bow is only two-thirds the standard height. The design elements of Stoner's chairs support the idea that he spent his journeyman years in Frederick County or Lancaster. In addition, a Steiner family member has been identified as an original owner of a related Frederick County Windsor (fig. 3-83).

Stoner's Windsor production also included sack-back chairs (fig. **3-76**). The slimmer turnings may indicate a mid to late 1790s date. Unlike the side chairs, the seat edges are flat, then chamfered, following the pattern of the first high sack-back Windsor (fig. 3-65). The pronounced swell of the spindles through their lower halves visually complements the slender turnings of the arm posts. Knuckle construction follows standard regional practice; the small, shaped, wood blocks completing the lower inside faces are clearly visible. The plain, square-arch bow meets the rail in Philadelphia-style flaring, blocked tips.

THE EASTERN AND CENTRAL MARYLAND BORDER REGION

Windsor seating identified with the southern Pennsylvania border is less common than production associated with the lower Susquehanna region. Several watercolor portraits of area residents attributed to Jacob Maentel (1778–after 1858), a semi-itinerant York folk painter, picture bow-back side chairs with three- or four-part bamboo legs (fig. **3-77**). Maentel's Windsors have the stout, shapely supports characteristic of Baltimore work. This seaport's influence on southern Pennsylvania life should be noted here, since the impact of Baltimore design was later substantial. Although the border settlements were strongly Germanic in background, there is less obvious German inspiration in local vernacular seating than is encountered farther north. Identified production also dates from slightly later, beginning only at the close of the eighteenth century. The area was

Fig. 3-77 *General Schumacker's Daughter,* attributed to Jacob Maentel, York Co., Pa., ca. 1815. Watercolor on paper; H. 14½", W. 9½". (Former collection Edgar William and Bernice Chrysler Garbisch.)

Fig. 3-78 Bow-back Windsor side chair, southern Lancaster or Chester cos., or adjacent Maryland, 1800–1815. Yellow poplar (seat); H. 37⅜″, (seat) 16⅛″, W. (seat) 17″, D. (seat) 13⅞″. (E. S. Wilkins collection: Photo, Winterthur.)

Fig. 3-79 Bow-back Windsor side chair, southern Lancaster or Chester cos., or adjacent Maryland, 1800–1815. Yellow poplar (seat); H. 34¾″, (seat) 15⅛″, W. (seat) 21″, D. (seat) 14¼″. (Private collection: Photo, Winterthur.)

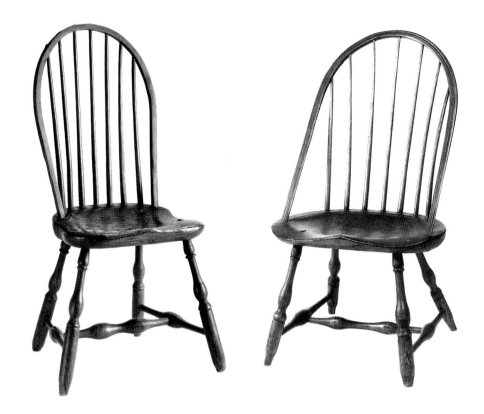

somewhat removed from the bustling commerce surrounding Lancaster, and soon the westward migration brought settlers from the Delaware Valley and Baltimore with their firsthand knowledge of current metropolitan styles, to and through the region. With some exceptions, distinctly regional seating characteristics died out following a brief flowering, and local patterns began to mirror more closely the metropolitan product. After 1815 little time elapsed between the introduction of a fashionable city design and its dissemination in the country.

An unusual combination of elements occurs in a small, rural, bow-back chair recovered around Quarryville, south of Lancaster near the Maryland border (fig. **3-78**). The bow lacks incised ornament, and the spindles are hand shaved to irregular form. The chairmaker produced a shield seat of considerable sculptural quality with a deeply scooped center and high-rising pommel. The lathe-turned legs have stylish tops terminating in blunt-toed cylinders that appear to be related to those on rush-bottomed, slat-back seating but may simply be worn versions of the profiles illustrated in figures 3-83 and 3-84. The craftsman was certainly familiar with chairs like those in figure 3-83, a Maryland fan-back whose baluster turning with its necked base and adjacent ring is almost identical. The medial stretcher looks like an exaggerated version of the bamboo-turned element in figure 3-83, which provides a distinct clue to dating. Another bow-back chair, whose support structure is virtually identical to that of the Quarryville chair, shows a closer connection with the fan-back chair (fig. **3-79**). The feet confirm that the supports of both bow-back chairs once duplicated those of the fan-back Windsor. Whether of Pennsylvania or Maryland origin, figure 3-79 definitely links the two groups. The upper structure, with its well-modeled, broad oval plank, awkward back curve, and forward-placed bow ends, mimics that in the Maryland chair. The hands of three different chairmakers may be represented here; two, and possibly all three, likely worked just south of the Pennsylvania border.

A rare, early nineteenth-century bow-back armchair with rural Pennsylvania characteristics seems closely linked to southern York County (fig. **3-80**). Several features relate to two contemporary settees at Winterthur. The chair legs are slimmer versions of those in the long seats, and the bulbous swells of the stretchers are comparable, although much smaller. With minor variation, the arm supports duplicate the ornamental profiles of the

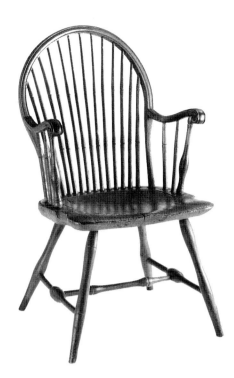

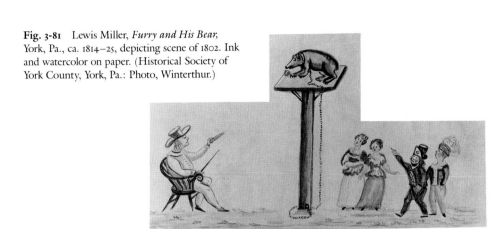

Fig. 3-80 Bow-back Windsor armchair, probably York Co., Pa., 1800–1815. Yellow poplar (seat) with maple, ash, oak, hickory, and walnut (microanalysis); H. 38⅞″, (seat) 16⅞″, W. (arms) 23½″, (seat) 21¼″, D. (seat) 18¾″. (Winterthur 65.837.)

Fig. 3-81 Lewis Miller, *Furry and His Bear*, York, Pa., ca. 1814–25, depicting scene of 1802. Ink and watercolor on paper. (Historical Society of York County, York, Pa.: Photo, Winterthur.)

settee spindles, and all relate to mid eighteenth-century Philadelphia work (fig. 3-4). The bow-back chair's creased, nodular bamboo spindles flare slightly at the bottom and are enclosed within a broad, molded bow that slims and nips in under the arms. Bow and spindle profiles show familiarity with Baltimore design (fig. 4-2). Behind the compact, thirteen-spindle back, the chairmaker shaped the seat edges in the usual flat-chamfered Pennsylvania German manner. Lewis Miller (1796–1882) of York captured the character of this chair in an amusing early nineteenth-century drawing (fig. **3-81**), although the relationship may be only coincidental. "Furry's" bow-back armchair has the same stance and scroll terminals as figure 3-80.[60]

Another bow-back armchair, in a private collection, identified by both maker and origin, combines features of late eighteenth- and early nineteenth-century design and demonstrates how the metropolitan influence gradually obliterated regional features. Samuel Humes of Lancaster, born about 1753, was of Scotch-Irish descent; the 1779 local tax records list him as a turner. He also made chairs and spinning-wheels and was evidently successful at all three trades. Sometime before his death in 1836, Humes retired and assumed the sobriquet "Gentleman," indicating that he had accumulated sufficient means to see him comfortably through his later years. Humes began making Windsor chairs before 1795, when he made twelve for Judge Jasper Yeates, who bought the chairs for his son. The branded armchair follows the Philadelphia model in all respects except the arms, which imitate the hollow forward sweep of the metropolitan scroll arm only to the front posts, where they terminate abruptly without completing the forward roll (fig. 3-51, left). Although the effect is unusual, the work suggests that even conservative craftsmen were becoming conscious of "fashion's" importance.[61]

Family histories and data on recovery locations identify distinctive groups of Windsor furniture in several areas west of the Susquehanna in Frederick and Carroll counties, Maryland, and Adams and Franklin counties, Pennsylvania. The area was rural, except for a few towns and villages. Early nineteenth-century travelers commented on the region's appearance and economic life. Weld found Frederick "a flourishing town," which carried on "a brisk inland trade." La Rochefoucauld Liancourt noted: "The greater number of houses are stone buildings. . . . The population of Frederick-Town amounts to about two thousand souls, a fourth of whom are negroes. It carries on a

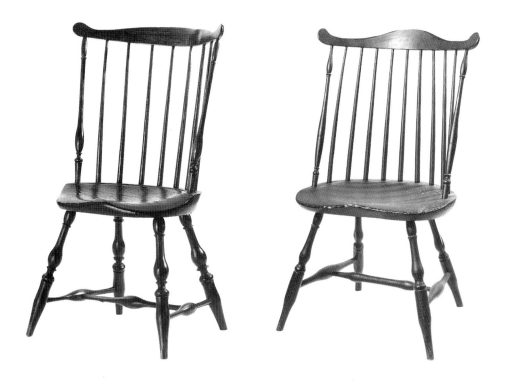

Fig. 3-82 Fan-back Windsor side chair, Frederick Co., Md., 1795–1805. Yellow poplar (seat); H. 37½", (seat) 17½", W. (crest) 23⅝", (seat) 19⅝", D. (seat) 19⅝". (Edward and Helen Flanagan collection: Photo, Winterthur.)

Fig. 3-83 Fan-back Windsor side chair, Frederick Co., Md., 1800–1815. H. 36", (seat) 17", W. (seat) 21", D. (seat) 14½". (Katharine Wright Sailer collection: Photo, Benno M. Forman.)

considerable trade with the back country, which it supplies with merchandise drawn from Baltimore, and transmits to the latter place in return the produce of the back country."[62]

A fan-back side chair purchased at an old Frederick family's estate auction dates to the late 1790s and is the earliest identifiable Windsor of Frederick County origin (fig. **3-82**). The chair relates to southern Pennsylvania work in the slight swell of the stretcher ends and the broad-backed oval seat. Instead of the usual 2-inch seat plank, the chairmaker began with a 2½-inch slab. While the seat front is sculptured deeply, the plank's full depth is visible at the back corner. The turned legs and posts are of exceptional quality; the post tops are too small by comparison. Like many country products, the design's shortcomings become more readily apparent when compared with metropolitan work, and, as here, the fault usually lies in the craftsman's selection and combination of parts. For many modern collectors, however, this provincialism adds to an object's visual appeal. The swelled leg tapers are the outstanding feature of the chair, although such feet are usually associated with southeastern New England. Tapered feet also occur on a Winterthur settee purchased in southern Pennsylvania and on an unusual rocking chair from the Taneytown-Emmitsburg area of northern Frederick and Carroll counties (fig. 3-90). All three pieces show enough variation to assign them to different shops.[63]

A fan-back chair once owned by Hannah Steiner (1748–1818) dates to the early nineteenth century, given its bamboo medial brace (fig. **3-83**). A companion chair in another private collection has a family history in Frederick. This design shares several characteristics with figure 3-82. The posts reflect Delaware Valley design, and the oval seats produce broad backs in the German manner but with regularly spaced spindles. In the Steiner chair, Germanic influence appears again in the incised banding of the post balusters. The chairmaker exaggerated the crest pattern by increasing the size of the arch, flattening the low areas, and introducing a slight hook to the plain, scroll ends. Beneath the seat, baluster turnings reveal their Germanic origin, while tapered feet again duplicate a pattern commoner in New England.

The sack-back chair in figure **3-84** conforms to a pattern found in Frederick County. The chair belonged to the Seiss family of Graceham, a town with a strong Moravian background. Two similar chairs were owned by families in Libertytown and Frederick. All three communities are located within a 15-mile area. The chairmaker planned the

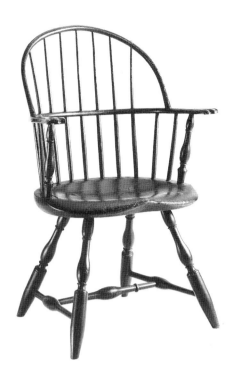

Fig. 3-84 Sack-back Windsor armchair, Frederick Co., Md., 1795–1805. Yellow poplar (seat); H. 37⅞″, (seat) 17½″, W. (arms) 25⅜″, (seat) 22″, D. (seat) 16⅞″. (Edward and Helen Flanagan collection: Photo, Winterthur.)

Fig. 3-85 Detail of sack-back Windsor armchair, Frederick Co., Md., 1795–1805. (Private collection: Photo, Museum of Early Southern Decorative Arts, Winston-Salem, N.C.)

Fig. 3-86 Detail of seat bottom of figure 3-84. (Photo, Winterthur.)

proportions and coordinated the parts to produce a harmonious, integrated design. Arm post turnings, for example, duplicate those of the legs. The squared bow ends and the collarless rings of the medial stretchers show Delaware Valley influence. The tapered feet, although somewhat thick, balance the strong horizontal line of the large, round-edge seat. The hollow below the pommel is uncommon in American Windsors but occurs occasionally in English chairs (fig. 1-15). Several construction aspects of these sack-back chairs are unusual. The curved sidepieces of the arm terminals attach with double pins driven in from either side surface; the small carved blocks that once completed the knuckles are now lost but have survived in a related chair (fig. **3-85**). The posts fail to penetrate the seat, unlike usual Windsor construction; the leg tips that pierce the plank top also lack wedges. Instead, the legs are held firmly in place by large squared pins driven obliquely into the seat bottom until they pierce the legs (fig. **3-86**). Faintly visible on the seat bottom are laying-out marks to insure proper leg placement; the lines form overlapping isosceles triangles.

A small fan-back side chair with a heart-shaped seat, acquired at auction in Frederick, is related to the armchair in figure 3-84 through its leg profile below the baluster (fig. **3-87**). There is a hollow beneath the seat pommel, and the leg tenons are secured in the plank by pins driven from the seat bottom. The worn medial stretcher tips relate to Pennsylvania German work of the lower Susquehanna region (figs. 3-65, 3-67, 3-76) and occur in a local fan-back chair (fig. 3-82). The upper and lower elements in the back-post turnings relate to those in figure 3-83.

A bow-back armchair comes from a group of ten or more bow-back side chairs and armchairs, including a child's high chair, that are interrelated through their distinctive leg turnings, bows, and arms (fig. **3-88**). The chairs originated in a small area encompassing parts of Adams and Franklin counties, Pennsylvania, and Frederick County, Maryland. The chairs range in design from the full baluster to the full bamboo style. The illustrated armchair, from a family in Fairfield, Pennsylvania, only a few miles north of Maryland, represents a transitional pattern since the arm supports reflect the later bamboo style. Sometimes the transitional elements are reversed to feature bamboo-turned legs and baluster posts. In a close study of this group, it is possible to identify design influences from other chairs from the Pennsylvania-Maryland border region and to isolate the work of several craftsmen. The high-shouldered balusters, although longer, are similar to those of two early Pennsylvania German Windsors (figs. 3-58, 3-64). The

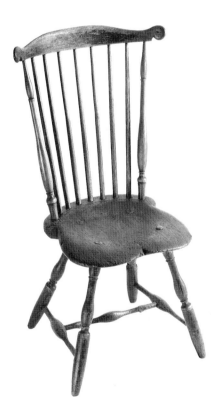

Fig. 3-87 Fan-back Windsor side chair, Frederick Co., Md., 1795–1805. Yellow poplar (seat); H. 37¼″, (seat) 16¼″, W. (crest) 21½″, (seat) 16¾″, D. (seat) 15⅞″. (Edward and Helen Flanagan collection: Photo, Winterthur.)

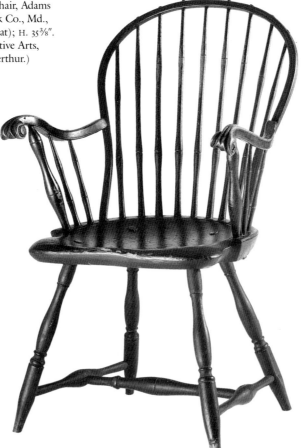

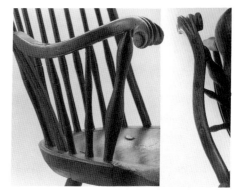

Fig. 3-89 Details of arm post and arm of figure 3-88. (Photo, Winterthur.)

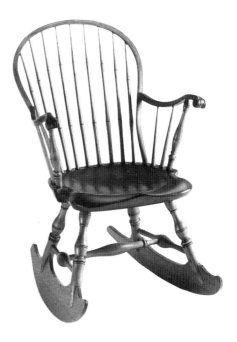

Fig. 3-90 Bow-back Windsor rocking armchair, Adams and Franklin cos., Pa., and Frederick Co., Md., region, 1795–1805. Yellow poplar (seat); H. 35½", (seat) 15⅞", W. (arms) 22⅞", (seat) 18⅛", D. (seat) 17"; rockers replaced. (Private collection: Photo, Winterthur.)

Fig. 3-91 Details of seat top and arm scroll of figure 3-90. (Photo, Winterthur.)

feet, rings, and spools resemble closely those of two chairs from Frederick County (figs. 3-84, 3-87). The tipped medial stretcher and swelled-end side stretchers have counterparts in other German work (figs. 3-65, 3-76). The spindles, somewhat exaggerated in profile, relate to those of figure 3-80 in their swelled, creased nodules and flaring bases; both show direct Baltimore influence (fig. 4-2). Chair bows within the group generally have low, broad profiles with pronounced bends at the waist. The arms represent outstanding individual expression in American Windsor furniture. The sinuous rhythm of their forward reach culminates in a vigorously carved, suspended scroll (fig. 3-89).

A rocking chair of related design came from the Emmitsburg, Frederick County, estate of Alice Taney, grandniece of Chief Justice Roger B. Taney (fig. 3-90). Post balusters follow the usual elongated pattern; the leg balusters are necessarily shorter. The vase-shaped balusters and the swelled-taper feet relate directly to similar elements in a unique Winterthur settee. The tapered feet are also close to those in a Frederick County fan-back chair (fig. 3-82). The unusual ornamental band around each baluster is complemented by incised lines on the other turnings. The bow face is flat with a narrow incised line at either edge forming a bead in the New England manner, a detail repeated at the lower inside and outside arm edges. A fanciful gouged channel intertwines between the elements socketing into the seat top (fig. 3-91). Although the arm scrolls

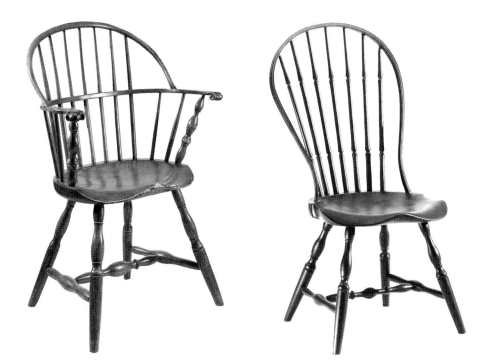

Fig. 3-92 Sack-back Windsor armchair, Franklin Co., Pa., 1795–1805. (Metropolitan Museum of Art, New York.)

Fig. 3-93 Bow-back Windsor side chair, Franklin Co., Pa., 1795–1805. Yellow poplar (seat); H. 38¾", (seat) 16¼", W. (seat) 18", D. (seat) 15⅝". (Private collection: Photo, Winterthur.)

lack the full sculptural quality of figure 3-89, delicately carved four-petal flowerettes finish the inside faces.[64]

Another interpretation of the high-shouldered baluster appears in Windsors from Franklin County in southern Pennsylvania (fig. 3-92). Similar chairs are in Franklin County private collections and the Renfrew Museum and Park, Waynesboro. Chambersburg, the county seat, was a bustling community at the beginning of the nineteenth century. Its situation on the Conococheaque Creek in the lower Cumberland Valley fostered numerous small manufactures—grist, paper, oil, and fulling mills and weaving establishments. The area's economic prosperity was noted as early as 1795 when a traveler described Chambersburg as a thriving town. At least one craftsman discovered that the valley needed a good chairmaker. A group of seven sack-back armchairs and three bow-back side chairs shows subtle variation from chair to chair, indicating that a single craftsman produced the furniture over a period of time. The side chairs show a definite progression in the leg turnings, culminating in the chair in figure 3-93. Despite minor differences, key design elements are constant: spool turnings form broad bands, thin baluster collars have knifelike edges, side and medial stretchers end in exaggerated swells, and the seat front is deeply modeled. The spindle placement, characterized by sizable voids at either end, suggests that the craftsman trained in the region's eastern section before settling in the Cumberland Valley. Franklin County was heavily populated by Germans, and one of the four local weekly newspapers was printed in German. The posts of the Franklin County armchair echo, with modification, the unusual turnings of its medial stretcher. The swellings at the bases of the posts replace tapered cones and form a substantial visual alteration. The arm scrolls, while only of moderate size, are bold, and the short rail returns behind the knuckles form exaggerated curves. The sweeping lines of the narrow, beaded side chair bow capture the movement of the seat, while the deeply grooved and swelled spindles visually balance the vigorous support structure.[65]

EASTERN CENTRAL PENNSYLVANIA

North of Philadelphia and Lancaster County is another large and fertile region mostly inhabited in the late eighteenth century by German-speaking peoples. The territory stretched from Bethlehem in the east, down to Reading, and west to Lebanon and the Moravian village of Lititz in northern Lancaster County. Windsor furniture identified

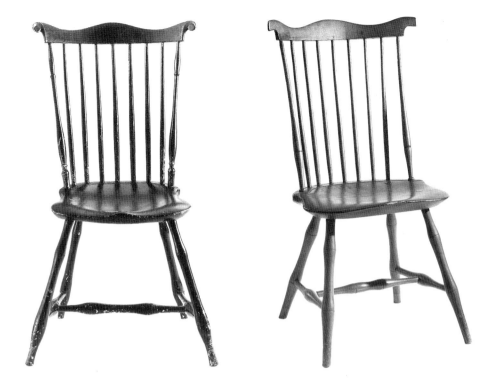

Fig. 3-94 Fan-back Windsor side chair, probably northern Lancaster Co., Pa., 1800–1815. Yellow poplar (seat); H. 37″, (seat) 17⅛″, W. (crest) 21⅛″, (seat) 16¾″, D. (seat) 16⅛″. (Mr. and Mrs. Floyd C. Hinden collection: Photo, Winterthur.)

Fig. 3-95 Fan-back Windsor side chair, probably Bethlehem, Pa., 1800–1815. Yellow poplar (seat); H. 36⅝″, (seat) 17″, W. (crest) 21″, (seat) 18¾″, D. (seat) 15″. (Moravian Museums and Tours, Bethlehem, Pa.: Photo, Winterthur.)

with this area falls into two groups: that associated with the Moravians and that made in or near Reading in Berks County. The Moravians, a Protestant European "unity of brethren" whose beliefs directed their material culture as well as their spiritual life, founded a communal settlement at Bethlehem in 1741. By the postrevolutionary period, diversified activities included farming, innkeeping, and light industry and crafts. The community practiced economic self-sufficiency whenever possible. Weld described local business in 1797: "The manufactures in general carried on at Bethlehem consist of woollen and linen cloths, hats, cotton and worsted caps and stockings, gloves, shoes, carpenters, cabinet-makers, and turners work, clocks, and a few other articles of hardware."[66]

About 65 miles southwest of Bethlehem, the Moravians founded the village of Lititz in the 1750s. The community developed along the Bethlehem pattern with an economy based on farming, milling, and handicrafts. Jedidiah Morse noted that about 1787 the settlement included "an elegant church, and the houses of the single brethren and single sisters, which form a large square," private houses for families, a store, a tavern, "a good farm, and several mill works." Other members of the congregation lived on neighboring farms.[67]

The Moravian communities needed many chairs for living quarters, craft shops, schools, and taverns; special chairs were required for their musical activities. Chairs were produced in community workshops and on local farms. With constant intercommunication between Moravian communities and frequent exchanges of workmen, the identification of chairs with a specific congregation is often impossible. A fan-back side chair (fig. **3-94**) represents an early Moravian pattern. The posts are slim copies of the Philadelphia style, and the seat also follows metropolitan work. The crest, with beaded perimeter and relief-carved scrolls, represents typical eastern Pennsylvania German patterns, although the volutes are reduced in breadth. The exaggerated, bamboo leg profile is unique to the Moravians; some legs have delicate, flared toes. Besides several fan-back chairs with this leg profile, tall bow-back chairs used by community musicians have similar but longer legs. Given the community's conservatism, the use of bamboo-turned supports, some combined with the late eighteenth-century bow back, suggest an early nineteenth-century date.

Another fan-back Windsor of about the same date again shows strong German influence both in individual parts and overall proportions (fig. **3-95**). The chairmaker

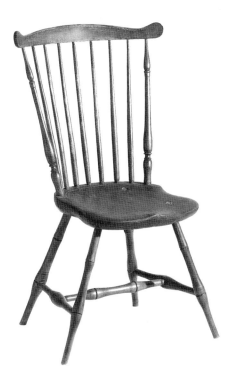

Fig. 3-96 Fan-back Windsor side chair, eastern Pennsylvania, 1795–1805. Yellow poplar (seat); H. 37½", (seat) 16¾", W. (crest) 22⅜", (seat) 17⅛", D. (seat) 16⅛". (Edgar and Charlotte Sittig collection: Photo, Winterthur.)

reduced the design to the basics. The bamboo legs swell just enough to provide visual interest. The broad, ample seat, while light in appearance, retains the old-style, flat-chamfered shaping at the back edges. In making the posts, the chairmaker economized on labor by turning only one small base ring and an incised swell. The spindles still tend to pinch together at the seat. The crest, with blunt projections in place of scrolls, is a basic regional pattern.

Three fan-back side chairs in private collections, represented by figure **3-96**, originated in eastern Pennsylvania, but lack of information prevents pinpointing the specific area. The chairs vary slightly in profile and diameter of the turnings, but each has a distinctive, short, inverted-baluster element at the post bases. The feature is highly reminiscent of late 1780s Philadelphia work and may represent a direct copy of a Philadelphia model in this respect (fig. 3-48). The bamboo support structure places the earliest date at 1795, but 1800 seems more likely. The legs may be slimmer versions of those in figure 3-95, although none of the chairs has any known Moravian association.

Seven chairs of squared bow-back form illuminate the progression and modification of another northern pattern between about 1795 and 1810 (fig. **3-97**). Each chair retains a central groove in the bow face and clustered spindles at the seat. Three chairs, including the one illustrated, have baluster legs that combine ball and tapered feet braced by stretchers of swelled and conical ends; the turnings are similar to those in Stoner's work (figs. 3-74, 3-75). Each chair also has a broad, shield-shaped seat and a bow that duplicates the arch of a tall, German, sack-back chair (fig. 3-65). The illustrated Windsor came from the Moravian congregation at Lititz. A similar chair with a bamboo medial stretcher is still owned by the same congregation. Other chairs in regional collections have full bamboo support structures that are almost identical in profile to figure 3-95, and each has a known church affiliation in Bethlehem or Lititz.

Reading, like Lancaster and Bethlehem, looked to Philadelphia to supply imported and manufactured articles in exchange for surplus area commodities. With the metropolitan goods came news, technology, and the latest fashions in personal and household goods. Wealthy men often bypassed local distributors and traded directly with Philadelphia. Englishman William Bird, ironmaster at Berkshire Furnace southwest of Reading near Wernersville, was one who obtained goods in this manner. At his death in 1761, the parlor of his Reading home contained a Windsor chair amid other cosmopolitan furnishings that included leather-bottomed chairs and a carpet-covered walnut table.

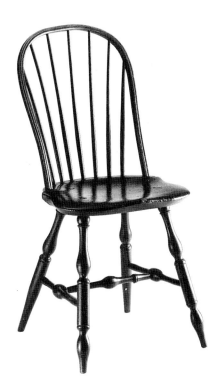

Fig. 3-97 Bow-back Windsor side chair, Lititz, Pa., 1795–1805. Yellow poplar (seat); H. 41", (seat) 20¼", W. (seat) 20⅜", D. (seat) 16". (Mr. and Mrs. Floyd C. Hinden collection: Photo, Winterthur.)

Fig. 3-98 *Daniel Rose,* attributed to William Witman, Reading, Pa., 1795–1800. Oil on canvas, H. 64″, W. 40½″. (Historical Society of Berks County, Reading, Pa.: Photo, Winterthur.)

Fig. 3-99 Bow-back Windsor side chair and detail of brand, George Keim, Reading, Pa., 1800–1805. Yellow poplar (seat); H. 36¼″, (seat) 16⅜″, W. (seat) 17¼″, D. (seat) 16″; center spindle replaced, medial stretcher suspect. (Edgar and Charlotte Sittig collection: Photo, Winterthur.)

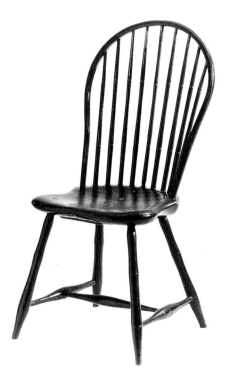

Four more Windsors furnished the "Compting Room," which may have doubled as a second dining area. This is an early date to find Windsors in use beyond Philadelphia.[68]

During the Revolution, an auction of "goods and chattles" from the estate of Reynold Keen of Reading offered the public eleven Windsor chairs, two of which appraisers described as "small." All were probably of Philadelphia origin. Visual evidence from the postrevolutionary period documents another Reading citizen's ties with Philadelphia. In a portrait attributed to local artist William Witman, Daniel Rose (1749–1827), clockmaker, revolutionary war captain, and later state assemblyman, stands in a sophisticated provincial setting (fig. 3-98). Rose is surrounded by the many musical instruments that he had mastered—woodwinds, a violin, and a pianoforte. Rose's household furnishings are quite fashionable for the mid 1790s, the approximate date of the painting. Both the square-legged, mahogany breakfast table and the green, sack-back Windsor chair are in the Philadelphia style. The carved knuckles and elongated balusters of the Windsor are surprisingly similar to Henzey's work, and the chair may be a metropolitan product.[69]

Reading was a flourishing center by the 1790s. La Rochefoucauld Liancourt noted a "lively and populous" country where "corn and saw mills are numerous . . . and there are many creeks with strong currents, which turn the wheels of some iron forges." The town contained about 500 homes. Some early log structures still stood, but the primary building materials were stone and brick. The traveler found the town's streets "broad and straight" and the footpaths "shaded by trees, planted in front of the houses." A major manufacture of the town was hats, which received broad distribution. Thomas Cope, a Philadelphia Quaker, described the majority of inhabitants as "descendants of Germans."[70]

No documented Windsor chairs from Reading survive from the 1790s. Of later identified work, only a bow-back side chair branded by George Keim about 1800 exhibits firsthand knowledge of the Philadelphia style—knowledge the craftsman may have gained directly through working experience in the city (fig. 3-99). The federal census of 1800 lists Keim in the borough of Reading, where he appears to have remained through 1806. Other area Windsors reveal their provincial origin. John Lackey's contemporary bow-back armchair follows Philadelphia design in the crowned bow face and scroll arms (fig. 3-100). However, Lackey chose an oval rather than the standard shield seat. The chair also has Baltimore connections. The full, rounded bow with exaggerated waist and the heavy support structure relate to an armchair made for the Maryland State House in 1798 (fig. 4-2). Lackey's provincial interpretation of the bow-back style is manifest in the arm structure. The curved members are longer than those in Philadelphia chairs (fig. 3-53), and the posts have a bulbous quality characteristic of regional furniture. A side chair branded by Lackey duplicates the back curve of the armchair but combines the bow with a shield-shaped seat. The 1800 census documents Lackey's general working period, and his brand "I:LACKEY/READING" pinpoints his location.[71]

Windsor chairs made by Jacob Fox of Tulpehocken Township, Berks County, are a rural expression of Lackey's provincial interpretation of Philadelphia work (fig. 3-101). Since Fox, né Fuchs, was born in 1788, he practiced his trade only after 1808 or 1809. His earliest known Windsors, a bow-back side chair and the illustrated armchair, were already outdated by Philadelphia standards. Tulpehocken customers in 1810, however, accepted bow-back chairs with H-plan stretchers and flat, beaded-front seats. The bow

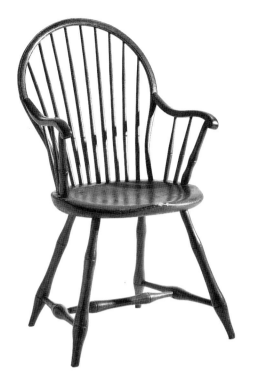
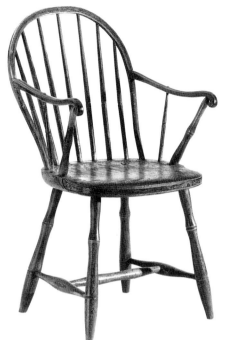
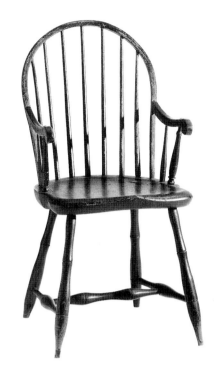

Fig. 3-100 Bow-back Windsor armchair and detail of brand, John Lackey, Reading, Pa., 1800–1805. Yellow poplar (seat); H. 36⅞", (seat) 16⅝", W. (arms) 22", (seat) 19⅛", D. (seat) 14⅛". (Reading Public Museum and Art Gallery, Reading, Pa.: Photo, Winterthur.)

Fig. 3-101 Bow-back Windsor armchair and detail of brand, Jacob Fox, Tulpehocken Twp., Berks Co., Pa., ca. 1808–15. Yellow poplar (seat); H. 36", (seat) 17⅝", W. (arms) 21⅜", (seat) 19⅛", D. (seat) 16⅝". (Judith E. Beattie collection: Photo, Winterthur.)

Fig. 3-102 Bow-back Windsor armchair, Jonestown, Pa., region, 1805–15. Yellow poplar (seat); H. 38¼", (seat) 18⅞", W. (arms) 19¾", (seat) 19⅞", D. (seat) 17⅝". (Edgar and Charlotte Sittig collection: Photo, Winterthur.)

curves less than in Lackey's work, but the face is equally broad. The arms follow the same model and demonstrate the degree to which rural craftsmen modified even provincial designs. The slope and length of the arms are greater in Fox's chair, and only one short spindle fills the broad void between post and bow. Fox coordinated the design by turning the legs in the same pattern as the posts. The chairmaker produced another bow-back design. Accompanying a back that is curved in the Lackey manner are a knifelike seat front, box stretchers, four-part bamboo legs, and ornamental medallions centered in some of the turned rods.[72]

Fox was a farmer and part-time chairmaker, although he apparently stopped producing bow-back chairs after 1820. He used at least two branding irons during his lifetime. The first, found on the bow-back chairs and at least one spinning wheel, shows an old style *I* for *J* and includes the second letter of his given name, an unusual practice (fig. 3-101, detail). The extant second iron, dated 1839, reads "J.FOX," and he probably used it only on spinning wheels. At the craftsman's death in 1862, his inventory listed a full range of farming and woodworking tools, including turning chisels and two lathes. With "chair Planks," "wood for ½ doz chairs," and "spinning wheels Iron" on hand, Fox had probably continued his trade until his death, although his later chair production is anonymous.[73]

A bow-back armchair found in Jonestown, a community west of Reading, relates to Fox's work (fig. 3-102). The leg profiles are almost identical. Since the seat height of the two differs by more than an inch, it seems possible that the Fox chair, the shorter of the two, once had pointed toes like those in the Jonestown Windsor. The craftsman employed different models for the other elements. The arm posts look like condensed versions of fan-back posts; the medial stretcher follows Moravian work (fig. 3-94). Laying-out marks scribed on the plank bottom form a trapezoid with two diagonals.

Because Philadelphia dominated the southeastern Pennsylvania furniture market, chair-makers had little incentive to establish businesses in neighboring areas before the expanding prosperity of the 1790s. The first identifiable regional Windsors date primarily to the century's end and, understandably, exhibit strong metropolitan influence. Both Chester and Bucks counties had rural economies, and no towns matched the size of Reading or Lancaster. Even after 1800, Philadelphian Gilbert Cope could remark about Chester County, "'Tis a fine, healthy, productive country, which the industry of its inhabitants & the late improvements in agriculture have greatly contributed to enrich." The main route to northern New Jersey and New York lay north of Philadelphia along the Delaware River in Bucks County. There were ferries at Bristol and Morrisville, the latter replaced by a bridge in the mid 1790s; inns and taverns catered to travelers. Both Bucks and Chester counties were popular summer retreats from the city's heat and congestion. Many Quakers lived there not only in the summer but also year-round. Close Philadelphia connections through family ties and Yearly Meeting provided frequent opportunity for communication. Windsor chairs occur in Chester County household inventories as early as the 1760s, and Andrew Allen of Bucks County furnished his home with eight Windsors, six of which appraisers described as "small" in 1778.[74]

Tentatively documented fan-back side chairs are associated with Chester County. The work of A. Carr, presumably Alexander, appears with some frequency in Chester County, although various postrevolutionary records place a man of this name in several locations, including Philadelphia and Wilmington, Delaware (fig. 3-103). By 1790 the United States census lists an Alexander Carr in London Grove Township, Chester County. The chair reveals knowledge of Philadelphian Francis Trumble's work in the legs and posts (fig. 3-46). The crest varies; the sharp, angular, upward thrust of the ends and the long sweep of the crown may represent the influence of German design (fig. 3-82). Spinning wheels also occur with the Carr brand.[75]

The countryside from Downingtown west to Gap, as described by John Melish in the early nineteenth century, consisted of "a high tract . . . the lands rather barren." In the valley he found "a fine . . . country, with a limestone bottom" that was "elegantly

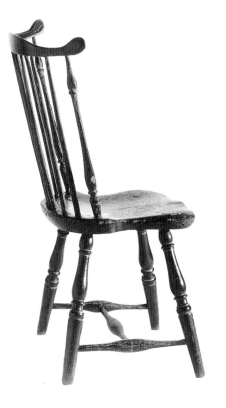

Fig. 3-103 Fan-back Windsor side chair and detail of brand, A[lexander] Carr, probably Chester Co., Pa., 1785–95. H. 35⅝", (seat) 16⅝", W. (crest) 21¾", (seat) 16¼", D. (seat) 16⅛". (Chester County Historical Society, West Chester, Pa.: Photo, Winterthur.)

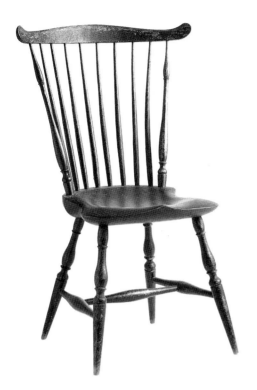

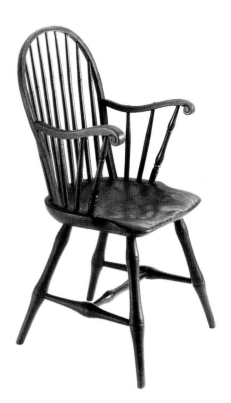

Fig. 3-104 Fan-back Windsor side chair, L. Armstrong (brand "L·ARMSTRONG"), probably southeastern Pennsylvania, 1795–1805. H. 37″, W. 17″, D. 16½″. (Chester County Historical Society, West Chester, Pa.)

Fig. 3-105 Bow-back Windsor armchair and detail of brand, Isaiah Steen, West Caln Twp., Chester Co., Pa., 1795–1805. Yellow poplar (seat); H. 37¾″, (seat) 17¼″, W. (arms) 21¼″, (seat) 18⅝″, D. (seat) 17¾″. (Mr. and Mrs. Floyd C. Hinden collection: Photo, Winterthur.)

improved" and "very fertile." Gap lies just over the Chester County border in Lancaster County. A fan-back side chair bought in the 1930s "from the old Brinton place at Gap" and branded "L·ARMSTRONG" exhibits both Philadelphia and German features (fig. 3-104). Like Carr's stamp, the chairmaker's brand relates to those of Philadelphia in the small, diamond-shaped pellet between the first initial and the surname. The crest, which displays a strong Germanic touch in its extension beyond the posts, is poorly integrated into the total design. The most important features, however, are the turnings, which are similar to the work of another Chester County craftsman, Jesse Custer. The legs and posts are almost identical to those in Custer's high-back armchair (fig. 3-106). Armstrong and Custer almost certainly worked together sometime during their careers.[76]

Isaiah Steen worked a short distance east of Gap in Chester County's West Caln Township where the 1796 local tax assessment lists him as a chairmaker. Aside from this reference and a branded bow-back armchair, Steen's name fails to appear in any eastern Pennsylvania records (fig. 3-105). While Steen's chair imitates those of Delaware Valley origin, it nonetheless differs greatly from Philadelphia Windsors. The bow face is flat rather than crowned in the Philadelphia manner, and the bamboo-style legs almost duplicate a Baltimore model (fig. 4-2). The long arms seem related to provincial work of adjacent Lancaster and Berks counties. The sensitively carved scrolls, a handsome touch, indicate Steen's familiarity with Philadelphia volute-carved, fan-back Windsors.[77]

Records provide little information about Chester County craftsman Jesse Custer. The Vincent Township 1796 tax assessment lists Custer as a chairmaker; two years later he is named in Coventry Township records. Both areas are located in the northernmost part of the county. The six chairs bearing Custer's brand describe a career spanning the baluster and bamboo style periods. His earliest Windsors have spindles that are thicker below the rail (fig. 3-106). His latest chair, made for a child, exhibits a square-back pattern that is found beyond Philadelphia only after 1805. Custer's early high-back Windsor illustrates his skill with the turning chisel. Spool, ring, and baluster elements have distinctive profiles; the tapered feet are slightly rounded. A second high-back chair with an identical upper structure is somewhat shorter. A child's high-back highchair also has thickened spindles, a feature that Custer used long after it had become outdated in Philadelphia.[78]

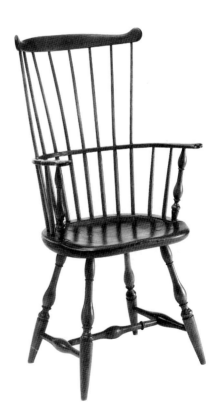

Fig. 3-106 High-back Windsor armchair, Jesse Custer (brand), Vincent or Coventry twp., Chester Co., Pa., 1790–1800. (Photo, Philip H. Bradley Co.)

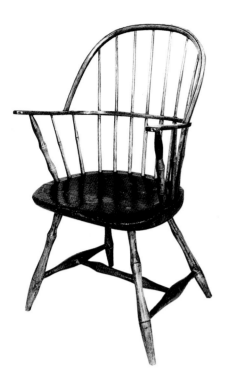

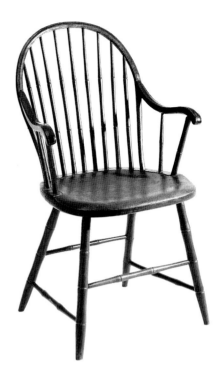

A subtle stylistic progression marks Custer's work from his early high-back chair to a baluster-turned sack-back chair in a private collection. The spindles of the sack back taper more below the rail, while the broad spool-and-ring turnings are slightly more compressed. The bow ends are squared in the Delaware Valley manner. The chair resembles another by Custer in the bamboo style (fig. **3-107**). Overall proportions, stance, seat, long spindles, and arm rail are the same. The bow ends square, but the face introduces a groove similar to that in a tall Lancaster County sack-back chair (fig. 3-65). The profiles of the legs and heavy stretchers resemble the work of Fox and other chairmakers of adjacent Berks and Lebanon counties (figs. 3-101, 3-102). Custer's arm posts basically mimic the legs. In comparison, the bamboo supports of the child's square-back chair, which ends Custer's known production, are much coarser in design, although the small seat retains eighteenth-century H-plan stretchers.

Samuel Moon, a chairmaker generally associated with Bucks County, worked in Downingtown in central Chester County between 1803 and 1807. He had formed a brief Philadelphia partnership with David Moon (died 1805, aged 27), presumably his son, in 1801 and 1802. Several Chester County Windsors bearing the Moon brand (fig. 3-108) naturally resemble Philadelphia chairs (fig. 3-55, right). The chair in figure **3-108**, discovered in the attic of Samuel Pennock's house near Chatham, Chester County, in 1938, is an early nineteenth-century version of the bow-back pattern that was popular in the 1790s. The support structure uses the four-part bamboo leg and box stretcher of the new Philadelphia square-back style (fig. 3-114). This updated base also appears on Moon's square, serpentine-top Windsor like those in figure 3-112.[79]

Only a few eighteenth-century Bucks County chairs have been identified to date. Local craftsmen often trained in Philadelphia, and city furnishings easily found their way to the country. A low-back armchair, probably dating to the Revolution, is reasonably attributed to the area (fig. **3-109**). The present owner acquired the chair many years ago in Bucks County. The chair's turned work is very similar to that of an early high-back Windsor obtained from an old Bucks County family. Except for minor differences in baluster proportions, the unusual arm supports are identical. The top element has a pronounced triangular profile, and a well-defined disk separates it from the baluster. The customary necked baluster bottom has become a spool turning with a crowned head, creating a double-spool-and-ring base (fig. 3-14). Otherwise, the low-back chair is indistinguishable from its Philadelphia counterparts.[80]

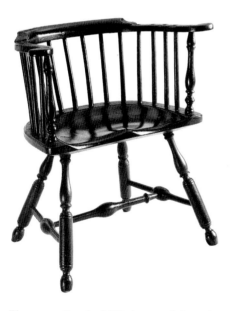

Other early Bucks County Windsors were armchairs. In 1786 Samuel Moon, then living in his native Fallsington just south of Morrisville, constructed "12 Windsor Chairs" for Philadelphia merchant Samuel Meredith. Heading the bill is the word "Bucks," which confirms the origin. At a cost of 20s. apiece the Windsors were high- or sack-back armchairs. Meredith purchased twelve more Windsors in 1791. Since the merchant could have obtained chairs for city use more conveniently in Philadelphia, he may have bought the Windsors from Moon to furnish a Bucks County summer residence. Unfortunately, the only chairs with Moon's brand are those presumed made in Chester County. At other times in his career, Moon apparently failed to use a marking iron.[81]

David Stackhouse, a Quaker like Moon, worked northwest of Fallsington in Buckingham Township. He apprenticed in Philadelphia with Henzey from 1772 until about the Revolution's end. Stackhouse's Windsor production is unmarked. In later years he and his family moved to New Garden, near present-day Avondale, Chester County, where farming likely substituted for chairmaking. Also identified from eighteenth-century Bucks County is a pair of bow-back armchairs in the 1790s Philadelphia bamboo style. Family history attributes these chairs to Moses Quinby, a member of the Buckingham Monthly Meeting of Friends. Quinby was born in 1759 and, like Stackhouse and Moon, began his chairmaking career just after the Revolution. His chairs, which have bamboo turnings and H-plan stretchers, are indistinguishable from the metropolitan product.[82]

PITTSBURGH

Pittsburgh, a newly established, fast-rising manufacturing center, figures in a discussion of eighteenth-century Windsor furniture. Located at the juncture of the Allegheny, Monongahela, and Ohio rivers, the city was a gateway to the West. The distance from Pittsburgh to Philadelphia is about 300 miles, and it is only slightly less to Baltimore. Nevertheless, wagons loaded with various goods made regular westward trips, and a stage line operated by 1804. The population reached about 2,500 in 1803, and almost 4,800 in 1810. By 1798 at least one sawmill and one cabinetmaker's shop operated in the town, and entrepreneurs established a glass industry before 1800. Seventeen master woodworkers were in business in 1807—seven cabinetmakers, one turner, three wheelwrights, one spinning-wheel maker, and five Windsor-chair makers. The budding industrial community encompassed boatyards, distilleries and breweries, an air furnace, a glassworks, and a cotton factory. Settlers moved through the area, and hundreds of river boats annually carried local products and surplus produce down the Ohio and Mississippi rivers to New Orleans.[83]

The first Windsors manufactured in Pittsburgh were bow-back chairs. In the late 1790s, [Thomas?] Ramsey and [William?] Davis stamped each of a pair of side chairs with three separate name and location brands (fig. 3-110). The chairs resemble Philadelphia products but have baluster-turned supports with the bow back; the legs are similar to those in Philadelphia fan-back chairs (figs. 3-46, 3-48). By 1807, the five local Windsor-chair makers had probably introduced the bamboo support. Davis's bow-back side chair (fig. 3-111), an updated model of his and Ramsey's earlier chairs, has bamboo legs and spindles of similar pattern. He marked his new chair with two of the name and location brands used during the partnership. James Pentland, who left Philadelphia and settled in Pittsburgh about this time, may have produced the square-back pattern newly fashionable in the East.[84]

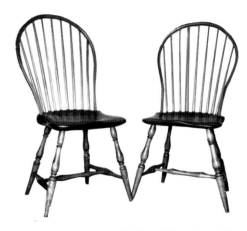

Fig. 3-110 Bow-back Windsor side chairs (pair), T[homas?] Ramsey and W[illiam?] Davis (brand "T. RAMSEY / & W. DAVIS / PITTSBURGH"), Pittsburgh, Pa., 1795–1800. H. 37 ¹¹⁄₁₆", W. 20½", D. 15 ¹¹⁄₁₆". (Private collection: Photo, Winterthur.)

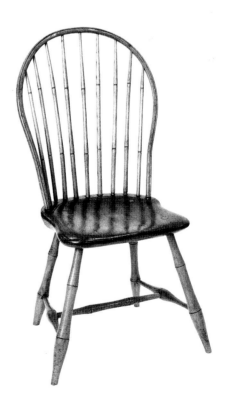

Fig. 3-111 Bow-back Windsor side chair, W[illiam?] Davis (brand "W·DAVIS / PITTS-BURGH"), Pittsburgh, Pa., 1800–1805. Yellow poplar (seat) with maple, oak, and hickory; H. 36½". (Indianapolis Museum of Art.)

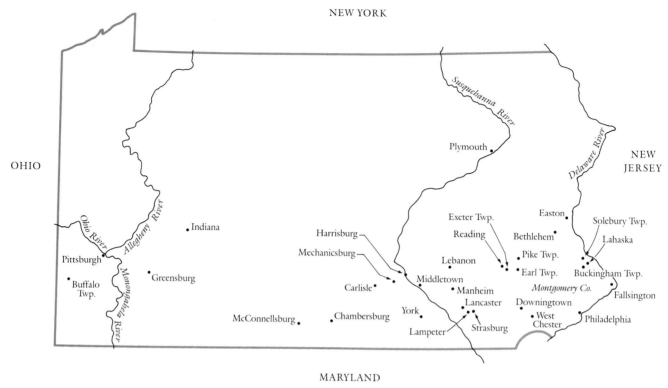

1 inch = 51.6 miles

Philadelphia and Pennsylvania from 1800 to the 1870s

From 1800 to 1850 startling and dramatic changes occurred throughout Pennsylvania and the young nation. The state's population increased by about 30 percent every decade. Between 1820 and 1840 the Philadelphia and suburban population almost doubled, from 108,750 to 205,850. By 1840 a Pennsylvania frontier no longer existed. Pittsburgh, little more than a small town at the gateway to a vast wilderness in 1800, was the nation's fifth largest city before 1850. The state's rural population decreased by about 20 percent from 1790 to 1860 as Philadelphia expanded and many new cities and towns developed. State and national government seats had left Philadelphia before 1800, but the city continued to be a financial, commercial, industrial, and cultural center. Trade had opened with the Far East at the end of the eighteenth century. Waterpower and steam began to change the face of industry. Large, impersonal manufactories replaced a network of small owner-operated shops and created a new class of citizen, the factory worker. Transportation and communication improved through the development of turnpikes, canals, steamboats, and railroads. Factories could now be located wherever raw materials and an adequate labor supply were accessible. Waves of Irish immigrants flowing into Philadelphia provided a substantial work force.[85]

This boom, however, was also accompanied by bad times. The conflict between England and France disrupted neutral shipping during the 1790s and culminated in the Embargo Act of 1807. Soon after this difficult economic period came war with Britain, followed by a brief postwar boom and then a severe recession that lasted into the early 1820s. Even worse economic times hit Philadelphia and the country in the mid and late 1830s when the Bank of the United States's downfall led to the failure of many banks and

businesses. Long working hours, low wages, and poor working conditions brought labor unrest. Society's rapidly changing structure led to ethnic and racial conflict, although in the midst of the turmoil there was positive social progress. Prison reform began in Pennsylvania, philanthropic and temperance organizations spread with new vigor, and the handsome new Fairmount Waterworks assured the city of a bountiful water supply. Architecture was now handled by professionals like Benjamin Henry Latrobe and William Strickland. Men of finance, such as Stephen Girard and Nicholas Biddle, led the city and state to new economic opportunities. The arts lay in the hands of the prolific Peale family, Thomas Sully, the Birches, and others; the common man could enjoy his likeness in an inexpensive profile cut at Peale's Museum. The life of Philadelphia merchant Thomas P. Cope spanned this new era of prosperity. In the mid 1840s he still recalled clearly his early mercantile days in the 1790s when "the ground on Sixth Street west of Independence Square was in grass & surrounded by post & rail fences" and marveled at the changes that had occurred within his own lifetime.[86]

PATTERNS INTRODUCED IN THE FIRST DECADE

The year 1800 was a major turning point in Windsor-chair design. The round-back patterns in vogue for fifteen years and longer gave way to square backs, which completely dominated design until the mid nineteenth century. The initial transition period lasted six or eight years. As noted earlier, Gilbert Gaw sold oval-back chairs to Girard for exportation as late as 1806, although such seating had already adopted the four-part bamboo leg and box stretcher (fig. 3-55). Square-back chairs probably appeared in the Philadelphia market a year or two before the turn of the century. One design was John Letchworth's square, serpentine-top, slat-back Windsor, patterned after his fancy bow-back chair (fig. 3-53) and the rectilinear cross-banister mahogany chair (fig. 3-54). These Windsors retain the three-part bamboo leg and H-plan stretchers of the 1790s, indicating that their introduction occurred prior to general acceptance of the new four-part bamboo leg. A contemporary chair was the "plain" serpentine-top Windsor, some with three-part bamboo legs (fig. **3-112**). The crest, the flaring, beaded posts, and the front seat curve, which approximates the wavy crest line, imitate similar elements in the fancy serpentine-top Windsor. The flat-edged plank, which was introduced in the late bow-back chair (fig. 3-55), became flared, and soon a single groove marked the seat top about an inch from the edge. The groove extends to the back corners where it joins the narrow channel defining the spindle platform. Daniel King, a partner in Taylor and King, branded such a chair. Perhaps the "1 Doz Newfashioned Wite Dining Chairs" sold by Taylor and King to Girard in May 1799 were of this plain, serpentine pattern. The reference to new-fashioned chairs documents a change in Windsor design before 1800. A few unmarked serpentine-top chairs have scroll arms and S-curved posts similar to those in bow-back armchairs (figs. 3-51, 3-53).[87]

Samuel Moon's years in Philadelphia (1800–1802) permitted him to absorb a thorough knowledge of current design trends. When he moved to Chester County in 1803, he combined the serpentine crest and the box support in his Windsor work. The new back quickly reached Pittsburgh where Andrew McIntire (d. 1805), a furniture craftsman formerly of Chester County and Philadelphia, produced an H-braced, square-back chair whose plank bears his name and location brands (fig. **3-113**). In comparison to Philadelphia work, the chair is narrow, the vertical back framing members slim and straight, and the seat somewhat more modeled. Joseph Armstrong perhaps referred to these chairs when he advertised at Greensburg, southeast of Pittsburgh, on August 22, 1801, offering "WINDSOR CHAIRS made in the newest fashion." Craftsmen in New Jersey, New York City, and southern New England produced their own variations of the pattern within the next few years.[88]

A square-back chair with a straight cross rod entered the Philadelphia market prior to 1800. An early Windsor of this pattern branded by Gaw has a rounded shield seat without a pommel, three-part bamboo legs with appropriate stretchers, and grooved-

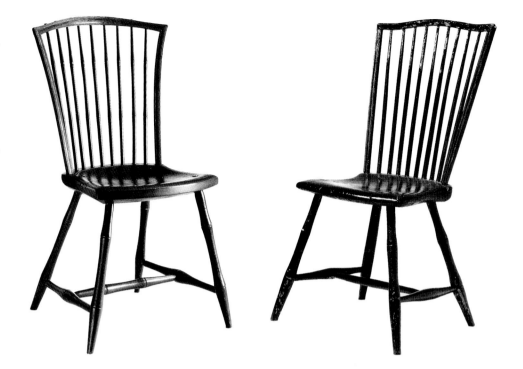

Fig. 3-112 Square-back Windsor side chairs (one of a pair), Philadelphia, ca. 1798–1802. Yellow poplar (seat) with maple and hickory (microanalysis); H. 34¹⁵⁄₁₆", (seat) 17⅜", W. (crest) 20½", (seat) 17⅞", D. (seat) 15⅞". (Winterthur 70.1359, 56.571.)

Fig. 3-113 Square-back Windsor side chair, Andrew McIntire (brand "A.M'INTIRE / PITTSBURGH"), Pittsburgh, Pa., 1800–1805. Yellow poplar (seat); H. 35", (seat) 16½", W. (crest) 18½", (seat) 16¼", D. (seat) 15½"; left rear leg, medial stretcher, and right stretcher replaced. (Carnegie Museum of Art, Pittsburgh, Pa., gift of Mr. and Mrs. James A. Drain.)

edge flat posts and cross rod. When the new support structure was adopted, the posts and cross rod were turned to simulate bamboo. The seat edges became angular, marked by a top and bottom groove, similar to Letchworth's side chairs (fig. **3-114**).[89]

A square-back armchair entered the market at the introduction of the four-part bamboo leg. Scroll arms supported on short, grooved posts appear on some early chairs, but a bamboo-turned arm either capping or extending beyond the post soon became standard. The new chair was in the market only a short time before a variation appeared. The cross rod that caps the back posts was lowered an inch or two and set between the stiles. Jonathan Tyson of Philadelphia produced this pattern in 1808 and possibly as late as 1812, and the style lingered much longer in the hinterlands.[90]

A shipping manifest dated December 1, 1801, documents a "double back square top" chair along with "single top" and "Bow back" Windsors in the early nineteenth-century

Fig. 3-114 Square-back Windsor side chairs (set of six), John Letchworth (brand "I·LETCH-WORTH"), Philadelphia, 1800–1807. Yellow poplar (seats) with maple, oak, and hickory (microanalysis); H. 34", (seat) 17½", W. (crest) 19⅛", (seat) 16⅝", D. (seat) 15". (Winterthur 73.393.1–73.393.6.)

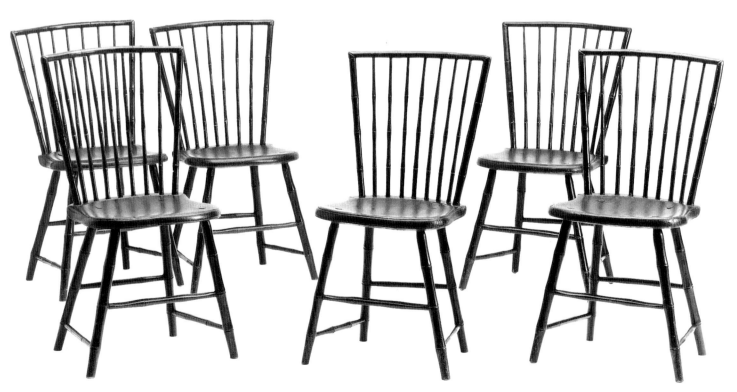

Fig. 3-115 Anthony Steel shipping manifest, Philadelphia, December 1, 1801. (Philadelphia Customhouse Records, Historical Society of Pennsylvania, Philadelphia.)

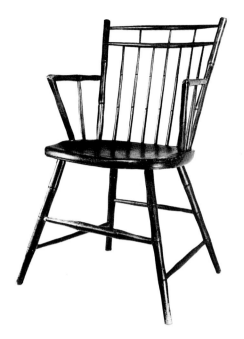

Philadelphia market (fig. **3-115**). Thomas Jefferson ordered double-back chairs from Letchworth in May 1800. An early double-back chair from John B. Ackley's shop has scroll arms supported on bamboo posts. Gaw framed a bamboo armchair with both cross rods set between the posts (fig. **3-116**). Several spindles connect the lower rod with the top piece in a regular pattern. The arms cap their supports, a construction found on federal-era joined chairs; some arms extended beyond the supports (fig. 3-119, right). Both designs also occur in double-rod chairs framed with the top piece capping the posts. Craftsmen made the double-back chair until around the War of 1812; a chair marked by William Lee and Nicholas Fricker dates between 1807 and 1811, the partnership period. Charles C. Robinson sold double-back chairs for $7.50 and $8.00 the half dozen in 1811 and 1812; as late as 1813 one customer purchased "½ dozn Windsor Chairs Single Bow" for $6.00.[91]

Bow, the contemporary term for the cross rod or rods that capped the new square-back chairs, refers to the bend of the rods. The principal curve is lateral, but some crests curve both in the horizontal and vertical planes. Ackley's "Double bow Table Chair," probably with arms, sold for $3.00 in 1805. When young Philadelphia chairmaker Henry Prall died during the 1802 yellow fever epidemic, his estate appraisers, James Pentland and Thomas Mason, found finished and partially finished chair parts in the shop. They listed both "Ovel Back Bows" and "Bent Short Bows," describing the older round-back chair and the new square-back Windsor. Several early square-back chairs, including a double-bow side chair bearing Prall's brand, have vigorous bamboo-turned tops.[92]

Fancy painted chairs with cane or rush seats had a tremendous impact on Windsor design from the early 1800s. They derived from joined seating interpreted in the neoclassical manner of Robert Adam, George Hepplewhite, Thomas Sheraton, and other English designers whose published works were well known in American metropolitan centers along with current editions of *The London Chair-Makers' and Carvers' Book of Prices*. The use of cross rods in American chairwork may have originated in Baltimore, where a simple rush-bottomed fancy chair from a local family dates early in the century (fig. **3-117**). The chair's plain, tapered posts are slimmer than those in slatback seating, and the back bend is pronounced; the top cross rods center a small, rectangular medallion, or tablet, with hollow corners. Some chairs have spindles with similar medallions. Larger, clipped-corner rectangles form part of the painted crest decoration in other Baltimore fancy chairs (fig. **3-118**). Some chairs featuring local views on the crest are attributed to John and Hugh Finlay and date to about 1804/5, when the

Fig. 3-116 Square-back Windsor armchair, Gilbert Gaw (label and brand *G. GAW*), Philadelphia, 1800–1810. H. 34″, W. (seat) 18¼″, D. (seat) 16¾″. (Private collection: Photo, Winterthur.)

Fig. 3-117 Fancy side chair (one of three), Baltimore, 1800–1810. H. 32⅜″, W. 17¾″, D. 15¾″. (Baltimore Museum of Art, gift of Lydia Howard de Roth in memory of Nancy H. De Ford Venable.)

Fig. 3-118 Fancy side chair (one of three), Baltimore, 1800–1810. Maple, yellow poplar, and mahogany (microanalysis); H. 33¼″, W. 19″, D. 15″. (Winterthur 57.1060.2, 57.1060.3.)

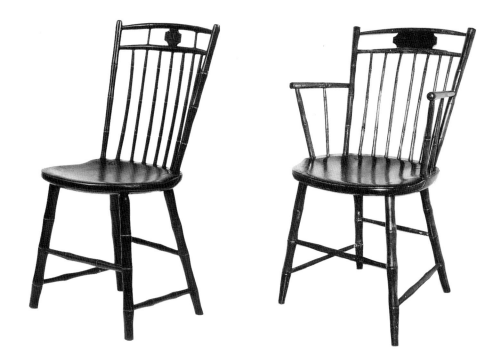

Fig. 3-119 Square-back Windsor side chair and armchair, Joseph Burden (*left*) and John Wall (brands "J. BURDEN / PHILADA." and "J. WALL"), Philadelphia, 1801–12 (*left*) and 1805–15. Left: H. 34½″, W. 16¾″, D. 16¼″; right: H. 35″, W. 21¼″, D. 16⅞″. (Independence National Historical Park, Philadelphia [*left*], and private collection: Photos, Winterthur.)

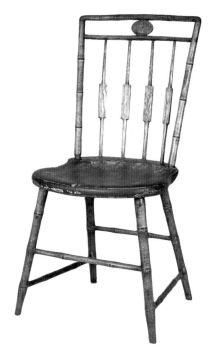

Fig. 3-120 Square-back Windsor side chair, Isaac Bird (brand "I·BIRD"), Philadelphia, 1810–15. H. 34½″, (seat) 16½″, W. (crest) 16⅝″, (seat) 16½″, D. (seat) 15⅝″. (Private collection: Photo, Museum of Early Southern Decorative Arts, Winston-Salem, N.C.)

firm advertised this type of decoration. Comparable work was presumably current in Philadelphia, although identified painted seating from that city is rare today.[93]

An early double-bow square-back chair with a small, clipped-square medallion in the crest and 1790s-style scroll arms bears Robert Taylor's printed label and dates between 1801 and 1807. Joseph Burden's side chair and John Wall's armchair illustrate the two most popular ornamental medallions in early nineteenth-century Philadelphia chairs, the small square and large rectangle with hollow corners (fig. 3-119). The small-medallion Windsors were apparently first in the market, but the broad rectangle soon followed, and customers could choose between the two patterns. Partners Lee and Fricker (1807–11) made both types, as did Burden, Anthony Steel, and others. The Philadelphia career of Daniel Steever, Jr., extends the date, since a branded chair with a small medallion dates from about 1811 to 1814. The small tablet served as a flat panel for ornamentation. Most Windsor bows with centered medallions exhibit a slight arch, and most, but not all, are set between the posts. Toward the end of production, some craftsmen introduced a new seat shape that combines serpentine sides with a rounded front. The new seat design was probably an innovation of the war years, since it occurs more frequently in chairs of later pattern.[94]

Design idiosyncrasies appeared from time to time in the double-bow chair. Chairmaker Adam Snyder created an unusual crest by placing a cylindrical collar at each end of the top bow and attaching it to the post tops with small, caplike wooden pins. Taylor labeled a set of medallion-top side chairs whose center spindle forms a short, arrowlike ornament. A side chair with an oval crest medallion and four fancy spindles came from the Philadelphia shop of Isaac Bird, whose earliest known working date is 1810 (fig. 3-120). The elongated rectangles of the spindles derive from Baltimore work, their form similar to that of a fancy-chair stretcher (fig. 3-118). In general, fancy Windsor work was uncommon in Pennsylvania and the Delaware Valley at this time. The bent back, although an early feature of Baltimore fancy seating, appeared only later in the Middle Atlantic Windsor, despite its currency in Boston and southern New Hampshire. Delaware Valley chairmakers produced a few tall-back chairs with double bows, some probably used for reclining. At least two served organizational functions. One chair is the property of Christ Episcopal Church, Philadelphia, and was used by the bishop at Missionary Society meetings; another, in the Metropolitan Museum of Art, has an extremely tall back and painted Masonic symbols on the crest.

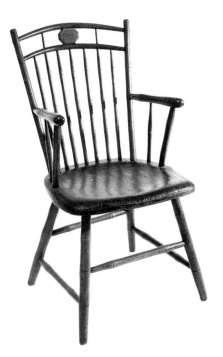

Fig. 3-121 Square-back Windsor armchair and detail of brand, Storel Hutchinson, Solebury Twp., Bucks Co., Pa., 1810–20. Yellow poplar (seat); H. 35⅝", (seat) 16", W. (crest) 19½", (seat) 18¾", D. (seat) 17". (Charles V. Swain collection: Photo, Winterthur.)

Pennsylvania craftsmen outside Philadelphia produced the double-bow chair by the 1810s, and it became far more popular than the single-bow Windsor. Storel (also called Storr) Hutchinson, listed as a Solebury Township, Bucks County, resident in the 1810 federal census, made square-back chairs with squarish, well-modeled seats. He constructed six single-bow chairs with nine-spindle backs, now in a private collection, for the Carver family of Solebury. When Hutchinson turned to the double-bow pattern, he reduced the number of spindles and incorporated a small clipped-corner medallion in the crest (fig. **3-121**). Special features include grooves delineating small caps at the backpost tops and sausagelike elements at the turned-arm fronts. This Windsor is one of six mixed chairs that descended in the Ruckman family of Bucks County; the original owner was probably John Ruckman (1771–1861) of nearby Lahaska. Hutchinson's brand is a simple initial stamp that can be read in either direction, making identification difficult without other information.

The work of another southeastern Pennsylvania chairmaker, who used the brand "s.PUGH," shows greater variety and spans a longer period than that of Hutchinson. Pugh's earliest Windsor is a double-bow side chair with arched rods. He later made chairs with narrow or broad rectangular medallions in the crest and, finally, bent-back chairs; the seats vary from a squared shield to a balloon or serpentine profile. Beyond Bucks County, Windsor chairs were also popular in neighboring Chester County by the 1810s. Margaret Schiffer's comprehensive study of county probate inventories shows that appraisers listed several hundred Windsors in estate enumerations during the 1810s; many more remain identified only as "chairs." This figure represents just a fraction of the total number of Windsors used in contemporary county households.[95]

In the town of Lancaster, the Fetter brothers, Nathaniel and Jacob III, had probably only begun their trade when commissioned in 1811 to make a set of chairs for the local Masonic lodge. Giant oval medallions in the crests, spindles, and front stretchers provide flat areas for special painted decoration. Chairs with normal-sized crest medallions were made farther west in Franklin County by John McClintic, who worked in Chambersburg, as indicated on his brand (fig. **3-122**). Several men of this name are noted in census records as early as 1810, and the listings continue until 1850. Without the brand, McClintic's chair would be impossible to identify regionally within Pennsylvania, since westward migration and improved transportation facilitated rapid communication of ideas from one area to another after 1800.[96]

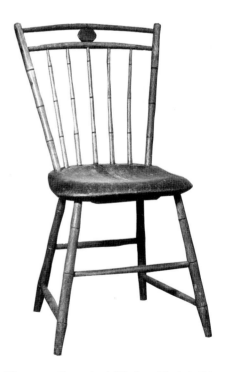

Fig. 3-122 Square-back Windsor side chair, John McClintic (brand "J·M'CLINTIC / CHAMBERS-BURG"), Chambersburg, Pa., ca. 1807–15. H. 34¾", W. 19", D. 15 ¹³⁄₁₆". (Private collection: Photo, Winterthur.)

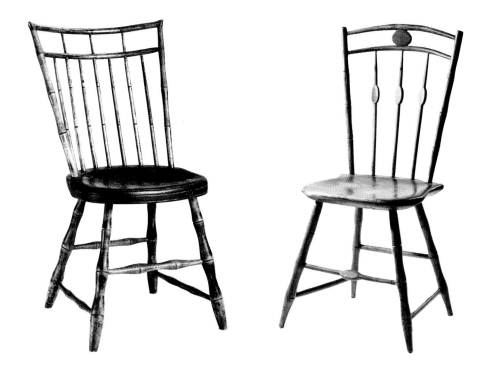

Fig. 3-123 Square-back Windsor side chair, Susquehanna Valley of southern Pennsylvania at Maryland border or northeastern Maryland, 1810–20. Yellow poplar (seat) with maple and other woods; H. 34¾", (seat) 17¼", W. (crest) 19¼", (seat) 16¾", D. (seat) 15¼". (Edward and Helen Flanagan collection: Photo, Winterthur.)

Fig. 3-124 Square-back Windsor side chair, southern Pennsylvania west of Susquehanna Valley at Maryland border, 1810–20. Yellow poplar (seat) with maple and other woods; H. 37¹⁄₁₆", (seat) 17", W. (crest) 18½", (seat) 16⅝", D. (seat) 14". (Nathan Liverant and Son: Photo, Winterthur.)

Lingering traces of German design influenced by Philadelphia and Baltimore work are manifest in two square-back chairs from the Susquehanna Valley at the Pennsylvania-Maryland border or farther west (figs. **3-123**, **3-124**). The vigorous bamboowork and thick, flat-edge or broad-shield seats reveal the ethnic influence. A related bow-back with similar legs and a square-back chair with a single cross rod come from the same region. The sharp, projecting crest tips of figure 3-123 are unusual in the Pennsylvania double-bow design. The fancy medallion spindles and stretcher of figure 3-124 contrast with the otherwise mannered features.

THE WAR PERIOD TO THE 1830S

New Windsor patterns entered the Philadelphia market about 1810 to 1812 and several variations followed. The first profile was a plain, slatlike top with a central rectangular projection, or tablet. Thomas Ashton combined this back with the recently introduced serpentine seat (fig. **3-125**). Ashton's brand appears on several other side chairs and armchairs, and Lee made a child's chair of this pattern about 1812 or 1813 after dissolving his partnership with Fricker. John Lewis Krimmel delineated a slat-back tablet chair in one of his sketchbooks (fig. **3-126**). The crest prototypes in high-style and fancy seating reflect design-book sources (fig. 2-2). By the 1810s many craftsmen combined Windsor- and fancy-chair making as one trade specialty. Directory entries frequently list both occupations or simply drop the adjectives in favor of "chairmaker." Craftsmen soon modified the rectangular tablet into a longer, lower element with rounded corners. An armchair and a child's side chair of this pattern were branded by Louis Case, who worked in Philadelphia between 1811 and 1813. Provincial chairs with squared-tablet crests are known in the Lebanon-Bethlehem area in eastern Pennsylvania.[97]

A labeled metropolitan side chair made by Lee between 1813 and 1815 has an enlarged, hollow-cornered, rectangular tablet that projects above and below the thin slat (fig. **3-127**). The tablet is similar to the long, rectangular medallion of the double-bow chair, although the design looks entirely new. The model was either a Baltimore fancy chair (fig. 3-118, stretcher) or a Windsor inspired by fancy seating (fig. 4-5). The serpentine seat front of a slat-back armchair (fig. **3-128**) of similar crest perhaps derives from the same Windsor or from a painted fancy or formal chair. The addition of ornamental spindles demonstrates how a craftsman could embellish the wooden-seat

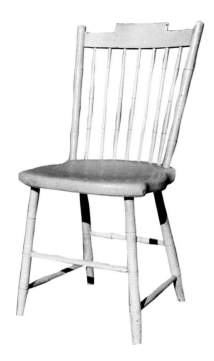

Fig. 3-125 Slat-back Windsor side chair with tablet, Thomas Ashton (brand "TH⁵ ASHTON"), Philadelphia, ca. 1810–15. H. 33″, (seat) 16⅝″. (Old Salem, Inc., Winston-Salem, N.C.: Photo, Museum of Early Southern Decorative Arts, Winston-Salem, N.C.)

Fig. 3-126 John Lewis Krimmel, detail of sketch, southeastern Pennsylvania, 1815–20. Pencil and watercolor on paper; H. 7¹⁄₁₆″, W. 4¾″. (Winterthur Library.)

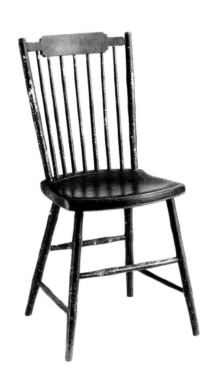

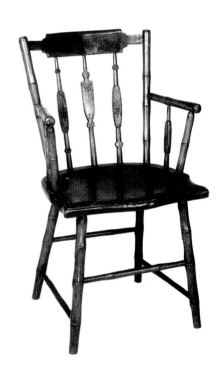

Fig. 3-127 Slat-back Windsor side chair with tablet, William Lee (label), Philadelphia, ca. 1813–15. Yellow poplar (seat) with maple, oak, and hickory (microanalysis); H. 35¼″, (seat) 18⅛″, W. (crest) 17⅛″, (seat) 16¾″, D. (seat) 15⅛″. (Winterthur 73.381.)

form for a customer willing to pay the extra charge. The Haydon and Stewart firm, for instance, in 1810 sold James J. Skerrett "3 fancy wooden bottom chairs" at the substantial price of $2.25 each. A plain Windsor could be purchased for half that amount, which still represented the average daily pay of a Philadelphia journeyman at this time. Several plain-stick Windsors of similar crest, identified with southeastern Pennsylvania by their brands or provincial features, link the new hollow-cornered tablet-back chair and its variants with craftsmen outside Philadelphia. Pugh, probably of Bucks or Northampton County, branded two such chairs, and Francis Jackson of Easton and Aaron Jones of Buckingham Township, Bucks County, also made similar Windsors. The chairs likely date from the 1820s, since they reflect other design changes introduced in that decade.⁹⁸

Tablet-centered crests with decided Baltimore influence appear in Berks County chairs (fig. 3-129). The subtle, undulating top line duplicates fancy profiles found in formal Baltimore furniture of the 1810s, such as the facades of card tables and the crests of shield-back chairs, one set with a history of descent in the family of Charles Carroll of

Fig. 3-128 Slat-back Windsor armchair with tablet, Philadelphia, Pa., ca. 1812–18. (Former collection J. Stogdell Stokes.)

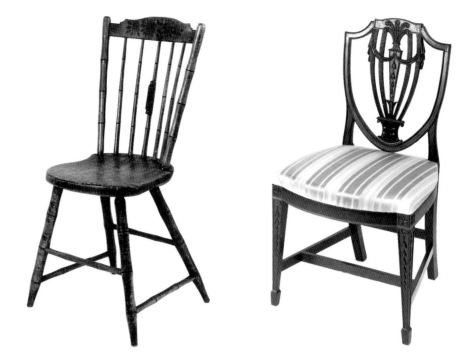

Fig. 3-129 Slat-back Windsor side chair with tablet, J. Schumm (brand "J:SCHUMM"), Berks Co., Pennsylvania, possibly Oley Valley, 1815–25. (Private collection: Photo, Winterthur.)

Fig. 3-130 Shield-back side chair (one of a pair), Baltimore, 1795–1810. Mahogany, walnut, cherry, and yellow poplar (microanalysis); H. 36½", W. 20¾", D. 19". (Winterthur 57.770.1.)

Fig. 3-131 Pennsylvania Windsor seat shapes, introduced 1810–25.

Carrollton, the Signer (fig. **3-130**). The ornamental medallion of the center spindle in the Windsor appears in fancy-chair stretchers (fig. 3-118). The Windsor also bears original or slightly later painted decoration and the brand of its maker "J:SCHUMM." Federal census records show that a Jacob Shum, possibly the chairmaker, resided in Exeter Township, Berks County, from 1810 to 1830. Samuel Lobach of Pike Township in Berks County's Oley Valley made chairs with related crests. For the rough country life, the Windsor was more practical in construction and cost than fancy seating with its highly perishable rush or cane bottoms. In a rural economy, the limited household furnishings were passed on from generation to generation. Alexander Martin, Sr., a farmer and blacksmith of Earl Township, Lancaster County, in 1821 bequeathed to his sons both money and household goods. Each of two sons received three Windsor chairs, possibly making up one original set.[99]

The period between 1815 and 1825 was one of transition for the Philadelphia Windsor industry. Customers could now choose between bent or straight backs, bamboo turnings or ringed cylindrical supports, and "arrow" spindles or bamboo-style sticks. Three distinct seat shapes were in the market (fig. **3-131**). The first seat type, the serpentine plank, appeared in the early 1810s and lingered for more than a decade. The Schumm chair uses the second type, the balloon form, which came on the market in the mid 1810s. The third plank, of modified shovel shape, was probably introduced in the 1820s (fig. 3-140).

As usual, design changes occurred in Philadelphia and then spread to the hinterlands. Steel's estate inventory documents the transitional period. In 1817, the year he died, Steel still made rod-back (cross-rod) chairs, as indicated by the "1600 round bows" itemized by appraisers; "96 fancy backs" for tablet-centered, slat-back chairs were also on hand. Appraisers listed a total of 451 additional "broad bows," or plain slats, for a recently introduced pattern, and chances are good that the seats were serpentine. Enoch Tomlin of Philadelphia used a serpentine plank for a straight-back broad-top side chair datable through its label to 1823/24. In 1824, Tomlin sold "Six dining chairs strait Backs" to one of Girard's associates for $4.50, and about the same time Aaron Jones made chairs of this pattern in Bucks County. Robert Burchall and William Wickersham produced similar, labeled Windsors in West Chester between August 1822 and February 1824 (fig. **3-132**). Their Windsor, which documents how up to date fashions were in areas near

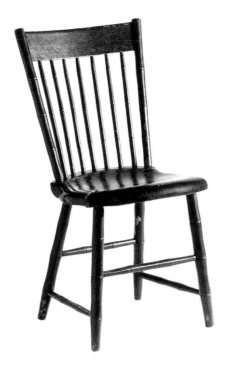

Philadelphia, differs from the Tomlin chair only in the rounded seat edges; the planks usually have blunt, angular edges with a groove around the upper surface. Before the partnership terminated, Burchall and Wickersham made the same pattern with rounded or flat-edged balloon seats. Lobach of Berks County branded an armchair of this pattern. Balloon-seat side chairs in the Philadelphia Athenaeum's collection may be part of a set of twelve Windsors that the institution purchased from Philip Halzel in 1822, since the pattern is correct for the date. Plain, slat-back Windsors appear in a print popularly called "Fair Deborah" from *Life in Philadelphia,* a series first published in 1828 at Philadelphia and later copied in London (fig. **3-133**). The straight-back broad-top chair with bamboo spindles remained a Philadelphia staple through the 1820s; the style continued much longer in rural areas.[100]

Steel's inventory documents other changes in the 1817 market. The appraisers, one of whom was chairmaker Burden, listed many unassembled chair parts and numerous chairs ready for sale. Among the finished Windsors were nearly fifty-seven dozen "bent back chairs" and thirty armchairs of similar pattern. The estate administrators' accounts indicate how they disposed of this quantity of seating without glutting the local market: "Amount of return of Adventure to St. Thomas," a Caribbean island long important in the Philadelphia furniture export trade.[101]

In moving from the straight- to the bent-back Windsor, some Pennsylvania chairmakers constructed an intermediate pattern. Starting with straight, bamboo- or ring-turned back posts, they shaved the upper half or one-third of the face to a flat surface. They combined this back with a serpentine or balloon seat, and sometimes centered an ornamental, arrow-shaped spindle between the creased sticks; the legs are also creased. The fully converted bent back has cylindrical posts angled backward along nearly two-thirds of the upper length; the post faces are shaved to a flat surface above a band of multiple rings. The fancy chair of figure 3-118 illustrates a general prototype for the angled back. The broad Windsor tops enclose either "bent-back common sticks" or the new, arrow-shaped "bent flat sticks," as described in the Steel inventory (fig. **3-134**). Early bent-back armchairs use the typical bamboo, or creased, arm current from the start of the century; the ringed legs follow the back post pattern. Side chairs with arrow spindles have either straight or angled back posts, frequently combined with the new shovel-shaped seat. A medallion stretcher, the "flat" stretcher noted in Steel's inventory,

Pennsylvania 141

Fig. 3-135 Fancy slat-back Windsor side chairs and armchair, attributed to Samuel Moon, Fallsington, Bucks Co., Pa., ca. 1814–18. Yellow poplar (seats); (*left only*) H. 35½″, (seat) 17⅝″, W. (crest) 18¾″, (seat) 16¾″, D. (seat) 15¾″. (Mr. and Mrs. James Palmer Flowers collection [*left and right*] and Historic Fallsington, Inc.: Photo, Winterthur.)

sometimes replaces the bamboo-turned front brace. Although only a few Pennsylvania chairs with full-length arrow spindles are known today, they were apparently common in the 1820s and early 1830s.[102]

Samuel Moon of Fallsington, Bucks County, is important in postwar Windsor design. Although his work is undocumented, chairs owned by direct family descendants and formerly common in Bucks County and Trenton, New Jersey, homesteads describe the features. Moon appears to have had a genius for utilizing earlier seating designs to produce fresh, delicate, and harmonious chair patterns. His crest rails, which represent variations on a basic theme, all date from about 1814 to 1825. Starting with the armchair of figure **3-135**, the distinctive, curved, crest ends derive from a late eighteenth-century mahogany cross-slat chair, which Moon likely knew from his Philadelphia working experience and his close Quaker ties (fig. 3-54). Two halves of a single slat form the crest terminals, and between them Moon inserted the central arch of a Philadelphia French-style cabriole chair that dates to about 1810. The side chair crests have less vigorous top curves, but the low, hollow arches along the bottom introduce comparable movement. The perforations of the left chair suggest that the direct model was the earlier double-rod Windsor with central medallion. The low arches appear based upon Sheraton and Hepplewhite designs. Another pattern from Sheraton's *Cabinet-Maker and Upholsterer's Drawing Book* may have suggested the two-tier arrangement of some spindles. Moon's distinctive, slim spindle design with its high serpentine arch resembles chair banisters pictured in Hepplewhite's *Cabinet-Maker and Upholsterer's Guide* and in Chippendale's *Gentleman and Cabinet-Maker's Director*.[103]

Another Moon armchair duplicates the lower structure of the first (fig. **3-136**). The back posts, however, are shaved and bent, and they anchor forward-scroll arms like those found in 1790s Windsor work (fig. 3-53). The crest, although closely related to figure 3-135 (center), has thicker ends and a center section marked by two shallow arches on the lower edge. There are just three centered back spindles. A similar armchair, one of a pair, with old, possibly original, medium brown paint bears the painted inscription "made 1816" in a bold hand across the seat bottom. The date corresponds with Moon's work. The illustrated side chair, which appears to date slightly later because of the heavier elements, has the bent posts of the scroll-arm chair with a new crest that resembles the

Fig. 3-136 Fancy slat-back Windsor armchair and side chair, attributed to Samuel Moon, Fallsington, Bucks Co., Pa., ca. 1816–20 (*left*) and 1820–25. Yellow poplar (seats); left: H. 33¼″, (seat) 17 ¹⁵/₁₆″, W. (crest) 17¾″, (arms) 21½″, (seat) 20″, D. (seat) 15½″; right: H. 34″, (seat) 18³/₁₆″, W. (crest) 17¼″, (arms) 21½″, (seat) 16½″, D. (seat) 15⅜″. (Mr. and Mrs. James Palmer Flowers collection [*left*] and State of Rhode Island and Providence Plantations, Providence, R.I.: Photos, Winterthur.)

splat profile of a Philadelphia mahogany chair. Moon's work also includes two settees that relate closely to his chairs in the crests and spindles.[104]

Chair legs common to postwar Windsor work are itemized in Steel's 1817 Philadelphia inventory as "creased feet," "plain feet," and "readed ditto." He likely used creased feet in his tablet-centered slat-back chairs. The plain feet may have had only painted creases or grooves. Steel's reeded legs perhaps are those used in the arrow-back armchair of figure 3-134; this Windsor also has the contemporary flat sticks and creased elbows mentioned in the inventory. An early 1820s support, which is best described as a "fancy" leg since it derives from fancy painted seating, occurs in two armchairs labeled by Joseph Jones of neighboring West Chester (fig. 3-137). Jones, a frequent advertiser from 1817 onward, offered "bent back Windsor Chairs" to the public in 1821, although he continued to make the straight-back design. Burchall and Wickersham of West Chester

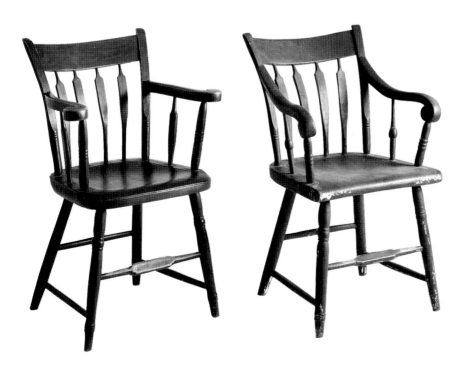

Fig. 3-137 Slat-back Windsor armchairs, Joseph Jones (labels), West Chester, Pa., ca. 1824–30 (*left*) and ca. 1828–35. Yellow poplar (seat) with hickory (*left*); left: H. 33½″, (seat) 18⅛″, W. (crest) 19⅛″, (arms) 23½″, (seat) 19″, D. (seat) 16¼″; right: H. 33½″, (seat) 17⅜″, W. (crest) 18⅞″, (arms) 21⅝″, (seat) 19″, D. (seat) 17″. (Chester County Historical Society, West Chester, Pa., [*left*] gift of Samuel Butler.)

Fig. 3-138 Scalloped-top Windsor side chair (one of six), I. Hull (maker or owner, penciled), Mechanicsburg, Pa. (penciled), 1835–45. Magnolia (seat, microanalysis); dark green ground with creamy peach, gray, white, medium blue, pinkish red, green, and gilt; H. 32″, (seat) 16¾″, W. (crest) 15¾″, (seat) 15⅛″, D. (seat) 14⅜″. (Wendell and Anne Pass collection: Photo, Winterthur.)

Fig. 3-139 Scalloped-top fancy side chair (one of eight), possibly by John W. Patterson., Philadelphia, 1830–40. Yellow poplar, basswood, and maple; H. 32½″, W. (seat) 17⅞″, D. (seat) 16⅜″. (Winterthur 85.56.1.)

used the same support in a side chair with a flat front stretcher. The work of Philadelphia chairmaker Lee, who was in business until 1824, perhaps offers a prototype for other new features in the Jones chairs, namely, the arm assembly in the right one and the rounded-square seat in the left. Lee's chair lacks short underarm spindles, a characteristic noted in other Philadelphia seating, but chairmakers soon rectified this structural and design weakness. The short, flat, arm spindle of the left chair suggests a date of about 1824. The short, ball-centered sticks of the right chair date slightly later, as does the D-shaped seat with flat sides and rounded front.[105]

The new arms employed by Joseph Jones and Lee resemble those used on Philadelphia fancy chairs at least a decade earlier. In 1812 Haydon and Stewart made a large set of chairs with rush-bottomed, balloon seats for a local customer. The armchairs have scrolled rests mounted high on shaved and bent back posts similar to the Jones Windsor (right). Narrower slats join the back elements. Windsor-chair makers varied the pattern by mounting the forward scroll arm horizontally. The reeded (ringed) arm posts vary in height according to the design. Jackson, of Easton, made an armchair of related pattern in the late 1820s. He combined a slightly modified leg and forward scroll arms of exaggerated curves with an old-fashioned, tablet-centered slat.[106]

Horizontal, scrolled arms supported by reeded posts and two ball spindles socketed into a large, serpentine seat embellish an armchair from Burden's Philadelphia shop, probably dating to the late 1820s. The back posts and legs repeat the multiple rings, and a long, ringed stretcher joins the front supports. The two short spindles under each arm signal a design progression similar to developments in a prerevolutionary, high-back pattern (figs. 3-19 to 3-21). Remnants of original painted decoration recall the importance to the Windsor's visual appeal of this embellishment from the 1810s onward. Stripped of paint and ornament, such seating appears clumsy. The quality of the original decoration, however, also varied. When chairmaker Wall sold Windsors to a Philadelphia customer in 1823, he charged $17 for "1 doz fancy Bent Chairs" but only $13 a dozen for "4 Doz Bent D[itt]o." Description and price emphasize the interrelationship of decoration and quality.[107]

The ball-centered spindle noted in figure 3-137 (right) dates only to the late 1820s in the Philadelphia area. References to these spindles are absent from Steel's comprehensive 1817 shop inventory. Firm evidence appears only in 1838 when the ball spindle was documented by James C. Helme of Plymouth, Luzerne County, in "Book of Prices for Making Cabinet and Chair Furnature," a handwritten guide prepared for area employers and journeymen. This document contains prices for framing Windsor chairs and brief descriptions of five types, each with the crest framed between the posts. The first two entries for common straight- and bent-back chairs, types already discussed, refer to Windsors with long spindles, probably creased (bamboo). Helme fails to refer specifically to long, flat (arrow) or ball spindles, the latter a reasonably uncommon pattern in Pennsylvania work. Two other chairs, described by Helme as "Ball back chairs with 2 Bows" (also called slats) and "Ball back chairs with Scalloped top," are variants of a common Pennsylvania bent-post style (fig. 3-138). The basic feature is the crest arch, which may be ornamented with tiny sawed scallops, as shown; otherwise, the two patterns are the same. Below the narrow midslat, short ball spindles socket into the seat, and the front stretcher sometimes repeats the ball motif. The shovel seat is common in Pennsylvania side chairs from the second quarter of the century. While chairmakers in other states used a similar seat, the Pennsylvania design has distinguishing features. The narrow back section extends about one-third the seat length, considerably farther than the related New England plank, and the rounded front cuts off abruptly without completing a full scroll. The front leg turnings differ slightly from work introduced in the 1820s. The multiple top rings are broad and well defined; below the bottom ring, the leg rounds and tapers into a short foot that sometimes terminates in a ball. Penciled on the seat bottom of this Windsor, one of a set of six, is "Mechanicsburg," a small town near Harrisburg. A similar scalloped-top chair is inscribed "James T. Nott Middletown, Pa." The two communities are about fifteen miles apart on opposite sides of the

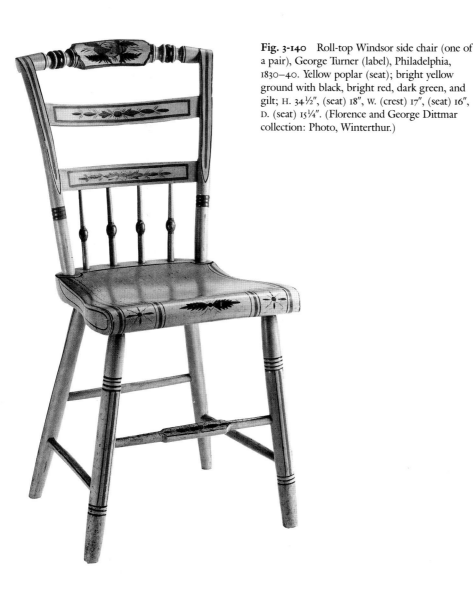

Fig. 3-140 Roll-top Windsor side chair (one of a pair), George Turner (label), Philadelphia, 1830–40. Yellow poplar (seat); bright yellow ground with black, bright red, dark green, and gilt; H. 34½″, (seat) 18″, W. (crest) 17″, (seat) 16″, D. (seat) 15¼″. (Florence and George Dittmar collection: Photo, Winterthur.)

Susquehanna. Other chairs of this pattern are attributable to Chester County and southern Pennsylvania west of the Susquehanna, but the style was probably common throughout the eastern part of the state.[108]

While documented Philadelphia scalloped-top Windsors as Helme described are unknown, the crest prototype had a metropolitan origin. According to tradition, a painted, fancy scroll-back chair with a comparable five-lobed, scalloped crest was made for a Philadelphia family by an uncle, John Pattenson—probably John W. Patterson, a chairmaker (fig. **3-139**). This fancy chair reflects Baltimore chairmaking in its central back feature, front stretcher, and painted ornament.

A Windsor that is perhaps even less common than the scalloped-top pattern is linked with at least two Philadelphia craftsmen (fig. **3-140**). Helme described the pattern as "Ball back chairs 2 slats, role top" in his price book. The Windsor, one of a pair, bears the printed 1830s label of George Turner. A related chair, stenciled by George F. Sites, dates at the earliest to 1833, although the general pattern was probably current from the late 1820s. Lambert Hitchcock's Connecticut "rolled top" fancy chairs date at least to 1825, when he first advertised this pattern, and by 1834 his business records specifically mention "Role Top Windsor chairs." Hitchcock may have based his design on Hartford chairs, but the model was probably New York City fancy seating. The roll top, however, was invented in England where joined chairs with similar tops and midrails, usually turned with a spiral, date from the early 1800s. Their curved Grecian legs relate to chairs labeled "Trafalgar" in *The London Book of Prices* (1802). The plank-seat Philadelphia models, however, are little reminiscent of the Greek prototypes.[109]

Fig. 3-141 Tablet-top Windsor side chair, Philadelphia, ca. 1828–35. Light olive green ground with gilt. (New-York Historical Society, New York.)

Fig. 3-142 Abraham McDonough billhead and bill to Joseph H. Liddall, Philadelphia, 1833 (inscribed). From Carl W. Drepperd, *Handbook of Antique Chairs* (Garden City, N.Y.: Doubleday, 1948), p. 166. (Photo, Winterthur.)

THE CLASSICAL IMPULSE

Within two years of Thomas Hope's London publication of *Household Furniture and Interior Decoration* in 1807, Latrobe designed a set of side chairs in the new "classical" manner for the President's House. Baltimore craftsmen John and Hugh Finlay constructed the chairs along with other seating furniture. The Finlays' bill to Latrobe as "agent for furnishing the presidents House" describes the thirty-six cane-seat chairs, destined for the drawing room, as "made to a Grecian Model." This marked the beginning of an intense American interest in a new chair with a tablet crest framed above or on the face of the posts. Baltimore chairmakers were the first to make fancy and Windsor chairs with tablet tops, and the chair remained popular past midcentury. Early crest pieces reached just beyond the posts (fig. 3-118); about 1815, craftsmen extended the overhang and introduced a pronounced lateral curve to the board. The feature occurred in Philadelphia fancy furniture by the 1820s, and a Windsor chair with a crest framed on the posts was probably in the Philadelphia market by the late 1820s (fig. **3-141**). Both a Windsor and a fancy chair appear in a pictorial billhead printed for chairmaker Abraham McDonough (fig. **3-142**). The craftsman occupied the South Second Street premises in 1832 and dated this document a year later. The engraver clearly delineated the main features of the new Windsor at the left: a broad, curved crest attached to the faces of bent, shaved posts; four short, ball-centered spindles; striped and ringed posts and legs; and an ornamental front stretcher. Because so few similar Philadelphia chairs exist today, the design was either unpopular or, more likely, quickly superseded by another. Helme fails to identify or list this pattern in his price book.[110]

By the 1830s large, sawed scrolls were integral to high-style design. Hitchcock introduced a scroll-end crest to his fancy and Windsor production. He described these chair backs as "Crown top," although the term was probably used only in New England. Round top was an alternate designation. A patented, rush-seat, convertible settee manufactured in Albany, New York, by Chester Johnson, perhaps as early as 1827, used slim scrolls to terminate the crest and forward scrolls to form arms similar to those in the Joseph Jones chair (fig. 3-137, right). The "Ball Bows" and "Baltimore Bows" listed in chairmaker Charles Riley's 1842 Philadelphia estate probably describe the currency of both round-end and square-end tablets.[111]

Development of the round-end tablet in formal and painted American chairs likely stemmed directly from published English sources. Rudolph Ackermann's *Repository of*

Arts, Literature, Commerce, Fashions, and Politics (1809–28), a monthly publication that included a furniture plate, illustrated a round-end, tablet-top dining chair in October 1815 (fig. **3-143**). Comparison of the scroll-ornamented crest with figure 3-144 shows the continuing impact of English design upon American seating. Prominent, painted or gilt, leafy scrolls were an integral part of the shouldered-tablet Pennsylvania Windsor from its inception. The exact profile of the top piece may derive from design books that circulated during the 1820s. The enlarged edition of Richard Brown's *Rudiments of Drawing Cabinet and Upholstery Furniture* (1822) possibly first delineated a crest of this exact profile, but it is difficult to ascertain how well known Brown's work was in America. George Smith's *Cabinet-Maker and Upholsterer's Guide* (1826) certainly circulated here. A Baltimore bookseller stocked it by January 1830, and it was probably available earlier. Smith's book offers several plates that interpret the same shouldered profile (fig. 4-21).[112]

Although the scroll-end tablet was current in New England and New York in the late 1820s, Philadelphia consumers probably knew this pattern only in the early to mid 1830s. Turner constructed the tablet-top side chair in figure **3-144,** and from about 1830 to 1852 he did business at the Front Street address given on the seat label. The only change from the McDonough pattern is the updated crest profile. As in fancy-chair making, the tablet is set into recesses, or rabbets, on the post (stump) faces and fastened by screws inserted from the back. Other chairs socket the crest on tenons extending from the post tops, in the usual Windsor manner. A chair made in the metropolitan shop of John D. Johnson and John T. Sterrett between 1843 and 1848 has rectangular tenons, the joint pinned (fig. **3-145**); most chairs employ round tenons turned in the lathe. Each front leg of the Johnson and Sterrett chair has a swelled, striped central section between well-defined,

Fig. 3-143 Design for a dining-room chair. From Rudolph Ackermann, ed., *The Repository of Arts, Literature, Commerce, Fashions, and Politics,* vol. 1 (October 1815), pl. 21. (Winterthur Library.)

Fig. 3-144 Tablet-top Windsor side chair (one of two) and detail of label, George Turner, Philadelphia, ca. 1835–42. H. 33¼″, (seat) 17¼″, W. 16″. (Private collection: Photo, Winterthur.)

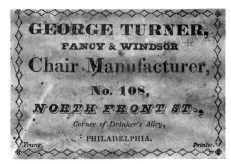

Fig. 3-145 Tablet-top Windsor side chair and detail of stencil, John D. Johnson and John T. Sterrett, Philadelphia, ca. 1843–48. Yellow poplar (seat); medium-light gray ground with black, gold bronze, and dark bronze; H. 32″, (seat) 17¼″, W. (crest) 18″, (seat) 16¼″, D. (seat) 15″. (Fonthill Museum of the Bucks County Historical Society, Doylestown, Pa.: Photo, Winterthur.)

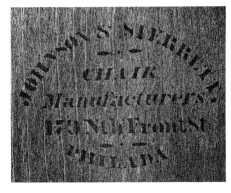

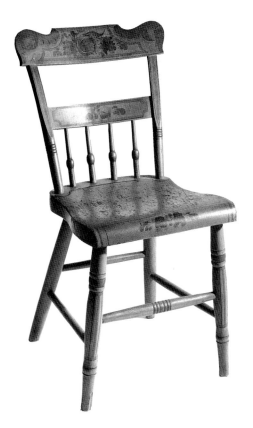

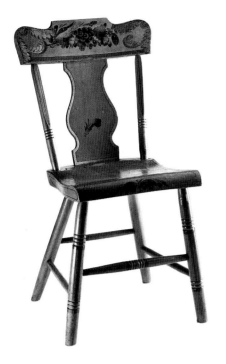

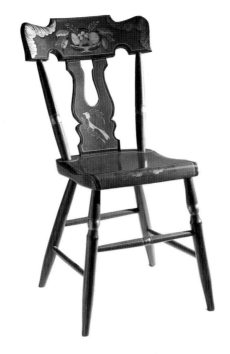

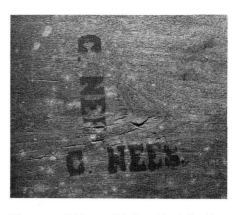

Fig. 3-147 Tablet-top Windsor side chair with splat and detail of stencil, George Nees, Manheim, Pa., 1850–60. Yellow poplar (seat); bright green ground with chocolate brown, golden mustard, dark green, red, black, gilt, and other colors; H. 32¼", (seat) 17⁵⁄₁₆", W. (crest) 19½", (seat) 14⅝", D. (seat) 14¼". (Dr. and Mrs. Donald M. Herr collection: Photo, Winterthur.)

Fig. 3-146 Tablet-top Windsor side chair with splat (one of four), John Swint (brand "J.SWINT. / CHAIR MAKER"), Lancaster Pa., 1845–55. Yellow poplar (seat, microanalysis); pea green ground with dark pea green, black, wine red, shaded bronze, and silver; H. 33", (seat) 17⅛", W. (crest) 18⅜", (seat) 15⅜", D. (seat) 14⅝". (Lancaster County Historical Society, Lancaster, Pa.: Photo, Winterthur.)

compressed, ball turnings in the Baltimore style; multiple rings ornament the front stretcher. The crest has enlarged shouldered ends that flare at the lower corners. A high-back rocking chair of similar crest bears Riley's (d. 1842) stenciled label. As late as 1857 or 1859, Emmor D. Jefferis, who operated a "Furniture Wareroom" at 79 North Front Street, sold Windsor chairs of this pattern. The design was also popular in rural and semirural eastern Pennsylvania, and several examples are marked or have family histories. For the Wilkes-Barre area, Helme listed only settees and rocking chairs with shouldered crests in his 1838 price book.[113]

Just before midcentury, Pennsylvania chairmakers, like John Swint of Lancaster, introduced a broad, solid baluster or modified baluster splat to the shouldered-tablet chair (fig. 3-146, pl. 11). High-style chairs of figured cabinet wood with similar panels had entered the market during the 1830s. The 1833 New York broadside advertisement of Joseph Meeks and Sons illustrates two general prototypes, possibly based on a "Roman" chair illustrated in the 1808 *Supplement to the London Chair-Makers' and Carvers' Book of Prices* (fig. 3-164). Painted chairs originating in the shops of Swint, Frederick Fox, George Hay, and John Murdick identify production in Berks, York, and Lancaster counties. Swint began chairmaking sometime between 1840 and 1847, when he advertised that he continued "the Chair Manufacturing business." Shop production also included arrow-spindle chairs with plain, broad, slat crests framed between the posts. Central Pennsylvania chairmakers sometimes substituted heavy, straight, cylinders for the shaved posts and angular or tulip-shaped panels for the splat (fig. 3-163), both reflecting the continued popularity of the Baltimore style in the region.[114]

Swint and other central Pennsylvania chairmakers produced a "new fashioned" splat-back chair in the 1850s (fig. 3-147, pl. 12). The back panel now has an opening that duplicates the curves of the outer profile. This treatment was perhaps inspired by the open lyre ornament popular in earlier joined furniture. The lower edge of the crest, which is straight in most unpierced backs, now bears two, sometimes three, pointed or rounded arches; the posts and legs are heavy, tapered cylinders with turned ball or multiring ornament. This chair is documented to George Nees, who worked in Manheim, Lancaster County, although probably after 1850 since his name is absent from the federal census for that year.

Production of pierced and unpierced splat-back Windsors extended east and west from the central Pennsylvania region, where chairs of both patterns are frequently found today. In 1846, for example, James Wilson of Buffalo Township, Washington County,

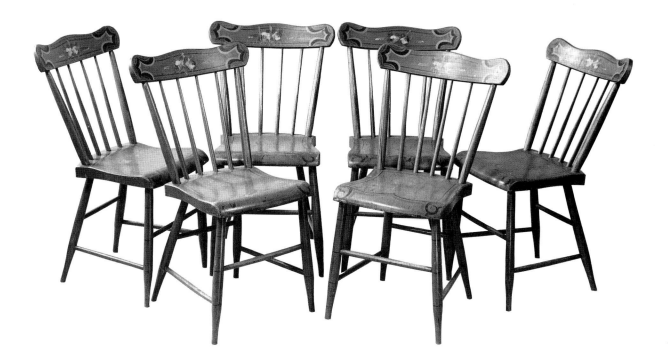

southwest of Pittsburgh, left home at age twenty to train in Philadelphia. Fragmentary records indicate that by 1849 he had become a journeyman and ornamented chairs for payment. About 1852, Wilson returned to Buffalo Township and set up his own shop. Surviving patterns indicate that he made chairs with pierced and unpierced splats and notched or plain crests.[115]

Long, plain spindles, common in the 1820s, remained in south-central Pennsylvania chairmaking as late as the 1850s and 1860s. William Stoner (b. 1827) of McConnellsburg made six side chairs with plain, tapering posts that harmonize with the spindles and complement the trim legs (fig. 3-148). The plain, slim supports suggest that the chairmaker was familiar with earlier Baltimore work (figs. 4-11, 4-12). Other chairs of this pattern incorporate ball turnings into legs, posts, and spindles. The crest is a simplified version of the shouldered top rail introduced in the 1830s. The chairs date from about 1855 to 1870, based on the absence of Stoner's name in the 1850 federal census and his marriage and his first child's birth (1853) during the next several years. Similar chairs have ball-turned front legs like those in the Nees Windsor, a pattern introduced with the splat (fig. 3-147). Other features also support the suggested date: the circular saw marks on several plank bottoms identify a mechanical aid in widespread use only after midcentury; the painted, naturalistic flowers of the crest reflect a decorative style generally associated with the third quarter of the century.[116]

In the 1830s, American interest in French-style seating was stimulated by Smith's *Cabinet-Maker and Upholsterer's Guide* and the 1823 edition of the *London Book of Prices*. The principal design components were an arched back and a large splat. The style became popular and before long had spread from the leading metropolitan center in all directions. By 1835, Walker, Osborn, and Company of New Haven advertised "the most fashionable patterns of French, half French, and Grecian Mahogany Chairs." A Cincinnati auction house offered midwestern customers "French Mahogany Chairs" in 1846. The style was firmly entrenched by the early 1850s when John B. Robinson, proprietor of the Philadelphia Great Western Chair Manufactury ornamented his billhead with a French cane-seat chair. A painted, plank-seat interpretation of the French chair known today as the balloon-back Windsor probably entered the market before the decade's end (fig. 3-149, pl. 13). A composite pattern, which added a rounded crest to the splat-back chair with posts, was inspired partly by the fashionable Boston rocking chair favored by the 1840s (fig. 3-150). This late example comes from the "A & T" firm, probably Apple and Thompson, of Indiana, a western Pennsylvania town. Wilson made chairs with similar

Fig. 3-148 Tablet-top Windsor side chairs (set), William Stoner (penciled), McConnellsburg, Pa., 1855–70. Yellow poplar (seats); medium-dark blue-green ground with black, white, pink, yellow, green and bronze; H. 33⅛", (seat) 17¾", W. (crest) 19⅛", (seat) 14⅞", D. (seat) 15". (Fulton County Historical Society, McConnellsburg, Pa.: Photo, Mary Longsworth Antiques.)

Fig. 3-149 Balloon-back Windsor side chair (one of a pair), Pennsylvania, 1855–70. Yellow poplar (seat); dark brown and red grained ground with green, yellow, orange-red, blue, and gilt; H. 33½", (seat) 17⅜", W. (seat) 16", D. (seat) 15¼". (Mary Lou and Robert Sutter collection: Photo, Winterthur.)

Fig. 3-150 Tablet-top Windsor side chair with splat (one of four), A&T (painted) possibly Apple and Thompson, Indiana, Pa., ca. 1864–70. Yellow poplar (seat); H. 33½", W. 18¾", D. 16⅞". (Historical and Genealogical Society of Indiana County, Indiana, Pa.: Photo, Winterthur.)

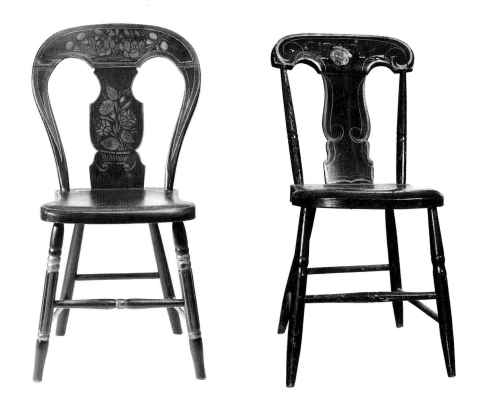

top pieces in Washington County. Both this pattern and the fully developed balloon-back Windsor have rounded-edge balloon seats that complement the back arch. The splats consist of angular or rounded balusters, some pierced at the center. Craftsmen throughout Pennsylvania made balloon-style chairs, which continued in popularity for many years. A set consisting of a large, painted rocking chair and six side chairs has a splat design comparable to figure 3-149. The rocking chair bears the seat-bottom inscription: "Painted and decorated by Frederick Fox, Chair Maker, August 25, 1877." Fox, who worked in Reading, Berks County, may not have manufactured the chairs. The inscription, however, demonstrates that the balloon style remained current into the late 1870s.[117]

MID NINETEENTH-CENTURY WORK

Of the many entries for finished chairs in Riley's 1842 Philadelphia estate records, one listing is of special interest in the study of late Windsors: "Twenty Horse Shoe Chairs" valued at $40. The picture that comes to mind is a low-back armchair, the arms and back together forming a flat semicircle repeated in the rear curve of the seat. A pictorial notice of the following year confirms the image. James Hazlet's Utica, New York, directory advertisement offers "the newly invented PIVOT REVOLVING CHAIRS" and illustrates a swivel-type, low-back seat. A plain Windsor of this pattern, documented by its brand to Swint's Lancaster shop and probably dating to the 1840s, has heavy, forward-scroll arms, arrow spindles, a tall backpiece with a roll, and late bamboo-style legs. A related, though later, chair is owned by the Athenaeum of Philadelphia (fig. 3-151, left). Ball spindles replace arrow sticks, the backpiece is taller, and the turned legs are fancy. A similar cushioned chair appears in an 1857 billhead of Philadelphia chairmaker William Sanderson. Another horseshoe-style chair, also in the Athenaeum's collection, has narrow rail sections that bend forward to combine arm and arm support in one unit (fig. 3-151, right). Athenaeum records for 1861 document the purchase of chairs from Sanderson; one or both illustrated patterns could have been part of that purchase. The styles remained popular for several decades. An 1887 Brooklyn Chair Company catalogue illustrated similar seating with wood or cane bottoms, with or without iron reinforcing rods.[118]

Fig. 3-151 Low-back Windsor armchairs, Pennsylvania, probably Philadelphia, 1855–70. (Athenaeum of Philadelphia.)

In 1854–55 the town of Lancaster completed building its third county courthouse, designed by architect Samuel Sloan of Philadelphia, and county commissioners engaged local craftsmen to supply chairs for courtrooms and offices. When the commissioners later ordered additional seating, they bypassed the local market and made their purchases in Philadelphia (fig. **3-152**). Subtle differences in the two metropolitan chairs indicate either more than one supplier or separate purchases. (The wire reinforcements are later additions.) A third chair in this group of twenty-two that were sold at auction some years ago bears a printed manufacturer's label on the seat bottom with the customer's name added in longhand: "For *Commissioners Office, Lancaster County, Pa.* from Daniel M. Karcher & Sons, Cabinet Ware-Rooms and Manufactory, Nos. 236 and 238 South Second Street, Philadelphia." City directories confirm Karcher's address in 1859 and later. In the same period, Bethlehem chairmakers produced almost identical armchairs with heavy bows and blunt-end arms. Local directory advertisements and stenciled seat bottoms identify these as "GENUINE MORAVIAN" chairs. Although

Fig. 3-152 Round-top Windsor armchairs (two), attributed to Daniel M. Karcher and Sons, Philadelphia, Pa., 1859–75. Yellow poplar (seats); (*left*) H. 34½", (seat) 17½", W. (arms) 22¾", (seat) 20⅞", D. (seat) 15"; wire bracing added later. (The late John W. Aungst, Jr., collection: Photo, Winterthur.)

Fig. 3-153 Tablet-top Windsor side chair, south-central or southwestern Pennsylvania, ca. 1812–20. H. 34″, W. 17⅝″, D. 15¼″. (Private collection: Photo, Winterthur.)

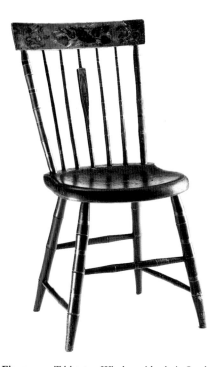

Fig. 3-154 Tablet-top Windsor side chair, Jacob Fetter III (brand "I·FETTER"), Lancaster, Pa., ca. 1815–22. Yellow poplar (seat); H. 35¼″, (seat) 17⅝″, W. (crest) 18¾″, (seat) 16⅜″, D. (seat) 15⅜″; nineteenth-century paint and decoration not original. (Dr. and Mrs. Donald M. Herr collection: Photo, Winterthur.)

horseshoe and "Moravian" chairs are of eighteenth-century inspiration, neither the designs nor the combinations of elements could be mistaken for the earlier products by the careful observer.[119]

BALTIMORE INFLUENCE ON CENTRAL PENNSYLVANIA

In 1788 Jacques-Pierre Brissot de Warville noted the "astonishing growth" of Baltimore as a seaborne trade center. Commercial rivalry already existed between the city on the Chesapeake and the metropolis on the Delaware. In the late 1790s La Rochefoucauld Liancourt remarked, "Baltimore is, after Philadelphia and New-York, the most important trading port in America." He also described Baltimore's accessibility to interior Pennsylvania beyond the Susquehanna and its brisk reciprocal trade. Along the Susquehanna itself, trade was limited before the development of canals because only small, flat-bottomed boats could ply the shallow, rock-filled waterway. The routes from Baltimore to central Pennsylvania, as well as to the western regions, were thus overland across eastern Maryland and up through the many valleys in the Appalachian and Allegheny mountains. Baltimore's industrial and cultural life funneled into Pennsylvania through these valleys.[120]

In 1806 Edwin R. Mulhern and Moses Bullock, chairmakers of Carlisle, a town southwest of Harrisburg, advertised "Windsor, cane and rush bottom chair making . . . and gilding in all the various branches and fashions now offered in Baltimore" as Baltimore chairmakers gradually infiltrated the southern Pennsylvania region. Gilbert Burnett, "lately from Baltimore," announced a new Harrisburg business in 1812 "in the noted stand formerly occupied by James Ingram, dec'd, in Front street Where he means to keep a handsome supply of fancy and Common Chairs." The chairmakers who came to Pennsylvania would have known a Baltimore pattern popular before the War of 1812, as illustrated in a portrait of two young schoolboys attributed to Joshua Johnson of Baltimore (fig. 4-8). The winglike, slant-end crests attach to the post tops, a construction common to early nineteenth-century Baltimore fancy seating. The pattern spread into southern Pennsylvania, Frederick County, Maryland, and the Shenandoah Valley, and continued westward. A chair from south-central or southwestern Pennsylvania illustrates the strong influence of this unusual pattern throughout the region, although Baltimore was only one source of inspiration (fig. **3-153**). The crest projection imitates a Philadelphia chair (fig. 3-125), and the local German tradition introduced a bold bamboo leg identical to other regional work (figs. 3-123, 3-124). Windsors of similar crest appear in areas south of Pittsburgh. A small medallion occasionally embellishes the central spindle (fig. 4-9), and a vertical central splat is featured in an unusual chair set.[121]

Pittsburgh, which continued to grow rapidly, attracted craftsmen. In 1818 business was good for Thomas Heslip, who had "commenced Fancy & Windsor Chair making" in Pittsburgh three years earlier. He maintained "a constant supply" of chairs, which he finished in a "superior style" with paint and ornament. Chairmakers in other western areas constructed slant-end Windsors. Similar side chairs have been found in West Virginia and Tennessee, and an armchair owned by Old Salem, Inc., in Winston-Salem, North Carolina, may have been made in the local Moravian community.[122]

Baltimore influence is apparent in a fancy-spindle postwar Windsor whose rectangular tablet mounted on the post tops has little overhang (figs. **3-154**, 3-118). The plank bears the Lancaster brand of Jacob Fetter III. The balloon seat and heavy bamboo post and leg turnings reflect the Pennsylvania style. Later paint and decoration includes a fanciful landscape on the upper seat surface. In an 1820s watercolor portrait at Winterthur, a southern Pennsylvania family sits in Windsor side chairs, armchairs, and children's rockers constructed to this pattern.

Slat-back counterparts of the pattern represented by the Fetter chair (fig. 3-154) are illustrated in plates 9 and 10. The flat edges in the balloon seat of plate 9 date the chair a few years later, but the bamboo work is still of high quality. The distinctive feature of the chair is the back posts, shaved on the face of the upper segment only. Like the Fetter chair

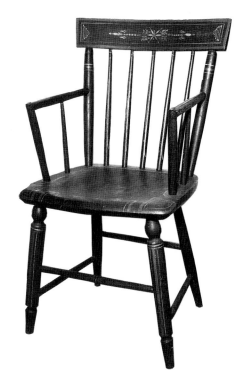

Fig. 3-155 Tablet-top Windsor armchair and details of brand and painted inscription, Wilhelm Schroeder (maker), Emanuel Schroeder (decorator), York, Pa., 1825–35. Yellow poplar (seat); green ground with yellow; H. 34½″, (seat) 17½″, W. (seat) 18⅟₁₆″, D. (seat) 16¾″. (Private collection: Photo, Winterthur.)

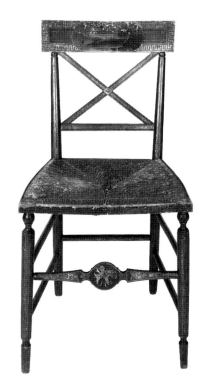

Fig. 3-156 Fancy side chair (one of three), Baltimore, 1805–15. H. 33⅜″, W. 18⅛″, D. 15⅞″. (Maryland Historical Society, Baltimore, gift of Dr. James Bordley, Jr., and Mrs. Charles A. Webb.)

design, this pattern was produced in south central Pennsylvania within relatively confined regional boundaries. In a slightly advanced design (pl. 10), the shaved work is carried below the center of the post faces, and the balloon seat is exchanged for a serpentine-sided straight-front plank. An ornamental arrow-shaped, or flat, spindle is again used for a center-back accent.

Wilhelm and Emanuel Schroeder of York collaborated on an armchair inspired by Baltimore fancy seating introduced around 1805 (fig. **3-155**). Wilhelm, who made the chair, branded his initials on the seat bottom; Emanuel, the ornamenter, added his name and location in black paint. The heavy character of the Windsor suggests a late 1820s or early 1830s date. The squared seat is a late version of Baltimore Windsor furniture made in the 1810s (figs. 4-4, 4-5). The profile and leg turnings spring directly from fancywork. The shallow, slightly curved crest has a typical short overhang. As figure **3-156** shows, many early 1800s Baltimore fancy chairs have small, button-shaped turnings in the upper back posts. In the Windsor, a shallow groove around the post tops reproduces this feature rather coarsely. The arms reflect Philadelphia square-back design of the early 1800s. In April 1830, Wilhelm advertised locally that he continued "the CHAIRMAKING BUSINESS," describing his stock as "a general assortment of fancy and common chairs, of the best materials . . . finished in a new and beautiful style." About the same time, Emanuel advertised his "CHAIR FACTORY" and reminded consumers that he also did "SIGN & ORNAMENTAL PAINTING."[123]

In the late 1820s or 1830s, William Bullock of Carlisle, and later Shippensburg, constructed a set of side chairs, which, like the Fetter and Schroeder chairs, shows Baltimore influence (fig. **3-157**). Bullock used a Pennsylvania balloon seat on plain, tapered, cylindrical legs that are painted with vertical stripes and a horizontal bottom cuff to approximate the slender legs of earlier Baltimore Windsors (fig. 4-5). The striped back posts and rectangular tablet duplicate Baltimore elements in the Schroeders' chair down to the small, compressed balls at the post tops. Substitution of a stay rail for spindles beneath the broad tablet marked a new 1820s Baltimore design, one rooted in classical antiquity. Shortly after 1800, European designers introduced "antique style" chairs with broad tops and crosspieces in the lower back. Baltimore and other metropolitan craftsmen freely copied or adapted the new designs, available in published form, and knowledge of this work filtered into the hinterlands.[124]

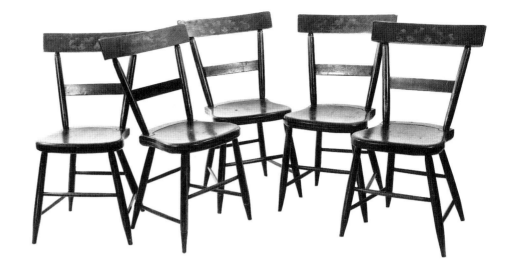

Fig. 3-157 Tablet-top side chairs (five), William Bullock (brand "WBULLOCK"), Carlisle or Shippensburg, Pa., 1825–37. H. 32⅞″, W. 18⅞″, D. 14¾″. (Indianapolis Museum of Art, Mr. and Mrs. Julius F. Pratt Memorial Fund.)

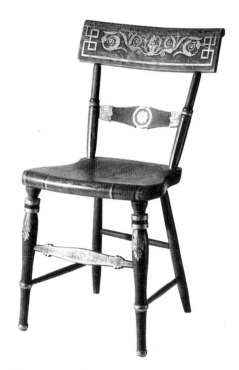

Fig. 3-158 Tablet-top side chair (one of five), Ezekiel Bullock (brand "E.BULLOCK"), Carlisle, Pa., ca. 1828–35. Medium brown grained ground with gilt, black, and reddish brown; H. 32⅝″, (seat) 17½″, W. (crest) 19″, (seat) 16⅜″, D. (seat) 15⅜″. (Cumberland County Historical Society, Carlisle, Pa.: Photo, Winterthur.)

Ezekiel Bullock took over the Carlisle woodworking shop of his father, Moses, and brother, William, in 1819 and advertised his "fancy and Grecian chairs." The spindleless Windsor illustrated in figure **3-158** and plate 14, one of five with original decoration and bearing Ezekiel's brand, dates about a decade later. Like other semirural craftsmen, he chose elements and motifs from various chairs, mostly of Baltimore origin. The "key" border, gilt leafy scrolls, and tablet roll occur on early 1820s fancywork (figs. 3-156, 4-18). The posts are modified versions of those in figures 3-156 and 3-157. The front legs indicate knowledge of the "beehive," an inverted baluster support first popularized in Baltimore in the 1820s (fig. 4-18). The heavy rings below the beehive indicate Bullock's familiarity with other recent fashion changes in the Baltimore market. Philadelphia design is evident only in the cross slat and stretcher profiles (fig. 3-142) and the serpentine seat (fig. 3-131), whose rounded front edge is painted with rings that imitate a fancy Baltimore cased pattern (fig. 4-18).[125]

Baltimore tablet-top, stay-rail chairs in their many variations remained popular in the lower Susquehanna region during the 1830s. A third chair from Carlisle, one of a ring-turned set of six with a settee, has original paint and decoration (fig. **3-159**, pl. 15). Cornelius E. R. Davis, the maker and decorator, stenciled his oval label on the plank bottom: "C E R DAVIS, / Chair & Cabinet Maker / -&- / House & Sign Painter. / CARLISLE PA." The front of the shovel seat, like the Ezekiel Bullock Windsor, has been painted to simulate a woven-seat casing. The chair's crowning glory is the tablet with a sepia view on a creamy tan background, which is enhanced by dark brown and gilt banding. The views, which differ on each chair and the settee's three panels, are divided between waterscapes and rural landscapes.

Baltimore influence in Lancaster County is represented by a side chair now at Wheatland, the Lancaster home of James Buchanan during the last twenty years of his life (fig. 3-160). Buchanan brought the Windsor from a previous residence in Lancaster, the town where he practiced law from the early part of the century. A darkened label on the seat bottom reads, "one of Mr Buchanan Library Chairs 75 years Old Made by the Humes Father." Humes may be Lancaster chairmaker and turner Samuel Humes, who died in 1836 at age eighty-three. The heavy leg and post turnings and the plain, slat-type front stretcher reveal late Baltimore design influence (fig. 4-17). The Pennsylvania ball spindles and shovel seat with serpentine sides reflect this long-established community's strong traditional ties with Philadelphia.[126]

A contemporary Lancaster County Windsor has an unusual, although successful, mixture of features that differ greatly from those of the Buchanan chair (fig. **3-161**). Chairmaker John Gormly, who resided in the Strasburg-Lampeter area south of Lancaster, combined Baltimore and Philadelphia styles in his work. Gormly had practiced his trade for several decades when he constructed the chair. The plank curves complement other rounded features—the Baltimore-style swelled legs, the lower back posts,

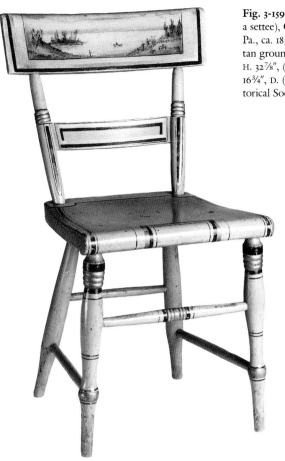

Fig. 3-159 Tablet-top side chair (one of six with a settee), Cornelius E. R. Davis (stencil), Carlisle, Pa., ca. 1831–35. Yellow poplar (seat); creamy tan ground with dark reddish brown and gilt; H. 32⅞″, (seat) 17⁷⁄₁₆″, W. (crest) 19¼″, (seat) 16¾″, D. (seat) 15⅛″. (Cumberland County Historical Society, Carlisle, Pa.: Photo, Winterthur.)

Fig. 3-160 Tablet-top Windsor side chair, possibly by Samuel Humes, probably Lancaster, Pa., ca. 1832–40. Yellow poplar (seat, microanalysis); H. 32⅞″, (seat) 18″, W. (crest) 19″, (seat) 15⅜″, D. (seat) 15⅜″; paint and decoration not original. (James Buchanan Foundation for the Preservation of Wheatland, Lancaster, Pa.: Photo, Winterthur.)

and the stay-rail profile. A strong horizontal emphasis in the crest, stay rail, seat front, and flat stretcher also unifies the design. Although Gormly framed this chair in the Philadelphia manner, his other branded Windsors testify to his flexibility in constructing Baltimore-style tablet chairs. The unusual stay-rail profile relates closely to an upright Windsor back feature in an early 1830s portrait attributed to Jacob Maentel (fig. 3-162). The artist supported the seat on pencil-slim Baltimore legs.[127]

Fig. 3-161 Slat-back Windsor side chair, John Gormly (brand "I. GORMLY"), probably Lampeter Twp., Lancaster Co., Pa., ca. 1832–40. H. 32″, W. 17″, D. 16″. (Herbert Schiffer Antiques: Photo, Winterthur.)

Fig. 3-162 Seated Gentleman, attributed to Jacob Maentel, York, Pa., ca. 1830–35. Watercolor on paper; H. 12⁷⁄₁₆″, W. 7⅞″. (Winterthur 57.1112.)

Fig. 3-163 Tablet-top Windsor side chair, John Murdick (stencil), Strasburg, Pa., 1845–60. H. 33″, W. 17¾″, D. 15″. (Private collection: Photo, Winterthur.)

Fig. 3-164 Design for chair. From the *Supplement to the London Chair-Makers' and Carvers' Book of Prices* (London: T. Sorrell, 1808), pl. 1. (Winterthur Library.)

Fig. 3-165 Tablet-top Windsor side chair, George Hay (stencil), York, Pa., 1855–65. H. 32½″, W. 15¾″, D. 14¾″. (Private collection: Photo, Winterthur.)

Two chairs, one documented to Lancaster County, represent later rural interpretations of metropolitan designs (fig. **3-163**, pl. 16). The chairs share several features, and both exhibit important elements adapted from Baltimore fancywork. Cylinders and balls form the basic support components. A broad splat is the integral back unit, and Pennsylvania-style, shouldered crest rails crown the posts. The scalloped crest of figure 3-163, made by John Murdick of Strasburg, is reminiscent of an earlier pattern with a similar top set between the posts (fig. 3-138). The tulip-shaped splat, whose surface contains painted, scrolled leaves, was originally based on the lyre, a fashionable motif in painted and fine Baltimore furniture of the 1820s and later. Plate 16, branded by T. Suplee, possibly a resident of Montgomery County, north of Philadelphia, introduces a new feature to the Pennsylvania plank chair—sweep (curved) posts with shoe-shaped bases inset into the sides of the seat and held by screws. The pattern comes from Baltimore painted furniture (figs. 4-16, 4-17), but the inspiration derives from classical design current in Europe from the early 1800s. The general model, like that for the balloon-back chair (fig. 3-149), is the French *chaise gondole*, which appeared in the 1808 *Supplement to the London Book of Prices* (fig. **3-164**).[128]

A new influence in furniture design, today known as Gothic revival, invaded England in the 1820s and was formalized in the next decade with the publication of Augustus Welby Northmore Pugin's designs and the broad dissemination of John Claudius Loudon's *Encyclopaedia of Cottage, Farm, and Villa Architecture and Furniture*. Although American architect Alexander Jackson Davis designed Glen Ellen, the Gilmors' Baltimore home, in the Gothic style as early as 1832, the late Grecian style and French-inspired designs were still gaining strength in American furniture. The Gothic furniture style, which was adapted from Gothic architecture and ornament, was well established in this country only in the late 1840s. A plank-bottomed Windsor by George Hay of York, featuring a row of pointed arches across the crest base, is an interpretation of Gothic-style Baltimore seating (fig. **3-165**). Seats with heavy sidepieces and short, stout posts were first introduced to Baltimore painted chairs in the 1820s (fig. 4-16).[129]

Notes

1. Adolph B. Benson, ed., *Peter Kalm's Travels in North America*, vol. 2 (New York: Dover Publications, 1966), pp. 26–27. Max Savelle, *George Morgan: Colony Builder* (New York: Columbia University Press, 1932), p. 3, and *Burnaby's Travels through North America* (1798; reprint, New York: A. Wessels Co., 1904), p. 91, as quoted in Nancy Ann Goyne (Evans), "Furniture Craftsmen in Philadelphia, 1760–1780" (Master's thesis, University of Delaware, 1963), p. 1.

2. Sam Bass Warner, Jr., *The Private City: Philadelphia in Three Periods of Its Growth* (Philadelphia: University of Pennsylvania Press, 1968), pp. 5, 11; Carl Bridenbaugh, *Cities in Revolt: Urban Life in America, 1743–1776* (New York: Alfred A. Knopf, 1955), p. 217n; Philip Padelford, ed., *Colonial Panorama 1775: Dr. Robert Honyman's Journal* (San Marino, Calif.: Huntington Library, 1939), p. 19; [Alexander Graydon], *Memoirs of a Life, Chiefly Passed in Pennsylvania, within the Last Sixty Years* (Harrisburg, Pa.: John Wyeth, 1811), p. 34.

3. Goyne, "Furniture Craftsmen," pp. 2–3; Robert Proud, *The History of Pennsylvania* (Philadelphia, 1798), p. 278; Patrick M'Robert, *A Tour through Part of the North Provinces of America, 1774–1775* (Edinburgh, 1776), ed. Historical Society of Pennsylvania, Narratives and Documents, no. 1 (Philadelphia: Historical Society of Pennsylvania, 1935), p. 32.

4. Chambers advertised in *Pennsylvania Gazette* (Philadelphia), August 25, 1748. Entry for *Charming Polly*, October 4, 1752, shipping returns for Barbados, 1728–53, Colonial Office, Public Record Office, London; Philadelphia outward, coastwise, and foreign entries, U.S. Customhouse Records, National Archives, Washington, D.C.

5. Jedidiah Snowden bill to John Reynell, September 14, 1754, business papers, and Mary Coates, receipt book, 1748–59, Coates-Reynell Collection, Historical Society of Pennsylvania, Philadelphia (hereafter cited as HSP) (references courtesy of Arthur W. Leibundguth). Twentieth-century connoisseurs often refer to the high-back pattern, a period term, as a "comb-back" chair. Joseph Webb, account book, 1745–54, Joseph Downs Collection of Manuscripts and Printed Ephemera, Winterthur Library (hereafter cited as DCM). Jedidiah Snowden, *Pennsylvania Journal* (Philadelphia), November 24, 1773, as quoted in Alfred Coxe Prime, comp., *The Arts and Crafts in Philadelphia, Maryland, and South Carolina, 1721–1785* (Philadelphia: Walpole Society, 1929), p. 183.

6. Webb account book; Samuel Emlen, daybook, 1751–67, and ledger, 1751–72, HSP (on deposit from the Library Company of Philadelphia); Garrett Meade, receipt book, 1759–62, Dreer Collection, HSP.

7. Assessors' returns, County of Philadelphia, 1767, Van Pelt Library, University of Pennsylvania, Philadelphia (document brought to author's attention by Stephanie G. Wolf).

8. Nancy A. Goyne (Evans), "Francis Trumble of Philadelphia, Windsor Chair and Cabinetmaker," in *Winterthur Portfolio 1*, ed. Milo M. Naeve (Winterthur, Del.: Winterthur Museum, 1964), pp. 228–29, 233; Charles Norris, account book, 1739–70, Norris of Fairhill Manuscripts, HSP (reference courtesy of Lynn Delahanty di Stefano).

9. Goyne, "Francis Trumble." The 1767 returns list Trumble's tax as 45s., compared to 2s. for Gilpin and 34s. for Snowden.

10. Patrick Gordon, estate records, 1736, Philadelphia Register of Wills (microfilm, DCM).

11. Benno M. Forman, "Delaware Valley 'Crookt Foot' and Slat-Back Chairs," in *Winterthur Portfolio* 15, no. 1 (Spring 1980): 41–64.

12. Information supplied by the Louise Steinman Von Hess Foundation, Wright's Ferry Mansion, Columbia, Pennsylvania; Elizabeth Meg Schaefer, "Wright's Ferry Mansion," *Antiques* 122, no. 6 (December 1982): 1242–51.

13. The Hicks chair, in a private Newtown collection, is illustrated in Barbara Snow, "Living with Antiques," *Antiques* 78, no. 3 (September 1960): 242, top. The converted writing-arm chair is in the Monmouth County Historical Association, Freehold, New Jersey. For another early Philadelphia Windsor with the barrel-shaped stretcher turning, see Charles Santore, *The Windsor Style in America* (Philadelphia: Running Press, 1981), fig. 8. *South-Carolina Gazette* (Charleston), June 24, 1766 (citation file, Museum of Early Southern Decorative Arts, Winston-Salem, N.C. [hereafter cited as MESDA]).

14. For more information on the walnut chair, see Milo M. Naeve, "An Aristocratic Windsor in Eighteenth-Century Philadelphia," *American Art Journal* 11, no. 3 (July 1979): 67–74.

15. Examples of early Pennsylvania work are illustrated in Margaret Berwind Schiffer, *Furniture and Its Makers of Chester County, Pennsylvania* (Philadelphia: University of Pennsylvania Press, 1966), pls. 120, 122, 124.

16. The converted chair appears in Brown's portrait by Martin Johnson Heade (1819–1904), illustrated in "Current and Coming," *Antiques* 120, no. 2 (August 1981): 262.

17. A tapered-leg low-back chair is illustrated in William Macpherson Hornor, Jr., *Blue Book: Philadelphia Furniture* (1935; reprint, Washington, D.C.: Highland House, 1977), pl. 467.

18. The Savery commode-seat chair is discussed and illustrated in Forman, "Delaware Valley Chairs," pp. 60–61, fig. 19.

19. For splat prototypes see Joseph Downs, *American Furniture: Queen Anne and Chippendale Periods* (New York: Macmillan Co., 1952), figs. 121 (top), 122 (top and bottom).

20. *Pennsylvania Gazette*, November 30, 1758, and August 27, 1767; *Pennsylvania Gazette*, September 5, 1765, as quoted in Prime, *Arts and Crafts*, p. 182; Harrold E. Gillingham, "The Philadelphia Windsor Chair and Its Journeyings," *Pennsylvania Magazine of History and Biography* 55, no. 3 (October 1931): 305. Sherald is listed in the Assessors' returns.

21. Hornor, *Blue Book*, p. 298; *Pennsylvania Journal*, October 3, 1765, as quoted in Prime Cards, Winterthur Library (hereafter cited as WL); "Bonds of Indemnity & Memorandum of & Indentures of the Poor," Philadelphia Municipal Archives, Philadelphia, Pa. (microfilm, DCM); Cadwalader information in Goyne, "Francis Trumble," p. 230; William Cox, various bills to Stephen Girard, 1786–91, Girard Papers, Girard College, Philadelphia, Pa. (hereafter cited as GC) (microfilm, American Philosophical Society, Philadelphia, Pa. [hereafter cited as APS]); William Cox, estate records, 1811, Philadelphia Register of Wills (microfilm, DCM).

22. "Names of Persons for Whom Marriage Licenses Were Issued in the Province of Pennsylvania Previous to 1790," as quoted in John B. Linn and William H. Egle, eds., *Pennsylvania Archives*, 2d ser., vol. 2 (Harrisburg, Pa.: B. F. Meyers, 1876), p. 231; Assessors' returns; Goyne, "Furniture Craftsmen," pp. 56, 61, 99; Hornor, *Blue Book*, pp. 306, 312, 319; Anthony N. B. Garvan et al., eds., *The Architectural Surveys, 1784–1794*, Mutual Assurance Co. Papers, vol. 1 (Philadelphia: Mutual Assurance Co., 1976), p. 159.

23. Assessors' returns; Goyne, "Furniture Craftsmen," pp. 21, 70, 76, 98–99, 104–5, 132, 180; Hornor, *Blue Book*, pp. 296, 300; William Wade Hinshaw and Thomas Worth Marshall, comps., *Encyclopedia of American Quaker Genealogy*, vol. 2 (Ann Arbor, Mich.: Edwards Bros., 1938), p. 547. Henzey's affiliation with Pennsylvania Hospital is indicated in the 1790 federal census and Philadelphia city directories for 1791, 1793, and 1795.

24. For arm prototypes in formal furniture, see Downs, *American Furniture*, figs. 27–28, 39–40.

25. Many years ago, J. Stogdell Stokes, noted Pennsylvania collector and author, attributed an identical heavy-rail chair in his collection (as well as a writing-arm chair) to "one Richmonde on Sassafras Street, a joiner of much repute who has come out from the motherland." The basis for this attribution was twofold: an entry from a manuscript journal kept by a female member of an unidentified Philadelphia family, of which the quotation is a part, and Stokes's acquisition of the two chairs, through another individual, from a "direct descendent" of the journal author. To date the journal remains unidentified and undocumented except for two short passages quoted in Stokes's articles. It is impossible to verify the dates given for the quotations (1763 and 1774) or even the spelling of the joiner's name. The passages, which fail to use the term *Windsor*, refer to "the large chairs, one of commodius seat" and "the walnut wood bracket chair with the oak top and the mate chair with the oak top." While Philadelphia Windsors generally have oak crest rails, the extensive use of walnut for such chairs occurs only in the cabriole-leg type illustrated in fig. 3-9. Add to these uncertainties the almost complete lack of evidence that someone by the name of Richmonde existed in Philadelphia before the Revolution, and the whole case for the enigmatic Mr. Richmonde is very thin indeed (J. Stogdell Stokes, "The American Windsor Chair," *Pennsylvania Museum Bulletin* 21, no. 98 [December 1925]: 53, 55).

26. When Wallace Nutting discussed and illustrated the cylindrical-foot chair in *A Windsor Handbook* (1917; reprint, Framingham and Boston: Old America Co., n.d.), pp. 88a and 192d, it was owned by Francis C. Mireau at Old Fountain House, Doylestown, Bucks Co., Pa.

27. The Trumble bill is reproduced in Carl W. Drepperd, *First Reader for Antique Collectors* (Garden City, N.Y.: Doubleday, 1946), p. 25. The eleven-spindle chair is illustrated in Wallace Nutting, *Furniture Treasury* (1928; reprint, New York: Macmillan Co., 1966), fig. 2563; see also Nutting, *Handbook*, p. 88c. The uppercase *I*, as in the Henzey brand, served double duty as the letters *I* and *J* into the early nineteenth century.

28. A branded Trumble high-back chair illustrated in Hornor, *Blue Book,* pl. 466, and examined by the author some years ago, is a conversion from a sack-back chair.

29. Evidence for the attribution of the Savery rush-bottomed chair is supplied by Forman in "Delaware Valley Chairs," pp. 58–59, fig. 15.

30. Nutting, *Handbook,* pp. 88a, 88d.

31. Thomas Lynch Montgomery, ed., *Pennsylvania Archives,* 6th ser., vol. 12 (Harrisburg, Pa.: Harrisburg Publishing Co., 1907), p. 723.

32. *New-York Gazette; or, The Weekly Post-Boy,* April 18, 1765, as quoted in Rita S. Gottesman, comp., *The Arts and Crafts in New York, 1725–1776* (1938; reprint, New York: Da Capo Press, 1970), pp. 112–13.

33. *Pennsylvania Gazette,* December 27, 1775, as quoted in Goyne, "Francis Trumble," p. 233; Francis Trumble bills to Levi Hollingsworth, September 5, 1770, November 26, 1772, and April 24, 1786, Harrold Gillingham Collection, HSP.

34. Hornor, *Blue Book,* pp. 305–6.

35. Ephraim Evans is listed in the 1785 Philadelphia city directory; in 1786 he advertised from Alexandria, Virginia, as noted in Ethel Hall Bjerkoe, *The Cabinetmakers of America* (Garden City, N.Y.: Doubleday, 1957), p. 90. Pentland is listed in Philadelphia city directories from 1785 through 1806; he is listed in the United States Census of 1810 as a resident of Pittsburgh. Widdifield was apprenticed to William Cox, as recorded in "Bonds of Indemnity." Steel is first listed as a Philadelphia chairmaker in the United States Census of 1790. John Lambert, estate records, 1793, Philadelphia Register of Wills (microfilm, DCM).

36. Goyne, "Furniture Craftsmen," pp. 124–27; David Evans, account book, 1774–82, HSP (microfilm, DCM); J. P. Brissot de Warville, *New Travels in the United States of America* (Dublin: P. Byrne et al., 1792), p. 325.

37. Joseph Henzey bills to Levi Hollingsworth, July 2 and October 18, 1779, Hollingsworth Manuscripts, Business Papers, HSP.

38. Francis Trumble bill to Greenberry Dorsey, November 13, 1780, DCM; Thomas Mushett, who received payment for Trumble, may have been a shop journeyman at the time. Other fan-back references include Francis Trumble bill to Tench Coxe, June 14, 1784, Coxe Papers, Tench Coxe Section, HSP; Joseph Henzey bill to [Coates family], November 25, 1785, Coates-Reynell Papers, Business Papers, HSP; Francis Trumble bill to Levi Hollingsworth, April 24, 1786, Society Collection, Levi Hollingsworth Papers, HSP; William Cox bill to Stephen Collins, September 27, 1786, and Stephen Collins to Ebenezer Hall, September 27, 1786, in letter book, 1786–87, Stephen Collins Papers, Manuscript Division, Library of Congress, Washington, D.C. (hereafter cited as LC). Isaac Hazlehurst, invoice of cargo, December 1, 1789, and bill of disbursements, December 12, 1789, Constable-Pierrepont Papers, New York Public Library, New York, N.Y. (hereafter cited as NYPL). William Cox bill to Stephen Girard, September 5, 1787, Girard Papers, GC; Zaccheus Collins to Joseph Blake, June 15, 1795, in letter book, 1794–1801, Collins Papers, LC.

39. Marriage Record of the Third Presbyterian Church, Philadelphia, 1785–1799, as quoted in John B. Linn and William H. Egle, eds., *Pennsylvania Archives,* 2d ser., vol. 9 (Harrisburg, Pa.: B. F.

Meyers, 1880), p. 515; Wire information in Hornor, *Blue Book,* p. 321. Lambert estate records; Joseph Henzey and Francis Trumble, estate records, 1796 and 1798, Philadelphia Register of Wills (microfilm, DCM).

40. Cox's fan-back chairs are in private collections.

41. Gisela M. A. Richter, *The Furniture of the Greeks, Etruscans, and Romans* (London: Phaidon Press, 1966), figs. 73, 76, 217, 219; Gisela M. A. Richter and Albert W. Barker, *Ancient Furniture* (Oxford: Clarendon Press, 1966), p. 122, figs. 68, 92–94, 259, 347–48, 350. William Chambers, *Designs of Chinese Buildings, Furniture, Dresses, Machines, and Utensils* (London, 1757), as illustrated in John Gloag, "The English Chinese Style in Furniture," *Antiques* 97, no. 5 (May 1970): 719. William Linnell, inventory, February 17, 1763, Chancery Masters' Exhibits, C-107, no. 69, Public Record Office, London. The John Linnell bill is quoted in Helena Hayward, "The Drawings of John Linnell in the Victoria and Albert Museum," *Furniture History* 5 (1969): 33. Lord Bristol's personal estate advertised in *Bristol Journal* (England), July 27, 1782, is transcribed in the Robert Wemyss Symonds Collection, DCM. Thomas Sheraton, *Cabinet Dictionary,* vol. 1 (1803; reprint, New York: Praeger, 1970), p. 29.

42. *Pennsylvania Packet* (Philadelphia), January 8, 1785, as quoted in Prime, *Arts and Crafts,* p. 162; Henry Hill, invoice, September 28, 1789, Society Miscellaneous Collection, HSP. The Trumble chairs are listed in Hazlehurst, invoice of cargo and bill of disbursements. John Letchworth bills to Jonathan Williams, October 2, 1790, and February 23, 1792, DCM; Lambert estate records.

43. Lambert's name does not appear in the 1785 city directory or on the 1783 Occupational Tax List quoted in Hornor, *Blue Book,* pp. 317–21. The Lambert data comes from the Hinshaw Card Index to Quaker Meeting Records, Friends Historical Library, Swarthmore College, Swarthmore, Pa. The term *crease,* which describes the groove in a bamboo turning, is found in Anthony Steel, estate records, 1817, Philadelphia Register of Wills.

44. Thomas Chippendale, *The Gentleman and Cabinet-Maker's Director* (1762; reprint of 3d ed., New York: Dover Publications, 1966), pls. 21, 22, 23. Fauteuils and oval-back chairs are illustrated in Helena Hayward, ed., *World Furniture* (New York: McGraw-Hill Book Co., 1965), pp. 119, 139, 141, and Maurice Tomlin, *Catalogue of Adam Period Furniture* (London: Victoria and Albert Museum, 1972), pp. 52–53, 64–65, 127. Robert Blackwell, receipt book, 1783–92, HSP.

45. Lambert estate records.

46. Lambert estate records; Forman, "Delaware Valley Chairs," figs. 20, 21, 22. An armchair made by Steel combines baluster arm supports and bamboo legs like the Lambert tall chair of fig. 3-50, but this union of design elements is unusual in the Philadelphia bow-back Windsor.

47. The eight craftsmen whose careers began in the early 1790s are Joseph Burden (1791), Gilbert and Robert Gaw (1793), John Mullen (1792), Michael Murphy (1790), James Pentland (1791), William Snyder (1793), and Anthony Steel (1790), as recorded in the United States Census of 1790, Philadelphia city directories, and, for Mullen, a notation dated October 26, 1792, in Stephen Collins and Son, daybook, 1786–94, Collins Papers, LC.

48. William Cox bills to Henry Knox, July 29, 1794, and May 19, 1795, Papers of Henry Knox, Maine Historical Society, Portland; Stephen Collins to Samuel Cheesman, October 27, 1792, in letter book, 1792–1801, Collins Papers, LC.

49. The Ackley chairs are at Independence National Historical Park, Philadelphia; Hornor, *Blue Book,* pls. 476, 477; Joseph Henzey bill to Stephen Girard, September 20, 1792, Girard Papers, GC; Francis Trumble bill to Edward Shippen, July 24, 1769, as illustrated in Carl W. Drepperd, *Pioneer America: Its First Three Centuries* (Garden City, N.Y.: Doubleday, 1949), p. 265.

50. *Commercial Advertiser* (Philadelphia), July 10, 1798, as quoted in Prime Cards, WL; Gilbert Gaw bill to Stephen Girard, August 19, 1806, Girard Papers, GC; *Federal Gazette and Baltimore Daily Advertiser* (Baltimore), November 8, 1805, as quoted in William Voss Elder III, *Baltimore Painted Furniture, 1800–1840* (Baltimore: Baltimore Museum of Art, 1972), p. 11; *New-York Gazette and General Advertiser,* December 14, 1804, as quoted in Rita Susswein Gottesman, comp., *The Arts and Crafts in New York, 1800–1804* (New York: New-York Historical Society, 1965), p. 144.

51. Pownall is quoted in Carl Bridenbaugh, *Cities in Revolt* (New York: Alfred A. Knopf, 1955), p. 50.

52. Thomas Anburey, *Travels through the Interior Parts of America,* vol. 2 (Boston: Houghton Mifflin Co., 1923), pp. 175–76; Isaac Weld, *Travels through the States of North America,* vol. 2 (London: John Stockdale, 1800), pp. 116, 123; Duc de La Rochefoucault Liancourt, *Travels through the United States of North America,* vol. 1 (London: R. Phillips, 1799), pp. 42–44.

53. Doris Devine Fanelli, "The Building and Furniture Trades in Lancaster, Pennsylvania, 1750–1800" (Master's thesis, University of Delaware, 1979), abstract and p. 9; Weld, *Travels,* 1:129; Joshua Gilpin, "Journal of a Tour from Philadelphia thro the Western Counties of Pennsylvania in the Months of September and October, 1809," *Pennsylvania Magazine of History and Biography* 50, no. 2 (April 1926):164; François André Michaux, *Travels to the West of the Alleghany Mountains* (London: D. N. Shury, 1805), p. 31.

54. Don Yoder, trans. and ed., *The Picture-Bible of Ludwig Denig: A Pennsylvania German Emblem Book* (New York: Hudson Hills Press, 1990), pp. 135–36, pl. 18.

55. William Jevon, estate records, 1767, Lancaster County Historical Society, Lancaster, Pa. (hereafter cited as LCHS); Mathias Groff bill to Thomas Wharton, Jr., April 8, 1778, DCM; William Lorimer, estate records, 1773, York Co., Pa., Register of Wills (reference courtesy of Frederick S. Weiser).

56. Background information accompanies several of these sack-back chairs: one came from southern Lancaster Co.; a second bears the brand *M GROS[S],* a name associated with Lancaster; the owner of a third chair found it in Hanover; a fourth chair bears the brand *J. KNOUSS,* the slanted serif letters and use of a *J* rather than an old-style *I* suggesting a nineteenth-century owner.

57. The chair with "wings," in the Philadelphia Museum of Art, is illustrated in Dean A. Fales, Jr., *American Painted Furniture, 1660–1880* (New York: E. P. Dutton, 1972), fig. 142.

58. The two variant sack-back chairs circulated in the dealer market some years ago.

59. Stoner is listed in Harrisburg Township in the 1790 census. Birth and marriage information comes from Lancaster Moravian marriage records (reference courtesy of John J. Snyder, Jr.). Michael Stoner, property records, 1792/93, Dauphin Co., Pa., Registry of Deeds; *Oracle of Dauphin and Harrisburg Advertiser*, July 1, 1793 (notice brought to author's attention by William Bowers); Michael Stoner, U. S. Direct Tax of 1798, City of Lancaster, Federal Archives and Records Center, Philadelphia, Pa.; Michael Stoner, property record, 1806, Lancaster Co., Pa., Registry of Deeds; *Lancaster Journal*, August 15, 1801 (reference courtesy of Vicky Uminowicz); tax assessment information in Card File of Joiners, Carpenters, and Cabinetmakers, LCHS; Michael Stoner, estate records, 1810, LCHS.

60. The Winterthur settees (1800–1815) are nos. 59.1548 and 59.1658.

61. Background information on Humes from Fanelli, "Building and Furniture Trades in Lancaster," pp. 16, 27, and Card File of Deaths, LCHS.

62. Weld, *Travels*, 1:133; Liancourt, *Travels*, 2:124.

63. Fig. 3-82 is one of two such chairs known, the second also acquired from a county family and now in the same collection. The Winterthur settee, no. 59.1615, is dated 1795–1810.

64. Information on fig. 3-90 was supplied by the owner. The Winterthur settee is no. 59.1615.

65. John Melish, *Travels through the United States of America*, vol. 2 (Philadelphia: John Melish, 1815), p. 31; Thomas Chapman, "Journal of a Journey through the United States, 1795–6," *Historical Magazine*, 2d ser., vol. 5 (1869): 358. In the second quarter of the twentieth century, chairs like those in figs. 3-92 and 3-93 were reproduced in John M. Bair's cabinet shop at Abbottstown, Pa. The most obvious difference between the old and the new designs occurs in the legs. The modern baluster has a longer, slimmer neck; the new spool turning with a rounded cap at the top differs from the plain collar of the old chair. The reproduction side chair has a standard bow-back design.

66. Weld, *Travels*, 2:363.

67. Jedidiah Morse, *The American Geography* (Elizabethtown, N.J.: Shephard Kollock, 1789), p. 323.

68. William Bird, estate records, 1761–63, Berks Co., Pa., Register of Wills.

69. Keen estate auction, as quoted in Montgomery, *Pennsylvania Archives*, 6th ser., vol. 12 (1907), pp. 42–44. Information on Rose is based on Harold E. Yoder, Jr., to Joyce Hill Stoner, November 15, 1978, and Mary P. Dives, "Reading's First 'First Citizen'," *Historical Review of Berks County* 1, no. 2 (January 1936): 51–54.

70. Liancourt, *Travels*, 1:23–25; Eliza Cope Harrison, ed., *Philadelphia Merchant: The Diary of Thomas P. Cope, 1800–1851* (South Bend, Ind.: Gateway Editions, 1978), p. 81.

71. A George Keim is listed without occupation in Matthias S. Richards, comp., *Directory of 1806* (Reading, 1806). The Lackey side chair is illustrated in *Walter Himmelreich Collection*, October 4, 1971 (Reading, Pa.: Pennypacker Auction Centre, 1971), no. 137.

72. The other Fox bow-back chair is owned by a private institution in southeastern Pennsylvania.

73. The information on Fox is based upon a fraktur birth and baptismal certificate, estate inventory, and 1862 Berks Co. map owned by descendants. Harrison, *Diary of Thomas P. Cope*, p. 266. A Fox spinning wheel is in the Chester County Historical Society, West Chester, Pa.

74. Kenneth Roberts and Anna M. Roberts, trans. and eds., *Moreau de St. Méry's American Journey [1793–1797]* (Garden City, N.Y.: Doubleday, 1947), pp. 100–101; Margaret B. Schiffer, *Chester County, Pennsylvania, Inventories, 1684–1850* (Exton, Pa.: Schiffer Publishing, 1974), p. 133; Montgomery, *Pennsylvania Archives*, 6th ser., vol. 12 (1907), p. 68.

75. For information on Carr in Wilmington, see Charles G. Dorman, *Delaware Cabinetmakers and Allied Artisans, 1655–1855* (Wilmington: Historical Society of Delaware, 1960), p. 19.

76. Melish, *Travels*, 2:25.

77. Schiffer, *Furniture of Chester County*, p. 223.

78. The child's chair is illustrated in Herbert F. and Peter B. Schiffer, *Miniature Antique Furniture* (Wynnewood, Pa.: Livingston Publishing Co., 1972), fig. 91. The shorter high-back chair appears in Schiffer, *Furniture of Chester County*, p. 62, pl. 18. The child's highchair is owned by the Pennsylvania Historical and Museum Commission, Harrisburg, Pa.

79. Schiffer, *Furniture of Chester County*, p. 162; Samuel Moon's name appears in Philadelphia city directories between 1800 and 1802. David Moon is listed in Hinshaw and Marshall, *Quaker Genealogy* 2:600, as being received on certificate at the Philadelphia Monthly Meeting, Society of Friends, from the Falls Monthly Meeting, Bucks Co., May 7, 1800.

80. The Bucks Co. high-back chair is illustrated in Santore, *Windsor Style*, pl. 7.

81. Samuel Moon bills to Samuel Meredith, March 23, 1786, and April 5, 1791, Clymer-Meredith-Read Papers, Samuel Meredith Accounts, 1767–92, NYPL. Moon's name appears in the Bucks Co. returns for state taxes levied between 1779 and 1787, as quoted in William Henry Egle, ed., *Pennsylvania Archives*, 3d ser., vol. 13 (Harrisburg, Pa.: William Stanley Ray, 1897), pp. 21, 128, 281, 324, 494, 515, 618, 729. In the 1782 returns, Moon was listed as a "chairmaker."

82. "Record of Indentures of Individuals Bound Out as Apprentices, Servants, Etc. in Philadelphia, Pennsylvania, by Mayor John Gibson, 1771–72, and Mayor William Fisher, 1773," Pennsylvania-German Society Proceedings, vol. 16 (1907), pp. 164–65. Stackhouse resided in Buckingham Twp., Bucks Co., when he paid the Pennsylvania state tax in 1787, as quoted in Egle, *Pennsylvania Archives*, 3d ser., vol. 13 (1897), pp. 769. He was married at the Falls Monthly Meeting of Friends on June 11, 1789, as quoted in Linn and Egle, *Pennsylvania Archives*, 2d ser., vol. 9 (1880), p. 266. Stackhouse and family were granted a certificate to the New Garden Meeting on May 8, 1818, as listed in Hinshaw and Marshall, *Quaker Genealogy* 2:1029. Quinby and family are listed in Hinshaw and Marshall, *Quaker Genealogy* 2:1022, as being associated with the following Monthly Meetings: Buckingham, Pa. (1813); Falls, Pa. (1813–16); and Wrightstown, N.J. (1816).

83. Christian Schultz, Jr., *Travels on an Inland Voyage*, vol. 1 (1810; reprint, Ridgewood, N.J.: Gregg Press, 1968), pp. 124–26; "Letters from a Swiss Farmer" and "The Travels of John Melish" in John W. Harpster, ed., *Pen Pictures of Early Western Pennsylvania* (Pittsburgh, Pa.: University of Pittsburgh Press, 1938), pp. 248, 250; Dorothy Smith Coleman, "Pioneers of Pittsburgh: The Robinsons," *Western Pennsylvania Historical Magazine* 42, no. 1 (1959), pp. 59, 61; William A. Sullivan, *The Industrial Worker in Pennsylvania, 1800–1840* (Harrisburg, Pa.: Pennsylvania Historical and Museum Commission, 1955), pp. 4–5; [Zadok Cramer], *The Navigator* (Pittsburgh: Cramer, Spear, and Eichbaum, 1811), p. 58.

84. Pentland is listed in Philadelphia city directories between 1791 and 1806; the 1810 federal census lists him in Pittsburgh.

85. Sullivan, *Industrial Worker*, pp. 5, 31; Sylvester K. Stevens, *Pennsylvania: Birthplace of a Nation* (New York: Random House, 1964), chaps. 8–9.

86. Edwin Wolf II, *Philadelphia: Portrait of an American City* (Harrisburg, Pa.: Stackpole Books, 1975), chaps. 5–6; Stevens, *Pennsylvania*, chaps. 8–9; Harrison, *Diary of Thomas P. Cope*, p. 425.

87. The Letchworth chair is illustrated in Hornor, *Blue Book*, pl. 477. A photograph of the King chair is in Visual Resources Collection, Winterthur Library (hereafter cited as VRC). Taylor and King bill to Stephen Girard, May 21, 1799, Girard Papers, GC. Taylor and King were partners only in 1799 and 1800.

88. *Farmer's Register* (Greensburg, Pa.), August 22, 1801 (reference courtesy of Marilyn M. White).

89. The Gaw chair is in Independence National Historical Park, Philadelphia.

90. A photograph of the Tyson chair is in VRC.

91. Thomas Jefferson to George Jefferson, July 19, 1800, Papers of Thomas Jefferson, Massachusetts Historical Society, Boston. A photograph of the Ackley chair is in VRC. Charles C. Robinson, daybook, 1809–25, HSP.

92. John B. Ackley bill to William Trotter, September 10, 1805, Nathan Trotter Collection, Baker Library, Harvard University, Cambridge, Mass. Henry Prall, estate records, 1802, Philadelphia Register of Wills.

93. The Finlay attribution is discussed in Stiles Tuttle Colwill, *Francis Guy, 1760–1820* (Baltimore: Maryland Historical Society, 1981), pp. 76–85.

94. The Taylor chair is illustrated in Hornor, *Blue Book*, pls. 501, 502. The dating of the Steever chair, in a private collection, is based upon the craftsman's listings in Philadelphia city directories.

95. Photographs of some Pugh chairs are in VRC. Schiffer, *Chester County Inventories*, pp. 133–34.

96. The Fetters' chairs are still owned by Lancaster Lodge No. 43, Free and Accepted Masons.

97. Photographs of other Ashton chairs and the Lee chair are in VRC. For mahogany and fancy prototypes, see Charles F. Montgomery, *American Furniture: The Federal Period in the Henry Francis du Pont Winterthur Museum* (New York: Viking Press, 1966), figs. 97, 98. A photograph of the Case child's chair is in VRC.

98. Haydon and Stewart bill to James J. Skerrett, May 7, 1810, Loudoun Papers, HSP. Philadelphia woodworkers' wages are discussed in Montgomery, *American Furniture*, p. 23. The Jackson chair is in the Annie S. Kemerer Museum, Bethlehem, Pa.

99. A Baltimore card table prototype is illustrated in Elder, *Baltimore Painted Furniture*, fig. 17. The Carroll family chairs are discussed in

Montgomery, *American Furniture,* cat. 99, and William Voss Elder III and Jayne E. Stokes, *American Furniture, 1680–1880, from the Collection of the Baltimore Museum of Art* (Baltimore, Md.: Baltimore Museum of Art, 1987), cat. 23. Photographs of Lobach chairs are in VRC. Alexander Martin, Sr., will, 1821, DCM.

100. Steel estate records. The Tomlin chair is owned by the State of Delaware at the Lindens, Smyrna, Del.; the label addresses of chairmaker and printer coincide in Philadelphia city directories only for the dates given. Enoch Tomlin bill to Roberso [Roberdeau?], June 22, 1824, Girard Papers, GC. Newspaper notices document the duration of the Burchall and Wickersham partnership, as quoted in Schiffer, *Furniture of Chester County,* pp. 44–45. The Athenaeum's furnishings and purchases are discussed in Robert C. Smith, "The Athenaeum's Furniture—1," *Athenaeum Annals* 4, no. 1 (January 1958): 1, 2.

101. Steel estate records.

102. Steel estate records.

103. The Philadelphia cabriole chair is illustrated in Montgomery, *American Furniture,* fig. 93. Thomas Sheraton, *The Cabinet-Maker and Upholsterer's Drawing Book* (1793; reprint, New York: Dover Publications, 1972), pls. 33, right, and 36, no. 4; [George] Hepplewhite, *The Cabinet-Maker and Upholsterer's Guide* (1794; reprint of 3d ed., New York: Dover Publications, 1969), pl. 3, left, and (2d ed., London: I. and J. Taylor, 1789), pl. 3, left; Chippendale, *Director.*

104. The Philadelphia mahogany chair is illustrated in Montgomery, *American Furniture,* fig. 90.

105. Steel estate records. Jones advertised in *Village Record* (West Chester), November 7, 1821, and October 29, 1823, as quoted in Schiffer, *Furniture of Chester County,* p. 132. The Lee chair is illustrated in Albert T. Gamon, *Pennsylvania Country Antiques* (Englewood Cliffs, N.J.: Prentice-Hall, 1968), fig. 49.

106. Haydon and Stewart chairs are illustrated in Anthony A. P. Stuempfig, "William Haydon and William H. Stewart," *Antiques* 104, no. 3 (September 1973): 452–57. The Jackson chair is in the William Penn Memorial Museum, Harrisburg, Pa.

107. A photograph of the Burden chair is in VRC. John Wall bill to William R. Boone, October 20, 1823, Jeremiah Boone Papers, 1795–1833, HSP.

108. Steel estate records; James C. Helme, "Book of Prices for Making Cabinet and Chair Furniture," 1838, DCM.

109. Helme, "Book of Prices"; photograph of Sites chair in VRC; John Tarrant Kenney, *The Hitchcock Chair* (New York: Clarkson N. Potter, 1971), pp. 74, 106, 134. For information on the *London Chair-Makers' and Carvers' Book of Prices,* see Montgomery, *American Furniture,* p. 131. Rolled-top English seating is illustrated in Hayward, *World Furniture,* fig. 753, and Ralph Edwards and L. G. G. Ramsey, eds., *The Regency Period, 1810–1830* (London: Connoisseur, 1958), pl. 21c.

110. Thomas Hope, *Household Furniture and Interior Decoration* (1807; reprint, New York: Dover Publications, 1971); Robert L. Raley, "Interior Designs by Benjamin Henry Latrobe for the President's House," *Antiques* 75, no. 6 (June 1959): 568–71; John and Hugh Finlay, Papers Relating to Furniture for the President's House, Treasury Department Records, Miscellaneous Treasury Ac-

counts of the First Auditor, account no. 28,634, National Archives, Washington, D.C.; Helme, "Book of Prices."

111. Kenney, *Hitchcock Chair,* p. 134, illustrations facing p. 148. The Johnson settee is illustrated in Fales, *American Painted Furniture,* fig. 186. Charles Riley, estate records, 1842, Philadelphia Register of Wills (microfilm, DCM).

112. Pauline Agius, *Ackermann's Regency Furniture and Interiors* (Marlborough, England: Crowood Press, 1984), p. 102. Designs by Brown, Smith, and others are illustrated in *Pictorial Dictionary of British 19th Century Furniture Design* (Woodbridge, England: Antique Collectors' Club, 1977), pp. 190, 213–16, 236; see also pp. xviii–xxv. The availability of Smith's work in Baltimore is documented in Gregory R. Weidman, *Furniture in Maryland, 1740–1940* (Baltimore: Maryland Historical Society, 1984), p. 90.

113. Since Riley died between August and October 1842, this crest modification was introduced before that date. A photograph of Riley's rocking chair is in VRC. The stenciled address on Jefferis's scroll-crested chair coincides with locations given for him in Philadelphia city directories from 1857 to 1859. Helme, "Book of Prices."

114. The Meeks broadside is illustrated in Robert Bishop, *The American Chair* (1972; reprint, New York: Bonanza Books, 1982), p. 313. Swint advertisement in *Examiner and Herald* (Lancaster, Pa.), April 14, 1847, LCHS. Photographs of Hay and Murdick chairs are in VRC.

115. Donald L. Tuttle and Joyce Bauduin, "James Wilson: A Pennsylvania Chairmaker," *Chronicle* 32, no. 4 (December 1979): 53–57.

116. The Stoner chairs are at the Fulton County Historical Society, McConnellsburg, Pa. (Stoner family genealogical information courtesy of Anne Lodge).

117. A French-style formal chair is discussed and illustrated in *19th-Century America* (New York: Metropolitan Museum of Art, 1970), pp. xi–xv, fig. 77. Walker, Osborn, and Company advertisement in *Palladium and Republican* (New Haven), June 13, 1835 (reference courtesy of Wendell Hilt); A. Kellogg's Cincinnati auction notice in *Cincinnati Daily Gazette* (1846), as quoted in Jane E. Sikes, *The Furniture Makers of Cincinnati 1790–1849* (Cincinnati: By the author, 1976), p. 50; John B. Robinson billhead, 1850–55, inscribed in 1855, DCM; Tuttle and Bauduin, "James Wilson." The Fox chairs are illustrated in *Public Auction Sale,* April 23–26, 1947 (New York: Parke-Bernet Galleries, 1947), nos. 119, 120.

118. Riley estate records; Hazlet advertisement in William Richards, comp., *Utica City Directory, for 1843–'44* (Utica, N.Y.: Roberts and Henry H. Curtiss, 1843), p. 144. The Sanderson billhead is illustrated in Page Talbott, "Cheapest, Strongest and Best: Chairmaking in 19th Century Philadelphia," *Chronicle* 33, no. 3 (September 1980), fig. 6. Smith, "Athenaeum's Furniture," p. 2; *A Victorian Chair for All Seasons: A Facsimile of the Brooklyn Chair Company Catalogue of 1887* (Watkins Glen, N.Y.: American Life Foundation Library of Victorian Culture, 1978), pp. 46–49. Today these seats are called *captain's* and *firehouse* chairs, terms that would have had been meaningless to a nineteenth-century furniture manufacturer.

119. Courthouse background and purchase data are described in Franklin Ellis and Samuel Evans,

History of Lancaster County, Pennsylvania (Philadelphia: Everts and Peck, 1883), pp. 206–7; Fay Follet Kramer, "Lancaster County's Present Court House: A History of Its Construction, 1852–1855," *Journal of the Lancaster County Historical Society* 71, no. 1 (Hilarymas 1967): 1–52; and Notes from the Records of the Lancaster County Commissioners, LCHS. *The Northampton County Directory, for 1873,* compiled by J. H. Lant (Easton and Bethlehem, Pa., 1873), p. 232, carries an advertisement of C. E. Oestereicher, which reads, "Dealer in . . . THE Moravian Arm Chair." An Oestereicher sack-back armchair in the New-Haven Colony Historical Society collection bears the following stencil on its plank bottom: *GENUINE MORAVIAN/ CHAIR/MADE BY/C.F. OESTEREICHER./ Successor to/M.STUBER/ Bethlehem, Pa.*

120. Brissot de Warville, *New Travels,* p. 325; Liancourt, *Travels,* 2:129.

121. Mulhern and Bullock advertisement in *Kline's Gazette* (Carlisle, Pa.), 1806 (reference courtesy of Milton Flower); Burnett advertisement in *Harrisburg Times,* March 24, 1812 (reference courtesy of William Bowers).

122. *Mercury* (Pittsburgh), May 9, 1815, and March 20, 1818 (references courtesy of Marilyn M. White); Derita Coleman Williams and Nathan Harsh, *The Art and Mystery of Tennessee Furniture and Its Makers Through 1850* (Nashville: Tennessee Historical Society and Tennessee State Museum Foundation, 1988), figs. 348–49, 351–52, pl. 30.

123. Wilhelm and Emanuel Schroeder advertisements in *York Gazette,* April 13 and March 2, 1830.

124. Hope, *Household Furniture,* pls. 2, 11, 26. Smith's 1808 antique designs appear in *Dictionary of British Design,* pp. 176, 212.

125. Bullock advertisement in *American Volunteer* (Carlisle, Pa.), March 24, 1819, as quoted in "Museum Accessions," *Antiques* 116, no. 3 (September 1979): 504.

126. Late Baltimore seating design is illustrated in Elder, *Baltimore Painted Furniture,* pp. 47, 61–62, 64–65, 69, 74–75.

127. Gormley is listed in Strasburg and Lampeter Twp. tax assessment records between 1802 and 1828, as recorded in Card File of Joiners, LCHS.

128. Baltimore design sources are illustrated in Elder, *Baltimore Painted Furniture,* pp. 64–65, 82, 86–87, Weidman, *Furniture in Maryland,* figs. 73, 74, and Weidman, Gregory R., "The Furniture of Classical Maryland, 1815-1845" in *Classical Maryland, 1815-1845* (Baltimore: Maryland Historical Society, 1993), figs. 118, 129. A Thomas Suplee was a Montgomery Co. resident, probably in Lower Merion Twp., from 1840 to 1860, as indicated in federal census records.

129. Augustus Welby Northmore Pugin, *Gothic Furniture in the Style of the 15th Century* (London, 1835); John Claudius Loudon, *An Encyclopaedia of Cottage, Farm, and Villa Architecture and Furniture* (London: Longman, Rees, Orme, Brown, Green, and Longman, 1833); *19th-Century America,* pp. xvi–xviii, figs. 98–103.

Maryland, Delaware, and New Jersey

Maryland

"Baltimore offers every mark of prosperity—new churches and banking-houses, handsome private buildings, . . . well-stocked stores, and a numerous and busy population," noted Philadelphian Samuel Breck in September 1809 while traveling to Washington. From a village of 25 houses in 1752, Baltimore grew to a small city of almost 2,000 houses by 1785 and became the commercial center of the state and the Chesapeake Bay region. In 1789 Jedidiah Morse commented, "Baltimore has had the most rapid growth of any town on the continent, and is the fourth in size and the fifth in trade in the United States." Several factors contributed to the community's growth and prosperity: the influx of German immigrants and redemptioners, the construction of an improved road to the interior town of Frederick, and the seaport's development as a grain and flour exportation center. Baltimore grew around an "excellent harbour," which by the Revolution had "commodious wharves." The Jones Falls creek divided the city into two parts. Deepwater ships anchored at Fell's Point to discharge their cargoes, but merchants conducted business in their counting houses in town, a mile across the Falls. By the mid 1790s Médéric-Louis-Elie Moreau de St. Méry recorded various established industries, including "refineries, distilleries, tobacco factories, rope works, paper mills, cotton mills, nail, shoe and boot factories, lumber yards, tanneries." In the adjacent country were iron furnaces and forges and numerous flour mills. Baltimore soon vied with Charleston and Boston as the third busiest American port after Philadelphia and New York. As François Alexandre Frédéric, duc de La Rochefoucauld Liancourt, observed, "Baltimore possesses a part of the trade of the back country of Pennsylvania, supplies most of the stores which furnish the western territories with merchandize, and receives in return a part of their produce."[1]

Baltimore's town plan was a fairly regular grid dotted with brick houses. Many thoroughfares were paved, and the principal streets were lighted. Progress continued at a fast pace until the start of a prolonged depression caused by the political and economic upheaval resulting from Jefferson's Embargo of 1807, and the War of 1812 and British blockade of the Chesapeake. Growth slowed measurably. Nevertheless, by 1817 the population was about 60,000, and steamboat travel linked Baltimore with the lower Chesapeake, New York, and New London, Connecticut. The arts were alive and well in a city noted for its monuments and handsome domestic and public architecture. The furniture trades flourished and exerted substantial influence on craftsmen working in central Pennsylvania, Virginia, and Kentucky, and in Pittsburgh and Wheeling. The influence of German customs and language, prominent in the hinterlands at the turn of the century, diminished gradually. The flow of overland trade helped speed the acculturation process, as did the new technology of canal and railroad transportation. By 1850 Baltimore had a population of 195,000 and was "in as thriving a condition as any city in the Union."[2]

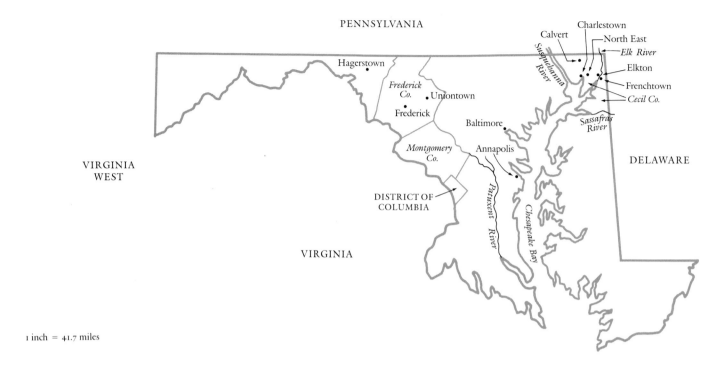

1 inch = 41.7 miles

Baltimore dominated the popular seating market in Maryland from the 1790s. North of the city, small pockets of independent activity existed in Cecil, Frederick, and Carroll counties, all influenced by Philadelphia work with Germanic overtones. Baltimore's merchandising power later provided strong competition for furniture craftsmen throughout the state and even met Philadelphia's influence head on from southern Lancaster County to the western frontier at the Ohio River. While Baltimore fancy furniture is well known, little attention has been focused on Baltimore Windsor furniture. Close study of local fancy work and nineteenth-century Windsor design in the Delaware Valley and southern Pennsylvania has made it possible to identify the products of the seaport center. Most Baltimore work is anonymous, although between 1795 and 1822 more than 100 boys began Windsor-chair-making apprenticeships in the city and more than 50 master woodworkers retailed Windsor furniture.[3]

BALTIMORE AREA TO 1800

Maryland residents were acquainted with Philadelphia Windsor chairs before 1770. Coasting vessels from the Delaware River pursued a brisk trade in the Chesapeake Bay region. Port of entry records for the trading centers of Oxford, Chester River, and Annapolis list small numbers of Windsor chairs among ships' cargoes, which also included apples, candles, twine, and anchors. The traffic in Philadelphia Windsors increased during the 1770s. Annapolis merchant James Brice purchased eleven Philadelphia Windsor chairs in September 1771. In the same decade limner John Hesselius, who owned a plantation in Anne Arundel County outside Annapolis, left his heirs household goods including mahogany, walnut, and Windsor chairs. The many rivers, tidal streams, harbors, and coves that dotted the bay facilitated communication between village and plantation and Philadelphia. When specie was scarce, bartered foodstuffs were acceptable since they generally found a ready market in Philadelphia.[4]

In surveying American colonial wealth on the eve of the Revolution, Alice Hanson Jones examined the inventories of thirty-seven individuals who died in Queen Anne County on the eastern shore. Three documents within the group refer to Windsor chairs and represent estates of plantation owners who held from five to fourteen slaves; two estates exceeded £1,000 valuation. In Talbot County where Lloyd family members were prominent landowners and officeholders in the eighteenth century, inventories of both Richard Bennett Lloyd (1788) and his brother Edward (1796) list Windsor chairs. The brothers had strong commercial ties with Philadelphia, home of their brother-in-law, General John Cadwalader. All three patronized Maryland artist Charles Willson Peale, who resided in Philadelphia from 1776.[5]

Baltimore may have been the home of one or more Windsor-chair makers at a relatively early date, since local probate inventories of the mid 1770s list Windsor seating along with slat-back chairs. In the winter of 1783/84, Mark Pringle, Esq., purchased five dozen Windsors chairs locally and sent them to the Annapolis legislature. At 21s.3d. apiece they were probably high-back chairs imitating the contemporary Philadelphia product. Peter Hoffman of Baltimore and his wife sat in high-back Windsors when Charles Peale Polk painted their portraits in 1793. By that date some Windsor seating was already described as "old" in several city estates, and local chairmakers had taken notice of the first Windsor side chair introduced at Philadelphia. Joseph Lemmon of Baltimore posed for his portrait with one arm extended over his scroll-top fan-back chair.[6]

Bow-back Windsors were current in Baltimore by 1794 when Polk painted Richard Lawson and his wife seated in side chairs of that pattern. Local silversmith William Whetcroft (d. 1799) sat for Charles Willson Peale in a bow-back armchair, and a stylized version of the pattern occurs in a portrait of Benjamin Yoe, a tailor, and his son attributed to Baltimore artist Joshua Johnson (fig. 4-1). A bow-back armchair with a Maryland history appears to be one of a group of Windsors constructed for the State House at Annapolis in 1798 (fig. 4-2). Since no Windsor-chair makers have been identified in Annapolis, it is likely that a Baltimore or regional craftsman supplied the seating. The distinctive chair is quite unlike Philadelphia work. The seat has saucerlike depressions at the front corners, and long bamboo spindles of exceptional nodular profile flare at the base. Although the arms have the Philadelphia forward scroll, they attach lower on the bow and slope less than their Pennsylvania counterparts. The well-shaped, bold turnings had considerable influence on Windsor work in south-central Pennsylvania (figs. 3-100, 3-105). A bow-back Windsor side chair with a similar back was used in the Somerset County courthouse at Princess Anne.[7]

U.S. customhouse records for the 1790s document an emerging export trade in Baltimore Windsor furniture. Early destinations included towns along the Chesapeake and its tributaries; Caribbean ports figured in the trade by mid decade. Most manifests that itemize Windsor chairs fail to identify patterns, but unless indicated otherwise seating furniture shipped prior to 1800 was probably in the bow-back style. When the schooner Weymouth left Baltimore for Havana on June 10, 1799, however, her cargo included side chairs and armchairs in the new "Single Back" pattern. Local chairmakers, such as Caleb Hannah, were happy to supply "merchants and captains of vessels" with seating and kept on hand "a large assortment of the best finished Chairs." William Snuggrass advertised Windsor chairs in 1800, the year his competitor John Oldham sold Windsors to William Patterson, owner of the schooner Little John.[8]

BALTIMORE AREA, 1800 TO 1850

Introduction of the square-back chair in the Baltimore market coincided with its appearance in Philadelphia. A Baltimore double-bow pattern centered with a hollow-cornered square medallion has a shield seat with distinctive front shaping (fig. 4-3). Rounded corners terminate abruptly on the lower surface in a sharp chamfer, while the center front extends forward in a deeply rounded projection. The new four-part, bamboo-turned leg supports the chair. The turned work, marked by well-hollowed

Fig. 4-1 *Benjamin Yoe and His Son, Benjamin Franklin Yoe*, attributed to Joshua Johnson, Baltimore, 1806/7. Oil on canvas; H. 35¾", W. 29½". (Museum of Early Southern Decorative Arts, Winston-Salem, N.C., gift of John W. Hanes.)

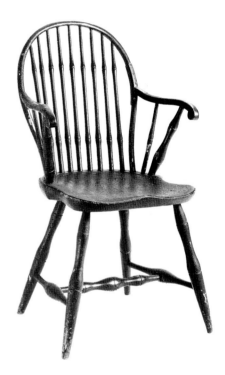

Fig. 4-2 Bow-back Windsor armchair, probably Baltimore, ca. 1798. Yellow poplar (seat); H. 35¾", W. 21¼", D. 20½". (Maryland Historical Society, Baltimore, gift of Henrietta W. Slicer and Laura Cooper Sadtler.)

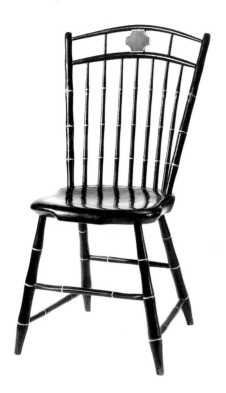

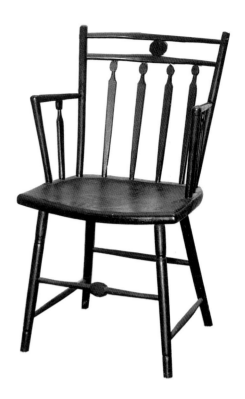

Fig. 4-3 Square-back Windsor side chair (one of four), Baltimore, 1802–12. H. 35¼″, (seat) 16¾″, W. (crest) 19½″, (seat) 15¾″, D. (seat) 15¼″. (Orkney and Yost: Photo, Winterthur.)

Fig. 4-4 Square-back Windsor armchair, Baltimore, 1808–15. Yellow poplar (seat); H. 33½″, W. 18⅝″, D. (seat) 16 ¹¹⁄₁₆″. (Private collection: Photo, Winterthur.)

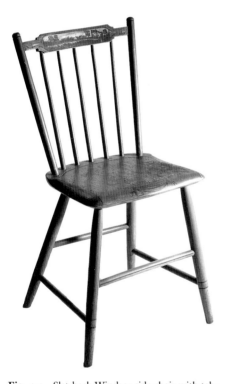

Fig. 4-5 Slat-back Windsor side chair with tablet, Baltimore, 1810–20. Yellow poplar (seat); dark pinkish maroon ground with black, brown, transparent yellow, and gilt; H. 33½″, (seat) 17¹¹⁄₁₆″, W. (crest) 18⅛″, (seat) 16½″, D. (seat) 14⅛″. (Fonthill Museum of the Bucks County Historical Society, Doylestown, Pa.: Photo, Winterthur.)

segments and a triangularity from top to bottom, is similar to that in some Pennsylvania German seating. When appraisers evaluated the shop goods of Baltimore chairmaker Godfrey Cole's estate in 1804, they identified the materials for square-back chairs as "4 set new fashioned Chair stuff." The old pattern's continued salability is indicated in an item for two sets of "round back d[itt]o." The valuation of "9 doz ready made Chairs" at $16 per dozen was an average price for new Windsors. A year earlier John Oldham had charged the Baltimore merchants Wessels and Primavesi $18 a dozen. John and Hugh Finlay, suppliers of fancy furniture for the President's House at Washington in 1809, sold a dozen Windsors that year to Benjamin C. Colhoon at a substantial $28. These were no ordinary wooden-seat chairs. The chairmakers may have shaped the seats with a projection and embellished surfaces with unusual ornament.[9]

A square-back armchair with double bows, a small medallion in the crest, and spindles of unusual shape, copied with minor variation from fancy chairwork, could be a product of the Finlay shop (fig. **4-4**). The spindle silhouette derives directly from a fancy Baltimore pattern reasonably attributed to the Finlays and comprising a large suite of furniture made for the local Buchanan family (fig. 3-118). In adapting the fancy arrow spindle for Windsor use, the chairmaker shortened the neck and enlarged the round head. His product may be the earliest arrow-spindle chair known in American Windsor seating. The oval medallion of the front stretcher balances and integrates the design. Other features besides the spindles were borrowed. The plank profile with its serpentine front duplicates that of a cane seat. The front legs with their top collars and bottom creases suggesting feet relate to supports on Buchanan furniture and on another early fancy chair (fig. 3-156). The arms are typical of early nineteenth-century Windsor work.[10]

A slat-crested chair with a centered tablet first marketed in Philadelphia about 1810 (fig. 3-127) may have followed a Baltimore lead (fig. **4-5**). Although the Baltimore chair is undocumented, its features relate directly to local fancy and Windsor chairs: slim, striped legs (figs. 3-118, 4-14); serpentine-front seat plank (fig. 4-4); painted drapery swag centered on the forward plank edge (fig. 4-11); compressed ball-like turnings capping plain posts (figs. 3-118, 3-156); and hollow-cornered crest tablet (figs. 3-117, 4-3). Five-spindle backs are common to early nineteenth-century Baltimore Windsors, as opposed to the seven-spindle backs of Philadelphia chairs (fig. 3-127). The Baltimore tablet is longer and shallower than Philadelphia ones.

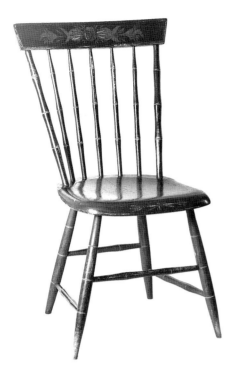

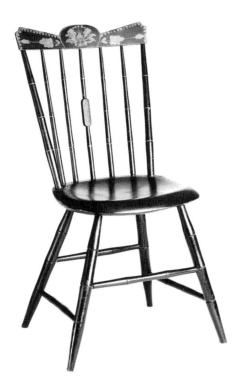

Fig. 4-8 *John and James Hasson,* attributed to Joshua Johnson, Baltimore, 1815–18. Oil on canvas, H. 47″, W. 39½″. (Winterthur 84.7.)

Fig. 4-6 Tablet-top Windsor side chair, Baltimore, ca. 1805–12. H. 40⅜″, (seat) 20⅛″, W. 18¼″. (Private collection: Photo, Museum of Early Southern Decorative Arts, Winston-Salem, N.C.)

Fig. 4-7 Fancy tablet-top Windsor side chair, Baltimore, ca. 1807–15. Yellow poplar (seat); H. 34⅝″, (seat) 17″, W. (crest) 17⅞″, (seat) 16¼″, D. (seat) 15¾″; paint and decoration old but not original. (Mr. and Mrs. Donald A. Fry collection: Photo, Winterthur.)

A plain, round-edge seat and legs of moderate splay provide the base for a tablet-top Windsor dating to the early 1800s (fig. **4-6**). The chair descended in a family with roots west of Baltimore in Frederick County, Maryland, and Jefferson County, West Virginia. The laterally curved tablet, which sockets on the post tops, fits closely with little overhang. The canted ends herald a distinctive, ornamental Baltimore crest with wing-like ends flanking either a large, central oval (fig. **4-7**) or a rectangular projection (fig. 3-153). The round-cornered, rectangular seat of knifelike edge was contemporary with the U-shaped plank (figs. 4-4, 4-5). An 1810s portrait of Baltimore schoolboys John and James Hasson at their lessons, attributed to Johnson, depicts a pair of similar chairs with oval centerpieces (fig. **4-8**). Painted decoration delineated the crest features, as illustrated by both the chair and the painting. A crest variation with a central, hollow-cornered rectangular extension interrelates with that in contemporary slat-back Windsors (fig. 4-5). Winged crest interpretations occur in central and western Pennsylvania, across northern Maryland, and possibly farther south (fig. 3-153). A provincial version was owned in Virginia's Shenandoah Valley, although it may have been brought there by a rural Maryland family (fig. **4-9**). The vigorous bamboowork of the legs relates significantly to several rural Pennsylvania or Maryland chairs (figs. 3-123, 3-153). The turnings are strongly Germanic, and the scribe line around the crest face is a direct adaptation from Pennsylvania German fan-back chairs (figs. 3-67, 3-70). The nodular sticks and the stumpy seat projection also indicate that the craftsman had direct knowledge of Baltimore work (figs. 4-2, 4-3). The new crest pattern appears to have spread westward rather than south along the bay. The embargo, the threat of British incursions, and the 1813/14 Chesapeake Bay blockade restricted, and even halted, coastal commerce, but the inland trade paths remained open.[11]

Craftsmen introduced a shallow rectangular Windsor crest imitating the top piece in a Baltimore fancy chair, probably in the prewar years (fig. 3-118). Reinforcing that date is a Windsor writing-arm chair bearing the stenciled label of chairmaker Jacob Daley,

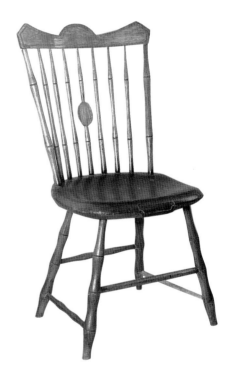

Fig. 4-9 Fancy-tablet-top Windsor side chair, rural Maryland, 1810–20. H. 33¾″, (seat) 16¾″, W. 18¾″. (Private collection: Photo, Museum of Early Southern Decorative Arts, Winston-Salem, N.C.)

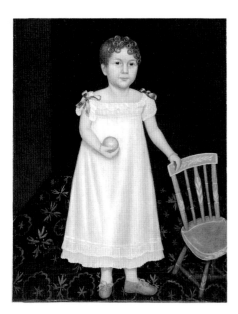

Fig. 4-10 *Henrietta Frances Cuthbert*, probably Norfolk, Virginia, ca. 1816. Oil on canvas; H. 36¼″, W. 27¾″. (Abby Aldrich Rockefeller Folk Art Center, Williamsburg, Va.)

Fig. 4-11 Tablet-top Windsor side chair, Baltimore, 1805–15. Yellow poplar (seat); coral red (coquelicot) ground with shaded brown and gilt; H. 35½″, (seat) 17¼″, W. (crest) 18¼″, (seat) 16½″, D. (seat) 15½″. (Historical Society of York County, York, Pa.: Photo, Winterthur.)

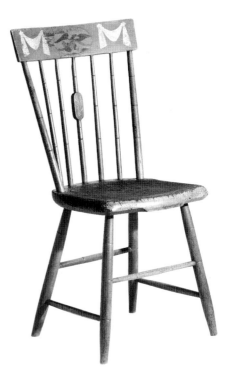

whose shop was located on Baltimore Street from 1807. Henrietta Frances Cuthbert of Norfolk, Virginia, stands by a small, fancy, painted Windsor of short-end crest, probably from Baltimore, in her portrait painted about 1816 (fig. **4-10**). Her chair resembles one made by Jacob Fetter III of Lancaster County, Pennsylvania, under the influence of Baltimore design, down to the rounded seat and ornamental central spindle (fig. 3-154).

Contemporary with chairs of shallow rectangular crest were Windsors crowned by broad tops that slightly overhang the posts. The ornamental seat projection continued in use, and the plank was sometimes shaped to form a D rather than a shield or a rounded rectangle. One broad-top chair with bamboo-turned members has a painted crest featuring draped swags (fig. **4-11**, pl. 17), a motif also found on a slat-back side chair (fig. 4-5) and local fancy seating. The festoon and other decorative motifs used in Baltimore work may spring from classical designs that Thomas Hope published in London in 1807. The spread eagle within the centered oval panel is a typical patriotic motif that sparked widespread interest and remained popular through the nineteenth century. Similar bird motifs were used as inlay for case furniture and as the central figure in the touchmarks of Baltimore pewterers George Lightner and Samuel Kilbourn. Under the seat, the width of a large, scribed arc at the center front corresponds to the breadth of the front projection, serving as a guide in shaping this feature.[12]

A second broad-top chair has a rounded-corner rectangular seat and introduces plain, tapered legs (fig. **4-12**). The front legs are marked near the bottom with deep, cufflike grooves that form feet. A medallion in the center spindle is counterbalanced by another in the front stretcher. The medallions and leg cuffs along with the trophy and sawtooth decoration of the crest come directly from the fancy chair (figs. 3-118, 3-156). The Finlays introduced similar ornament to Baltimore painted furniture at the beginning of the century. Chairs of this general pattern were distributed within the Baltimore trading area, as attested by a portrait found in South Carolina in which a child plays with a cat seated on a Baltimore chair (fig. **4-13**). The stance and the fancy leg, which substitutes a ball for the cuff, compare closely with figure 4-12. The identifying feature is the front seat projection, which the artist has carefully delineated and accented with striped decoration.[13]

A third broad-top chair (fig. **4-14**) employs the newest Windsor features—the D-shaped plank (fig. 4-11) and the cuffed, cylindrical leg (fig. 4-12). Thin, compressed

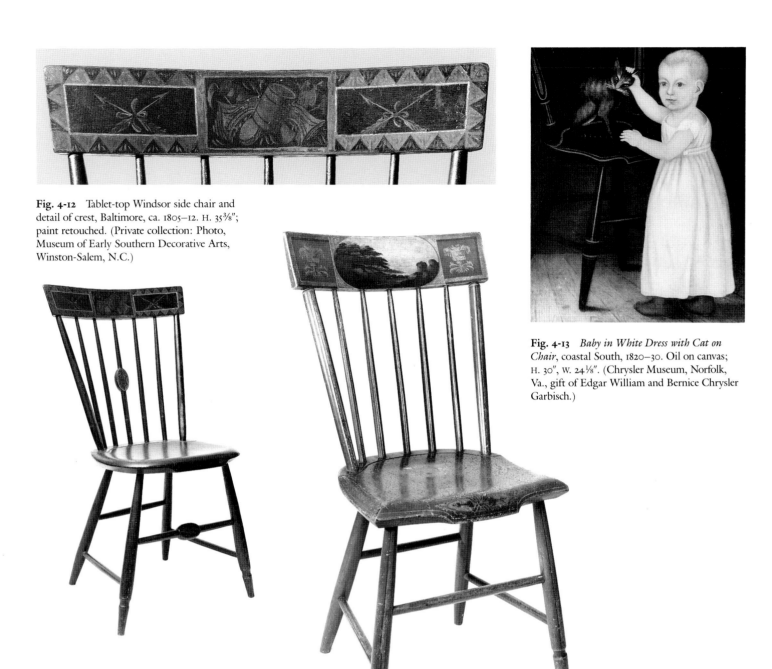

Fig. 4-12 Tablet-top Windsor side chair and detail of crest, Baltimore, ca. 1805–12. H. 35⅜″; paint retouched. (Private collection: Photo, Museum of Early Southern Decorative Arts, Winston-Salem, N.C.)

Fig. 4-13 *Baby in White Dress with Cat on Chair*, coastal South, 1820–30. Oil on canvas; H. 30″, W. 24⅛″. (Chrysler Museum, Norfolk, Va., gift of Edgar William and Bernice Chrysler Garbisch.)

buttons that cap the back posts are borrowed from the fancy chair (fig. 3-156). Centered in the crest is a painted scene. Painted views first ornamented Baltimore crests early in the century when the Finlays featured local estates and public buildings on their furniture. Along with the "real Views," the brothers offered "Fancy Landscapes." The scene on this chair falls into the latter category and relates in quality and subject matter to ornamental work that John Barnhart executed for Thomas Renshaw. The flanking gilt classical motif originated in published European designs.[14]

By the 1820s the lavish use of gilt ornament on high-style painted furniture had swept Baltimore by storm, as illuminated by Matthew McColm's 1825 advertisement, "300 DOZEN CANE, RUSH and WINDSOR CHAIRS, . . . painted in brilliant colours, ornamented in gold, and comprising an ELEGANT ASSORTMENT." Leafy gilt scrollwork also embellished tablet-top Windsors. The spindle back, however, was soon

Fig. 4-14 Tablet-top Windsor side chair (one of a pair), Baltimore, ca. 1807–15. Red ground with gilt and polychrome paint; H. 34½″, (seat) 18″, W. (crest) 18¾″, (seat) 17″. (Location unknown: Photo, Gary C. Cole.)

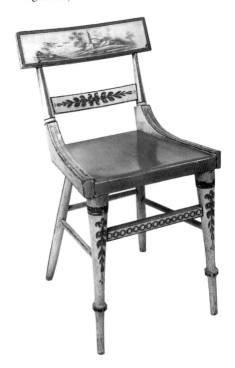

modified by a thin stay rail, or slat, positioned between crest and seat to imitate the Grecian fancy chair in the local market. A detail of Dr. Edmondson's Baltimore estate painted by Nicolino V. Calyo in 1834 shows an 1820s chair with thick legs and back posts and prominent gilt scrollwork on the crest (fig. **4-15**).[15]

Most fashionable Baltimore fancy seating dating from just before 1820 to 1840 shows a long, slim trapezoidal seat that is wider at the front than the back, a shape duplicated in many wooden-seat chairs (fig. **4-16**). Baltimore interpretation of the antique, or Greco-Roman, style is distinctive. Turned conical legs embellished with varied ring-and-ball forms firmly anchor the chair at the front; slim sticks serve as rear legs in wooden-seat chairs and some fancy seating. Heavy, shaped pieces of wood frequently case the seat sides and rise above the rear legs to form platforms that support the back structure. Chairmaker Bryson Gill in 1824 described such seating as "Wooden seat, Side piece, slat back" chairs. Painted views continued in popularity and spread beyond their central panels to cover the entire crest. Structural features were integrated by balancing the stay rail with a rectangular front stretcher, inverting a cone in each back post, and repeating the painted leaf decoration of the legs on the stay rail. A slightly later Windsor introduces heavy turned ornament highlighted by carved, gilt leaves on the front legs (fig. **4-17**). The tapered pattern suggests French Restoration chair legs with carved leaves, as illustrated by Pierre de la Mésangère about 1814 to 1818 in his periodical, *Collection de meubles et objets de goût*. Baltimore furniture makers were long familiar with European design sources. The Finlays advertised in 1810 that they possessed "Drawings, from furniture in the first houses in Paris and London, which will enable them to make the most approved articles." The rounded front corners of the seat form a smoother visual transition with the supports than a square-cornered plank. This change, in turn, dictated the use of a modified sidepiece to avoid an awkward termination. Striped back supports integrate the crest with the base, and the increased tablet depth eliminates the need for a stay rail. Typical gilt ornament fills the crest. This may be the wooden-seat, sidepiece chair that Gill described as finished in gold.[16]

Around 1820 a Baltimore fancy Grecian chair entered the consumer market (fig. **4-18**). The salient design features are a broad, overhanging crest with backward scrolled top edge; a large, centered back panel of ornamental profile; a roll-front seat with bands of multiple rings; a flat, shaped front stretcher; and plump, inverted-baluster legs with balls at the feet and inverted beehive elements at the seat. The multiring beehive turning was extremely popular in 1820s Baltimore fancy furniture, and craftsmen used it in bases and backs of chairs, pillars of tables and stands, and supports of benches and window seats. Similar inverted balusters embellish chairs illustrated by Mésangère from about

Fig. 4-18 Fancy side chair, Baltimore, 1820–30. H. 32¾″, W. (crest) 18⅝″, (seat) 17⅝″, D. (seat) 15½″. (Private collection: Photo, Winterthur.)

Fig. 4-19 Tablet-top Windsor side chair, Baltimore, 1820–30. Yellow poplar (seat); H. 33″, W. 19¾″, D. 19″. (Private collection: Photo, Winterthur.)

1802 until 1820. The decorative back panel, the focal point of the design, ranges from the scrolled anthemion in this chair to pairs of crooked-neck swans, griffins, or cornucopias to a scroll-framed lyre, motifs found in French furniture and assimilated into the Baltimore repertoire of popular ornament. A rush-seat chair with an anthemion has an ownership history in the Miller family of Baltimore. Its gilt decoration includes oak leaves, a star, and small bellflowers, all typical local and period motifs.[17]

The new Baltimore fancy pattern influenced Philadelphia fancywork (fig. 3-142) and wooden-seat chairs made in Baltimore and areas within the city's trading sphere. A Baltimore Windsor side chair with a plank-seat adaptation appears lighter than wooden-bottom Greco-Roman chairs (fig. **4-19**). Slim back posts echo the narrow profiles of the rear legs and, like those supports, socket directly into the seat; sophisticated front turnings are balanced by gilt ornament. Oak leaves and a foliate lyre decorate the crest. Acorn and oak-leaf motifs also frame land- and seascapes that occur on 1820s Baltimore fancy tabletops. The stylish bellflowers of the stay rail, a type found on local Greco-Roman chairs, have slim, elongated tongues tipped with beads like the central element in the anthemion of figure 4-18. The simple ornament of the plank front suggests a turned, fancy seat casing, and the relationship continues in the beehives and the broad, gold leaves of the legs.[18]

A provincial adaptation of the baluster-leg chair probably originated in rural Maryland west of Baltimore. A set of pale mustard-color chairs features the new round-end tablet of the 1830s (pl. 18). The focal point of these Windsor side chairs, however, is the painted decoration of the crest, which features polychrome rural scenes of framed houses, barns, and small outbuildings. Windows dot many structures, and several buildings have Germanic-style shed dormers in the roofs. The architecture as a whole suggests the central European medieval building tradition still preserved in the restored dwellings at Ephrata Cloister in Ephrata, Lancaster County, Pennsylvania, the site of a small German monastic community founded by Johann Conrad Beissel in the mid eighteenth century. A similar building style was traditional among German settlers in the Maryland-Pennsylvania border region that includes Frederick County, Maryland. The heavy, overstated front leg turnings, particularly when combined with slender bamboo rear legs, again point to this region. The seat has a molded quality, especially at the front where the corners wrap around the leg tops in a manner similar to an earlier Baltimore Windsor (fig. 4-17). The spearlike stay-rail ornament recalls Baltimore

Fig. 4-20 Tablet-top Windsor side chair, Baltimore or adjacent southern Pennsylvania, 1840–50. Black and red grained ground with light and dark striping; H. 33¼". (Abby Aldrich Rockefeller Folk Art Center, Williamsburg, Va.)

Fig. 4-21 Designs for chair backs. From George Smith, *The Cabinet-Maker and Upholsterer's Guide* (London: Jones, 1826), pl. 119. (Winterthur Library.)

Fig. 4-22 Design for music stool. From John Hall, *The Cabinet Makers' Assistant* (Baltimore: John Murphy, 1840), fig. 188. (Winterthur Library.)

painted motifs of the 1820s and 1830s. A considerable amount of metropolitan furniture found its way to country areas for rural craftsmen to copy. As early as 1810, Francis Younker of Baltimore had advised export and country merchants to examine his stock and select any quantity of furniture, which could "be supplied and delivered on the shortest notice."[19]

A pair of contemporary related chairs from rural Maryland has large rectangular crests rounded only at the upper corners. Centered panels are painted with water scenes, real or imaginary, flanked by lacy anthemia derived from a Baltimore design. Another area seating suite duplicates line for line the structural elements of the chairs in plate 23. The original painted decoration, however, is restrained. On a pea-green ground, gilt and black banding highlight turned and flat forms. Single gilt leaves and inverted beehive turnings accent the legs, and gilt crest scrolls frame delicate, central, ribbon-tied wreaths.[20]

A regional Baltimore chair from the 1840s has a fully developed scroll-end crest (fig. 4-20). From about 1810 French furniture had employed a related top piece with a back roll, or "scroll," at the center extension. George Smith, who drew heavily on French sources for his *Cabinet-Maker and Upholsterer's Guide* (London, 1826), illustrated a chair back of rounded profile and central projection that relates significantly to the Baltimore pattern (fig. 4-21, right). The companion design, when inverted, is similar to the Pennsylvania shouldered crest, complete with the scrolling foliage that embellishes many examples retaining original decoration. John Hall's compilation of Baltimore furniture designs published in *The Cabinet Makers' Assistant* (1840) illustrates a music stool that combines a scrolled crest and broad baluster (fig. 4-22). Both splats relate to a lyre profile used by Joseph Hisky in a pianoforte of the 1830s. The chair dates slightly later, since it introduces small Gothic arches in the crest. The chair seat, while similar to Pennsylvania examples, is broader at the back and completes a full roll at the front. The forward legs reflect elements from various support types, and the tapered back feet appear in other Baltimore work.[21]

RURAL MARYLAND

Beyond Baltimore, evidence of Windsor-chair making is thin, except for the German-influenced work of Frederick and Carroll counties, a few newspaper notices for chair-makers in the Frederick-Hagerstown area, and a small group of chairs associated with

Cecil County. Windsor furniture appears to have been common in Frederick County. In 1811 George Jacob Schley, a Frederick innkeeper, possessed twenty-three Windsors and a few splint-seat chairs. Thomas Newens advertised locally as a Windsor-chair maker and house painter, and business was apparently good. His biggest problem was keeping his apprentices happy, since there were frequent notices of runaways. About twenty miles to the northeast in Uniontown, Carroll County, Jacob and John Thomas practiced chairmaking along with turnery and sign and house painting.[22]

Hagerstown, west of Frederick, was reasonably prosperous from the Revolution onward. Probably before the turn of the century, John Watt made spinning wheels and Windsor chairs. His son Archibald took over the shop in 1801 and notified customers that he could supply his products "on the lowest terms, for cash or country produce." The family arrangement was temporary, since by January 1802 John Watt had "recommenced his business at his old stand." In 1814 John Martiney initiated a wheelwright and chairmaking business in the same town. His Windsor chairs were "elegantly ornamented and finished in a superior stile in the newest fashion, of the best materials." Hagerstown, like Frederick, had a large German population. From the mid eighteenth century, its location south of Chambersburg, Pennsylvania, in a limestone valley dotted with small watercourses encouraged manufacturing, particularly milling and ironwork. At the beginning of the nineteenth century, saddlers, coppersmiths, blacksmiths, hatters, tanners, gunsmiths, potters, and "blue dyers" worked in the town. John Bradshaw, like Martiney and Watt, made spinning wheels and Windsor chairs. In August 1815, he gave public notice of his intention "to remove to the Western country" in the autumn. He found, however, "that he could not suit himself" and by October had "returned from the back country." Business improved, and by 1820 Bradshaw took a partner, John H. Rutter, who was "lately from Philadelphia." If the firm's chairs were identifiable, they would likely show a mixture of Pennsylvania and Maryland features.[23]

Two late eighteenth-century fan-back side chairs with family histories in Cecil County exhibit strong Philadelphia and Pennsylvania German design influences. The first chair is one of five recovered in the Elkton-Northeast area (fig. 4-23). The saddled seat follows a typical Philadelphia shield-shaped pattern, and the slim crest and long leg balusters echo the work of Joseph Henzey (fig. 3-47). The back posts, however, recall German chairmaking. The placement of a ring near the crest relates to fan-back turnings from Lancaster and York counties, Pennsylvania (fig. 3-69). There are also similarities with a framed, spindle-back bench at Stratford Hall, the Virginia home of the Lee family, and a bench in the Baltimore Museum of Art. Both have histories in Montgomery County, south of Frederick. Cecil County's location at the head of Chesapeake Bay opened it to various currents of furniture design. North and west were large German populations; Philadelphia lay to the northeast. Major overland trade routes between Philadelphia and the Chesapeake Bay via New Castle or Christiana Bridge, Delaware, passed through the village of Elkton and terminated a few miles south at a landing called Frenchtown. Goods arrived by water at Delaware or Chesapeake ports and were loaded onto wagons for the short overland trip. Elkton, noted La Rochefoucauld Liancourt in the late 1790s, "contains about 100 houses, almost all built in one street, which leads to Philadelphia." Across Elk Neck, a small peninsula at the head of the bay, lay the village of North East. A few miles south along the Northeast River was Charlestown, described by Joseph Scott in 1807 as "a flourishing little post town . . . [which] contains 45 dwellings, and 250 inhabitants." He also noted that "the cabinet, windsor chair, and the blacksmith business, are carried on here." Six sloops or schooners sailed to and from the small port weekly. The close proximity of Charlestown to the recovery area of this chair group may suggest its origin.[24]

A second Windsor chair bought from an estate in Calvert, a few miles south of Lancaster and Chester counties, Pennsylvania, appears unrelated to figure 4-23, although they share common influences (fig. 4-24). The seat duplicates a Philadelphia pattern, and the three rings of the back posts indicate knowledge of German work. The crest and support structure of this chair reveal a strong affinity to a Pennsylvania fan-

Fig. 4-23 Fan-back Windsor side chair, probably Cecil Co., 1790–1805. Yellow poplar (seat, microanalysis) with maple and other woods; H. 37″, (seat) 17½″, W. (crest) 23¾″, (seat) 18¼″, D. (seat) 17¹⁄₁₆″. (E. S. Wilkins collection: Photo, Winterthur.)

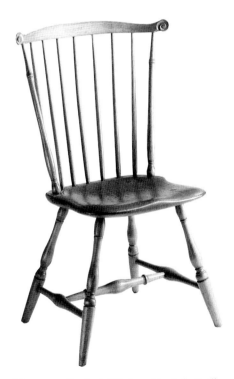

Fig. 4-24 Fan-back Windsor side chair, Cecil Co., Md., or southern Lancaster Co., Pa., 1790–1805. Yellow poplar (seat) with maple, ash, and hickory; H. 35⅜″, (seat) 15″, W. (crest) 24¾″, (seat) 16½″, D. (seat) 16⅝″. (E. S. Wilkins collection: Photo, Winterthur.)

back chair (fig. 3-104). The use of ash for turned work in this chair also occurs from time to time in Pennsylvania German Windsors.

The Cecil County fan-back chairs nearly coincide in date with documented use of Windsor seating in rural Montgomery County, southwest of Baltimore. When Quaker Richard Thomas died in 1807, he owned three dozen black or green Windsors, of which one-third were armchairs and the rest side chairs. The house had other seating, although appraisers described fourteen leather-bottomed and walnut chairs as "old." Considering the inland location of Montgomery County, Thomas's Windsors either came from Baltimore or were made by a local, unidentified craftsman.[25]

The paucity of chairmaking evidence outside Baltimore suggests that metropolitan competition was substantial and discouraging. Craftsmen who left the city in the nineteenth century seem to have migrated into central and western Pennsylvania or to new industrial centers such as Cincinnati and Wheeling.

Delaware

WILMINGTON FROM THE REVOLUTION TO 1800

"Wilmington is the most important city in Delaware," wrote Moreau de St. Méry in the mid 1790s when the local population was about 1,500. By comparison, Philadelphia and suburbs, located only thirty miles away, had about 45,000 residents. Several other contemporary authors commented on Wilmington's pleasant situation along the Christina River west of its juncture with Brandywine Creek and a half mile from the Delaware River. Jedidiah Morse typically noted that Wilmington "contain[s] about 400 houses, which are handsomely built upon a gentle ascent of an eminence, and show to great advantage as you sail up the Delaware." La Rochefoucauld Liancourt observed: "Wilmington, like Philadelphia . . ., does not cover all the ground marked out for it; the houses, though almost all built in streets, do not join each other; on the contrary, there are fields of considerable size betwixt several of them. They are, in general, handsome substantial brick buildings, and are almost all of them built in the English style. The town contains about four square miles exclusive of a tract of land not yet built upon."[26]

Wilmington's location in northern New Castle County near the navigable Delaware dictated its early focus on trade, much of it upriver to Philadelphia. La Rochefoucauld Liancourt reported that twelve or thirteen sailing vessels, mostly sloops and shallops, participated regularly in Wilmington's coasting trade. Although it was a small community, there were advantages to living in Wilmington. La Rochefoucauld Liancourt noted, "The necessities of life are cheaper by two fifths at Wilmington than at Philadelphia." Like its neighbor to the north and Baltimore to the south, Wilmington was situated in a productive, grain-growing region. Along the lower Brandywine Creek was a flourishing flour-milling complex that provided a modest entry into West Indian and European commerce. The lower Brandywine was also the site of a large papermill owned by the local Gilpin and Fisher families.[27]

John Ferriss, Sr., whose sign on Market Street was the "Hand-Saw," may have been the only local Windsor-chair maker in 1775 when he sold plank-bottomed seating to the Borough of Wilmington to furnish the burgesses' meeting room in the Upper Market House at Fourth and Market streets. As indicated by his shop sign, the craftsman's main line of work was cabinetmaking, although he also operated a general merchandise and hardware store. The absence of further chairmaking evidence suggests that Ferriss concentrated on other businesses following the Revolution, when continued expansion of milling and manufacturing along the Brandywine stimulated city growth and attracted other woodworking specialists. Among the newcomers were Sampson Barnet and Jared Chesnut, who dominated the local Windsor trade. The chairmakers' careers overlapped, thus providing a continuous period of about forty years of documented production.[28]

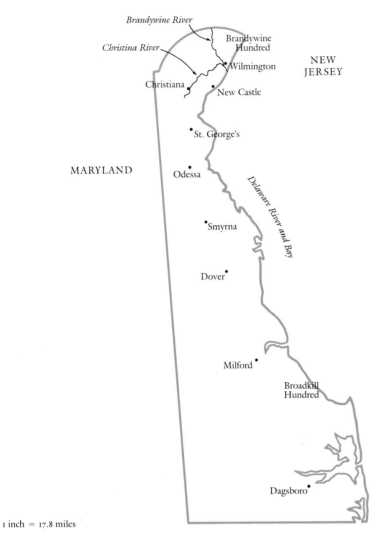

PENNSYLVANIA

Brandywine River

Brandywine
Hundred

Christina River

NEW
JERSEY

Wilmington

Christiana

New Castle

St. George's

MARYLAND

Odessa

Delaware River and Bay

Smyrna

Dover

Milford

Broadkill
Hundred

Dagsboro

1 inch = 17.8 miles

MARYLAND

Barnet married in Wilmington on December 7, 1776, although at the time he may have resided in Chester County, Pennsylvania. He paid taxes in Goshen Township between 1779 and 1781 and probably began his Wilmington career between 1782 and 1785. The borough paid Barnet £3 in September 1786 for his services as a "pettit constable," a job probably assigned to established residents. In October 1789 the craftsman advertised that he continued "the Turning Business at his shop in Market Street." With journeyman assistance he made rush-bottomed and Windsor chairs, settees, bedsteads, and spinning wheels. By 1795 Barnet had relocated to Fourth (High) and King streets, where he likely remained until about 1807 when he (or someone of the same name) is listed as a turner in the Lancaster, Pennsylvania, tax assessment. The chairmaker was back in Wilmington by 1810 but probably left Delaware for good shortly thereafter. Barnet is again listed as a Chester County resident in 1814 and between 1818 and 1823, based upon tax records for Goshen and East Goshen townships.[29]

Barnet's earliest documented chairs, which date to the 1780s, imitate the tall, contemporary, oval-seat Philadelphia Windsor. At least three branded examples remain, one with plain pad-end arms (fig. **4-25**), the other two with scrolled "knuckle" terminals.

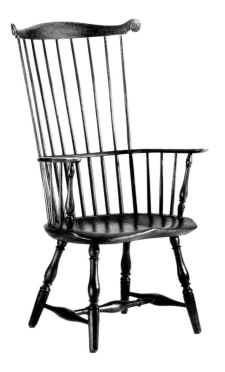

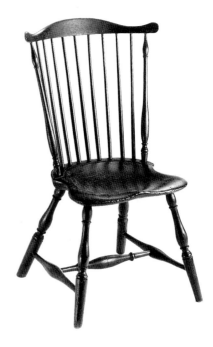

Fig. 4-26 Fan-back Windsor side chair and detail of brand, Sampson Barnet, Wilmington, Del., ca. 1790–98. Yellow poplar (seat) with maple, oak, and hickory (microanalysis); H. 34¼", (seat) 16", W. (crest) 21⅞", (seat) 17¼", D. (seat) 15⅝". (Winterthur 59.2150.)

Fig. 4-25 High-back Windsor armchair, Sampson Barnet (brand "s·barnet"), Wilmington, Del., ca. 1782–90. Yellow poplar (seat) with maple, oak, and hickory; H. 44¼", (seat) 16³⁄₁₆", W. (crest) 23⅛", (arms) 25⅝", (seat) 22½", D. (seat) 17". (Winterthur 90.85.)

Barnet's work closely resembles high-back chairs attributed to Philadelphia craftsman Francis Trumble (fig. 3-27), and the two men may have worked together. In 1779/80 when Barnet was a resident chairmaker of Goshen Township, Trumble also paid township taxes on a 100-acre livestock farm where he probably resided during the height of the war. The support structure of Barnet's chair is similar to Trumble's turned work; the oval saddled seat, thick spindle bases, and back cant are general trademarks of contemporary Philadelphia chairmaking. Barnet chose a simple, pad-end arm terminal whose chamfered sides lighten the profile. The elongated balusters below the arm recall Joseph Henzey's work, although Barnet's turnings are slimmer, like those in his later sack-back chairs. Barnet employed a full, broad arch in his crest, which resembles that in Trumble's braceless, fan-back side chair (fig. 3-46); the end scrolls, however, are larger, higher, and better designed. Barnet's top rail is deeper than its Philadelphia prototypes, forming a good balance with the rest of the chair.[30]

Barnet probably constructed fan-back chairs from the start of his Wilmington career. Side chairs, which were less expensive than armchairs, were the bread and butter of the trade. During the early 1790s Barnet acquired a new marking iron containing both his name and location; almost half of his known fan-back production bears this second brand (fig. **4-26**). Inclusion of a place name on chairs destined for wholesale and retail markets was almost unknown in the Philadelphia chair trade, but New York City chairmakers practiced similar advertising during the 1790s. In the crest, seats, and turned profiles, Barnet's fan-back chairs, like his tall Windsors, closely resemble Philadelphia seating. The chairmaker appears to have used only plain, rounded-end crests on these chairs. Wilmington merchant James Brobson's shipping papers, which record many West Indian voyages in the early 1790s, list cargos of flour and "Green Chairs." The chairs were probably fan-back Windsors, given the date and quantities, and Barnet could have been the supplier.[31]

Barnet's sack-back chair combines excellent proportions and turnings with a flair for craftsmanship (fig. **4-27**). Slim leg and post balusters, which duplicate the high-back arm supports, introduce a trim look balanced by full stretchers, a double-sweep seat front, and flaring, squared bow ends. Spindles that thicken at the bottom are common on Barnet's early armchairs. Of about six known branded sack-back armchairs, only one bears Barnet's later name and location stamp. All but one have slim arm supports, although most have heavier legs. Arm terminals are equally divided between pad ends and knuckles, both reflecting the Philadelphia fashion.

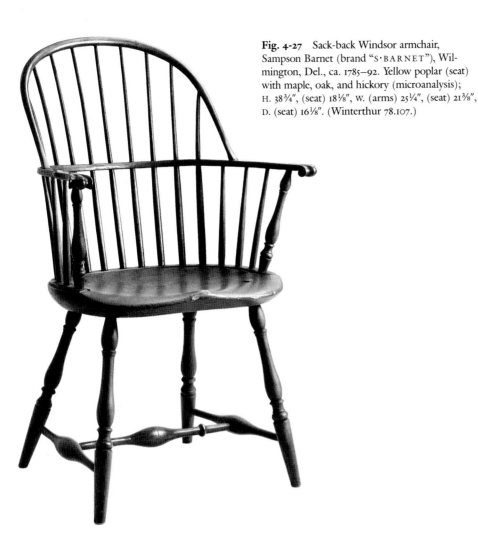

Fig. 4-27 Sack-back Windsor armchair, Sampson Barnet (brand "s·BARNET"), Wilmington, Del., ca. 1785–92. Yellow poplar (seat) with maple, oak, and hickory (microanalysis); H. 38¾", (seat) 18⅛", W. (arms) 25¼", (seat) 21⅜", D. (seat) 16⅛". (Winterthur 78.107.)

Barnet's bow-back chairs are close imitations of their Philadelphia prototypes (fig. 4-28). Bamboo leg turnings, shaped seats, and crowned bow faces are typical of greater Delaware Valley bow-back production. The nodular medial stretcher follows the early Philadelphia pattern (fig. 3-51, left). There was little room for innovation in a small river community situated just south of America's largest city. However, unlike some Windsors made in Bucks and Chester counties, which lie within an equal radius of Philadelphia, the Wilmington chairmaker's work reveals some provincialism. The central hollow of the legs is longer than the same unit in the models, although the profile is still well balanced. In using similar proportions in the spindles and thickening the spindle bases, Barnet introduced a bottom-heavy figure to his chair back. A few bows pinch at the waist more than others, and spindle profiles change somewhat from early to late work. The spindles of the bow-back illustrated here swell at the grooves, a late 1790s metropolitan characteristic (fig. 3-55). Barnet's companion armchair has a full, round bow without a waist; as in Philadelphia work, a bead finishes the curved arm and support edges.[32]

The shop inventory of Timothy Hanson—a Little Creek, Kent County, native who worked in Wilmington where he was a member of the Society of Friends—sheds more light on local Windsor-chair making at the century's close. The detailed enumeration indicates that Hanson produced both round- and square-back chairs at his death in November 1798. The listing notes three groups of finished chairs: "Winsor," "Bamboo," and "Armed." The last were probably bow-back Windsors, since among chair parts appraisers found only "Walnut arms," a type fashioned in a forward scroll and used primarily on round-back chairs. Business was apparently good; appraisers counted thousands of chair parts, including "rods," "feet," "stretches," "top rails," and "bows." Rough-formed or ready for use were "462 Chair bottoms"; 236 feet of "Chair plank" was yet to be sawed and shaped. Hanson may have employed journeymen, since three

Fig. 4-28 Bow-back Windsor side chair, Sampson Barnet (brand "s.BARNET / WILMINGTON"), Wilmington, Del., ca. 1798–1807. H. 35⅞", (seat) 15⁹⁄₁₆", W. 19¾", D. 16¼". (Mr. and Mrs. Robert L. Raley collection: Photo, Winterthur.)

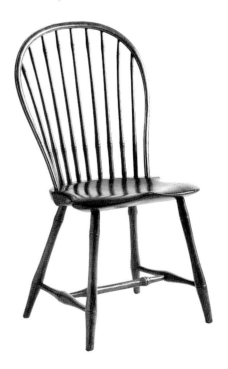

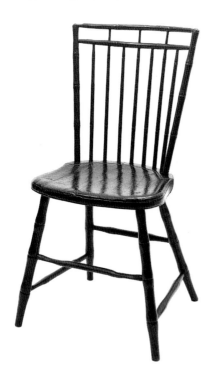

Fig. 4-29 Square-back Windsor side chair, George Young (brand "G. YOUNG"), Wilmington, Del., ca. 1799–1803. Yellow poplar (seat); H. 34½", W. 19", D. 14¾". (Hagley Museum and Library, Wilmington, Del.)

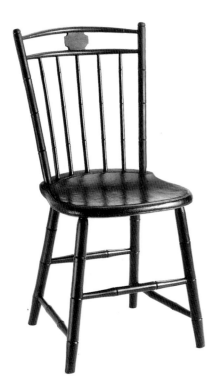

Fig. 4-30 Square-back Windsor side chair, Jared Chesnut (brand "J.CHESNUT / WILMING-TON / DEL."), Wilmington, Del., ca. 1804–10. Yellow poplar (seat) with maple, walnut, oak, and hickory (microanalysis); H. 33 ¹⁵⁄₁₆", (seat) 17¼", W. (crest) 18¼", (seat) 16⅞", D. (seat) 16¼". (Winterthur 63.88.)

workbenches were enumerated; roundwork was produced on the shop lathe. Fifty-six painted chairs stood ready for sale, and another 127 were framed and ready for paint. Hanson prepared his own paints, as he owned dry pigment, stones for grinding, and paint pots.[33]

WILMINGTON FROM 1800 TO 1850

George Young, a Philadelphia cabinet- and chairmaker, arrived in Wilmington about 1799. His King Street shop was located only two blocks from Sampson Barnet's. Most of Young's marked bow-back production originated in Philadelphia; however, a square-back Windsor with double bows, box stretchers, and a late grooved-edge shield seat dates during his residence in Wilmington and has a history of ownership in the du Pont family (fig. **4-29**). The top rail caps the posts, although an alternative Delaware Valley design frames the cross rods between the posts. The double-bow style was the "latest fashion" in 1803 when Young was a partner of Samuel Nichols. In May the chairmakers sold "6 Bamboo Chairs" to David West at $1.50 apiece; two matching armchairs cost $2.50 each. Three years earlier Nichols had sold chairs to the Borough of Wilmington, although they may have had round rather than square backs.[34]

The Delaware career of Jared Chesnut, who followed Barnet as Wilmington's leading Windsor-chair maker, began in Christiana, a village along a small river of the same name (now the Christina). The waterway provided direct communication with neighboring Wilmington through small, shallow-draft boats; the village also lay on the main land route between New Castle on the Delaware and Elkton and Frenchtown on the Elk River at the head of the Chesapeake Bay. Purchases of tools and household utensils from the village general store in 1800 document the start of Chesnut's career. Business at this location may have been slow, since by February 1804 he had moved to Hemphill's Wharf in Wilmington and formed a partnership with James Ross. In September 1809, Eleuthère Irénée (E. I.) du Pont, a leading area manufacturer, purchased "6 Squareback Chairs" for $10. Chesnut's production at this date centered on small, medallion-crested, double-bow side chairs, such as the one in figure **4-30**, which has a Wilmington history. Rounded, shield seats with grooved edges originally picked out in contrasting paint are typical Delaware Valley work of the early 1800s. Most, if not all, of Chesnut's square-back-chair posts are tipped with small caps, unlike contemporary Philadelphia work, which is plain. The feature may derive from Baltimore work (fig. **4-5**). Five spindles, instead of seven, fill the chair backs, and none pierce the void between the two bows. Some top rods arch to a greater degree than others. These features also occur in square-back armchairs; the seats, though broader, are related in design, and bamboo-turned arms extend beyond heavy turned posts of similar form (fig. **4-32**).[35]

Before 1810 the medallion in the Delaware Valley square-back crest increased in size (fig. **4-31**). The change, though subtle, provided new momentum for advertising "fashionable" chairs. Chesnut innovated on Philadelphia design and occasionally substituted medallions with astragal or double-rounded ends. A few Chesnut chairs from the early 1810s document both Baltimore's rising influence on lower Delaware Valley chair design and Philadelphia's continuing impact on area production. Chesnut added fancy front legs and ornamental rectangular medallions in the front stretcher and spindles. Although the medallion is a Baltimore feature borrowed from Philadelphia work (fig. **3-120**), the chairmaker's new leg design is a direct and vigorous interpretation of the Baltimore collared and cuffed support (figs. **3-156, 4-4**). While an early Chesnut chair of this pattern lacks ankle cuffs, a deep groove delineating a foot soon appeared in his work. Armchairs with similar supports indicate that Chesnut sometimes produced this furniture in sets. Perhaps the "fancy winsor chairs" repainted in his shop for E. I. du Pont in 1819 were of this pattern.[36]

Concurrent with the fancy-leg chair, Chesnut offered the first of several Philadelphia-inspired, slat-back designs with a central tablet (fig. **4-32**). The low, hollow-cornered slat

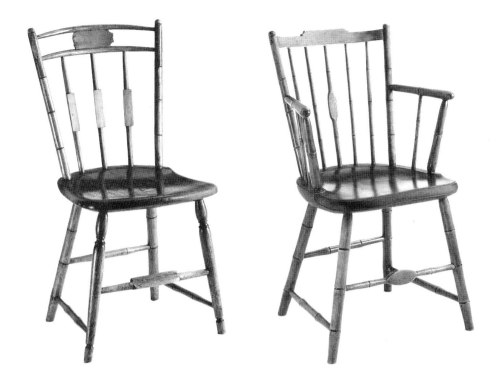

Fig. 4-31 Square-back Windsor side chair, Jared Chesnut (brand "J.CHESNUT / WILMINGTON / DEL."), Wilmington, Del., 1810–15. Yellow poplar (seat) with maple and other woods; H. 34⅝", (seat) 17¼", W. (crest) 18½", (seat) 17", D. (seat) 16"; left side of crest tablet damaged. (Private collection: Photo, Winterthur.)

Fig. 4-32 Slat-back Windsor armchair with tablet and detail of brand, Jared Chesnut, Wilmington, Del., ca. 1812–18. Yellow poplar (seat) with maple, walnut, and hickory (microanalysis); H. 34½", (seat) 17⅝", W. (crest) 18", (arms) 22", (seat) 18½". (Winterthur 66.129.)

extension also occurs in Philadelphia Windsor work (fig. 3-127). Turned sticks with oval medallions are uncommon in Pennsylvania Windsors, and Chesnut may have copied this feature directly from a Baltimore source; the profile appears in all of his documented armchair production. Through the first two decades of his career Chesnut marked his work with a brand (fig. 4-32, detail) and, like Barnet, added a location as part of his merchandising scheme. Perhaps this device first attracted Pennsylvanian Samuel Pennock of neighboring West Marlborough Township, Chester County, to Chesnut's shop. From 1815 to 1828 Pennock purchased large sets of chairs that were given to his four daughters as parts of their dowries. Eighteen "bent back Winsor Chairs" acquired in 1825 for Elizabeth Pennock probably duplicated the Philadelphia arrow-spindle chair illustrated in figure 3-134, without the arms.[37]

Before 1820 the Delaware Valley tablet-centered, slat-back Windsor acquired a second, longer projection below the slat, producing a crest similar to one in a labeled chair by William Lee of Philadelphia (fig. 3-127). Sawing and finishing this intricate tablet likely slowed production measurably, and Chesnut soon substituted a less complex slat with sloping ends. While the craftsman continued to use the shield seat for armchairs, he introduced balloon and serpentine profiles to his side-chair planks (fig. 3-131). Chesnut continued to work in Wilmington until about the early 1830s, although his later production seems to be unmarked.[38]

Evidence of other local seating is meager from the 1820s and later, centering only on several unmarked Windsors with family histories. Various records, however, identify city chairmakers who worked before midcentury. One craftsman was William D. Chesnut, the son and probably former apprentice of Jared, who in 1827 advertised that he had taken over his father's place of business. Whether Jared Chesnut continued to work in the shop or opened another establishment is unclear, although the former seems more likely. When William went to Baltimore to work as a fancy-chair maker from 1829 to 1831, Jared appears to have supervised the shop once again, since he accepted five apprentices in this period. In a last reference, the 1837 Philadelphia city directory lists the elder Chesnut and describes his occupation as chairmaker. After his return from Baltimore, William worked in Wilmington through the 1850s.[39]

Despite a paucity of documented postwar seating, records show that Windsor furniture figured prominently in Wilmington households through the 1840s. Thirty-two Windsors partially furnished Dr. Henry Latimer's home at 123 Market Street in

1820; other seating consisted of mahogany chairs, a rush-bottomed chair, and three settees. Black Windsors were enumerated in Pennell Corbit's estate in St. George's Hundred, New Castle County, the following year; cabinetmaker John White possessed two sets of "Green winsor Chairs" at the decade's end. David Penny, a cabinetmaker of Brandywine Hundred near Wilmington, owned a bent-back Windsor settee, which he either constructed or purchased locally before his death in 1832. The angled back had been introduced to Philadelphia chairmaking fifteen years earlier. Midcentury production at a typical seating manufactory is itemized in John S. Barber's 1845 Wilmington advertisement that noted "a general assortment of Windsor and Fancy Chairs, Rocking Chairs, Settees, Horse Shoe and Pivot Chairs for offices, &c."[40]

RURAL DELAWARE

Prior to the Revolution, several rural or small-town Delaware residents, probably with business connections in Philadelphia, owned Windsor furniture. Andrew Caldwell, Esq., of Kent County possessed "1 winsor Chair" valued at 12s. at his death in 1774. The same year, six Windsor chairs furnished the county residence of John Wood, owner of a sailing vessel. Eighteenth-century records provide the name of only one craftsman who constructed wooden-seat furniture beyond Wilmington and its environs. Christopher Horton, a turner and possibly a carpenter, made Windsor chairs for the Dover state-house in 1791 and also provided turned work for the building itself. The craftsman vanished as mysteriously as he appeared, and there is no other trace of him in the Delaware Valley.[41]

Research has identified almost two dozen Windsor-chair makers or apprentices working in rural New Castle County and "downstate" Kent and Sussex counties during the early nineteenth century, but almost all exist in name only. Among fragmentary Delaware returns in the 1820 United States Census of Manufactures, Purnell Hall of Milford, Sussex County, is one of only three named state chairmakers. A second craftsman worked in the same locale, and another practiced elsewhere in the county. An unnamed rush-bottomed-chair maker was enumerated in neighboring Dagsboro Hundred. Information supplied by the United States marshal who directed the Sussex County census indicates that Hall employed two men; annual income and material cost are unspecified. Hall was probably still developing his career in 1820, since at his death in 1848 his shop inventory described the tools, materials, and finished stock of a substantial cabinetmaking business. Chairmaking activity is indicated in listings for "1 chairmakers Bench, 1 Lott chair rounds & posts, . . . one Turning Lathe," and "1 Lott Chair makers tools." Although records fail to identify Hall as a Windsor-chair maker, a marked spinning wheel documents his production of a form whose turned members relate significantly to Windsor work. In rural and semirural areas, wheel- and reelmaking went hand in glove with chairmaking. When Perry Prettyman of Broadkill Hundred, Sussex County, took Minos Phillips as an apprentice in 1831, the indenture described the young man's proposed training as "windsor and rush bottom chair making together with ornamental painting and also the spinningwheel business in all its various branches of the several arts," confirming that downstate craftsmen commonly practiced multiple woodworking skills.[42]

Delaware's long coastline with its many inlets and tidewater creeks bordering the Delaware River and Bay opened southern areas to stylistic influences from Philadelphia and Wilmington and, in the nineteenth century, from Baltimore. Rural merchants, businessmen, and owners of small sailing craft had regular contact with the large ports. William Corbit of Odessa in southern New Castle County trained in Philadelphia as a tanner in the 1760s. When his own yards prospered, he built a spacious brick house in the Philadelphia Georgian style. At his death in 1818, more than twenty Windsor chairs and a settee furnished the household. Corbit's neighbor David Wilson also used Windsor seating, and both men probably acquired the furniture outside the immediate area. By 1840, Thomas Thompson Enos had moved to Odessa and set up shop as a cabinet- and

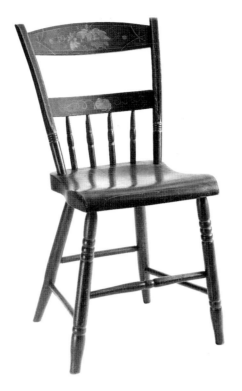

Fig. 4-33 Slat-back Windsor side chair (one of six) and detail of inscription, "Thomas Thompson Enos" (penciled), Odessa, Del., 1845–60. Yellow poplar (seat) with birch, beech, and yellow poplar (microanalysis); dark brown ground with black, pale yellow, green, and other colors; H. 32⅛", (seat) 17¼", W. (crest) 17½", (seat) 15½", D. (seat) 13⅞". (Winterthur 81.70.6.)

chairmaker. Born and trained in neighboring Smyrna, he had worked in 1839 as a journeyman in Philadelphia. An ornamented plank-seat chair, one of a set penciled on the bottom with his name and location, closely resembles Pennsylvania chairwork current from the 1830s (fig. 4-33). James C. Helme of Luzerne County, Pennsylvania, described such Windsors in his 1838 "Book of Prices for Making Cabinet and Chair Furnature" as ball-back chairs with two bows and priced them slightly lower than ball-back chairs with "roll" (fig. 3-140) or scalloped tops (fig. 3-138). The fancy front legs also copy work executed in Pennsylvania. Bold ring turnings and striped decoration combined with inverted baluster feet relate to midcentury and later Pennsylvania chairs (figs. 3-138, 3-149).[43]

New Jersey

Lord Adam Gordon described "the Jerseys" during a 1765 American tour as "a pleasant, open, and well cultivated country . . . often called the Garden of America, and its appearance very much resembles England." New Jersey's location between Philadelphia and New York City, two of America's largest mercantile centers, and its agricultural orientation precluded its rise to commercial eminence except along the Hudson River. The state was divided early into two proprietary colonies, East and West Jersey, roughly equivalent geographically to northern and southern New Jersey, the dividing line from Trenton on the Delaware River to southern Monmouth County on the coast. Northern New Jersey, its center in the greater Newark area, lay in the shadow of New York City. Southern New Jersey, extending from Trenton south and dominated by the presence of Philadelphia across the Delaware, embraced an extensive farming and fishing region, much of it out of the commercial mainstream.[44]

The 1753 household inventory of John Coxe of Trenton lists a Windsor chair and six New England chairs in the "front Hall," a room furnished with tables and dishes, presumably for dining. Use of "imported" chairs and the newly fashionable Windsor describes Coxe's close connections with Philadelphia and his awareness of current furnishing trends. The Delaware above Philadelphia was navigable by sloops and other small craft as far as the falls at Trenton, facilitating trade between the seaport and this rising community of about 100 dwellings.[45]

Locations of Craftsmen and Product Destinations
New Jersey, 1750–1850

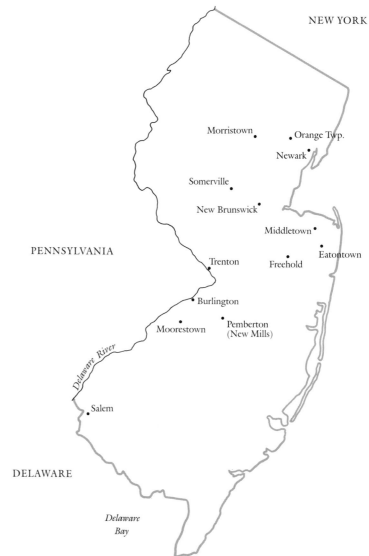

NEW YORK

• Morristown
• Orange Twp.
Newark •

Somerville •

New Brunswick •

Middletown •

PENNSYLVANIA

Trenton •
Freehold •
Eatontown •

• Burlington

Moorestown •
• Pemberton
(New Mills)

Delaware River

Salem •

DELAWARE

*Delaware
Bay*

1 inch = 29 miles

Joseph James, a moderately prosperous farmer at Woodstown, southern New Jersey, in 1767 owned "4 Low backed Windsor Chairs," which complemented rush-bottomed seating in his "Front Room below Stairs." A combination dining room and parlor, this area was the most important room in the house from a social standpoint. By the century's end when Samuel Stout, Jr., a Princeton silversmith, furnished his house with Windsor and rush-bottomed seating, Windsors were common throughout New Jersey except in rural areas distant from the main commercial routes. Such regions were strongholds of rush-bottomed seating into the nineteenth century.[46]

SOUTHERN NEW JERSEY

The earliest documented New Jersey Windsor is branded on the seat bottom "E·HEWES" and "SALEM," a community southeast of Wilmington, Delaware (fig. 4-34). At midcentury Peter Kalm described Salem, whose principal commerce was with Philadelphia, as "a little trading town, situated a short distance from the Delaware River." While Ezekiah Hewes's fan-back side chair shows Philadelphia influence, it varies sufficiently from general metropolitan design to indicate that the chairmaker

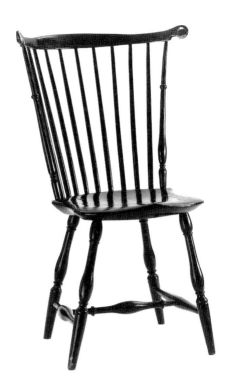

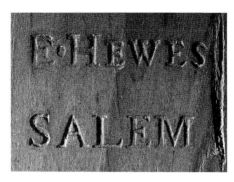

Fig. 4-34 Fan-back Windsor side chair and detail of brand, Ezekiah Hewes, Salem, N.J., 1790–1800. Yellow poplar (seat); H. 35½", (seat) 17⅞", W. (crest) 23¼", (seat) 16¼", D. (seat) 16⅝"; left post and right stretcher probably replaced. (Mr. and Mrs. Roy S. Olsen collection: Photo, Winterthur.)

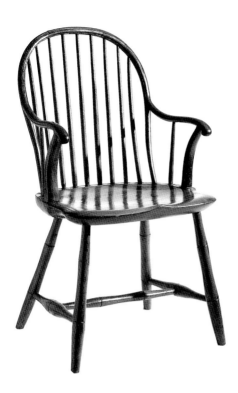

Fig. 4-35 Bow-back Windsor armchair, Ezekiah Hewes (brand "SALEM / E·HEWES"), Salem, N.J., ca. 1798–1805. Yellow poplar (seat) and mahogany (arms); H. 35 1/16", (seat) 17⅛", W. (arms) 21½", (seat) 21¼", D. (seat) 16½"; left arm support replaced. (Private collection: Photo, Winterthur.)

received his training elsewhere. Hewes married at Salem in 1786, probably about the time he commenced chairmaking. After his first wife's death, he remarried in 1794 at the Quaker Meeting House in Concord, Pennsylvania, near Philadelphia. This connection with an area family suggests that Hewes had trained with a Quaker chairmaker in southeastern Pennsylvania. During the early 1780s, the likely period of Hewes's apprenticeship, Concord Township was part of eastern Chester County, whose western and southern boundaries join Lancaster County, Pennsylvania, and Cecil County, Maryland. The southeastern Pennsylvania features that influenced Cecil County chairmaking are evident in Hewes's design in the extremely long leg balusters and ringed back posts (fig. 4-23). Another Hewes chair, a bow-back Windsor armchair, conforms more closely to the Philadelphia model (fig. 4-35). The bends forming a waist in the bow suggest that he adopted the general design after it had been in the market for several years. John Letchworth of Philadelphia bent the bow of his late fancy armchair in the same fashion, although the arch is taller and more rounded (fig. 3-53). Hewes copied other Philadelphia features, such as the crowned bow face and the beads edging the arms and posts. Impressed on the plank are the brands found on the fan-back chair but in reverse order, indicating that Hewes had two separate irons.[47]

North of Philadelphia along the Delaware River was Burlington, described by Isaac Weld as "one of the largest [cities] in New Jersey, built partly upon an island and partly on the main shore." In the 1790s the "city" included about 200 houses and a young ladies' academy. The rural landscape surrounding the community was a deceptive backdrop for a decidedly cosmopolitan citizenry. Communication between Burlington and Philadelphia was frequent and regular, and contemporary evidence suggests that Windsor furniture was in common use. About 1810, for example, area resident Joseph Shinn and his wife Mary commissioned illustrated birth records of their three daughters. The watercolor drawing made for Elizabeth, born in 1795, features a domestic scene with figures, possibly her parents, and furniture comprising matching chests of drawers and fan-back Windsors viewed from the top (fig. 4-36). The costumes suggest an early 1790s date, about the time the Shinns began their married life, and the furniture may represent actual household items.[48]

South of Burlington and nearly opposite Philadelphia, William McElroy operated a chair shop in or near the village of Moorestown, then part of Chester Township.

Fig. 4-36 Birth record of Elizabeth Shinn, probably Burlington Co., N.J., ca. 1805–10. Pen-and-ink and watercolor on paper; H. 7 9/16", W. 10 13/16". (Philadelphia Museum of Art, gift of Mrs. William D. Frishmuth.)

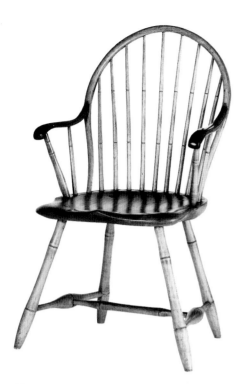

Fig. 4-37 Bow-back Windsor armchair, William McElroy (brand "W·M'Elroy"), Moorestown, N.J., area, ca. 1798–1805. Yellow poplar (seat) with maple, oak, hickory, and mahogany (arms) (microanalysis); H. 38″, (seat) 17½″, W. (arms) 22″, (seat) 19″, D. (seat) 17½″. (Winterthur 71.597.)

Production began with bow-back Windsor chairs, settees, and children's furniture. A New Jersey militia census identifies McElroy as a Chester Township resident in 1793, and as late as 1830 and 1840 federal census records place a William McElroy in the same area. Between 1813 and 1818 McElroy regularly purchased painting materials from Amos Stiles, a Moorestown wheelwright and vehicle manufacturer. Stiles's records and the militia census generally define McElroy's known chairmaking career, as exhibited by his documented furniture. In 1793 the craftsman was probably an apprentice or journeyman, since the moderate bends of his chair bows are associated with late 1790s Philadelphia work (fig. 4-37). His side chairs and armchairs have saddled, shield-shaped seats, well-formed bamboo legs, and crowned bow faces; spindles are usually grooved. McElroy constructed his armchairs with curved or bamboo arm supports and scroll arms, some of mahogany, which duplicate the best contemporary metropolitan work. Although the paint has been stripped from the illustrated chair, the light wood suggests the pale yellow color first popular in the 1790s and demonstrates the effectiveness of contrasting light-painted surfaces with dark, natural-wood arms finished in stain and varnish. McElroy's name brand, like that of Hewes, employs uppercase letters in two sizes.[49]

McElroy's square-back production is varied. The chairmaker took full advantage of the flexible style to create both single- and double-bow designs of straight and arched tops, with and without medallions (fig. 4-38). Armchairs have elbow rests that cap short posts or extend beyond them, and all understructures consist of four-part bamboo legs and box stretchers. The latest documented McElroy chair, a broad slat-back Windsor dating to the early 1820s, has a tradition in the Stokes family, many of whom were nineteenth-century Burlington County residents. Similar chairs were constructed in Philadelphia by 1817, as demonstrated in Anthony Steel's shop inventory.

A double-bow side chair branded "S. ROBERTS / NEWMILLs" relates closely to McElroy's work, and the men may have been associated early in their careers (fig. 4-39). The square-back pattern appears to have been Roberts's first, an indication that he entered the trade later than McElroy. Both men constructed Windsors into the 1820s. Roberts may have worked elsewhere before settling at New Mills, since he branded that place-name on his chairs with a separate iron whose letters are larger and cruder than those on his name brand. The chairmaker likely acquired his location stamp after the

Fig. 4-38 Square-back Windsor side chair, William McElroy (brand "W. McElroy."), Moorestown, N.J., area, 1805–15. H. 32¼″, W. 16″, D. 15½″. (Private collection: Photo, Winterthur.)

Fig. 4-39 Square-back Windsor side chair, S. Roberts (brand "S·ROBERTS / NEWMILLs"), Pemberton, N.J., 1805–15. Yellow poplar (seat) with maple and hickory; straw-color ground with black, tan, and reddish brown; H. 32″, (seat) 17″, W. (crest) 17½″, (seat) 16¼″, D. 15⅝″; legs tipped; paint possibly refurbished. (Mr. and Mrs. James Palmer Flowers collection: Photo, Winterthur.)

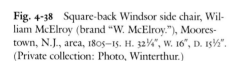
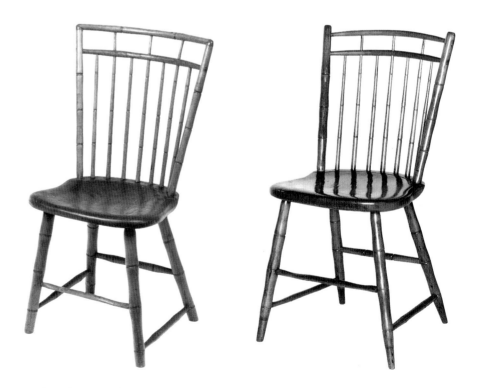

name iron was in use; the clumsy letters suggest a rural blacksmith. The small village of New Mills on the Rancocas Creek began as a prerevolutionary grist- and sawmill site and was incorporated as Pemberton in 1826. Roberts may have originally located farther west in Burlington County along the Delaware River. The 1793 militia census notes a Samuel Roberts in Chester Township, McElroy's neighborhood, and local records of the neighboring Evesham Township Monthly Meeting of Friends list the same name. The rising mill community likely offered the youthful chairmaker greater opportunity.[50]

Between 1750 and the 1790s, Trenton doubled in size and became the state capital. At the latter date Weld described a community consisting of about 200 houses and four churches lining "commodious" streets, although he called the statehouse "a heavy clumsy edifice." Notwithstanding the stir of legislative and court sessions, bargaining in the marketplace, and the general din of daily business, another Englishman saw Trenton only as "a neat country town." The community was a haven for those traveling between New York and Philadelphia, a trip considerably improved in 1806 with the construction of a bridge over the Delaware.[51]

Trenton's prosperous business climate enabled several chairmakers to establish shops. Some authors have associated the names of Alexander Carr and Alexander Chambers with the local spinning-wheel and Windsor-chair businesses before and after the Revolution, but published evidence fails to support these claims. In 1759 when David Chambers, Sr., Philadelphia stonecutter, died, his brother Alexander (trade undocumented) of Trenton served as estate administrator; the name Alexander occurs in other earlier and later Philadelphia records. The brand "A.CARR" appears on Windsor chairs and spinning wheels found in Chester County, Pennsylvania, dating to the 1780s and 1790s (fig. 3-103). In Carr's case, the New Jersey association is unsubstantiated; based on available evidence, the Chambers link to New Jersey chairmaking is also indefinite. Both documents and furniture, however, substantiate activity by several early nineteenth-century Trenton chairmakers.[52]

The work of Daniel Baker and Ebenezer Prout Rose follows standard Delaware Valley square-back Windsor design. Baker's double-bow medallion chair duplicates the Roberts chair profile, except for the crest embellishment, and, aside from rounded seat edges, is similar to a chair made by Philadelphian Joseph Burden (fig. 3-119, left). Baker's chairmaking career began shortly after 1800 and ended in 1812 with his enlistment into military service. Following his 1815 discharge he became armorer of the Trenton arsenal. Rose started his Windsor-chair and spinning-wheel business in 1807 and selected an advantageous Second Street location "opposite the State-House." Rose appears to have supplemented his shop sales by placing spinning wheels on consignment in stores at Burlington and Rowley's Mills. The craftsman owned or rented the entire building housing his Trenton establishment, as implied by cabinetmaker John Fithian who in 1808 identified his own business location as "in the building of Ebenezer P. Rose, Chair Maker." Two double-bow, square-back armchairs bear Rose's brand. Both feature a long, hollow-cornered, rectangular crest medallion and turned arms extending beyond the short posts; front seat edges vary slightly (fig. 4-40). One plain, standard-type chair has seven long bamboo spindles, none extending to the upper bow. In the illustrated fancy Windsor, the number of spindles is reduced to four; two anchor in the top bow, and all contain a centered, rectangular ornament. A medallion in the front stretcher between shapely bamboo legs and pointed toes gives the understructure a stylish flair that balances the chair back. The freehand ornament appears original and relates stylistically to the decoration of several contemporary Delaware Valley chairs. The similarity of this Windsor to regional fancywork is understandable, since Rose's 1807 advertisement also informed the public that he had "acquir[ed] his art from BENJAMIN LOVE at Frankford" (figs. 3-120, 4-31). Frankford was then a suburb and now forms a district of Philadelphia. Rose continued the chairmaking business until his death in 1836, just prior to his fifty-second birthday. An 1819 exportation record documents his shipment of chairs from Philadelphia to the West Indies, while his household inventory describes several sets of Windsor chairs in stylish colors, such as green, yellow, rust, and sage.[53]

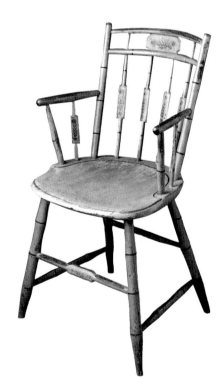

Fig. 4-40 Square-back Windsor armchair, Ebenezer Prout Rose (brand "E.P.ROSE"), Trenton, N.J., 1810–15. H. 34¼", (seat) 16⅞", W. (arms) 20", (seat) 18⅜", D. (seat) 17". (Marjorie Wyman collection.)

As Baker and Rose retailed their Windsors, William Kerwood, a local cabinet- and chairmaker located "opposite The Market House," offered competitive "imported" Windsors made across the river in Pennsylvania. Kerwood's August 1808 advertisement in the *State Gazette* announced his sale of "Windsor chairs, manufactured by Samuel Moon, near Morrisville" and stated that "the general applause [of] Mr. Moons work . . . makes any recommendation of it unnecessary." The date coincides with Moon's return to his native Fallsington (near Morrisville) from Downingtown, Chester County.[54]

NORTHERN NEW JERSEY

Windsor chairs bearing the "S.JAQUES" stamp are contemporary with those made by William McElroy and Ezekiah Hewes in southern New Jersey. The Jaques chairs range in date from about 1795 to 1810. Of the three known branded examples, two fall outside direct Delaware Valley design influence and instead demonstrate knowledge of New York chairmaking. The family name "Jaques" (or Jacques) occurs frequently in records for counties fringing New York City from Monmouth north to Essex, but only "Samuel" qualifies as a given name. There are three possibilities: Samuel E. of Middlesex County (d. 1802); Samuel, Sr., of Woodbridge in the same county (d. 1803); and a Samuel mentioned in the 1811 estate accounts of Stephen Vanbrackle of Freehold, Monmouth County. The last probably refers to the chairmaker. Vanbrackle's inventory also shows that he had eleven Windsor chairs in his household.[55]

The earliest branded Jaques Windsor is a bow-back side chair with bulbous turnings and a flat-faced, backward-canted bow imitating New York prototypes (fig. 4-41). Only the unusual character of the seat prevents the chair from passing for a metropolitan Windsor. New York shield-shaped planks of the 1790s turn down, or droop, at the front corners (fig. 5-14), while the Jaques seat exhibits a cupped appearance. The prominence of this slightly provincial feature suggests that Jaques copied New York models but probably had no direct working experience in the city.

The next Jaques chair in chronological sequence is a bow-back armchair with bamboo-style turnings (fig. 4-42). This design differs so completely from the first chair that only the presence of the same brand under the seat ascribes it to the New Jersey chairmaker. The basic form derives from Delaware Valley work, and Freehold is indeed

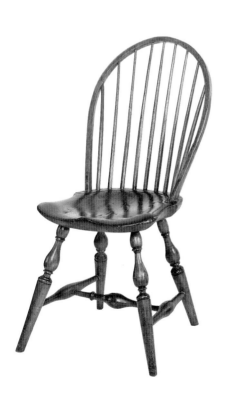

Fig. 4-41 Bow-back Windsor side chair, S[amuel?] Jaques (brand "S·JAQUES"), New Jersey, probably Monmouth Co., 1795–1805. (Monmouth County Historical Association, Freehold, N.J.)

Fig. 4-42 Bow-back Windsor armchair and detail of brand, S[amuel?] Jaques, New Jersey, probably Monmouth Co., ca. 1800–1808. Yellow poplar (seat); H. 38¾", (seat) 17⅞", W. (arms) 21", (seat) 18¾", D. (seat) 18⅛". (Philip H. Bradley Co.: Photo, Winterthur.)

Fig. 4-43 Detail of arm of figure 4-42.

only about thirty miles from Trenton. Jaques interpreted the Philadelphia crowned bow face with a single outside groove, and his forward placement of the bow ends on the seat creates awkward voids at each side of the back. The arm's attachment to the bow is unusual. Rectangular tenons pierce conforming mortises at shallow rabbets cut into the bow face (fig. 4-43). The slender arm rests terminate at the front in tiny, snoutlike scrolls of distinctive profile. In Philadelphia work the small platforms behind the scrolls cap curved supports rather than bamboo turnings, as here. In contrast to the chair's substantial Philadelphia influence, the large, horseshoe-shaped seat, which merely suggests a shield form at the front, relates more to early nineteenth-century New York planks or even to Baltimore work.

A slightly later Jaques chair is as individual as his previous designs (fig. 4-44). At first sight, the square back appears to follow a Philadelphia pattern (fig. 3-112); however, the profile is closer to New York interpretations, such as those labeled by Charles Marsh after 1800 (fig. 5-32). In the New Jersey and New York Windsors the posts flare more at the top than in Philadelphia models; crest and post surfaces are flat and incised with beads rather than crowned like Delaware Valley work. Philadelphia cross rods arch in a low serpentine curve, while New York rods are straight or swelled slightly, top and bottom, at the center. Jaques chose a thick top piece of the latter profile. His chair seat follows a squared-shield pattern found in a New York chair made by Reuben Odell, which is datable (through the label address and directory listings) to 1803 at the earliest and more likely between 1806 and 1809 (fig. 5-33). The Jaques chair was therefore probably made between 1803 and 1810. The understructure duplicates that of his armchair, the increased leg splay compensating for the smaller seat.

Windsor furniture was popular in the New Jersey counties surrounding New York City, especially from the 1790s when the industry became prominent in the metropolitan area. Chairs itemized in early nineteenth-century probate documents probably represent both local seating and New York production and indicate the popularity of side chairs and the above-average use of the more expensive armchair. Prior to his death in 1801, Peter Anspach, a storekeeper of Middletown, Monmouth County, furnished his home with sixteen Windsor chairs and mahogany seating. In nearby Eatontown, John Wilson made Windsors at the start of the century. Householders bought directly from him or from George Corlies, a general Eatontown storekeeper with whom Wilson exchanged goods. In New Brunswick, Middlesex County, an eleven-piece set of green Windsors that furnished John Lupp's home in 1805 included two armchairs, and twenty-three wooden-seat chairs were scattered throughout the Reverend Joseph Clark's residence. The men may have patronized Campbell Dunham, owner from 1793 of a chair shop "at the upper end of Albany-Street, nearly opposite the Printing Office." Dunham's 1801 and 1805 advertisements identify Windsor, fancy, and "rush matted" production. At their Albany Street shops near the White Hall tavern, Joseph Ward and Henry V. Low offered Windsor chairs in 1797/98 and 1804. Low's entry into the dry goods and grocery business by 1812 may reflect the pressures of local competition or increasing commercial influence from New York.[56]

Somerset County residents who owned Windsor seating included two farmers and Jacob Ten Eyck, a captain in the revolutionary war. Andrew Coeyman owned "one doz Windsor chairs 2 with arms" and "one doz common Green windsor chairs." Somerville cabinetmaker Philip P. Tunison furnished his home with "8 black stick Chairs," possibly of his own construction, before his death in 1813. Moses Force, probably a clockmaker and engraver, of Morristown, Morris County, had equal numbers of Windsor and "Slat back Chares" in 1801. The substantial Bergen County estate of Thomas Gautier, Esq., valued at more than $8,000 in 1802, contained a dozen Windsor chairs and a settee. Two 1820s appraisals provide more descriptive notes. Ann Corlies's Monmouth County home had two "small" wooden-bottom chairs and a set of green Windsors comprising six side chairs and two armchairs. Appraisers of Jared Harrison's small Orange Township, Essex County, estate recorded "8 best green chairs 6 doll[ars]" and "eight other green chairs 3 doll," all later identified as Windsors at Harrison's personal property sale.[57]

Fig. 4-44. Square-back Windsor side chair, S[amuel] Jaques (brand "s·JAQUES"), New Jersey, probably Monmouth Co., ca. 1803–10. Yellow poplar (seat) with maple, oak, and hickory; H. 35″, (seat) 16⅞″, W. (crest) 19″, (seat) 15⅝″, D. (seat) 15″. (Winterthur 80.1.)

Surviving records, at best, provide only glimpses of organization and business practice among American chairmakers who flourished before 1850. The records of David Alling of Newark and William G. Beesley of Salem serve to explicate the craft's dimensions at metropolitan versus rural sites and to illuminate the scope of operations within the large and small shop.

Newark, a "city" of several thousand people, began to distinguish itself as a small manufacturing center before the nineteenth century. The community's location on the Passaic River in Essex County provided direct water access to the New York City business district nine miles away. The ease of communication and transportation between the two places influenced Newark's development. Mail coaches and travelers between Philadelphia and New York passed through Newark, encouraging "a number of good inns." Many visitors commented on the town's handsome appearance, noting that the streets were lined with trees, attractive houses, and neat gardens. Public buildings included churches, a courthouse, prison, market, and combination academy and Masonic hall. When in 1834 *The Traveller's Guide* described Newark as "one of the most elegant villages in the union," the population was about 15,000 and the city had just become a port of entry. Exports in 1835 reached a value of $8 million and included leather goods, clothing, carriages and parts, metalware, cabinetware, and chairs.[58]

Alling's career spanned a half century of community growth. He is the best known of Newark's chairmakers, who numbered seventy-nine in 1826. Writing later in the century, Joseph Atkinson remarked that Alling, "a leading manufacturer for many years . . . was highly esteemed as one of the most active and energetic business men of the town. He established a high reputation for style and workmanship, and not only supplied a large home trade but an extensive Southern demand, especially between the years 1825 and 1836." Alling probably learned his trade from his father Isaac, also a Newark chairmaker. The younger Alling began his own business shortly before 1801, the earliest date recorded in his business accounts. During his long career Alling maintained many contacts with parts and materials suppliers and master craftsmen throughout the Newark-New York City area. Based on extensive recorded activity, Alling appears to have launched his fancy- and Windsor-chair-making business on a fairly substantial scale. He learned the trade quickly during several years' experience as a journeyman, either in Newark or New York. An early, but short-lived, metropolitan contact for chair sales was William Palmer, proprietor of a prosperous chair- and furniture-painting business. Newcomer Alling's somewhat overzealous record keeping irritated Palmer, who indicated that his word was as good as his signature. An entry in Alling's first receipt book leaves no doubt about Palmer's state of mind: "Recei'd New York July 12. 1803 from Dav'd Alling 14 Dozen & 2 Chairs for which I paid him £97.12 at the same time and for which he very foolishisly demand a Rec't and which is the last Wm Palmer." [59]

Alling's records detail his reliance on outside parts suppliers and skilled specialists. Linus Condit turned and hand-shaped more than 30,000 individual chair components for Alling in a fifteen- to eighteen-month period in 1801/2. He supplied all the necessary chair parts except the seats or seating materials, from "benders" (curved top pieces) to "rounds" (stretchers). Early production centered on the fancy chair fashioned with spindles and stretchers of related design, which he described as "oval," "squar'd" (with medallions), or "Cumberland" patterns. The last probably combined upright and inverted teardrop forms, the elements separated by a small bead or disk (fig. 5-34). Accounts from the 1810s describe Moses Lyon's work in decorating or embellishing thousands of chairs, cornices, and other furniture forms. Standard colors ranged from cane to black with more flamboyant finishes available in coquelicot (poppy), satinwood, or rosewood.[60]

Alling produced Windsor seating throughout his career. In 1816 he offered a choice of four spindle patterns—plain, bamboo, flat (arrow shape), and "organ," probably the greater New York name for the highly ornamental bamboo-type spindle illustrated in

Fig. 4-45 *House and Shop of David Alling*, Newark, N.J., 1835–45. Oil on canvas; H. 21″, W. 30″. (Newark Museum, Newark, N.J.)

figure 5-43. The chairmaker combined all patterns with a slat-style crest. Bent-back Windsors are first named in Alling's books in 1819, and several 1820 entries mention square seats, possibly fashioned after a Baltimore pattern (figs. 4-4, 4-5). Alling produced a roll-top Windsor by 1832 and a flat-top, or large Grecian-style tablet-top, chair by 1836.[61]

Broad Street, a busy Newark thoroughfare, was the location of Alling's shop and house long before he advertised in 1830 that he continued to "manufacture . . . Sitting Chairs at his old stand" (fig. **4-45**). The painted view of his property is a rare document, rendered even more unusual by the existence of a second version which exhibits subtle differences in figure placement within the scene. Alling's business was prosperous at this date. His wide-ranging chair production offered the public "Curled Maple Grecian Cane-seat Chairs, Curled Maple Rush-seat Chairs, a commoner article, Cane and Rush bottom Fancy Chairs of most fashionable patterns. Windsor and Common Chairs— together with Rocking and children's Chairs." In 1833 a large shipment to J. Clark and Company of Mobile, comprising fancy and Windsor chairs, included roll-top rush seating of both "inferior" and "better" quality. Alling guaranteed that his chairs would "do good service," although his merchandising of "a commoner article" may have made that promise hard to keep at times. Long-distance consumers sometimes experienced difficulties in gaining satisfaction for a product's shortcomings. In a January 4, 1801, letter concerning business conditions at Savannah, John Hewitt, a furniture middleman and later a New York cabinetmaker, wrote to Matthias Bruen, a Newark cabinetmaker and merchant, complaining about chairs purchased from Alling: "I would thank you to satisfy that fearful man Alling for thes[e] Chairs and Deduct for Varnish and Varnishing five Dollars. That is what I have pay'd. I would of return'd them on [h]is hands if I had seen them before I sail'd, for they are finished in a shamefull manner. And [h]as chargd more then Common and was not finished." His choice of the word *fearful* may also explain Palmer's consternation over signing Alling's receipt book in 1803. Ironically, in spite of Alling's comprehensive business records, no known chairs are documented to his shop. The Newark Museum attributes an unmarked, fancy, cane-seat, roll-top chair with a cross slat shaped and painted to form double cornucopias to Alling because it descended in the family of his first cousin John Alling III.[62]

Alling's highly commercial operation in northern New Jersey contrasts greatly with Beesley's business in Salem, a small southern New Jersey county center near the Delaware River. As "a snug little, out-of-the-way town—the market of a rich and widely-cultivated tract," Salem in 1830 had a population of only 1,570, although the community enjoyed daily communication with Philadelphia via stage and steamer. Beesley's day-book records his chairmaking activity between 1828 and 1836, the period when Alling enjoyed a flourishing export trade and thriving metropolitan business. Local customers patronized Beesley's shop on East Broadway as frequently for painting and repairs as to purchase new seating furniture. When other woodworkers exchanged cabinetwork for chairs, Beesley bartered that merchandise for still more goods and services. Like Alling, the chairmaker purchased many, perhaps all, of his chair parts. During the 1820s as turning mills permitted inexpensive mass production of round parts, Nathaniel G. Swing of Salem County erected a large, horse-powered machine works to manufacture turned and ornamental work. Beesley was a local customer, although Swing also sold chair parts in Philadelphia and New York. The increase in similar activity throughout the country explains why regional characteristics in furniture became more tenuous as the nineteenth century progressed.[63]

When Beesley began his accounts, his stock consisted of bent-back and straight-back chairs, probably duplicates of those made in Philadelphia (figs. 3-132, 3-134, 3-137). He framed purchased parts, finished surfaces with paint and ornament, and sold the product, charging 83¢ for a plain Windsor and $1.17 for a highly decorated one. In 1829 Beesley introduced slightly more expensive ball-back and scroll-back chairs to his stock, although neither sold in great quantity. These chairs had ball spindles, purchased from Swing, and either lipped tablet tops (scrolled across the upper back) or Grecian-style slat backs with scroll-back posts (figs. 3-142, 3-139). The broad-top chair mentioned in 1834 may have duplicated a Philadelphia pattern with a wide slat (fig. 3-132). Beesley also sold rocking and sewing chairs, settees, children's furniture, and stools of two sizes. As business was prospering, the chairmaker wrote in his accounts on August 2, 1834, "This day transferd my stock in Trade to Elijah Ware." Beesley began to work for the young man who had formerly been a hired hand in the shop and henceforth painted and ornamented chairs, a less strenuous job than framing. In another formal agreement with Ware on March 25, 1835, Beesley agreed "to tend his shop and ornament his Chairs at $1.00 per week." Beesley's activity decreased substantially after he transferred the shop to Ware, and his health may have been failing. The craftsman died in 1842 at about age forty-five.[64]

The existence of only a basic group of documented Windsor furniture prevents a wide-ranging exploration of New Jersey chairmaking. The documents and objects examined, however, demonstrate that area production was heavily influenced by seating styles in commercial centers adjoining the state's northeastern and western boundaries. Occasional local eccentricities add a measure of provincial interest to New Jersey Windsors.

Notes

1. H. E. Scudder, ed., *Recollections of Samuel Breck* (Philadelphia: Porter and Coates, 1877), p. 266; Jedidiah Morse, *The American Geography* (Elizabethtown, N.J.: Shepard Kollock, 1789), p. 353; Richard Walsh and William Lloyd Fox, eds., *Maryland: A History, 1632–1974* (Baltimore: Maryland Historical Society, 1974), pp. 87–91; J. F. D. Smyth, *A Tour in the United States of America*, vol. 2 (London: G. Robinson, 1784), p. 186; Kenneth Roberts and Anna M. Roberts, trans. and eds., *Moreau de St. Méry's American Journey [1793–1797]* (Garden City, N.Y.: Doubleday, 1947), p. 81; Duc de La Rochefoucauld Liancourt, *Travels through the United States of North America*, vol. 2 (London: R. Phillips, 1799), p. 129.

2. Roberts and Roberts, *Moreau Journey*, pp. 76–77; Isaac Weld, *Travels through the States of North America*, vol. 1 (London: John Stockdale, 1800), pp. 43, 59–60; Henry Bradshaw Fearon, *Sketches of America* (2d ed.; London: Longman, 1818), p. 341; Walsh and Fox, *Maryland*, pp. 164–97; W[illiam] Chambers, *Things as They Are in America* (Philadelphia: Lippincott, Grambo, 1854), p. 254.

3. William Voss Elder III, *Baltimore Painted Furniture, 1800–1840* (Baltimore: Baltimore Museum of Art, 1972); John Henry Hill, "The Furniture Craftsmen in Baltimore, 1783–1823" (Master's thesis, University of Delaware, 1967), appendix A.

4. Annapolis Port of Entry Books, vol. 1, 1756–75, Inward Entries, Maryland Historical Society, Baltimore (hereafter cited as MDHS); Oxford Port of Entry Account Books, 1759–73, Inward Entries, MDHS; James Brice, ledger, 1767–1801, private collection (microfilm, Maryland Hall of Records, Annapolis [hereafter cited as MDHR]) (reference courtesy of Karin E. Peterson); Richard K. Doud, "John Hesselius, Maryland Limner," in *Winterthur Portfolio 5*, ed. Richard K. Doud (Charlottesville: University Press of Virginia, 1969), appendix D.

5. Alice Hanson Jones, *American Colonial Wealth*, vol. 2 (New York: Arno Press, 1977), pp. 1183, 1192, 1221; Richard Bennett Lloyd, estate records, 1788, Talbot Co., Register of Wills; Edward Lloyd, estate records, 1796, Talbot Co., Register of Wills; Karol A. Schmiegel, "Encouragement Exceeding Expectation: The Lloyd-Cadwalader Patronage of Charles Willson Peale," in *Winterthur Portfolio 12*, ed. Ian M. G. Quimby (Charlottesville: University Press of Virginia, 1977), pp. 87–102.

6. Mark Pringle to Daniel of St. Thomas Jennifer, January 13, 1784, Maryland State Papers, MDHR (document brought to author's attention by William Voss Elder III). The Hoffman portraits are in a private collection (photo, Visual Resources Collection, Winterthur Library [hereafter cited as VRC]). The Lemmon portrait, oil on canvas, ca. 1780–97, is possibly by James Peale (Historical Society of Pennsylvania, Philadelphia [hereafter cited as HSP]; photo, VRC).

7. The location of the Lawson portraits is unknown (photo, VRC). The Whetcroft portrait is at Yale University Art Gallery, New Haven, Conn. A photo of Somerset Co. courthouse chairs is in photographic files, no. 10,376, Museum of Early Southern Decorative Arts, Winston-Salem, N.C. (hereafter cited as MESDA).

8. Baltimore Outward Entries, 1792–99, U.S. Customhouse Records, French Spoliation Claims, National Archives, Washington, D.C.; Caleb Hannah, *Federal Gazette and Baltimore Daily Advertiser*, December 2, 1799 (citation file, MESDA); William Snuggrass, advertisement in *American Daily Advertiser* (Baltimore), March 28, 1800 (reference courtesy of Dwight Lanmon); Oldham cited in Hill, "Furniture Craftsmen in Baltimore," p. 187.

9. Godfrey Cole, estate records, 1804, Baltimore Co., Register of Wills (microfilm, Joseph Downs Collection of Manuscripts and Printed Ephemera, Winterthur Library [hereafter cited as DCM]); John Oldham bill to Wessels, August 17, 1803, Wessels and Primavesi Papers, MDHS (reference courtesy of Dwight Lanmon); Benjamin C. Colhoon, receipt book, 1807–12, HSP.

10. For a discussion of Finlay fancy furniture, see Elder, *Baltimore Painted Furniture*, pp. 28–29.

11. A settee at Winterthur, no. 59.3627, is framed with the varient wing-end crest having a hollow-cornered rectangular projection at the center.

12. Thomas Hope, *Household Furniture and Interior Decoration* (1807; reprint, New York: Dover Publications, 1971), pls. 45, 60. Pewterers' touchmarks of the 1810s are illustrated in Ledlie Irwin Laughlin, *Pewter in America* vol. 2 (1940; reprint, Barre, Mass.: Barre Publishers, 1969), pl. 68, nos. 567, 568.

13. John Barnhart ornamented a suite of furniture with comparable decoration for chairmaker Thomas Renshaw around 1812, as illustrated in Elder, *Baltimore Painted Furniture*, pp. 42–43.

14. The works of the Finlays and Renshaw are discussed and illustrated in Elder, *Baltimore Painted Furniture*, pp. 20–27, 42–44. For insights on Francis Guy as painter of the "real views" on the Morris family furniture, which is attributed to the Finlay brothers, see Stiles Tuttle Colwill, *Francis Guy, 1760–1820* (Baltimore: Maryland Historical Society, 1981), pp. 23–25, 75–85. Finlay Brothers, advertisement in *Federal Gazette and Baltimore Daily Advertiser*, October 24, 1803, and November 8, 1805, as quoted in Elder, *Baltimore Painted Furniture*, pp. 11, 95.

15. *American and Commercial Daily Advertiser* (Baltimore), October 6, 1825.

16. Bryson Gill, *Matchett's Baltimore Directory for 1824* (Baltimore: R. J. Matchett, 1824), n.p.; [Pierre] de la Mésangère, *Meubles et objets de goût, 1796–1830*, comp. Paul Cornu (Paris: Librairie des arts décoratifs, [1914]), pl. 79, lower left; Finlay brothers, advertisement in *Baltimore American*, December 19, 1810, as quoted in Gregory R. Weidman, *Furniture in Maryland, 1740–1940* (Baltimore: Maryland Historical Society, 1984), p. 77.

17. For various beehive forms, see Elder, *Baltimore Painted Furniture*, pp. 47–69. Mésangère, *Meubles*, pls. 49 (bottom), 71 (bottom left), 79 (3d row left); photo of Miller chair in Photographic Files, no. 6,833, MESDA.

18. Oak-leaf borders are illustrated in Elder, *Baltimore Painted Furniture*, pp. 53–54, 86–87.

19. For spear motifs, see Elder, *Baltimore Painted Furniture*, pp. 78–79. Younker advertisement in *American and Commercial Daily Advertiser*, September 12, 1810 (citation file, MESDA).

20. The pair of anthemion-decorated chairs is illustrated in Zilla Ryder Lea, ed., *The Orna-*

mented Chair (Rutland, Vt.: Charles E. Tuttle Co., 1960), p. 150, figs. 10, 11. At one time the rural Maryland chairs of the color plate were accompanied by an eight-legged, slat-back, arrow-spindle settee dating from about two decades earlier, as indicated by the presence of a former finish of green paint under the present pale mustard coat.

21. Mésangère, *Meubles*, pls. 41 (top), 49, 71 (top). The Hisky pianoforte is illustrated in Elder, *Baltimore Painted Furniture*, pp. 86–87.

22. George Jacob Schley, estate records, 1811, MDHR (photostat, DCM); Thomas Newens, advertisement in *Frederick-Town Herald*, October 27, 1809, November 28, 1812, March 27, 1813, January 15, 1814, and May 18, 1816 (citation file, MESDA); Jacob Thomas and John Thomas, advertisement in *Engine of Liberty and Uniontown Advertiser*, March 24 and July 21, 1814 (citation file, MESDA).

23. Archibald Watt and John Watt, advertisement in *Maryland Herald and Elizabeth-Town Weekly Advertiser* (Hagerstown), March 12, 1801, and January 14, 1802 (citation file, MESDA); John Martiney, advertisement in *Maryland Herald and Hagerstown Weekly Advertiser*, January 26, 1814 (citation file, MESDA); Smyth, *Tour*, 2:257–58; Henry Wansey, *An Excursion to the United States of North America in the Summer of 1794* (2d ed.; Salisbury, England: J. Easton, 1798), p. 167; John Bradshaw, advertisement in *Maryland Herald and Hagerstown Weekly Advertiser*, August 23 and October 11, 1815, April 25, 1820.

24. The Baltimore Museum of Art bench is illustrated and described in William Voss Elder III and Jane E. Stokes, *American Furniture 1680–1880 from the Collection of the Baltimore Museum of Art* (Baltimore: Baltimore Museum of Art, 1987), pp. 57–58. Liancourt, *Travels*, 2:352; Joseph Scott, *A Geographical Description of the States of Maryland and Delaware* (Philadelphia: Kimber, Conrad, 1807), p. 120.

25. Richard Thomas, estate records, 1807, Montgomery Co., MDHR.

26. Roberts and Roberts, *Moreau Journey*, p. 88. Population figures based on actual enumerations are unavailable for Wilmington between 1775 and 1830. The estimate has been calculated using a city figure of "over 1,200" for 1775 and state enumerations for 1775 and 1787, which reflect a 23 percent increase. See Evarts B. Greene and Virginia D. Harrington, *American Population before the Federal Census of 1790* (New York: Columbia University Press, 1932), pp. 7–8; John A. Munroe, *History of Delaware* (Newark, Del.: University of Delaware Press, 1979), p. 58. Morse, *American Geography*, pp. 33, 346; Liancourt, *Travels*, 2:250.

27. Liancourt, *Travels*, 2:263–64; Jonathan L. Fairbanks, "The House of Thomas Shipley, 'Miller at the Tide' on the Brandywine Creek," in *Winterthur Portfolio 2*, ed. Milo M. Naeve (Winterthur, Del.: Winterthur Museum, 1965), p. 157.

28. Charles G. Dorman, *Delaware Cabinetmakers and Allied Artisans, 1655–1855* (Wilmington, Del.: Historical Society of Delaware, 1960), pp. 27–28.

29. Dorman, *Delaware Cabinetmakers*, pp. 11–12. Barnet is listed in Chester Co. returns for state taxes levied from 1779 through 1781, as quoted in William Henry Egle, ed., *Pennsylvania Archives*, 3d ser., vol. 12 (Harrisburg, Pa.: William Stanley Ray, 1897), pp. 194, 328, 369, 624. Lancaster Co. tax assessment information is in Card File of Joiners,

Carpenters, and Cabinetmakers, Lancaster County Historical Society, Lancaster, Pa. Barnet is listed as a Wilmington resident in the 1810 federal census. Margaret Berwind Schiffer, *Furniture and Its Makers of Chester County, Pennsylvania* (Philadelphia: University of Pennsylvania Press, 1966), pp. 28–29.

30. Trumble and Barnet Chester Co. tax data are quoted in Egle, *Pennsylvania Archives*, 3d ser., vol. 12 (1897), pp. 193–94, 327–28. Barnet's tall knuckle-arm chair, which is branded on the seat bottom and accompanied by a label listing his address and furniture production, is illustrated in Dorman, *Delaware Cabinetmakers*, pl. unnumbered, and Deborah Dependahl Waters, *Delaware Collections in the Museum of the Historical Society of Delaware* (Wilmington, Del.: Historical Society of Delaware, 1984), fig. 8. The lower legs of this chair have been replaced, raising questions about the original support pattern. Barnet's working dates and the chair's taper-foot Philadelphia prototypes suggest the leg treatment illustrated in fig. 4-25.

31. James Brobson, shipping record book, 1790–1805, DCM.

32. A Barnet bow-back armchair is at the Historical Society of Delaware, Wilmington.

33. Dorman, *Delaware Cabinetmakers*, p. 37. The inventory is quoted in Harold B. Hancock, "Furniture Craftsmen in Delaware Records," in *Winterthur Portfolio 9*, ed. Ian M. G. Quimby (Charlottesville, Va.: University Press of Virginia, 1974), appendix 2, p. 203.

34. Samuel Nichols and George Young bill to David West, May 7, 1803, DCM; Dorman, *Delaware Cabinetmakers*, p. 62.

35. Dorman, *Delaware Cabinetmakers*, pp. 20–21; Jared Chesnut bill to E. I. du Pont, September 28, 1809, Longwood Mss., Hagley Museum and Library, Wilmington, Del. (hereafter cited as HML). A single-rod child's chair, illustrated in Deborah Dependahl Waters, *Plain and Ornamental: Delaware Furniture, 1740–1890* (Wilmington, Del.: Historical Society of Delaware, 1984), fig. 7, associates Chesnut with other early square-back styles.

36. Jared Chesnut bill to E. I. du Pont, August 13, 1819, Longwood Mss. (reference courtesy of Maureen O'Brien Quimby); photo of an early Chesnut square-back chair is in VRC.

37. Jeannette Lasansky, *A Good Start: The Aussteier or Dowry* (Lewisburg, Pa.: Oral Traditions Project of the Union County Historical Society, 1990), pp. 16, 20–21, 48.

38. A Chesnut tablet-back chair, owned by the State of Delaware, Division of Historical and Cultural Affairs, Bureau of Museums and Historical Sites, is at the John Dickinson Plantation, Dover, Del.

39. Dorman, *Delaware Cabinetmakers*, pp. 20–21. William Chesnut's name appears in "Cabinetmakers and Allied Tradesmen Working in Baltimore, 1800–1840" in Elder, *Baltimore Painted Furniture*, p. 100. A. *M'Elroy's Philadelphia Directory for 1837* (Philadelphia: A[rchibald] M'Elroy, 1837), p. 37. William Chesnut is listed in Wilmington, Del., city directories between 1845 and 1857.

40. Dr. Henry Latimer and Pennell Corbit, estate records, 1820 and 1821, DCM; White and Penny, estate records, as quoted in Dorman, *Delaware Cabinetmakers*, pp. 99–101, 107; *The Wilmington Directory for 1845* (Wilmington, Del.: Lewis Wilson, 1845), p. 100.

41. Caldwell and Wood estate records are quoted in Jones, *American Colonial Wealth*, 1:370–73, 400–401. Christopher Horton bills to State of Delaware, January and October 1791, Legislative Papers, Auditors Accounts, Delaware Hall of Records, State of Delaware, Division of Historical and Cultural Affairs, Dover (references courtesy of Madeline Dunn Hite). Ann M. Baker, "State House, Dover, Delaware," *Antiques* 114, no. 1 (July 1978): 132–39.

42. Dorman, *Delaware Cabinetmakers*; Hancock, "Furniture Craftsmen," including "Listing of Delaware Furniture Craftsmen," Hall inventory, and Prettyman indenture, pp. 181–97, 208; Records of the 1820 Census of Manufactures, State of Delaware, National Archives, Washington, D.C. (microfilm, DCM).

43. William Corbit, estate records, 1818, DCM; David Wilson, assignment of household property, 1829, DCM. Enos biographical data is in Dorman, *Delaware Cabinetmakers*, p. 25, and Waters, *Plain and Ornamental*, p. 22. James C. Helme, "Book of Prices for Making Cabinet and Chair Furnature," 1838, DCM.

44. "Journal of Lord Adam Gordon" in *Narratives of Colonial America*, ed. Howard H. Peckham (Chicago: R.R. Donnelley and Sons, 1971), p. 266.

45. John Coxe, Esq., estate records, 1753, DCM; Adolph B. Benson, ed., *Peter Kalm's Travels in North America*, vol. 1 (New York: Dover Publications, 1966), p. 117.

46. Joseph James and Samuel Stout, Jr., estate records, 1757 and 1795, DCM; Deborah Dependahl Waters, "Wares and Chairs: A Reappraisal of the Documents," in *Winterthur Portfolio 13*, ed. Ian M. G. Quimby (Chicago: University of Chicago Press, 1979), p. 172. Waters quotes an 1856 survey of the Cumberland County chair industry: "Until within a short time since, but few or no chairs and settees were manufactured in this part of the state, except rush bottom chairs."

47. Benson, *Kalm's Travels*, 1:294; William Wade Hinshaw and Thomas Worth Marshall, comps., *Encyclopedia of American Quaker Genealogy*, vol. 2 (Ann Arbor, Mich.: Edwards Bros., 1938), p. 78.

48. Weld, *Travels*, 1:258; Roberts and Roberts, *Moreau Journey*, p. 100.

49. James S. Norton, comp., *New Jersey in 1793: An Abstract and Index to the 1793 Militia Census of the State of New Jersey* (Salt Lake City, 1973), p. 49; Amos Stiles, daybook, 1812–21, HSP.

50. John W. Barber and Henry Howe, *Historical Collections of the State of New Jersey* (Newark, N.J.: Benjamin Olds, 1844), p. 106; Norton, *1793 Militia Census*, p. 49; Hinshaw Card Index to Quaker Meeting Records, Friends Historical Library, Swarthmore College, Swarthmore, Pa.

51. Weld, *Travels*, 2:259; Wansey, *Excursion*, p. 91.

52. References to Carr and the Chamberses are in *Early Arts of New Jersey* (Trenton, N.J.: New Jersey State Museum, 1953), p. 10; *Early Furniture Made in New Jersey, 1690–1870* (Newark, N.J.: Newark Museum Association, 1958), pp. 47–48; Margaret E. White, *The Decorative Arts of Early New Jersey*, New Jersey Historical Series, vol. 25 (Princeton, N.J.: D. Van Nostrand Co., 1964), p. 115; and Walter Hamilton Van Hoesen, *Crafts and Craftsmen of New Jersey* (Rutherford, N.J.: Fairleigh Dickinson University Press, 1973), p. 226. David Chambers, estate records, 1759, Philadelphia Register of Wills; see also chap. 2, n. 4.

53. Baker information was supplied by the New Jersey State Museum, Trenton, N.J., which owns the documented double-bow medallion chair. Ebenezer Prout Rose and John Fithian, *Trenton Federalist*, November 30, 1807, and May 27, 1808 (references courtesy of James R. Seibert). The other Rose double-bow chair is in a private collection. Manifest of schooner *Gleaner*, October 5, 1819, Philadelphia Outward Foreign Entries, U.S. Customhouse Records, National Archives, Washington, D.C.; Ebenezer P. Rose, estate records, 1836, Archives and History Bureau, New Jersey State Library, Trenton, N.J. (hereafter cited as NJSL).

54. Kerwood advertisement in *Trenton Federalist*, August 15, 1808.

55. Samuel E. Rose and Samuel Rose, Sr., estate records, 1802 and 1803, NJSL; Stephen Vanbrackle, estate records, 1811, DCM.

56. Peter Anspach, estate records, 1801, DCM; Wilson accounts listed in George Corlies, account book, ca. 1797–1816, Papers of the Corlies Family, Rutgers University Library, New Brunswick, N.J. (hereafter cited as RUL); John Lupp, estate records, 1805, DCM; Rev. Dr. Joseph Clark, estate records, 1815, James Neilson Papers, RUL; Dunham, Ward, and Low advertisement excerpts, as quoted in *Early Furniture Made in New Jersey*, pp. 54, 67, 85.

57. Jacob Ten Eyck, estate records, 1794, Ten Eyck Family Papers, RUL; Andrew Coeyman, estate records, 1804, James Neilson Papers, RUL; Philip P. Tunison, Moses Force, and Thomas Gautier, Esq., estate records, 1813, 1801, and 1802, DCM; Ann Corlies, estate records, 1822, Papers of the Corlies Family, RUL; Jared Harrison, estate records, 1827, Papers of Abraham Harrison, RUL.

58. Liancourt, *Travels*, 1:545–46; Wansey, *Excursion*, p. 185; Roberts and Roberts, *Moreau Journey*, pp. 112–13; [Gideon Miner Davison], *The Traveller's Guide* (6th ed., Saratoga Springs, N.Y.: G. M. Davison, 1834), pp. 91–92; Joseph Atkinson, *History of Newark, New Jersey* (Newark, N.J.: William B. Guild, 1878), pp. 162, 328.

59. Atkinson, *History of Newark*, pp. 151, 161. David Alling, receipt book, 1802–24, New Jersey Historical Society, Newark, N.J. (hereafter cited as NJHS) (microfilm, DCM). Other Alling accounts are in the same collection. For information on Alling, see also Don C. Skemer, "David Alling's Chair Manufactory: Craft Industrialization in Newark, New Jersey, 1801–1854," *Winterthur Portfolio 22*, no. 1 (Spring 1987): 1–21.

60. David Alling, account book, 1801–39, ledgers, 1803–53 and 1815–18, invoice book, 1819/20, and daybook, 1836–54, NJHS (microfilm, DCM).

61. Alling account book, ledgers, invoice book, and daybook; David Alling, receipt book, 1824–42, NJHS (microfilm, DCM).

62. *Sentinel of Freedom* (Newark, N.J.), October 26, 1830, as quoted in *Early Furniture Made in New Jersey*, p. 40; see also fig. 92, p. 31, for attributed Alling fancy chair and discussion. The New Jersey Historical Society's painting of Alling's shop is illustrated in Marvin D. Schwartz, "Fine Arts in the New Jersey Historical Society," *Antiques* 106, no. 2 (August 1974): 241. J. Clark shipment in Alling account book. General information on Hewitt in Marilynn A. Johnson, "John Hewitt, Cabinet-

maker" in *Winterthur Portfolio 4,* ed. Richard K. Doud (Charlottesville, Va.: University Press of Virginia, 1968), pp. 185–205. John Hewitt to Matthias Bruen, January 4, 1801, DCM.

63. Charles Joseph Latrobe, *The Rambler in North America,* vol. 2 (London: R.B. Seeley and W. Burnside, 1836), p. 87, as quoted in Waters, "Wares and Chairs," p. 170; Barber and Howe, *Historical Collections of New Jersey,* pp. 432–33; William G. Beesley, daybook, 1828–41, Salem County Historical Society, Salem, N.J. Gilbert S. Swing, *Events in the Life and History of the Swing Family* (Camden, N.J.: Graw, Garrigues and Graw, 1889), pp. 113–18 (reference courtesy of Deborah Dependahl Waters).

64. Beesley daybook; Hinshaw and Marshall, *Quaker Genealogy,* 2:129.

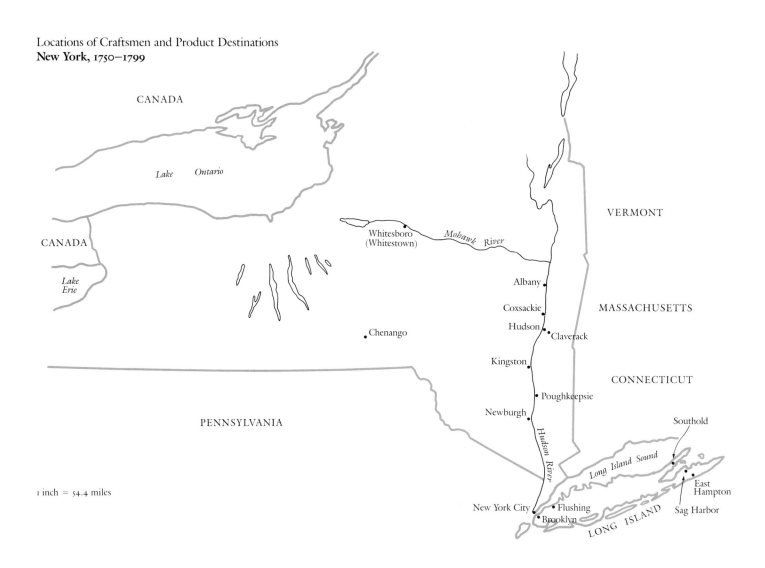

Locations of Craftsmen and Product Destinations
New York, 1750–1799

CANADA

Lake Ontario

CANADA

Lake Erie

Whitesboro (Whitestown)

Mohawk River

VERMONT

Albany

Coxsackie

MASSACHUSETTS

Hudson

Claverack

Chenango

Kingston

CONNECTICUT

Poughkeepsie

PENNSYLVANIA

Newburgh

Southold

Hudson River

Long Island Sound

East Hampton

1 inch = 54.4 miles

New York City

Flushing

Sag Harbor

Brooklyn

LONG ISLAND

New York

New York City from the 1740s to 1800

New York City's advantages over other American metropolitan seaports facilitated its rise to a preeminent position by the early nineteenth century. Salt water washed the wharves and quays, keeping the port ice free except in the coldest weather and permitting almost year-round commerce. Philadelphia, New York's formidable rival, was icebound for weeks, sometimes months, during the depth of winter. As a rising, accessible trading center located on a narrow, fingerlike land projection, New York enjoyed another advantage: "Such is its Figure, its Centre of Business and the Situation of its Buildings, that the Cartage in Town from one part to another does not at a Medium exceed one-quarter of a mile. . . . It facilitates and expedites the lading and unlading of Ships and Boats, saves Time and Labour, and is attended with Innumerable Conveniences to its inhabitants."[1]

During a 1748 New York visit, Peter Kalm described a pleasant, gradually changing city. The streets, although sometimes crooked, were paved and lined with trees. Most houses were built of brick. Old houses were turned with the gable end toward the street; newer ones often had balconies, where people sat on summer evenings. A serious drawback was the lack of a good supply of fresh water. Carters brought springwater from outside the community and sold it door-to-door until the century's end, when the city installed a piped water system.[2]

By 1759 New York was reputed to have between 2,000 and 3,000 houses and 16,000 to 17,000 inhabitants. Prerevolutionary trading commodities consisted mainly of furs brought down the Hudson River from the interior; timber, boards, and staves from the river regions; and grain from New Jersey and the New York hinterlands. New York was occupied by the British during the war. Within a week of its seizure in mid September 1776, a conflagration destroyed about 500 houses, churches, and businesses, many vacant because of the occupation; another fire occurred the following year. To obtain fuel, the British felled trees throughout the city, pulled down wooden houses, and broke up ships. Citizens' houses were "indiscriminately plundered" or their possessions destroyed, and many people, including craftsmen, fled the city before and during the occupation. The British evacuated New York in 1783, but four years later Philadelphian Samuel Breck found parts of the city still "in a state of dilapidation, and not at all recovered from the effects of the war." Commerce was beginning to thrive, however, and New York led the way in direct American trade with the Far East; the *Empress of China* returned from Canton with a lucrative cargo in May 1785. Full prosperity was restored by 1794, when William Strickland of Yorkshire visited the seaport. Awakened by city sounds during an early morning approach by passenger vessel, he found himself "in the midst of a forest of masts, some hundreds of vessels surrounding, more in number and in closer tier than I ever before saw, except on the Thames below London bridge." Quays were "covered with workmen, merchandize and carriages."[3]

Like other metropolitan centers after the war, New York continued to grow with little municipal planning. Isaac Weld described the typical urban waterfront as "confused heaps of wooden store houses built upon wharfs projecting one beyond another in every direction." Good sanitation was still wanting, and this contributed significantly to the yellow-fever epidemics that occurred each summer in many seacoast cities. Although New York's population had risen to more than 60,000 by 1800, it was "not unusual to see animals of all sorts wandering about, chiefly cows and pigs."[4]

THE ASHES AND OTHER CRAFTSMEN

Windsor chairs, imported from England or more likely from Philadelphia, furnished New York households as early as the 1740s and 1750s. Before his death in 1750, Abraham Lodge, a prosperous lawyer, placed four high-back Windsor chairs in the entrance hall of his two-story brick house; merchant Thomas Duncan housed six Windsors in his entrance hall. In 1758, estate appraisers found the Windsors owned by Captain William White "Some what broak," indicating that they had probably been made a decade or more earlier.[5]

Windsors were available to the general public by the 1760s. The earliest recorded advertisement dates to January 4, 1762, when storekeepers Thomas and James Franklin offered "a Parcel of low and high back Windsor Chairs." Later that year, Perry, Hayes, and Sherbrooke advertised "Philadelphia made Windsor chairs," suggesting the high repute of the Pennsylvania commodity. Andrew Gautier, a house carpenter of French Huguenot ancestry and a city freeman by 1746, dabbled in merchandise by the mid 1760s; he gave public notice that he intended to stock "a Large and neat Assortment of Windsor Chairs . . . and Settees" at his Princes Street business. Gautier was perhaps the first in America to advertise a Windsor form other than a chair and to include a representation of a Windsor (fig. 5-1). Although the woodcut image of a high-back chair is crude, the ball-foot legs and ornamental medial stretcher identify a Philadelphia chair. Jonathan Hampton used the same woodcut and repeated Gautier's advertisement, word for word, in 1768.[6]

The earliest representation on canvas of an American Windsor chair may be William Williams's 1772 painting of the William Denning family in the garden of their Wall Street residence (fig. 5-2). English-born and -trained Williams placed his American subjects in

Fig. 5-1 Advertisement of Andrew Gautier. From the *New York Gazette; or, Weekly Post Boy*, June 6, 1765. (American Antiquarian Society, Worcester, Mass.)

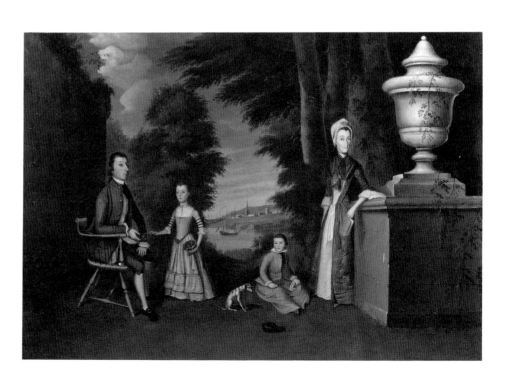

Fig. 5-2 William Williams, *The William Denning Family*, New York, 1772. Oil on canvas, H. 35½", W. 52". (Photo, Hirschl and Adler Galleries, Inc.)

194 *American Windsor Chairs*

informal outdoor settings that are similar to those in paintings by Arthur Devis and John Zoffany (figs. 1-16, 1-22). The distant buildings presumably represent New York, and the ship symbolizes merchant Denning's livelihood and wealth. The family's status is further enhanced by the portrait commission and their use of a fashionable Windsor chair out of doors in the English manner. The low-back American chair has ball-foot legs and baluster arm supports, although the tall, scrolled back seems to be an artistic device or a feature adapted from an English chair.[7]

Several Windsor-furniture specialists began advertising locally in 1774. Thomas Ash was born in New York; both John Kelso and Adam Galer migrated from Philadelphia. Since Ash, eldest son of cabinetmaker Gilbert Ash, and his brother William became chairmakers, they likely received their training outside the family shop. Thomas married Elizabeth Stanton in 1763, when he may have started his career. An eleven-year hiatus in advertising as a Windsor-chair maker probably indicates that the young man concentrated on producing rush-bottomed chairs early in a career that was interrupted by the war. William was in business at least by 1775, when his name appears on a city musket list. Thomas or William must have supplied the six Windsor chairs that their father exchanged toward a purchase from pewterer Henry Will in the mid 1770s. The account remained unsettled until 1789, four years after Gilbert's death, when Will recorded, "By Cash in full of Thos & Wm Ash."[8]

Kelso described his Philadelphia Windsor-chair-making background in a newspaper advertisement, noting that he had "served a regular apprenticeship in one of the first shops in that way." Several weeks later, a woodcut of a shield-seat, high-back chair accompanied the same text (fig. 5-3). The design copies a Philadelphia chair of the immediate prerevolutionary period, when craftsmen reduced the size of the tall chair and drew the long back spindles closer together at the bottom in a stylish fanlike profile (fig. 3-21). The "two small high-back Windsor chairs" itemized in Quaker merchant Walter Franklin's substantial 1780 estate were probably of this type. The same household contained five large high-back and six low-back Windsors. Formidable outside competition induced both Kelso and Thomas Ash to urge consumers to buy local products and keep "the balance of trade in our favour." Ash noted in his advertisement that several hundred pounds had already been sent out of New York to buy Windsor chairs elsewhere. Galer, who followed Ash's lead in illustrating his notice with a sack-back chair, appealed to "masters of vessels" to market the local product (fig. 5-4). The chairmaker had formerly resided in Philadelphia's Northern Liberties section, where the 1767 County Assessors' Returns listed him as owning a house and four acres of land.[9]

The war and British occupation, which dampened the promise of a flourishing New York Windsor trade, were a burden to householders of all economic backgrounds. Thomas Ash relocated temporarily on Long Island and then sought refuge in Connecticut in 1781. In 1776 estate appraisers who listed two Windsor chairs in Frederick Wolffes's "Double House with a Painters Shop" also noted that due to "the present Trouble" Wolffes had sent some possessions out of the city to "Mrs Keysers in the Camp above Reinebec." Four months earlier, Robert Ray, New York agent for wealthy landowner Philip Van Rensselaer, had written to his employer in Albany, "I had thoughts to have sent some Chairs . . . pr Vanbueren; but as he is near or quite full it is omitted; shall perhaps send them pr some other Sloop; we live in a troublesome Situation; we pray God will preserve us."[10]

Following the war the Ash brothers resumed the Windsor-chair-making business as partners. Their 1784 illustrated notice pictures a sack-back chair nearly identical to that used by Thomas ten years earlier. Business was returning to normal; only fourteen days after the British evacuation in 1783, the brothers sold twelve Windsor chairs to Robert R. Livingston, chancellor of New York State. That same year James Beekman, member of another prominent New York family, supplemented his household furnishings with ten Windsors, whose 5s. unit price identifies side chairs or secondhand furniture. Beekman failed to record his source, although in 1785 his aunt, Cornelia Walton, purchased twelve Windsors at 12s. each from the Ash shop. In May 1784 the city of New

Fig. 5-3 Advertisement of John Kelso. From the *New York Gazette and Weekly Mercury,* supplement, September 5, 1774. (Rare Books and Manuscripts Division, New York Public Library, Astor, Lenox, and Tilden Foundations, New York.)

Fig. 5-4 Advertisement of Adam Galer. From *Rivington's New York Gazetteer,* September 2, 1774. (American Antiquarian Society, Worcester, Mass.)

Fig. 5-6 *Thomas Ash I*, New York, 1795–1800. Oil on canvas; H. 30″, W. 24¾″. (Mead Art Museum, Amherst College, Amherst, Mass.)

York purchased three Windsors from the brothers; at 16s. apiece, they were likely sack- or high-back armchairs. The Ash brothers shipped twelve full-size and four children's Windsors to Virginia in August 1786 for St. George Tucker, Esq., of Williamsburg (fig. 5-5). Only a month later Tucker was a Virginia commissioner at the Annapolis Convention, an interstate meeting called to discuss uniform commercial regulations. New York City's seaborne Windsor trade gradually increased, and by 1788 export accounts reported the shipment of 1,132 Windsor chairs.[11]

In 1788 the city also celebrated the pending ratification of the Constitution of the United States. A parade known as the Federal Procession was held on July 23, and 5,000 marchers from fifty-eight professions and trades were led by horsemen with trumpets and an artillery company. Leading the chairmakers in procession were Thomas and William Ash, representing the "Windsor Chair Manufactory," and Jacob Smith and Joseph Dow of the "Rush Chair Manufactory." After them followed: "sixty men with green and red cockades in their hats, emblematical of their business; The [chairmaker's] standard borne by two men represent[ed] a large manufactory shop, with a number of workmen at work; in front of the Shop a view of the river, several vessels bound to different ports, taking in chairs, boys carrying them to the wharfs; in one corner, the American Union, in the other, the Chair-maker's arms, a turning lath, and two Windsor chairs properly emblazoned; [the] Motto: 'Free Trade.' 'The federal states in union bound, O'er all the world our chairs are found.'"[12]

In spite of the interruption of their careers, the Ashes appear to have been eminently successful in business. When Thomas drew his will in 1805, he called himself a gentleman; a painted portrait is further testimony to his affluence (fig. 5-6). At his death the following year, he bequeathed a silver tankard to his nephew and namesake, Thomas II; the elder man and his wife, Elizabeth, had no children. Only a few labeled chairs remain as examples of the Ash brothers' excellent craftsmanship. Their use of printed paper labels as identification accounts for the present anonymity of almost all their production; the glue on the notices dried up, and the labels fell off. The earliest Windsor to carry an Ash label is the sack-back armchair, of which several documented examples remain in addition to unlabeled ones (fig. 5-7). The existence of about eighteen local chairmaking establishments in the 1780s and the lack of documented contemporary work preclude assigning unmarked examples solely to the Ash brothers.[13]

The New York sack-back pattern is subtle but distinctive. Like the Philadelphia sack-back chair that inspired it, the New York Windsor has a low, compact, rectangular profile

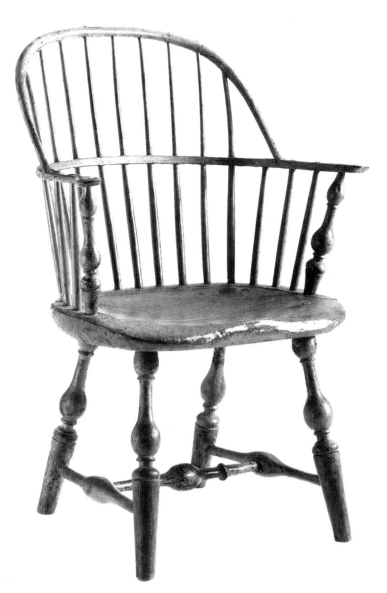

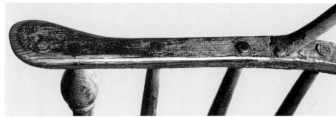

Fig. 5-7 Sack-back Windsor armchair and detail of arm, possibly by Thomas Ash I and William Ash I, New York, ca. 1783–90. Yellow poplar (seat, microanalysis) with maple, oak, and hickory; H. 34″, (seat) 16″, W. (arms) 24½″, (seat) 21⅜″, D. (seat) 16¼″. (Private collection: Photo, Winterthur.)

with little leg splay, which anchors it firmly to the ground. Seats are comparable in size and shape; the bows also form a low arch, but here the similarity ends. New York chair tops have a definite angularity. The bow ends slim noticeably, then flair again to form squared terminals. New York chairmakers employed a distinctive tenon to anchor the bow in the arm-rail mortises (fig. 5-7, detail). Each tip is shaped to a thin foot with a central projecting toe on the face that forms part of the acute, forward angle of the internal tenon; the tenon back ends in a right angle.

New York sack-back turnings exhibit a robust character unknown in Philadelphia work. Full swells mark leg and post tops, balusters, and stretcher centers. Completing the slim, spoollike elements of the legs and posts are small mushroom-shaped caps and bases that spread in wafer-thin disks over thick rings. The small, oval pads terminating the arm rail are sharply chamfered at the edges but lack the extended side pieces of the Philadelphia chair (figs. 5-7, 3-37); the knuckle scroll is rare. The spindles thicken noticeably toward the bottom but in a less abrupt manner than in earlier Philadelphia work (fig. 3-38, left).

Joining the Ashes in reestablishing the New York chairmaking industry in the 1780s were craftsmen who had been shop masters before the Revolution and a group of newcomers to the trade. Partners Thomas Timpson and William Gillihen, who advertised in 1785 as "Cabinet and Windsor Chair-makers," dissolved their association within a year or two, and Timpson may have continued both trades until after 1800. Gabriel Leggett, Jr., a nephew of the Ashes through his mother, Catherine Ash Leggett, advertised in 1786 from his Crugar's Wharf location; his chairmaking career continued at

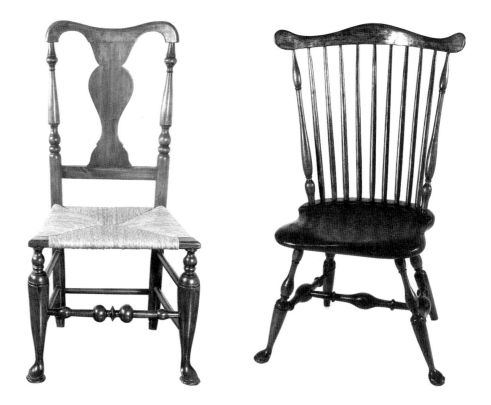

Fig. 5-8 Vase-back (york) side chair (one of a pair), David Coutant (stamp "D·Coutong"), New York, ca. 1786–95. Maple, pine, hickory; H. 40¾", W. 20½", D. 17½". (Historic Hudson Valley, Tarrytown, N.Y.)

Fig. 5-9 Fan-back Windsor side chair, New York, 1785–95. Yellow poplar (seat); H. 32", (seat) 14". (Photo, John Walton, Inc.)

least through 1806. David Coutant (also spelled Coutong), a chairmaker of Huguenot descent, practiced his craft in the city from about 1786 to 1795. Three years later he purchased land in neighboring New Rochelle, a town settled by Huguenots, where he continued chairmaking, since his 1829 probate inventory lists shop tools and equipment. Along with Windsors, Coutant made the well-known, vase-back "york" chair, also called a "fiddleback," which is closely associated with New York and regional chairmaking (fig. **5-8**). Coutant's brand appears on the seat block above one leg of the rush-seat, club-foot chair. The remaining parts of a Coutant sack-back Windsor bear similar stamps at the seat edges below each arm support. Several features of the york chair relate to local Windsor work. The flaring cones and compressed balls at the rear post tops reflect the inverted bases of Windsor arm supports. The capped spool turnings above the front leg domes originated from the same traditional models that influenced Windsor turnings. Coutant's york chair is almost identical to another that is marked with the brand of Jacob Smith, a rush-bottomed-chair maker who participated in the Federal Procession.[14]

A fan-back Windsor side chair with club-type front legs represents a strange mixture of features and is probably part of only a small seating group (fig. **5-9**). A rare bow-back side chair in a private collection has an almost identical base and seat. The chairs certainly originated in New York, the products of versatile craftsmen like Coutant or the Ashes who made both rush- and plank-bottomed chairs. The fan-back Windsor shares several features with Coutant's chair: the feet and lower legs have similar elements, varying only in size; the york back-post balusters and tapered (inverted) Windsor legs are again comparable in size and shape; and the york stretcher tips are repeated in the Windsor post bases, although this element also occurs in Philadelphia Windsors (fig. 3-48). The hybrid chair also relates to local Windsor production. The crest shares a profile with figure 5-10, medial and side stretchers duplicate a shape found in figure 5-12, and the plank droops somewhat at the front corners as in both of these examples. This is the only identifiable New York fan-back chair. The style is rare in city chairmaking, and production must have been limited. The long British occupation occurred at the height of Philadelphia fan-back development, and the style was almost out of fashion before New York returned to commercial normalcy. After the evacuation, New York chairmakers produced forms they had known before the war, and within a short time bowback styles swept the market.

Isaac Kitchell, whose career began about 1789, produced a Windsor whose high-back form is rare for its 1790s date and New York origin (fig. 5-10). Using the shield-shaped seat newly fashionable in New York, he added sack-back-style bulbous turnings with oval instead of round balusters. The arms terminate in typical New York small, chamfered-edge pads; the spindles thicken below the rail. The source of the crest profile is a Philadelphia fan-back chair (fig. 3-49). Inspiration for the overall design, however, may have come from neighboring Connecticut, where New Haven chairmakers enjoyed commercial success with a tall chair during the 1780s (fig. 6-177). Kitchell's high-back chair is a rarity probably because the craftsman marketed it just as local chairmakers introduced consumers to an elegant round-back armchair.

Windsors of the new design are known today as continuous-bow armchairs. The bow, fashioned from a single strip of wood, encloses all the spindles and forms a continuous unit with the arms. Brands or labels associate at least eleven city chairmakers or firms with this production during the 1790s, and five or more of them were working before the decade began; circumstantial evidence also links Thomas and William Ash (fig. 5-18). Among the craftsmen presumed working before 1790, John DeWitt may have been a city assessor in 1785, although directories fail to list the craftsman until 1794, when his occupation is given as turner. Thomas Timpson, represented by a few marked examples, was a partner of William Gillihen in 1785/86 and possibly later (fig. 2-7). He advertised his own cabinetmaking and Windsor-chair-making business in 1788 and is so listed in the 1792 and 1793 directories (fig. 5-13); in the interim he was called a cabinet-maker only. The Ashes, James Bertine, Kitchell, and John Sprosen, the last from Philadelphia, operated their own chair shops in 1789, although Bertine specialized in rush-bottomed chairs until the following year. Six other chairmakers or firms represented by documented seating entered the trade between 1791 and 1796, if not earlier. In summary, circumstantial evidence based on working dates suggests that the continuous-bow armchair was marketed at the earliest in 1789.[15]

The first chairs made in the new pattern have large, oval seats and broad, balloon-shaped backs, one of which bears the brand "I.ALWAYS" (fig. 5-11). The name John Always first appeared in city directories in 1791, that of James Always, in 1794. By 1795 John had formed a two-year chairmaking partnership with Joseph Hampton. From the directory dates, John appears to be the Always family member who branded the oval-seat chairs, which suggests that his career probably began as early as 1789. In general, the Always chair owes much to the New York sack-back Windsor, and its spindle arrangement duplicates that of a contemporary bow-back armchair (fig. 5-19). The back is broad, the arms end in simple pads, and the long spindles swell then slim again at the bottom; the oval seat has a pronounced front pommel, and the legs stand firm with minimum splay. The full parts of the balusters are more elongated than those in the tall Kitchell or sack-back Windsors.

Walter MacBride produced many continuous-bow armchairs, although his chair-making career appears to have been short. City directories first list him as a craftsman in 1792. By 1797 he had become a cartman, an occupation he pursued until 1812, when he became a grocer. MacBride's identified production, which is of uniformly high quality, demonstrates how a shield-shaped seat and narrower back streamlined the Always design and led to the development of a classic Windsor form (fig. 5-12). Credit for the modification remains unestablished, since at least twelve other Windsor-chair makers, including John Always (and the Ash brothers, based on circumstantial evidence), produced similar chairs during MacBride's five-year chairmaking career. From about fifty marked New York continuous-bow chairs, more than half have a coffin-shaped projection at the seat back to support a pair of bracing spindles. The brace is absent from the documented work of Bertine and Henry Lock, another New York chairmaker. The flat-faced, beaded bow of the shield-seat chair frequently becomes noticeably thinner just above the arm bends; near the front a small point, or projection, often accompanies

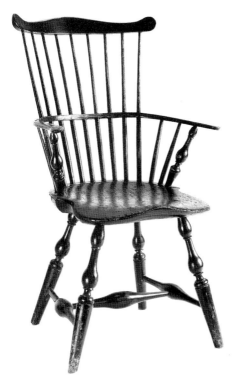

Fig. 5-10 High-back Windsor armchair, Isaac Kitchell (brand "I⸱KITCHEL"; owner's brand "G.M.TIBBITS"), New York, 1790–95. Yellow poplar (seat) with maple and other woods; H. 36¼", (seat) 17½", W. (crest) 20¾", (seat) 17¾", D. (seat) 17⅞"; medial stretcher replaced. (Private collection: Photo, Winterthur.)

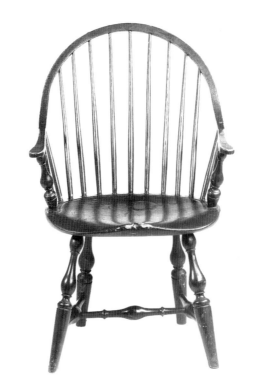

Fig. 5-11 Continuous-bow Windsor armchair, attributed to John Always (brand "I ALWAYS"), New York, ca. 1789–92. H. 35¼″, W. 23″, D. 21″. (Brooklyn Museum, Brooklyn, N.Y., gift of Mr. and Mrs. Henry Sherman.)

Fig. 5-12 Continuous-bow Windsor armchair (two views), Walter MacBride (brand "W·MACBRIDE / N-YORK"), New York, ca. 1792–96. Yellow poplar (seat) with maple and oak (microanalysis); H. 37⅝″, (seat) 18″, W. (arms) 25½″, (seat) 18⅛″, D. (seat) 17⅜″. (Winterthur 65.832.)

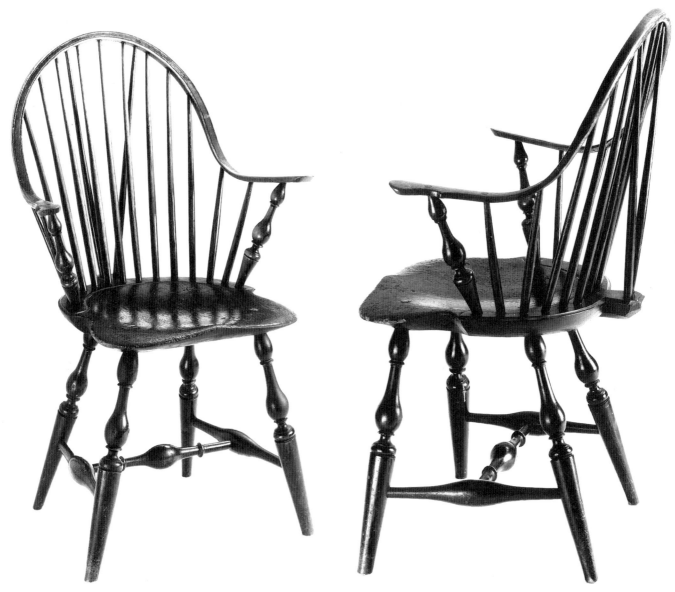

Fig. 5-13 Advertisement of Thomas Timpson. From the *New-York Packet,* August 8, 1788. (American Antiquarian Society, Worcester, Mass.)

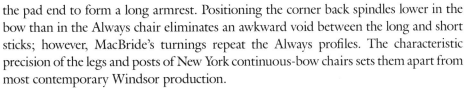

Fig. 5-14 Bow-back Windsor side chair, Isaac Kitchell (brand "I·KITCHEL"), New York, ca. 1789–1800. H. 35½". (Newark Museum, Newark, N.J., Alice W. Kendall bequest purchase.)

the pad end to form a long armrest. Positioning the corner back spindles lower in the bow than in the Always chair eliminates an awkward void between the long and short sticks; however, MacBride's turnings repeat the Always profiles. The characteristic precision of the legs and posts of New York continuous-bow chairs sets them apart from most contemporary Windsor production.

Related to the continuous-bow armchair was the bow-back side chair, whose introduction to New York consumers can be pinpointed in two of Timpson's pictorial notices. With his partner Gillihen, Timpson advertised from Golden Hill in 1785/86, featuring a mahogany slat-back chair and a sack-back Windsor. When Timpson was on his own at 16 Nassau Street in August 1788, he used two new designs in another notice—a bow-back Windsor side chair and a formal shield-back chair (fig. **5-13**). Timpson used this woodcut again with a new text after returning temporarily to Golden Hill in 1792. Both illustrations appear to have been made only for Timpson, who chose chairs in the fashion forefront at the advertisement dates. Sometime between July 1785 and August 1788 (and probably closer to the latter date), the bow-back Windsor became highly fashionable in the city. As late as 1792, chairmaker Peter Tillou described an order as "12 New Fashion Painted chairs at 9s/6d per piece"; on the reverse of the bill, another hand identified the merchandise as "winsor Chairs." The Ash brothers sold twenty Windsors to Governor George Clinton at 8s. and 10s. apiece in 1790; the prices indicate side chairs. Green paint was still a popular choice among many consumers; for example, Cornelius Van Slyck bought eight green bow-backs from Kitchell in 1794.[16]

Viewed almost in profile, the braced Windsor in Timpson's second advertisement emphasizes a salient feature of the New York bow-back chair—the pronounced rake, or slant, of the back structure. The angle is comparable to that of its related armchair, the continuous-bow Windsor. The feature occurs in Kitchell's side chair along with another local characteristic, the exaggerated droop of the front seat corners (fig. **5-14**). The flattened bow face, thickened spindles, and bold turnings are typical New York details. A view of the seat bottom provides a close look at other design elements: the shield-shaped seat with rounded edges; the typical New York coffin-shaped seat projection with flat-chamfered sides; the rectangular through tenons of the bow; and the collared rings of the medial stretcher (fig. **5-15**). Kitchell's bold name stamp is also plainly visible. A frontal view of a braceless bow-back chair from the shop of John Always and Joseph Hampton, partners in 1795/96 only, illustrates the wider front-leg splay common at the century's end, in contrast to the moderate rake of early postrevolutionary work

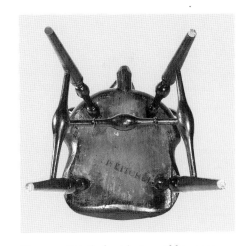

Fig. 5-15 Detail of seat bottom of figure 5-14.

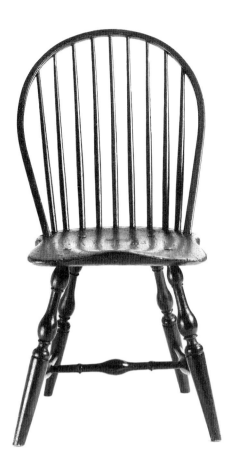

Fig. 5-16 Bow-back Windsor side chair, John Always and Joseph Hampton (brand "ALW[AYS &] / H[A]M[T]O[N]"), New York, 1795/96. Yellow poplar (seat) with maple and hickory (microanalysis); H. 35⅝", (seat) 17⅛", W. (seat) 16⅜", D. (seat) 15¾". (Winterthur 67.36.)

(figs. **5-16**, 5-7). The flat sides of the New York bow differ significantly from the nipped waist of the Philadelphia prototype.

A bow-back side chair whose spindles are ornamented with a turned vase and a tiny top bead, elements that may have originally been picked out in a contrasting color, can be classified as a fancy Windsor (fig. **5-17**). Inspiration derives from the American banister-back chair with long, turned split spindles known to the Ash brothers in their youths and early careers, and from prewar Rhode Island Windsor work. A large, fragmented label on the seat bottom, long unidentified, is reasonably associated with the Ash firm. Within the oval bottom panel, enough engraved inscription remains to identify "Windsor Cha[ir]/MAKE[RS]/[__Jo]hn S[treet]/[New] Y[ork]." The Ashes were located on John Street in 1784 and from 1789 to 1794, when they dissolved their partnership. The only other Windsor-chair maker to occupy a shop at this location was John Coldwell (or Caldwell). He can be eliminated as a possible maker, however, since the letter spacing in the second line of the inscription confirms that the word *MAKE[RS]* is plural. Above the oval, an ornamental banner with a long, slightly curved central section is terminated by folded, arching scrolls that support foliate drops. The letters *AM*, visible at the center right, are part of the inscription "THO/MAS & WILLIAM/ASH," as sketched. The lower right leg of the *H* in the surname is visible just above the leaflike drop. The label is similar to those designed for New York cabinetmakers.[17]

Other fancy-spindle Windsors originated in the Ash shop. A study of the furnishings of wealthy Providence merchant John Brown has located a similar, braced, bow-back side chair with upholstered seat in a descendant's possession. The plank still retains a small makers' label, printed with the "No. 17 John-street" address occupied by the Ash brothers in 1790 and 1791, according to city directories. A second label was placed on the plank by upholsterer Josias (Josiah?) Byles of "No. 4, Water-street." A braced, bow-back armchair with the seat made for stuffing is another ornamental-spindle Windsor made by the Ashes. The label is similar to that on the Brown chair, and the armchair may have once been part of the Brown family's seating furniture. The early 1790s date of these

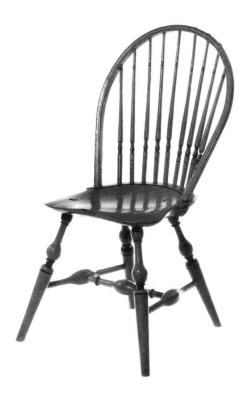

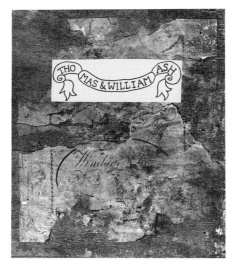

Fig. 5-17 Bow-back Windsor side chair (one of a pair) and detail of label, Thomas and William Ash, New York, ca. 1789–94. Yellow poplar (seat); H. 36⅜″, (seat) 17½″, W. (seat) 16½″, D. (seat) 16⅞″. (Henry Ford Museum and Greenfield Village, Dearborn, Mich.)

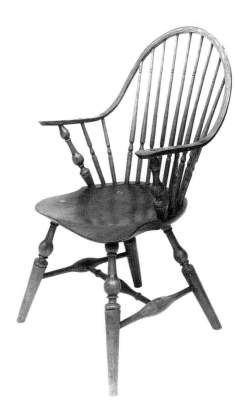

Fig. 5-18 Continuous-bow Windsor armchair, possibly by Thomas and William Ash, New York, ca. 1789–95. (Photo, Pleasant Bay Antiques, Inc.)

Windsors is significant. Through them it is possible to trace the *origin* of the postwar baluster-turned spindle and, by extension, the continuous-bow armchair to New York City rather than southeastern New England, where both designs occur with frequency. An unmarked New York continuous-bow Windsor with spindles, turnings, and a plank identical to those in the Ash side chair provides an important link (fig. **5-18**). The visual evidence is underscored by the highly unstable state of postrevolutionary economic conditions in Rhode Island.[18]

Following the Revolution, New York's stable business climate contrasted greatly with the fluctuating economy of Rhode Island, whose citizens were caught in a disastrous monetary scheme "where a wildly depreciating paper currency [was] made legal tender . . . [and] debtors . . . were paying off their obligations in worthless paper, leaving their creditors bankrupt." Although the paper currency was declared equal to silver when first issued, it depreciated quickly and soon became almost worthless. This depressed economic climate discouraged craftsmen from establishing local businesses or introducing fashionable new merchandise. Brown's purchases of Windsor furniture from the Ashes of New York and John Letchworth of Philadelphia underscore this point. Rhode Island's failed economy probably led to the importation of still other "typical" Rhode Island Windsor features from New York, namely the forward-scroll arm, which occurs in the Brown family's labeled Ash armchair, and the flat, beaded bow face common to Rhode Island and eastern Connecticut.[19]

The Ash brothers' bow-back *armchair,* probably made for Brown, is a rare form in New York Windsor furniture. The continuous-bow Windsor so perfectly complemented the bow-back side chair that it dominated production during the 1790s. In Philadelphia, however, the bow-back armchair reigned almost supreme, and the continuous-bow Windsor was unknown, except as an imported commodity. Two unusual bow-back armchairs originated in New York. The first bears a striking resemblance to John Always's early continuous-bow Windsor in its breadth and almost vertical spindle arrangement (fig. **5-19**). The plain, pad-end arms are similar to those of Always's continuous-bow chairs and the Ash sack-back chair (fig. 5-7); the turnings compare favorably with the bulbous examples of the 1780s. The broad, shield-shaped seat already droops somewhat at the front corners. Comparison with the oval seats of figures 5-7 and 5-11 suggests that this bottom constitutes an evolutionary stage in the plank that became

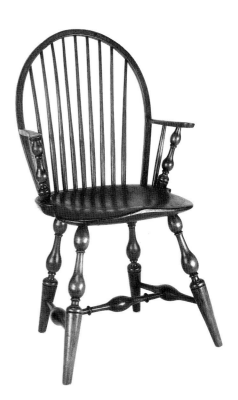

Fig. 5-19 Bow-back Windsor armchair, New York, ca. 1788–92. (Former collection J. Stogdell Stokes.)

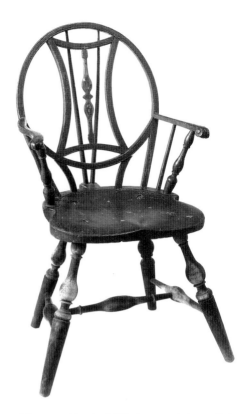

Fig. 5-20 Bow-back Windsor armchair, retailed by Richard Kipp, Jr. (label), New York, ca. 1786–90. Yellow poplar (seat) with maple, oak, and other woods; right arm replaced. (Private collection: Photo, Winterthur.)

the typical 1790s New York shield-shaped seat. The saddlelike form imitates the deeply scooped forward edges of the oval-seat chairs.

The second armchair, which may be unique, is one of the most ambitious ornamental designs known in American Windsor-chair making; it bears the large, fragmented label of upholsterer Richard Kipp, Jr. (d. ca. 1793) on the seat bottom (fig. 5-20). An elaborately draped bedstead frame encloses the text. The label was engraved by John Hutt in 1771, and Kipp apparently ordered a large supply of the printed notices. A perfect manuscript copy contains a contemporary handwritten inscription dated December 1784, indicating that the upholsterer continued to use the advertisement after the Revolution and possibly even until his death. The labeled chair probably dates well into the 1780s. The inspiration came from English round- or oval-back chairs based upon the French fauteuil and executed in fine cabinet woods or finished in fancy paint. The short, vertical, segmental elements of the lower back, which flank the rear seat projection, simulate the rear leg extensions that support the back unit in joined chairs. Such chairs likely found their way to New York during the long British occupation. After the war, imported furniture continued to arrive, since both furniture makers and clients were anxious to keep abreast of changing English fashions. The Kipp leg balusters are full bodied in the manner of postwar sack-back chairs, although the necks are shorter. The vertical ornament of the center back is likely based on the front stretcher of the still popular New York club-foot chair, such as the one made by David Coutant (fig. 5-8). Construction of the round back required a full balloon-style bow, a pattern preferred in the city over the Philadelphia-style nipped waist. The same full bow occurs on many Rhode Island Windsors. The flat edges in an otherwise typical New York shield seat indicate that the chairmaker prepared the plank for stuffing. The straight right arm is a replacement; the gracefully curved left one has ornamental scratch beads that complement similar detailing on the bow face and the segmental back elements.[20]

New York State before 1800

THE HUDSON VALLEY AND UPSTATE NEW YORK

Information on the use and construction of Windsors outside New York City is sparse for the late eighteenth century. Most recorded activity centers in the Hudson River valley along the metropolitan commercial paths, with a few examples originating on Long Island. A small group of New York City seating and an early Pennsylvania Windsor documented by brands to original owners is identified with the Hudson as far north as Albany. Two continuous-bow chairs of unmistakable New York origin bear the owners' stamps "J.M. HASBROUCK." and "JOB B. COFFIN." Many Hasbrouck family members made their homes in Ulster County on the Hudson's west bank. The Hasbrouck chair is associated with Kingston, the county seat, through a later inscription. The Coffin brand is probably that of Job Bunker Coffin (b. 1783), who married in 1805 at Hudson and was identified as a house carpenter in an 1807 deed. Hudson, which was founded in 1783 by families from Rhode Island and Nantucket (including the Coffins), was a port of entry, carrying on a flourishing West Indian trade. Local ships made stops in New York when both outward and inward bound; by 1785, town residents owned twenty-five vessels. The Coffin brand is also on a child's Windsor from the 1820s, when Coffin was a Hudson alderman.[21]

A Philadelphia low-back Windsor armchair bears the stamp "PVR," identifying its former owner as Philip Van Rensselaer of Albany. This 1760s chair is virtually identical to the Philadelphia low-back in figure 3-10. Van Rensselaer married Maria Sanders in 1768 at about age twenty-one, suggesting that the couple acquired the chair when they set up housekeeping. In 1787 Van Rensselaer purchased two Windsor chairs at 24s. apiece from Thomas and William Ash through his New York agent. Since Van Rensselaer was completing a new mansion at his Cherry Hill farm near Albany, the chairs were likely

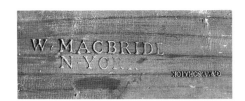

Fig. 5-21 Detail of seat bottom from continuous-bow Windsor armchair, Walter MacBride (brand, and owner's brand "G.W.V. SCHAICK"), New York (owner, Albany, N.Y.), ca. 1803. (New York State Museum, Albany, on loan from Wunsch Americana Foundation.)

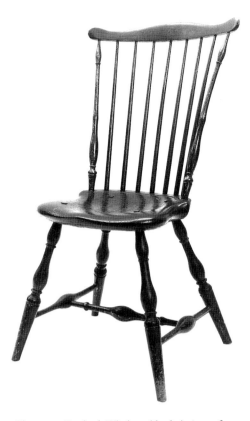

destined for that residence. Quantity and price indicate that these were armchairs with stuffed seats or loose cushions.[22]

Chairs from two sets of Windsors branded by another Albany resident survive. The stamp of Gerrit Wessel Van Schaick, Bank of Albany cashier, occurs on three New York continuous-bow armchairs and two fan-back side chairs possibly made in Albany. The armchairs, all with seats shaped for stuffing, also bear the brand of chairmaker Walter MacBride (fig. 5-21). John Bleecker, Jr.'s, 1803 bill for "12 Chairs purchased at N Yk" for 22s. each indicates that they were stuffed armchairs. Van Schaick's household inventory of about 1816 lists "1 3/12 Dozen Green Chairs with Stuffed bottoms," suggesting that three similar chairs entered the residence sometime before or after the documented New York purchase. The date of Bleecker's bill, however, poses a problem. New York City directories between 1797 and 1811 list a Walter MacBride as a cartman, yet the branded chairs, bill, and inventory entry seem interrelated. Nothing suggests that the chairs were secondhand or that Bleecker was collecting for an earlier purchase. It also seems unlikely that MacBride bought the chairs from another craftsman and marked them with his own stamp. Except for the blunt-edge plank for stuffing, the chairs duplicate the MacBride armchair illustrated in figure 5-12. Three explanations are possible: MacBride still operated or maintained control over a chair shop in 1803 but gave preference in the directory listing to his hauling business; since the dozen chairs were intended to supplement three (or more) purchased earlier from MacBride, the former chairmaker supervised their construction in another shop and marked them with his own name iron; or, the three extant chairs represent the fractional dozen of the inventory listing and were purchased earlier than the others.[23]

Fan-back side chairs marked with the Van Schaick brand, without the initial *G*, are probably those described as "1 Sett common Green chairs" in the financier's inventory (fig. 5-22). Other general seating listed in the document includes two sets of fancy chairs, one purchased in New York in 1814 and painted yellow and gilded. Still another group is described as "24 Common Rush Bottomed chairs . . . at the farm at Great Imboght in the county of Greene." An unusual feature of the green fan-back chairs is the knot, midway up the back posts, which probably reflects the work of a particular shop or locale. This hint of provincialism in an otherwise straightforward, fan-back design suggests an Albany origin. Overall, the Windsors seem related more closely to Philadelphia than to New York City work, especially in the seats, crest rails, and legs (figs. 3-47, 3-49). Fragmentary shipping records document the importation of at least one group of Philadelphia Windsors into Albany on the sloop *Betsey* in 1792. This information and the presence of identified Pennsylvania Windsors in the Hudson Valley suggest that a sufficient number of models were available for craftsmen to imitate.[24]

At least one chairmaker worked in Albany by 1790. James Chestney's name appears in the 1790 and 1800 federal censuses. In 1793 the craftsman made "8 Red Common Chairs" at 5s. apiece for Philip Schuyler's wife. These were slat-back, rush-bottomed chairs colored with the brick-orange stain frequently used for kitchen seating. Chestney advertised his "Chair Manufactory" at 72 Market Street in 1797 and illustrated the notice with the three types of chairs that he produced: the common three-slat chair like those sold to Schuyler; the still popular york, or fiddleback, chair with club feet; and the bowback Windsor (fig. 5-23). To date, no documented Chestney work has surfaced, yet he was in business until 1830. Production versatility was the key to success in provincial towns and small cities; specialization required a large urban population for support.[25]

Fig. 5-22 Fan-back Windsor side chair (one of a pair), owned by Gerritt Wessel Van Schaick (brand) and probably later by Wessel Van Schaick (incised initials), Albany, N.Y., or area, 1790–1805. H. 36″, W. 21″, D. 17½″. (New York State Museum, Albany, on loan from Wunsch Americana Foundation.)

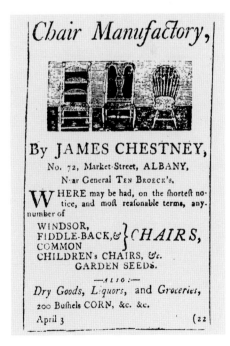

Fig. 5-23 Advertisement of James Chestney. From the *Albany Chronicle*, Albany, N.Y., April 10, 1797. (Photo, Winterthur.)

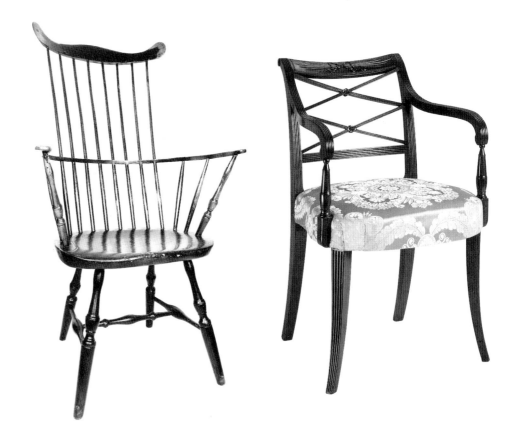

Fig. 5-24 High-back Windsor armchair, Henry Titus Shipman (brand), Coxsackie, N.Y., 1805–10. (Photo, Hazel Marcus.)

Fig. 5-25 Armchair (one of a pair), attributed to Duncan Phyfe (bill), New York, 1807. Mahogany with other woods; H. 33″, W. 21¼″, D. 21″. (Winterthur 57.720.1.)

About twenty miles south of Albany, the village of Coxsackie served as a temporary home for the transplanted Connecticut chairmaker Henry Titus Shipman, born in Saybrook about 1782. When Shipman married a Saybrook girl in 1805, he had already relocated in Coxsackie. Census records indicate that he continued to move westward and by 1820 had settled in Chenango, Broome County, near present-day Binghamton. Shipman's chair, documented by name and location, probably dates about 1805 to 1810 (fig. **5-24**). The high-back armchair, which reflects a late eighteenth-century New England style, has the large, "eared" crest that is characteristic of coastal Connecticut work. Henry may have learned the trade from his uncle, William Shipman, a Saybrook chairmaker who worked at Middletown on the Connecticut River in the 1780s and relocated to Hadley, Massachusetts, by the 1790s. Henry, however, had his own ideas about Windsor design. In the high-back chair he substituted urns for balusters. The design began with great promise but degenerated into undistinguished lumps at the tops of the turned members. Despite the shortcomings, the urns are linked with high-style New York work, including chairs made by Duncan Phyfe (fig. **5-25**). Shipman's short, slim urns almost duplicate those supporting the arms of Phyfe's mahogany chair, including the spool turning at the base. Shipman had obviously seen similar New York scroll-back chairs and possibly even had one in the shop when he constructed the Windsor. The chair may have been ordered by a local customer and destined for use with mahogany furniture purchased in the city. A documented side chair further identifies Shipman with early nineteenth-century Windsor design, although this chair is also highly mannered. Long, swelled, stretcherlike backposts support a slim, projecting, cylindrical crest; the squared, shield seat has thick, canted sides. The undefined legs, each of which consists of a slim swell, long hollow, and tapered foot, exhibit definite knowledge of late eighteenth-century eastern Connecticut bamboowork, as interpreted by the Tracy family and their contemporaries.[26]

A short distance across the Hudson in Claverack, Stacy Stackhouse set up shop in 1795. He had worked in New York City as early as 1775 and later in Hartford, where he remained until coming to Claverack. In the new town, Stackhouse probably produced chairs that revealed his Connecticut background. Once settled, he quickly recognized

that competition in the river communities came primarily from downriver. His November 1795 advertisement explicitly advises potential customers that they could "depend on having their work done in the genteelest manner, and on as reasonable terms for cash in hand, as in New-York." While Claverack is only a hamlet today, it was a bustling village when Stackhouse settled there. Neighboring Hudson flourished as a shipping port, and local farmers and wealthy landowners, such as the Van Rensselaers, profited from area development. Claverack was also the temporary seat of Columbia County and attracted professionals and craftsmen.[27]

A sack-back Windsor with a Poughkeepsie-Newburgh area history is either a 1790s New York chair or a local modification of two metropolitan designs; the former seems more likely (fig. **5-26**). The overall form with its wide, oval, well-defined saddle seat is that of a 1780s New York sack-back Windsor (fig. 5-7). The bow is also broad, although the arch is rounder, and it terminates in squared tips with a typical New York tenon. In certain details, however, the chair exhibits a greater affinity to the early John Always continuous-bow armchair, especially in the turned profiles, leg splay, bow arch, and spindle taper (fig. 5-11). Unlike most metropolitan work, the plain pad arms are only slightly chamfered at the edges. The sweeping contours of the oval plank and the modest outward bend of the long spindles are features that influenced Rhode Island work.

Beyond Albany and the Hudson Valley, early chairmaking records are limited. In Whitestown, an Oneida County township, Joseph Foster advertised Windsor and kitchen chairs in 1798, illustrating his notice with a small woodcut showing a slat-back chair and continuous-bow and bow-back Windsors (fig. **5-27**). Whitestown (now Whitesboro), organized in 1788, originally included the small settlement of Utica. Foster probably migrated from Ulster County on the Hudson, where the 1790 census lists a man of that name.[28]

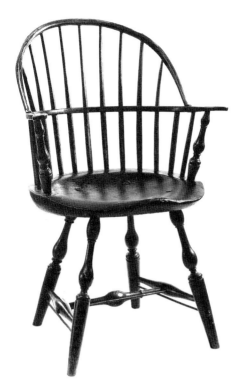

Fig. 5-26 Sack-back Windsor armchair, New York or lower Hudson Valley, 1790–1800. Yellow poplar (seat); H. 35⅜", (seat) 18", W. (seat) 20¾", D. (seat) 17⅛". (M. K. collection: Photo, Winterthur.)

LONG ISLAND

Brooklyn, because of its proximity to New York City, was the most cosmopolitan Long Island community in the later eighteenth century. An entry for "2 Whinsor Setting Chairs" in the 1772 inventory of local blacksmith Isaac DeGraw is unusual, since the village had no known resident Windsor-chair maker at the time. Such seating was only then coming into general use across the East River in New York, but that was a boat ride away. Seating similar to DeGraw's seven rush-bottomed "Common Setting Chairs" would have been available in King's County and at prices cheaper than Windsors. Brooklyn turner James DeGraw (d. ca. 1767 and likely a kinsman) possibly supplied the blacksmith's common chairs and his Windsors as well. As late as 1786, when the household of John H. Smith of Flushing, Queens County, contained "one windsor sitting chair" and "straight backed" and "old" chairs, the Windsor-chair-making trade appears to have been little known on Long Island. Although Southold cabinetmaker John Paine, who made slat-back and fiddleback chairs, constructed four Windsor chairs for David Goldsmith in June 1794, the few other references to Windsors in his accounts concern repairs. Paine's entrepreneurial pursuits of rope- and cidermaking were as important to his personal economy as woodworking. In a comprehensive study of the versatile Dominy craftsmen of East Hampton, Charles Hummel also describes their limited contact with Windsor seating. Only in the early nineteenth century did this form begin to gain a foothold on Long Island.[29]

Everardus Warner, a New York City chairmaker, operated a Brooklyn shop in 1801 and 1802. The village contained about 100 houses mostly scattered along the highway forming the main street. Médéric-Louis-Elie Moreau de St. Méry noted that Brooklyn was "the point of departure for all roads to different settlements on Long Island." In 1802 William Hall advertised cabinetwork and Windsors at Sag Harbor, near the island's eastern end; he repeated the notice in 1804, when fellow townsman Peleg C. King first advertised his slat-back and Windsor chairs. Hall may be the same chairmaker who later worked across Long Island Sound in New London, Connecticut. Commercial exchange

Fig. 5-27 Advertisement of Joseph Foster. From the *Western Centinel*, Whitestown, N.Y., November 2, 1798. (Photo, Winterthur.)

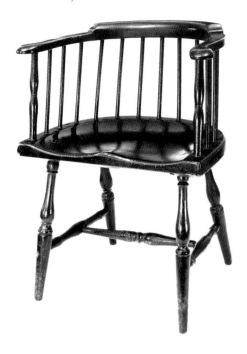

Fig. 5-28 Low-back Windsor armchair, Nathaniel Dominy V (incised name), East Hampton, N.Y., 1794. Mahogany; H. 28¼", W. 21¾", D. 15¼". (Private collection: Photo, Winterthur.)

Fig. 5-29 William Sidney Mount, *Catching the Tune*, Setauket, N.Y., 1866. Oil on canvas; H. 22", W. 27". (The Museums at Stony Brook, Stony Brook, N.Y.)

between the two regions was substantial, and strong Connecticut and Rhode Island influence occurs in Long Island furniture design.³⁰

Long Island is best described in this period as rural, agrarian, and provincial. When Timothy Dwight, Yale College president, visited East Hampton, home of the Dominys, in 1804, he found a "compactly built" community of about 100 unpainted dwellings along a single street on a perfectly level site. Dwight captured the essence of rural Long Island: "it is regulated rather by the long-continued customs of this single spot, than by the mutable fashions of a great city. . . . Living by themselves . . . the people . . . become more attentive to whatever is their own, and less to the concerns of others. Hence their own customs, especially those which have come down from their ancestors . . . have a commanding influence on their conduct."³¹

Nathaniel Dominy V was a young man in 1794, when he constructed a set of six or nine low-back Windsor chairs made entirely of mahogany for Captain William J. Rysam (fig. **5-28**). Although this expensive cabinet wood is seldom used in American Windsor chairs, Rysam owned a mahogany grove in Honduras. At least one chair in the set has complete documentation on maker, owner, date, and cost chiseled into the seat bottom. In Philadelphia and New York the low-back pattern had been outdated since before the Revolution. The slim leg balusters appear to be based on Philadelphia design, but other features show eclectic influences. The arrow-tipped side stretchers suggest eastern Connecticut chairmaking, although John Always and Joseph Hampton used this feature in a New York settee constructed in the mid 1790s. The double-baluster-and-disk arm supports draw on prerevolutionary coastal Rhode Island work, which also influenced the Dominy Windsor plank in outline, contour, and flat edge. More than seventy years after Dominy made Rysam's mahogany Windsors, Long Island's rural customs and simple pleasures were little altered. As seen in William Sidney Mount's painting *Catching the Tune,* long-outdated bow-back chairs, either made locally or imported earlier by neighborhood sea captains, were as much a part of everyday life as the lilies that bloomed every summer (fig. **5-29**).³²

New York City from 1800 to 1850

New York's prosperity and rise to a premier position among American cities in the early nineteenth century can be summarized in two words—*trade* and *transportation*. In 1797 the city's annual foreign trade volume was already greater than Philadelphia's, and a vast, new domestic market was opening in the Deep South. During an 1807 visit, English traveler John Lambert observed, "New York is the first city in the United States for wealth, commerce, and population." He found the seaport, with its crowded wharves, more like London than any other large American or Canadian city and described New York as a "happy medium" between the "narrow and confined irregularity of Boston" and the "monotanous regularity" of Philadelphia. City boundaries expanded continually, and new structures, both private and public, rose in all quarters, among them Joseph Mangin and John McComb's new City Hall. A profusion of shops lined Broadway and other fashionable streets. Despite northward expansion, lower Manhattan between the East River and Broadway and along the Hudson was still "the chief seat of business," the merchants located on Pearl Street and the bankers on Wall Street.³³

The Embargo of 1807 temporarily disrupted New York commerce and life, but when the hard times passed, the city led the way into the age of steam transportation. Timothy Dwight proclaimed, "Hardly any sight is more rare or more beautiful than the steamboats which move on the waters connected with New York, and which began their first operation deserving of any notice at this place." By 1810, regular service extended to Albany; steam-powered ferry service to New Jersey followed. In 1817 the state legislature, at Dewitt Clinton's urging, authorized construction of a waterway to link Lake Erie and the Atlantic Ocean. Eight years later the Erie Canal opened to barge traffic from Buffalo to a point north of Albany on the Hudson. The vast New York interior regions and

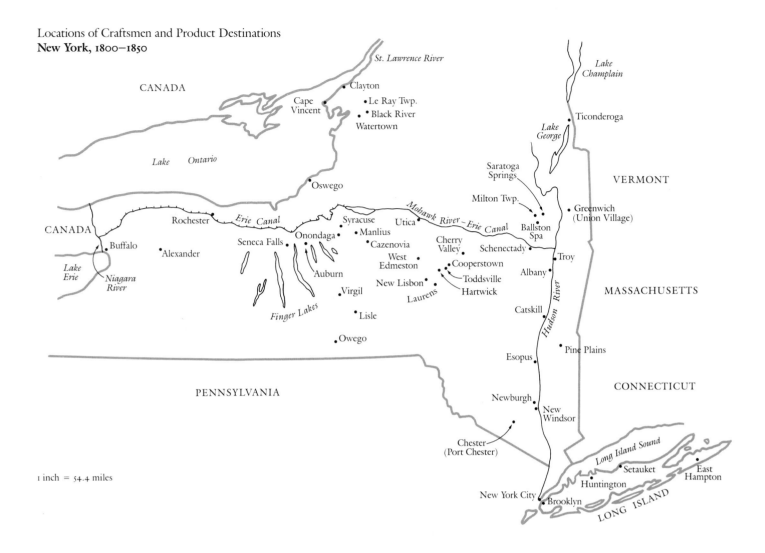

the West were now accessible for settlement and extensive commercial development. Cadwallader D. Colden, in commemorating the event, remarked, "The establishment of steam navigation, and the opening of Canals, have not only consolidated the interests of our own State, but undissolubly united every part of the Union." As part of the celebration, New York held a grand procession that included 200 members of the Chairmakers' Society, comprising masters, journeymen, and apprentices, among the marching "mechanics." Each wore the society's badge—a straw-colored ribbon with the image of an eagle-back fancy chair in the center of a laurel-bordered glory crowned by a banner printed with the chairmakers' motto "Rest for the Weary" (fig. 5-51). The group carried several large banners, including the "Grand Standard of the Society" (fig. **5-30**). On the front was the female figure of Plenty, her left hand resting on a fancy chair, surrounded by symbols representing agriculture, commerce, and manufacturing and the legend, "By Industry We Thrive." On the reverse, the chairmakers' arms consisted of a shield with a fancy settee at the top and two fancy chairs underneath; the crest was "a Chairmakers boring bitt, crossed vertically by a shaving tool."[34]

About the time work began on the canal, New York City inaugurated a regularly scheduled transatlantic packet service with Liverpool known as the Black Ball Line. By the late 1830s, the first steamship crossed the Atlantic from Ireland to New York. During the next decade, sleek new clippers sailing from New York harbor set speed records throughout the world. Another transportation revolution occurred in land travel with

Fig. 5-30 Chairmakers' Society emblems. From Cadwallader D. Colden, *Memoir Prepared at the Request of a Committee of the Common Council of the City of New York and Presented to the Mayor of the City at the Celebration of the Completion of the New York Canals* (New York: W. A. Davis, 1825), facing p. 373. (Winterthur Library.)

the gradual development of a railroad system by the 1840s. These advances, however, were tempered by disasters and economic turmoil. In 1835 a great fire swept through New York, and within two years the city was plunged into the Panic of 1837. Many businesses failed, and affluent men became bankrupts overnight; inflation and recession continued until about 1840. The first five decades of the nineteenth century constituted a period of increasing unrest among skilled laborers, as they struggled for recognition and security in a rapidly changing society.[35]

1800 TO 1820

Almost fifty Windsor-chair makers worked as masters in New York City during the first two decades of the nineteenth century, yet few chairs are known today. Fortunately, the labels of six firms have survived, documenting five distinct patterns or modifications manufactured in this period, beginning with the rod-back styles and continuing with variations of the slat-back Windsor. The latter includes chairs with long spindles of several patterns, double- and single-cross backs, and ball backs. A square-back side chair with a single cross rod from Cornelius Timpson and John Vangelder's Greenwich Street shop dates the earliest (1799–1801). The bamboowork is similar to that of figure 5-31, and the seat resembles the angular planks of figure 5-32. Seat contours, although modified from eighteenth-century design, are rounder than those in contemporary Philadelphia chairs, the general source for the overall design. The old H-plan bracing system lingered in New York, and grooved spindles were uncommon. George W. Skellorn, whose chairmaking career lasted more than three decades, made the square-back chairs in figure **5-31** and fixed his label (now fragmentary) to the armchair bottom after 1800. Although Skellorn remained on Pearl Street for many years, the chairs probably date well before 1810. William Ash's July 3, 1802, bill to Captain Randell, master of the ship *Wonolancet,* provides insight into the cost of such chairs. Sailing from Hallett's Wharf in New York for his home port of Portsmouth, New Hampshire, Randell carried two sets of eight Windsors, one white, the other black, each comprising six side chairs and two armchairs priced at 10s. and 11s. apiece.[36]

Another Philadelphia-inspired chair, made by Charles Marsh of John Street, is a variation of the serpentine-bow Windsor (fig. **5-32**). The early form of this chair had three-part bamboo legs and H-plan stretchers, but most of the surviving examples have

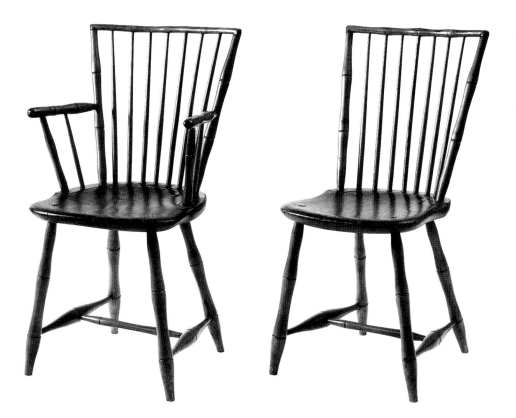

Fig. 5-31 Square-back Windsor armchair and side chair (two of three), George W. Skellorn (label), New York, ca. 1800–1806. Yellow poplar (seats) with maple and ash; left: H. 33¼″, (seat) 16¾″, W. (crest) 17¾″, (arms) 19¼″, (seat) 15¼″, D. (seat) 15⅛″; right: H. 33⅛″, (seat) 16¾″, W. (crest) 18⅝″, (seat) 16½″, D. (seat) 15⅞″. (Historic Deerfield, Inc., Deerfield, Mass.)

four-section legs and box stretchers. Two characteristics distinguish the New York chair from the Philadelphia product (fig. 3-112): the top bow has only a slight serpentine curve, and the back posts bend sharply outward. Most of these New York chairs have double rather than single bows. Four, and possibly six, Marsh Windsors are documented, with an equal number of side chairs and armchairs. Posts and bows have flattened faces that are grooved near both edges to form narrow beads.

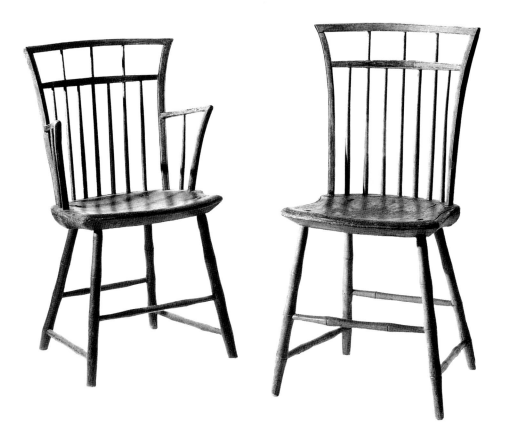

Fig. 5-32 Square-back Windsor armchair and side chair (two of four), and detail of label, Charles Marsh, New York, ca. 1802–11. Yellow poplar (seats); left: H. 34″, (seat) 17⅜″, W. (crest) 18½″, (arms) 18⅝″, (seat) 16½″, D. (seat) 15¼″; right: H. 32″, (seat) 16⅜″, W. (crest) 18½″, (seat) 17″, D. (seat) 16″. (The late Robert J. McCaw collection: Photo, Winterthur.)

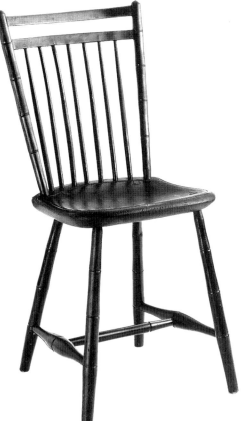

Fig. 5-33 Square-back Windsor side chair and detail of label, Reuben Odell, New York, ca. 1806–9. Yellow poplar (seat) with maple and hickory (microanalysis); H. 35¼″, (seat) 18⅞″, W. (crest) 17⅛″, (seat) 16″, D. (seat) 15″. (Winterthur 58.30.)

A double bow in the form of two narrow cross slats is the dominant feature of a labeled side chair made by Reuben Odell, probably between 1806 and 1808/9, when directories give his location as 51 Barley Street (fig. **5-33**). The unusual crest is a variation of the Philadelphia square-back, double-bow chair, but the flat rods reflect influence from the previous flared-back pattern. Odell apparently continued to make this pattern after he left Barley Street in 1808 or 1809, but he had probably already substituted box stretchers for the early braces. Chairs with similar backs were used at the New York Economical School that Baron Jean-Guillaume Hyde de Neuville and his wife founded in 1810 for children of French refugees. Sometime between 1810 and 1814 the baroness sketched a female student seated at a writing table in a similar square-back chair. The school's first location on Broadway between Duane and Reed (now Reade) streets is significant, since after leaving Barley Street, Odell moved to Duane and may have been in the neighborhood. The school likely purchased the chairs during its first year of operation. In January 1811, Odell became insolvent, but by March 1812 he had discharged his financial obligations.[37]

Another Odell chair bearing a different-style label shares some elements with the double-bow chair, but introduces several new features (fig. **5-34**). The overall profile and bamboo-style turnings are the same, but box stretchers replace H-plan braces. The broad slat top, common in fancy chairs from 1800 and perhaps earlier, is unusual in an American Windsor dating before 1812. The slat depth approximates that of the double-bow chair crest with its intervening void. In 1804 turner Linus Condit first supplied David Alling of neighboring Newark, New Jersey, with flat "benders," or slat-type crest pieces, for his developing chair trade. In 1801, he had delivered the first of many "Cumberland" spindles and stretchers. Although the source is obscure, the term *Cumberland* apparently refers to the style of turnings found in this chair back. In 1794 Nathaniel Dominy V used the double-baluster form as an arm support on a low-back Windsor, probably copying a Rhode Island model (fig. 5-28). Front stretchers of related design were common in coastal Connecticut rush-seat chairs, and Dominy had sometimes also used similar braces. Placing the Cumberland spindle in a chair back, however, was new. Some New York fancy chairs employ both Cumberland front stretchers and spindles. Odell likely manufactured fancy seating, since his insolvency inventory lists

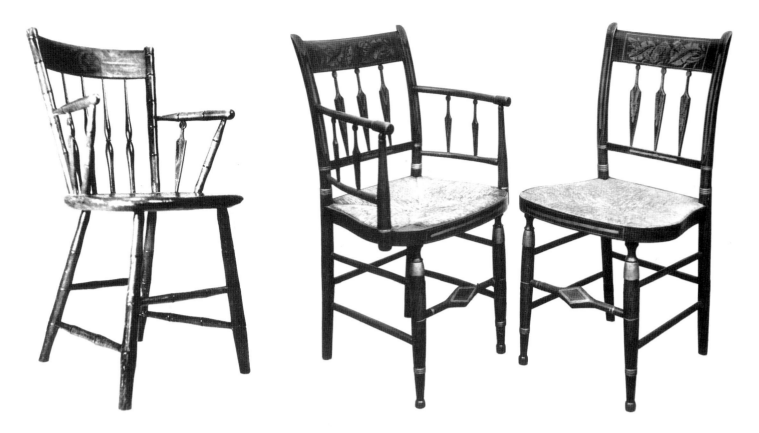

Fig. 5-34 Slat-back Windsor armchair, Reuben Odell (label), New York, ca. 1806–9. (Photo: Winterthur.)

Fig. 5-35 Fancy armchair and side chair (two of six), New York, ca. 1808–20. Left: H. 32½", (seat) 17½", W. 17". (Photo: Winterthur.)

rush for seat bottoms. Another feature shared by Odell's Windsor and fancy seating is the arrow-shaped spindle, here inserted below each arm. The profile is comparable with those in two fancy chairs that relate closely to documented New York fancywork (fig. **5-35**); however, the original influence came from Baltimore (fig. 3-118).[38]

Stephen Egbert employed similar bamboo-turned arms and posts in a labeled Windsor that dates between 1802, his first city directory listing, and 1809, the year of his death (fig. **5-36**). The presence of a seat pommel suggests an early date. The "flat bender" of the crest is shallower than that used by Odell, and the spindles thicken toward the bottom in the New York manner. Like other New York Windsors made about 1800, the Egbert chair rakes backward and curves laterally but without a fancy back bend.

A simple, yet fashionable, side chair forms a bridge between the Odell and Egbert Windsors and a new back style current by the 1810s (fig. **5-37**). Although the chair has a slat-type crest that is only slightly deeper than Egbert's, the straight, bamboo-turned back posts have been replaced by bent supports featuring multiring turnings below flat,

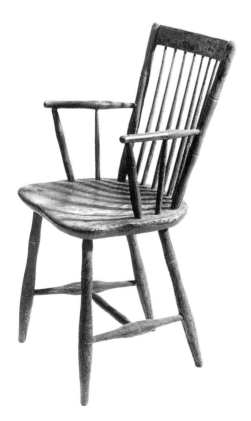

Fig. 5-36 Slat-back Windsor armchair and detail of label, Stephen Egbert, New York, ca. 1803–8. Yellow poplar (seat); H. 34½", (seat) 17¾", W. (crest) 16½", (arms) 19⅛", (seat) 18⅜", D. (seat) 15¾". (Elizabeth B. Hunsaker collection: Photo, Winterthur.)

New York 213

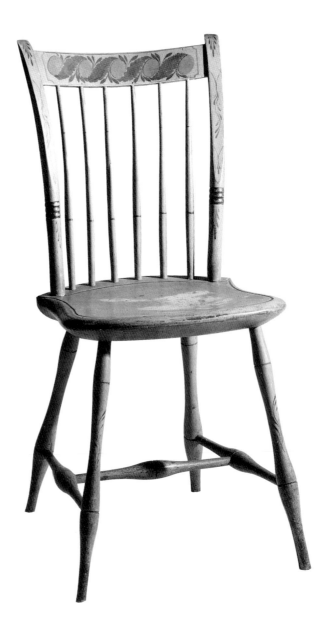

Fig. 5-37 Slat-back Windsor side chair, New York, ca. 1809–15. Yellow poplar (seat); light mustard ground with dark green and brownish red; H. 34¾″, (seat) 17¾″, W. (crest) 16⅜″, (seat) 16¾″, D. (seat) 14¼″. (Steven and Helen Kellogg collection: Photo, Winterthur.)

shaved surfaces. The 1802 edition of *The London Chair-Makers' and Carvers' Book of Prices for Workmanship* describes this bent upper structure as a "sweep back." The 1808 price book identifies the tapered, rounded post tips as "thumb tops" because the profile is similar to the side view of the human thumb. This otherwise up-to-date Windsor has an eighteenth-century, three-piece stretcher system, although the bracing plan is in keeping with the small size and delicacy of the chair. On the painted pale mustard ground, wisps of green leaves curl up the front legs, and leafy pendants cap the posts. The continuous band of leaves and ovals across the slat forms a chainlike guilloche. Similar ornament occurs in a New York drawing book kept by Christian Nestell and dated 1811/12, attesting to the currency of the motif. Young Nestell, later a painter of ornament, was completing his studies with a drawing master and copied this and other decorative patterns as training exercises.[39]

William Buttre, fancy- and Windsor-chair maker, illustrated an 1810 New York directory notice with a London-inspired, single-cross chair and employed both cut and text as a billhead. Two years later, Asa Holden advertised "a superb assortment of highly finished Fancy Chairs, such as double and single cross." These chairs feature narrow, single or double cross sticks in the back between the slat crest and the stay rail. Buttre again advertised in 1814, picturing the double-cross chair (fig. **5-38**). A trade card or small broadside distributed by the chairmaker in 1813/14 depicts a shop interior containing chairs of both patterns. Cosmopolitan New York was au courant with English seating

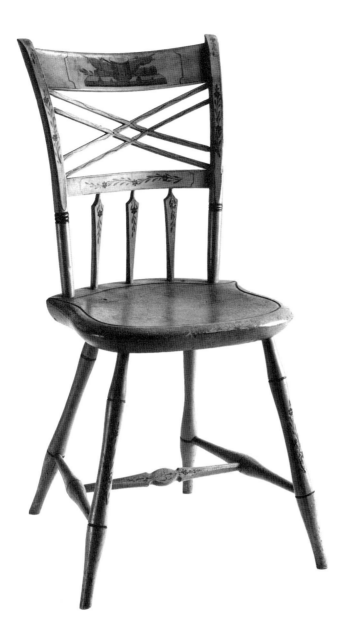

Fig. 5-39 Fancy slat-back Windsor side chair, New York, 1810–15. Yellow poplar (seat) with maple and other woods; pinkish tan-gray ground with light to dark brown and coral red; H. 34⅜″, (seat) 17¼″, W. (crest) 17⅛″, (seat) 16⅜″, D. (seat) 14¼″. (Formerly owned by James and Nancy Glazer: Photo, Winterthur.)

fashions; little time elapsed between the introduction of a new pattern in London and its transmission across the Atlantic. As early as 1807, Duncan Phyfe constructed a set of high-style mahogany chairs with two single back crosses for William Bayard (fig. 5-25). The next year, Henry Dean billed Elizabeth Dyckman of Boscobel on the Hudson for a set of "12 Cross Back Green & Gold Fancy Chairs" and two settees. New York was also a dissemination point for new European-derived fashions. In Newark, Alling had painter Moses Lyon bronze twelve double-cross fancy chairs in November 1815, the first of many references to the cross-back style in the manufacturer's records. Closely following the introduction of cross-back patterns to formal and fancy New York furniture were modest imitations in Windsor seating.⁴⁰

An undocumented, wooden-bottomed chair of delicate proportions and original paint introduces the double-cross-back style to Windsor seating (fig. **5-39**). The pattern is identical to the double cross pictured in Buttre's advertisement; the seat is a duplicate of the plank in figure 4-37. The ornamental medial stretcher reproduces a larger Baltimore pattern that is repeated in the front braces of figure 5-40, down to the four small points around the medallion of the prototype (fig. 3-156). These design crosscurrents that characterized the New York chair market also appear in another double-cross Windsor with box stretchers, four-part bamboo legs, and arrow-shaped sticks similar to those in Odell's chair (fig. 5-34). By the early 1810s, the bent back was firmly established in New York Windsor work. Delicate floral and leafy motifs often contrasted with bold

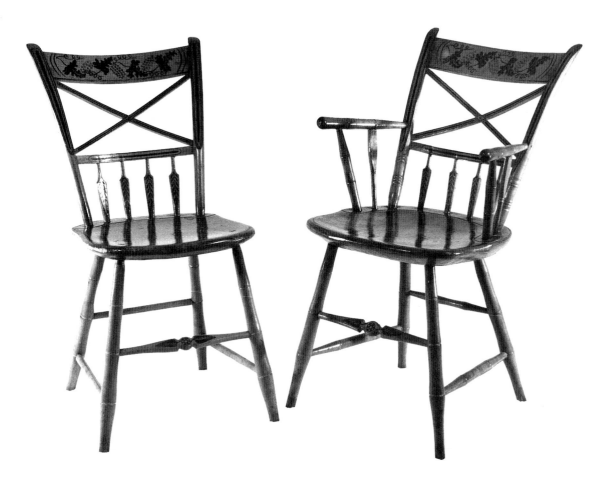

Fig. 5-40 Fancy slat-back Windsor side chair and armchair (two of four), New York, ca. 1811–17. Left: H. 32½", (seat) 17", W. (seat) 15", D. (seat) 14¼"; right: H. 32¾", (seat) 17½", W. (seat) 17", D. (seat) 16½". (Location unknown: Photo, Elizabeth R. Daniel.)

featured ornament, although the freehand-painted military trophy in browns and coral red is an unusual subject in Windsor seating.

Contemporary with the double-cross Windsor was the single-cross chair with short, arrow-shaped spindles (fig. 5-40). Simulated bamboo turnings follow contemporary design, while double-banded, pointed-base back posts introduce a new stylistic feature to the New York Windsor. Local fancy seating furnished the prototype for the double bands (fig. 5-35). Complete conversion to the four-part bamboo leg and box stretcher accompanied the change. The modern painted decoration is applied directly to the bare wood.

Holden's 1812 advertisement for cross-back chairs also offered consumers ball-back fancy seating. His chairs were probably similar to a set of eight Windsors constructed in Joseph Durbrow, Jr.'s, shop (fig. 5-41). The two armchair seats bear handwritten inscriptions in brown chalk that give the chairmaker's address as 442 Pearl Street, a location that he occupied between 1811 and 1822. Based upon contemporary records and design, the chairs date early in the period. The distinctive, turned, cross rods are designed with tiny, paired spools between shaped tips and centers (fig. 5-42). The bands on the front legs echo the paired spool motif that is repeated in the ornamental front stretcher. The tiny balls centered between the cross sticks give the pattern its name. Since New York enjoyed a brisk trade with England, inspiration for the turnings likely sprang directly from an English fancywork pattern dating to about 1800. The unusual seat fronts of the Durbrow chairs recall Baltimore work (figs. 4-3, 4-11). The feature was undoubtedly imported from that southern city, where its earliest use occurs on double-bow, square-back seating dating before 1810 (fig. 4-3). The short sticks of the lower back are updated Cumberland spindles. Beneath each arm is one short spindle of a new profile that resembles an organ pipe; these are probably the "organ spindles" recorded in Alling's accounts with Lyon beginning in 1815. The backs of nine rush-seat "Bamboo Chairs" that Skellorn sold in June 1819 feature three organ spindles set between horizontal rods.[41]

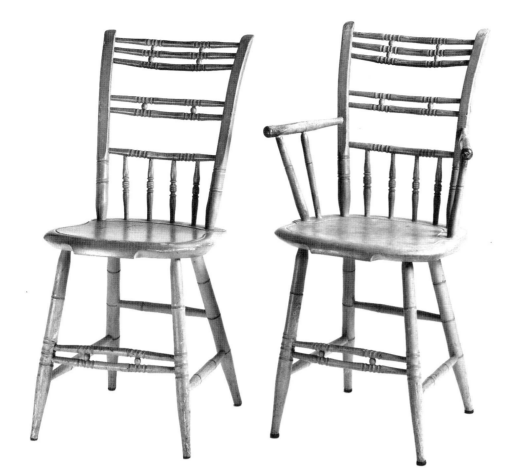

Fig. 5-41 Square-back, bamboo-style Windsor side chair and armchair (two of eight), Joseph Durbrow, Jr. (penciled), New York, ca. 1811–16. Yellow poplar (seats); left: H. 34⅞″, (seat) 18¾″, W. (seat) 16½″, D. (seat) 15½″; right: H. 35¾″, (seat) 18½″, W. (arms) 21¼″, (seat) 17¼″, D. (seat) 16⅛″. (Walter E. Nash collection: Photo, Winterthur.)

Fig. 5-42 Detail of armchair back of figure 5-41.

Organ spindles are prominent in a ball-back Windsor side chair of somewhat different character than the Durbrow chairs (fig. **5-43**, pl. 19). The three-part bamboo legs and H-plan braces of this organ-spindle chair predate the Durbrow examples. The chairmaker lengthened the single, multiring band of the back posts and accented the turned decoration with contrasting light and dark paint carried across the tops of the organ spindles. The painted, wavy, ribbonlike banding on the cross rods is also present on the flat diagonal sticks of the double-cross-back chair, although here the slat decoration is better integrated into the scheme (fig. 5-39). Few chairmaking centers equaled New York's early 1810s Windsor production in the rich vocabulary of its structural and painted ornament.

When Henry Bradshaw Fearon visited New York City in 1817/18 during a fact-finding tour undertaken to advise other Englishmen about emigration prospects, he observed the business community and noted, "chair-making here, and at the town of Newark, ten miles distant, is an extensive business." Exchanges of materials, parts, workmen, and products were substantial. In the absence of New York resource material, Alling's business records become integral to interpreting the metropolitan furniture market. His accounts with Lyon document two ball-back patterns current in 1815: "Ball Back Bamboo" (fig. 5-41) and "Wide top Ball Backs" (fig. 5-43). The records also show that Lyon ornamented ball-back chairs with fruit decoration.[42]

Grapes, accompanied by cornucopias and floral motifs, provide a strong focus at the top of a ball-back armchair of elaborate pattern and bright color (pl. 20). The ball fret varies somewhat from that in figure 5-43; the chairmaker has also slightly modified the back spindles from the profile of figures 5-39 and 5-40. The squared-top underarm spindles, which relate to those in figure 5-45, advance the design to the mid or late 1810s. The dating is reinforced by the stout back posts, shaved arm tops, flat-edged seat, and heavy, four-part bamboo legs with box stretchers. The ornamental front brace is a slightly more flamboyant interpretation of that in figure 5-40, both updated versions of the simpler profile in figure 5-39.

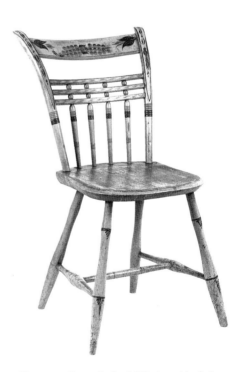

Fig. 5-43 Fancy slat-back Windsor side chair, New York, 1810–15. Yellow poplar (seat) with maple; faded robin's egg blue ground with yellow, green, and red; H. 32⅝″, (seat) 17⅝″, W. (crest) 17⅞″, (seat) 15⅛″, D. (seat) 15″. (Winterthur 93.69: Photo, David A. Schorsch, Inc.)

The career of Thomas Ash II, named for his uncle Thomas, also illuminates the New York chairmaking business. After his father William died in 1815, Thomas "succeeded to the long established and well known manufactory of Fancy and Windsor chairs" at 33 John Street. Ash's proprietorship announcement noted: "He has already in [his] employ a number of the very best and most tasteful workmen, and is ready to receive orders, which will be executed with fidelity and promptness. Those persons who may please to favour him with their commands, may rely upon strict attention to the execution of their orders. On hand, an assortment of Chairs, both Fancy and Windsor, of the newest fashions, and suited for domestic use or the foreign market." Illustrating the notice is a fancy ball-back armchair and a rush-bottomed settee with vertical spindles. As early as May 23, Ash shipped seventy-one "bundles" of chairs to Savannah, Georgia. Upon settlement of his father's estate, which was appraised on June 8 by chairmakers William Sigison and Philip I. Arcularius, Jr., Ash likely inherited the shop materials and stock. Seating furniture on hand included "251 Fancy Chairs, Settees, Music Stools &c finished & unfinished" and "282 Windsor chairs & Settees." Parts and supplies included "Turn'd Stuff, Chair & Settee Seats, plank, Glue &c, Paints, Varnishes, Painters articles, Tools &c."[43]

1820 TO 1850

Uptown from Thomas Ash's John Street shop, John Knox Cowperthwaite did business at 4 Chatham Square, near present-day Chinatown, from 1808, when he began chairmaking, until the late 1820s. During the War of 1812 Cowperthwaite kept the business alive by making army cots and stools. Between 1810 and 1812 the chairmaker had engaged John C. Totten of nearby Chatham Street to print a supply of pictorial billheads (fig. 5-44). The rush-bottomed fancy chair with openwork back at the left probably illustrates the "dimond fret" that David Alling referred to in his invoice book. The flat-, or arrow-, spindle Windsor at the right had broad and lasting influence on the chairmaking trade. Cornwell and Smith, also of Chatham Street, featured the same Windsor-chair cut on a billhead printed about 1817, and Richard D. Blauvelt used the woodblock again in 1832. Alling purchased sets of parts to make "flat spindle winsor" chairs as late as 1840. On Long Island, Nathaniel Dominy V made or bought a New York chair of this pattern; and, in upstate Washington County, J. C. Bartlett labeled a pair of similar armchairs about 1820. An undocumented Windsor armchair of metropolitan origin with full-length, bent, flat spindles like those in the Cowperthwaite billhead, exhibits several other contemporary New York characteristics (fig. 5-45): thick, tapered-base back posts with ringed bands; turned, shaved armrests that slope to a point at the front; and a double-baluster-and-ball-turned front stretcher similar to that pictured in the billhead. The modified shield seat is considerably less modeled than earlier versions; the blunt edges, which are incised top and bottom with a groove, follow earlier Philadelphia work (figs. 3-114, 3-116).[44]

By 1818 Cowperthwaite was advertising that his "Factory" at 4 Chatham Square extended to 2 Catherine Street, an indication that business was flourishing. In 1823/24 a new, ambitious, and probably costly, billhead pictured Cowperthwaite's manufactory and store, as well as other businesses in the square (fig. 5-46). The billhead likely served the chairmaker until 1826/27, when he moved to a new location. Cowperthwaite inscribed the illustrated sheet in 1825, the year he was president of the "Master Chair Makers' Society." He and George W. Skellorn, the society's vice president, helped to plan the "Grand Erie Canal Celebration" with a committee representing the city and also marched in the November 4 procession.[45]

Although Duncan Phyfe constructed a set of scroll-back mahogany chairs in 1807, the 1810 *New-York Revised Prices for Manufacturing Cabinet and Chair Work* is the first American volume to list scroll-back seating (fig. 5-25). The general form remained current in the New York area for several decades. Alling made painted, bronze-ornamented "Scroll Backs" in 1817. Chairmakers Charles Fredericks and Benjamin

Fig. 5-44 Billhead and bill of John Knox Cowperthwaite, New York, printed ca. 1810–12, inscribed 1816. (Winterthur Library.)

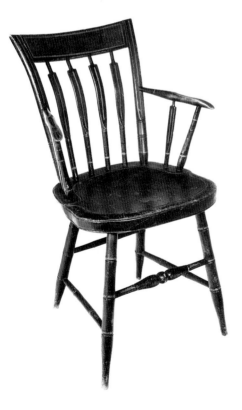

Fig. 5-45 Slat-back Windsor armchair, New York, 1815–25. Black ground with yellow. (Photo, Priscilla H. Ziesmer.)

Fig. 5-46 Billhead and bill of John Knox Cowperthwaite, New York, printed ca. 1823/24, inscribed 1825. (Bronson Family Papers, Rare Books and Manuscripts Division, New York Public Library, Astor, Lenox, and Tilden Foundations, New York.)

Fig. 5-47 Scroll-back fancy side chair, Charles Fredericks and Benjamin Farrington, New York, ca. 1818–25. Mahogany; H. 32⅛″, (seat) 17⅝″, W. 17⅝″. (Winterthur 56.514.)

Fig. 5-48 Designs for chair parts. From *The New-York Book of Prices for Manufacturing Cabinet and Chair Work* (New York: J. Seymour, 1817), pl. 6. (Photo, Winterthur.)

Fig. 5-49 Roll-top Windsor side chair, New York, 1820–25. H. 32½″, W. 15½″, D. 16″. (Photo, Jay Johnson Gallery.)

Farrington formed a partnership the following year to produce scroll-back and other popular seating. Sometime before the association ended in 1825, they constructed a splendid mahogany fancy chair as a presentation piece, according to a label on the crest back (fig. **5-47**). The delicately proportioned chair introduces the so-called Hitchcock leg in its most elegant form: two compressed balusters center a long, multiringed cylinder above a flared foot. As Alling's 1819 records indicate, fancy chairs with "bent front feet" provided an alternative, albeit a costlier one, to the commoner "strait front feet" of the contemporary furniture market. The most important feature of the chair, however, is the carved crossrail, or "bannister," of the back, described in the 1817 New York price book as a "stay [rail] with double Prince of Wales feathers, tied with gothic moulding" (fig. **5-48**, item D). Chairmakers adapted the prince-of-wales pattern for rush- and wooden-bottom seating. One Windsor substitutes an oval tablet in the crossrail for the carved leafwork of the mahogany chair but retains the horizontal end plumes known as prince-of-wales feathers (fig. **5-49**). Rectangular center tablets are also known on seating furniture ranging from formal examples to Windsors. New to the Windsor crest was the "roll," a top piece that remained popular in fancy and Windsor seating for several decades. Alling listed "fancy rolls" as late as the 1840s, and E. G. Partridge's Worcester, Massachusetts, firm pictured a roll-top fancy chair on an 1850s billhead. Roll tops, however, also crowned other types of banisters. The plain cross slat was more popular, since it offered greater flexibility in decoration.⁴⁶

The 1817 New York price book fails to mention eagle-pattern cross slats, although the volume describes and pictures the related lyre and harp banisters (fig. 5-48, items E and F). New York chairmaker William Buttre, now relocated in Albany, had introduced a unique and somewhat impractical "Eagle Fancy Chair," which he illustrated in an 1815 Albany advertisement (fig. **5-50**). The eagle's head, however, was eliminated in the actual

Fig. 5-50 Advertisement of William Buttre. From the *Albany Register*, Albany, N.Y., February 17, 1815. (Photo, American Antiquarian Society, Worcester, Mass.)

Fig. 5-51 Chairmakers' Society emblem. From Cadwallader D. Colden, *Memoir Prepared at the Request of a Committee of the Common Council of the City of New York and Presented to the Mayor of the City at the Celebration of the Completion of the New York Canals* (New York: W. A. Davis, 1825), facing p. 372. (Winterthur Library.)

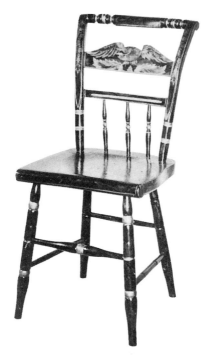

Fig. 5-52 Roll-top Windsor side chair, New York, 1820–30. (Photo, Museum of the Historical Society of Early American Decoration, Inc., Albany, N.Y.)

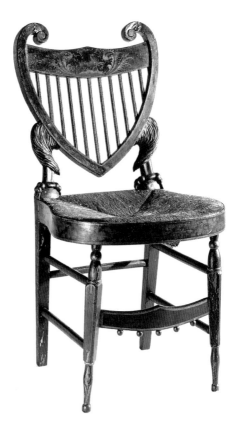

Fig. 5-53 Eagle-back fancy side chair (one of a pair), attributed to William Buttre, New York or Albany, N.Y., ca. 1814–23. Beech, yellow poplar, ash, and maple (microanalysis); H. 35⅛″, W. 18⅜″, D. 19⅝″. (Winterthur 52.50.1.)

construction of the chair (fig. 5-53). Buttre had listed his "American Eagle Chairs" almost a year earlier in a New York notice illustrating the double-cross-back chair (fig. 5-38). The chairmaker's choice of adjectives and illustrative material leaves little doubt that his source of inspiration was the Great Seal of the United States. The heart-shaped chair back with the broad slat above slim, vertical bars represents the striped federal shield that conceals the eagle's body. Contemporary craftsmen may have had more than just a passing interest in eagle chairs, since on June 14, 1816, W. I. Weaver of New York City received a patent for an "eagle chair." Exactly what this was remains undocumented, since early patent records were destroyed during several disastrous nineteenth-century fires. New York directories for the 1810s and 1820s identify only a William Weaver, ship carpenter or joiner.

The eagle motif executed in more practical form as a carved banister was perhaps introduced after publication of the price book. Delicate chairs of this design were certainly in the forefront of New York fashion by 1825. As noted, the badge worn by Chairmakers' Society members in the Erie Canal procession depicted an eagle-back fancy chair in a glory (fig. **5-51**). Colden adds that the chair on the badge employed "the State crest as an ornament for the middle back rail." The crest accompanying the New York State arms is a spread eagle atop a partially visible world globe that rests upon a heraldic wreath. This "local" symbol probably inspired both the painted and the carved mahogany chairs constructed preceding the celebration. The incomplete set of standing-eagle mahogany chairs reputedly owned by DeWitt Clinton probably dates from this period when Clinton was governor and canal commissioner rather than during his earlier New York City mayoralty, as currently surmised. Of particular note, the Clinton eagle stands upon a heraldic wreath in the manner of a crest.[47]

A Windsor side chair with an eagle painted on the back rail originated in New York City (fig. 5-52). Its ball-turned elements, including spindles, front legs and stretcher, and roll top are similar to the Windsor with the prince-of-wales-feathers banister (fig. 5-49); a companion eagle-back armchair also relates to the prince-of-wales Windsor in its balloon-shaped seat. Both eagle-back chairs have typical heavy New York back posts that taper noticeably below turned and gilded double rings. A pair of similar side chairs with balloon-shaped wooden seats, the property of the Halifax, North Carolina, Masonic Lodge, was probably imported from New York. A ball-back chair with a painted spread-eagle crest is illustrated in an 1822 metropolitan advertisement for John G. Bartholf's "Eagle Chair Store."[48]

Information on Windsor-chair making in New York City during the 1830s and 1840s rests in documents rather than artifacts. In the mid 1830s Alling described two contemporary styles as "flat top" (fig. 5-45) and "roll top" Windsors (5-49). Some of Alling's seating still featured flat spindles. A shop inventory taken after the death of New York chairmaker Benjamin W. Branson in 1835 describes flat-top chairs more precisely as "Slatt Top" Windsors, since the rectangular boardlike crests are framed between the back posts rather than above them. Crown-top chairs featured a tablet crest with scroll ends. Both ball- and fret-type center rails remained popular in fancy seating, and some Grecian-style designs were also in the market. The "office" armchair figured in production by 1839, when Arthur Bronson, Esq., purchased a seat of that description. Similar chairs are listed in Alling's 1855 inventory along with eight other painted fancy and Windsor styles.[49]

New York State, 1800 to the 1850s

Land speculation and settlement in New York's backcountry gained momentum after the Revolution. At the Erie Canal's completion, small communities dotted the state as far as the western and northern boundaries. Most new settlers were Yankees; in 1820 Timothy Dwight called New York State "a colony from New-England." Agriculture almost completely dominated life in the interior; from 1784 to 1821, the amount of "improved farmland" increased from about 1 million acres to 5.5 million acres. Barter and credit were the mainstays of business in this predominantly self-sufficient rural economy. Albany and other large communities along the Hudson continued to prosper from the river trade, while Schenectady was an early transfer point for goods destined for the interior. Transportation improved with turnpike construction, and by the late 1810s steam travel enhanced communication along the lakes that form the state's northwestern border. Real commercial encouragement, however, came only with the opening of the Erie Canal and shorter waterways.[50]

When the Atlantic Ocean and Lake Erie were linked in 1825, the cost of transporting freight from Buffalo to Albany dropped by more than 90 percent. Commerce grew by leaps and bounds, and the canal business provided jobs for thousands. The rise of villages and cities along the waterway was phenomenal. Several communities became boomtowns overnight: Utica as a transportation crossroads; Syracuse as a salt producer; Rochester as a milling center in a rich, wheat-growing valley; Buffalo as the canal terminus and a gateway to the West. Englishwoman Frances M. Trollope aptly described the transformation from forest to city: "Rochester is one of the most famous . . . cities built on the Jack and Bean-stalk principle. There are many splendid edifices in wood; . . . more houses, warehouses, factories, and steamengines than ever were collected together in the same space of time; but I was told by a fellow-traveller that the stumps of the forest are still to be found firmly rooted in the cellars." Immediately after the canals came the railroads, the first line opening in 1831. By 1853 Erastus Corning consolidated eight railroads and spanned the state with one line, the New York Central, expediting freight and passenger travel. Railroad linkage with New England complemented the long-established water route.[51]

Outside New York City, early nineteenth-century chairmaking followed the established paths of commerce—up the Hudson to Albany and west beyond the Mohawk River valley, near the later canal route. The 1809 inventory of George Clinton, Jr.'s, farm in New Windsor along the Hudson in Orange County included Windsor and "common" rush chairs. In Esopus, south of Kingston, J. W. Bedell branded Windsors that imitate New York City work. James Chestney still pursued chairmaking in State Street, Albany, where he painted and put new "bottoms" on rush chairs for Peter E. Elmendorf, Esq. Like Chestney, fellow chairmaker Gilbert Ackerman supplied residents with "Windsor, Fiddle-back, and Common Chairs."[52]

About the same time, at Ballston Spa, near Saratoga Springs, New York City merchant and entrepreneur Nicholas Low was developing his extensive landholdings. The proven attraction of the medicinal springs encouraged Low in 1803 to construct a large and well-appointed hotel, which he named the Sans Souci. Through his land agent, Low purchased furnishings from local craftsmen. Chairmakers Milton Alvord and Miles Beach made many "round" (bow-back) and square-back Windsors for the hotel. West of Ballston Spa, land speculation opened vast interior tracts. At Cazenovia, John Lincklaen, a young Dutch agent of the Holland Land Company, built a large federal-style house called Lorenzo in 1807. Family furniture still at the mansion includes several fancy-chair sets documented through Lincklaen's "house book" to local chairmaker Nehemiah White. The fashionable single-cross, rush-bottomed seating is similar to that pictured in William Buttre's 1810 New York advertisement and illustrated again on his 1813/14 trade card. Communication of design from the metropolis to the interior occurred rapidly.[53]

During the 1810s the chair industry responded to continuing territorial expansion as new communities sprang up across the state in what had formerly been wilderness areas, although the old commercial ties between the Hudson Valley and New York remained important. Chairmaking flourished on Albany's State Street, where Chestney was located at No. 134, Buttre kept a shop at No. 124, and Caleb(?) Davis and John Bussey occupied No. 112. Across the street at No. 115, George G. Jewett produced fancy, Windsor, and common chairs, as did Bates and Johnson at No. 99. Chestney still did business with old, established Dutch families. In 1815 the widow Catharine Van Schaick Gansevoort hired him for chair repairs, painting, and ornamenting. Her son, Peter Gansevoort, Esq., employed several chairmakers, including Buttre. Buttre's striking "American Eagle Chairs" were probably a novelty in Albany as well as in New York (figs. 5-50, **5-53**). The chairmaker likely continued to produce this design after he moved to Auburn in the Finger Lakes region about 1821. The broad front stretcher with pendent balls visually balances the chair back, and square legs angled with a forward-facing corner echo the peaks of the crest and front brace. The block-and-turned support is rare in painted fancy seating.[54]

Upriver from Albany, the small city of Troy developed as a commercial center and became the Rensselaer county seat in 1791. When passing through Troy on his way to Saratoga Springs in 1820, Thomas P. Cope noted, "It is a place of business—some persons trading to the extent of $150,000 annually." A three-way exchange of goods and services among several Troy chairmakers in 1818, in lieu of paper and hard money, gives some idea of business practice outside the large metropolitan centers. James Young, who acquired "8 Bamboo fancy chairs" costing $20 from David McKelsey, paid him in Windsor chairs and a promissory note on chairmaker Simon Smith. Smith owned a prosperous business in 1809, when Allen Holcomb, a Greenfield, Massachusetts, craftsman, began to work in the shop. Holcomb recorded activities that varied from repairwork to painting and ornamenting. He framed many sets of chairs and constructed other seating, including the fashionable cross-back chair, from start to finish. The craftsman later settled permanently in Otsego County.[55]

North of Troy in Washington County near the Vermont border, John Miller, a Cambridge farmer, owned a set of fourteen Windsors at his death in 1812. At the sale of his household effects, the chairs, including two with arms, were divided among four purchasers. This and similar dispersals of matched seating help to explain why complete sets of chairs dating before 1825 are uncommon today. John C. Bartlett made Windsor chairs only a few miles away in Union Village (now Greenwich), where his name appears in the 1820 Census of Manufactures. Two labeled arrow-back armchairs relate to New York City work but also reveal New England influence, as expected in this border region. Farther north in Ticonderoga, at the head of Lake George in Essex County, Bush Fitch made Windsor chairs in a region that today remains lightly settled. For the 1820 census, he reported that his shop was in good condition after five years of operation, although sales were slow due to the postwar recession. The establishment employed three men, and water supplied power for the lathe.[56]

Nehemiah White continued chairmaking in central New York, although by 1812 he had moved from Cazenovia to neighboring Manlius and set up shop "a few rods west of Barrett's tavern." By 1820, when two men and an apprentice worked in the shop, business was "rather declining." Sales were slow, and the chairmaker exchanged most chairs for commodities rather than cash. Southwest of Syracuse in the nearby town of Onondaga, Travers Swan, working with one apprentice, made fancy and Windsor chairs as well as drums. He also reported poor sales in 1820. Partners Fields and Brown operated a chair and wheel factory at Seneca Falls in the adjacent Finger Lakes region. Despite the hard times, they manufactured 1,000 chairs and 25 wheels in 1819. Kitchen, or common, chairs sold for $.75, Windsors were $1.00, and fancy seating cost $2.50.[57]

In south-central New York, evidence of chairmaking occurs along the Tioughnioga River toward Binghamton. Philo Green of Lisle, Broome County, turned fancy, common, and Windsor chairs using waterpower and the help of a part-time assistant. At Virgil in adjacent Cortland County, John Lanphier (or Lanphear) and a full-time journeyman manufactured both chairs and cabinetware. Business was slow, but the establishment was in satisfactory repair. Chair sets sold for as little as $6; bureaus were $16. Chairmaker Holcomb was well established at New Lisbon, near Cooperstown, by 1813, when records indicate that he borrowed a wagon belonging to cabinetmaker William Bentley of neighboring Butternuts. Perhaps he used the vehicle to fetch timber or deliver finished chairs to a private customer or retailer. Holcomb provided local residents with dining-chair sets and turned work, including candlestands, bedposts, and clockcase pillars; charges for furniture repairs and painting occur frequently in his accounts. In lieu of cash payments, he often accepted lumber or agreed to commodity exchanges. Sutten Pearsoll, for example, acquired a set of "Dining Chairs" in July 1821 for which Holcomb was "to be paid 7 Bushels and 4 quarts of wheat at $1 per bushel." Aron Holenbech paid for a "little" chair "in shoemaking." Holcomb hired out as a journeyman or laborer for occasional short periods, and he also rented time at his shop lathe to a local handyman. He sometimes employed skilled workmen like Abraham Voris, who "bottom[ed] 12 fancy Cross back" chairs and framed 42 Windsors in December 1813, or Edward Rowley, who in 1821 made 125 common dining chairs, 75 "Bent Backs," and 13 rockers.[58]

A chairmaker who branded his production "A. WING." (the "N" reversed) probably pursued his business in Otsego County or the Chenango River valley from the 1820s. A marked side chair is believed to have been found in that central New York region (fig. 5-54). Although the Wing name is generally associated with Barnstable County, Massachusetts, the 1810 New York federal census lists five family members with the same first initial; the number increases to eight in 1830. The chair exhibits New York characteristics, although some features, such as the banded back posts and front stretcher, are simplified. The blunt-edged, balloon-shaped plank and tapered feet were part of New York City work before 1820 (fig. 5-45); the sharp taper of the leg tops and stretcher tips first appeared in state production in the mid 1820s (fig. 5-57).

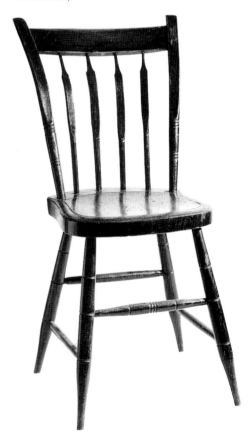

Fig. 5-54 Slat-back Windsor side chair and detail of brand, A. Wing, eastern central New York, 1825–40. Basswood (seat, microanalysis); H. 34", (seat) 17⅞", W. (crest) 18⅛", (seat) 15", D. (seat) 14⅞". (Mary Scala collection: Photo, Winterthur.)

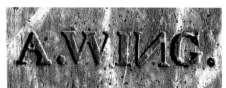

Fig. 5-55 Slat-back Windsor side chair, greater Albany, N.Y., region, ca. 1820–28. Yellow poplar (seat, microanalysis); medium-light gray ground with medium blue-green, brown, black, pinkish red, lemon yellow, blue, and gilt; H. 33⅞16″, (seat) 18⅛″, W. (crest) 16¼″, (seat) 15½″, D. (seat) 15″. (New York State Historical Association, Cooperstown, N.Y.: Photo, Winterthur.)

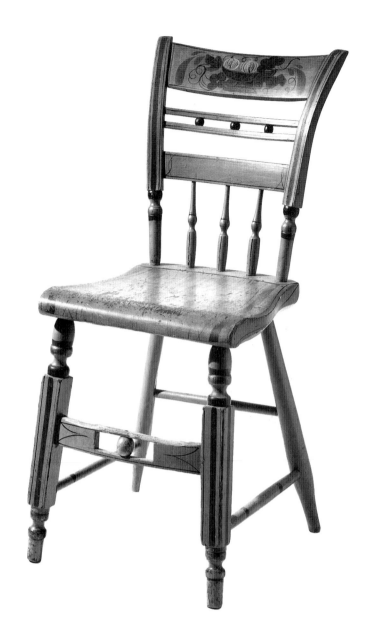

Otsego County chairmakers probably had only limited competition until the 1820s, although craftsmen in the densely populated regions along the Hudson had been contending with the presence of New York furnishings in their local markets for several decades. J. C. Clark, who located near Newburgh in Orange County, wisely established his "factory" at the busy "junction of the Cochecton and Snake Hill turnpike near Belknap's mills," where he offered a full line of fashionable Windsor and fancy chairs in 1824. Upriver at Albany, the chairmaking business continued to flourish and the momentum spread to nearby Troy and Schenectady. State Street, Albany, remained a local trade center, with Chestney, Jewett, and Bussey still there and Gerrit Visscher joining them from 1821 to 1824. Visscher and his short-term partner, Ashley C. Baker, offered slat- and ball-back chairs. Mindful of competition, they carefully stated that their work was not "exceeded by any in this city, or the city of New-York."[59]

Perhaps a similar concern prompted chairmaker David McKelsey to move from Albany to Troy by 1829, when he made a strong bid for the steam and canalboat furnishing trade. Northwest of Albany at Schenectady, Caleb Lyon, who was a chairmaker in 1818, continued the trade for several decades. In 1828 he repaired Windsor seating for John Sanders in exchange for "wool or cash." Fellow chairmaker Thomas Kinsela, with a decade or more of experience in 1820, produced common, fancy, and Windsor chairs with the help of a journeyman and an apprentice. Kinsela was producing a full line at the time of his death two years later. Several dozen assembled Windsor chairs

in adult and child sizes were in the shop or storage. The substantial inventory also included 125 adult and 11 "Small Chair frames" and "53 Bundles flags" (rush) for woven seats. Some chair frames probably had banister backs, since known shop production includes a documented example of that type of seating.[60]

A distinctive slat- and ball-back side chair probably originated in the Hudson Valley between New York City and Albany during the early 1820s (fig. **5-55**). Mistakenly called a Pennsylvania chair, it is instead related to identified New York work. The chair was purchased in the Finger Lakes region in the early 1950s. Squared legs and back posts recall Buttre's earlier eagle chairs offered in New York and Albany (fig. 5-53); the same elements relate significantly to another fancy design from that area (fig. **5-56**). Early 1800s New York mahogany seating with squared and tapered legs and back posts provided the general prototype (fig. 5-25); a variant pattern introduced turned round-work above the seat. The strong visual contrasts of the rounded and squared elements in the Windsor and the related fancy chair dominate the designs (figs. 5-55, 5-56). The Windsor's shovellike wooden seat "migrated" from Pennsylvania to influence both New York and New England work. Ball spindles and squared, tapered back posts are also present in a pair of 1824/25 Windsors, possibly of New York State origin, painted with the name "LAFAYETTE."

The free-flowing quality of the bright, polychromed, hand-painted decoration of figure 5-55 relates to a roll-top Windsor side chair from eastern central New York (fig. **5-57**). The crest roll was current in Albany by 1819, when the Bates and Johnson firm offered the public regular seating and "Johnson's Patent Portable Settees" of this design. The multiring turnings of the roll in figure 5-57 suggest a late 1820s date. The motif is repeated in the fancy front legs and stretcher, the latter close in design to ornamental braces in later, documented New York State chairs (figs. 5-59, 5-62). Several other bent-back chairs have crests and ball spindles that relate to the roll-top Windsor. Each has a middle slat of varying depth with a slight peak at the center top. Lambert Hitchcock in Connecticut used this shape by 1832; it also occurs in Massachusetts work. One balloon-seat Windsor is stenciled: "BY / L.BREWER / CHERRY Valley." The village of Cherry Valley lies west of Albany in Otsego County, where chairmaker Holcomb resided. Although Holcomb described his mid 1820s Windsor production only as "dining," "fancy wood seat," or "bent Back" chairs, Miles Benjamin of neighboring Cooperstown specifically noted the sale of "1 sett Roll Back chairs" for $7 in 1826. Chairmaker Omar Boden supplied at least some of Benjamin's stock.[61]

Chairmakers of the interior regions found their success increasingly linked to transportation technology. In 1819 Sylvester H. Packard established a chair factory in flourishing Rochester to produce common, Windsor, and fancy chairs. By 1821 he employed Richard Freeland and Lewis Britton. After the Erie Canal opened, the need for woodworkers grew rapidly. City directories, which began in 1827, record the dramatic increase in the number of craftsmen. In Owego, a village in south-central Tioga County, Alvan Dana advertised his cabinet and chair business by 1829. Dana's potential trading area was sizable, since the community was well situated for trade. The New York and Erie Railroad was establishing a line between Owego and Ithaca, thirty miles away on Lake Cayuga. In addition, the upper Susquehanna River, which extended into the Owego region, permitted the regular transport of local commodities—grain, lumber, and salt—to Pennsylvania and Maryland markets.[62]

UPSTATE AND CENTRAL NEW YORK, 1830 TO THE 1850s

Freehand decoration like that on the roll-top chair of figure 5-57 gave way to stenciling in the 1830s. Stencil patterns found in the account book of chairmaker Ransom Cook, who worked in Milton Township and Saratoga Springs from before 1820 until the 1840s, consist of footed bowls, baskets, cornucopias, fruits, and flowers, all embellished with leaves. Variant patterns are stenciled under the hinged top of a six-board chest that once belonged to the Stephens chair factory at Toddsville, Otsego County. Roll-top chairs

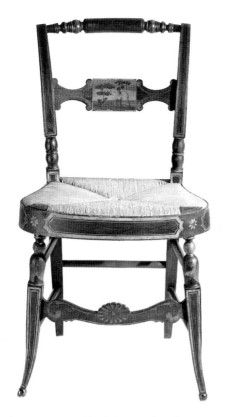

Fig. 5-56 Fancy side chair (one of a pair), New York or Albany, N.Y., ca. 1818–25. Maple, yellow poplar, and ash (microanalysis); H. 33½″, W. 18½″, D. 16¾″. (Winterthur 57.614.1.)

Fig. 5-57 Roll-top Windsor side chair (one of a pair), eastern central New York, 1825–35. Yellow ground with red, ocher, green, black, and gilt; H. 33″, (seat) 18″, W. 15½″, D. 17⅜″. (Photo, Gary C. Cole.)

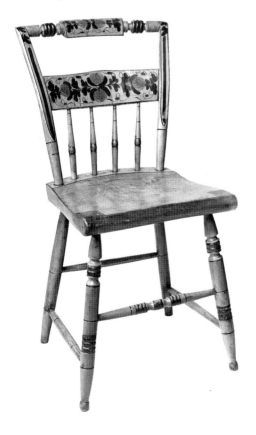

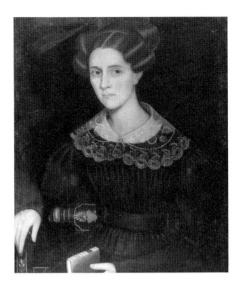

with either wooden or fancy seats were popular throughout southern New England and New York State by this time. Ammi Phillips detailed a roll-top chair with stenciled decoration in his portrait of Mrs. Morgan Hunting of Pine Plains, a village near the Connecticut-Massachusetts border (fig. 5-58). At Alexander, a village in Genesee County, western New York, Noah North in 1833 painted a posthumous portrait of his young neighbor, Dewit Clinton Fargo, seated in a similar ornamented chair. While the chair was only a prop, its use demonstrates the prevalence of the roll-top pattern.[63]

Chair styles in the northwestern Adirondack Mountains were basically similar to other New York patterns. In the Watertown area in Jefferson County near Lake Ontario, three chair manufactories operated in 1840. One may have been that of David Dexter of Black River. A table-top chair with a roll-front seat bears Dexter's name brand on the seat bottom (fig. 5-59). While the short spindles lack ball turnings, their thickened profiles relate to contemporary New York and New England production. Flat and chamfered surfaces define the seat edges; stenciled bowl decoration is featured on the cross slat.

Dexter migrated from Athol, Massachusetts, to Black River in the late 1830s. The abundant waterpower supplied by local streams and rivers encouraged the establishment of area manufactories. A sawmill and a gristmill had been erected early in the century, but residential settlement was slow. In 1854, Dexter still had the only chair factory in the community, although other woodworking facilities included a shingle factory, wagon shop, and three sawmills. When fire destroyed the Dexter property in 1865, the family rebuilt on the same site (fig. 5-60). About a decade later, the *History of Jefferson County, New York* reported: "the firm manufactures all kinds of chairs, and have acquired an excellent reputation for the quality of their work. They have one of the best water-powers in northern New York, and their factory is supplied with all the modern improvements in machinery and general appointments." By 1864 David had taken his son Everette A. into the business. As late as 1895, the factory, operated by David E. Dexter, another son, employed from 75 to 100 workers. In the immediate vicinity of Watertown and Black River, C[hristian?] E. Claus worked in Le Ray township beginning about the late 1840s. The 1850 New York federal census lists him in Jefferson County, but his name is absent a decade earlier. A marked chair has the same features as

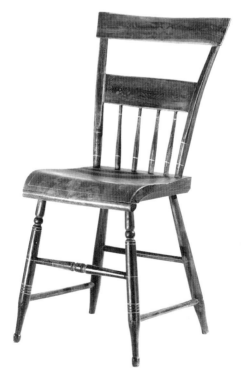

Fig. 5-61 Tablet-top Windsor side chair, C[hristian?] E. Claus (stencil "C.E.Claus"), probably Le Ray Twp., Jefferson Co., N.Y., 1845–55. H. 33", (seat) 15½", W. 15", D. 14½". (Michael K. Brown collection: Photo, Winterthur.)

Fig. 5-62 Tablet-top Windsor side chair (one of six) and detail of back, attributed to Allen Holcomb, New Lebanon, Otsego Co., N.Y., 1840–45. Pinkish brown and dark brown grained ground with bright yellow, pea green, bronze, and gilt; H. 35¼", (seat) 17", W. (crest) 18⅛", (seat) 14½", D. (seat) 14⅛". (New York State Historical Association, Cooperstown, N.Y.: Photo, Winterthur.)

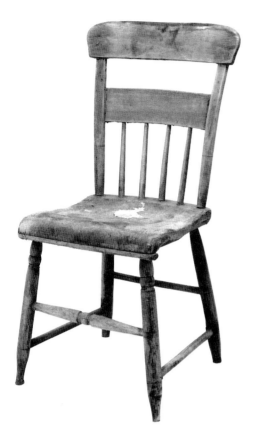

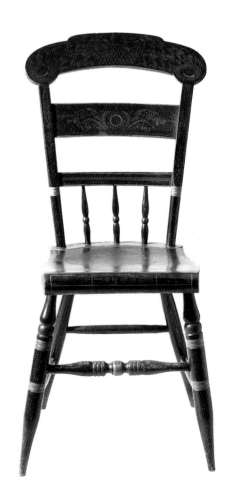

the Dexter Windsor, except for the crest profile (fig. **5-61**). The rounded, loaf-shaped top piece identifies the chair as a late pattern.[64]

Chairmaking continued to gain momentum in Otsego County. To complement a full line of cabinetware, Robert C. Scadin of Cooperstown produced sets of "common windsor chairs" at $4.50, as recorded in 1831. From time to time Billie R. Thurston supplied Scadin with turned work for chairs and joined furniture. Justus Dunn, another local woodworker, also engaged Thurston's services. A contract between the two describes the business relationship: Dunn framed a group of seating using chair rolls supplied by Thurston; Thurston then painted the chairs, using his own materials. Profits from sales at Dunn's shop were divided equally.[65]

West of Cooperstown in Hartwick, Leonard R. and James R. Proctor constructed popularly priced chairs during the 1830s. Holcomb in New Lisbon made a set of six ornamented side chairs, which descended to his great-granddaughter (fig. **5-62**). The vigorous curved sides of the modified shovel seat reflect Pennsylvania work rather than that of contemporary upstate New York. The chunky ornamental turnings initially suggest a late date, but the model was the New England and New York fancy leg that was popular from the 1820s. The crown-top crest duplicates top pieces used in Connecticut work. Chauncey Strong, who worked at Laurens in the next valley, described chairs of similar crest as "scroll top winsors" in a January 4, 1842, account. He also concurrently manufactured roll-top and "common," or slat-back, Windsors.[66]

References to straight-back Windsors in Strong's records beginning in 1842 and continuing into the 1850s seem to describe a chair documented to the area through the name stencil of George Washington Bentley, a chairmaker of neighboring West Edmeston (fig. **5-63**). Other features of the Bentley chair appear explicated in a

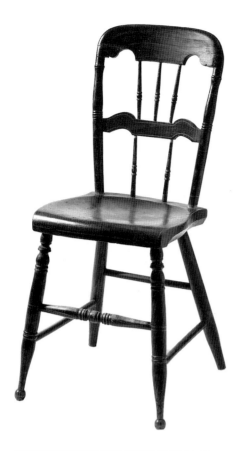

Fig. 5-63 Tablet-top Windsor side chair (one of four) and detail of stencil, George Washington Bentley, West Edmeston, Otsego Co., N.Y., 1850–60. Basswood (seat, microanalysis); pinkish brown and dark brown grained ground with yellow and gilt; H. 34⅝″, (seat) 18″, W. (crest) 13¾″, (seat) 15″, D. (seat) 15″. (New York State Historical Association, Cooperstown, N.Y.: Photo, Winterthur.)

Strong account of December 1851 for "½ Doz Round Post [chairs] serpentain seats." The chair is further identified with upstate New York production by the squared central bead of the front stretcher (figs. 5-59, 5-61). In overall design, the Bentley Windsor blends elements of two periods: the seat and base date from the 1830s, but the back lies solidly in the 1850s. Both the delicate beaded spindles and rounded crest are typical midcentury features. The arched ends of the middle slat simulate the lower profile of the top piece and unite the back structure into a harmonious design.[67]

Substantial chairmaking activity took place along the waterway from Buffalo to New York City. Cabinetmaking establishments, which dealt profitably in painted Windsor and fancy chairs purchased at wholesale, rivaled local chair shops in sales. Buffalo cabinet- and chairmaker William Galligan sold inexpensive seating in 1838 and added plank-seat steamboat stools to his line by 1846. A. and E. Brown, proprietors of Rochester's "NEW CABINET AND CHAIR WARE-ROOM," offered a complete assortment of chairs at both wholesale and retail. They directed their 1841 notice to the regional migratory population, "Persons moving to the West will find it an object to call and purchase." The Browns themselves were part of this westward migration; they had only recently settled in Rochester after conducting business in Schenectady for eight years. A decade later Brewster and Fenn offered twelve chair styles, ranging from mahogany to painted seating. Many establishments were becoming modest emporiums where customers could choose from a broad range of household furniture to suit their varied needs.[68]

The Robinson family were successful chairmakers in Rochester. Charles T. is identified as a turner in the 1834 city directory. By 1838 both he and his brother Oliver H. also practiced chairmaking. The two enjoyed a brief partnership in 1842 but separated the following year. Oliver manufactured bedsteads by 1847, while Charles continued to make chairs at least through 1859, when he carried a stock of 25,000 finished chairs of all descriptions. Charles later held various contracts for work performed in the local reformatory. He branded some of his midcentury wooden-seat rocking chairs on the back of the crest rail.[69]

Chairmakers along the Erie Canal had certain trade advantages, but they experienced other problems. Cheap transportation encouraged chair importations from other areas, leaving local chairmakers with two options—to sell imported chairs with their own or to make their product cheaper or more attractive. Ashley and Williston of Syracuse appear to have done both. In 1851 they advertised their own "warranted" cane-, rush-, and wooden-seat chairs and chairs of "Eastern manufacture" for sale "VERY CHEAP to get rid of them." Utica chairmakers James C. Gilbert and Charles L. Fairbanks advertised in 1839/40 to purchase lumber. The partnership was dissolved by 1842, when Gilbert opened the Utica Chair Store, offering "Chairs of the latest New York patterns" from Grecian to Windsor styles. The chairmaker made his bid "to share a portion of [the public's] generous patronage," citing his thirty-five years of experience, some at Troy and the rest possibly in Albany or New York. He also employed "the very best of workmen from the city of New York." The next year James Hazelet broadened his business by offering furniture, willowware, and "every variety of household utensils." One enticement was the "newly invented [Windsor] PIVOT REVOLVING CHAIRS, Manufactured and kept constantly on hand," which he pictured in an advertisement.[70]

Chairmaking remained an important business in the Albany-Troy area. In 1831 Tunis Morrell sold lawyer Peter Gansevoort "6 Yellow Windsor chairs" from his Albany "warehouse" near the busy City Hotel. The same year, Windsor-chair maker Thomas Perkins closed shop in Salem, Massachusetts, and moved to Troy, where his kinsman William Perkins had settled after migrating from Middletown, Connecticut, two years earlier. The Birge brothers also settled in Troy during this period. Edward arrived first and formed a two-year partnership with Calvin Stebbins in 1837. He operated a chair factory between 1839 and 1852, the final years in partnership with his brother Francis. The brothers came from Greenfield, Massachusetts, where land records describe Francis's 1837 financial difficulties. Successful in his new location, Edward was able to purchase

Francis's Greenfield property from court-appointed trustees in 1839. He retained his brother as agent until 1842, when Francis repurchased the property "with the building thereon situate being the shop now occupied . . . as a Chair Factory." Three years later Francis sold the real estate and "all of his stock & 3 benches" to cabinetmakers Isaac Miles and Joel Lyons and joined Edward in Troy. In February 1846 the brothers leased land on River Street, where the owner erected a four-story brick building for their use by August 1. Two years later, the Birges leased additional buildings on adjacent lots. Francis took over all the leases in May 1852 for ten years; however, he continued in business only a year and a half before conveying the unexpired term to three new tenants.[71]

John F. Huntington's career further illuminates chairmakers' migrations during the 1830s and 1840s. Starting at Troy around 1829, he moved south along the Hudson to Catskill, a community of almost 5,000 inhabitants, where by 1833 he had located his business "2 doors below Sayre & Armstrong's Tin Manufactury." Continuing his southward trek, Huntington was in Newburgh by 1842. The town, whose population had doubled to about 9,000 during the previous seven years, enjoyed brisk trade with New York City and western towns. The quays and docks of the 200-yard-long riverfront bustled with activity (fig. **5-64**). Within a few years Huntington manufactured the heavy low-back Windsor popular just before midcentury. A ball-turned regional example with a scrolled back extension bears the painted legend "C. M. Crissey/Chester Depot" on the bottom (fig. **5-65**). Chester, which lies southwest of Newburgh, was "a considerable village" in 1841. Although Crissey's revival low-back chair represents the stylistic end of innovative Windsor design, its parts are well integrated. Moderate-sized turnings unite the heavy, blunt-edge arm rail and large seat, and related sticks provide a suitable base. Windsor patterns were now unrestricted by geographic bounds. A similar chair was used on Long Island, where William Sidney Mount painted *The Mischievous Drop* in 1857 (fig. **5-66**).[72]

LONG ISLAND AFTER 1800

During the nineteenth century, western Long Island, encompassing Queens County and Brooklyn, was little more than a New York satellite. The eastern region also felt strong metropolitan influence and further shared close contacts with southern, coastal New England. Regular commerce with regional trading centers and the presence of craftsmen with metropolitan shop experience kept Long Islanders aware of prevailing fashions, although well-entrenched conservatism and accessibility to coastal traders seem to have limited the local Windsor industry.

Until the War of 1812, Brooklyn was little more than a village. Postwar growth was rapid, and in 1826 Philadelphian Samuel Breck reported that the population numbered

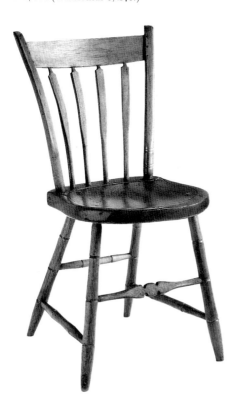

Fig. 5-68 William Sidney Mount, *The Sportsman's Last Visit*, Long Island, N.Y., 1835. Oil on canvas; H. 21¼″, W. 17¼″. (The Museums at Stony Brook, Stony Brook, N.Y., gift of Mr. and Mrs. Ward Melville.)

about 10,000. Brooklyn's visitor attraction and economic asset was the New York Naval Shipyard. By the mid 1830s many New York merchants and businessmen selected Brooklyn "as a place of residence in preference to the upper part of [New York]." Brooklyn Heights, in particular, offered handsome building sites overlooking New York Bay. The village was incorporated as a city in 1834, and before 1840 had become the second largest city in New York.[73]

Almost a dozen Windsor-chair makers worked in Brooklyn at some point from 1825 to 1850, but only about three enjoyed reasonable success. William V. Smith, who manufactured fancy and Windsor chairs, was the first to advertise; in 1826 he described his chair prices as "cheap, if not cheaper than the New York prices." Smith probably drifted into chairmaking from the "Carpentry Business," but he soon dropped from sight. Metropolitan competitors proved a formidable obstacle to many fledgling craftsmen. John Commerford, who advertised in 1829 that he had been the foreman of a large New York City shop, returned to the metropolis after only two years in Brooklyn. John T. Hildreth turned Commerford's Hicks Street site into a furniture warehouse in 1831. He sold cabinetware and a full line of chairs before he abandoned the enterprise in 1837 in favor of his second business, that of money collector and agent for an insurance company.[74]

Barzillai Russell and Joseph Weeks were among the more successful Brooklyn woodworkers. Partners in 1832 in a furniture warehouse located at 11 Hicks Street, they supplemented their cabinetware stock with curled maple, fancy, and Windsor chairs. Weeks formed another short-lived partnership at the same location the following year, but Russell worked on his own. Both men remained in the furniture business until 1856, although their principal focus was cabinetware.[75]

Two generations of the Arcularius family sold chairs in Brooklyn. Philip I. Arcularius, Jr., began his career in New York City. He commenced his own business about 1809; two years later he was a creditor in the insolvency proceedings of chairmakers David Brientnall, Jr., and John Kelso. In 1815 he and William Sigison appraised chairmaker William Ash I's estate. Local enumerations of 1816 and 1819 list Philip as a chairmaker at 75 John Street. Near the end of his chairmaking career in 1831/32, Arcularius placed his name in the Brooklyn directory as a chair manufacturer and gave his business location as John Street, New York, although he seems to have resided in Brooklyn. The chairmaker closed his New York City business about 1833; he had become a coal and lumber dealer in Brooklyn by 1836. The same year, his son, Philip I. Arcularius III, opened a chair manufactory on High Street and operated it until 1841, when his name disappears from Brooklyn directories. Perhaps he joined his father's new business.[76]

Concurrent with Brooklyn activity was Carman Smith's 1826 advertisement for his fancy- and Windsor-chair manufactory in Huntington, Suffolk County. Like other craftsmen, he accepted old chairs to mat, mend, paint, gild, or bronze. At the island's eastern end, Nathaniel Dominy V still made clocks, cabinets, and chairs. Rush-seated fiddle- and slat-back chairs made up most of his production, although in 1794 he had made mahogany Windsors for Captain William J. Rysam (fig. 5-28). A side chair with arrow-shaped spindles, formerly owned by a direct descendant of Nathaniel V, was in the Dominy House at East Hampton early in this century (fig. **5-67**). The flat spindles and front stretcher conform to metropolitan New York work (figs. 5-44, 5-39). The balloon seat, used in fancy rush chairs of the period, is occasionally seen in plank form. Dominy or another area craftsman could have made the chair, or it may have been imported from New York. By the early nineteenth century, chairmakers residing in outlying districts frequently copied city chairs so closely that it is difficult to distinguish between them. The chair resembles a bent-back, arrow-spindle Windsor in a genre scene painted by William Sidney Mount at Setauket in 1835 (fig. **5-68**). Mount has delineated a chair with a center front seat extension similar to that employed earlier by Joseph Durbrow of New York City (fig. 5-41). The Dominy family chair and the one in the painting confirm that Long Islanders knew and used such seating.[77]

Notes

1. Adolph B. Benson, ed., *Peter Kalm's Travels in North America*, vol. 1 (New York: Dover Publications, 1966), p. 133; Tench Coxe, *A View of the United States of America* (Philadelphia: William Hall and Wrigley and Berriman, 1794), p. 72; Esther Singleton, *Social New York under the Georges, 1714–1776* (New York: D. Appleton, 1902), p. 5.

2. Benson, *Kalm's Travels,* 1:131–32; *Burnaby's Travels through North America,* 3d ed. (1798; reprint, New York: A. Wessels Co., 1904), p. 112.

3. *Burnaby's Travels,* p. 111; Benson, *Kalm's Travels,* 1:135; John W. Barber and Henry Howe, *Historical Collections of the State of New York* (New York: S. Tuttle, 1841), p. 304; David M. Ellis et al., *A History of New York State* (rev. ed., Ithaca, N.Y.: Cornell University Press, 1967), pp. 82, 105, 108; H. E. Scudder, ed., *Recollections of Samuel Breck* (Philadelphia: Porter and Coates, 1877), pp. 89–90; Marshall B. Davidson, *New York: A Pictorial History* (New York: Charles Scribner's Sons, 1977), p. 72; William Strickland, *Journal of a Tour in the United States of America, 1794–1795,* ed. J. E. Strickland (New York: New-York Historical Society, 1971), pp. 43–44, 64.

4. Isaac Weld, *Travels through the United States of North America*, vol. 1 (London: John Stockdale, 1800), pp. 264–65; Kenneth Roberts and Anna M. Roberts, trans. and eds., *Moreau de St. Méry's American Journey [1793–1797]* (Garden City, N.Y.: Doubleday, 1947), p. 146; Henry Tudor, *Narrative of a Tour in North America,* vol. 1 (London: James Duncan, 1834), p. 32.

5. Lodge estate information, as quoted in Singleton, *Social New York,* p. 66; Thomas Duncan and William White, estate records, 1760 and 1758, Joseph Downs Collection of Manuscripts and Printed Ephemera, Winterthur Library (hereafter cited as DCM).

6. Thomas and James Franklin, advertisement in *New-York Gazette,* January 4, 1762, as quoted in Rita Susswein Gottesman, comp., *The Arts and Crafts in New York, 1726–1776* (New York: New-York Historical Society, 1938), p. 123; Perry, Hayes, and Sherbrooke, advertisement in *New-York Mercury,* December 6, 1762; Jonathan Hampton, advertisement in *New-York Journal; or, The General Advertiser,* June 2, 1768.

7. Other American families painted in outdoor settings include *The Gore Children* (ca. 1753) by John Singleton Copley and *The Edward Lloyd Family* (1771) by Charles Willson Peale, both at Winterthur, and Joseph Blackburn's *Isaac Winslow and His Family* (1755) at the Museum of Fine Arts, Boston.

8. Thomas Ash and Adam Galer, advertisements in *Rivington's New-York Gazetteer,* February 17 and August 25, 1774, and John Kelso, advertisement in *New-York Gazette and the Weekly Mercury,* August 8, 1774, as quoted in Gottesman, *Arts and Crafts, 1726–1776,* pp. 110, 112, 115. Ash's marriage is listed in Gideon J. Tucker, *Names of Persons for Whom Marriage Licenses Were Issued by the Secretary of the Province of New York Previous to 1784* (Albany, N.Y.: Weed, Parsons, 1860), p. 11. New York City Musket List, July 8, 1775, Alexander McDougall Papers, New-York Historical Society, New York (hereafter cited as NYHS); Henry Will, account book, 1768–96, Museum of Early Southern Decorative Arts, Winston-Salem, N.C. (microfilm, DCM).

9. Kelso, advertisement in *New-York Gazette;* Walter Franklin, estate records, 1780–86, DCM. Assessors' Returns, County of Philadelphia, 1767, Van Pelt Library, University of Pennsylvania, Philadelphia, Pa. (document brought to author's attention by Stephanie G. Wolf).

10. Frederic Gregory Mather, comp., *The Refugees of 1776 from Long Island to Connecticut* (Albany, N.Y.: J. B. Lyon Co., 1913), p. 660; Frederick Wolffes, estate records, 1776, DCM.

11. Thomas and William Ash, advertisement in *New-York Packet,* October 7, 1784, supplement; Thomas and William Ash bill to Robert R. Livingston, December 9, 1783, Robert R. Livingston Papers, NYHS; James Beekman, account book of personal affairs, 1761–96, entry for November 1783, and Thomas and William Ash bill to Cornelia Beekman Walton, September 24, 1785, White-Beekman Papers, NYHS; *Minutes of the Common Council of the City of New York, 1784–1831,* vol. 1 (New York: By the city, 1917), p. 34; "General Account of Exports, from the Port of New-York," 1788, as published in *Journal of the Assembly of the State of New-York, at Their Twelfth Session, Begun and Holden at the City of Albany, the Eleventh Day of December, 1788* (Albany, N.Y.: Samuel and John Louden, [1789]), p. 71.

12. Mable M. Swan, "Artisan Leaders of 1788," *Antiques* 27, no. 3 (March 1935): 90. Description of the Federal Procession is quoted in Rita Susswein Gottesman, comp., *The Arts and Crafts in New York, 1777–1799* (New York: New-York Historical Society, 1954), p. 109.

13. Thomas Ash, estate records, 1806, liber 47, p. 272, Historical Documents Collection, Queens College, Flushing N.Y. (hereafter cited as QC). The Ash portrait, which was identified as William by a great-granddaughter about 1916, seems instead to be a likeness of Thomas, owner of a country estate at Throgs Neck on Long Island Sound. Elizabeth Ash, Thomas's widow, presented the painting to a grandnephew, in whose family it descended. William, who lived until 1815, went through a devastating insolvency in 1811 as a result of acting as surety for his son Thomas II, a chairmaker-merchant whose business failed. City directories list William as a chairmaker until his death, and the several household and shop inventories taken at the time of his insolvency fail to mention a portrait (William Ash, insolvency and estate records, 1811 and 1815, liber 52, p. 305, and Thomas Ash II, insolvency records, 1811, QC). Thomas II had his portrait painted by John Wesley Jarvis in 1816 (see Helen Comstock, "Portraits of American Craftsmen," *Antiques* 76, no. 4 [October 1959]: 323, top center).

14. Timpson and Gillihen, advertisement in *New-York Packet,* July 11, 1785 (and continuing into 1786). Leggett's relationship to the Ashes is established through his grandfather, Gilbert Ash's, will, "To the children of my deceased daughter, Catherine Ash, otherwise Tomlinson, namely Gabriel Legget, her son by her first husband, Gabriel Legget, deceased" (*Collections of the New-York Historical Society for the Year 1904* [New York: New-York Historical Society, 1905], p. 75). Gabriel Leggett, advertisement in *Daily Advertiser* (New York), March 20, 1786, as quoted in Gottesman, *Arts and Crafts, 1777–1799,* p. 123; he was imprisoned in 1791 for holding a private lottery (*Boston Gazette,* May 23, 1791). Information on Coutant from Herbert B. Nichols, *Historic New Rochelle* (New Rochelle,

N.Y.: Board of Education, 1938), p. 33, and estate and property records, 1798 and 1829/30, West Chester Co., N.Y., Surrogate Court and Registry of Deeds. The Coutant sack-back is in a private collection. Smith's rush-bottomed chair is illustrated in "Museum Accessions," *Antiques* 101, no. 2 (February 1972): 315.

15. A man named John DeWitt is called an assessor in *Minutes of the Common Council,* 1:172. Other makers of documented continuous-bow chairs, first listed in directories between 1791 and 1796, were John Always, John Samler, Walter MacBride, Harmon Vosburgh, Henry Lock, and the firm of Karnes and Hazlet.

16. Timpson and Gillihen, advertisement in *New-York Packet,* July 11, 1785 (and continuing into 1786); Thomas Timpson, advertisement in *The Diary; or, Loudon's Register* (New York), May 11, 1792, as quoted in Gottesman, *Arts and Crafts, 1777–1799,* pp. 128–29; Peter Tillou bill to Mrs. Montgomery, March 6, 1792, Robert R. Livingston Papers, NYHS; Thomas and William Ash bill to George Clinton, February 19, 1790, Papers of George Clinton, Manuscript Division, New York Public Library, New York (hereafter cited as NYPL); Isaac Kitchell bill to Cornelius Van Slyck, May 22, 1794, Sanders Papers, NYHS.

17. Shop locations, as given in New York City directories. Discussion of this chair was previously published in Nancy Goyne Evans, "Fancy Windsor Chairs of the 1790s," *Antiques and the Arts Weekly* (Newtown, Conn.), November 6, 1981, pp. 66–68. The bottom of a plain, bow-back side chair bears a small printed label with only the name of William Ash; the label contains the same oval panel as the illustrated one, and the lettering is identical in style and format.

18. Wendy A. Cooper, "The Purchase of Furniture and Furnishings by John Brown, Providence Merchant," *Antiques* 103, no. 2 (February 1973): 335; advertisement of Mabel K. Rogers, *Antiques* 16, no. 2 (August 1929): 147. Byles is unlisted in city directories.

19. Edward S. Morgan, *The Birth of the Republic, 1763–89* (Chicago: University of Chicago Press, 1956), p. 127. For an additional statement on Rhode Island's legal tender, see Board of Trade Records, American Trade Volume, 1784–91, Public Record Office, London. The Rhode Island postwar economic situation is further illuminated in letters written by Olney Winsor, a Rhode Island businessman, to his wife in Providence. Winsor resided in the flourishing town of Alexandria, Virginia, for a few years, where he established a store. On October 17, 1786, he wrote, "My greatest ambition in life is to support myself & family in Character & Reputation, & to pay my honest Debts; and I think our business here is in a fair way to do it, if we do not suffer very largely by the destructive Politicks of Rhode Island." A month later he queried, "Does not the Town look desolate [with] so many removals & empty houses?" (Olney Winsor to wife, October 17 and November 28, 1786, Letters of Olney Winsor, 1786–88, State Library of Virginia, Richmond). An advertisement of Ansel Goodrich, a western Massachusetts chairmaker who probably trained in New York City, also links the continuous-bow Windsor chair with the French bergère, as interpreted in Thomas Burling's 1790 New York cabinet shop.

20. The Kipp label is illustrated in Rita Susswein, "Upholsterers Were 18th Century Decorators," *American Collector* 1, no. 7 (March 20, 1934): 3. A perfect copy is owned by NYPL.

21. Hasbrouck and Coffin chairs are in the Art Institute of Chicago. Census records associate the Hasbrouck family with Ulster Co. Louis Coffin, ed., *The Coffin Family* (Nantucket, Mass: Nantucket Historical Association, 1962), p. 329; Job Bunker Coffin, property record, March 30, 1807, Columbia Co., N.Y., Registry of Deeds; data on Hudson in Barber and Howe, *Historical Collections*, pp. 117–18.

22. The low-back chair and the Ash bill are illustrated in *The Glen-Sanders Collection* (Williamsburg, Va.: Colonial Williamsburg, 1966), p. 18. Roderic H. Blackburn, *Cherry Hill* ([Bethlehem, N.Y.]: Historic Cherry Hill], 1976).

23. Van Schaick chairs are at the Art Institute of Chicago and the New York State Museum, Albany. John Bleecker, Jr., bill to Gerrit Wessel Van Schaick, May 30, 1803, and Gerrit Wessel Van Schaick, estate records, ca. 1816, Van Schaick Papers, NYPL. John L. Scherer (*New York Furniture at the New York State Museum* [Alexandria, Va.: Highland House Publishers, 1984], p. 25) has indicated that MacBride continued to advertise his Windsor-chair-making business as late as July 18, 1799; however, this is a misreading of 1795 (see Gottesman, *Arts and Crafts, 1777–1799*, pp. 123–24).

24. Van Schaick bequeathed his estate to his brother John's children; the eldest son, Wessel Van Schaick, likely altered the brand upon inheriting the chairs (Scherer, *New York Furniture*, p. 26). Van Schaick estate records; Alexander Patterson bill to Gerrit W. Van Schaick, June 1, 1814, Van Schaick Papers, NYPL; manifest of sloop *Betsey*, May 21, 1792, Philadelphia Outward Coastwise and Foreign Entries, U.S. Customhouse Records, French Spoliation Claims, National Archives, Washington, D.C. (hereafter cited as NA).

25. James Chestney bill to Mrs. Philip Schuyler, May 14, 1793, Schuyler Papers, NYPL.

26. Shipman vital data from Indexes of Connecticut Church Records, censuses, and Barbour Collection of Connecticut Vital Records, Genealogical Section, Connecticut State Library, Hartford, Conn. See also notes on William Shipman in Phyllis Kihn, "Connecticut Cabinetmakers, Part II," *Connecticut Historical Society Bulletin* 33, no. 1 (January 1968): 14; Peter Rippe, "Daniel Clay of Greenfield 'Cabinetmaker'" (Master's thesis, University of Delaware, 1962), p. 111; and Shipman Family, comps., *The Shipman Family in America* (N.p.: Shipman Historical Society, 1962), pp. 244, 246. The Shipman side chair is illustrated in Scherer, *New York Furniture*, p. 130.

27. Stackhouse is listed in the 1775 New York City Musket List. He advertised in the *Hudson Gazette*, November 26, 1795, as quoted in Alfred Coxe Prime, comp., *The Arts and Crafts in Philadelphia, Maryland, and South Carolina, 1786–1800* (Topsfield, Mass.: Walpole Society, 1932), p. 197. Margaret B. Schram, comp., *Claverack Township History and Heritage* (Claverack, N.Y.: Claverack Bicentennial Committee, 1976), pp. 22–23, 52.

28. Barber and Howe, *Historical Collections*, p. 304.

29. Isaac DeGraw inventory, as published in Alice Hanson Jones, *American Colonial Wealth*, vol. 2 (New York: Arno Press, 1977), p. 1098. Dean F. Failey's regional study, *Long Island Is My Nation* (Setauket, N.Y.: Society for the Preservation of Long Island Antiquities, 1976), documents only minor Windsor production through the late eighteenth century; it includes information on James DeGraw and Paine (pp. 232, 280) and on turners John Bossley and George Ferguson (pp. 225, 235). John H. Smith, estate records, 1786, QC; John Paine, account book, 1761–1815, Institute for Colonial Studies, State University of New York, Stony Brook, N.Y.; Charles F. Hummel, *With Hammer in Hand: The Dominy Craftsmen of East Hampton, New York* (Charlottesville: University Press of Virginia for the Henry Francis du Pont Winterthur Museum, 1968), pp. 252–53, 264.

30. Information on Warner, Hall, and King in Failey, *Long Island*, pp. 276, 278, 290, including Hall advertisement in *Suffolk County Herald* (Sag Harbor, N.Y.), September 4, 1802. Roberts and Roberts, *Moreau Journey*, pp. 168, 170.

31. Thomas Anburey, *Travels through the Interior Parts of America*, vol. 2 (Boston: Houghton Mifflin Co., 1923), pp. 313–14; Timothy Dwight, *Travels in New England and New York*, ed. Barbara Miller Soloman, vol. 3 (Cambridge, Mass: Belknap Press, 1969), pp. 212, 218–19; Failey, *Long Island*, p. 151.

32. Hummel, *With Hammer in Hand*, pp. 252–53, 349. The Always and Hampton settee is illustrated in Roderic H. Blackburn, "Branded and Stamped New York Furniture," *Antiques* 119, no. 5 (May 1981): 1134, fig. 9.

33. Davidson, *New York*, p. 72; John Lambert, *Travels through Canada and the United States of North America*, vol. 2 (London: C. Cradock and W. Joy, 1813), pp. 49–50, 55–59, 61–62. In population, Philadelphia and New York were still in a dead heat when Lambert made his remarks. Dwight, *Travels*, 3:330.

34. Dwight, *Travels*, 3:330; Davidson, *New York*, p. 99; Cadwallader D. Colden, *Memoir Prepared at the Request of a Committee of the Common Council of the City of New York and Presented to the Mayor of the City at the Celebration of the Completion of the New York Canals* (New York: W. A. Davis, 1825), pp. 93–94, 148, 157, 229, 373–74.

35. Davidson, *New York*, p. 97; Marshall B. Davidson, *Life in America*, 2 vols. (Boston: Houghton Mifflin Co., 1951), 1:346–47, 352–53; 2:244–51; Barber and Howe, *Historical Collections*, p. 325; Stokes, *Iconography*, 5:1746; Howard B. Rock, *Artisans of the New Republic* (New York: New York University Press, 1979).

36. The Timpson and Vangelder chair is in Winterthur Study Collection, no. 81.41. A labeled set of Skellorn single-rod Windsors, comprising six side chairs and an armchair, is at the New York State Museum, Albany. The arms cap the front supports; under each arm are two short spindles. William Ash bill to Captain Randell, July 3, 1802, Wendell Papers, Baker Library, Harvard University, Cambridge, Mass.

37. Economical School information in Richard J. Koke, comp., *A Catalogue of the Collection including Historical, Narrative, and Marine Art*, vol. 2 (Boston: New-York Historical Society, 1982), no. 1429; Reuben Odell, insolvency records, 1811–13, QC.

38. David Alling, account book, 1801–39, New Jersey Historical Society, Trenton (hereafter cited as NJHS) (microfilm, DCM). A New York fancy chair with Cumberland spindles is illustrated in Zilla Rider Lea, ed., *The Ornamented Chair* (Rutland, Vt.: Charles E. Tuttle Co., 1960), p. 54, fig. 40. Assignment of the term *Cumberland* to the double-baluster turning is given impetus in Bernard D. Cotton, *The English Regional Chair* (Woodbridge, Suffolk: Antique Collectors' Club, 1990), pp. 320–35, where the author illustrates many rush-bottomed chairs with similar or related spindles. The seating, identified as "Dales" chairs, originated in the northwest of England, comprising the counties of Cumberland, Westmoreland, Lancashire, and Cheshire. Although the chairs illustrated are dated 1800 and later, earlier examples may have existed. The turned patterns may have been carried to the New York area by an emigrating craftsman or craftsmen. A second and more cogent explanation centers on William Augustus, Duke of Cumberland (1721–65), a military commander and third son of George II. On his return to England in July 1746, following defeat of the Scots at Culloden, one of the honors accorded him was the rangership of the great park at Windsor Castle. Cumberland and Cranbourne lodges there became his chief residences. Assisted by Thomas Sandby, deputy ranger, the duke made substantial improvements in the park. One of the furnishings of Windsor Great Lodge when the duke died was a "mahogany elbow Windsor chair." The chair was perhaps similar to that illustrated in figure 6-12, a low-back mahogany Windsor with Cumberland spindles of Thames Valley origin. A reasonable surmise is that these ornamental turnings were introduced to fine Windsor seating during the duke's tenure at Windsor great park, the site where the Windsor was first developed, and named in his honor. (*The Dictionary of National Biography*, 1937–38, s.v. "William Augustus"; Edward T. Joy, *The Country Life Book of Chairs* [London: Country Life, 1967], p. 57.)

39. *The London Chair-Makers' and Carvers' Book of Prices for Workmanship* (London: T. Sorrell, 1802), pl. 5, no. 13, and p. 26; *Supplement to the London Chair-Makers' and Carvers' Book of Prices for Workmanship* (London: T. Sorrell, 1808), pl. 4, p. 21. Nestell's drawing book is in DCM.

40. *Longworth's American Almanac, New-York Register, and City Directory* (New York: David Longworth, 1810), n.p.; William Buttre bill with pictorial billhead to Oliver Wolcott, December 8, 1810, Wolcott Papers, Connecticut Historical Society, Hartford, Conn.; Holden advertisement, as quoted in Lea, *Ornamented Chair*, p. 38. Buttre's 1813/14 trade card is in DCM. Henry Dean bill to Elizabeth Dyckman, 1808, as quoted in Berry B. Tracy, *Federal Furniture and Decorative Arts at Boscobel* (New York: Harry N. Abrams, 1981), p. 30; David Alling, ledger, 1815–18, NJHS (microfilm, DCM).

41. Durbrow's location is given in New York City directories. English fancy chairs are illustrated in *Fine English and Continental Furniture, Clocks, and Objects of Art*, June 26, 1982 (New York: Christie, Manson and Woods, 1982), no. 115. Alling ledger. Photographs of one Skellorn fancy bamboo chair and the bill are in the Visual Resources Collection, Winterthur Library.

42. Henry Bradshaw Fearon, *Sketches of America*, 2d ed. (London: Longman et al., 1818), pp. 24–25; Alling ledger.

43. *Longworth's American Almanac, New-York Register and City Directory* (New York: David

Longworth, 1815), n.p.; manifest of brig *Savannah Packet,* May 23, 1815, New York Outward Entries, U.S. Customhouse Records, NA (photocopy, DCM); William Ash, estate records, 1815, DCM.

44. Cowperthwaite's location is given in New York City directories. Cowperthwaite advertisement booklet (New York: By the company, ca. 1920), Landauer Collection, NYHS; David Alling, invoice book, 1819/20, and daybook, 1836–54, NJHS (microfilm, DCM); Cornwell and Smith and Richard D. Blauvelt billheads, ca. 1817 and 1832, DCM. The Bartlett chairs are illustrated in *An Important Collection of American Antique Furniture* (New York: John Wanamaker, 1930), p. 42.

45. Cowperthwaite's advertisement appeared in *Longworth's New-York Register, and City Directory* (New York: Thomas Longworth, 1818), n.p. Garrit Lansing of Cherry Street drew the view of Cowperthwaite's place of business in 1823/24, and Benedict Bolmore printed the billhead. Cowperthwaite's woodworking neighbors included James W. Dominick, cabinetmaker; Augustus Cregier, carver; and Abraham Hadley, turner (data on artist, printer, and neighbors from New York City directories). Colden, *Memoir,* pp. 130–31, 230.

46. Description of a scroll-back chair in *New-York Revised Prices for Manufacturing Cabinet and Chair Work* (New York: Southwick and Pelsue, 1810) is reproduced in Charles F. Montgomery, *American Furniture: The Federal Period in the Henry Francis du Pont Winterthur Museum* (New York: Viking Press, 1966), p. 104. Alling ledger and invoice book. The duration of the Fredericks and Farrington partnership is indicated in New York City directories. Description of the chair banister in *The New-York Book of Prices for Manufacturing Cabinet and Chair Work* (New York: J. Seymour, 1817) is reproduced in Montgomery, *American Furniture,* p. 104. David Alling, ledger, 1803–53, NJHS (microfilm, DCM); E. G. Partridge billhead, inscribed in 1857, DCM.

47. Colden, *Memoir,* p. 373. For illustration of the New York State crest and discussion of Clinton's career, see Barber and Howe, *Historical Collections,* title page and p. 427. The standing-eagle mahogany chair is illustrated and discussed in *19th-Century America* (New York: Metropolitan Museum of Art, 1970), fig. 25.

48. Photograph of Masonic chair in Photographic Files, no. 5707, Museum of Early Southern Decorative Arts, Winston-Salem, N.C.; John G. Bartholf advertisement, December 1822, source unknown (photocopy, DCM).

49. Alling account book, ledgers, and daybook; David Alling, receipt book, 1824–42, NJHS (microfilm, DCM); Benjamin W. Branson, estate records, 1835, DCM; Peter Wood bill to Arthur Bronson, December 1839, Bronson Papers, NYPL; David Alling, estate records, 1855, Archives and History Bureau, New Jersey State Library, Trenton.

50. Ellis et al., *History of New York State,* p. 163; quote from Dwight's *Travels,* p. 189, and chaps. 13–16.

51. Ellis et al., *History of New York State,* chap. 20 and p. 189; Colden, *Memoir,* pp. 91–93; Frances M. Trollope, *Domestic Manners of the Americans,* vol. 2 (London: Whittaker, Treacher, 1832), pp. 250–51.

52. George Clinton, Jr., estate records, 1809, DCM. The Bedell chair is illustrated in *Antiques* 107, no. 2 (February 1975): 216. James Chestney bills

to Peter E. Elmendorf, November 7, 1803, and November 19, 1805, Sanders Papers, NYHS; Gilbert Ackerman, advertisement in *Albany Register,* August 31, 1798, as quoted in Prime, *Arts and Crafts, 1786–1800,* p. 164.

53. Nancy Goyne Evans, "The Sans Souci, a Fashionable Resort Hotel in Ballston Spa," in *Winterthur Portfolio 6,* ed. Richard K. Doud and Ian M. G. Quimby (Charlottesville: University Press of Virginia, 1970), pp. 111–26. Lincklaen information was supplied by Russell A. Grills in a letter to the author, August 1977; excerpts from John Lincklaen, house book, 1807–10; and Susan B. Grills, "Documented Furniture of the Lorenzo Collection" (Master's thesis, State University of New York, 1975), pp. 18–23.

54. Chestney, Buttre, Davis and Bussey, Jewett, and Bates and Johnson are listed in various Albany directories from 1813 to 1826. James Chestney bill to Catherine Gansevoort, June 22, 1815, Papers of Catherine Van Schaick and Papers of Peter Gansevoort, Gansevoort-Lansing Collection, NYPL; Charles Semowich, "The Life and Chairs of William Buttre," *Furniture History* 28 (1992): 130-32.

55. Barber and Howe, *Historical Collections,* pp. 470, 472; Eliza Cope Harrison, ed., *Philadelphia Merchant: The Diary of Thomas P. Cope, 1800–1851* (South Bend, Ind.: Gateway Editions, 1978), p. 355; David McKelsey bill to James Young, December 19, 1818, DCM; Allen Holcomb, account book, 1809–ca. 1828, Metropolitan Museum of Art, New York.

56. John Miller, estate records, 1812, DCM. The Bartlett chairs are illustrated in *Important Collection,* p. 42. Records of the 1820 Census of Manufactures, State of New York, NA (microfilm, DCM).

57. Nehemiah White, advertisement in *The Pilot* (Cazenovia, N.Y.), November 10, 1812 (reference courtesy of Russell A. Grills). White, Swan, and Fields and Brown are enumerated in the 1820 Census of Manufactures, New York.

58. Green and Lanphier are enumerated in the 1820 Census of Manufactures, New York. Holcomb account book; William Bentley, ledger, 1812–15, DCM.

59. J. C. Clark, advertisement in *Newburgh Gazette,* June 12, 1824 (reference courtesy of David Schuyler); Visscher and Baker in B. Pearce, *Albany Directory* (Albany, N.Y.: E. and E. Hosford, 1821), n.p. Bussey is listed in Albany city directories from the 1820s through the 1840s.

60. David McKelsey in *Troy Directory for 1829* (Troy, N.Y.: John Disturnell, 1829), n.p.; Caleb Lyon bill to John Sanders, December 1828, Glen-Sanders Papers, NYHS (microfilm, DCM). Kinsela is listed in the 1820 Census of Manufactures, New York. Thomas Kinsela, estate records, 1822, Schenectady Co., N.Y., Surrogate Court. Kinsela's banister-back chair is illustrated in Roderic H. Blackburn, "Branded and Stamped New York Furniture," *Antiques* 119, no. 5 (May 1981): 1139.

61. Bates and Johnson in Pearce, *Albany Directory* (1819), n.p. Examples of the patent settee are illustrated in John L. Scherer, "Labeled New York Furniture at the New York State Museum, Albany," *Antiques* 119, no. 5 (May 1981): 1125, and Dean A. Fales, Jr., *American Painted Furniture, 1660–1880* (New York: E. P. Dutton, 1972), pp. 186–87. Several documented Bates and Johnson benches have roll tops. Another convertible bench with a scroll-end crest that is related in profile to the Boston rocking

chair and marked "C. Johnson. Patent" probably reflects the design patented by Chester Johnson of Albany in 1827 as an "Improvement in the Manufacture of Sofas." The Brewer chair is illustrated in *Estate of Katherine S. Countryman* (Garrison-on-Hudson, N.Y.: O. Rundle Gilbert, 1969), n.p. Holcomb account book; Miles Benjamin, daybook and ledger, 1821–29, New York State Historical Association, Cooperstown, N.Y. (hereafter cited as NYSHA) (microfilm, DCM).

62. Packard information is in Joan Lynn Schild, "Furniture Makers of Rochester, New York," *New York History* 37, no. 1 (January 1956): 98. Alvan Dana, advertisement in *Owego Gazette,* February 24, 1829 (reference courtesy of Wendell Hilt). Owego information appears in Barber and Howe, *Historical Collections,* pp. 549–51.

63. The Cook stencils are illustrated in Lea, *Ornamented Chair,* pp. 99–100. The Stephens chest is illustrated in John Tarrant Kenney, *The Hitchcock Chair* (New York: Clarkson N. Potter, 1971), p. 85. Mary Black, "Ammi Phillips," in *American Folk Painters of Three Centuries,* ed. Jean Lipman and Tom Armstrong (New York: Whitney Museum of American Art, 1980), pp. 139–44. The Fargo portrait is illustrated in Nancy C. Muller and Jacquelyn Oak, "Noah North (1809–1880)," *Antiques* 112, no. 5 (November 1977): 940.

64. Franklin B. Hough, *A History of Jefferson County in the State of New York* (Albany, N.Y.: Joel Munsell, 1854), p. 239; *History of Jefferson County, New York* (Philadelphia: L. H. Everts, 1878), p. 501 (reference courtesy of Michael Brown); William H. Horton, ed., *Geographical Gazetteer of Jefferson County, N.Y., 1684–1890* (Syracuse, N.Y.: Hamilton Child, 1890), pp. 658–59 (reference courtesy of Michael Brown); John A. Haddock, *The Growth of a Century: As Illustrated in the History of Jefferson County, New York, from 1793 to 1894* (Albany, N.Y.: Weed-Parsons Printing Co., 1895), p. 628.

65. Robert C. Scadin, daybook, 1829–31, NYSHA (microfilm, DCM); Justus Dunn, miscellaneous papers, 1831, NYSHA (microfilm, DCM).

66. Leonard R. and James R. Proctor, ledger and daybook, 1834–65, NYSHA (microfilm, DCM); Chauncey Strong, daybook, 1842–52, NYSHA.

67. Strong daybook; Chauncey Strong, daybook, 1852–69, NYSHA.

68. William Galligan in Leonard P. Crary, *Directory for the City of Buffalo* (Buffalo, N.Y.: Charles Faxon, 1838), n.p., and *J. F. Kimball and Company's Eastern, Western, and Southern Business Directory* (Cincinnati and New York: J. F. Kimball, 1846), p. 300. A. and E. Brown in *King's Rochester City Directory and Register, 1841* (Rochester, N.Y.: Welles and Hayes, 1840), n.p.; Brewster and Fenn in *Daily American Directory of the City of Rochester for 1851–2* (Rochester, N.Y.: Lee, Mann, 1851), p. 62.

69. Schild, "Furniture Makers of Rochester," pp. 99–100; Carl W. Dreppard, *Handbook of Antique Chairs* (Garden City, N.Y.: Doubleday, 1948), p. 265.

70. Ashley and Williston, advertisement in *Syracuse Weekly Journal,* May 14, 1851 (reference courtesy of Wendell Hilt); Gilbert and Fairbanks in A. P. Yates, comp., *Utica Directory and City Advertiser for 1839–40* (Utica, N.Y.: R[ufus] Northway, Jr., 1839), p. 1; Gilbert's Utica Chair Store in William Richards, comp., *Utica Directory: 1842–43* (Utica, N.Y.: John P. Bush, 1842), as reproduced in

Made in Utica (Utica, N.Y.: Munson-Williams-Proctor Institute and Oneida Historical Society, 1976), p. 11; James Hazelet in William Richards, comp., *Utica City Directory for 1843–44* (Utica, N.Y.: Robert and Henry H. Curtiss, 1843), p. 144.

71. Tunis Morrell bill to Peter Gansevoort, November 1831, Papers of Peter Gansevoort, Gansevoort-Lansing Collection; Tunis Morrell in E[dmund] B. Child and W[illiam] H. Shiffer, comps., *Albany Directory and City Register for 1831–32* (Albany, N.Y.: E. B. Child, 1831), n.p.; information on the Perkinses from city directories; Francis and Edward Birge, property records, 1837–42, Franklin Co., Mass., Registry of Deeds; Francis and Edward Birge, property records, 1846–53, Rensselaer Co., N.Y., Registry of Deeds; Winifred C. Gates, "Journal of a Cabinet Maker's Apprentice," *Chronicle* 15, no. 3 (September 1962): 35.

72. Huntington, advertisement in *Catskill Recorder,* April 18, 1833 (reference courtesy of Wendell Hilt); [Gideon Miner Davison], *Traveller's Guide,* 6th ed. (Saratoga Springs, N.Y.: G. M. Davison, 1834), pp. 129, 131; Barber and Howe, *Historical Collections,* p. 124.

73. "The Diary of Samuel Breck, 1823–1827," *Pennsylvania Magazine of History and Biography* 103, no. 1 (January 1979): 100; [Davison], *Traveller's Guide,* p. 115; Barber and Howe, *Historical Collections,* p. 221.

74. Smith and Commerford, advertisement in *Long Island Star* (Brooklyn), August 10, 1826, and June 4, 1829, as quoted in Failey, *Long Island,* pp. 154–55, 272, 287. Hildreth listed in Lewis Nichols, *Brooklyn Directory for the Year 1831* (Brooklyn, N.Y.: A. Spooner, 1831), p. 83; other information from later city directories.

75. Russell and Weeks in *Brooklyn Directory for 1832–33* (Brooklyn, N.Y.: William Bigelow, 1832), p. 99; other information is from later city directories.

76. Jury lists, New York City, 1816 and 1819, QC; *Minutes of the Common Council,* 5:578; David Brientnall, Jr., and John Kelso, insolvency records, 1811, QC; William Ash estate records. Other information is derived from Brooklyn and New York City directories, including the Arcularius advertisement in *Brooklyn Directory for 1832–33* (Brooklyn, N.Y.: William Bigelow, 1832), p. 99.

77. Carman Smith, advertisement in *Portico* (Huntington, N.Y.), July 20, 1826, as quoted in Failey, *Long Island,* p. 286.

SECTION TWO

Chair Production in New England

New England, 1750 to 1800

1750 to 1775

By the mid eighteenth century, New England had been settled for more than 125 years and enjoyed a stable government, established customs, and economic opportunity. Although deficient in arable land, New England abounded in good harbors. Commerce became the backbone of the economy, despite obstacles such as restrictions imposed by the motherland, privateering, maritime disasters, wars with the French, Indian uprisings, territorial disputes, recessions, a fluctuating currency, and the perennial scarcity of specie. Successful New England fisheries operated off Newfoundland and Nova Scotia; whaling was on the rise, and sales of spermaceti oil and candles increased annually. A constant demand for sailing vessels encouraged the construction of many shipyards. Coasters plied small harbors and landings from Newfoundland to Georgia; larger craft carried provisions, lumber, and horses to the West Indies. The triangular trade in rum, slaves, and molasses with Africa and the West Indies was profitable. Massachusetts and Rhode Island led in commerce, with Boston and Newport as metropolitan centers; Connecticut and New Hampshire also enjoyed their fair share of trade.[1]

New England seating at midcentury consisted mainly of popularly priced banister- and slat-back chairs. Side chairs occurred in the greatest numbers; seats with arms were generally known as "great" chairs. Rockers introduced an enticement for leisure moments. The New England chairmaker was a well-patronized craftsman who not only constructed new chairs but also mended, colored, varnished, and bottomed used ones. Some craftsmen became suppliers and provided parts for other chairmakers. Money seldom changed hands between chairmaker and customer; services, craft products, and produce were the usual exchange mediums.[2]

NEWPORT AND VICINITY IN THE 1750S AND 1760S

Newport was home to Aaron Lopez, a Sephardic Jew who left his native Portugal in search of religious freedom. Lopez arrived in America with his family in 1752 and joined his elder brother, Moses. A founder of Touro Synagogue, Aaron became a leading merchant by the time of the Revolution. The Lopez shipping records contain the first known direct references to New England Windsor chairs. The young merchant engaged in an active coastal trade by the early 1760s, with spermaceti candles as his prime exchange commodity. He also had interests in the slave traffic and in trade with western England through Bristol; however, the calamities of the 1765 Stamp Act and the ensuing depression led the merchant to shift his attention to the Caribbean.[3]

About January 1767 Aaron Lopez sent the first of many commodity shipments to Jamaica and other tropical or southern coastal ports. Early records describe chair cargoes in general terms, but specific details are gradually added. On August 21, "12 Round Green Chairs" valued at 16s. apiece left Newport on the brigantine *Charlotte*

Fig. 6-1 High-back Windsor armchair and detail of arm terminal, Newport, R.I., 1760–70. Maple with hickory (spindles) (microanalysis); H. 42⅞″, (seat) 16″, W. (crest) 22¼″, (arms) 26⅝″, (seat) 21¾″, D. (seat) 17⁵⁄₁₆″. (Winterthur 59.1667.)

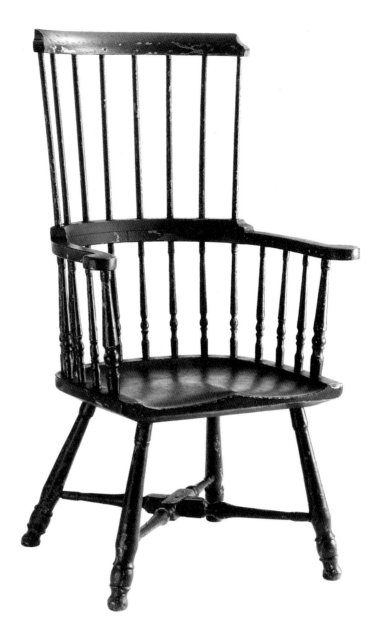

bound for Kingston or the Gulf of Honduras. The brigantine *Industry* made a Caribbean voyage the following month, transporting green chairs, foodstuffs, horses, and sheep. In December the brigantine *Sally,* bound for Savannah, Georgia, carried "Green Round Chairs" supplemented by "four D[itt]o with high backs." A cargo list of the sloop *Florida,* which sailed for Maryland the following July, lists "Round back" and "high back" seating described as "wooden bottom Green Chairs." By 1773 when the sloop *Betsey* voyaged to Môle St. Nicholas on Hispaniola (Haiti), Lopez referred to the green chairs as Windsors.[4]

Although the Lopez shipping records associate Rhode Island with Windsor-chair production by the late 1760s, documents and artifacts suggest strongly that the manufacture predated Lopez's initial exportations by several years. The evidence centers on the Redwood Library Company (called the Redwood Library and Athenaeum beginning in the nineteenth century), a private institution founded in 1747 and generously supported by Quaker Abraham Redwood. Some of Newport's "first gentlemen" became members. Moses Lopez joined in 1749, although it seems that Aaron was unassociated with the library. Members subscribed money for a building, completed in 1750, which Peter Harrison designed as a "Doric temple" of rusticated wood. On September 26, 1764, the library record book notes that the members "Voted That a Tax be Levyed on the Society of Four pounds old Tenor for purchasing Twelve Chairs for the use of the Library & a covering for the Table & writing Desk." Further description of the chairs is

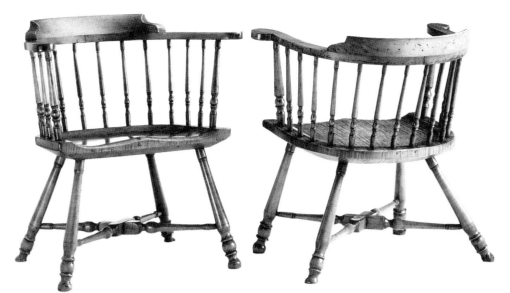

Fig. 6-2 Low-back Windsor armchairs (two), Newport, R.I., 1760–70. Maple (throughout) (microanalysis); left: H. 27⅜", (seat) 15⁵⁄₁₆", W. (arms) 27⁵⁄₁₆", (seat) 22³⁄₁₆", D. (seat) 15¹¹⁄₁₆"; right: H. 26³⁄₁₄", (seat) 15½", W. (arms) 27⅛", (seat) 22", D. (seat) 16". (Winterthur 65.833, 65.834.)

lacking, and the maker's identification remains unknown. Several high- and low-back Windsors with early D-shaped seats, unusual cross stretchers, and tipped spindles remain at Redwood Library, most probably part of the original group. Chairs of the same designs are illustrated in figures **6-1** and **6-2**.[5]

The Reverend Ezra Stiles, a Redwood Library member and also the group's librarian, owned a remarkably similar low-, or "round-," back chair, which appears in his portrait painted by Samuel King (fig. **6-3**). Stiles described the portrait, which was begun in 1770 and completed the following August, in his diary: "The Piece is made up thus. The Effigies sitting in a Green Elbow Chair, in a Teaching Attitude, with the right hand on the Breast, and the Left holding a preaching Bible. Behind & on his left side is a part of a Library—two Shelves of Books." Stiles's reference to his chair and its presence in the painting suggest that he was fond of the seat and used it in his own library. A detail of the minister's right elbow, which rests on a chair arm, reveals that the low-back green chair is *identical* to those at the Redwood Library (fig. **6-4**). The artist delineated the arrow-shaped tips that appear only on the arm supports and spindles of these early Rhode Island Windsors. What could be more fitting or symbolic of Stiles's library position than to furnish his private study with the same type of chair used at that select private institution.[6]

Rhode Island craftsmen probably made both high- and low-back chairs from the start, drawing inspiration from seating close at hand, such as Philadelphia Windsor furniture, English Windsors, Boston banister-back seating, and the locally popular formal roundabout, or corner, chair. Communication between Philadelphia and Newport merchants and Quakers was commonplace at midcentury. In 1747 Redwood sent his daughter, Mehetable, to Pennsylvania "for her improvement" and placed his son Jonas there "for a few years," presumably as a local merchant's apprentice. Since about 1744, Jonas's brother William had been in Philadelphia to train for a mercantile career in Quaker John Reynell's counting house. The elder Redwood likely knew of Philadelphia Windsor seating and was also familiar with the English product, since Rhode Island had some direct trade with London. Several local businessmen had been educated in England, and nearly all traded heavily in English goods obtained through merchant houses in Boston, New York, and Philadelphia.[7]

The chairs in figures 6-1 and 6-2, the "high-" and "round-" back Windsors described by Lopez, are virtually identical in construction and design to those in the Redwood Library. They may date a few years earlier, since the high-back chair and one of the lowbacks have fourteen spindles, while the library's Windsors have only twelve. In Philadelphia work, the number of spindles in high and low backs tended to decrease as the styles developed through the 1750s and 1760s. The greater back flare of the tall Redwood

Fig. 6-3 Samuel King, *Ezra Stiles*, Newport, R.I., 1771. Oil on canvas; H. 33½", W. 27½". (Yale University Art Gallery, New Haven, Conn.)

Fig. 6-4 Detail of figure 6-3.

New England, 1750 to 1800 239

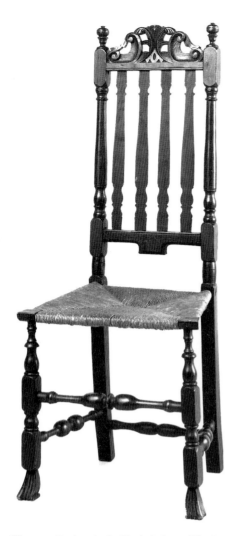

Fig. 6-5 Banister-back side chair (one of four), Boston, 1710–40. Maple with birch and ash; H. 47¹⁵⁄₁₆″, (seat) 19″, W. (seat) 14¹⁄₁₆″, D. (seat) 12¹⁄₈″. (Mabel Brady Garvan Collection, Yale University Art Gallery, New Haven, Conn.)

Library chair also indicates a mid 1760s date for that design. As represented by the illustrated examples, the general style of the early high- and low-back Rhode Island Windsor is distinctive. The front edge of the large, D-shaped plank is usually blunter and less modeled than in American and English counterparts; the legs terminate internally, rather than extending through to the top surface in the usual eighteenth-century construction mode. A prominent ridge generally extends several inches behind the centered pommel, while the front corners flare outward almost imperceptibly as in some English work, such as the earl of Egmont chair (fig. 1-20). The arms in both high- and low-back chairs consist of three pieces of sawed wood, a design that relates generally to the Philadelphia low-back pattern and has prototypes in English Windsors and the roundabout chair (fig. 3-10). The rear rail in the Rhode Island low-back Windsor is taller than in the Philadelphia back because of structural differences. Philadelphia arms slip under a solid backpiece to form a lap joint at each back corner. Rhode Island arms continue to the center back and butt against each other; the top piece is merely a cap, as in the Rhode Island roundabout chair. In the high-back chair, the ends of the flat-top crest repeat the ogee profile of the rail, instead of following the Philadelphia volute style. English Windsor prototypes for this feature include the raised crest flanking the roundel of the low-back chair in figure 1-20 and the crests of various high backs. In general, Rhode Island spindles and posts fail to pierce the arm tops, unlike Philadelphia work, and scratch beads defining the arms are usually absent (fig. 3-10). The small projection at the outside angle where the arm meets the scrolled terminal is unknown in Philadelphia (fig. 6-1).

Early Rhode Island Windsor turnings, such as those in figures 6-1 and 6-2, differ substantially from those of Philadelphia. Spindle, arm-support, and leg profiles derive totally from the banister of the Boston chair (fig. **6-5**). Prior to the Revolution, merchants and sea captains regularly sold Boston chairs in coastal centers along the eastern seaboard. The lower elements of the Rhode Island leg reveal strong influence from the English colt's-foot support (fig. 1-20); the extreme splay of the rear legs appears to be unique to local Windsors. The cross-stretcher design directly reflects the Rhode Island roundabout chair; turned and tipped cross braces interlock at center blocks to form a rabbet that is often secured from the bottom with a rosehead nail. The stretcher profile is basically the generic Boston front brace that was introduced in the early eighteenth century. The pattern was transferred to Rhode Island probably through the coastal trade or by migrating craftsmen, in much the same manner as Boston blockfront case construction found its way to Newport.⁸

When Stiles sat for his portrait, Newport was at the height of its prosperity. Windsor furniture, which was appearing in homes of the well-to-do, eventually eased out most other painted chairs. John Coddington, a local merchant who died in 1768, used "9 Green Chairs" in his "keeping room." The following year appraisers enumerated a "Windsor high Back'd Chair" in merchant Miller Frost's parlor; a second Windsor, probably of low back, stood at a desk in another room. Inventories of Loyalist estates that were confiscated during the Revolution, including those of the Wanton family, Nicholas Lechmere, Esq., and Captain Linn Martin, list Windsors among household furnishings. By 1782, two Windsors in apothecary William Tweedy's estate had been in service long enough to be called "old."⁹

Who were Rhode Island's prerevolutionary Windsor-chair makers? Evidence points to three Newport craftsmen. Jonathan Cahoone's sale of "4 winser Chears" to Aaron Lopez in April 1773, probably for exportation, identifies him as a chairmaker. Cahoone was in business in 1760, when he married at Newport. During the Revolution, however, he lost his house, furnishings, and trade accouterments, described as "Cheresmakers Tules of all sorts one Dussen of Chers made and maney more sawed out stuff for Chers." He and his family escaped from Newport in December 1776 with only the clothes on their backs as the British fleet entered the harbor.¹⁰

Timothy Waterhouse is never positively identified in documents as a Windsor-chair maker, but strong circumstantial evidence almost certainly establishes such activity. In

the late 1740s, Waterhouse made new chairs and repaired old rush-bottomed seating for Abraham Redwood. A list of Newport craftsmen prepared before 1916 by a Rhode Island resident refers to chairs made by Waterhouse in 1762; the chairmaker's name also occurs in a 1770s public record, which is discussed below. By the 1780s, Waterhouse's customers included merchant Christopher Champlin and the Newport Society of Friends. Most chairmakers in this period had to sustain themselves by making wooden-bottomed chairs (Windsors) as well as rush-bottomed seating.[11]

Evidence of Joseph Vickary's prerevolutionary Newport chairmaking activity, including exportation work, is considerable, although direct Windsor references date only after the war. Vickary married at Newport in 1756, and in 1758 he sold six dozen "3 back" and two dozen "Roundabout" chairs, probably also rush-bottomed, to Captain Ignatious Bertar, a Champlin employee. Vickary was still doing business with the firm in 1773, when three cabin chairs and two bundles of rush were loaded on the sloop *Adventure* for a voyage to Africa. Vickary also had business connections with Providence chairmaker and turner William Barker in 1762. Barker may have been involved in Providence Windsor production during the 1760s, when he turned many "chair sticks" for furniture maker Philip Potter. The turner sustained his establishment primarily by working for others and made quantities of legs, probably for tables, and feet for chairs or chests. He occasionally turned "rounds," or chair stretchers. Given the proximity of Newport and Providence and their commercial connections, Newport Windsors, along with local chairs and imports, were likely used in Providence households. Moses Brown's high-back chair imported from Philadelphia to Providence dates to the early 1760s (fig. 3-12).[12]

RHODE ISLAND, THE 1760S TO 1775

From initial development as a turned-spindle, cross-stretcher chair, Rhode Island Windsor design moved in several directions prior to the Revolution. The legs of a late 1760s cross-stretcher, low-back armchair are turned to a definite baluster profile (fig. **6-6**). The well-defined flaring spools of the feet derive directly from the back posts of English cane chairs known locally early in the century. Stretcher balusters repeat the leg silhouette, and their ringed necks and spools duplicate elements in the long posts of coastal banister-back seating, as represented in the midcentury Connecticut "crown," or pedimented, chair (fig. **6-7**). Newport merchant-traders were familiar with New England's

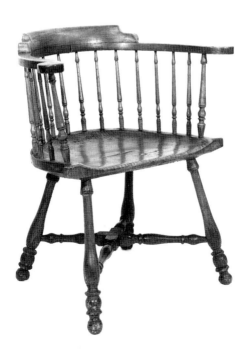

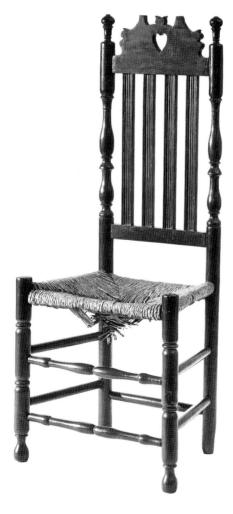

Fig. 6-6 Low-back Windsor armchair, Newport, R.I., 1765–70. Maple (seat); H. 28⅞″, (seat) 16⅛″, W. (seat) 24″, D. (seat) 16″. (Mr. and Mrs. Joseph K. Ott collection.)

Fig. 6-7 Banister-back side chair, attributed to Andrew Durand, Milford, Conn., 1740–50. Maple and ash; H. 45½″, (seat) 18″, W. (seat) 19⅛″, D. (seat) 14″. (New Haven Colony Historical Society, New Haven, Conn.: Photo, Winterthur.)

Fig. 6-8 Low-back Windsor armchair, Newport, R.I., ca. 1770–76. Maple (throughout); H. 32½", (seat) 18⅝", W. (arms) 26", (seat) 23", D. (seat) 15⅟₁₆". (Redwood Library and Athenaeum, Newport, R.I.: Photo, Winterthur.)

many inlets where merchandise could be exchanged, and the Connecticut coast was particularly handy. The arm rail in figure 6-6 is unchanged from earlier Rhode Island work, but the seat corners curve sharply outward. Spindles and posts also flare at the top, and the tiny spools and rings near the base reflect a common Philadelphia profile.[13]

Cross-stretcher Windsors received their final prerevolutionary interpretation in combination with the tapered cylindrical foot, which eliminated the ball turnings at the toes. The Redwood Library owns several low-back chairs of this pattern (fig. **6-8**). The turned legs with their short, thick-neck balusters appear influenced by Philadelphia work (fig. 3-21); arm posts imitate those of the previous Windsor (fig. 6-6). Leg splay is moderate compared with earlier Rhode Island work, although the back legs still show the greater rake; seat corners flare less emphatically than before. A similar chair, probably part of an original set of twelve, stands in the foreground of a late nineteenth-century interior view of Colony House, a Newport public structure completed in 1741 (fig. 6-17). The craftsman who made the Colony House chairs is identified in assembly records for December 1774: "WHEREAS Mr. *Timothy Waterhouse* exhibited unto this Assembly an Account, by him charged against the Colony, for One Dozen Chairs for the Court-House in Newport: And the said Account being duly examined, *It is Voted and Resolved,* That the same be, and hereby is, allowed; and that Three Pounds, lawful Money, being the Amount thereof, be paid the same *Timothy Waterhouse,* out of the General Treasury." The price seems low for Windsors, but fluctuating prerevolutionary currency makes a true cost determination difficult. Fragile rush-bottomed chairs would have been impractical for courthouse use, and wooden-bottomed seating was readily available.[14]

Another late 1760s Rhode Island chair, contemporary with figure 6-6, employs H-plan stretchers (fig. **6-9**). The braces echo Philadelphia work, although the bullet-shaped tips vary an early Rhode Island Windsor profile (figs. 6-1, 6-2). The legs, which again feature a long, central baluster, probably terminated originally in ball feet, repeating in reverse the top turnings and duplicating the post elements. The butt-joint arm structure is the usual Rhode Island construction. A backward curl is suggested at the top edge of the capping piece, a subtle element borrowed from the roundabout chair. The seat, which lacks the flaring front corners, retains the flat-chamfered edges copied from Pennsylvania and English prototypes. The deeply scooped seat surface may reflect contemporary Philadelphia work but more likely copies an English model (fig. 6-12). This unusual design and others like it were undoubtedly products of a single shop.[15]

The next Rhode Island chair of H-plan base is figure **6-10**. The seat copies a basic Philadelphia form in which the legs pierce the top surface, a new construction technique in Rhode Island; the pommel is rounded rather than angular. Other changes occur in

Fig. 6-9 Low-back Windsor armchair, Rhode Island, 1765–70. H. 28¾", (seat) 16½", W. (arms) 30", (seat) 21¾", D. (seat) 15¼"; end of left arm replaced. (Private collection: Photo, Winterthur.)

Fig. 6-10 Low-back Windsor armchair, Rhode Island, ca. 1770–76. Maple (turnings); H. 30", (seat) 17¼", W. (seat) 21⅜", D. (seat) 15½". (Colonial Williamsburg, Williamsburg, Va.)

the turnings. Stretcher tips mirror earlier Rhode Island Windsor work, although the source for all may have been formal and rush-bottomed seating, which employed arrowlike terminals even earlier (figs. 6-5, 6-7). The ball turnings of the post and leg tops have elongated tips. The legs introduce spool-and-ring elements like those in the Redwood Library and Colony House Windsors (fig. 6-8), but the straight, untapered feet identify a slightly earlier chair. Similar feet preceded the Philadelphia tapered cylindrical support of the late 1760s and early 1770s (figs. 3-17, 3-22); their appearance in Rhode Island, however, probably dates no earlier than about 1770. Newport craftsmen had ample opportunity to observe changes in Philadelphia Windsor design as such chairs were imported into the community. For instance, in June 1771 the sloop *Retrieve* left the Delaware River with white oak hogshead staves, provisions, and "Six Winsor Chaires" destined for the Vernon family of Newport. The date indicates seating with either straight or tapered cylindrical feet. Repairwork, the backbone of the furniture industry, often took a craftsman to merchants' homes, where the latest furnishings from Philadelphia, New York, or Boston shared space with local products.[16]

English Windsor work again had substantial impact on Rhode Island Windsors made from the mid 1760s until the Revolution. Immigrant craftsmen familiar with the English Windsor could have settled in the area; more likely, local craftsmen had direct access to English seating, possibly of several patterns. Some English influence is manifest in the flaring seat corners and long, full, leg balusters of figure 6-6. Highly anglicized turnings also occur in a high-back chair with a typical Rhode Island flared seat (fig. 6-11). The supports are similar to those in the Egmont and Goldsmith Windsors; however, the baluster is less full, and the cylindrical colt's foot, almost worn away here, fails to round at the top (figs. 1-20, 1-21). The influence of early Rhode Island cross-stretcher work appears in the pronounced baluster neck above the ball. Stretchers resemble the Egmont braces, although they are slimmer. The double-baluster-and-disk turnings of the arm posts may also derive from English models (fig. 6-12); however, southern New England chairmakers had long combined two balusters in the stretchers of banister-back chairs (figs. 6-5, 6-7).[17]

Arm rails in the tall chair are constructed in various ways. Some examples have the back-centered lap joint, a technique derived from the roundabout chair. Alternative construction follows the Philadelphia lap, which unites three pieces of wood at the back corners or simulates this construction in a four-piece rail to save stock. The crest and arm rail design is simplistic, even when compared with the tall cross-stretcher chair (fig. 6-1). Like figure 6-10, the sharply defined seat has a rounded pommel. Except for the post and leg turnings, the Rhode Island profile has been reduced to the basics. Production may have been aimed principally at the coastal trade, since such chairs have been found in shore areas southwest of Newport and around the northern city of Portsmouth, New Hampshire. The seat of one chair bears the stamp of John Salter (1740–1814), a Portsmouth sea captain; a descendant was the last private owner. Recent research has identified the common use of an owner's stamp on Portsmouth-owned furniture; the Salter brand also occurs on an imported mahogany armchair.[18]

OTHER NEW ENGLAND AREAS

With one possible exception, prerevolutionary Windsor production in New England was confined to Rhode Island—a sweeping but documentable statement. Most evidence to support this claim originates in Massachusetts, specifically Boston, where trade sustained the city and gave rise to an opulent merchant class. Before the Revolution, the well-to-do purchased many household furnishings in England, but they simultaneously patronized local craftsmen sufficiently to encourage the growth of a large "mechanic," or artisan, community. Vendue notices, household inventories, business accounts, and other documents survey the general range of household seating. The Windsor is notably absent from these sources, which instead list rush-bottomed chairs with slat and banister backs and walnut or mahogany joined work with cabriole and Marlborough legs.[19]

Fig. 6-11 High-back Windsor armchair, Rhode Island, ca. 1765–76. Birch (seat); H. 42⅝", (seat) 15⅝", W. (crest) 18⅜", (arms) 29⁵⁄₁₆", (seat) 23⅞", D. (seat) 14¼". (Mary Lou and Robert Sutter collection: Photo, Winterthur.)

Fig. 6-12 Low-back Windsor armchair (one of six), England, probably London, 1755–65. Mahogany; H. 30½". (Ham House, Richmond, Surrey, England: Photo, Victoria and Albert Museum, London.)

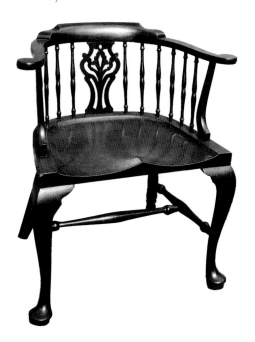

The use of Windsor seating in Boston is documented to the early 1760s, but local production is indicated only in 1786, when Ebenezer Stone advertised that he made and sold "WARRANTED Green Windsor Chairs." Two respected authors writing about New England furniture a century ago reached similar conclusions. Alice Morse Earle, discussing mid eighteenth-century furniture, noted that Philadelphia manufactured Windsors in the 1760s but concluded that such chairs were "not common in New England till a score of years later." Irving Whitall Lyon concurred: "The manufacture of Windsor chairs, which in this country seems to have started in Philadelphia, did not reach Boston, according to our investigations, till 1786, although Windsor chairs are occasionally mentioned in the records and in the newspapers before that date." Both authors were apparently unaware of Rhode Island's prerevolutionary Windsor production.[20]

The earliest known document identifying the importation of American Windsors into Massachusetts dates to September 13, 1763, when the sloop *Deborah* entered Boston harbor from Philadelphia carrying "6 Winsor Chairs" among other cargo. In December 1764 the schooner *Jane* arrived from Philadelphia with three Windsors. The traffic in Windsors continued. Boston's Daniel Malcolm, part owner of three sloops, supplemented walnut and mahogany framed seating with two Windsors prior to 1769. Malcolm's interest in the coasting trade suggests that his Windsors were of American manufacture, purchased directly in Newport or Philadelphia. Samuel Parker, owner of "a Sloop & appurtenances," possessed two Windsor chairs, as documented in a 1773 inventory that reflects a long-established household. Parker had a two-thirds' interest in land in Rochester, Plymouth County, near Buzzard's Bay and a short sail from Newport. This connection may identify the area of Parker's greatest coasting activity and also suggests that his Windsors came from Newport.[21]

Windsor furniture use in Boston was broadening by the early 1770s. Daniel Rea, a prosperous painter of ornament, refurbished Windsor chairs for Samuel Quincy and Jonathan Amory in 1772, indicating that the furniture had already been used for some years. Specific import information occurs in correspondence between merchant-factor John Andrews and his brother-in-law William Barrell, a New Englander working in Philadelphia for the Boston firm of Amory and Taylor. Early in 1772 Barrell began to ship Windsor chairs to Andrews, who had received at least one group when he wrote to Barrell on June 22 to complain about the furniture's condition upon arrival. Barrell had meanwhile placed a second order with his Philadelphia supplier, but his June 12 letter to Andrews noted an unexpected delay: "I fully depended on sending you the Chairs desired by this oppo'ty but to my great mortification on seeing those designed for you this Evening find them too Clumsey to go with the others, owing to the great hurry the person has been in that makes them, have Laid by the number you require which need only painting to compleat them, when they shall be sent you." The careless craftsman was probably Joseph Henzey, since Barrell's 1772 and 1773 business records show that he supplied chairs on several occasions. Barrell noted twice that seating acquired from Henzey, who was just beginning his trade, was "for J.A." or had been "sent J. Ands."[22]

On February 26, 1773, Andrews placed a new order with Barrell for a chair that was to be made several inches higher in the back to permit his friend, Dr. Loring, "to take a Nap in, upon occasion" (fig. 6-13). To prevent any misunderstanding, Andrews sketched the bow, or arch, of a sack-back Windsor chair at the letter's end. The following month Barrell acknowledged the order and promised a prompt response. With quality being monitored by Barrell and shipping conditions apparently improved, Andrews remained pleased with his Philadelphia chairs, as noted in a June 4 postscript, "Should be glad of two more such Chairs as the last sent by Rogers." A final reference of September 2 centers on a special order for another friend, merchant Samuel Breck, Sr., "My principal motive in writing this, is to oblige Mr Breck, who is about moving into Capt Ingraham['s] house at the back of Bacon [Beacon] Hill, and wants six chairs of the same kind as you sent me last with two high back'd ones, which should be glad you'd send me as soon as possible, as one of his rooms must remain unfurnish'd till they come." The Andrews-Barrell correspondence provides an unusual look at an eighteenth-century

Fig. 6-13 Detail of letter from John Andrews (Boston) to William Barrell (Philadelphia), February 26, 1773. (Andrews-Eliot Papers, Massachusetts Historical Society, Boston, Mass.)

factor's activity and pinpoints the personal qualities and business acumen necessary for a successful career. To secure and maintain a customer's trust, an agent had to exercise quality control over purchased merchandise, make timely delivery, and keep his client well informed, whether he was providing Windsor chairs, foodstuffs, or manufactured goods.[23]

Other evidence indicates that the Philadelphia sack-back Windsor gained a place in affluent Boston households during the course of the Barrell shipments. Jules David Prown, an authority on John Singleton Copley, states that the painter first posed a sitter in a Windsor in his 1772 portrait of Massachusetts octogenarian Eleazer Tyng (fig. **6-14**). A Harvard graduate, Tyng owned a large family estate at Tyngsboro on the Merrimack River and had held various public offices. Several features of his chair that are visible in the portrait, especially the squared bow terminal, suggest a Philadelphia origin. Copley painted several other portraits using the Philadelphia sack-back Windsor as a prop, including those of the Reverend Thomas Cary (1773) and Mr. and Mrs. Isaac Winslow (1774). As in Rhode Island, businessmen appear to have been the principal users of Windsor furniture in prerevolutionary Boston, as confirmed by the Andrews–Barrell correspondence, the Copley portraits, and other contemporary documents. Before 1774, Benjamin Coats, a "trader," placed two green Windsor chairs in his front room, or parlor, to supplement six "hair bottom" mahogany chairs used at a round dining table. Other green American Windsors, six leather-bottomed chairs, and a square mahogany table furnished the keeping, or "family," room. When appraisers inventoried Andrew Oliver's estate, valued at nearly £4,000, on March 16, 1774, they found one Windsor. Almost a decade earlier, Oliver had served as Boston's stamp officer and was forced to flee a mob that was protesting the Stamp Act. An unidentified Boston-area estate account of 1775 lists Windsor and other household seating. A Windsor stood in each of two bedrooms, the "Green Chamber" and the "Blue Chamber"; a Windsor in the "Hall" was accompanied by black walnut and mahogany chairs. Rush-bottomed chairs, probably the joined type, furnished the parlor; other seating, likely "common" rush-bottomed chairs, stood in the kitchen.[24]

Fig. 6-14 John Singleton Copley, *Eleazer Tyng*, Boston, 1772. Oil on canvas; H. 49¾", W. 40⅛". (National Gallery of Art, Washington, D.C., gift of the Avalon Foundation.)

Just two years after Oliver's death, many Loyalists left Boston permanently during General William Howe's March 17, 1776, evacuation. Following Howe's departure, George Minot of Boston carefully made a "Memorandum of What Goods I rec'd of my Son in Law's Nath'l Taylors under my Care when he left Boston March 17th 1776 & went off with the Troops to Hallifax." The following year Minot began to sell Taylor's household furnishings, including red leather chairs with claw feet and "2 Low back Windsor Chairs." Richard Lechmere left behind a "stick back chair green painted" and a "green camp bedstead." The sequential inventory listing of these items and color similarity suggest that the chair was also used as portable military equipment.[25]

Throughout the war, and especially during the occupation, many "American" merchants left Boston to pursue business elsewhere. Samuel Salisbury joined his brother in Worcester, where Stephen managed a "branch store" and had built himself a mansion. Worcester served as Samuel's base of operation for eight or ten years until he returned to Boston. In April 1779, Samuel, while a Worcester resident, received a letter from his brother-in-law, Samuel Barrett of Boston, requesting him to purchase household furnishings from a local estate. Barrett wanted "6 Green Chairs" but only "if made at Philadelphia." About this time, Stephen may have acquired his Philadelphia scroll-arm chair(s); he chose to sit in a green Windsor when Christian Gullager painted his portrait in 1789 (fig. **6-15**). Other family members who sat for Gullager at Worcester selected different chairs.[26]

In Connecticut, typical 1770s seating consisted of crown- and slat-back chairs, as listed, for example, in the 1774 inventory of John Beard, a farmer of coastal Milford. Jireh Bull's local estate probated that year contained nine york, or vase-back, chairs, which were popular in the region. Up the coast in more affluent New Haven, the household of Christopher Kilby, a storekeeper and farmer, included mahogany and black walnut chairs supplemented by cheaper rush-bottomed seating. Kilby possessed two Windsors,

Fig. 6-15 Christian Gullager, *Stephen Salisbury I*, Worcester, Mass., 1789. Oil on canvas; H. 35⅝", W. 29". (Worcester Art Museum, Worcester, Mass.)

one of high back, in 1774. Since New Haven was Connecticut's largest seaport, owner-ship of Windsor chairs by someone engaged in merchandising is to be expected.[27]

In prerevolutionary New Hampshire, references to Windsors appear in documents from Portsmouth, a small, bustling seaport engaged in coastal and some foreign commerce. An early mention in a bill dated September 1, 1766, from Richard Mills, a Portsmouth turner, to William Barrell charges the merchant £1.16.0 for two chairs. The price suggests high-back Windsors. The Moffatt family papers contain another note. Samuel Moffatt, on the verge of bankruptcy in 1768, fled to the West Indies; his father, Captain John, successfully maneuvered to preserve the family estate, since he had built young Moffatt's well-appointed house about the time of his son's marriage in 1763. The household seating is of particular interest. Joined chairs, some of cherry, with seats covered in leather, green furniture check, or yellow damask, furnished the principal bedrooms. A set of twelve "Mehogony French Easy Chairs" (upholstered-back chairs with arms) stood in the "Hall Chamber" on the second floor. Common rush-bottomed chairs were located in the kitchen. The back parlor contained black walnut chairs with leather seats, and the front parlor had mahogany chairs with haircloth bottoms. In the "Hall," upstairs and downstairs, were "6 Cherrytree Windsor Chairs" and framed leather-bottomed cherry and walnut seating. No American Windsor furniture fits this description, but records of the Gillow Lancashire firm document the use of cherry in English Windsors (chapter 1). An English provenance is also substantiated by Samuel's background, since after graduating from Harvard in 1758 he spent several years as an "independent agent" in London before marrying and establishing his own Portsmouth business. In London, Samuel likely encountered both upholstered-back and Windsor seating in the establishments and households of his business acquaintances.[28]

Other Portsmouth inventories list Windsors. When Captain Samuel Warner died in 1771, his well-furnished house included "5 green Wooden Chairs" in the hall. By that date, the Reverend Arthur Browne, a local Episcopal clergyman, probably already owned the "Gardner Winzor" chair listed in his 1773 estate. The term *Gardner*, likely a corruption of the word *garden*, probably refers to the chair's original outdoor function, although at the time of the appraisal the chair stood indoors with a cushion on its seat. By the Revolution, Windsors furnished a number of Portsmouth inns. In the "Setting Room" at James Dwyer's establishment were "6 Winsor chairs" and "1 ditto with a Back," a description suggesting that the group included high- and low-back seating, possibly of Rhode Island origin. Several high-back Rhode Island chairs have Ports-mouth histories. At James Stoodley's death in 1779, six Windsor chairs stood in the entry to his tavern.[29]

1776 to 1800

George Washington's inauguration in 1789 marked the beginning of a half century of extensive national growth. Boston, Salem, and Providence led the way in commercial expansion and prosperity that were previously unequaled in New England. The Orient was a new area of activity and remained a lucrative market until the late nineteenth century. Elias Hasket Derby of Salem, an aggressive Yankee merchant, emerged as a leader in this trade and influenced New England mercantile life long after his death in 1799. Derby's ship *Grand Turk I* left Salem in 1785 for a voyage to Canton, and he soon extended his commercial interests to India and the East Indies. The smaller New England ports continued to pursue the West Indian trade, while the vast South Pacific broadened the whaling territory and provided a livelihood in the fisheries for several generations of Nantucket, New Bedford, and New London families. Commercial activity stimulated shipbuilding and provided a growing home market for naval stores. Timber merchants in the Connecticut River valley supplied spars and masts, many cut upriver beyond Northampton, Massachusetts, which became a flourishing provincial center by the 1790s.[30]

Locations of Craftsmen and Product Destinations
Rhode Island, 1775–1799

MASSACHUSETTS

MASSACHUSETTS

CONNECTICUT

Providence

East
Greenwich

Narragansett Bay

Jamestown

Kingston

Newport

Westerly

1 inch = 9.9 miles

The business community struggled to stabilize trade and mercantile affairs following the Revolution, while Congress adopted the dollar as the basic monetary unit. Gradual industrial growth diversified New England's economy, and before the century's end British know-how and American inventiveness had combined to establish an infant textile industry, financed largely by Providence merchant-entrepreneur Moses Brown, that grew to maturity after the War of 1812. Iron-processing facilities encouraged the domestic manufacture of nails for building and other purposes. By the 1790s New England was fairly alive with activity. Progressive Providence citizens had founded the Association of Mechanics and Manufacturers in 1789 to stimulate the mechanical arts, or trades; other East Coast communities soon followed suit.[31]

RHODE ISLAND

Rhode Island recovered slowly from the economic and commercial hardships resulting from the Revolution. Newport failed to regain its prewar status as a premier seaport, although it had one of America's best harbors. Jacques-Pierre Brissot de Warville, who

visited Newport about 1788, summarized the changes: "The reign of solitude is only interrupted by groups of idle men, standing with folded arms at the corners of the streets; houses falling to ruin; miserable shops." From 1774 to 1783 the state lost 7,600 of its 59,000 inhabitants; Newport's population decreased by almost half. At Providence economic conditions forced businessmen like Olney Winsor to leave Rhode Island and their families for several years. Winsor had established a store in the flourishing town of Alexandria, Virginia, by the time that he wrote to his wife in October 1786 saying, "My greatest ambition in life is to support myself & family in Character & Reputation, & to pay my honest Debts; and I think our business here is in a fair way to do it, if we do not suffer very largely by the destructive Politicks of Rhode Island." A month later he asked, "Does not the Town look desolate so many removals & empty houses?"[32]

Newport eventually regained economic stability and became a moderate-sized seaport. The city served as a summer retreat for wealthy southerners and New Englanders a century before New York's elite erected opulent mansions along Bellevue Avenue. Although Newport had been the state's prewar furniture-making center and the leading manufacturer of New England Windsors, Providence soon outdistanced it in both production and design. François Alexandre Frédéric, duc de La Rochefoucauld Liancourt, described Providence in the mid 1790s: "The town lies on both sides of the river: a well-constructed bridge affords a ready communication between its two divisions. Lofty, well-built and well-furnished houses, are numerous in this town, which is becoming continually larger: and the prospect of an encrease of wealth and populousness, has induced the inhabitants to set aside a considerable extent of the adjacent hill for new buildings." Leading industries included ironworking and the distillation of spirits. In the early nineteenth century, Timothy Dwight described the results of postwar growth and prosperity: "Providence is the third town in New England in its population and commerce, and probably the first as to manufactures."[33]

Despite Providence's remarkable economic turnabout, little documented furniture, including Windsor chairs, survives from the late eighteenth century; only a few documented Windsors are known from other regions within the state. A history of the Rhode Island Windsor trade from the early 1780s to 1800 is based largely upon a reexamination of prewar design, a few written documents, and artifacts of known recovery area or family association.

The 1780s: Design Diversity

The first Rhode Island Windsors in the postwar market were large sack-back chairs with S-curved arm posts, notched arm terminals, and bulging feet; a few examples have tall extensions to support the head (fig. **6-16**). About two dozen chairs still exist in this design, which represents an amalgam of English and Philadelphia influences. Within the group there are two pattern variations based upon the leg turnings. The first, and simpler, design, pictured at the left, consists of a long, tubular-neck baluster that rises to the seat, a short cylinder to socket the stretchers, and a swelled foot. The second design, at the right, introduces a collar to the flared baluster neck several inches below the seat. The impact of prewar design is obvious in the placement and rake of the legs in both chairs (figs. 6-1, 6-11). Another chair has an inverted caplike element between the baluster and the cylinder of the front legs, copying a different prewar chair (fig. 6-6). The edges of the large, D-shaped seat, now slightly canted, are still sharply chamfered at the bottom; the front pommel and ridge remain prominent. The braces are precisely turned, with a ring or ball positioned between the flaring inner ends of their sticks; stretchers on other chairs may display the elongated swell introduced just before the war (figs. 6-9, 6-10). The ring-turned stretcher seems traceable to the turned back posts of a nearly vanished fan-back armchair design, probably of Newport origin. The Newport chair, in turn, likely interprets a back-post feature that was common in some coastal Connecticut crown chairs manufactured from the 1720s until about 1800.[34]

The heavy, sawed, S-curved arm posts were probably directly influenced by Philadelphia work, which was adapted from English design (figs. 3-20, 1-21). The arm rails are

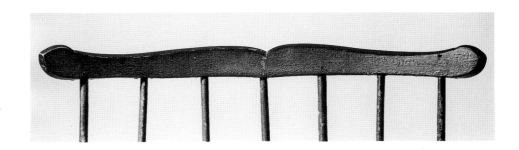

Fig. 6-16 Sack-back Windsor armchairs (two) and details of an arm terminal and a crest piece, Providence, R.I., 1780–90. Maple (seat) with ash (left), probably maple (seat) with ash and oak; left: H. 34″, W. (arms) 24⅜″, (seat) 21¾″, D. (seat) 14¼″; right: H. 37¼″, (seat) 18″, W. (arms) 28½″, (seat) 22½″, D. (seat) 15¹³⁄₁₆″. (Mr. and Mrs. Joseph K. Ott collection, Norman Herreshoff collection, and private collection [details]: Photos, Winterthur [right and details].)

of one-piece, bent construction and terminate in large, circular pads. The outside pad edges sweep backward to the squared rail, forming a gentle, notched arc rather than the sharp angle characteristic of earlier sawed-rail chairs. Spindles vary from plain sticks to rods with elongated or nodular swells below the rail, a feature that probably occurred first in these early Rhode Island Windsors and soon appeared in eastern Connecticut work. The bows, with their distinctive, low-sloping arch, are extremely thick, a condition that is atypical of eighteenth-century work. Above the arch, some sack backs rise in a high fan usually capped by a double-ogee crest that is pointed slightly at the center and tips (fig. 6-16, upper right detail).[35]

Construction techniques used in the S-curved-post chairs are also distinctive. Chair-makers preferred maple seats, although at least one plank is shaped from chestnut or ash. Maple is present in some turnings, but ash is much commoner. Both arm posts and bow ends anchor in their supporting members with concealed mortise-and-tenon joints, and an extraordinary amount of pinning ensures tight construction. One, sometimes two, large pins are used at the bow ends; these fasteners angle diagonally from the front surface of the bow into the rail. Small pins pierce the spindles along the faces of both the bow and the rail and sometimes at the seat edges; other pins secure post tenons at the rail and seat. Pins strengthen the stretcher joints and also bind the stretchers to the legs, which pierce well-modeled, dished planks. The inside edge of the spindle platform is undefined by a groove; an outer groove lying inside the rounded seat edge forms a broad bead.

The Rhode Island origin of this furniture, amply substantiated by design details, is reinforced by ownership and recovery histories. A pair of sack-back chairs that descended in the John Brown family bears the scratched name "I. BROWN" in the arm terminals. La Rochefoucauld Liancourt, when visiting the city in 1795, spoke of John, the brother of Moses, as the "richest merchant in Providence." Several modern owners purchased their chairs in the Providence area, and one Winterthur highchair was acquired in neighboring Wickford in 1928. Despite strong prewar Newport design influence, the S-post chairs likely originated in the immediate vicinity of Providence.[36]

The postwar chronology continues with furniture purchased for Rhode Island public facilities in the early 1780s, as described in the October 1783 Rhode Island General Assembly proceedings: "the Sheriff of the County of Newport be . . . directed to purchase for the Use of the State House in said County Three good large Windsor or stick-back chairs, with resting Elbow-Pieces and also Two Dozen of good common Windsor chairs, and the same to be paid out of the General Treasury." Sheriff William Davis presented his bill at the following May session. The assembly accepted Davis's account, which deviated slightly from the original order. The "24 Green chears for the State House" cost 12s. apiece and "1 D[itt]o Large with high back" cost 15s. Another assembly order under the same date directed the Washington County sheriff to make a similar purchase "for the use of the State House in said County." Assembly records for December 20, 1784, indicate that Joseph Vickary of Newport "Made and Delivered to the Sheriff of the County of Washington Twenty-Seven Green Windsor Chairs according to the within Resolve." Thomas Cottrell transported the chairs by water from Newport to "Updike New Town" (Wickford), where wagons carried them to South Kingstown (Kingston).[37]

The choice of Vickary to construct Windsor chairs for Washington County, located across Narragansett Bay from Newport, implies that he may also have been commissioned to provide Windsors for Newport County. The two sack-back Windsors shown at the extreme left in an 1886 photograph of the Old Jury Room at Newport's Colony House could be part of that order (fig. 6-17). The style and features of the chairs are appropriate for the 1784 date. Comparison of the sack-back chairs with the low-back, cross-stretcher chair in the foreground, presumably constructed by Timothy Water-house in 1774 at the assembly's direction, reveals a striking similarity in the short balusters and long spool turnings of the legs and the cone-shaped post tops. Placement of the bow ends far back on the rail creates low bulges above the joints that differ from the forward reach of the armchair with S-curved posts (fig. 6-16). These two distinct designs perhaps represent typical immediate postwar production in Rhode Island's two largest cities.[38]

Vickary's work for private customers is well documented in the business papers of Isaac Senter, a Newport doctor who called on him frequently between 1786 and 1798 to buy seating furniture and to make repairs. The six chairs making up the doctor's first recorded purchase in May 1786 appear to have been common, rush-bottomed, or "kitchen," seating. Although the cost was substantial, prices during the 1780s are generally unreliable for identification purposes due to Rhode Island's unstable currency.

Fig. 6-17 Photograph of Old Jury Room at Colony House, Newport, R.I., 1886. (N. David Scotti collection.)

In June the doctor bought six dining chairs, probably in the fan-back style, from Vickary. Their one-third advance in price constitutes a normal range between the two seating types. In 1787 Senter acquired two children's chairs; by January 1788, he added another six dining chairs to his furnishings. These chairs likely matched the first group, which by this time required mending and painting. Four years later Senter refurbished the dining room with eight new chairs, and by now the bow-back style was fashionable. The older fan-back chairs were relegated to less important rooms in the house after receiving another coat of paint and additional repairs. The Senter family was apparently a lively group, since the "new" chairs themselves required painting and mending little more than a year later. At the doctor's death in 1800, the household contained "5 sets Green Chairs 8 in a set," a group of "Roundabouts," a set of "Cane Chairs," and various individual chairs.[39]

Before the appearance of fan-back chairs, such as Vickary could have made for Senter, several types of armchairs entered the market. The armchair in figure 6-18 has several noteworthy features: spindles with low swells, probably influenced by the S-post chair; pronounced, tapered toes; and large, prominent spool turnings above the feet. These spools are identical to those in the chair at the far right in the Old Jury Room photograph (fig. 6-17), and the elements above the spools also correspond to this chair. The medial stretcher knobs duplicate those seen occasionally in prerevolutionary Rhode Island low-back chairs. Advanced stylistic features include the large, collared, baluster

Fig. 6-18 Sack-back Windsor armchair and detail of arm terminal, Rhode Island, 1780–90. Pine (seat) with maple and oak; H. 38½", (seat) 17⁵⁄₁₆", W. (arms) 24⁵⁄₁₆", (seat) 20³⁄₁₆", D. (seat) 15¾". (Edward and Helen Flanagan collection: Photo, Winterthur.)

Fig. 6-19 Fan-back Windsor side chair, Rhode Island, 1785–95. H. 39⅝″, (seat) 17⅞″, W. (crest) 21⅛″, (seat) 16″, D. (seat) 16¼″. (Nathan Liverant and Son: Photo, Winterthur.)

caps and the double scroll of the arm terminals. The seat is made of white pine, a common wood in Rhode Island furniture along with yellow poplar, maple, walnut, chestnut, and basswood.

Several features of the armchair also appear in a sophisticated fan-back side chair, which may have been the type that Vickary constructed for Senter (fig. 6-19). Leg turnings, stretchers, and spindles are comparable, despite the larger spindle swells in the fan-back chair. The post design, with two balusters of almost equal length, occurs regularly in southeastern New England work, although posts with one long baluster are commoner. The chairmaker also deliberately positioned the spindle swells to coincide with the fullest part of the central baluster. Philadelphia chairs served as the overall prototype and were probably the direct source for the plain crest.[40]

A rare 1780s high-back Windsor shares several characteristics with the contemporary sack-back chair of figure 6-18, including crownlike baluster caps and collared knobs in the center stretcher (fig. **6-20**). A subtler common feature is the leg-top turning, which is a small baluster. The same silhouette became an integral part of contemporary eastern Connecticut Windsor design, especially among woodworkers in the Tracy family and neighboring New London County craftsmen. The high-cheeked swells of the tapered feet herald a feature that became a trademark of 1790s Rhode Island production. The three-part sawed arm rail follows Philadelphia construction by introducing a long lap, or

Fig. 6-20 High-back Windsor armchair, Rhode Island, 1780–90. Pine (seat); H. 43¾″, (seat) 17⁵⁄₁₆″, W. (crest) 19⅝″, (arms) 25⅜″, (seat) 22⅜″, D. (seat) 16¼″; lower leg tips restored. (Norman Herreshoff collection: Photo, Winterthur.)

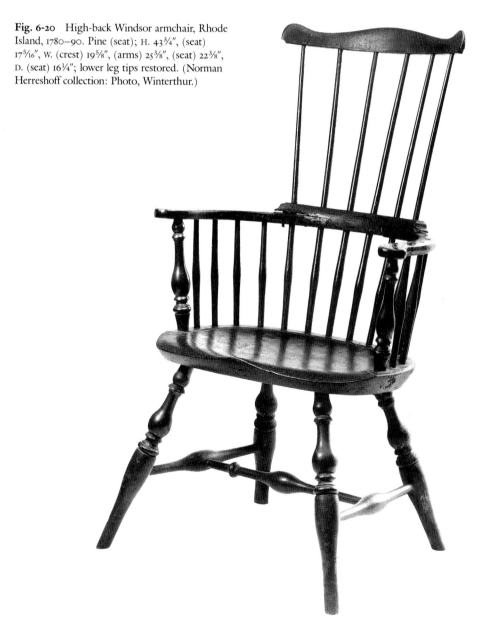

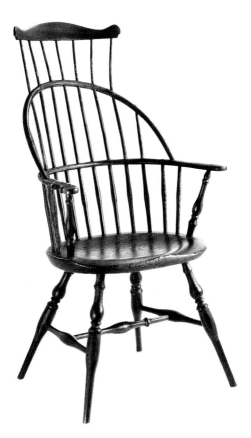

Fig. 6-21 Sack-back Windsor armchair with top extension, and detail of arm terminal, Rhode Island, 1785–90. White pine (seat) with maple and hickory (microanalysis); H. 43$\frac{7}{16}$", (seat) 17$\frac{5}{8}$", W. (crest) 17$\frac{1}{4}$", (arms) 24$\frac{13}{16}$", (seat) 20$\frac{3}{4}$", D. (seat) 16"; lower half of leg tapers restored. (Winterthur 59.1628.)

rabbet, joint at each back corner; the short, back-rail ends reverse the ogee scroll of the early high-back, cross-stretcher chair (fig. 6-1). The uncommon plain crest has two unusual elements, a straight bottom edge and a small hollow in the lower corner of each shouldered end.

A sack-back armchair with an extended top has a related crest and introduces arm returns with short, angular, oxbow profiles (fig. **6-21**). The legs pierce the upper surface of the white pine seat. Instead of knobs, the medial stretcher has angular rings that echo the spool caps of the post and leg turnings. The short, full balusters and swelled feet (extended considerably in the twentieth century) form another bond with the high-back chair in figure 6-20, although the pointed tips of the upper legs recall prewar Rhode Island design (fig. 6-6). The compressed spools with sharply defined caps also resemble the turnings of the high-back chair. The prototype for the compressed spool may be found in a small group of postwar fan-back Windsors probably of Newport origin, as related by family history (fig. **6-22**). These chairs are identified by their unusual turnings and distinctive crest rails with peaked tips. A similar crest tops the high back of a Newport ball-foot, fan-style armchair that probably dates to the early 1770s.[41]

The shield-shaped seat of the Newport fan-back chair in figure 6-22 has a pronounced ridge that defines many Rhode Island plank pommels from an early date (fig. 6-1). Maple, sometimes of prominent curl or stripe, is the primary material. The vigorous quality of the support structure is the result of increasing the leg splay and introducing full-bodied turnings, whose umbrellalike baluster tops and long, close-fitting collars may stem from crown chairs of prerevolutionary coastal Connecticut origin (fig. 6-7). Similar caps appear in the spool turnings. Stubby, pointed feet are also typical of these postwar chairs. Bracing spindles were rare in New England until the 1790s; their use here probably reflects 1760s and 1770s Philadelphia design or earlier English work. Most stretchers have long, thick, central swells that are sometimes blocked (abruptly reduced in diameter at the ends) to repeat the back-post profile. The medial stretcher sometimes consists of double-baluster-and-ring turnings, such as those found in Connecticut vase-back, rush-bottomed chairs, some originating as close as New London. The illustrated braced-back chair and a companion piece were acquired

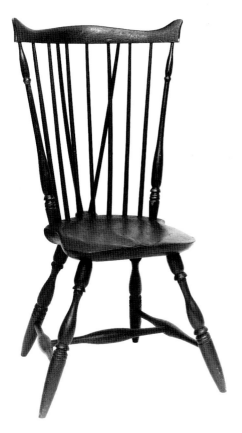

Fig. 6-22 Fan-back Windsor side chair, Rhode Island, 1780–90. Pine (seat); H. 39$\frac{1}{2}$", (seat) 17", W. (seat) 14$\frac{5}{8}$", D. 15$\frac{1}{4}$". (Mr. and Mrs. Joseph K. Ott collection.)

from descendants of Robert Lawton, Jr., a Newport cabinetmaker, and Christopher Robinson of South Kingstown, where Vickary supplied chairs for the courthouse.[42]

The lingering influence of the bottle-shaped baluster is manifest in several tall Rhode Island armchairs from the 1790s. A broad, shield-shaped white pine seat supports an exceptional frame with projecting "ears," short, sloping arms, and long, pennantlike arm supports that anchor in the side stretchers (fig. **6-23**). The baluster neck-cuff and body lengths vary from those of the chair in figure 6-22, but the basic character is the same. The spool turnings flare less at the base, and the rings are twice as thick. The central swell of the medial stretcher, although somewhat worn, still shows traces of a precise, narrow band cut into the end surfaces, similar to the side stretchers in both chairs in figure 6-16. Side stretcher rings, an uncommon feature, visually balance the lower ends of the rare, long, one-piece arm posts. At seat level, each arm post fits into a shallow rabbet that is cut into the plank side and held by a screw; round tenons secure the posts at arm level. The least successful aspect of the design is the plain, tapered back posts; turned work would have better integrated and balanced the upper and lower structures. Since the back-post profile is likely a late feature, the chair may date into the next century. The low crest arches, top and bottom, balance the small projecting end scrolls that are cut with incised grooves.[43]

Another chair with bottle-shaped balusters relates to figure 6-23 in general features only (fig. **6-24**). Although it has a recovery history east of Worcester in Northboro, Massachusetts, its initial home was likely Rhode Island, since the leg turnings are close to those of the fan-back side chair in figure 6-22. The blocked upper-leg turnings are also similar to those of figure 6-23. The use of blind, or internal, leg sockets reinforces the Rhode Island origin. Behind each rounded arm pad is a small, asymmetrical oxbow return. The crest with its large, uncarved scroll ends is uncommon but recurs in some Rhode Island work; most top pieces cut to this profile finish in carved volutes. The bamboo medial stretcher probably extends the chair's date into the early nineteenth century.

Fig. 6-23 Fan-back Windsor armchair, Rhode Island, 1795–1805. White pine (seat, micro-analysis) with maple and other woods; H. 40⅜″, (seat) 17¾″, W. (crest) 21½″, (arms) 20¾″, (seat) 17¾″, D. (seat) 17″. (Private collection: Photo, Winterthur.)

Fig. 6-24 High-back Windsor armchair, Rhode Island, 1795–1805. Pine (seat) with maple and other woods; H. 44⅜″, (seat) 16¼″, W. (crest) 19⅞″, (arms) 23⅞″, (seat) 19¼″, D. (seat) 16¼″. (Private collection: Photo, Winterthur.)

Fig. 6-25 Fan-back Windsor side chair, Rhode Island, 1780–90. Chestnut (seat, microanalysis); H. 36⅜″, (seat) 17¼″, W. (crest) 21⅛″, (seat) 14⅛″, D. (seat) 14¾″. (The late Elvyn G. Scott collection: Photo, Winterthur.)

Fig. 6-26 Sack-back Windsor armchair, Rhode Island, 1780–90. Chestnut (seat) with maple and other woods; H. 38¼″, (seat) 17¾″, W. (arms) 25⅛″, (seat) 19¾″, D. (seat) 14⅞″. (General Artemas Ward Memorial Fund Museum, Shrewsbury, Mass.: Photo, Winterthur.)

A few Windsors with unified but highly individual turnings fall outside mainstream postwar design. The fan-back side chair and the sack-back armchair of figures **6-25** and **6-26** retain strong bonds with prewar work, since their turnings relate to the tapered cones and flaring spools of an early cross-stretcher chair (fig. 6-6). The continued use of a flared-base baluster from the S-post group and the presence of a bow-back side chair, a postrevolutionary pattern, within the current group also confirm the 1780s date (fig. 6-16). The rather abruptly tapered toes of figures 6-25 and 6-26 perhaps represent an early attempt to modify the heavy feet, which become more refined in later examples. The seats of these chairs are made of chestnut, a common wood in Rhode Island and eastern Connecticut Windsor planks. The seat of a related bow-back chair is maple, a material also used in Windsors from the same regions. All the planks are narrowly chamfered around the bottom edges; this feature is perhaps best seen in the armchair (fig. 6-26).⁴⁴

The uniform turning of these fan-, bow-, and sack-back chairs suggest that one craftsman or a few close associates made them. The use of swelled-center stretchers in the sack- and bow-back Windsors instead of the heavy, provincial, sausagelike braces of figure 6-25 denotes a slight advance in the pattern. Just visible at the left in the armchair is the hollow sweep of the arm pad, which terminates abruptly farther back in a right-angle rail return. Except for the angle, the profile is similar to that used by the Tracy family in nearby Connecticut. Two more fan-back chairs once in the dealer market are part of this variant postwar group. The turnings of one are similar to those of figure 6-25 but introduce a thick ring between the foot and the baluster; the crest terminates in large, full-rounded, hook-type scrolls. The crest of the other side chair is identical to that of figure 6-25, but the leg turnings are less exaggerated.

Angular, hook-type crest terminals are a prominent feature in a fan-back Windsor that draws on several postrevolutionary designs (fig. **6-27**). The upper structure of the "new" chair influenced Connecticut fan-back work associated with the Tracy family. A skilled turner modified a standard sequence of back-post elements, such as that in figure 6-22, producing a flowing, sophisticated composition. The elongated, flared-base central baluster was probably adapted from the short balusters in a contemporary sack-back chair (fig. 6-42). The long spool and round-top base derive from other Rhode Island

Fig. 6-27 Fan-back Windsor side chair, Rhode Island, possibly Providence, 1785–95. Chestnut (seat); H. 35⅝″, (seat) 16″, W. (crest) 20½″, (seat) 15⅛″, D. (seat) 15⅝″. (The late I. M. Wiese collection: Photo, Winterthur.)

Fig. 6-28 Sack-back Windsor armchair and detail of arm terminal, Rhode Island, probably Providence, 1785–95. Maple, oak, and other woods; H. 38½″, (seat) 16⅞″, W. (arms) 24¾″, (seat) 19¼″, D. (seat) 14¾″. (Private collection: Photo, Winterthur.)

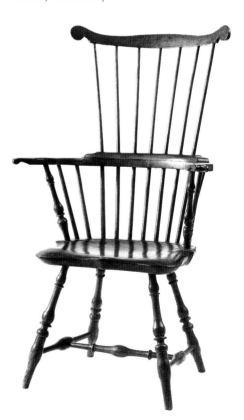

Fig. 6-29 High-back Windsor armchair, Rhode Island, 1790–1800. Ash, maple, oak, and other woods; H. 43⅛″, (seat) 16½″, W. (crest) 23⅛″, (arms) 26¼″, (seat) 19¼″, D. (seat) 14¾″. (Memorial Hall Museum, Pocumtuck Valley Memorial Association, Deerfield, Mass.: Photo, Winterthur.)

work (fig. 6-43). Below the thick chestnut seat, well-defined leg turnings appear unrelated to the back posts; however, the leg tops reverse the base elements of the posts, and the spool turnings are similar in character. The short, bulging, large-headed baluster derives directly from the high-back armchair in figure 6-20 or its prototype. The chairmaker followed a late eighteenth-century Rhode Island technique by sharply undercutting the full-rounded ring turning. The turnings of figure 6-27 represent a vocabulary of Rhode Island design. The crest is as notable as the turnings. The angular terminals, the product of a straight lower edge and sharp hooks, contrast sharply with the curvilinear features. In other chairs, the crest rounds at the bottom corners to soften the line and unify the design; the turned profiles vary from example to example.

An unusual combination of stylish and outmoded elements appears in a sack-back chair (fig. **6-28**). The balusters, spools, and thick, undercut rings of the support structure are virtually identical to figure 6-27, while the tapered feet and stretcher knobs share general characteristics. Notable differences, however, occur in the profiles of the stretchers and leg tops; the latter may be the latest feature of the sack-back chair. The short, shouldered leg-top baluster appears occasionally on Providence area chairs dating to the 1790s. A prototype for the contoured plank leads back to figure 6-18, which also supplies a model for the bow arch. It is difficult to explain why the chairmaker chose to retain outdated S-curved arm supports that differ so completely in character from the finely turned legs; nevertheless, he integrated the diverse elements with amazing skill. Small, well-designed oxbow sidepieces and circular rail terminals duplicate those in figure 6-21. The components of figure **6-29**, a high-back armchair, again blend contemporary and outdated design elements. The three-piece sawed arm rail and the shield-shaped seat are the earliest elements. The arm rail dates from the 1760s, when heavy rails were centered with a butt joint at the back and the capping piece terminated in ogee ends (fig. 6-1). Seat contours follow those introduced and refined in prewar Philadelphia Windsors (fig. 3-20). The horizontal lines of the seat and the rail complement the tall crown of the chair. The wide crest sweep, far exceeding that of figure 6-24, balances the thrust of the undercut, scrolled arms and modifies the design's verticality. Individual turned elements come from several sources; for example, the leg-top turnings reflect a

Fig. 6-30 Fan-back Windsor side chairs (two), Rhode Island, 1790–1800. Left: H. 38⅛", (seat) 17", W. (crest) 22¾", (seat) 17⅞", D. (seat) 13¾"; right: H. 37", (seat) 17⅜", W. (crest) 22¾", (seat) 17⅝", D. 14½". (Private collection: Photo, Winterthur.)

Fig. 6-31 High-back Windsor armchair, Rhode Island, 1780–85. Chestnut (seat); H. 43½", (seat) 17½". (Photo, Peter A. Nelson.)

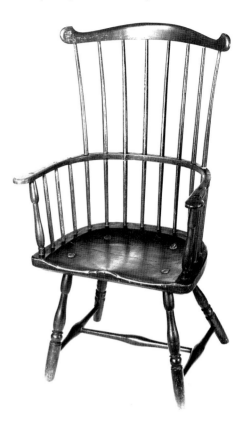

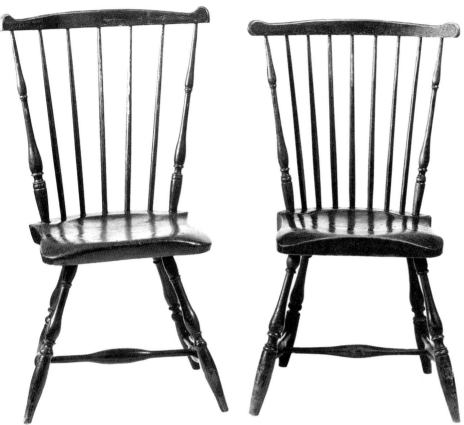

Fig. 6-32 Vase-back, rush-bottomed side chair, Massachusetts, 1730–35. Poplar with ash (micro-analysis); H. 42", W. (seat) 18¹⁵⁄₁₆", D. (seat) 14". (Winterthur 58.1576.)

profile in figure 6-19. The spool and the ring are modifications of those in figure 6-27. The swelled and hollowed foot is the latest feature and probably dates in the 1790s.

The competent handling of the angular-top chair in figure 6-27 contrasts sharply with the provincialism of two fan-back side chairs (fig. **6-30**). The crest of the left chair reveals its maker's familiarity with the new top piece, although its profile seems too slender and the angular ends too abrupt; the rounded ends of the right chair vary the line. The chairs also differ in spindle count and turned profiles. The unusual seat, common to both chairs, probably originated in the same local area. A groove defines the spindle platform of the right chair; the other is plain.

Individuality in Craftsmanship

Rhode Island Windsor-chair making of the 1780s and 1790s is remarkable for the variety of individual designs. Although a single element is often used and reused, the way in which it is handled differs from one chair to the next. The chair in figure **6-31** represents the middle stage of an ongoing creative process. The design springs directly from the prerevolutionary D-seat Windsor. The posts and legs are modified versions of the turned base supports in figure 6-11; extended feet compensate for the reduced baluster length. More current elements occur in the top piece and arms. The hook terminals of the crest vary the profile of those in figure 6-27. The source was a popularly priced rush-bottomed chair that was ubiquitous in New England households from the 1730s through the century's end (fig. **6-32**). The negative areas flanking the upper splat of the chair back become the rounded hook ends of the Windsor crest when rotated outward ninety degrees. Some craftsmen likely made both types of chairs. The arms, while of new

Fig. 6-33 High-back Windsor armchair and detail of arm terminal, Rhode Island, 1785–95. Pine (seat) with maple and oak; H. 41½", (seat) 17", W. (crest) 21", (arms) 27½", (seat) 21⅜", D. (seat) 14⅞". (Russell Ward Nadeau collection: Photo, Winterthur.)

Fig. 6-34 Sack-back Windsor armchair, Rhode Island, 1785–95. Maple, oak, ash, and other woods; H. 35¾", (seat) 15½", W. (arms) 24¾", (seat) 20", D. (seat) 13⅝". (Private collection: Photo, Winterthur.)

design, relate to those in prewar high- and low-back chairs; the long, straight extensions behind the scroll terminals return to the narrow, bent rail in shallow curves. In later interpretations of the armchair in figure 6-31, the arm terminals exhibit small, stepped projections at the juncture of the scroll and the sidepiece, a prewar feature (figs. **6-33, 6-34,** 6-1). Although the chairs in figures 6-31, 6-33, and 6-34 are quite different, the three are firmly linked through their arm posts, which eliminate spool and ring turnings. In other features the later chairs reflect contemporary design. The highly modeled oval seat with rounded edges sometimes has a hollow beneath the pommel, as in figure 6-33; legs pierce the top surfaces, but no grooves define the spindle platforms (fig. 6-34). The leg balusters of figure 6-33 harmonize with the elongated arm-post profile, although the bulges vary in thickness. The long, baluster-turned end spindles unite the two-tiered back design. Family tradition links the Windsor to Noyce (or Noyes) Billings, a New London resident who is enumerated in 1830 and 1840 federal census records. Another tall chair in a private collection is almost an exact mate; it lacks a slight rise under the seat pommel, and the plank is made of chestnut instead of pine. The sack-back Windsor in figure 6-34, which is linked to the tall chair through its arm-post design, is also comparable to figure 6-19 in the profiles of its short leg balusters and long feet.

High- and sack-back chairs making up a small seating group with roots in the prewar period, when short balusters and ornamental stretcher knobs were introduced, are also linked by broad, shield-shaped planks and heavy arm rails (figs. **6-35,** 6-36). The

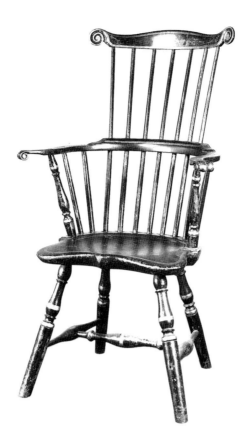

Fig. 6-35 High-back Windsor armchair, Rhode Island, 1780–90. (Photo, Israel Sack, Inc.)

prototype for the tall design, and for the plank and rail features of both patterns, was a Philadelphia high-back chair (figs. 3-20, 3-21). The provincial, and somewhat clumsy, seats are copies of the plank in figure 3-20; the arms and large knuckle scrolls duplicate those of figure 3-21. The rail construction is similar to Philadelphia work. The arms slip under the back rail in a diagonal lap, or rabbet, joint at the point of each ogee return. In the support structure, a short, Philadelphia-style baluster either has a thick neck or is of slim profile with a large cap, the latter more popular in Rhode Island. Lower legs are heavy with little taper, a characteristic of some prerevolutionary Philadelphia turnings.

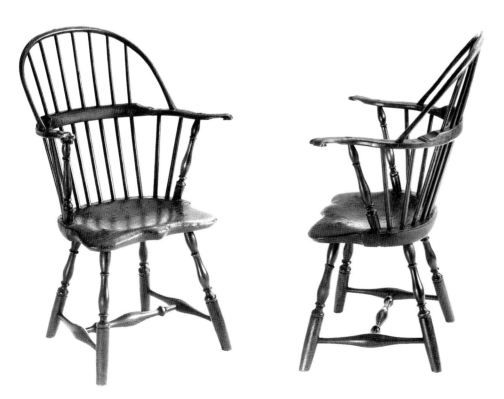

Fig. 6-36 Sack-back Windsor armchair (two views), Rhode Island, 1780–90. White pine (seat) with maple, oak, and birch (microanalysis); H. 36¹³⁄₁₆″, (seat) 15⅞″, W. (arms) 25¼″, (seat) 19″, D. (seat) 15″. (Winterthur 65.836.)

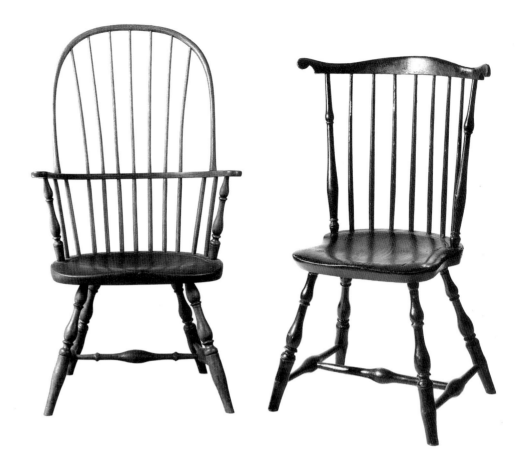

Fig. 6-37 High sack-back Windsor armchair, Rhode Island, 1785–95. Pine (seat) with maple and oak. (Metropolitan Museum of Art, New York.)

Fig. 6-38 Fan-back Windsor side chair, Rhode Island, 1785–95. Pine (seat); H. 35⅞″, (seat) 16½″, W. (crest) 25¼″, (seat) 16¾″, D. (seat) 16¼″. (Private collection: Photo, Winterthur.)

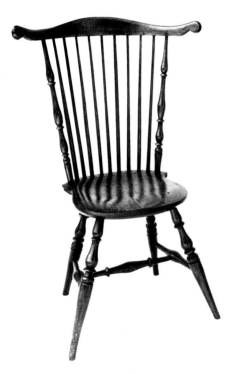

Fig. 6-39 Fan-back Windsor side chair (one of a pair), Rhode Island, 1790–1805. Pine (seat) with maple and other woods; H. 35⅞″, (seat) 17¾″, W. (crest) 25⅝″, (seat) 15½″, D. 15⅜″. (Photo, Nathan Liverant and Son.)

Large, Philadelphia-type stretcher knobs were popular in Rhode Island through the century's end; they were sometimes combined with an enlarged central swell. The carved-volute crest of figure 6-35 duplicates the top piece of the fully developed Philadelphia shield-seat Windsor (fig. 3-21). The curved top element in the sack-back chair has unusual, flaring, blocked ends (fig. **6-36**). The scroll returns that once completed the arm tips are now lost. A second chair, likely from the same shop, is at Colonial Williamsburg. Later versions of the sack-back chair substitute an oval seat for the shield bottom and a bent rail for the sawed one. One related design has a tall, block-tipped bow that creates a "high-back" Windsor, probably intended for reclining (fig. **6-37**). The feet introduce another type of swelled taper that originated in Rhode Island. Unlike the rounded feet of the chairs in figure 6-30, these supports, with slightly hollow tops, swell in the middle before forming pointed toes.[45]

A fan-back side chair almost duplicates the tall sack-back leg profile from the baluster down (fig. **6-38**). The broad crest with uncarved terminals varies the profile of figure 6-24. The seat, which is almost square in dimension, forms a pronounced sharp-edged curve at the front that continues along the sides. The tops of all four legs terminate in small rounded swellings as they enter the plank. This distinctive feature, which prevents further penetration into the plank, occurs in other Rhode Island work. The long, oval balusters of the posts relate generally to figures 6-25 and 6-27.

A rural craftsman took the crest of figure 6-38 and extended the terminals beyond the normal post points to create a vigorous, although awkward, interpretation (fig. **6-39**). Several other features of figure 6-38 appear in this chair. The rounded seat has the same sharp top edge, although the prewar flat-chamfered sides still prevail (fig. 6-2). The pommel is marked by a long, sharp ridge similar to that of figure 6-22, a recurring Rhode Island feature. The right central post-baluster has an angular body like that of figure 6-38. The entire post is unusual, since the chairmaker used two elements in place of a long, central baluster. The extra turnings visually minimize the exaggerated crest proportions. The lower post and the leg turnings are of comparable profile, indicating that the craftsman was striving to achieve visual unity. The turned elements share

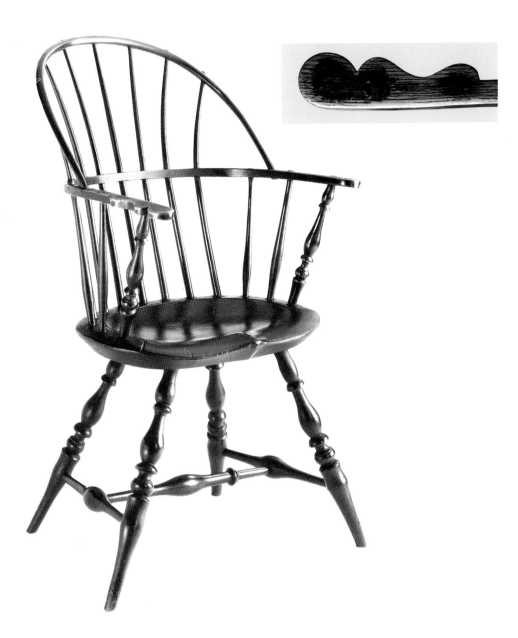

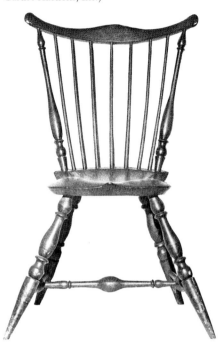

Fig. 6-40 Sack-back Windsor armchair and detail of arm terminal, Rhode Island, probably Providence, 1790–1800. White pine (seat) with maple and oak (microanalysis); H. 39½″, (seat) 18⅛″, W. (arms) 23³⁄₁₆″, (seat) 21¼″, D. (seat) 15½″. (Winterthur 54.74.7.)

Fig. 6-41 Fan-back Windsor side chair, Rhode Island, probably Providence, 1790–1800. (Photo, Garth's Auctions, Inc.)

Fig. 6-42 Sack-back Windsor armchair, Rhode Island, 1790–1800. White pine (seat) with maple and other woods; H. 34¼″, (seat) 20″, W. 21¾, D. 16″. (Colonial Williamsburg, Williamsburg, Va.)

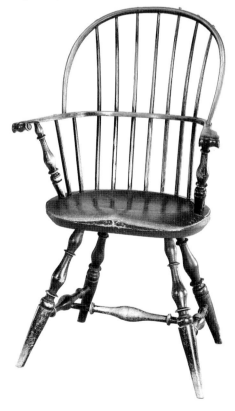

characteristics with other Rhode Island work. The round leg profiles compare with those of figures 6-18 and 6-19; the feet are slim versions of those in figure 6-20.

A Rhode Island Windsor in the Winterthur collection represents an extraordinary design, from the excellent proportions and superlative turnings to the delicate form and generously splayed legs and spindles (fig. 6-40). The arms, which are flat, are more successful than the carved knuckles of several related chairs, which visually anchor the design to the ground and compromise the graceful, elastic quality. The arms here move vigorously in a horizontal plane, forming a flat scroll followed by a long, rounded oxbow. The legs socket firmly inside the oval, white pine plank, which is marked by a prominent, central front ridge. Introducing structural stability to the legs are short, shouldered necks that prevent the supports from breaking through the plank top. The master turner had perfect control over his tools and material and an advanced sense of design. The deep cutting of the individual leg elements makes each one a distinct entity, yet the rhythmic sequence of hollows and rounds causes one unit to flow into the next, forming a unified whole. The sharp definition of the collars that flank the long swell of the medial stretcher visually ties the bracing structure to the supports.

The stance and vigorous turnings of a fan-back side chair repeat some of the exceptional qualities found in the sack-back armchair (fig. 6-41). A slight heaviness in the leg balusters and the absence of a pronounced swell in the feet, which taper both top and bottom, detract somewhat from the overall design. A delicate touch occurs in the

slim, rounded tips of the medial stretcher. Although these tips are found in some regional turned work, similar ones also appear in a Philadelphia shield-seat, high-back Windsor, a chair type that Rhode Island craftsmen of the 1780s knew and used as a model (fig. 3-20). Rounded, arrowlike stretcher tips are common in southern coastal New England banister- and vase-back chairs; some are accompanied by tiny rings, or buttons.[46]

The oval quality of the balusters in figures 6-40 and 6-41, introduced in the slim turnings of figure 6-36, was modified in a sack-back armchair at Colonial Williamsburg (fig. **6-42**). The bulging elements in this chair are angular. The large, crisp, disklike caps projecting in a horizontal plane above the spools and balusters heighten the angularity. The rounded slope of the caps reveals the moderate influence of earlier postwar work (fig. 6-22). Like the side chair in figure 6-41, the double tapers are almost flat in both planes, creating an angular version of the foot illustrated in figure 6-20. The unusual cleft disks that embellish the medial and side braces repeat the thin, sharp profile of the leg caps. The oval seat with a broad, sloping pommel and flat-chamfered edge that tapers to points at the front corners is typical of planks in a few related sack-back Windsors. Several of these chairs have arms that end in carved knuckles, either with wavy, oxbow profiles, as in figure 6-42, or with simple, curved rail returns; tiny carved volutes mark the scroll faces on the sides. Other chair rails are flat and terminate in full circular pads with long oxbow returns.

Focus on Structure and Turnings

Within the body of individual designs in the postwar Rhode Island Windsor market, some innovation was structural in nature—such as a rear brace in a sack-back chair, a triple back in a tall chair, or an extension above a back bow (figs. 6-43, 6-45, 6-49). Standard elements were sometimes exaggerated in shape and size. Considerable variation was manifest in the turnings, whose disklike caps, long spool forms, round-top feet, and bulbous centers are distinctive. The usual sequence of turnings was sometimes altered, or certain elements were eliminated. The following chairs illustrate these features and also demonstrate how area chairmakers produced highly innovative patterns for special orders or limited markets.

The solid stance of a sack-back Windsor is reinforced by heavy, bulbous stretchers (fig. **6-43**). The bold turnings lack an exact model, although ideas flowed freely within

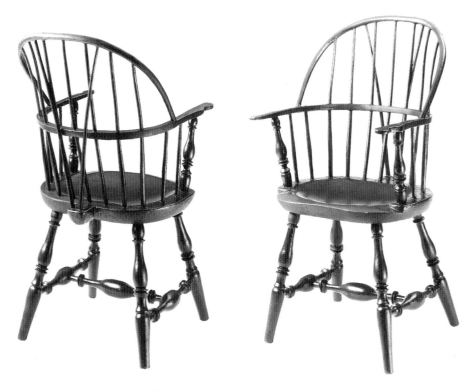

Fig. 6-43 Sack-back Windsor armchair (two views), Rhode Island, 1790–1800. White pine (seat) with maple (microanalysis) and other woods; H. 39″, (seat) 18⅛″, W. (arms) 20⅞″, (seat) 20¾″, D. (seat without extension) 15½″. (Private collection: Photo, Winterthur.)

Fig. 6-44 Sack-back Windsor armchair and detail of arm terminal, Rhode Island, 1790–1800. Pine (seat); H. 37⅝″, (seat) 16⅜″, W. (arms) 24″, (seat) 20″, D. (seat) 14¾″. (Essex Institute, Salem, Mass.: Photo, Winterthur.)

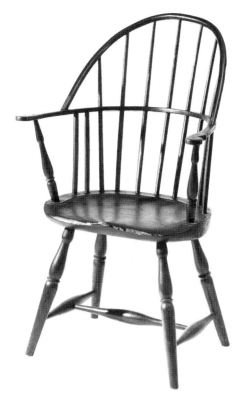

Fig. 6-45 High-back Windsor armchair and detail of arm and upper-rail terminals, Rhode Island, 1790–1800. White pine (seat) with birch, ash, and oak (microanalysis); H. 45¼″, (seat) 17½″, W. (crest) 15⅜″, (arms) 21⅞″, (seat) 21⅝″, D. (seat) 16¼″. (Winterthur 64.1520.)

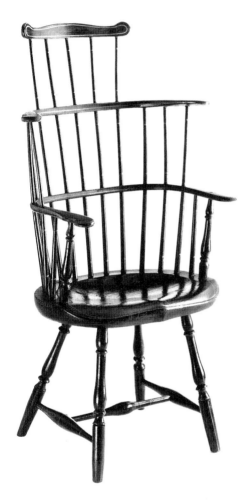

the Rhode Island–Connecticut border community. An unusual settee branded by Ebenezer Tracy of nearby New London County, Connecticut, has a bracing structure with similar large swells and disks. The skillfully and boldly executed cleft stretcher rings of this sack-back chair dwarf those of the Windsor in figure 6-42. Balusters are longer versions of those in figure 6-38; a small disk, repeated at the base, replaces a true cap, or crown, above the neck. The exaggerated spools, or hollow turnings, probably reflect the influence of both early postwar design and rush-bottomed chairs. Spools of all sizes, some quite long, are common to southern New England crown-top chairs, as illustrated in the leg tops of a Boston banister-back chair (fig. 6-5). The round-top feet have few parallels in Windsor work (fig. 6-44). The abrupt endings of the spindle platform at the front seat corners reveal a provincial yet well-planned design, since the rounded steps follow normal groove-end curves at this point. Equally unusual are the seat projection and back bracing spindles, since the added support is unnecessary in this type of Windsor. The short arm terminals detract somewhat from the overall design.[47]

The sack-back Windsor in figure **6-44**, which has a recovery history in Jamestown, Rhode Island, shares several features with the disk-turned armchair of figure 6-43. Although this chair is of plainer design, the profiles of the balusters, round-top feet, and arm terminals are similar to those of figure 6-43. Several features relate to other Rhode Island Windsors: the awkward placement of the short spindles supporting the arm within the area below the bow ends; the deep, slightly canted plank edges; the angular projection behind the arm pad.

The triple, or stacked, back of a tall Windsor produces another unique design, which is classified somewhere between a high-back and a sack-back Windsor with a top extension (fig. **6-45**, pl. 4). The chairmaker constructed an "easy" chair with a head-rest and a structure to support a draped cloth for shielding the sitter from drafts. The arm and comparable upper rail terminals link the chair to the Windsors in figures 6-43 and 6-44; the point behind the circular pad is defined more clearly than in these two chairs, although several other Windsors display this feature as a precise, angular projection. Prototypes exist in both joined and turned seating, including an upholstered Rhode Island roundabout chair and a rush-bottomed chair from the Connecticut–Rhode Island coastal area with arm terminals forming angular sweeps (fig. **6-46**). The arm posts of the Windsor are closely related to those in figure 6-35; the

Fig. 6-46 Detail of arm rail from rush-bottomed roundabout chair, Rhode Island, 1770–1800; overall view, figure 6-134. (Winterthur 66.1203.)

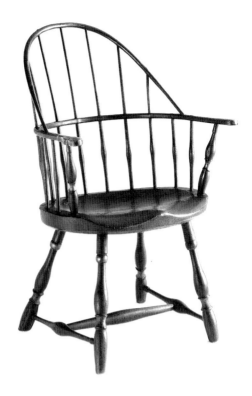

Fig. 6-47 Sack-back Windsor armchair and detail of arm terminal, Rhode Island, 1780–1800. Yellow poplar (seat) with maple, hickory, and birch (microanalysis); H. 34⅝″, (seat) 15¹¹⁄₁₆″, W. (arms) 23⁹⁄₁₆″, (seat) 21¼″, D. (seat) 16¹³⁄₁₆″; medial stretcher replaced. (Winterthur 59.1822.)

spool turnings recur in other armchairs. The pointed front ridge of the seat is similar to that in a sack-back chair (fig. 6-40). The groove is missing from the spindle platform, but the legs pierce the plank top.⁴⁸

A chair of provincial quality relates both to earlier and contemporary chairs (fig. **6-47**). The style is difficult to date; it could be from the immediately postwar period but likely belongs to the 1790s, since both the balusters and long spools relate directly to figure 6-43. The thick seat has the typical Rhode Island sharp chamfer around the bottom edge and a contoured front. The flat arms with double-scroll outside edges also occur in figure 6-18, which eliminates the narrow step behind the second scroll. The slender, slightly pointed bow slopes backward in the manner of an S-post chair (fig. 6-16). The leg turnings appear to spring from an early source. The ball turning and foot of a prewar high-back design are inverted to form the leg top; the transition with the baluster is abrupt (fig. 6-11). The feet are shortened, heavier versions of those in figure 6-30. The somewhat stocky medial stretcher was probably replaced early; it bears only the outer two of three coats of paint, the last coat probably applied at the end of the nineteenth century. A privately owned identical chair, the feet less worn and the original medial stretcher gracefully swelled, has a family history in Pomfret, a Connecticut border town.

Another sack-back chair shares a stylistic relationship with figure 6-47 in the provincial design of the arm posts (fig. **6-48**, pl. 5). Although the profiles differ, the same rare combination of elements is present. A long, tapered cylindrical sleeve and baluster are repeated in inverted form beneath a spool. The lower sleeve may function as a shouldered stop, as found in some chair legs (fig. 6-38). The long spools with slightly flaring tops and bottoms also occur in the legs. The ribbonlike, rectangular arm rail is thick; only the rail of the double-disk-turned chair is comparable in size (fig. 6-43). The abrupt, semicircular arm terminal is unusual, although it does appear on other chairs. The white pine seat, which is chamfered around the lower edge, is an uncommon D-shaped plank of arc-shaped front with a projecting center point. Although the medial stretcher is a replacement, the original design may have been close to that of the side stretchers, whose compact round turnings seem to have developed from the ball-centered brace of the S-post chair (fig. 6-16).

A Windsor with a D-shaped seat related to that of figure 6-48 is a much more sophisticated design (fig. **6-49**). The seat lacks the sharp chamfer of figure 6-48, although when viewed frontally the double sweep rising to high points at the center and corners is similar. These precise, rhythmic curves are comparable to those in the S-post Windsor plank (fig. 6-16). Other sweeping forms occur in the arm terminals, which are identical to those in figure 6-47, and in the crest that terminates in incised scrolls of a new pattern. Innovative features include the flaring tips and bases of the arm posts, profiles that are repeated in the compressed leg spools. The shape relates to the leg tops of figure 6-21; the balusters of both Windsors are also similar. The round-tipped side stretchers recall prewar Rhode Island design (figs. 6-8, 6-10).

The same spool turning appears in the legs of a unique high-back chair (fig. **6-50**). The spool flares more at the base here, evoking a prewar design (fig. 6-6); other leg elements, such as the balusters, thick rings, and feet, are also similar in the two chairs. From the seat up, however, this tall chair is very different. The high, fan-style back and distinctive crest completely dominate this Windsor. The crest shows the influence of a side chair with peaked ends in the top piece (fig. 6-22). This unusual feature in an

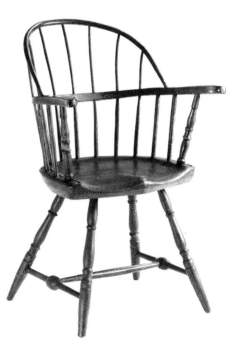

Fig. 6-48 Sack-back Windsor armchair, Rhode Island, 1780–1800. White pine (seat) with maple, oak, hickory, and ash (microanalysis); H. 39⁹⁄₁₆″, (seat) 16⅞″, W. (arms) 23″, (seat) 18¹³⁄₁₆″, D. (seat) 16¼″; medial stretcher replaced. (Winterthur 65.2037.)

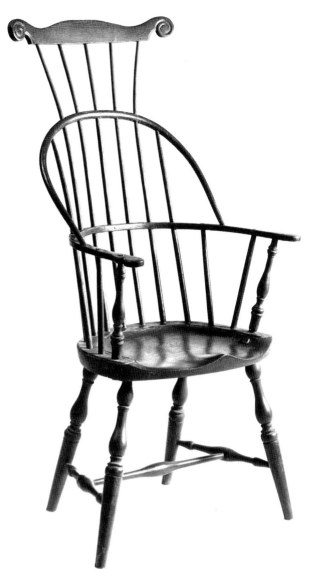

Fig. 6-49 Sack-back Windsor armchair with top extension, Rhode Island, 1785–95. H. 47½″, (seat) 17¾″, W. (crest) 21¼″, (arms) 23⅝″, (seat) 20⅝″, D. (seat) 15″. (Maurice Sendak collection: Photo, Winterthur.)

Fig. 6-50 High-back Windsor armchair and detail of arm terminal, Rhode Island, 1785–1800. Pine (seat); H. 42⅝″, (seat) 17⅞″, W. (crest) 28″, (arms) 23⅝″, (seat) 21″, D. (seat) 15¼″. (The late I. M. Wiese collection: Photo, Winterthur.)

otherwise straightforward design is still another characteristic of provincial work, and such individual expression holds strong appeal for the modern collector. Also noteworthy are the large knuckle-type arm terminals that extend backward along the rail in broad pads. Uncarved terminals of related profile occur from time to time in the Rhode Island–Connecticut border region.

The central leg elements of a documented sack-back Windsor exhibit a strong affinity to the baluster and the spool profiles of figure 6-47 (fig. **6-51**). The sculptural quality of the oval plank is a typical Rhode Island feature. The chair relates to figure 6-40 in the bow arch and slight tension of the long outer spindles. This Windsor is a rarity because beneath the seat it bears the brand of an identifiable, eighteenth-century Rhode Island chairmaker, Joseph Stone. He is listed in state census and town records for 1790, when he purchased property in East Greenwich. Although Stone had sold six Windsor chairs on December 19, 1788, to Christopher Spencer of that town, the chairmaker was neither born nor married there. From 1790 to 1795, William Arnold, an affluent local resident, employed Stone for miscellaneous tasks, including bottoming chairs, painting a schooner, and replacing "one post in a green Chair." Through a third party, Lydia Greene acquired "½ dozen Greene Chares" from Stone in 1796 or 1797. Early in 1798 the

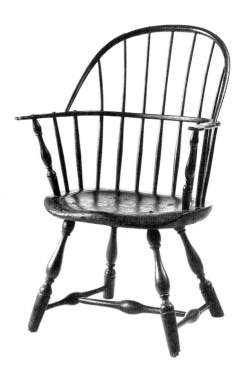

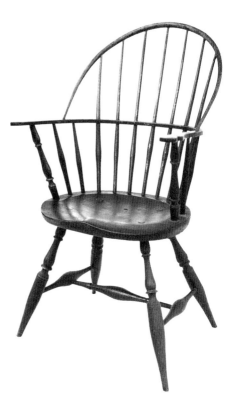

Fig. 6-52 Fan-back Windsor side chair, attributed to Joseph Stone, East Greenwich, R.I., 1788–98. Basswood (seat, microanalysis) with maple and oak; H. 38¼″, (seat) 18⅛″, W. (crest) 20⅞″, (seat) 15¾″, D. (seat) 17½″. (Private collection: Photo, Winterthur.)

Fig. 6-53 Sack-back Windsor armchair, Rhode Island, 1780–95. Yellow poplar (seat, microanalysis); H. 40½″, (seat) 18¼″, W. (arms) 23½″, (seat) 20⅛″, D. (seat) 15½″. (Earl and Edythe Osborn collection.)

chairmaker sold his property to a local innholder and probably left East Greenwich, since later town and state records fail to mention him. Stone's known Rhode Island work includes other unmarked armchairs. One is an unusual whimsy with three-dimensional "hands" for arm terminals, a feature that occurs in several Rhode Island Windsors.[49]

Stone's sack-back chair relates so closely in its roundwork and spindle profile to a plain-crested, fan-back side chair that the two must have originated in the same shop (fig. 6-52). In both chairs the distinctive leg turnings have bulging top members, full-bodied balusters marked by broad caps that step out from the neck, large spools, thick rings, and stout feet that hint at a double taper. The long posts in the side chair are also comparable with the short arm posts of the sack-back chair. The baluster is attenuated in the side chair but exhibits the same lean, oval body. In both chairs, the unusual spindles swell toward the base and end in short tapers. Another uncommon feature of the side chair is the abrupt lower angle of the crest ends where the scrolls rise from a flat base.

A sack-back Windsor, dating to the mid 1780s or later, again has long spools as the design focus (fig. 6-53). The chairs at the extreme left in the Jury Room at Colony House share the same profile (fig. 6-17). The arm terminals of figure 6-53 follow the same pattern as those of figure 6-18, and the posts are also comparable. The upper leg turnings are dwarfed by the large spools and exceptionally long swelled and tapered feet. The legs pierce the top of a finely modeled yellow poplar seat; a sharp ridge, instead of a groove, defines the spindle platform. The slim, tipped medial stretcher is a holdover from prewar Windsor work (fig. 6-10); the ultimate source is formal seating furniture.

Similar but larger stretcher tips embellish all three braces of another sack-back Windsor (fig. 6-54). Above the feet, the legs relate in profile, with slight differences occurring in the lengths and diameters of the elements. The chair also relates significantly to several other sack-back chairs in stretcher pattern, hollow-tapered feet, and spindles that draw together like a fan at the seat back. Another Rhode Island feature introduced here concerns the unusual arm-post proportions. The base taper has been lengthened to fill half the space between the seat and the arm; the remaining elements are confined to the top half.

The arm posts in a pair of tall armchairs repeat the unusual post proportions of figure 6-54 (fig. **6-55**). The bottom-heavy turnings duplicate the leg proportions and profiles. In other features, the tall knuckle-arm Windsors relate to various regional chairs. The finely turned legs exhibit the sensitivity of pattern that is associated with the earliest, and some of the best, postwar work (fig. 6-18); the disklike rings accenting the medial stretcher suggest a date approaching the 1790s. The steep-sided planks with contoured fronts fall midway between highly sculptured and blunt-edge seats. Spindle profiles seem closest to figure 6-53 and the East Greenwich chairs (figs. 6-51, 6-52). The sweep carving of the crest volutes is a new feature in Rhode Island Windsors and also occurs in other contemporary chairs. The arms, which curve deeply behind the large knuckles and sweep outward to form prominent elbows near the tall back, have few Rhode Island Windsor counterparts (fig. 6-35); they relate instead to chairs from the Rhode Island–Connecticut border region and New London County. The profile stems from formal chairs or high-style rush seating (fig. 3-54).

Rhode Island characteristics are found in several chairs represented by figure **6-56**, whose turnings deviate from standard patterns. The work probably is that of several chairmakers from the state's eastern or northern border with Massachusetts. Bold, tipped stretchers centered by oval elements link this chair immediately to figure 6-54. The double-baluster and disk-turned medial stretcher profile is repeated in the arm posts. The bows terminate at the rail in enlarged, blocked tips that are similar to those of figure 6-37. The long spindles fan out to divide the negative space within the bow curve into equal segments. The sticks rise from an exceptionally sculptural plank, featuring a deep hollow and a prominent, ridged pommel. The upper element connecting the leg and seat is the familiar Rhode Island vase, which is inverted and separated from a similar

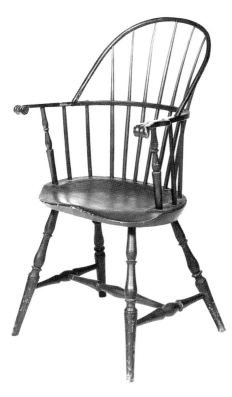

Fig. 6-54 Sack-back Windsor armchair, Rhode Island, 1785–95. (Photo, Bert and Gail Savage.)

Fig. 6-55 High-back Windsor armchairs (pair), Rhode Island, 1785–1800. Pine (seat) with maple and oak; right: H. 45¼″, (seat) 17⅝″, W. (crest) 21⁹⁄₁₆″, (arms) 27⅛″, (seat) 20⅛″, D. (seat) 15⅛″. (Private collection: Photo, Winterthur.)

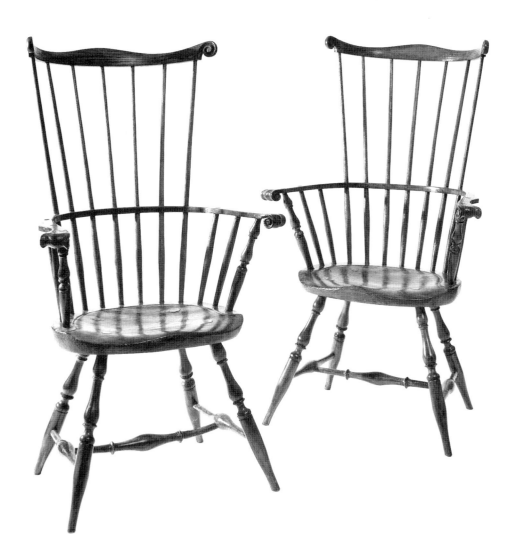

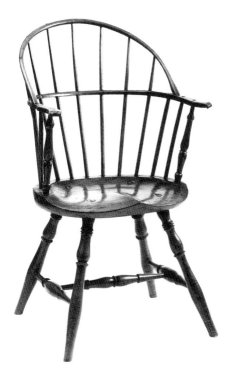

Fig. 6-56 Sack-back Windsor armchair, Rhode Island, 1795–1805. Pine (seat) with maple, oak, and ash; H. 37⅜″, (seat) 17½″, W. (arms) 22¾″, (seat) 20⅜″, D. 14¾″. (Mr. and Mrs. Ted Burleigh, Jr., collection: Photo, Winterthur.)

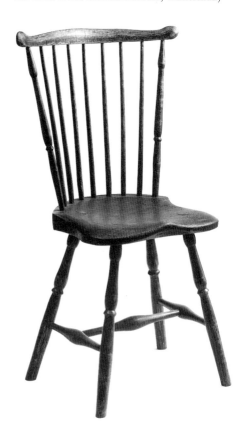

Fig. 6-57 Fan-back Windsor side chair, Jonathan Young (brand "Jon' Young"), Rhode Island, 1795–1805. Pine (seat); H. 36", (seat) 17¾", W. (crest) 22½", (seat) 16½", D. (seat) 14⅝". (The late I. M. Wiese collection: Photo, Winterthur.)

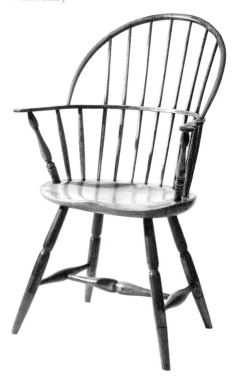

Fig. 6-58 Sack-back Windsor armchair, Rhode Island, 1795–1805. Pine (seat) with ash, maple, and oak; H. 39", (seat) 17½", W. (arms) 25⅝", (seat) 20½", D. (seat) 14⅞"; legs pieced out below stretchers. (Private collection: Photo, Winterthur.)

upright by a knife-edge disk (fig. 6-43). The profile imitates the central element of the medial stretcher but shows greater verve and style. The long, scored, club-shaped lower leg, or foot, which seems influenced by early bamboowork, is directly related to Boston and southern Massachusetts chairs. The stumpy arm-rail terminals have shaved lower surfaces and tiny, rudimentary scrolls, a feature that is developed in later Rhode Island chairs (fig. 6-64).[50]

The plain turnings of a fan-back Windsor characterize another seating group with similar club-shaped lower legs but varying back posts (fig. 6-57). A slim cylinder of moderate swell forms the club turning in this chair. Related chairs feature either a cylindrical foot with a substantial upper bulge and a slim, pointed toe or a round-top, carrot-shaped support (fig. 6-44). A prominent mushroom-shaped cap marks all leg centers. Above this turning, most balusters form an abrupt, collarless union with the bulbous top element, a feature found in other Rhode Island and coastal Connecticut chairs (fig. 6-31). The illustrated shield-shaped, grooveless chair plank has a prominent hollow pommel at the center front; a similar treatment occurs in other Rhode Island Windsors (fig. 6-33). Another fan-back Windsor has a rounded, shield-type plank with flat-chamfered edges. The back posts repeat the leg elements, but in many other examples the tall back posts have standard components. The short posts of related armchairs often duplicate the leg turnings; some have a standard baluster or a round-top element at the base. The spindles of almost all similar chairs are plain, tapered sticks. One high back features a pair of tiny vase turnings joined end to end near the base of each long rod. This feature probably originated in the Rhode Island–Massachusetts border region.[51]

Crest rails when present in the seating group represented by figure 6-57 are usually plain or marked by large, cut-scroll ends. The plain top pieces are slim with long, low arches; scroll-end tops are carved with volutes or uncarved (figs. 6-49, 6-24). The common arm terminal is a rounded pad that continues into a wavy sidepiece. One sack-back chair has projecting knuckle scrolls; another has pad tips with flaring points (fig. 6-44). Among bow-back examples, the bow faces are plain or patterned with incised beads.[52]

Closely related to the preceding Windsors is a small group of chairs whose leg turnings eliminate the caplike element and thereby unite a swelled foot and baluster with only a crease between them. The same turning occurs in some posts and medial stretchers, although the combinations vary from chair to chair. The feature is shared by two braced, balloon-back Rhode Island armchairs with forward-scroll arms, vase-and-bead turned spindles, and finely modeled shield-shaped seats. Both have creased legs and center braces; one has arm posts of similar pattern. Some leg tops are shouldered at the plank.[53]

Another variation of the club-shaped foot is present in a sack-back chair; upper and lower cylindrical elements are separated by a narrow, spoollike collar (fig. 6-58). The same turning divides the swelled elements of the medial stretcher. Although the legs below the stretchers have been restored, their form is likely close to the original. Legs in a similar chair toe in more abruptly at the base. Legs socket blindly inside the planks of both chairs, and the spindle platform is defined by a ridge. The contoured oval seat, vertical spindle orientation, and tension of the bow ends recall other Rhode Island chairs. Spindles that narrow at top and bottom occur frequently in Windsors from the Connecticut-Rhode Island border region. The arm terminals with their serpentine sidepieces are similar to those in figure 6-40.

In striking contrast to the simple fan-back Windsor in figure 6-57 is a chair with highly modeled carved, turned, and shaved features (fig. 6-59). The contours of the shield seat are almost identical to those in another side chair (fig. 6-41); the same baluster profile occurs in figure 6-43. Large spool turnings and thick rings join the upper legs to the swelled-taper feet, which are slimmer and better constructed than most earlier work (fig. 6-21). Several variations of the swelled foot became popular in Rhode Island Windsors in the 1790s, when new round-back styles came onto the market. The crest

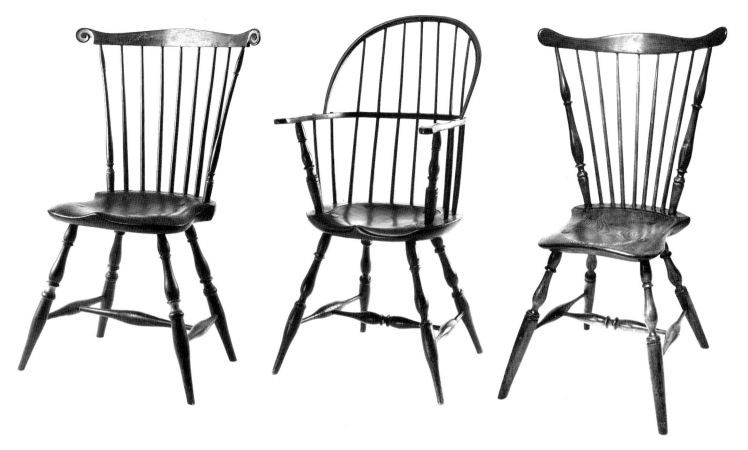

Fig. 6-59 Fan-back Windsor side chair, Rhode Island, 1785–95. Chestnut (seat); H. 37″, (seat) 18″, W. (crest) 27¾″, (seat) 18″, D. (seat) 15¾″. (Thomas K. Woodard Antiques: Photo, Winterthur.)

Fig. 6-60 Sack-back Windsor armchair, Rhode Island, 1785–95. Maple (seat); H. 40¾″, (seat) 18⅛″, W. (arms) 21¼″, (seat) 19⅞″, D. (seat) 13⅞″. (Private collection: Photo, Winterthur.)

Fig. 6-61 Fan-back Windsor side chair, Rhode Island, 1785–95. Chestnut (seat). (Photo, James Bok.)

volutes, which are well delineated because of later gilding, represent a type carved in a single sweep that originated in Rhode Island. Similar volutes also appear in two high-back chairs (fig. 6-55). The slender back posts, which inadequately balance the other elements, weaken the overall design.

Another group of Windsors, originating in the 1780s and refined in the 1790s, combines provincial, bottom-heavy arm posts with stylish turned work and almost perfect overall proportions (fig. **6-60**). The sack-back chair relates to several contemporary Windsors. Arm posts of comparable length and general shape appear in figure 6-48. The superbly modeled maple seat, the leg splay, the tight bow curve, and the barrellike interior space relate to another Windsor (fig. 6-40). Arm terminals are similar to those of figure 6-31, although the pads are slightly reduced here. Two new support features are the necked-base baluster and the spool-centered medial stretcher, a form that appears in the legs of some small, rectangular-top New England tables. The baluster profile reflects prewar chairs (fig. 6-11); these turnings relate ultimately to necked elements in earlier regional painted furniture. The lower New England shore had long been an active trading region where stylistic influences were bound to intermingle; at the century's end, enough early turned furniture remained in local households to serve as models. Together or singly, the baluster and the stretcher turnings of the armchair appear in other chairs. Swelled-taper feet, although unusual in this group, lend vigor to the supports by continuing the sequence of alternating swells and hollows from seat to floor. The long swells in the side stretchers relate directly to the medial brace of an earlier fan-back chair (fig. 6-22).[54]

The fan-back chair in figure **6-61** has a tiny chestnut seat with an exceptionally deep chamfer on the lower back plank edge. Delicate leg and stretcher turnings duplicate the profiles of figure 6-60, but a straight taper replaces the swelled foot. The back posts with

Fig. 6-62 Fan-back Windsor side chair, Rhode Island, 1790–1800. Yellow poplar (seat, micro-analysis) with maple and other woods; H. 36¼", (seat) 17⅛", W. (crest) 21¹⁄₁₆", (seat) 17", D. (seat) 15½". (Private collection: Photo, Winterthur.)

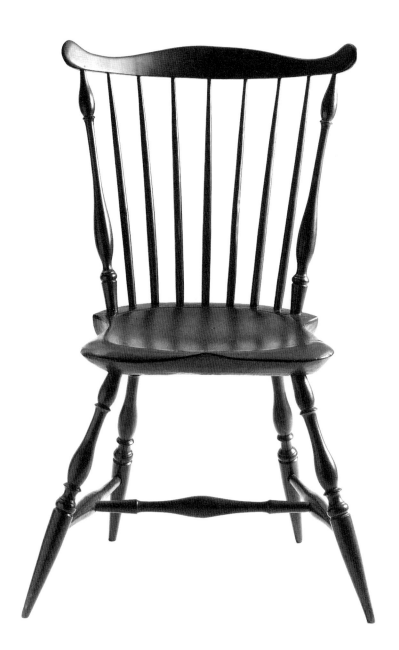

two balusters of almost equal length and the crest rail silhouette recall the fan-back chair in figure 6-19. In sharp contrast to the provincial quality of this small chair is the streamlined design of another fan-back Windsor dating to the 1790s (fig. **6-62**). The turnings, especially the toes, are slim, and the chair unites upper and lower structures in a large, modeled seat. The wide rear arc of the yellow poplar plank creates a broad back with a deep, lateral curve. Turnings in the widely spaced front legs balance the sizable back posts to create visual harmony. A delicate center brace has slim, tapered tips. The necked balusters at the base of the back posts link this chair with other Windsors (figs. 6-60, 6-61). The crest also relates to figure 6-19, the longer center arc dictated by the broader back; a similar "lift" marks the ends.

An unusual Windsor design features a uniquely shaped plank and an undercarriage with simple, "long-stemmed" supports (fig. **6-63**). Two characteristics link the rudimentary leg turnings to other Rhode Island work: the collar near the top varies only slightly from that of figure 6-58; the swelled leg is simply an elongated version of the feet in figures 6-20 and 6-60. The high stretchers are hand shaved. Above the plank, the arm-post balusters swell through the body, and the slim necks extend to the rail, where they form a small nodule. The turnings may be a variant of the baluster found in figure 6-47; the base usually angles sharply to form a short stem and knob. At least eight other sack-back chairs share this same general arm-post profile. Each chair has five long back

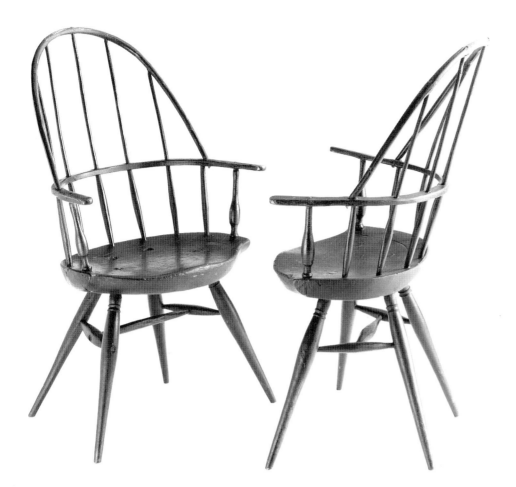

Fig. 6-63 Sack-back Windsor armchairs (pair), Rhode Island, 1795–1810. Basswood (seats) with birch and ash (microanalysis); left: H. 33⅝″, (seat) 14¾″, W. (arms) 20½″, (seat) 18¼″, D. (seat) 13½″. (Winterthur 58.125.1, 58.125.2.)

spindles under a tall, pointed or rounded bow; all spindles swell between the seat and the arm rail. The delicate bend of the rail terminates in long, round-tipped pads that are only slightly wider than the rail. The heavy planks of these chairs are of two shapes: figure 6-63 combines an arc back and serpentine front; other planks are oval, sometimes almost round. All planks are thick with rounded edges and a center front pommel. In most chairs the legs pierce the top surface, where a broad spindle platform, defined by a wide groove, terminates in front of the arm posts.[55]

Like the above sack-back chairs, another Windsor with necked-baluster arm posts is a unique design (fig. **6-64**). The chair represents a potpourri of Rhode Island elements, yet the parts are linked by an emphasis on full, turned profiles. The necked balusters and adjacent rings of the arm posts relate generally to comparable leg elements in figures 6-60 and 6-61. The round-topped cone at the base duplicates the back-post turnings of figure 6-27. The short, vaselike baluster immediately below the arm rail also appears in the upper leg; the profile recalls the leg top in figure 6-40. Several features derived from figure 6-41 occur in this chair: oval-bodied balusters with crowned caps (in the arm posts), large flaring spools and ball-shaped rings that are deeply undercut above the feet, and a round-tipped medial stretcher. Flared-top balusters, like those in the legs, are commoner in Connecticut work, although they are present in other Rhode Island chairs (fig. 6-56). The large, oval seat with flat sides and a prominent saddled front almost duplicates that in figure 6-47, except for the hollowed surface beneath the pommel. Both seats lack the groove defining the spindle platform, but the legs pierce the top surfaces. The truly outstanding feature of this chair is the provincial but distinctive knuckle arm. The carver, using only the rail thickness, emphasized the knuckle by deeply shaving the underside of the projection.

Another chairmaker used knuckle arms in a sack-back chair of smaller dimensions (fig. **6-65**). The delicacy and sensitivity of the violin-shaped scrolls point to an artisan of

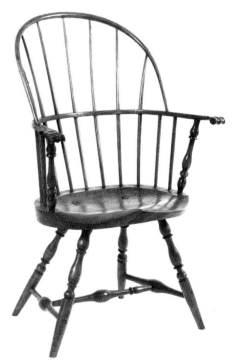

Fig. 6-64 Sack-back Windsor armchair and detail of arm terminal, Rhode Island, 1790–1800. Chestnut (seat) with maple and ash; H. 47½″. (Photo, David A. Schorsch, Inc.)

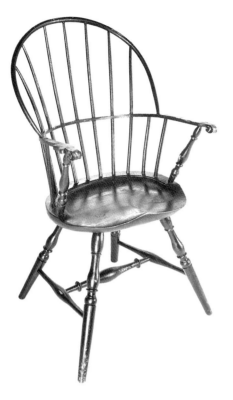

Fig. 6-65 Sack-back Windsor armchair and detail of arm terminal, Rhode Island, 1790–1800. (Photo, John Walton, Inc.)

Fig. 6-66 James Earl, *Capt. Samuel Packard*, Providence, R.I., 1796. Oil on canvas; H. 35″, W. 29¼″. (Museum of Art, Rhode Island School of Design, Providence, R.I.)

superior ability—one who was probably both a cabinetmaker and a chairmaker. Scrolls with projecting side faces terminate the arms or crest tips of several seating types, such as the early rush-bottomed chairs associated with the Gaines family of southern New Hampshire and framed formal chairs in the Chippendale style. The short, oxbow arm sidepiece, a variant of that in figure 6-64, is relatively common in Rhode Island Windsor work (figs. 6-21, 6-28). The high, round-arch bow with tight end curves relates to figures 6-42 and 6-60. The plank has counterparts in figures 6-40 and 6-60; leg balusters are similar to those in figure 6-64 but substitute a collar for the flared top.

The 1790s: Design Stability

Rhode Island, which steadfastly pursued its own course in fiscal matters during the 1780s, achieved a stable business base only in 1790, when it ratified the Constitution and became part of the Union. Once again the area grew in population and wealth, the growth sustained by maritime trade and an emerging industrialism. Owner-captains of small trading vessels continued to make a living by exchanging commodities in the coastal market.[56]

The state's unreliable monetary policies of the 1780s and early 1790s and the unsettled nature of the times—the insecurity, social upheaval, and business stagnation that followed the war—explain the diverse nature of Rhode Island Windsor design during this period. Craftsmen constructed Windsor chairs in limited numbers for local customers or for coastal markets and the Caribbean trade. Many chairmakers supplemented their woodworking activity with odd jobs and subsistence farming. Export records show that chairs became increasingly important trading commodities after the war, although business declined in the troubled financial times of the late 1780s. During the early 1790s French spoliation on the high seas curtailed activity in southern waters; however, the home market was just beginning to flourish, and Providence emerged as the new business center.[57]

Daniel Lawrence of Providence advertised his seating business in 1787, noting that he made and sold Windsor roundabout, dining, and garden chairs as well as sofas and settees "in the newest and best Fashions, neat, elegant and strong, beautifully painted, after the Philadelphia Mode." Except for this advertisement, however, nothing is known about Lawrence's work. The Pennsylvania metropolis remained a strong rival in the local market, and by the early 1790s New York and Boston also became competitors in the painted seating trade. In May 1792 New York chairmaker James Bertine sold fifteen Windsor chairs priced at 7s. apiece to an agent of the East Greenwich Arnold family. William Arnold transported the side chairs to Rhode Island in his schooner, and at his death several decades later, the "green" chairs still furnished three rooms of his home.[58]

Lawrence's 1787 listing of his production warrants explanation. Although it is unclear if his dining Windsor was of the new bow-back or older fan-back pattern, the roundabout was probably a low-back Windsor and derived its name from the circular sweep of the heavy rail, as in comparable rush-bottomed chairs. The term *garden* may have applied to several chair styles. Alpheus Hews's 1787 advertisement includes a woodcut of a sack-back chair to draw attention to his New Haven shop where he made "WINDSOR SETTEES, and GARDEN CHAIRS, . . . in the neatest manner and different fashions" (fig. 6-178). Hews's phrase "and different fashions" likely means that he made chairs with various back designs but called them all garden chairs. The chairmaker probably constructed both high- and sack-back Windsors. One unusual low-back, cross-stretcher Rhode Island Windsor bears several tiny holes bored in the plank to permit water drainage.[59]

The sack-back was the primary Windsor armchair used in Rhode Island through the mid 1790s. James Earl, after his return from England in 1794, painted several Providence residents seated in sack-back Windsors. Earl's portrait of Samuel Packard is undated, although other evidence points to 1796 (fig. **6-66**). Packard returned from a long sojourn in England in the early months of that year, and Earl died that August at Charleston, South Carolina. Captain Packard sits on a green chair with a mahogany-colored arm

rail, the same chair and color combination found in another Earl portrait. The two-color contrast may be the "Philadelphia Mode" referred to in Lawrence's advertisement. Several Philadelphia chairmakers worked on perfecting paints for chairs, and craftsmen also used natural mahogany arms in some Windsors (figs. 3-24, 3-41).[60]

In 1787 when Lawrence sought to attract the public to his shop, several Providence craftsmen were constructing only rush-bottomed chairs. In addition to cabinetwork, Job Danforth, Sr., produced slat- and banister-back chairs, as recorded in his 1788-1818 account book. Rufus Dyer, a chairmaker of nearby Cranston, made only slat and york chairs (fig. 5-8). Daniel and Samuel Proud constructed these types as well as "crooked back" (Queen Anne style with a rush bottom), "frame seat," and "parlor" (probably painted fancy) chairs. The Proud brothers also made Windsors, first recorded in their accounts on May 7, 1787, when they debited pewterers Samuel Hamlin and Gershom Jones for three Windsor chairs priced at 12s. each. Danforth purchased nine Windsors from the Prouds in 1789. Armchairs of any style were often simply called "Windsors." This is substantiated here since the Prouds' first sale of side, or "dining," chairs occurred only in 1789 at prices ranging from 7s. to 10s. apiece. Production of seating furniture was the shop's mainstay; from 1772 until the brothers closed the family accounts in 1833, the general output totaled around 2,900 items. In wood-bottomed seating, 18 Windsor chairs, 52 green chairs, and 118 dining chairs are specifically mentioned; many more Windsors were likely listed only as "chairs" in the records. Despite the Prouds' substantial production, their chairs are unidentified.[61]

Windsor production began to increase in Rhode Island, especially in Providence, just before the 1790s with the introduction of the round-back styles. The trade's growing importance is confirmed by the many surviving late eighteenth-century chairs. In 1791 the Providence Association of Mechanics and Manufacturers supplied Alexander Hamilton, secretary of the treasury, with information on the products manufactured in their district, reporting, "There is also large Quantities of Cabinet Work and Chair Work . . . made in this Town." One mark of contemporary production is a tapered foot with a full, rounded top that narrows to form a slim, cylindrical toe. The prototype occurs in the chunky foot of a high-back Windsor chair (fig. 6-20). The next design phase appears in a fan-back whose support taper "necks in" noticeably at the top (fig. 6-59). As a result, the ring turning above the taper overhangs the foot top, and the greatest swelling is just above the center point, creating a new leg style. A derivative design became popular in the Boston chair market in the 1790s. Another fan-back Windsor illustrates the final stage, in which chairmakers increased the taper's diameter to balance the full-bodied baluster above it (fig. **6-67**). This support is uncommon in the fan-back chair because it appeared in the market just as the bow-back Windsor superseded that style as the popular side, or dining, seat. The fan back lingered for some time, as demonstrated in a few examples with legs of slightly later pattern.[62]

The baluster profile used in Rhode Island with the fully developed tapered foot relates to New York work (figs. 5-12, 5-14, 5-16). Coastal trade resumed after the war and began to approach its earlier volume by the mid 1780s, especially in Providence. Sixteen percent of all clearances registered there in 1786 list a New York destination, while 12 percent represent trade with Connecticut ports. New York was also important in Newport's general commerce. While local ship captains carried Rhode Island products, including some furniture, to the metropolis, the flow of household goods was likely greater in the opposite direction, especially in inexpensive seating, such as Windsor chairs. Fragmentary shipping records show that in 1792 the sloop *Lively* brought twenty-four green chairs from New York to Newport. Merchant Christopher Champlin imported fourteen green chairs from the city the following year. Members of the coastal-trading Cahoone family made several trips a year to New York during this period.[63]

The Proud brothers' account book documents the manufacture of bow-back Windsors in Providence by August 1793, when an entry in a "Minnet of Edward Killy work" reads, "6 dining [chairs] with our Bows." Kelly had been a shop apprentice between 1786 and 1788; he returned in 1792 and for several years worked as a journeyman on a

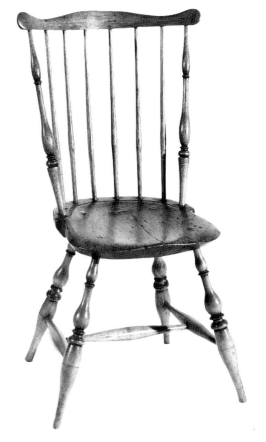

Fig. 6-67 Fan-back Windsor side chair, Rhode Island, 1790–95. (Photo, Jerome Blum.)

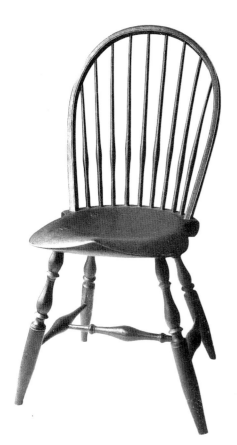

Fig. 6-68 Bow-back Windsor side chair, Rhode Island, ca. 1788–92. H. 38½", (seat) 18¾", W. (seat) 16½", D. (seat) 16½". (Private collection.)

Fig. 6-69 Bow-back Windsor side chairs (pair), Rhode Island, 1790–95. (Photo, Stephen Score, Inc.)

Fig. 6-70 Sack-back Windsor armchair, Rhode Island, 1790–95. H. 39⅛", (seat) 18¼", W. (arms) 23", (seat) 19⅞", D. (seat) 13¾". (Russell Ward Nadeau collection: Photo, Winterthur.)

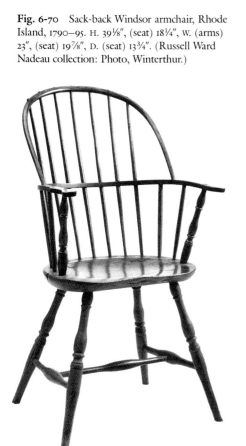

piecework basis. "Dining chairs" are first listed in the January 1789 Proud accounts, and nothing indicates that they were anything other than bow-back Windsors. New York City craftsmen introduced this pattern to domestic and foreign markets between 1785 and August 1788, possibly only months after Philadelphia chairmakers offered the new design to the public. The New York–Rhode Island commercial bond, which facilitated the communication of ideas, suggests that bow-back chairs were produced in Providence and Newport by 1789.⁶⁴

The first Rhode Island bow-back pattern, which is based on the New York straight-sided arch without a waist, is a simple design (fig. **6-68**). Two features are similar to the fan-back chair in figure 6-19: full spindles swell below the center point and form a line across the back; the scooped seat rises and dips, closely imitating the New York plank. The turnings encompass typical Rhode Island features: a short baluster with an enlarged head, a large spool, and a thin, disklike ring. The long, slim, tapered feet, which toe in at the bottom like those of the fan-back chair, are characteristic of Rhode Island work through the 1780s. Small medial stretcher knobs complete the pattern.

A pair of bow-back chairs indicates the next stage (fig. **6-69**). The bows introduce a slight tuck in the waist, and the spindles have lost their pronounced swell. Seat pommels are again high at the front, although less wood is shaved away at the corners; the resulting planks are somewhat blunt. Although worn, the stretchers are similar in form to those in figure 6-68; the legs reflect contemporary design. The slim, swelled-taper feet are generally comparable to those of the fan-back chair in figure 6-59; the balusters, although larger here, relate to those in the sack-back chair of figure 6-53.

Long, slim, tapered feet of the same profile occur in several types of chairs, including high-, fan-, and sack-back Windsors. Spool-and-ring turnings like those in figure 6-69 separate the foot of a sack-back armchair from an elongated baluster of blocked body (fig. **6-70**). The short posts of the upper structure repeat the profile to scale. The slim

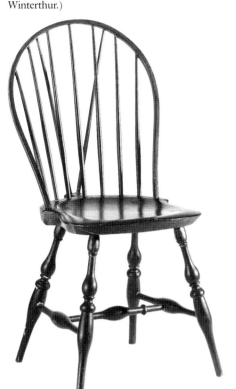

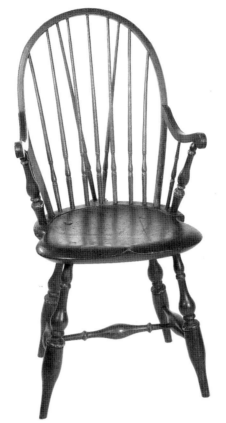

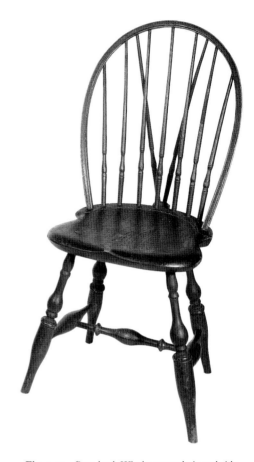

Fig. 6-71 Bow-back Windsor side chair, Rhode Island, 1790–95. White pine (seat, microanalysis) with maple and ash; H. 37″, (seat) 18″, W. (seat) 16″, D. (seat) 16⅝″. (Private collection: Photo, Winterthur.)

Fig. 6-72 Bow-back Windsor armchair and side chair (two of eight), Rhode Island, probably Providence, ca. 1792–1800. Pine (seats) with maple and other woods; left: H. 39″, W. 20″, D. 20¼″; right: H. 37½″, W. 16″, D. 16⅞″. (Museum of Fine Arts, Boston, anonymous gift and Helen and Alice Colburn Fund.)

stretchers with long, swelled centers and the moderately contoured oval seat were introduced shortly after the war (figs. 6-22, 6-20). The simple, curved arm pads, which form mittenlike terminals, reflect eastern Connecticut work. The slight backward cant and vertical emphasis of the spindle arrangement appears frequently in Rhode Island design. The distinctive, thin-tipped stick profile is considerably less common, although an exact duplicate occurs in figure 6-58.

Distinctive, full turnings link the mature Rhode Island bow-back chair in figure **6-71** with New York design (figs. 5-14, 5-16). The broad-back bows are also similar, although the slight nip at the waist may reflect Philadelphia influence. New York and Rhode Island bow faces are flat with shallow scratch beads defining the forward edges, and the spindles swell through more than a third of their length. Braced backs are relatively common in this type of chair. The Rhode Island Windsor lacks the typical New York droop at the seat front, although it retains the old Rhode Island flat-chamfered plank back. The balusters are full bodied, and the medial stretcher buttons are well defined. The full swells of the feet set this chair apart from New York, Philadelphia, and Connecticut production. Local chairmakers carried the support design to its ultimate expression by lengthening the toes. Despite these exceptional qualities, the chair received limited production and is far less common than bow-back styles with embellished spindles and shorter feet. Buttons on the medial stretcher became more common in this period; an occasional example has rounded, arrowlike tips (fig. 6-49).

The Rhode Island Windsor considered by many scholars and collectors to be the classic American bow-back was probably in the market by the early 1790s (fig. **6-72**). The influence of New York craftsmanship lingered, and elements from postwar Rhode Island chairmaking were consciously retained and modified to suit the overall scheme of the new pattern. Substantial changes occurred in the back and support structures. Chairmakers narrowed the bow loop and eliminated the waist. They often added

decorative spindles of a small baluster pattern suggested by fancy Windsors made in New York shops, such as that of the Ash brothers (fig. 5-17). Actually, the baluster-spindle design, as manifested first in postwar New York work, originated with the ornamental sticks on prewar Rhode Island cross-stretcher chairs (figs. 6-1, 6-2). The small bead below the baluster is occasionally repeated in the spindle tops. In some chairs, the projection behind the well-contoured, shield-shaped seat is about half its normal length of 2½ inches, resulting in a short, stubby brace. Below the seat, bulbous New York leg tops gave way to slim, occasionally shouldered, vases (figs. 6-59, 6-67). The full-bodied balusters are enhanced by rounded caps, which form a common eighteenth-century Rhode Island profile; the tapered feet are thicker and shorter. Few fan-back Windsors have this type of leg because the chair was passing out of fashion by the mid 1790s.[65]

Rhode Island chairmakers first introduced arms to the bow-back Windsor with the vase-spindle pattern (fig. 6-72). These arms, which tenon into the bow, form vertical scrolls defined by scratch beads on the top surface, continuing those of the bow face. When such arms were constructed of mahogany, they were stained and varnished to contrast with the chair's painted surfaces. The Rhode Island scroll arm, which differs from the Philadelphia one, may have originated in New York, since an early vase-spindle chair with similar arms bears the label of Thomas and William Ash. The brothers occupied the No. 17 John Street address printed on the identification between 1789 and 1794. Providence may have been the first Rhode Island production center of the New York vase-spindle design, a theory reinforced by ownership histories. The chairs in figure 6-72 are part of a set of two armchairs and six side chairs. The first owner, Samuel Scott, Jr., resided in Providence County, within or near the city; the last private owner was his direct descendant. A single armchair bears the brand "A G CASE" in two sizes of uppercase letters on the seat bottom. Long thought to be an unidentified maker's stamp, the name probably refers to a later owner. A listing for an Allen G. Case occurs in Providence census records between 1830 and 1850. An unusual chair of this pattern, an adult-sized highchair with arms, served in the 1830s as the organist's seat at the first Baptist Meeting House of Providence. The chair, whose seat was originally stuffed, may have earlier furnished a counting house.[66]

Some Rhode Island provincial chairs from the close of the eighteenth century are characterized by short, swelled-taper feet with pointed, pencil-slim toes. These fan-, sack-, or bow-back chairs include various elements drawn from the extensive vocabulary of Rhode Island design. One seating group is identified by a large ball or squat baluster turning above the short feet. Other characteristic features include moderate-length balusters, which are similar to those in figures 6-37 or 6-38; golf-tee-shaped elements at the bases of back posts; spool turnings with flared bottoms (fig. 6-49); and a spool-centered medial stretcher (fig. 6-60). The bow-back chairs form the most striking provincial group with their short, swelled, and pointed feet (fig. 6-73). A ring may separate the foot from the baluster, as illustrated, but in most chairs the transition is abrupt. The upper leg consists of two or three undivided swells and hollows. A slight swell may occur near the medial and side stretcher tips. The contoured, shield-shaped seat is thin, frequently less than two inches thick; as in the present chair, a slight hollow sometimes appears beneath the pommel at the center front. The legs pierce the top surface, and a groove surrounds the spindle platform, which usually supports six sticks. The bow angles sharply to form a waist, which is positioned anywhere from the lower center, as illustrated, to just above the seat. Most bows are channeled at the center; one flat bow face is beaded at either edge.[67]

The vase-spindle Windsor was in popular production for many years before it was modified (fig. 6-74). In the new design, the backs are straight sided, as illustrated, or pinched to form a waist. The number of long spindles increased from seven to nine. Bracing spindles reinforce most backs, and small beads positioned in the sticks above the arms, as in the present chair, are an occasional feature. Many seats are stuffed; some have flat-chamfered rear edges. The greatest change is in the turnings. The new, long balusters have short, thick necks; the spools are also longer, and sharp, projecting caps replace

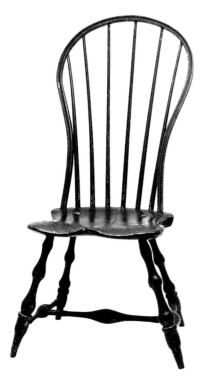

Fig. 6-73 Bow-back Windsor side chair, Rhode Island, 1800–1810. White pine (seat, micro-analysis); H. 38½", (seat) 15⅛", W. (seat) 15⅞", D. (seat) 15¾". (Private collection: Photo, Winterthur.)

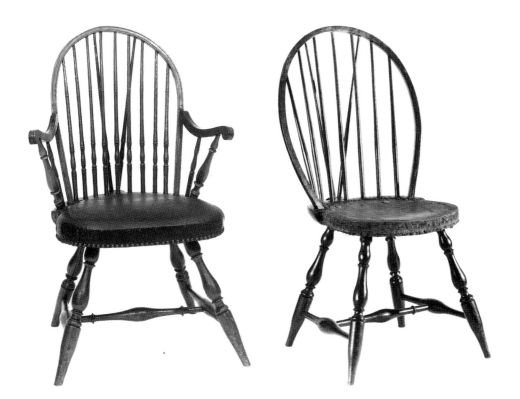

Fig. 6-74 Bow-back Windsor armchair with stuffed seat, Providence, R.I., ca. 1798–1808. Mahogany (arms); H. 38¾″ (seat) 16⅞″, (with stuffing) 18″; W. (seat) 20″; D. (seat, without extension) 19⅞″. (Mr. and Mrs. Joseph K. Ott collection.)

Fig. 6-75 Bow-back Windsor side chair with seat for stuffing, Rhode Island, probably Providence, 1795–1805. White pine (seat, microanalysis) with maple and ash; H. 36½″, (seat) 16¾″, W. (seat) 16″, D. (seat) 16¾″. (Private collection: Photo, Winterthur.)

rounded ones. The short, stocky feet are shaped in double tapers. Medial stretcher buttons repeat the sharp profile of the caps in the leg balusters and spools. Some chairs within this updated vase-spindle group exhibit features held over from previous designs or influenced by other patterns in the market.

Several of the updated Windsors are in Providence public collections, giving currency to the notion of a local origin. One other chair is said to have descended in the Sheldon family of neighboring Cranston. Definite proof of provenance and a suggested date range exist for the illustrated chair, which descended directly from Sullivan Dorr (born 1778), China trade merchant and city capitalist. In 1804 Dorr married Lydia Allen, and the young couple set up housekeeping on Orms Street. Within five years they began building a splendid mansion on Benefit Street; the chair was part of the furnishings of this house, which descended to the last family owner in the twentieth century.[68]

The support structure of the bow-back side chair in figure **6-75** is similar to that of figure 6-74. The leg is modified just below the seat by a shouldered baluster, an element already introduced to sack- and bow-back chairs (figs. 6-40, 6-72). The distinctive feature of the chair is the full, balloon-shaped bow that is accompanied by a back brace. Some chairs of this profile have long, slim, swelled feet similar to those of figure 6-71; however, rapid design evolution during the 1790s carried the pattern to its final stage before 1800. Many examples, like figure 6-75, have roughly finished seats made for stuffing. A few backs have vase-turned spindles, but plain sticks that are slightly swelled in the lower half are commonest. Like the bow in the present chair, others are thin and triangular in section rather than rectangular; the top and back surfaces complete a quarter round, and the scratch-beaded face and bottom surfaces are flat. The side chair prevails, since the thin bow is scarcely adequate to support arms; nevertheless, several armchairs exist in this pattern. A related chair with a different seat contour and abruptly pointed toes bears the owner's stamp "E. DYER," identifying a Providence family.[69]

In a rural area beyond Providence or Newport, a craftsman familiar with Windsor design constructed a chair with an unusual combination of elements (fig. **6-76**). Carefully incised beads mark the broad-faced bow and arm tops, but the bow arch is straight sided and the arms droop. The seat has a slight forward tilt. Hand-shaved spindles demonstrate the craftsman's skill with the spokeshave; their slim tips link them with other regional chairs (figs. 6-58, 6-70). Although the craftsman has demonstrated his

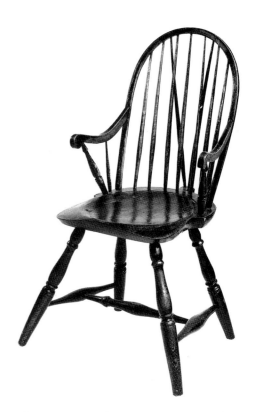

Fig. 6-76 Bow-back Windsor armchair, Rhode Island, 1800–1810. H. 39½″, (seat) 17¼″, W. (seat) 16⅞″, D. (seat, with extension) 21⅝″. (National Museum of American History, Smithsonian Institution, Washington, D.C.)

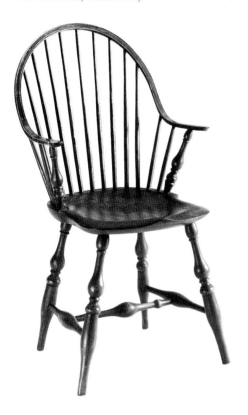

competence on the lathe, his turnings are unusual; the legs seem to show Connecticut influence. Large, golf-tee-shaped stretcher tips relate to 1780s post turnings (fig. 6-49). The tiny, pointed arm-post tips in this chair stem from prewar design (fig. 6-2). The bow, however, places the chair at the century's end or slightly later. Eclectic combinations of outdated and new features and a clumsy assembly technique are often rural trademarks.[70]

The classic Rhode Island continuous-bow armchair in figure **6-77** is contemporaneous with the first swelled-taper, bow-back Windsor side chair (fig. 6-71). Similar features in the two types of chairs indicate that they were sometimes used as companion pieces. The side chair has a braced back, an optional feature in the continuous-bow armchair. The present armchair features rounded, arrowlike medial stretcher tips that have a collar on the inner face, although about two-thirds of these continuous-bow armchairs have moderate to heavy rings, plain or detailed. A few related side chairs also have arrowlike tips. The plank rounds at the back, although some seats have a narrow chamfer at the bottom back edge. The gracefully curved bow terminates at the front in small, almost oval, pads similar to those used in New York sack-back and early continuous-bow designs (figs. 5-7, 5-11). The proportions of these Rhode Island chairs are comparable to the second continuous-bow pattern in the New York market (figure 5-12). When the forward scroll arm was introduced to the bow-back chair, a few continuous-bow Windsors were also constructed with that terminal. The round scroll ends visually draw the bow closer to its supports and create a compact design. A set of six Windsors with this feature may represent a unique, original group (fig. **6-78**). The ultimate expression of the pattern is seen in individual Windsors that appear to have been part of two distinct sets (fig. **6-79**). The spindle balusters are larger than comparable southern New England or New York turnings.

Construction of continuous-bow seating in the swelled-taper pattern likely centered in Providence during the 1790s. A contemporary foot variation is the straight-sided taper, which produced an armchair that is nearly indistinguishable from the New York Windsor that inspired it (figs. **6-80**, 5-12). Rhode Island baluster turnings have longer necks and squatter bodies, and the seats generally show more lift at the front corners. The arm pads are usually plain, and most backs are unbraced. Yellow poplar forms the seats of Windsors from New York and many from southern New England; a plank made of a wood other than yellow poplar, however, assures a New England provenance. Although yellow poplar was used for the seat of this chair, the lower back edge is chamfered in the Rhode Island manner, a characteristic that is absent from New York production.

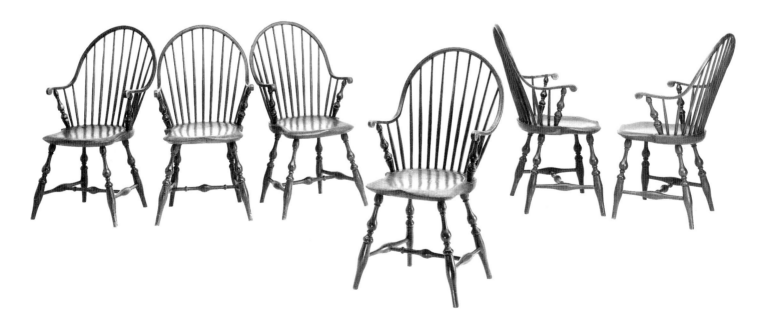

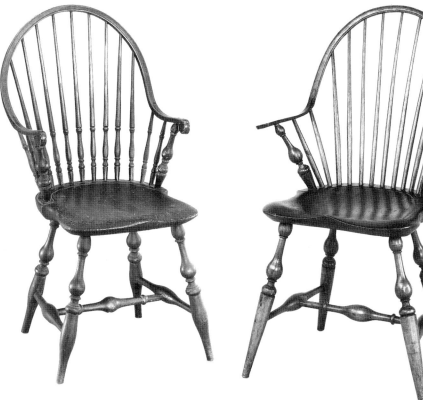

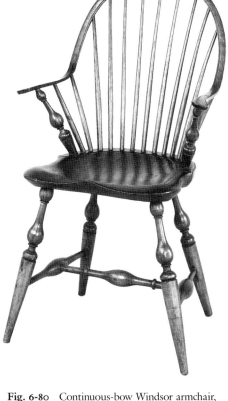

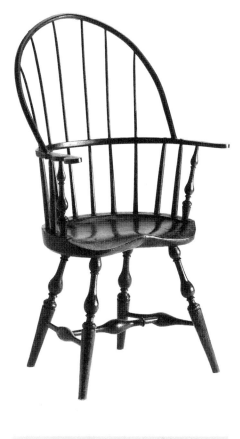

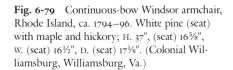

Fig. 6-79 Continuous-bow Windsor armchair, Rhode Island, ca. 1794–96. White pine (seat) with maple and hickory; H. 37″, (seat) 16⅝″, W. (seat) 16½″, D. (seat) 17⅛″. (Colonial Williamsburg, Williamsburg, Va.)

Fig. 6-80 Continuous-bow Windsor armchair, Rhode Island, 1790–1800. Yellow poplar (seat) with maple and ash (microanalysis); H. 36½″, (seat) 18¹⁄₁₆″, W. (seat) 17¾″, D. (seat) 16½″. (Yale University Art Gallery, New Haven, Conn., gift of C. Sanford Bull.)

Fig. 6-81 High sack-back Windsor armchair and detail of arm terminal, Rhode Island, 1790–1800. White pine (seat, microanalysis); H. 45¼″, (seat) 18½″, W. (arms) 25¼″, (seat) 21″, D. (seat) 15⅛″. (Private collection: Photo, Winterthur.)

Variants of the 1790s

As is characteristic of pre-1800 Rhode Island and New England chairmaking, many Windsors are of individual form, although elements in various designs interrelate. A direct link exists between a Rhode Island continuous-bow chair of New York pattern and an unusual sack-back chair (figs. 6-80, **6-81**). The undercarriages of both chairs are almost duplicates; arm-post turnings vary the same profile. The maker of the sack-back chair may have been a provincial turner, since the rest of the chair lacks similar unity. The oval pine plank combines several Rhode Island seat designs, with emphasis on deep, canted sides that are chamfered at the bottom, a vigorously contoured top surface, and a pronounced hollow under the pommel in the English manner (figs. 6-33, 1-15). The tall bow occurs in some Rhode Island sack-back work (fig. 6-37). Another distinctive feature of the chair is the unique sawed arm pattern in which the curves sweep backward, just as the seat rises and falls along the forward edge. The spindles, which thicken markedly as they enter the seat, are also unusual; some Boston chairs have similar but modified spindles.

Although a low, broad arch is atypical of the continuous-bow armchair and seldom occurs in New England work, the broad-seated Windsor in figure **6-82** seems safely placed in Rhode Island based upon a "history" and one turned feature. A 1925 catalogue indicates that the chair is marked "A. Thayer" and that the owner assigned it to Rhode Island. A craftsman with that name is unknown, and the name Thayer occurs in Rhode Island and Connecticut census records only once before 1820. The name may be that of a

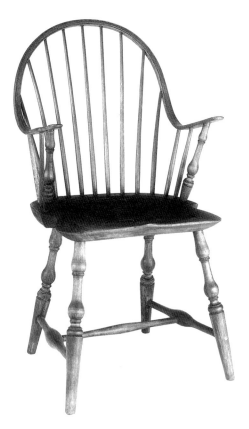

Fig. 6-82 Continuous-bow Windsor armchair, possibly by A. Thayer, Rhode Island, 1790–1800. (Former collection J. Stogdell Stokes.)

later owner. The turning with a Rhode Island association is the spool of the posts and the legs—a broad, compressed element with a narrow chamfer at the head and a flared, upturned base. A similar turning is present in several tall armchairs (figs. 6-49, 6-50); the tapered feet of all three show an almost imperceptible hollow from top to bottom. Baluster turnings of thick, straight neck and ball-shaped body are uncommon in Windsor-chair making, although other examples appear in the Connecticut–Rhode Island border region. Because the medial stretcher varies substantially in size and character from the other braces, it may be a replacement. Wide planks are generally oval rather than shield-shaped. An oval chestnut seat occurs in a privately owned continuous-bow chair of similar low, broad form with sharply angled arms and related turnings. The chair has a top extension and carved-knuckle arm terminals.[71]

Another continuous-bow chair has features that interrelate with elements found in 1780s Rhode Island Windsors, although it has a pointed arch that is slightly taller than average (fig. **6-83**). The saddled, shield-type seat is pierced by the legs; the platform is defined by a groove, and the lower part of the seat back is chamfered. The short arm-post balusters and the leg-baluster profiles are similar to those in other Rhode Island chairs (figs. 6-55, 6-37). The large swellings near the spindle bottoms are distinctive. Prototypes for the compressed spool turnings of the legs exist in early postwar work (fig. 6-20). A unique embellishment occurs in the arms, where the craftsman took an oxbow return, like that in figures 6-21 and 6-28, and reduced it to a short, narrow projection.

The legs of an extension-top, sack-back Windsor almost duplicate the supports in figure 6-83, with slight differences only in the spool-and-ring profiles (fig. **6-84**). Stretcher centers are full, like many other area chairs, and the arm posts are slender copies of the legs. The oval plank with its rounded edges and graceful, double-sweep front is also found in other Rhode Island work (figs. 6-34, 6-50). Slim, swelled spindles are commoner than both full-swelled spindles and plain sticks. The unusual crest may derive from an earlier pattern with a similar long, low arch and narrow ends terminating in projecting scrolls that "hint" of a top hook (fig. 6-31). A less exaggerated profile than that of the crest is the elongated, mittenlike arm terminal, which also appears in

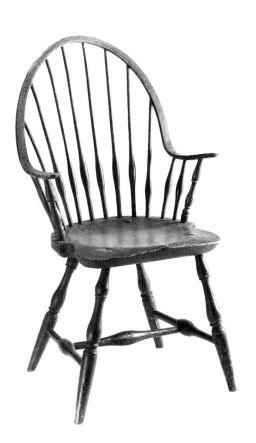

Fig. 6-83 Continuous-bow Windsor armchair and detail of arm terminal, Rhode Island, 1790–1800. White pine (seat) with maple, ash, and hickory (microanalysis); H. 37¾", (seat) 17⅛", W. (arms) 22", (seat) 17⅝", D. (seat) 17¾". (Winterthur 77.514.)

Fig. 6-84 Sack-back Windsor armchair with top extension and detail of arm terminal, Rhode Island, 1790–1800. Basswood (seat) with birch and ash (microanalysis); H. 44⅝", (seat) 17⁷⁄₁₆", W. (crest) 21", (arms) 23¾", (seat) 20⅛", D. (seat) 16". (Winterthur 54.74.6.)

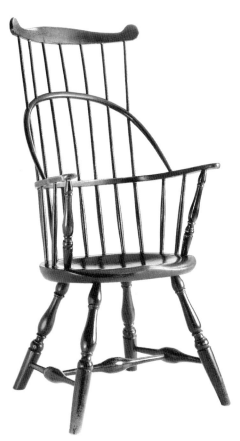

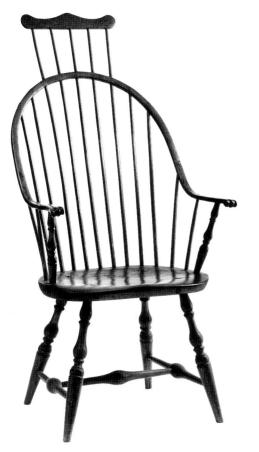

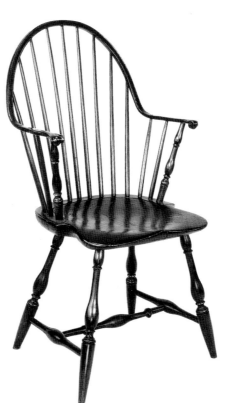

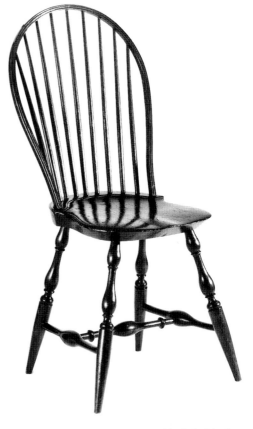

Fig. 6-85 Tall continuous-bow Windsor armchair with top extension, Rhode Island, 1790–1800. Pine (seat); H. 50⅛″, (seat) 17¼″, W. (crest) 14⅛″, (arms) 24½″, (seat) 21¾″, D. (seat) 14¾″. (The late I. M. Wiese collection: Photo, Winterthur.)

Fig. 6-86 Continuous-bow Windsor armchair, Rhode Island, 1790–1800. (Former collection J. Stogdell Stokes.)

Fig. 6-87 Bow-back Windsor side chair, Rhode Island, 1790–1800. White pine (seat) with maple (microanalysis) and other woods; H. 38½″, (seat) 17⅜″, W. (seat) 15⅜″, D. (seat) 16⅝″. (Private collection: Photo, Winterthur.)

Fig. 6-88 Continuous-bow Windsor armchair, Rhode Island, 1790–1800. (Former collection J. Stogdell Stokes.)

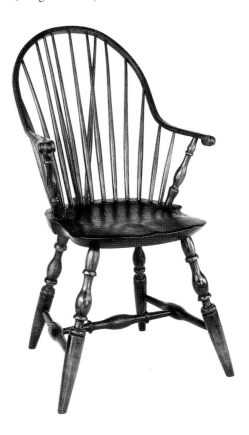

Windsors from New London County, Connecticut, and Boston. In overall size and form, figure 6-84 relates to another tall sack-back Windsor with typical Rhode Island characteristics: large, cut-scroll, crest terminals (fig. 6-24); heavy, blocked, bow ends (fig. 6-56); oxbow sidepieces in the arms; and flaring, tee-shaped, medial stretcher tips (fig. 6-76).[72]

Knuckle arms and a small, peaked crest extension supported on five spindles are present in an unusual, large continuous-bow chair, which represents a small group of related Rhode Island Windsors of variable knuckle profile (fig. **6-85**). The wide, oval plank is socketed with straight sticks that support a bow with a broad, tall arch. This Windsor shares several features with another large Rhode Island chair crowned by a double-ogee crest (fig. 6-50). The seat and the turnings have an unmistakable relationship; the knuckle-arm carvings are similar, although they vary in dimension.

Another continuous-bow chair with small, knuckle scrolls similar to those in figure 6-85 has turned features interrelated with those in the Rhode Island side chair of figure 6-62 (fig. **6-86**). The slim, shapely legs are comparable to the back posts of figure 6-62; the legs of the two chairs are also similar from the spools to the tapers. The latter elements are present in a side chair with a rare, patterned bow consisting of three narrow, parallel reeds (fig. **6-87**). The bow-back chair with its sharply canted seat edges is also unusual, since the pine plank is shaped with only shallow contours on the upper surface. At the center front is a distinctive, broad, bullet-shaped ridge.

Identical, but larger, planks appear in a small group of about four continuous-bow armchairs that may possibly come from the same shop. Only one has back braces (fig. **6-88**). The group has long, swelled spindles; the knuckle-scroll arms are similar to those

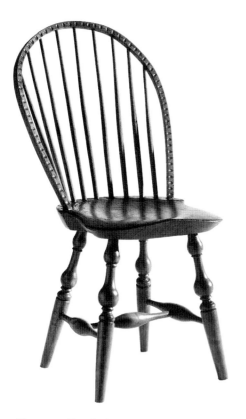

Fig. 6-89 Bow-back Windsor side chair (one of a pair), Rhode Island, 1795–1800. White pine (seat, microanalysis), maple, and other woods; H. 37½", (seat) 18¼", W. 16¼", D. 16⅞". (Mr. and Mrs. Harry M. Matthews collection: Photo, Winterthur.)

in figures 6-85 and 6-86. As in figure 6-88, three bow faces are flat with a scratch bead at each edge; the fourth appears to be reeded like the side chair in figure 6-87. Near the arm bases, oval-bodied balusters terminate in low, spoollike necks, as in figure 6-64; the base cone forms a swelled tee like that found in the medial stretcher tips of figure 6-76. The leg turnings constitute the distinctive feature of this group. The balusters reflect the sophisticated turnings of figure 6-40 in their full, oval bodies, thick, stalklike necks, and large, crowned caps repeated in the spool tops. The elements are slightly more exaggerated here, and the caps are raised on long necks. Plain feet focus visual attention on the upper legs.[73]

Distinctive features link other bow-back and continuous-bow chairs. Ornamental gougework, forming a continuous band of oval cuts around the flat-faced bow, is the primary focus of the side chair in figure **6-89**; the resulting interplay of light and shadow further heightens the decorative effect. Six known side chairs have related straight-sided arches, a pattern found in other Rhode Island work (figs. 6-68, 6-72). Armchair arches are round and broad, and the bows end in simple pads; the long back spindles swell in the lower half. The seat planks of these chairs are shield-shaped; armchair seats are slightly broader. Planks seem a little wider at the front than at the back due to a pronounced droop at the forward corners and a blunt, front-edge chamfer (fig. 6-67). Undercarriages share related forms; the boldest turnings are illustrated in figure 6-89. Variation occurs in baluster length and diameter, although the basic profile remains the same. The shape is comparable to the slim-necked, full-bodied baluster of the classic continuous-bow group represented in figure 6-77. The profile may derive from an early postwar prototype, such as figure 6-20, and ultimately from New York City chairwork. Figure 6-20 may also have provided a model for the compressed spool-and-ring turnings, although the same feature occurs in figures 6-82 and 6-83. The stretchers generally form an elongated, full swell; the medial braces of the armchairs also include small, turned caps. Some chair backs incline slightly and are occasionally supported by two bracing sticks that rise from a coffin-shaped rear extension.[74]

A unique rear bracing structure supports the arch of a bow-back side chair, which otherwise relates closely to the side chairs in the gouge-carved group (fig. **6-90**). The stretchers are similar; the legs vary only in their oval-bodied balusters; and the back

Fig. 6-90 Bow-back Windsor side chair and detail of brace, Rhode Island, 1795–1800. White pine (seat) with maple (microanalysis) and other woods; H. 36⅜", (seat) 16", W. (seat) 14¾", D. (seat, without extension) 16⅛". (Private collection: Photo, Winterthur.)

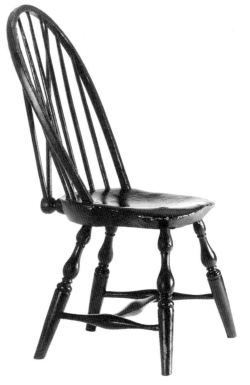

arches and inclines are comparable. The flat bow face has a scratch bead at each edge. Although the seat front is contoured like the plank in figure 6-89, the back edge is extremely thick. The 2⅝-inch depth accommodates a large, ball-shaped projection that supports two bracing sticks. Balancing the ball on the inner side of a spool, or neck, is a rounded base that sockets into the seat, probably with a large, cylindrical tenon reduced in diameter just inside the plank. The tenon was easily formed in the lathe when the chairmaker turned the main support.

A rare bow-back Windsor has flat arms tenoned through the bow, a design based on a formal-chair pattern (fig. **6-91**). A related but simpler arm type is found in figure 6-23. Bulging balusters of angular profile are present above and below the seat; their large caps represent a Rhode Island feature. The shield-shaped pine plank is extraordinarily long and produces a large, sloping, front overhang. Flat beads edge a bow with a modified balloon arch. A related chair with greater leg splay was exhibited anonymously in the Girl Scouts Loan Exhibition of 1929. Comparison of the Rhode Island chair with a similar New York armchair reveals their common bond but also pinpoints several design differences (fig. 5-19). Notable are the stick placement, the larger balusters and spools in the Rhode Island chair, and the introduction of a chamfer around the arm pads of the New York chair.[75]

A documented, bamboo-turned, fan-back chair takes the history of Rhode Island Windsor-chair making into the nineteenth century (fig. **6-92**). The chair is one of a pair branded by George Gavit, Jr., whose birth date is recorded in Westerly as April 16, 1773. On his twenty-first birthday in 1794, Gavit was made a town freeman, and he married the following year. A 1795 town deed referring to Gavit as a cabinetmaker confirms his identity as a woodworker. The craftsman plied this trade most of his life, as indicated in his will, which was probated in 1855: "I give and bequeath to my three sons . . . all my joiners and Carpenters tools, to be equally divided between them asserting to quality and value." The woodworking implements, along with farming tools, are also mentioned in Gavit's inventory of the same year.[76]

Gavit's chair exhibits several important features. The hook-end crest, although modified slightly, has survived into the new century (figs. 6-27, 6-31). This appearance confirms the legitimacy of its earlier influence on neighboring New London County, Connecticut, craftsmen, especially members of the Tracy family. The rounded back and squared front of the seat provide another link with Tracy work. Stephen Tracy used a similar plank in his single-bow, square-back, bamboo-style chairs made between 1800 and 1810 (fig. 7-5). He also combined four-part bamboo back posts with three-section bamboo legs and H-plan stretchers. The bamboowork of the two men varies, since Tracy introduced slim midsections to his early supports. Gavit's turned work may typify Rhode Island post-baluster design in the southern part of the state, but without other documented examples this theory remains unconfirmed.

CONNECTICUT

Introduction

Connecticut was a "country . . . covered with villages." As Thomas Anburey traveled across the state during the Revolution, he commented, "Most of the places you pass through . . . are not regular towns as in England, but a number of houses dispersed over a large tract of ground. . . . About the centre of these townships stands the meeting-house . . . with a few surrounding houses; sometimes the church stands singly." Despite the scattered settlement pattern, habitations and buildings were sufficiently close that Brissot de Warville noted that "Connecticut appears like one continued town." Houses were timber framed, "weather boarded and roofed with shingles." Generally, they rose two stories with an attic and cellar. White and stone color prevailed, with green for doors and shutters.[77]

Unlike Rhode Island and Massachusetts, Connecticut had no one preeminent city immediately following the Revolution. In fact, it had no cities at all until the state

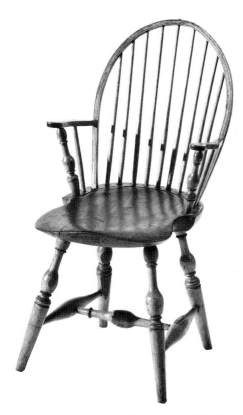

Fig. 6-91 Bow-back Windsor armchair, Rhode Island, 1790–1800. Yellow poplar (seat) with maple and other woods; H. 35⅝", (seat) 16¾", W. (arms) 19⅜", (seat) 16½", D. (seat) 19¼". (New Haven Colony Historical Society, New Haven, Conn.: Photo, Winterthur.)

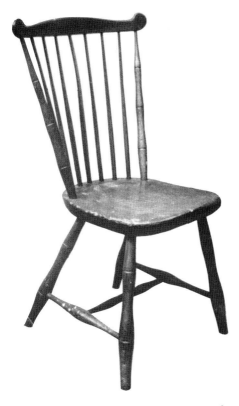

Fig. 6-92 Fan-back Windsor side chair (one of a pair), George Gavit, Jr. (form of brand unknown), Westerly, R.I., 1800–1810. (Photo, Winterthur.)

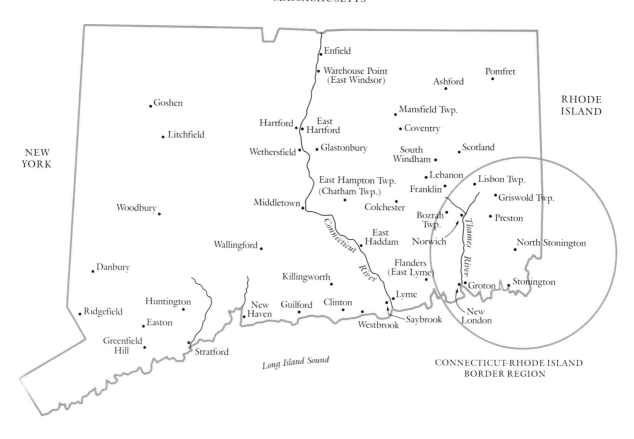

MASSACHUSETTS

NEW
YORK

RHODE
ISLAND

Enfield

Warehouse Point
(East Windsor)

Pomfret

Ashford

Goshen

Mansfield Twp.

Hartford · East
Hartford

Coventry

Litchfield

Wethersfield ·

Glastonbury

South
Windham

Scotland

Lebanon

Lisbon Twp.

East Hampton Twp.
(Chatham Twp.)

Franklin

Griswold Twp.

Middletown

Colchester

Woodbury

Bozrah
Twp.

Preston

East
Haddam

Norwich

North Stonington

Wallingford

Flanders
(East Lyme)

Danbury

Killingworth

Lyme

Groton

Stonington

Huntington

New
Haven

Guilford

Clinton

New
London

Ridgefield

Westbrook

Saybrook

Easton

Greenfield
Hill

Stratford

Long Island Sound

CONNECTICUT-RHODE ISLAND
BORDER REGION

Connecticut River

Thames River

1 inch = 17.5 miles

assembly incorporated the communities of New Haven, New London, Hartford, Middletown, and Norwich in 1784. By then the total population stood above 200,000, most of it concentrated along the coast and up the several small rivers that penetrated the interior. Because of its long coastline and many small harbors and inlets, Connecticut had an economy oriented principally toward waterborne commerce, mainly coastal, in which Rhode Island was prominent. Distant markets included the West Indies and, later, the northern coast of South America. New Haven, New London, and Norwich were the principal postwar centers, but Hartford rose to prominence by the 1790s. The mainstays of commerce were provisions, livestock, and lumber. European goods were obtained in the West Indies or through trade with Boston and New York. Shipbuilding was an important adjunct.[78]

Unlike the situation in Rhode Island, sound money practices prevailed in Connecticut following the war. On January 9, 1788, a special convention ratified the Constitution, and Connecticut became the fifth state to join the new republic. Aside from rising commerce, "other proofs of the prosperity of Connecticut," observed Brissot de Warville, were "the number of new houses everywhere to be seen, and the number of rural manufactories arising on every side." Banking was well established by the end of the century. The development of turnpikes, or toll roads, was a first step in improved accessibility. Despite the state's small size, the population continued to increase rapidly, and land for occupation and cultivation became increasingly scarce. Substantial migration began following the Revolution—to the Berkshires and Vermont, to New York state, and, eventually, to the Western Reserve of Ohio and beyond.[79]

Before the Revolution Windsor furniture from Philadelphia, Rhode Island, and New York was marketed in limited quantity along the New England coast. Since Connecticut lacked a large seaport, its closest commercial ties were with Rhode Island

and New York through the coasting trade, although at New Haven the mixed influences of Rhode Island, New York, *and* Philadelphia may have directed early local Windsor production. Roger Sherman's portrait by Ralph Earl (fig. 3-15) pictures the statesman seated in a low-back Philadelphia Windsor of prerevolutionary style. Sherman was in Philadelphia in the mid 1770s as a Connecticut delegate to the Continental Congress where he signed the Declaration of Independence; he likely purchased the chair at that time. A 1773 notice of David Burbank, cabinetmaker and chairmaker of New Haven, makes no mention of Windsor construction in soliciting patronage, nor does Abishai Bushnell's Norwich advertisement of the following year. The picture had changed by 1779 when Felix Huntington, a leading cabinetmaker of the same town, charged Colonel Joshua Huntington £13.1.0 to make "2 Dozn Windsor Chairs." The individual price of 10*s*.10½*d*. identifies the armchair. Huntington's other commissions for the colonel measure the range of his skill: "a Case Draws Chist upon Chist," "8 open Back Chairs" with upholstered seats, and "2 Large Square Mehogeny [Tables]."[80]

The Tracy Family of Craftsmen

Felix Huntington's construction of Windsor furniture for Norwich customers in the late 1770s probably stimulated development of a Windsor-seating industry in the area. The most prominent figure associated with the regional trade is Ebenezer Tracy (fig. **6-93**). He, with members of his family and other craftsmen, was responsible for the manufacture of thousands of Windsor chairs for domestic and foreign markets within a period of several decades. Surprisingly, in view of the large number of documented and attributable Tracy chairs in existence, there was for a long time little published information on the life, training, and career of this artisan. Ebenezer was the son of Andrew Tracy and a direct descendant of Lieutenant Thomas Tracy of England who settled in Norwich in 1659–60. The chairmaker was born on April 20, 1744, at Norwich and died in March 1803 at Lisbon (near Jewett City) in the fifty-ninth year of his life. Tracy married three times, and of those unions nine children were born. All three Tracy sons, Elijah, Ebenezer, Jr., and Frederick, pursued careers in the furniture trades until their relatively early deaths at ages ranging from twenty-nine to forty-two. Two Tracy daughters married furniture craftsmen. Lydia became the wife of Amos Denison Allen a little more than a year after he had completed an apprenticeship with her father. Rebecca married her first cousin Stephen Tracy the year following Ebenezer's death; Stephen continued the cabinet- and chairmaking business in the Tracy shop for several years longer.[81]

Only the barest details of Ebenezer Tracy's life have come to light. The craftsman purchased twenty-five acres of land in Newent (Lisbon Township) north of Norwich between the Shetucket and Quinebaug rivers in 1769 at age twenty-five, several years after his first marriage. Presumably, he was a journeyman working for another master craftsman; church records give his residence as Norwich. With the acquisition of land Tracy was in a position to establish a homestead by erecting a house, barn, shop, and other buildings. One local historian credits Tracy with building the Second Church in Lisbon about 1773, an indication of his skill at house joinery as well as furniture making. The Tracy house (fig. **6-94**), which still stands although on a new site, is a five-bay rectangular structure, finished in clapboards. The main entrance (fig. **6-95**) with its raised-panel, double doors is surmounted by a simple arched pediment typical of contemporary regional architecture. The same profile appears in the "bonnets" of tall case pieces and the tops of Chippendale and Windsor chairs.[82]

Lisbon town records refer to Ebenezer Tracy as "Captain" in February 1787, just before his official appointment to that rank in the Fourth Company of Militia of the Twentieth Regiment. Tracy had achieved the rank of ensign in 1778 and lieutenant in 1783, but there is no indication that he saw active duty during the Revolution. Norwich was free of British incursions during the war, although New London, located downriver at the mouth of the Thames, suffered several attacks. After the war Tracy experienced a minor setback when lightning ignited his barn and burned it to the ground. Subsistence farming was integral to the lives of most nonmetropolitan craftsmen until well into the

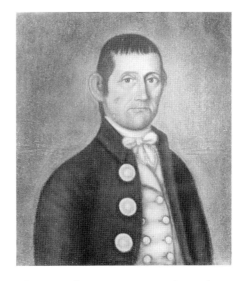

Fig. 6-93 *Ebenezer Tracy*, eastern Connecticut, ca. 1787–95. Pastel on paper; H. 20″, W. 18″. (Private collection.)

Fig. 6-94 Ebenezer Tracy house, Lisbon Township, New London County, Conn. (now re-located), ca. 1769–72. (Photo, Winterthur.)

Fig. 6-95 Doorway from Ebenezer Tracy house. (Photo, Winterthur.)

nineteenth century. Before the elder Tracy children were grown enough to help with the farming, Ebenezer probably spent as much time working on the land as at his trade. Less than a year after Lisbon's formal incorporation as a town(ship) in 1786, "Capt" Tracy supplied "a wrighting Desk" for the town at a cost of £1.4.0. In 1790 the woodworker took Amos Denison Allen as his first and only apprentice *of record,* though undoubtedly there were others, as indicated by the census records. In 1790 six females resided in the Tracy household—Ebenezer's five daughters and, apparently, his second wife, Thankful Ayers, who would become the mother of his youngest son, Frederick (b. 1792). The lone male inhabitant under the age of sixteen was Tracy's second son, Ebenezer, Jr. (b. 1780). Of the four older males in the household, one was the head of the family and another the apprentice, Amos Denison Allen. Tracy's eldest son, Elijah, who was already twenty-four, was no longer living at home. The remaining two adult males probably were other apprentices, journeymen, farm hands, and/or relatives. The first two possibilities seem the most plausible, especially in light of the large body of Tracy-style chairs still in existence.[83]

The nine males who lived in the Tracy home in 1800 ranged in age from young son Frederick "under 10 years" to the master himself "over 45" and now a lieutenant colonel in the militia. In between were two "boys," apprentices no doubt, aged ten to sixteen years, and five young men aged sixteen to twenty-six, of whom Ebenezer, Jr., at twenty years was one. Eighteen-year-old Stephen Tracy, young Ebenezer's first cousin, probably was another. The remaining three youths or men under the Tracy roof probably served as boarding journeymen or apprentices.[84]

Amos Denison Allen remained in the Tracy household for something more than five years, long enough to become a competent craftsman like his master and to form a strong bond with Tracy's fourth daughter, Lydia, his future wife. Following expiration of the apprenticeship at his twenty-first birthday on March 13, 1795, Allen may have remained with Tracy as a journeyman for a short period. Upon reaching his majority, the young man apparently came into a share of his deceased father's estate at South Windham; and about that time he was one of the heirs of his deceased brother, Oliver, who may have occupied the family homestead. Through purchase and lease Amos Denison Allen augmented his landholdings. The craftsman was later described as "a respected citizen of the town, living on the old homestead." The first evidence of Allen's independent woodworking activity dates to July and August 1796 at the time of his marriage to Lydia Tracy. Accounts of his uncle and former guardian Elijah Babcock (also Badcock), a resident of neighboring Lebanon, itemize Allen's purchases of over 1,000 feet of slitwork. By October Allen had bought several hundred feet of 2-inch plank, probably for chair seats; the following January he acquired a short piece of plank for a workbench. The addition of another working surface indicates that even then Allen had plans to expand, and the 1800 census confirms such a move. In addition to his two infant sons and a young woman in the household to assist his wife, Allen housed a lad of less than sixteen years along with three young men between the ages of sixteen and twenty-six. These could only have been apprentices and/or journeymen. Miraculously, one of the first record books kept by the young woodworker between September 1796 and January 1803 survives. This volume and a few accounts of 1797 for Ebenezer Tracy in the records of Ebenezer Devotion, probably Judge Devotion of Scotland, Connecticut, chronicle the activity of the two men at this crucial period of regional stylistic development. The records show that *all* the Windsor patterns associated with these craftsmen were being manufactured simultaneously.[85]

A few words of explanation regarding the actual chairmaking members of the group are appropriate. Heretofore, four Tracy men have been associated with the chairmaking trade—Ebenezer, Sr., his son Ebenezer, Jr., his nephew Stephen, and his son-in-law Amos Denison Allen. A fifth name also belongs on the list, that of Elijah, Ebenezer's eldest son. It was he who used the "E. TRACY" brand, a mark almost as common as his father's familiar "EB: TRACY" stamp. After the patriarch's death in 1803 his iron also was used briefly by Ebenezer, Jr.[86]

Analysis of Tracy records and the study of approximately 150 marked examples of family work indicate that it was stylistically impossible for Ebenezer, Jr., to have been the owner of the "E. TRACY" brand, as surmised in recent years. Ebenezer, Jr., did not reach his majority until 1801, only two years before his father's death. By that time the bamboo-turned support dominated in Tracy work and the sack-back chair, a type that bears the "E. TRACY" brand, was passing out of fashion. Reinforcing this hypothesis are A. D. Allen's accounts, which suggest that after 1798 armchair production centered in the continuous-bow Windsor.

As noted, Elijah Tracy was already twenty-four years old in 1790. The census of that year lists him, his father, and his grandfather, Andrew, as heads of households in New London County. The enumeration included Elijah's wife, one or two young children, and a male resident sixteen years or older. Elijah's name also occurs in town records for 1794. Further insight into the family business can be gained from Ebenezer Tracy's probated estate. Appraisers listed three items of real property in the inventory. One was the "Home Farm 165 Acres with the Buildings & apurtainencas" valued at $4,290. Another was the "Elijah Tracy lott & barn 16 Acres," indicating that Elijah was a tenant on his father's land. As stated in Ebenezer's will, his son had already received £200. With this money Elijah probably erected a house and shop, acquired specialized equipment, and set up an auxiliary business. Ebenezer's generosity to his family is further revealed in the accounts of clockmaker and metalworker John Avery, Jr., of neighboring Preston. On May 14, 1792, Avery debited the "Captain" for "makeing a turning Lathe for Elijah," a purchase that probably represented only the metal parts of the machine. Apparently, production had expanded to the point where a second lathe was essential. Ebenezer also purchased "a turning Lathe for Mr Allen" in August 1799, three years after the young man had commenced business. Between November 1799 and November 1800 Elijah Tracy purchased four more lathes, or new metalwork for his equipment, from Avery on his own account.[87]

The similarity of the elder and younger Tracys' work can be explained by their close business connection and near location and the probability that Elijah trained with his father. There is every reason to believe that they vended much of their work together, as well. From a production survey it is possible to determine that of the four Tracy chair styles constructed with baluster-turned members, Elijah also produced at least three of the same patterns with bamboo-type supports. Ebenezer, the father, seems to have made only the continuous-bow armchair and possibly the bow-back side chair with bamboo turnings.

Ebenezer, Jr., the second son, likely worked as a journeyman in his father's shop after completing his apprenticeship in 1801. He never married. Young cousin Stephen Tracy was only just finishing his training when his uncle died in March 1803. The death of Ebenezer, Sr., greatly altered the status quo, since he had been the dominant force in the family enterprise. Aside from Amos Denison Allen, who was independently pursuing his own successful career in South Windham by 1803, Stephen Tracy emerged as the prime mover of the Lisbon clan. On July 6, within three months of his uncle's death, Stephen advertised in the *Norwich Courier:* "The Cabinet and Chair making business is still carried on at the shop of the late Col. EBENEZER TRACY, in Lisbon." For a twenty-one-year-old this was a big step. The young entrepreneur probably rented or leased the woodworking shop from his uncle's estate. No doubt he paid board to continue to live in the Tracy household, whose residents included Annavery, Ebenezer's third wife, and the unmarried children Ebenezer, Jr., Frederick (age eleven), Mary, and Rebecca.[88]

Evidence indicates that Ebenezer, Jr., continued to work in the family shop for some years longer. The first order of business at his father's death was to vend for the estate the "103 Chairs of Different sorts" that stood ready for sale in the shop or storage areas. Young Ebenezer probably helped to convert the stock of "6400 Chair rounds & legs" and "277 Chair bottoms" into saleable merchandise. Stephen would have participated in the work as well, although the bulk of this production probably is unmarked. It was in this period that Ebenezer, Jr., probably altered his father's branding iron for his own use.

The young man removed the lower dot following the two letters of the given name so that the brand read "E B·T R A C Y." The change is subtle, but distinct impressions occur on a small group of late, marked Windsors, comprising all four patterns produced by the family (fig. 6-105, detail). In comparing strikes made before and after the alteration the same characteristics and inconsistencies of letters within the name are evident. Furthermore, damage sustained by the iron during the 1790s with the loss of the right arm of the letter "Y" appears in the altered stamp.[89]

Stephen Tracy married his first cousin Rebecca on May 7, 1804. Later that year he felt sufficiently secure and confident in his new woodworking career to advertise for an apprentice. The newlyweds probably were living in other quarters by this time, possibly the house vacated by cousin Elijah. The first division of Ebenezer Tracy's estate took place in April 1805. Ebenezer, Jr., acquired real estate and miscellaneous household items. Daughter Rebecca received as part of her allotment "shop tools, brushes, paint pots," and sundries valued at about $140. Her share of the real estate is significant. Located on the west side of the "Turnpike road," the land contained "about 11 acres" with "a cabinet shop, weaving house, corn house, & shed standing thereon." Thus, Stephen was now both master and owner of his shop. Simultaneously, he acquired an additional thirty-two and a half acres of Tracy land through the purchase of distributions held by Sarah, Lydia, and Zipporah Tracy in common with their respective husbands (Elisha Burnham, A. D. Allen, and Caleb Bishop) for the sum of $469. Where Stephen obtained all or part of the money to make this purchase is explained with the death of Annavery Tracy, Ebenezer's widow, in 1808. She held four notes at interest against loans made to Stephen, then totaling about $191. Meanwhile, following distribution of the elder Ebenezer's estate, young Ebenezer Tracy, Jr., probably became a journeyman to his cousin Stephen. As a bachelor he continued to live in the family home with young Frederick and sister Mary.[90]

Elijah Tracy took a different path. Sometime after obtaining a letter of dismissal from the church in Newent on October 15, 1801, he went off with his family to "Clinton, town of Paris," in New York state to pursue a similar or new career. Presumably, he disposed of his house and outbuildings in Lisbon before leaving Connecticut. He died in Paris, near Utica, Oneida County, before February 1, 1807, when the *Norwich Courier* reported his death at age forty. Elijah's removal from Connecticut and the death of his father left Stephen and Ebenezer, Jr., to carry on the family chairmaking business in Lisbon, probably with the help of several apprentices. However, before the end of the decade pending hostilities with Great Britain, French depredations on the high seas, and Jefferson's Embargo Act combined to cause a business depression that engulfed the nation. As early as 1807 Stephen Tracy purchased thirty-five acres of land at Plainfield, New Hampshire. His father, Andrew, Jr., had located on an adjacent property within the town of Cornish many years earlier. Stephen made no further move until December 1810, when he and Rebecca sold their entire interest in the Tracy estate to Joel Hyde, a cabinetmaker of Preston. By May 1811 they had obtained a letter of dismissal and recommendation from the Newent Congregational Church and removed to Plainfield, New Hampshire. Rebecca died in 1816, and Stephen married twice again. In the 1830s he established his last permanent residence in the family homestead at Cornish.[91]

The removal of Stephen and Rebecca to New Hampshire directly affected the life of Ebenezer Tracy, Jr. No longer was there a family chair shop in Lisbon where he could earn a modest living; nor, apparently, was he capable of becoming his own "master." Ebenezer, Sr., hinted at the situation in his will when he wrote, "It is also my Will that my son Ebenezer Tracy should have the same privilege of my House for a home during his life which his two sisters have [Rebecca and Mary, then unmarried] . . . unless he should be provided for other ways." A single, inconspicuous entry in the 1811 accounting of Elijah Tracy's estate tells more of the story. Samuel Barstow, administrator, paid a debt of $271.41 to Freeman Tracy, described as "Conservator to Ebnr Tracy, Jr." A conservator is a guardian, usually appointed by a court to manage the business affairs of legally unqualified individuals, such as minors and mental incompetents. On January 1, 1811,

Ebenezer sold his share of the family land and his right in the dwelling house to Joel Hyde. Fortunately, the young man had somewhere to turn; brother-in-law Amos Denison Allen was prospering in South Windham. Tracy needed only to pack his clothes and chairmaking tools and head for the familiar surroundings of sister Lydia's home. Ebenezer probably was one of the three men and five boys listed as working in the shop in the 1820 manufacturing census. Allen reported the value of his chair and cabinet production as almost $2,300 annually but noted that the depressed times had diminished his business by more than one-third during the previous two years. Ebenezer Tracy, Jr., died on June 19, 1822, at age forty-two. Although the probate inventory of his modest personal estate, which included a note on Allen for $353, bears the heading "Late of Lisbon," the *Hartford Courant* reported that Tracy died at Windham; he is buried in the Windham Center cemetery. Joel Hyde was one of the estate appraisers. Tracy's complete collection of chairmaking tools describes a man who was a capable, practicing chairmaker. He owned no furniture or real estate, indicating that he either rented a furnished room or lived within the Allen family.[92]

Windsor furniture produced by the Tracy family is distinctive, although what emerged as the elder Ebenezer's personal style is a composite of many outside influences. Just when Tracy turned to Windsor-chair making is unknown. He had been in the business for some years before he took Amos Denison Allen as an apprentice in 1790 and before his elder son, Elijah, reached his majority in 1787. As stated, Felix Huntington, cabinetmaker and chairmaker of Norwich, produced Windsor seating in 1779, possibly in a prewar Rhode Island style but more likely under the strong influence of English design (fig. 6-97). Tracy probably was moving into Windsor construction by 1784, the year his barn burned. Elijah was already eighteen years old; four years later the young man married and within another two years he was operating his own shop. Rush-bottomed slat- and fiddle-back chairs probably represent Ebenezer's earliest low-priced seating, and he likely continued to produce these styles after he turned to Windsor-chair making. At his death armchairs of all three types were in the household along with eleven "old" chairs and six fiddle-back side chairs.[93]

Positive evidence of Tracy's establishment in the Windsor business during the 1780s is found in the accounts of two Norwich residents. The craftsman purchased white lead and sugar from merchant Andrew Huntington in December 1787. The following March he covered his debt by providing Huntington with "a Green Armd Chair" valued at 12*s*. Although six years passed before Tracy made ten "Green Chairs stuff Bottoms" priced at 13*s*. each for Huntington, the reference to green *stuffed* chairs lends credence to identifying the earlier green chair as a Windsor. Another significant reference involves an exchange of products between Tracy and the clockmaker-silversmith Nathanial Shipman, Jr. To pay for an eight-day movement Tracy supplied Shipman with two sets of green chairs, one delivered in May 1787 and the other in July. The substantial cost for painted seating identifies the chairs as either high-backs, Tracy's earliest pattern, or sack-backs; their purchase in sets suggests the latter. As expected, Tracy's earliest design reflects Rhode Island work. The candidate, although unmarked, is a high-back chair of sawed-rail construction from an old Norwich estate (fig. **6-96**). Use of rabbeted, horizontally scrolled arms and an oval seat follows postwar Rhode Island practice (fig. 6-20). Swelled spindles and tipped stretchers also are features that have similar prototypes. The hollowed seat pommel and flared balusters provided models for the master's sack-back work, as well. Although the crest is inordinately thick, a similar top piece occurs on a tall writing-arm chair. The shape is also correct in view of its use on another chair ascribed to Tracy (fig. 6-100) and the influence of English Windsor design on early local production (fig. 6-97).

Probably, it was Tracy's close connection with Norwich, a flourishing little seaport involved in the coastwise and foreign trade, that was responsible for stimulating his interest in the Windsor chair as a rising commodity. Toward the end of the 1780s Felix Huntington shipped three dozen green Windsors and six writing chairs on the brig *Polly* bound for British Guiana. The size of the shipment suggests the venture was not

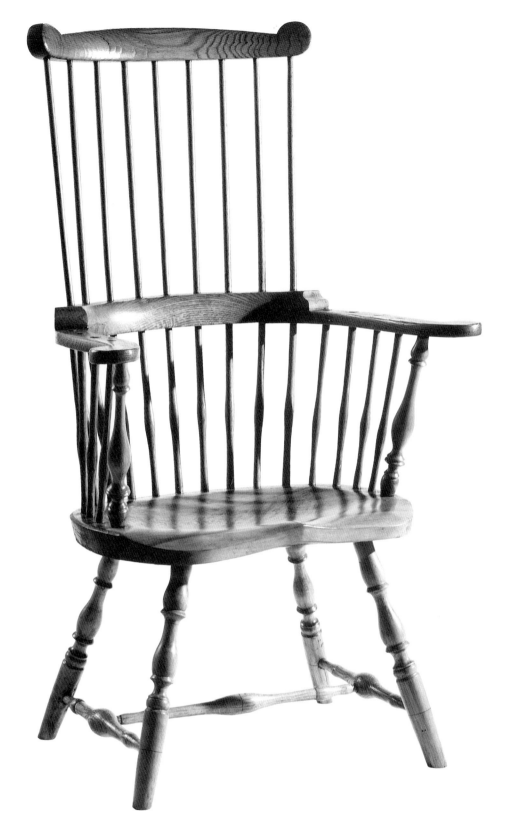

Fig. 6-96 High-back Windsor armchair, attributed to Ebenezer Tracy, Lisbon Township, New London County, Conn., ca. 1784–90. Yellow poplar (seat) with maple, ash, and oak; H. 45¼″, (seat) 15¾″, W. (crest) 21¾″, (arms) 27⅛″, (seat) 22″, D. (seat) 16⅝″. (Slater Memorial Museum, Norwich Free Academy, Norwich, Conn.: Photo, Winterthur.)

Huntington's first. His success and possibly that of others undoubtedly had encouraged Tracy to enter the market himself during the mid 1780s. Shipping was particularly brisk in the Thames at New London and Norwich, and by that time the Windsor was in general local use, although older seating lingered on. Silversmith Gurdon Tracy owned "6 Green Chairs" in 1792 supplemented by "1 Great Chair" and "6 other Chairs," probably mixed types of varying ages. The household of Ezra Dodge, also a silversmith of New London, had six fan-back Windsors at his death in 1799 complemented by framed, fiddle-back, and armchairs, whose age is reflected in their low evaluations.[94]

Following the revolutionary war, chairmakers in Philadelphia, New York, and Rhode Island quickly revived the production of Windsor seating. With some exceptions Philadelphia work exerted only minor direct influence on Connecticut craftsmen, but the seating of Rhode Island and New York had a profound impact on local design. Chairmakers borrowed or adapted elements to suit their needs. Ebenezer Tracy's work is a good example of the combined influence of outside stimuli and the creative imagination of a capable craftsman. Nor was American seating the only influence that shaped the Tracy style. The English Windsor, a strong force in prerevolutionary Rhode Island design, appears to have had considerable impact on Connecticut work about the time of the war (fig. 1-23). The American chair of figure **6-97**, one of a pair which is a copy of the English pattern, was, according to tradition, owned by Samuel Huntington of Norwich, governor between 1786 and his death in 1796. Two sets of painted green chairs are listed in Huntington's inventory, one set further described as "High top'd green Chairs." The governor was first cousin to Eunice Huntington, wife of Judge Ebenezer Devotion, one of Tracy's known customers, and his wife, Martha, was the judge's sister. A pair of identical chairs descended from William Floyd, a gentleman-farmer and public office holder of Mastic, Long Island. Chances are there were other chairs on Long Island, since the short distance across the Sound encouraged frequent contact between islanders and Connecticut residents. During the British occupation of New York in the revolutionary war, thousands of Long Islanders fled to Connecticut, Floyd included.[95]

Similar Windsors may have furnished other Norwich-area households during the 1780s, including those of patrons and business associates of Ebenezer Tracy. Indeed, Tracy himself could have owned or made such a chair, since his high-back Windsor, which is clearly inspired by the English-style seating piece, pushes his Windsor production to an early date. Felix Huntington or another unidentified craftsman seem more likely candidates, however. Further evidence for the Norwich-area provenance of this design comes from the material of the seat. Samuel Huntington's Windsors employ butternut, a wood of the walnut family used locally on occasion in Windsor seating; the Floyd chair seats are maple, another regional choice in Windsor furniture. Points of comparison between the English-patterned chair and the Tracy high-back Windsor include the crest profile, spindle swell, rabbeted rail construction, hollow seat pommel and blunt forward edge, tipped stretchers, and vaselike leg tops—too many similarities to be merely coincidental.

Insufficient information exists to determine *precisely* which of Ebenezer Tracy's four production styles followed the high-back chair into the consumer market, since impressions of his branding iron both in its complete and damaged states with the broken *Y* occur on all four patterns documented to the shop—the sack-back and continuous-bow armchairs, and the fan- and bow-back side chairs. However, design subtleties and their division between states of the iron reveal a great deal about stylistic progression within each group. Similarities in Tracy's sack-back and tall Windsors suggest that the chairmaker produced the round-back seating next, beginning about the mid 1780s. This is the Windsor that Amos Denison Allen referred to as an "armed chair" in his memorandum book a decade later. There are somewhat fewer of these chairs bearing the Ebenezer and Elijah Tracy brands than of marked Windsors in the other styles (except Ebenezer's bow-back chair), which may mean that the craftsmen marked only a small portion of their initial production. In fact, when father and son first began to construct Windsor chairs, they may not have employed the marking iron. Design variation in documented production, while subtle, suggests that Elijah worked independently of his father perhaps as early as 1787 when he was twenty-one, presumably clear of his apprenticeship bonds, and free to mark his work. Clearly, he was his own master by 1790 when the census enumerated a young man in his household, probably an apprentice or journeyman.[96]

Although Ebenezer Tracy probably made sack-back chairs before Elijah finished his apprenticeship and left the shop, the son's documented production deviates consistently from the master's in the profile of the leg baluster. This element as interpreted by Elijah lacks the vitality of the elder Tracy's work. It is a heavier version of the baluster seen in

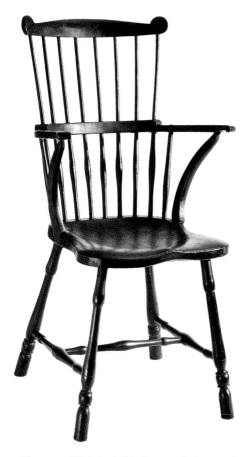

Fig. 6-97 High-back Windsor armchair (one of a pair), New London County, Conn., 1775–80. Butternut (seat, microanalysis); H. 38⅛″, (seat) 17⁹⁄₁₆″, W. (crest) 18¾″, (arms) 21⅝″, (seat) 17⅛″, D. (seat) 16½″. (Winterthur 91.51.2).

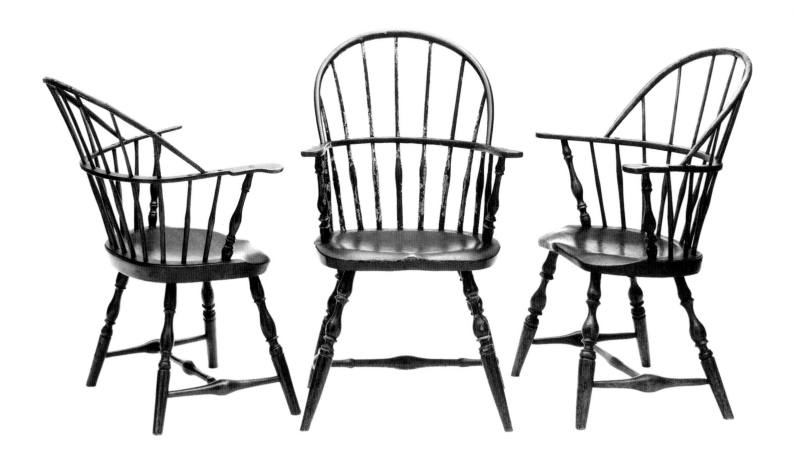

Fig. 6-98 Sack-back Windsor armchairs (three), (*left to right*) Beriah Green (brand "B:GREEN"), Amos Denison Allen (brand "A.D.ALLEN"), and Ebenezer Tracy, Sr. (brand "EB:TRACY"), New London and Windham counties, Conn., ca. 1795, ca. 1796, and ca. 1792–1800. (*Left to right*) Yellow poplar (seat) with maple and other woods, chestnut (seat) with maple and oak (micro-analysis), chestnut (seat) with maple and other woods; H.33", 36⅛", 35", (seat) 15⅝", 16⅝", 16", W. (arms) 26¼", 22¹³⁄₁₆", 26⅛", (seat) 20", 19½", 19½", D. (seat) 15¼", 15¼", 15½". (The late Elvyn G. Scott collection and Winterthur 57.107.1 [center]: Photo, Winterthur.)

the sack-back chair at the left in figure 6-98. As late as autumn 1796 when Amos Denison Allen opened shop, the sack-back chair was the first Windsor he manufactured; he usually charged 9s. or 10s. for it. His production of this form tapered off sharply by 1799.[97]

Three views of the Tracy-style sack-back Windsor executed by as many master craftsmen form a comparative group in figure **6-98**. Upon close examination a number of subtle variations are discernible. Closest in feature are the chairs of Ebenezer Tracy (right) and Amos Denison Allen (center), although the chair at the left made by Beriah Green of Lebanon and Lisbon reveals the chairmaker's close connection with the Tracy group. Green did not open his own shop in Lebanon until 1795, even though he married in 1793. In his early career as a resident of Preston, near Lisbon, he likely worked for a time as a Tracy journeyman, probably in Elijah's shop, based upon a comparison of turnings. There is a flamboyant character to the full-bodied leg balusters in chairs made by the elder Tracy and young Allen that is wanting in those produced by Green and Elijah Tracy. This flared, collarless turning was common to early eighteenth-century furniture from Connecticut and southern New England and continued as a decorative element in inexpensive turned chairs right up to the period of the Windsor, beginning with such styles as the high-back chair of figure 6-96 and the Rhode Island work of figures 6-8 (arm posts) and 6-34. A prominent full baluster sometimes forms the pillars of New York and Connecticut tea tables and candlestands. One of particularly robust form with a flaring neck is found in a table labeled by Theodosius Parsons of Windham, Connecticut, during the mid 1780s or 1790s; that shaft may be typical of other, unidentified examples. When executing the large-headed spool turning common to the sack-back chair, Ebenezer Tracy came closest to imitating the pattern of figure 6-27, a Rhode Island fan-back Windsor of the general type that influenced Tracy side-chair production. Back post elements in the same chair are elongated versions of those used as arm supports in the Tracy sack-back Windsor.[98]

Flat-edge oval seats are characteristic of the sack-back group, but in these three examples only Ebenezer's plank is thin along the front and hollowed across the lower

Fig. 6-99 Sack-back Windsor armchair and detail of arm terminal, attributed to Ebenezer Tracy, Sr., Lisbon Township, New London County, Conn., 1785–90. Yellow poplar (seat) with maple and oak; H. 35⅞", (seat) 16½", W. (arms) 25⅛", (seat) 19⅝", D. (seat) 15⁵⁄₁₆". (E. S. Wilkins collection: Photo, Winterthur.)

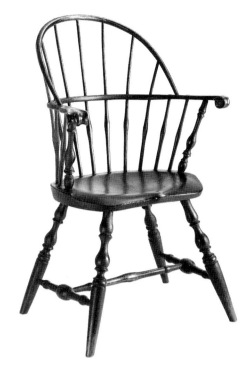

center. In this feature and the slight droop of the ends it compares well with the English-patterned chair plank (fig. 6-97) and duplicates that of the high-back Windsor (fig. 6-96). From certain angles the droop lends a clipped appearance to the front seat corners. In the English-style chair there is a close model for the Tracy and Allen leg tops, and diminutive versions of the turnings are repeated in the upper arm posts. Plain arm pads of a standard "mitten" design with prototypes or counterparts in Rhode Island work (figs. 6-50, 6-84) are common to almost all Tracy family sack-back chairs and provide broad, comfortable rests for the sitter's arms. Of particular note are the pinched bends of all the arm rails and bows.

Tracy-type sack-back chairs with carved knuckle arms appear to be undocumented. Such unmarked Windsors can be attributed to the group when they otherwise duplicate the plain, branded chairs (fig. **6-99**). Comparison of the knuckle-arm Windsor with the previous illustration reveals the work to be closest to that of Ebenezer Tracy. The arm supports, legs, and seats are almost interchangeable, and the same undersize swell occurs in the medial stretcher. Indeed, the scroll-arm seating probably represents the master's earliest production of this form. In all ascribable chairs the stretchers are tipped, a characteristic associated with Ebenezer Tracy's earliest production, based upon a survey of documented work. Use of the undamaged brand is more frequent on chairs so embellished. The fact that none of the knuckle-arm chairs is documented suggests that the work was executed before Ebenezer's general use of the branding iron. One chair in the group whose yellow poplar seat is incised with the serif-style letters "EH" bears a local history of ownership by Ebenezer Huntington, a resident of Norwich from before 1800 until at least 1830.[99]

The top profiles of the knuckle arms agree in basic form with the plain pad arms, and both could derive from Rhode Island models (figs. 6-50, 6-55). The knuckle is a full, deep scroll further carved on either side face. Comparison with the terminals of a documented sack-back settee from the shop of Ebenezer Tracy shows excellent conformity of line, given the larger scale of the settee arms. Amos Denison Allen implied the duality of arm patterns for the sack-back Windsor when he referred specifically to "plain-armed Chairs" in his memorandum accounts. An order for Doctor Samuel Lee under the date May 1797 contains another item of unusual interest, "1 armed chr high top," priced at 11s.6d. Lee had purchased six "armed" chairs from Allen several months earlier, which may indicate that the new Windsor was constructed as a master or special purpose chair. A well-turned, undocumented Windsor that fits this description (fig. **6-100**) exhibits characteristics below the bow associated with the work of both Allen and Ebenezer Tracy. Above the bow, the English-inspired top piece places the chair firmly within the scope of Tracy's production of the 1780s. The Tracy craftsmen made this rare and unusual Windsor only infrequently and on special order.[100]

Another sack-back variant that is rare and unusual is marked with the damaged brand of Ebenezer Tracy (fig. **6-101**). The bow is about six or seven inches higher than a standard chair. Amos Denison Allen's order book sheds light on special seating of this type. In November 1801 David Hows ordered a rocking chair, which Allen noted was to

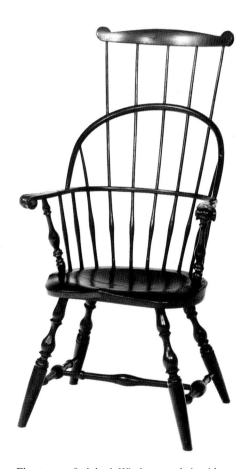

Fig. 6-100 Sack-back Windsor armchair with top extension, attributed to Ebenezer Tracy, Sr., Lisbon Township, New London County, Conn., 1785–90. (Photo, Estate of Florene Maine.)

Fig. 6-101 High sack-back Windsor armchair and detail of brand, Ebenezer Tracy, Sr., Lisbon Township, New London County, Conn., ca. 1792–1800. Chestnut (seat) with maple and oak; H. 42¾″, (seat) 15⅛″, W. (arms) 26″, (seat) 19⅝″, D. (seat) 15¼″. (Bennington Museum, Bennington, Vt.: Photo, Winterthur.)

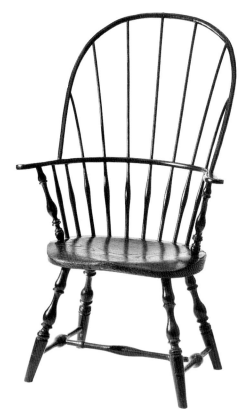

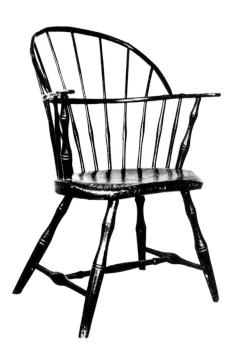

Fig. 6-102 Sack-back Windsor armchair, probably Elijah Tracy overstamped by Stephen Tracy, Lisbon Township, New London County, Conn., 1801–7. (Private collection: Photo, Winterthur.)

be "2½ Ins higher than Common"; one month later a Mr. Ripley of Lebanon wanted a writing-arm chair increased in back height by two inches. The extra tall sack-back chair also calls to mind John Andrews's Boston correspondence with his brother-in-law William Barrell of Philadelphia, requesting two sack-type chairs with the backs three or four inches taller than usual for his friend Dr. Loring "to take a Nap in, upon occasion." Perhaps Mr. Ripley had the same purpose in mind.[101]

Another Windsor brings the Tracy sack-back design to its final form (fig. **6-102**), although the bamboo turning is rare in this pattern. Use of a tipped medial stretcher is hard to explain in view of the Tracys' early abandonment of similar braces in their fan- and bow-back chairs. A few examples are branded by Elijah Tracy, although other stamps may occur. The illustrated Windsor, which is something of an enigma, could be Elijah's work. The brand is unclear, being overstamped with the mark of Stephen Tracy; the first initial in the original brand, followed by the Tracy surname, seems to be "E." The small size of the first stamp introduces a further puzzle, since Tracy family brands usually measure five-eighths of an inch in height. Here the letters of the first stamp are slightly less than half an inch. Another Elijah Tracy stamp is found on the bottom of a board-end stool in letters measuring three-eighths of an inch, although that mark is unknown on chairs. Apparently, either Ebenezer or Elijah acquired the small name stamp around the turn of the century and used it to mark the plank. Elijah's departure for New York state (1801) and Ebenezer's death (1803) followed shortly after. Stephen acquired the remaining family stock, remarked it, and vended it on his own account. The lighter, less complete impression made by Stephen's iron indicates that the wood was drier than when first struck with the smaller brand.

The second type of Tracy Windsor to enter the consumer market was the fan-back side chair. Hook-type crests and tipped stretchers identify the earliest pattern, which was branded by Ebenezer, Sr., and Elijah (fig. **6-103**). The elder Tracy's Windsors appear to bear only strikes of his undamaged brand. Rhode Island chairmaking heavily influenced the design. Swelled spindles appear on the postwar Rhode Island S-post chair (fig. 6-16) and in the English pattern produced in the Norwich area (fig. 6-97). Angular-end crests cap several Rhode Island patterns of the mid 1780s (figs. 6-27, 6-31),

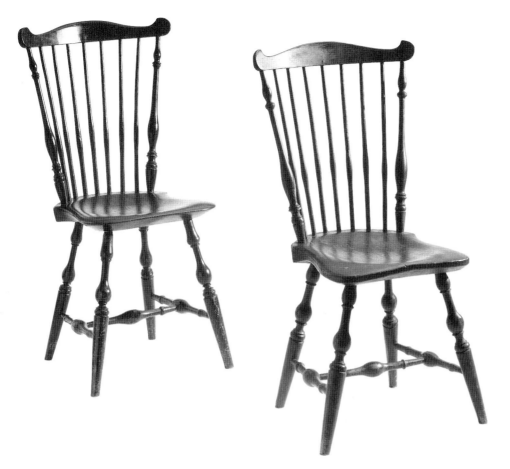

Fig. 6-103 Fan-back Windsor side chairs (each, one of three) and details of brands, (*top to bottom*) Ebenezer Tracy, Sr., and Elijah Tracy, Lisbon Township, New London County, Conn., ca. 1787–92 and ca. 1789–95. Yellow poplar (seats) with maple and other woods; (*left to right*) H. 38″, 36¹⁵⁄₁₆″, (seats) 18⅜″, 17⅛″, W. (crests) 20½″, 20³⁄₁₆″, (seats) 16½″, 16⅜″, D. (seats) 17″, 16¾″. (State of Delaware, Division of Historical and Cultural Affairs, Dover: Photo, Winterthur.)

and there are counterparts in English production of the 1750s and 1760s. The back posts of figure 6-27 may represent the general prototype for the Connecticut pattern. In compressed form the same turning is found under the arms of Tracy sack- and high-back chairs (figs. 6-96, 6-98). The Connecticut work duplicates the flaring, necked base of the Rhode Island long baluster, but here, unlike on the arm posts, a ring and taper replace the round-top base terminal.

Several fan-back chairs of Rhode Island origin have shield-shaped seats of a type that probably served as a model for Ebenezer Tracy (figs. 6-19, 6-38). Elijah's early planks with their flat, ribbonlike forward edges have more the character of seats in the English style (fig. 6-97) or those used in the family's sack-back chairs (figs. 6-99, 6-100). The legs are a pastiche of various influences and may be the Tracys' most original contribution to the design. The somewhat lumpy element at the top of Ebenezer's supports appears to mark his earliest production, and perhaps springs from several Rhode Island chairs in the market shortly after the war (figs. 6-18, 6-20). Rhode Island (figs. 6-20, 6-49, 6-50) or New York chairs (fig. 5-7) could have provided the model for the compressed spool turning employed consistently by Ebenezer in his fan-back work and occasionally in modified form by Elijah. On the other hand, there may have been a prototype in the Norwich region. Hollow turnings of related form with narrow heads and broad, speading bases are seen in the pillars of two similar candlestands, one of which descended in a Groton family. Since the Tracys were cabinetmakers as well as chairmakers, they were familiar with such work. The longer, balanced spools of Elijah's chair legs relate to the post turnings. The shapely, bulbous leg balusters characteristic of the fan-back chair are found in other family work. The turning has its counterparts in Rhode Island round-back Windsors of the late 1780s and 1790s, and chairmakers of both areas probably looked directly to New York sources (figs. 5-10, 5-12, 5-14). Certainly, the large tapered foot is common in metropolitan production. However, the tipped stretchers bracing the legs are more akin to Rhode Island work. Some of Elijah Tracy's

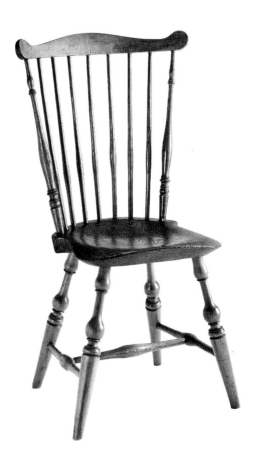

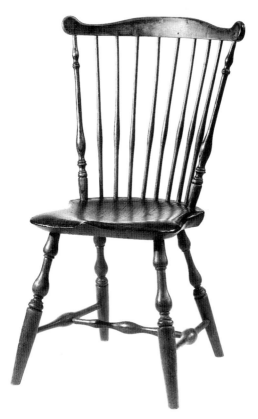

Fig. 6-104 Fan-back Windsor side chair (one of two), Elijah Tracy (brand "E.TRACY"), Lisbon Township, New London County, Conn., ca. 1795–1801. Chestnut (seat) with maple and oak (microanalysis); H. 37⅛", (seat) 16⅛", W. (crest) 21⅜", (seat) 16⅛", D. (seat) 16¾". (Winterthur 65.3028.)

Fig. 6-105 Fan-back Windsor side chair and detail of brand, attributed to Ebenezer Tracy, Jr., Lisbon Township, New London County, Conn., ca. 1803. Chestnut (seat) with maple and oak; H. 35¼", (seat) 17", W. (crest) 21¾", (seat) 16⅜", D. (seat) 16¼". (E. and E. Wallace collection: Photo, Winterthur.)

Fig. 6-106 *Dr. Philemon Tracy*, probably Norwich, Conn., 1795–1800. Oil on canvas; H. 31⅛", W. 28⅞". (National Gallery of Art, Washington, D.C., gift of Edgar William and Bernice Chrysler Garbisch.)

fan-back chairs duplicate his father's pattern by employing three tipped braces and compressed leg spools. The illustrated chair represents a second stage that substitutes longer spools and uses rings in place of tips on the medial stretcher. Ebenezer apparently did not employ either turning in this type of chair.[102]

Structural affinities in Rhode Island and Connecticut Windsors, along with similarities of design, are important to this discussion. Chairmakers of both areas employed chestnut plank for seats, the Tracys to a considerable degree. From the start Tracy craftsmen socketed chair legs inside the plank, a construction common in Rhode Island. Use of a groove around the seat back to define the elevated platform supporting spindles, posts, or bow, is usually absent from Tracy work; some Rhode Island chairs also omit this standard feature.

As the Tracys proceeded with their fan-back production, a number of changes took place, some of them subtle. The rounded-end crest probably appeared at the beginning of the 1790s, early enough that tipped stretchers remain in some chairs. Although the uncarved, rounded top was common in Rhode Island and Philadelphia work from shortly after the war, the pattern developed by the Tracys shows pronounced English influence (figs. 6-104, 6-105). The inside top corners are not as sharply defined as in the prototype (fig. 6-97), but the profile relates more closely to that pattern than to contemporary American work. Chairs made by the two Tracys reveal both similarities and differences. Seats follow individual patterns, as earlier, but both chairmakers produced posts whose short upper balusters are modestly angular, not unlike Rhode Island work (fig. 6-42). Leg tops turned in Ebenezer's shop are smoother than in former work. Ebenezer's rounded-crest chairs seem about evenly divided between strikes of the perfect and broken branding tool. Even the iron employed by Elijah sustained damage; a toe at the foot of the *T* is missing in some impressions.

The popularity of the Tracy fan-back chair in the greater Norwich area is affirmed by its appearance in an undated portrait of the Norwich physician, Doctor Philemon Tracy (fig. 6-106). Although only a small portion of the doctor's chair is visible, the profile of the back post with its small, angular upper baluster and buttonlike element is sufficient

to identify the Windsor as a likely product of his Lisbon kinsmen. Philemon and Ebenezer, Sr., were fifth-generation Tracys in collateral lines. Doctor Tracy (b. 1757) "practiced medicine in his native town for more than fifty years [and] excelled in the diagnosis of chronic diseases." The doctor's haircut, stock, vest, and style of coat point to a date of about 1795 to 1800 for the painting. An anonymous man similarly clothed is the subject of another canvas dated 1798.[103]

In later fan-back work the Tracys deemphasized the button feature originally so prominent in their back posts (fig. 6-103, right). Elijah's planks changed as the chair-maker shaved a deep, angled surface across the front (fig. 6-104). The blunt quality of the "new" seat renders it less successful aesthetically than the former design. Clearly visible are the use of chestnut and the absence from the seat surface of both leg tops and a groove defining the spindle platform. The Tracys often employed white oak for stretchers; when stripped of paint the grain contrasts sharply with the fine, smooth texture of the maple legs.

Documented examples of bamboo-turned, fan-back Windsors by Ebenezer or Elijah Tracy may be nonexistent, yet the craftsmen used similar turnings extensively in their marked continuous-bow chairs. Elijah employed bamboowork in his bow-back Wind-sors, as well. Unmarked fan-backs with Tracy-style bamboo legs sometimes employ eight or nine spindles instead of the usual seven. Several baluster-leg fan-backs also have even-numbered sticks (fig. 6-105). Triple-swelled medial stretchers of vigorous form are seen in some chairs, among them one branded by Ebenezer Tracy, Jr. (fig. 6-105). The name impression is from his father's iron altered by the removal of one dot so that only a pellet remains between the first letters and the surname. Young Ebenezer likely con-structed the chairs from parts left in the shop at his father's death. This would explain the unusual addition of a modified bamboo medial stretcher, which does not occur in the documented work of Ebenezer, Sr. The chair also introduces a groove to the seat plank to define the spindle platform.[104]

Stephen Tracy and Amos Denison Allen also produced bamboo-turned fan-back chairs. Although Allen's memorandum book contains many entries for Windsors of this general pattern (Houghton Bulkeley counted 156), few documented examples have come to light. Orders for fan-back chairs began early in 1797. Those produced first probably had baluster-turned legs; the price varied from 6s.6d. to 8s.0d.[105]

The bulk of Allen's chair production was unmarked. During the six years covered by his order, or memorandum, book, there are entries for more than 650 Windsors, yet only a few dozen documented examples are known, or about one-quarter the number recorded for Ebenezer Tracy. The craftsman enjoyed good custom. He was a cabinet-maker as well as a chairmaker and produced a wide range of sophisticated joinery along with chairs—clock cases, bureaus, dining and Pembroke tables, and an inlaid sideboard, to name a few forms. Allen recorded 357 orders in six years. His customers were local people or residents of other eastern Connecticut towns, including Pomfret, Lebanon, Colchester, Franklin, Mansfield, and Coventry. The occupations of his patrons varied from innkeeper to blacksmith, from clerk of the probate court to merchant.[106]

The continuous-bow Windsor was popular among Tracy customers. More chairs of this type than any other are branded by Ebenezer, Sr., a circumstance attesting to the enthusiastic acceptance and production of the pattern during the 1790s when Tracy made common use of the marking iron. The family interpretation follows New York design more closely than patterns of Rhode Island origin, as indicated by the presence of similar features, such as bracing spindles, a point behind the arm pads, drooping front seat corners, full baluster profiles and thick rings, and long, heavy leg tapers. However, when viewed side by side with a New York continuous-bow Windsor, the arch of a Tracy chair is noticeably narrower.

Evidence suggests that direct New York influence in Connecticut was substantial, particularly in the New London-Norwich area. Customhouse records, which at best are incomplete, record at least one shipment of "Forty eight Windsor Chairs" from New York to Norwich in February 1794. The shippers were none other than Thomas and

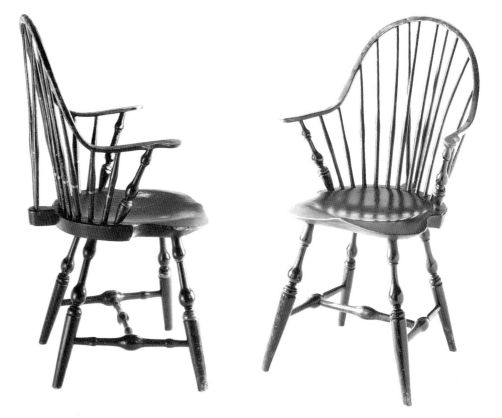

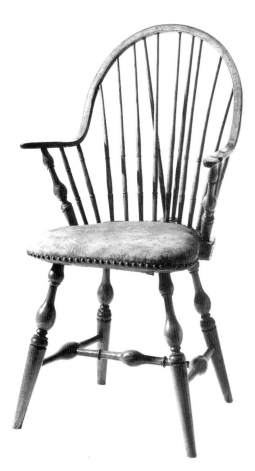

Fig. 6-108 Continuous-bow Windsor armchair with stuffed seat, Elijah Tracy (brand "E.TRACY"), Lisbon Township, New London County, Conn., ca. 1792–96. Maple and other woods; H. 38¼", (seat with stuffing) 19¼", W. (arms) 21½", (seat) 18⅛", D. (seat, without extension) 17¾". (Denison Society, Inc., Mystic, Conn.: Photo, Winterthur.)

William Ash. Chances are this was not their first consignment of chairs to an area retailer. Only a few months later Asa Stanton, a "Cabinet and Chair Maker" of New York City, advertised in a New London newspaper that he offered "good encouragement . . . to a journeyman who is well acquainted with the above business." The same itinerant craftsman who heeded the call could have returned to Connecticut with a knowledge of "The Latest New York Fashions." Indeed, Stanton himself had settled in Stonington by 1799, where he advertised his newly established cabinet business. Stacy Stackhouse, a Windsor-chair maker from New York City, arrived in Hartford to practice his trade as early as 1784; John Colwell followed suit in 1786, settling in Groton on the Thames opposite New London.[107]

Like their New York and Rhode Island counterparts, Tracy continuous-bow Windsors are graceful. Figure 6-107 illustrates the work of Amos Denison Allen and his master, side by side. Basically, the chairs are similar. Minor differences, such as baluster length and the diameters of roundwork, are common variables within family practice. Ebenezer Tracy employed a tipped stretcher early in his career and continued its use for awhile after his marking iron was damaged. Allen also employed the embellished turning. His accounts indicate that he sold his first "fancy," or continuous-bow, chairs in August 1797 after he had begun to construct fan- and sack-back seating. A rounded tab replaces the New York coffin-shaped seat projection in Tracy chairs, although the plank shape and contour owe much to metropolitan production (fig. 5-12). Following New York and Rhode Island practice, an incised groove forms a small bead at either edge of the flat bow face. Sometimes at the arm bends the bow depth is reduced sharply by the removal of a curved slice of wood. Use of compressed spools in post and leg turnings seems common to the work of both Allen and the elder Tracy. Elijah Tracy employed this feature in his early work (fig. 6-108) but soon turned to a larger spool. His medial stretchers frequently contain rings flanking the central swell. Elijah's chair is one of a small number of Tracy continuous-bow Windsors enhanced by the addition of baluster-turned spindles, a feature borrowed from the best Rhode Island work (figs. 6-72, 6-74).[108]

The Tracys used a stuffed seat for the first time to embellish their continuous-bow Windsor (fig. 6-108). Ebenezer's brand is found on baluster-turned chairs of this form

before and after the tool sustained damage. Family production continued into the bamboo period (fig. 6-109). As shown, planks made for stuffing were not finished in the same manner as other Windsors. A saucerlike depression fills the center, the front pommel is missing, and the forward edges are flat, then sharply chamfered. The tacking line for the covering is along the lower edge of the flat surface. Amos Denison Allen's first order for "fancy arm'd Chs with cushions in ye bottoms" was recorded on April 23, 1798, when Deacon Samuel Perkins "bespoke" such work. Allen seems to have marked few, if any, of his "cushioned" chairs; probably all were in the bamboo style. An unusual variation of the stuffed seat is seen in two chairs made by Ebenezer Tracy. Heavy, rough planks of modified shield form with serpentine fronts and sides have deep, flat edges for complete "over the rail upholstery."[109]

The Tracys' early bamboowork is distinctive (fig. **6-109**). It is a hybrid design combining the tapered foot of the baluster leg with two short, well-hollowed upper sections. A double groove marks the separation. Late production adopted a second bamboo support of more standard form (fig. **6-110**). Turnings are still well shaped with full, grooved swells and a long central section; the medial stretcher is compatible. Ebenezer, Sr., probably did not construct Windsors of this support type. Elijah's brand is found on a rocking chair, Beriah Green's on an armchair. Several chairs bear Stephen Tracy's brand, including that shown in figure 6-110. Back braces are absent from the later group. Entries for "Fancy Chs without braces" first appear in Amos Denison Allen's order book in spring 1799. From that date most of his continuous-bow chairs appear to have had plain backs, with "cushion" seats on about half the production. By November 1801 the new braceless form was common enough that Allen made special note of chairs *with* back supports. Apparently, the chairmaker all but stopped marking his production by the late 1790s.[110]

The many minor variations in Tracy Windsors constructed in the bow-back style make it difficult to call any one chair truly a standard type; however, certain basic classifications are possible. The earliest pattern followed Rhode Island's lead and introduced a modified balloon-type bow. There are more unmarked than documented chairs

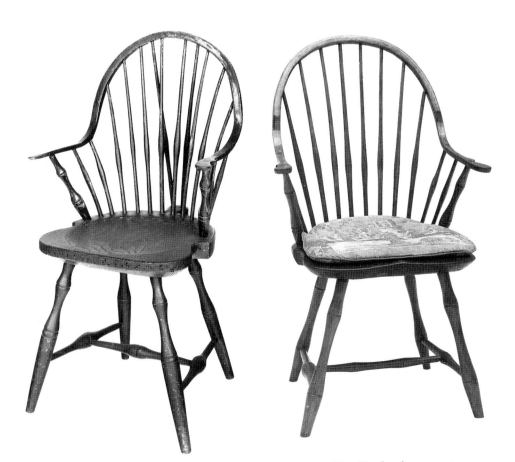

Fig. 6-109 Continuous-bow Windsor armchair with seat for stuffing, Ebenezer Tracy, Sr. (brand "EB:TRACY"), Lisbon Township, New London County, Conn., ca. 1796–1803. Chestnut (seat) with maple and other woods; H. 27¼", W. 21½", D. 19¼". (Henry Ford Museum and Greenfield Village, Dearborn, Mich.)

Fig. 6-110 Continuous-bow Windsor armchair, Stephen Tracy (brand "S.TRACY"), Lisbon Township, New London County, Conn., ca. 1803–6. Maple and other woods; H. 36½", W. 21¾", D. 17⅛". (Metropolitan Museum of Art, New York.)

Fig. 6-111 Bow-back Windsor side chairs (two),
(*left to right*) attributed to the Tracy family, and
Ebenezer Tracy, Sr. (brand "E B : T R A C Y"), Lis-
bon Township, New London County, Conn.,
1790–95. (*Left to right*) Yellow poplar (seat) with
maple, hickory, and oak (microanalysis), and
chestnut (seat) with maple and other woods;
H. 36⅞", 39", (seats) 17¼", 18¼", W. (seats) 16",
16¼", D. (seats, without extensions) 16¾", 16⅞".
(Winterthur 64.1767 and E. and E. Wallace collec-
tion: Photos, Winterthur.)

of this profile, indicating that production began early, probably soon after the Tracys
introduced their fan- and sack-back chairs. The occasional use of tipped stretchers and
Ebenezer's unbroken brand on several Windsors confirm this. The tipped and plain-
stretcher chairs illustrated in figure **6-111** represent the early work of Elijah and
Ebenezer, respectively. Although the younger Tracy's chair is unmarked, its vigorous
turnings and other features relate to his documented work. Elijah soon replaced the
stretcher tips with medial stretcher rings, while Ebenezer converted to plain stretchers,
as shown. Back braces were also part of the Tracys' early bow-back work. Several
unusual, unmarked chairs are fitted with tipped-end, box-style stretchers. Double
balusters, spools, and a thick central ring mark the front turning. The general profile
relates to the front stretchers of coastal Connecticut fiddle-back, crown, and split-
banister chairs (fig. 6-5). Predictably, Ebenezer's inventory includes fiddle-back seating,
probably of his own construction.[111]

According to entries in Amos Denison Allen's memorandum book, the young
chairmaker made his first bow-back, or dining, Windsors in August 1797. Only a few
months later Ebenezer Tracy sold a dozen such chairs to Judge Ebenezer Devotion of
neighboring Scotland. Like his master's chairs, Allen's early bow-back Windsors have
knife-edge seats, plain stretchers, baluster legs, and balloon bows. Standard production
centered in the plain back, since orders for braces and cushioned seats are specially noted
in Allen's records. Few artists have depicted the balloon-back Windsor on canvas. In that
respect a likeness of a young woman of the Harrington family seated in a boldly drawn
Connecticut or Rhode Island chair (fig. **6-112**), painted about 1810, is unusual.[112]

Allen's documented bow-back work includes a chair of slim baluster design with a
narrow back, long tapered feet, and a bow that deviates from the true swelled balloon
form (fig. **6-113**, right). As illustrated more clearly in the chair constructed by Ebenezer
Tracy (left), the lower ends of the arch straighten to form a variant profile; appropriately,
the brand on the seat bottom contains the broken "Y." Elijah Tracy also branded chairs
with similar backs. In the last production phase, oval-back work entered its most variable
period. The flat-faced bow with beaded edges acquired a nipped waist (fig. **6-114**) and
double-swelled, grooved spindles. An early chair of the pattern made by Elijah has

Fig. 6-112 *Miss Harrington*, Connecticut,
ca. 1810. Oil on canvas; H. 31", W. 25½". (Lyman
Allyn Art Museum, New London, Conn.)

Fig. 6-113 Bow-back Windsor side chairs (two), (*left to right*) Ebenezer Tracy, Sr. (brand "E B : T R A C Y") and Amos Denison Allen (brand "A . D . A L L E N"), Lisbon Township, New London County, and South Windham, Windham County, Conn., ca. 1794–1800 and ca. 1797–1800. (*Left*) Chestnut (seat) with maple and other woods; (*left to right*) H. 37⅞", 39⅛", (seat) 17⅜", 19⅝", W. (seat) 15¾", 16⅛", D. (seat) 16⅞", 16¾"; (*right*) legs pieced out below stretchers. (Private collections: Photos, Winterthur.)

bamboo legs of the first type. Several unmarked Windsors with related turnings appear to be the work of craftsmen outside the family group. Bamboo production did not reach its stride, however, until just after the turn of the century when bamboo supports were converted to the second Tracy pattern.

All the younger family members made and branded chairs of this type—A. D. Allen, Stephen Tracy, Ebenezer, Jr., and Elijah. Ebenezer, Jr., marked his product with the

Fig. 6-114 Bow-back Windsor side chairs (two) and detail of brand, Elijah Tracy, Lisbon Township, New London County, Conn., ca. 1800-1802. (*Left to right*) Chestnut (seat) with maple and other woods, and maple (seat, microanalysis) with maple and other woods; H. 36", 36¾", (seat) 15¾", 17⅜", W. (seat) 16", 16⅛", D. (seat) 15⅞"; (*right*) leg tips pieced out. (E. and E. Wallace collection and Private collection: Photos, Winterthur.)

converted iron of his father. Several of Elijah's chairs are strengthened with back braces. Bow-back Windsors in the bamboo style have from seven to nine spindles, while baluster-leg chairs contain seven or eight. Amos Denison Allen's chairs varied in price from 6s.6d. to 8s.6d., and the addition of a stuffed seat almost doubled the price. Even as late as 1801 one customer ordered dining chairs in the "old fashion," probably a reference to the baluster-leg style. Late production introduced several subtleties: arches of more angular waist, bow faces formed of pronounced beads and grooves, and tapered spindles with a single, elongated swell (fig. 6-114, right). Just before the change Elijah Tracy acquired a new marking iron with letters one-sixteenth of an inch taller than his first brand, suggesting that the old iron had sustained irreparable damage. Generally, the letters of the new brand conform to those of the first iron (fig. 6-103, right, detail), although notable changes occur in the right leg of the "R," now straight, and the full-rounded "C," which has only a single serif. Elijah's use of the iron was brief, as he soon left Connecticut for New York state.[113]

Influence of the Tracy Craftsmen

A number of craftsmen worked within the sphere of Tracy family influence in eastern Connecticut. The best known is Beriah Green, although his exact connection with the Tracys remains unclear. Green's Windsor chairs are of individual character, yet their particular features speak of a firsthand knowledge of Tracy-style seating. The chairmaker's production exhibits greater affinity with the work of Elijah Tracy than with that of Ebenezer, giving rise to speculation that he may have worked for a time as a journeyman in Elijah's shop.

Beriah Green was born on November 22, 1774. In December 1793 he married Elizabeth Smith at Preston, and a son was born there in March 1795. There is every reason to believe that Green worked as a journeyman in his early career. Within the general area of Preston more than a dozen furniture artisans pursued their trade. By June 7, 1795, Green had moved his family to Lebanon, northwest of Norwich, where he advertised as a cabinet- and chairmaker and solicited the services of an apprentice. Passing through the town a year later the duc de La Rochefoucauld Liancourt described 150 to 160 "small, but neat" houses lying in a broad, single street which served "as a sort of common pasture for the cattle" (a village green). Green's business appears to have prospered for several years; the town assessment of August 1796 listed him as a "joiner." In 1799 he provided Judge Ebenezer Devotion of neighboring Scotland with Windsor chairs as part of an account settlement. The following year the federal census described Green's residence as neighboring Lisbon, and local church records suggest that he had left Lebanon not long before. Green's status as a master or journeyman at this time is uncertain. He purchased property in Lisbon in 1802 but disposed of it two years later when he and his wife were dismissed from the church in Hanover (town of Lisbon, now Sprague) and recommended "to any church in Randolph, Vermont."[114]

If Beriah Green did not receive part of his training in a Tracy shop, he was a perceptive copyist and clever adapter. The crest of his fan-back side chair (fig. **6-115**) duplicates the Tracy profile (figs. 6-104, 6-105), and the posts modify Elijah's turnings (fig. 6-104) with new shapes above and at the base of the long balusters. Spool, ring, and taper turnings compare closely in profile. The bold spindles harmonize well with the posts. At least one fan-back side chair bearing Green's brand contains a long, top-heavy spool in either post that is well on target with Ebenezer Tracy's work (fig. 6-103, left). Below the seat, which is a composite of the Tracy knife-edge and blunt-edge planks, Green introduced the flared baluster leg of the Tracy sack-back chair (fig. 6-98). Further comparison of the supports with Amos Denison Allen's sack-back Windsor suggests that his South Windham shop near Lebanon may have been another source of influence on Green's style.

A second fan-back Windsor, one with embellished spindles, almost surely came from Green's shop, although it is unmarked (fig. **6-116**). Points of similarity with the first chair can be seen in the crest, turnings, and seat; the minor variations are no more than is

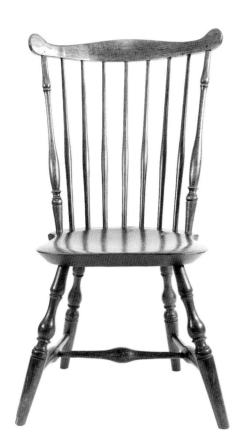

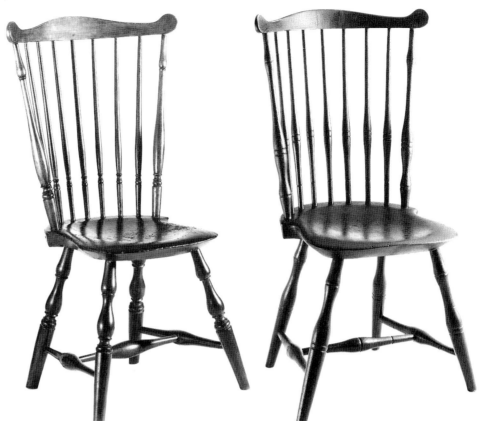

Fig. 6-115 Fan-back Windsor side chair, Beriah Green (unknown brand), New London County, Conn., ca. 1797–1800. (Webb-Deane-Stevens Museum, Wethersfield, Conn.)

Fig. 6-116 Fan-back Windsor side chair, attributed to Beriah Green, New London County, Conn., ca. 1797–1800. Basswood (seat) with maple and other woods; H. 37⅛″, (seat) 16⅛″, W. (seat) 15½″, D. (seat) 16⅝″. (Private collection: Photo, Winterthur.)

Fig. 6-117 Fan-back Windsor side chair and detail of brand, Beriah Green, New London County, Conn., 1800–1805. Walnut (seat) with maple and oak (microanalysis); H. 35¾″, (seat) 15⅝″, W. (crest) 20½″, (seat) 16″, D. (seat) 16¾″. (Winterthur 74.155.)

common in the work of any craftsman. The long, full body of the leg baluster is repeated in Green's sack-back chair (fig. 6-98), while the compressed spool turnings of the legs and posts relate significantly to Elijah Tracy's work (fig. 6-104). Whether Green constructed this Windsor for a special order or speculation can only be guessed at. Ornamental spindles are almost unknown in the fan-back chair; their common association is with the round-back Windsor styles. Green, like the Tracys, knew Rhode Island chairmaking, as indicated by comparing his ornamental stick turnings with similar elements in a continuous-bow chair (fig. 6-79).

A third fan-back Windsor to originate in Beriah Green's shop represents a substantial departure from his early turned work (fig. **6-117**), although the stance, seat, crest, internal seat sockets, and grooveless spindle platform are the same. Green's adaptation of highly stylized bamboowork of Tracy origin may coincide with his removal from Lebanon to Lisbon, which brought him once again into close contact with the Tracy shops. Since Tracy fan-back chairs seldom employ bamboowork, Green again looked to his own resources. The result is a back structure of extraordinary vigor and boldness, although perhaps overstated. In the evolutionary process, the chairmaker produced several examples that retain the plainer spindles of his baluster-turned chairs and have fewer grooves in the posts and legs. His brand, stamped twice on the bottom, relates in character to the Tracy stamps but is cruder in execution.

A rare sack-back armchair branded by Beriah Green is illustrated and compared with Tracy seating in figure 6-98. Green's fondness for the flared-neck baluster carried over into still a third Windsor pattern, the continuous-bow armchair (fig. **6-118**). He also

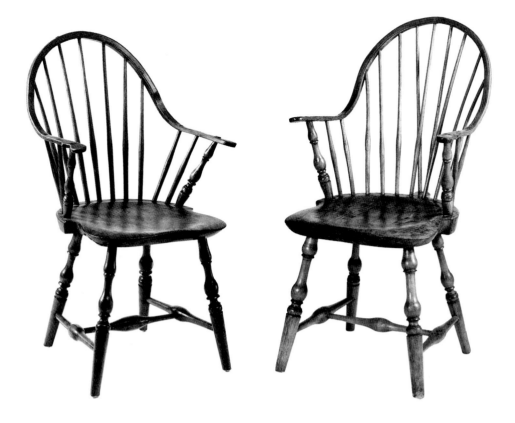

Fig. 6-118 Continuous-bow Windsor armchairs (two), Beriah Green (brand "B:Green"), New London County, Conn., (*left to right*) ca. 1797–1800 and ca. 1795–98. Maple and other woods; (*left to right*) H. 35¾", 36⅝", (seat) 17", 16⅜", W. (arms) 21⅞", 19⅞", (seat) 17⅜", D. (seat) 17½". (Gray-Davis Associates and Mr. and Mrs. Oliver Wolcott Deming collection: Photos, Winterthur.)

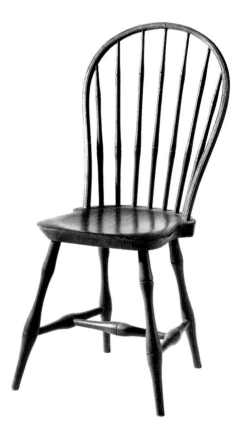

Fig. 6-119 Bow-back Windsor side chair, Beriah Green (brand "B:GREEN"), New London County, Conn., ca. 1803–5. Maple and other woods; H. 36⅞", (seat) 17", W. (crest) 15⁵⁄₁₆", D. (seat) 15⅞". (Connecticut Historical Society, Hartford, Conn.: Photo, Winterthur.)

tried his hand at a standard baluster leg, which in detail relates well to Tracy work (figs. 6-107, 6-108). Green's braced-back chair probably is the earlier in date; the plain back of the second chair likely coincides with Allen's introduction of that modification. Green next produced bamboo-turned, continuous-bow seating that follows the pattern of his fan-back chair. A late model adopted the Tracy bamboo leg of the second type (fig. 6-110). Both bamboo patterns also are present in Green's bow-back production (fig. **6-119**).

In another area relationship, Amos Denison Allen recorded a contact with Theodosius Parsons, a local cabinetmaker and Windsor-chair maker of Windham County, in 1799. Parsons was older than Allen, since he had advertised in November 1787 for two journeymen, including one who "understands Turning, and the Windsor-chair business." Similar advertisements followed in 1788 and 1792. Parsons offered "steady employment for a length of time" and "good wages in cash." The advertisements suggest that Parsons enjoyed good custom, when in fact the minister of the local Scotland parish described the family as "poor folk." On June 24, 1799, Allen recorded Parsons's order for "6 Fancy Chs without braces bottom and Bows found not painted for Cushions." As indicated by the language of the period, Parsons supplied the seats and bows. Allen provided the turned parts—legs, stretchers, arm supports, and spindles—and framed the chairs. He returned the seating to Parsons "in the wood" for painting at his Scotland shop. A second order for dining chairs constructed under a similar arrangement followed in August, although Allen noted in a postscript entry: "bows ware found by me for these chs." In a final exchange in December Allen made fan-back chairs and Parsons again supplied the seats. Since documented seating by Parsons is unknown, there is no way of determining how closely the elements of his chairs corresponded to those in Allen's product, although the baluster in the pillar of a labeled tea table by Parsons is identical to that in the legs of Tracy family sack-back chairs (figs. 6-98, 6-99). Such exchanges point up still another way in which the features of one craftsman's work became intermixed with those of another.[115]

A pair of continuous-bow chairs that descended in the Knowlton family of Connecticut, probably in central Windham County near Ashford, incorporates into the design

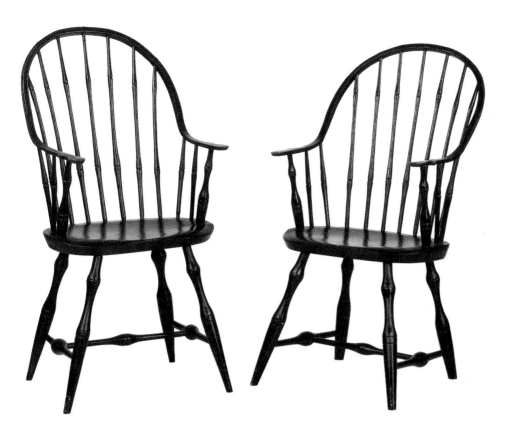

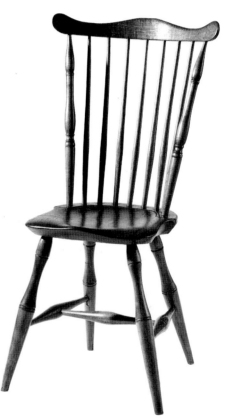

Fig. 6-120 Continuous-bow Windsor armchairs (pair); eastern Connecticut, possibly Windham County, ca. 1798–1805. (*Left to right*) H. 39″, 37″, (seat) 17″, 16″, W. 20″. (Mr. and Mrs. Harry H. Schnabel, Jr., collection.)

Fig. 6-121 Fan-back Windsor side chair (one of a pair), New London or Windham County, Conn., ca. 1798–1805. Yellow poplar (seat) with maple and other woods; H. 36¼″, (seat) 17¹⁄₁₆″, W. (crest) 19¾″, (seat) 14¾″, D. (seat) 14½″. (Antiquarian and Landmarks Society, Inc., Hartford, Conn.: Photo, Winterthur.)

turned elements associated with Tracy family work (fig. **6-120**). The choice of bamboo-baluster legs and posts identifies the chairmaker's debt to the Norwich-area craftsmen. He departed from the basic Tracy pattern, however, in selecting an oval seat with flat, canted sides, a shape more common to the sack-back armchair. In comparing the bow sweep with typical Tracy work of the late 1790s (fig. 6-109), the boxlike curves of the Knowlton chairs are apparent. The deeply incised double nodular spindles are a late type used by the Tracys (fig. 6-114, left). Although the chairs appear to be a pair, they vary by an inch in height from seat to bow top. The difference probably was intentional, perhaps to create "master" and "mistress" chairs.

A fan-back side chair, one of a pair, with hybrid legs of less exaggerated profile and baluster-turned posts exemplifies the common practice along the Connecticut-Rhode Island border of intermingling chair features (fig. **6-121**). While almost certainly a product of New London or Windham County, the chair exhibits typical Rhode Island features in the flat/chamfered seat back and short post balusters. Capping the balusters are tiny, domed collars identical to those in a border chair (fig. 6-148). The two Windsors also have planks of common shape, contour, and groove-defined spindle platform with internally socketed legs.

The particular silhouette of the long spindles of the Knowlton chairs, with their thin midsections, deeply grooved nodules, and thickened lower segments, links them with another area Windsor (fig. **6-122**). Below the seat of this bow-back chair further evidence of regional influence can be seen in the legs and stretchers. The blocked and tapered feet follow the Rhode Island fashion. The deeply grooved medial stretcher occurs in both the Knowlton chairs and a Beriah Green Windsor (figs. 6-120, 6-119). Above a vigorously contoured, shield-shaped seat pierced through by the legs and marked with a groove around the spindles, a flat-faced, beaded bow forms a round arch. The bow is unusual in employing a nodular bamboo form beneath arms that tenon through a flattened pad on the bow face. The arms also differ from standard production in several respects: they have beaded top surfaces, tiny hooklike scrolls, curves in both the vertical and horizontal planes, and a generous front overhang that caps molded and beaded segmental supports. The chairmaker based the general design on Rhode Island models, although the

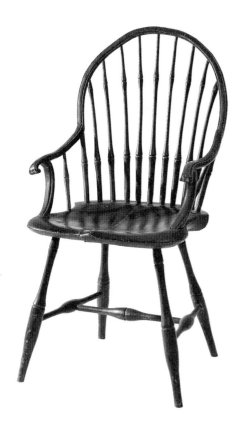

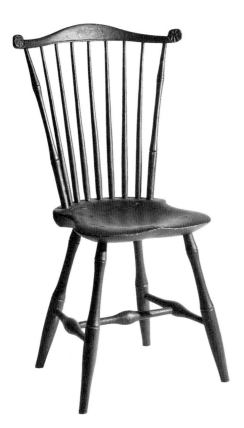

Fig. 6-123 Fan-back Windsor side chair,
New London or Windham County, Conn., ca.
1798–1805. White pine (seat, microanalysis);
H. 37⅝″, (seat) 17½″, W. (crest) 21⅝″, (seat) 15¾″,
D. (seat) 15½″. (Museum of Art, Rhode Island
School of Design, Providence, gift of Mrs.
Gustav Radeke: Photo, Winterthur.)

Fig. 6-122 Bow-back Windsor armchair,
New London or Windham County, Conn., ca.
1798–1805. Maple and other woods; H. 36⁹⁄₁₆″,
(seat) 17⅛″, W. (arms) 20⁵⁄₁₆″, (seat) 19″, D. (seat)
15⅞″. (Mr. and Mrs. John A. McGuire collection:
Photo, Winterthur.)

arm scrolls may relate directly to banister-back seating since coastal Connecticut crown-top chairs have sharp, hook-type arm terminals. There is at least one other chair of this exact pattern.[116]

An understructure of close form marks the base of a fan-back Windsor whose crest serves again to emphasize the originality of coastal Connecticut chairmakers (fig. 6-123). The broad, sweeping, English-style crown swings upward at the ends in fanciful flower-carved pinwheels. While the incised line detail along the bottom of the crest is uncommon, it occurs again in a regional variation discussed in the next section (fig. 6-134). Spindles are noticeably thick in their lower halves. By contrast, the white pine seat has relatively normal contours and construction details, although there is a slight hollow beneath the pommel. A few side chairs of comparable crest have plain scrolls; turnings include both baluster and bamboo patterns.

A more flamboyant variation of the upturned scroll appears on figure 6-124, whose origin can be defined no more closely than the Connecticut–Rhode Island border; yet with the chair that follows (fig. 6-125), it holds a recognized place in this crest-centered sequence. Within the small group represented by the present chair are seen the hands of two, possibly three, craftsmen. The high peak at the crest center, shaped in a small cupid's bow, continues its rhythmic movement to the spirally carved scrolls. As in the chair that follows, there may be direct English influence in the design, since without the center feature the profile duplicates that of the Slough chair (fig. 1-24); with its double-ogee peak, it also copies early furniture at Oxford (figs. 1-17, 1-18). Crest curves and swelled spindles both relate to features in a border chair (fig. 6-134) whose top piece has incised-line detail like the previous Windsor. The posts, which are a modification of the roundwork in the legs, duplicate element for element the legs of a Rhode Island chair (fig. 6-47). Further Rhode Island influence is apparent in the collarless balusters under the seat (fig. 6-31) and the flat/chamfered rear plank edge. The turnings in two similar wavy-crested chairs are more standard. Without knowledge of the preceding flower-carved chair or the pattern that follows, it would be difficult to see how the present group of wavy-crested chairs relates to a discussion of Tracy-influenced seating. Technically, it forms a collateral line.

The next pattern (fig. 6-125), which represents a pair of chairs, further modifies the roundwork of the legs and posts. The crest is an early profile found in Tracy and Norwich chairmaking (figs. 6-96, 6-97, 6-100). The highly mannered plank appears to represent a stage between the shield and oval seat. Leg balusters run up to and through the seat without benefit of short connecting elements. The chair may be the Connecticut product of a relocated Rhode Island craftsman; the relevance of this statement will become clear in the next section.

If the Windsor with the wavy crest exhibits a mannered provincial character, then the chair in figure 6-125 displays a complete naïveté of design. Yet in its simplicity, the chair commands attention. There are at least two sack-back Windsors from the hand of the same craftsman; the roundwork of the undercarriage is the same, the legs somewhat stouter. The arm posts duplicate the leg tops above the spool but a short section is added to the base. Spindles swell modestly, and the arm terminals reverse the curve pictured in figure 6-81. The oval seat with its thick flat-chamfered edges relates generally to that of figure 6-47.[117]

A sack-back chair with features that parallel Tracy work is one of two known, both probably originating in the same shop (fig. 6-126). The only appreciable difference is the substitution here of large knuckles for flat arms. The illustrated chair has no recorded

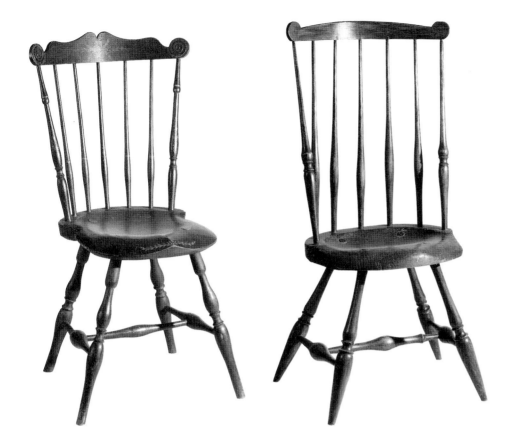

Fig. 6-124 Fan-back Windsor side chair (one of three), Connecticut-Rhode Island border region, 1795–1805. White pine (seat); H. 37³⁄₁₆″, (seat) 17³⁄₄″, W. (crest) 20¼″, (seat) 15³⁄₈″, D.(seat) 17⁷⁄₈″. (Shelburne Museum, Shelburne, Vt.: Photo, Winterthur.)

Fig. 6-125 Fan-back Windsor side chair (one of a pair), Connecticut-Rhode Island border region, 1795–1810. Ash and other woods; H. 41½″, (seat) 17⁷⁄₈″, W. (crest) 21¼″, (seat) 19″, D.(seat) 15⁵⁄₈″. (Shelburne Museum, Shelburne, Vt.: Photo, Winterthur.)

history; however, recovery of the second seating piece reinforces an eastern Connecticut provenance. A former owner purchased the chair in New London in the early 1940s. Stylistic comparison with documented Tracy work reveals similarities in the shape and fanlike arrangement of the spindles, and the bows arch in similar fashion, although the curved piece of wood employed here is thicker. The arm posts compare well in overall profile with the Tracy support, down to the flare at the base of the balusters. Tipped

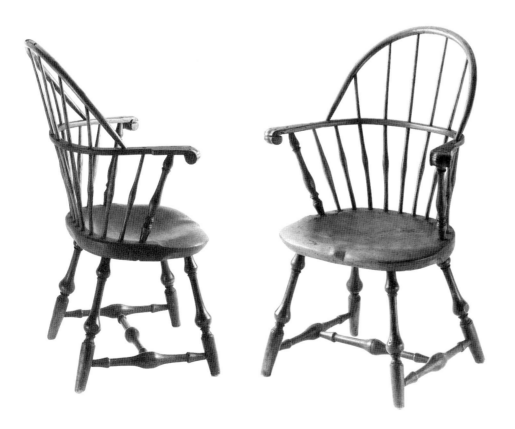

Fig. 6-126 Sack-back Windsor armchair (two views), New London County, Conn., ca. 1792–1802. Basswood (seat) with maple and oak (microanalysis); H. 35⁷⁄₁₆″, (seat) 14⁵⁄₈″, W. (arms) 25⁹⁄₁₆″, (seat) 19½″, D. (seat) 15¼″. (Winterthur 59.1821.)

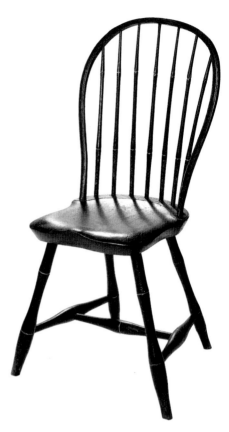

Fig. 6-127 Bow-back Windsor side chair, Charles Cotton (label), Pomfret, Conn., ca. 1801–5. H. 37¼", (seat) 17⅛", W. (seat) 14¾", D. (seat) 16⅝". (Old Sturbridge Village, Sturbridge, Mass.)

stretchers form another direct link with Tracy seating and Rhode Island work, but the leg turnings are a substantial departure from other regional support types. The compressed, bulging lower profile of the long-necked baluster is repeated in the element at the leg top to form a unified, though provincial, support. What appears to be a thin ring below the spool actually is a deeply scored line on the taper top. The feature is better defined in the second chair. Close inspection of the spool reveals its similarity to that in the Rhode Island chair of figure 6-49, marked, as here, by a pronounced upturn at the base. Balancing the robust elements of the support structure are large knuckle scrolls. Generally, these are similar in profile to Tracy terminals, although they fail to capture the same vigor in their outward thrust and shorter length.

A bow-back side chair made in Pomfret is the lone documented Windsor to represent northern Windham County (fig. **6-127**). Charles Cotton's label is attached to the seat. Born in 1778, Cotton was four years younger than his first cousin Thomas Cotton Hayward, who moved from Pomfret to the Boston area in about 1799. Presumably, young Cotton was working as a journeyman chairmaker somewhere in eastern Connecticut at the time of his cousin's departure, although he is not included in the 1800 census. Shortly after that date Cotton probably opened a shop in his native town, and by 1810 his household contained five members. The young craftsman's bow-back chair exhibits several influences. Comparison of the bamboo-turned legs with those in a high-back chair made by cousin Thomas shortly after his arrival in Massachusetts (fig. 6-216) shows considerable similarity of profile. The shape probably is indicative of the eastern Connecticut style. Similar legs occur in a fan-back side chair with the "hook" terminals typical of some regional crests. The brand "G. GAVIT" identifies that Windsor as the product of a Westerly, Rhode Island, shop near the Connecticut border (fig. 6-92). The Cotton chair also shares characteristics with Tracy design—the loop, flat bow face, nodular spindles, and stance (fig. 6-114). The seat with its deep, chamfered front appears influenced by Rhode Island work (figs. 6-87, 6-88). Charles Cotton may be the same man who, along with a Simon Cotton, Jr., was a resident of central Vermont in the Brookfield-Roxbury area several decades later.[118]

Connecticut–Rhode Island Border Work

Most craftsmen who pursued the chairmaking trade in the general vicinity of the Tracys are anonymous, although the region comprising New London and Windham counties and the western parts of Rhode Island abounded with chairmakers. Much of the Windsor seating from this border region incorporates into its construction elements of design identified with one or both areas, along with a whole vocabulary of individual features. Timothy Dwight documented the circumstances that led to this fusion of Connecticut and Rhode Island chairwork in observations made about 1800 in the township of Stonington, Connecticut:

The farms . . . contain from sixty to three hundred acres each. Almost half of them are cultivated by tenants. A great part of these are poor people from Rhode Island, who make Stonington their halfway house in their progress toward the new settlements. Accustomed from their childhood to labor hard on a sterile soil, and to live on very scanty means of subsistance, they come with their families to the rich lands of Stonington and take small farms or parts of farms upon lease. Here, with the most assiduous industry and a minute frugality, they gradually amass money enough to purchase farms in the wilderness. They then leave their habitation to successors from the same state. . . . In this manner a considerable part of the inhabitants of this township are almost annually changed.[119]

The interaction of many border craftsmen and the broad spectrum of individual expression in the region are well demonstrated in a body of Windsor seating dating to the late eighteenth century. In the sack-back Windsor, an armchair New England woodworkers embraced with particular enthusiasm, the knuckle arm adopted by the Tracys for their sack-back work (via Rhode Island, figures 6-50, 6-54) received variable treatment in the hands of other craftsmen. Some terminals feature broader, longer

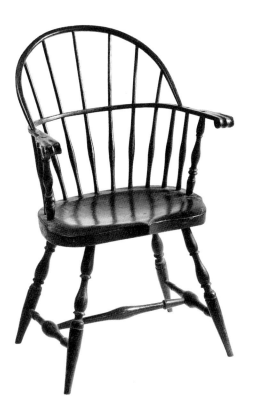

Fig. 6-128 Sack-back Windsor armchair and detail of arm terminal, New London County, Conn., 1790–1800. Chestnut (seat), oak, and other woods; H. 34½", (seat) 15¹⁵⁄₁₆", W. (arms) 22⅝", (seat) 19⅛", D. (seat) 14¾". (Steven and Helen Kellogg collection: Photo, Winterthur.)

Fig. 6-129 Sack-back Windsor armchair, Connecticut-Rhode Island border region, ca. 1795–1802. Cottonwood (microanalysis); H. 36¾", (seat) 17½", W. (arms) 24½", (seat) 20⅝", D. (seat) 15⅛". (Private collection, on loan to the Society for the Preservation of New England Antiquities, Boston, Mass.: Photo, Winterthur.)

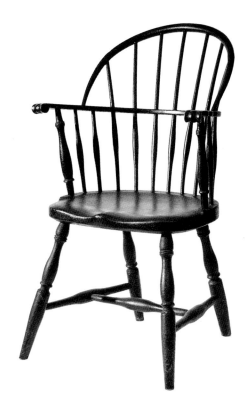

knuckles that exhibit less outward flare. A provincial interpretation of considerable length and blocked form, the scroll extending well forward of its post support, has a small pip midway along its outer edge (fig. 6-128). The pattern is close to Rhode Island work (fig. 6-42). Other elements, aside from the legs which are marked by similar influence, conform well to the Tracy model—the fanned spindles, the post turnings, the tipped stretchers, and the seat. Although the seat bears an exaggerated front profile with a prominent projection at the center, internal leg construction and the absence of a groove outlining the spindle platform are in keeping with Tracy practice and that of some Rhode Island chairmakers.

A modification of the same knuckle arm in another group of sack-back chairs introduces a normal front overhang (fig. 6-129). Here, however, there is a radical departure in the turned work. While balusters are collarless and flare at the top, there is no chance of mistaking them for Tracy work. The presence of thin wafers or disklike rings in the turnings is reminiscent of Rhode Island design (fig. 6-43). Close inspection of the arm-post tips also reveals an affinity with the same element in figure 6-49. Like the previous chair, spindle placement conforms well to the Tracy idiom. The oval cottonwood seat (genus *Populus*) with its internal leg construction exhibits a slight rise at the front corners replacing the characteristic droop of the Tracy seats at these points. Common to many though not all oval planks of the border region is the pronounced step, or drop, just forward of each arm post. Characteristically, the stretcher profiles are "lumpy" at the center. At least half a dozen chairs of this pattern or a variation are known.

An arm variant of long, lean, stylized form is present in several chairs of record, including a high-back Windsor (fig. 6-130). The small knuckles, formed completely from the single thickness of the rail, have tiny carved volutes on either face comparable to those of the crest. Like Tracy work, the seat edges are flat with a slight cant, but they lack the undercut pommel at the center front. Because the leg design is close to that of Amos Denison Allen's sack-back Windsor (fig. 6-98), the supports may represent a purchase from the Allen shop. While the leg turnings appear at odds with the arm posts, there is a close affinity in the rings. An almost identical medial stretcher occurs in a Rhode Island chair (fig. 6-23). A sack-back Windsor with arms of this type has turnings that are totally different; the stretchers end in long, slim, conelike tips comparable to those of figure 6-54.

Fig. 6-130 High-back Windsor armchair, New London County, Conn., 1790–1800. H. 42½", (seat) 16⅛", W. (crest) 24⅞", (arms) 28¾", (seat) 20¹³⁄₁₆", D. (seat) 15¾". (Henry Ford Museum and Greenfield Village, Dearborn, Mich.)

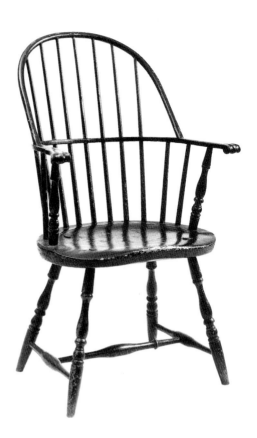

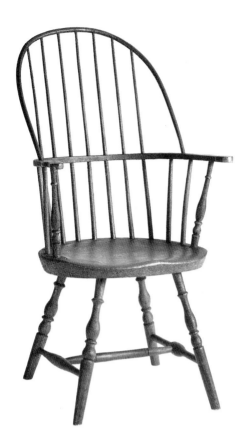

Fig. 6-131 Sack-back Windsor armchair, Connecticut-Rhode Island border region, ca. 1785–95. White pine (seat); H. 38¾", (seat) 16¾", W. (arms) 25¼", (seat) 21½", D. (seat) 15¾". (Russell Ward Nadeau collection: Photo, Winterthur.)

Fig. 6-132 High sack-back Windsor armchair and detail of arm terminal, Connecticut-Rhode Island border region, ca. 1790–1800. White pine (seat) with maple and oak (microanalysis); H. 41¾", (seat) 17⁵⁄₁₆", W. (arms) 24½", (seat) 21", D. (seat) 16½"; medial and left stretchers old replacements. (Winterthur 65.3027.)

Long sweeping knuckles of still another form are found in a group of sack-back chairs all interrelated through the arms and/or the conelike tips above the balusters (fig. **6-131**). Family background and identifiable owner's stamps place the chairs in southeastern New England. Some grips flare broadly at the front and occasionally form an angular sweep along the outside edge. One chair with a top extension crowned by a hook-end crest also has Tracy-style sack-back arm posts. In some chairs the legs socket internally and the spindle platform is without a groove. Here, short delicate balusters curve and flare like those found in postwar Rhode Island work (figs. 6-18, 6-19); the large heads are repeated in the spool caps. Two rings below the spool turnings—one thick, one thin—form an unusual feature. All elements are modified visually by the presence of a long, straight-sided cone at the support tops, possibly a holdover of prewar Rhode Island design (figs. 6-1, 6-6, 6-47). Other features that link these chairs to the border region are the hollow arch of the seat front and the narrow chamfer around the plank bottom.

Figure **6-132** pictures a chair of comparable leg but naïve interpretation. Above a baluster of similar profile, the cone-shaped articulation with the seat has been inverted. Below the baluster, spool and ring unite to form a small, compressed secondary baluster. In another sack-back chair of obvious kinship a disklike ring separates the compressed baluster from the tapered foot, as in the prototype. In a third chair, the support turnings are reduced to a compressed baluster between a long foot and an elongated cone. Two of the three braces in the present Windsor have been replaced; only the swelled stretcher at the right is original. The oval seat, a fairly standard slant-sided plank like that of figure 6-130, occurs with some frequency along the Connecticut-Rhode Island border. A groove surrounds the spindle platform, and the legs pierce the top surface. In other construction large wooden pins driven into the plank sides secure the legs and posts; three can be seen in this view. The leg turnings are duplicated in the arm posts, although the primary baluster is drawn out to almost unrecognizable form. The asymmetrical arm pads, which are similar to a Rhode Island shape (fig. 6-24), probably represent a provincial interpretation of the oxbow sidepiece frequently seen in the work of that state. Bow height is about midway between that of a standard chair and the tall Windsors illustrated in figures 6-37 and 6-101.

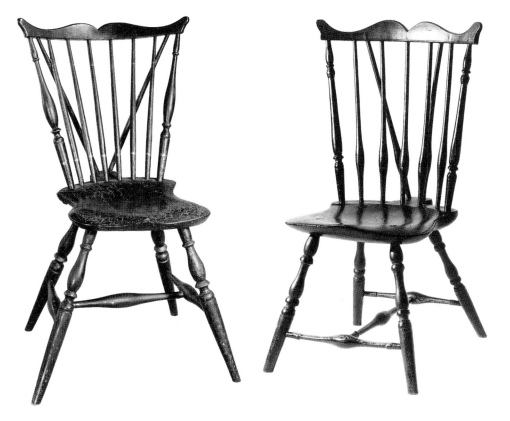

Fig. 6-133 Fan-back Windsor side chair, southwestern Rhode Island, 1785–95. Maple (throughout); H. 34", (seat) 17⅝", W. (seat) 15¹⁄₁₆", D. (seat, without extension) 18½". (Mabel Brady Garvan Collection, Yale University Art Gallery, New Haven, Conn.)

Fig. 6-134 Fan-back Windsor side chair (one of four) and detail of seat extension, Connecticut-Rhode Island border region, 1790–1800. H. 36⅛", (seat) 16⅛", W. (crest) 22", (seat) 17⅝", D. (seat, without extension) 15½". (Private collection: Photo, Winterthur.)

A small number of fan-back Windsors with variable individual elements share a distinctive crest that occurs in both Connecticut and Rhode Island contexts. The most sophisticated chair of the group, probably the prototype for the others, almost certainly had its origin in Rhode Island (fig. 6-133). It is constructed entirely of maple, and its shield-shaped seat, deeply incut at the sides, is identical to the chestnut plank of figure 6-25. The coffinlike back extension supports a pair of bracing spindles whose broad V visually dominates the chair's upper structure; the wide angle is comparable to the back profile of another Rhode Island chair (fig. 6-50). The pointed-end, double-ogee crests of both are mature variants of earlier Rhode Island top pieces (figs. 6-16, 6-22), which probably derive from a common source in joined seating. Profiles generally comparable to those in the medium-length, full-swelled post balusters are found in other Rhode Island chairs (figs. 6-41, 6-52); balusters with large heads similar to those in the legs appeared shortly after the Revolution (fig. 6-20). Other Rhode Island features within the group include forward scroll arms, swelled and double-tapered feet, and a medial stretcher related to the ball-type braces of the early S-post chairs (fig. 6-16).

Although a group of chairs (fig. 6-134), four with Connecticut provenances, deviates somewhat from the maple Windsor of figure 6-133, there is no mistaking the general relationship. The new leg profile is close to that of figure 6-131 from the baluster through the ring. The unusual placement of the tipped stretchers is original. One chair, the only Windsor in the group without bracing spindles (removed?), was in the Philadelphia collection of J. Stogdell Stokes in 1928. The wide shield-shaped seats, although boxy, exhibit a good rise that forms a front pommel; the legs pierce the top surface. The spindle platform is well defined and elevated but has no encircling groove. Four chairs, presumably a set, have a large tab-shaped back extension that is continuous with the plank. The projection in a sixth chair is similar in shape and size but consists of a separate piece of wood attached to the plank by means of a long wedge-shaped spline visible on the bottom surface. Chair backs support crests of exaggerated ogee profile with a bead along the lower edge and rounded-point tips larger than those in Rhode Island seating (fig. 6-22). The prototype for the center curves is a rush-bottom corner chair (fig. 6-135), or related seat, of regional origin. Rhode Island construction is manifest in the center butt joint of the arm rail and the short, ogee-tipped crest. The sticks of the extension are

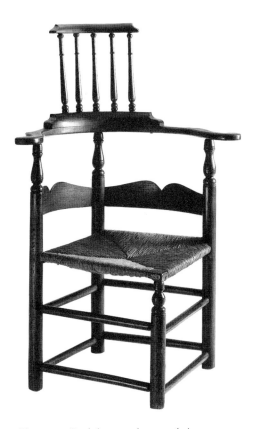

Fig. 6-135 Rush-bottomed corner chair, Connecticut-Rhode Island border region, 1790–1800. Maple, ash, and poplar (micro-analysis); H. 42½", W. 28⅞", D. 27¼". (Winterthur 66.1203.)

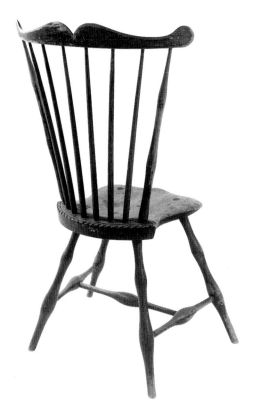

Fig. 6-136 Fan-back Windsor side chair, Connecticut-Rhode Island border region, 1800–1805. (Photo, Allan L. Daniel.)

comparable to those in the three-spindle backs of early Connecticut rush-seated chairs originating in the coastal area between Branford and Saybrook. The same exaggerated double-ogee cross slat is found as an inverted stay rail in other rush seating, including a banister-back chair with a family history in Guilford. Windsors in the double-ogee-crest group have both even and odd numbers of spindles. Those with swelled sticks appear to employ only an odd number, the center member positioned directly below the depression where the ogee curves meet.[120]

A crest variant introduces to the double-ogee profile (occasionally to just a plain arch) uncarved, round-end terminals of the type employed by the Tracy family (fig. 6-104). Spindles vary from plain to swelled sticks. The shield-shaped seats are distinctive: deep incuts are near the back corners, the forward corners droop, a circular depression marks the upper surface, and the spindle platform lacks a groove. The forward legs frequently are set so close together as to give the chair a pinched appearance; many stretchers are tipped. One chair is branded "Z. STORRS" in serif letters on the seat bottom. The name, which may be a later addition, is common in Connecticut, although the initial *Z* occurs in the state census only from 1830. The surname is an occasional one in Rhode Island census records.[121]

Slightly later a round-end ogee crest embellished the tops of a few fan-back chairs in the bamboo style (fig. **6-136**). Here, the small seat duplicates that of figure 6-133. Legs and posts are slim and stylish with three distinct grooveless swells, the third occurring where the supports enter the seat. The roundwork tenons through the plank, and a groove encloses the platform supporting spindles and posts. A second distinctive feature, which vies for attention with the unusual crest, is the gouge-carved seat back. Gougework is rare in Windsor seating and is usually confined to a repeating "thumbprint" on the bow faces (fig. 6-89). Here, cuts made on the diagonal produce an effect comparable to gadrooning. Traces of old red and blue paint remain on the surfaces. The sweep of the crest ends recalls a profile found in Hartford work (figs. 6-187, 6-189), demonstrating once again the migratory nature of chair design and the difficulties inherent in developing criteria for regional identification.[122]

As unusual as the preceding chairs is the braced fan-back Windsor illustrated in figure **6-137**. The two views exhibit the several distinctive features of the chair, front and back. The baluster profile of the back post closely follows that of figure 6-134 below the cap, while the shaped surfaces of the long, narrow basswood seat show considerable influence from Rhode Island design. A prominent ridge extends backward from the pommel, and a chamfer marks the rear edges, including those of the unusual flared seat projection supporting broadly angled bracing sticks. The seat extension profile is reminiscent of the central crown or base element of Chippendale-style looking glasses. At least one other fan-back Windsor of related though not identical form has a similar extension. That chair shares the same crest terminated by sharply angular, projecting carved tips; a third chair of similar top profile has a standard coffin-shaped seat extension. The turnings of a tall high-back armchair, the crest identical to the one illustrated, are sufficiently alike to suggest that it may have originated in the same shop. There is, in fact, an entire group of Windsors whose crests feature squared, projecting "ears"; the illustrated example represents just one variety. Potential prototypes are seen occasionally in vase-back, rush-bottomed chairs and even in English Windsor seating, but the feature is most common in formal chairs. In painted seating plain terminals are more common than the grooved faces of the illustrated Windsor. The two broad channels defining the tips can be compared with those of the joined chair in the background of a Denison family portrait painted in the early 1790s at Stonington, Connecticut (fig. **6-138**).[123]

Linking the chair of figure 6-137 with two seemingly unrelated examples (figs. **6-139, 6-140**) are unusual and distinctive spindles shaved to extremely narrow tips, top and bottom, which flank a long, low-centered swelled section. Figures 6-137 and 6-139 show a further relationship in the turned elements of their support structures, and both, the latter especially, relate in the same turnings to the ogee-crested chair of figure 6-133.

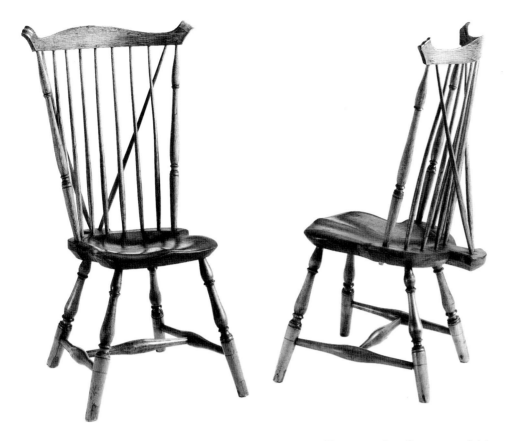

Fig. 6-137 Fan-back Windsor side chair (two views), Connecticut-Rhode Island border region, 1790–1800. Basswood (seat) with maple, oak, ash, and hickory (microanalysis); H. 36⁹⁄₁₆″, (seat) 15½″, W. (crest) 22¼″, (seat) 13¹³⁄₁₆″, D. (seat, without extension) 16¼″. (Winterthur 65.1613.)

Long, narrow, shield-shaped seats of deep, oval, saucerlike top surface form part of this unusual bow-back group. The thick planks are canted sharply at the front and sides, while the back has a flat-chamfered profile. The wood is genus *Populus*, the same unusual material found in a sack-back chair (fig. 6-129). Before its acquisition for the Winterthur collection, someone reworked the tops of the front legs and cut down the rear tapers, probably to reduce the seat height. The rear leg tops, which are intact, are of short vase form terminated by a large ring at the plank, as illustrated, a feature common to this

Fig. 6-138 Denison limner, *Miss Denison of Stonington, Connecticut*, ca. 1790. Oil on canvas; H. 34½″, W. 27⅛″. (National Gallery of Art, Washington, D.C., gift of Edgar William and Bernice Chrysler Garbisch.)

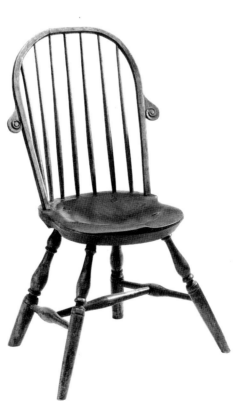

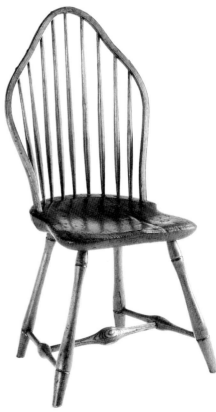

Fig. 6-139 Bow-back Windsor side chair and detail of leg top, Connecticut-Rhode Island border region, 1795–1805. Cottonwood (seat) with maple, oak, and hickory (microanalysis); H. 34⁹⁄₁₆″, (seat) 15⁹⁄₁₆″, W. (seat) 14⁵⁄₁₆″, D. (seat) 16½″. (Winterthur 64.1173.)

Fig. 6-140 Bow-back Windsor side chair, Connecticut-Rhode Island border region, ca. 1798–1805. Yellow poplar (seat) with maple, oak, and ash (microanalysis); H. 36¹⁄₁₆″, (seat) 15⅜″, W. (seat) 15¾″, D. (seat) 16″. (Winterthur 64.1922.)

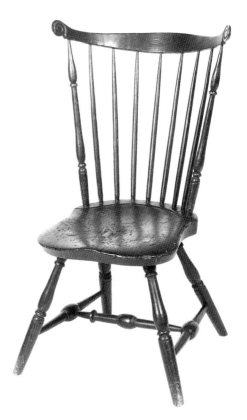

bow-back group. The rings serve as "stops" to prevent the legs from working their way above the top surface. The chair is also one of only a few whose rear legs are turned to a heavier diameter than the front supports. The major focus of this group is the chair back with its eccentric, pendent, earlike scrolls. These embryonic appendages are shaped from the same piece of wood that forms the bow; the projections are flush at the back and inset at the front. The volutes are carefully, though not expertly, carved, and the bow face lacks beads or other markings. The contrast between the naïve design of the backs and the proficient turning of the supports may indicate a semiskilled workman's purchase of specialized parts (the turned undercarriage) to combine with elements of his own making.

The spindle-focused relationship of the two previous chairs continues in a Windsor of wavy bow form (fig. 6-140), one of a small group whose common bond is a multicurved back. The chairs vary considerably; few have spindles or bamboo legs of the illustrated profiles. The present chair has been exposed to general wear in the legs and has undergone substantial repair, including a center spindle replacement. The support pattern is not too different from one used by the Tracys (fig. 6-110). The trilobed bow with its flat, beaded face is found in at least four other side chairs, comprising both bamboo- and baluster-leg examples. An armchair of trilobed form with a broad back, forward scroll arms, and bamboowork was once in the Stokes collection. Models for the unusual wavy back are found in English design books and fashionable neoclassical work by both British and American joiners.[124]

A fan-back Windsor (fig. 6-141) whose medial and side stretchers are centered by precise, oval turnings and sharply defined rings of Rhode Island design serves to introduce the armchair that follows. The side chair's lean baluster profile with its thick neck resembles that of figure 6-137. The posts are of comparable silhouette, and the elongated teardrop at the top relates to the same work. A distinctive crest feature is the sweep-carved terminals, an uncommon Rhode Island pattern that occurs in a pair of tall chairs (fig. 6-55).

The legs and ball-defined stretchers of the fan-back chair (fig. 6-141) relate to the understructure of a bold sack-back armchair (fig. 6-142). Above a broad, oval basswood seat in the eastern Connecticut style (figs. 6-100, 6-101), the post turnings follow another regional pattern (fig. 6-131), allowing for some variation. Vigorously swelled, fanlike spindles recall other sack-back work of the border region (figs. 6-128, 6-129). However,

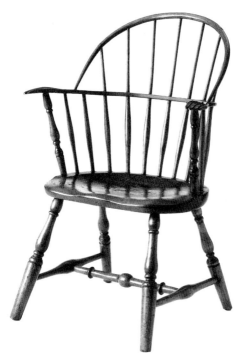

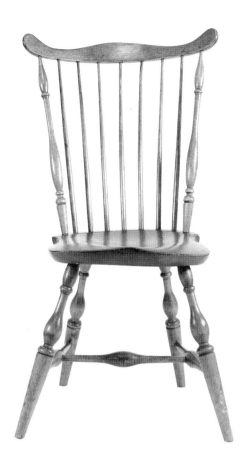

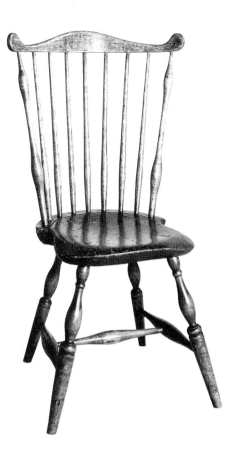

Fig. 6-143 Fan-back Windsor side chair, Connecticut-Rhode Island border region, 1790–1800. Yellow poplar (seat, microanalysis) with maple and other woods. (Webb-Deane-Stevens Museum, Wethersfield, Conn.)

Fig. 6-144 Fan-back Windsor side chair, Connecticut-Rhode Island border region, 1795–1805. Maple and other woods; H. 37″, W. 21″. (Mabel Brady Garvan Collection, Yale University Art Gallery, New Haven, Conn.)

the outstanding feature of this chair is the design of the arm terminals, which suggests a human hand. The arms were fashioned in this manner originally, as confirmed by the continuity of wood fibers from the "hands" to the rail and the extra depth in the knuckle area. As unusual as the feature may seem, it is not unique. Another chair in the market some years ago has similar "hands." Fingers extend back to the post tops, and fingernails define the tips. A third pattern, the fingers partially bent, terminates the arms of a Rhode Island chair closely related to that pictured in figure 6-51 and possibly from the same East Greenwich shop.[125]

A small Windsor group whose distinctive feature is a thin, compressed spool beneath the leg balusters embraces a sufficient number of Rhode Island and eastern Connecticut elements to preclude unequivocal placement in either area. The first, and classic, representative is a fan-back chair in the full baluster style (fig. **6-143**). Turnings could indicate either a Connecticut or Rhode Island origin. The long, full-swelled leg balusters resemble those of a Rhode Island sack-back chair (figure 6-51), while the large baluster caps are not unlike those in a chair labeled by William Harris, Jr., of New London (fig. 6-165). The source for both features may lie in a Rhode Island example, such as figure 6-28. The long, stylish post balusters and swelled upper members have much in common with a Rhode Island side chair of the same type (fig. 6-62); the similarity extends to the crests and to the profile and contour of the yellow poplar seats. The feature that sets this chair and others in the group apart from contemporary work is the spreading, collarlike spool below each leg baluster. The manner in which the spool flares outward and covers the top of the well-rounded ring beneath it recalls the Connecticut work of Ebenezer Tracy (fig. 6-103, left).

Several other fan-back chairs fall into this group. One has a braced back with a coffin-type seat projection. A sack-back chair and two high-back chairs with writing leaves, one recovered in Windham, Connecticut, are also part of the group. The Windham chair has a tradition of ownership in the Leffingwell family, whose members were concentrated in New London County through 1810. Another fan-back Windsor advances the collared spool design to the early bamboo period (fig. **6-144**). The chair is a transitional type,

New England, 1750 to 1800 315

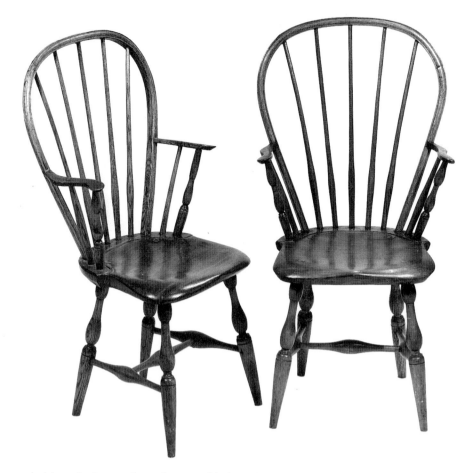

Fig. 6-145 Bow-back Windsor armchairs (pair), Connecticut-Rhode Island border region, 1795–1805. (Photo, Nathan Liverant and Son.)

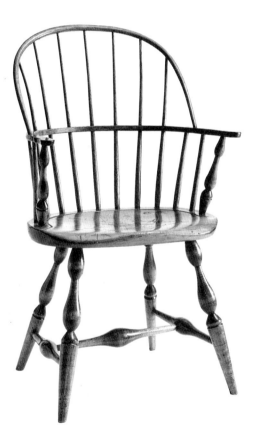

Fig. 6-146 Sack-back Windsor armchair, Connecticut-Rhode Island border region, 1795–1805. Maple and other woods; H. 37¼″, (seat) 17½″, W. (arms) 22⅞″, (seat) 21¼″, D. (seat) 14¾″. (Private collection: Photo, Winterthur.)

and although the turnings above and below the seat do not relate, that circumstance is not atypical of the period. While the legs vary in particular form from the previous side chair, the two support structures correspond in general character. The present crest terminals are shaped with a mere suggestion of a hook. This feature is better defined in another distinctive regional chair (fig. 6-167) with a corresponding sweep between the crest ends.

Two armchairs, which perhaps are unique, fall into this sequence, even though the work has little in common with other examples aside from the spool treatment (fig. **6-145**). The chairs were recovered in Glastonbury, Connecticut, a quarter century ago, although several features speak to a Rhode Island origin. The planks have flat-chamfered backs. The abrupt, collarless transition between the baluster and leg tops appears on early postwar Rhode Island work (fig. 6-31) but has its roots in prerevolutionary design (fig. 6-11). That feature in eastern Connecticut is generally accompanied by a short, full baluster (figs. 6-168, left, and 6-173) rather than the elongated form illustrated. Short post balusters appear in Rhode Island work by the late 1780s (figs. 6-48, 6-54). Here, the turnings support delicate, almost embryonic, tenoned arms that derive from chairs like the lath-post Windsor (fig. 6-23) or a bow-back of more conventional pattern (fig. 6-91). The chamfered pads relate directly to Rhode Island and New York continuous-bow work. Connecticut craftsmen, including the Tracys, seem to have made much less use of this subtle shaping device. Were it not for the presence of peculiarly shaped bows, small high-mounted arms, and the spare use of long spindles, these chairs would be relatively orthodox in appearance. As it is, they are distinctive, the effect heightened by the mixture of eclectic elements.

Daring in concept yet basically simple in pattern are the turnings of a sack-back chair assigned to the current group (fig. **6-146**). Although recovered in Worcester County, Massachusetts, the chair straddles the line between work identified with Connecticut and Rhode Island. This example may even extend the range of mixed influence north into Worcester County. The bold maple roundwork has been reduced at the baluster ends to delicate, collarless diameters, yet the craftsman knew his material because the

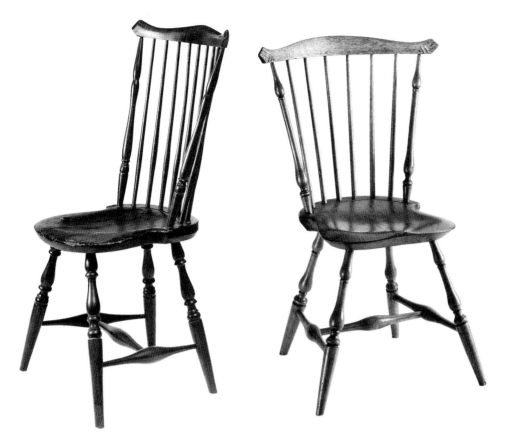

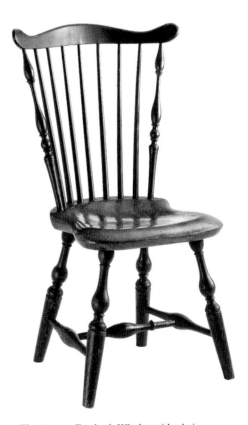

Fig. 6-147 Fan-back Windsor side chair, Connecticut-Rhode Island border region, 1790–1800. Maple and other woods; H. 39", (seat) 17¾", W. (crest) 20¾", (seat) 15", D. (seat) 17¾"; bears suspect brand "W. M. WHITE" in four impressions. (Private collection: Photo, Winterthur.)

Fig. 6-148 Fan-back Windsor side chair, Connecticut-Rhode Island border region, 1790–1800. Yellow pine (seat) with ash, oak, and maple (microanalysis); H. 35½", (seat) 17³⁄₁₆"; W. (crest) 27⅝", (seat) 15¾", D. (seat) 15⅝"; spurious brand "S. O. PAINE." (Winterthur 75.68.)

supports have withstood the test of time. Replacing the well-defined collar and ring above the foot is a cone-shaped element that reduces the more complex profile of the previous chair to basic terms. In the simple termination of the "mitten"-shaped arms, the Windsor relates to the Connecticut work of the Tracy family (fig. 6-98).

Another sequence appropriate to a discussion of border work is illustrated in figures 6-147 and 6-148. These fan-back side chairs share similar crest terminals and chamfered rear plank edges, but otherwise they are different. Following Rhode Island practice, figure 6-147 draws its design from many sources. The diamond-pointed crest may originate in rush- and splint-bottom seating. The next most obvious feature, the post pattern with a baluster-to-baluster articulation, occurs in rush- and plank-bottom seating produced in the Stonington-New London area (fig. 6-176). The compressed spool turning below the long baluster compares well with elements in the legs of two Rhode Island chairs (figs. 6-58, 6-63). The legs are close in profile to those of figures 6-131 and 6-134, and still other prototypes are found in two Rhode Island Windsors (figs. 6-18, 6-19). A coastal Connecticut fan-back chair (fig. 6-173) shares a similar rounded, shield-shaped seat.[126]

The addition of grooved ornament to the diamond tips (fig. 6-148) deceptively alters the pattern by emphasizing an upward rather than horizontal thrust and is closer in concept to the top piece of figure 6-137. That chair also has a flat-chamfered plank edge. The present example borrows a classic turned leg baluster from New London-area work. At the top of this element is an unusual, close-fitting collar. Below the baluster the combination of a flaring spool and undercut ring speak of Rhode Island influence (figs. 6-20, 6-87). The well-formed shield-shaped plank with legs socketed inside is of yellow pine, a wood mentioned from time to time in southeastern New England records. Among related chairs, most of which display plain ungouged tips, are other identifiable characteristics. A high-back chair has wide, spreading arms in the manner of work executed by the Shipmans, uncle and nephew, who probably trained in the Saybrook area (figs. 5-24, 6-247); a high-back rocking chair has a cone-tipped medial stretcher.[127]

Figure 6-149 shares with the side chair of grooved, diamond crest an identical spool turning in the legs. Other Connecticut-Rhode Island links include a basswood seat of

Fig. 6-149 Fan-back Windsor side chair, Connecticut-Rhode Island border region, 1790–1800. Basswood (seat) with maple (micro-analysis) and other woods; H. 35⅜", (seat) 16⅛", W. (crest) 21¼", (seat) 17⅜", D. (seat) 16¹⁄₁₆". (Private collection: Photo, Winterthur.)

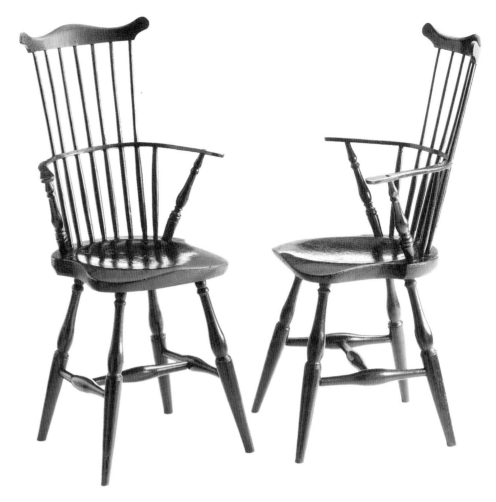

Fig. 6-150 High-back Windsor armchairs (pair), southwestern Rhode Island, 1790–1800. White pine (seats) with birch, maple, beech, oak, chestnut, and hickory (microanalysis); H. 38⁹⁄₁₆″, (seat) 18⅞″, W. (crest) 14⅛″, (arms) 19⅝″, (seat) 14⅝″, D. (seat) 15¾″. (Winterthur 59.1395, .1396.)

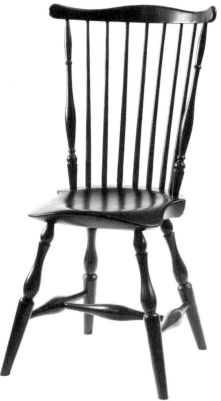

Fig. 6-151 Fan-back Windsor side chair (one of four), Connecticut-Rhode Island border region, 1790–1800. Yellow poplar (seat) with maple and other woods; H. 39¼″, (seat) 18¼″, W. (crest) 21″, (seat) 16⅛″, D. (seat) 15¹⁄₁₆″. (Historic Deerfield, Inc., Deerfield, Mass.: Photo, Winterthur.)

broad, spreading front with counterparts in fan-back chairs of comparable crest and back post. The long, hollow-sided back-post cones common to these chairs are also present in a Rhode Island fan-back Windsor (fig. 6-67). The ball turnings above them provide a link with coastal Connecticut chairmaking (fig. 6-170). This feature also occurs above short, hollow tapers in a side chair of large, oval-ended crest at the New London County Historical Society.

As suggested by figures 6-125 and 6-146 and to be demonstrated again in a Windsor group with unusual double-swelled leg elements (figs. 6-166, 6-167), simple turnings frequently coexisted with traditional work along the northeastern Connecticut border. A plain pattern places a large baluster almost directly on a heavy, tapered foot (fig. **6-150**). In contrast, the arm posts exhibit a standard sequence of elements. The illustrated chairs are far from ordinary in other respects. Their small, delicate size suggests they are youths' chairs. The seats are deep and narrow, less than fifteen inches in breadth at the widest point, and yet they stand more than eighteen inches off the floor at the pommel. Seats with flat-chamfered backs and blunt fronts are a regional type (figs. 6-30, 6-104), and the flaring spools and rounded baluster caps of the arm posts provide another regional link (figs. 6-49, 6-144). The entire upper structure is small, from the diminutive pad arms to the short rise of the back crowned by a top piece with projecting, tab-shaped terminals in the manner of New London work (fig. 6-176). Use of a side-chair plank, which confines the arm assembly to the back of the seat, contributes to the effect. The presumed Rhode Island origin of the chairs is further reinforced by the use of white pine for the seats and birch for the legs. Although this combination occurs frequently in Boston and southeastern Massachusetts, the use of chestnut for the arm rails of one chair (hickory for the other) points to a more southerly New England provenance.

Another molded foot-and-baluster articulation appears in a set of four fan-back Windsors (fig. **6-151**). The prominent elongated tulip shape may relate to Tracy family turnings (fig. 6-98), but the prototype for both probably lies in Rhode Island work, such

as the long baluster of the S-post chair (fig. 6-16). The front seat rise corresponds well to that of the previous pair of chairs and the work of Elijah Tracy (fig. 6-104). Unlike Tracy design, however, the legs pierce the top of the yellow poplar plank, and a groove defines the spindle platform. A second positive relationship to Tracy work is seen in the long, tapered swell of the post; below that point the turnings resemble those of figure 6-143. A single side chair almost exactly duplicates this set of four in line and shape, with one exception: Beneath the leg baluster the molded taper top is replaced by a compressed, close-fitting collar and a thick, ball-like ring, forming an articulation identical to that of figure 6-144. A bow-back side chair identifies the tulip-shaped baluster with still later work.

The Windsors illustrated in figures **6-152** and **6-153** interrelate significantly with chairs produced in Connecticut and Rhode Island, so it is appropriate to study them in a border context. Both exhibit exceptionally bold turned work linked by feet of blocked pattern. Two features of the side chair suggest an eastern Connecticut provenance, the swelled spindles and the roundwork above the feet. Comparison of the latter with the work of Beriah Green (fig. 6-118, right) reveals a marked similarity. Although sharply tapered feet are not known in documented work of the Norwich area, they occur in a border chair with slim, flaring balusters of the type found in figure 6-151. The present chair seat is deeply chamfered at the lower back edge, and neither a groove nor leg tips mark the upper surface. The bow face is molded with an unusual pattern, consisting of a broad, shallow channel at the center and a double bead at either side.

In time a chairmaker combined the blocked foot with bamboowork (fig. 6-153). Eastern Connecticut influence marks the leg turnings, whose hollow midsection is reminiscent of the first bamboo pattern used by the Tracy family (figs. 6-109, 6-114, left). A similar comparison can be drawn with the border chair illustrated in figure 6-156. In addition, that Windsor introduces a blocked swell in the back posts at arm level. Although a blocked bamboo turning is potentially awkward, the work here coordinates perfectly. The chairmaker has kept the design under control by carefully alternating hollow and blocked areas to maintain lightness. Even the stretchers continue the rhythm of the vertical members. The modeling of the pine plank is not as successful, however. Like the previous chair, the front lacks sufficient breadth to adequately balance the strong back curve. The same peculiarity is seen in other chairs of this pattern. Another weak point is the design of the back. The long end spindles are awkwardly angled in relation to both the adjacent spindles and the bow. Overly squared bends cause the elbows to hang in space without sufficient appearance of support. A continuous-bow chair of Rhode Island origin also is squared in the back (fig. 6-82), although not to the same degree. The flat bow face is common throughout southeastern New England, but the shallow, one-piece knuckles derive from Rhode Island work (figs. 6-85, 6-86). With their stepped-out sidepieces the terminals are similar to those in a sack-back border chair (fig. 6-131). An otherwise identical armchair has flat terminals of the general pattern illustrated in figure 6-40.

A set of six bow-back side chairs (fig. **6-154**, pl. 8) constructed of white pine, birch, and ash subtly extends the use of blocked detailing. Rhode Island influence is visible in the chamfered back and ridged pommel of the seat. The flat-faced bow with scratch

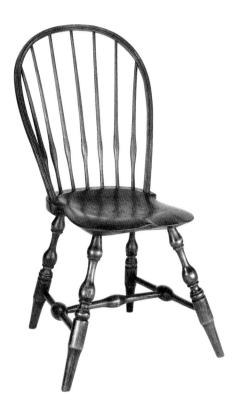

Fig. 6-152 Bow-back Windsor side chair, Connecticut-Rhode Island border region, 1795–1800. (Former collection J. Stogdell Stokes.)

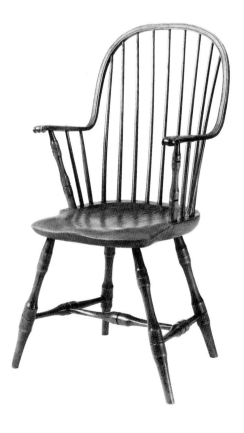

Fig. 6-153 Continuous-bow Windsor armchair, Connecticut-Rhode Island border region, ca. 1798–1805. White pine (seat, microanalysis) with maple and other woods; H. 37⅞″, (seat) 17¼″, W. (arms) 21⅛″, (seat) 17⅜″, D. (seat) 17½″. (Private collection: Photo, Winterthur.)

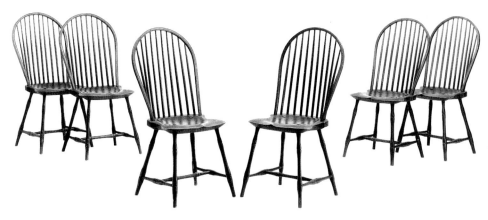

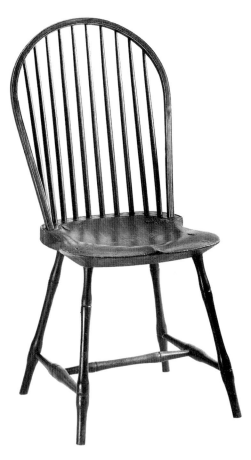

Fig. 6-154 Bow-back Windsor side chairs (set of six), Connecticut-Rhode Island border region, ca. 1797–1805. White pine (seats) with birch and ash (microanalysis); H. 38″, (seat) 17¼″, W. (seat) 16¾″, D. (seat) 16³⁄₁₆″. (Winterthur 69.1563.1–.6.; dimensions given are 69.1563.3.)

beads at the edges encloses ten slim spindles, an unusually large number for a side chair, and one that is also distinctive because the sticks are even numbered rather than odd. Another rare feature is the presence on all surfaces of the original painted finish, which has not been obscured by later coats. Applied to the turned work, sticks, bow, and spindle platform is a vivid Prussian blue (now dulled and darkened by the aged, original varnish). Seat surfaces were painted in Venetian red covered with medium light umber and finally treated with red and brown glazes to form a bold looping pattern. Henry Francis du Pont bought this set of chairs in 1929 directly from the American Art Gallery auction of the Frederick W. Ayer collection of Bangor, Maine. In recent years a set of eight, almost identical, ten-spindle chairs said to "retain traces of blue and red paint" emerged from another New England collection to be sold at auction. The blocked work of the turnings in those chairs is not as prominent as that illustrated.[128]

The elements of a tall, fan-back armchair (fig. **6-155**) represent a whole vocabulary of design. Recovered in Williamstown, Massachusetts, the chair possibly was carried there in the early nineteenth century directly from its place of origin along the Rhode Island-Connecticut border. Nothing in the chairmaker's choice of elements or their combination is ordinary; he selected them indiscriminately from both Rhode Island and Connecticut sources. Beginning at the top, the "hook" terminals of the crest stretch outward on narrow necks like those in a fan-back border chair (fig. 6-144). Supporting the top piece are posts whose design relates to the same chair. The flared element above the ball turning reverses the baluster profile of the legs in figure 6-151. Arm posts are miniature versions of the tall back posts, modified by a spool and ring in place of the ball. The inverted pipe-shaped arms may be unique in Windsor-chair making, probably "interpreted" from an earlier rush-bottomed prototype. To form the seat the chairmaker sawed a thick, straight-sided oval slab, saucered the top surface, shaped the front in an undulating sweep of curves rather like those in figure 6-30, and socketed the legs inside. Below the seat the legs exhibit some variability of size; the left front baluster almost shares a profile with figure 6-151. Feet taper twice in the Rhode Island manner, and side stretchers reflect the Tracy school of chairmaking with their compact, blocked oval centers and rounded tips (figs. 6-99, 6-107, left). The straight tapered tips of the medial stretcher represent a Rhode Island influence (fig. 6-62).

The distinctive and cohesive feature of a seating group represented by figure **6-156** is the slender, serpentine crest with upturned ends terminating abruptly in flat tips. Most terminals are plain; a few are gouge carved, as illustrated. The armchair is rare. Turned work in the side chairs ranges from the baluster to the bamboo style. In the former, the balusters generally are of medium length, the heads normal to large, and rounded. Occasionally, the tapered feet exhibit a slight swell. At least two early chairs are known to have chestnut seats. Another large subgroup mixes baluster and bamboo features. The long posts of a side chair in the full bamboo style are a modification of those in figure 6-144, while the illustrated armchair introduces blocked work in the central swells of the posts. Delicate, almost embryonic arms, which repeat the crest curves, terminate in blunt tips similarly gouged.

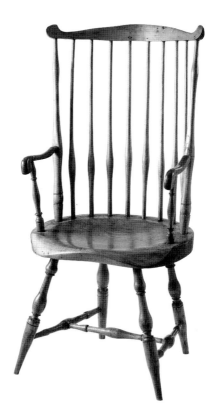

Fig. 6-155 Fan-back Windsor armchair, Connecticut–Rhode Island border region, 1795–1805. White pine (seat) with maple and ash; H. 41¼″, (seat) 15⅞″, W. (crest) 22″, (arms) 20″, (seat) 20⅜″, D. (seat) 14¾″. (William L. Hubbard collection: Photo, Winterthur.)

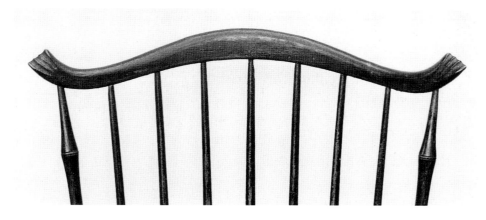

Fig. 6-156 Fan-back Windsor armchair and detail of crest, Connecticut-Rhode Island border region, ca. 1798–1808. H. 36⅝″, (seat) 17½″, D. (seat) 16⅛″. (Photo, Frank and Barbara Pollack.)

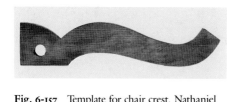

Fig. 6-157 Template for chair crest, Nathaniel Dominy V, East Hampton, Long Island, N.Y., ca. 1790. White pine; L. 9⅝″. (Winterthur 57.26.321.)

Two features of the armchair invite attention on stylistic grounds. The bamboo legs with their tapered feet and double-scored divisions are a New London County type that derives either from Tracy family work (figs. 6-109, 6-114, left) or from that of a chairmaker under their influence (figs. 6-117, 6-120). The crest is based on rush-bottomed chairwork indigenous to the area around Long Island Sound (fig. **6-157**). Although coastal Connecticut rush-seated chairs have crests in the double-ogee-and-lunette style, their curves and tips do not relate as well to the present Windsor as do those in chairs made by Nathaniel Dominy V of East Hampton (and probably other chairmakers on Long Island). The illustrated template is one that Dominy actually used. Curves from a similar Long Island-style crest may have had some bearing on the tops of other border chairs (figs. 6-133, 6-134), and on that of a tall Rhode Island Windsor (fig. 6-50). The geographic proximity of and ease of communication between Connecticut and Long Island have been noted.[129]

A ribbonlike crest of less vigorous curve occurs in a smaller group of Windsors (fig. **6-158**). The top piece can be completely plain, grooved at the tips in a pattern variation of the previous chair, or beaded at the top and bottom edges of the terminals, as illustrated. Like other characteristic border work, a single feature links otherwise diverse designs. Here, it is the crest. The broad shield-shaped plank with its thick front edge and slightly

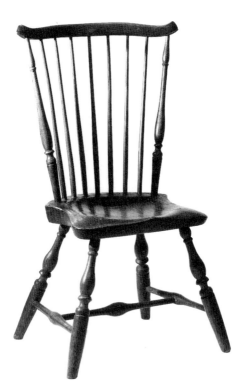

Fig. 6-158 Fan-back Windsor side chair (one of a pair), Connecticut-Rhode Island border region, 1790–1800. Pine (seat). (Philip H. Bradley Co.: Photo, Winterthur.)

Fig. 6-159 Rufus Hathaway, *Lady with Her Pets* (Molly Wales Fobes Leonard), Raynham, Bristol Co., Mass., 1790. Oil on canvas; H. 34¼", W. 32". (Metropolitan Museum of Art, New York, gift of Edgar William and Bernice Chrysler Garbisch.)

drooping corners has close mates in several regional chairs (figs. 6-127, 6-141, 6-150). The plank is grooved around the spindle platform, and the legs pierce the top surface. Related, although slimmer, roundwork with longer feet occurs in a small border chair (fig. 6-133). The posts also compare well, with the exception of the balusters. The seat of the same small chair relates in its vigorously contoured front edge to another side chair in this group, which has bracing spindles positioned in a similar wide V. That chair, like the one illustrated, has large, top-heavy spools on thick rings. Models are found in the Connecticut work of the Tracys (figs. 6-99, 6-101) and in an early Rhode Island side chair (fig. 6-19). A chair in this group with a plain unbeaded crest has bamboo legs turned in stylized single-groove modifications of those in the Knowlton family chairs (fig. 6-120). Bamboo turnings in a pair of chairs resemble the work of Beriah Green (fig. 6-119). Joined and rush seating with this crest was produced over a wide area of New England. In 1790 Rufus Hathaway delineated a formal chair of this type in his *Lady with Her Pets*, identified as Molly Wales Fobes (also Forbes) Leonard (fig. **6-159**) of Raynham, Massachusetts. The artist executed the work while he was living in neighboring Free-town, Bristol County, near Narragansett Bay.[130]

A set of four fan-back Windsors (fig. **6-160**) relates through the crest to a vase-back (or fiddle-back) rush-bottomed chair (fig. **6-161**) of a pattern that differs from the Long Island work just cited. The Windsor crest is unusual in its long, low upper curve and grooved, swept-back terminals. The features are duplicated from the rush-seated chair, which was once owned in Bristol, Connecticut, but more likely made in or influenced by work of the border region. When the vase splat is inverted—and it almost certainly was originally—its profile and that of the voids between the splat and posts are identical to the Milford, Connecticut, work of Samuel Durand I. The Windsor itself shares several independent links with the coastal region: the seat approximates the plank in the chair that follows; the balusters and upper leg elements almost duplicate those in a Rhode Island armchair (fig. 6-91); the large, round-headed spools and thin rings of the legs are part of the vocabulary of Rhode Island design (figs. 6-68, 6-88); and the feet bear a trace of a double taper. The bracing spindles form a wide V, just as they do in two other border-region chairs with projecting crest terminals (figs. 6-133, 6-137). Like those chairs the posts have long cone-shaped bases.[131]

A chair that appears to stand alone and yet is compatible with eastern Connecticut and Rhode Island design features a fanciful, although well executed, floret in the crest

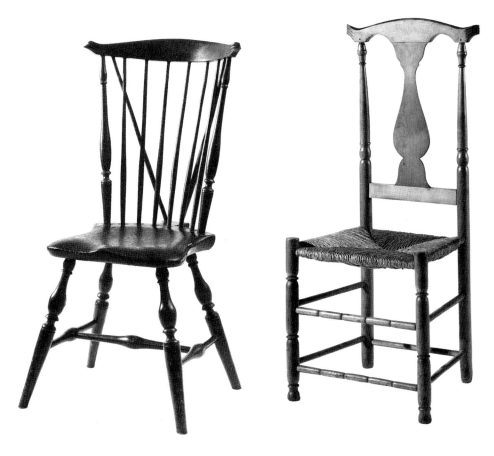

Fig. 6-160 Fan-back Windsor side chair, Connecticut-Rhode Island border region, 1790–1800. White pine (seat, microanalysis) with maple and other woods; H. 37¼″, (seat) 17¼″, W. (crest) 19¹³⁄₁₆″, (seat) 15⅞″, D. (seat, without extension) 14⅞″. (Historic Deerfield, Inc., Deerfield, Mass.: Photo, Winterthur.)

Fig. 6-161 Rush-bottomed vase-back side chair, Connecticut-Rhode Island coastal region, 1780–95. Maple; H. 41″, (seat) 16⅝″, W. (crest) 18⅛″, (seat) 18⅜″, D. (seat) 14⅜″. (Connecticut Historical Society, Hartford, bequest of George Dudley Seymour: Photo, Winterthur.)

scrolls (fig. **6-162**). Carved decorative embellishment of any kind other than a volute is rare in Windsor design. The tight lateral curve and long, low profile of the crest duplicates Rhode Island work (fig. 6-62). The bold posts are blocked through the long central turning in the manner of figures 6-115 and 6-143 and the previous "swept ear" Windsor. The seat of the latter also compares well with the present plank in outline and modeling. The full-bodied baluster turnings of the legs are typical of the border region (fig. 6-152).

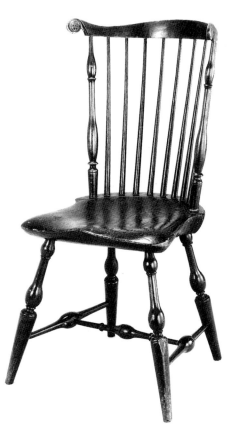

Fig. 6-162 Fan-back Windsor side chair and detail of crest scroll, Connecticut-Rhode Island border region, 1790–1800. (Photo, James Brooks.)

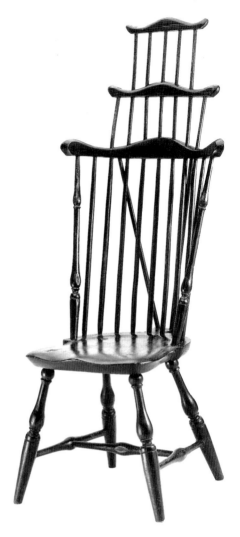

Fig. 6-163 Tall fan-back Windsor side chair, Connecticut-Rhode Island border region, 1790–1800. White pine (seat, microanalysis) and other woods; H. 52½", (to lower crest) 38½", (seat) 16¾", W. (lower crest) 21⅞", D. (seat, without extension) 17"; seat extension and back braces restored. (Private collection: Photo, Winterthur.)

A fitting climax to a review of border seating is a triple-tier fan-back Windsor of extraordinary height (52½ inches) and design (fig. **6-163**). The chair borrows heavily from regional Windsors. The three pointed crests, which are especially thick to accommodate the construction, seem to be turned inside out at the tips. Generally, such deep chamfering occurs on the back surface (fig. 6-176). The long-necked post balusters of small round body have counterparts in figure 6-148, where there is a good relationship between the leg balusters, as well. A comparable profile is illustrated in figure 6-145, and a Rhode Island chair may serve as the basic inspiration for all (fig. 6-20, arm supports). The under-arm turnings of the prototype also employ a crowned, stepped cap and budlike tip comparable to elements in the fan-back chair legs. In another relationship, the compressed, diminutive spool turnings of the legs compare well with those in the back posts of figure 6-147. No groove defines the spindle platform of the contoured white pine plank, but the legs pierce the top surface.

Central New London County

Aside from craftsmen who were directly or indirectly associated with the Tracy family, there are few identified Windsor-chair makers in the interior parts of New London County. One name to surface is that of Amos Wells, a cabinetmaker and chairmaker of Colchester who died in 1801 at age sixty-six. Only through his estate inventory compiled in January 1802 is Wells identified with Windsor-chair making. Besides a "New Cupboard," bedstead, and maple bureau on the shop premises, appraisers listed "18 New winsor Chairs." Wells owned a wide range of turning chisels and other hand tools necessary for Windsor-chair making. The absence of a turning lathe may indicate that the craftsman purchased his turned work from a specialist, or the machine may have been removed from the premises before the appraisal.[132]

More is known about the career of Gilbert Sisson of Bozrah Township, northwest of Norwich, and a specimen of his work appears in figure **6-164**. Sisson probably was new to the business in the 1790s when he constructed the sack-back armchair. He was born in Stonington in 1769 and married there in 1791. Town records list the births of children in 1800 and 1811. Based upon this information, Sisson's practice of chairmaking in Bozrah appears to be confined to the years between 1791 and 1800, if indeed he was there that long. His labeled Bozrah chair could well represent the local Stonington style. Upon returning to the town of his birth, Sisson apparently remained there until his death in 1840 at age seventy-one, except for several years during the early 1820s when he worked in Cooperstown, New York. The severe economic depression of that period must have driven the craftsman, like so many others, to look for greener pastures. The tremendous influx of settlers into the interior parts of New York during the first half of the nineteenth century made that area a good choice, particularly as the Erie Canal neared completion and segments opened to water traffic.[133]

The Sisson chair back recalls Tracy work, and the comparison extends to the "mitten" arm terminals. The seat bears some relationship to the work of Amos Denison Allen (fig. 6-98, center), who began his career in neighboring South Windham in 1796, although a closer model may exist in figure 6-130. Turnings are of independent design, except for the top-heavy spools, which occur occasionally in Connecticut-Rhode Island border work and in chairs made by Ebenezer Tracy (fig. 6-100). Balusters with thick, straight-sided necks and ball-shaped bodies are not common in New England chairmaking. The closest comparison is in the legs of Amos Denison Allen's continuous-bow chair (fig. 6-107, left).[134]

The Northeastern Coastal Region

New London in the late eighteenth century was a focus of the eastern Connecticut coastal and overseas trade; it served as a collection point for products drawn from the surrounding country, which brought a measure of prosperity to the local area. Upon occasion chairmakers from as far away as Hartford sent seating furniture to New London via the Connecticut River for transshipment to southern ports. The duc de La

Rochefoucauld Liancourt when traveling through the town in about 1796 remarked, "New London is reckoned the principal sea-port town in Connecticut." He observed that it "lies on the banks of the river [Thames], at two miles distance from the sea. Its principal street is a mile in length. The houses do not stand close together; but the intervals between them are small, and are every day more and more filled up with new buildings. An adjacent street . . . contains several considerable and handsome houses." The trade of New London and its near neighbor Norwich gave "an air of activity and animation to the whole country adjacent." Norwich ships generally loaded their cargos at New London.[135]

W. P. Ledyard is one of a half dozen or more names associated with Windsor-chair making in the area. Although his brand appears on several Windsors, he seems to have used the marking iron in the capacity of an owner-shipper rather than a craftsman. A continuous-bow chair bearing his stamp is of New York manufacture, and a sack-back chair may have originated in Rhode Island. William Pitt Ledyard was a son of Colonel William Ledyard, who died at Fort Griswold in 1781 during a bloody surrender to the British. William P., a resident of Groton on the Thames River opposite New London, was engaged in shipping foodstuffs and furniture at the end of the century. He resettled in Bath, Maine, after 1800 and continued to follow a mercantile career until his early death in 1812.[136]

Following regional and, indeed, New England practice, Oliver Avery pursued the dual trades of cabinetmaker and chairmaker, advertising both occupations in a Norwich notice dated 1781. Avery's book of accounts begins in 1789 when he was already in his early thirties and residing in North Stonington. There are entries for furniture from tea tables to chests of drawers as well as repair work and odd jobs. The craftsman appears to have made only a few chairs during the 1790s; the price range of 2s.6d. to 6s. describes principally rush-bottomed seating. Particular activity in Windsor-chair making did not begin for a decade or more. Even as late as 1813 Avery constructed a set of fan-back chairs, a good indication of the lingering popularity of the older style in semirural areas. From the 1790s through the following decade Avery spent a portion of his time working for other craftsmen, primarily at cabinetmaking. The artisan first began employment with Gilbert Sisson in May 1802 on an occasional basis; from November 1805 until August 1808 he worked almost fulltime in the Sisson shop, mostly under short-term agreements. Avery was still practicing his craft in 1831, the year his accounts end.[137]

A sophisticated bow-back Windsor chair from New London bears the label of William Harris, Jr. (fig. 6-165). The craftsman was already forty-six in 1788 when he first advertised the construction of "all kinds of . . . Chairs, Settees and Writing Chairs." During the ensuing years notices appeared frequently for "Whitewood Plank" suitable to the Windsor business. Harris's final advertisement of record dates to February 1798 when he sought an apprentice. If his quest was successful, his young trainee eventually completed his service elsewhere, since Harris died in July 1802. Little more than a year later Josiah Dewey took over the shop and advertised Windsor chairs. Perhaps Dewey was the person of that name listed at Lebanon in the 1800 census. His stock may have been worked up from parts and materials left upon Harris's death.[138]

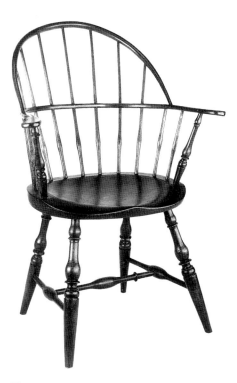

Fig. 6-164 Sack-back Windsor armchair, Gilbert Sisson (label), Bozrah Township, New London County, Conn., ca. 1791–1800. (Former collection J. Stogdell Stokes.)

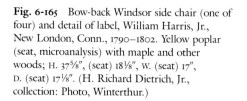

Fig. 6-165 Bow-back Windsor side chair (one of four) and detail of label, William Harris, Jr., New London, Conn., 1790–1802. Yellow poplar (seat, microanalysis) with maple and other woods; H. 37⅝", (seat) 18⅛", W. (seat) 17", D. (seat) 17⅛". (H. Richard Dietrich, Jr., collection: Photo, Winterthur.)

CHAIRS
MADE and SOLD by
WILLIAM HARRIS, jun
In New London

Harris's bow-back chair bears few traces of the provincialism common to Windsor production in southeastern New England, suggesting the presence of outside influences. The craftsman was in New London when he married in 1763, and a son was born there in 1770. Subsequently, he may have worked elsewhere for awhile. Harris's competence as a chairmaker appears to have led him to select a New York model to emulate. Direct knowledge of metropolitan design is credible, since packets sailing from New London made regular runs to the Hudson River. Harris's chair approximates the New York bow-back Windsor of the 1790s in overall appearance, proportions, and stance (figs. 5-14, 5-16), and the similarity of features is unmistakable: the bow curve and flat, beaded face; the coffin-type seat extension; and the full-swelled support structure. Variation occurs in spindle number—seven instead of nine—and the shape of the baluster cap (Harris's turning is more akin to regional work). The chair legs tenon through the plank, but there is no groove defining the front of the spindle platform. Looking down on the plank, the profile differs significantly from New York shapes. The form is deeper and noticeably broader at the front, giving prominence to rounded forward corners and a sharp back definition. Harris's preference for yellow poplar is indicated in the plank, which has been sawed with dark heartwood through the center and light sapwood at either side, a figure often prominent in *Liriodendron tulipifera*.[139]

Documents describe other Windsor craftsmen who worked in the New London-Norwich area. George Packwood, who was born in New London in 1773, advertised there in 1800 and 1801 as a cabinetmaker and, in the latter year, as a Windsor-chair maker. He, like William Harris, sought a teenage apprentice to train in woodworking. Packwood possibly was one of the partners in the firm of Packwood and Shapley who advertised cherry boards for sale in 1796. The young woodworker continued to do business in New London at least until July 1803 when maritime records show that he shipped furniture to Norfolk, Virginia, consigned to the sloop *Industry*'s captain.[140]

Upriver in Norwich Stephen B. Allyn and Daniel Huntington III announced their joint venture in the cabinetmaking and chairmaking business "on the point at Chelsea . . . a few rods west of Shetucket bridge" on June 7, 1797. Their hopes were high when informing potential customers that they were able "to exhibit as good work, and as cheap as can be had from New-York or else where." Their plans came to nought, and by December James Rogers III announced as a cabinetmaker and chairmaker at the shop "lately improved by Messrs. ALLEN & HUNTINGTON." Whether this notice signaled the end of the Allyn-Huntington business relationship or the partners removed to another location is unclear; however, indications are that the two men parted company. Census records for 1800 describe the occupants of the Allyn household as the craftsman, his wife, a female child under ten, and a young boy, no doubt an apprentice, between the ages of ten and sixteen. Allyn did not advertise alone until September 1803; Huntington's notice appeared the following February 22.[141]

Elisha Swan worked at Stonington about twelve miles east along the coast from New London and south of Oliver Avery at North Stonington. He married in 1778 at age twenty-two, shortly after completing an apprenticeship in the cabinetmaking and chairmaking trades. Since the first six children born to the Swans were girls, two of the three males listed as household residents aged sixteen years and older in the 1790 census must have been apprentices or journeymen, an indication that Swan was in business for himself. By 1800 part of Swan's family was growing up, but there were several young children under ten years. The lone young male in the household between the ages of sixteen and twenty-six probably worked in the shop with Elisha. Apparently, business was brisk enough that two hands could not keep up, and in November Swan advertised for two apprentices to the "CABINET & CHAIR-MAKING business" aged fourteen to sixteen years. Elisha Swan, the cabinet- and chairmaker, appears to have been the man who served late in the Revolution as a sort of civilian quartermaster responsible for a community store of flour. The state assembly later appointed him quartermaster of a troop of horse, in which organization he rose to the rank of captain. Swan served as Stonington town representative in a state assembly held at New Haven in October 1797.

Fig. 6-166 Continuous-bow Windsor armchair and detail of brand, Elisha Swan, Stonington, Conn., ca. 1792–1800. Chestnut (seat) with maple and other woods; H. 38⅞″, (seat) 17½″, W. (arms) 24″, (seat) 17⅜″, D. (seat) 17⅞″. (The late Robert J. McCaw collection: Photo, Winterthur.)

The only other known candidate bearing this name was just seventeen years of age in 1800 and not a son of the elder man.[142]

At least two Windsors have survived that bear the Elisha Swan brand. One is a fan-back side chair with heavy posts similar to Ebenezer Tracy's early work (fig. 6-103, left). The crest has rounded ends instead of "hooks," the seat front is shaved differently, and the necks of the leg balusters are longer; however, the influence is unmistakable. Perhaps Swan worked for a period during the 1780s as a journeyman in the Tracy shop before opening his own establishment. His second, and later, marked chair is in the continuous-bow style with bracing spindles anchored in a pointed-end projection at the back of a chestnut seat with internally socketed legs (fig. 6-166). The slim spindles swell in the regional fashion, and small, rounded, pad-shaped terminals sweep backward in tiny, pointed projections duplicating the arms in the Tracy continuous-bow chair. Other features are far from standard, however. A deep, flat channel in the bow face that extends to the arm bends forms a raised bead along either edge. Tracy-style arm posts are modified by the introduction of a cone directly under the rail and a large spool head. The legs can only be described as bizarre. In what appears to be an attempt to achieve a new pattern, Swan and others (figs. 6-167, 6-168, right) eliminated the spools, rings, and baluster caps. Although some previous work had dispensed with the cap, a precise definition had remained between the baluster and the upper leg element. Here, one flows into the other, producing two large lumps. The design is not especially pleasing aesthetically, nor does it harmonize well with the turned members under the arms; however, it is an intriguing support subtype in the study of Windsor furniture. At least one other continuous-bow chair exhibits similar features; presumably, it is unmarked. The baluster-on-taper articulation is inspired by other seating. Short, thick-necked balusters resting directly on cylindrical turnings without transitional elements are often found in coastal Connecticut rush-bottomed work, from the Stratford-Milford area to New London County. The feature appears first in heavy slat-back chairs dating to about 1700 and continues to the spindle- and fiddle-back styles of the 1780s and 1790s.[143]

A number of Windsor side chairs have double-swelled leg turnings. A set of six is in the bow-back style. However, most chairs have fan backs and form two basic groups. Identifying the first are distinctive, projecting, hooklike crest terminals supported on posts resembling those employed in Tracy seating (fig. 6-167). Long post balusters flare appropriately at the base, although double swells at the top echoing the leg profile sometimes replace a short baluster. The broad, shield-shaped seat has much the character of Elijah Tracy's spreading fan-back plank (fig. 6-103, right) and imitates other family work in introducing a slight rise under the front pommel (figs. 6-99, 6-102).

A second fan-back pattern of double-swelled leg design features a striking "new" top piece (fig. 6-168, right). The profile is that used by the Tracys, but both the arch and terminals are increased in size. The tips are thinly shaved, but the deep curve retains sufficient thickness to accommodate the socketed sticks. Serving to balance the over-

Fig. 6-167 Fan-back Windsor side chair, north-eastern coastal Connecticut, 1790–1800. Maple, ash, and other woods; H. 37″, (seat) 16⅛″, W. (crest) 22⅛″, (seat) 16⅜″, D. (seat) 16⅞″; seat split. (Williams College Museum of Art, Williamstown, Mass., bequest of Charles M. Davenport: Photo, Winterthur.)

Fig. 6-168 Fan-back Windsor side chairs (two), northeastern coastal Connecticut, 1790–1800. Yellow poplar (seats); (*left to right*) H. 37⅞", 37⅜", (seat) 17½", 17⅛", W. (crest) 20⅛", 21½", (seat) 14¾", 14⅛", D. (seat) 15¾", 15⅝". (Old Saybrook Historical Society, Saybrook, Conn., and Charles B. Wood III collection: Photos, Winterthur.)

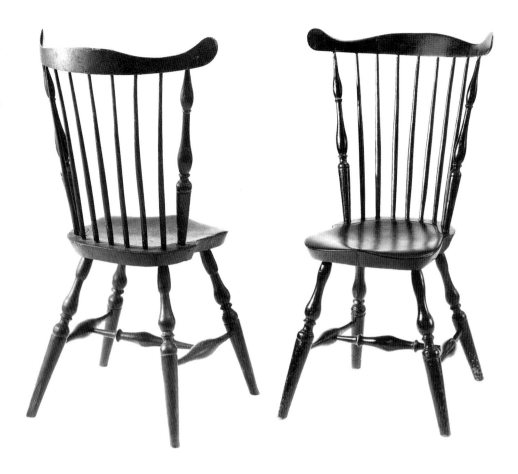

stated crest are short, boldly swelled post balusters reminiscent of Rhode Island work (fig. 6-67). The seat is relatively narrow, a circumstance that places the posts closer than usual and creates a deep back curve. Legs tenon inside the plank. The seat with its thick, slightly canted edges has as crisp a profile as the top piece. Introduced to the support structure are two features absent from the previous double-baluster chairs: spool and ring turnings that achieve a better transition between the upper and lower leg, and a tipped medial stretcher whose flaring, arrowlike ends recall Rhode Island work (fig. 6-54).

Several features link the double-swelled baluster chair of figure 6-168, right, with other coastal Windsor work from the Connecticut River to Rhode Island. A small group of high-back chairs (fig. **6-169**), including one with a writing arm, employs large top pieces of the new type. The tall, illustrated Windsor was recovered in East Lyme (now Flanders), north of Niantic, while the writing-arm chair, according to an engraved plaque on the crest, belonged to the Reverend Frederick W. Hotchkiss, pastor of the Congregational Church of Old Saybrook from 1783 to 1844. A third Windsor of similar back, collected in 1917 as noted in a handwritten label under the seat, has a background history in Old Saybrook and Deep River. Most group representatives exhibit prominent medial stretcher tips that are almost knoblike at the inner ends, their bulging form complementing the thick leg rings. Short full-bodied balusters have caps identical to those in William Harris's bow-back Windsor. The oval seat, which tenons the legs inside, is marked by precise, canted edges, paralleling the work of Gilbert Sisson (fig. 6-164) and suggesting further that Sisson carried elements of the coastal style inland when he worked in Bozrah. The long, wavy-arm profile is new to this discussion.

To accompany the tall chair of full-blown crest and bold turned legs, furniture craftsmen made a companion fan-back Windsor almost identical to the example pictured in figure 6-168, left. Top pieces and turnings are close imitations; variation is introduced in the absence of a collar in the leg balusters or a slight modification in the stretcher tips. Some braces have a ball-type knob of the general pattern shown in figure

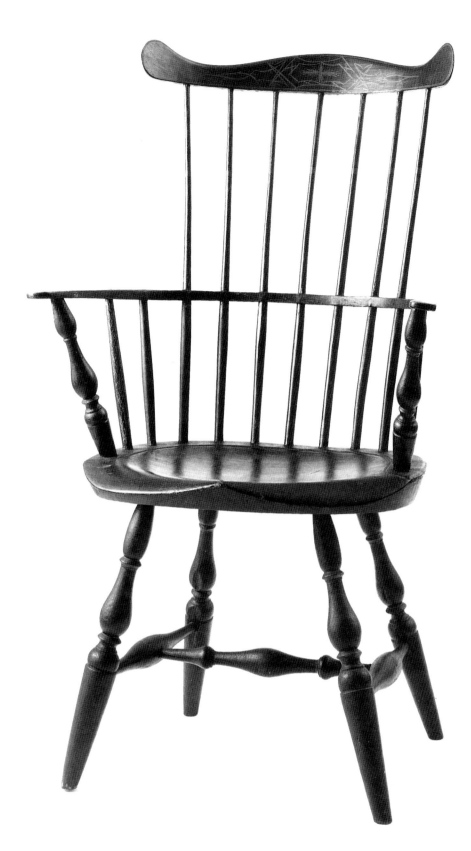

Fig. 6-169 High-back Windsor armchair and detail of arm terminal, northeastern coastal Connecticut, 1790–1800. Oak and other woods; H. 41″, (seat) 18″, W. (crest) 20″, (arms) 24⅜″, (seat) 20⅛″, D. (seat) 14¾″. (Private collection: Photo, Winterthur.)

6-172. One chair was owned in the Boardman family of Griswold, a township of New London County, until 1917.

A second fan-back chair with features typical of this group contains a large ball turning in each post below the central baluster. The most sophisticated example is pictured in figure **6-170**. The features modify the general pattern under discussion by introducing a shorter crest, longer balusters, and a variant medial stretcher, but the same curves are in evidence. A departure is the well-modeled seat with a pommel ridge. Other Windsors introduce "hook" terminals to the crest or a medial stretcher of the general

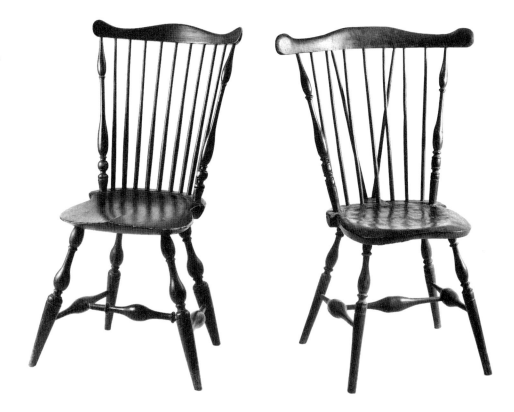

Fig. 6-170 Fan-back Windsor side chair, northeastern coastal Connecticut, 1790–1800. Yellow poplar (seat, microanalysis); H. 38⅛″, (seat) 17½″, W. (crest) 19½″, (seat) 16⅛″, D. (seat) 17⅛″. (Thomas K. Woodard Antiques: Photo, Winterthur.)

Fig. 6-171 Fan-back Windsor side chair, northeastern coastal Connecticut, 1795–1800. H. 39½″, (seat) 18⅛″, W. (crest) 27″, (seat) 15¾″, D. (seat, without extension) 14⅜″. (Steven and Helen Kellogg collection: Photo, Winterthur.)

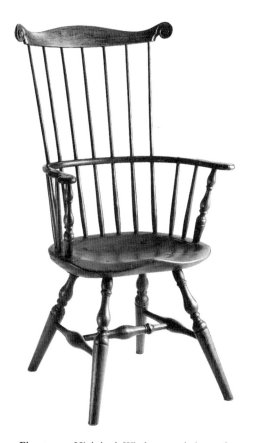

Fig. 6-172 High-back Windsor armchair, northeastern coastal Connecticut, 1790–1800. Yellow poplar (seat, microanalysis) with maple and other woods; H. 45¼″, (seat) 17¹³⁄₁₆″, W. (crest) 23⅞″, (arms) 25⅜″, (seat) 21¼″, D. (seat) 16⅛″. (Private collection: Photo, Winterthur.)

pattern illustrated in figure 6-175. The most original chair in the group is a highly personal interpretation completely hand shaped and whittled, in both its round and flat parts (fig. **6-171**). Leg, stretcher, and post "turnings," while crude, are meticulously shaped with the knife to show every detail normally found in mechanical production. Proportions and diameters are perfect and even more consistent throughout than the roundwork of many chairs offered in the commercial market. Crest ends project well beyond the posts in an exaggerated interpretation of the long-eared top piece. The seat, while broader than usual to compensate for the extra crest length, follows eastern Connecticut design (fig. 6-103, right): the sides swell in full rounded curves to the rear platform where a tablike projection in the Tracy manner supports a pair of bracing spindles; legs socket inside the seat; and the plank arches slightly beneath the pommel, an English feature used extensively by the Tracys in their sack-back work (figs. 6-98, right; 6-99).

Another line of development introduced well-defined, modeled knobs to the medial stretcher (fig. **6-172**). In the present example the principal leg turning duplicates early Rhode Island work (figs. 6-20, 6-27). Tall, slim spools adopt a new silhouette marked by sharply canted heads, a profile repeated in the baluster caps. Unlike the plank of figure 6-169, the yellow poplar seat is deeply rounded, and the legs pierce the top surface. The crest arch is about the same depth and breadth as the full-blown top pieces of the previous chairs, but carved volutes add a sophisticated touch. The fancy, notched ogee arm profile approximates in elongated form the terminal in a Rhode Island chair (fig. 6-28).

A further modification of the turned work eliminated the cap, or collar, from the leg balusters and occasionally from the arm posts. The absence of this transitional element undoubtedly relates directly to Rhode Island work, and the idea may spring from chairs of the type shown in figure 6-31. Several high-back, writing-arm Windsors combine this feature with the full-blown crest. One was once the property of William Noyes (1760–1834) of Lyme. A fan-back side chair that falls into this group (figure 6-168, left) is owned by the Old Saybrook Historical Society. Another was recovered in neighboring Westbrook.[144]

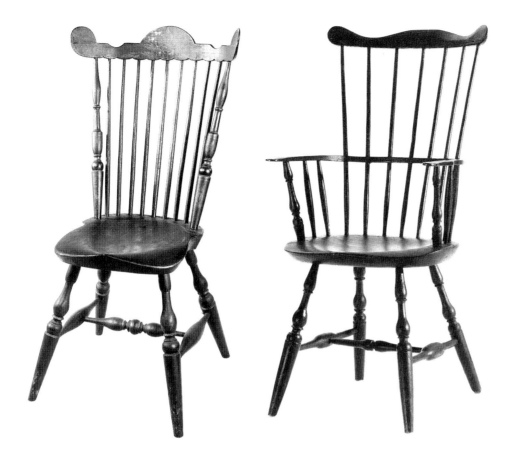

Fig. 6-173 Fan-back Windsor side chair, northeastern coastal Connecticut, 1790–1805. Yellow poplar (seat) with maple and oak (microanalysis); H. 38″, (seat) 18¼″, W. (seat) 14″, D. (seat) 15⅝″. (Yale University Art Gallery, New Haven, Conn.)

Fig. 6-174 High-back Windsor armchair, northeastern coastal Connecticut, 1790–1800. H. 40⅜″, (seat) 17¾″, W. (crest) 21″, (arms) 20¾″, (seat) 19⅝″, D. (seat) 15⅛″. (Private collection: Photo, Winterthur.)

One of the most innovative designs in Connecticut Windsor-chair making also originated in the Westbrook area (fig. **6-173**); at least two chairs are known. The craftsman drew inspiration from several sources. In basic design and proportions the chair copies area seating of the full-crested, fan-back type (fig. 6-168). Inviting comparison are the leg and side stretcher turnings, the yellow poplar seat that conceals the leg tops, the post proportions, and the full-rounded crest ends. Tapered spindles are increased in number from seven to nine to accord with the crest. Two back features seem influenced by rush-bottomed chairwork. Turned urn shapes are present in some early Connecticut chair posts, and large, centered arches of lunette form, both pierced and unpierced, adorn the crests of banister-back chairs. A lunette is used occasionally in the fiddle-back top, as well. Here the craftsman-designer has given his creative imagination full rein and produced a top piece of exceptional vigor and novelty. The sequence of scallops, rounds, and hollows ripples with movement. The deep, lateral back curve common to this general group keeps the design confined in breadth and visually anchors the crest to the chair top. Beneath the seat a handsomely turned medial stretcher probably draws its general pattern from other furniture of Connecticut origin. Similar elements, comprising double balusters and spools flanking a centered ball, or modifications thereof, appear in the front stretchers of rush-bottomed seating.[145]

Elements of the two high-back chairs illustrated in figures 6-169 and 6-172 are seen in another tall Windsor that further develops Connecticut coastal chair design (fig. **6-174**). The crest repeats the vigorous serpentine profile of local production, although the large ends are not as exaggerated as those in previous work. The terminals are actually oval. The crest has its mates in a border chair (fig. 6-149) and the side chairs that follow. Spindles swell below the rail in a manner similar to figure 6-172, while the slender arms duplicate those of figure 6-169 both in top profile and thinly shaved tip. Like that chair, the legs do not tenon through the plank. The steeply rounded seat edges seem a compromise between the profiles of the same two chairs. The legs are an eclectic blend of the short, round-bodied balusters from the one chair and the spools and rings from the other. The new feature is the deeply channeled medial stretcher comprising two blunt-

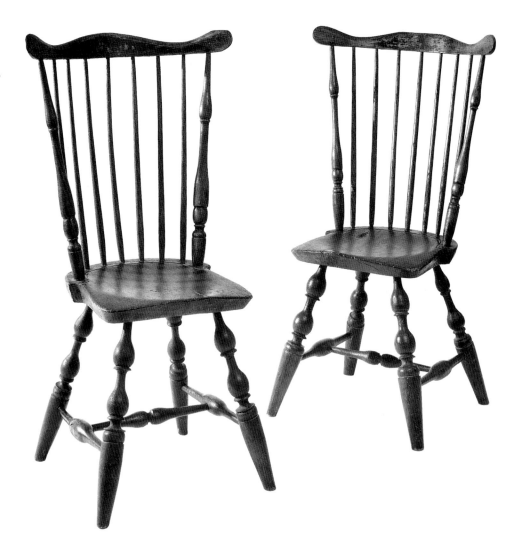

Fig. 6-175 Fan-back Windsor side chairs (two), northeastern coastal Connecticut, 1790–1805. Yellow poplar (seats, microanalysis); (left) H. 37¹³⁄₁₆″, (seat) 17″, W. (crest) 20¼″, (seat) 14¼″, D. (seat) 15⅜″. (Private collection: Photo, Winterthur.)

based balusters, end to end. Similar cross braces and oval-ended crests link several fan-back patterns to this group.

One variation features an unusual adaptation of the ball-turned post (fig. **6-175**). Every turning is a forceful statement of the provincial turner's art carried to its limits. Blunt, broad seat fronts relate generally to Elijah Tracy's later fan-back work (fig. 6-104), while Rhode Island influence occurs in the flat-chamfered backs. Posts seem highly influenced by other regional work (fig. 6-155). The distinctive feature is, of course, the oval ball turning positioned below a baluster terminated abruptly at its widest end in a repetition of the medial stretcher profile. Flat-bottomed balusters also appear in the rear posts of Connecticut rush-bottomed chairs, some with cylinder-and-ball-turned front legs but many supported on club feet like those in New York fiddle-back chairs (fig. 5-8). The Dominys of Long Island constructed rush-bottomed seating with this turning well into the new century, although the profile may first occur in the Boston chair of the early eighteenth-century coastal trade (fig. 6-5).[146]

A second pair of fan-back Windsors, close in basic design to those illustrated, seems to represent another phase in the development of the same craftsman. Blunt-edge seat fronts are rounded rather than squared, and legs are considerably slimmer than those illustrated. Important to present interpretation is the family descent of the chairs in the Clinton-Madison-Killingworth area just south of the Connecticut River. The name of housebuilder Hiel Buell is associated with the chairs as an original owner or maker. Indeed, the Connecticut census for 1790 shows two men of this unusual name; one termed the "2d" resided in Killingworth. Single census entries continue until 1840 when the place of residence is given as Clinton.

A classic Connecticut pattern comprising a number of design subgroups has as its identifying and unifying feature a crest rail terminated by small, rounded, projecting

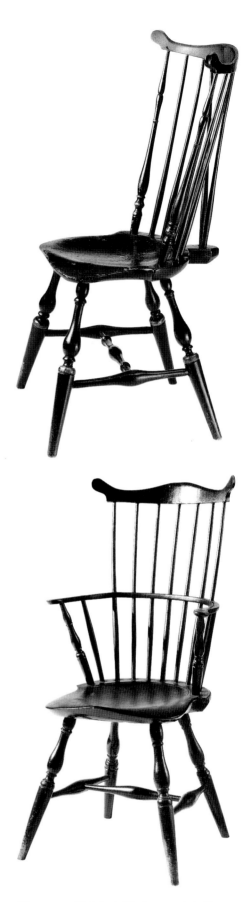

Fig. 6-176 Fan-back Windsor side chair, New London, Conn., area, 1790–1800. Basswood (seat, microanalysis); H. 39″, (seat) 17¾″, W. (crest) 20¾″, (seat) 16½″, D. (seat, without extension) 15⅝″. (Private collection: Photo, Winterthur.)

"ears." There probably are several hundred such Windsors in existence today. Based upon incidence of recovery, family history, and an identifiable secondary characteristic, the chairs can be divided into two localized groups—one from the New London area, the other from New Haven and vicinity. The New London chairs are fewest in number (fig. **6-176**) but represent a more sophisticated, and slightly later, interpretation. Although there are no "histories" associated with this group, the unusual post turnings relate directly to those in a rush-bottomed, fiddle-back chair ascribed to New London. Key features are the ringed neck of the long baluster and the bonelike articulation between that turning and the upper element. The "new" chair is as refined as the best examples of metropolitan Windsor seating.[147]

The distinctive tab-end crest appears to be directly related to patterns developed by Rhode Island chairmakers. First came a somewhat rigid top (fig. 6-22) and then a more flowing double-ogee crest of rounded-point terminal (figs. 6-50, 6-133). The illustrated braced-back chair also shares several points with William Harris's New London Windsor (fig. 6-165); indeed, Harris may have been responsible for some production. Except for minor differences in the bulbs at the leg tops and the rounded baluster caps, the support structures are the same. Seat shapes generally are comparable; the planks employ a New York–style, coffin-shaped back extension, although the Harris chair lacks a groove defining the spindle platform. The double spool-and-ball turning in the lower posts is found in several other chairs of New London origin. To compensate for the fragile character of the crest terminals, chairmakers retained the full thickness of the curved piece of wood almost to the tips, lightening the feature by cleverly modeling the back surface rather than shaving the ends. Other fan-back chairs in the group relate closely, but most lack the bracing structure. A companion high-back chair, its shield-shaped seat not unlike that pictured in figure 6-23, copies the fan-back turnings so closely as to suggest an origin in the same shop.

The Central and Southern Coastal Regions

Were it not for the overwhelming body of evidence pointing to New Haven and environs as the origin of the largest group of tab-crested chairs, all made in the high-back style, these Windsors would surely be mistaken for Rhode Island products. That region exerted profound influence on the design, as analysis will show. While a few chairs within this subtype exhibit obvious points of variation, most are sufficiently interrelated that clear-cut lines for grouping are hard to draw. In studying a representative sampling comprising several dozen chairs whose features fall into the mainstream of design, it is possible to generalize about the pattern (fig. **6-177**). A distinctive tab-end crest is common to all chairs. The shape of the tab varies from a full rounded tip on a narrow neck, which approaches the New London profile, to a rounded, rounded-point, or obviously pointed terminal. The latter, which closely follows basic Rhode Island prototypes (figs. 6-50, 6-133), seems the least common. Round-tip crests are also present in a small group of fan-back side chairs from the northeastern Connecticut coast whose H-plan stretchers have a front-to-back orientation (fig. 6-134). All chairs in the present group have shield-shaped seats, usually of generous size. In every case where the seat back is visible, Rhode Island flat-chamfered shaping prevails. Similarly, where it can be determined, legs pierce seat tops and a groove surrounds the spindle platform. Spindles with elongated swells below the rail occur in about 90 percent of the examples studied. The universal arm is a delicate one ending in a small rounded pad, a feature that may derive directly from New York chairmaking, in view of the pre-1790 date for initial

Fig. 6-177 High-back Windsor armchair, New Haven, Conn., 1785–95. Maple and other woods; H. 39¹³⁄₁₆″, (seat) 16½″, W. (crest) 19¹⁄₁₆″, (arms) 19⅞″, (seat) 16½″, D. (seat) 17⅜″. (Connecticut Historical Society, Hartford, gift of Judge Edward Y. O'Connell.)

production of this chair in Connecticut. The New York sack-back chair, a tall Windsor, and the early continuous-bow chair all possess similar terminals (figs. 5-7, 5-10, 5-11); New Haven and New York are separated by only about seventy miles of water in Long Island Sound. Turned parts are uniformly generous in size; the medium-length balusters have moderate, if not full, bodies. A small group, in the range of 15 to 20 percent of the total sample, has long leg balusters, although other features fall in line. Medium to full-swelled stretchers without rings form the bracing structure of all chairs. A point of design that splits the group almost evenly is the length of the baluster in the arm posts. The short turning, as illustrated, is slightly more common than one of medium length.[148]

Minor feature variations can be noted. In a few chairs there is a tendency for the spindles to bow slightly from top to bottom, as illustrated. Such tension results from the boring patterns of the rail and top piece. A few chairs in the sample have only six long spindles instead of seven, in which case the seats are proportionally smaller and the front legs exhibit a generous splay. Outside the sample are a few chairs with seats of unusual shield form, the plank thick across the front and the front narrower than the back. Other features follow the standard pattern. Another small group has large, oval seats, swelled-tab crests, short rail returns behind pad-shaped terminals, and miscellaneous features relating closely to New London work. Again excluded from the sample but part of this regional group are almost a dozen tall writing-arm Windsors, ranging in design from the full baluster to the full bamboo style. In general, the chairs conform to the model, except for the seats, which are oval. Here, too, plank edges (where visible) have chamfering. Of further consideration is the similarity of baluster profiles in the New Haven chair, a Windsor made on Nantucket (fig. 6-235), and Joseph Stone's Rhode Island chair (fig. 6-51). The obvious conclusion is that the active coasting trade of the 1780s and 1790s deposited and intermixed seeds of design that took root and flourished in various coastal locations where the craft "climate" and economic conditions were favorable.[149]

The basic characteristics of the New Haven tab-crested chair were developed sometime between 1785 and 1788. Shipping records provide some enlightenment but at best are incomplete for the early national period. Sailing vessels registered at New Haven before the Revolution were mostly of small tonnage and suitable primarily for the river and coastal trade. During the late 1770s most waterborne commerce was with Massachusetts, Rhode Island, and other Connecticut towns. Following a period of depression in 1781, shipping began to increase, and after April 1783 it "soared upward." In the mid 1790s the duc de La Rochefoucauld Liancourt still found Connecticut trade "confined to the exportation of the surplus produce of the lands, to the West Indian Isles, or to the other States of Union." Of New Haven he observed, "Most of the 50 vessels in the port are engaged in the coasting trade particularly with New York." Thomas Chapman, who traveled through the city in the same period, found the houses "Built and finished with great Taste and neatness, they are mostly of Wood, and being painted White, makes a strong & beautifull Contrast with the green Trees before them, for every Street has two Rows of Trees planted from one End to the other." Many houses were separated from their neighbors by a court or garden.[150]

Beginning in December 1786 and continuing through 1790 shipping records document the exportation of over 1,450 chairs and two settees from the small coastal city; some seating is identified as "Windsor Chairs." The rest is anonymous, although since most was shipped unassembled and not accompanied by rush to provide seats, there is every reason to believe that it was also of Windsor construction. If these statistics represent only a fraction of local production for exportation, how many more chairs did craftsmen supply to the trade and for domestic consumption?[151]

The lone New Haven chairmaking advertisement of this period is that of Alpheus Hews in Chapel Street, which dates to early 1787 (fig. 6-178). Although the accompanying cut illustrates a sack-back Windsor, Hews clearly states that his "GARDEN CHAIRS" constructed "in the neatest manner" were made in "different fashions."

Fig. 6-178 Advertisement of Alpheus Hews. From the *New Haven Gazette and Connecticut Magazine*, New Haven, Conn., April 5, 1787. (Photo, American Antiquarian Society, Worcester, Mass.)

Purchase terms were easy: Town residents could pay in cash or with "wet or dry goods"; rural customers were encouraged to exchange "any kind of country produce for family use" or timber suitable to the chair business. Complementing the advertisement and the shipping records is a pair of New Haven portraits executed by Sarah Perkins (fig. **6-179**). The artist completed the likenesses of Dr. and Mrs. Hezekiah Beardsley about 1789, less than a year before their early deaths. The Beardsleys sit in tall green Windsors of unmistakable crest pattern. The chairs represent furniture at the height of fashion and thus would have been appropriate for use in a commissioned work reflecting the status of the doctor and the success of his drugstore business. Since the item "6 Green Chairs high Backs" occurs in the doctor's probate inventory, the Windsors likely belonged to the couple, as opposed to being artist's props, as was frequently the case in paintings. As to the origin of the chairs, an interesting point for speculation crops up in a local nineteenth-century history that includes a "PLAN OF PART OF CHAPEL STREET, *Showing the Buildings and Occupants about the Year 1786*" in the central, two-block area between Church and State streets. Clearly delineated is "Hez. Beardsley's *House and Drug Store*" in a business district dotted with stores, warehouses, craft shops, and a few private dwellings. In the immediate vicinity Alpheus Hews occupied a woodworking shop where he produced his Windsor settees and garden chairs.[152]

Fig. 6-179 *Dr. Hezekiah Beardsley*, attributed to Sarah Perkins, New Haven, Conn., 1789. Oil on canvas; H. 45″, W. 43″. (Yale University Art Gallery, New Haven, Conn.)

Family traditions of ownership and modern recovery locations are other aspects of the documentation process that permit assignment of the high-back and tall writing-arm chairs to the New Haven region. In the late nineteenth century Irving Whitall Lyon illustrated a tall chair found in North Haven. Other chairs with family histories originated in neighboring Shelton, Southbury, and Guilford-Bridgeport. A writing-arm chair owned by the United Church of Christ in Bethlehem has an ink inscription on the seat bottom describing its early ownership by Joseph Bellamy, D.D., who died in 1790. The Reverend Bellamy was born in Wallingford and studied theology at Yale, so he likely had close connections with the coastal city.[153]

Portraits of local residents picture Windsor chairs in a range of styles. Young Maria Sherman, granddaughter of Roger Sherman, sat in a carved-scroll, fan-back side chair when Abraham Delanoy painted individual family portraits in 1786–87. Bradford Hubbard, also of New Haven, rested his left arm on the crest of a similar chair when Reuben Moulthrop took his likeness a few years later. Within a decade Moulthrop painted the young Reverend Thomas Robbins seated in a sack-back chair, and Jonathan Budington signed and dated a double portrait, possibly of Ebenezer Burr and his son Timothy of near Fairfield (fig. **6-180**). The man sits in a continuous-bow Windsor of plain pad arm. Ralph Earl drew an almost identical chair in his 1795 portrait of John Nichols of Easton, another community in Fairfield County.[154]

The chair trade between New Haven and the West Indies was particularly active in 1791–92. Information gleaned from French spoliation claims shows that in a two-year period through February 1793 more than 2,600 chairs, probably all Windsors, and 30 settees left the port. A shipping manifest dated March 30, 1792, specifically identifies 600 seating pieces as "Loop Chairs," establishing an early date for area manufacture of the bow-back style. The word *loop* must describe side chairs rather than sack-back armchairs, since the Windsors made up a single shipment; production accounts invariably show that the Windsor side chair was the popular seat, while armchairs were produced in much smaller numbers. The port of Fairfield also shipped a minimum of several hundred Windsors to the West Indies during this period.[155]

In the later 1790s Titus Preston, cabinetmaker and chairmaker, made bow-back Windsors at his shop in neighboring Wallingford, a small town "beautifully situated on a fine elevation" near the Quinnipiack River. The community consisted "principally of a single street extending along the ridge of the hill, from a mile and a half to two miles." Preston's ledger, which begins in 1795, records his first sale of Windsors on September 1, 1797, when he debited the account of Amasa Hitchcock, Jr., for "6 dining chairs your Father had" and charged him 7s. apiece. A transaction the following month shows that Preston, like many woodworkers located outside a metropolitan or commercial center,

farmed the land he lived on. He agreed with Martin Dudly to accept the 8s. owed for a Windsor chair "in threshing oats at 2/6." At that rate for unskilled labor, Dudly worked slightly more than three days to pay for his chair. Esther Morse, a more affluent customer, purchased eight dining chairs in June 1799 along with a "4 feet dining table." Presumably, the chairs and table were intended for use together. Eight side chairs will just fit around a rectangular table of this length, although the "elbow room" is limited. By June 1800 Titus Preston had begun to construct chairs in the "double bow," or square-back, style. He priced these seats at 8s. apiece, a shilling more than the bow-back dining chair. Green paint remained a popular finish, but "fancy" colors followed shortly, along with stuffed seats.[156]

Fairfield County

Several locations in Fairfield County were small centers of Windsor-chair making before 1800—Ridgefield in the west, Huntington in the east, and Danbury to the north. In contrast to work turned out in the coastal towns, production was primarily for domestic consumption. Ridgefield Windsor work is well documented in the accounts of Elisha Hawley (1759–1850). Hawley's grandfather, the Reverend Thomas Hawley, was one of the town's first settlers. Young Hawley served in the military during the Revolution and by age twenty-two in 1781 had settled down in Ridgefield to follow the trade of cabinetmaker and chairmaker. Presumably, he acquired his skills under the tutelage of an area master, although his revolutionary service may have shortened the training period. For the most part, Hawley's customers were local residents. When he performed work for someone living beyond the neighborhood, he made note of it. He enjoyed the patronage of occasional customers residing in Norwalk, Fairfield, and Wilton; several others who sought his services lived across the border in Salem, New York. Hawley produced a variety of cabinetware, including tables, desks, and chests of drawers, although he appears to have derived his basic income from chairmaking. His accounts record a variety of rush-bottomed seating—kitchen, fiddle-back, banister, black, white, "plane" (possibly two slats), armed, and great chairs. The earliest reference to Windsor-chair making occurs on December 22, 1786, when Hawley completed "three winzor Chairs" priced at 7s.6d. apiece, for Euriah Wollis (Uriah Wallace?) of Salem, New York. Wollis purchased nine additional chairs in January 1789 to make an even dozen. By 1788 business in plank-bottom seating had picked up to the extent that Hawley accepted "timber for winsor Chairs" in exchange for his furniture-making services. Nathan Smith, who supplied the raw material, also provided other lumber from time to time and in September 1789 received credit for making "54 Chair Bottoms" at the rate of 4d. each. Smith probably adzed and shaved the planks to a reasonably finished state. James Sturgis supplied twenty-seven chair bottoms in 1792 as a partial exchange for a set of Windsor chairs.[157]

Elisha Hawley's plank-bottom production can be divided into two groups, as identified in his account book—dining chairs and Windsors. Seating in the first group, which he began to manufacture in 1792, falls into the 6s. to 7s. range, a normal price for the side chair. Whether Hawley constructed more than one dining pattern cannot be determined, since price can vary according to embellishment or quality of finish. Presumably, all the craftsman's "Windsor" chairs had arms. A few retailed for as low as 7s. each, but normally the price varied from 7s.6d. to 9s. Hawley's accounts, which extend into the early nineteenth century, show that he constructed Windsors only between 1786 and 1796. The date when he began production—in the mid 1780s—would indicate that most of his "Windsors" had sack backs. However, an entry dated June 20, 1792, suggests that eventually he also made armchairs of another pattern: "To Winsor Chair three boss [bows]." Hawley likely was describing the continuous-bow Windsor, which has three bends, or bows, in the rail forming the back arch and the two arms.[158]

A continuous-bow armchair with a history of ownership in the prominent Keeler family may have originated in Hawley's shop, since the chairmaker lists eight or nine family members in his business records. At least three—Timothy, Jr., Aron, and

Jeremiah—bought Windsor seating. Timothy was the proprietor of the Keeler Tavern and also owned a sizable interest in two Ridgefield retail stores. Along with several fellow townsmen, he had commercial ties with New York. Both Timothy and Jeremiah purchased armchairs from Hawley. The so-called "Keeler chair" features turnings that are bold and bulbous in the New York manner. Under each arm is a full-bodied baluster that flows into a short neck and connects to a small, upper budlike element. The artist Jonathan Budington duplicated these shapes in the chair pictured in his portrait of a *Father and Son* dated 1800 (fig. 6-180). Nina Fletcher Little has written that "the portrait came from the old Burr homestead on Burr Street, Greenfield Hill, Fairfield, and may represent Ebenezer Burr (1760–1819) and his son Timothy (1788–1858)." Indeed, there is mention of an Ebenezer Burr in Hawley's accounts in 1805. Ralph Earl delineated similar arm posts in the continuous-bow chair that supports the seated figure of John Nichols of Easton (1795).[159]

Elisha Hawley's exchange of furniture-related services with other individuals, such as the fabrication of plank "bottoms" by Nathan Smith and James Sturgis, has been noted. Beginning in 1785 Elisha had occasional dealings with Thomas Hawley, probably a kinsman, who appears to have been a rush-bottom-chair maker. Upon occasion Thomas or one of his apprentices wove rush chair bottoms for Elisha. In 1785 Thomas also provided his kinsman with over 700 "Chair Rounds" (stretchers) and spent several days helping to make chairs. The men exchanged new seating now and again, probably at times when there was a large order to fill. Elisha also made case furniture for Thomas, some of which the latter further exchanged with *his* customers. In March 1790 Thomas acquired ten Windsors at a cost of 8s. apiece.[160]

Occasionally, Elisha Hawley recorded services performed by shop workmen. A number of young men received their training with him, as confirmed by an entry in his account with Captain Nathaniel Scribner of Norwalk in 1794: "to painting Six days with two Apprentices." The reference further illuminates the range of Hawley's activity. Aaron P. Cleveland "began to work" for the craftsman on July 24, 1788, probably as a journeyman. During the next eight months he performed such tasks as felling timber, grinding pigments, painting chairs, and making chair parts. He also constructed a "wing Chair" and three and a half dozen Windsor chairs. Three brief entries that refer to a man named Joseph Birdsey are of more than passing significance. Twice in the summer of 1787 Birdsey provided assistance to other family members in raking rye or hay, suggesting that he was merely a farm laborer. However, on March 24, 1790, Hawley wrote in his accounts, "Joseph Birdsey began to work." Birdsey probably was a Hawley apprentice when he performed the farm labor but served as a journeyman in 1790. This theory is reinforced by the existence of two sack-back Windsors bearing Birdsey's label and unmarked side chairs and armchairs with the same distinctive detailing (fig. **6-181**).[161]

Birdsey's small paper label bordered by an oval, foliate band printed in black reads: "Joseph Birdsey Jur. / Cabinet Maker / PAINTER / HUNTINGTON." Huntington lies about eighteen miles due east of Ridgefield and north of Stratford. Young Birdsey (b. March 10, 1769) appears to have been the son of Captain Joseph Birdsey (d. 1817), who was born in Stratford and later removed to Huntington. In passing, it can be noted that Hawley, too, had ties with Stratford through his wife Charity, a member of the Judson family of that town. Birdsey's employment with Elisha Hawley occurred just fourteen days after he had attained his majority. He may have worked in the shop just long enough to accumulate sufficient money to start his own business in Huntington; he may also have had some financial help from his father. The young man's Connecticut Windsor production seems datable to the 1790s, and likely the period was shorter. The 1800 federal census lists only the elder Joseph Birdsey in the township. A family genealogy provides other information. At an unknown date, probably just before 1800, Birdsey became a resident of Hopewell, New York, east of Canandaigua. This is confirmed by the Ontario County census for 1800. Before his early death in 1805 Birdsey had migrated farther west to Geneseo in Livingston County.[162]

Fig. 6-180 Jonathan Budington, *Father and Son*, Connecticut, 1800. Oil on canvas; H. 41″, W. 35½″. (National Gallery of Art, Washington, D.C., gift of Edgar William and Bernice Chrysler Garbisch.)

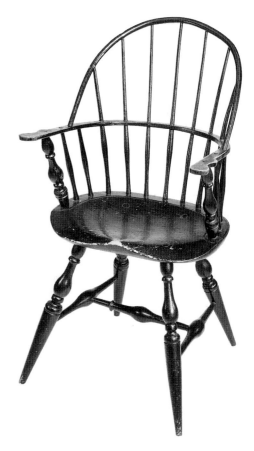

Fig. 6-181 Sack-back Windsor armchair, attributed to Joseph Birdsey, Jr., Huntington, Conn., 1790–1800. H. 37″. (Photo, Thomas K. Woodard Antiques.)

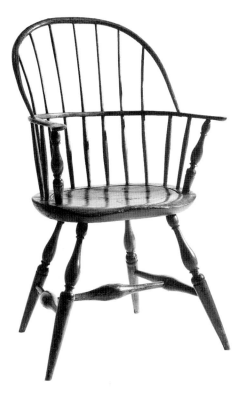

Fig. 6-182 Sack-back Windsor armchair and detail of label, William Chappel, Danbury, Conn., ca. 1792–1800. Maple and other woods; H. 37⅞", (seat) 17⅞", W. (arms) 23⅜", (seat) 20½", D. (seat) 14½". (Private collection: Photo, Winterthur.)

Birdsey's sack-back chairs, represented here by an unmarked example, have distinctive qualities (fig. 6-181). Proportions, turnings, and design details speak to the competent training he received at the hands of Elisha Hawley. The character of the turned work suggests either that Birdsey worked for a time along the northern Connecticut coast before commencing business or that such work was well known in the southern region. The latter possibility may not be wide of the mark in view of the strong presence of northern influence in the almost contemporary work of neighboring New Haven (fig. 6-177). Birdsey's crowned balusters and spools bear a remarkable similarity to New London and Rhode Island turnings (figs. 6-176, 6-72). The heavy rings below the spool turnings offer a further point of comparison with New London work, and the arm pads with their accompanying projections have prototypes in Rhode Island (figs. 6-43, 6-45). Birdsey's seat planks are well modeled; the leg tops pierce the upper surface, and a prominent groove defines the platform area. Two outstanding features of his production are the flare at the spindle bases and the deep, squared profiles of the spool and some baluster caps. The combination is sufficiently distinctive and unusual to justify the present attribution. An unmarked, braced bow-back side chair with baluster legs of close profile may also be a Birdsey product. Identical spindles embellish another sack-back armchair whose distinctive leg turnings duplicate those of a Connecticut-Rhode Island border chair (fig. 6-143), further cementing a northern connection.

Danbury in northern Fairfield County had at least one practicing Windsor-chair maker of record before 1800. By a stroke of luck a chair bearing the label of William Chappel still exists (fig. **6-182**). Like his regional contempories who produced Windsor seating, Chappel also followed the trade of cabinetmaker. Two labeled, tall case clocks attest to his skill in that branch of woodworking. Chappel was in business by November 1790, when he and a partner, Ebenezer B. White, advertised cabinetwork and the sale of "Windsor, and all other kinds of Chairs, Settees, Etc. on the most reasonable terms, and payment made easy." Custom must have been good, since in 1790 and 1792 the partners advertised for one or two journeymen. Apparently the partners had hardly completed their own training when they joined forces and opened shop near the courthouse, since Chappel was still under forty-five years of age at the 1810 census. The young craftsman married Lilly McLean of Danbury in 1793. Despite the considerable promise of the early years, Chappel's career closed on a note of despair. Records show that he was active in land dealings over the years, presumably of a speculative nature. He is also said to have manufactured carriages and owned machinery for carding wool. But the entrepreneur seems to have overextended himself, and in 1828, just as he was to be arrested for debt, he left Danbury for Norfolk, Virginia, apparently never to return.[163]

In many respects Chappel's chair is more akin to Rhode Island Windsor design than to the work of area craftsmen. The elongated balusters with their sloping profile are reminiscent of Joseph Stone's East Greenwich work; bows, spindles, and seats also share similarities (fig. 6-51). Chappel apparently grew up in New Haven. As an apprentice he may have had exposure to Windsor furniture from coastal regions other than New

Haven. His arm rail with plain pad ends resembles New Haven work, and the oval seat compares well with Birdsey's chair plank. Possibly Chappel's work was itself a model for seating constructed in western Connecticut, in view of the surprising similarity of his chair and the Windsor pictured in Simon Fitch's 1802 portrait of Ephraim Starr of Goshen (fig. **6-183**): baluster turnings are elongated, and slightly compressed spools with thick rings connect long, tapered feet braced by stretchers mounted high. As a young man Ephraim Starr migrated from Middletown to Litchfield County, where within a few years he married the widow of his former employer and became the proprietor of her produce and timber business; in time he made a "considerable fortune" for himself. No doubt, Starr's commercial interests kept him in touch with people and events throughout Litchfield County as well as in neighboring Fairfield County with its coastal access to the important trading center of New York.[164]

To be sure, other craftsmen were active in the area. The Booths, father and son, of Newtown may have constructed the Windsor furniture itemized in their probate records, but it seems more likely that they acquired it by exchange with other craftsmen. Ebenezer Booth IV left "6 round top chairs" in his estate when he died in 1790. Young Joel, who lived only four years longer, counted "Six Dining Chairs" and "five winsor D[itt]o" among his household furnishings. About the time of Joel's death, Nicholas Jebine resettled in neighboring Woodbury from New Haven, where he also followed the dual trades of cabinetmaker and chairmaker. Although Jebine's production of Windsor seating is documented in local records, his work remains unidentified. The craftsman made both joined furniture and Windsor chairs for the local storekeeper Jabez Bacon in 1798, somewhat more than three years after moving to Woodbury. Edward S. Cooke, Jr., has suggested that the sixty Windsor chairs at the store in 1807 were of Jebine's make and cites a further business link in property rental. Another local resident purchased Windsors from Jebine by the set.[165]

Northern Middlesex County

Middletown, centrally located as its name suggests and situated midway between New Haven and Hartford, enjoyed some flurry of Windsor-chair-making activity in the late eighteenth century. Before moving farther north, Lewis Sage worked in this town "built on a beautiful declivity along the western bank of Connecticut River," where he sought the services of two journeymen Windsor-chair makers in 1790. Joseph C. Clark, a local cabinetmaker, owned "6 Green Chairs," possibly of his own making, at the end of the same decade. There is a record that at least one cargo comprising sixty Windsor chairs left the Middletown custom district in 1800 on the sloop *President* bound for the Cape Verde Islands off the western coast of Africa.[166]

On the eastern river bank in the township of Chatham (now East Hampton), David Hall, whose woodworking activity may have been confined mainly to carpenter-type joinery, received "half a load of Slabs for Seats" from the estate of Daniel Brewer in 1788. As Hall's daybook gives no indication that he constructed Windsor seating, he may have passed the raw material along to a third party. On two occasions in 1791 an individual named Abraham Scalnix bottomed rush-seated chairs for Hall. At the carpenter's death about 1815 he still possessed "Chest Joiners Tools" along with five Windsor chairs, possibly the same "Five Green Chairs" received as credit from a John Dean in 1797. The same year Matthew Noble of Chatham announced his specialization in making "chairs of all kinds (except cabinet)." His need for whitewood or bass plank eighteen inches wide identifies his production of Windsor seating. Likewise, he both sold and repaired rush-seat furniture. This may be the same Matthew Noble who was born in Willington, Tolland County, in 1773. Another who advertised as a Windsor-chair maker in the mid 1790s was Elihu Smith of East Haddam, a river town south of Chatham. To gain public confidence in 1796, Smith stated that he had "served a regular apprenticeship at the Windsor Chair Making Business" and noted that "he also professes to understand Painting." Apparently East Haddam was not Smith's green pasture, for by 1798 he had relocated at Lyme where he enjoyed success for well over a decade.[167]

Fig. 6-183 Simon Fitch, *Ephraim Starr*, probably Litchfield County, Conn., 1802. Oil on canvas; H. 59″, W. 42″. (Ella Gallup Sumner and Mary Catlin Sumner Collection, Wadsworth Athenaeum, Hartford, Conn.)

The County and City of Hartford

Hartford gave its name to both the county and city. In 1765 Lord Adam Gordon found "a large scattering town on a small river" where "they build vessels for the lumber trade to the West Indies, from 100 to 500 tons, and float them down [to the coast] in freshets in the spring and fall." Under normal conditions only small craft could navigate the Connecticut River over the thirty-five miles from Long Island Sound to Hartford. Near the close of the Revolution the town still consisted of a "long street, parallel with the river," although that situation changed with the rising prosperity of the postwar years. Brissot de Warville described the Hartford environs in 1788 as a "charming cultivated country; neat elegant houses, vast meadows covered with herds of cattle." Eight years later the duc de La Rochefoucauld Liancourt reported that Hartford's population had reached 6,000 inhabitants. He found the town "regularly built," although the houses were not "so handsomely painted and decorated as in the environs of Boston." However, according to Thomas Chapman, Hartford then was "very thriving, carrying on a great Trade."[168]

Following his training as a cabinetmaker and chairmaker, Solomon Cole of Chatham moved just south of the town of Hartford to Glastonbury. Analysis of his seating production between 1795 and 1807 is revealing. He made rush- and plank-bottomed chairs, the former in just sufficient numbers to indicate the presence of a lingering conservatism among his customers. "Slatback" chairs may have been differentiated from "kitchen" seating by the number of crosspieces in the backs; prices varied from 3s.6d. to 5s.6d. Chairs in the lower range often represented frames without seats, the customers supplying the rush bottoms and possibly the "coloring" as well. The few "great" chairs recorded probably refer to companion seating with arms, and the several rocking chairs made between 1795 and 1797 are priced sufficiently low (6s.6d. to 7s.) to indicate that they, too, were rush-seated furniture.[169]

The Windsor terminology in Cole's accounts follows that in Amos Denison Allen's South Windham memorandum book. The craftsman described "dining" (bow-back) and "fanback" side chairs. "Armed" chairs were sack-backs, and "fancy" chairs had continuous bows. Cole never used the word *Windsor*. Construction of plank-bottomed chairs began in 1795 with the sack-back Windsor. Assuming that Cole's term "table chair," used only in 1795 and the first half of 1796, is an early reference to the dining chair, which name he introduced into his accounts in December 1796 and continued to use thereafter, then the craftsman manufactured bow- and sack-back chairs simultaneously as companion seating. Reinforcing this supposition are entries, such as one for customer Edward Benton, who purchased six dining chairs at 8s.6d. and two "arm'd" chairs at 10s.6d. in February 1797. Cole's accounts show no Windsor-chair construction in 1798, and when production resumed, slowly, in 1799, the shop may have converted to bamboo turnings. Cole recorded his first sales of fan-back chairs only in 1801. Whether at this late date he was making the chair recognized today as a fan-back Windsor or the new single-rod, square-back chair, which also has a spreading fanlike profile (fig. 7-5), is speculative. Between 1801 and 1807, fan-back sales totaled 190 chairs, as compared to only thirty-three dining chairs in the same period. Cole sold no "fancy" (continuous-bow) chairs until 1805 and 1806, the 9s. price just about what he charged for the new-fashioned "square top [chair] with double bows." Shop construction of the two styles was limited; output amounted to fewer than forty chairs of each pattern. Windsor prices in all styles sometimes varied as much as 2s. This is explicable in terms of finish, since chairs in both one and two colors of paint were available, as Cole plainly notes; ornamentation also increased the price.[170]

During the period covered by Cole's records, a number of workers supplied labor. The two most comprehensive early shop accounts are those of Elijah W. Webster and Aziel Pierce. The men worked together briefly in the Cole shop during the early months of 1796. In March Cole credited Webster with "turning timber for 124 Chairs"; by May 25 the workman had completed eleven months' labor, was paid, and departed. Pierce, on the other hand, was employed on a piecework basis. He purchased a quantity of turned

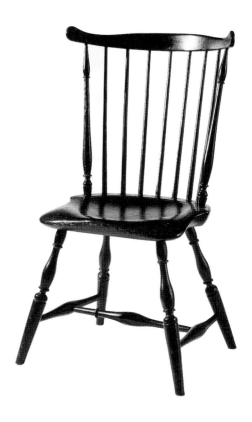

work from Cole, including material prepared by Webster, and supplemented this with additional "timber for Chairs," whitewood plank, glue, and painting materials. Most "credits" derived from chair framing late in 1796. Pierce set up 158 "table chairs" (bow-backs) and forty-eight "armd chairs" (sack-backs) along with two "great" seating pieces.[171]

Edward Shepard, who later conducted business in Wethersfield as a cabinetmaker and chairmaker, worked for Cole from August 1803 until October 1804. The young man was just twenty when he began his trade. His primary activity involved cabinetry—bureaus, stands, tables, and the like. On a number of occasions, however, Shepard was employed at chairwork. He framed seating, including chairs identified as "armd" and "fanback," spoke-shaved stock, split "Chair timber" from logs, and applied paint. The only other chairmaker of record employed by Cole was Ira Hubbard, who worked in 1806 making "fan-back" and "square-top" chairs. An individual named Samuel Taylor wove rush bottoms for seating furniture from October 1798 to February 1800 at a charge of 1s.6d. per chair. Despite the existence of Cole's reasonably detailed accounts, no documented Windsor chairs from his shop are known.[172]

Stacy Stackhouse arrived in Hartford about 1784. He had migrated "from New-York" where a "Musket List" identifies him as a chairmaker in 1775, the year he married. The craftsman's advertisement in the *American Mercury* for November 20, 1784, suggests that he had been in Hartford only a short time. The "great demand" for Windsor chairs and the "encouragement promised him by a number of Gentlemen" in the area apparently were the inducements that prompted Stackhouse to move northward. By the time he repeated his advertisement in January 1786 and added a postscript calculated to attract an apprentice, Stackhouse numbered among his customers Daniel Butler, a local physician, to whom he had sold eight Windsor chairs at 10s. apiece. Presumably, the seating comprised a set of side chairs in the fan-back style, as depicted in the woodcut that accompanies some of the chairmaker's advertisements (fig. 6-186), since bow backs were scarcely known, even in Philadelphia, in 1785. Circumstantial evidence indicates that a group of four fan-back Windsors owned by the Antiquarian and Landmarks Society (Hartford) could be part of that original set of eight chairs purchased by Dr. Butler in September 1785 (fig. **6-184**). Butler began construction of a clapboarded house on Main Street in 1782, the present Butler-McCook Homestead and headquarters of the society. Purchase of the chairs coincides with the period when the physician was furnishing his new home and raising the first of his six children. The house and contents remained in the family for several generations until the great-grandchildren of Daniel Butler bequeathed the homestead to the society. A 1910 photograph of the kitchen shows two of the Windsors silhouetted against the north windows (fig. **6-185**). Whether the Butler-McCook chairs are typical of Hartford Windsor production in the late eighteenth century is difficult to say, since documented chairs from the city are almost unknown. In any case, their yellow poplar seats are unusually broad, and the long wood fibers run crosswise instead of from front to back as is common in side chairs. Neither planks nor turned members betray any evidence of New York influence. Stackhouse may have worked elsewhere, possibly along the Connecticut coast, following his departure from the Hudson River city and before settling in Hartford.[173]

Stacy Stackhouse worked in Hartford at his shop and home located "a little north of the State-House" for about a decade. When advertising during these years he regularly compared the quality and price of his products with those of New York and even Philadelphia (fig. **6-186**). Whitewood plank was a constant need; both in 1786 and 1792

Fig. 6-185 Photograph of kitchen, Butler-McCook House, Hartford, Conn., 1910. (Antiquarian and Landmarks Society, Inc., Hartford, Conn.)

Fig. 6-186 Advertisement of Stacy Stackhouse. From the *Connecticut Courant*, Hartford, Conn., February 2, 1789. (Photo, American Antiquarian Society, Worcester, Mass.)

Stackhouse searched for an apprentice. The lapse of six years between the two notices appears to indicate that he found a suitable "boy" in 1786 who completed his training. After 1792 Stackhouse was more interested in acquiring journeymen, and such advertisements continue as late as August 21, 1794. Suddenly, in December of that year the chairmaker announced his intention to dispose of his house. Whether rising competition in the Hartford chair market or the growing attraction of westward migration was responsible for this decision is not indicated. In any event, Stackhouse had relocated in Claverack near Hudson, New York, by November 26, 1795, when he advertised his newly established business.[174]

One of Stackhouse's early Hartford competitors was Jacob Norton, whose first advertisement appeared on October 1, 1787. Norton, like Stackhouse, was anxious to purchase "White Wood and Poplar Plank, from 16 to 18 inches wide." None of his three known advertisements identifies his Windsor production by style, but, certainly, he was making fan-back chairs. Norton constructed writing-arm Windsors, as well. One made in October 1790 for Thomas Lloyd, Jr., priced at 12s., was far simpler than those constructed by Stacy Stackhouse and sold to John Sutton and Dr. Mason Fitch Cogswell for £1 apiece. Ralph Earl painted Cogswell seated in his low-back writing chair in 1791.[175]

Silas Easton set up in the Windsor-chair business at East Hartford, his home town, "a little South of the Paper-Mills." His first advertisement of March 1793 illustrates a fan-back Windsor like that shown in Stacy Stackhouse's advertisement. By 1795 Easton had joined forces with a man named Butler to manufacture chairs in a variety of popular styles. According to census records, Easton still lived in East Hartford in 1800. Business probably continued on an even keel until passage of the Embargo Act in December 1807. Following that date all of coastal New England, which relied heavily on trade, quickly felt the pinch. It may have been economic conditions that led to Easton's army enlistment on April 7, 1813. His artillery duty was brief, however; he died in a military hospital less than three months later.[176]

John I. Wells, a Quaker, began his cabinet business in Hartford west of the "great bridge" as early as 1789, after having worked as a journeyman in "one of the most noted Cabinet Shops in New York." His venture into the painted chair business appears to have begun some years later. A first step in this direction was his advertisement for a "Journeyman at the common flagg seat Chair making business" in early October 1796, when he expected to "be able soon to furnish [such chairs] in abundance." By the end of the month he had accomplished part of his scheme: "Old chairs are painted and bottomed with flag, at his new Chair-shop, by a good workman." Wells's advertisement of the following March indicates that he then maintained a constant supply of "Common Flagg seat Chairs, ready for customers, at the first cost." He manufactured Windsor chairs by September 1797, when he offered "a good berth for an Apprentice to the Windsor and Common Chairmaking business." Thereafter, evidence of his Windsor-chair-making activity continues through the early part of the nineteenth century as his business expanded and diversified.[177]

The Windsor-chair-making career of John Wadsworth probably commenced about the time he first advertised on June 3, 1793. Using in his notice the fan-back chair cut previously employed by Silas Easton and Stacy Stackhouse, he pinpointed his location for potential customers as "opposite to Mr. Daniel Jones's Store . . . about sixty rods north of the Court House." The site appears to have served as Wadsworth's business center until he gave notice on December 21, 1795, that he had "taken the Shop lately occupied by Stacy Stackhouse." John Wadsworth achieved distinction among Hartford chairmakers for having constructed furnishings for the new Statehouse occupied in 1796.[178]

The duc de La Rochefoucauld Liancourt, who visited Hartford about that time, described the structure as it neared completion: "A house is now in building for the reception of the meetings of the Assembly of the representatives of the State. . . . The foundations of this house are laid with great solidity of structure, and are built of a sort of red stone that is common in this country. Its two upper stories are of bricks."[179]

On the second floor of the Statehouse, which still stands, are the rooms that were occupied by the state assembly. The large one on the south side served as the senate chamber, presided over by the governor; across the hall was the house chamber. Lemuel Adams, a Hartford cabinetmaker, constructed twenty shield-back mahogany armchairs for use by the senators and two companion upholstered-back chairs for the governor and speaker. Ten upholstered window stools completed the room seating. John Wadsworth provided Windsor furniture, as follows:

John Wadsworth Bill of Cabinet Work for the New State House			
To 25 settees	@	51/	£63.15.0
To 12 Green painted Chamber Chairs	@	8/6	5. 2.
To Painting 18 Old Chairs			
belonging to the old Court House	@	2/	1.16.0
John Wadsworth			£70.13.0

The chairmaker may have secured the job by reason of his proximity to the seat of government.[180]

For the past several decades it has been assumed that the twelve green chairs listed in the account were for use in the room occupied by the house of representatives, but even the addition of eighteen repainted chairs would have provided only a fraction of the seating necessary to accommodate 160 members, the speaker, a clerk, and possibly others. Newton C. Brainard has stated that the representatives sat on green settees well into the nineteenth century, although he does not cite his source. If that was the case, Wadsworth's twenty-five settees augmented others, perhaps brought from the former legislative chambers. All or part of the dozen new chairs could have been used by the speaker and other officials. On the ground floor the supreme court chamber also required seating. The repainted chairs from the old courthouse likely were used there and may have been supplemented by some of Wadsworth's new green chairs or the thirty-six "Windsor Chairs" purchased from the craftsman the following year.[181]

Tradition associates a group of distinctive high-back Windsors with the Statehouse furnishings (fig. **6-187**). The design suggests the chairs were part of the new seating supplied by Wadsworth rather than the older, repainted chairs. A pair of Windsors presented many years ago to the Colebrook Historical Society and now at the Connecticut Historical Society is part of a group of six chairs once in the possession of a former secretary of the state, John Boyd (1858-61), who used them in the dining room of his Winsted, Litchfield County, home. Boyd is said to have removed the chairs from the Statehouse, perhaps at a time when the furnishings were being replaced by more "modern" seating. The design bears some affinity to New Haven work in the disposition of its back elements and use of thickened spindles, simple pad arms, shield-shaped seat, and bold roundwork. At least two chairs of this pattern also have New Haven-style, peaked-tip crest rails. In general, seat edges are rounded at the back. The turned profiles and baluster-taper articulations relate to work produced in Rhode Island and along the central and northeastern coast of Connecticut (figs. 6-151, 6-166). Hartford's direct access to the coast via the Connecticut River encouraged such contacts. Another substantial relationship can be seen in the crests of the Statehouse chair and a fan-back Windsor from the Connecticut-Rhode Island border (fig. 6-136). The only difference in profile is the central notch of the smaller chair. The angular sweep also links the crest with a border chair of the "hook" ear type (fig. 6-144).[182]

Although the Statehouse Windsor seems to be a composite design reflecting several stylistic influences, practicality was likely an important factor in selecting a pattern that eliminates some turned elements. On June 8, 1796, Wadsworth appeared before a local justice of the peace to swear that the charges in his account were "set at the lowest Cash price and equally low with any similar work by him executed where the Jobs are equally extensive." In effect, Wadsworth was expected to produce a quality product at an economy price, and 8s.6d. was, indeed, a low figure for a Windsor armchair. Wadsworth's

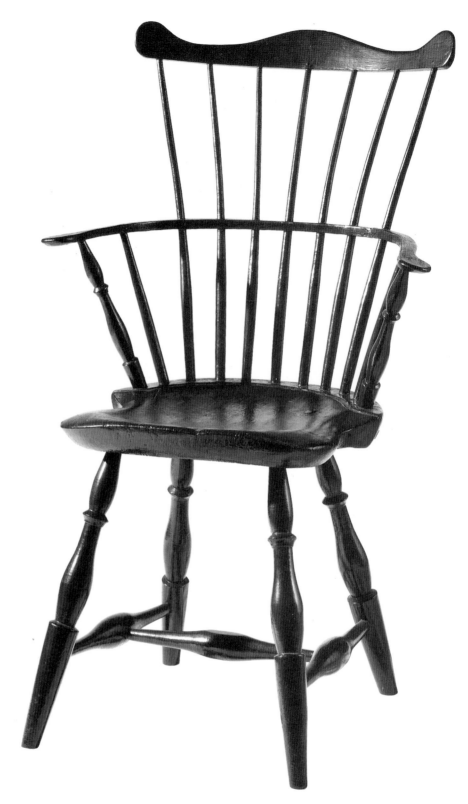

Fig. 6-187 High-back Windsor armchair, possibly by John Wadsworth, Hartford, Conn., ca. 1796–1800. Basswood (seat, microanalysis); H. 37⅞″, (seat) 17⅞″, W. (crest) 21¼″, (arms) 24¼″, (seat) 16½″, D. (seat) 17⅛″. (Connecticut Historical Society, Hartford, gift of the Colebrook Historical Society through Mrs. Mabel Newell: Photo, Winterthur.)

margin of profit must have been slim; therefore, shortcuts were in order. A dozen or more chairs of the pattern still exist. Wadsworth or another local chairmaker also produced fan-back side chairs of a companion design (fig. **6-188**), although that form is rare today. A portrait of the Reverend Benjamin Boardman, pastor of the Second Church of Hartford from 1784 to about 1790, reinforces the case for ascribing the seating to city craftsmen (fig. **6-189**). The clergyman sits in a high-back, green Windsor with large, rounded crest terminals, pad arms, and swelled spindles similar to those in the Statehouse chairs. Following his retirement Boardman remained in Hartford where Joseph Steward (probably) took his likeness in 1796 when the sitter was sixty-five years of age, as inscribed on the canvas.[183]

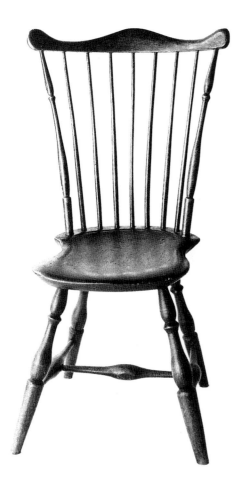

Fig. 6-188 Fan-back Windsor side chair (one of five), Hartford, Conn., 1795–1800. (Photo, Fred J. Johnston.)

Fig. 6-189 *Reverend Benjamin Boardman*, attributed to Joseph Steward, Connecticut, 1796. Oil on canvas; H. 40″, W. 37½″. (Connecticut Historical Society, Hartford.)

Extending the pattern versatility of this seating group is a sack-back chair (fig. **6-190**) that has the same distinctive turnings, thickened spindles, and pad arms of the tall chair. Even the seat profiles are similar at the back. A precise, long, low plank line of modest central elevation marks both the sack- and fan-back chairs. There is little doubt that all three patterns were developed in the same shop or neighborhood. A further relationship exists between these chairs and the Stacy Stackhouse fan-back Windsor (fig. 6-184), since the leg-top and baluster profiles are comparable; the affinity extends to the post tips and balusters of the upper structures, notwithstanding differences in element length. On the other hand, considerable diversity can be observed in an extended seating group identified by the baluster-taper articulation. Among a number of tall, narrow, fan-back chairs with projecting, pointed crests and bulbous leg tops, there are both Hartford and New Haven associations. Bamboo supports are present in some chairs. Among the fan-backs another prominent variation is a large-eared crest with a tall, truncated central arch flanked by angular sweeps to the tips. Baluster and mixed baluster-bamboo turnings occur. Related seating may exhibit flat-chamfered seat edges, Rhode Island-style arm pads, and both hook and rectangular crest tips.

Sometime after rendering his bill to the Statehouse in June 1796 but before November 7, John Wadsworth formed a partnership with his kinsman Horace Wadsworth. The two removed to a shop "80 rods North of the Court-House," apparently John's original location. Expecting to do a good business in "Windsor CHAIRS and SETTEES, of the neatest and newest fashions," the partners were anxious for the assistance of "two active Lads, as Apprentices." Later in November, they let it be known that they wanted to contract for "one thousand set of turned Stuff" and were willing to pay cash. Obviously, a shop that purchased chair parts would have had only limited control over pattern fidelity, and if the supplier employed several hands, even more variation could creep into the work. In time the partners searched for a journeyman to provide direct assistance. Finally, on September 4, 1800, the men announced the dissolution of their business, and John continued on his own at the Hartford shop. Horace went to Charleston, South

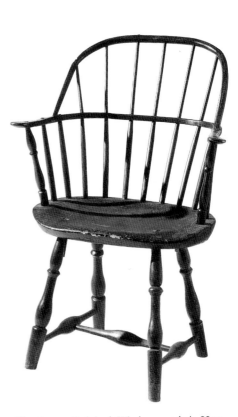

Fig. 6-190 Sack-back Windsor armchair, Hartford, Conn., 1795–1800. Maple, oak, and other woods; H. 34½″, (seat) 15⁹⁄₁₆″, W. (arms) 24³⁄₁₆″, (seat) 20¾″, D. (seat) 14½″; right rear leg replaced and left arm replaced forward of bow. (Connecticut Historical Society, Hartford, bequest of Roderick Bissell Jones: Photo, Winterthur.)

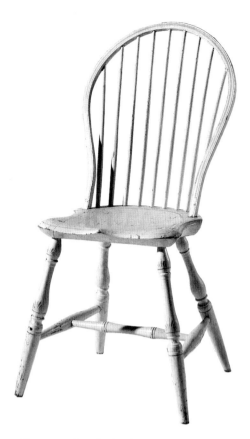

Fig. 6-191 Bow-back Windsor side chair, John and/or Horace Wadsworth (ink inscription), Hartford, Conn., ca. 1798–1802. Basswood (seat); H. 36⅞", (seat) 17¾", W. (seat) 15⅞", D. (seat) 15¹⁄₁₆". (Connecticut Historical Society, Hartford: Photo, Winterthur.)

Carolina, but his reasons are unknown. On November 10 when the sloop *Little Patty* left New London bound for Charleston, she carried "fifteen Windsor chairs" consigned by John Wadsworth of Hartford to Horace Wadsworth at Charleston. John's business apparently prospered, since three years later in December 1803 he announced the opening of his "new Factory" for chairmaking located "directly back of his old Shop."[184]

By this time local styles in Windsor furniture had changed appreciably (fig. 6-191). A bow-back side chair bears a handwritten inscription in black ink on the seat bottom: "Made By M[essrs?] Wadsworth/hartford." If the handwriting is not contemporary with the chair, it is certainly of early nineteenth-century date. Aside from the seat and spindle shapes (fig. **6-191**), the design is an obvious departure from earlier work. The bow is fairly typical of Connecticut-Rhode Island design in its use of a flat face with beaded edges. Below the plank, leg turnings have slimmed considerably and include all the standard elements. Except for the balusters, the profiles are similar to New Haven work (fig. 6-177). The transitional bamboo-turned medial stretcher pinpoints a date in the late baluster period. An exceptionally long baluster collar of the type shown occurs again in the legs of a fan-back chair in the baluster-taper group. Several illustrated Hartford chairs, including this one, have planks made of basswood, a timber greatly favored in the Connecticut Valley for Windsor-chair work (fig. 6-187).

Meanwhile, Lemuel Adams, the cabinetmaker who supplied mahogany furniture to the Statehouse in 1796, took Windsor-chair maker Erastus Dewey into his shop later the same year. Young Dewey apparently leased space from Adams, since he advertised on his own account. Little more than a year later Dewey had become a resident of Bolton, east of Hartford, probably the town of his birth. The census for 1800 indicates that he was still under the age of twenty-six. Adams and Dewey may have shared a family connection through Adams's wife Phila Warner of Bolton. Following Dewey's removal from Hartford, Adams continued in the Windsor business, advertising for "a good workman at Windsor Chairs" to whom he was prepared to give "constant employ." However, business turned sour by 1800, and Adams advertised to sell or lease his shop described as "the three Story Green STORE in Ferry Street." He found a lessee and removed to Norwich where he became the proprietor of a hotel, but that business was short-lived. In May 1801 Adams finally sold his Hartford shop. The craftsman returned to the furniture business, although it was in Norfolk, Virginia, that he advertised the "best warranted" Windsor chairs "on the shortest notice" in July of that year. Adams's Hartford lessee in 1800 was Eli Wood, cabinet- and chairmaker, who continued the production of Windsor chairs at the Ferry Street shop; little more than a year later he formed a partnership with Nathaniel Watson. At the time of his death in 1818 Wood resided at Barkhamstead where he owned a sawmill and chair factory.[185]

The presence of sandbars, falls, and shoals in the Connecticut River seriously compromised early navigation north of Middletown, but in time dredging and other work turned the narrow waterway into "the main avenue of trade in western New England." The head of navigation for shallow-draft river sloops in the late eighteenth century was Warehouse Point (East Windsor), opposite present-day Windsor Locks. Above that place, and especially beyond the falls at Enfield a few miles upriver, flatboats in great numbers plied the river northward well into Vermont. In some cases it was even possible to pole the flatboats up over Enfield Falls. Only modest evidence of Windsor-chair making remains for the river valley between Hartford and the Massachusetts border. Bethuel Phelps, entrepreneur or craftsman of Warehouse Point, advertised in August 1791 for a journeyman cabinetmaker or Windsor-chair maker. He offered "constant employment and good encouragement for one year or more." The Enfield account book of Stephanus Knight—painter, furniture maker, and general handyman—shows limited production of Windsor, "great," and common chairs between 1795 and 1809. The craftsman constructed a set of six Windsors priced at 7s.6d. each in the mid 1790s for Zebulon Pease of Enfield, himself a cabinetmaker. Knight, while in Pease's occasional employ for more than ten years, performed other work, such as making varnish, painting chairs, "hueing Chare Poasts," and "getting out rungs." Evidently, there was a family

bond between the men, since Knight's second wife was a Pease. Even though Knight's probate inventory of 1810 fails to itemize any woodworking tools, it lists a treatise on japanning, which is of particular interest in view of his skill in furniture painting.[186]

Litchfield County

Furniture making in northwestern Connecticut centered mainly in Litchfield in the late eighteenth century. When the county of the same name was incorporated in 1751, Litchfield became the local seat of government. As such, the town enjoyed a "large and relatively cosmopolitan population." During his visit the marquis de Chastellux remarked the town's situation "on a large plain more elevated than the surrounding heights." Already in 1780 there were "about fifty houses pretty near each other, with a large square . . . in the middle," and the eminent jurist Tapping Reeve had founded the Litchfield Law School in 1774. All told more than a dozen furniture craftsmen worked in the town during the 1790s; Joseph Adams "from BOSTON" was one of the first. The Boston city directory for 1789 lists Adams as a cabinetmaker and Windsor-chair maker, although his first Connecticut advertisement of June 7, 1790, refers only to his cabinet-making business. Public records and notices indicate that during the next ten years Adams divided his time between Litchfield and Boston, so that more than a hint of Boston influence may have been present in Adams's Connecticut furniture. His first reference to Windsor-chair making was in 1797 when he announced that he had "an approved workman" in that line working at his shop.[187]

Meanwhile, New Haven-born David Pierpont had settled in Litchfield before June 20, 1787, when he married Sarah Phelps. There are accounts for Pierpont in the ledger of Samuel Sheldon, general merchant of Litchfield, beginning in January 1787 and continuing into the same month in 1796. To pay for cash advances, foodstuffs, rum, and the like, Pierpont exchanged services—chairmaking, painting, and some joiner's work. In one account dated August 17, 1792, Sheldon recorded: "By 10 New Chairs part armd & part dining Chairs" and noted immediately following, "Recd at several times some time since." Thus, the late 1780s and early 1790s also brought the New Haven style in Windsor-chair making to Litchfield. The Danbury influence in Windsor design has already been cited in the portrait of Ephraim Starr (fig. 6-183), a resident of neighboring Goshen. What, then, distinguished a Litchfield Windsor, subject as it was to influences from Boston, New Haven, and possibly Danbury? Unfortunately, there are no known documented chairs of the period to provide an answer, although some idea of the range of local painted seating is offered in the advertisements of two Windsor-chair makers toward the end of the 1790s. John Mattocks, who wanted "Bass wood Plank proper for chair seats," also had "York" and "Plain" (common slat-back) chairs for sale. Nathaniel Brown, whose shop was "half a mile west of the Court-House," kept a similar selection on the premises, although he referred to the "York" chair as a "Fiddle back." His terms "Windsor" and "Dining" refer to plank-seat chairs with and without arms. The partners Oliver Clark and Ebenezer Plumb, Jr., sold both cabinetwork and vernacular seating and charged anywhere from 8s. to 15s. each for their Windsor chairs. If cash was unavailable, they accepted "all kind of stuff fit for Cabinet or Shop work."[188]

MASSACHUSETTS

Boston and Environs

THE CITY AND ITS EARLY CRAFTSMEN The focus of Windsor-chair making in postrevolutionary Massachusetts is Boston. Contemporary estimates place the city's population at between 18,000 and 25,000 during the 1780s. As the marquis de Chastellux observed in 1782, Boston's location was "a peninsula in the bottom of a large bay . . . accessible one way on the land side, by a long neck or tongue of land, surrounded by the sea on each side, forming a sort of causeway." Work began to fill in the Back Bay only in the early nineteenth century. During a visit in 1784 Francisco de Miranda found Boston "happily situated for commerce." The great number of wharves was clearly an indication

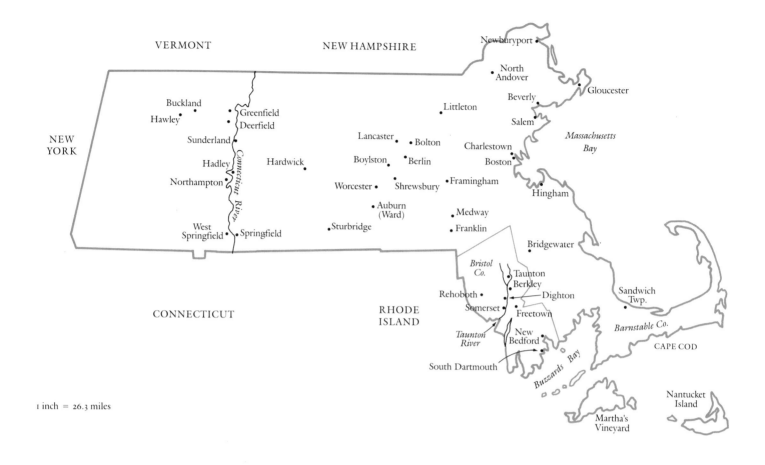

1 inch = 26.3 miles

to him of the port's extensive commerce. Long Wharf was one of the most imposing commercial structures. Henry Wansey described it in 1794 as "projecting into the sea, four or five hundred yards, and . . . about eighty feet wide." "Store houses" formed a long row down the middle, permitting ships to unload on both sides of the wharf. The duc de La Rochefoucauld Liancourt observed, "Boston trades to all parts of the globe."[189]

Visitors complained about the "exceeding" irregularities of the city streets. However, the Common, "designed for the recreation of the Inhabitants," afforded "a delightful Prospect" with its surrounding "Governors House [Hancock Mansion] Situate on a high Hill [Beacon Hill] & a grand Monument erected to Independance." One native described contemporary Boston as "growing fast into mercantile importance," noting that "our merchants all build themselves elegant houses." He remarked, "There is no surer sign of the increasing opulence of a town, than the increase of its buildings and the rising of their rents."[190]

When "Messrs. *Skillins*' Carver's Shop, near Governor Hancock's wharf" advertised "a large assortment of Elegant Windsor Chairs . . . cheap for cash" on December 29, 1785, Boston probably still had only limited local production of the form. Most Windsors were imported from Philadelphia and other metropolitan centers, but that situation changed quickly. In a pictorial notice of April 13, 1786, Ebenezer Stone offered "WAR-RANTED Green Windsor Chairs," including "ROUND-TOP CHAIRS, fan-back Garden-Chairs, Soffes, stuff-seat Chairs, and . . . Dining-Chairs, painted equally as well

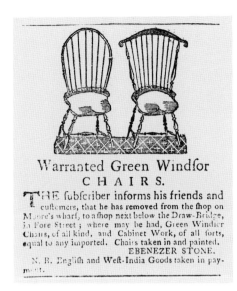

Warranted Green Windſor
C H A I R S.

THE ſubſcriber informs his friends and
cuſtomers, that he has removed from the ſhop on
Moore's wharf, to a ſhop next below the Draw-Bridge,
in Fore Street; where may be had, Green Windſor
Chairs, of all kind, and Cabinet Work, of all ſorts,
equal to any imported. Chairs taken in and painted.
EBENEZER STONE.
N. B. Engliſh and Weſt-India Goods taken in pay-
ment.

Fig. 6-192 Advertisement of Ebenezer Stone. From the *Massachusetts Gazette* (Boston), September 11, 1787. (Photo, Dr. Melvyn and Bette Wolf.)

Fig. 6-193 High-back Windsor armchair and detail of brand, Ebenezer Stone, Boston, ca. 1786–91. White pine (seat); H. 44″, W. (arms) 22¾″, (seat) 20″, D. (seat) 14½″. (Edward P. Alexander collection: Photo, Colonial Williamsburg, Williamsburg, Va.)

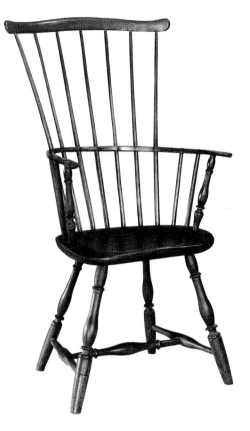

as those made at Philadelphia." He modified and repeated the advertisement several times the following year and advertised cabinetwork as well (fig. **6-192**). Meanwhile, he found a customer for his "Green Chears" in David S. Greenough, who purchased six on May 18, 1786.[191]

Stone appears to have been a newcomer to the furniture business when he advertised in the mid 1780s, since records document his baptism at Charlestown in 1763. Two branded chairs date from this early period of his short career. One is a sack-back Windsor, the "Round-Top" chair of his 1786 advertisement. The other is a high-back chair of almost identical appearance below the arm rail (fig. **6-193**), probably the seat Stone identified as a "Garden-Chair." Both betray their substantial debt to contemporary Philadelphia and Rhode Island work in the presence of umbrellalike caps above oval-bodied balusters, complemented by top-heavy spool turnings below. Elongated balusters seem to be typical of early Boston production; Philadelphia influence can be seen in the thick necks. Following the Philadelphia fashion, too, are the squared arm rail with long, narrow rail returns (figs. 3-37, 3-39) and the slim crest of revolutionary date (fig. 3-24), the rounded ends plain in keeping with the simple character of the arms. In appearance, Stone's chair captures something of the quality of Joseph Henzey's bent-arm-rail, high-back Windsor (fig. 3-25). The Bostonian's use of a thin-shaved oval seat and long balusters probably derives from that work, and Henzey is known to have supplied Windsor seating for the Boston market (see chapter 3). Shipping papers support the visual evidence. Sporadic Philadelphia records of the 1780s document a shipment of eighteen chairs to Boston in 1783 and another in August 1785. In September the *Winthrop* cleared the Delaware River for Boston carrying "18 Windsor chairs." Manifests for the 1790s, which have survived in greater number, include a single Boston shipment of almost 400 chairs and 3 settees, most identified as Windsors. On two occasions at least, William Cox, a Philadelphia chairmaker, was the shipper. Underscoring the wide distribution of Philadelphia Windsors in postrevolutionary Boston is an unidentified inventory for Middlesex County, possibly Concord, compiled about 1791. Listed among the seating furniture are "two philadelphia Chairs" valued at 7s. apiece, and a "Larg Joiner Chair" of similar value. Newport and Providence, like Philadelphia, had regular water contact with Boston, and both also supplied furniture as a trading commodity.[192]

During the 1780s, as a Windsor-chair industry developed in Boston, Daniel Rea, ornamental painter, refurbished old, imported Windsors for customers, as he had done before the war; chairmakers, too, began to offer this service. Thomas Blackford, identified by Rea in his accounts as a "Chair-maker," purchased painting materials,

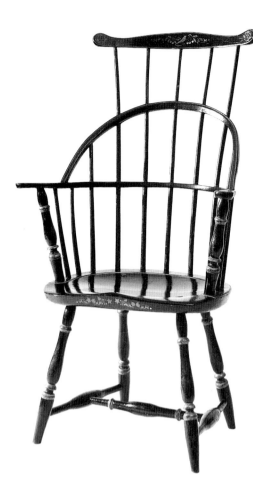

Fig. 6-194 Sack-back Windsor armchair with top extension and detail of brand, Thomas Blackford, Boston, 1786–90. Maple (seat) with maple, oak, and hickory (microanalysis); H. 45", W. (crest) 21⅛", (arms) 26¼", (seat) 21½", D. (seat) 15⁷⁄₁₆". (Winterthur 86.2.)

consisting of oil, colors, lead, and pencils (fine brushes) in 1786. Two documented sack-back chairs, one with a back extension (fig. **6-194**), constitute Blackford's known work. Similarities with Ebenezer Stone's chair are evident. The oval seats, elongated crowned turnings, stretchers, squared arm rails, and plain spindles show related profiles. Blackford chose maple for the seat of the illustrated chair, a rare use of that wood for the plank outside Rhode Island. His slim crest is better contoured than Stone's pattern, enhancing its aesthetic quality. The bows compare favorably with that in Stone's unillustrated sack-back chair; all slope in like manner and terminate in blunt tips. In shaving the bow face of the tall chair to a flat surface to make it more comfortable for reclining, Blackford introduced a rare feature in Windsor work. The bow also retains traces of beading at the edges, a feature that is better defined in Blackford's second chair. That Windsor may date slightly earlier, as the spindles thicken below the rail in the Philadelphia fashion (fig. 3-38, left). The similarity is not coincidental. Blackford described himself in a label beneath the seat as a "WINDSOR CHAIR-MAKER, Lately from Philadelphia." Of further interest, he had just "left Mr. Stone, joiner, at the North-End" to open his own shop. The Mr. Stone referred to may have been Ebenezer rather than his brother Samuel. Such a working relationship would explain the close similarity of the two men's products.¹⁹³

As a craft group chairmakers began to gain recognition in Boston by the close of the 1780s. The Federal Procession of February 1788, comprising "mechanics and artisans of every description in town," was a popular testimony to the approval accorded state ratification of the Federal Constitution. Although the chairmakers were not identified among the twenty-nine marching trade groups, they probably took their places in the division labeled "CABINET and COACH-MAKERS, WHEEL-WRIGHTS, &c." They took a more prominent place in the next parade, organized in October 1789 to greet the newly elected first president of the United States. The procession, upon meeting President Washington on the city outskirts, proceeded to the Statehouse. Behind the guest of honor followed a band, the town officers, members of the professions, and, in alphabetical order by trade, the "Artizans, Tradesmen, Manufacturers, &c.," with the "Cabinet and Chair-makers" holding fifth place in the line of march.¹⁹⁴

Within a fortnight, Samuel Blake, Jr., became the second Boston cabinetmaker and chairmaker to publicize his business. He illustrated his first notice of November 2 with the woodcut previously used by Ebenezer Stone. During the month he replaced that illustration with one depicting a four-slat rush-bottomed chair, perhaps to demonstrate his flexibility in constructing either "Chamber or Kitchen Chairs." Examples of Blake's work have yet to be identified, but he was one of a small group of Boston chairmakers who heralded the heyday of local Windsor production that began in the 1790s. The Windsor chair's rise in popularity is noted in Daniel Rea's furniture-painting accounts. And even before the 1780s closed, Christian Gullager painted several Boston subjects seated on Windsors, including Captain David Coats (ca. 1787) and an unidentified Boston gentleman (ca. 1789). The latter (fig. **6-195**) is one of the few full-length subjects executed by the artist and includes one of the best representations of an eighteenth-century Windsor chair found in any portrait. The turned profiles and pronounced point of the seat front suggest an imported chair from Rhode Island.¹⁹⁵

Fig. 6-195 Christian Gullager, *A Boston Gentleman*, Boston, ca. 1789. Oil on canvas; H. 71¼", W. 54". (Corcoran Gallery of Art, Washington, D.C., gift of Eva Markus through the Friends of the Corcoran.)

Considerable insight into the expanding Boston chair industry of the late eighteenth century can be gained from a group of records rescued from two centuries of neglect in the Suffolk County Inferior Court of Common Pleas. A particularly illuminating case is that of Robert McKeen, a journeyman chairmaker under the age of twenty-one. McKeen agreed in April 1789 to work two months, board and lodging provided, for chairmaker Joseph Adams, himself a newcomer to the business at age twenty-two. Two months stretched to eight, the time divided between labor at wages and piecework. On January 13, 1790, the two men sat down and calculated McKeen's wages for labor during four months and nineteen days. Piecework computations were based upon the production of 252 chairs and 1,416 turned chair parts. A running account of McKeen's work identifies all the chairs as Windsors; references to both "long stretches" and "Long corner pieces" indicate that the turnings were for similar use. McKeen was unable to collect the monies owed him and never received board and lodging, as promised; he sued and won his case. Perhaps Adams found it "uncomfortable" to remain in Boston under circumstances of such notoriety; he left for Litchfield, Connecticut, where he advertised as a cabinetmaker "from BOSTON" in June. McKeen, on the other hand, may be the chairmaker of the same name who advertised in Virginia in 1793.[196]

Several other new faces appeared in the chairmaking ranks of the early 1790s. The first was Samuel Jones Tuck(e), who entered the furniture market by March 1790 when he advertised; early the next year he constructed a "Riting chair" for a private customer. Tuck's advertisement for his "Windsor Chair Manufactory," dated October 3, 1795, identifies imported Windsor seating as a lingering source of competition for the Boston chairmaker: "He flatters himself, the work will be as well executed, as that which arrives from Philadelphia, or New-York." The master felt sufficiently confident of his own product to announce that he would hire two journeymen and was searching for two apprentices.[197]

Tuck was born in 1767 at Epsom, New Hampshire, the son of a Congregational minister who was a Harvard graduate. He married Judith Gardner of Nantucket in 1791 after setting up shop in Boston and joined the Massachusetts Charitable Mechanic Association in 1795, possibly as an original member. The history of that organization includes a brief biography, stating that Tuck "made himself rich in the business of chair-making, to which he afterwards added that of selling paints, at a large store on the easterly side of Liberty-square. He built two or three elegant brick houses on [adjacent] Fort Hill. He was deeply concerned in navigation during the war of 1812, but he became embarassed, and withdrew from the association." A genealogy indicates that Tuck moved to Baltimore in 1817 where he remained until 1822. City directories confirm this, identifying him as a ship chandler and grocer in 1817 and later as a "gentleman." He returned to Boston about 1822 and a decade later removed to Nantucket, where he died in 1855. His children intermarried with the Hussey and Chase families of the island.[198]

William Seaver is the next craftsman of record to begin making Windsor chairs in Boston. He probably was a Massachusetts native, since the surname was common in the Boston area. In his first advertisement of May 1793, Seaver—who like Tuck was concerned over the local preference for imported Windsors—promised, should the quality of his chairs "not answer the expectations of the Purchaser, to return the money, provided complaint is made in a reasonable time." When three years later competition from domestic "imports" was still a factor, the chairmaker announced again that he could "make as good work, as can be imported from any other place whatsoever." By then Boston itself was exporting chairs to the West Indies and Nova Scotia. In the interim Seaver had been chosen to supply fan-back Windsor chairs for the First Boston Theatre, located in Federal Street. In January 1794, just before the opening, the chairmaker constructed a dozen and a half green-painted Windsors. Sixty additional chairs were ready for use in the autumn at the start of the second season.[199]

Boston court records of the mid 1790s identify two chairmakers who but for their legal difficulties would be mere names on a checklist. In a suit brought against a fellow artisan for defamation of character, Jesse Foster stated that Josiah Willard had accused

him of stealing a note of hand dated in 1795. One witness to the document was Windsor-chair maker William Dalton. In the course of his December 1798 complaint to the Court of Common Pleas, Foster remarked that he had "for a long time followed the art, trade, and mystery of Windsor chair making" and was "a workman well capable of performing in workmanlike manner any work in his trade." To resolve the matter, the court appointed referees, who in turn called witnesses from the trades, comprising painters, turners, and chairmakers; Windsor-chair craftsman Edward Scott was among them. The court finally found Willard not guilty, but after his acquittal Foster paid him the disputed $26 and received a receipt. Foster died not long afterward in 1800; Willard continued in the furniture trade for several decades.[200]

When listed in the second Boston directory of 1796, Reuben Sanborn had been in business only a short time, as confirmed in the accounts of ornamental painter George Davidson. On March 14, 1797, Davidson charged the chairmaker $8 for "Painting a Sine [sign] Chair &c." The price was not inconsequential, being equivalent to the cost of eight Windsor side chairs. When Davidson repainted the sign two years later on April 13, 1799, Sanborn may already have removed to Doane's Wharf, an advantageous location for a chairmaker wishing to expand his business. One substantial sale, probably due to the move, took place in 1801 when Nathaniel Treadwell purchased "12 large fanback Chairs" on behalf of Captain John Lovett of Beverly. In the same year the chairmaker became a member of the Massachusetts Charitable Mechanic Association. Sanborn maintained his Doane Wharf location until his name disappeared from the directories after 1809.[201]

The year 1800 marked the start of a three-year partnership between William Seaver and James Frost, a cabinetmaker. Their work, discussed below, includes some of the most innovative furniture known in contemporary Boston Windsor-chair making. The craftsmen's first location was State Street, which then as now ran into Long Wharf. By 1803 the partners were in Battery March. An early commission was a set of ten chairs made for the Boston merchant Benjamin H. Hathorne in 1800.[202]

A latecomer to Boston was Thomas Cotton Hayward (b. 1774). He migrated from Pomfret, Connecticut, where he advertised between 1796 and 1798. Hayward had settled in Massachusetts by May 25, 1799, when George Davidson, the ornamental painter, debited him for painting his "Sine." Five days later the craftsman was well into business, having to purchase "Three Dolars worth [of] Varnish." The chairmaker was a young man and still wore his hair in a queue when he sat for his profile likeness, probably to William Doyle of Boston (fig. 6-196). He married in Charlestown in 1800 and purchased the first of several properties there in 1801; he achieved membership in the Massachusetts Charitable Mechanic Association in 1805. Hayward's trade card engraved and printed between 1803 and 1811 is a *pièce de résistance* (fig. 7-26), one of only two trade documents of its kind datable before 1815.[203]

Windsor-chair makers were beginning to enjoy good custom in Boston by the turn of the century, and the fashion had also gained a substantial foothold among householders in the surrounding towns. William Erving, Esq., of Roxbury used Windsors along with seating bottomed in leather, hair, and flag. His fellow townsman, John Lowell, Esq., furnished his back parlor with thirteen Windsor chairs painted green. Doctor John Sprague I of Dedham used Windsor seating in his entry, upstairs hall, and a sitting room-bed chamber on the first floor, while Cambridge painter Elisha Richardson owned eight bow-back chairs in 1801.[204]

OTHER BALUSTER-TURNED WORK The first fan-back side chairs in the Boston furniture market, produced in the mid to late 1780s, probably bore some resemblance to the Stone and Blackford armchairs. Long swelled stretchers, elongated oval balusters, and large spools with projecting knife-edge caps would have been the order of the day. However, with outside influences coming from all directions, local chairmakers soon modified and refined the design (fig. 6-197). Knife-edge spool caps appear to represent one thread of continuity. Otherwise, the balusters are shorter and fuller, and the caps

Fig. 6-196 *Thomas Cotton Hayward*, attributed to William Doyle, Boston, ca. 1799–1806. Hollow-cut paper with cloth backing. (Private collection.)

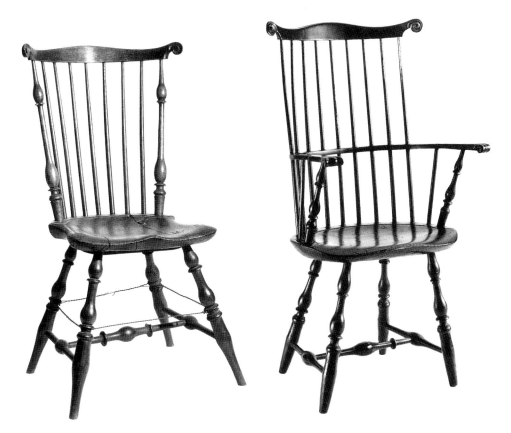

Fig. 6-197 Fan-back Windsor side chair, Boston, 1790–95. White pine (seat, micro-analysis); H. 36¾″, (seat) 17½″, W. (crest) 20½″, (seat) 17¼″, D. (seat) 16⅜″. (Museum of Art, Rhode Island School of Design, Providence, gift of Frank Brownell Bishop: Photo, Winterthur.)

Fig. 6-198 High-back Windsor armchair, Boston, 1790–95. White pine (seat, micro-analysis); H. 42¼″, (seat) 17⅞″, W. (crest) 23″, (arms) 24¼″, (seat) 21¼″, D. (seat) 14⅞″. (David Stockwell, Inc.: Photo, Winterthur.)

resemble those of the spools. Leg and post tops are vase-shaped, and full centers characterize many stretchers. Large disks ornament the medial brace. The illustrated chair is one of two interpretations from the early 1790s, both rare. The difference occurs in the feet, here interpreted in the Rhode Island manner as swelled tapers but also found as straight-tapered supports. The swelled pattern may be slightly later than the straight foot, which is accompanied by stretcher rings more widely spaced from the center (fig. 6-198). As the design progressed the rings were moved toward the swelling and then thickened (fig. 6-202). One chair of straight foot and wide rings has leg turnings that resemble those illustrated. The seats are also comparable, and the carved crests are identical. That chair is branded "U. TUFTS," probably identifying the owner as Uriah Tufts, Sr. or Jr. (b. 1796), of the greater Boston area. In the nineteenth century the younger man became a woodworker in Lowell. Some chairs of this type have eight rather than seven spindles. An excellent comparison can be made between the seat of the present chair and that of figure 6-202. Other comparisons point up the primacy of Rhode Island as an influence on Boston chairmaking at this stage of its development.[205]

The first Boston high-back Windsor with swelled-taper supports may be earlier in date than the previous side chair. Its flat arms have oxbow sidepieces, as found in some sack-back chairs with straight-taper feet. Chairmakers experimented with a number of "borrowed" elements in their search for a "local" design. They first used spindles with long swells through the midsection but abandoned these in favor of plain, tapered sticks (fig. 6-198). Another transitional feature is an arm-post baluster of long, attenuated neck, close in form to the upper element of the fan-back post. This turning is also found occasionally in the sack-back chair. Soon to follow was a high-back design whose features demonstrate that chairmakers had resolved the fine points of the pattern (fig. **6-198**). The crest generally resembles that in the fan-back chair; the volutes project more, producing rounded triangular notches, below. Straight sticks guide the viewer's eye downward to the carved knuckle arm terminals, which have tiny scrolls inside and out. The oval white pine seat with legs piercing the top surface is typical of Boston armchair planks; its contour resembles the preceding and following examples. The arm posts duplicate the leg turnings, but a cone is substituted for the swelled taper. The medial

stretcher with its widely spaced rings is an early pattern. Although several tall chairs are branded by Samuel Jones Tuck, most, like the present variant, are unmarked. Tuck's production of this form is consistent in its use of the elongated swell in the side stretchers, introduced in Boston by Stone and Blackford in the mid 1780s.

Side stretchers of the same form are also seen in several sack-back chairs branded by Tuck (fig. **6-199**). The long swells are slightly hollowed on either side of the central crease, duplicating early Philadelphia bamboowork (figs. 3-50, 3-51). No chair is an exact copy of the others; each has at least one element that sets it apart. Here, the "modeled" side braces are connected by a medial stretcher whose worn rings probably once duplicated those of the previous tall chair. The rounded baluster caps that step out from the neck surfaces are present in the same high-back chair but have their prototype in Rhode Island work (fig. 6-20). Stylistically, they are representative of Boston turnings executed in the early 1790s. At a later date close-fitting, rounded caps crowned the balusters (fig. 6-200). In the present chair, flat arms are sawed to the shallow oxbow found in high-back chairs documented to Tuck's shop. Features of two other sack-back Windsors bearing Tuck's brand place their date later in the decade. A chair at Colonial Williamsburg has a thick, bamboo-turned medial stretcher supported by side braces whose heavy cylindrical centers show none of the subtle modeling found earlier (fig. 6-205); its flat arms follow the previous pattern.[206]

The late date of another, "round-topped" Windsor by Tuck is betrayed by the presence of short, delicate bamboo-turned spindles under the arms (fig. **6-200**). In this chair Tuck converted to stretchers of another pattern—the oval, swelled-center braces of the previous fan- and high-back chairs. One variation is the substitution of large, flat-edged reels set close to the medial swell for widely spaced rings. This bold design is a classic feature of Boston work dating from the mid to late 1790s. William Seaver used similar rings in some of his marked work. Special forms with this stretcher include a writing-arm chair and a small settee. The idea of moving the rings closer to the stretcher center to form an eye-catching feature may derive from Rhode Island work. Chairs like figure 6-50 employ related turnings with considerable success. The actual model for the reel may be earlier rush-bottomed seating, since the Boston banister-back chair of figure 6-5 has such a turning centered in the front stretcher. Aside from the stretcher variation,

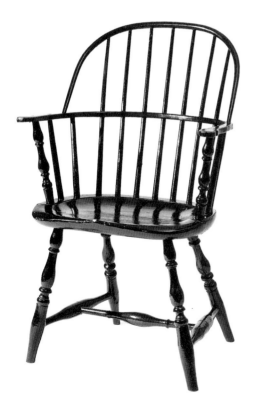

Fig. 6-199 Sack-back Windsor armchair and detail of brand, Samuel Jones Tuck(e), Boston, ca. 1791–98. White pine (seat); H. 37¼", (seat) 17⅝", w. (arms) 24¾", (seat) 21³⁄₁₆", D. (seat) 15⅞". (Private collection: Photo, Winterthur.)

Fig. 6-200 Sack-back Windsor armchair, Samuel Jones Tuck(e) (brand "S·J·TUCKE"), Boston, 1795–1800. H. 36¼", (seat) 16⅞", (arms) 21⅞", (seat) 16⅞", D. (seat) 15¼". (Photo, Betty Sterling.)

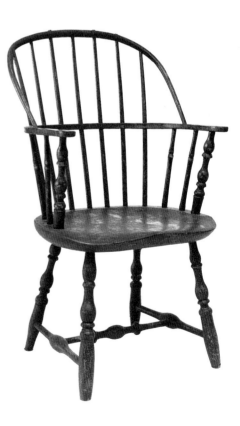

there is a change in arm profile. Simple pad ends appear to follow the New York style with only the barest suggestion of a curved rail return immediately forward of the bow tips. Turnings show some advance, as well. Balusters are noticeably short, round, and full; the cap sleeves fit close around the neck.

A number of unmarked sack-back chairs that date to about the mid 1790s and feature reel-type knobs in their medial stretchers have a distinctive spindle arrangement (fig. 6-201). The long sticks are framed almost vertically and sufficiently close to leave sizable voids under the bow ends, as in some Rhode Island work (fig. 6-42). Within the group subtle variations in turning reveal the hands of several craftsmen. Most side stretchers have oval swells, although several braces are blocked. Like the second Tuck chair (fig. 6-200), leg rings usually are relatively thick, having the appearance of compressed balls. Flat arms follow the oxbow profile of figure 6-199. One armchair of this type has been found in company with a set of six bow-back side chairs documented to Tuck's shop.

Use of the classic Boston medial stretcher, or a close variation, was not limited to the sack-back chair. The feature is present in Windsors made in various patterns during the mid 1790s, including fan-, bow-, and high-back chairs. A striking Boston fan-back design makes good use of the turning (fig. 6-202). To date, one chair can be documented

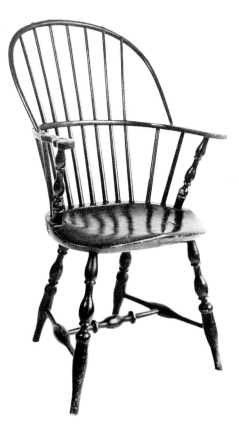

Fig. 6-201 Sack-back Windsor armchair, Boston, ca. 1793–98. (Photo, F.O. Bailey Co.)

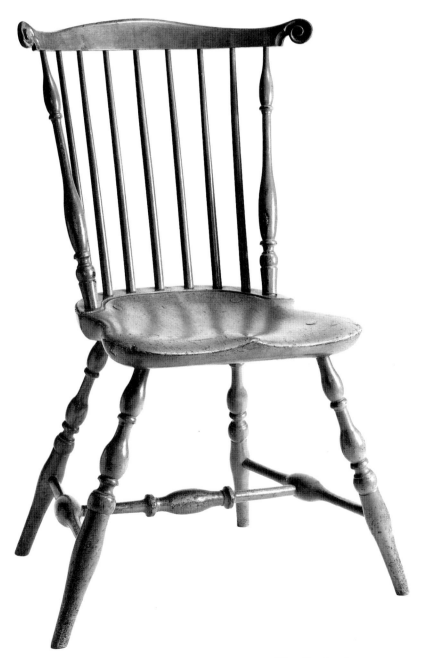

Fig. 6-202 Fan-back Windsor side chair, D. Danforth (owner brand), Boston, ca. 1793–98. H. 35½″, (seat) 17⁷⁄₁₆″, W. (crest) 21¹³⁄₁₆″, (seat) 17³⁄₈″, D. (seat) 16¼″. (Private collection: Photo, Winterthur.)

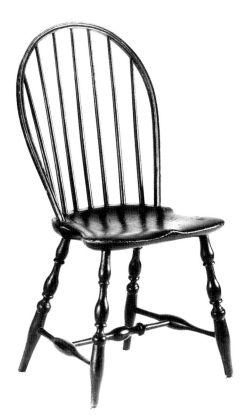

Fig. 6-203 Bow-back Windsor side chair and detail of brand, William Seaver, Boston, 1795–1800. White pine (seat) and birch (micro-analysis) with other woods; H. 37⅜", (seat) 17⅜", W. (seat) 17½", D. (seat) 16⅟₁₆". (Private collection: Photo, Winterthur.)

to Tuck's shop; other examples have traditions of use in the greater Boston area. Two chairs, including the one illustrated, are stamped on the seat bottom "D : DANFORTH," probably the name of an owner. A search of records has revealed no such craftsman working during the 1790s or later, and appropriate owner candidates have been found only in 1810 and later.[207]

There are two basic fan-back designs, although the differences between them are subtle. The carved crest volutes provide the key to separating the groups. As illustrated, one type of hollow-cut scroll sweeps wide in an oval and ends in a broad cut at each lower rail corner, a technique repeated in figure 6-197; the other scroll forms a circle with a narrow final cut (fig. 6-204). The variation suggests that at least two shops were involved in production. Whereas post balusters in chairs with broad-cut volutes exhibit long, heavy bodies, as illustrated, the second type of post has shorter swells of similar profile. All seats have the same distinctive contours featuring high, cheeked front corners. Looking down on the shield-shaped plank, these corners project markedly in comparison to the breadth of the back. The side stretchers often are rounded and blocked; oval-centered stretchers are common in the second design. Differences in ring size and spindle height from chair to chair are normal variations. On the fringes of the group are individual specimens that reveal close kinship but vary sufficiently in carved or turned elements to fall outside the mainstream of design.

Contemporary with the fan-back Windsor is a bow-back side chair of comparable pattern (fig. **6-203**). There are documented examples for Samuel J. Tuck and William Seaver. Both men used a brand or, more rarely, a label. Seaver fixed both his brand and a label on the bottom of a chair whose stretcher knobs are spaced more widely than those illustrated. Enough printed text remains on the floral-bordered paper to determine that the chairmaker's location was that given in his 1793 advertisement. The frequent use of labeling in Boston Windsor work may explain why none of the fan-back seating is marked (fig. 6-202). Exposed on the seat bottoms, these bits of paper soon peeled or crumbled and disappeared. Seaver's marked bow-back work is slightly more plentiful than Tuck's, but there is as much subtle variation within the work of each man as between the two. As expected, shaped planks and birch legs stockpiled in the shop were used interchangeably in the bow- and fan-back chair. Long, tapered sticks needed only

to be cut to length to suit the arch of the bow, whose moderately full, straight sides show decided New York influence. Boston chairmakers introduced their own bow-face pattern—a broad, shallow channel that extends almost the width of the surface, leaving a rounded, raised bead at either edge. Windsors dating from the beginning and end of the bow-back period usually exhibit longer leg balusters. The early chairs employ widely spaced stretcher knobs; chairs closing out the design have thick bamboo medial stretchers.

At the close of the century one or more chairmakers introduced an alternative swelled-taper foot to the Windsor-chair market (fig. 6-204). The illustrated example retains other familiar elements: full baluster turnings, a reel-style medial stretcher, narrow-cut carved volutes, and oxbow arm returns. The "new" foot actually is an extension of the previous swelled taper capped like a baluster; the spool and ring are eliminated. Although the change produced a well-formed "tenpin"-shaped support, use of the foot was limited and of short duration. The model perhaps is contemporary bedstead feet, although the design may be a conscious emulation of the swelled foot found in federal-period tables and stands. Other Windsor furniture to employ this taper includes a low three-legged stool, a two-seated settee, a fan-back chair, and bow-back side chairs similar to figure 6-203, one branded by Samuel J. Tuck. Still newer designs were about to take the market by storm. The unusual short posts at the back of the illustrated chair herald the bamboo era, current in Boston by 1800. Use of bamboo sticks in an otherwise baluster-turned Windsor seems somewhat incongruous; but this chair is a rare design, and the chairmaker gave his imagination free play.

BAMBOO-TURNED WORK The unusual bamboo pattern of the short sticks supporting the crest, as in figure 6-204, is seen again in a branded fan-back chair from the shop of Samuel J. Tuck, dating to the late 1790s (fig. 6-205). The chair fuses both old and new elements into one design, thus providing a rare insight into the industry during a period of stylistic transition. The fan-back pattern was in its last phase of development, soon to be driven completely from the market by the bow-back chair. Both the volute-carved crest and well-modeled seat were used for the last time in this brief transitional period at

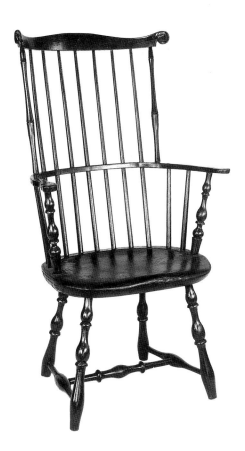

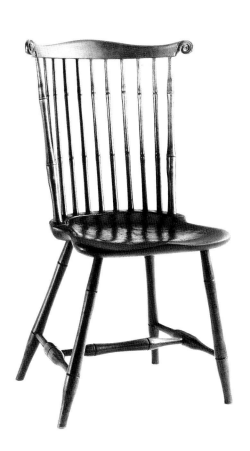

Fig. 6-204 High-back Windsor armchair, Boston, ca. 1797–1800. (Former collection J. Stogdell Stokes.)

Fig. 6-205 Fan-back Windsor side chair, Samuel Jones Tuck(e) (brand "s·j·tucke"), Boston, ca. 1797–1800. White pine (seat) with maple and ash (microanalysis); H. 37¹⁄₁₆″, (seat) 17⅞″, W. (crest) 21½″, (seat) 18″, D. (seat) 16¾″. (Winterthur 67.1907.)

Fig. 6-206 *Justice Seated on a Windsor Chair.* From billhead of James Murphy, Boston, ca. 1808, inscribed August 6, 1818. (General Moses Porter Papers, Essex Institute, Salem, Mass.)

the turn of the century. The sausage-shaped side stretchers and heavy bamboo medial brace are present in a sack-back Windsor by Tuck, now at Colonial Williamsburg. The plain, grooved legs, cup-turned bamboo posts, and bonelike spindles are elements that will be encountered again.

The popularity of the bow-back chair in Boston, and for that matter throughout the country, by 1800 is demonstrated in a billhead engraved for James Murphy of Marlboro Street (fig. **6-206**), who embellished his business document with Masonic emblems announcing his fraternal affiliation. Murphy may have selected the figure of Justice to suggest his integrity in the watchmaking and jewelry trade, which he entered about 1803. The draftsman's portrayal of Justice seated in a bow-back Windsor chair speaks to the popular use of the seating form. Individuals at all levels of society could relate to Justice thus supported, since the Windsor was ubiquitous in American life. Murphy's first use of the billhead can be pinpointed to about 1807–8 when he added "ENGLISH GOODS" to his line of merchandise and called himself a "Shopkeeper" in the city directory. The name of engraver Thomas Wightman first appears in local directories in 1805.

The Boston chair market of the early nineteenth century was alive with innovation. William Seaver and James Frost, business partners between 1800 and 1803, have left for posterity a key group of documented bow-back furniture. Chairs of the first several patterns to be discussed can truly claim the title "fancy Windsors." Examples featuring an unusual curved front stretcher with oval medallions connected to straight back stretchers, once associated generally with eastern Massachusetts, have been finely pinpointed with the discovery of several chairs branded by Seaver and Frost (fig. **6-207**). Some legs terminate in a swelled-taper foot that seems a holdover from the baluster leg made earlier by Seaver (fig. 6-203). Similar legs and feet, scaled to size, occur on a child's cradle bearing the partners' double label. Chair bows now are pinched at the waist. In place of a central groove, this particular example has an unusual band of spaced gouges on the face. The seat is that found earlier.

Most other chairs in the curved-stretcher group substitute plain bamboo-style legs of the type found in Tuck's fan-back chair (fig. 6-205) for the fancy support. Some are blocked slightly at the lower groove. One exception is a side chair with a seat for stuffing

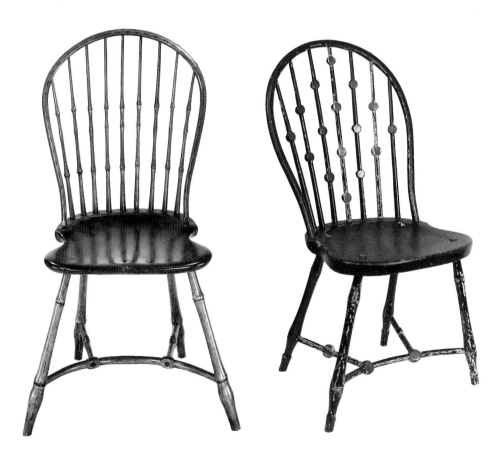

Fig. 6-207 Bow-back Windsor side chair, William Seaver and James Frost (brand "SEAVER & FROST"), Boston, ca. 1800–1802. Probably white pine (seat) with ash and oak; H. 38⅝″, W. (seat) 17½″, D. (seat) 17″. (Chipstone Foundation, Milwaukee.)

Fig. 6-208 Bow-back Windsor side chair with seat for stuffing, Boston, ca. 1799–1802. (Private collection: Photo, Nantucket Historical Association, Nantucket, Mass.)

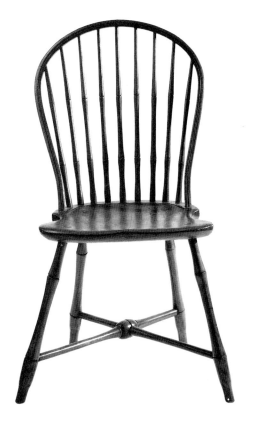

Fig. 6-209 Bow-back Windsor side chair and detail of brand, William Seaver and James Frost, Boston, ca. 1800–1802. White pine (seat) with other woods; H. 37¼″, (seat) 17¾″, W. (seat) 18⅜″, D. (seat) 17″. (Dr. and Mrs. J. Goodman collection: Photo, Winterthur.)

that has "spade" toes (fig. 6-208). In this fanciful Windsor the chairmaker duplicated the stretcher medallions in the spindles where they appear to hang like so many pendants in a beaded curtain. A square-back, fancy rush-bottomed chair with spade feet served as the inspiration. Within a bow crowned on the face in the Philadelphia manner the medallions limit the spindles to seven. Windsors with plain bamboo legs have eight plain sticks; the labeled Seaver and Frost chairs, nine. Another nine-spindle chair stands on bamboo supports of a fourth type. Slim in the midsection, the grooved areas are thickened above and below to form angular swells. The bow face, like that in plain bamboo seating, features a deep narrow, centered groove. The pattern probably succeeded that with the broad, shallow groove (fig. 6-203). The curved-stretcher feature is found in an occasional forward-scroll armchair and *possibly* other patterns.

A number of plain bow-back Windsors with bamboo supports and H-plan stretchers enclose within the backs from seven to nine spindles of the general type found in the Seaver and Frost curved-stretcher chair. Some sticks are close copies, while others eliminate the central swell or flare at the bottom. Two chairs vary the pattern. One has compressed rings at the grooves; the other has sticks with three egg-shaped nodules and an exaggerated flare at the base. The latter repeats the egg shape in the two leg nodules. Most chairs have a broad or deep groove in the bow face, although the Windsor with exaggerated nodules has a flat face with a scratch bead at either edge. Represented in this group are Boston products as well as chairs constructed in adjacent areas where craftsmen were influenced by Boston work.

Nodular spindles flared at the base but without an extra row of swellings across the center fill the arched backs of a special group of Boston side chairs braced with cross stretchers (fig. 6-209). Some chairs are documented. The illustrated Windsor is one of a set of six, of which three are branded and one labeled by the firm of Seaver and Frost. The illustrated bow has the deep, centered groove found in many curved-stretcher chairs, while other bows exhibit a broad channel or crowned face. The seats appear interchangeable with that of Seaver and Frost's curved-stretcher chair. Leg diameters vary from slim to stout, and the bamboowork is marked by long midsections and blocked, or cuplike, turnings below the lower groove. The cross braces uniting the legs are nothing more than gently swelled cylindrical rods; one contains a turned oval ball positioned behind the center point. The balls vary slightly in size from one chair, or set, to the next, but the basic design is similar, and a groove circumscribes the center. Rods flare slightly in trumpet style where they join the ball. Sometimes the crossing is a left-sided one, as here; at other times, the rods reverse. The ball turning and its articulation with the flared rod ends appear to relate to the stretchers in early Rhode Island S-post chairs (fig. 6-16) or later regional examples (figs. 6-23, 6-141).

The cross-stretcher Windsor may have been developed first as a fan-back chair (fig. 6-210). Several features of the illustrated specimen suggest this possibility. The ribbonlike crest has much in common with Ebenezer Stone's top piece (fig. 6-193). Plain, tapered spindles were the rule in Boston work until the late 1790s, and the elongated swelling of the main crosspiece is a typical shape in H-plan braces. The extremely thin midsections of the turned legs and posts represent one of several types of

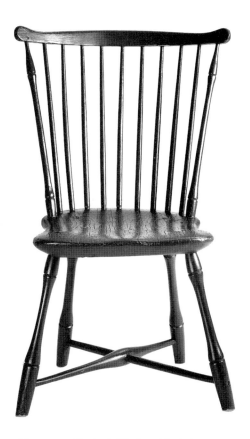

Fig. 6-210 Fan-back Windsor side chair, Boston, ca. 1799–1802. White pine (seat) with maple, oak, and ash (microanalysis); H. 40¼″, (seat) 16″, W. (crest) 22⅝″, (seat) 17¼″, D. (seat) 15⅞″. (Winterthur 59.1824.)

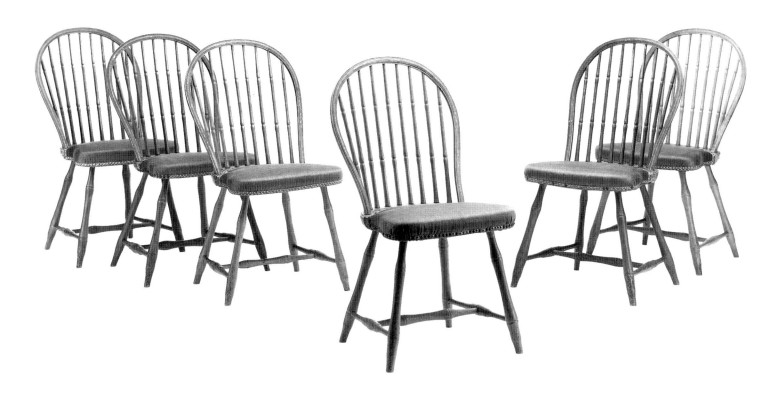

Fig. 6-211 Bow-back Windsor side chairs with stuffed seats (set), possibly by Samuel Jones Tuck(e), Boston, 1795–1800. White pine (seat) with birch, ash, and oak (microanalysis); H. 35¹³⁄₁₆″, (seat, with stuffing) 17¾″, W. (seat) 18¾″, D. (seat) 17″. (Winterthur 59.2976–.2981.)

bamboowork in the chair market during the transitional period of the late 1790s. Several features similar to those illustrated can be seen in a second fan-back Windsor once in the J. Stogdell Stokes collection. Crests, stretchers (reversed), and planks appear to be from the same patterns; however, the seat of the illustrated chair lacks a groove around the back platform. Differences occur in leg and post turnings; those of the Stokes chair are quite nodular. Four swells mark the posts; three large swells, lightly grooved, form the legs.

Emphasis upon ornamental spindles in Boston Windsor work at the turn of the century apparently stimulated some interest in a now rare pattern (fig. 6-211) noted briefly (figs. 6-200, under arms; 6-205). An unknown craftsman, possibly Samuel J. Tuck, introduced nine bold, "bone-articulated" sticks (fig. **6-211**) to six chairs that may well constitute a unique *set* of bow-backs. The chairs also are distinguished by having planks for stuffing. Recovered in Boston in the 1940s, the chairs are said to have

Fig. 6-212 Details of figure 6-211.

Fig. 6-213 Bow-back Windsor armchair and detail of label, William Seaver and James Frost (label, and brand "SEAVER & FROST"), Boston, ca. 1800–1802. Legs cut down. (Old York Historical Society, York, Maine.)

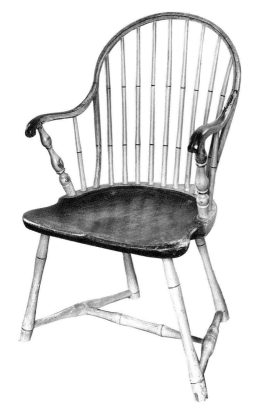

belonged originally to Samuel Minot, a Boston silversmith (d. 1803). Although appraisers listed thirty chairs in Minot's household inventory, none is identified by type, and the values are relatively low. Heavy bows of intricate molded face enclose the flared-base spindles (fig. **6-212**). The unusual breadth of the back and seat (almost nineteen inches) resulted in chairs of considerable size. Stout, deftly turned legs with cuplike swells below the lower grooves harmonize well with the chair's overall size and character. Lending additional structural and visual strength are thick, double-swelled bamboo medial stretchers and side braces with long, double cup-shaped swells (fig. 6-212), all coordinating with the lower legs. Tuck employed similar side stretchers, though not so boldly executed, in one of his sack-back chairs (fig. 6-199). The heavy bow and sturdy base of the Windsor supporting the figure of Justice (fig. 6-206) is reminiscent of these chairs.[208]

Standard bow-back patterns were not the rule in Boston chairmaking circles. Subtle design variables permitted craftsmen to alter their product at will; thus, chairs frequently varied slightly from shop to shop or order to order. In chairs made at the turn of the century, bows are grooved, crowned, and flat-beaded. Spindles are plain, or grooved and nodular with flaring bases. Shield-shaped seats frequently have broad, exaggerated front corners, even when designed for stuffing. Bamboo legs with slim midsections vary at the feet from tapered toes to blocked or cup-turned tips. Double-swelled bamboo medial stretchers have slender or heavy proportions. Whether thick or thin, the side stretchers have long central swells, some exhibiting cup-turned work (fig. 6-213).

In 1800 when the bow-back Windsor dominated the Boston market, any number of craftsmen worked in the city and environs. William Seaver had joined forces with the cabinetmaker James Frost; Reuben Sanborn marked some of his production; and Samuel Jones Tuck continued to produce a quality product. These "veterans" were joined by several newcomers who have left documented chairs, including William Dalton and Joseph Ruggles Hunt (later an emigrant to New Hampshire). Across the river in Charlestown, Thomas Cotton Hayward was just getting his feet on the ground and would soon be joined by Amos Hagget.

Some sets of bow-back chairs were sold with armchairs of similar form, which employed one of three arm supports fashionable in the city from about 1799 to 1805. Stylistically, the earliest chair is one of transitional design with baluster posts and bamboo legs (fig. **6-213**). The labeled and branded example by Seaver and Frost is datable to the brief period when the firm occupied a shop at 57 State Street. The Boston shield-shaped seat with its cheeked front corners is here enlarged to accommodate arms. The undercarriage and spindles follow the usual contemporary patterns. The post turnings are a holdover from styles made earlier by Seaver; the elements almost duplicate those in the legs of his bow-back side chair (fig. 6-203). The deep, centered groove in the bow face relates directly to Seaver and Frost's work in the cross-stretcher pattern (fig. 6-209); indeed, at least one similar armchair with cross braces exists. The finely

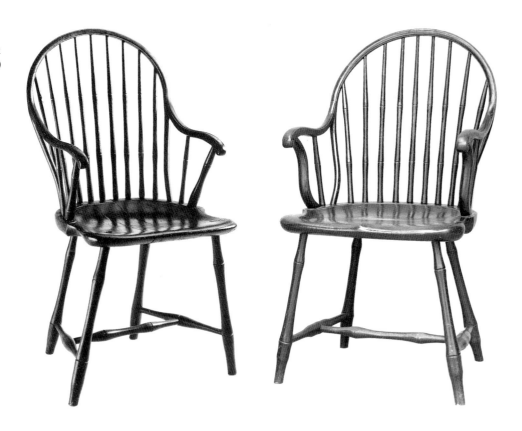

Fig. 6-214 Bow-back Windsor armchair, William Seaver and James Frost (brand "SEAVER & FROST"), Boston, ca. 1800–1803. H. 37⁷⁄₁₆″, (seat) 18″, W. (arms) 19⁷⁄₈″, (seat) 19⁵⁄₈″, D. (seat) 17½″. (David C. Stacks collection: Photo, Winterthur.)

Fig. 6-215 Bow-back Windsor armchair, Boston, ca. 1799–1805. (Metropolitan Museum of Art, New York, gift of Mrs. Russell Sage.)

coordinated detailing of Seaver and Frost's work is evident in the continuation of the bow-face groove down the center of the arm tops and over the scroll ends. Below arm level the bow rounds in typical Philadelphia fashion.

Almost contemporary with the baluster-post Windsor are armchairs fitted with arm supports in the form of bamboo sticks or sawed and molded, curved rods, both of Philadelphia inspiration. At least one bamboo-post chair is branded by Seaver and Frost (fig. **6-214**), providing a reliable date range and an opportunity to compare the slightly advanced pattern with the firm's previous work. The support structure is about the same, except for the side stretchers, which have lost their modeled quality; however, cup-shaped turnings are found in chairs of this type from other shops. The seat rounds more at the front corners and appears to be slightly less broad at that point. The bamboo-style arm supports coordinate well with the legs. The spindles are the same as those in the previous chair. The bow face is now crowned, its rounded surface defined by beads at the edges, which continue down the arms in imitation of Philadelphia work. Many similar chairs, including one branded by William Dalton, omit the arm beads. Dalton probably constructed his chair in 1799 or 1800, when records place him in Boston. An undocumented but rare chair with plain, grooveless spindles is patterned on the bow face, and its arms are marked in a grooved pattern similar, if not identical, to the molded surfaces of the stuffed-seat chairs (fig. 6-211). Bow-back side chairs, similar in their turned work and angular waist to that illustrated, are visible in a late nineteenth-century photograph of the early collector Benjamin Perley Poore seated on the veranda of Indian Hill Farm, his house in West Newbury.²⁰⁹

Armchairs in the sawed-support group (fig. **6-215**) again show variety from the seat fronts to the turned work. Side-stretcher swells vary from short to long ovals; the cup-shaped pattern also occurs, as illustrated. At least two chairmakers, Reuben Sanborn and Samuel J. Tuck, branded similar chairs; both men worked before and after the turn of the century. One of Sanborn's chairs has tiny carved scrolls facing the arm tips, as illustrated, and the feature also occurs on a small, two-seated Boston settee. Characteristic of this group is a sawed and molded arm support whose S-curve profile frequently is more exaggerated than in Philadelphia work. As shown, a few local chairmakers carried

the curve to the extreme. At least one chair has elegantly turned spindles of the bone-articulated variety. A chair in the Moffatt-Ladd House at Portsmouth, New Hampshire, has cross stretchers. Another example features a curved medallion stretcher and inverted baluster feet (fig. 6-207).

CHARLESTOWN CRAFTSMEN Thomas Cotton Hayward's work in Pomfret, Connecticut, appears to have varied from his production at Charlestown, Massachusetts. A branded continuous-bow armchair he made in Connecticut or soon after his arrival in Massachusetts has many features associated with eastern Connecticut design. The influence of the Tracy family is evident in the large, shield-shaped seat of shaved and arched front (fig. 6-104), the full-bodied leg and post balusters of moderate length (figs. 6-103, 6-107), and the enlarged, bulbous swellings of the arm posts (figs. 6-98, 6-99). The ample size and placement of the latter nearly duplicate turnings in an unusual writing-arm chair with a history in Pomfret. Rhode Island influence is present in the full-rounded bow and sharply angled, flat arms. Tapered feet that "neck in" at the top also reflect Rhode Island (or Boston?) practice.

All of Hayward's early documented Charlestown chairwork, which includes several styles, appears to have been produced simultaneously, since many designs interrelate. His high-back chair in the bamboo style (fig. **6-216**) is the logical successor to the tall, club-foot Boston chair in figure 6-204. His crest has smaller, simply carved, volutes; the flat arm pads vary in their oxbow returns. The even-numbered, long back sticks are anchored in a Boston-style oval plank. The slim, turned legs appear to be contemporary with those in a bamboo-style, continuous-bow armchair (fig. **6-217**), also marked with the Hayward brand. The definite blocking of the lower legs and side stretchers in the two chairs indicates how readily the craftsman absorbed design elements in his new environment. The pronounced flare of the arm-post bases duplicates that of the spindles in local work. From that point Massachusetts influence appears to end, and Connecticut styling reasserts itself in the continuous-bow design. The back arch is strongly influenced by Tracy-type work; at the bends of the bow the wood is reduced appreciably in thickness, and the arms continue foward in flat pads flanked by single, pointed projections. The

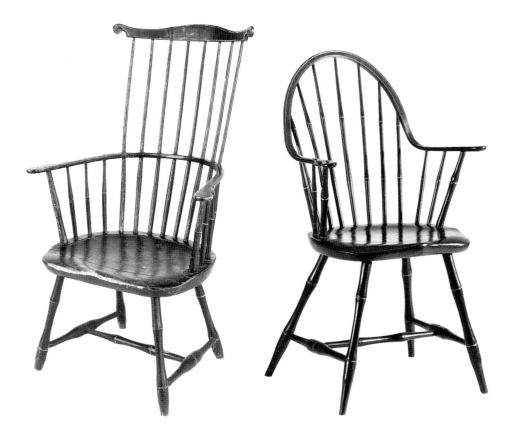

Fig. 6-216 High-back Windsor armchair, Thomas Cotton Hayward (brand "T. C. HAY-WARD"), Charlestown, Mass., ca. 1799–1803. (Photo, Jerome Blum.)

Fig. 6-217 Continuous-bow Windsor armchair, Thomas Cotton Hayward (brand "T. C. HAY-WARD"), Charlestown, Mass., ca. 1800–1803. White pine (seat) with maple (microanalysis) and other woods; H. 37¼", (seat) 17¹¹⁄₁₆", W. (arms) 23", (seat) 18⅞", D. (seat) 15½". (Private collection: Photo, Winterthur.)

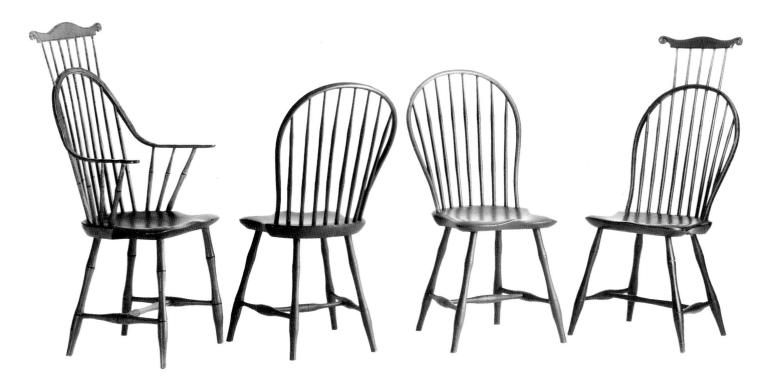

bow face is flat and beaded at the edges in a pattern common to Connecticut, Rhode Island, and New York. The seat, too, betrays Hayward's background. Its oval form with short front corners, hollow pommel, and flat, canted edges could not be mistaken for Massachusetts work even if the chair were unmarked (figs. 6-98, 6-99, 6-100). Furthermore, the legs socket inside the plank, which is uncommon in Boston practice. Hayward's one concession in this part of the chair was his use of white pine for the plank, the common local material.

A group of documented Hayward chairs provides further insight into the craftsman's versatility (fig. **6-218**). The chairs do not form an original set but suggest how master's and mistress's chairs could have been accompanied by, perhaps, from four to eight plain, bow-back side chairs. The plain chairs actually are the earliest stylistically, since their medial stretchers have a single swell. The braces in the tall chairs have a bamboo profile. Legs and side stretchers in the plain and master's chairs are blocked. The mistress's chair is less definite in this feature; however, it has a crowned bow face, like the side chairs. A varied spindle arrangement indicates that even and odd numbers were contemporary features in Hayward's work. While he did not construct the two illustrated tall chairs as companion pieces, their features are compatible. The carved-volute crests are similar, though not identical in profile or width. The master's chair shares a number of features with the previous continuous-bow chair, including a flat bow face and similar arms and posts.

The bow-back armchair featured in a vignette on Hayward's tradecard (fig. 7-26) must have quickly followed the continuous-bow Windsor as the companion piece to his bow-back side chairs; however, marked examples are unknown. Several sets of unmarked square-back chairs have descended in the chairmaker's family, along with the tradecard and a group of silhouettes (fig. 6-196). Hayward apparently discontinued use of a name brand a few years after settling in Charlestown, or about the time he first manufactured the bow-back armchair and seating in the newer square-back style.

The career of Amos Hagget probably commenced in Charlestown sometime after Thomas Cotton Hayward established his business in that rising community. Although settled early, the community began to develop economically only in the postrevolutionary period. In part, its expansion was due to the construction in 1786 of a toll bridge across the Charles River, which replaced a cumbersome ferry route to Boston. Local prosperity was heightened in 1798 when the federal government established the U.S. Navy Yard at Charlestown.[210]

Little is known of Hagget's life and career. He married a Charlestown girl in 1806. Three years earlier he served as witness to Thomas C. Hayward's sale of property, suggesting he had attained his majority by that time. Hagget's role as witness further hints that he and Hayward shared a close relationship, possibly that of journeyman and master. Hagget may have struck out on his own by 1806, since at least one bow-back side chair is branded "A. HAGGET / CHARLESTOWN." Without the name, the eight-spindle chair, which possesses a crowned bow face, bamboo medial stretcher, and blocking in the legs, could not be distinguished from Hayward's work. Hagget left the area sometime after the baptism of a daughter in 1808 and before 1817, when he arrived at Fredericton, New Brunswick.[211]

North of Boston

Salem dominated the furniture market north of Boston; it attracted the greatest number of cabinetmakers and chairmakers in northeastern Massachusetts. Some were native born, but many resettled in the prosperous commercial center in their mature years. The most successful woodworking craftsmen were the Sanderson brothers, Elijah and Jacob. Preeminent among patrons and merchants before his untimely death in 1799 was Elias Hasket Derby, who left an estate of about one million dollars. Derby, along with the Crowninshields, was a pioneer in the East India, India, and Chinese trade. A wholly commercial city, Salem ranked sixth in population in the United States by 1790. A casual observer noted, "This place has a rich and animated appearance." Although the town was situated between two fingers of the sea, Salem harbor was somewhat incommodious. Only small vessels could unload at the wharves; larger craft had to discharge their cargoes into lighters in deeper water. Nor were the harbor's shortcomings Salem's only handicap. The duc de La Rochefoucauld Liancourt and other travelers commented that the town lacked "cultivated land behind it to supply its exports, which in America is . . . considered as one of the most essential articles of commerce." All agreed that "the great extent and rapid progress" of Salem's trade was due to "the uncommonly active and enterprising spirit of its inhabitants." In the mid 1790s annual freightage exceeded 20,000 tons, and the three local shipyards hummed with activity. Although busy, Salem was small—only 1¼ miles long and ½ mile wide. Three parallel streets were the principal avenues of commerce and residence.[212]

In a sampling of 102 Essex County probate inventories dating from the eve of the Revolution, Alice Hanson Jones found no record of Windsor seating. Documents filed in court following the war, such as that for Captain Benjamin Hind, continue to mention only familar forms, such as roundabout, leather-bottom, maple, and great chairs. Like their Boston neighbors, local inhabitants probably first knew the Philadelphia version of the Windsor. In October 1789 the *Alice* arrived in Salem from the Delaware River carrying twenty-two Windsor chairs and a spinning wheel. Half a dozen Windsor chairs supplied by James Magee to Elias Hasket Derby the previous January probably originated in Philadelphia or New York, cities Magee visited on Derby's behalf at about this time. Even in the mid 1790s, Salem chairmaker James Chapman Tuttle recognized the formidable competition from the south when advertising that his own Windsors were "made in the Philadelphia style."[213]

Evidence that local production had begun occurs in a dated bill of 1790 for twelve dining chairs made by cabinetmaker and chairmaker Josiah Austin and sold for 6s. each to Captain Joseph Waters. This seating, along with "12 Round Chairs" (either sack-back Windsors or rush-bottomed roundabouts), probably was destined for exportation. From as early as the revolutionary period Salem was a center of furniture-merchandising activity. In 1779 the Sandersons and Austin first united their skills in a business partnership to construct or acquire large quantities of furniture for venture sales to domestic and foreign ports. Doubtless, such activity was minimal during the war years, but when normal commerce resumed, business prospered into the early nineteenth century. At one time or another most Salem furniture makers had dealings with the Sandersons, either directly or through a craftsman-middleman. Upon occasion some artisans even

sponsored ventures of their own. By reason of kinship or marriage, several craftsmen outside the area occasionally participated. Local residents did not lack for a good selection of merchandise when making domestic purchases, although some men of affluence and wide-ranging commercial connections, like Elias Hasket Derby, made substantial furnishing purchases outside the community.[214]

Construction of popularly priced chairs was a flourishing local activity during the 1790s. James Chapman Tuttle (b. ca. 1772) was one of several woodworkers who practiced the dual trades of chairmaking and cabinetmaking. By August 1796, in answer to "demands" in the local market, he supplemented his cabinetwork and "common" chairwork with the manufacture of Windsor seating at his shop in Federal Street. By 1801 his customers could choose from a selection of chairs "ready made in the different fashions . . . and painted different colours." The "different fashions" of the 1790s are itemized in a 1794 bill of work rendered to Elijah and Jacob Sanderson by Micaiah Johnson as "dyning," "round top," and "fanback" chairs, all priced from 5s.6d. to 10s. apiece.[215]

The Salem estate records of Samuel Phippen demonstrate to what degree a furniture craftsman could enjoy success during the heyday of production in the 1790s. At his death in 1798 the craftsman's holdings were valued at $7,888.78. His real property alone was substantial for a man of his calling. It comprised his residence, a "mansion house" with outbuildings and land near Union Wharf; two shops in Salem, one of which he occupied; and half a house with outbuildings and land in neighboring Danvers. Despite his attempt to retire in 1793, Phippen was an active craftsman at his death, as attested by the quantity of furniture parts, finished and unfinished chairs, and furnishings itemized in his inventory. Supplementing a variety of plain and elegant tables, bedsteads, and case pieces, were quantities of chairs stored or standing in the four or more shop rooms. Although appraisers made no distinction between Phippen's personal furnishings and those made for sale, listings for 392 seating pieces give some idea of the craftsman's business. Among the sale merchandise were most of the 121 birch, or fancy, chairs ranging in wholesale price from 80¢ to $1.25, depending upon whether the seats were rushed and wooden surfaces finished. Fifty unpainted bow-back chairs were valued at 75¢ each; fifty-eight with paint were only a nickel more apiece. The eighty dining chairs appraised at 80¢ to 93¢ each are a puzzle: ordinarily, dining and bow-back chairs were one and the same at this date, as implied in Micaiah Johnson's bill to the Sandersons. Perhaps in this case the dining chairs had fan backs, an interpretation reinforced by the existence of documented bow- and fan-back side chairs from the shop of James Chapman Tuttle.[216]

While local chairmakers were busy making new furniture, ornamental painter William Gray of Salem wove new rush bottoms for old seats and repainted worn chairs; green was a popular choice. Green seating is listed in the estates of Ezra Burril, a cordwainer who died in 1797, and John Chamberlain, a leather dresser; other references occur in contemporary export records. Lending status to the use of Windsor seating locally was the wealthy Elias Hasket Derby, owner of twenty-two or more wooden-bottomed chairs at his death. Six green Windsors furnished his counting room on the wharf. More green chairs stood in his handsome new mansion on Essex Street—six in the "South West" room, furnished as a library and study, and two more in the southeast bed chamber accompanied by eight mahogany chairs with "Silk bottoms." Windsors of a different color furnished other rooms.[217]

Chairs documented to the shop of James Chapman Tuttle are the only existing Windsors associated with Salem, despite the scope of local chairmaking. Like the products of several other New England craftsmen, Tuttle's work reveals his personal style through its turned work, even when the chairs carry no markings. He probably marketed the fan-back Windsor first (fig. 6-219). Those illustrated are from different sources; although similar, they are not identical. Illustrating them together points up the subtle variation inherent in the work of even one shop—differences in the diameters and lengths of turnings, and shifting proportions between top and bottom structures. Yet

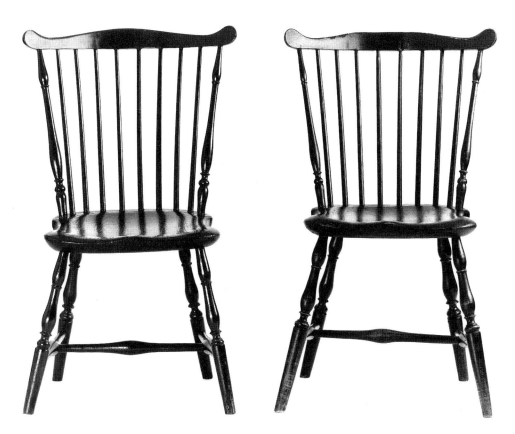

Fig. 6-219 Fan-back Windsor side chairs (two) and detail of brand, James Chapman Tuttle, Salem, Mass., ca. 1795–1802. White pine (seats) with birch and ash (microanalysis); (*left to right*) H. 35¼″, 35½″, (seat) 16⅞″, 18″, W. (crest) 22⅜″, 22¼″, (seat) 17½″, 17¼″, D. (seat) 16⅞″, 16⁷⁄₁₆″. (Winterthur 55.64.1 [*left*] and Private collection.)

the basic character is the same. Turnings often are the least consistent parts of a chair because craftsmen executed them by rote, that is, they used the eye as a gauge once they had developed a personal style. The chair at the left may have lost some wood from its toes, although in total height it equals the second chair. Minor differences are introduced in the lengths of turned elements. Since a chairmaker sawed his crest pieces directly from a pattern, they are uniform in size and shape. Here, the one at the right is damaged slightly at the crown. Seats, too, derive from patterns that provide outlines and contours. Within these set boundaries, hand-tool shaping was more consistent than turnery. The character of Tuttle's turned work bears notice. His balusters are oval-bodied with a small, sharp collar at the top. A rounded cone anchors the posts to the seats. In the support structure the relatively slim medial stretchers are ringless, and the slim leg tapers tend to be slightly hollow. The spool-and-ring profile is repeated from chair to chair.

Tuttle's first advertisement of 1796 is revealing, since his fan-back production "in the Philadelphia style" has identifiable prototypes. Most obvious among these is a chair by John Wire (fig. 3-48), its back posts terminating at the bottom in inverted, rounded cones. Post and leg tops simulate the Philadelphia teardrop profile found below the crest. Chairs made by Francis Trumble (fig. 3-46) suggest why Salem and Boston chair backs (fig. 6-210) are broad and low. The pine seats, too, are about as generous as any made in New England. Of particular note in Tuttle's work is the internally socketed leg construction. One wonders where and how he assimilated this technique. Certainly, he was making chairs this way before Thomas Cotton Hayward arrived in Charlestown from eastern Connecticut where such construction was common. Tuttle's use of eight spindles in his fan backs when odd numbers were commoner recalls both Boston production and the late work of the Tracy family. Indeed, shipping records for the district of New London, including Norwich, itemize Windsors in cargoes bound for Boston as early as 1794.[218]

Corresponding in pattern to Tuttle's fan-back chairs is another group of eight-spindle Windsors with related turnings and rounded cone-shaped lower posts. Most examples have double rings in the medial stretcher and internal leg construction. Leg tapers tend to be heavier than Tuttle's work, and balusters frequently have fuller, more

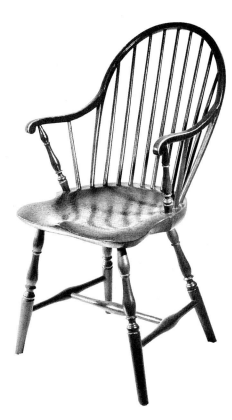

Fig. 6-220 Bow-back Windsor armchair, attributed to James Chapman Tuttle, Salem, Mass., ca. 1795–1802. White pine (seat); H. 38″, (seat) 18½″, W. (seat) 19½″, D. (seat) 17¼″. (Photo, Elizabeth R. Daniel.)

rounded bodies. Most crests peak slightly at the center. One chair without stretcher rings bears a paper label with a handwritten notation, probably of nineteenth-century date: "Made James Mansfield / Gloucester / 1785." Belknap does not list this man in his index of Essex County craftsmen, although the name occurs in the general census of 1800 for Essex County and in specific enumerations for Gloucester in 1810 and 1820. In 1844 a James Mansfield, merchant and trader, died in Gloucester. Another fan-back side chair, one of individual element, is branded "E.MOSELEY," which appears to be a contemporary stamp. Moseley as either a craftsman or an owner has defied identification. An unusual chair illustrated by Wallace Nutting has an extension above the rail; however, the vigorously shaped secondary crest raises questions as to the superstructure's originality. A small group comprising both eight- and nine-spindle chairs also has interrelated features, such as leg tapers slightly blocked in the Rhode Island fashion, turnings of large diameter, and crests that hook slightly at the terminals. Late fan-back production introduced bamboo-style turnings. The posts and legs of a branded Tuttle chair are turned to the same profile as a pair of stuffed-seat, bow-back chairs from his shop; the crest, seat, and stretchers duplicate those in his baluster-turned work. A related group with bamboo-style medial stretchers retains the baluster-turned back post.[219]

Bow-back side chairs whose baluster support structure is identical to that in Tuttle's fan-back Windsors bear the chairmaker's brand. The seats, too, appear similar. Chair backs are relatively low, and the bow faces are flattened in a modified version of the Philadelphia crowned surface. The unmarked armchair of figure **6-220** almost certainly represents a companion piece to the Tuttle side chairs. Comparison of the turnings with his fan-back work leaves little doubt of the attribution. With the introduction of the bow, Tuttle moved from an eight- to a nine-spindle back. The scroll arms compare well with Boston work, although Tuttle's version does not continue the crown of the bow onto the arms, which would have better coordinated the elements. Below the arms the bow remains full rather than pinched at the waist, in an alternative version of Philadelphia styling. Legs socket within the plank. Again, a small number of bow-back Windsors imitate Tuttle's seating but do not appear to be by his hand. Bamboo turnings probably replaced balusters before the end of the century. Tuttle's bamboowork appears to be consistent; the profile features a long, slim taper at the top and a long, well-hollowed midsection.

Immediately adjacent to Salem across the North River lies the town of Beverly. The community was one-third the size of Salem, its commerce small by comparison but its fishing industry thriving. A few chairmakers enjoyed custom there. Jervis Cutler sold five green chairs to druggist Robert Rantoul in 1798, although the artisan appears to have specialized in ornamental painting. In 1793 Mrs. Elizabeth Buckman purchased "six green dineing Chairs" from Moses Adams for £2.2.0. At Adams's death in 1796 appraisers carefully noted a good selection of woodworking tools, although there seem to have been no ready-made chairs in the shop. Two woodworking craftsmen witnessed Adams's will: Samuel Stickney, who has left posterity a pencil-inscribed chair in the square-back style (fig. 7-46), and Ebenezer Smith, Jr., who later became a well-known manufacturer of Britannia ware. Fan-back chairs, some with stuffed seats, were used locally in the home of Hale Hilton, who died in 1802. Windsors also enjoyed ready acceptance in other towns in the area. Eight green chairs were sold from the estate of Doctor Luke Drury of Marblehead when the physician's household furnishings were dispersed in 1790. Near the turn of the century John Dodge, a blacksmith of Danvers, owned several green chairs.[220]

Farther afield, Newburyport residents from various walks of life furnished their homes with Windsor seating. Mercy Greenleaf, member of a family of ship chandlers, owned six bow-back Windsors en suite with a pair of armchairs in 1796. Captain Jonathan Dalton placed "Green Chairs" in several rooms; the "6 yellow Chairs" in a bedroom were either Windsor or fancy chairs. Jonathan Kettell, a local cabinetmaker who constructed chairs from time to time, itemized green seating in his accounts on several occasions; the individual price was set at 7s.6d. In western Essex County the

Fuller-Page family of North Andover made extensive use of Windsor furniture. Daniel Page, who died in 1801, was a housewright and joiner-turner. Appraisers listed "Twenty one unfinished chairs" and "Dry Flags" (rushes) among his effects. In daily household use were six bow-back and six "stickback" (square-back) chairs, although there is no evidence that Page himself constructed the Windsor seating. Residing in the other half of Page's two-family dwelling were his daughter and son-in-law, Hannah and Abijah Fuller, who inherited the stick-back chairs. Their adopted son, Nehemiah, who died only five years later at age twenty-five, also owned half a dozen fan-back chairs, which were still in his widow's possession in 1812.[221]

West of Boston

Documentation of Windsor-chair making west of Boston is limited, but an account book kept by David Haven of Framingham indicates that area residents did use such seating. Apparently the region was a stronghold of traditional chairmaking as well. Haven's production, which supplemented cabinetwork, favored slat-back and other rush-bottomed styles. Like the Page and Fuller families of North Andover, Haven lived in a two-family dwelling referred to as "Half of the Homestead" in his probate inventory (1801). He shared the house with his son, Abner, and the two also held considerable land in common. David Haven enjoyed good custom, including residents of towns west and east of Framingham, such as Southboro and Natick, and residents of at least seven towns south of the community, from Dedham to Milford. Framingham's location on the main east-west route between Boston and Worcester appears to have been advantageous to Haven. At least two customers whose purchases included heavy case pieces resided thirty or forty miles away in Rutland and Hubbardston, northwest of Worcester. In 1788–89 Haven supplied "Mr Munroe joynor in Roxbury" (probably Nehemiah) with two desks and twenty-four chairs. Munroe repaid the debt two years later with a clock valued at £10. Presumably Haven then built himself a case to house what must have been a Willard movement. Just such an article of furniture is listed in his modest inventory as a "Clock & Case" valued at $28.[222]

David Haven's business in slat-back seating appears to have been brisk from the late 1780s until his death. His probate inventory itemizes, in part, 350 bunches of flag, a quantity of chair parts, and "13½ dozen unfinished chairs." Haven made both three- and four-back chairs ranging in price from 2s. to 4s., depending upon whether the wood was stained and probably upon whether the seats were provided with rush bottoms. (The term *back* refers to the crosspieces, or slats, centered between the rear posts. Chair cost was a reflection, in part, of the number of backs present.) On one occasion a great chair priced at 5s.4d. accompanied the purchase of a dozen slat-back side chairs. On December 19, 1795, a William Bullard bought half a dozen three-back and forty-two four-back chairs, presumably for resale. He acquired on the same date for 4s.6d. apiece "12 Squair Corner'd Chairs," probably a rush-bottomed, turned type with a fiddle, or splat, back. The price was substantially more than Haven usually charged for his rush seating. A great many customers appear to have bought chairs without paint or seats; the rushwork added about 8d. to the price, and painting another 6d. By contrast, Haven's "Joyner" chairs cost 9s. or 9s.6d.; cherrywood is mentioned. Again, these were simple pieces with rush bottoms. Haven's accounts show that he acquired much of his chair stock from outside suppliers. At least six men, including his son Abner, produced quantities of long posts, short posts, rounds, backs (slats), and seat lists (framing pieces). Two suppliers lived about ten miles distant in Hopkinton. Luther Metcalf, a cabinetmaker of Medway who is listed in the accounts, is said by Mabel Swan to have made Windsor chairs as well.[223]

David Haven's limited construction of Windsor seating began by October 1787, not long after Boston craftsmen initiated production. The craftsman's accounts indicate that he sold Windsors of several patterns between that date and his last recorded entry in March 1797. Prices varied from 6s. to 9s. per chair, the usual charge being 7s.6d. There is good evidence that 6s. chairs were unpainted. Haven used four terms when describing

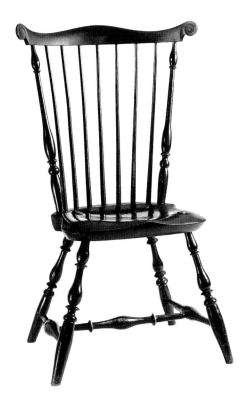

Fig. 6-221 Fan-back Windsor side chair, area of Framingham, Mass., ca. 1795–1802. White pine (seat, microanalysis) with maple and other woods; H. 38½″, (seat) 16¾″, W. (crest) 23⅞″, (seat) 18″, D. (seat) 15¹⁵⁄₁₆″. (The late William S. Bowers collection: Photo, Winterthur.)

this work: "dining" and "fan-back," whose meanings are obvious, and "green" and "Windsor," of which the exact significance is less definite. Chances are the latter two were applied indiscriminately to several patterns. "Green" obviously referred to finish. Some "Windsors" may have had arms, since at least half a dozen reached Haven's top price of 9s. On several occasions customers purchased "Dining Chairs" en suite with a "Dining Table."[224]

A Windsor recovered from a family in Framingham, where it was owned for some time, seems representative of one area pattern (fig. **6-221**). The interaction of Rhode Island and Boston design is particularly evident, the former contributing a crest with scrolls carved in a single sweep (fig. 6-59), the latter, full-swelled turnings and knife-edged disks in the understructure (fig. 6-198). A writing-arm chair said to have belonged to General Artemas Ward of neighboring Shrewsbury has slim feet of similar pattern. Otherwise, the present chair has a coastal Massachusetts orientation. In outline the seat resembles that of a Boston chair (fig. 6-202). An unusual feature is the rounded base of the back post, which with its adjacent ball and spool turnings is identical to elements in chairs made by James Chapman Tuttle of Salem. Variation in other local fan-back production includes a standard cone-shaped base in the posts and changes in seat contour. Stylistic evidence supplied by the Framingham and Salem chairs suggests that the round-base post was prominent in local design. Another sizable fan-back group of similar feature appears to originate in Rhode Island. Present are such indicators as elongated spool turnings, double-tapered feet with pointed toes, elongated leg balusters, projecting crowned baluster caps (fig. 6-20), and crests with shouldered terminals (fig. 6-163). The Framingham chair is one of the few Windsors of round-base post to have a carved crest.

Other evidence broadens the picture. A 1789 inventory of Isaac Reed's Littleton estate in western Middlesex County lists two groups of Windsor chairs, each in an area of the house containing a dining table. Several cabinetmaking craftsmen believed to have made Windsor chairs worked in Norfolk County. Mabel Swan wrote about three men in Franklin and Medway. The eldest, Elisha Richardson (d. 1798), is said to have made both a sack-back and a fan-back Windsor. If the chairs, which claim descent in local families, are correctly ascribed, the influence of Rhode Island chairmaking is pronounced. Swelled-taper turnings are similar to those shown in figures 6-59 and 6-69, and the carved-volute crest pattern appears to derive from the same Rhode Island sources.[225]

Elisha Richardson's apprentice during the revolutionary period was Luther Metcalf, who later set up business in Medway. Swan attributes to him a seven-spindle, bow-back chair, each spindle of which has an elongated swell. The shapely bamboo legs alternate long swellings with hollows; the bamboo medial stretcher is bolder than that employed by Seaver and Frost (fig. 6-214). Metcalf advertised in April 1801 for a "Journeyman Windsor Chair Maker" and several apprentices. No doubt he was preparing for a business arrangement with Cyrus Cleaveland of Providence, which was formalized later that year. Their joint advertisement of October 3 tells the story:

CHEAP CABINET FURNITURE STORE. The Subscribers . . . have commenced the Cabinet and Chairmaking Business in Providence, at their Shop near the Foot of Constitution Hill; where any Kinds of Cabinet Furniture or Chairs may be had at the shortest Notice; and as the Business is carried on upon a large Scale by one of the Proprietors in the Country, where Furniture can be afforded much cheaper than in Town, (the work being chiefly done there, and transported here to be finished) it will be sold at such reduced Prices as cannot fail of giving Satisfaction to Purchasers. Liberal Credit will be given to those who may want large Quantities of Windsor Chairs or other Furniture for Exportation.

How long the partnership lasted is unknown. Certainly, Metcalf produced Windsors in large numbers for awhile and thought nothing of transporting them twenty-five miles to Cleaveland's store. Undoubtedly, the patterns reflected prevailing metropolitan styles that customers and exporters in Providence found acceptable. Metcalf may have taken young Eleazar Daniels (b. 1788) as an apprentice about this time. Swan illustrates chairs

attributed to Daniels. The bamboo legs are similar to those of Metcalf's chair; the bow faces have a central groove or broad channel in the Boston style.[226]

South and Southeast of Boston

A preliminary investigation of Boston-style bow-back chairs branded "J.BEAL Jr" suggested that they originated in the coastal area south of Boston. The recent discovery of a Hingham, Plymouth County, inventory of 1805 for Jacob Beal, Jr., has confirmed the supposition. The bow in an armchair documented to Beal forms a full balloon arch marked with a deep, central groove that extends onto the arm tops. Spindles are nodular, grooved, and flaring (fig. 6-213). The S-curved arm supports are restrained in the Philadelphia manner (fig. 3-51); the legs, too, show similar influence in their slim, simply modeled quality (fig. 3-53). Bow-back side chairs branded by Beal have stouter legs and alternative patterns on the faces of their pinched-waist bows.[227]

Other woodworkers pursued their trades southwest of Hingham. On July 28, 1796, John Blackman of Stoughton announced his temporary need of "A Hand to work at the Windsor Chair Business," stating that one "expert at Turning with the Wheel-Lathe, would suit best." Turning appears to have been only one specialty of Asa Jones, carpenter and joiner of Bridgewater. Just once in his late eighteenth-century accounts did Jones mention Windsor chairs, which suggests that the six Windsors he charged to Benjamin Packard were acquired from a third party rather than made in his own shop. Occasionally, the craftsman repaired a chair, but he probably was not actually in the chairmaking business.[228]

Because Bristol County shares a common border with Rhode Island, the area was subject to cross currents of design. Taunton, the county seat, is thirty-two miles from Boston and twenty from Providence. In 1790 its population was 3,800, and the manufacture of iron nails was an important industry. Located at the head of the Taunton River, the community was accessible by sloop. A few miles downriver, the town of Dighton was a port of entry for vessels of greater burden. Shipping records note the arrival of New York Windsor chairs at Dighton twice in 1796; five dozen chairs were imported from Boston in 1800. The region's extensive coastline in upper Narragansett Bay, penetrated by innumerable rivers and streams and pushing eastward to Buzzard's Bay, also enhanced its accessibility.[229]

Two small groups of chairs identified by brand and other documentary evidence with the area south of Taunton clearly show the considerable influence of Rhode Island and Boston on local chairwork. Both groups also exhibit an independent spirit of design (figs. 6-222, 6-223). The earliest Windsors are constructed in the fan-back style and number more than ten similar examples, probably the products of just one or two shops. Three chairs, including the one illustrated, bear the brand "AS" contained within a small serrated rectangle, the identification unusually placed at the back edge of the seat (fig. 6-222). Two features of these chairs attract attention: the shell-like gouging of the raised crest terminals, and the absence of a short bulbous element at the leg tops. The former seems confined to marked chairs, the latter occurs throughout the group. Seat backs are flattened then chamfered, a characteristic of neighboring Rhode Island; the front edges often are deeply oblique and the top surfaces "cheeked" at the corners. Most chairs have seven spindles; a few have only six. The short, centered balusters of the back posts recall Rhode Island and northern coastal Connecticut design (figs. 6-61, 6-67, 6-168). A few chairs in the group have standard leg turnings.[230]

Circumstantial evidence identifies Abraham Shove as the maker of the marked Windsors in the present group. Contemporary documents frequently refer to him as a cabinetmaker. Lending additional weight to the assignment is a second group of chairs in the bow-back pattern marked "SHOVE / BERKLEY" on the seat backs in small rectangular stamps, one above the other. A later square-back chair is marked "AX-SHOVE" in the same place (fig. 7-51), and case pieces are known with the brand "TX SHOVE." Shove appears to have commenced business at the close of the eighteenth century, although there is no record of him in the 1800 census. His name first occurs in

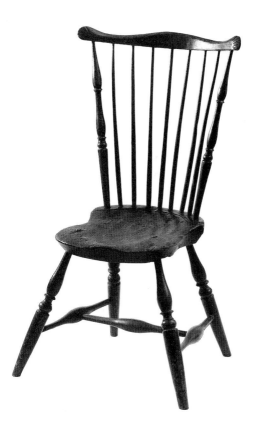

Fig. 6-222 Fan-back Windsor side chair and detail of brand, Abraham Shove, probably Berkley, Bristol County, Mass., ca. 1798–1802. White pine (seat, microanalysis) with maple and other woods; H. 35¼", (seat) 14¾", W. (crest) 20", (seat) 14⅛", D. (seat) 15". (Historic Deerfield, Inc., Deerfield, Mass.: Photo, Winterthur.)

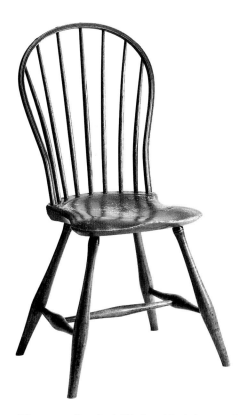

Fig. 6-223 Bow-back Windsor side chair (one of six) and detail of brand, Abraham Shove, probably Berkley, Bristol County, Mass., ca. 1800–1805. White pine (seat) with maple and other woods; H. 36⅞″, (seat) 17″, W. (seat) 16³⁄₁₆″, D. (seat) 16¹⁄₁₆″. (Private collection: Photo, Winterthur.)

Bristol County deeds in 1804, when as a resident of the village of Berkley on the Taunton River he sold a parcel of inherited land to two kinsmen. Sometime before May 10, 1816, when he was named in a complaint, the craftsman became a resident of Freetown, just south of Berkley; by 1821 he had moved across the river to Somerset.[231]

The 1816 complaint against Abraham Shove was filed by the selectmen of Freetown, who were concerned that the artisan would become a public ward. In their judgment Shove "does by excessive drinking so spend and lessen his estate as thereby to expose himself and family to want and suffering and does also thereby endanger and expose the said Town of Freetown to a Charge or expense for his and their maintenance." They asked the probate court to appoint a guardian, and in that capacity Benjamin Slade prepared an inventory of Shove's estate. The cabinetmaker's dwelling, barn, and outbuildings stood on three acres of land. In addition, he owned twenty-two acres of pasture and twelve acres of woodland. Seating in the house included Windsor, dining, great, and kitchen chairs. The appraisers valued "New Chairs unfinished" at $6. Fortunately, Shove was sufficiently rehabilitated by 1824 to warrant his guardian's petitioning the court to be released from his trust, which the court granted.[232]

The second Bristol County seating group, stamped "SHOVE / BERKLEY" (fig. 6-223), could be the work of Abraham or Theophilus Shove, since the latter is also called a cabinetmaker in public records. Because the grooveless leg pattern is similar in profile to the legs of a square-back chair marked "AXSHOVE" (fig. 7-51), Abraham seems the more likely candidate. Without the brands, however, it would be impossible to associate the two groups with the same or even neighboring shops, since the bow-back chairs are more directly influenced by Boston design than the fan-backs. The seat front is broad in the manner of William Seaver's work, and there is a wide, shallow channel in the bow face. The legs are a simplistic interpretation of the bamboo style. Only near the tops are there nodular swells scored by grooves. The illustrated chair is one of a set of six, all marked. A nearly identical unmarked set, the leg-top knobs less pronounced, has a history in the Wardwell family. A candidate of appropriate surname is listed in the federal census as a contemporary resident of neighboring Dighton. A single side chair of similar design has a top extension; the crest is shaped in the manner of New Haven work (fig. 6-177). Whether inspiration came from Rhode Island, where the pattern was also used, or directly from Connecticut through New Haven's active coastal trade, can only be guessed at. In passing, a word may be said about cabinetmaker Theophilus Shove, who was a lifelong resident of Berkley, where he died in 1856. His brand, found on some case furniture, interrelates in its letter style with that of Abraham's initial-and-surname stamp.[233]

The Southern Coastal Area and the Islands

Records pertaining to the general region encompassing New Bedford, western Cape Cod, Martha's Vineyard, and Nantucket provide insight on regional seating furniture. Genealogical materials hint further at the highly complex family interrelationships common to this area. Tangible evidence of individual chairmakers is less plentiful; only occasionally is it possible to isolate the work of specific craftsmen or even that of particular communities. Life in the southern Massachusetts region revolved around the sea. Merchandising, trading, and whaling dominated the economy and provided employment for thousands in support trades. The maritime focus subjected local chairmakers to a barrage of internal and external influences, a situation that is amply borne out in records. Joseph K. Ott, in his study of furniture exports from Newport and Providence between 1783 and 1795, shows that Rhode Island enjoyed direct contact with Martha's Vineyard, Nantucket, New Bedford, Yarmouth, and Falmouth. Of the few manifests listing New York chair exports, one records the transport of "Six Green Chairs" to Nantucket on board the sloop *Liberty* in 1799; other Windsors were landed in New Bedford. Captain Elisha Luce carried a dozen chairs from the mainland at New Bedford to Edgartown on the Vineyard in the schooner *Freedom*. There also is evidence of reverse island contact when Samuel Wing, a cabinetmaker and chairmaker of Sand-

wich, received a recipe for making green paint from Obed Faye, "Nantucket Windsor Chr maker." Before this, Captain John Hussey had transported three separate groups of Windsor chairs from Philadelphia to Nantucket. Other ship captains appear to have been responsible for venturing most of the seventy-three recorded Windsor or green chairs entering the port of New Bedford between 1791 and 1799.[234]

Probate records for the town of Nantucket, which was known as Sherburne until 1795, cite further contacts and influences that had an impact on chairwork in southern coastal Massachusetts. Before his death in 1784 Silvanus Coffin owned "6 Newberry Chairs." This probably was rush-bottomed seating, since "6 fram'd bottom d[itt]o" follow immediately in the inventory. Two years later appraisers itemized "6 new Boston Made Chairs" among Abraham Pease's household effects, and "6 Lynn Chairs" were part of the 1801 estate of widow Susanna Folger. Parallel evidence links local furnishings with Pennsylvania in the item "2 Philadelphia Platters" from the household of merchant Christopher Hussey. The Nantucket-Philadelphia bond was exceedingly strong due to religion. A modern chronicler of the island states that there were 2,000 members of the Quaker faith by the mid eighteenth century, and the list of "Visiting Friends" from Philadelphia commences as early as 1706. By midcentury, several travelers from the Delaware Valley passed through each year. John Elliott, Jr., and William Savery, sons of Philadelphia cabinetmakers, visited in the 1780s. Earlier in 1736 and 1753 there are recorded visits from Quaker Theophilus Shove of Dighton, Bristol County, possibly the joiner of that name who had a shop in Boston between 1736 and 1740. He would also appear to be a kinsman of the later Shove family members who worked as cabinetmakers in Bristol County around 1800. Aside from these visits, miscellaneous contacts are recorded for sect members from New Jersey, Delaware, rural southeastern Pennsylvania, Rhode Island, the Hudson River Valley, Long Island, Connecticut, North Carolina, Virginia, New York, Kennebec in Maine, and "Swanzey" and Dartmouth in Bristol County. Little wonder that the "Nantucket style" in Windsor-chair making is a fusion of elements from other regions.[235]

New Bedford, once known by the Indian name Acushnet, was incorporated in 1787 as a separate town from Dartmouth, of which it had been a part. Timothy Dwight described the area as an "easy sloping declivity" on both sides of the river Acushnet, which "forms a noble basin about a mile in breadth." Concerning the harbor he noted that "the entrance is narrow, the anchorage good, and the depth sufficient to admit ships of four hundred tons to the wharves, where they are sheltered from every wind." Many early residents were Quakers, some of considerable substance, particularly the Russells, Rotches, and Rodmans, who had close business and family connections in Nantucket. William Logan Fisher of Philadelphia described New Bedford Friends of the 1790s as "very plain." Then an adolescent, young Fisher was serving an apprenticeship with William Rotch, Jr., "an eminent merchant." He later wrote: "The town was small and I soon became acquainted with every man in the place. There was no way out . . . but through the main street to the top of the hill. Then the road diverged either way." There were 3,300 inhabitants in 1790 and about 450 dwellings.[236]

A small group of woodworking craftsmen practiced their trade in New Bedford following the Revolution. Furniture-making accounts recorded by Luthan Wood between 1786 and 1802 itemize a limited selection of cabinetware and a small production of green chairs. Bartholomew Akin, seemingly more a jack of all woodworking trades than a furniture craftsman, made everything from oars to coffins. Recorded exchanges with William Russell (probably William, Sr.) for 1787 and 1791 credit the latter with chairs, some described as "Green." At the turn of the century when Captain Thomas Duncan died in possession of half a dozen green chairs, both William Russell, Sr., and William Russell, Jr., were plying their trades. The older man was a painter and glazier, as well as a chairmaker; the younger man also sold painters' supplies and paper hangings. A nine-spindle, bow-back side chair in the bamboo style bears the brand and label of William, Jr. The chair is not unlike one of similar style branded "WING" on the plank (fig. 6-225). Both chairs have pinched waists, nodular spindles, well-shaped legs with long center

Fig. 6-224 House and shop of Samuel Wing, Sandwich, Mass., late nineteenth century. The door at the extreme left in the low building was the entrance to the cabinet shop. (Old Sturbridge Village, Sturbridge, Mass.)

sections, and a double-swelled medial stretcher. The Wing chair, however, lacks a well-saddled seat.[237]

If either of New Bedford's two cabinetmakers named Reuben Swift made Windsor chairs at the turn of the nineteenth century, the work probably resembled that of William Russell and Samuel Wing (fig. 6-225). The first Reuben purchased land at New Bedford in the 1790s, when deeds describe him as a "shop joiner" or "cabinetmaker." This appears to be the same craftsman who later migrated to Cincinnati. The second Reuben constructed a labeled tambour desk now in the Metropolitan Museum of Art. Although he and his brother, William, advertised Windsor and fancy chairs during their cabinetmaking partnership of the early 1820s, there is no evidence that Reuben constructed painted seating at an earlier date. His advertisements from the opening years of the century concentrate on cabinetwork. Three square-back chairs owned by the Old Dartmouth Historical Society and branded "SWIFT" are almost certainly Delaware Valley chairs. The chairs and a branding iron reading "R. SWIFT" were gifts to the society from a family descendant. The seats are marked near the plank edge with the surname only, using a hot iron that burned the wood. The character and placement of the brand indicates that the marking is of later date than the chairs. In the 1840s Swift became a merchant of Falmouth, Barnstable County. The branding iron was a common implement in the merchant trade for marking wooden containers and even lumber. Swift could have acquired an iron at that time, if he did not own one earlier. Upon removing from New Bedford to Falmouth he may have chosen to mark his household furnishings with an identifying stamp, especially since the move was almost certainly made by water, as the two towns are located on opposite shores of Buzzard's Bay.[238]

Thirty miles east of New Bedford is the township of Sandwich, whose population stood at about 2,000 in 1790 and 1800. In the early nineteenth century Sandwich was considered the "most agricultural town in the county" of Barnstable. Nor was agriculture the only local pursuit. Timothy Dwight identified a "Town Harbor" and township inlets where "about thirty vessels are employed in the coasting business, especially in carrying wood to Boston."[239]

Cabinetmaker and chairmaker Samuel Wing, a member of the Society of Friends, lived in Sandwich. In 1800 at age twenty-five he purchased from his uncle Benjamin for $1,900 "part of the homestead farm" of his grandfather Zaccheus Wing. The property consisted of open ground and woodlands, swamp and salt marsh, parts of "the sheep pasture lots," and the "dwelling house and other buildings together with all the priviliges" (fig. 6-224). Samuel was a farmer as well as a woodworker, a fact borne out by his accounts. In 1808 and 1809 in association with Abraham Freeman he also engaged

in the lumber business. Some wood was sent up the coast to Boston, a testimony to the accuracy of Timothy Dwight's observations.[240]

Samuel Wing's furniture accounts, begun in 1801, record the construction of a modest number of "green chars." Not until 1807 did he note the sale of "blak" chairs. A seven-spindle, bow-back Windsor probably is representative of Wing's earliest production (fig. **6-225**), although the chair may not be his first bow-back design. The bamboo elements above and below the seat show careful shaping, which effectively contrasts hollows and swells. Good modeling and exposed leg construction mark the plank; the flat bow face is flanked by beads.[241]

A second bow-back chair associated with Wing was assembled several decades ago from parts found in his shop (fig. **6-226**). The homestead with its attached buildings, including the cabinet shop, remained in the hands of descendants until 1965; the family accumulation was little disturbed. Assuming that all the chair parts were made by Wing, although not necessarily destined for assembly in this fashion, it is possible to note stylistic influences from several sources. The bow of straight-sided arch and broad, shallow channel and the seat, which exhibits a lift at the front corners, are associated with Boston work (fig. 6-203). The legs seem a hybrid type, falling between the baluster and bamboo styles. Except for the collar near the top, the profile almost duplicates that of Wing's bamboo chair; again, the general inspiration possibly is derived from Boston work. The club-shaped sections could be an elongation of a late baluster foot developed in that city (fig. 6-204), although similar supports are found in Rhode Island and coastal Connecticut chairs (fig. 6-56). The Shove chair legs (fig. 6-223) are a simplistic approach to the same design. Reinforcing the theory that Wing actually used this leg early in his career is a child's chair of similar support recovered on Cape Cod. In its original construction a bow-back chair of this pattern would have had at least seven spindles.[242]

Windsors originating in the coastal and inland regions lying between Rhode Island and Cape Cod are boldly styled and often exhibit overtones of Boston and Rhode Island influence. Individual groups share distinctive characteristics, and selected features interrelate one group with another. Linking a number of fan- and high-back Windsors are slim, long-bodied leg balusters. Two chairs of similar crest, though not a pair, illustrate varied interpretations of this distinctive turning (fig. **6-227**). The profile at the extreme left front can be considered a typical prototype. The elongated oval swell, short thick neck, and close-fitting, folded collar are characteristic. The long, slim turning above the baluster and the collarlike spool, thick ring, and double-tapered foot are also typical. Stretchers usually are thin and without rings. The present shield-shaped seats are thicker across the front than many chairs, and the corners exhibit something of a lift common to some Boston work (figs. 6-202, 6-219). The posts are related, the profiles modified in baluster length and base profile. Both post shapes are found in other chairs within the group, and both relate directly to Rhode Island work; the shorter base element repeats the double taper of the foot. The bulging base element in the left chair back also occurs in the legs, arm posts, and medial stretchers of seating pieces in a subgroup related to figure 6-56. Possibly without exception, spindles of southern Massachusetts show little or no swell in their gradual taper from bottom to top. Crest rails of individual form crown the backs of the illustrated examples. Similar at the center, they vary in scroll size and treatment, although not in projection or in the use of an incised groove to mark the slim necks supporting the scrolls. The rondels at the left have hollow, concave centers. At the right the incised groove delineating the neck swings around the scroll to terminate in a tiny, three-petaled floret. Small projecting scrolls and collarlike spools also appear on Rhode Island work (fig. 6-23).

Fig. 6-227 Fan-back Windsor side chairs (two) and detail of crest volute, southern Bristol or Plymouth County, Mass., 1795–1805. (*Right*) white pine (seat, microanalysis) with maple and oak; H. 36¾″, (seat) 17¾″, W. (crest) 22⅜″, (seat) 16⅛″, D. (seat) 16⅛″. (Private collections: Photo, Winterthur.)

The sawed ornament at the center in the illustrated chair crests is original. The subtly notched oxbow flanked by flaring points, while reminiscent of Chippendale design, seems more a conscious reflection of English Windsor work (fig. 1-26). Edges round softly, and the low shoulders flanking the points probably were never shaped as projections. The half dozen or so chairs of this crest probably represent two original sets. The materials of the right-hand chair include a white pine seat and oak crest. All turnings, including the spindles, are maple, a wood that is uncommon for chair spindles but is found in several examples of Rhode Island origin (figs. 6-2, 6-40, 6-48).

More than a dozen other side chairs are classified within this general group. Most have small projecting crest terminals, each volute marked by an incised curl of small diameter (fig. 6-228). Where the volutes have broken off, crests may be reshaped in abrupt points. The profiles of several plain, uncarved top pieces resemble that of a Boston chair (fig. 6-194). A few Windsors have thick seats like those illustrated; however, most planks are more finely shaped across the front. Leg balusters are at times less oval and more rounded, but the elements below this turning are fairly consistent. Most back posts follow the form of the right-hand chair. Family and recovery histories link some chairs with Rhode Island; another was offered at a local auction in neighboring Rehoboth, Massachusetts. A critical piece of evidence is an ink inscription on the bottom of one of a pair of fan-back Windsors at the Newport Historical Society, which describes the chairs' descent in the Sowle (or Soule) family of South Dartmouth, Massachusetts, near New Bedford. A bow-back Windsor also belongs to this group, based on the profile of its baluster-turned undercarriage.

A rare, tall fan-back armchair at Winterthur is associated with this stylistic group on the basis of its turnings and crest (fig. **6-228**). The roundwork is a bold statement of the southern Massachusetts style. Arm posts duplicate the profiles of the legs, while the spool, ring, and double-tapered base are repeated in the back posts. The base turning is more boldly developed here than previously (fig. 6-227, right). The crest of this statuesque chair is typical of group production. Beneath it are a series of well-formed balusters that owe a considerable debt to Rhode Island design. The bold teardrop at the top almost duplicates a shape in a fan-back side chair (fig. 6-62) and recalls Philadelphia

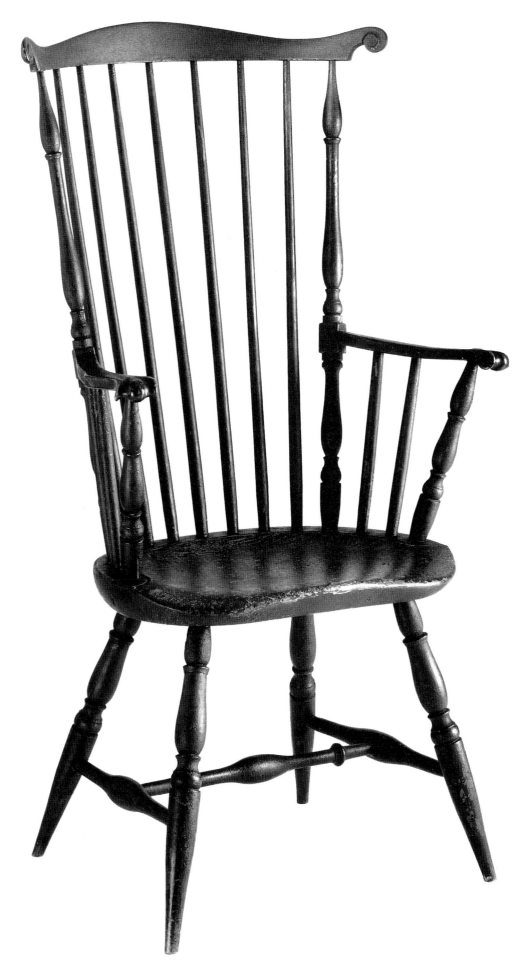

Fig. 6-228 High fan-back Windsor armchair and details of crest volute and arm scroll, southern Bristol or Plymouth County, Mass., 1795–1805. White pine (seat) with maple and oak (microanalysis); H. 43⅞″, (seat) 16⅞″, W. (crest) 23⅝″, (arms) 25″, (seat) 20⅛″, D. (seat) 15″; tips of legs pieced. (Winterthur 65.1614.)

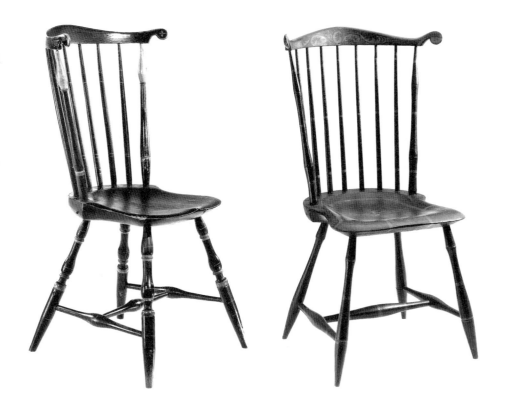

Fig. 6-229 Fan-back Windsor side chair, southern Bristol or Plymouth County, Mass., 1800–1805. (Henry Ford Museum and Greenfield Village, Dearborn, Mich.)

Fig. 6-230 Fan-back Windsor side chair, southern Bristol or Plymouth County, Mass., 1800–1805. White pine (seat, microanalysis); H. 35⅜″, (seat) 16¼″, W. (crest) 21¾″, (seat) 16¾″, D. (seat) 16⅝″. (James C. Sorber collection: Photo, Winterthur.)

work as well (fig. 3-46). The long, stylish, primary baluster compares favorably with the underarm supports in a Rhode Island high-back chair supported on double-taper feet (fig. 6-33). Short, almost flat, one-piece, knuckle-carved arms tenon into well-detailed blocks in the long posts, held fast with pins. In their right-angled articulation, the arms complement the rectangularity of the back structure, yet a subtle curvature in the horizontal plane precludes any harshness of line. Slim serpentine side pieces and carved knuckles with incised curls on the side faces that duplicate those of the crest complete the design. The white pine seat and maple spindles are found in other area chairs.[243]

The Society for the Preservation of New England Antiquities owns a fan-back armchair of similar pattern, one so close, in fact, that the chairs probably originated in the same shop. The only difference between the two is the introduction of rounded post blocks at the arm junctures. Another chair is at the Mayflower Society in Plymouth. Two high-back chairs with bent arm rails that sweep across the back fall into this group by virtue of their crests, arm terminals, and turnings. The rounded-edge oval seats are the same as illustrated, and the medial stretchers have identical rings.

Chairs of a different character, interrelated to the preceding examples through their projecting crest rails, also share an affinity with Rhode Island work and chairs documented to Bristol and Barnstable counties. The earliest, stylistically, is a chair with hybrid post turnings that link baluster and bamboowork (fig. **6-229**). The spool-shaped elements of the legs have an unusual stalklike quality found in some Rhode Island seating (fig. 6-88). The bold teardrop forms in the back posts may derive directly from a Rhode Island chair (fig. 6-62) or from the previous tall fan-back Windsor. The lower post, accented by a deep groove near the base, is clublike and in that respect also relates to Rhode Island work (fig. 6-56). There is an affinity between these posts and the lower legs of another fan-back chair (fig. **6-230**, pl. 3) whose profile bears comparison with the work of Samuel Wing and Abraham Shove (figs. 6-225, 6-226, 6-223). In the latter comparison even a conelike element is present in the upper legs. The late nineteenth-century painted ornament in the crest of this chair, which features curled leaves that resemble a paisley print, has a decorated mate in a baluster-turned, fan-back chair also of projecting crest.

The third chair of this group (fig. **6-231**), another hybrid type, introduces to the same cone-top bamboo leg a special embellishment at stretcher level, consisting of an oval ball

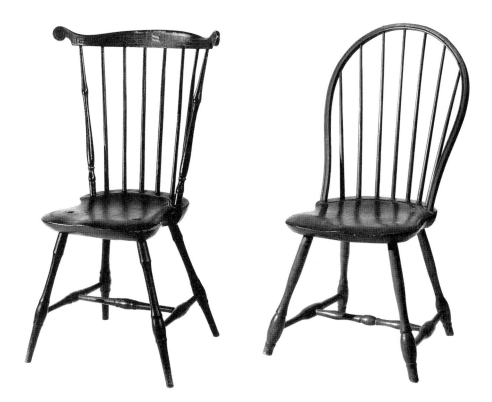

Fig. 6-231 Fan-back Windsor side chair, southern Bristol or Plymouth County, Mass., 1800–1805. White pine (seat) with maple and other woods; H. 36¼″, W. 14″, D. 16⅛″. (Museum of Fine Arts, Boston, gift of Mrs. Samuel Cabot.)

Fig. 6-232 Bow-back Windsor side chair, southern Bristol or Plymouth County, Mass., 1800–1805. White pine (seat) with maple and other woods; H. 34¾″, (seat) 14⅝″, W. (seat) 15½″, D. (seat) 15¹¹⁄₁₆″. (Williams College Museum of Art, Williamstown, Mass.: Photo, Winterthur.)

secured between flared cones. The feature, which is repeated in the stretchers, appears to be a simplified version of Rhode Island turned work (figs. 6-54, 6-56). The chair back also has received special treatment. Projecting scrolls are patterned with raised concentric circles. Posts of slim form contain a small vase near the base in place of the usual spool and ring. This diminutive turning probably was inspired by fancy spindles in New York or Rhode Island chairs (figs. 5-17, 6-72), with which area craftsmen would have been familiar. The chair has a history of ownership in the Stetson family of southeastern Massachusetts, a tradition seemingly confirmed by the late nineteenth-century painted Gothic letter *S* centered in the crest.²⁴⁴

Two bow-back chairs relate generally to the Stetson family's Windsor. Both have bulbous leg elements that socket the stretchers and Boston-type channeled bow faces, although the chairs are not mates. The medial stretcher of one (fig. **6-232**) is of unusual form, with a small oval ball in the center, flanked by flared, swelled "sticks," a profile repeated in inverted form in the legs. The turning is that found in the lower back posts of figure 6-227 (left), thus linking the two southeastern groups. Both spindles and turned work are of maple.

Although few, if any, extant accounts detail Windsor furniture production on Nantucket, other kinds of documentary evidence show that the output must have been substantial. Probate records of the late eighteenth century are a chief data source. The earliest estate to itemize the Windsor form dates to 1776. On September 27, 1776, appraisers evaluated the property of young George Macy, a trader, and found in his reasonably appointed household one "Winsor Chair" among twenty-two seating pieces. The next mention of Windsor furniture comes in the early 1780s after the tumultuous years of the Revolution, during which diligent public recordkeeping fell by the wayside. References to "Green" chairs are found regularly during the decade, occasionally accompanied by descriptive terms, such as "large," "high back," "low round," "Child's . . . arm'd," or "old." Evidence is about the same for the 1790s and early 1800s but more frequent. John Ramsdell, a cabinetmaker of "Sherborn," owned a "large green Chair" at his death in 1790, although he may not have constructed it himself. Green bow-back chairs appear in the 1792 estate of Henry Clark, a butcher; appraisers of another estate referred to the same form as "Green Table Chairs." A household valued in 1794 contained an "*old* Green Bow back'd Chair," possibly a Windsor of sack-back pattern.

Occasionally appraisers referred to Windsors as wooden-bottom or stick-back chairs, and there are also references to fan-back chairs.[245]

The Windsor most closely associated today with southeastern Massachusetts and Nantucket is a tall fan-back armchair. Unlike figure 6-228 which interrelates with other regional forms, this tall chair appears to have been developed specifically as a large seating piece. Its turnings draw on elements of more standard shape. Although these chairs are not common, a sufficient number exist to determine that examples fall into three groups, based upon back posts and crest patterns. Posts consisting of double balusters above a long cylinder, sometimes interrupted, mark the two principal groups; the crests follow two patterns (figs. 6-233, 6-234). One top rail terminates in large, full-rounded scrolls; the other has small, slim-necked volutes incised with curls in the manner of the previous tall chair (fig. 6-228). The third group (fig. 6-235) consists of chairs with modified lower back posts. A cylinder remains at the arm juncture, but below that point there is substituted a plain, inverted baluster. These chairs have projecting crest scrolls. Within the three groups modifications in post elements occur only occasionally. On the other hand, baluster profiles show little consistency from one chair to the next; they are long, short, full, or slim, an indication that many hands produced the seating and probably for as long as two decades. Overall, the chairs also vary in size and special features. Some seats are large, others smaller. Most legs are of normal length, but a few are "slipper" height, placing the seats relatively low to the floor. Of approximately forty tall Windsors in the study group, about half have bracing spindles. In general, backs slope modestly, but a few incline in the extreme. The recovery and family history of many link them to Nantucket, although there are associations with Martha's Vineyard and New Bedford as well. The presence of such chairs in the latter community is confirmed in a nineteenth-century drawing of a waterfront interior.[246]

Two of the three tall chairs illustrated and described in this sequence may be ascribed to Nantucket chairmakers with a fair degree of certainty. Beginning in 1783 island probate records document the use of large Windsors, although those mentioned earliest were likely of Philadelphia or Rhode Island construction. Close commercial and religious ties linked the three areas. At his death in 1789 Benjamin Barnard owned an "old" Windsor chair; he also owed a debt to the Philadelphia merchant house of Jeremiah Warder and Son, testifying to his connections with that area. References to "large Green," "high Back Green," and "Great Green" chairs run through inventories dating from the 1780s until after the turn of the century. The item "2 Green Chairs with Braces" in the 1793 household enumeration of widow Mary Pease, called a "Trader," may describe fan-back Windsor armchairs of southeastern Massachusetts origin. However, a pair of Philadelphia braced armchairs in a prerevolutionary fan-back style (fig. 3-31), which descended from the Nantucket merchant James Cary (d. 1812), suggests an indefinite provenance for Mrs. Pease's Windsors. References to large wooden-bottom chairs in probate documents dating to the early nineteenth century more likely refer to regional seating produced in the 1790s.[247]

Nantucketers faced a constant challenge in providing themselves with the necessities of life. From the start the island was nearly barren of trees, the soil unproductive, and industry, aside from whaling and related activity, almost unknown. Commerce kept Nantucket alive, and in times of peace it prospered. St. John de Crevecoeur was surprised at its success:

Would you believe that a sandy spot, of about twenty-three thousand acres, affording neither stones nor timber, meadows nor arable, yet can boast of an handsome town, consisting of more than five hundred houses, should possess above 200 sail of vessels, constantly employ upwards of 2000 seamen, feed more than 15,000 sheep, 500 cows, 200 horses; and has several citizens worth 20,000£. sterling!

Crevecoeur further noted that most of the 530 houses in Sherburne had been framed on the mainland. Stones for cellars were imported, as were household furnishings in great variety, fuel for the hearth, and timber. Cabinet- and chairmakers had to struggle in the

face of furniture imports and a lack of local raw materials. Yet the town managed to support several craftsmen.[248]

The first Nantucket chair to be considered (fig. **6-233**) is a modification of its general type—a cylindrical post structure with large-scrolled crests. Below double baluster turnings, the posts consist of three individual units separated by spools, instead of one long cylinder. A paper tacked under the seat is inscribed in a later hand: "made by Frederick Slade in Nantucket 1799." The identification seems valid, since a man of this name was born on Nantucket in 1777; he was the son of Benjamin Slade, who is identified in a legal document of 1807 as a chairmaker. Frederick would have been twenty-two years old at the time he is said to have constructed the chair. He was still single in July 1800 when he died "coming from Havana." Periodic voyages as seamen were not unusual for young Nantucket men who pursued other trades. Frederick's untimely death could further explain why the posts of this chair appear unique. The crest is heavier than most in the group, but then the chair itself is of considerable size. The generous crown and scrolls lend a bold character not unlike that found in the crest of a smaller Pennsylvania chair owned on the island (fig. 3-31). Arms are equally generous and well carved with huge knuckles flanked by scrolls. Comparison of the spool-and-ring turnings with those of the Pennsylvania chair reveals further similarity. Among other Windsors in this general group are four that were once part of local collections, including a chair from the island studio of Eastman Johnson. A fifth chair, now at Yale University, was by tradition owned at Edgartown, Martha's Vineyard, by Obediah Pease (1743–1831).[249]

A second chair of cylindrical post, the crest terminated by small projecting scrolls, is branded "C. CHASE" within a border (fig. **6-234**). The chair is smaller and more delicate than the previous Windsor. The oval white pine seat is rounded at the edges, as opposed to the canted surfaces of the Slade chair. Beneath the crest the five long back spindles pinch together at the top, a characteristic noted on most braced examples. The flat, blocked post faces that receive the arms form elongated, squared diamonds. Chase's design exhibits a blend of influences. The bold medial stretcher with its large caps set close demonstrates direct knowledge of Boston and Rhode Island chairmaking (fig.

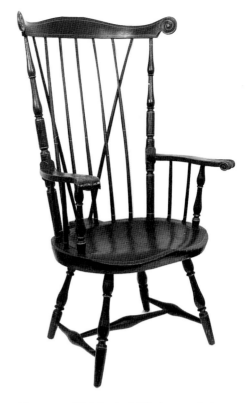

Fig. 6-233 High fan-back Windsor armchair, attributed to Frederick Slade, Nantucket, Mass., ca. 1799. (Private collection: Photo, Nantucket Historical Association, Nantucket, Mass.)

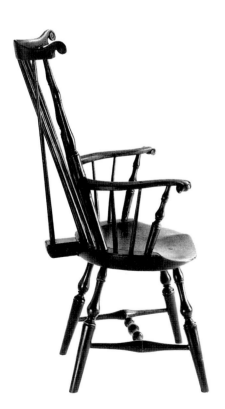

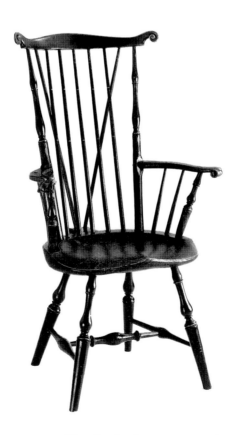

Fig. 6-234 High fan-back Windsor armchair (two views) and detail of brand, Charles Chase, Nantucket, Mass., 1790–1805. White pine (seat) with birch, ash, and oak (microanalysis); H. 42¾", (seat) 17¼", W. (crest) 22", (arms) 27⅜", (seat) 21⅛", D. (seat, without extension) 15⅞", (brace) 4⅛". (Winterthur 59.1637.)

6-204). The pronounced angularity of the back-post balusters speaks of Salem work (fig. 6-219). Chase's use of a diminutive baluster and long tapered base in the arm supports almost certainly reveals his familiarity with Rhode Island design (figs. 6-55, 6-85). Most Windsors in this group employ the feature. The legs duplicate the arm posts. Certain affinities with Philadelphia work are apparent in the spool-and-ring turnings (fig. 3-25, arm posts). The crest resembles others of the local region. A side view of the chair focuses on the sculptural quality of the seat and the raking angle of the back structure, positioned more for repose than work. The large, wedge-shaped seat extension supporting the bracing spindles is, as is typical in these chairs, a separate piece.

The search for C. Chase, a common name in New England, ended after several years' pursuit on Nantucket in the Registry of Deeds. On May 7, 1776, Charles Chase, "houseright" aged forty-five, purchased a lot of land on Wesco Hill adjoining his home property. Records during the next thirty-five years generally identify Chase as a carpenter or house carpenter. Not until the 1811 sale of his dwelling house, "shop," barn, fences, and outbuildings, located at the corner of Fair Street and Martins Lane, is there a reference to him as a "Chair Maker." As Nantucketers were reasonably self-sufficient, Chase probably found chairmaking an easy transition for his woodworking skills. Undoubtedly, he was already an accomplished turner; he would have had facility with the shave and possibly also possessed some carving skill. The illustrated chair is one of several tall Windsors branded by Chase. While all follow the same basic pattern, there are sufficient differences in the particular parts to indicate that the chairs were made at different times. Probably all represent "bespoke," or special order, work. There are several unmarked chairs, with and without the bracing structure, whose elements resemble Chase's style. A fan-back side chair marked with the Chase brand has also come to light. The crest and turned work relate to the tall chair, while the shield-shaped seat appears to follow Rhode Island work.[250]

The third tall armchair variant of the southeastern Massachusetts group is one with small crest scrolls and posts containing an inverted baluster of moderate size below the arm blocks. The medial stretcher often is in the bamboo style. A tradition of family ownership on Nantucket accompanies one chair. Three superlative Windsors in the group, two at Winterthur (fig. 6-235, pl. 2) and one privately owned, have fairly robust leg turnings. Although acquired separately, the Winterthur chairs appear to have originated in one shop. Nothing about them is ordinary—their large size, inclined backs, and bold features. The crests project farther than any others in the entire tall fan-back production of the region.

The delicate incised curl that marks the crest scrolls of both chairs is duplicated on the side faces of the large knuckles. Strong horizontal lines represented by crest, seat, arms, and stretchers effectively balance equally forceful vertical turned members. These chairs and one in private hands are the only inverted-baluster Windsors known to have bracing spindles. Following work from this area, the pairs of sticks are anchored in large, wedge-shaped blocks attached to the seat backs. The detail shows the construction. Two rectangular tenons projecting from the narrow end of the block fit into mortise holes cut into the seat back flanking the center spindle. Pins just forward of that stick secure the tenons. Both chairs were originally painted green; late nineteenth-century paint and line decoration now covers their outer surfaces. The third chair in this group was acquired by a former owner directly from an old family on Nantucket.

Worcester County

Worcester County is the largest county in Massachusetts. Its terrain is "undulating," to borrow the term Timothy Dwight used in the 1790s. The countryside surrounding Worcester, the county seat, was "divided into farms," while the "well situated inland Town" itself was "principally built on a single street, extending from east to west about a mile and a half on the road . . . and containing . . . about one hundred and twenty houses, generally well built; surrounded by neat fences, outhouses, and gardens." Agriculture and trade dominated the county's economy at the end of the eighteenth century and

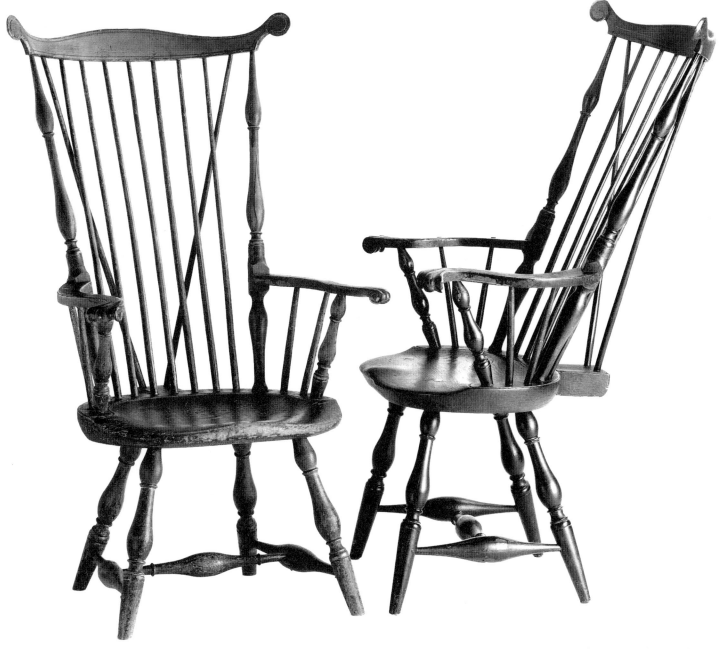

Fig. 6-235 High fan-back Windsor armchairs (two) and detail of seat extension (*right*), Nantucket, Mass., 1790–1805. White pine (seats) with maple, birch, oak, and beech (*left*) and maple, oak, and birch (*right*) (microanalysis); (*left to right*) H. 45 1/16″, 45 3/4″, W. (crests) 26″, 26 7/8″, (arms) 27″, 27 1/8″, (seats) 21 3/4″, 21 7/8″, D. (seats, without brace) 16″, 16″, (braces) 4 1/8″, 4 5/8″. (Winterthur 59.1617, 59.1650.)

later. Beyond milling activity, manufacturing was not a substantial pursuit until the nineteenth century, although Dwight observed that in addition to grist- and sawmills Worcester had two fulling mills and "a large paper mill."[251]

Only modest chairmaking activity is identified with Worcester County in this period; surprisingly, there is no evidence of Windsor production in the town of Worcester before the early nineteenth century. The considerable trade of this local center with other areas, particularly Boston and likely Rhode Island, may have discouraged early enterprise in this branch of the furniture industry. Stephen Salisbury's preference for Philadelphia Windsors, previously noted, hints at such a situation. In the small

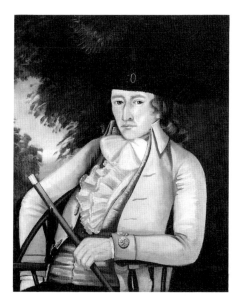

Fig. 6-236 *Oliver Wight*, attributed to Sarah Perkins, Sturbridge, Mass., ca. 1792. Oil on canvas; H. 31¼″, W. 25½″. (Abby Aldrich Rockefeller Folk Art Center, Williamsburg, Va.)

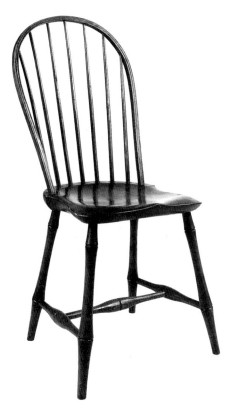

Fig. 6-237 Bow-back Windsor side chair (one of six), attributed to Solomon Sibley, Ward (Auburn), Mass., ca. 1799–1806. White pine (seat) with maple and ash; H. 37½″, (seat) 16½″, W. (seat) 16⅛″, D. (seat) 16″. (Old Sturbridge Village, Sturbridge, Mass.)

communities surrounding Worcester, however, there is recorded activity. Such commerce was encouraged, no doubt, by prosperous conditions at the local seat of government. For the most part, the work falls at the turn of the century, although the styles are slightly earlier.

The rural Windsor craftsman of earliest record in the Worcester area is Oliver Wight of Sturbridge, whose portrait was painted about 1792, perhaps by Sarah Perkins (fig. **6-236**). He and his wife, Harmony Child, whose likeness adorns a companion canvas, sit in Windsor armchairs of sack-back form, presumably constructed by the furniture maker himself. Both portraits have been dated to the early 1790s, just after Wight launched his cabinetmaking and chairmaking career and built a substantial house to shelter his growing family. However, Wight's life was not destined to be rosy. He was constantly in debt and soon gave up his house, moving from Sturbridge temporarily in 1793; he returned in 1795 and remained for slightly more than a decade. Records of the local Walker family detail the scope of Wight's craft activity in the early 1800s. For Josiah Walker he constructed chests of maple, cherry, and painted wood along with card and breakfast tables. Seating ranged from rocking and kitchen chairs to "Winsor" and "Dining" styles, the latter probably sack-back armchairs and bow-back side chairs. The craftsman is reputed to have left Sturbridge again in 1806 and, perhaps, did not return until later life. The inventory taken after his death in 1837 suggests that he was eking out a living. The enumeration contains a "Chest & Tools" valued at $13; lumber on hand was worth only $4.50. Two items attest to the fact that Wight still pursued his trade: "3 Sets of Toilets & wash stands" and "3 Wash stands partly finished."[252]

Solomon Sibley worked just south of Worcester in Ward (now Auburn). Entries in his account book begin in 1793 and continue well into the nineteenth century, although his activity in Windsor-chair making seems confined to the period between 1799 and 1806. Typical of New England rural craftsmen, Sibley also farmed and worked part time at several other trades—cabinetry, glazing, and painting. Upon occasion he hired out his horse and/or riding chair (a one-person, two-wheeled open vehicle fitted with a legless armchair supported on metal straps). From time to time he made or received in exchange for his services chair frames to be finished with rush bottoms. Sibley constructed plank-seat chairs of three types. Most expensive at 9s. was his "Windsor" chair, probably a sack-back armchair, since the bow-back armchair was uncommon in New England outside Rhode Island and Boston. Sibley also made a "green" chair between 1800 and 1803, the price varying from 7s.6d. to 8s.6d. This must have been a fan-back Windsor, possibly one with bamboo-turned supports. Mostly he made "dining" chairs, for which the usual price was 7s. or 7s.6d. Production of these spanned the entire period of Sibley's Windsor output.[253]

A set of dining, or bow-back, side chairs (fig. **6-237**) seems attributable to Solomon Sibley, since the set came from the Sibley house in Auburn and is thought to have always been there. The features reflect production in an area located some distance from Boston influence. The narrow back curves little below the top arch, and its structure is somewhat out of proportion to the lower half of the chair. The chair has a well-shaped shield seat, which sockets legs marked by a pronounced angularity at the two deeply incised grooves. Similar creases mark the stretcher centers. Angular bamboowork may be typical of central Massachusetts production. Two side chairs with related turnings are labeled by Calvin Bedortha of West Springfield (fig. 6-240). His price, as marked in ink on one label, was 6s.6d.

Strong influence from Rhode Island, which shares most of its northern border with Worcester County, is present in the southern part of the county. A group of chairs bearing family histories associated with towns lying southwest and west of Worcester (fig. **6-238**) exhibit in their clublike turnings a debt to such design (fig. 6-56). A direct link appears in a high-back chair recovered a few years ago in Greenfield on the Connecticut River but likely made somewhere in Worcester County. The long foot of the tall, oval-seat Windsor is shorter than that in the Rhode Island prototype. The same turning inverted constitutes the upper leg. The flaring caps of the two elements (fig.

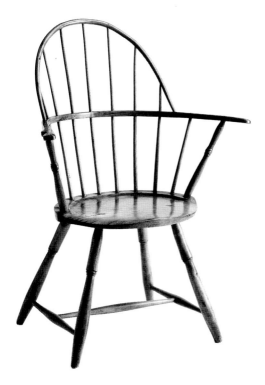

Fig. 6-238 Sack-back Windsor armchair, southern Worcester County, Mass., 1795–1805. Maple, ash, and other woods; H. 37¼″, (seat) 15⅞″, W. (arms) 29″, (seat) 19¼″, D. (seat) 15⅛″. (Private collection: Photo, Winterthur.)

6-25), which meet at the center, give the appearance of cleft disks. The same unusual double baluster forms the arm posts. Leg tips are confined within the plank, although a broad groove defines a spindle platform of generous size. Arm terminals are rounded and flare outward in a graceful ogee curve reminiscent of the work of the Tracy family (fig. 6-98).

In the present sack-back chair the stretchers and slim legs lack the bulbous quality of the tall Windsor. Substituting for flaring caps where the leg and post elements meet is a thin collar or a compressed ball. Arm rails follow the general pattern, although the present interpretation is more exaggerated. In lieu of a groove the spindle platform has been elevated by removing extra wood from around the base. Although the legs pierce the pointed, oval plank top, those at the rear are set well back, partially penetrating the edge of the spindle platform. This awkward arrangement is seen in another sack-back chair whose rail is more pinched in curve and terminates in arm pads of different profile; the turnings follow those in the high-back chair. The second sack-back Windsor was owned in a branch of the Bigelow family, whose members in former generations resided in Charlton and Spencer. The present chair, also in the hands of descendants, originated in neighboring Hardwick.

Still another sack-back chair belongs to this group. More sophisticated, it may actually be a product of Rhode Island or of a craftsman trained there. The well-contoured oval seat and prominent oxbow arm returns are indistinguishable from work of that area. However, the turnings relate more closely to the vigorously shaped members of the present group than to figure 6-56. The chair is said to be stamped "S. N. Herrck," probably the name of an early owner. The surname Herrick is rare in Rhode Island. On the other hand, it is common in Massachusetts, and candidates were resident in Barre and later in Royalston, Worcester County, between 1790 and 1840. It is notable that Rhode Island as a provincial style setter during the late eighteenth century actually stimulated parallel responses in two areas simultaneously. A comparison of the turned work in figure 6-238 with that of figures 6-227 (left) and 6-232, executed in southeastern Massachusetts, reveals striking similarities.[254]

North of Worcester in Boylston, Levi Prescott briefly operated a cabinet and chair shop. Prescott spent his entire life within a fifteen-mile radius of Worcester. He was born in 1777 at Sterling; twenty years later he married at Bolton. By 1800 he had removed his business from Boylston eastward to Berlin. Census compilations record still another move to neighboring Lancaster before 1810. Prescott's chair in the sack-back style with simulated bamboo turnings (fig. **6-239**) has a Boylston label under the seat dated 1799.

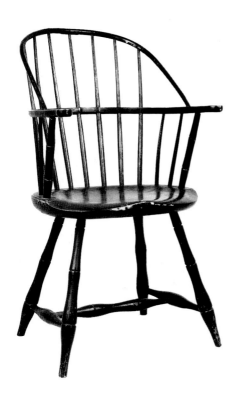

Fig. 6-239 Sack-back Windsor armchair, Levi Prescott (label), Boylston, Mass., ca. 1799–1800. H. 36″, W. 19½″, D. 15½″. (Old Sturbridge Village, Sturbridge, Mass.)

New England, 1750 to 1800 385

Similar documentation is found inside a tall clockcase. It seems unlikely that the craftsman would have continued to use this printed identification much beyond the time of his removal from Boylston without making a suitable alteration, such as cutting off the place name or crossing it through and substituting the name Berlin. Thus, the chair can be dated with some confidence to 1799 or early 1800. The work is competent, employing a well-shaped seat in the Rhode Island style and bold H-plan stretchers. The suggestion of a four-part bamboo leg moves the pattern forward. Deep grooves and angular joints recall Sibley's work; Prescott's bold medial stretcher has double swells in contrast to the single swell of Sibley's chair.[255]

In summary, there is strong evidence to suggest that several Rhode Island-trained chairmakers were at work in southern Worcester County at the end of the eighteenth century. The presence of an identifiable body of Windsor furniture exhibiting characteristics linked stylistically with the coastal region but tied firmly by family association with interior Massachusetts seems to confirm this. In view of the situation that existed at Stonington, Connecticut, where Rhode Islanders took up farm land on leasehold, as recorded by Timothy Dwight and as manifest in the heterogeneity of the area's Windsor furniture, a similar migratory influence could have prevailed in central Massachusetts.

The Connecticut River Valley

Visitors to Springfield at the end of the eighteenth century found the oldest community in Hampshire (later Hampden) County "a very pleasant country town, the houses neat, clean, and well painted, chiefly of weather board." Timothy Dwight noted that the community of about 1,800 people was "built chiefly on a single street, lying parallel with the river nearly two miles." Across the river on the east bank was the U.S. arsenal. Like Worcester, Springfield was involved in inland commerce, and its location on the Connecticut River permitted relatively easy access to a sizable territory. Communication with Hartford and the lower river was possible because canoes and small flatboats could be poled over Enfield Falls and the shoals northward to South Hadley. Here, however, there was "an insurmountable difficulty in a waterfall of about fifty feet descent in two and a quarter miles," and freight for Northampton and the upper river had to be transported by road around the natural barrier.[256]

Calvin Bedortha (Bedourtha) was born near this prosperous southern Massachusetts community in 1774. By the mid 1790s he would have completed his apprenticeship to the cabinet- and chairmaking trades. He achieved master status within a few years, since a local advertisement of September 1803 notes that he "still carries on" the "warranted" chair and cabinet business at his "usual place about a mile west of Agawam meeting house." The location was a little south of West Springfield. Within a group of three "WARRANTED CHAIRS" made by Bedortha early in his career (fig. 6-240), two bear printed labels giving his location as West Springfield, and the third has the outline of a label now lost. The Windsors are not unlike those attributed to Solomon Sibley. Turnings are slimmer and differently proportioned; the back arch is more graceful and its size better related to the rest of the chair. The bow faces have grooved patterns. County deed books record considerable activity by Bedortha between 1802 and 1848; his occupation is described variously as joiner, cabinetmaker, chairmaker, and yeoman. The craftsman owned rights in one or more sawmills standing near the homestead, an indication that the raw materials of his trade were near at hand. At his death in 1853 Bedortha's inventory contained both "Mechanics" and "farming tools," underscoring, again, the duality of a craftsman's life in colonial and federal America.[257]

Located just fifteen miles upriver from Springfield, Northampton with its 300 houses and commercial and public buildings qualified as "the largest inland town in Massachusetts" in 1796. The community was irregular in plan, although its situation in a valley flanked by mounts Tom and Holyoke was magnificent. Surrounding the town were meadows described in the 1830s as "some of the best land in New England, and . . . in the highest state of cultivation." During a brief stop in 1793, the Reverend William Bentley of Salem noted a good meetinghouse at the center of town "just below a neat

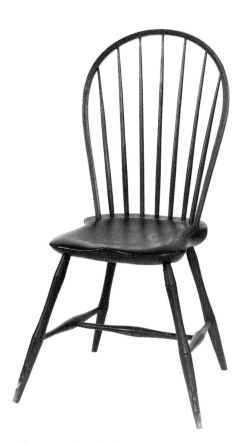

Fig. 6-240 Bow-back Windsor side chair (one of three) and detail of label, Calvin Bedortha, West Springfield, Mass., ca. 1798–1805. Basswood (seat) with maple and ash; H. 38⅞". (Historic Deerfield, Inc., Deerfield, Mass.)

Fig. 6-241 View of Northampton, Massachusetts. From John Warner Barber, *Historical Collections . . . of . . . Massachusetts* (Worcester, Mass.: Dorr, Howland, 1839), facing p. 329. (Winterthur Library.)

Court House with a Cupola, & below that an Academy" (fig. **6-241**). Most telling, however, was Timothy Dwight's remark that "a great deal of mechanical and mercantile business is done in Northampton." In short, the craft and manufacturing sectors were beehives of activity.²⁵⁸

The first craftsman of record to construct Windsor chairs in Northampton was Lewis Samuel Sage, whose advertisement is dated March 27, 1793. Since Sage had previously practiced his craft downriver in Middletown, Connecticut, he probably introduced prevailing Connecticut design to central Massachusetts. This point remains speculative, however, since Sage, like most of his Northampton competitors, apparently did not mark his products. Sage married in Connecticut in 1790 and was still there in November of the following year. His removal to Northampton probably did not occur before 1792. The young craftsman located in a shop "a few rods north of the Meeting-House" in the heart of town, possibly in a building at the center of the illustrated view. He offered in addition to Windsor chairs "all kinds of Furniture in the Cabinet Line" and was ready to engage an apprentice. Sage made his first property purchase in December 1794 when he acquired a lot near the courthouse and erected a dwelling. Not quite a year later he purchased a shop in the new Tontine Building, but both were offered for sale in 1799. Since later deeds record the acquisition of more acreage, the craftsman possibly engaged in limited farming for the better support of his growing family; the shop probably was located somewhere on the premises.²⁵⁹

Benjamin Alvord Edwards, identified variously as a joiner, carpenter, and gentleman in Hampshire County deeds, was baptized in Northampton on January 23, 1757. He made his first land purchase of record in March 1788. During his career Edwards changed residences, and probably working locations, several times. In March 1793 and again in August 1795 he advertised for an apprentice to the joiner's business, the first while associated with a joiner named Pomeroy (probably Simeon with whom he made joint land purchases in 1793). The partnership lasted little more than a year, since in October 1794 Edwards independently offered for sale "a quantity of best made Windsor CHAIRS." The nature of the reference, the joiner's only direct recorded association with Windsor furniture, suggests that he was a retailer only, giving rise to speculation as to how he acquired the merchandise. Two possibilities are obvious: Edwards may have obtained the chairs from a local craftsman, or he may have employed a Windsor-chair maker on the premises. The latter theory has considerable merit based upon circumstantial evidence. In 1803 the Hampshire County probate court appointed the same Benjamin Edwards administrator of the estate of Ansel Goodrich, a local Windsor-chair maker. Goodrich was only thirty years of age at his death, placing his birth date around 1773. At the time of Edwards's 1794 Windsor chair advertisement, Goodrich would have just completed an apprenticeship and attained his majority. It seems more than coinci-

dental that the young craftsman's first advertisement as an independent chairmaker did not occur until a year later on September 16, 1795, only a month after Edwards advertised for an apprentice to the joiner's business following a silence on the subject of more than two years. The removal of journeyman Goodrich from the Edwards shop would have released working space needed to accommodate an apprentice.[260]

Ansel Goodrich is the only Windsor-chair maker of Northampton whose work can be identified. Chairs of several patterns bear his printed label under the seat. Florence Thompson Howe first wrote of Ansel Goodrich in 1930, and little more is known today about the chairmaker's life, career, and untimely death at age thirty. He had set up shop "a few rods north of the court house" by September 16, 1795, in a neighborhood vacated by Lewis Sage two months later in favor of the new Tontine Building. Goodrich's initial public notice lists a variety of Windsor seating: "Arm Chairs, Dining d[itt]o of all kinds, Fanback d[itt]o., Fanback Foretails, Rocking Chairs, Settees and Cannopies." Nowhere does Goodrich suggest that cabinetwork or fancy rush-bottomed seating were part of his output. Most items on the list are easily identified. As in Connecticut, the term "Arm Chairs" described sack-back seating. "Dining" Windsors were bow-back side chairs and probably available in a variety of colors. "Fanback" is self-explanatory; however, the use of "Foretail" to describe a bracing structure at the back is more than a little misleading. The last term, "Cannopies," does not seem to fit the picture at first sight. It is a word of French origin, variously associated with a cover that overhangs a piece of furniture or several styles of upholstered sofa. Goodrich's knowledge of the term is suggested elsewhere in the advertisement, where he states that he had been "regularly bred to the [chairmaking] business" and had "worked among the French."[261]

The young man's statement of his exposure to French chairmaking or design is tantalizing and vague. The great influx of French émigrés to the United States did not take place until the following decade, at which time New York City became a leading American center of the French taste. There was, however, a limited French presence along the eastern seaboard during the early 1790s. Goodrich may have spoken only of an "exposure" to French influence during a metropolitan apprenticeship or as it pervaded early federal design through the English furniture design books of George Hepplewhite (1788), Thomas Shearer (1788), and Thomas Sheraton (1791–94 and later), and through imported European furniture in the French taste. Any suggestion that Goodrich referred to working experience in French Canada can be ruled out, since Windsor construction is foreign to the French culture.[262]

The "cannopy" of Goodrich's advertisement was not a suspended cover nor a sofa but rather a derivative single seat. The French applied the term *canapé* to several eighteenth-century upholstered sofas. The style has a low, sloping, curved back with a capping rail that swings around each upholstered end to form semi-circular arms. The English copied sofas of this type from the French; Hepplewhite illustrates several in his *Guide* of 1788. American craftsmen, in turn, copied their designs from the English sources. Price books in the United States refer to the form as a "cabriole" sofa. The individual seat, or chair, of similar pattern is called a "bergère." *This* is the form that Goodrich had in mind when he referred to his wood-seat chair, or continuous-bow Windsor, as a "cannopy." Based upon this hypothesis, it is possible to speculate further that Goodrich trained in New York. As stated previously, the continuous-bow Windsor originated in New York City in the late 1780s, the period when Goodrich served his apprenticeship. Pertinent in terms of that date is the firm attribution of two high-back bergère chairs to the New York cabinet shop of Thomas Burling (fig. 6-242). Purchased by George Washington and Thomas Jefferson in 1790, the chairs still survive. The top profile of the bergère was interpreted in bent wood to create a new Windsor armchair "in the French taste."[263]

Goodrich had only eight more years of life ahead when he embarked upon his independent career as a chairmaker. He followed his 1795 advertisement with one the next year, stating his intention to take on both a journeyman and an apprentice. Early in 1797 the chairmaker bought a piece of land containing several buildings located between

Fig. 6-242 Revolving bergère chair, attributed to Thomas Burling, New York, 1790. Mahogany, mahogany veneer, and oak; H. 48″, (seat) 16½″, Diam. (seat) 24″; reupholstered, feet restored. (Thomas Jefferson Memorial Foundation, Charlottesville, Va.)

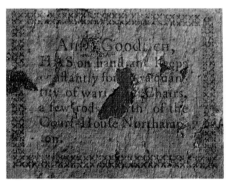 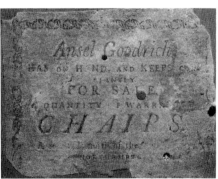

Fig. 6-243 Fan-back and bow-back Windsor side chairs and details of labels, Ansel Goodrich, Northampton, Mass., ca. 1795–1803. Basswood (seats) with maple and other woods; (*left to right*) H. 37¹³/₁₆″, 37⅝″, (seats) 17⅞″, 18¾″, W. (crest) 20″, (seats) 16¼″, 16⅝″, D. (seats) 16¼″. (Historic Deerfield, Inc., Deerfield, Mass.: Photo, Winterthur.)

the courthouse and the meetinghouse, the neighborhood where he first settled. The following years saw further advertisements, as the craftsman sought raw materials and labor. Goodrich's business was prospering when he died suddenly on July 31, 1803. Benjamin A. Edwards assisted in making an inventory of the shop and house, besides serving as administrator. Chair parts and seating in various stages of completion identify Goodrich's production as dining and fan-back chairs, armchairs, and Windsors for children. The chairmaker appears to have used only paper labels to document his work.[264]

A full range of labeled or attributable chairs provides a comprehensive core of material for the study of Ansel Goodrich's style. Side-chair production was the craftsman's bread and butter. His fan-back and bow-back Windsors (fig. **6-243**) are of good form, light in appearance with well-shaped individual parts. From the seat down the basic design is interchangeable. Close comparison points up the minor differences that are normal even in the production of one individual. Plank shapes vary across the front from the knife edge of the fan-back chair to the deeper surface of the "dining" Windsor. Balusters differ somewhat in overall length and collar depth. Below the spools, ring turnings vary from wafer to almost compressed-ball size. Stretchers are uniformly slim, and leg tapers moderate in length and diameter. The spindles compare well in their long

Fig. 6-244 Sack-back Windsor armchair, Ansel Goodrich (label), Northampton, Mass., ca. 1795–1803. Basswood (seat) with maple and other woods; H. 37¹³⁄₁₆″, (seat) 17⅝″, W. (arms) 24⅞″, (seat) 20½″, D. (seat) 14″. (Northhampton Historical Society, Northhampton, Mass.: Photo, Winterthur.)

swells, and the posts of the fan-back chair conform to other roundwork. Marking the bow faces is a narrow groove beginning at the center bottom and increasing to three depressions across the arch. Documented side chairs number upwards of half a dozen; unmarked Windsors increase that figure.[265]

Two labeled sack-back armchairs by Goodrich are closely related, given the subtle variations of normal production (fig. **6-244**). Turnings repeat shapes found in the side chairs, including the pronounced triangular profile of the leg tops. This feature seems something of a trademark of Goodrich's (or Northampton?) style, as it occurs in all the chairmaker's identifiable baluster-turned production. The oval planks are markedly square at the front, with slightly drooping corners and a large dished oval in the top surface forming the "seat." Comparison of the two labeled Windsors of this pattern reveals differences in the bow arch. The one shown is broad and rounded, while the other forms a tall, narrow, pointed arch. Differences in framing are found as well. Here bow tips tenon into the rail between the two short spindles. The second pattern anchors the bow in the rail behind the second short spindle, forcing the arch higher. Arms terminate in small pads with narrow, slightly curved rail returns.[266]

At least two pairs of unmarked continuous-bow Windsors representing Goodrich's "cannopy" chairs still exist; one pair is at Historic Deerfield, the other at Winterthur (fig. **6-245**). While a definite attribution to Goodrich may be unwise in the absence of a documented chair of this pattern for comparison, Northampton certainly was the origin. Turnings and other features, including the pad arms, relate significantly to Goodrich's documented work. The Winterthur chairs differ from those at Deerfield in the greater diameter of the arm posts and the use of a broad, shield-type seat. Seat contours relate to those of the previous sack-back Windsor. Henry Francis du Pont acquired this pair of continuous-bow chairs in 1930 from a dealer in Longmeadow, Massachusetts, a Connecticut River town just south of Springfield. The seats are basswood, a material favored by Northampton chairmakers, as demonstrated in a Lewis Sage advertisement: "Will pay cash for Basswood Plank, if sound and seasonal, and suitable for Chair seats if delivered soon." The grooved bow faces flanked and centered by squared beads repeat an ornamental treatment in the bow of Goodrich's side chair.[267]

Fig. 6-245 Continuous-bow Windsor armchairs (pair), attributed to Ansel Goodrich, North-ampton, Mass., ca. 1795–1803. Basswood (seats) with maple, ash, and oak (microanalysis); (*left to right*) H. 38¾″, 38¹⁄₁₆″, (seats) 18⅜″, 17¼″, W. (arms) 21⅜″, 21⅞″, (seats) 18½″, D. (seats) 15⅝″, 15½″. (Winterthur 65.3022, 65.3018.)

Goodrich's rocking chair, represented by both labeled and unmarked examples, is a high-back Windsor whose features resemble his other work. It is worth noting here that all Northampton chairs described so far socket the legs internally, still another instance of Rhode Island's impact on chairmaking in interior Massachusetts.

Only one documented example of Goodrich's bamboo-turned work has come to light—a labeled dining chair of bow-back form (fig. **6-246**) with the bow curved in an arch similar to that of the baluster-leg example. Treatment of the bow face is different; the surface is flat with a scratch bead at either edge. The plank and spindles reflect Goodrich's usual styling. The legs exhibit a stout quality, the product of a short, thick midsection and sizable swells at the grooves. The form may serve to identify other area bamboowork. The grooved swells that center the stretchers are longer than those in the chairmaker's previous work.

As Ansel Goodrich established his chairmaking career in Northampton, a number of competitors entered the market. In neighboring Westhampton Justin Parsons first gave public notice as a Windsor-chair maker in February 1796 when he sought an apprentice. Little is known of his activity. Presumably, he supplied vernacular seating to country householders west of Northampton, such as John Stone whose Chesterfield probate inventory of 1804 lists "Green dining Chairs" along with "Armd" and "Rocking d[itt]o." Parsons had connections in Northampton, too. The estate of Ansel Goodrich owed him a debt of $14.50 in 1803, the equivalent of more than fourteen days' pay for a working man with a trade. At Parsons's own death in 1807 his stock on hand included ten "green Chairs with arms" and sixty-four "common dining Chairs partly finished."[268]

Julius Barnard advertised as a cabinetmaker in Northampton in 1792. He followed this notice with others for cabinetwork through the 1790s. Barnard was a native of Northampton (b. 1769), but in his first public advertisement he advised readers that he had "worked sometime with the most distinguished workmen in New York." He appears to have entered the Windsor trade about November 1799, when he added a postscript to his notice: "A WINDSOR CHAIR MAKER who is a good workman may find good encouragement and constant employ." Windsor production continued at Barnard's shop in the Tontine Building until the craftsman's permanent removal from Northampton early in 1802. The scope of Barnard's trade in Windsor seating may be gauged by his notices to secure plank. In July and August 1800 he advertised for sufficient footage to make 300 or 400 seats; on a more expansive scale in February 1801 he solicited "BASS PLANK for a thousand Windsor Chair Seats." The furniture maker worked briefly in Hanover, New Hampshire, during the summer of 1801, returned to Northampton, but left for good the following summer. He established himself in Windsor, Vermont, where he remained until about 1809. During the next three years he was in Montreal.[269]

After Barnard's removal from Northampton, Oliver Pomeroy served as agent to settle all "demands against him for Cabinet work." Pomeroy himself was a cabinetmaker. In fact, a brisk rivalry seems to have existed between the men during Barnard's last few years in Northampton. Pomeroy, also a town native, early stated that he had "worked two or three years in the city of Philadelphia," thus establishing his qualifications in the cabinet business. As Leigh Keno has pointed out in his study of Northampton furniture craftsmen, Pomeroy's entry into Windsor-chair making did not take place until after Barnard left town. This fact has given rise to speculation that Pomeroy was merely completing and selling off Windsor stock left behind by Barnard, a theory that seems particularly cogent in view of Pomeroy's status as Barnard's agent. On November 11, 1801, only three months before his departure for Vermont, Barnard had advertised that he would pay cash for 400 Windsor-chair seats. Presumably, part of this stock was used in the "warranted windsor chairs" that Pomeroy offered for sale at the Tontine Building on March 3, 1802. That venture appears to have been his first and last into this branch of woodworking. The cabinetmaker remained in Northampton until about June 1816 when he left with his family for Buffalo, New York.[270]

Although Harris Beckwith's independent woodworking career probably commenced only after the death of Ansel Goodrich, to whose estate Beckwith owed a debt of

Fig. 6-246 Bow-back Windsor side chair, Ansel Goodrich (label), Northampton, Mass., ca. 1800–1803. (Photo, Sotheby's.)

$28, his account book indicates that he made Windsors of eighteenth-century style from 1803 to 1805. Beckwith also worked as a joiner and carpenter. His debt to the Goodrich estate may reflect a purchase of shop stock after the chairmaker's death. Appraisers itemized eighty-two fan-back chairs in various stages of completion when they evaluated the Goodrich shop on October 23, 1803. Beckwith sold thirty such chairs to his own customers between December 1803 and March 1804; after that date there are no further entries for the pattern in his records. References to dining, arm, and children's chairs also are found in both records. In addition, the newcomer sold eight rocking chairs between October 1803 and April 1804, a form that while not listed in the Goodrich inventory was part of his advertised production. Beckwith kept shop at No. 8 Tontine Row. In his first notice of November 8, 1803, he advised that he stocked "for sale, an assortment of WINDSOR CHAIRS, warranted to be made in the best manner."[271]

David Judd, like Harris Beckwith, retailed Windsor chairs only after Goodrich's death. When he and Ansel Goodrich worked as neighbors a few rods above the courthouse just after 1800, Judd pursued only the cabinet trade. After Goodrich's death he removed to Pleasant Street. His first reference to Windsor furniture came only in June 1804, an indication that he probably did not acquire Windsor stock from the Goodrich estate the previous year, although he purchased six fan-back chairs from Beckwith in February 1804.[272]

The village of Hadley across the river from Northampton counted the services of at least one Windsor-chair maker during the 1790s. William Shipman probably first practiced the woodworking trade in his native Saybrook, Connecticut, since the birth of a first son is recorded in that place. By 1787 he had moved upriver to Middletown, where he advertised Windsor seating. An entrepreneurial instinct and the accessibility of the upper river by flatboat may have induced Shipman to travel to Hadley in spring 1788 and set up temporary quarters "north of Kelloggs Tavern" to sell or barter turpentine, varnish, and "WINDSOR CHAIRS, as good and cheap as any where on the continent." He stood ready to exchange chairs for "a few thousand of white pine SHINGLES." Thus, a number of Connecticut chairs probably found their first homes in central Massachusetts, where some may still retain "old family histories."[273]

Shipman returned to Middletown, where he advertised Windsor chairs again in November 1790. But Hadley had its appeal, located as it is on the neck of a peninsula within a long, hairpin bend in the river. From the south end of town there was a delightful view of the gorge between mounts Holyoke and Tom. Here, as a permanent resident, Shipman advertised in spring 1794 for journeymen to the wheel- and chaisemaking trades, while simultaneously looking for "an ingenious man, to serve a short term of time, for the art of making windsor chairs and painting." Shipman died in Hadley in 1824. The William Shipman who began a broom business about 1801 with two other men may have been his eldest son. John Warner Barber noted in 1839 that "large quantities of broom-corn are annually raised, and the manufacture of brooms is an important branch of business in this town."[274]

William Shipman, Sr., was uncle to Henry Titus Shipman who migrated from Saybrook to Coxsackie, New York, shortly before 1805 where he constructed a distinctive high-back Windsor with urn-shaped turnings (fig. 5-24). Henry's chair is relevant here because it relates in several features to a sack-back chair with a nineteenth-century history in Sunderland, a town ten miles upriver from Hadley (fig. **6-247**). Resemblances can be seen in the seat planks of steeply rounded edge and spindles that thicken below the rail. Of particular note, the chairs share arm rails of extraordinary breadth supported by well-angled short spindles and spindly posts. The present chair exhibits a slight swell in the leg tapers, which is not surprising if this is the work of a man trained in coastal Connecticut near the Rhode Island border. Branded on the seat bottom in late sans-serif letters is the name "J. H. WOODBURY" accompanied by the penciled inscription, "Jason H. Woodbury / Sunderland." A will for this estate was filed on June 26, 1891. Still another early association between Windsor seating and the town of Sunderland occurs

Fig. 6-247 Sack-back Windsor armchair, probably Hadley, Mass., area, 1788–1800. H. 37⅛″, (seat) 16⅝″, W. (arms) 26⅞″, (seat) 18¹⁵⁄₁₆″, D. (seat) 13⁵⁄₁₆″. (Memorial Hall Museum, Pocumtuck Valley Memorial Association, Deerfield, Mass.: Photo, Winterthur.)

in an anonymous watercolor portrait of a Miss Greene in empire dress seated in a sack-back armchair.[275]

Northwest of Sunderland, in Deerfield, Doctor Thomas Williams recorded a ledger credit of 18s. in July 1786 for Nathan Oakes who exchanged two chairs for medicines. The valuation suggests Windsor seating, since rush-bottomed chairs cost considerably less and joiner's chairs, more. A Windsor-chair maker of the same name worked in St. John, New Brunswick, for several years before succumbing to smallpox in 1797, but whether the two are the same man has not been determined. Other townspeople of Deerfield used Windsor furniture in their homes during the 1790s and later. John Williams's inventory of 1816 presents a comprehensive picture of local household seating. Supplementing cherry and haircloth-covered chairs were six "large" Windsors, a dozen "old dining chairs" (probably bow-backs), tall rush-bottomed kitchen chairs, and a dozen flag-bottomed seats whose valuation at $2 apiece suggests they were fancy, painted chairs.[276]

A few miles north of Deerfield in the larger community of Greenfield, Daniel Clay began his career as a cabinet- and chairmaker early in the 1790s. His first public notice of February 1794 mentions only cabinet work. Within three years Clay found it expedient to branch out and advertised for "WHITE OAK, ASH, and WHITE MAPLE TIMBER, suitable for WINDSOR CHAIRS." By July 1800 he was ready to employ a journeyman Windsor-chair maker. Notices for Windsor chairs occur periodically through 1811, and along the way Clay added fancy and common (rush-bottom kitchen) chairs to the list. Increasing competition likely forced his expansion into chaise repair and the looking glass and picture-framing business. Clay was born in New London, Connecticut, in 1770. He spent his youth in Middletown, which may be where he learned his trade.[277]

West of Greenfield, Ezekiel Edgerton probably was well established in Hawley by January 1804 when he advertised for an apprentice and journeymen competent in cabinetmaking and Windsor-chair making. At neighboring Buckland, Joseph Griswold had opened a cabinet and joiner's shop six years earlier. The bulk of his chairwork was rush bottomed and sold at recorded prices of 3s. and 4s. apiece. Cabinet and other articles ranged from tables, clockcases, and chests to wheels, reels, and sleighs. In 1801 Griswold began limited production of "winsor chairs," which he sold for 9s. each. Comparison of the price with his 6s. dining chair constructed between 1801 and 1803 identifies the former as armchairs. Griswold tried his hand at "fanbackt" Windsors in 1806, which sold for 7s.

Fig. 6-248 Bow-back Windsor side chair, Connecticut River Valley in Massachusetts, 1798–1808. Basswood (seat) with birch, ash, and maple (microanalysis); H. 35¾", (seat) 17⁵⁄₁₆", W. (seat) 12¾", D. (seat) 13¼". (Winterthur 56.38.102.)

apiece. All told, his Windsor output amounted to just over forty chairs. Griswold's limited production is typical of the chair market in rural New England before the 1810s, and it explains why the eighteenth-century New England Windsor exhibits so many subtleties of design from chair to chair.[278]

Illustrated in figure **6-248** and plate 7 is a chair whose features and materials suggest an origin in the Connecticut River valley in Massachusetts. On stylistic grounds there is good reason to compare the support structure with that of Bedortha's and Sibley's chairs (figs. 6-240, 6-237). The bamboowork shares angular joints, hollow feet, and a slender form. The grooved and beaded bow face is analogous to other Massachusetts work of the valley, and the long spindle swells have a decided affinity with Northampton chairs. The blunt surface at the forward seat edge calls to mind coastal Connecticut and Rhode Island styling (figs. 6-27, 6-168, 6-175); in view of the several migratory patterns described in this chapter, such influence is not surprising. The extremely delicate seat (12¾ inches by 13¼ inches) is a feature not previously noted. The chairmaker scaled other dimensions accordingly, including the height, which is two or three inches shorter than normal. Perhaps this is the "youth's chair" mentioned from time to time in period documents. Supporting an origin in the northern valley are the materials of the chair: basswood, birch, and ash.

NORTHERN NEW ENGLAND

Introduction

The settlement of southeastern New England was basically complete by 1760. In the French and Indian War, the English had won control of Canada, thus lessening fears of Indian raids. After the war, settlers in increasing numbers left the old established areas to seek opportunities to the west and north. Individuals, families, and groups moved into the open lands of western Massachusetts, New York state, and the upper Connecticut River valley in New Hampshire and Vermont. They often named newly established communities for their former homes. The Revolution curbed migration, but with the restoration of peace new waves of settlers headed for the northern frontier. Characteristic of most settlements into the early nineteenth century was the heterogeneity of the population and the continual state of flux within the community. Peoples from many areas often inhabited the same town; as new families arrived, some left for still more distant frontiers. For many years Vermont was the center of a jurisdictional controversy between New Hampshire and New York, a feud resolved in 1791 when the territory was admitted to the Union as the fourteenth state. With this final barrier to peaceful settlement lifted, the area blossomed. At the first census enumeration of 1790, Vermont's population stood above 85,000; the figure rose to 154,500 by 1800.[279]

The constant movement of peoples within the several areas that make up northern New England prevented inhabitants from feeling a real sense of permanence and stability like that enjoyed by the residents of the southern region. Under these circumstances, nonagricultural pursuits were limited. Common household seating introduced by prerevolutionary settlers consisted mainly of rush-bottomed chairs, a traditional form in southern New England. Even after the war production of Windsor chairs was limited. Few local examples are identifiable, and those with firm "histories" usually have bamboo-style turnings. Thus, several groups of baluster-turned chairs firmly associated with northern New England are all the more remarkable. In general, chairmaking activity is concentrated in specific regions and dates principally to the 1790s. New Hampshire craftsmen were located in the counties bordering Massachusetts or in the central part of the state; Vermont chairmakers were centered either in Bennington, a town near the Massachusetts and New York borders, or along the Connecticut River in Windsor County. In Maine, which did not gain statehood until 1820, chair production is elusive until after 1800.

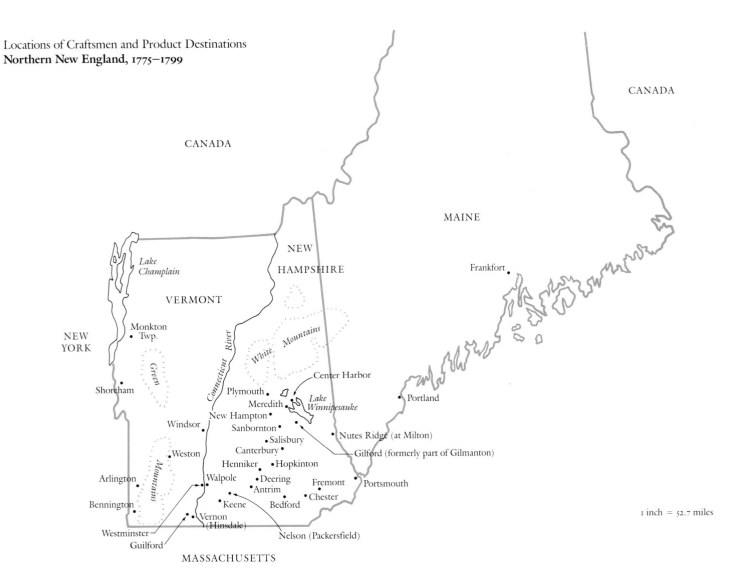

New Hampshire

Although the town of Portsmouth was settled as early as 1623, more than a century passed before it began to flourish. The immediate prerevolutionary years witnessed a brisk traffic in furniture to coastal and Caribbean markets. Even the incomplete figures that are available for chair shipments from the Piscataqua District between 1768 and 1771 illuminate the industry's scope:

1768	Coastal destinations, 217 chairs
1769	Coastal destinations, 795 chairs
	West Indies, 420 chairs
1770	Coastal destinations, 354 chairs
1771	West Indies, 462 chairs

Most seating was described as "House Chairs," which meant rush-bottomed, although documented use of Windsors in Portsmouth households suggests that some wooden-bottomed seating may have been produced locally. The Revolution halted this trade, and Portsmouth only slowly recovered from the effects of its temporary loss. In a town where "everything . . . is commerce and shipping," Brissot de Warville found "a thin population [and] many houses in ruins." At the time of the Reverend William Bentley's visit in 1787, commerce on the Piscataqua River had begun to revive. By the turn of the century Portsmouth could claim eighty-eight large sailing vessels, besides coasting and fishing craft. Viewed from across the river the town formed "a delightful assemblage," but up close many found its irregular plan less pleasing.[280]

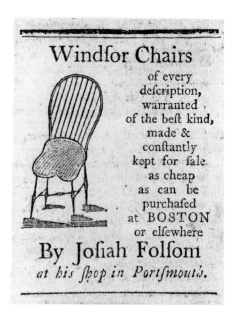

Fig. 6-249 Advertisement of Josiah Folsom. From the *New Hampshire Gazette* (Portsmouth), September 19, 1797. (Photo, New Hampshire Historical Society, Concord.)

In this setting several chairmakers practiced their craft during the 1790s. One of them, Josiah Folsom, born north of Portsmouth in Dover, had completed an apprenticeship and taken a wife by 1786. The marriage took place in Boston, suggesting that the city was also the site of his training and journeyman experience. Folsom removed to Portsmouth in 1788, although he may not have set up shop immediately. His only known eighteenth-century advertisement, dating to 1797, offers Windsors "of every description" and illustrates a bow-back side chair with bamboo-style supports and a well-saddled seat (fig. **6-249**). Folsom may have advertised to counteract competition from imported Windsors, especially chairs of Boston manufacture, as hinted in his notice. Philadelphia, too, cornered its share of the Portsmouth market, as suggested in shipping records of the 1790s. The schooner *Industry* carried eighteen Windsors to Portsmouth in November 1791 and within a year and a half visited again with a similar cargo. In the interim the brig *Betsey* left Philadelphia in April 1792 loaded with three dozen chairs. The sloop *Nancy* arrived with "fifteen Winsor Chairs" just before Folsom's advertisement was published. Local "mariners" probably imported chairs for their own use. The early nineteenth-century estates of two such men—William Fernald and George Frost—itemize Windsor seating. Frost's "12 Green Chairs" valued at $9 furnished his "South West sitting Room." Josiah Folsom eventually gave up woodworking to merchandise West India goods, possibly capitalizing on contacts made during his chairmaking career.[281]

The lad who was sought as "an apprentice to the Windsor Chair business" in an anonymous Portsmouth notice of 1799 may have been solicited by Josiah Folsom. By this time another craftsman, Langley Boardman, had come to Portsmouth from Massachusetts and commenced the cabinet business. In 1802 he sold Jacob Wendell furniture valued at $188, consisting of tables, a commode, an easy chair, a sideboard, a bedstead, and half a dozen fan-back chairs. As there is no further evidence that Boardman was anything but a cabinetmaker, the Windsors he sold may have been obtained elsewhere. Boardman and Folsom were original members of the Associated Mechanics and Manufacturers of the State of New Hampshire, founded in 1802, although in time Boardman developed other career interests.[282]

In decided contrast to the trading center were the inland towns and villages where agriculture was the main pursuit. John Melish noted in 1806 that although mountains covered a large part of New Hampshire, approximately 184,000 inhabitants occupied the "large and rich valleys among the mountains, and a number of level plains along [the] Connecticut river," primarily in the central and southern parts of the state. "Small villages and farm-houses [were] numerous, and the country . . . pretty well supplied with good roads, and . . . bridges." Recent studies of New Hampshire furniture have found similar patterns of furniture production. For the most part rural eighteenth-century New Hampshire furniture was traditional, conservative, and sometimes of retarded or individual pattern. Making do probably was a common way of life. A case in point was recorded by woodworker Matthew Patten of Hillsborough County, who commented that a Mrs. Sullivan "made a present to our Polly of a broken Oval table—there was one leg gone and one leaf was in three pieces and cant be mended [i.e., the leaf had to be replaced]."[283]

A short distance inland from Portsmouth at Fremont along the Exeter River, Moody Carr practiced several trades, among them chairmaking. His book of accounts detailing early nineteenth-century activity indicates that chair production was thin indeed. Mentioned most frequently are "red" and "Citchen" chairs. His entire output of Windsor seating may have been confined to the six "Dining" chairs he sold in 1804 and the "six wooden botom Chairs" purchased by a customer for 10s. apiece about 1809. The Windsors are just as likely to have been of eighteenth-century pattern as of a later style. When estate appraisers detailed Carr's household many years later they found kitchen chairs and "old dining chairs."[284]

Bedford, beyond Manchester, was the home of several craftsmen who jointly pursued the cabinetmaking and Windsor-chair-making trades. One resident was Major John

Dunlap who died in his mid forties in 1792. Evidence linking him with Windsor-chair making is scant despite many personal records. Dunlap's book of accounts dating between 1768 and 1787 lists only two tentative possibilities, both recorded in 1784: "to 2 Round Backt Chairs" and "Six bowbackt Chairs." At first sight both entries seem obviously to refer to Windsors, but there are problems. Round-back chairs could be sack-backs, but the relatively early date for rural New England production and the mention of only two chairs indicate something else, possibly a low corner chair, or roundabout. Bow-back chairs are mentioned only once, and the date is early—even earlier than the introduction of this form in Philadelphia. The price is the same as that charged for half a dozen banister-back chairs sold in 1784. Most likely the term describes a chair with either a concave or an ox-bow crest. In 1791 Major Dunlap held a vendue at neighboring Chester where he offered "6 Dining chairs" for sale. Although the date and language are compatible with Windsors, Dunlap could have obtained the chairs by exchange rather than making them himself. There were several "Windsor" chairs in Dunlap's household at his death.[285]

A more important chairmaking figure in Bedford was David McAfee (1770–1809), who trained several young men at the turn of the century. Documented examples show that all of them later constructed Windsor chairs. As might be expected in a small community like Bedford, McAfee had a number of contacts with the Dunlap family. In 1786 he worked for Major Dunlap for seventy-eight days and boarded in the Dunlap home. Family tradition asserts that after the major's death young John Dunlap II became an apprentice to McAfee between 1800 and 1804. Another Bedford group linked to McAfee is the Atwood family. An indenture of apprenticeship for David Atwood (b. 1779) made between his father Isaac, a cooper, and McAfee, described as a cabinet-maker and chairmaker, is dated August 1, 1795. Young Atwood was bound to McAfee "to learn the trade, mystery or occupation of a Cabinet-Joiner & Windsor-Chair-maker" for a term of four years, seven months, and twenty-three days. The agreement called for Atwood to attend school for three months to learn "Arithmetick" from an "approved teacher." Because the brand of Thomas Atwood (b. 1786), younger brother to David, also occurs on Windsor seating, it is likely that he, too, trained with McAfee sometime after 1800.[286]

There is evidence of further Windsor activity in southern New Hampshire from the Contoocook Valley westward to the Connecticut River. Thomas Aiken (b. 1747) of Antrim is linked with spinning wheel production; perhaps he also constructed a few wooden-bottomed chairs from time to time. Thomas Aiken, Jr., of nearby Deering, presumably a son or close kin, died in 1805 on the ninety-acre farm he had "lately purchased of John Aiken." One building on the farm was a shop containing "Sundry Chair Tools" and furniture parts that attest to his Windsor-chair making activity: "14 chair bottoms," "10 Rough d[itt]o," "31 doz Chair Rods," and "1½ doz Chair Bows." Jonas Childs practiced chairmaking the same year at Packersfield (now Nelson), where he offered kitchen chairs and eighteenth-century style "Fanback" Windsors along with wheels for spinning wool, and cheese presses. Childs later migrated south to Gardner, Massachusetts. Along the Connecticut River at Walpole, Stephen Prentiss, Jr., offered in 1797 to receive "almost any kind of Produce . . . in payment for Chairs" constructed of "seasoned . . . stuff."[287]

Keene, the Cheshire County seat, is located south of Walpole in the Connecticut Valley. Both the Reverend William Bentley in 1793 and Timothy Dwight in 1803 visited and described the town. Bentley commented on the "appearance of Trade, & prosperity" in the town but faulted some of the public buildings and noted that the main street had little uniformity, giving it a "scattered appearance." Dwight described Keene as one of the largest and prettiest towns in western New Hampshire. Contributing in part to the town's prosperity was the presence of the Wilder family. Members of this woodworking clan arrived before the Revolution. Abijah, Sr., followed the cabinetmaking and sleigh-making trades. His younger brother Peter was a cabinetmaker during the 1780s and may have constructed chairs at this time, as he did later at New Ipswich. Two of Abijah's sons

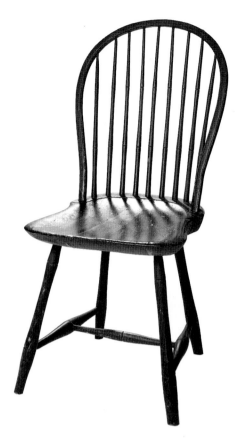

Fig. 6-250 Bow-back Windsor side chair, probably Abel Wilder (brand "A.WILDER"), Keene, N.H., ca. 1798–1805. H. 35⅛", (seat) 16½", w. (seat) 17¼", D. (seat) 16¾". (Old Sturbridge Village, Sturbridge, Mass.)

worked in Keene, Abijah, Jr. (b. 1784), and Azel (b. 1788). They formed a three-year partnership in 1812, advertising cabinetwork and sleighs along with bamboo, fan-back, and kitchen chairs. The lingering currency of the fan-back style at this late date helps to explain the survival of so many chairs of this pattern with bamboo-turned supports. In 1823 Abijah built a large manufactory to mass-produce cabinetwork and chairs.[288]

A kinsman of the Wilder brothers named Abel (b. 1771), son of Samuel, settled in Keene and learned the trades of cabinetmaking and sleigh-making from Abijah, Sr. Abel worked in partnership with a man named Luther Holbrook between 1805 and 1807. Illustrating an advertisement for their furniture warehouse is a square-back Windsor with double cross rods—the "bamboo"-style chair mentioned by Abel in an 1807 advertisement after the dissolution of the partnership. Abel also listed fan-back and kitchen chairs, the latter probably of slat-back form with rush seats, a type that remained popular in rural areas well into the nineteenth century. A year later Abel sold the business, as indicated by the new owners Wilder, Rugg and Company (John Wilder and Elisha Rugg), who announced that they had "purchased of Mr. Abel Wilder of this town his Turning Works and Tools and will carry on their business at his Shop." John Wilder continued to operate the business at the termination of the partnership in 1810.[289]

Windsors branded "A. WILDER" on the plank bottom include two bow-backs and a square-back armchair with double cross rods. The three chairs show a definite progression of style. The earliest is a side chair with swelled stretchers (fig. **6-250**). In a second side chair, the design is modified by the introduction of a bamboo-turned medial brace. This chair has a seven- spindle back as opposed to the nine sticks of the first Windsor; otherwise, the chairs are fairly similar. Crowned-face bows in the Philadelphia style introduced via Boston form a waist near the bottom. Spindles flare at the base and seat fronts lift at the corners, suggesting Boston influence. The identity of the chairmaker is uncertain. Each of the three chairmaking family members whose given name begins with *A* is a candidate. Area documents make no mention of the bow-back style of chair. Like the rod-back Windsor, it probably was described under the umbrella term of "bamboo chair." If so, Abel Wilder, who was born in Lancaster, Massachusetts, in 1770–71, emerges as the likely choice. Neither Abijah, Jr. (b. 1784), nor Azel (b. 1788) began their careers until well after 1800.[290]

Other chairmaking activity centered in the upper Contoocook and Merrimack valleys west and north of Concord. Lieutenant Samuel Dunlap, younger brother of Major John, took up residence in Henniker around 1779, remaining there until about 1797 when he removed to Salisbury. An account book details his woodworking activity for these and later years. Charles Parsons analyzed the document and found the greatest concentration of chairwork between 1790 and 1795, when production numbered 134 seating pieces. About half that number is recorded for the next five-year period; after 1800 chair construction fell off sharply. Parsons's compilations show that Dunlap made four "Round Backt" and twenty-four "Bow Backt" chairs. The former term seems as indefinite here as in Major John's accounts; however, the bow-backs could be Windsors, since most, if not all, were made in the 1790s. The record mentions neither the "fan-back" nor "dining" chair.[291]

James Dinsmore probably did not commence cabinetmaking in neighboring Hopkinton until after Dunlap had moved to Salisbury. He advertised in 1803 and 1805 and by 1809 had migrated to Maine. His second notice focuses on cabinet furniture, but a postscript offers "a handsome assortment of Dining, Fanback, and Bamboo Chairs." A question may be raised as to whether Dinsmore constructed the chairs, although his stock is similar to that detailed for other small regional centers. Stephen C. Webster (b. 1779), a contemporary who worked in Salisbury, began his accounts in 1804. His work consisted mainly of coffins and sleighs. Webster's chairmaking activity was limited to six dining chairs, three fan-backs, and a rocker, all probably dating from early in his career. Visual evidence confirms that tentative output of this sort was typical of sparsely settled areas, especially in New England, until after the War of 1812, when advancing

technology and a rising national economy brought about sweeping changes in chair production and markets.[292]

A fan-back side chair stamped on the seat bottom "J. KIMBALL" (fig. 6-251) may be a product of Joseph Kimball, Jr. (b. 1772), whose Canterbury shop was north of Concord. Records describe Kimball as a cabinetmaker and chairmaker, turner, spinning wheel maker, and fabricator of farming tools; from 1797 he occupied a farm. The Kimball chair was recovered in New Hampshire, which strengthens the identification. Although it is of standard size, the branded Windsor resembles a group of fan-style chairs with short backs (fig. 6-252). A pair was recovered in New Hampshire, and a single chair was found in Maine. Comparison reveals the following: compatibility of leg turnings except for the top element; good stretcher conformity except for medial rings in the full-size chair; and crest rails with rounded projecting ends flat on the lower edge almost to the tips. Modifications in back height make comparison of the posts irrelevant.[293]

James Chase, cabinetmaker and chairmaker, served customers along Lake Winnipesaukee's western shore at Gilmanton (in an area later part of Gilford) until his death in 1812. Patrons included local householders and residents of neighboring Meredith, Sanbornton, Center Harbor, and New Hampton. Several account books kept by Chase from 1797 until his death show active production of Windsor seating. Figures compiled by Charles Parsons from these records reveal that Chase constructed more than 350 dining Windsors, about 150 fan-backs, and several dozen "bamboo" chairs, along with kitchen, common, "little," and banister-back seating and an occasional great and rocking chair. Parsons's figures for Chase's plank-bottomed work, tabulated on an annual basis, help illuminate the early Windsor industry of northern New England. The dining chair was already in production in 1797 when the accounts began, and sales continued until

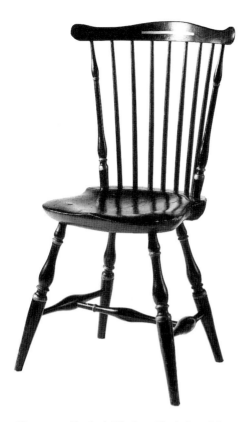

Fig. 6-251 Fan-back Windsor side chair and detail of brand, possibly Joseph Kimball, Jr., possibly Canterbury, N.H., 1793–1805. H. 35⅞", (seat) 17⁷⁄₁₆", W. (crest) 16⅞", (seat) 16⅞", D. (seat) 16¼". (Robinson D. Wright collection: Photo, Winterthur.)

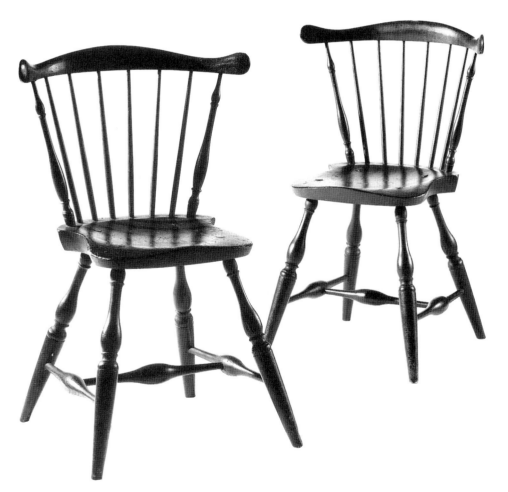

Fig. 6-252 Fan-back Windsor side chairs (pair), probably south-central New Hampshire, 1795–1805. H. 31¾", (seat) 17", W. (crest) 22", (seat) 14⅞", D. (seat) 15⅝". (Robinson D. Wright collection: Photo, Winterthur.)

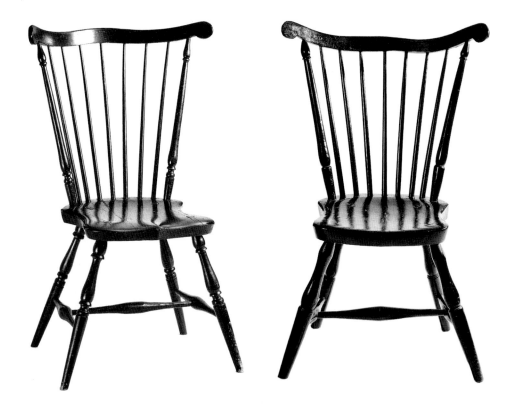

Fig. 6-253 Fan-back Windsor side chairs (two), east-central and southern New Hampshire, 1795–1810. (*Left to right*) pine (seat) with maple, black walnut, and ash (microanalysis) and basswood (seat, microanalysis); H. 37⅛", 34¾", (seat) 16½", 15¾", W. (crest) 23¼", 24¾", (seat) 15¼", 14¾", D. (seat) 15¾", 15¼". (Winterthur 59.3663, and Strawbery Banke, Inc., Portsmouth, N.H.: Photo, Winterthur.)

Chase's death. The usual price was 7s.; special decoration increased the cost slightly. There are no entries for fan-back chairs until 1801, and they, too, continue until Chase's death. At 9s. the chair was priced higher than the bow-back Windsor; decoration often raised the cost to 10s. Several fan-back chairs with rockers, which sold for 12s., may have had arms to account for the substantial price increase. Beginning in 1809 Chase made bamboo-style chairs retailing for 12s., or $2, apiece. The price reflects their decorative nature, described as "Stript" or "tipt" in the entries. Unfortunately, Chase's Windsor production is unidentified; the presence of basswood plank in his estate may suggest the seating material.[294]

Not far from Chase at Plymouth, Jacob Merrill, Jr., cabinetmaker and chairmaker, constructed a few dining chairs in the early 1800s at his homestead joiner's shop. Since rush-bottomed chairs constituted Merrill's usual production, it is no surprise to find that he made Windsors only in limited number. The price varied from 7s.6d. to 8s. It may be that Chase's substantial production of this seating form only thirty miles away dominated the Windsor market throughout the Winnipesaukee region. Merrill's item for "a round Chair" priced at 6s.8d. in 1793—less than the price of a Windsor side chair—sheds more light on the Dunlap account book entries for "Round Backt" chairs. Clearly this was a rush-bottomed seating piece.[295]

Appropriate to a discussion of New Hampshire Windsor work of the late eighteenth century is a group of fan-back side chairs of distinctive ribbonlike crest (fig. **6-253**). Basically, the group divides into two parts: chairs with true baluster turnings and chairs of composite roundwork. In other respects the two are similar and substantially influenced by Windsor design of the Rhode Island-Connecticut border region. That circumstance is not unexpected in view of the substantial migration from southern New England into the northern states. The ribbon crest, which has a central arch rising along the upper and lower surfaces and large, plain, precise scroll ends, seems to combine influences from various Rhode Island and Connecticut sources (figs. 6-23, 6-24, 6-130). The shield-shaped seats with their thick, crisply defined, canted edges, sometimes accompanied by a prominent ridge behind the pommel, recall other Rhode Island seating (figs. 6-22, 6-25). The turnings also appear linked with Windsors of similar origin. The umbrellalike spool-and-baluster caps of the left chair are close to those of figures 6-22 and 6-24, and there is a kinship with the spools and rings in the back posts of

figure 6-30. One ribbon-top example even has leg turnings close in profile to the left-hand chair in that illustration.

Turnings in the ribbon-top chairs of variant pattern bear a direct and unmistakable relationship to the work of northern coastal Connecticut (figs. 6-166, 6-167) where a double-swelled upper leg rests directly on the tapered foot. A groove suggesting bamboowork, which marks the top swell of some chairs, is characteristic of a later phase. Back-post balusters and bases are articulated in the same manner. The modification may be the work of an emigrant craftsman who combined previous experience with prevailing local design. One chair in this group was recovered in New Hampshire. The Windsor illustrated at the right was removed by a former owner from his maternal grandfather's home at Nutes Ridge, Strafford County, a location near Rochester on the New Hampshire-Maine border. A side chair of similar pattern served during the 1870s and 1880s as a prop in the White Mountains studio of artist Frank H. Shapleigh. All told, more than two dozen chairs are known to make up this general design group.[296]

Vermont

With one notable exception, there is little eighteenth-century Windsor-chair making to report for Vermont. This is due in large part to the prerevolutionary controversy over territorial title that raged between New Hampshire and New York, and which effectively curtailed settlement. The adoption of a constitution at Windsor in 1777 brought greater stability and paved the way for statehood in 1791. Jedidiah Morse described the region as having a "hilly, but not rocky" terrain that provided good pasturage for cattle. Tracts of rich land bordered the lakes and streams, and timber growth was heavy. John Melish reported that the Vermont population stood at 154,500 in 1800, or about 30,000 fewer inhabitants than New Hampshire. The state had no seacoast to stimulate the growth of a large commercial city. Instead, the principal manufactures were "of the domestic kind . . . for family use." The inhabitants were "mostly all agriculturists or mechanics . . . their wants being mostly supplied among themselves."[297]

Bennington, located in the state's southwestern corner near the New York and Massachusetts border, was a principal town in the 1790s. The Green Mountains effectively separated the community, indeed the western half of the state, from convenient communication with the eastern settlements along the Connecticut River. During a visit to Bennington in 1798, Timothy Dwight found that "the houses and their appendages exhibit[ed] abundant proofs of prosperity," although some public buildings did not measure up. Both in 1790 and 1800 the population stood between 2,000 and 2,500. Only two Windsor-chair makers of record, Ralph Pomeroy and Amasa Elwell, worked in Bennington before 1800. Pomeroy advertised in the summer of 1796 as a chairmaker and painter of houses and signs, but by 1802 he had already sought greener pastures in Troy, New York, a fast-growing community on the Hudson about thirty miles distant. Communication between southwestern Vermont and the rising city-towns along the upper Hudson appears to have been frequent. James Chestney, a leading Albany chairmaker, deemed the Bennington market sufficiently accessible in 1798 to venture a chair advertisement in the local *Vermont Gazette*. Amasa Elwell, the second chairmaker residing at Bennington in the late 1790s, made Windsor and dining chairs. He is listed in the 1800 census but within a decade had removed to Arlington, a town several miles north.[298]

On the opposite side of the Green Mountains modest activity is recorded at Westminster, a community located across the Connecticut River from Walpole, New Hampshire. David Wells advertised for a journeyman chairmaker, offering to "one who is acquainted with making windsor and dining chairs, constant employ, and good wages." His products consisted of sack-back and bow-back chairs. Although Westminster is a mere dot on the map today, in the late eighteenth century it was the scene of several conventions that focused attention on achieving a state government. More important to area commerce were the state legislative conventions held there between 1780 and 1803. In Guilford and Vernon (named Hinsdale until 1802), located farther

south, green Windsor chairs and "green dining ditto" are listed in household inventories dating to 1798. Perhaps some of this green-painted seating was obtained from Luther Ames, who advertised as a cabinetmaker and Windsor-chair maker at Guilford in March 1797.[299]

Upriver at Windsor, in 1789–90 Jacob Patrick exchanged "Turned wooden Buttons" and Windsor chairs for miscellaneous goods obtained from Isaac Greene's general store. Little more than a decade later Nathan Trask, a local physician, traded services with chairmaker William Rogers of nearby Hartland and acquired six dining chairs valued at 8s. apiece. Rogers was dead within ten years at age thirty-five, leaving in 1812 a widow and four minor children. In the house and shop on his 228-acre homestead farm were a dozen dining chairs, six kitchen chairs, and a chest of carpenter's and joiner's tools. As the county seat, Windsor was a good location for craftsmen. During a 1783 visit the Reverend William Bentley observed "many new buildings." Compared with other area towns he thought that here "the mechanic arts were more flourishing & employment more sure."[300]

The flat, productive farming country of Shoreham in western Addison County on Lake Champlain was the home of a cabinetmaker and chairmaker of notable skill during the 1790s and later. Samuel Hemenway (1755–1813) moved to Shoreham from Massachusetts in 1792 to join his father and older brother who had settled there earlier with their families. Samuel, a native of Shrewsbury, married Martha Salmon of Boston in 1779, and their first child was born there. These events suggest that Hemenway not only worked in the seacoast city but also received his training there. The couple resided in Grafton from 1781 until about 1786 and then returned to Shrewsbury, where they remained until their migration to northern New England. Family tradition asserts that soon after his arrival in Vermont Hemenway made furniture for his niece Polly Hemenway on the occasion of her marriage to Benjamin Miner, Jr., in 1793; the furnishings included a tripod table, bedsteads, chests of drawers, and Windsor chairs. The table and three Windsors—two fan-backs and a continuous-bow armchair—have descended in the family. Several distinctive features in the design of the chairs permit further identification of the craftsman's work, which is unmarked.[301]

A number of Hemenway's braced fan-back chairs (fig. **6-254**) are in private collections or have appeared in the antiques market from time to time. Wallace Nutting once owned such a Windsor. Several unusual characteristics identify the general pattern. The crest is shallow with a decided center peak and ruler-straight bottom edge. The shield-shaped seat droops in the extreme at the front corners and is hollowed under the pommel. Leg balusters are well rounded with close-fitting collars and flaring, necked bases spreading onto broad rings. One chair in the group has an inked inscription identifying its family origin as Monkton, a township about twenty-five miles north of Shoreham. A pair of related chairs, executed by another hand, entered the auction market in 1926, having come from the Catamount Tavern in Bennington via a collector.[302]

Two features of the fan-back chairs permit identification of another Hemenway pattern. The seat and undercarriage in a bow-back armchair (fig. **6-255**) are virtually identical to the same elements in the fan-back chairs; the under-arm turnings, which repeat those of the legs, duplicate the supports in the Hemenway family's continuous-bow chair. The present squarish bow with its almost flat, beaded face also forms a bond with the Hemenways' armchair and another of that pattern (fig. 6-256). The vigorously curved arms seem always to have butted against the bow, secured either with nails or wooden pins. The short, broad, coffin-type tail piece copies that of the side chairs. The seat is basswood, as in figure 6-256. At least one other chair of the pattern exists, and a related armchair illustrated by Nutting was once part of a New Hampshire collection. That chair has tenoned arms, certainly a more substantial construction than here.[303]

Hemenway produced his third distinctive Windsor in the continuous-bow pattern. The chair illustrated in figure **6-256** is one of two known; the second example is the Hemenway family's Windsor. Here again the features are unmistakable, yet the design

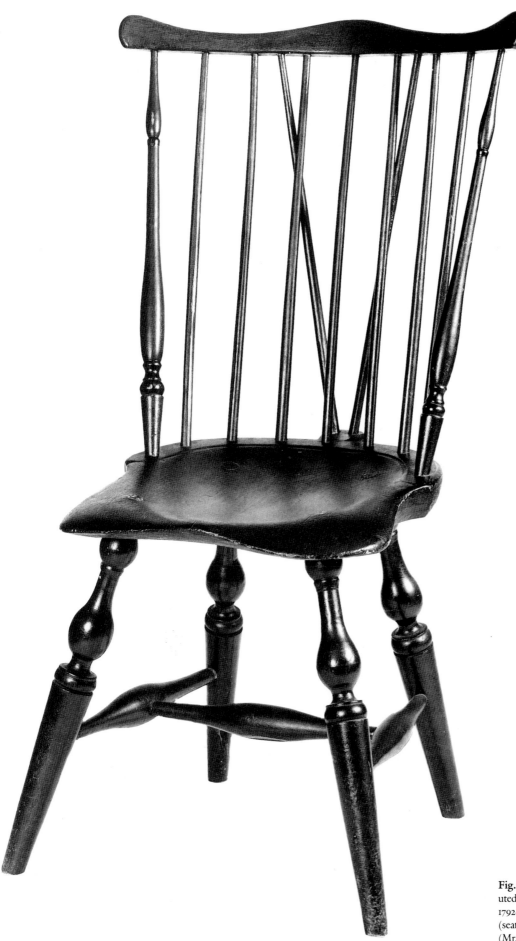

Fig. 6-254 Fan-back Windsor side chair, attributed to Samuel Hemenway, Shoreham, Vt., ca. 1792–1800. H. 37½″, (seat) 16⅝″, W. (crest) 22″, (seat) 16″, D. (seat, without extension) 16⅛″. (Mr. and Mrs. Oliver Wolcott Deming collection: Photo, Winterthur.)

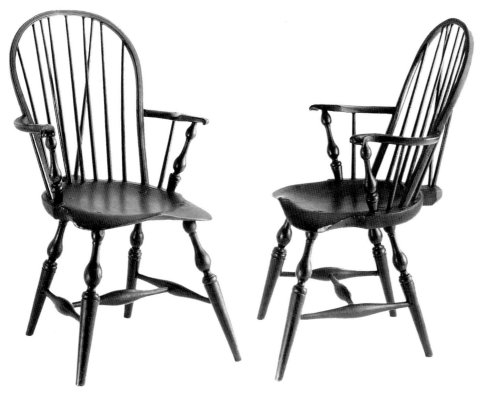

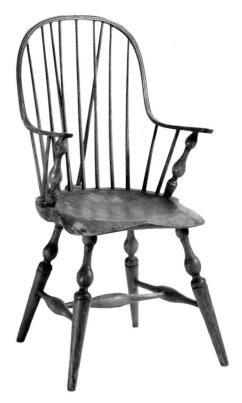

Fig. 6-255 Bow-back Windsor armchair (two views), attributed to Samuel Hemenway, Shoreham, Vt., ca. 1792–1800. Basswood (seat) with maple, oak, hickory, and black cherry (arm) (microanalysis); H. 36″, (seat) 16⅝″, W. (arms) 22⅝″, (seat) 17⅝″, D. (seat) 17⁵⁄₁₆″. (Winterthur 59.1632.)

Fig. 6-256 Continuous-bow Windsor armchair, attributed to Samuel Hemenway, Shoreham, Vt., ca. 1792–1800. Basswood (seat, microanalysis); H. 37¾″, (seat) 17″, W. (arms) 20⅛″, (seat) 17½″, D. (seat) 19⅞″. (Private collection: Photo, Winterthur.)

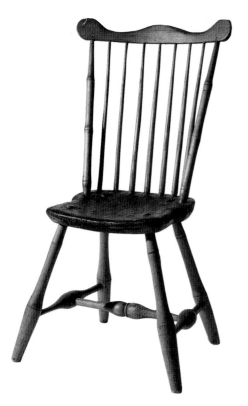

Fig. 6-257 Fan-back Windsor side chair, south-central Vermont, 1800–1810. Basswood (seat, microanalysis); H. 36¾″, (seat) 16⁹⁄₁₆″, W. (crest) 21″, (seat) 15″, D. (seat) 14⅜″. (Weston Community Club, Inc., Farrar-Mansur House, Weston, Vt.: Photo, Winterthur.)

exhibits its own distinct character. Comparison of the three illustrated chairs with those belonging to Hemenway's descendants reveals only minor differences in the profile of the balusters. Those illustrated are round and robust in body; the turnings of the family chairs are slimmer and more oval through the full parts.[304]

The stylistic sources of Hemenway's Windsor work seem clear. The craftsman probably received his first exposure to Windsor-chair making during the 1780s while a resident of Grafton and Shrewsbury, Massachusetts, towns lying just east of Worcester. The Rhode Island border is less than twenty miles away, only half the distance to Boston, and indeed, Rhode Island influence is strong in Hemenway's work. Most obvious is the similarity of the chairmaker's full-bodied balusters to area work dating to his last years in Massachusetts (figs. 6-81, 6-89, 6-90). One of these Rhode Island Windsors (fig. 6-81) continues the analogy in its stemlike spool turnings with spreading feet on broad, bulging rings; above the balusters the legs anchor in a seat with drooping front corners and a hollow pommel. The slim spool with spreading foot occurs again in a Rhode Island chair of continuous-bow design whose arm balusters have necked bases (fig. 6-88). The curves and general arm attachment of Hemenway's bow-back chair may spring from a knowledge of the tall fan-back armchairs of southeastern Massachusetts (figs. 6-228, 6-233–235); but more likely the influence came from formal design and construction practice common in armchairs of the late Chippendale and early federal periods.

A fan-back side chair owned in the early nineteenth century at Weston, a southern Vermont village bordering the Green Mountains in Windsor County, reveals the naïve quality of chairwork executed in an area off the beaten path of commerce and communication (fig. 6-257). Elements are exaggerated, from the full-blown crest and nodular posts to the bulging roundwork of the undercarriage. Reputedly, Deacon Parker

Shattuck brought the chair to Vermont from Temple, Hillsborough County, New Hampshire. It seems just as likely, however, that the chair was made in Vermont. The plank is basswood, a material common to the Connecticut Valley and other areas of the state. At Temple white pine was the more common construction material. That town is but a few miles from New Ipswich, where Wilder family members later worked and employed pine plank in their Windsor production (fig. 7-86). Wherever the craftsman located, however, he undoubtedly migrated from eastern Connecticut or Rhode Island. The chair legs are a stouter version of those in figure 6-123 and the medial stretcher a variation of those in figures 6-56 and 6-58; the slightly damaged crest interprets such examples as figures 6-168 and 6-169.

Maine

Maine, a territory of Massachusetts, joined the Union in 1820 as the twenty-third state. With 278 miles of seacoast, the area based its economy on commerce, as it had from the beginning of settlement. Portland was the chief coastal town. Timothy Dwight commented in 1797, "The site of the town is an easy, elegant, arched slope. The principal streets run parallel with the length of the peninsula. . . . The houses are new, and many of them make a good appearance." The duc de La Rochefoucauld Liancourt was pleasantly surprised during the mid 1790s to find "the inns so decent and well kept, in a part of the country so remote." Dwight described Portland's commercial assets and prospects:

The harbor is safe, capacious, and rarely frozen. It is sufficiently deep to admit ships of the line. The wharves of no great length reach to the channel. . . . Lumber, fish, and ships are the principal materials of their commerce. Several roads from the interior of New Hampshire and Vermont, partly made and partly in contemplation, are opening an extensive correspondence between Portland and these countries. . . . An extensive fertile country, which is already settled to a considerable extent and will soon be filled with inhabitants, will through these channels pour their produce into this town.[305]

Philadelphia influence, which pervaded most of coastal New England in the late eighteenth century, was not absent from coastal Maine. The schooner *Peggy* left Philadelphia on August 16, 1796, bound for the Penobscot district with a dozen Windsors shipped to a local resident. During the next decade other cargoes were discharged in Portland. One order, shipped by the Philadelphia merchant house of John Warder and Sons to Joseph McLellan and Son, contained 183 chairs. Another consignee received chair parts shipped in bundles to be framed. It is only to be expected that the Windsor market in imported and domestic chairs was centered in the vicinity of Portland, the future state's commercial center.[306]

A chair branded "S. DOLE" is thought to be the work of Samuel Dole (b. 1765) of Windham, a town northwest of Portland (fig. **6-258**). However, early nineteenth-century records indicate that a man of the same name worked as a cabinetmaker and chairmaker in Newburyport, Massachusetts. Indeed, the illustrated chair has definite Boston characteristics, although they could just as easily have been transmitted to the Portland area as to Newburyport, since the Maine coastal city is only 110 miles from the Massachusetts center. Characteristic of the Boston style are the centered groove in the bow, the cupped seat-front corners, and the slim diameter of the legs and stretchers.[307]

Assuming that the chair has some chance of being an early Maine product, a sketch of Dole's life is helpful. Samuel followed in the footsteps of his father, Richard, who was a carpenter, joiner, and chairmaker. The younger Dole married Mehetable Winship in 1787. Cumberland County deeds refer to him as a wheelwright in four separate transactions between 1794 and 1798, suggesting that he and his father actually were makers of riding chairs (light, two-wheeled, single-horse vehicles). Raising a further question about Dole's furniture-making career is a deposition he made in 1841 at age seventy-six at the request of the Cumberland Cotton Manufacturing Company of Gorham, in which he stated: "I worked at Gambo when the Winship Mills were standing. I did most all their work for them. Daniel Haskell & I built one Saw Mill and a Grist mill for the

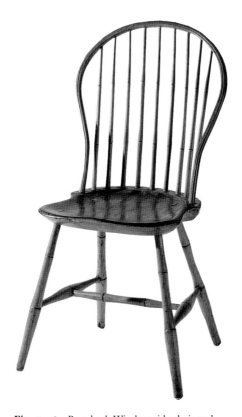

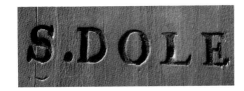

Fig. 6-258 Bow-back Windsor side chair and detail of brand, attributed to Samuel Dole, Windham, Me., or Newburyport, Mass., ca. 1801–10. H. 37⅜", (seat) 18⁵⁄₁₆", W. (seat) 17¼", D. (seat) 16⅝". (Maine State Museum, Augusta: Photo, Winterthur.)

Winships at Gambo." The time Dole referred to was during his early career in the late eighteenth century. The job of millwright for the Winships may have devolved to him through marriage into the family. In any event, there is considerable room to speculate on how much time Dole would have had at his disposal to practice chairmaking.[308]

Also tentative in terms of a Maine origin is a pair of seven-spindle, bow-back side chairs purchased in Portland. Both are branded on the seat bottom with the name "G. BISHOP," and one is further stamped "D. TOBEY." The Windsors relate to the Dole chair (fig. 6-258) in their bamboowork and single-groove bow face. The shield-shaped seats exhibit an advance over the Dole plank, substituting a groove around the front edge in place of the pommel.

Cumberland County deeds from between 1803 and 1815 identify Bishop as a house carpenter or housewright; by 1829 he was called a "trader." The same records refer to Daniel Tobey of Frankfort, Waldo County, as a trader in 1822. Since the chairs in question appear to date to between 1800 and 1810, Bishop probably was the maker or retailer and Tobey, an owner. As a trader Tobey likely possessed one or more brands to mark merchandise. If chairs purchased from Bishop for personal use were to have been sent any distance, Tobey likely elected to stamp his property. His ownership of marking equipment would not be unusual, as suggested by a Cumberland County court document of 1808. To settle a suit, goods in the possession of "trader-merchant" Jonathan Leeds were attached, including "1⅓ doz marking Irons." Other legal records identify an iron in the possession of a local innholder. The fact that George Bishop was a builder at the time the chairs were constructed lends credence to the theory that Portland wood-workers often wore two or more hats, a hypothesis that reinforces Samuel Dole's tentative role as a chairmaker.[309]

Notes

1. Oscar Theodore Barck, Jr., and Hugh Talmage Lefler, *Colonial America* (New York: Macmillan Co., 1958), pp. 249–66, 279, 294–317, 335–55, 362–78; William B. Weeden, *Economic and Social History of New England, 1620–1789,* vol. 2 (Boston: Houghton, Mifflin, 1891), pp. 679–93, 731–48, 757–62; Walter Freeman Crawford, "The Commerce of Rhode Island with the Southern Continental Colonies in the Eighteenth Century," *Rhode Island Historical Society Collections* 14, no. 4 (October 1921): 100.

2. Information on New England chair production and business methods appears in contemporary records, including the following: John II and Thomas Gaines, account book, 1712–62, Joseph Downs Collection of Manuscripts and Printed Ephemera, Winterthur Library (hereafter cited as DCM); Thomas Pratt, account book, 1730–68, DCM; Isaiah Tiffany, account book, 1746–67, Connecticut Historical Society, Hartford, Conn. (hereafter cited as CHS); William Barker, account books, 5 vols., 1750–97, Rhode Island Historical Society, Providence, R.I. (hereafter cited as RIHS); Elijah Pember, account book, 1756–1811, DCM; Robert Crage, ledger, 1757–81, Old Sturbridge Village, Sturbridge, Mass. (hereafter cited as OSV).

3. Stanley F. Chyet, *Lopez of Newport: Colonial American Merchant Prince* (Detroit: Wayne State University Press, 1970), pp. 66, 98–99.

4. Aaron Lopez, outward bound invoice book, 1763–68, and letter book, 1767, Newport Historical Society, Newport, R.I. (hereafter cited as NHS).

5. George Champlin Mason, *Annals of the Redwood Library and Athenaeum, Newport, Rhode Island* (Newport, R.I.: Redwood Library, 1891); "Record Book of the Proceedings of the Annual and Special Meetings of the Redwood Library Company," 1747–, Redwood Library, Newport, R.I.

6. William B. Stevens, "Samuel King of Newport," *Antiques* 96, no. 5 (November 1969): 729–30; Franklin Bowditch Dexter, ed., *The Literary Diary of Ezra Stiles,* vol. 1 (New York: Charles Scribner's Sons, 1901), pp. 131–32.

7. Albert Cook Myers, *Quaker Arrivals at Philadelphia, 1682–1750* (Baltimore: Southern Book Co., 1957), p. 112. Documentation on William Redwood's apprenticeship with Reynell occurs in Samuel Coates, receipt book, 1740–56, Gratz Collection, Historical Society of Pennsylvania, Philadelphia, Pa. (hereafter cited as HSP), in entries dating 1744–47.

8. The blockfront furniture link between Boston and Newport is noted in Nancy Goyne Evans, "The Genealogy of a Bookcase Desk," in *Winterthur Portfolio 9,* ed. Ian M. G. Quimby (Charlottesville: University Press of Virginia, 1974), p. 215, and Margaretta Markle Lovell, "Boston Blockfront Furniture," in *Boston Furniture of the Eighteenth Century* (Boston: Colonial Society of Massachusetts, 1974), pp. 118, 120.

9. Crawford, "Commerce of Rhode Island," p. 106; John Coddington and Miller Frost, estate records, 1768 and 1769, Town Council Book, 1768–71, Newport, R.I., NHS; Col. Joseph Wanton, Jr., William Wanton, Nicholas Lechmere, and Capt. Linn Martin, confiscated Loyalist estates, 1779, Rhode Island State Archives, Providence, R.I.

(hereafter cited as RISA) (photocopy, DCM); William Tweedy, estate records, 1782, Newport, R.I., Registry of Probate (microfilm, DCM). In Providence, the Windsors in Oliver Arnold's 1771 household included both high and low backs (Esther Singleton, *The Furniture of Our Forefathers* [Garden City, N.Y.: Doubleday, Page, 1913], p. 344).

10. Jonathan Cahoone bill to Aaron Lopez, April 27, 1773, NHS. The Cahoone marriage is recorded in James N. Arnold, ed., *Vital Records of Rhode Island, 1636–1850,* vol. 4 (Providence, R.I.: Narragansett Historical Publishing Co., 1893), p. 14. Jonathan Cahoone, "Petition for Losses Sustained during British Occupation of Newport," n.d., RISA (photocopy, DCM).

11. Timothy Waterhouse bill to Abraham Redwood, 1746, Wetmore Papers, vol. 1, Massachusetts Historical Society, Boston (hereafter cited as MHS); George H. Richardson, "Craftsmen in Newport, and Other Information about the Towns Inhabitants," n.d., NHS (photocopy, RIHS). "Timothy Waterhouses Acco't for Chairs" is listed in William Greene, account with Christopher Champlin for brig *Betsey,* 1786, Wetmore Papers, vol. 14. The Society of Friends record is quoted in Joseph K. Ott, "Still More Notes on Rhode Island Cabinetmakers and Allied Craftsmen," *Rhode Island History* 28, no. 4 (November 1969): 119.

12. Vickary marriage recorded in Arnold, *Vital Records,* 4:73; Joseph Vickary bill to Ignatious Bertar, June 21, 1758, Cabinetmakers Signatures, NHS; Joseph Vickary bill to Christopher Champlin, and sloop *Adventure,* cargo list, 1773, Shepley Papers, vol. 3, RIHS; Barker account books, vols. 1–3.

13. An English cane-seat chair is illustrated in Robert F. Trent, *Hearts and Crowns: Folk Chairs of the Connecticut Coast, 1710–1840, as Viewed in the Light of Henri Focillon's Introduction to "Art populaire"* (New Haven, Conn.: New Haven Colony Historical Society, 1977), fig. 1.

14. *Acts and Resolves of the Colony of Rhode Island,* vol. 7 (Newport, R.I.: Solomon Southwick, 1774), p. 127 (reference brought to author's attention by Richard L. Champlin).

15. The banister-back chair with bullet-type stretchers is illustrated in Trent, *Hearts and Crowns,* fig. 26. The roundabout chair is illustrated in Joseph Downs, *American Furniture: Queen Anne and Chippendale Periods* (New York: Macmillan Co., 1952), fig. 63.

16. Josiah Hewes, bill of lading for goods shipped on sloop *Retrieve,* June 27, 1771, Wetmore Papers, vol. 6.

17. Although Newport merchant Aaron Lopez traded with Bristol, England, during the early 1760s, English influence in the early Rhode Island Windsor appears oriented more to Thames Valley work than to that of the southwest. See Bernard D. Cotton, *The English Regional Chair* (Woodbridge, England: Antique Collectors' Club, 1990), chaps. 2, 5. Several tall chairs of this pattern with New Hampshire histories may have been imported into Portsmouth.

18. Myrna Kaye, "Marked Portsmouth Furniture," *Antiques* 113, no. 5 (May 1978), pp. 1101, 1103. New London County chairwork is illustrated and discussed in Robert F. Trent and Nancy Lee Nelson, "Legacy of a Provincial Elite: New London County Joined Chairs 1720–1790," *Connecticut Historical Society Bulletin* 50, no. 4 (Fall 1985):

145–53. An alternative high-back design, sometimes constructed with seven instead of six long spindles, modifies two Rhode Island features; seat corners flare noticeably, and a long leg baluster rests directly on the foot. Two of these chairs are at Strawbery Banke, Inc., Portsmouth, New Hampshire. A low-back Windsor illustrated in a Herbert F. Schiffer advertisement in *Antiques* 90, no. 1 (July 1966): 27, lower left, has baluster-and-taper legs that relate to fig. 6-8 and arm posts with a design similar to fig. 6-11.

19. An English-inspired Windsor made in the Norwich, Connecticut, area may have been in production earlier than the late 1770s (see fig. 6-97). James A. Henretta, "Economic Development and Social Structure in Colonial Boston," *William and Mary Quarterly,* 3d ser., vol. 22, no. 1 (January 1969): 89.

20. Ebenezer Stone, advertisement in *Independent Chronicle* (Boston), April 13, 1786, as quoted in Irving Whitall Lyon, *Colonial Furniture of New England* (1891; new ed., Boston: Houghton Mifflin Co., 1924), p. 179; see also p. 178. Alice Morse Earle, *Customs and Fashions in Old New England* (New York: Charles Scribner's Sons, 1893), p. 111.

21. Manifests of sloop *Deborah* and schooner *Jane,* September 13, 1763, and December 27, 1764, shipping returns for Massachusetts, 1752–65, Colonial Office, Public Record Office, London (hereafter cited as PRO); Daniel Malcolm and Samuel Parker, estate records, 1769 and 1773, Suffolk Co., Mass., Registry of Probate (microfilm, DCM).

22. Daniel Rea II, daybook, 1772–1800, Baker Library, Harvard University, Cambridge, Mass.; Winthrop Sargent, ed. and comp., "Letters of John Andrews, Esq., of Boston," in *Proceedings of the Massachusetts Historical Society,* vol. 8 (Boston: For the society, 1866), p. 318; John Andrews to William Barrell, June 22, 1772, and Barrell to Andrews, June 12, 1772, Andrews-Eliot Papers, MHS; William Barrell, memorandum and account book, 1772–76, and daybook, 1772, Stephen Collins Papers, Library of Congress, Washington, D.C. (hereafter cited as LC).

23. Andrews to Barrell, February 26, March 16, June 4, and September 2, 1773, Andrews-Eliot Papers.

24. Jules David Prown, *John Singleton Copley* (Washington, D.C.: National Gallery of Art, 1965), p. 74; Cary and Winslow portraits, pp. 73, 78. Tyng background is given in Barbara Neville Parker and Anne Bolling Wheeler, *John Singleton Copley: American Portraits* (Boston: Museum of Fine Arts, 1938), p. 190. Benjamin Coats and Andrew Oliver, estate records, 1774, are transcribed in Alice Hanson Jones, *American Colonial Wealth,* vol. 2 (New York: Arno Press, 1977), pp. 907, 966–67. Jonathan L. Fairbanks and Wendy A. Cooper, *Paul Revere's Boston: 1735–1818* (Boston: Museum of Fine Arts, 1975), p. 111; "Account of Sund'y Articles left at Ashford March ye 1st 1775," probably MHS (photocopy, DCM).

25. George Minot, account book, 1732–84, DCM; Richard Lechmere, confiscated Loyalist estate, 1776, State Library of Massachusetts, Boston (hereafter cited as SLM) (photocopy, DCM).

26. Harriette M. Forbes, "The Salisbury Mansion, Worcester, Mass." *Old-Time New England* 20, no. 2 (January 1930): 99–110, and "Some Salisbury Family Portraits," *Old-Time New England* 21, no. 1 (July 1930): 3–18; Samuel Barrett to Samuel Salis-

bury, April 1, 1779, Salisbury Papers, American Antiquarian Society, Worcester, Mass. (hereafter cited as AAS).

27. John Beard, Jireh Bull, and Christopher Kilby, estate records, 1774, as transcribed in Jones, *American Colonial Wealth,* 2:501–2, 519, 561–63. The york chairs are illustrated in Trent, *Hearts and Crowns,* figs. 38, 39. In a study of Wethersfield, Conn., probate inventories, Kevin M. Sweeney, in "Furniture and the Domestic Environment in Wethersfield, Connecticut, 1639–1800," *Connecticut Antiquarian* 36, no. 2 (December 1984): 10–39, found that no Windsor chairs were listed in local estates before the 1780s and that they were common only in the 1790s. Edward S. Cooke, Jr., in *Fiddlebacks and Crooked-backs: Elijah Booth and Other Joiners in Newtown and Woodbury, 1750–1820* (Waterbury, Conn.: Mattatuck Historical Society, 1982), pp. 21, 24, 94–95, also failed to find Windsor seating listed in pre-1791 Newtown probate records or in Woodbury records before 1800.

28. The Barrell chair reference is in Brock Jobe, ed., *Portsmouth Furniture: Masterworks from the New Hampshire Seacoast* (Boston: Society for the Preservation of New England Antiquities, 1993), pp. 385-86. Barrell's high-back chairs could have been patterned after English, Rhode Island, or Philadelphia prototypes. Fellow merchant Samuel Moffatt's cherrywood Windsors were undoubtedly of English origin, and several Rhode Island-made or Rhode Island-style tall Windsors have long Portsmouth histories. By 1771 William Barrell pursued his mercantile career at Philadelphia, suggesting a long-standing association with business interests in that city and his prior knowledge of the Philadelphia Windsor. Samuel Moffatt, estate records, 1768, Court Files, New Hampshire Archives, Concord, N.H.; Jane C. Giffen, "The Moffatt-Ladd House at Portsmouth, New Hampshire," *Connoisseur* 175, pt. 1, no. 704 (October 1970): 113–22; pt. 2, no. 705 (November 1970): 201–3; Thomas Chippendale, *The Gentleman and Cabinet-Maker's Director* (1762; reprint of 3d ed., New York: Dover Publications, 1966), pls. 19–23; William Ince and John Mayhew, *The Universal System of Household Furniture* (1759–62; reprint, Chicago: Quadrangle Books, 1960), pls. lviii, lix.

29. Capt. Samuel Warner, Rev. Arthur Browne, and James Stoodley, estate records, 1771, 1773, and 1780, are quoted in Jane C. Giffen, "A Selection of New Hampshire Inventories," *Historical New Hampshire* 24, no. 1 (Spring 1969): 48–52; no. 2 (Summer 1969): 62–69. James Dwyer, estate records, 1777, Rockingham Co., N.H., Registry of Probate (reference courtesy of Elizabeth Rhoades Aykroyd).

30. Weeden, *Economic and Social History,* 2:821–33.

31. Weeden, *Economic and Social History,* 2:845–57.

32. J. P. Brissot de Warville, *New Travels in the United States of America* (Dublin: P. Byrne et al., 1792), pp. 144–45, 148; Jedidiah Morse, *The American Geography* (Elizabethtown, N.J.: Shepard Kollock, 1789), pp. 201, 203; Olney Winsor to his wife, October 17 and November 28, 1786, Letters of Olney Winsor, 1786-88, State Library of Virginia, Richmond, Va.

33. Duc de La Rochefoucauld Liancourt, *Travels through the United States of North America,* vol. 1 (London: R. Phillips, 1799), pp. 504–5; Clarkson

A. Collins III, ed., "Pictures of Providence in the Past, 1790–1820: The Reminiscences of Walter R. Danforth," *Rhode Island History* 10, no. 1 (January 1951): 10–11; Timothy Dwight, *Travels in New England and New York,* ed. Barbara Miller Solomon, vol. 2 (Cambridge, Mass.: Belknap Press, 1969), p. 20.

34. The chair with the caplike element is illustrated in a David and Marjorie Schorsch, Inc., advertisement in *Maine Antique Digest* (Waldoboro), October 1982. A Newport fan-back armchair is illustrated in Wallace Nutting, *A Windsor Handbook* (1917; reprint, Framingham and Boston: Old America Co., n.d.), p. 62. Crown chairs are illustrated in Trent, *Hearts and Crowns,* figs. 12–18.

35. At least one chair, in the former collection of J. Stogdell Stokes, Philadelphia, has arm supports curved in the manner of those in the Oliver Goldsmith chair (fig. 1-21), although the bend is less extreme. One high-back chair in the dealer market has features relating to those of the S-post, sackback chairs. A low-back Windsor in the dealer market with a three-part sawed rail and reversed S-curved posts forms a transitional link with prewar work via its composite leg turnings. Two rare children's high chairs at Winterthur introduce another furniture form (nos. 51.77.2, 68.534). Both are similar above the seat. Below the seat one exhibits the described early postwar leg turnings; the second moves toward later Rhode Island design in its turned understructure.

36. Liancourt, *Travels,* as quoted in Wendy A. Cooper, "The Purchase of Furniture and Furnishings by John Brown, Providence Merchant, Part I: 1760–1788," *Antiques* 103, no. 2 (February 1973): 331. The Winterthur highchair is illustrated in a Wickford Hill Antique Shop advertisement in *Antiques* 14, no. 4 (October 1928): 369.

37. The Newport order and bill are recorded in Rhode Island Colony Records, vol. 12, p. 517, and Accounts Allowed by the General Assembly, box 12, RISA (reference courtesy of Keith Morgan). The Washington Co. order and purchase is recorded in *Narragansett Historical Register* 2 (1883/84): 314 (reference courtesy of Richard Champlin). Chair transportation is documented in the Beriah Brown Papers, RIHS, as quoted in Ott, "Still More Notes," p. 119.

38. At least two of the sack-back Windsors illustrated in the Jury Room still remain at Old Colony House, Newport, along with the prewar low-back chair.

39. Joseph Ott, "Recent Discoveries among Rhode Island Cabinetmakers and Their Work," *Rhode Island History* 28, no. 1 (February 1969): 4–9, 25.

40. The chair is one of a pair owned in Norwalk, Conn., at the beginning of this century, although in 1893 it had been exhibited in the Massachusetts Building at the Chicago World's Columbian Exposition, according to an old printed label on the seat bottom. Three identical chairs in a private collection indicate the distance that some furniture traveled from its place of origin. One was found in eastern Massachusetts, and two came from the home of a family long settled in South Hadley on the Connecticut River.

41. The fan-style armchair is illustrated in Nutting, *Handbook,* p. 62. Two Connecticut portraits also document the fan-back chairs to the 1780s.

Sarah Perkins painted Hezekiah Beardsley and his wife seated on green Windsor chairs with similar crests sometime between 1784, when they established their New Haven, Conn., residence, and their early deaths in 1790 (see fig. 6-179). The peaked-crest design spawned many variant interpretations from southern Massachusetts to southern Connecticut (see fig. 6-177). See Christine Skeeles Schloss, *The Beardsley Limner and Some Contemporaries* (Williamsburg, Va.: Colonial Williamsburg Foundation, 1972), frontispiece, pp. 19–21, 23; Colleen Heslip and Helen Kellogg, "The Beardsley Limner Identified as Sarah Perkins," *Antiques* 26, no. 3 (September 1984): 548.

42. Trent, in *Hearts and Crowns,* illustrates general prototypes of turnings, such as bottle-shaped balusters (figs. 23, 27), baluster caps (fig. 26), and double-baluster stretchers (figs. 63, 65–68, 72–74).

43. In form and size the crest scrolls of this chair relate to contemporary southeastern Massachusetts works (figs. 6-227, 6-228, 6-230). A similar child's Windsor in a private collection retains all the basic features of fig. 6-23: arched crest (the tips broken), flat arms, long lathelike arm supports, broad shield seat, and bottle-shaped turnings.

44. The bow-back side chair is the property of the Congregational Church of Thompson, Conn., a town near the Rhode Island border. A metal plate fixed to the back carries an inscription, "This chair was the property of/Rev. Noadiah Russel/Pastor of/Thompson Congregational Church/1757–1795/Presented by/Miss Ellen Larned/1912." A small, red-bordered, gummed label fixed to the fan-back seat bottom, probably early in this century, bears an owner's name, "Isaac Steere," printed in black ink. Assuming some family continuity in the descent of the chair, the 1850 census for Connecticut and Rhode Island confirms the provenance. The Connecticut volume lists two household heads with this surname. The Rhode Island index contains seventy-three; all but one were Providence Co. residents, and most lived in townships north and west of the seaport.

45. Barry A. Greenlaw, *New England Furniture at Williamsburg* (Williamsburg, Va.: Colonial Williamsburg Foundation, 1974), fig. 154. There are several chairs in this tall pattern, including one at the John Quincy Adams birthplace in Quincy, Mass. See H. Hobart Holly, "The Birthplaces of John and John Quincy Adams, Quincy, Massachusetts," *Antiques* 16, no. 6 (December 1979): 1348, pl. ix.

46. Tipped-stretcher banister- and vase-back chairs are illustrated in Trent, *Hearts and Crowns,* figs. 13–15, 34–36, 62, 65–66.

47. The Ebenezer Tracy settee is illustrated in Nancy Goyne Evans, "A Connecticut Settee at Winterthur," *Antiques and the Arts Weekly* (Newtown, Conn.), June 19, 1981.

48. Wallace Nutting, *Furniture Treasury* (1928; reprint, New York: Macmillan Co., 1966), figs. 2076, 2077. The complete chair of fig. 6-46 is illustrated in fig. 6-134. A rush-bottomed, vase-back chair with related arms is illustrated in Trent, *Hearts and Crowns,* fig. 63.

49. Index of Vital Records, and Joseph Stone, property records, 1790–98, East Greenwich, R.I., Office of the Town Clerk. Information on Stone's work for William Arnold and Christopher Spencer appears in Ott, "Recent Discoveries," p. 23; Joseph Stone, accounts of William Arnold, 1790–95, and

anonymous account book, 1796–1809, with account of Lydia Greene, in A.C. and R.W. Greene Collection, RIHS. The chair with "hands" is illustrated in a David A. Schorsch advertisement, *Antiques* 24, no. 4 (October 1983): 622.

50. A related high-back chair is in the Concord Antiquarian Society, Concord, Mass., and is said to have belonged to the Reverend Ezra Ripley of Concord. The chair is illustrated in Carol L. Haines and Lisa H. Foote, *"Forms to Set on": A Social History of Concord Seating Furniture* (Concord, Mass.: Concord Antiquarian Museum, n.d.), p. 25, and Singleton, *Furniture of Our Forefathers*, facing p. 370. Related chairs have turned up in southern Worcester Co., Mass., and as far west as Greenfield. Boston and southern Massachusetts work is discussed later in this chapter; see especially figs. 6-204 and 6-226.

51. The fan-back chair with a rounded, shield-type plank was in the dealer market. A photograph of the high-back chair with vase turnings is in Visual Resources Collection, Winterthur Library (hereafter cited as VRC); the profile duplicates that of a diminutive vase found in the posts of a side chair from southeastern Massachusetts (fig. 6-231).

52. The illustrated chair, which was found in New Hampshire, is branded *Jon' Young*, a common name throughout New England and one that could indicate owner or maker. Several chairs in the group have been found in Maine and New Hampshire. Their original or later owners could have migrated north and taken along their household possessions. Another chair that circulated in the dealer market several years ago is branded *R Hart*, now identified as a Portsmouth, N.H., owner.

53. One balloon-back armchair was in the dealer market, and the other is illustrated in *The Collection of the Late Philip Flayderman*, January 4, 1930 (New York: American Art Association Anderson Galleries, 1930), no. 284, left.

54. Earlier necked-baluster prototypes are illustrated in John T. Kirk, *Connecticut Furniture, Seventeenth and Eighteenth Centuries* (Hartford, Conn.: Wadsworth Atheneum, 1967), fig. 136, and an advertisement of Stallfort Antiques in *Maine Antique Digest*, June 1986. A stretcher prototype is illustrated in *George Dudley Seymour's Furniture Collection in the Connecticut Historical Society* (Hartford, Conn.: Connecticut Historical Society, 1958), p. 106.

55. Of the eight sack-back chairs related to fig. 6-63, three are in private collections, one is in the former collection of J. Stogdell Stokes, Philadelphia, and four are illustrated in advertisements in *Antiques and the Arts Weekly*, September 16, 1979, and in *Antiques* 136, no. 4 (October 1989): 705.

56. William G. McLoughlin, *Rhode Island* (New York: W. W. Norton, 1978), pp. 108–11.

57. Joseph K. Ott, "Exports of Furniture, Chaises, and Other Wooden Forms from Providence and Newport, 1783–1795," *Antiques* 107, no. 1 (January 1975): 135–41.

58. Daniel Lawrence, advertisement in *United States Chronicle* (Providence, R.I.), July 19, 1787, as quoted in Lyon, *Colonial Furniture of New England*, pp. 180–81; James Bertine bill to Dean Sweet, May 8, 1792, and William Arnold, inventory of personal estate, November 18, 1817, Greene Collection.

59. Hews's advertisement is illustrated in fig. 6-178. The low-back chair with the seat holes, which was in the dealer market, is illustrated in *Important American Furniture*, October 23, 1982 (New York: Sotheby's, 1982), no. 133.

60. The other Earl portrait is of Mrs. Thomas Smart, as illustrated in Frank H. Goodyear, Jr., *American Paintings in the Rhode Island Historical Society* (Providence, R.I.: Rhode Island Historical Society, 1974), fig. 16. The portrait seems to date to the mid 1790s, rather than ca. 1780–84, as assigned by the Rhode Island Historical Society, based upon the sitter's costume and the chair's similarity to that in the Packard portrait. Information on James Earl is found in *The American Earls* (Storrs, Conn.: William Benton Museum of Art, University of Connecticut, 1972), pp. 32–35.

61. Job Danforth, Sr., ledger, 1788–1818, RIHS; Rufus Dyer, account book, 1792–1802, RIHS; Proud family, ledger, 1772–1825, RIHS; William Mitchell Pillsbury, "The Providence Furniture Making Trade, 1772–1834" (Master's thesis, University of Delaware, 1974), pp. 48–49, 54, appendix B, tables II, IV.

62. "Records of the Providence Association of Mechanics and Manufacturers," vol. 1, 1789–94, RIHS.

63. Crawford, "Commerce of Rhode Island," 107; Ott, "Exports of Furniture," pp. 135–41; manifests of sloops *Lively* and *Peggy*, April 20, 1792, and April 11, 1793, New York outward entries, U.S. Customhouse Records, French Spoliation Claims, National Archives, Washington, D.C. (hereafter cited as NA).

64. Proud family ledger.

65. A rare example of a fan-back Windsor with this leg is illustrated in Nutting, *Handbook*, p. 150.

66. The Ash chair and label are illustrated in an advertisement of Mabel K. Rogers, *Antiques* 16, no. 2 (August 1929): 147. Family history for the Scott chairs was supplied by Museum of Fine Arts, Boston. See also advertisement in *Antiques and the Arts Weekly*, October 1, 1976. By the nineteenth century the chairs were in the hands of Scott's granddaughter Calista, who married Cashel F. Cory in 1835. The name "C Cory" inscribed in chalk is found on the seat bottoms of several side chairs, along with the tiny brand *H BACON* in one-eighth-inch letters. Although the chair is dated around 1790, the stamp is atypical of that period. The name is probably that of a later restorer, and several H. Bacons are listed in Providence directories between 1847 and 1873. The chairs were sold at auction by a great-grandson of the Corys.

67. While the bow-back chairs with the short, swelled-taper foot are sufficiently alike in form to suggest a common local origin, their histories vary. One chair is associated with a Connecticut family, although the background is indefinite. The set is penciled with the name "A S Garland." Census records list this surname in northern Massachusetts and New Hampshire beginning in 1810, and the chairs are associated with the New Hampshire town of Wakefield on the Maine border. The only listing for a man whose first initials fit the inscription occurs in 1840 in Rye, Rockingham Co., which is near Portsmouth and the Piscataqua River and on a direct route to Wakefield, a likely destination for a migrating family. The plank bottom of another chair is branded *I. DOW*. A Joseph Dow,

possibly the owner, lived in Scituate, Providence Co., Rhode Island, in 1820. The surname also occurs in Massachusetts. Turnings derived from this pattern lingered through the first decade of the nineteenth century in a few square-back Windsors.

68. Examples of chairs in this vase-spindle group are in the Rhode Island Historical Society and the Museum of Art, Rhode Island School of Design, Providence, R.I. Information on Dorr comes from Howard Corning, "Sullivan Dorr, China Trader," *Rhode Island History* 3, no. 3 (July 1944): 76–77, 90; Vincent P. Carosso and Lawrence H. Leder, eds., "The Samuel Snow-Sullivan Dorr Correspondence," *Rhode Island History* 15, no. 3 (July 1956): 67–68; and Antoinette F. Downing, "New Light on the Sullivan Dorr House," *Rhode Island History* 16, no. 2 (April 1957): 33–34.

69. Most bow-back chairs that are similar to fig. 6-75 are in private collections. One chair with a balloon-shaped bow and arms is illustrated in an Elizabeth R. Daniel advertisement in *Antiques* 118, no. 6 (December 1980): 1149.

70. The fan-back chair with related post turnings is illustrated in *English and American Furniture of Douglas Curry*, October 29, 1947 (New York: Parke-Bernet Galleries, 1947), no. 160.

71. *Windsor Chairs and Pennsylvania German Painted Chests* (Philadelphia: Pennsylvania Museum, 1925), no. 27b.

72. The tall sack-back chair was once in the collection of J. Stogdell Stokes (Nutting, *Treasury*, fig. 2667).

73. One continuous-bow armchair appears in a David Schorsch, Inc., advertisement in *Maine Antique Digest*, March 1981.

74. Other chairs with gouge-carved bows are in the Shelburne Museum, Shelburne, Vt., and the Henry Ford Museum, Dearborn, Mich.

75. National Council of Girl Scouts, *Loan Exhibition of Eighteenth and Early Nineteenth Century Furniture and Glass* (New York: National Council of Girl Scouts, 1929), fig. 530.

76. Town of Westerly Records, Town Meetings, Births, Marriages, and Ear Marks, vol. 4, 1779–1819, pp. 143, 372, 464; Probate Proceedings, vol. 5, pp. 102, 105; Land Evidence Book, vol. 12, 1795–1802, p. 30.

77. Dwight, *Travels*, 1:245; Thomas Anburey, *Travels through the Interior Parts of America*, 2 vols. (Boston: Houghton Mifflin Co., 1923), vol. 2, p. 152; Brissot de Warville, *New Travels*, p. 133; Henry Wansey, *An Excursion to the United States of America in the Summer of 1794* (1796; 2d ed., Salisbury, England: J. Easton, 1798), p. 55.

78. Albert E. Van Dusen, *Connecticut* (New York: Random House, 1961), pp. 113–14, 116, 175, 315–16; Morse, *American Geography*, p. 33.

79. Van Dusen, *Connecticut*, pp. 177–78, 187, 191–200; Brissot de Warville, *New Travels*, p. 135; Liancourt, *Travels*, 1:535.

80. David Burbank, notice in *Connecticut Journal and New Haven Post-Boy* (New Haven, Conn.), June 18, 1773; Abishai Bushnell, advertisement in *Norwich Packet* (Norwich, Conn.), May 19, 1774 (references courtesy of Wendell Hilt); Felix Huntington, account of Col. Joshua Huntington, 1775–84, DCM.

81. Nancy Goyne Evans, "The Tracy Chairmakers Identified," *Connecticut Antiquarian* 33, no. 2 (December 1981): 14–21; Evert E. Tracy, *An-*

cestors and Descendants of Lieutenant Thomas Tracy of Norwich, Conn., 1660 (Albany, N. Y.: Joel Munsell's Sons, 1898), nos. 68, 251, 534–35, 549.

82. Ada R. Chase, "Ebenezer Tracy, Connecticut Chairmaker," *Antiques* 30, no. 6 (December 1936): 266; index, Connecticut Church Records, Genealogical Section, Connecticut State Library, Hartford, Conn. (hereafter cited as CSL); Henry F. Bishop, *Historical Sketch of Lisbon, Conn.* (New York: By the author, [1903]), pp. 31–32.

83. Lisbon Town Accounts, Ledger A, 1786–1827, Manuscript Section, CSL; Charles J. Hoadly, comp., *The Public Records of the State of Connecticut* (Hartford, Conn.: Case, Lockwood, and Brainerd Co., 1895), vol. 2, p. 142; Leonard Woods Labaree, comp., *Public Records* (Hartford: State of Connecticut, 1943), vol. 5, p. 132. Tracy is not listed in *Rolls and Lists of Connecticut Men in the Revolution,* Collections of the Connecticut Historical Society, vol. 8 (Hartford, Conn.: By the society, 1901). For the Tracy barn fire, see *Norwich Packet* (Norwich, Conn.), September 2, 1784 (reference courtesy of Mrs. Burton Gates). Amos Denison Allen, apprenticeship indenture, February 5, 1790, CHS; Tracy, *Descendants of Lt. Thomas Tracy,* no. 251.

84. Leonard Woods Labaree and Catharine Fennelly, comps., *The Public Records of the State of Connecticut* (Hartford, Conn.: State of Connecticut, 1951), vol. 8, p. 379.

85. Allen, apprenticeship indenture; Amos Denison Allen, leases, May 19, 1796, and April 1, 1797, CHS; Albert E. Van Dusen, comp., *The Public Records of the State of Connecticut* (Hartford, Conn.: State of Connecticut, 1953), vol. 9, p. 75; William L. Weaver, *History of Ancient Windham, Connecticut* (Willimantic, Conn.: Weaver and Curtiss, 1864), p. 32; Elijah Babcock, account book, 1785–1822, CSL; Amos Denison Allen, memorandum book, 1796–1803, CHS; Devotion accounts, as quoted in Minor Myers, Jr., and Edgar de N. Mayhew, *New London County Furniture, 1640–1840* (New London, Conn.: Lyman Allyn Museum, 1974), p. 127.

86. Myers and Mayhew, *New London County Furniture,* pp. 107, 127–28; Chase, "Ebenezer Tracy," pp. 266–69; Ada Chase, "Amos D. Allen, Connecticut Cabinetmaker," *Antiques* 70, no. 2 (August 1956): 146–47.

87. Lisbon Town Accounts; Ebenezer Tracy, Sr., estate records, 1803, Lisbon, Conn., Genealogical Section, CSL; John Avery, Jr., account book, 1780–1814, CHS.

88. Stephen Tracy, advertisement in *Norwich Courier* (Norwich, Conn.), July 6, 1803, as reproduced in Myers and Mayhew, *New London County Furniture,* inside front cover.

89. Ebenezer Tracy, Sr., estate records.

90. Ebenezer Tracy, Sr., estate records; Stephen Tracy, property records, 1805, and Annavery Tracy, estate records, 1807, both in Lisbon, Conn., Genealogical Section, CSL.

91. Index, Connecticut Church Records; *Norwich Courier,* February 1, 1807; Stephen Tracy, property records, 1807, Plainfield, N. H. (recorded at Lisbon, Conn.), and 1810, Lisbon, Conn., Genealogical Section, CSL; Tracy, *Descendants of Lt. Thomas Tracy,* no. 549.

92. Ebenezer Tracy, Sr., estate records; Elijah Tracy, estate records, 1811, and Ebenezer Tracy, Jr.,

property records, 1811, both in Lisbon, Conn., Genealogical Section, CSL; records of the 1820 Census of Manufactures, State of Connecticut, NA (microfilm, DCM); Ebenezer Tracy, Jr., estate records, 1822, Lisbon, Conn., Genealogical Section, CSL.

93. Ebenezer Tracy, Sr., estate records.

94. Andrew Huntington, Ledger C, 1780–94, Leffingwell Inn, Norwich, Conn. (hereafter cited as LI); Nathaniel Shipman, Jr., Ledger A, 1785–1812, LI; Joseph Williams, invoice of brig *Polly,* March 31, 1789, Joseph Williams Papers, Mystic Seaport Museum, Mystic, Conn.; Van Dusen, *Connecticut,* p. 316; Gurdon Tracy and Ezra Dodge, estate records, 1792 and 1799, DCM.

95. Samuel Huntington, estate records, 1796, Norwich, Conn., Genealogical Section, CSL. Floyd information and chair illustration in Dean F. Failey, *Long Island Is my Nation* (Setauket, N.Y.: Society for the Preservation of Long Island Antiquities, 1976), pp. 68–71, fig. 78. Another who left Long Island for Connecticut was Grover L'Hommedieu, a ropemaker of Bridgehampton. He settled in Norwich and in 1752 married as his second wife Ebenezer Tracy's sister Elizabeth. See Frederic Gregory Mather, *The Refugees of 1776 from Long Island to Connecticut* (Albany, N.Y.: J. B. Lyon Co., 1913), p. 450.

96. Allen, memorandum book.

97. Allen, memorandum book.

98. Mary and Frederick Mahler, "Beriah Green, Chair and Cabinetmaker," *Spinning Wheel* 34, no. 2 (March 1978): 32–34. Examples of early flared baluster turning are illustrated in *George Dudley Seymour's Furniture Collection,* pp. 81, 110–11; and Trent, *Hearts and Crowns,* figs. 28, 31–32. The Parsons table is illustrated in Kirk, *Connecticut Furniture,* fig. 166.

99. One knuckle-scroll sack-back chair may be branded by Amos Denison Allen, but that has not been substantiated. The Ebenezer Huntington chair is in the Slater Memorial Museum, Norwich, Conn.

100. Evans, "A Connecticut Settee," pp. 1, 64–65; Allen, memorandum book; Nutting, *Handbook,* p. 44.

101. Allen, memorandum book; John Andrews, letter to William Barrell, February 26, 1773, Andrews-Eliot Papers.

102. Hollow candlestand turnings are illustrated in *Seymour's Furniture Collection,* p. 134; and Myers and Mayhew, *New London County Furniture,* fig. 107.

103. Tracy, *Descendants of Lt. Thomas Tracy,* nos. 181, 251. Dated portrait of anonymous man illustrated in Peter H. Tillou, *Nineteenth-Century Folk Painting: Our Spirited National Heritage* (Storrs, Conn.: William Benton Museum of Art, 1973), fig. 2.

104. Chase, "Ebenezer Tracy," fig. 4.

105. Allen, memorandum book; Houghton Bulkeley, "Amos Denison Allen, Cabinetmaker," *Connecticut Historical Society Bulletin* 24, no. 2 (April 1959): 63.

106. Allen, memorandum book; Bulkeley, "Amos Denison Allen," pp. 60–64.

107. Manifest of schooner *Hope,* February 22, 1794, New York outward coastwise entries, U.S. Custom House Records, French Spoliation Claims, NA; Asa Stanton, advertisement in *Connecticut Gazette* (New London, Conn.), June 26,

1794 (reference courtesy of Wendell Hilt); Asa Stanton, advertisement in *Journal of the Times* (Stonington, Conn.), July 30, 1799; Stacy Stackhouse, notice in *American Mercury* (Hartford, Conn.), November 22, 1784; John Colwell, notice in *Connecticut Gazette and the Universal Intelligencer* (New London, Conn.), June 30, 1786; all as quoted or noted in Phyllis Kihn, "Connecticut Cabinetmakers, Parts I, II," *Connecticut Historical Society Bulletin* 32, no. 4 (October 1967): 117–18, and 33, no. 1 (January 1968): 19–21.

108. Allen, memorandum book.

109. Allen, memorandum book.

110. Allen, memorandum book.

111. A marked Elijah Tracy bow-back chair is at the Metropolitan Museum of Art, New York. Ebenezer Tracy, Sr., estate records.

112. Allen, memorandum book; Ebenezer Devotion, ledger, 1775–99, New London Co. Historical Society, New London, Conn. Companion portraits depict Captain and Mrs. Harrington. The family's residence is unknown, although census records list a few persons of the Harrington surname in coastal Rhode Island towns. A number of Harrington family members resided in the northern Connecticut ports of New London, Norwich, Saybrook, and Essex during the early nineteenth century.

113. Allen, memorandum book.

114. Mahler, "Beriah Green," p. 32. The woodworking shops closest to Preston were those of Felix Huntington of Norwich and Ebenezer and Elijah Tracy of Lisbon. An extended list includes Amos Wells of Colchester, Theodosius Parsons of Scotland, and Jabez Gilbert and Orrin Ormsby of Windham. Beriah Green, advertisement in *Connecticut Gazette,* June 11, 1795; Liancourt, *Travels,* 1:515, 535; Lance Mayer and Gail Myers, ed., *The Devotion Family* (New London, Conn.: Lyman Allyn Art Museum, 1991), p. 57; index, Connecticut Church Records, and Beriah Green, property records, 1802, 1804, Genealogical Section, CSL.

115. Allen, memorandum book; Theodosius Parsons, advertisement in *Connecticut Gazette,* November 30, 1787, as quoted in Kihn, "Connecticut Cabinetmakers, Part II," p. 5; Theodosius Parsons, advertisement in *Connecticut Courant and Weekly Intelligencer* (Hartford, Conn.), December 29, 1788, and *Connecticut Gazette,* October 18, 1792. The Reverend James Cogswell described his interaction with the Parsons family in his diary. That information and an illustration of Parsons's tea table are in Mayer and Myers, *Devotion Family,* pp. 21–22.

116. Crown-top chairs are illustrated in Trent, *Hearts and Crowns,* figs. 12–18, 22–23.

117. One armchair is in the Scott-Fanton Museum, Danbury, Conn.

118. LaVerne C. Cooley, comp., *Cotton Genealogy* (Batavia, N.Y.: Privately printed, 1945), pp. 32, 40, 51.

119. Dwight, *Travels,* 3:11.

120. The Stokes chair is pictured in Nutting, *Treasury,* fig. 2563. The Branford-Saybrook rush-bottomed chair is illustrated in Patricia E. Kane, *300 Years of American Seating Furniture* (Boston: New York Graphic Society, 1976), fig. 4. See also Kirk, *Connecticut Furniture,* figs. 200–202. The Guilford banister-back chair is illustrated in Trent, *Hearts and Crowns,* fig. 29.

121. A pair of chairs of this pattern was advertised by Robert E. Kinnaman and Brian A. Ramaekers in *Antiques* 119, no. 1 (January 1981): 113.

122. A chair of identical form, probably from the same set, is in the Strawbery Banke Museum, Portsmouth, N.H.

123. The seat extension profile may be compared with elements in looking glasses such as Downs, *American Furniture: Queen Anne and Chippendale Periods,* figs. 266–68. For a crest prototype in a rush-bottom chair, see Myers and Mayhew, *New London County Furniture,* fig. 84. For crest prototypes in joined chairs, see Joseph K. Ott, *The John Brown House Loan Exhibition of Rhode Island Furniture* (Providence, R.I.: Rhode Island Historical Society, 1965), figs. 9–10, 12–13. The six Denison family portraits are illustrated in Mary Black and Jean Lipman, *American Folk Painting* (New York: Clarkson N. Potter, 1966), figs. 26–31. See also Nina Fletcher Little, *Paintings by New England Provincial Artists, 1775–1800* (Boston: Museum of Fine Arts, 1976), figs. 34, 35.

124. Another trilobed Windsor chair is at the American Museum, Bath, England. The Stokes chair is illustrated in Nutting, *Treasury,* fig. 2656; the legs appear to be replacements.

Modified trilobed backs were fashionable for stuffed back stools and French chairs before the mid eighteenth century. Ince and Mayhew, Manwaring, and Chippendale included the profile in their published designs of the 1760s. See Ince and Mayhew, *Universal System of Household Furniture,* pl. 54; Robert Manwaring, *The Cabinet and Chair-Maker's Real Friend and Companion* (London: Henry Webley, 1765), pl. 23, rt.; Chippendale, *The Gentleman and Cabinet-Maker's Director,* pl. 20, rt. The undulating line continued to find favor with designers and consumers during the late eighteenth century, when early neoclassical seating was framed with pierced cross slats or banisters, painted to resemble bamboo, or elongated and stuffed to produce the cabriole sofa. See Charles F. Montgomery, *American Furniture: The Federal Period* (New York: Viking, 1966), cats. 83, 84; Maurice Tomlin, *Catalogue of Adam Period Furniture* (London: Victoria and Albert Museum, 1982), cats. E/1, O/4, Q/2, Q/3; George Hepplewhite, *The Cabinet-Maker and Upholsterer's Guide* (London: I. and J. Taylor, 1788), pls. 24, 27; John T. Kirk, *American Furniture and the British Tradition to 1830* (New York: Alfred A. Knopf, 1982), figs. 1048, 1193.

125. Other chairs with "hands" were advertised by Gary C. Cole in *Antiques* 102, no. 5 (November 1972): 753, and David A. Schorsch, *Antiques* 124, no. 4 (October 1983): 622.

126. Baluster-to-baluster articulation in New London rush-bottom seating is illustrated in Trent, *Hearts and Crowns,* figs. 65–66, 68.

127. This chair is branded on the seat bottom near the back with the spurious mark *S. O. PAINE* in large, half-struck letters. The stamp occurs on at least two other completely unrelated Windsors, one a sack-back chair of New England origin, the other a Pennsylvania low-back chair at Independence National Historical Park, Philadelphia. The iron used to impress the name may be of contemporary vintage, since the letters are in the serif style; however, the application is of twentieth-century date.

128. Second set of chairs sold from Justine Milliken collection; see *Antiques and the Arts Weekly* (Newtown, Conn.), October 6, 1978; later advertised by Stephen Score in *Maine Antique Digest* (Waldoboro, Maine), May 1980.

129. For Dominy chairs with this top piece, see Charles F. Hummel, *With Hammer in Hand* (Charlottesville: University Press of Virginia, 1968), pp. 246–47.

130. For joined and rush-bottomed seating with comparable top pieces, see Kirk, *Connecticut Furniture,* fig. 240; Dean A. Fales, Jr., *The Furniture of Historic Deerfield* (New York: E. P. Dutton, 1976), figs. 81, 85, 104, 111–13. For information on Rufus Hathaway, see Nina Fletcher Little, "Rufus Hathaway," in *American Folk Painters of Three Centuries,* ed. Jean Lipman and Tom Armstrong (New York: Whitney Museum, 1980), pp. 35–40. The Massachusetts census for 1790 lists Molly's father, Perez Fo[r]bes, and her future husband, Elijah Leonard (m. 1792), as residents of Raynham, Bristol Co.

131. Durand's work is discussed and illustrated in Benno M. Forman, "The Crown and York Chairs of Coastal Connecticut and the Work of the Durands of Milford," *Antiques* 105, no. 5 (May 1974): 1147–54; Trent, *Hearts and Crowns,* figs. 38–41.

132. Index, Barbour Collection of Connecticut Vital Records, and Amos Wells, estate records, 1802, Colchester, Conn., both in Genealogical Section, CSL.

133. Index, Barbour Collection. Sisson is listed in Cooperstown, N.Y., daybook and ledger (1821–29) of Miles Benjamin between 1823 and 1825.

134. Identification of the Sisson chair is possible through the catalogue of an exhibition that featured, in part, the J. Stogdell Stokes collection. A number eight penciled on the reverse of the photograph corresponds to entry number eight in the catalogue, which offers the following description: "Hoop-back arm chair. New England middle period. Made by Gilbert Sisson Bozrah Conn., 1795. Label under seat." Whether the date is speculation or noted on the label is unknown. *Windsor Chairs and Pennsylvania German Painted Chests,* no. 8.

135. John Wadsworth, chairmaker of Hartford, consigned "fifteen Windsor Chairs" to Horace Wadsworth at Charleston, S.C., to be shipped from New London on sloop *Little Patty,* November 10, 1800. New London, Conn., outward entries, U.S. Custom House Records, French Spoliation Claims, NA. Liancourt, *Travels,* 1:510–11; Dwight, *Travels,* 2:367–68.

136. William P. Ledyard of Groton consigned merchandise to a W.P. Ledyard (possibly himself) at Boston to be shipped from New London on the sloop *Herald,* March 9, 1803. New London, Conn., outward coastwise entries, U.S. Custom House Records, Federal Archives and Records Center, Waltham, Mass. (hereafter cited as FRC-Waltham). Walter H. Powell, "The Strange Death of Colonel William Ledyard," *Connecticut Historical Society Bulletin* 40, no. 2 (April 1975): 64; index, Hale Collection of Newspaper Death Notices, Genealogical Section, CSL; estate of William P. Ledyard, daybook and account book, 1818–52, OSV.

137. Oliver Avery, advertisement in *Norwich Packet,* January 23, 1781, as excerpted in Ethel Hall Bjerkoe, *The Cabinetmakers of America* (Garden City, N.Y.: Doubleday, 1957), p. 33; Oliver Avery, account books, 1789–1813 and 1789–1831, DCM.

138. Index, Barbour Collection; William Harris, Jr., advertisements in *Connecticut Gazette,* November 14, 1788, as quoted in Irving Whitall Lyon, *Colonial Furniture of New England,* p. 181; *Connecticut Gazette,* March 19, 1790, February 7, 1798; *Connecticut Gazette,* August 2, 1792, December 21, 1796, and February 7, 1798, as excerpted in Kihn, "Connecticut Cabinetmakers, Part I," pp. 128–29. Myers and Mayhew, *New London County Furniture,* p. 119. Dewey advertisement in *Connecticut Gazette and the Commercial Intelligencer* (New London, Conn.), August 10, 1803, as quoted in Kihn, "Connecticut Cabinetmakers, Part I," p. 120.

139. Index, Barbour Collection; Van Dusen, *Connecticut,* p. 316.

140. Index, Barbour Collection; Kihn, "Connecticut Cabinetmakers, Part II," p. 4; Myers and Mayhew, *New London County Furniture,* pp. 122–23; manifest of sloop *Industry,* July 15, 1803, New London, Conn., outward coastwise entries, FRC-Waltham.

141. Allyn and Huntington, notice in *Chelsea Courier* (Norwich, Conn.), June 7, 1797; James Rogers III, notice in *Chelsea Courier,* December 7, 1797, as quoted in Kihn, "Connecticut Cabinetmakers, Part II," p. 11. Allyn and Huntington sketches in Kihn, "Connecticut Cabinetmakers, Part I," pp. 104, 134–35; and Myers and Mayhew, *New London County Furniture,* pp. 108, 120. The Allyn sketch also illustrates a bow-back side chair in the collection of the Connecticut Historical Society with features similar to the work of Ebenezer Tracy; the chair is branded *ALLYN* on the plank. The sans serif letter style is incorrect for the period, an indication that the stamp is a later addition.

142. Index, Barbour Collection; Richard Anson Wheeler, *History of the Town of Stonington* (New London, Conn.: Day Publishing Co., 1900), pp. 612, 614–15; Elisha Swan, advertisement in *Impartial Journal* (Stonington, Conn.), November 4, 1800 (reference courtesy of Wendell Hilt). *Public Records,* Hoadly, vol. 3 (1922), p. 474; Labaree, 5:387, and vol. 6 (1945), p. 480; Labaree and Fennelly, 8:200; Van Dusen, 9:80.

143. Comparable rush-bottomed work is illustrated in Trent, *Hearts and Crowns,* figs. 27, 38–41, 45, 62, 65–68; and Myers and Mayhew, *New London County Furniture,* figs. 3–4.

144. Noyes chair in Henry V. Weil advertisement in *Antiquarian* 14, no. 3 (March 1930): 90.

145. Rush-seat prototypes for urn-shape turnings, lunette crests, and double-baluster stretchers appear in Trent, *Hearts and Crowns,* figs. 8, 26; Kane, *American Seating Furniture,* figs. 48–49, 84–85; Kirk, *Connecticut Furniture,* figs. 204, 210–12, 223. Henry B. Stoddard, "Special Windsor Style Found," *American Collector* 1, no. 9 (April 19, 1934): 1, 6.

146. Rush-seat prototypes for flat-bottom balusters appear in Trent, *Hearts and Crowns,* figs. 33–34, 37–41, 58, 70; Hummel, *With Hammer in Hand,* figs. 188, 190.

147. Trent, *Hearts and Crowns,* figs. 65–66, 68.

148. A chair with long leg balusters is illustrated in Kane, *American Seating Furniture,* fig. 175.

149. A writing-arm chair of this group is illustrated in Kane, *American Seating Furniture,* fig. 174.

150. Van Dusen, *Connecticut,* pp. 114, 162, 174; Liancourt, *Travels,* 1:521–22, 534; Thomas Chapman, "Journal of a Journey through the United States, 1795–6," *Historical Magazine,* 2d ser., 6 (1869): 70; Wansey, *Excursion,* p. 50.

151. New Haven outward foreign entries, 1786–90, U.S. Custom House Records, French Spoliation Claims, NA.

152. Schloss, *Beardsley Limner,* frontispiece, pp. 19–21; Heslip and Kellogg, "Beardsley Limner Identified as Sarah Perkins," pp. 548–65; Hezekiah Beardsley, estate records, 1793, New Haven, Conn., Genealogical Section, CSL; John W. Barber and Lemuel S. Punderson, *History and Antiquities of New Haven, Conn.* (New Haven: L. S. Punderson and J. W. Barber, 1856), p. 172.

153. Advertisement of Whitlock's Book Store in *Antiques* 17, no. 5 (May 1930): 478; Lillian Francis estate auction, as advertised by Maison Auction Co., *Antiques and the Arts Weekly* (Septmber 26, 1980); Lyon, *Colonial Furniture,* fig. 86. The Bellamy chair is illustrated and described in John F. Page, *Litchfield County Furniture* (Litchfield, Conn.: Litchfield Historical Society, 1969), fig. 66. Yale University chairs are illustrated and described in Kane, *American Seating Furniture,* figs. 174–75.

154. Maria Sherman is illustrated in Schloss, *Beardsley Limner,* fig. 26; Bradford Hubbard and Rev. Thomas Robbins illustrated in Ralph W. Thomas, "Reuben Moulthrop," *Connecticut Historical Society Bulletin* 21, no. 4 (October 1956): 105, 109; John Nichols is illustrated in Little, *New England Provincial Artists,* pp. 98–99; also pp. 86, 154–55.

155. New Haven outward foreign entries, 1791–93, and Fairfield outward foreign entries, 1791–92, U.S. Custom House Records, French Spoliation Claims, NA.

156. Dwight, *Travels,* 2:31; Titus Preston, ledger, 1795–1817, Sterling Memorial Library, Yale University, New Haven, Conn.

157. Samuel Griswold Goodrich, *Recollections of a Lifetime,* 2 vols. (1857; reprint, Detroit: Gale Research Co., 1967), vol. 1, pp. 519–20; Elisha Hawley, account book, 1781–1800, CHS.

158. Hawley, account book.

159. The Keeler family's continuous-bow Windsor is illustrated in *Antiques and the Arts Weekly* (December 10, 1976). Timothy Keeler sketch is in Silvio A. Bedini, *Ridgefield in Review* (Ridgefield, Conn.: Ridgefield 250th Anniversary Committee, 1958), p. 144. Hawley, account book; Nina Fletcher Little, "Little-Known Connecticut Artists, 1790–1810," *Connecticut Historical Society Bulletin* 22, no. 4 (October 1957): 104, 109; Little, *New England Provincial Artists,* pp. 98–99.

160. Hawley, account book.

161. Hawley, account book.

162. George F. H. Birdseye, comp., *Outline of the Birdseye Family in America,* ed. Lucien H. Birdseye (Hartford, Conn.: Connecticut State Library, 1951), p. 28 (bound typescript); Goodrich, *Recollections,* p. 520; Hawley, account book.

163. Chappel and White, advertisement in *Farmer's Journal* (Danbury, Conn.), November 9, 1790; Chappel biographical data in David and Mary Lou Thomas, "A Tall Clock by William Chappel, Cabinetmaker of Danbury," *Connecticut Historical Society Bulletin* 31, no. 2 (April 1966): 55–57; William Chappel, property records, 1796–1810, Danbury, Conn., Genealogical Section, CSL.

164. Thomas, "William Chappel," p. 55; William Lamson Warren, "Captain Simon Fitch of Lebanon, 1758–1835, Portrait Painter," *Connecticut Historical Society Bulletin* 26, no. 4 (October 1961):

114, 120–21; Little, *New England Provincial Artists,* pp. 108–9.

165. Cooke, *Fiddlebacks and Crooked-backs,* pp. 22–23, 27–33, 94–95, 99–105.

166. Dwight, *Travels,* 1:157; Lewis Sage, advertisement in *Connecticut Courant* (Hartford, Conn.), August 9, 1790 (reference courtesy of Wendell Hilt); Joseph Clark, estate records, 1799, Middletown, Conn., Genealogical Section, CSL; manifest of sloop *President,* March 19, 1800, Middletown, Conn., U.S. Custom House Records, French Spoliation Claims, NA.

167. David Hall, daybook, 1785–1812, CHS; David Hall, estate records, 1815, Middletown, Conn., Genealogical Section, CSL; Matthew Noble, advertisement in *Connecticut Courant,* March 27, 1797 (reference courtesy of Wendell Hilt); Noble vital records in index, Barbour Collection; Elihu Smith, advertisement in *Connecticut Gazette,* April 28, 1796, as quoted in Prime Cards, Winterthur Library (hereafter cited as WL); Smith record, index, Connecticut Church Records.

168. "Journal of Lord Adam Gordon" in *Narratives of Colonial America,* ed. Howard H. Peckham (Chicago: R. R. Donnelley and Sons, 1971), p. 287; J.F.D. Smyth, *A Tour of the United States of America,* 2 vols. (London: G. Robinson et al., 1784), vol. 2, p. 368; Marquis de Chastellux, *Travels in North-America in the Years 1780, 1781, and 1782,* 2 vols. (London: G.G.J. and J. Robinson, 1787), vol. 1, pp. 36–37; Warville, *New Travels,* pp. 131–32; Liancourt, *Travels,* 1:517–19; Chapman, "Journal," p. 71.

169. Index, Barbour Collection; Solomon Cole, account book, 1794–1809, CHS.

170. Cole, account book.

171. Cole, account book.

172. Cole, account book.

173. New York City Musket List, July 8, 1775, Alexander McDougall Papers, New-York Historical Society, New York; Gideon J. Tucker, comp., *Names of Persons for whom Marriage Licenses Were Issued by the Secretary of the Province of New York Previous to 1784* (Albany, N. Y.: Weed, Parsons, 1860), p. 369; Stacy Stackhouse, advertisement in *American Mercury,* November 20, 1784; *Connecticut Courant,* January 30, 1786 (newspaper references courtesy of Wendell Hilt); Daniel Butler, ledger, 1775–90, Antiquarian and Landmarks Society, Hartford, Conn. (reference courtesy of Arthur W. Leibundguth); Ronna L. Reynolds, *Images of Connecticut Life* (Hartford, Conn.: Antiquarian and Landmarks Society, 1978), pp. 87–93.

174. Kihn, "Connecticut Cabinetmakers, Part II," pp. 19–20; Stacy Stackhouse, advertisements in *Connecticut Courant,* June 27, 1787, December 24, 1792, July 7 and December 29, 1794; *Hartford Gazette* (Hartford, Conn.), August 21, 1794 (reference courtesy of Wendell Hilt); *Hudson Gazette* (Hudson, N. Y.), November 26, 1795, as quoted in Alfred Coxe Prime, comp., *The Arts and Crafts in Philadelphia, Maryland, and South Carolina, 1786–1800* (Topsfield, Mass.: Walpole Society, 1932), p. 197.

175. Kihn, "Connecticut Cabinetmakers, Part II," pp. 3–4; 20 (Sutton writing-chair account); Jacob Norton, advertisements in *Connecticut Courant,* October 1, 1787 (reference courtesy of Wendell Hilt); *American Mercury,* June 29, 1789 (reference courtesy of Nancy E. Richards); Jacob Norton, bill to Thomas Lloyd, Jr., October 20, 1790, Phelps-Gorham Papers, New York State Library, Albany.

176. Index, Connecticut Church Records; *Connecticut Courant,* March 18, 1793 (reference courtesy of Wendell Hilt); Butler and Easton, advertisement in *Connecticut Courant,* November 9, 1795, as excerpted in Kihn, "Connecticut Cabinetmakers, Part I," p. 111; "Registers of Enlistments in the United States Army, 1798–1814," NA (microfilm, DCM).

177. John I. Wells, advertisements in *American Mercury,* August 17, 1789, December 5, 1791, as quoted in Kihn, "Connecticut Cabinetmakers, Part II," pp. 28–29; *Connecticut Courant,* October 3, 1796 and *American Mercury,* March 20 and September 25, 1797 (references courtesy of Nancy E. Richards); *American Mercury,* October 31, 1796 (reference courtesy of Wendell Hilt).

178. John Wadsworth, advertisements in *American Mercury,* June 3, 1793 (reference courtesy of Wendell Hilt); *American Mercury,* December 21, 1795 (reference courtesy of Nancy E. Richards); Kihn, "Connecticut Cabinetmakers, Part II," pp. 26–27.

179. Liancourt, *Travels,* 1:517.

180. Newton C. Brainard, *The Hartford State House of 1796* (Hartford, Conn.: Connecticut Historical Society, 1964), pp. 22–32; John F. Page, "The Hartford State House," *Connecticut Antiquarian* 18, no. 1 (July 1966): 5–8; Wilson H. Faude, "Old State House, Hartford, Connecticut," *Antiques* 117, no. 3 (March 1980): 626–33; John Wadsworth, bill to State House, [June 2, 1796], CHS (photostat, DCM).

181. Brainard, *Hartford State House,* pp. 17, 23–24, 32.

182. Brainard, *Hartford State House,* p. 24; Trent, *Hearts and Crowns,* figs. 23, 27, 45.

183. Wadsworth, bill to State House with Oath Appended, June 8, 1796, CHS (photostat, DCM); "Joseph Stewart and the Hartford Museum," *Connecticut Historical Society Bulletin* 18, nos. 1, 2 (January–April 1953): 4–5.

184. John Wadsworth and Horace Wadsworth, advertisements in *Connecticut Courant,* November 28, 1796; *American Mercury,* November 7, 1796, November 14, 1799, September 4, 1800, and December 15, 1803 (references courtesy of Nancy E. Richards); manifest of sloop *Little Patty.*

185. Erastus Dewey, advertisement in *Connecticut Courant,* October 10, 1796; Dewey record, index, Church Records; Lemuel Adams, advertisement in *American Mercury,* April 17, 1797 (reference courtesy of Nancy E. Richards); Adams and Wood data in Kihn, "Connecticut Cabinetmakers, Parts I and II," pp. 99–102 and 33; Lemuel Adams, notice in *Norfolk Herald* (Norfolk, Va.), July 11, 1801 (typecard, Museum of Early Southern Decorative Arts, Winston-Salem, N.C., hereafter cited as MESDA); Eli Wood, estate records, 1818, Barkhamstead, Conn., Genealogical Section, CSL.

186. W. DeLoss Love, "The Navigation of the Connecticut River," *Proceedings of the American Antiquarian Society,* new ser. 15, pt. 3 (April 1903): 394, 397, 402; Bethuel Phelps, advertisement in *Connecticut Courant,* August 15, 1791; Stephanus Knight, account book (and genealogical data) 1795–1809, CHS; Stephanus Knight, estate records, 1810, Enfield, Conn., Genealogical Section, CSL.

187. Page, *Litchfield County Furniture,* pp. 6–7, 84–85; Chastellux, *Travels,* 1:48; Joseph Adams, advertisements in *Weekly Monitor* (Litchfield,

Conn.), June 7, 1790, December 20, 1797, as quoted in Page, *Litchfield County Furniture*, p. 117.

188. Pierpont record, index, Barbour Collection; Samuel Sheldon, Ledger B, 1786–1805, New Haven Colony Historical Society, New Haven, Conn.; John Mattocks, advertisement in *Weekly Monitor*, May 10, 1797, as excerpted in Kihn, "Connecticut Cabinetmakers, Part II," p. 2, and Page, *Litchfield County Furniture*, p. 123; Nathaniel Brown, notice in *The Monitor* (Litchfield, Conn.), April 3, 1799, as excerpted in Kihn, "Connecticut Cabinetmakers, Part I," p. 110, and Page, *Litchfield County Furniture*, p. 118; Clark and Plumb advertisement, 1797, as quoted in Alain C. White, comp., *History of the Town of Litchfield, Connecticut, 1720–1920* (Litchfield, Conn.: Litchfield Historical Society, 1920), p. 130.

189. Chastellux, *Travels*, 2:268; Samuel Eliot Morison, *The Maritime History of Massachusetts, 1783–1860* (London: William Heineman, 1923), p. 124; *The New Democracy in America: Travels of Francisco de Miranda in the United States, 1783–84*, trans. Judson P. Wood and ed. John S. Ezell (Norman: University of Oklahoma Press, 1963), pp. 158, 170; Wansey, *Excursion*, pp. 27–28; Liancourt, *Travels*, 2:409.

190. Joseph or Nathaniel Richardson, "Diary of a Journey from Philadelphia to Boston, 1791," DCM; John Clark Howard to Mrs. Elizabeth Wainwright, July 13, 1791, MHS.

191. Messrs. Skillin, advertisement in *Independent Chronicle* (Boston, Mass.), December 29, 1785; Ebenezer Stone, advertisements in *Independent Chronicle*, April 13, 1786, June 21, 1787; *Massachusetts Gazette* (Boston), September 11, 1787; Thomas Bellows Wyman, comp., *The Genealogies and Estates of Charlestown*, 2 vols. (Boston: David Clapp and Son, 1879), 2:907; Ebenezer Stone, bill to David Greenough, May 18, 1786, Greenough Papers, MHS.

192. Wyman, *Genealogies and Estates*, 2:907; Harrold E. Gillingham, "The Philadelphia Windsor Chair and Its Journeyings," *Pennsylvania Magazine of History and Biography* 55, no. 3 (October 1931): 315; Philadelphia outward coastwise and foreign entries, 1791–97, U.S. Custom House Records, French Spoliation Claims, NA, including Cox shipment listed in manifest of ship *Three Brothers*, August 6, 1795; Philadelphia outward coastwise entries, 1799–1800, U.S. Custom House Records, NA, including Cox shipment listed in manifest of schooner *Almira*, September 3, 1799; Anonymous, estate record of Middlesex Co., Mass., ca. 1791, Concord Free Public Library, Concord, Mass.; Ott, "Exports of Furniture," pp. 140–41.

193. Daniel Rea II, daybooks, 1772–1800, 1789–93, and ledger, 1773–94, Baker Library, Harvard University, Cambridge, Mass. (hereafter cited as BL).

194. Federal Procession, Boston, February 1788, as published in *Pennsylvania Gazette* (Philadelphia), February 20, 1788; broadside for Procession in Honor of President Washington, Boston, October 19, 1789, MHS, as illustrated in Fairbanks and Cooper, *Paul Revere's Boston*, p. 142.

195. Samuel Blake, Jr., advertisement in *Boston Gazette* (Boston, Mass.), November 2, 9, 1789; Rea, daybooks; Capt. David Coats, as illustrated in Marvin Sadik, *Christian Gullager: Portrait Painter to Federal America* (Washington, D.C.: National Portrait Gallery, Smithsonian Institution, 1976), pl. 2.

196. Robert McKeen, lawsuit vs. Joseph Adams, 1790, Colonial Court Records, Social Law Library, Boston, Mass. (hereafter cited as SLL) (reference courtesy of John T. Kirk and Charles A. Hammond); Joseph Adams, advertisement in *Litchfield Weekly Monitor* (Litchfield, Conn.), June 7, 1790, as quoted in Page, *Litchfield County Furniture*, p. 117; Robert McKeen, advertisement in *Virginia Gazette and Petersburg Intelligencer* (Petersburg, Va.), September 6, 1793 (typecard, MESDA).

197. Samuel J. Tuck, advertisement in *Massachusetts Centinel* (Boston, Mass.), March 3, 1790; Samuel J. Tuck, bill to Samuel Barton, February 18, 1791, Papers of Samuel and John Barton, Essex Institute, Salem, Mass. (hereafter cited as EI); Samuel J. Tuck, advertisement in *Columbian Centinel* (Boston, Mass.), October 3, 1795, as quoted in Prime Cards, WL.

198. Joseph Dow, comp., *Robert Tuck, of Hampton, N.H., and his Descendants, 1638–1877* (Boston: David Clapp and Son, 1877), pp. 53–54, 67; Joseph T. Buckingham, comp., *Annals of the Massachusetts Charitable Mechanic Association* (Boston: Crocker and Brewster, 1853), pp. 10, 37.

199. William Seaver, advertisement in *Columbian Centinel*, May 29, 1793, April 20, 1796; Boston outward entries, 1791–1801, U.S. Custom House Records, French Spoliation Claims, NA; William Seaver, bills to Joseph Russell for Boston Theatre, January 21 and October 18, 1794, Boston Theatre Papers, Boston Public Library (hereafter cited as BPL).

200. Jesse Foster, lawsuit vs. Josiah Willard, 1798–99, SLL (reference courtesy of John T. Kirk and Charles A. Hammond); Jesse Foster, estate records, 1800, Suffolk Co., Mass., Registry of Probate. Willard's furniture-making career is outlined in Boston city directories of this period.

201. George Davidson, waste book, 1793–99, OSV; Reuben Sanborn, bill to Nathaniel Treadwell, June 13, 1801, Papers of Captains John and Jonathan Lovett, EI; Buckingham, *Annals*, p. 74.

202. Seaver and Frost partnership dates compiled from Boston city directory listings; Seaver and Frost, bill to Benjamin H. Hathorne, October 24, 1800, Ward Family Manuscripts, EI.

203. Hayward birthdate given in Index, Barbour Collection; Thomas C. Hayward, advertisements in *The Phenix or Windham Herald* (Windham, Conn.), October 15, 1796, June 23, 1797, March 29, 1798, as quoted in Kihn, comp., "Connecticut Cabinetmakers, Part I," p. 131, and courtesy of Wendell Hilt; Davidson, waste book.

Thomas Cotton Hayward's silhouette is similar in style to cuttings of three other Hayward family members whose images Doyle signed, including that of Hayward's father, who also wears his hair in a queue. A similar pressed metal frame with glass encloses each portrait. All silhouettes are privately owned. Wyman, *Genealogies and Estates*, 1:490; Buckingham, *Annals*, p. 94.

204. Estate of William Erving, Esq., Notice of Public Vendue, July 7, 1791; Daniel Starr, account of David S. Greenough, April to November, 1800, Greenough Papers, MHS; John Lowell, Esq., and James Cutler, estate records, [1802] and 1799, source unknown (photostats, DCM); Dr. John Sprague I, estate records, 1797, John Sprague Papers, AAS; Elisha Richardson, estate records, 1801, Middlesex Co., Mass., Registry of Probate.

205. Information on the Tufts family was conveyed to the author in a memorandum from Elizabeth Tufts Brown, August 1, 1983.

206. The Colonial Williamsburg chair is illustrated in Greenlaw, *New England Furniture*, fig. 156.

207. For the chair documented to Tuck's shop, see Brian Cullity, *Plain and Fancy: New England Painted Furniture* (Sandwich, Mass.: Heritage Plantation of Sandwich, 1987), cat. 10.

208. Samuel Minot, estate records, 1803, Suffolk Co., Mass., Registry of Probate (microfilm, DCM).

209. William Dalton is listed as a Windsor-chair maker in *Boston Furniture*, p. 277. About 1799 he signed a receipt as witness, attesting to Jesse Foster's payment of a note of hand held by Josiah Willard, as recorded in Jesse Foster, lawsuit vs. Josiah Willard, 1798–99, SLL.

The Benjamin Perley Poore photograph is illustrated in Richard H. Saunders, "Collecting American Decorative Arts in New England, Part I: 1793–1876," *Antiques* 109, no. 5 (May 1976): 998.

210. A view of the bridge is engraved on the barrel of a silver tankard, as illustrated and described in Fairbanks and Cooper, *Paul Revere's Boston*, pp. 146–47; Richardson, "Diary"; John Warner Barber, *Historical Collections . . . of . . . Massachusetts* (Worcester, Mass.: Dorr, Howland, 1839), p. 365.

211. Wyman, *Genealogies and Estates*, 1:452; Thomas C. Hayward, property records, 1803, Middlesex Co., Mass., Registry of Deeds; James F. Hunnewell, *A Century of Town Life: A History of Charlestown, Massachusetts, 1775–1887* (Boston: Little, Brown, 1888), p. 226; Huia G. Ryder, *Antique Furniture by New Brunswick Craftsmen* (Toronto: Ryerson Press, 1965), pp. 98, 167.

212. Weeden, *Economic and Social History*, 2:777–78; Morison, *Maritime History*, p. 79; Chastellux, *Travels*, 2:255; Liancourt, *Travels*, 1:474–75; Dwight, *Travels*, 1:322–23.

213. Jones, *American Colonial Wealth*, vol. 2, pp. 607–800; Capt. Benjamin Hind, estate records, 1781, Essex Co., Mass., Registry of Probate; Gillingham, "The Philadelphia Windsor Chair and Its Journeyings," p. 315; James Magee, account of Elias Haskett Derby, 1789, Derby Family Papers, EI; James C. Tuttle, advertisement in *Salem Gazette* (Salem, Mass.), August 19, 1796, as quoted in Mabel M. Swan, *Samuel McIntire, Carver, and the Sandersons, Early Salem Cabinet Makers* (Salem, Mass.: Essex Institute, 1934), pp. 29–30.

214. Josiah Austin, bill to Waters and Sinclair, March 1, 1790, Waters Family Papers, EI; Swan, *Samuel McIntire*; Margaret Burke Clunie, "Salem Federal Furniture" (Master's thesis, University of Delaware, 1967), pp. 115–19.

215. James C. Tuttle, advertisements in *Salem Gazette*, August 19, 1796, September 29, 1801, as quoted in Swan, *Samuel McIntire*, pp. 29–30; Micaiah Johnson, account of Elijah and Jacob Sanderson, 1794–95, Papers of Elijah Sanderson, EI.

216. Samuel Phippen, estate records, 1798, Essex Co., Mass., Registry of Probate; Singleton, *Furniture of Our Forefathers*, pp. 546–48; Henry Wyckoff Belknap, *Artists and Craftsmen of Essex County, Massachusetts* (Salem, Mass.: Essex Institute, 1927), pp. 63–64.

217. William Gray, ledger, 1774–1814, EI (microfilm, DCM); Ezra Burril, estate records, ca. 1797, Hathorne Family Manuscripts, EI; John Chamberlain, estate records, 1798–1800, Papers of John Chamberlain, EI; manifests of schooners *Olive* and *Betsey,* Decmeber 24, 1792, May 12, 1795, and December 31, 1800, Salem-Beverly outward coastwise entries, U.S. Custom House Records, French Spoliation Claims, NA; Elias Hasket Derby, estate records, 1800, Essex Co., Mass., Registry of Probate; and Singleton, *Furniture of Our Forefathers,* pp. 548–53.

218. Manifests of schooner *Eliza* and sloop *Hercules,* November 26, 1794, April 8, 1796, New London outward coastwise and foreign entries, U.S. Custom House Records, French Spoliation Claims, NA.

219. Belknap, *Artists and Craftsmen*; James Mansfield, estate records, 1844, Essex Co., Mass., Registry of Probate. The Moseley chair is in the collection of Historic Deerfield, Inc., Deerfield, Mass. See Nutting, *Windsor Handbook,* pp. 154–55.

220. Dwight, *Travels,* 1:321–22; Jervis Cutler, bill to Robert Rantoul, February 28, 1798, Papers of Robert Rantoul, Beverly Historical Society, Beverly, Mass. (hereafter cited as BHS); Moses Adams, bill to Elizabeth Buckman, February 6, 1793; Hale Hilton, estate records, 1802, Dane Papers, MHS; Moses Adams, estate records, 1796, Essex Co., Mass., Registry of Probate; Dr. Luke Drury, sale of personal estate, November 5, 1790, Dr. John Drury Manuscripts, EI; John Dodge, estate records, 1798, Papers of Benjamin and Stephen Goodhue and Family, EI.

221. Mercy Greenleaf, estate records, 1796, Papers of Joshua Greenleaf, EI; Somerby Chase, estate records, 1803, Essex Co., Mass., Registry of Probate; Capt. Jonathan Dalton, estate records, 1803, Papers of James Locke, and Jonathan Kettell, account book, 1781–94, EI; Larkin Thorndike, estate records, 1797, Bowdoin-Temple Papers (probably), MHS (photostat, DCM); Daniel Page and Nehemiah Fuller, estate records, 1801 and 1806, Essex Co., Mass., Registry of Probate.

222. David Haven, account book, 1785–1800, DCM; David Haven, estate records, 1801, Middlesex Co., Mass., Registry of Probate.

223. Haven, account book. For general examples of square-cornered chairs, see Fales, *Furniture of Historic Deerfield,* figs. 83, 85, 108, 111; Trent, *Hearts and Crowns,* figs. 72–73. Simple joiner's chairs are illustrated in Greenlaw, *New England Furniture,* figs. 53, 58. Mabel M. Swan, "Some Men from Medway," *Antiques* 17, no. 5 (May 1930): 417–21.

224. Haven, account book.

225. Isaac Reed, Esq., estate record, 1789, as quoted in *Early American Furniture of the Reed Family,* May 9–10, 1930 (New York: American Art Assn. Anderson Galleries, 1930), frontispiece; Swan, "Some Men from Medway," pp. 417–21.

226. Swan, "Some Men from Medway," pp. 417–21, including advertisement of Luther Metcalf, *Columbian Minerva* (Dedham, Mass.), April 14, 1801; Cyrus Cleveland, advertisement in *Providence Gazette* (Providence, R.I.), October 3, 1801, as quoted in Wendell D. Garrett, "Providence Cabinetmakers, Chairmakers, Upholsterers, and Allied Craftsmen, 1756–1838," *Antiques* 90, no. 4 (October 1966): 516.

227. Jacob Beal, Jr., is identified as a chairmaker of Hingham in Margaret K. Hofer, "The Tory

228. John Blackman, advertisement in *Independent Chronicle* (Boston, Mass.), July 28, 1796, as quoted in Prime Cards, WL; Asa Jones, account book, 1790–1840, DCM.

229. Barber, *Historical Collections,* pp. 117, 142–43; Dwight, *Travels,* 2:3; manifests of sloop *Friendship,* May 27 and August 13, 1796, New York outward coastwise and foreign entries, and manifest of brig *Celia,* June 19, 1800, Boston-Charlestown outward entries, U.S. Custom House Records, French Spoliation Claims, NA.

230. A chair of related crest is illustrated in Fales, *Furniture of Deerfield,* fig. 164.

231. Abraham Shove, property records, 1804–21, Bristol Co., Mass., Registry of Deeds; Selectmen of Freetown, complaint against Abraham Shove, May 10, 1816, Bristol Co., Mass., Registry of Probate.

232. Selectmen of Freetown, complaint; Abraham Shove, inventory, November 22, 1817, and release from guardianship, August 6, 1824, Bristol Co., Mass., Registry of Probate.

233. Theophilus Shove, property and estate records, 1810–32 and 1856, Bristol Co., Mass., Registries of Deeds and Probate.

234. Ott, "Exports," pp. 140–41; manifest of sloop *Liberty,* May 10, 1799, New York outward coastwise and foreign entries, U.S. Custom House Records, French Spoliation Claims, NA; manifests of sloops *Rose, Lark,* and *Lydia,* May 25, 1807, July 12 and December 31, 1808, New Bedford inward and outward entries, U.S. Custom House Records, FRC-Waltham; Obed Faye, recipe for green paint, ca. 1800–1808, Samuel Wing Papers, OSV. John Hussey is named in manifests of sloops *Hope* and *Beaver,* September 18, 1791, June 14, 1794, and April 21, 1796; New Bedford voyages are named in manifests of sloops *Keziah* and *George,* October 24 and November 11, 1791, and November 7, 1792, and ship *Lively,* December 6, 1792, Philadelphia outward coastwise and foreign entries, U.S. Custom House Records, French Spoliation Claims, NA. New Bedford voyages are named in manifests of sloop *Fox,* March 20, 1798, May 3, 1799, Philadelphia outward coastwise and foreign entries, U.S. Custom House Records, NA.

235. Silvanus Coffin (1784), Abraham Pease (1786), Susanna Folger (1801), and Christopher Hussey (1801), estate records, Nantucket Co., Mass., Registry of Probate; William Oliver Stevens, *Nantucket the Far-Away Island* (New York: Dodd, Mead, 1936), p. 113; Lydia S. Hinchman, comp., *Early Settlers of Nantucket* (Philadelphia: Ferris and Leach, 1901), pp. 317–30; *Boston Furniture,* p. 296.

236. Dwight, *Travels,* 3:43–45; "Memoir of William Logan Fisher (1781–1862) for his Grandchildren," *Pennsylvania Magazine of History and Biography* 99, no. 1 (January 1975): 97; Elton W. Hall, "New Bedford Furniture," *Antiques* 113, no. 5 (May 1978): 1108.

237. Hall, "New Bedford Furniture," pp. 1109, 1111, 1124–25; Bartholomew Akin, account book, 1774–1829, DCM; "Enter Bamboo Turnings," *American Collector* 2, no. 6 (September 6, 1934): 2.

238. Reuben Swift, property records, 1793–99 and 1842, Bristol and Barnstable Cos., Mass., Registries of Deeds. A Reuben Swift "from Massachusetts" is listed in Cincinnati directories for 1819

and 1825. Marilynn Johnson Bordes, "Reuben Swift, Cabinetmaker of New Bedford," *Antiques* 112, no. 4 (October 1977): 750–52. The Swift advertisements are detailed in Hall, "New Bedford Furniture," p. 1126; the chair and branding iron are pictured on p. 1111.

239. Dwight, *Travels,* 3:48–49; Barber, *Historical Collections,* p. 52.

240. Samuel Wing, property record, 1800, Barnstable Co., Mass., Registry of Deeds; Samuel Wing, account books, 1800–1808, Samuel Wing Papers, OSV; Henry J. Harlow, "The Shop of Samuel Wing, Craftsman of Sandwich, Massachusetts," *Antiques* 93, no. 3 (March 1968): 372–77.

241. Wing, account books.

242. Harlow, "Samuel Wing," pp. 372–77.

243. Chair illustrated in Nutting, *Handbook,* pp. 60–61.

244. The Stetson family chair is discussed in Richard H. Randall, Jr., *American Furniture in the Museum of Fine Arts, Boston* (Boston: Museum of Fine Arts, 1965), pp. 236, 239. Census records from 1790 to 1810 identify southeastern Massachusetts as a Stetson family stronghold. A few members were residents of Barnstable and Bristol counties, but the greatest concentration was in northern Plymouth County, within a triangular area bounded by Scituate and Plymouth on the coast and Abington, near Brockton, about fifteen miles inland. Forty-seven Plymouth County family heads carried the Stetson name in 1800.

245. George Macy (1776), Silvanus Coffin (1784), Andrew Myrick (1783), Dinah Jenkins (1788), Benjamin Barnard (1789), John Ramsdell (1790), Henry Clark (1792), Oliver Spencer (1794), Richard Bunker (1788–94), Benjamin Coffin (1794), Jethro Starbuck, Jr. (1796), Thomas Delano (1800), and Peleg Bunker (1806), estate records, Nantucket Co., Mass., Registry of Probate.

246. The waterfront interior, *Office of Humphrey Hathaway at the Head of Rotch's Wharf* (ca. 1825–50), was published in Horatio Hathaway, *A New Bedford Merchant* (Boston: Privately printed, Merrymount Press, 1930).

247. Benjamin Barnard (1789), Silvanus Coffin (1784), Andrew Myrick (1783), Henry Clark (1792), Mary Pease (1793), Jonathan Burnell (1799), Peter Coffin (1800), Henry Clark (1801), Joseph Russell (1802), and William Morton (1806), estate records, Nantucket Co., Mass., Registry of Probate.

248. Michel Guillaume St. John de Crevecoeur, *Letters from an American Farmer* (London: Thomas Davies and Lockyer Davis, 1782), p. 119.

249. Slade label, as quoted in *18th Century Nantucket* (Nantucket, Mass.: Nantucket Historical Assn., 1976), p. 13; Susannah Whippy, appointment of Benjamin Slade as attorney, 1807, Nantucket Co., Mass., Registry of Deeds; Frederick Slade listed in *Vital Records of Nantucket, Massachusetts, to the Year 1850,* 5 vols. (Boston: New England Genealogical Society, 1925), vol. 2, p. 472, vol. 5, p. 532. The Garvan collection chair is illustrated and discussed in Kane, *American Seating Furniture,* pp. 199–200.

250. Charles Chase, property records, 1776–1811, Nantucket Co., Mass., Registry of Deeds. A Chase chair at Colonial Williamsburg is illustrated and described in Greenlaw, *New England Furniture,* pp. 180–81. A third Chase chair is illustrated in an advertisement of Kenneth and Paulette Tuttle, *Antiques* 129, no. 5 (May 1986): 939. Related Chase

chairs are illustrated in an advertisement of Betty Sterling, *Antiques* 108, no. 1 (July 1975): 55; Kane, *American Seating Furniture*, p. 200; Nutting, *Handbook*, pp. 58–59. The fan-back side chair is illustrated in Charles H. Carpenter, Jr., and Mary Grace Carpenter, "Nantucket Furniture," *Antiques* 133, no. 5 (May 1988): pl. 7.

251. Dwight, *Travels*, 1:264, 266; "To the West on Business in 1804: An Account, with Excerpts from His Journal, of James Foord's Trip to Kentucky in 1804," *Pennsylvania Magazine of History and Biography* 64, no. 1 (January 1940): 3; Barber, *Historical Collections*, p. 550.

252. Background information on the Wights is found in Schloss, *Beardsley Limner*, pp. 25, 27. See also Heslip and Kellogg, "Beardsley Limner Identified as Sarah Perkins," p. 565. Oliver Wight, bills to Josiah Walker, January 11, 1803, and November 2, 1804, Walker Family Collection, OSV; Oliver Wight, estate records, 1837–38, Worcester Co., Mass., Registry of Probate.

253. Solomon Sibley, account book, 1793–1840, OSV.

254. The "Herrck" chair is illustrated in *American Heritage Auction of Americana*, January 28–31, 1981 (New York: Sotheby Parke Bernet, 1981), lot 789.

255. Levi Prescott is discussed in Florence Thompson Howe, "Labeled Clockcases," *Antiques* 30, no. 1 (July 1936): 23.

256. Brissot de Warville, *New Travels*, p. 130; Liancourt, *Travels*, 2:208; Wansey, *Excursion*, p. 37; Dwight, *Travels*, 1:231–32; W. DeLoss Love, "The Navigation of the Connecticut River," *Proceedings of the American Antiquarian Society*, n.s. 15, pt. 3 (April 29, 1903): 402–3, 406.

257. Calvin Bedortha, advertisement in *Republican Spy* (Springfield, Mass.), September 26, 1803, and other data, as published in Florence T. Howe, "Chairs Bear Labels of C. Bedortha," *New York Sun* (New York), January 8, 1938; Calvin Bedortha, property and estate records, 1802–48 and 1846–53, Hampden Co., Mass., Registries of Deeds and Probate.

258. Dwight, *Travels*, 1:238–39; Barber, *Historical Collections*, pp. 329–30; *The Diary of William Bentley*, 4 vols. (Salem, Mass.: Essex Institute, 1905), vol. 2, p. 56.

259. Lewis S. Sage, advertisements in *Connecticut Courant* (Hartford, August 2, 1790, and *Hampshire Gazette* (Northampton, Mass.), March 27, 1793 (references courtesy of Wendell Hilt and Susan B. Swan); Sage marriage and renewal of baptism, 1790–91, as found in Index, Connecticut Church Records, Genealogical Section, CSL; Lewis S. Sage, property records, 1794–1808, Hampshire Co., Mass., Registry of Deeds; other information in Leigh Keno, "The Windsor Chair Makers of Northampton, Massachusetts, 1790–1820" (Historic Deerfield Summer Fellowship Program Paper, August 1979), pp. 21, 135–36. See also Leigh Keno, "The Windsor-Chair Makers of Northampton, Massachusetts, 1790–1820," *Antiques* 117, no. 5 (May 1980): 1107.

260. Benjamin A. Edwards, property records, 1788–1810, Hampshire Co., Mass., Registry of Deeds; Edwards's vital data from Samuel Morgan Alvord, comp., *A Genealogy of the Descendants of Alexander Alvord* (Webster, N.Y.: A.D. Andrews, 1908,) p. 70; Benjamin A. Edwards, advertisements in *Hampshire Gazette*, March 20, 1793, October 27,

1794, and August 5, 1795, as excerpted in Keno, "Windsor-Chair Makers of Northampton," *Antiques*, p. 1105; Ansel Goodrich, estate records, 1803, Hampshire Co., Mass., Registry of Deeds; Ansel Goodrich, advertisement in *Hampshire Gazette*, September 16, 1795 (reference courtesy of Susan B. Swan).

261. Florence Thompson Howe, "The Brief Career of Ansel Goodrich," *Antiques* 18, no. 1 (July 1930): 38–39; Ansel Goodrich, advertisement in *Hampshire Gazette*, September 16, 1795 (reference courtesy of Susan B. Swan).

262. Edmond Charles Genêt biography in Allen Johnson and Dumas Malone, eds., *Dictionary of American Biography* (New York: Charles Scribner's Sons, 1933), vol. 7, pp. 207–9; Eleanore P. Delorme, "James Swan's French Furniture," *Antiques* 107, no. 3 (March 1975): 452–61.

263. French and English canapé sofas and a French bergère chair are illustrated in Helena Hayward, ed., *World Furniture* (New York: McGraw-Hill, 1965), facing p. 128, figs. 523, 402. American examples are illustrated in Charles F. Montgomery, *American Furniture: The Federal Period* (New York: Viking Press, 1966), figs. 265–66. Hepplewhite, *The Cabinet-Maker and Upholsterer's Guide*, pls. 22, 24. Documentation for the Washington and Jefferson bergère chairs is given in Charles L. Granquist, "Thomas Jefferson's 'Whirligig' Chairs," *Antiques* 109, no. 5 (May 1976): 1056–57. Nancy Goyne Evans, "Design Sources for Windsor Furniture, Part 1: The Eighteenth Century," *Antiques* 133, no. 1 (January 1988): 292–93, 296–97.

264. Ansel Goodrich, advertisements in *Hampshire Gazette*, September 16, 1795, June 22, 1796, September 25, 1799, April 12, 1801, July 13, 1802, and May 25, 1803, as quoted in Keno, "Windsor-Chair Makers of Northampton," *Antiques*, p. 1105; Ansel Goodrich, property and estate records, 1797 and 1803, Hampshire Co., Mass., Registry of Deeds and Probate.

265. Nutting, *Handbook*, pp. 132–33.

266. The second sack-back chair is illustrated in Howe, "Ansel Goodrich," fig. 1.

267. The second continuous-bow pattern is illustrated in Keno, "Windsor-Chair Makers of Northampton," *Antiques*, fig. 4; Lewis Sage, advertisement in *Hampshire Gazette*, November 8, 1808, as quoted in the same article, p. 1107.

268. Justin Parsons, advertisement in *Hampshire Gazette*, February 18, 1796, as quoted in Keno, "Windsor-Chair Makers of Northampton," *Antiques*, p. 1107; John Stone, Ansel Goodrich, and Justin Parsons, estate records, 1804, 1803, and 1807, Hampshire Co., Mass., Registry of Probate.

269. Julius Barnard, advertisements in *Hampshire Gazette*, December 5, 1792, August 18, 1796, January 24 and February 14, 1798, February 4, June 13, and November 11, 1801, as quoted in Keno, "Windsor-Chair Makers of Northampton," *Antiques*, p. 1104; Julius Barnard, advertisements in *Hampshire Gazette*, November 13, 1799, August 13, 1800, and June 30, 1802 (references courtesy of Susan B. Swan; other data in Keno, "Windsor Chair Makers of Northampton" (paper), pp. 16, 108–9; Julius Barnard, advertisement in *Post Boy* (Windsor, Vt.), September 24, 1805, as excerpted in Margaret J. Moody, *American Decorative Arts at Dartmouth*, catalogue of an exhibition, January 10 to March 1, 1981 (Hanover, N.H.: Dartmouth College Museum and Galleries, 1981), p. 23; Julius Bar-

nard, advertisement in *Montreal Herald*, May 30, 1812, as quoted in Elizabeth Collard, "Montreal Cabinetmakers and Chairmakers: 1800–1850," *Antiques* 105, no. 5 (May 1974): 1137.

270. Julius Barnard, advertisements in *Hampshire Gazette*, November 11, 1801, and June 30, 1802, as quoted in Keno, "Windsor-Chair Makers of Northampton," *Antiques*, p. 1104; Oliver Pomeroy, advertisements in *Hampshire Gazette*, April 8, 1795, and March 3, 1802 (references courtesy of Susan B. Swan); other data on Barnard and Pomeroy in Keno, "Windsor Chair Makers of Northampton" (paper), pp. 16, 22–24, 108–9, 132–33.

271. Harris Beckwith, account book, 1803–7, Forbes Library, Northampton, Mass. (document brought to author's attention by Leigh Keno); Ansel Goodrich, estate records, 1803, Hampshire Co., Mass., Registry of Probate; Harris Beckwith, advertisement in *Hampshire Gazette*, November 8, 1803, as quoted in Keno, "Windsor-Chair Makers of Northampton," *Antiques*, p. 1105.

272. David Judd, advertisements in *Hampshire Gazette*, January 30, 1799, December 6, 1802, and June 27, 1804, as quoted in Keno, "Windsor-Chair Makers of Northampton," *Antiques*, p. 1106.

273. Shipman Family, comp., *The Shipman Family in America* (n.p.: Shipman Family Historical Society, 1962), pp. 244, 246; William Shipman, advertisement in *Middlesex Gazette* (Middletown, Conn.), October 22, 1787, as excerpted in Kihn, "Connecticut Cabinetmakers, Part II," p. 14; William Shipman, advertisement in *Hampshire Gazette*, April 23, 1788.

274. William Shipman, advertisement in *Middlesex Gazette*, November 13, 1790, as excerpted in Kihn, "Connecticut Cabinetmakers," Part II, p. 14; William Shipman, advertisement in *Hampshire Gazette*, April 16, 1794, as excerpted in Keno, "Windsor Chair Makers of Northampton" (paper), p. 137, which also contains the comment on the broom business; Shipman Family, *Shipman Family*, pp. 244, 246; Barber, *Historical Collections*, p. 322.

275. Shipman Family, *Shipman Family*, p. 244; Jason H. Woodbury, estate records, 1891, Franklin Co., Mass., Registry of Probate. The portrait of Miss Greene is illustrated in *Fine Americana*, January 26 to 29, 1977 (New York: Sotheby Parke Bernet, 1977), lot 563.

276. Dr. Thomas Williams, ledger, 1749–75, New-York Historical Society, New York (hereafter cited as NYHS); Ryder, *Antique Furniture*, p. 18. The Deerfield inventories are excerpted in Keno, "Windsor Chair Makers of Northampton" (paper), pp. 55–56, 67–68.

277. Daniel Clay, advertisements in *Greenfield Gazette* (Greenfield, Mass.), February 18, 1794, November 15, 1797, July 26, 1800, November 28, 1808, July 24, 1809, November 19, 1810, and July 23, 1811, as quoted in newspaper file, Historic Deerfield, Inc., Deerfield, Mass. (hereafter cited as HD); Ethel Hall Bjerkoe, *The Cabinetmakers of America* (Garden City, N.Y.: Doubleday, 1957), p. 65.

278. Ezekiel Edgerton, advertisement in *Hampshire Gazette*, January 25, 1804 (reference courtesy of Susan B. Swan); Joseph Griswold, account books, 1798–1804 and 1804–13, DCM and privately owned (microfilm, DCM).

279. Lois Kimball Mathews Rosenberry, *Migrations from Connecticut Prior to 1800*, Tercentenary Commission of the State of Connecticut (New

Haven, Conn.: Yale University Press, 1934), pp. 7–11, 17–18, 22–23.

280. Charles S. Parsons, *The Dunlaps and Their Furniture,* catalogue of an exhibition, August 6 to September 13, 1970 (Manchester, N.H.: Currier Gallery of Art, 1970), p. 3; Ledger of Imports and Exports: America, 1768–73, pp. 32–33, 53, 59, 150, 199, Board of Customs and Excise, PRO; Brissot de Warville, *New Travels,* pp. 450–51; Bentley, *Diary,* 1:64; Dwight, *Travels,* 1:311–12.

281. Josiah Folsom, advertisement in *New Hampshire Gazette* (Portsmouth, N.H.), September 19, 1797; also data found in Donna-Belle Garvin, James L. Garvin, and John F. Page, *Plain and Elegant, Rich and Common: Documented New Hampshire Furniture, 1750–1850* (Concord: New Hampshire Historical Society, 1979), pp. 145–46. Manifests of schooner *Industry,* November 18, 1791, and March 27, 1793, brig *Betsey,* April 3, 1792, and sloop *Nancy,* June 28, 1797, Philadelphia outward coastwise and foreign entries, U.S. Custom House Records, Some French Spoliation Claims, NA; William Fernald, estate records, 1802, Wendell Papers, BL; George Frost, estate records, 1815–16, Rockingham Co., N.H., Registry of Probate.

282. *Portsmouth Oracle* (Portsmouth, N.H.), February 16, 1799; Garvin, Garvin, and Page, *Plain and Elegant,* pp. 141–42; Langley Boardman, account of Jacob Wendell, July-August 1802, Wendell Papers, BL; *Constitution of the Associated Mechanics and Manufacturers of the State of New-Hampshire* (Portsmouth, N.H.: Miller and Brewster, 1832).

283. John Melish, *Travels through the United States of America,* 2 vols. (Philadelphia: By the author, 1815), 1:97, 99; Parsons, *The Dunlaps;* Garvin, Garvin, and Page, *Plain and Elegant;* Matthew Patten (1719–95), diary, n.d., in Charles S. Parsons, New Hampshire Notes, VRC.

284. Moody Carr, account book, 1800–1844, OSV; Moody Carr, estate records, 1851, Rockingham Co., N.H., Registry of Probate.

285. Parsons, *The Dunlaps,* pp. 5–8, 20, 36–37, 43, 242, 288; fig. 77.

286. Parsons, *The Dunlaps,* pp. 7, 18, 55; David McAfee, indenture with David Atwood, August 1, 1795 (photocopy courtesy of Charles H. Vilas).

287. Notes on Thomas Aiken and Jonas Childs, in Jane C. Giffen, "New Hampshire Cabinetmakers and Allied Craftsmen, 1790–1850," *Antiques* 94, no. 1 (July 1968): 78, 80; Thomas Aiken, Jr., estate records, 1805, Hillsborough Co., N.H., Registry of Probate. The Childs data for Massachusetts come from Duane Hamilton Hurd, *History of Worcester County, Massachusetts,* 2 vols. (Philadelphia: J.W. Lewis, 1889), vol. 2, p. 841, and Henry Wilder Miller, account book, 1827–31, Worcester Historical Museum, Worcester, Mass. Data on Stephen Prentiss, Jr., are found in Parsons, New Hampshire Notes, VRC.

288. Bentley, *Diary,* 2:46; Dwight, *Travels,* 2:240–41; Charles S. Parsons, Wilder Family Notes, VRC; Giffen, "New Hampshire Cabinetmakers," p. 87.

289. Rev. Moses H. Wilder, *Book of the Wilders* (New York: Edward O. Jenkins, 1878), p. 72; Parsons, Wilder Family Notes, VRC, based in part on data from *New Hampshire Sentinel* (Keene, N.H.), 1805, 1807, 1808; Giffen, "New Hampshire Cabinetmakers," pp. 83, 85, 87.

290. The bow-back chair with the bamboo medial stretcher is in the Hingham Historical Society, Hingham, Mass. See Wilder, *Book of Wilders,* pp. 72, 182–83, 253.

291. Parsons, *The Dunlaps,* pp. 6–7, 9, 38, 41, 43.

292. James Dinsmore, *Political Observatory* (Walpole, N.H.), December 6, 1805. Data on Dinsmore and Webster are found in Parsons, *The Dunlaps,* pp. 23, 38–39; Parsons, New Hampshire Notes, VRC.

293. Giffen, "New Hampshire Cabinetmakers," p. 83; Parsons, New Hampshire Notes, VRC; Paul H. Burroughs, "Furniture Widely Made in New Hampshire," *American Collector* 6, no. 5 (June 1937): 7.
A cautionary note is in order regarding the Joseph Kimball, Jr., identification. State census records for 1800 list forty-two Kimballs whose first name begins with the letter *J* and three more whose name begins with *I.* Sixty names are listed in 1810. Among these is that of John Kimball of Concord (1739–1817), another known woodworker. On the basis of entries in Kimball's account book and the existence of two case pieces signed and dated "1762," this man probably can be eliminated as a maker of painted seating at the century's end. Data on John Kimball are found in Garvin, Garvin, and Page, *Plain and Elegant,* pp. 46–49, 148.

294. James Chase, account books, 1797–1812; data as recorded in Parsons, New Hampshire Notes, VRC; Parsons, *The Dunlaps,* p. 38; James Chase, estate records, 1814, Belknap Co., N.H., Registry of Probate.

295. Jacob Merrill, Jr., ledger, 1784–1812, New Hampshire Historical Society, Concord, N.H., as recorded in Parsons, New Hampshire Notes, VRC; Parsons, *The Dunlaps,* p. 38.

296. The Shapleigh studio is illustrated in James and Donna-Belle Garvin et al., *Full of Facts and Sentiment: The Art of Frank H. Shapleigh* (Concord: New Hampshire Historical Society, 1982), p. 8.

297. Morse, *American Geography,* p. 470; Melish, *Travels,* 1:103–4.

298. Dwight, *Travels,* 2:280–81; Pomeroy advertisement, as noted in H.C. Day Papers, Book U, p. 178, Bennington Museum, Bennington, Vt.; Ralph Pomeroy, property records, 1796–1802, Town Clerk's Office, Bennington, Vt; James Chestney, advertisement in *Vermont Gazette* (Bennington, Vt.), 1798; Elwell data as recorded in Janet R. Houghton, "Household Furnishings in Southern Vermont, 1780–1800" (Master's thesis, University of Delaware, 1975), p. 26.

299. Westminster history is given in A.J. Coolidge and J.B. Mansfield, *A History and Description of New England,* 2 vols. (Boston: Austin J. Coolidge, 1859), vol. 1, p. 941. David Wells, advertisement in *Farmers Weekly Museum* (Walpole, N.H.), May 26, 1801, as quoted in Parsons, New Hampshire Notes, VRC; inventories of Samuel Ward and Mrs. Lydia Jones, as noted in Houghton, "Household Furnishings," p. 44; Luther Ames advertisement, as noted in William N. Hosley, Jr., "Vermont Furniture, 1790–1830," in *New England Furniture* (Boston: Society for the Preservation of New England Antiquities, 1987), p. 247.

300. Isaac Greene and Nathan Trask, ledgers, 1788–1800, and 1801–15, Nathan Stone Collection, Vermont Historical Society, Montpelier, Vt; Wil-

liam Rogers, estate records, 1812–15, Windsor Co., Vt., Registry of Probate; Bentley, *Diary,* 2:49.

301. Coolidge and Mansfield, *History of New England,* 1:903; Pauline W. Inman, "House Furnishings of a Vermont Family," *Antiques* 96, no. 2 (August 1969): 228–33; Rev. Asa Hemenway, comp., *A Genealogical Record of One Branch of the Hemenway Family from 1634 to 1880* (Hartford, Conn.: Case, Lockwood and Brainard Co., 1880); personal communication, Pauline W. Inman, January 31, 1970.

302. Nutting, *Handbook,* pp. 144–45; *A Collection of Fine Early American and Old English Furniture,* November 6, 1926 (New York: Anderson Galleries, 1926), lots 60–61.

303. The Hemenway family's continuous-bow chair is illustrated in Inman, "House Furnishings," p. 230. See also Nutting, *Handbook,* pp. 22–23.

304. Inman, "House Furnishings," p. 230.

305. Louis Clinton Hatch, ed., *Maine: A History,* 3 vols. (1919; reprint, Somersworth, N.H.: New Hampshire Publishing Co., 1974), vol. 1, chap. 7; Coolidge and Mansfield, *History of New England,* 1:13–19; Dwight, *Travels,* 2:113–14; Liancourt, *Travels,* 1:458.

306. Manifests of schooner *Peggy,* August 16, 1796, brig *Comet,* August 17, 1804, schooner *Beaver,* June 12, 1806, and sloop *Hannah,* June 6, 1807, Philadelphia outward coastwise and foreign entries, U.S. Custom House Records, Some French Spoliation Claims, NA.

307. Mabel M. Swan, "Newburyport Furniture-makers," *Antiques* 47, no. 4 (April 1945): 225.

308. Information in Samuel T. Dole, *Windham in the Past* (Auburn, Me.: Merrill and Webber Co., 1961); personal communication, Ronald J. Kley, Maine State Museum, September 7, 1978; Samuel Dole, property records and deposition, 1794–98, 1841, Cumberland Co., Me., Registry of Deeds.

309. George Bishop and Daniel Tobey, property records, 1803–15, 1841, 1822, Cumberland Co., Me., Registry of Deeds. Five pieces of painted furniture in the Maine State Museum, Augusta, including a dressing table, washstand, bedstead, Boston-style rocking chair, and rocking settee, were formerly owned by Raymond W. Tobey, a fourth-generation member of the family to live in Fairfield, Somerset County. It is unknown whether there was a link between Daniel Tobey and the Tobeys of Fairfield, a location forty miles due west of Frankfort. See Edwin A. Churchill, *Simple Forms and Vivid Colors* (Augusta: Maine State Museum, 1983), pls. 7, 19, 31–32. Legal suits, Portland Bank vs. Jonathan Leeds, February 9, 1808, and Thomas Beck vs. William Campbell, February 8, 1808, DCM.

New England, the Nineteenth Century before 1850

Introduction

Throughout the nation the first half of the nineteenth century was a time of astounding growth and change. The populations of Boston and Philadelphia more than tripled between 1800 and 1840, while that of New York, which achieved preeminence as a commercial leader, increased fivefold. Towns like Baltimore and New Orleans became important cities. The United States, consisting of thirteen states and some western lands, including the Northwest Territory, doubled in size in the early nineteenth century with the acquisition of the Louisiana Purchase lands (1803) and the Floridas (1819) from France and Spain. While New Englanders continued their northeastern migration, they also began an earnest trek to the western frontier and beyond. Much of the eastern population was on the move. For those New Englanders who stayed behind, subsistence farming using improved agricultural methods, often coupled with a trade, continued as a way of life for many. The Northeast remained primarily a country of small towns and hamlets. As population and village size increased, more farming families established homesteads in the surrounding countryside, returning to town for meeting, business, or shopping. The landscape changed with the construction of factories, canals, and railroads.[1]

Many New Englanders who lived along the coast or on navigable waterways were involved in commerce or the whale fishery. New Bedford became the preeminent whaling center of the world; Nantucket, Edgartown, New London, and Mystic were successful, as well. Boston remained New England's center of overseas commerce. Fifty percent of the region's foreign business was transacted with Britain or its possessions. Direct trade to the Far East and continental Europe expanded and diversified. Increasingly, Central and South America were visited by Yankee merchantmen, causing President Madison to send consuls to Buenos Aires and Caracas during the 1810s. The Monroe Doctrine gave voice to the U.S. position on future European colonization in the Americas as dangerous to the nation's peace and safety. Meanwhile, Boston merchants had discovered the lucrative trade on the northwestern and Californian coasts. All was not smooth sailing, however. Both England and France, at war with one another, refused to respect U.S. neutrality and brazenly seized shipping and impressed seamen. President Jefferson and Congress finally retaliated in December 1807 by passing the Embargo Act. Because the act closed U.S. ports to practically all shipping except the coasting trade, it had disastrous effects on New England, which relied heavily on commerce. Fourteen months later the unpopular legislation was repealed, but within a few years Britain's open conflict with the United States led to a crippling blockade of American ports. New England sought relief by turning to manufacturing.

Cotton spinning, a modest experiment in the late eighteenth century, now received earnest attention. Mills sprang up where water power was available, and technology improved steadily. Societies for the encouragement of domestic manufactures gained

new momentum, light industry began to flourish, and Congress responded with a protective tariff in 1816. Before the era of the immigrant worker, factories drew their labor supply from the New England countryside. Some industrial settlements with their neat factory housing, such as Lowell, Massachusetts, rose almost overnight. Young women joined the workforce. This was the era when new, precision technology permitted the introduction of interchangeable parts as the basis of production in the clock and small arms industries. Since the late eighteenth century that principle had been applied to the manufacture of inexpensive furniture, especially turned chairs, in areas of substantial production. The practice now became commonplace in many rural centers as well.

Water carriage had long been the cheapest way to transport raw materials and wrought goods, even over short distances. The development of canals, then railroads, made possible greater interior distribution, usually in exchange for produce. This kind of communication and economic interaction hastened the breakdown of local regionalism, a condition manifest in the study of painted seating during the early nineteenth century and later. Indeed, more than a hint of things to come can be found in the late eighteenth-century Windsor work of coastal New England, especially that originating between southeastern Massachusetts and southern Connecticut. An active regional coasting trade encouraged a fusion of design and construction details between local centers.

Greater inland accessibility and increased interaction between business interests and independent workers also meant that depressions and recessions began to have far greater national impact. Aside from the economic difficulties resulting from Jefferson's Embargo Act and the War of 1812, which by no means affected the entire country, two crises produced widespread distress before 1840. The first occurred in 1819. Extensive speculation and a reckless extension of credit in western land purchases after the war led to the collapse of numerous state banks and businesses in the West. The effects were far-reaching, as chronicled in the 1820 Census of Manufactures. Among others, Amos Denison Allen of South Windham, Connecticut, who was an active participant in the domestic and overseas furniture trade, reported, "My business has deminished more than ⅓rd within two years." Hard times continued until 1824. Then, with minor ups and downs, the economy remained relatively stable until the mid 1830s when President Jackson, mistrustful of the power of the Bank of the United States, the bulwark of a large part of the nation's business community, refused to renew its charter, due to expire in 1836. Beginning October 1, 1833, the government also ceased to use the bank as a depository for federal receipts. These events and others led to the panic of 1837, which with a series of aftershocks plunged the country into its worst economic calamity since the Revolution.[2]

Rhode Island

The story of nineteenth-century Windsor-chair making in Rhode Island is centered almost completely in Providence due to a paucity of material for other areas. Providence was a rising, prosperous community, the regional center of commerce and manufacturing. The Providence River divided the city, although a bridge "with a draw in it to allow vessels to pass" permitted convenient access between the principal "houses of business" along both sides of the river. From 1800 to the mid 1830s the population rose from 7,600 to 20,000. As early as 1806 John Melish noted the city's involvement in the East India trade.[3]

In large part, city growth was due to manufacturing; textiles and goods made of iron and steel led the way. Cotton manufacturing was still in its infancy during John Melish's visit of 1806, but following the War of 1812 Henry Fearon found as many as thirteen company-owned textile mills along the river in neighboring Pawtucket. By the mid 1820s Providence had become the business center of a substantial state industry. Internal improvements in transportation were prominent by 1832, when Carl Arfwedson noted

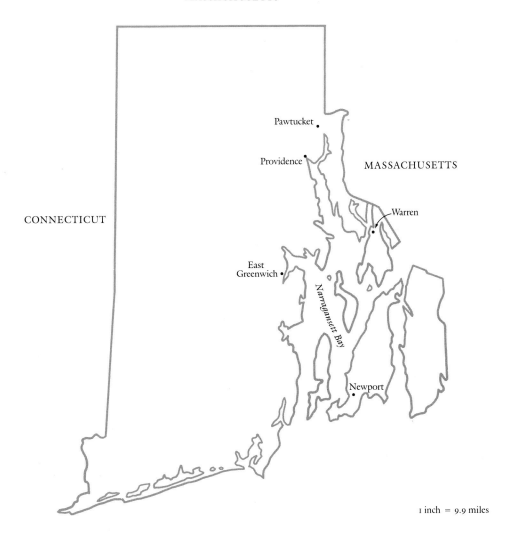

MASSACHUSETTS

Pawtucket

Providence

MASSACHUSETTS

Warren

CONNECTICUT

East
Greenwich

Narragansett Bay

Newport

1 inch = 9.9 miles

the start of the Blackstone Canal, linking Providence and Worcester. Two railroads were also under construction.[4]

EVIDENCE OF PRODUCTION

The early nineteenth-century accounts of the Proud brothers, turners and chairmakers of Providence, describe their Windsor production. They made "dining" chairs from 1788 until at least 1804. Between 1799 and 1807 William Colegrow and Mial (Myles?) Smith occasionally supplied the shop with chair bows and received credit of from 3*d*. to 6*d*. per item. Prices reflect a transitional period in the dining-chair market as styles moved from round to square backs. Undoubtedly, the Prouds' term "dining" chair identifies the former. Their production of "green" chairs from 1801 to 1808 refers to single and double "bow" square-back seating, also used for dining. Replacing the Windsor armchair was the "parlor," or fancy painted, chair added to their line in 1794 and manufactured until 1807.[5]

Fig. 7-1 High-back Windsor armchair, Rhode Island, 1800–1810. H. 46″, (seat) 17¼″, W. (seat) 19½″, D. (seat) 15″. (Mr. and Mrs. John A. McGuire collection.)

No further mention of parlor or green chairs occurs in the Proud accounts after 1808. The focus is on the manufacture of "grate," "littel," and rocking chairs, although each year the brothers recorded unspecified seating priced from 4s. to 16s. Probably some production represented a continuation of earlier patterns. One design that remained fashionable in Rhode Island was the tall, high-back chair, its profile now spare. The illustrated example (fig. 7-1) retains the distinctive uncarved crest and bent arm rail of earlier Rhode Island baluster-turned work (figs. 6-24, 6-38). The well-modeled oval plank is a pattern introduced about 1780 in Rhode Island (fig. 6-20). The bamboo supports, while less complex than baluster turnings, still show considerable variation; those illustrated are almost sticklike in their severity. Perhaps reflecting New York practice, the H-plan stretcher system lingered into the early nineteenth century, competing for some time with the newer box-type brace.[6]

By the mid 1820s Samuel and Daniel Proud were well past middle age, and shop production had all but ceased. Even during their most productive years, the brothers' seating output was nowhere comparable to that of an average shop in a large metropolitan center. Annual production exceeded 130 chairs only five times during their long careers. Total output from 1772, when their father started the accounts, until 1833 amounted to just under 2,900 chairs. A progressive metropolitan establishment could produce many more chairs in a single year. The Prouds' market was primarily local and limited. Competition in Providence at the start of the century was not overwhelming, but following the War of 1812 local production and sales increased substantially.[7]

A pair of children's square-back Windsors with single-bow tops probably of Providence manufacture (fig. 7-2) is branded "CRAPO" (a name pronounced with a long *a*) on the plank bottom. There is good reason to associate these chairs with the family of Philip Crapo (1767–1838), a Providence lawyer who married on March 1, 1801. In 1796, about the time he set up practice, Crapo patronized the local cabinetmaker Job Danforth, Sr., for a sign and a writing desk frame. The chairs' transitional style is correct for the early nineteenth century, when craftsmen often combined a single-bow top with the H-plan support popular in the 1790s. The legs appear to be standard turnings shortened at the top to suit the particular use. Shield-shaped planks with arced fronts and flaring, squared corners are not common in Windsor-chair making. The style was current briefly in Philadelphia around 1800 (fig. 3-112) and influenced the eastern Connecticut work of the Tracy family (fig. 7-7). The illustrated chair copies the Philadelphia model closely, down to the double-groove detailing at the plank edges. The bold, double-swelled bamboo medial stretcher combined with single-swell side braces is another feature transmitted to New England from Philadelphia (figs. 3-51, 3-55). The technique of capping the back posts with the bow rather than insetting the cross rod became the more common New England construction.[8]

While no double-bow chairs documented to Providence or Rhode Island have come to light, there exist several seven-spindle Windsors of this pattern with angular seats of comparable form. The bamboowork of the backs, while slimmer, shares similar characteristics, and slim, four-part, bamboo-turned legs have pointed feet. The legs connect by means of box stretchers. One armchair is branded "H. HAMLIN," likely another owner; the surname occurs in Rhode Island and Connecticut.

In the discussion of Massachusetts furniture in chapter 6, note was made of a business arrangement between Cyrus Cleaveland, a cabinetmaker and chairmaker of

Fig. 7-2 Child's square-back Windsor side chair and detail of brand, Crapo (owner), probably Providence, R.I., ca. 1802–5. Probably pine with ash; H. 22¼″, (seat) 9¾″, W. (crest) 12⅜″, (seat) 12⅜″, D. (seat) 11″. (Rhode Island Historical Society, Providence: Photo, Winterthur.)

Providence, and Luther Metcalf, a furniture craftsman of neighboring Medway, Massachusetts. Furniture and chairs constructed in Metcalf's "country" shop were transported to Providence "to be finished." Large quantities of furniture and "Windsor chairs" manufactured in this way were available for exportation. The partnership began in October 1801, although its duration is unknown. The arrangement may have been profitable for a time, since two years later Cleaveland bought a lot and house on Constitution Hill. Purchase of another parcel of land on the same hill in 1812 extended his holdings. Until Cleaveland's death in 1837 little else is known of his life and career. A complete inventory of his residence and shop made in 1838 indicates that he had given up his interests in chairwork. Inventory entries for mahogany, rosewood, and lesser woods, sets of table and washstand legs, bureau feet, and veneers speak of cabinetwork, but primary activity centered in the production of "dippers." Stock on hand included 1,720 "Cocoa Nut Shells," 517 handles, and 193 dozen completed dippers."[9]

In 1812 Thomas Howard, Jr. (1774–1833), moved to Providence from Pawtucket where he had successfully conducted business as a cabinetmaker and lumber dealer. Continuing in South Main Street, Howard supplemented his stock with purchased looking glasses, upholstery goods, and ivory furniture knobs. Another new venture, as identified in a Providence advertisement of March 1812, was the sale of "1000 Fancy and Windsor Chairs." The introduction of popular seating to his furniture line may have represented the entrepreneur's first step toward warehouse retailing on a large scale. Indeed, the following year Tunis and Nutman of Newark, New Jersey, announced their appointment of Howard as "Agent for the Sale of CHAIRS of their Manufactory," an arrangement that apparently proved satisfactory to both parties. The New Jersey firm assured local inhabitants that Howard would stock "a constant Supply of CHAIRS and SETTEES, of the first Quality." Ten years later, in 1823, Howard still advertised "Newark Chairs, both Fancy and Windsor, made and warranted by Tunis & Nutman; also, other kinds of Newark Chairs, of a more inferior quality; [and] best New-York ditto." At that time he had on hand 4,000 seating pieces of "superior quality with handsome patterns from 50 cents to 5 dollars." In the face of such substantial competition it is no wonder that the Proud brothers ceased production of Windsor furniture around 1812 and constructed only inexpensive traditional seating during their remaining years. Howard himself finally abandoned the furniture warehouse business in 1827 in favor of merchandising imported ivory and making ventures in real estate. He died in 1833 at age fifty-nine, a wealthy man with an estate valued at $90,000.[10]

Outside Providence there is evidence of other activity. Thomas Taylor, working in the vicinity of East Greenwich, charged Henry Arnold $14 for a set of Windsors in 1817. Earlier, in 1808, he had billed William Greene for painting and mending chairs. In Newport Joseph Vickary, who had enjoyed a long chairmaking career in the late eighteenth century, was now well advanced in years. In 1814 he and his wife conveyed their lot on John Street to grandson Thomas Spooner "Together with the Work Shop thereon standing and all the Tools & Implements for Chair Making therein," in exchange for his care and support during their lifetimes. Apparently, this arrangement was not satisfactory because the following year young Spooner purchased the complete chairmaking establishment for $140. Vickary died at Newport in 1818, and Spooner pursued the chairmaking trade for some years. An 1825 entry in Jonathan Easton Hazard's accounts refers to "Thomas Spooner, chairmaker." In notes pertaining to "Craftsmen in Newport" George H. Richardson (1830–1916) also called Spooner a painter.[11]

Christian M. Nestell, a native New Yorker, established himself in business at Providence in the early 1820s. He is the only Rhode Island Windsor craftsman of this period whose product is documented. The title page of an extraordinary copy book containing hand-drawn, painted ornament produced in 1811–12 identifies Christian M. Nestell of New York as the owner. The young man was eighteen or nineteen years of age when he made the drawings. Because Rhode Island records refer to Nestell as a painter and gilder, there is a strong suggestion that he served his New York apprenticeship in this or a dual capacity. The first mention of Nestell in Providence occurs in the accounts of Samuel and

Daniel Proud under the date February 17, 1820, when the brothers credited him with "fifteen doll's for Quarter Shop Rent." The Prouds were winding down activity in their Broad Street establishment and likely welcomed the opportunity to make extra money by renting space (and, no doubt, equipment) to Nestell. They probably also enjoyed the companionship of the newcomer. The relationship appears to have been friendly. As Nestell moved forward with his career, he occasionally employed the Prouds at odd jobs, particularly chair repairs or alterations for his growing circle of customers—a new "round," posts or legs, or the addition of rockers. The brothers made several "high seats" and also bottomed chairs from time to time. Nestell probably remained in the Proud shop until November 17, 1820, when the three settled all accounts for shop rent.[12]

Nestell moved to larger rental quarters where he combined shop and wareroom space. The site probably was in Broad Street, since an early, labeled chair identifies his stand as "Opposite the Rev. Mr. Wilson's Meeting-House," which was in Broad Street. Nestell was at a new address by August 28, 1822, when he advertised that he had

removed his Chair Ware Room and Shop to the well known stand formerly occupied by Mr. Mumford, No. 112, South Main-street, where he has constantly for sale, a full assortment of Fancy Chairs of the Newark make, which are superior to any other chairs of the kind; they excel in finish those made in New York. Windsor and common Chairs, high back and rocking ditto, of the newest patterns, and upon the very lowest terms. Shippers of Chairs can be supplied with any number at short notice. Families can have their Chairs re-painted and gilt upon fair terms. Cabinet Furniture of the first rate work and on reasonable terms can be furnished at any time.

If the notice can be interpreted at face value, Nestell imported only fancy rush- and cane-bottomed seating; he constructed his own wood-seat chairs or obtained the stock locally. The cabinet furniture he speaks of probably was obtained by discount from other craftsmen.[13]

The first Providence directory of 1824 lists Nestell in a "chair store" at 111 South Main Street, apparently across the street from No. 112, where he remained until 1836. After that date the chairmaker-dealer changed occupations and became clerk of the Merchants Bank; he died in 1880. Scattered references provide insight into Nestell's early activity. For Edward Carrington, a merchant in the China trade, he repaired chairs in 1824 and painted and gilded others in 1826. In the latter year he painted chairs for Sullivan Dorr and saw to "carting" them to the customer's house. The next year, 1827, Nestell refurbished furniture for Richard W. Greene, varnishing a bureau and repairing and painting a "large wash Table."[14]

Three bent-back Windsors with arrow, or flat, spindles, of which two are illustrated (fig. 7-3), are documented by a printed label as the work of Nestell. The seating retains its original peach surface paint and decoration of green and soft red. The slat backs indicate the chairs were constructed during Nestell's early years in business, and the label pinpoints the date as between 1820 and 1822 when his shop and residence were in Broad Street. Arrow spindles were first popular in New York at the time Nestell completed his apprenticeship around the time of the War of 1812. Also new then was the bent back with its shaved posts of projecting tip. London chairmakers' price books published during the first decade of the century illustrate chair backs of this profile described as sweep backs with thumb tops. The contour appeared first in American fancy seating (fig. 5-35). By the 1820s a comparable Windsor pattern was popular throughout New England. Other indications of Nestell's New York training are the chair's plank contours and the decoration. The Windsor pictured on the label, for which Nestell may have cut the woodblock himself, bears his initials and plainly displays a New York type, ball-centered front stretcher (figs. 5-44, 5-45, 5-49). A slightly later chair in the same general style and with similar legs, stretchers, and back posts is marked with the craftsman's oval stencil on the plank bottom. The crest is deeper, the squared, shield-type seat has flat, thick edges, and the back contains four long, ball-centered spindles thickened substantially in the lower half (fig. 7-62). This pattern probably is datable to the second half of Nestell's chairmaking career.[15]

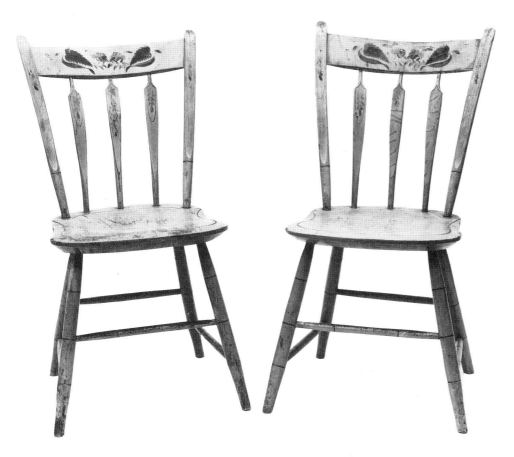

Fig. 7-3 Slat-back Windsor side chairs (two of three) and detail of label (left), Christian Nestell, Providence, R.I., 1820–28. H. 33¼″, (seat) 17½″, W. (crest) 17¾″, (seat) 16¼″, D. (seat) 15″ (*left*); peach ground with red and medium dark green. (Mr. and Mrs. Joseph K. Ott collection.)

Figure 7-4 illustrates one of a pair of arrow-back armchairs that appears to have originated in Rhode Island, probably around Providence, based upon visual and circumstantial evidence. Visually the design relates to Nestell's side chairs; the posts, spindles, legs, and planks share common features. The plain, turned cylindrical arm rests, supported on short, single-groove bamboo posts and anchored in the shaved post faces, reflect further New York influence on Providence chairmaking (figs. 5-40, 5-41, 5-45). Stamped on the seat bottom is the brand "R. Sarle," probably the name of an owner rather than a maker.[16]

Newspaper advertisements provide information about other Providence craftsmen working in the 1820s and later. Rhodes G. Allen, who was in business by 1815, was an active cabinetmaker and lumber dealer. When in April 1823 he gave notice of an auction of his "entire stock of CABINET FURNITURE" along with fancy and children's chairs, he mentioned "new arrangements in . . . business" that he was about to make. An advertisement the following year makes it clear that he had branched out substantially. Supplementing his cabinetware were "CHAIRS of almost every description, viz. Fancy cane seat, Flag ditto, Newark make, Dining Chairs (very handsome); Children's Chairs, high and low; Rocking and Easy ditto." Although Allen rebuilt his furniture factory two years later, he continued to import chairs "of all descriptions, from the best manufactory in New-York." Whether he had changed suppliers or simply used "New-York" as a synonym for nearby Newark is unclear. Allen appears to have abandoned the entire enterprise by 1830 and become a paperhanger.[17]

Next in date of appearance is Charles Scott, who was active in the cabinet trade by 1819 when he sold an easy chair to Albert C. Greene. In 1822 he advertised a full line of cabinet furniture warranted for workmanship, style, and material. Also covered by Scott's guarantee were "Fancy and Windsor Chairs . . . well painted and handsomely ornamented." Scott listed his cabinet warehouse in Providence directories through 1830, after which he dropped from sight in city records. The craftsman had relocated to southeastern Massachusetts by the 1840s; however, a gap remains during the 1830s. The answer may lie in an announcement by one Charles Scott, cabinetmaker and chairmaker,

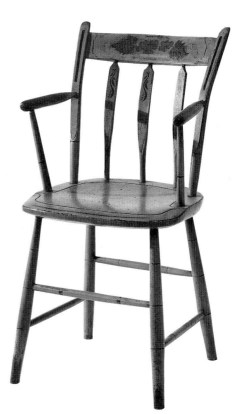

Fig. 7-4 Slat-back Windsor armchair (one of a pair), R. Sarle (owner brand), Rhode Island, probably Providence, 1820–30. Maple and other woods; H. 33¹³⁄₁₆″, (seat) 17⅝″, W. (crest) 18¹⁄₁₆″, (arms) 18⅝″, (seat) 17⅜″, D. (seat) 15¾″; paint and decoration not original. (Mr. and Mrs. John A. McGuire collection: Photo, Winterthur.)

in the Charleston, South Carolina, *Mercury* for December 8, 1831, advising "friends, former customers, and the public generally" that he had "returned from the North, with the intention of making Charleston, his permanent residence." Listings are found in Charleston directories from 1835 through 1840. Presumably, Scott returned north shortly thereafter. Charleston was by no means unknown to the Providence furniture community. The Rawson family of cabinetmakers enjoyed a brisk trade to the southern city between 1816 and 1820 and even sent one of its members to oversee retail sales. A Rawson bureau with dressing glass has a Charleston label.[18]

Early in business but a latecomer to Providence was Amasa Humphreys. The craftsman made his first public announcement in 1816, when he took over the cabinet-making and chairmaking business of Thomas Howard, Jr., in Pawtucket and promised to keep on hand "a handsome assortment of CHAIRS." Eight years later he was doing business in Warren, southeast of Providence. He sold cabinet furniture of his own manufacture but acquired chairs elsewhere. An assortment of seating furniture "just received" retailed "from 87 cents to $2.75." About 1837 Humphreys moved to Providence, where he advertised. The 1838 directory describes expanded activity that included undertaking and the sale of lumber, looking glasses, and feathers. The financial panic of the late 1830s may have swept Humphreys out of business, since his name does not reappear in city directories until 1847, and then as a carpenter. However, his affairs appear to have been back in order by 1845 when he purchased property on Federal Hill.[19]

In 1832 Ezekiel Adams, a business contemporary, first leased a shop in Westminster Street as a furniture wareroom for five years; he occupied the second and third stories of the building as a residence. Adams may have renewed his lease in 1837, since one of two furniture bills rendered to Perez Peck of Providence in 1840 has a Westminster Street address. Peck acquired stands, tables, and bedsteads; his chair purchases included both plank-seat and fancy styles. The practice of retailing imported chairs in Providence may have set a distribution pattern for the state as well. W. A. and D. M. Coggeshall, who advertised from their Newport "Ware Room" in May 1835, offered customers cabinet-work "made to order as usual" and also retailed cane- and rush-bottomed and wood-seat chairs "of a quality second to none in [the] market." Since the partners sold the seating furniture "at fair prices, for moderate profits," it appears they acquired it from someone else. The firm continued in business as late as 1845.[20]

Connecticut

Overland travel and product distribution within Connecticut was facilitated in the early nineteenth century by the development and rapid proliferation of turnpike roads. By 1839 ninety-two turnpike charters had been issued. The roads ran through a fertile and productive land where fine meadows sustained large quantities of livestock and fields produced grains, vegetables, and other crops in abundance. Good water power in Windham County, adjacent to Rhode Island, encouraged the development of a small cotton industry. The manufacture of clothing, paper, clocks, small arms, tinware, flaxseed oil, rope, and leather was scattered throughout the state. The growth of both agriculture and industry helped to stem the tide of emigration from Connecticut.[21]

NEW LONDON COUNTY

Documented nineteenth-century Windsor work from New London County is confined to a few chairs made in the shops of two members of the Tracy family and to the New London chairmaking establishment of Thomas West. Household inventories dating to the first decade of the century document the continuing popularity of "green chairs" and the increasing use of "yellow Windsor" and "yellow dining" chairs. This was the pale straw color that became increasingly popular after 1800. Nathan Smith of Stonington

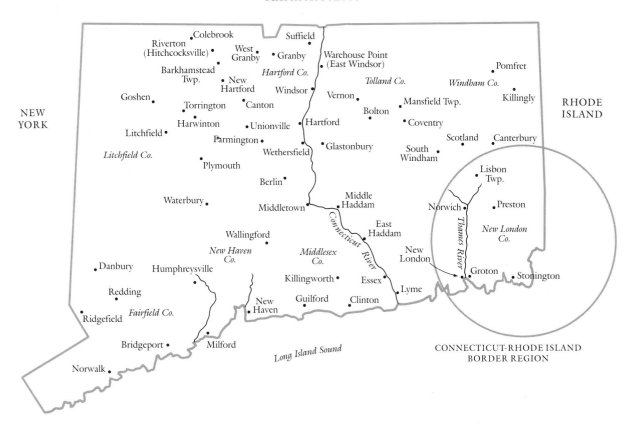

MASSACHUSETTS

NEW
YORK

RHODE
ISLAND

Colebrook
Riverton
(Hitchcocksville)
West
Granby
Suffield
Granby
Warehouse Point
(East Windsor)
Pomfret
Barkhamstead
Twp.
New
Hartford
Hartford Co.
Tolland Co.
Windham Co.
Windsor
Killingly
Goshen
Vernon
Mansfield Twp.
Torrington
Canton
Bolton
Harwinton
Unionville
Hartford
Coventry
Litchfield
Farmington
Scotland
Canterbury
Litchfield Co.
Wethersfield
Glastonbury
South
Windham
Plymouth
Lisbon
Twp.
Berlin
Norwich
Preston
Waterbury
Middletown
Middle
Haddam
*New London
Co.*
Wallingford
East
Haddam
*New Haven
Co.*
*Middlesex
Co.*
New
London
Groton
Danbury
Humphreysville
Killingworth
Essex
Stonington
Redding
Guilford
Clinton
Lyme
Ridgefield
Fairfield Co.
New
Haven
Connecticut River
Thames River
Bridgeport
Milford
Long Island Sound
CONNECTICUT-RHODE ISLAND
BORDER REGION
Norwalk

1 inch = 17.5 miles

owned dining chairs of this hue, while Isaac Treby placed yellow Windsors in his "South front Room" at New London. Treby's half interest in a brig identifies him as a trader.[22]

At Norwich, the river community adjacent to Lisbon Township where the Tracys worked, two chairmakers commenced careers after 1800. James N. Barber first advertised in July 1802. His outlook was optimistic, since he wanted to engage "two good workmen at the WINDSOR CHAIR making business." Two years later Barber renewed his search for trained workmen—a Windsor-chair maker and a journeyman who "understands turning all kinds of CHAIR STUFF." Barber was able to offer employment to the turner for six or eight months.[23]

Dempster Beatty opened a cabinet business in Norwich in 1806, just before his first announcement in *The Courier* on February 26. By his own statement he had "worked in a number of principle [*sic*] towns of the United States" and had "served his time in one of the first Shops in Philadelphia." Thus, the young man would have been familiar with stylistic developments in a major Windsor furniture market at the turn of the century. It was not until two years later, however, that the craftsman "commenced making Windsor and Fancy Chairs at his Cabinet shop." Apparently, production was in the hands of "a good workman at the business," and it is likely that the journeyman, like Beatty himself, had migrated to Norwich from elsewhere, infusing the local Windsor style with other regional subtleties. Less than two years later, in May 1810, Beatty elected to close his business in Norwich and "remove from this State."[24]

While no documented seating from the Barber and Beatty shops is known, there survives a small group of Windsors made by the Tracy family in neighboring Lisbon

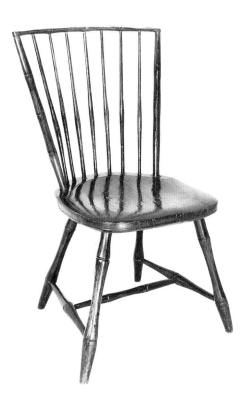

Fig. 7-5 Square-back Windsor side chair, Stephen Tracy (brand "s. TRACY"), Lisbon Township, New London County, Conn., ca. 1803–10. H. 32½". (Photo, Herbert Schiffer Antiques.)

Fig. 7-6 Square-back Windsor side chair and detail of brand, Stephen Tracy, Lisbon Township, New London County, Conn., ca. 1803–10. (Nathan Liverant and Son.)

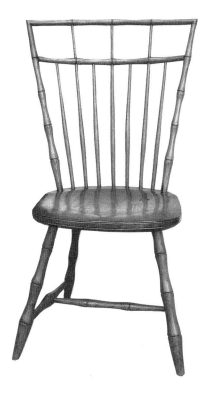

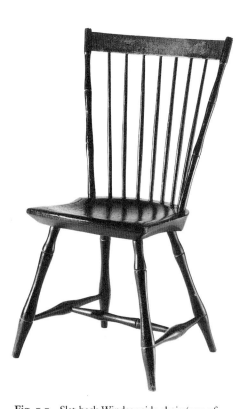

Fig. 7-7 Slat-back Windsor side chair (one of five), Stephen Tracy (brand "s. TRACY"), Lisbon Township, New London County, Conn., ca. 1803–10. H. 35¼", (seat) 16½", W. (crest) 20", (seat) 15⅞", D. (seat) 15½". (Private collection: Photo, Winterthur.)

Township. Five or more square-back chairs are branded by Stephen Tracy, and another bears the second stamp of his older cousin Elijah (fig. 6-114, right, stamp). No two chairs are exactly alike, and among them are three styles. One chair has rockers and arms; the rest are side chairs. Earliest in pattern are a chair constructed by Stephen (fig. 7-5) and the one made by Elijah. Both have a single "bow," or rod, at the back. Whereas Stephen turned his posts to a four-segment bamboo pattern, Elijah's posts have only three sections. The capping rod in the latter also peaks at the tips. Elijah's chair spindles thicken through most of their length, as in figure 7-7, as opposed to the definite swells illustrated here. In the chair seats, Stephen's rounded-square plank contrasts with Elijah's flared-corner shield (fig. 7-7), although both are contemporary. Elijah's use of the shield-shaped plank would appear to date from about 1801, since the bottom surface is marked with his second brand and church records suggest he left Connecticut possibly as early as 1802. The legs of both chairs feature a second bamboo pattern employed by the Tracys (fig. 6-114, right). Two other chairs branded by Stephen Tracy have single-bow tops. One of six-spindle back is like the illustrated chair, except that it introduces four-part bamboo legs and box stretchers. The other is the rocker already mentioned, which has peaked tips at the rod ends, a square-cornered plank, and three-section bamboo supports.

In stylistic sequence the next Tracy pattern is a square-back Windsor with "double bows" (fig. 7-6). Here Stephen retained the rounded-square plank of the previous chair but converted to rather vigorously turned four-section bamboo legs and five-part posts. Echoing the rhythm of swells and hollows in the vertical members are nodules in the cross rods and medial stretcher. Although the chairmaker carefully coordinated the back when he placed the lower bow at the upper post groove, the design does not quite work; the large void between the bows weakens the overall effect, in spite of the shapely turnings. The fact that this chair has H-plan braces while one of single bow has box stretchers is an indication that both patterns were being constructed simultaneously.

The third pattern produced by Stephen Tracy during his tenure in Connecticut features a single narrow slat set between the posts (fig. 7-7). Use of three-section bamboowork, inside stretchers, and an angular seat duplicating Elijah Tracy's plank points to a date early in Stephen's career. To ensure sound construction the design required post tops of cylindrical form to accommodate the rectangular mortices that

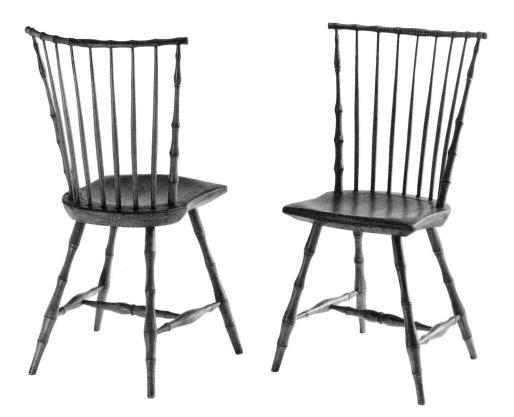

Fig. 7-8 Square-back Windsor side chairs (pair), Connecticut-Rhode Island border region, 1800–1805. White pine (seats) with maple and other woods; H. 35⅛″, (seat) 18⅛″, W. (crest) 20″, (seat) 16″, D. (seat) 15⅛″. (Edgar and Charlotte Sittig collection: Photo, Winterthur.)

socket the crest; the construction is held firm by two pins piercing each post face. The early appearance of the slat-back Windsor in coastal Connecticut almost certainly is another reflection of the pervasive influence of New York chair production on southern New England from the 1790s onward. Windsors like Stephen Egbert's armchair (fig. 5-36) and Reuben O'dell's side chair (fig. 5-33) could well have served as models for the crest and rounded seat. A new feature in Tracy Windsors from the late bow-back period was a groove defining the spindle platform. Legs continued to terminate within the plank, although after 1800 this construction became common in all areas.

A pair of unusual "bamboo" Windsors is now known to have originated in the Connecticut-Rhode Island border region (fig. **7-8**); the chairs were long thought to be of Pennsylvania origin because of their recovery in the Oley Valley and former ownership by the late collector Asher Odenwelder, Jr., of Easton, Pennsylvania. The key factors in their identification are the seat and medial stretcher. Comparison of the plank with that used by Stephen Tracy in the previous chair, and before him by Elijah Tracy in a single-bow chair, reveals the close relationship: the top surface, forward edge, and contoured sides have the unmistakable stamp of this region. Variation is seen in the grooved detailing. Inspiration for the flared seat likely filtered into coastal Connecticut from Pennsylvania via the export trade. A serpentine-top, square-back chair with related plank had brief currency in Philadelphia and environs around 1800 (fig. 3-112). The ring-centered, double-baluster medial stretcher bears close comparison with the cross brace of a Rhode Island armchair (fig. 6-56) and the work of Zadock Hutchins at Pomfret (fig. 7-12). Considering the stylistic advances represented by the bamboo chairs, the pointed stretcher ends could be viewed as a logical modification of the more prominent trumpet-style tips of the Rhode Island armchair. A similar profile occurs in the side stretchers. Other vestiges of the eighteenth century can be seen in the plain spindles swelled along much of their length. Tiny collars of a subtle design are placed just below the short balusters in the upper back posts and again near the leg tops. These adaptations of earlier work in combination with the craftsman's naturalistic interpretation of the bamboo form have produced chairs of particularly imaginative design.

Another chair constructed under the influence of the Tracys and New York City craft practice features roundwork executed with considerable flair (fig. **7-9**). Slender hollows

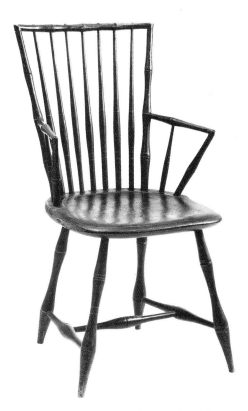

Fig. 7-9 Square-back Windsor armchair, New London County, Conn., probably Norwich, 1800–1810. H. 35¾″, (seat) 17⅛″, W. (crest) 18⅜″, (seat) 18½″, D. (seat) 18¼″. (Russell Ward Nadeau collection: Photo, Winterthur.)

contrast effectively with generous swells to create a stylish silhouette. Although designed in the Tracy manner (fig. 7-5), the chair makes its own statement. There are particular points of comparison, however. With the introduction of a second bamboo pattern (fig. 6-110), the Tracys set the stage for a local style. Beriah Green's bow-back chair (fig. 6-119) takes the roundwork a step further. That chair also employs a full swelled medial stretcher marked by a deep groove, as found in the present Windsor. The same element occurs in a bamboo-turned armchair by Ebenezer Tracy (fig. 6-109) and a bow-back Windsor by Amos Denison Allen. The illustrated cross-rod design is an improvement on Tracy work (figs. 7-5, 7-6), since the bolder size provides visual definition at the top and better balances the other elements. The arms with their unusual single swell repeat the profile of their supports, and a modeled seat still retains the chamfered edges of late eighteenth-century work. The chair has been in the same family since the early nineteenth century when it was received from a relative in "Old Norwichtown."

There remains a moderate record of early nineteenth-century Windsor-chair making at New London. Shipping records document a steady flow of painted seating to the West Indies and several coastal ports. John French II advertised Windsor chairs "OF ALL qualities and fashions, made in the neatest manner" early in 1807. The following year carriage maker Samuel H. P. Lee offered a dozen and a half new Windsors "handsomely painted." Within twelve months James Gere (Geer) II had set up as a turner across the river in Groton. With the assistance of hired help he soon branched into many businesses—tanning, loom making, and storekeeping, to name a few. Gere enjoyed a long and productive career, even after moving from Groton to the family homestead in neighboring Ledyard during the 1830s. The number of area residents to whom he supplied turned work from 1809 until the early 1840s is substantial. The group includes fifteen identified craftsmen in six communities.[25]

Isaac Allyn purchased large quantities of roundwork from James Gere between 1809 and 1812. All the parts were for Windsor seating, as determined through analysis of Gere's four surviving account books. Allyn acquired legs, rounds (stretchers), posts, and "banisters," Gere's term for spindles. The supplier's wholesale price for turned parts was 1¢ per item, regardless of the form. During the 1810s the price increased to 1½¢, and through the 1820s the cost varied from less than 1¢ to more than 3¢ per unit. This circumstance likely reflects the contemporary market, which saw the "bamboo" Windsor pass from style with the introduction of chairs whose elements varied from plain grooved to highly ornamented sticks. After Isaac Allyn sold his Preston cabinet shop to Allyn Chapman in 1813, he may have withdrawn completely from the furniture trade. Gere and Chapman began their business exchanges in 1814, when the newcomer acquired a load of maplewood. Chapman made further purchases of "Chair Stuff" from the turner in 1817 and 1818, but the general nature of Gere's accounts precludes positive identification of Chapman as a Windsor-chair maker.[26]

Another member of the Allyn family, Stephen B., had extensive dealings with Gere. All told, Allyn purchased more than 18,000 individual Windsor chair parts from the turner, excluding the seat planks and perhaps the crest pieces. By the 1820s he also produced fancy seating. Payments to Gere included raw materials and some furniture, the latter possibly for Gere's personal use or, more likely, to exchange with a third party. Allyn began in Norwich around 1797 as a cabinet- and chairmaker in partnership with Daniel Huntington III; after 1803 he worked on his own. He died in 1822, perhaps suddenly. He was described then as General Allyn. Tools, raw materials, chair seats, and yellow paint are all itemized in his probate inventory. Two new chair groups were in household use—six yellow Windsors and three armchairs as yet unpainted.[27]

Five years before Allyn's death James Gere and Park Avery of Preston began a series of exchanges that extended over a four-year period. Avery's purchases of chair parts amounted to less than half the number acquired by Stephen Allyn. An 1824 account also lists varnish and finishing materials. Ebenezer Avery, Jr., of the same town made modest purchases of chair parts in 1820 and 1824, which he paid for in unspecified labor. The

purchase pattern of Jonah Witter, a Groton-area resident, was similar, although he made payment in lumber.[28]

George Button's business relationship with Gere differed from those described. In April 1820 he purchased parts to frame eight chairs. Two years passed before he patronized the shop again; this time he acquired miscellaneous furniture, a mortising chisel, and finishing materials for use in his business at Preston. By autumn 1822 Button was in Groton, where he apparently worked as a journeyman in Gere's shop, constructing cabinet furniture and bedsteads. The arrangement probably lasted until March 22, 1823, when Gere noted, "Settled this account in full." Button was back in Preston by September when he purchased "391 chair rounds, Bannisters & Legs"; he continued to supply Gere with cabinet furniture. The ongoing business relationship prompted Button to return to Groton in 1825, where he remained through his last recorded association with Gere in June 1829.[29]

Horace Colton (b. 1784) of Norwich had publicized his cabinet furniture business for at least a decade when he first patronized James Gere for chair parts in 1821. He was not a newcomer to chairmaking, since on October 21, 1812, he had advertised cash payments for "White Wood or Bass Wood Plank, suitable for Chair Bottoms." He offered "a variety of fashionable Windsor CHAIRS" in May 1816 and by 1819 had added fancy chairs to his line. Colton's purchases from Gere between 1821 and 1833 comprise parts for common Windsor chairs as well as turnings for special work, including "fancy rounds" and "front rounds reeded." He made payment in lumber, varnish, and glue. The craftsman probably was a partner in the Norwich firm of Colton and Huntington, which advertised cabinet furniture and chairs in March 1834. Colton advertised alone again in 1840 when he offered "Mahogany, Curled Maple and painted *Chairs* of every description."[30]

One of the few chairmakers of south-central New London County who is not represented in James Gere's accounts is Thomas West of New London. As a young man of about twenty-one in April 1807 Thomas formed a partnership with his kinsman David S. West to manufacture chairs and settees "of various fashions." The two occupied a new shop opposite the Methodist meetinghouse. The duration of the partnership is unknown, but Thomas advertised on his own February 10, 1810, in a public notice that is more specific about his production. He itemized fancy chairs of New York pattern, Windsor chairs "of all Fashions," chamber chairs with "flag" seats, and kitchen chairs at 75¢ apiece; he also stocked large and small rocking chairs and children's seating. The chairmaker expressed his interest in locating "a smart active Lad, 15 or 16 years of age" to begin training as an apprentice and in securing a steady supply of whitewood plank for chair seats. In the following year the young chairmaker married Abby Weeks of New London. By April 1, 1812, West had vacated his shop opposite the meetinghouse for other quarters, since on that date chairmaker Timothy Swayne advertised that he had taken over the premises. Swayne's career later took him to New York City and Tennessee.[31]

By April 1815 Thomas West was back at his "old stand" near the meetinghouse. Presumably, he remained at this location, which in February 1824 he called his "Chair Factory." By that date "gilt and bronzed Fancy and Windsor Chairs" were the order of the day. West also kept a complete line of painting supplies for sale. West had only four more years to live, however, and on February 27, 1828, an advertisement offered for sale "700 STAIN'D and Painted, Gilt and Bronz'd FANCY AND WINDSOR CHAIRS, of various patterns," the stated purpose being "to close the concern." Few if any chairs were sold, since by April 7 when appraisers made an inventory of the estate, the same number remained, along with miscellaneous raw materials, shop tools, and 160 chair seats. Either West or his wife Abby also operated a dry goods business on the premises, since the inventory includes a sizable listing of textiles, notions, and small items of personal dress. In order to close out her interests in New London, Abby West advertised chairs and dry goods for sale in October. She then sold the property and moved away, possibly relocating in Colchester.[32]

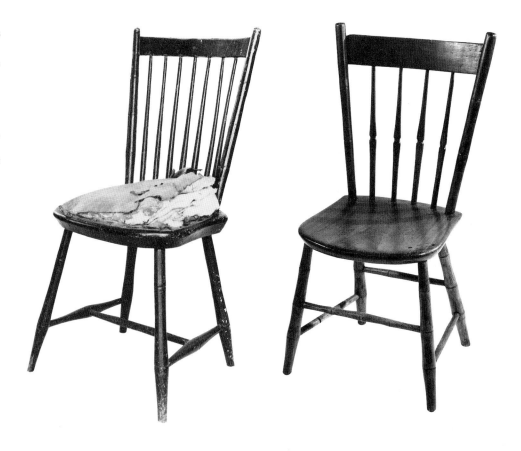

Fig. 7-10 Slat-back Windsor side chair, Thomas West (brand "T. WEST"), New London, Conn., ca. 1808–12. H. 33¾", (seat) 16¾", W. (crest) 15¾", (seat) 15⅜", D. (seat) 15"; stuffing added later. (Herbert Schiffer Antiques: Photo, Winterthur.)

Fig. 7-11 Slat-back Windsor side chair, Thomas West (brand "T. WEST"), H. 33", (seat) 16", W. (seat) 14⅞", D. (seat) 14⅞". (Lyman Allyn Art Museum, New London, Conn.)

Aside from Tracy family members, Thomas West is the only nineteenth-century chairmaker of New London County who is represented by documented Windsor seating. Two chairs differing slightly in date testify to his competence as a craftsman. The first chair, one of modified bamboo form, has a narrow, slat-type crest (fig. **7-10**). Comparison with Stephen Tracy's chair of similar pattern shows decided differences in styling. Here, the bamboowork is more perfunctory in execution, as expected of production in an area where competition was keen and costs had to be trimmed. The seat, too, differs in shape from those of the Tracys, although it still has merit. The plank has some semblance of a shield form, and the edges are well trimmed in a long chamfer. The exact shape, obscured by the later addition of stuffing, is that found in the next chair. West soon enlarged the crest and introduced box stretchers and four-part bamboo legs (fig. **7-11**). The two styles may have overlapped by several years. Although the chairmaker reduced the spindles to just four, he retained some feeling of eighteenth-century styling in this rare and unusual design with its centered channel. The feature strongly recalls the deep groove in the medial stretcher of a baluster-turned, high-back chair from the same coastal Connecticut region (fig. 6-174). In striving to market a "new pattern," West and fellow chairmakers may have consciously searched the local chairmaking tradition for inspiration. The continued use of straight bamboo posts versus bent and shaved supports suggests that the chair was made early in West's career. James Gere specifically noted the use of turned and shaved posts in New London, in an account dated June 10, 1817.[33]

With the 1820s a new generation of chairmakers launched careers in the greater New London-Norwich area, many recorded in James Gere's accounts. Two New London men, Isaac S. Sizer and Isaac Treby, worked briefly in Gere's shop in 1822 and 1827, probably ornamenting chairs. Sizer was in business for himself by 1823 when he advertised fancy and Windsor chairs of his own make as well as his auxiliary business of gilding, and sign and ornamental painting. Treby, during his brief employment with Gere, worked exclusively on rocking and "Roll Top Chairs," some of the latter described specifically as Windsors. Norwich men also figured among Gere's business associates. John Ashley Willet boarded with Gere while painting and ornamenting chairs at various

times during 1824 and 1825. Terms used in the accounts help to illuminate chair production. "Windsor," "bamboo," "fancy," and "slat back armed" all appear. Gilding and "striping" were part of the vocabulary of decoration. Six years after Willet's departure another Norwich man, Samuel Foster, ornamented chairs for Gere, although his primary shop function was to construct cabinet furniture.[34]

Gere's production of chair parts for other craftsmen was still in full swing during the 1820s and extended into the next decade. Norwich craftsmen were his best customers. Francis Wells Bushnell, probably newly established in business, patronized Gere from 1821 to 1827. The accounts mention parts for fancy, Windsor, and bamboo chairs. Bushnell made payment in incidental trade supplies and lumber, including mahogany. In the conduct of his own business Bushnell traveled to New York to select his mahogany. Visits to the metropolis allowed him to keep abreast of trends in furniture fashions; thus he could offer his customers fancy and Windsor chairs "according to the most recent New York patterns." Hyde and Rogers, located at the "Falls" in Norwich, manufactured slat-back and roll-top Windsors, acquiring some components from Gere. William L. Cheney, who in September 1828 advertised his chair business, worked occasionally in Groton where he framed and matted (wove seats for) fancy chairs for Gere and received payment in chair parts and whitewood plank. James Pettit, a contemporary whom Gere once referred to as a varnisher, enjoyed a long association with the Groton craftsman that extended from 1822 to 1841. Pettit's principal work for Gere was in framing and "seating" chairs with rush or cane, and making varnish. Occasionally he "got out" special chair parts that did not require turning, such as seats and "frets" for backs. Occasionally he "cleaned off" chairs in preparation for painting. Pettit sometimes boarded while he worked for Gere, taking his pay in cash, food, and small amounts of "Chair Stuff."[35]

Through the 1820s and 1830s much chairmaking activity took place in New London County. Many small firms flourished, and in an era of improved communication, advertising proliferated. Some craftsmen sought a supply of "Windsor and Fancy Chair Stuff," while others wanted whitewood, basswood, or butternut plank for seats. "A first rate Chair-maker" was needed in some shops, but for the most part proprietors searched for a market to retail their products—fancy, curled maple, Windsor, double-back, five-rodded, rocking, nursing, children's, mahogany, cane seat, and Grecian chairs. Some shops, like that of Benjamin Franklin Sisson at North Stonington, offered the added enticement of delivery "any distance under twelve miles, free from expense to the purchaser."[36]

WINDHAM COUNTY

Amos Denison Allen's memorandum book, covering the years between September 1796 and January 1803, gives no direct indication that square-back chairs were under construction in South Windham at the start of the nineteenth century. In reviewing his references to dining chairs, however, one item dated November 5, 1801, is of particular interest in this regard: "three Dineing Chs old fashion." The obvious implication is that Allen's current dining production was in the "new fashion." It follows that in 1801 he equated the term *old-fashioned* with the bow-back Windsor; new-fashioned chairs, then, had square backs. Unfortunately, Allen did not mark his later production. Further insight into his work after 1800 occurs in the accounts of a blacksmithing firm of which one proprietor was charged with the purchase of four bamboo chairs at a cost of $5.34, or 8s. apiece. The price is on target for Windsor chairs of the latest fashion. The term *bamboo* frequently identifies the early square-back chair in New England.[37]

Frederick Tracy (b. 1792), youngest son of Ebenezer Tracy, Sr., received his training in woodworking during the early nineteenth century. He may have served part of his apprenticeship with Stephen Tracy, his first cousin, but more likely he received all of his instruction from his brother-in-law Amos Denison Allen in South Windham. If young Frederick began training about 1808 when he was sixteen, he would have completed only

slightly more than two years of his term when Stephen closed the family shop in Lisbon and moved to New Hampshire. Stephen, apparently, had such a plan in mind already in 1808, since he had purchased land in Plainfield, New Hampshire, the previous year. Speculation about Frederick's training with Allen is reinforced by a later business relationship between the two men. In the normal course of events Frederick would have completed his apprenticeship in 1813. He likely stayed on in the Allen shop as a journeyman and in time became a business associate, as suggested in a legal document dated March 30, 1819. On that date Allen and Tracy became masters to Elisha Harlow Holmes, of Montville, New London County, who came to South Windham to serve an apprenticeship "at the Cabinet-making business." Since Holmes was already more than nineteen years of age, he may have begun his training elsewhere.[38]

Further insight into the Allen-Tracy relationship exists in other records. A New London shipping manifest documents the clearance on October 25, 1817, of the sloop *Candidate* from the Thames River for Savannah, Georgia, carrying in part a cargo shipped by "D Allyn of Windham." (The name Denison distinguished Allen from his father and grandfather, who were also named Amos.) Allen's freight consisted of "Sixteen Boxes Cabinet furnture, Forty two Chairs, Two Settees, [and] Sundry articles of Cabinet work," all consigned to "F. Tracy" in Savannah. The newly developing coastal and interior areas of the South were beginning to flourish. Young Tracy's service as southern business agent for Allen seems to be confirmed in the 1820 manufacturing census. Allen reported that market sales of "Cabinet furniture & Chairs" amounted to $2,290 in 1819, of which "about 700$ worth was shiped to Georgia." Young Tracy died in Milledgeville, Georgia, sometime between October 9, 1821, when he signed a note of hand, and April 1, 1822, when his wife Eunice took out letters of administration on his estate. Residing with Frederick in Georgia at the time of his death was his nephew Frederick Allen, aged twenty-two, son of Amos D. and Lydia Tracy Allen. It was young Frederick who attended to "funeral Charges and other expenses . . . in Georgia." At his death Tracy was in possession of about nineteen acres of land with buildings in Windham, although brother Ebenezer, Jr., held a mortgage on the property. To satisfy this claim the widow sold all right and title in the property to Amos Denison Allen.[39]

In responding to other questions posed during the manufacturing census of 1820, Amos Denison Allen noted that he employed three men, identified through other records as Frederick Tracy; Frederick's brother, Ebenezer Tracy, Jr.; and Allen's son Frederick. One of "Five boys" in the shop was Elisha Harlow Holmes. Ebenezer Tracy, Jr., died about a year after his brother Frederick, and Frederick Allen died on January 19, 1830, at age thiry. The young man had advertised only a few months earlier in the *Norwich Courier* of July 22, 1829, offering 600 fancy and Windsor chairs for sale, as well as rocking chairs and cabinet furniture, all of his own manufacture. Frederick also enjoyed a business association with Elisha H. Holmes, then practicing the cabinet trade in Essex. Allen obtained cabinet woods and bundles of flag for rush seats in exchange for chairs, which Holmes sold at a small commission. The two men were brothers-in-law, Holmes having married Lydia Allen, Jr., Frederick's sister, in 1823. Holmes gave up the chairmaking business in 1830; his last account entry dates to June 10. By March 24 of the following year he had set up as a storekeeper in Norwich, where he sold foodstuffs, coal, iron, steel, pot ash, and other items. In little more than two years he abandoned that business as well and removed to Windham. Holmes continued some retail activity, and he appears to have owned a blacksmith's shop, which someone else operated. Other records identify a gristmill and a plaster mill. To finance these enterprises Holmes borrowed $6,000 from the Norwich Savings Society on April 5, 1832. Eleven years later the debt remained unpaid, and the society brought suit. Several members of the Allen family were named as sureties for the loan, including Holmes's father-in-law, Amos D. Allen. On February 6, 1843, a sheriff's deputy attached the defendant's farm in Windham as well as that belonging to Allen. Evidently the matter was resolved, since both homesteads remained in the family.[40]

Estate papers drawn in 1815 for two of Amos Denison Allen's near neighbors, Stephen Payne and Doctor Samuel Lee, invite comparison with entries in the craftsman's memorandum book. Payne, whose land adjoined that of the furniture maker, owed debts at his death to Allen and Allen's brother-in-law Stephen Tracy. Among the seating furniture listed in the inventory and estate distribution were four side chairs and a great chair in a kitchen group purchased from Allen in 1799. A rocking chair acquired at the same time was also there. Six dining chairs sold by Allen to Payne late in the year probably were part of the dozen such enumerated chairs, some painted green, others black. Lee's "6 Yellow dining Chairs" bought in August 1800 were the same color as purchased; his Windsor rocking chair acquired in 1798 was green, presumably also the original color.[41]

Other Windsor craftsmen of Windham who advertised in the late 1700s and remained in the area were Orrin Ormsby and Jabez Gilbert. Tools and lumber are listed in Gilbert's inventory, although there is no evidence that he still made chairs.[42]

The pages of two ledgers kept by Thomas Safford record early nineteenth-century furniture construction in Scotland, the town adjoining Windham. Safford, principally a cabinetmaker, framed and sold approximately 260 chairs from 1808 to 1821, the years when he was most active. The craftsman used fourteen different terms when referring to his seating, excluding a category simply labeled "chairs." One of his most popular seats was a "fancy" chair priced generally from $1.17 to $1.50. Lower and higher figures account for the "economy" and extra-ornamented models. Most customers purchased their chairs in sets, usually in groups of six, occasionally in lots of nine or twelve. At $1.17 apiece, it seems likely that several sets referred to simply as "cream-colored" or "red" also fall into the fancy class. The largest group, comprising sixty chairs bought in lots of six, was described as "black"; with one exception, the price was $1. These were almost certainly Windsors. Another group of twenty chairs described as "green" and priced identically appears to fall into the same category. Safford's cheapest seating was the "kitchen," or slat-back, rush-bottomed chair. Except for one group, the price was 66½¢. Ordinarily these too were bought in sets of six, although purchases of two, three, and four chairs were not unusual. This type of low-priced dining chair could be easily added to the household as a family grew in number and young children took their places at the table. The eight "great" chairs constructed by Safford had arms. Some were bought in conjunction with sets of side chairs; their various cost indicates slat-back, Windsor, and fancy types. Safford's most expensive painted seat was a "writing chair" made for Doctor Rufus Johnson in November 1811, priced at $2.50. Most customers appear to have been local people, although on one occasion Safford identified a resident of adjacent Canterbury.[43]

Perez Austin, a cabinetmaker, joiner, and builder of wheeled vehicles, worked in Canterbury. He repaired chairs occasionally and even made a few, such as the three dining chairs constructed for Drusillar Pellit in 1811 and priced at slightly more than $1 apiece. Limited Windsor production of this sort explains the occurrence of so many chairs that deviate appreciably in design from standard patterns.[44]

Aside from Amos Denison Allen, the only Windham County chairmaker of the early nineteenth century whose Windsor work has been identified is Zadock Hutchins (Huchens), Jr., of Pomfret. Born in 1793 at Thompson, he died in 1830. Hutchins reached his majority about 1814. Public records dating to April 1818 describe his purchase of property in Pomfret while a resident of neighboring Killingly. Presumably, after leaving the family home in Thompson, the chairmaker worked at Killingly as a journeyman or even a master in a rented shop. The Pomfret property, acquired from the estate of David Goodell, contained about three acres upon which stood "a Dwelling house, Barn & Joiners Shop"; the location was the south side of the turnpike road leading from the Pomfret post office to Killingly. Hutchins occupied this site until October 1826, when he conveyed the real estate to Thomas Walter Ward II of Shrewsbury, Massachusetts, who operated a general store in Pomfret. After an interim move the craftsman took a ten-year

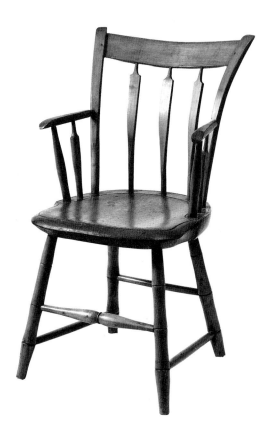

Fig. 7-12 Slat-back Windsor armchair, Zadock Hutchins, Jr. (brand "Z.HUCHENS"), Pomfret, Conn., ca. 1818–25. White pine (seat) with maple; H. 31⅞", (seat) 16⅛", W. (crest) 19⅜", (arms) 18⅝", (seat) 16¾", D. (seat) 16⅝". (Mary Means Huber collection: Photo, Winterthur.)

lease in January 1828 on ten rods of land across from the Baptist meetinghouse on the Boston and Hartford turnpike for the purpose of erecting a "Mechanics Shop." Hutchins's widow renewed the lease in 1838 but the following year sold "one certain Waggon makers shop standing" thereon to her son-in-law, Charles Burton.[45]

About 1802 Benjamin H. Grosvenor of Pomfret began to operate a general store; he added the operation of a sawmill to his business activity around 1819. Entries for Zadock Hutchins are found in the mill accounts between 1823 and 1825, once "for chair stuff," and another time for cutting "Butternut logs" into 4 × 4-inch stock. Hutchins also purchased 1,302 pounds of hay, which he stored in the barn that housed his livestock—a cow, a sorrel horse to draw his wagon, and a bay mare. Based on stylistic evidence Hutchins's known chairwork probably is representative of his career output. Earliest is a rocking chair, which dates either from his Killingly period or his first years in Pomfret.[46]

Five Windsor chairs representing three patterns are documented or attributable to the Hutchins shop, starting with the tall, branded rocking chair, which has three-section bamboo legs, H-plan stretchers, and a "bent" back. While the seat, arms, and posts are similar in enlarged form to the corresponding parts in Hutchins's slat-back armchair (fig. **7-12**), the crest above the plain spindles is a curious mixture of patterns from two design periods, suggesting the chair's transitional nature. Below the slat-shaped top piece, a slim cross rod pierced through by three of seven long stick-type spindles suggests a style dating from the beginning of the century. The ornamental stretcher forms another link between the chairs; its double-baluster-and-disk profile is a late eighteenth-century Rhode Island pattern (fig. 6-56) that continued in use with the introduction of square-back seating (fig. 7-8). The squared-shield planks interrelate with other eastern Connecticut work (fig. 7-9). Overall, there is also some relationship to Christian Nestell's Rhode Island Windsors. Hutchins's bamboo turnings and flared back are more vigorous, and the Providence work lacks the ornamental stretcher. The shaved arms sloping to the tips, introduced by Hutchins to this work, follow a New York model (fig. 5-45).

In terms of general styling Hutchins's arrow-spindle Windsor (fig. 7-12) and its companion side chair relate to another pair of Windsors from his shop (fig. **7-13**). Changes are made in the decorative back elements, and the front stretcher is modified.

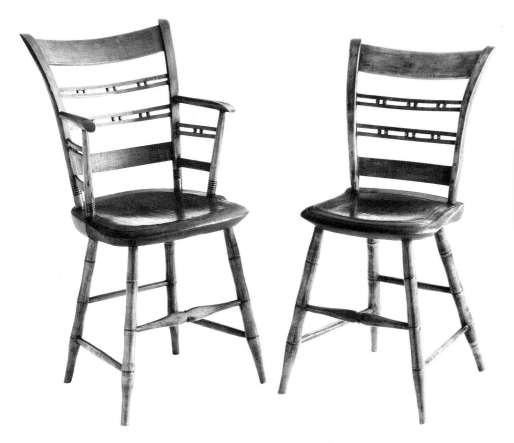

Fig. 7-13 Slat-back Windsor side chair and armchair and detail of brand, Zadock Hutchins, Jr., Pomfret, Conn., 1820–30. White pine (seats) with maple (microanalysis); (*left to right*) H. 33″, 35¼″, (seat) 18⅟₁₆″, W. (crest) 17¾″, 18¾″, (arms) 18¾″, (seat) 15½″, 17″, D. (seat) 14″, 16½″. (Winterthur 74.174, .175.)

To "update" that brace Hutchins simply shaved the face flat. The chair back introduces narrow ball-frets as the design focus with a broad stay rail below to stabilize the construction. Again, the ornament is repeated under the arms. The juxtapositon of side and back elements is more difficult to resolve with horizontals than verticals. In this respect Hutchins's arrow-back armchair is more successful, although perhaps not as interesting visually. Hutchins further varied the fret-back chair by introducing bands of rings near the bases of the posts. Those and the fret are borrowed from fancy chairmaking. Dickinson and Badger of Middletown featured a similar ball-fret fancy chair in an advertisement of 1816 (fig. 7-14); Seymour Watrous of Hartford used a related cut in 1824. Such designs identify the New York influence that shaped eastern Connecticut production from the late 1810s into the 1820s (figs. 5-41, 5-43). Hutchins himself manufactured fancy chairs, although his production is unidentified. His shop inventory of 1830 lists seven completed fancy chairs and seventy-one Windsors, the latter finished either in "dark" or "straw"-colored paint.[47]

During the early 1820s Thomas Walter Ward II, grandson of General Artemas Ward of revolutionary war fame, opened a general store in Pomfret, having previously pursued that business briefly in Boston. A surviving inventory book dating from about 1838–45 indicates that the property consisted of the store valued with its lot at $550 and a cabinet shop and lot estimated to be worth $619. The latter likely was the "Joiners Shop" purchased by Zadock Hutchins from the estate of David Goodell in 1818 and conveyed to Ward in 1826. The names of the man or men who worked for Ward in the craft shop are unknown, but the quantity of cabinetwork and/or chairs itemized in the store inventory each year is substantial. Ward probably commenced business at Pomfret about August 1824 when he leased John Champion's store; he married a local girl the following April. Presumably Ward ventured into furniture merchandising shortly after acquiring the cabinet shop, although there is no information about such activity before the period of the inventory book.[48]

The earliest list of seating in Ward's inventory book dates to about 1838. By then the storekeeper had removed to the family homestead in Shrewsbury, near Worcester, Massachusetts, leaving a manager in charge. Cane-and flag-seat chairs are itemized, along with children's and rocking chairs. Identified wooden-bottom patterns include

"4 rod" and "5 rod" chairs. The terms "Baltimore" and "light" seating pinpoint a style source and color. Supplementing such descriptions are terms describing crest patterns: fancy, mortise, Grecian, and flat "top." Any of the illustrated chairs constructed by Zadock Hutchins could qualify as "mortise tops," since the posts frame the slat and hold the ends secure in slots, or mortises, cut along the inside faces. The Grecian and flat-top chairs likely had rectangular crests framed on the post tops or faces, the ends extending beyond each upright. The "fancy top" could have been any of several crests of arched, scroll, or shaped form; indeed, there are individual entries for such chairs at slightly different prices. Among cheaper seating in 1841 were "Fancy Top" and "Dark din'g Chairs."[49]

Working in the neighboring town of Killingly was William Rawson, who like many woodworking contemporaries in rural New England was both a cabinetmaker and a chairmaker. Seating entries in Rawson's account book date from 1835 to 1841. He too sold fancy-top chairs, but at about twice the price listed in Ward's inventory book. (The Ward figures reflect chair cost; Ward, too, would have realized a considerable markup at their sale.) Rawson's dining chairs, like Ward's, were priced slightly lower than the fancy-top Windsors; Rawson realized between 72¢ and 75¢ apiece. Ward's construction price was 45¢ to 50¢. An occasional rocking or nursing chair and some children's seating rounded out Rawson's stock. The 1840 census lists the craftsman's age as over fifty years.[50]

TOLLAND COUNTY

Evidence of chairmaking in Tolland County is thin. Available data illuminate the career of only Daniel Weld Badger of Coventry and Bolton. Basic information comes from the account book of cabinetmaker Jeduthern Avery, who lived and worked in the same area. The two men exchanged products and services from 1816 to 1832. Some of Badger's first purchases from Avery were chair parts—"rockers" and "backs." In 1816 the latter term likely identified slats for Windsor or kitchen chairs. Badger occasionally acquired cabinet furniture from Avery, some for his own use, some to exchange with a third party. Usually Badger "paid" for his purchases in chairs, which Avery passed along to his own customers. In several instances such exchanges can be followed directly in Avery's accounts. For example, "one set of Chairs for Capt. Jones" credited to Badger in February 1819 was charged to the account of Silas Jones the same month.[51]

Entries in the Avery accounts shed some light on the seating constructed by Badger. References to "bottoming" indicate that he produced kitchen chairs, a notion confirmed later in a credit for "common" chairs valued at $3 the set. Dining chairs were twice the price. Other seating credited to him included rocking and "small" (possibly children's) chairs, the larger valued at $2 to $2.50, the smaller at 50¢. Badger's purchases from Avery also included raw materials: boards of all kinds, maple and walnut logs, bedstead timber, and varnish. Badger remained active until his death, as confirmed by the quantity of seating itemized in his inventory. Appraisers listed 260 chairs, finished and unfinished, new and worn, excluding the "Chair used in Shop." For family use in the house there were cane- and flag-seat chairs and six green dining chairs en suite with a rocker of the same color. Shop stock included kitchen frames not yet painted; Baltimore and children's seating, not completed; "Cane Seat Fiddle back Chairs," possibly an ornamental type with a vertical splat in varnished, figured wood; and unfinished "Roll back dining Chairs." At a private sale held before the public auction, Jeduthern Avery made a few minor purchases—a shop axe, a glue pot and kettle, and a drawing knife—and then purchased the "Horse Shed" for $11. His son, Josiah B. Avery, also a cabinetmaker, bought seven children's chairs and some chair timber.[52]

In the town of Mansfield, adjacent to Coventry, Israel Balch was at one time an active chairmaker. His probate inventory of 1828 itemizes a turning lathe and chisels, an axe and adz, shaves, saws, and the like. Stored in an outbuilding was a "Berel [barrel] & Chare rounds."[53]

Middlesex County, which had coastal access and a port of entry at Middletown, was a modest chairmaking center in the early nineteenth century. When the young cabinet-maker and chairmaker Sylvester Higgins married there on October 13, 1805, he and fellow craftsman Samuel Silliman had only recently returned to Connecticut from New York state. In Duanesburgh, west of Schenectady, the two had ventured a furniture-making business; they erected their own shop with hired help between August and October 1804. The men produced cabinetwork until the following May, but expectations were greater than sales and profits. Silliman worked in a shop at Schoharie in the summer of 1805 before returning home. In the ensuing years he and Higgins collaborated in business from time to time at East Haddam. Higgins advertised his dual trades in January 1807 from his shop "half a mile north of the meeting house" where he imitated "the first fashions from New York." It would be impossible to identify Higgins specifically as a Windsor-chair maker if it were not for the presence of his brand on the plank of a square-back chair with double bows (rods). The Windsor is a straightforward bamboo production and seems a mixture of both New York and Philadelphia styling.[54]

Upriver at Middletown, a "city of about 2,000" in the early 1800s, Josiah Powers offered 400 chairs for sale at his shop in August 1806. The substantial stock was part of his bid to carry on an extensive business in the community and to overcome competition "from New-York or elsewhere." In 1809 he and Eber Ward shared business interests for about four months before dissolving their brief partnership in October. Their initial advertisement of June 21 seeking "Plank for Chair Seats" identifies Windsor seating as part of their output. In little more than a year Powers "Commenced the Chairmaking Business" with Eleazer Badger "a few rods south of the Bank." They carried "a general assortment of fashionable Flagg and Wood seat CHAIRS." The duration of the partnership is unknown, although at best it lasted no more than a few years. Powers still worked at the chair trade when he died at age forty-seven in March 1827. One appraised item was a "New bit stock with complete sett of bits."[55]

Another Middletown man, Samuel Redfield Dickinson, worked for a while across the Connecticut River at Chatham, probably in the village of Middle Haddam. He labored in late summer 1810 at "setting Up 362 Winsor Chairs" for one Hezekiah Carpenter at 25¢ per chair, receiving payment by the hand of Jesse Hurd, a storekeeper and distiller who had shipping interests. The seating appears to have been destined for the export trade, since the embargo had been lifted and open conflict with England had not yet begun. The chairs were easily placed on shipboard from the river landing of this small community, which one visitor described as "a pleasant country village, stretching along a hill covered with orchards and house lots." Dickinson probably was a member of the firm of Dickinson and Badger, which advertised five years later in Middletown. Presumably, his partner was Eleazer Badger of the late firm of Powers and Badger. The new firm's notice dated December 5, 1815, still appeared in the *Middlesex Gazette* on January 2, 1817. The pictorial woodcut illustrating the announcement is unusual (fig. 7-14) with its classical-style arch, motto, and roundel centered with a slat-back Windsor above the featured ball-back fancy chair.[56]

Following Samuel Dickinson's departure from Chatham for Middletown, Jesse Hurd turned to Edmond Bowles for cabinetwork and chairwork. Bowles, who obtained mahogany timber from Hurd in September 1817, used the material the following year to construct furniture. From less expensive materials he also built "6 bent back Chairs" and sold them for $7. Bowles had other local commissions from the Shephard family. In 1821 he glued forty-seven chair seats for John Shephard and stored the seating. The large number suggests that these, too, were for exportation. The business relationship ended in 1825 when Bowles supplied the estate with a coffin.[57]

Through the 1820s most Middlesex County chairmaking centered in Middletown. J. and D. Hinsdale, probably entrepreneurs rather than craftsmen, announced in February 1820 that they had received "assignment of the Stock and Cabinet Furniture of

Fig. 7-14 Advertisement of Dickinson and Badger. From the *Middlesex Gazette* (Middletown, Conn.), May 2, 1816. (Connecticut Historical Society, Hartford: Photo, Winterthur.)

JOHN B. SOUTHMAYD." Everything was offered at reduced prices. Furniture and chairs that were not then on hand were to be "worked up" from stock and sold. It is tempting to speculate that Giles S. Cotton assisted the Hinsdales in assembling chairs from the stock they acquired in the Southmayd assignment. Cotton was just twenty-one in December when he opened shop on Main Street "at the Brick Store of Mr. E. Bound." Cotton's advertised chairs "of every description" were "neatly finished" and priced as cheaply as those bought in New York. He promised "good pay" for a supply of whitewood, basswood, and butternut plank for Windsor chairs.[58]

Despite competition from New York, the commercial climate in Middletown must have offered encouragement to chairmakers. William Perkins and Company opened for business in "a room directly over JONES & BUSCH (Painters)" in November 1824. Although representations of Grecian and roll-top fancy chairs embellish the notice, the firm "manufactured" Windsors as well. Old chairs were repaired, painted, and gilded "at short notice." Maintaining an adequate supply of chair plank seems to have been a real problem; Perkins appeared almost desperate the following August when he placed a "Wanted" notice in a local newspaper for immediate delivery of whitewood or basswood stock. He held out the enticement of payment in cash and urged prospective suppliers to call at his chair store. Less than a year later, when Perkins formed a partnership with Prentice Pendleton, a cabinetmaker, the new firm set up its cabinet and chair wareroom at Pendleton's business location. Earlier, the 1820 manufacturing census had reported Pendleton in the cabinet trade downriver at Saybrook where two men and two boys worked in the shop. In an unusual example of reverse migration, the craftsman had removed from Middlebury, Vermont, to Saybrook, where he married in 1814. Perkins, on the other hand, migrated westward. By 1829 his name appeared in a Troy, New York, directory as a chairmaker. Leading a varied career during the next two decades, Perkins was at times a chairmaker and on other occasions a collector, grocer, or clerk.[59]

Difficulty in earning a living may have beset Thomas H. Sill of Middletown. His father, Thomas, a cabinet- and chairmaker, died in January 1826. Apparently, the elder man had been unable to work for some time before his death, since Thomas H. announced under the date of November 30, 1825, that he had "purchased the Stock and taken the Shop lately occupied by Thomas Sill, in Main-Street, near the Episcopal Church" where he carried on the cabinet- and chairmaking business. It is important to note that Thomas H. had purchased only his father's stock. He probably rented the shop and tools. Evidently, he was not able to make ends meet, for on June 6, 1827, he and one H. Treadway, co-administrator of the elder Sill's estate, announced a sale of the real and personal property of Thomas Sill, "consisting of the SHOP and DWELLING-HOUSE . . . with a full set of Cabinet and Chair Makers' Tools." The completeness of the shop equipment is borne out by Sill's inventory and the account of sales. The production potential was substantial, since there were no fewer than five lathes in the shop. How Thomas H. Sill then supported himself until his own death in 1838 remains unanswered.[60]

Between 1825 and 1830 when Elisha Harlow Holmes practiced the furniture trade in Essex, a small village situated on an elevation above the lower Connecticut River, he recorded several associations of note with other woodworking craftsmen. Chronicled in his accounts are business dealings in 1828–29 with his brother-in-law Frederick Allen, son of Amos Denison Allen of South Windham. Frederick acquired raw materials—mainly cherrywood, mahogany, and flag for seating—and paid Holmes for the purchases in chairwork. In view of the distance between Essex and South Windham, it appears certain that Allen worked in the Holmes shop during this period. Along with chairs he may have constructed cabinet furniture to sell on his own account. Although descriptions are not always specific, Allen seems to have concentrated on fancy rush-bottomed seating in Essex. "Urn back chairs" may have featured a vertical splat variation of the fiddle-back chair. "Circular back" seating perhaps had a back feature, such as that illustrated in figure 7-22. Most rocking chairs probably had wooden seats, since one group is described specifically as having "flag" bottoms. There is mention of light and

dark-colored seating. "Rool" (roll-) top chairs had turned crosspieces at the upper back centered with a "pillow"; such seating had rush or wooden seats. Allen's probate inventory of February 13, 1830, shows that he also made cane-bottomed seating.[61]

Elisha Harlow Holmes conducted other business with one Charles Ely, possibly the man of that name listed in the vital records of neighboring Lyme. Presumably Ely made the "6 Wood seat chairs" for which he received credit in Holmes's accounts. He may also have operated an inn, since Holmes made a sign for that purpose. Another item of interest is written inside the front cover of Holmes's ledger: "John Hull came to learn Cabinet makeing the 15th of December 1826." John L. Hull of neighboring Clinton had just reached his eighteenth birthday on September 26 of that year. If he trained with Holmes until age twenty-one, he would have been in the shop when Frederick Allen worked there. After completing his period of service about 1829, Hull may have gone to New Haven to work as a journeyman, since he married there on February 22, 1831. On November 16, 1835, he and wife Sarah joined the First Church of Killingworth. Subsequently, they became residents of neighboring Clinton, where Hull's name occurs in the 1840 and 1850 census and where he died in 1862. An example of Hull's chairwork is recorded in the Index of American Design (fig. 7-15). The chair exhibits strong New York influence, particularly in the legs, front stretcher, back posts, and short spindles (figs. 5-49, 5-52). The projecting tablet was current in such divergent areas as New York state (fig. 5-59) and Portland, Maine, (fig. 7-108); all probably mirrored the influence of Baltimore seating. The laterally curved, plain rectangular top piece relies only on painted ornament for embellishment. It seems reasonable to identify the pattern with the "flattop" style mentioned in Thomas W. Ward's Pomfret store inventory book.[62]

HARTFORD COUNTY

During his brief passage through Hartford in 1808, John Lambert noted that the city was "composed of regular streets, and well built houses of red brick." He was impressed with the order and cleanliness of the place, as he had been in other parts of Connecticut. The population numbered perhaps something less than 10,000. Several churches and meetinghouses, and a statehouse, museum, and bank accounted for the major public facilities. Surrounding the community along the banks of the Connecticut River were meadowlands, "rich pasture," and fields under cultivation. Watson, Wood, and Company (Nathaniel Watson and Eli Wood) found the city an agreeable place to do business. Beginning in the cabinetmaking and chairmaking trade as partners in May 1801 at Lemuel Adams's old stand in Ferry Street, they shared a profitable enterprise for several years. They still worked together in December 1807 when they advertised "Fancy and Windsor Chairs, as Cheap and as durable as can be found in this or any other city." In notices dating to 1801 and 1807 they sought journeymen cabinetmakers. Maritime records list the firm's shipment of sixty fancy chairs to a consignee in Charleston, South Carolina, in December 1805 on board the schooner *Antelope*, probably one of many such ventures in which the firm engaged.[63]

John I. Wells, who first established his cabinet business in Hartford in 1789, pursued this career during the 1790s and early 1800s but worked at the trade only sporadically thereafter. At the beginning of the century Wells sought the services of "an active Man, to assist in preparing Stuff for Windsor and other Chairs, at his shop near the Bridge." Business must have been brisk because by October he advertised for "SEASONED PLANK suitable for Windsor chair seats." Wells was able to supply customers with "most kinds of wooden household stuffs," of which he kept a selection "ready made, for sale." Notices continued in much the same vein during the next six years until May 1, 1806, when the craftsman engaged the second and third floors of a brick store to display his cabinet furniture and chairs; he still maintained his shop south of the bridge. The following March Wells formed a copartnership with Erastus Flint, a cabinetmaker and chairmaker like himself. The two advertised regularly and for some time maintained separate business locations. In July they offered "an elegant assortment of gilt fancy

Fig. 7-15 Tablet-top Windsor side chair, John L. Hull (documentation unknown), Killingworth or Clinton, Conn., 1830–40. Dark green ground with gold and bronze stenciling. (Index of American Design, National Gallery of Art, Washington, D.C.)

Chairs of the newest patterns," and by September they increased the selection to "Gilt, Fancy, Bamboo, and Fanback Chairs." Here, then, is another example of the eighteenth-century fan-back Windsor maintaining its popularity in the New England market until well into the first decade of the new century. Solomon Cole of neighboring Glastonbury also made fan-back chairs in 1807, selling them in company with his newer round- and square-back patterns.[64]

Wells and Flint continued to advertise during 1808 and solicited patronage as far west as Litchfield. On March 28, 1809, the copartnership was terminated, and within eight months Wells had decided to limit his furniture business. He eventually concentrated on the manufacture of mattresses, easy chairs and sofas, and plank-bottomed seating. Wells also engaged in other activities: he manufactured paints, using his own patented grinding mills, and prepared "warranted" ink for printers' use. He continued chairmaking a few years longer, doing business in 1816 under the firm name of Joseph Choate and Company. At this point Wells moved forward with the development of an improved, patented lever printing press. This venture must have proved successful, since at his death in 1832 the entrepreneur owned a dwelling house on Main Street valued at $6,000.[65]

South of Hartford Ira Hubbard and Solomon Cole of Glastonbury led independent careers as furniture makers during the second and third decades of the century. The 1820 manufacturing census reported both as owners of cabinetworks in that town. The same census listed an unidentified cabinet- and chairmaker's shop at Berlin, where two "hands" were employed, while in neighboring Southington two shops accounted for ten workmen. But it is the towns north of Hartford that have provided more substantial evidence of chairmaking in records and documented seating.[66]

Ebenezer Williams was working as a Windsor-chair maker in May 1790 when he advertised that he conducted business "at the shop of Mr. Eliphalet Chapin in East Windsor." During the next several years Williams purchased painting supplies in Hartford from Isaac Bull; further association with that community is suggested in an 1806 payment of a debt to the Hartford estate of cabinetmaker John Porter II. Young Porter had served an apprenticeship in the 1790s with Aaron Chapin of Hartford (earlier of East Windsor), a cousin of Eliphalet Chapin.[67]

An early example of Williams's work is a bow-back side chair with three-section, bamboo-turned legs and H-plan stretchers of the swelled type. The shield-shaped seat is reasonably well formed, and seven spindles are enclosed within a flat-faced bow of beaded edge. Three chairs, or more, document Williams's work in the square-back style. Two chairs duplicate the support structure of the bow-back Windsor, while a third introduces a bamboo medial stretcher. All have similar seats (fig. **7-16**), a rounded square with edges shaped between a round and a chamfer. The illustrated top piece caps the posts in a construction duplicating that of a single-rod chair marked by Williams. In another double-bowed (rodded) chair with a bamboo medial stretcher, both rods are positioned between the posts; the post tips are grooved to form small caps, or buttons. Legs socket inside the planks, a technique that became increasingly common from the turn of the century. By 1811 a general stagnation of business brought about by the Embargo Act and pending hostilities with Great Britain prompted Williams to move his family to Painesville, Ohio, where he established himself as an innkeeper.[68]

Reubin Loomis, a cabinetmaker of Windsor and later Suffield, was born at Windsor about 1772. His book of accounts, which begins in 1793 at Windsor, suggests that he possessed a full range of cabinetmaking skills. Chairmaking entries commence only in 1800 but continue on a limited basis for the next twenty-two years. Many sales record sets of seating, which usually numbered six chairs. Loomis employed at least ten terms in referring to his chairwork, although he used many of them only once. One reference of May 1805 was to "windsor Chairs" priced at 7s.6d. apiece. Other terms include "small," "little," and "rocking" chairs, and there is mention of one "great chair." Probably most, if not all, the seating referred to simply as "chairs" was of Windsor construction. Production covered the years between 1800 and 1821. A price range from 6s. to 8s. may indicate different patterns or finishes. A rocking chair described as "striped" was the highest

Fig. 7-16 Square-back Windsor side chair and detail of brand, Ebenezer Williams, East Windsor, Conn., 1800–1811. H. 35¾", (seat) 17⅝", W. (crest) 20", (seat) 17⅜", D. (seat) 14⅜". (Paul Koda collection: Photo, Stowe-Day Foundation, Hartford, Conn.)

priced article of that form. Total output was small—fewer than 150 individual units in a twenty-one-year period. Sometime after 1800 Loomis moved from Windsor to Wethersfield. He still resided there in 1810 but by 1820 had removed to Suffield, where he remained until his death in 1860.[69]

Not far from Suffield Oliver Moore worked as a cabinetmaker, carpenter, and house painter in Granby or East Granby, according to his account book (1808–21). The amount of chairwork recorded is minimal, and much of it involved repairs, repainting, or the addition of rockers. There is mention of kitchen, or common, and small chairs on a few occasions beginning in 1810. The first of only four entries for newly constructed Windsor chairs is made on May 30, 1816. Whether Moore made all of these is open to question. An agreement between him and Timothy Marsh of Windsor, dated February 21, 1821, records the exchange of a wagon of Moore's construction for two sets of chairs made by Marsh valued at 7s. the chair. Perhaps other exchanges made during Moore's career provided additional Windsors for retail to his customers at a modest markup of 6d. On the other hand, Moore's shop was equipped to make Windsor seating. On one occasion in 1805 he noted the presence of a lathe in debiting "Phinehas" Newtown, Jr., for "helping your Father to turn bed posts (one day's work in my shop in ye labour)." Another time (1820) he constructed two sets of Windsors for "Ransum" Cook and noted "bottums found by your selfe," meaning that Cook supplied either the plank or the finished seats.[70]

A dearth of chairmaking data for Hartford in the 1820s may serve as a general gauge of activity in this period. Under the heading "Chair Warehouses" just four names appear in the 1825 city directory. Upon publication of the next compilation in 1828, more than a dozen craftsmen were associated with chairmaking, although not all of them were listed in the business guide. In the mid 1820s Seymour Watrous was active in the cabinetmaking and chairmaking business in Central Row near the Statehouse. As usual, his major concern was competition, some of local origin but the greater part still emanating from New York. The eye-catching woodcuts featuring fancy rush-bottomed chairs with rod-and-ball or pierced-scroll frets that head his advertisements are a partial record of contemporary styles. Cabinet and chair warehouses that offered large assortments of mahogany and curled maple, fancy and common chairs were the order of the day. Windsor seating likely was identified by the last term, despite earlier use of the word *common* in reference to rush-bottomed kitchen seating. Business was on the upswing in 1835 when Daniel Dewey announced that he stocked "1300 CHAIRS, of various patterns and prices."[71]

By 1835, Isaac Wright had been in the Hartford furniture trade for seven years or more, although his account book chronicles activities only from 1834. Starting as a cabinetmaker and furniture dealer, Wright gradually turned almost all his attention to the manufacture of pianofortes. This was his occupation at his death on June 10, 1838, at age forty. The entrepreneur's business contacts, which encompassed Hartford and county locations, also extended to Farmington, Canton, West Granby, Hitchcocksville, and Westfield, Massachusetts. He offered a selection of chairs, featuring cane, "flagg," or wood seats and of maple or painted wood construction. Size varied from the large rocker to children's seating. Specific patterns included roll-top, Grecian, and crown-top styles. Wright identified at least two suppliers of seating furniture. In January 1834 he recorded a "child's chair Hills make," probably referring to Ozias Hills, Jr., whose shop was nearby. Lambert Hitchcock, who operated a retail store in Hartford in addition to his factory in Litchfield County, furnished chairs in quantity. Wright accepted the merchandise on credit or commission. Some transactions mention Philemon Robbins of Hartford, who along with Joseph Winship became a partner of Wright in 1834 in the firm of Isaac Wright and Company.[72]

An extraordinarily complete record of Philemon F. Robbins's early career and the business transactions of the Wright firm is detailed in Robbins's Hartford account book, dating between 1833 and 1836. Daily entries shed light on the many facets of his business life and the partnership. Aside from any consideration of the firm's extensive production

of chairs and cabinet furniture, including painted, upholstered, and formal styles, the records provide a comprehensive picture of a furniture store, or "warehouse," at a time when this method of retailing was still a relatively new merchandising concept. The accounts include varied information: prevailing seating types and patterns of the mid 1830s; customer taste in pattern, color, and decoration; use of specialized seating forms; furniture repair and refurbishing; sources of raw materials and stock; and varied methods of doing business with suppliers. The most popular single purchase was the rocking chair. Scarcely two descriptive entries for such chairs are the same. Prices varied enormously—from less than $1 to $20 for a "first rate Boston Rocking chair." Next in demand were the wooden-seat chairs. Since most were bought in sets of six— sometimes more, sometimes less—the actual number of these exceeded those of other types. When Robbins provided further identification he usually mentioned paint colors: yellow, brown, quaker (gray), drab (a brown tone), tea color, or dark color. There were four- and five-rod chairs; others had roll, crown, or slat tops and, upon occasion, "double backs." Robbins described some planks as square; one wooden bottom was scrolled. Retail prices varied from 50¢ to 92¢, except for the scroll-seat chair, which commanded the sum of $1.25.[73]

Among the roll-top, crown, and slat-back chairs listed by Robbins, there were decidedly more with cane and flag seats than wooden bottoms, and the roll-top pattern (today's so-called Hitchcock chair) was far and away the most popular choice among consumers. Colors were about the same as those found in Windsor seating, although extra embellishment, which seems to have been absent from the wooden-seat chairs, was a feature and included "rich gilt," "half rich gilt," and "bronzed" decoration. Plain and curled maple seating remained popular, some with flag seats but most probably caned. Chairs made in the Grecian style continued to be well received; at $2.46 to $3.38 apiece, they also commanded high prices among the firm's stock. Price often related directly to materials and decoration, but the entrepreneur also hints that choice of supplier had something to do with fluctuations. Cost increases were passed on to the customer. The firm also accepted chairs for commission sales. Robbins's accounts note the occasional retailing of children's chairs for low prices. At the other extreme were the firm's mahogany chairs, usually purchased in sets of twelve, which realized a substantial $4.75 to $6.75 per chair. Even so, they were still cheaper than the newly fashionable black walnut seat, at prices ranging from $7 to $7.50 for the side chair and $9 for the armchair. Most of this general group had upholstered seats.[74]

Numerous suppliers of seating furniture or services are identified by Robbins in the three-year period covered by the account book. Locally, the firm purchased chair lots from Lambert Hitchcock or Hitchcock, Alford, and Company on at least eight occasions. One order for eighteen cream-colored, roll-top, cane-seat chairs with special decoration was destined for a specific customer. General purchases from Hitchcock almost always consisted of roll-top chairs with cane or flag seats; tea color was the only other painted finish itemized. The same company supplied two lots of maple chairs. Hartford cabinetmaker and chairmaker Ozias Hills exchanged services and chairs with Robbins as customer demand and stock on hand dictated. From nearby Wethersfield Edward Shepard, Jr., sent curled maple and Grecian chairs, chair parts, and "mahogany" seat chairs, perhaps all by the river route rather than overland. At 83¢ apiece the last group likely represented Windsor seating, with the planks painted mahogany color to contrast with other surfaces painted a different hue. Shepard was well established in business by the 1830s. As a young man he had worked for Solomon Cole in Glastonbury, where his activity included framing Windsors and preparing chair parts.[75]

Other suppliers of chairs to the partnership firm worked at some distance from Hartford. Several located along the Connecticut River probably found water carriage relatively easy and inexpensive. Horace Lee of Springfield, Massachusetts, sent flag-seat and fancy chairs, priced at $1 or more per unit in 1834–35. Cheaper chairs at 83¢ were not identified by type. Each of two "Large green Caned R[ocking] Chair[s]" sent down to Robbins in August and September 1835 was sold for $11 plus commission. The previous

year Philemon Robbins did business with a Mr. Gay of Springfield. He received a 15 percent commission when selling Gay's curled maple chairs for $3 apiece. Upriver at Greenfield in 1835 Robbins and the Wright parnership patronized Francis A. Birge and Company, large suppliers of wooden-seat chairs at wholesale prices of 30¢ or 33¢. Robbins ordered and received 704 Windsors from Birge in 1835 along with flag-seat, "ogee seat" (scroll), and Grecian chairs. There were also rocking chairs of several qualities and five special scroll-seat wooden chairs at 83¢ apiece.[76]

In his location at Spencer, west of Worcester, Sullivan Hill did not enjoy the same easy access to Hartford, although his production for that market was the largest of any supplier. Between February 14, 1834, and December 25, 1835, Robbins carted 1,710 seating pieces from Spencer to Hartford. Among the Windsors were 506 four- and five-rod chairs, which made up almost one-third of the total purchase. The 608 rocking chairs formed the largest group, including specialized nurse and sewing chairs as well as regular rockers of varied size and quality. Some had extra embellishments in the form of "ogee" seats or "urns." Third in recorded quantity were 262 "common" chairs. The term probably identified wooden-bottom seating, since the 35¢ price was the same as that for the four- and five-rod chairs. Children's low and high (dining) chairs made up Hill's last major seating group. A curious note is the listing of "twenty-four turkey legs" in the October 1835 accounts. At 30¢ per unit, these were chairs and not chair parts. A good candidate is the roll-top woven- or wooden-bottom chair with ring-turned legs tapering abruptly at the bottom and ending in small ball tips, a type associated with Lambert Hitchcock. The overall effect *is* that of a bird's leg with a slim ankle and feather-fluffed calf (fig. 7-22).[77]

On a few occasions Philemon Robbins acquired chair parts only, although this practice appears to have been relatively uncommon. Most stock arrived assembled, some probably unpainted. On January 17, 1834, Robbins credited one Allen Cotton for labor required to paint several hundred chairs. Later Robbins received a few sets of washstand legs and maple and "French posts" for chairs. He turned over the posts to Edward Shepard, who probably used the maple stock for his Grecian or curled maple production.[78]

On June 10, 1838, approximately two years after Robbins penned the last entries in his sole surviving account book, his partner Isaac Wright died. The Hartford firm now became a partnership of two, Philemon Robbins and Joseph Winship. Presumably, the surviving partners continued business along the same lines as formerly, constructing some furniture and acquiring other stock at wholesale or on commission. Under varied titles the firm remained in business until at least 1899. The first record of the firm in city directories dates to 1838, when the business is listed as a furniture warehouse. By 1840 the entry is more explicit: "Manufacturers and Dealers in Cabinet Furniture, Chairs, Feathers, Bedsteads, Cushions, Upholstery, &c."[79]

About the time Robbins and Winship reorganized their firm, Joel Pratt, Jr., of Sterling, Massachusetts, and his son Joel Pratt III opened a chair warehouse in Hartford a few rods west of the Great Bridge. On July 1, 1840, under the arresting broadside heading: "STRANGER, LOOK HERE! Where is the best place to buy CHAIRS?" the craftsmen itemized a "general assortment of Chairs" identified as "Grecian, Common Cane and Flag Seat, Common Wood Seat, Dining of all descriptions, and a great variety of Large and Small Boston Rocking chairs, Misses and Children's common d[itt]o., Settees, Desk Stools, &c., &c." From other evidence it appears that the elder Pratt remained in Sterling, conducting business there as usual, leaving the Hartford operation to his son. Joel Pratt III formed a partnership with Edward Doty Buckingham in 1841. The association lasted only until 1842, and in another year the younger Pratt was dead. His estate inventory includes no tools, raw materials, or finished stock, and few household furnishings.[80]

The coastal city of New Haven, although small, enjoyed a brisk domestic trade, particularly along Long Island Sound, and engaged in limited overseas commerce. Long Wharf usually bustled with activity. Regular contact with the outside world and the presence in the community of Yale College gave the town status beyond its size.

There is little direct knowledge about New Haven chairmaking of the early nineteenth century, but the activity in adjacent towns may reflect that in New Haven proper. The career of Titus Preston at Wallingford, a few miles north, has been mentioned earlier. He made "dining" Windsors in the 1790s that sold for 7s. apiece. In 1800 he introduced the "double bow" chair and added a shilling to the price. By any standards in the chair trade, Preston's work can be classified as "up to date." He introduced fashionable hues, two-color paint, and ornament to his product; he stuffed the seats of a number of special Windsors. After 1804 the craftsman no longer distinguished between dining and other wooden-seat styles. Presumably, the term *dining* then described the prevailing side-chair pattern.[81]

Preston and his son Almon (b. 1789), who also followed the occupations of chairmaker and cabinetmaker, enjoyed a close association. In October 1810 after the young man had reached his majority and completed an apprenticeship, probably served with his father, Titus wrote in his accounts: "I went to Salem [New York] to see about work for you." Apparently, he had connections with one or more woodworkers in this border community, although nothing seems to have come of the contact. Almon worked in his father's shop from November until the following March, apparently as an independent workman. During November Titus debited Almon's account for "materials for 12 chairs with the legs ready turned" and "boarding while you made them," the total charge being £2.2.0. Other activity included cabinetwork. Among Almon's credits were "50 chair legs ready turned" valued at 5s. On March 1 the two men settled their account: "Reckoned and ballanced accounts with Almon Preston by his giving up to me the stuff for the thirty six chairs that are partly made." Several later entries suggest that Almon established his own shop. In January 1815 he acquired from his father materials for a breakfast table and candlestand; two years later he got "flag to bottom 6 chairs." The elder Preston appears to have made a going concern of his business, since at his death in 1842 he owned considerable real estate. In drawing up his inventory, appraisers noted both his "Mechanical Tools" and "Farming Utensils," a reminder that despite technical skills a craftsman remained close to the land.[82]

Early in 1816 Levi Stillman and Seth Bliss left Springfield, Massachusetts, for new homes in New Haven where they were admitted to membership in the First Congregational Church on May 5. Circumstances indicate that the move was well planned. In New Haven the men formed a partnership in the cabinet- and chairmaking business, if they had not enjoyed a similar relationship earlier. On November 26 a Mr. Eastman, probably a son-in-law of the Reverend Benjamin Trumbull of North Haven, purchased from them a mahogany-front bureau and "One Sett Bow Back Bamboo Chairs." The terminology is a good example of the confusion encountered by the furniture historian in interpreting period documents. The partners' work was in the forefront of fashion, so that the reference was to square-back chairs with bent (bowed) rod or slat-style crests. The bamboo chair, its turned work subtly grooved and ridged at intervals along the horizontal and vertical members, was made with either a rush or wooden bottom. The partners' pictorial advertisement of October 7, 1817, illustrates three popularly priced chairs standing atop a sideboard of fashionable pattern (fig. 7-17). Two chairs have rush bottoms; the third is an arrow-spindle Windsor. Presumably, they identify shop production. On July 7, 1818, the partnership came to an end. Stillman continued in business on his own, while Bliss is said to have studied theology and entered the ministry.[83]

Levi Stillman's cabinet- and chairmaking accounts survive. Because some entries date during the period of the partnership, the record may chronicle activities of the firm as well. On the other hand, many partnerships enjoyed considerable flexibility, and

Fig. 7-17 Advertisement of Levi Stillman and Seth Bliss. From the *Connecticut Herald* (New Haven, Conn.), October 7, 1817. (Connecticut Historical Society, Hartford.)

Stillman could have conducted business independently of the association. The seating accounts fall between 1816 and 1831. During this period Stillman sold 2,074 chairs along with cabinetware. The Windsor was his bread-and-butter chair, accounting for more than half the seating sales. Prices varied widely, from a low of 75¢ to a general high of $1.55. The larger figures occur more frequently in the early years and may represent a greater degree of product ornamentation. Once established Stillman likely found that increased demand and competition dictated faster, cheaper production. The 1820 manufacturing census reported that ten men and six boys were employed in the shop—a sizable operation. By that time Stillman was already involved in the coastal and overseas trade, although he reported "demand Increasing for home consumption but less than formerly for Exportation." Business in 1820 appears to have been brighter for him than for Amos Denison Allen in South Windham. Details of Stillman's Windsor production are sketchy. Between August 1824 and April 1829 he produced a group of 105 roll-top Windsors priced from $1.13 to $1.25. Another group of 144 chairs manufactured in 1826, called fret or wide-fret Windsors, probably had the rod-and-ball or pierced back pieces popular in contemporary fancy seating. Some chairs were finished in an elegant manner, since their prices soared to $2.50. A group of slat-back Windsors constructed in 1826 commanded $2.25 apiece.[84]

The next largest seating group identified in the Stillman records comprised 313 roll-top chairs without further identification, produced between 1821 and 1829. Most chairs appear to have had wooden bottoms, since prices fall into the roll-top Windsor range. A few more expensive fret-back chairs probably had rush seats. Fancy chairs formed another large group, the prices noticeably higher at $2 to $4. Seating at the higher price likely had "gilt" decoration, as described in one entry. Most of this production was rush-bottomed, since Stillman specifically described a few lots as having cane seats, some accompanied by slat or fret backs. Bamboowork continued on a limited basis with 102 chairs recorded, $2 being the median price. The remaining production was miscellaneous—a few children's chairs, two writing-arm chairs, several dozen rockers of varied type, and thirty-four curled maple chairs that fetched prices between $3.25 and $3.75, suggesting that they had cane seats.[85]

Stillman's account book provides some evidence of his overseas trade. There is an invoice of furniture and chairs shipped to Lima, Peru, in 1826 via New York City. Other entries dated the same year show more than nineteen dozen chairs charged to the account of a man in St. Croix as well as the first of two lots totaling ten and one-half dozen chairs bound for Richmond and commission sales. The second consignment followed in March 1827. Quantity chair purchases by local individuals and firms hint at the scope of New Haven's domestic and overseas furniture market.[86]

Stillman's accounts give some indication of his Connecticut trade beyond New Haven. Near at hand were customers in Wallingford, Fair Haven, and Woodbridge; farther away were residents of Meriden and Southbury. Chairs and other goods freighted to a business customer in Hartford traveled by ship along the coast to Saybrook and up the Connecticut River. An account dated July 26, 1830, charging one Peter W. Colon $5 for six Windsor chairs, may refer to a Providence, Rhode Island, man known to have occupied a chair store in 1824. Colon, like Christian Nestell, probably removed to Providence from New York.[87]

Locally, Stillman maintained business contacts with several New Haven furniture craftsmen. From 1819 to 1825, James English acquired small quantities of curled maple plank, hardware, and chair parts, including "flat rods" for arrow-back Windsors. Sherman Blair, a cabinetmaker who commenced business around 1810 or 1812, sold chairs of Stillman's make on commission in 1821–22. Some chairs purchased outright by Blair appear to have been exported. In the early 1830s Edward Bulkley, a relative newcomer to the chair trade, bought quantities of chair parts from Stillman. Within a year or two Stillman's accounts ended. The craftsman probably left New Haven around 1833 when he received a contract to produce flag seating at the Connecticut State Prison in Wethersfield, but his connection with the state lasted only until July 1834. Thereafter,

Stillman probably resumed private business in Wethersfield until his retirement. He died there in 1871 at age eighty.[88]

Some measure of James English's "factory" operation is found in the 1820 manufacturing census. The enumerator counted three men and two boys who produced "Cabinet ware & Fancy Chairs at a market value of $3,300" annually. When asked the current state of business, English replied that he found "no alteration from former years," another testimony to the general prosperity of the city in the troubled financial times of the early 1820s. According to notes made by the census taker, the furniture businesses operated by English, Stillman, and Sherman Blair were the largest in town. The marshal reported, "There are besides the above, five small Establishments which All put together are perhaps as much as that." English remained in New Haven throughout his career and died there in 1850.[89]

John Doolittle II began working in New Haven in 1816 with his brother-in-law and partner Dan Davis under the firm name Davis, Doolittle and Company. The business appears to have been a semi-itinerant one, since the men also worked in Woodbridge the same year. By November 13 Doolittle had "rec[k]ond with Dan Davis and made even concerning things turned in to the Shop." Shortly thereafter Doolittle left for Wallingford. Woodworking records are few in his meager book of accounts. He may have been more occupied with farming than woodworking, or other record books may once have existed. Entries show that chair repair occupied as much of Doolittle's time as new construction. Two notes for chairwork dated in 1820 introduce significant terminology. On October 14 the craftsman debited Reuben Doolittle for making "8 balld back windsor Chairs," a reference to the "fret" pattern found in contemporary fancy chair advertisements (figs. 7-14, 7-17) and in Zadock Hutchins's work (fig. 7-13). The six "Streight windsor Chairs" made in December probably represent seating with straight, canted back posts as opposed to bent backs, a type illustrated in the New London work of Thomas West (fig. 7-11). Doolittle may have spent the majority of his time during the next two decades in the employ of others. A note entered in his book on October 8, 1838, suggests that was so but, more important, it provides a hint of the impact new technology was having on American life by the 1830s. On that date Doolittle wrote: "Commencd work at Meriden on the Rail Road." The following year he began to work on the depot for the Hartford and New Haven Railroad. Carpentry apparently was among Doolittle's skills; he noted such activity in the mid 1830s when working on a "shop Room" for a private customer.[90]

Edward Bulkley was thirty when he acquired 400 "sett Windsor chair Stuff" from Levi Stillman in 1831. Just the previous year he had advertised his "CHAIR WAREHOUSE" in Orange Street at the sign of the "Little Golden Chair." His statement concerning production serves to classify contemporary output: "CHAIRS OF EVERY DESCRIPTION, from the first rate Grecian Curl Maple down to the common Windsor Chair." The last part of Bulkley's statement should not be interpreted to mean that all Windsors stood at the bottom of the seating ladder. Comprehensive records detailing Levi Stillman's production document the degrees of quality that existed within the several seating types. Some Windsors, for instance, reached a level comparable to bamboowork and in a few instances competed with fancy chairs in the lower price range. Bulkley's term "common" describes a contemporary expansion of a word formerly reserved for rush-bottomed kitchen seating. Bulkley's purchase of Windsor stock from Stillman at a time when he was manufacturing the same material himself may indicate that he was preparing a large order or a consignment of chairs for shipment. Reinforcing this supposition is Bulkley's 1831 purchase from Stillman of a wardrobe sent to Mobile.[91]

The troubled times of the late 1830s affected Bulkley. He became insolvent and was forced to assign his stock in trade (tools excepted) and most of his personal property to his creditors. Attached to the assignment statement is a schedule of shop goods. Among the completed or partly completed stock were curled maple chairs, some in the Grecian style; a few rockers; flag-seat chairs, some of the kitchen variety; cane seating; specialized seating, including stools; and Windsors, a few painted to simulate "rosewood."

An indication of the size of Bulkley's operation is the amount of raw materials and "stuff" on hand, which included "nine hundred and forty feet of chair plank—five hundred bunches of flags—seven hundred feet of curled maple stuff, one hundred set of windsor stuff—two hundred pair of rockers—six hundred slats—eight dozen scrole tops—five hundred roll tops—six hundred slats." The chairmaker managed to weather the financial storm. He was listed as a chair manufacturer in New Haven directories from 1840 until at least 1860. An advertisement in the 1853 volume styles him a manufacturer of chairs, settees, and stools at his old address, No. 66 Orange Street.[92]

Two of Bulkley's contemporaries in the city furniture trade of the early 1830s were Israel Harrison and Jonas Blair Bowditch. Their "beautiful country town" was growing into an "elegant little city" of 11,000 inhabitants able to support an expanding "mechanic" community. Harrison advertised his furniture warehouse in March 1830 with a pictorial notice that includes a roll-top Windsor side chair with cross slats and short back spindles. He is listed in the *American Advertising Directory* the following year as a dealer in "chairs of every description." By 1840 Harrison had formed a partnership with Samuel M. Smith.[93]

Jonas Bowditch was at work by 1830, although his first known advertisement dates to October 18, 1834. His announced business was as a warehouse proprietor for cabinet-work, sofas, and bedding. His stock included chairs "of a variety of patterns and qualities." Bowditch's 1840 directory advertisement specifically mentions Windsor chairs, and a detailed notice of October 1846 lists priced cabinetware and chairs. "On hand and in process of finish" were 600 cane- and wooden-seat chairs retailing from 50¢ to $2.50. After Bowditch's son joined the firm in 1849, the company expanded into window dressings. Stock ranged from curtain fabrics to gilt cornices and painted window shades. The cabinet and chair wareroom was giving way to the home furnishings emporium.[94]

The 1840s brought a revolution in the furniture industry in cities throughout the nation. The small craft shop was almost a thing of the past, and even the furniture warehouse was changing. Some businesses were already known as "establishments." Supplementing cabinetwork and chairs were bedding, upholstery and drapery work, "patented" and mechanical furniture, and on occasion "patented metalic burial cases." Charles B. Lines proved an excellent commentator on the times. His furniture-making career in New Haven began when he served as an apprentice to cabinetmaker Sherman Blair in 1822. When he completed his training in 1827, work was scarce. A series of influential personal connections, well-chosen partnerships, diligence, and luck brought him success. A business association with William H. Augur in 1840–41 was followed by a partnership with Samuel M. Smith, former associate of Israel Harrison. In this period business began to change:

During the continuance of my partnership with Mr. Smith we had a good trade and were prosperous. . . . There was quite a revolution in the mode of conducting the business, a large part of the furniture being manufactured by power; and we bought instead of making. Now . . . dealers in furniture purchase almost all that they sell. In my day the furniture dealers in New Haven were generally prosperous, and no one had a better field than my self, but I was not as some others were, supremely devoted to making money.[95]

Cabinetmaker Daniel S. Redfield of Guilford was in business during Charles Lines's early career. His accounts kept between 1829 and 1843 record a credit of $47.01 for John Corly, a chairmaker of New York City who supplied seating furniture. That payment may identify the "little" and yellow chairs retailed by Redfield as commodities of the coasting trade. South along the Connecticut shore at his "Cabinet Shop" in Milford, T. Brooks distributed "a general assortment of FURNITURE and CHAIRS" in the local market and accepted "all kinds of produce . . . in part pay." In the village of Humphreysville Albert J. Steele, a seasoned businessman when he advertised in 1841, offered a good selection of furniture and chairs. Among the latter were 200 Windsors, curled and plain cane-seat maple chairs, and a less common product: "the Flag-seat

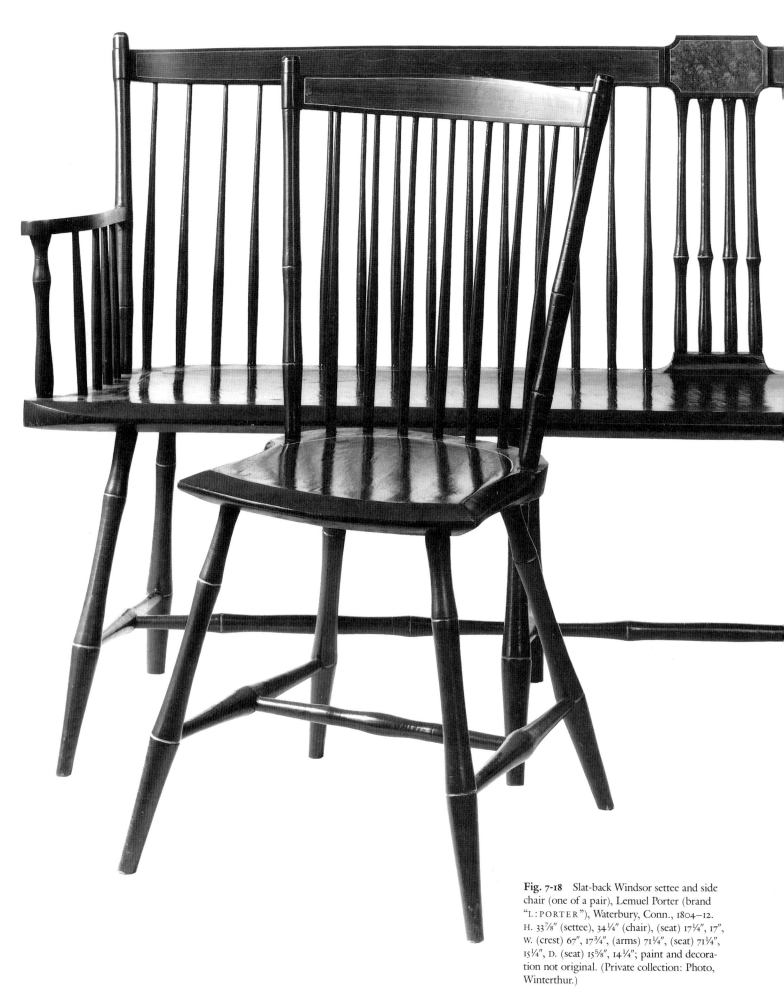

Fig. 7-18 Slat-back Windsor settee and side chair (one of a pair), Lemuel Porter (brand "L:PORTER"), Waterbury, Conn., 1804–12. H. 33⅞″ (settee), 34¼″ (chair), (seat) 17¼″, 17″, W. (crest) 67″, 17¾″, (arms) 71¼″, (seat) 71¼″, 15¼″, D. (seat) 15⅝″, 14¼″; paint and decoration not original. (Private collection: Photo, Winterthur.)

Kitchen Chair, an article so much called for, but seldom found." This was the traditional slat-back chair, a long-time holdout in the seating market.[96]

Lemuel Porter (1766–1829) and his family removed from their native Farmington in Hartford County to Waterbury sometime between 1790 and 1800; there Porter continued to practice cabinetry and chairmaking. The close proximity of rural Farmington to the small city of Hartford may suggest the latter as Porter's training ground; however, his known chairwork reflects a decided link with New London County, and a documented case piece shows definite provincial mannerism in its design. There is little direct information illuminating Porter's Waterbury career, although land records indicate that he experienced extreme financial difficulty in the 1810s. These records also reveal his acquaintance with members of the Bronson and Kingsbury families of Waterbury, known furniture customers. In December 1807 Porter acquired a thirty-acre "homestead" tract in the northwest part of Waterbury from Selah Bronson. Financial problems soon set in, culminating in 1816. On February 29 of that year the craftsman signed the first of several mortgage deeds. Of two tracts mortgaged in March one was the homestead, containing "a dwelling house & Cabinet Shop thereon." All told, Porter's mortgage liabilities amounted to $3,105, a staggering sum for the time. Porter may have emigrated to the Western Reserve of Ohio as early as 1817; his name does not occur in the 1820 Connecticut census. In Ohio Porter turned to another skill to earn a livelihood, that of house joinery. The craftsman was known in Ohio as an architect-builder, and he is generally credited with erecting in the 1820s the clapboard Congregational Church at Tallmadge, Summit County, now part of suburban Akron. One author has called this structure "the most New England-like church in Ohio." From Tallmadge Porter went on to design several buildings at the Western Reserve College in neighboring Hudson.[97]

Currently, Lemuel Porter is the only New Haven County chairmaker identified with documented Windsor furniture after 1800. His earliest known chair, executed in a 1790s bow-back pattern, is a curious design. It combines a sharply canted back in the New York manner with several provincial features found in northern coastal Connecticut work. The depressed bow face with a raised bead at either edge follows a rare pattern found in Elisha Swan's Stonington work (fig. 6-166); the double-swelled medial stretcher recalls late turnings by the Tracy family (fig. 6-114, right). An unusual ball-like turning at the bamboo leg top variously recalls Rhode Island work (fig. 6-38) or the swelled element above a collarless baluster in some Connecticut border chairs (figs. 6-124, 6-145, 6-168, left). The entire turning is repeated in modified fashion under the arm of Porter's settee (fig. 7-18) where half the ball and the toe of the "leg" are missing.

Porter's slat-back Windsor work dates from about the first decade of the new century (fig. **7-18**). The unusual illustrated settee, which forms a suite with a pair of side chairs, retains several distinct eighteenth-century characteristics. The long swelled spindles, three-section bamboowork of the legs, and H-plan stretchers testify to the transitional nature of the design. The bamboo medial stretchers are an unusual mutation with a swelled center. The highly original arm post with its half-ball turning above bamboowork springs directly from Porter's bow-back leg pattern. Arm terminals and seat corners form full front scrolls (fig. **7-19**), the curves echoing one another and emphasizing the roundness of the post bulges. In view of Porter's use of other New London County Windsor features, it seems more than coincidental that prominent rounded corners are also present in the plank of a settee made earlier by Ebenezer Tracy. The four heavy, vertical rods centered in the settee back repeat in modified form the profile of the arm post and form a kind of splat elevated on a pedestal. The tiny platform, drawn from the vocabulary of Queen Anne-Chippendale design, is balanced at the top by a hollow-cornered, rectangular tablet borrowed from the fancy chair. The feature as a whole forms a unique and highly successful focal point. The subtly tapered shallow slat of the crest is anchored at the posts in a raised collar, or cuff. Identical posts and collars are seen in the side chairs. The chair planks resemble those in eastern Connecticut Windsors (figs. 7-7, 7-8); there is no mistaking their distinctive angular, chamfered edges. A third side chair has a slat of similar form and bears the illustrated Porter brand. This chair varies from the

Fig. 7-19 Details of figure 7-18.

pictured example in several respects. The bamboowork of the posts is less pronounced, and cylindrical tops, such as those used by Stephen Tracy (fig. 7-7), replace the cuffs. A small nipple finishes each tip. The angular seat plank is exchanged for a thick rounded square similar to another Tracy design (fig. 7-5), although it is smaller and more boxy.

The Windsor settee, its matching side chairs, and the odd single chair, all made by Lemuel Porter, are in the possession of direct descendants of the original owner, Judge John Kingsbury. As a young man Kingsbury studied at the Litchfield Law School; he married Marcia Bronson of Waterbury in 1794. Both the judge and Bronson family members are mentioned in various deeds and mortgages involving Porter. Kingsbury's estate inventory of 1844 lists a settee and two sets of six chairs, one group described as green. It is possible that the two armchairs and a rocking chair also itemized in the document complemented in pattern the surviving furniture.[98]

Another Windsor-chair maker of Waterbury, David Pritchard II (or Jr.), whose work is identified in documents only, appears to have been more closely linked in his career with Litchfield County, and his work will be discussed later. However, it should be noted in passing that Pritchard had occasional business dealings with Lemuel Porter and was the more successful of the two craftsmen. A note in a small leatherbound account book that once belonged to Pritchard records under the date 1816 a business transaction with one "Amous Moris [Amos Morris]": "to 6 Cheirs from L P." Waterbury in 1816 was a small town by modern standards, and the chances of there being another chairmaker in the area with the same initials as Porter are rather remote. Perhaps the "bamboo Cheirs" that Pritchard sold another customer the same year were also made by Porter.[99]

FAIRFIELD COUNTY

Fairfield County was essentially rural during the early nineteenth century. James S. Chapman had pursued his business for some time in Redding when he advertised his partnership with John B. Merrit commencing on May 1, 1809. In general, a partner brought an additional pair of skilled hands to a shop and provided new monies or stock to expand or increase the business. At their advantageous location on the "Turnpike" the partners proposed to supply "all kinds of Cabinet work from the Cradle to the Coffin . . . on the shortest notice." Likewise, they were prepared to offer a complete selection of vernacular seating, including kitchen, Windsor, cane, and fancy chairs, of warranted quality and at New York prices. No doubt New York chairmakers and merchants were able to sustain a profitable trade in chairs along the New England coast by underselling local markets.[100]

West of Redding near the New York border, Ridgefield was still a rural center of cabinet- and chairmaking. Thomas Hawley Rockwell (1775–1865), said to have learned his trade with Elijah (probably Elisha) Hawley, announced in December 1799 the opening of his business as a shop joiner, cabinetmaker, and chairmaker. Likely a close kinship existed between the younger and older man. One James Rockwell, probably Thomas's father, had patronized Elisha Hawley in 1790 and 1792 for cabinetwork and chairs; payment was in timber. In 1799 young Thomas Rockwell gave his shop location as three-quarters of a mile north of the meetinghouse, a landmark that usually was a point of reference in establishing rural locations. In later years the shop site would be described as the upper end of Main Street. Part of Thomas Rockwell's business life is chronicled in an account book that begins about 1820. The record describes cabinet- and chairmaking activity and provides information about his life as a farmer. His chair production appears to have been reasonably small, allowing variation to creep into production over a period of even a few years. Rockwell's entries for Windsors usually lack further description, although on one occasion in 1830 he recorded the sale of "Six Slat Back winsor chairs." The slat formed the crest. Rockwell's usual price per chair was about $1. On one occasion he was explicit as to what constituted a "set" of seating: "To One Sett or Six fancy Chairs." Since the price was only slightly more than $1 a chair, this may actually have been fancy *Windsor* seating.[101]

Samuel Hawley of Ridgefield operated his furniture business on a much larger scale. He is identified as a nephew of Elisha Hawley, which suggests that he learned his trade in his uncle's shop. At one point in his career Samuel Hawley was in partnership with the Ridgefield cabinetmaker Rufus H. Pickett. Over the years Samuel appears to have been rather successful. His shop and residence were separate, the latter a brick house near the corner of Main Street and King Lane. Hawley is the only furniture maker of Ridgefield named in the 1820 manufacturing census. The marshal who surveyed the area noted that mahogany and cherry were his principal cabinet woods; fancy and dining chair production supplemented the cabinetwork. In Hawley's employ were another man and four apprentices. His statement concerning business conditions differs from those made at New Haven: "Demand for the Articles not as good As usual And price Depressed and pay bad owing to the presure of the times."[102]

Norwalk, a coastal crossroads south of Ridgefield, in 1823 was the site of James E. Kilbourne's cabinet shop. In a notice of January 27 Kilbourne announced plans to expand his business into a cabinet warehouse the following May. Plans went well, and he was able to open his wareroom ahead of schedule. Cabinetware was supplemented by fancy and Windsor chairs and a variety of painted articles, including tea boards, dressing boxes, and bellows. Kilbourne sought a journeyman to assist with production. However, his high hopes were soon dashed, and by September the woodworker announced a sale and solicited the public to call and purchase—to be "friends in time of need." Among articles still on hand were three sets of fancy chairs—one "elegant" and two "inferior"—and a few sets of Windsors. It was Kilbourne's declared intention "to commence business in New York" following the disposal of his merchandise. Advertisements and documents describe many similar situations. Depressed times, the competition of "imported" chairs, and insufficient population density to support even an enterprising craftsman all took their toll.[103]

Bridgeport at this period was scarcely larger than Norwalk. Timothy Dwight described it in 1811 as consisting of two parts separated by the Pequonnock River and joined by a bridge. The inhabitants, he continued, were "almost all merchants and mechanics, their commerce . . . principally carried on coastwise." The population stood at only 600 or 700 people. The firm of Barney and Thomas appeared sufficiently prosperous in 1820 when the census taker visited to compile data. The annual market value of the partners' cabinetware and chairs was $2,000. Three years later Henry Barney continued alone at the same location, which had been converted to a "Fancy, Bamboo and Windsor Chair Factory."[104]

The start of David Finch's career was anything but auspicious. At age sixteen he was the subject of a notice placed in the *Connecticut Courier* by William Chappel of Danbury, who identified him as a runaway apprentice to the chairmaking business and a native of Newtown. Finch apparently completed his training and hired out as a journeyman before the 1826 opening of his Bridgeport wareroom, where he sold fancy and Windsor chairs. He offered to take country produce in exchange for work and called for the services of one or two "first rate workmen." Produce would not pay all the bills, however, and by 1829 Finch was in such deep financial trouble that he was forced to assign his assets to a trustee. The inventory of his holdings and a later schedule of sales at auction reveal an active manufactory. There were "roll back" Windsors, the posts scrolling backward and possibly centering a crest roll, 500 finished chair seats, and 600 feet of whitewood plank to produce more "bottoms." The 725 bundles of flag on hand were to provide rush seats for "Curl maple frames," kitchen chairs, and perhaps children's seating. Additional lumber, varnish, and assorted chair parts, such as "rounds" and "backs," and a few personal possessions completed the assignment.[105]

Financial disaster was to plague furniture makers in the rising town of Bridgeport for some years to come. Frederick Wells Parrott stocked quantities of "CHEAP CHAIRS . . . Fancy and Windsor" in January 1832. He housed the chairs in a back room but kept samples in the front shop where he displayed his cabinetware. Possibly to broaden his horizons, but more likely to improve his cash flow, Parrott opened a cabinet and chair

warehouse in New Bern, North Carolina, sometime before December 1833 when he advertised there. No doubt he transferred Connecticut stock to the new location. Less than a year later Parrott advertised in Raleigh, where he had taken a store on busy Fayetteville Street. However, the axe was about to fall, even though Parrott had acquired a partner and, presumably, more capital. On February 7, 1835, appraisers began a lengthy inventory of the Bridgeport establishment of Frederick Parrott and Fenelon Hubbell for the benefit of their creditors. Quantities of raw materials, hardware, tools, furniture parts, veneers, cabinetware, and chairwork fill the nine-page schedule. The seating alone is extensive. There were curled maple and imitation maple (painted) chairs; chairs with flag, cane, or wooden seats; and crest pieces in crown, square, roll, or scroll patterns, along with another described as having the "Corners of Tops Rounded." The entire inventory amounted to $2,307.80 and took two appraisers five days to complete. Stock remaining in New Bern was purchased by Booth and Porters, local craftsmen and entrepreneurs. By 1843 Hubbell was in partnership with Gasford Sterling. Parrott may have left the chairmaking trade; in any case, he died at Bridgeport in 1891.[106]

The Bridgeport furniture industry was marked by frequent, short-lived copartnerships, which were dissolved as easily as they were formed. Typical headings in public notices read "New Co-partnership," or "Eureka! Eureka!" One firm no sooner vacated its warerooms than another moved in. For example, within two years or less David D. Lockwood and Company took over the former site of F. Lockwood and Company; the latter, in turn, occupied quarters vacated by Porter, Booth and Company; and Edwin Wood set up in still another "stand" formerly in the possession of F. Lockwood. The new D. D. Lockwood firm took aggressive steps to attract customers in 1844, advertising, "If you would furnish your house with Cabinet work for one half what it costs your neighbors, call at D. D. LOCKWOOD & Co's *Cabinet and Chair Ware House* . . . where you can buy 20 per cent. cheaper than you ever expected to." Certainly, the "assortment of from 1500 to 2000 chairs" was one of the largest around. The selection ranged from mahogany to Windsor chairs, and the firm also carried "Boston Rockers of their own manufacture." The company managed to keep its head above water until 1847, when creditors pressing for payment could no longer be held at bay. Among them were Sterling and Hubbell and F. Lockwood and Company. As in the case of the Parrott and Hubbell insolvency, the inventory of attached goods shows a varied selection of chair parts and finished seating. The scroll-top crest is the only specific pattern mentioned.[107]

LITCHFIELD COUNTY

Litchfield, the county center, was the principal regional focus of the furniture trade during the 1800s. The town, which had a population of about 4,000 in 1806, was also the site of an eminent law school. Five turnpike roads linked Litchfield with other western Connecticut towns and the important centers of New Haven and Hartford. As the area's business hub, it naturally attracted craftsmen. Preeminent among names associated with the Litchfield furniture trade is that of Silas E. Cheney. A native of Manchester, near Hartford, Cheney settled in Litchfield in 1799 as a young man of about twenty-three. Success was almost instantaneous. During the two decades of his career, the craftsman developed a large circle of customers, employed numerous workmen, and conducted business with a broad group of suppliers. Cheney's first workshop probably was rented, but on April 30, 1800, he made a decisive move. He purchased a "Joiners Shop" near the courthouse from Ebenezer Plumb, Jr., and simultaneously acquired "a Turners lay [lathe] belonging to Said Shop." The property was under the encumbrance of two mortgages, which he satisfied the following day. It is possible that Cheney, as a newcomer, had worked on the same premises, renting space from Plumb to conduct business on his own account. In March 1802 the rising craftsman removed to a second shop located about fifty rods west of the courthouse; he purchased the building from cabinetmaker Joseph Adams for $80. One of Cheney's few recorded advertisements, dating a few months later, itemizes only cabinetware.[108]

Five account books and miscellaneous papers permit an intensive study of Cheney's career from 1799 until 1821. The craftsman inaugurated his production of painted seating with the "dining" Windsor in January 1801 and continued to manufacture a seating piece identified by that name until 1816. This was Cheney's most salable seat. Some models cost as little as $1.16, but the median range was $1.25 to $1.33. Special dining sets described throughout the accounts as "fancy" generally commanded prices of between $1.50 and $1.67 the chair; they were extra-embellished with the ornamental work Cheney referred to occasionally. During the fifteen years of production the dining form likely included several patterns, ranging from the bow-back to the single and double cross-rod styles and the narrow slat top. If Lemuel Porter's Waterbury work is any gauge of consumer taste, the latter may have been the dining chair of greatest regional demand.[109]

Beginning in 1808 and continuing only through 1812, Cheney introduced the term "square back" to his chair accounts. Based upon cost and contemporary regional work, he probably was describing a plain-spindle chair of broad slat set between the posts. Chairmakers in the adjacent style center of New York had only recently introduced such a pattern (fig. 5-34), and the progressive Cheney likely kept abreast of fashionable developments in that market. The price ranged between $1.33 and $1.50; in one instance, Cheney referred to chairs rated at the lower figure as "plain." It follows, then, that seating priced at $1.50 had extra decoration beyond basic "penciling" in the grooves. To complicate interpretation, Cheney introduced the word "Windsor" to his records in 1813, continuing its use until his death in 1821. Individual prices generally fell between $1.25 and $1.50. On several occasions Cheney referred to chairs in the range between $1.25 and $1.33 as "plain" or "common." A set of chairs with "swelled rods" (fig. 7-18) cost $1.58 apiece. The "Windsors" probably were the former square-back chairs, although introduction of the word did not negate Cheney's use of other terms in referring to wooden-bottom seating. In 1817 and later years he manufactured chairs described as "bent back," some of which he further noted were wooden-seat chairs. What pattern were they? Was Cheney simply differentiating between Windsors with straight posts and those with shaved and bent "standards"? Perhaps he referred specifically to a chair with a shaped crest piece framed on top of the back posts then popular in neighboring Massachusetts (figs. 7-36, 7-55). Prices averaged about $1.50.[110]

From time to time Cheney referred to "bamboo" and "sprung back" chairs as Windsors, although primary production was oriented toward fancy rush-bottom seating. The craftsman manufactured the "bamboo" chair from 1814 and the "sprung back" (or "spring back") from 1815 until 1821. High-style bamboowork is seen in New York Windsor production (fig. 5-41), and Cheney's wooden-seat bamboo chairs may have borne a close resemblance. Reference to sprung-back Windsors, probably an alternate term for bent-back seating, is made only twice. Since Cheney manufactured a "ball-back," or ball-fret, fancy chair from 1818 to 1820, the sprung-back Windsor, like that seating piece, may have had multiple crosspieces and ornamental spindles (fig. 5-43).[111]

In all, the Cheney accounts record twenty-three chair terms, some of them alternates for other names, as, for instance, "women Chairs." Two such seats purchased on September 26, 1814, cost $1.42 each. A month later another customer purchased two "Soing Chairs," obviously seating for women's use, at the same price. The rocking armchair was popular throughout most of Cheney's career and always fetched a price between $2.25 and $2.50. The modifiers "childs," "little," and "small" all seem interchangeable references to children's seating. Prices varied from $1 to $1.42; the top-priced seats were described as "high" chairs. Cheney enjoyed a small but steady production of kitchen frames during his chairmaking years. The price of $1 or less reflects a plain utilitarian style and the absence of ornament. A group of "armed" chairs priced less than fancy work probably identifies companion seating for the Windsor side chair. Fetching top dollar, except for joined seating executed in mahogany and cherrywood, were several writing-arm chairs made in 1819–20, which Cheney priced at $4 or $5. By contrast, Levi Stillman of New Haven charged only $2 to $3.50 for his "leaf" chairs. At his death in 1821 Cheney had not yet commenced construction of the roll-top chair, which Stillman's

records show was a new style in the early 1820s. Mass production of this pattern was destined to be the province of another Litchfield County entrepreneur, Lambert Hitchcock.[112]

Cheney's accounts contain the names of no fewer than forty craftsmen who supplied parts, served as shop journeymen, or exchanged products and/or services with the entrepreneur during his career, and this number does not include those who supplied only timber and lumber. Ebenezer Plumb, from whom Cheney purchased his first shop, bought incidentals—table hinges and sandpaper—in 1802, an indication that he was still in business. Joseph Adams, former proprietor of Cheney's second shop, acquired furniture at various times between 1802 and 1818, possibly to fill orders at short notice or in exchange for unnamed services. Adams, who was also a Windsor-chair maker, first came to Litchfield in 1790, although he may not have produced Windsor seating in Connecticut before 1797, when he advertised this branch of the business. David Pierpont, a Windsor-chair maker working in Litchfield from at least 1792, was indebted to Cheney for 29 feet of basswood plank in 1808, presumably to "get out" chair seats. He appears to have been the "David" who assisted Cheney in house painting in July 1805. The daily pay rate for each man was 7s.6d., indicating that David was a craftsman of master status. Cheney appears to have been acquainted with John I. Wells of Hartford. In fact, in view of Cheney's birth in Manchester and his coming of age in the late 1790s, it is not unreasonable to speculate that the young man received his training in Wells's Hartford shop. In accounts with Abraham Knowlton, a cabinetmaker in his employ in 1806, Cheney noted settlement of a debt of Knowlton's for £6.3.3 "with John I wells for you." Eight years later Cheney bought "flaggs for 150 chir seats" from Wells at the rate of 7¢ per chair, "or if soon paid for in Hartford or Middletown money—at 6 cts."[113]

During Cheney's twenty-year career in Litchfield he recorded the part-time services of many men who assisted with shopwork. Some are names only, journeymen who worked for a brief period in Litchfield and then moved on. John Sanders constructed chairs and performed odd jobs and repair work from November 1800 through March 1801; Russell Hicok followed suit a few months later. Joseph Hooper made chairs and turned "Chare stuf" between 1803 and 1806. An unidentified Mr. Russell rented shop space in 1808–9 for eight months; he probably received the profits of his own production after expenses for materials. James Putnam remained in the shop only one day. Cheney noted in his records on April 30, 1810: "this Day James putnam & I settled after he had bottomed one Chair." Evidently, Putnam's work did not measure up to Cheney's standards. Late that year and following, a Mr. McNiel worked for thirty-three days, during which time he framed 107 chairs, wove seats, painted, and spent four and a half days "giting out rods," or spindles. Charles T. West spent most of February and March 1812 in Cheney's shop; he framed chairs and turned stock but devoted most of his time to painting and ornamenting. Sidney Twidel performed similar work. He also cased rush seats and varnished chairs. Solomon Buel, who seated chairs for Cheney, may have been a local resident working at home. In 1814 he brought his kitchen chairs to the shop for sixteen new rods—work that no doubt represented normal wear and tear by an average family.[114]

Some of the men who worked for Cheney were Connecticut craftsmen. Daniel Burnham who "put up" (framed) chairs in 1811 may have resided later in northern Litchfield County at Colebrook. Noah Dibble, a Danbury native, probably was experiencing financial difficulties when he came to work for Cheney in 1812. As the head of a household of seven in 1810, he had been trying to make ends meet in Norwalk. James May exhibited a craft versatility common to Cheney's workmen by both framing and ornamenting chairs. He worked by the day in 1813 and sometimes boarded at the Cheney home. Apparently, May remained in the area, since in 1816–17 he purchased gold leaf and sandpaper. Earlier, Ebenezer Bryant (1794–1867) of East Hartford made "Wood seat chairs" for Cheney; he prepared chair parts, painted, and ornamented. Young Bryant had just completed his apprenticeship, which he probably served in Hartford where the courts appointed a guardian at the death of his father in 1811. Orrin G. Winchell was

another who led a semi-itinerant life. Born in Rocky Hill, south of Hartford, he set up shop in Wallingford upon completing his apprenticeship in 1809. During the summer of 1819 Winchell framed and ornamented chairs for Cheney. He was a resident of Berlin, near Hartford, when he married in 1822 and again in 1825, but in the meantime he had buried a child at New Haven. The 1830 census gives his residence as Vernon, Tolland County.[115]

William Butler, perhaps the same man who was born, married (1803), and died (1868) at New Hartford, Litchfield County, appears to have been a Litchfield resident between 1807 and 1810. His chairwork for Cheney was, perhaps, more extensive than that of any other workman. The connection began in 1807 with Butler's purchases of cabinetwork, chair materials, painting supplies, and lumber. Once Butler borrowed a horse to go to "[Jake] Osberns to Cut timber." When the work was completed Cheney took his wagon to fetch the material and to help load and unload. The bass and whitewood seat plank that Butler bought directly from Cheney apparently came from another source. In February 1808 Cheney recorded Butler's first credit, $12.75 for nine chamber chairs. Based upon other evidence, Butler probably had a shop of his own somewhere nearby. On March 26 he submitted one of the most extensive accounts of chairwork to be found in Cheney's records; the bill amounted to $163.49. Butler framed or completely finished 197 chairs, of which square-back, fancy, and common styles accounted for the greatest number. He put rush seats into 20 frames and cased the seats of 8 fancy chairs; he painted at least 101 chairs, ornamented several dozen, gilded a few, and varnished others. Butler also provided chair parts—legs, stretchers, and bottoms— and did repair work. This was only the beginning, however. Later accounts itemize more chairs, some framed with "stuff" turned by one Daniel Eason. Butler incurred another debt in May 1808 when Cheney hauled chairs for him to Farmington, probably to a retail outlet. An account dated November 19 positively identifies Butler as an independent workman: "By Painting you & Boy Prise agread . . . 2.50." Only a man in business on his own would have had an apprentice. Cheney's last debit for Butler occurred on February 4, 1809, when he charged him 25¢ for "spoiling green Paint." The "mush mellons" Butler supplied in March at 21¢ almost covered the cost.[116]

Many individuals supplied Cheney with chair parts alone. All labored outside the shop; some owned independent supply businesses, and a few specialized exclusively in turnery. Frequently, the men exchanged their work for Cheney's products or materials. About half the group lived in Litchfield or the immediate area; the others carted their merchandise over some distance. Two suppliers actually lived and worked in Lee, Massachusetts, located almost due north in Berkshire County. One of these, West and Hatch, supplied Cheney with several hundred sets of chair stuff in 1814. A set represented all the parts needed to complete one chair, exclusive of a rush or cane seat. Five different chairs are represented: "Bamboo Ball Back," "Bamboo Winsor," "Plain Winsor," "Sprung Back," and "kitchen." In exchange, West and Hatch received cash and cut nails. Five years later in 1819–20 Daniel Foot and Company, also of Lee, supplied parts for much the same kind of seating, to which was added "fancy Chair stuff." A major exchange with Cheney was a wagon fitted with a chair, or seat, worth $26. Foot's property was described twenty years later at his death as a "Turning shop & dwelling with water privilege." Given such exchanges, how is it possible to differentiate between the chairwork of Litchfield County and that of western Massachusetts? Documented examples are unknown, but the products of the two areas probably were so similar as to be indistinguishable. Add to this the number of hands that worked in the Cheney shop ornamenting chairs, and the "local style" was even more diffused.[117]

Not all chair stuff was made or delivered to Cheney in complete sets for framing, and at times the exchange of parts was reciprocal. Nathanial Brown of Litchfield provided only front posts, rounds, and chair rods in 1813. Earlier, in 1802, he had acquired chair seats from Cheney. Brown made chairs on his own, advertising on April 3, 1799, "ready-made *Windsor, Dining, Fiddle back, Plain,* and small *Chairs* for children." In 1813–14 Russell Bull, possibly a Torrington resident, supplied Cheney with a miscellaneous

number of chair parts, comprising legs, stretchers, bows (crest pieces), standards (posts), and rods. He also seated chairs with rush. Many men provided plank seats only, since the work could be undertaken by one who was unskilled in furniture making but handy with tools. Miles Hart of Goshen is the only fabricator of seats identified as a furniture craftsman. Cheney kept close watch on the stock supplied him, noting short-comings and adjusting prices accordingly. In September 1813 Nathaniel Brown provided front rounds that Cheney deemed "poore"; the same month Russell Bull supplied standards that were too short. Several years later Cheney discovered, after he had framed stock sent by Daniel Foot, that "7 fancy Benders [cross slats] fell short"; he noted the same in his debit column. There were problems with seats, too. One lot from Asher Smith was "Badly Cracked & shakey" (full of clefts). Ten of thirty-five seats supplied by Amos Hine in the winter of 1813 were "narrow & sum shaky."[118]

A few craftsmen appear to have made purchases from Cheney without exchanging services or products. Ira Brown bought chair seats in 1802 and two years later got green paint for finishing chairs. Ambrose Norton visited the shop several times between 1817 and 1819 to obtain varnish, plank, and chair rods. On one occasion sixty-one chair rods were "lent" only, that is, they were to be repaid in kind. Another entry for Norton dated 1813 reads, "to part of Varnish kittle." This charge is illuminated in an entry in Cheney's inventory of 1821, "½ Varnish Kittle." Apparently, the two men shared the vessel's use and possibly the periodic preparation of the finish itself; however, the kettle remained in Cheney's shop. From Waterbury David Pritchard or his journeyman came on several occasions in 1815 to fetch turned chair stuff, including bamboo Windsor materials. The same craftsman bought plain, finished Windsors a few years later.[119]

David Pritchard's probate inventory of 1839 identifies him as a relatively prosperous maker of cabinetware, clocks, and chairs. Seating furniture itemized in the shop compares well with the contemporary production of Lambert Hitchcock, who, as it happens, was Pritchard's brother-in-law. During Pritchard's early career before the War of 1812, he constructed a range of seating appropriate to the time, as recorded in a ledger dating between 1800 and 1810. There is mention of rush-bottom, fiddle-back chairs on several occasions. From about 1802 through 1807 he constructed Windsor fan-back seating and also dining chairs, probably with bow backs. Two sets of chairs referred to as "miter tops," priced at $7.50 or $8 the set, are listed in the records for 1804 and 1807. They can be identified as single- or double-bow, square-back Windsors with cross rods capping the posts. The joints are actually horizontal, but often the squared corners have diagonal grooves that appear to constitute a miter (fig. 7-2). During the early 1800s Anson Stocking of Waterbury was an occasional workman in the Pritchard shop. Undoubtedly, this was the same man who made chair seats for Silas Cheney in 1815. Pritchard boarded Stocking from October 1808 until the following April and again from November through January 1810. Besides constructing chairs Stocking worked on bedsteads and joined furniture.[120]

The name of Lambert Hitchcock appears in Cheney's records. On May 13, 1814, the Litchfield furniture maker conveyed chair plank and bed screws to the budding entrepreneur, who, it seems, was none other than David Pritchard's journeyman. Hitchcock only reached his nineteenth birthday at the end of the month. His status as a journeyman to Pritchard, a man about twenty years his senior, speaks well of his abilities. The situation further suggests that Pritchard knew the capabilities of the young man because he himself had *trained* Hitchcock. Two memoranda dated in mid June shed light on Hitchcock's work for Pritchard. One speaks of a "contract" between them; the other defines the particulars:

Waterbury 18 June 1814
Now in Case the Cheirs that I have making for David Pritchard Jr which is one hundred dining Cheirs and one hundred Citching Cheirs and twenty four rocking Cheirs Should fail I will make them good. Lambert Hitchcock[121]

By August of the following year Hitchcock apparently was a journeyman in Cheney's shop, where he remained for several years. On his trips north from Waterbury the young man probably recognized in the Litchfield establishment a going concern, one likely to provide greater experience and opportunity for an ambitious young craftsman. Miscellaneous entries, such as those for center bits, "Panterloons," or cash, are all that chronicle Hitchcock's life in Litchfield until the appearance of an account in Cheney's records dated September 28, 1816. Doctor John M. West, who evidently had just ventured into the business world, paid his "first rent for Factory" but owed a debt to Hitchcock for "work at the mishean for lath about 2½ Day." The next month on the seventh "at night" Cheney "wreckond & ballancd book accmpts with L Hitchcock" and found that $30.45 was due the young man. John Tarrant Kenney states that Hitchcock left Cheney's employ at this time to attend the Episcopal Academy of Connecticut at Cheshire. However, the young man was back in Litchfield the following May, where he remained awhile longer. Within a few years Hitchcock had launched his own career, and Cheney was dead. Chairs detailed in Cheney's shop inventory are similar to the late styles listed in his accounts. Cheney, who had enjoyed a successful, though short, career, was worth the substantial sum of $4,600.[122]

Silas Cheney's death left an opening in the Litchfield furniture market for an aggressive, enterprising individual with practical trade knowledge and a good business sense. Benjamin Doolittle had established a chair factory in 1819 at the local shop of Dewey and Adams to manufacture fancy, bamboo, and Windsor chairs in the current New York patterns, but he appears to have moved on within a few years. Garwood Sanford, a house and sign painter for Cheney in 1817 and 1818 and debtor to six "sprung back" chairs in 1820, accepted orders for ornamental painting and gilding the following year through the shop of George and John Dewey. By 1822 Sanford had formed a partnership with Elizur B. Smith, a chairmaker. Sanford vacillated between the two trades and in 1828 advertised as a painter and paperhanger.[123]

The most substantial furniture maker and dealer in town was George Dewey (1790–1853), who worked alone or with partners. Dewey was in business as early as April 19, 1815, when he advertised. By June 1818 he had moved to a shop west of the courthouse, apparently close to Cheney. The facade of this building may be the one pictured in an advertisement of 1830 and on an advertising label affixed to his cabinet furniture. Dewey had a succession of partners between October 1819 and February 1826. He usually emphasized his cabinet business, although he also constructed chairs, as documented in a trade label of about 1830: "CHAIRS manufactured and sold at the same place." Imported or consignment seating also was available, as announced on April 8, 1818: "Just received an Assortment of Fancy & Dining CHAIRS." A trade notice of 1830 offered curled maple chairs of "L. Hitchcock's Manufacture."[124]

Despite the level of chairmaking documented to Litchfield through the 1830s, only a child's Windsor side chair branded "G. Dewey." (fig. 7-20) is positively identified with the town. In style, it best fits the general term "square-back chair"; certainly, it is not a bent-back Windsor. The period is that of Dewey's early working years. The rounded, late shield-type seat resembles a plank employed by Thomas West in New London County (fig. 7-11). The chair's reduced size dictated the use of fewer spindles. The narrow crossrail constitutes a pierced-end "bender," which is not particularly common in Windsor work, although it is found in Massachusetts and New Hampshire chairs (figs. 7-34, 7-61, 7-84). A type of framing very new to New England Windsor-chair making at this time appears in the crest, where the broad slat rests on a kind of shelf, or rabbet, cut into the face of each post. Repairs have introduced a screw and nails to the board face, which is also damaged at the upper right corner. Normally, countersunk screws at the post backs would pierce, but not completely penetrate, the slat, the holes being covered with a composition material and painted out of sight. The painted surfaces and applied, découpage decoration are later additions. There is also an unusual *old* repair at the base of the right post employing an angled, threaded, metal rod held secure below the plank with a large nut. An honest, early "make do" repair such as this may be viewed as a part of

Fig. 7-20 Child's square-back Windsor side chair and detail of brand, George Dewey, Litchfield, Conn., 1815–24. Basswood (seat, microanalysis); H. 20¼", (seat) 7½", W. (crest) 12¾", (seat) 12¼", D. (seat) 12¾". (Private collection: Photo, Winterthur.)

the object's history. The legs employ a fancy pattern borrowed from high-style, rush-bottom seating. The tapered cone, spool, and ring turnings at the top of each support are identical to the embellishment of a rush-seat "bamboo" side chair documented to George Skellorn's New York shop in 1819. Again, the pervasive influence of New York chairmaking is manifest in New England work of the early 1800s. Documented to the same year is a full-size New Hampshire Windsor (fig. 7-87) constructed with variants of three major features in the child's chair—a rabbeted crest, pierced bender, and cuffed leg top.[125]

Two rural areas of eastern Litchfield County contained small pockets of activity. Philemon Hinman of Plymouth enjoyed a respectable country trade as a cabinet- and chairmaker, filling in around that activity with carpentry, plastering, and general handiwork. Much of his pay was in timber, some sawed into boards. Although his accounts extend from 1804 to 1817, he made chairs only between 1808 and 1815. Hinman completed fourteen sets, presumably comprising six chairs each, along with two groups of four chairs, and a few rocking and "little" seats. The usual price was 36s. the set, or 6s. a chair, although two groups commanded individual figures of only 4s. and 4s.4d. The 2s. difference suggests that Hinman made two kinds of chairs in sets, probably rush-seat, slat-back kitchen seating and Windsors. When the craftsman died in 1835, he was living in Harwinton, the next border town to the north. His inventory lists a good range of woodworking tools along with both "Kitchen Chairs" and "Wood seat D[itt]o."[126]

While Hinman served customers in Plymouth, several woodworking craftsmen in the New Hartford-Canton area managed a diversified operation. Members of this enterprising group—Wait Garret, Samuel Douglas, and probably Samuel Douglas, Jr.—all used the same book of accounts simultaneously for their varied activity, including accounts for a general store, gristmill, several spinning factories, a wagon works, and furniture and chairwork. The dining Windsor was the chair of greatest production; ninety-five were constructed between 1811 and 1815. Generally made in sets of six, the chairs cost about $1.25 each. An unusual reference in 1816 to "one Set Fanback Chairs" at the same price raises a question about the dining pattern. Either the craftsmen served an extremely conservative populace or the term "fan back" identified a square-back pattern of the early nineteenth century. Nor is it possible to distinguish between the "common" and "kitchen" chairs made in the same period, since all were priced in the same range, the cost reflecting the presence or absence of a woven seat in the frame. The relatively high prices of rocking chairs at $2.35 and $2.50 suggest wooden-bottom seating, and accounts show a capability within the shop for some ornamentation. The few fancy seating pieces mentioned are too variable in price to classify.[127]

On January 21, 1818, Eli Wood died at age thirty-seven in Barkhamstead. He was a young man just out of his apprenticeship in 1800 when he advertised as a cabinetmaker at Lemuel Adams's old Hartford shop. The following year he began a six-year association with Nathaniel Watson to make chairs and cabinetware. Wood later removed to Barkhamstead in northern Litchfield County, where his success was substantial. At the time of his death he owned considerable land, a homestead, several houses, two sawmills, and a "Chair Factory with Lathes & Machinery." More than 7,000 chair parts were on hand to produce fancy, dining, "little," and rocking chairs. References to both bows and "broad Bows" suggest that chairs of narrow and wide slat were in simultaneous production. The fact that Ebenezer Bryant was a creditor of the estate may identify him as an employee of Wood. Bryant worked occasionally for Silas Cheney in this period, and records document his proficiency in all phases of chair construction and finishing. The closing of Wood's substantial manufactory in Barkhamstead offered a golden opportunity for a young man full of enthusiasm, eager for hard work, and with an appetite for success, but Ebenezer Bryant was not that person. Instead, Lambert Hitchcock stood ready, and the moment was right to launch his career. The closing of Cheney's shop at neighboring Litchfield a few years later may have increased his success.[128]

Lambert Hitchcock (1795–1852) was born in Cheshire. When he was six, his father was lost at sea, a situation that likely encouraged the family to apprentice the boy to a trade at an early age. As documented in the accounts of Silas Cheney, Hitchcock was already a journeyman in the employ of David Pritchard (1775–1838), his brother-in-law, before he reached his nineteenth birthday. Pritchard, who had married Lambert's older sister Anna, was twenty years the young man's senior and had been established in Waterbury since before the census of 1800. Three shared circumstances—proximity of location, family relationship, and the need for youthful employment—suggest strongly that Pritchard was Hitchcock's master at the cabinet and chair trades. Hitchcock became a journeyman to Cheney at Litchfield in 1815, where he remained at least until 1817. About 1818 the budding entrepreneur struck out on his own. He went to Fork-of-the-Rivers, a tiny hamlet in Barkhamstead Township, where he set up a woodworking shop in the enclosed portion of a water-powered sawmill on the Farmington River. For a beginner it was an excellent situation. The raw materials of his trade grew all about him, and the wood could be prepared for working into stock on the premises.[129]

Hitchcock began as a manufacturer of chair parts. With limited funds (and perhaps limited space), this was a good way to start. He had seen suppliers bring parts into the Cheney shop. The market was potentially broad, and chair parts were easily and economically transported. An early commentator on Hitchcock's career states that a considerable portion of his output was sent to the South, presumably shipped through Hartford. Several years at this business permitted Hitchcock to expand. A short distance away on the Farmington River was a two-story wooden building that, with adjacent land, suited his purposes. Hitchcock first advertised his "manufactory" on the River Turnpike in Barkhamstead on March 18, 1822.[130]

In 1825, with production on the rise, Hitchcock erected a three-story brick building along the Farmington River equipped with a large waterwheel to power the machinery. About this time the craftsman began stenciling his name and location on the backs of his fancy and Windsor seating. An advertisement placed in the *Connecticut Courant* on July 18, 1825, by Barzillai Hudson, proprietor of the Auction Store in Hartford, is thought to refer to Hitchcock: "RECEIVED THIS MORNING FROM THE MANUFACTURER, 250 Fancy and Plain Chairs." Indeed, Hudson offered "800 HITCHCOCK'S fancy flag-seat Chairs" at auction only two years later. To further publicize this event Hudson distributed chairs at local gathering places in communities surrounding Hartford so that residents could examine the workmanship and materials. His advertisements for warranted Hitchcock chairs continued regularly until in April 1829 he could state: "Hitchcock's Chairs are so well known, that it is not considered necessary to give a particular description of them. Every Chair is marked with his name and warranted." Within Litchfield County itself John and George Dewey independently advertised chairs from the manufacturer in 1829 and 1830, and Bulkley and Cooke still offered "a general assortment of Hitchcock's Chairs" in 1839. Hitchcock had introduced the name Hitchcocksville (today Riverton) to the small group of buildings formerly known as Fork-of-the-Rivers, although the place was still hardly a village (fig. **7-21**). The community contained "upwards of 20 dwelling houses, 1 chair factory, 2 mercantile stores, and an Episcopal church."[131]

A manufacturing complex the size of Hitchcock's needed many workers. The entrepreneur advertised regularly for hired help in newspapers around the state; on July 2, 1828, he sought six journeyman chairmakers at one time. In partnership with Samuel Couch, Hitchcock established a general store for the convenience of his employees and area residents; the establishment also served as a local wareroom and sales office. As Hitchcock's business expanded, so did the size of his distribution territory and the number of creditors. Income from sales and consignments proved erratic and uncertain, and by the late 1820s Hitchcock's success was beginning to unravel. Money borrowed from friends had to be repaid, and on June 16, 1829, fire destroyed the general store, which was not insured. Final collapse of Hitchcock's business world came on July 20,

Fig. 7-21 View of Hitchcocksville, Connecticut. From John Warner Barber, *Connecticut Historical Collections* (1836; rev. ed., New Haven, Conn.: Durrie and Peck, [1856]), p. 461.

when he executed a deed of assignment conveying his assets to a group of trustees for the benefit of his creditors. One of the latter was Hitchcock's friend William Moore, Jr., a local chairmaker some twenty years the young man's senior. At Moore's own insolvency a year later, brought on no doubt by Hitchcock's débâcle, his inventory detailed a surprising number of chairs in the hands of retailers. Moore's market encompassed Philadelphia, New York, Springfield, and Northampton, along with several small towns in southwestern Massachusetts.[132]

After the legal details of Hitchcock's bankruptcy had been worked out, business resumed on June 23, 1830. Under Hitchcock's guidance as agent the revived business began to gain much of its former momentum and stature. Almost immediately the manufacturer increased chair prices and introduced a line of painted furniture, the latter yielding a greater profit margin than the chairs. As early as August 14, 1830, the Hartford *Times* carried agent Hitchcock's advertisement for seating and "a good assortment of CABINET FURNITURE." A tireless worker, Hitchcock was able to pay off his creditors and satisfy the trusteeship in less than the allotted three years. On November 17, 1832, he resumed business on his own account. The *American Advertising Directory* of 1831 described the size and scope of the new enterprise: "Manufacturer and Vender of Chairs of all kinds; Shipping Merchants and Southern Traders furnished on the most reasonable terms; about 15,000 made annually." Supplementing these data are statistics published the following year in a national survey of manufactures. Hitchcock's production in 1831 grossed $13,500; his principal markets were Connecticut and adjacent states. The furniture maker employed fifteen men at 75¢ per twelve-hour day and six women stencilers at 42¢.[133]

In reassuming control of the firm, Hitchcock made changes. In partnership with his brother-in-law Arba Alford, he established Hitchcock, Alford and Company in 1832; chairs produced from that date until 1843 are identified with the stencil of the new firm. Hitchcock rebuilt the general store, and his wife's younger brother Alfred Alford became the manager-partner. With Arba Alford as superintendent of the manufactory, Hitchcock turned his attention to sales and distribution, opening his "NEW CHAIR STORE" in the now thriving city of Hartford about September 1834. From his State Street location Hitchcock sold cane-, flag-, wooden-seat, and mahogany and curled maple chairs at wholesale and retail. He also distributed chairs locally on consignment. Isaac Wright received twenty-four Windsors from Hitchcock in January 1834 for sale at 10 percent commission; he bought another six "Fancy flagg Seat chairs" outright at a 10 percent discount. Further contacts with Wright and his partner Philemon Robbins describe the acquisition of maple seating along with cane- and flag-seat chairs in the roll- and crown-top patterns painted tea or cream color and ornamented with "Rich gilt" or "Bronze" (stenciling).[134]

Expansion and reorganization characterize the Hitchcock manufacturing operation of the late 1830s and early 1840s. The company acquired the chair manufactory of Roberts and Holmes in neighboring Robertsville and also increased the manufacture of painted cabinetware. Hitchcock disposed of his interests in the general store and, eventually, the Hartford chair store. Increasingly, transportation became a problem for the company in its out-of-the-way location at Barkhamstead, especially with expansion of the cabinetware line. Hitchcock decided on a new facility in Unionville, west of Hartford, where he owned a large farm and where the new Farmington Canal could provide easy access to the coastal trade at New Haven and the central Connecticut Valley as far north as Northampton. On August 15, 1843, Hitchcock, Alford and Company was dissolved, terminating use of the identifying stencil, and Hitchcock undertook the new venture alone. He established a factory on the Farmington Canal in 1844, but it did not last long. The canal closed in the winter of 1847, and a fire damaged the factory in 1848. To make ends meet Hitchcock turned to production other than heavy furniture, but he was not successful. At his death a few years later at age fifty-seven, his estate was insolvent. The factory premises contained a few plain and Grecian maple chairs, some rockers, caned furniture, and late office-style chairs.[135]

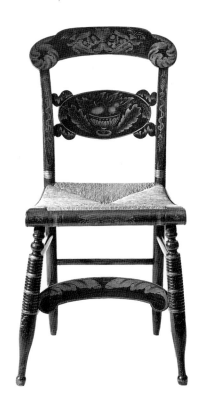

Fig. 7-22 Fancy crown-top side chair, Connecticut, 1830–45. H. 35¾″, (seat) 18″, W.(crest) 17¾″, (seat) 17″, D. (seat) 14⅞″. (Rhode Island Historical Society, Providence: Photo, Winterthur.)

Fig. 7-23 Crown-top Windsor side chair and detail of stencil, Union Chair Company, Winstead, Conn., ca. 1849–55. H. 31⅜″, (seat) 16⅜″, W. (crest) 16½″, (seat) 14⅝″, D. (seat) 14³⁄₁₆″; light blue-green ground with black, dark blue-green, and bronze-gilt. (Hitchcock Museum, Riverton, Conn.: Photo, Winterthur.)

The terminology associated with Connecticut seating patterns of the 1830s when Hitchcock, Alford and Company enjoyed good trade is relatively extensive. Frequently the terms are applicable to cane-, rush-, and wooden-seat chairs alike. The production records of chairmakers Isaac Wright and Philemon Robbins of Hartford, David Pritchard of Waterbury, the firms of Parrott and Hubbell and Lockwood and Waite of Bridgeport, and the Hitchcock organization identify roll- and crown-top chairs as the two most common patterns. The roll top is the only turned crest in the group, consisting of an enlarged center section and ends formed of spools and rings (fig. 7-24). Boston formal seating of the early nineteenth century probably provided the prototype. This joined seating in turn was influenced by English publications, such as the 1802 edition of *The London Chair-Maker's and Carvers' Book of Prices for Workmanship*. There was a lapse of several decades before the turned top piece was used in American painted seating. Fancy chairs signed "L. Hitchcock, Hitchcocks-ville, Conn. Warranted" (1825–32) employed the roll top from the mid 1820s onward. A woodcut illustrating a Hartford advertisement of Seymour Watrous dated March 2, 1824, pictures a similar crest. David Pritchard sold "Role top Cheirs winsor" at $1 apiece in 1831.[136]

The crown-top and remaining patterns have board-type crests (fig. **7-22**). Earliest mention of a crown occurs on March 16, 1832, in David Pritchard's accounts. The top piece has large downturned scrolls above the posts and a low tablet extension in the arched center section. The tablet is repeated on the lower edge in armchairs and early Boston-style rockers. The crown-top crest is most common in the rush-bottom side chair. The illustrated fancy piece has additional features of note. The multiple ring-turned legs with slim ankles and ball toes are the supports Philemon Robbins identified as "turkey legs" in October 1835. The pierced and ornamented cross slat below the crest, often referred to as a "turtle back" today, is undoubtedly the "frog fret" itemized in the February 1835 Bridgeport inventory of Parrott and Hubbell. The curved projections at the four corners resemble the amphibian's legs. Use of a crown-style crest in the Windsor, apart from the plank-bottom rocker, is uncommon. Representative are a group from Maine (fig. 7-118) and a few late chairs made by the Union Chair Company of West Winstead near Hitchcocksville (fig. **7-23**, pl. 21). The crest probably is the earliest feature of the Unionville chair. The slablike plank and tapered cylindrical turnings represent a last phase of design before recognizably Victorian styling took over.[137]

Fig. 7-24 Roll-top Windsor side chair and detail of stencil, Lambert Hitchcock, Hitchcocksville (Riverton), Conn., ca. 1825–32. H. 34″, (seat) 17¹¹/₁₆″, W. (crest) 15¾″, (seat) 15⅝″, D. (seat) 15″; dark brown ground with yellow and bronze-gilt. (Hitchcock Museum, Riverton, Conn.: Photo, Winterthur.)

The scroll-top pattern appears to have been next in demand. This rectangular crest with a small backward roll at the upper edge is curved laterally, sometimes arched slightly, top and bottom, and framed on the upper face of the back posts (fig. 7-39). Initial influence traveled from Baltimore (fig. 4-18), possibly by way of New York City. The square-top crest mentioned in several documents probably duplicates the scroll pattern except for the upper back roll. Again, the origin is Baltimore (figs. 4-11, 4-12). Of the two, this is the pattern usually found in the wooden-seat chair. Several other terms are less obvious. The flat-top chair mentioned in Philemon Robbins's accounts and the Pritchard inventory may be the slat-back chair popular in Connecticut from the beginning of the century (fig. 7-11). Lambert Hitchcock's stencil documents a plank-seat chair of this pattern. Or the term may identify a close-fitting, squared tablet framed on the post faces in the manner of figure 7-20. Two terms that could describe a single top piece—"round top" and "corners of top rounded"—occur in the Pritchard (1839) and Parrott and Hubbell (1835) inventories and may identify a flat-arched, rounded board set on the tips or faces of the back posts (fig. 7-65). Of the entire group this crest likely was the most recent pattern in the market. A rocking chair with a top piece of the same general form has stenciled decoration commemorating the "Log Cabin and Hard Cider" campaign of William Henry Harrison, who became president in 1841.[138]

Plank-seat chairs with crests duplicating two of the patterns just described have stenciled documentation on the back identifying them as products of Hitchcock, Alford and Company (fig. 7-24). One has a roll top, the other, a slat back with long, swelled spindles. The chairs share the multiple ring-turned ornament typical of the firm's fancy-chair production. In other features the two vary, although both were current in the 1830s. Straight cylindrical back posts are frequent companions of the slat-back crest, especially when accompanied by long spindles. The roll top is found in conjunction with a shaved-face post angled backward. Obviously, the turned top piece does not lend itself to the use of long spindles; thus, a middle slat (or sometimes a fret) provides the necessary structural support. Short, ball-centered spindles, three or four in number, are a frequent lower back embellishment. The thick cylindrical legs and the squared seat with flat, serpentine sides and rolled forward edge probably reflect Pennsylvania patterns introduced in the late 1810s. Front stretchers often feature an ornamental turning. Here, the narrow, centered tablet harmonizes well with the enlarged horizontal element of the top piece. The chair's decoration is similar in concept to that found in Hitchcock's slat-back Windsor.

Massachusetts

At the time of the embargo (1807–9) Massachusetts was preeminent among American states in volume of waterborne commerce. The state's registered foreign and domestic tonnage was substantial, and it owned 88 percent of the American fishing fleet. The sea was a major resource. Boston was second only to New York as a shipping center, and the communities of Salem and Newburyport were also important centers. The embargo brought hardship to maritime Massachusetts; France's continuing disregard of American neutrality and the conflict with Great Britian took their toll as well. When prosperity returned, only Boston retained its former commercial stature.

Inland, the availability of arable land diminished with the population rise following the Revolution. By the turn of the century Massachusetts, like all of southern New England, was supplying its share of emigrants to the northern and western frontiers. Samuel Eliot Morison has commented, "The younger and more far-sighted men put their money and brains into making Massachusetts a manufacturing state." Thus, by

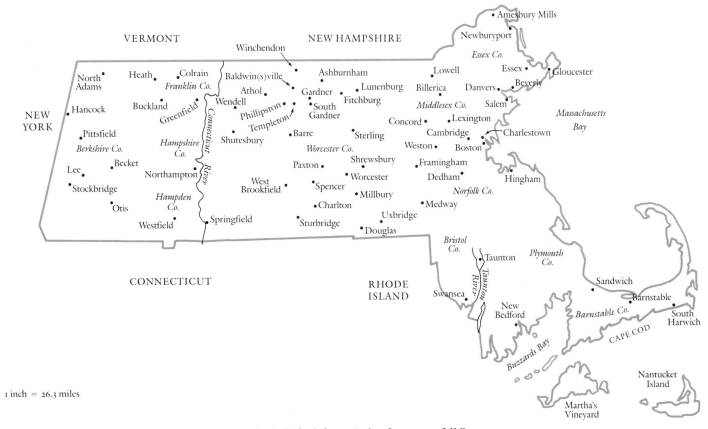

1 inch = 26.3 miles

1840 primary business interest in the region had shifted from "wharf to waterfall." However, seaborne commerce was not dead. Boston still prospered by following the old established trade routes, especially those yielding noncompetitive or exotic commodities, and the rising textile industry created a new market for imported raw wool and cotton. The capital reserves accumulated in shipping financed manufacturing, the growth of industrial towns, and the interior network of canals and railroads that made material and commodity distribution possible. Lowell, Lynn, Springfield, and Worcester became new or rejuvenated centers, producing—along with dozens of smaller communities—textiles, machinery, paper, and footwear. Water power, followed by steam, made it all possible. The former was responsible for initial development of a small chair industry in northern Worcester County in the second quarter of the century, which quickly drew into its fold the towns of Ashburnham, Athol, Fitchburg, Gardner, Royalston, Sterling, and Templeton. After 1850 steam assisted that industry in achieving national status and global distribution of its products.[139]

BOSTON AND ENVIRONS

Boston, like most U.S. communities, grew in population and size in the early nineteenth century. The 43,000 inhabitants residing in the city in 1820 represented almost twice the number recorded in 1800. By the early 1840s there were more than 100,000 residents. Physical expansion of the community introduced many new structures and also a drastic change in the physiography of the land itself. In 1803 Reverend William Bentley of Salem found in the city of his birth "great progress in their new Buildings, & much ornament from the new style of their Brick Houses & Stores." Construction continued at a frenzied pace during the next two decades. Wharves were built or rebuilt, new bridges improved city access, Faneuil Hall was enlarged, Quincy Market was erected, and a causeway was constructed across Back Bay to facilitate draining the Mill Pond. Anne Newport Royall

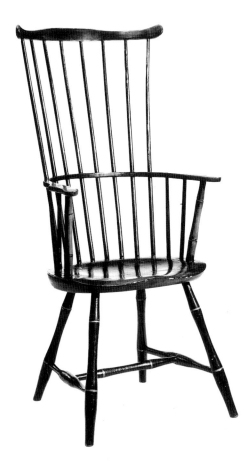

Fig. 7-25 High-back Windsor armchair, Boston, 1798–1808. (Philip H. Bradley Co.: Photo, Winterthur.)

Fig. 7-26 Trade card of Thomas Cotton Hayward, Charlestown, Mass., ca. 1803–11. (Private collection: Photo, Winterthur.)

remarked in 1824, "They are reclaiming the land from the water, and have succeeded to an astonishing degree." Following that project, reclamation centered in South and Back bays. By the 1880s Boston had lost much of its "peninsular character."[140]

Chairmaking records from early nineteenth-century Boston identify the production of five popular seating types: fancy, bamboo, fan-back, Windsor, and rush (kitchen) chairs. The well-known term *fan-back* identifies a side chair or armchair of fanned-spindle back crowned by a serpentine-profile crest (fig. **7-25**). The sale of "12 large fanback Chairs" by Reuben Sanborn to Nathaniel Treadwell on June 13, 1801, documents the continuing popularity of the pattern. Interest in the high-back chair after 1800 is further attested by its presence in Rhode Island (fig. 7-1) and by the work of Thomas Cotton Hayward of Charlestown (fig. 6-216), who migrated to the Boston area only around 1799. The simple, uncarved, low-arched crest of the illustrated chair resembles that in an earlier Boston Windsor (fig. 6-194), and the wavy arm pads reflect a popular area type. The bamboo support structure with its swelled, bulbous side stretchers closely follows Hayward's contemporary pattern. Here, however, the arm supports have two grooves instead of one. The dozen fan-back chairs, some painted white and green, sold by John Doggett, a looking-glass maker of suburban Roxbury, to Captain Tribbs of Boston in 1806 likely represented an exchange with one of three Windsor-chair makers mentioned in Doggett's accounts—Samuel Jones Tuck, Samuel H. Horton, or William Seaver. Reuben Sanborn advertised "a general assortment of warranted Fancy, Bamboo and Fanback Chairs and Settees" the following year. As late as 1811 when Thomas Cotton Hayward announced his removal to a new shop in Charlestown, he mentioned fan-back chairs. The 1811 inventory of Boston cabinetmaker Ebenezer Knowlton lists "7/12 Doz Fan Back Chairs @ 50¢" under the heading "Upper Chamber at Shop."[141]

A second eighteenth-century style of Windsor that was still current in the early nineteenth-century Boston market was the bow-back chair, although contemporary records do not refer to the pattern by that name. John Doggett sold "winsor Chairs" to several customers in 1806. Thomas Cotton Hayward employed the term in his pictorial trade card printed in the same decade (fig. **7-26**). This small, rare advertising piece is the only known document of its kind for an American Windsor-chair maker to predate the War of 1812. Hayward purchased the Washington Street property listed on the card in 1803 and discharged the mortgage in 1814. By that time he had already removed to "No. 4 Harris Buildings, Water Street," as indicated in an advertisement of June 22, 1811. It is possible to match terms with pictures in the trade card. The rush-bottom *fancy* chairs (and settee) are obvious. Two chairs and the same number of terms remain, one a Windsor, one a bamboo chair. There seems no question that the square-back chair with "double bows" qualifies as the "Bamboo Chair," since every turned part speaks of its botanical debt. The "Windsor," then, is the bow-back armchair shown in the lower left corner, a pattern introduced in Boston in the mid 1790s.[142]

Fan- and bow-back Windsors probably are the chairs referred to in a memorandum written in 1879 by Eliza Susan Quincy (1798–1884) when describing furniture in the "North East Room" of the house erected at Quincy in 1770 by Colonel Josiah Quincy: "The painted green chairs were bought by Mrs E. S Quincy for this room in 1800.—& the black small windsor chair was bought by her, at a chair maker's, Horton by name, on Boston neck. 1804." Horton's name first appears in Boston city directories the following year. The address given as on the neck probably was a location closer to Roxbury than the center of Boston. In 1805 Horton began a series of exchanges with John Doggett of Roxbury that continued for three years. He is mentioned again in a Boston indenture of September 1, 1809, when cabinetmaker William Fisk let a shop and cellar "improved" for cabinetmaking to Samuel Payson for a year. At the rear of the leased property, which stood between the dwellings of Fisk and Aaron Willard, the clockmaker (or his son), was a barn then occupied by Samuel Horton "as and for a chair maker's shop." The location probably is that described in the 1810 directory as Washington Street.[143]

Another chairmaker mentioned in the Doggett accounts is William Seaver. In 1804 the craftsman experienced temporary financial difficulties, and as a result one David

Fig. 7-27 Square-back Windsor side chair (one of a pair), Samuel H. Horton (brand), Boston, Mass., ca. 1804–10. (Photo, Stoney Fields Antiques.)

Tilden brought suit in the Court of Common Pleas to recover the sum of $40.04 owed him for supplying cordwood in 1803. The recorded schedule of property attached by the sheriff probably represents a reasonably comprehensive inventory of Seaver's shop. Production included straw-, cane-, and wooden-bottom chairs. Seaver's Windsor seating may have included all three patterns in the market. Among the thousands of itemized chair parts are "337 backs," or crests, presumably of fan-back design. Also listed are chair bows of two kinds. One group identified simply as "bows" probably was used in the bow-back Windsor; the other, described as "160 bows for backs," likely framed the bamboo, or square-back, Windsor. Ebenezer Knowlton's 1811 shop inventory describes forty-two "Black and Yellow Bamboo Chairs." The description identifies chairs of a single ground color, light or dark, with the grooves "picked out" in contrasting paint.[144]

Included in the "bamboo" group is the single- and double-bow work of at least eight Boston-area chairmakers. The production exhibits several variables: straight versus bent backs; H-plan or box stretchers; bamboo-turned arms or scroll arm rests. The shield-shaped seats are of several patterns. Representative of the bamboo style is a straight-back, double-bow chair with box stretchers made and branded by Samuel H. Horton (fig. 7-27), who was heavily influenced by Delaware Valley work. Shipping records dating between 1804 and 1811 record the departure of eighteen vessels from Philadelphia for Boston with chair cargos, some shipped directly by the producers. Almost half the consignments were destined for the shop of William Leverett, a furniture retailer. Leverett's notice of March 19, 1808, advertising his imported wares is typical:

PHILADELPHIA CHAIRS

WILLIAM LEAVERETT respectfully informs his friends and customers that he shall constantly keep for sale a great variety of Philadelphia Chairs of the newest patterns and he has just received a fresh supply of elegant chairs which are now offered for sale at his warehouse.

Little more than a year later John Hancock, nephew of the signer, purchased "1 doz Philadelphia Chairs @ $1.50" apiece from another supplier.[145]

Despite the flood of imported seating, Boston craftsmen managed to stay afloat and to develop subtleties of design peculiar to their area. Notable is the slim taper of the leg top (fig. 7-27), while Philadelphia supports are thick and rounded at that point. The flare of the spindle base is a feature carried over from local bow-back work, although it is

Fig. 7-28 Square-back Windsor side chair and detail of brand, Amos Hagget, Charlestown, Mass., ca. 1803–10. H. 34¾", (seat) 17½", W. (crest) 19¼", (seat) 17", D. (seat) 15⅝". (Private collection: Photo, Winterthur.)

considerably less prominent in this period than earlier (fig. 6-215). The flat-edged seat delineated by a groove, top and bottom, is almost an exact copy of a Philadelphia plank (fig. 3-55, left); indeed, in Horton's documented work there is also at least one leg interpretation that is indistinguishable from a Philadelphia turning. That set of chairs has small projecting peaks at the upper back corners where the top bow caps the posts, and the backs are bent, as in figure 7-28. The armchairs retain eighteenth-century-style, forward scroll arm rests, although the bamboo arm appears in other work. Several Windsors bear Horton's label advertising "Japanned, Bamboo and Fancy" chairs. Influence from another source is found in a single-bow armchair attributed to Thomas Cotton Hayward by reason of its direct family descent. The chairmaker introduced long swelled spindles that clearly recall his training in eastern Connecticut.

At least two square, bent-back patterns with forward-scroll arms and ornamental medallions in the crest appeared in the Boston furniture market of the early 1800s. One design features a long rectangular tablet with clipped corners, like that in figure 7-29. The combination of a fancy crest and scroll arms suggests that such chairs sold at a higher price than standard square-back production. To date, it is possible to associate only Samuel Gragg with this seating since most examples are unmarked. The second pattern, one of rare form, features a *row* of tiny medallions, the shape usually a hollow-cornered square (fig. **7-28**) or small vertical oval (fig. 7-34). The illustrated example is branded "A. HAGGET / CHARLESTOWN." Even aside from the ornamental crest and back bend, Hagget's chair still varies from the Horton Windsor. The back posts have no grooves, and the seat of rounded edge follows another Philadelphia pattern (fig. 3-116). The legs are comparable. It was common practice beginning in this period to socket legs inside the plank rather than through the top surface. A Hagget double-bow armchair of plain pattern employs an unusual arm used occasionally as a local alternative to the forward scroll or turned cylinder. This slim, rounded rod not much thicker than the full part of a spindle caps the short front post and is notable for its slight concavity from back to front.

In discussing Boston Windsor-chair making of the 1810s, the work of a small handful of craftsmen is central to interpretation. Advertisements, such as those of Bass, Barker and Company (1814), cabinetmakers and chairmakers, and Thomas Cotton Hayward (1811, 1817), continue to identify "bamboo" chairs (fig. 7-30). Surviving chairs suggest that still other Windsor patterns were fashionable, an observation confirmed in the extensive inventory of Benjamin Bass (1819). The document, which fills nineteen hand-written pages, shows that Bass made a full range of seating from turned to joined types along with tables and casework. Appraisers listed three distinct types of wooden-bottom chairs: bamboo, three-stick, and tablet (also bamboo tablet). Based upon surviving work, the term *flat-back* mentioned briefly may also have identified wooden-bottom seating.[146]

The typical bamboo chair of the 1810s had double bows in the crest, with or without ornamental medallions, and probably was almost indistinguishable from work executed earlier. This was still the wooden-bottom chair of greatest demand; 170 finished pieces were recorded in the Bass inventory. The rarest pattern was the three-stick Windsor (fig. **7-29**), the name apparently suggested by the mid-back feature; only nine of these were listed in the Bass inventory. The illustrated hybrid design is a cross between the bamboo Windsor and a fancy rush-seated chair. One of a pair, the chair has an old handwritten label on the bottom: "Katie / Chair in nursery of her *great grand- / mother*, Mrs Dr Geo Bates (Eliza Hall) of / Boston, Mass., when her children were little." Boston city directories first record the name of George Bates, physician, in 1807. Few three-stick Windsors exist, and the fancy prototype with the medallion crest is itself uncommon. Other rush-bottom chairs in the "three-stick" style have slat or tablet-type rectangular crests of several patterns (fig. **7-30**) or employ a second set of triple cross rods at the top. A few chairs use multiple rods as front stretchers; one is an unusual slat-seat fancy chair ascribed to the shop of Samuel Gragg. The illustrated oval-centered front stretcher with flanking roundels copies another pattern from fancy seating.[147]

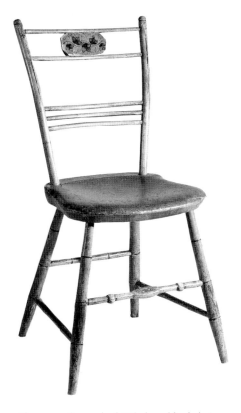

Fig. 7-29 Square-back Windsor side chair (one of a pair), Boston, 1810–15. White pine (seat); H. 34½″, (seat) 17¾″, W. (crest) 16¾″, (seat) 16¼″, D. (seat) 15⅝″; medium bright yellow ground with black and shaded gray. (Shelburne Museum, Shelburne, Vt.: Photo, Winterthur.)

Fig. 7-30 Advertisement of Thomas Cotton Hayward. From the *New-England Palladium and Commercial Advertiser* (Boston), July 11, 1817. Hayward used a cut of the same chair as early as June 22, 1811, in an advertisement in the *Columbian Centinel* (Boston). (Massachusetts Historical Society, Boston: Photo, Winterthur.)

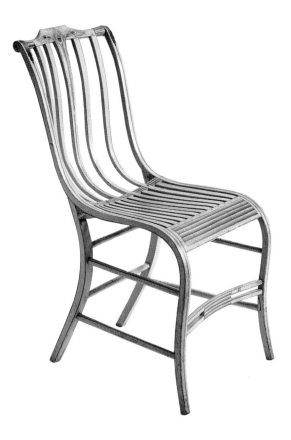

Fig. 7-31 Fancy bentwood side chair, Samuel Gragg (brand "S.GRAGG / BOSTON. / PAT-ENT"), Boston, ca. 1809–12. Birch, oak, and beech (microanalysis); H. 34⅜″, W. 18″, D. 25⅛″; pale yellow ground with shades of brown, black, green, and bronze. (Winterthur 61.321.)

Gragg's slat-seat or "elastic chair" (fig. **7-31**), for which he received a patent on August 31, 1808, was a daring innovation in the popular seating market. The chair was available in several pattern variations, of which only one used the three-stick front stretcher. The classic model is that illustrated. It takes the technique of bentwood construction to its furthest limit, both for this design and for bentwork dating to the early 1800s. Here, the back posts continue in a forward and downward sweep to form both the seat rails and the front legs. Gragg's pattern variants terminate the sweep at the seat front and employ cylindrical forward legs that attach separately. The slotted front stretcher is a variation of the "two-stick" brace, also favored by Gragg. The illustrated crest with its central projection and roller ends appears to have been the more common of two top pieces employed by the craftsman for this seating. The alternative pattern, also set between the back posts, is a slat with a squared projection similar to that in the chair advertised by Hayward (fig. 7-30). As Patricia E. Kane has written, there seems little doubt that the basic curves of Gragg's chairs derive from the ancient Greek klismos form. Influence was not direct, of course, but models to imitate were available. Thomas Hope's *Household Furniture and Interior Decoration* (1807), containing Grecian furniture designs, may already have been circulating in America. Jacques Louis David's portrait of Mme. Récamier (1800) reclining on her Grecian couch shows that furniture designs based upon patterns found in antiquity were already at the height of fashion on the Continent. English fancy chairs inspired by the klismos form may have been in the U.S. market by 1808.[148]

Gragg, who was born in 1772 at Peterborough, New Hampshire, settled in Boston at the turn of the century. He established a chairmaking partnership with William Hutchins, which continued until about 1807. On February 27, 1808, Gragg advertised the removal of his "Fancy Chair Factory" from Hanover Street to "the bottom of the Mall." Kane has pointed out in her study of Gragg that this move placed the craftsman in the fast growing South End business district, probably in the vicinity of what is today Tremont (Common) and Boylston streets. In this early public notice Gragg mentioned only that he made "fancy and bamboo Chairs," but his receipt of a patent to manufacture "elastic" chairs later that year indicates that the new design and construction were well in hand. There is little doubt that Gragg's creative genius guided his decision to strike out

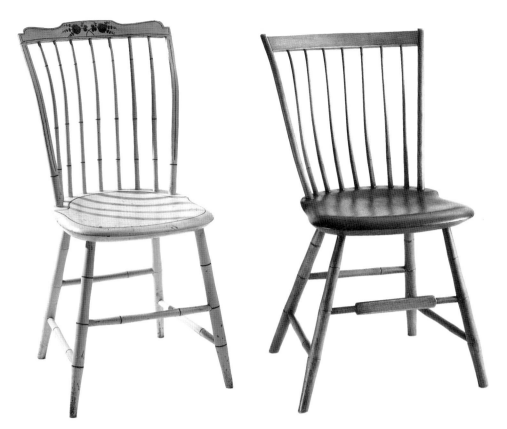

on his own. Within eight months of receiving his patent the chairmaker informed the public that his "Elegant Patent Chairs & Settee" were "now ready for sale." He described the furniture as made with "elastic backs and bottoms . . . of the best materials . . . very strong, light and airy and . . . most comfortable." He continued to carry bamboo, fancy, and "common" chairs, as he had in the past. In this connection the word *common* refers to Windsor seating in the fan- or bow-back patterns.[149]

There are a small number of square-back, double-bow Windsors, some with a rectangular medallion, which bear Gragg's brand. Other, unmarked, wooden-bottom chairs that appear to have been made in his shop (figs. 7-32, 7-33) take two forms. The first (fig. **7-32**) is a fairly standard Boston pattern from the seat down and features the new back bend illustrated in Hagget's chair (fig. 7-28). The craftsman also introduced a shaved-face back post, certainly one of its earliest uses in the Windsor, and a top piece that is a direct adaptation of the crest of the elastic chair. Who but Gragg would have capitalized simultaneously on the new elastic pattern in this manner? Gragg's special wooden-bottom chairs of the second pattern (fig. **7-33**) duplicate in the back curve— comprising posts and spindles—the cyma recta profile of the patented seating piece as closely as stick-and-socket construction will permit. Again, the lower structure is in the bamboo style. The slim, cylindrical back posts without grooves are those of the three-stick chair (fig. 7-29) bent to a different profile. The narrow, inset, slat-type crest was already current among Boston fancy-chair makers and Connecticut Windsor-chair makers. The element occurs again in the Boston Windsor that follows. In the present chair the narrow rectangular medallion, or tablet, featured in the front stretcher is a common element of Boston fancy-chair making; its use extended to the spindle. The seat, rounded and chamfered to a knifelike edge, approximates a shape found in square-back Windsors bearing the Gragg brand.

The Windsor illustrated in figure **7-34** may qualify as a type of "flat back" chair, such as those mentioned in the Benjamin Bass inventory of 1819. Its roots are obvious. Basically, the pattern is a square-back chair with double rods, the top bow squared and the under bow broadened to a flat slat. The slotted bow ends describe another version of the pierced design that appears in the front stretcher of Gragg's patented chair. The void between the bows once contained three small, oval medallions providing ornament

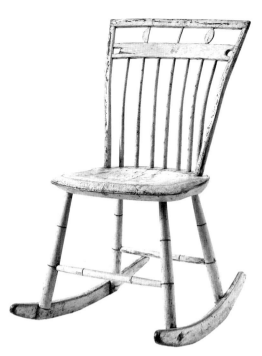

Fig. 7-34 Square-back Windsor side chair (converted to rocker), Boston, ca. 1808–15, with alterations (1835–50) by Henry Lawson and Francis Harrington. White pine (seat); H. 31½″, (seat) 16¼″, W. (crest) 18⅜″, (seat) 16¼″, D. (seat) 15½″. (Historic Deerfield, Inc., Deerfield, Mass.: Photo, Winterthur.)

comparable to that in Amos Hagget's fancy bamboo Windsor (fig. 7-28). The seat is virtually identical to the previous plank. The rockers are a later addition; each leg originally extended to a full fourth segment at the bottom.[150]

Another pattern identifying Windsor and fancy seating in the Boston market (fig. 7-35) has a double-slotted crest. Both patterns were also employed in northern New England. Fancy-chair making provided the design source, since rush-bottom seating with backs identical to the Hayward woodcut (fig. 7-30) have similar pierced openings in tablet-centered slats. A fancy chair of similar pierced crest in an institutional collection features an additional low-mounted stay rail of single slotted end, as pictured in figure 7-34. The date 1808 painted in gilt on the back is part of the original decoration. The illustrated Windsors also compare well with contemporary Boston plank-seat work (figs. 7-33, 7-34): the spindles thicken appreciably in the lower part; the rounded shield-shaped seats thin to sharp edges across the front; and the legs have similar slim, tapered profiles. The long, rounded-end medallion in the front stretcher is a bolder version of that found in the curved-back Windsor (fig. 7-33). Like that chair and the double-bow examples (figs. 7-28, 7-29), the back posts are undefined cylinders. One of the latter, the three-stick Windsor (fig. 7-29), has a button at each post tip. In the present examples, comprising a set of six side chairs and two armchairs, that feature is more precisely defined as a tiny finial that is repeated in the arm tips. Finials are found from time to time in Boston fancy work. One example has a front stretcher identical to that in Gragg's elastic chair (fig. 7-31), while the cylindrical front legs share a pattern found in another of his patented seats. The turned arms illustrated here are distinctive in their sharp back taper, a profile repeated in the tips of the arm posts and legs.[151]

A third wooden-bottom seat described in the Benjamin Bass shop inventory of 1819 is the "tablet," sometimes called the "bamboo tablet," chair. Based upon the number of finished examples on the premises, this chair was second in popularity to the bamboo-

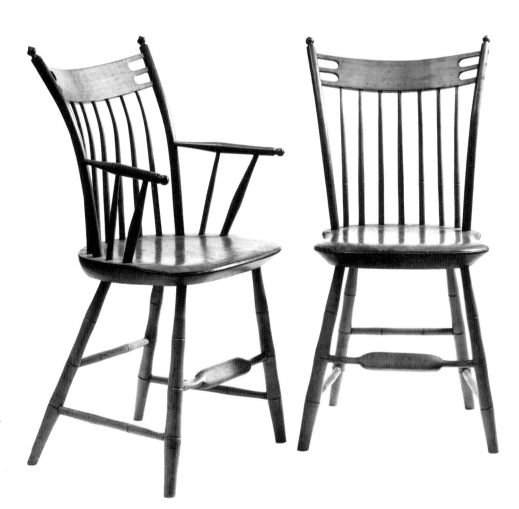

Fig. 7-35 Slat-back Windsor side chair and armchair (two of eight), Boston, ca. 1808–15. White pine (seats); (*left to right*) H. 35⅜″, 35¼″, (seat) 18⅛″, 18″, W. (crest) 18⅛″, 18¼″, (arms) 20⅞″, (seat) 18″, 16¼″, D. (seat) 16½″, 15¾″. (The late I. M. Wiese collection: Photo, Winterthur.)

style Windsor. Only one candidate fits the description—a chair referred to today as a "step-down" Windsor (fig. **7-36**). Although there is good circumstantial evidence to ascribe the origin of the pattern to Boston, there are no known documented examples. Boston is confirmed, however, as the early nineteenth-century center of the Massachusetts chair industry through statistics compiled and published by Rodolphus Dickinson in 1813. Suffolk County, which includes Boston, led the way with 1,000 dozens of chairs manufactured annually. In second place, Essex County to the north achieved only half that production, while Berkshire County in the west was a trailing third with 166 dozens.[152]

There is little doubt that the illustrated stepped-tablet Windsor is a product of the same hand that created the curved-back chair of figure 7-33. The bamboowork is similar, seat shapes correspond, and the basic post is a slim cylinder. Among stepped-tablet tops, this crest is distinctive for its slim shape and ribbonlike profile. The central tablet is sharply defined, usually rising substantially above the curved ends. A low arch, or hollow, on the bottom surface is shaped with a long, shallow curve through the center that is exceptionally subtle. The present chair is one of a small number of examples with a Grecian, or ogee-curved, back. A related armchair in the Museum of Fine Arts, Boston, has a tradition of family ownership in neighboring Hingham. Deeply carved volutes like those in the crest of figure 6-205 are found at the sides of the forward scrolls terminating the arms. Similar tablet tops sometimes crown a simple, bent back. A side chair of that pattern in the Museum of Fine Arts is said to have been made by Adam Davenport, a craftsman of Dorchester, now part of Boston. Another side chair, its front stretcher centered by a long rectangular tablet relating to that of figure 7-33, exhibits a transitional feature. Several inches below the stepped tablet is a single cross rod. Three alternating, extended spindles link the two elements. In the same chair the bases of the spindles and posts alike swell noticeably near the seat, a feature of other area work (figs. 6-214, 7-43). The name G. W. Kent branded on the plank is that of a later owner who resided in the Boston area. To further reinforce the Boston origin of the crest, one has only to compare the top piece with that of figure 7-32, which forms a variant or evolutionary stage between the top of Gragg's elastic chair and the true stepped tablet.[153]

A high-style prototype (fig. **7-37**) for the tablet-top crest had been in the Boston market for about a decade when the popular pattern appeared. By modifying the top profile of the mahogany and satinwood chair and filling the void beneath the low arch, local chairmakers created a fashionable new Windsor crest that was widely imitated in Massachusetts and northern New England. In describing this top piece, Charles F. Montgomery cited the 1802 edition of *The London Chair Makers' and Carvers' Book of Prices for Workmanship:* "Square back chair with elliptic cornered top containing a tablet." The design actually is a composite of two price-book drawings. A variant top with a raised central projection also became popular in fancy seating. Samuel Gragg used it at the back of an elastic chair, and the profile is seen again in an advertisement of Thomas Cotton Hayward (fig. 7-30).[154]

Boston statistics compiled for the 1820 manufacturing census record only three, unnamed chairmakers in the city; chairmaking specialists identified in supplementary records also number just three—Samuel Gragg, William Seaver, and Josiah Willard. Other information detailed in the census under the heading "Place of production" discloses that seating "imported" from Maine, New York, and Connecticut augmented Massachusetts production. Also providing competition were some of the twenty anonymous cabinetmakers noted in the same compilation, and that enumeration may not have included the proprietors of several home-furnishing warehouses that sold seating, among them those of Samuel Gridley and Samuel Beal. Yellow wooden-bottom chairs at $1 apiece or less were a fashionable article, as indicated in purchases made from Beal by separate customers in 1822, 1824, and 1826. Beal's warerooms at the corner of Hanover and Elm streets were always well stocked, as documented in a notice of July 24, 1830: "1400 Fancy Chairs, 1500 Wooden seat Chairs, all colors, 75 Rocking and Nurse Chairs, 6 Spring Seat Plush and Hair Cloth Rocking Chairs." An extensive selection was necessary

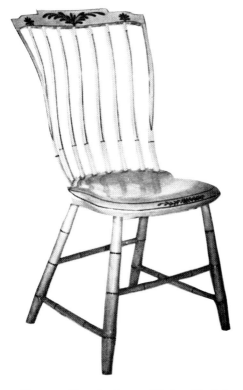

Fig. 7-36 Shaped tablet-top Windsor side chair, attributed to Samuel Gragg, Boston, 1810–15. From Zilla Rider Lea, *The Ornamented Chair* (Rutland, Vt.: Charles E. Tuttle, 1960), p. 72, fig. 17. (Photo, Winterthur.)

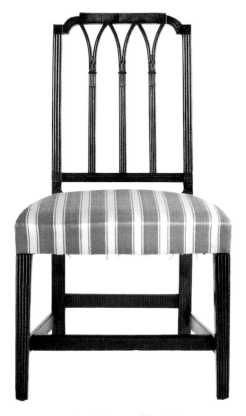

Fig. 7-37 Side chair (one of four), Boston, 1800–1805. Mahogany, satinwood veneer, birch, and maple (microanalysis); H. 35¾", W. 20¾", D. 17". (Winterthur 57.518.)

New England, 1800 to 1850 471

to gain and hold public favor and to meet the competition, such as that offered by Blake and Kittredge of Brattle Street, retailers of similar merchandise. John Doggett, looking-glass maker of neighboring Roxbury, described "the taste of Boston people" in a letter to a London correspondent in November 1828 as "very peculiar and difficult to please."[155]

By the second quarter of the century large-scale furniture auctions were regular merchandising events in Boston and commanded special printed catalogues. An 1829 compilation from the firm of Dorr and Allen itemizes "N. York pattern Chairs" of both "broad" and "narrow" back, some described as "Superior." An auction catalogue prepared by Jabez Hatch, Jr., in 1831 describes the "New–England Society's Semi–Annual Sale," mentioning Windsors in yellow or dark colors and fancy chairs with broad backs. In the face of stiff competition from furnishing warerooms and auction houses, independent craftsmen like Samuel Gragg may have largely turned away from private retail to wholesale marketing, a theory supported by ample evidence. Gragg supplied seating furniture to the Boston Athenaeum in 1822, consisting of sixty-four chairs of varied price, six window stools, and a settee. In the following decades newcomers to the business—J. C. Hubbard, William O. Haskell, and others—continued to supply public halls, courtrooms, schools, churches, businesses, and private organizations with a range of seating. To meet large demands chairmakers developed factory-type operations or looked to suppliers who could produce cheap goods in quantity. In the latter connection, Boston contributed substantially to the rise of northern Worcester County as a furniture-manufacturing center. The Boston directory of 1833, for example, carries an advertisement of Woods, Stevens and Company, of Ashburnham, wholesale and retail dealer in chairs and furniture, whose Boston agent was Jonathan O. Bancroft. Eventually, Bancroft decided there was more profit in manufacturing than selling and moved to Portland, Maine, where he worked closely with another entrepreneur, Walter Corey.[156]

Wooden-bottom seating firmly identified with Boston from the mid 1810s onward is not plentiful. Circumstantial evidence suggests that a tablet-type crest with hollow corners (fig. 7-38) originated in the city. Like other nineteenth-century Windsor seating, the style appears to have been strongly influenced by fancy work. Rush-bottomed and upholstered seating, alike, use top pieces of this form in combination with such familiar elements as three-stick front stretchers and stay rails, or single cross rods at midback

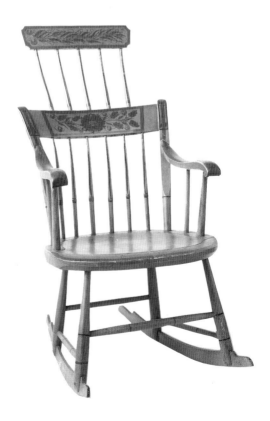

Fig. 7-38 Slat-back rocking armchair with top extension, Boston or southern New Hampshire, 1820–25. White pine (seat) with maple and mahogany (arms); H. 39½″, W. (seat) 20¼″, D. (seat) 18¾″; yellow ground with red, green, and black. (Daphne Farago collection: Photo, Museum of Art, Rhode Island School of Design, Providence.)

centered by a medallion resembling the front brace of figure 7-35. Even fancy and Windsor chairs with slat-type crests framed between the posts sometimes are embellished with painted hollow-cornered panels enclosing decoration (figure 7-48). The Boston double-bow Windsor medallion (fig. 7-29) is only a smaller version of the same general form. The low, broad-back rocking chair illustrated here appears to have had a straight-back counterpart without rockers or top extension. Perhaps a more familiar form is the tall rocking Windsor with contoured spindles, of which several have Boston histories. However, the hollow-cornered crest may actually have achieved greater popularity in New Hampshire after its first introduction in Boston (fig. 7-72). Several members of the Wilder family working at New Ipswich, including Abijah Wetherbee and Joseph Wilder (d. 1825), have left documented examples.

Contemporary with the hollow-cornered tablet top were modifications in the basic slat-back Windsor, although marked Boston examples are rare. There are, however, documented chairs in the production of northern Worcester County, which from the 1820s on frequently mirrored Boston developments as the area began its steady rise to industrial prominence by midcentury. A slat-style crest accompanied single or double slats at midback combined with short spindles (fig. 7-63); long, flat "arrow" sticks varied the offering somewhat (fig. 7-60). But by the late 1820s Boston chair design had begun its downhill rush to meet production demands.

A distinctive scroll-top pattern (fig. 7-39) is next in the design sequence. Setting this crest apart from others of similar type is the pronounced flare at the ends; the outward curve is emphasized by a tiny, projecting back roll at the top. Post, seat, and support patterns suggest a mature stage of this design. The first two elements, in particular, are sufficiently undistinguished to warrant speculation that such seating was manufactured cheaply in quantity for use by public bodies and private organizations. This chair bears the brand of Samuel Gragg. Similar crests are present in two tall, Boston-style rocking chairs with raised (scroll) seats, one with a Danvers family history, the other owned by the Rowley Historical Society. An armchair with rounded back posts is branded "J. THAYER," possibly Joseph, a chair painter of Boston (1833–35) and later Charlestown. Another armchair of more carefully shaped parts but designed with the same low, broad lines of Gragg's chair features four arrow-shaped back spindles, confirming Boston use of this feature. Again, the prototype is fancy seating, since rush-bottom examples are known with the Boston three-stick "fret" across the lower back. The diffusion of the pattern beyond the city is documented in a set of three cane-seat, saber-leg side chairs of less exaggerated crest labeled by George Kibling, who was a chairmaker of Ashburnham, Worcester County, from about 1830 to 1842.

The ball spindles of figure 7-39 bring to Boston work another feature that was widely distributed throughout New England. New York chairmakers introduced a related short spindle in the early 1810s that may have suggested the design (figs. 5-41, 5-49) and Christian Nestell, who trained in New York, used ball spindles in some of his Providence production.

The apparent successor to the scroll-type crest was a tablet with rounded, or loaf-shaped, ends that appeared first in joined and fancy seating. While there seem to be no documented urban plank-seat examples, the pattern influenced a related top piece that was particularly favored for a late Boston rocker. Several chairmakers of northern Worcester County have left documented examples of the pattern (fig. 7-65), one being Gilson Brown who died in 1834. The several crest patterns next in the market were variations on the theme. A side chair features a rounded-end, overhanging board sliced off at top and bottom to a flat surface, giving prominence to the horizontal line (fig. 7-40). The illustrated writing chair may have been manufactured as school furniture, general production of which appears to have dominated the Boston furniture market by the 1850s. The crest in a companion armchair is larger in scale, the ends rounding to a semicircle, with a low, flat-topped projection rising along the top surface. The spindles are plain tapered sticks, and the seats are minimally shaved. The settee that accompanied these chairs in furniture suites was designed with overhanging, squared ends. All three

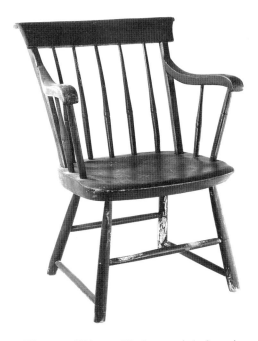

Fig. 7-39 Tablet-top Windsor armchair, Samuel Gragg, Boston, 1825–35. (Old Sturbridge Village, Sturbridge, Mass.)

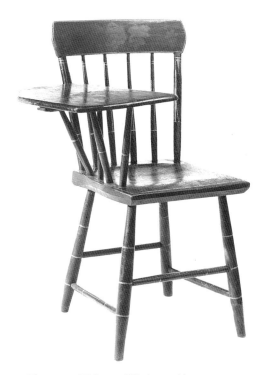

Fig. 7-40 Tablet-top Windsor writing-arm chair, Boston, 1840–60. White pine (seat); H. 31⅜", (seat) 17", W. (crest) 17¾", (seat) 15⅝", D. (seat) 15¾", leaf 23¾" by 11⅛"; dark and reddish brown ground with yellow and medium green; leaf repaired at outside front corner. (Hanford-Silliman House, New Canaan Historical Society, New Canaan, Conn.: Photo, Winterthur.)

Fig. 7-41 Daguerreotype of John Quincy Adams, eastern Massachusetts, 1843. H. 8½", W. 6½". (Metropolitan Museum of Art, New York.)

patterns once furnished the old County Courthouse in Cambridge (Middlesex County); John C. Hubbard of Boston supplied the furniture during a renovation of 1848. City chairmaker William O. Haskell furnished similar armchairs to the Portsmouth, New Hampshire, Athenaeum in 1855. The midcentury market also produced a revival of the eighteenth-century low-back chair (fig. 7-41). With its heavy, ring-turned legs, thick turned sticks below the rail, and blunt-edge arms and seat, there is no mistaking its nineteenth-century origin. The illustrated daguerreotype of John Quincy Adams is dated 1843.

MIDDLESEX COUNTY

From their near situation beyond the northern and western boundaries of Boston, craftsmen and householders of Middlesex County were familiar with—although they did not necessarily adopt—current fashions in home furnishings. The earlier discussion of David Haven of Framingham in chapter 6 demonstrates that although he maintained direct craft contacts in the Boston area his chair production was a blend of the fashionable and traditional. Son Abner, who had shared the family home before David's death in 1801, followed in his father's footsteps, even recording his cabinetmaking and chairmaking accounts from 1809 until 1830 in a portion of the book used earlier by his father. Chair repair, seating, and painting were steady demands. Along with orders for bamboo Windsors there were requests for great, kitchen, rocking, and little chairs. If Haven recorded all his orders, his production of bamboo seating was small—five sets, comprising three or six chairs each, constructed over a period of seventeen years and, perhaps, reflecting several pattern variations. At best Haven would have copied area patterns rather than interpret them on his own. Two of Haven's customers for bamboo chairs, purchased in 1825 and 1827, resided as far as ten miles away in Weston.[157]

Weston was the home of Isaac Jones at whose death in 1813 appraisers recorded fifteen fan-back chairs, valued at 67¢ or $1. Five "Windsor" chairs, probably bow-backs with and without arms, were of variable age, as indicated by their appraisals ranging from 50¢ to 75¢. The seating was distributed chiefly in dining and sleeping areas. Several bow-back side chairs of apparent family descent still remain in the Jones house, now open as the Golden Ball Tavern. Of particular interest is the marriage of Jones's daughter Sarah in 1802 to Caleb Hayward, brother of Thomas, the Charlestown chairmaker.[158]

Furniture was apt to be retained for long periods in rural and village homes, and at Concord, north of Weston, fan-back Windsors were common in older households even into the 1830s. Samuel Dakin, described as a yeoman in 1818, owned nine such chairs. The household of Samuel Barrett, proprietor of a farm and grist-sawmill contained many chairs in 1825, most of them probably purchased twenty-five or thirty years earlier when Barrett set up housekeeping. Appraisers listed eighteen fan-backs, some described as black, others with green bottoms. Accompanying these were two Windsor armchairs, a great chair, a rocking chair, and six seats with "Willow" bottoms. Humphrey Barrett's three green fan-back Windsors in the "South Chamber" all had cushions in 1827, but even so their total value was only $1.50. Three others without cushions were in the "Middle Room," used for tea and dining purposes.[159]

From its founding as a model textile-manufacturing community in the early 1820s, town growth at Lowell was steady and substantial. Publication of an annual business directory commenced in 1832 when the population stood at well over 10,000. Among woodworkers, only turners are named in the first volume. The second directory sheds more light on this occupation with many specific listings for "bobbin turners." The compilation also contains entries for two furniture warehouses, although throughout the 1830s there is no evidence of local chairmaking. From as early as 1803 the lower Merrimack River, which passes through Lowell, provided direct communication with Boston via the Middlesex Canal. During the 1820s and later this waterway became an important facility in transporting supplies and raw materials to the mills from the metropolitan center. Undoubtedly, many furnishings offered for sale in Lowell were of

similar origin. Seating for use in private homes and the boarding facilities located throughout town would have been an article of continuing demand. Fashionable at that date was an ornamented slat-back chair, such as that supporting the figure of James V. Atkinson of Lowell in 1831 (fig. **7-42**). A few years later William Wilson, painter, glazier, and paperhanger, offered his services to freshen old seating and other furniture with new paint, decoration, and varnish, as indicated in his account book for 1837–38.[160]

ESSEX COUNTY

Salem's role as a trading port declined in the early nineteenth century as a result of economic reverses sustained by American maritime interests during the embargo and the war. Moreover, this otherwise fine harbor had an incommodious entrance. Although considerable wealth remained in the town, Salem's heyday had passed by 1825 and Boston reigned supreme in the region. Many influences shaped early nineteenth-century Salem chairmaking. The taste of consumers, the size of their pocketbooks, and the requirements of the export market were important considerations. A miscellaneous memorandum in the Waters family papers at the Essex Institute, probably dating to the early 1820s, sheds light on the export trade in seating furniture to Central and South America: "Common Windsor Chairs are generally Saleable if of high colours, . . . chairs of a higher cost, will not answer." Philadelphia was still a prominent competitor, since Salem ships frequently anchored in the Delaware River where local factors and furniture makers were only too happy to be accommodating. Captain John Edwards of the brig *Welcome Return* arrived home in autumn 1807 with "Sixteen Packs contain'g Chairs, [and] Two Settees" for William Gray. Locally, James Chapman Tuttle, who had first produced "Philadelphia chairs" in the mid 1790s, continued to manufacture "WINDSOR CHAIRS . . . ready made, in the different fashions, warranted work, and painted different colours . . . for cash or country produce." Demand in domestic and foreign markets remained reasonably good. Caleb Manning searched for a "Journeyman to the Windsor Chair Making Business" in spring 1806 and wanted an apprentice as well. But competition from Boston loomed large. Merchant George Crowninshield, Jr., probably purchased the elegant settee that graced his private quarters on the yacht *Cleopatra's Barge* from a craftsman of that city. Direct evidence links local storekeeper Ebenezer Fox with importing "the stuff compleat for five hundred Bamboo Chairs & one hundred Fan-Back Ditto" from Boston in 1806. Two decades later Joseph Waters, Esq., paid freight and wharfage when the sloop *Common Chance* transported twelve chairs and a sofa from the city. Several Boston firms supplied merchant Daniel Rogers of neighboring Gloucester with fancy, Windsor, and rocking chairs in the late 1820s.[161]

Burpee Ames's advertisement of September 28, 1810, for a "large and fashionable assortment" of "FANCY, BAMBOO and Fanback CHAIRS, warranted as well made and handsomely ornamented as any in Salem or Boston" about sums up the local offering in popular seating through the 1810s. Not mentioned, but generally available, were flag-bottom chairs of the common, or kitchen, variety. Contemporary bills give details of local production. Both product and price may have been largely controlled by the Sanderson brothers, Jacob and Elijah, since they were the local prime movers in an extensive furniture export business and many community chairmakers had dealings with them. Flag-bottom, or kitchen, chairs, finished quickly and inexpensively with stain rather than paint sold for about 83¢. A difference of more than $1 separated such common seating from the fan-back chair, the cheapest Windsor offered. This usually sold for $2, but the addition of arms boosted the price to $3. On one occasion Edmund Johnson sold fan-backs at $1.58 to Samuel Holton, a physician of neighboring Danvers. Many factors could have dictated the price reduction, among them a special discount or the absence of finish.[162]

Bamboo Windsors, sometimes called "Squair-top" chairs, were the most popular article, exceeding even the fancy chair in sales. Price often reflected finish. A painted chair without any ornamentation, except perhaps penciling in the grooves, usually

Fig. 7-42 *James V. Atkinson*, attributed to Ruth W. and Samuel A. Shute, Lowell, Mass., ca. 1831. Watercolor on paper; H. 24″, W. 19″. (Lowell Historical Society, Lowell, Mass.: Photo, Winterthur.)

Fig. 7-43 Square-back Windsor side chair, James Chapman Tuttle, Salem, Mass., 1800–1810. White pine (seat) with maple (microanalysis) and other woods; H. 35″, (seat) 17⅛″, W. (crest) 18½″, (seat) 16½″, D. (seat) 16″. (Private collection: Photo, Winterthur.)

commanded $2.25 to $2.50, although Burpee Ames sold the Hathorne family bamboo chairs at the low price of $1.50 each. On the other hand, Richard Austin supplied Jacob Sanderson with half a dozen bamboo chairs in 1805, described specifically as "not Stript," at $2.50 each. The word *stript* here may refer to something more than penciled grooves, such as a painted band outlining the seat. In the same order were Windsors "Stript Green" priced at $2.67 apiece and "6 BAMBOO CHAIRS GOLD LEAF" at $3.34. Ornamenting took time, and time meant money. In the case of gilded chairs, the cost of gold leaf was an important pricing factor. Throughout the Sanderson records the striped bamboo Windsor was by far the best seller. Back posts of bamboo Windsors were straight but framed at a cant more often than bent. A typical description is that of a set of chairs with "Strait Backs two Boughs [Bows]" sold by Bernard Foot of Newburyport to Ebenezer Pearson in 1813. Isaac Stone described the alternative pattern as a "Fallback" Windsor. His side chairs cost $2 apiece, and an armchair "with Rockers" was double the price. Bernard Foot called the fall-back pattern a "Spring Back" chair; however, the term in widest geographic use was "bent back." More frequently than not, Salem bamboo chairs fitted with arms had rockers. In contrast to Windsor seating, fancy rush-bottom chairs commanded retail prices in the $5 range.[163]

The work of only two craftsmen documents early nineteenth-century Salem bamboo seating. James Chapman Tuttle is represented by several double-bow, square-back side chairs (fig. 7-43); a handful of unmarked Windsors, including a pair of rocking armchairs; and some unusual chairs with arched top bows (fig. 7-44). All examples have straight backs. One chair from a small set of double-bow, fall-back Windsors bears Nathan Luther's label. Tuttle's turned work ranges from a good, but relatively standard, interpretation of the Boston bamboo style (fig. 7-27) to the exaggerated nodular-turned chair illustrated in figure **7-43**, with several intervening interpretations. The nodular chair, one of only a few known, probaby was made in limited number to special order. A comparison may be drawn between this chair and the square-back Windsor in the upper right corner of Thomas Cotton Hayward's Charlestown trade card (fig. 7-26). It is curious that none of Hayward's known bamboo chairs has roundwork developed to the degree shown here in view of the advertisement. The flat-edge, scratch-beaded seat lightly saucered on the top surface follows Philadelphia prototypes (figs. 3-114, 3-116), although it substitutes the white pine common to eastern Massachusetts work for the yellow poplar of Pennsylvania. Two additional points relative to style are notable. Tuttle's marked square-back work features a top bow scored with two grooves widely flanking the center spindle. While grooves are common in general production, they usually fall directly above the outer extended spindles. There is also an obvious coordinate relationship here between the stout turnings above and below the seat; the legs when inverted mirror the post profiles.

Just as individual in its own way and of reasonable vigor is a Windsor of crowned, or arched, top representing one of a set of twelve side chairs that descended in the family of General Artemas Ward of Shrewsbury (fig. **7-44**). The Salem characteristics are unmistakable. In fact, an old handwritten label on the plank bottom of one chair, probably applied by a nineteenth-century family member, reads: "Made by / James Chapman Tuttle / Salem, March / 1793." The date is off by a decade, but written or verbal family records must have suggested this craftsman with good reason. Besides the present group, well over a dozen side chairs and armchairs of this pattern are known. A small set, said to have been acquired from a Salem family, has a top curve of more exaggerated form. In fact, the curve is quite like that in the top rail of a Salem-type, mahogany, shield-back chair in the Winterthur collection. Of less extreme curve is another chair (fig. **7-45**) in the Winterthur collection, one of a set made for Captain Joseph Waters of Salem who built a brick mansion on Derby Street in 1806–7. Waters likely purchased the mahogany chairs before that date and may even have acquired Windsors to match. The Waters family papers document Joseph's purchase of five bamboo side chairs en suite with two armchairs from one John Farrington of Salem in 1804. Tuttle himself is known to have sold bamboo chairs to a member of the local Hathorne family in 1807. A shipping

Fig. 7-44 Square-back Windsor side chair (one of twelve), attributed to James Chapman Tuttle, Salem, Mass., 1800–1810. White pine (seat); H. 36⅜″, (seat) 18″, W. (crest) 19⅝″, (seat) 16½″, D. (seat) 16″. (Russell Ward Nadeau collection: Photo, Winterthur.)

Fig. 7-45 Side chair (one of a pair), Salem, Mass., ca. 1795. Mahogany with birch, ash, and pine (microanalysis); H. 37¾″, W. 21½″, D. 18¼″. (Winterthur 57.878.)

invoice records his participation in the extensive Salem export trade when consigning "10 Cases of furniture Markt I.C.T Amounting To $500 to the brig *Massafeuro* in 1805." His wares joined those of seven other Salem cabinetmakers on a voyage to Havana. Two of Tuttle's sons, George and James, followed in their father's footsteps and became chairmakers. Both died in the early 1830s, reputedly of tuberculosis.[164]

There is likely a relationship between Jacob Sanderson's death in 1810, the general economic climate, and the absence of documented Salem Windsor work following the introductory years of the square-back style. Painted seating in Sanderson's household

included eighteen bamboo chairs (some painted black), half a dozen fan-backs, two rockers, and some old flag-bottom chairs. Reverend William Bentley, a keen but sometimes biased observer of town life, noted Sanderson's passing at age fifty-two. He commented on the cabinetmaker's early appointment as deacon of the North Church and lamented his unworthiness of the honor, since "the latter part of his life was under a cloud from the strange intemperance of his habits." Cabinetmaker and chairmaker Edmund Johnson died the following year while homeward bound "from the Southland" where, doubtless, he had been overseeing furniture sales. His estate was insolvent. About this time troubles involving other Salem woodworking entrepreneurs came to a head, probably encouraged by the political and economic upheaval of the times. Bentley described the circumstances in his diary on August 23, 1811, noting that those involved were members of the "little Sects" as opposed to the old established churches:

A strange deficiency of honesty among the officers of the Churches which have professed great zeal for conversions. Deacons S[anderson, Elijah] & L[amson] are added to the list of fraudulent bankrupts, & B[urpee] A[mes] is abroad upon the public courtesy.... Salem has been unhappy in the wretches designated for these offices. One an outcast for drunkenness, lately deceased, another for dishonesty, three remaining in debt, & one lately hung himself having left his shoemaker's bench, turned merchant & pennyless. These six in the space of one year.

On September 27, 1811, he added: "The Failures of the Speculators have strongly fallen upon the Enthusiastic leaders of little Sects.... None of these have been natives of Salem, or well informed men, but thrusting themselves from mechanic employments into mercantile affairs & venturing largely upon credit, breaking embargo laws, & making promises they have plunged themselves into the greatest evils."[165]

With fortunes reversed, overseas ventures at an end, and local woodworking ranks decimated, Salem was no longer an important area producer of vernacular seating. In a reduced market lacking that former spirit of enterprise, there probably was little reason to mark products for identification at distant sales outlets or as advertisements in the local consumer market where craftsmen were already known. Written records provide some continuity. At Jedidiah Johnson's death in the early 1820s appraisers listed both "new" and unfinished seating in the shop. The Johnson household contained bamboo Windsors and chairs of the newer "flat top" pattern. By 1824 Thomas Needham III, member of a new generation of cabinetmakers, was constructing the "high Back Rocking Chair"; in the next decade he sold "Scrolled Back" chairs to Robert Manning, a local patron. Unlike Needham, young Thomas Perkins elected to leave Salem in 1831 after working there for at least a decade. He sought his fortune in Troy, New York, where he started a "chair factory" in 1832. The death of Elijah Sanderson in 1825 brought to a formal end the overseas furniture-trading dynasty that had flourished in Salem for several decades at the turn of the century.[166]

The production of painted seating was minimal in the neighboring communities of Beverly and Danvers, which were substantially overshadowed by Salem. Two Beverly chairmakers of record worked in the early nineteenth century. Ebenezer Smith, Jr., practiced woodworking little more than a decade before defecting to the Britannia manufacturing business. He is recorded as performing odd jobs on many occasions for Robert Rantoul, a druggist, for whom he constructed two rocking chairs. Smith's contemporary Samuel Stickney practiced cabinetmaking and chairmaking in Beverly for the better part of half a century. He, too, was a versatile woodworker. Although written records describe only "an Easy Chare With Rockers," there is a side chair signed under the seat in penciled longhand with Stickney's surname (fig. 7-46); the signature matches that on bills rendered to Stickney's customers. Stickney, who was married at Beverly in December 1794, likely did not practice Windsor-chair making to any great extent or receive particular training in that branch of the trade. His chair is not executed in a production style; rather, it is a highly personal pattern. Probably once part of a set, the chair may represent one of a few excursions into stick construction by the craftsman. The design is a hybrid one, combining early bamboowork, an H-plan bracing structure, and

Fig. 7-46 Square-back Windsor side chair, Samuel Stickney (penciled), Beverly, Mass., 1800–1805. White pine (seat); H. 34½", (seat) 17¾", W. (crest) 20", (seat) 15⅜", D. (seat) 16⅜"; front legs replaced. (Michael and Carol Dunbar collection: Photo, Winterthur.)

a late eighteenth-century-style seat with a square back of early nineteenth-century date. Stickney may have had a Boston round-back chair close at hand when he developed the design, since both the seat and bamboo supports suggest work comparable to that of figure 6-208.[167]

Written evidence alone identifies a craftsman of neighboring Danvers. Stephen Whipple's business accounts run from May 1, 1803, to 1811. Census tabulations place him at Danvers in 1810 and 1820 and at Lowell in 1830. Like Stickney, Whipple was more involved in cabinetmaking than chairmaking. From April 1804 until August 1805 he boarded at the house of one Jonathan P. Pollard and also rented a shop from him. Since the 1800 census index lists Pollard in Middlesex County (no town given), Whipple had not yet settled in Danvers (Essex County). The Pollard shop was close enough to Boston to send there for materials. At the end of this short period Whipple apparently mortgaged most of his tools, equipment, and materials to Jacob Farrar, who had worked for him upon occasion. The mortgage money possibly provided the cash to purchase a shop at Danvers. Whipple's early output included both cabinet furniture and chairs made by himself and other craftsmen employed in the Middlesex shop where there were four workbenches. Because his chair prices reflect both wholesale and retail sales, it is difficult to analyze production where terminology is not specific. Most recorded work was carried out between 1803 and 1805. Aside from "kitchen" chairs priced at 83¢, Whipple made and sold perhaps as many as three other vernacular seating types. Most expensive at about $1.75 to $2.00 were his bamboo chairs, described on one occasion as "Double bow'd." Fan-back Windsors cost either $1.33 or $1.42 each; the green chairs recorded from time to time appear to have been of the same pattern. Whipple priced his "yellow" chairs at $1.50. Since the price is low for bamboo chairs, these may have been bow-back Windsors. After 1805 chairmaking is not mentioned in the accounts until 1810, when Whipple "Exchanged with Samuel Beal" of Boston "6 chairs, gave 1 Dollar to boot."[168]

As early as 1804 Whipple posted credits to various accounts for "bringing" or "trucking stuff from Boston." A partial explanation of this metropolitan connection is found under the date July 20, 1807, when the craftsman "Delivered to Mr Thomas Seamoure [Seymour of Boston], to sell on Commissions, 10 Condle Stands, and 6 tables; to sell at the prices they are morked." There followed a business association with the firm of Nathaniel Bryant and Solomon Loud from 1808 to 1810, for which Whipple made case pieces, such as a "Bureau with turned posts," and a "turn'd Leg Sideboard with knife Draws and legs strung in three parts." Whipple performed "6½ days work repairing furniture at 1.50 per day" for the firm in mid 1810, indicating that he worked at least part time in Boston. His exchanges with Samuel Beal in 1810–11 seem to confirm this. The accounts terminate at this point. Whipple may have continued business in much the same manner as recorded, supplying the local market at Danvers when possible and jobbing in Boston as necessary. Whipple's name does not occur in Boston directories published between 1800 and 1820. There is no obvious explanation why as many as seven, and possibly more, of Whipple's customers resided in Billerica, a town south of Lowell.[169]

Evidence of Windsor-chair making in Essex, a few miles northeast of Beverly, is seen in a side chair said to have been made by Caleb Strong Gage. The owner, a lineal descendant, reports that Gage was a wheelwright, coffin maker, and chairmaker toward the middle of the century, and the man's name occurs in the Essex census for 1840. The chair, probaby dating to the late 1820s or 1830s, has a bent back with a broad, inset slat top, shaved-face posts, and four tapered spindles, each containing a well-defined ball turning below the center point. Scratch grooves ornament the well-finished, squared-shield seat whose top edges are rounded to meet a deep chamfer. Four-section bamboo legs exhibit much the character of Boston work dating to the 1810s (fig. 7-35), although individual sections are little shaped, as expected at this later date. Two grooves mark each slim, cylindrical box stretcher.

Although hardly rivaling the Salem seating trade at its height, vernacular chairmaking in Newburyport was enduring; marked examples date from the early 1800s to the

Fig. 7-47 Square-back Windsor side chair, Daniel Abbot (brand "D. ABBOT & CO."), Newburyport, Mass., ca. 1809–11. H. 33⅝", (seat) 17", W. (crest) 20", (seat) 16", D. (seat) 15"; left stretcher replaced. (Mrs. David Mooberry collection: Photo, Winterthur.)

1840s. From its position on the south shore of the Merrimack River near the sea the town of irregular plan rose in an easy slope and extended about a mile along the waterway. Timothy Dwight thought the houses made "a better appearance than those of any other town in New England." Lombardy poplars lined many streets. Before the War of 1812 commerce was considerable, so that Dwight could observe, "The wealth of this town is everywhere visible." In 1800 the population stood close to 6,000; by 1810 it had reached 7,600. Business and life continued at a brisk pace until "the memorable Friday evening, the thirty-first of May, 1811." That day "the sun set in unclouded splendor, gilding the church spires, and gleaming upon tree tops, window panes, and the masts of the little fleet anchored at the wharves up and down the river" and "for the last time its rays illuminated the ancient town." Shortly after nine o'clock fire broke out in a stable in Mechanics Row. By morning 16½ acres in the heart of town, comprising nearly 250 dwellings and businesses, lay in ashes. Newburyport never recovered completely from the effects of two economic disasters in close succession—the fire and the war.[170]

The early years of the century were full of promise in Newburyport. There was a sizable established craft community, which included many furniture makers. Middle Street, in particular, was a center of cabinetmaking and chairmaking. Here Daniel Abbot worked with Benjamin McAllaster and later on his own. His shop probably was destroyed in the fire, since the *Herald* printing office located nearby was consumed. A small group of bent-back, or fall-back, Windsors branded "D. ABBOT & CO." under the seat are regionally oriented (fig. 7-47). Flared-base spindles (fig. 7-27), modeled leg turnings, and rounded planks exhibit characteristics of Boston work (fig. 7-33). The introduction of one groove near the post bases copies a Boston feature of about 1810 and later (fig. 7-32). Abbot worked on his own after June 6, 1809, when he and McAllaster dissolved their partnership. A native of Ipswich, the chairmaker married at Salem in 1796 and a second child was born there in 1799; he returned to Salem before 1820. Captain Edmund Kimball of Newburyport bought fancy chairs from Abbot and McAllaster in 1808. Two years later the captain purchased rocking chairs and plain chairs from Samuel Dole, another tenant of Middle Street. One of Abbot's Windsors is branded by a later owner "ELI ROBBINS / LEXINGTON," and a group of four chairs has original decoration consisting of dark penciling and leafy sprigs. Six single-bow side chairs sold in recent years bear the legend "Amesbury Mills, Mass," identifying a community across the Merrimack River from Newburyport.[171]

The Newburyport fire disrupted the furniture trade for a time. Sarah Anna Emery, a native, wrote that immediately after the disaster "the Shaker families at Canterbury and Enfield sent five wagon loads of furniture, bedding, clothing, and food." Between September 24, 1813, and the following January 1, Bernard Foot supplied a local customer with two sets of "Spring Back" chairs; a like number of straight-back, double-bowed Windsors; and a "high top" rocking chair. He constructed a rocking chair for a Byfield patron in 1818. The next documented plank-seat pattern associated with the town dates to about 1830 (fig. 7-48). Side chairs and armchairs in the half-spindle, slat-back style, some forming a set, bear the label of the Newburyport Chair Factory, whose location was a room over the market house. Nathan Haskell was "Agent for the Proprietors." Although the chairs are of one pattern, there are subtle variations. Ball-turned elements, remarkably similar to New York work (fig. 5-49), frequently appear in the front legs, stretchers, posts, and spindles. In other chairs ball spindles complement plain bamboo turnings; some lack the tiny spools found here. Decoration follows the illustrated freehand leaf-and-fruit pattern or substitutes a more structured, symmetrical floral design. Although the label texts are similar, typefaces and borders vary. The same chair was immensely popular among craftsmen of northern Worcester County (fig. 7-63).[172]

Another version of the slat-back Windsor, made perhaps as much as a decade later, bears the Newburyport label of John T. Loring (fig. 7-49). His location in Middle Street suggests that the rebuilt section of town may have once again become a community furniture center. Loring married in 1840 and was chosen a selectman five years later. Chair features are coarser than in earlier patterns. The ball-turned front legs and

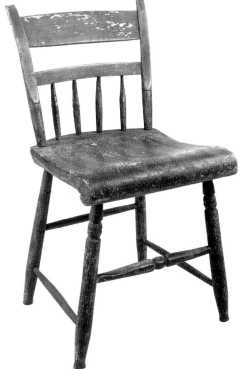

Fig. 7-48 Slat-back Windsor side chair and detail of label, Newburyport Chair Factory, Newburyport, Mass., 1825–35. White pine (seat); H. 34⅝", (seat) 17⁵⁄₁₆", W. (crest) 18⅜", (seat) 16¾", D. (seat) 16⁵⁄₁₆"; bright yellow ground with black, chocolate-brown, transparent brown, shaded gray, and dark green. (Hitchcock Museum, Riverton, Conn.: Photo, Winterthur.)

Fig. 7-49 Slat-back Windsor side chair and detail of label, John T. Loring, Newburyport, Mass., 1835–45. H. 30¼", (seat) 16½", W. (crest) 16¼", (seat) 16¼", D. (seat) 15½". (Old Sturbridge Village, Sturbridge, Mass.)

stretcher are grooveless, the short back has one less cross slat, and the large squared plank has a scrolled front formed by applying a half roll to the underside. Locally, the label as a vehicle of identification and advertisement vied with the more recently introduced stencil and long-lived branding iron.[173]

NORFOLK AND PLYMOUTH COUNTIES

Norfolk County, created from Suffolk County in 1793, based part of its economy on the supply of agricultural products to the Boston market; by the 1830s bootmaking and shoemaking had become a leading manufacture. Leather working was an important pursuit in adjacent Plymouth County, although that county's coastal location also gave rise to a substantial ship-building industry. Together the population of the two counties stood at almost 75,000 in 1820; in another decade the number had risen by 10,000. There appears to have been very little Windsor production in the area, but doubtless several dozen craftsmen produced plank seating between 1800 and 1840. Most probably were jacks of several trades rather than specialists. Two of them, Luther Metcalf and Eleazer Daniels, continued to work at Medway. Daniels was active until his death in 1858, as indicated by the new furniture and lumber that stood in the shop. Perhaps as much furniture entered the area from centers outside the two counties, such as Boston, Providence, and New Bedford, as was made locally.[174]

Inventories of 1812–13 that itemize the personal property of Doctor John Sprague II and his wife of Dedham, the Norfolk County seat, suggest that household seating

differed little from that in neighboring areas. The enumeration of widow Rebecca Sprague's possessions is the more complete of the two. The front entry contained six green Windsor chairs, possibly fan-backs, in contrast to the four chairs, three with cushions, standing there during her husband's lifetime. Half a dozen yellow Windsors in the dining room probably were bow-back or bamboo chairs, their valuation the same as that of the green chairs. Six unspecified Windsors in company with a lolling chair and a small rocker provided seating in the "Back Parlor."[175]

More positive evidence of local chairmaking occurs due east at Hingham, Plymouth County, where Caleb Hobart, Jr., practiced his trade. A branded set of six double-bow, square-back chairs is almost identical to Samuel Horton's Boston chair (fig. 7-27), although two minor variations suggest some knowledge of contemporary Salem work. In the back posts there is just the suggestion of a rounded base swell, and the grooves marking the top bow follow Tuttle's pattern (fig. 7-43). Hobart resided in Hingham between 1810 and 1830. Shortly after performing work at the local schoolhouses for the town in March 1830, he relocated in North Yarmouth, Maine. When the senior Caleb Hobart wrote his will in 1838, Caleb, Jr., was still a Maine resident; within two years he was back in Hingham. The younger Hobart prepared his own will thirteen years later. The craftsman called himself a "cabinet manufacturer," a business he seems to have pursued in partnership with his son Seth, since he referred specifically to his half share of the real property, machinery, and stock. Caleb owned a second shop, probably that formerly belonging to his father and listed in the 1846 inventory of the elder man. Both shops were in South Street, one on either side of brother Martin's residence. Hobart died at Hingham in 1865.[176]

BRISTOL COUNTY

John Warner Barber reported that navigation and manufacturing were two principal pursuits of Bristol County. Taunton, the seat of government, stood at "the head of sloop navigation" on the Taunton River where "about 30 sail of coasters of considerable burthen" sailed between the town and neighboring ports. The confluence of the Taunton, Canoe, and Rumford rivers produced a substantial waterpower that operated eight cotton mills and other manufactories. Eventually, a branch of the Boston and Providence Railroad provided overland access.[177]

Taunton was a rising community when Isaac Washburn constructed the single-bow Windsor illustrated in figure 7-50. Active by 1790, the furniture maker continued to run a successful business until his death in 1832. He and his sons William and Henry, all cabinetmakers, purchased a wood lot on Prospect Hill in 1811. That source probably provided Washburn with pine for plank and ash for most turned parts. His chair seat is similar to that in a Providence child's Windsor (fig. 7-2), and there are other affinities in the back posts and support structures. Barber reported the distance between Taunton and Providence as only twenty miles. At the time of Washburn's death there was a quantity of cabinetwork and chairwork standing in the shop. The former included French bedsteads, Grecian card tables, clockcases, mahogany stands, and cherry pembroke tables. The list of chairwork is not as specific, although the count stood at more than 300 items. There is mention of flag, rocking, common, and "turn'd back" (bent-back?) chairs; other seating was described as "small." A bill for dining chairs and small chairs dated in 1828 indicates that the turned-back chairs probably were of Windsor construction. Washburn's shop, which was well equipped with hand tools, contained a lathe and four workbenches. There were lumber wagons and business vehicles. A furniture store provided an outlet for shop production. In addition to the "Old Homestead House" and outbuildings, Washburn owned a "new brick house" and various lots. His estate totaled a sizable $24,426.[178]

A square-back armchair in the single-bow style branded "AXSHOVE" at the seat back is one of several early nineteenth-century Windsors to bear this mark (fig. 7-51). The brand identifies a product of the Berkley-Freetown shop of Abraham Shove south of

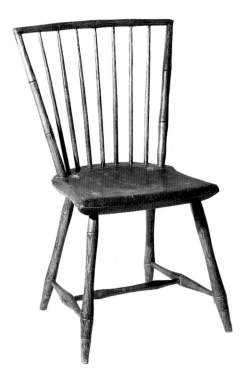

Fig. 7-50 Square-back Windsor side chair and detail of brand, Isaac Washburn, Taunton, Mass., 1802–12. (Photo, Museum of Early Southern Decorative Arts, Winston-Salem, N.C.)

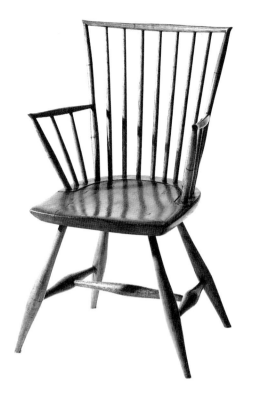

Fig. 7-51 Square-back Windsor armchair and details of brand and inscriptions, Abraham Shove, probably Berkley, Bristol County, Mass., 1806 (dated). White pine (seat) with maple and other woods; H. 33¼", (seat) 15½", W. (crest) 19½", (arms) 20¼", (seat) 16½", D. (seat) 17". (Henry B. Tinkham collection: Photo, Winterthur.)

Taunton. The back, seat, and leg tops represent an advance in style from Shove's bow-back chair illustrated in figure 6-223; however, several constants are represented in the leg, stretcher, and spindle profiles. The back posts, which are slim modifications of the legs, anchor a modeled crest and arms that terminate in prominent projecting tips. The squared-front seat owes a debt to the contemporary production of eastern Connecticut and Rhode Island (figs. 7-2, 7-7). The planks of Shove's side chairs are chamfered, rounded squares. Shove's seating demonstrates that he remained an independent provincial craftsman throughout his woodworking career. The present chair has descended in one family since its purchase in "5th Month / 1806," as painted in pale mustard yellow, probably the original color, on the plank bottom. Also present in white chalk are the script initials "MB" for Moses Buffington of Swansea, the original owner.

Shove and the Washburns likely had their timber sawed in a local mill, such as that owned by Joseph Dean in or near Taunton. Accounts entered in Dean's early nineteenth-century records reflect the close ties between local woodworkers, businessmen, and consumers:

furniture had Abiathar Williams	$56.11
½ Doz Chairs at Shoves @ 4/bottoming 1/6	5.50
Stand at Shoves 8/	1.33
Furniture at Washburns	65.00

Abiathar Williams appears to have been a trader. On October 17, 1818, he received $15 for twelve chairs delivered to Elizabeth Dean. An additonal $1.50 covered the cost of "Fraight of the above Chairs from N. York." The influence of New York was substantial in southern coastal Massachusetts, as further demonstrated in documented seating from New Bedford (fig. 7-53) and a New York chair imported by Abiathar Williams for his own use (fig. **7-52**). The Windsor is one of a set of six side chairs and an armchair inscribed with a family history. Crucial in identifying the New York style are the banded posts, squared-top spindles, ornamental front stretcher, late shield-type seat, and well-modeled bamboo legs (figs. 5-40, 5-45).[179]

John W. Barber wrote of Bristol County's southern coast, "Few towns in Massachusetts have increased more rapidly than New Bedford." From 1830 to 1836 the population rose from about 7,600 to 11,000. Barber further stated, "The almost entire

business of the place is the whale fishery and other branches of business connected with it." The prosperity of the fishery created numerous fortunes, and that money built grand and handsomely appointed houses, in decided contrast to the community's simple Quaker roots. Today little furniture can be documented to New Bedford, and only one Windsor armchair made by Bates and Allen (fig. 7-53) bears identification.[180]

Double-bow chairs, some centered with medallions, appeared in New Bedford households as influences streamed in from many areas. The sparsely furnished dining room in Abraham Russell's Quaker home contained chairs of this pattern. Although Russell operated the stage line between New Bedford and Boston, his small-medallion Windsors seem better ascribed to Philadelphia than to Boston where a large rectangle centered the crest (fig. 7-29). Shipping papers record the 1804 entry of the ship *Elizabeth* from Philadelphia with a set of chairs consigned to William Rotch, a leading New Bedford businessman. Within the community William Russell, Jr., made Windsor chairs for several decades beginning in the late eighteenth century. He also prepared paints and sold painters' and glaziers' supplies. He and William Bates, a chairmaker, dissolved a short-lived partnership in June 1804. Later Russell was involved in a joint business venture with George Reynolds and Courtlandt Charlot; it lasted until April 1823 when the partners went their separate ways. Reynolds probably had come from New York where a jury list of 1819 lists a journeyman gilder by that name, age twenty-three. Russell apparently continued to work on his own; when he died in 1833 he was involved in many enterprises. The store at the foot of Union Street contained "Painting Glazing & Chairmaking stock and Tools," including "130 wood Bottomed chairs." Besides his house in town, he owned various lots and a working farm across the Acushnet River in Fairhaven. Cognizant of where the real money was to be made, Russell had invested in shipping. His holdings ranged from one-eighth to three-eighth interests in the ship *Midas* and four sloops. In addition, his cargo of whale oil and whalebone on board the *Midas* was worth almost $1,500. The value of the estate was just over $50,000—a real success story for a chairmaker.[181]

William Bates, Russell's first partner, formed an association in April 1822 with Thomas Allen II, a chairmaker. The two men conducted a painting, glazing, and chairmaking business until November 1824, when Allen moved to a new location near William Russell, Jr. By the time Allen sold the property to William Bates and his new partner, Reed Haskins, in 1832, he was termed a "trader." The New Bedford city directory of 1836 further identifies Thomas and Joseph H. Allen as ship chandlers; Bates and Haskins are called painters in the same volume.[182]

William Bates and Thomas Allen II made the only known nineteenth-century Windsor documented to New Bedford during their brief partnership from 1822 to 1824 (fig. **7-53**). New York influence dominates. If not for the New Bedford label, there would be no stylistic reason to assign it to that area. The overall design springs from fancy chairmaking (fig. 5-35). Individual features compare well with the New York Windsor style (figs. 5-49, 5-52): the back posts are stout at the base and marked by double sets of rings; the short spindles have a small bead flanked by tiny spool turnings; the turned arms round off to sloping front tips and anchor in shaved post faces (fig. 5-45); the large, rounded seat is flat at the forward edge; and the front legs employ a New York fancy pattern. The front stretcher may identify a design variation peculiar to the region. The original painted surfaces are bright sunny yellow with black penciled lines and grooves forming a sharp accent. Medium green banding, fronds, and leaves complement both the ground color and the pinkish tan of the white-mouthed morning glories in the crest.

As Bates and Allen produced their painted seating, local competition was on the rise. Reuben Swift and his brother William joined forces in 1821 to operate a cabinetmaking and chairmaking establishment where they stocked an assortment of fancy and Windsor chairs. The partnership lasted at least until 1825. Thomas Ellis, a cabinetmaker, announced the sale of painted chairs in 1827 and by 1833 offered ladies' rocking chairs with "raised seats" (Boston rockers) painted a dark color or grained to simulate oak or curled maple. Ellis had moved completely into wareroom sales by 1834. Meanwhile, Thomas

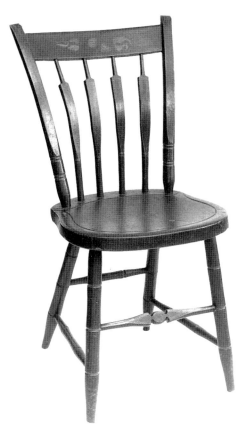

Fig. 7-52 Slat-back Windsor side chair (one of seven), owned by Abiathar Williams of Taunton, Mass., made in New York, 1815–25. (Photo, Patsy Braman Antiques.)

Fig. 7-53 Slat-back Windsor side chair and detail of label, William Bates and Thomas Allen II, New Bedford, Mass., ca. 1822–24. White pine (seat) with maple and other woods; H. 33¾", (seat) 17½", W. (crest) 16½", (arms) 17⅞", (seat) 17⅜", D. (seat) 16"; bright yellow ground with black, medium green, pinkish tan, and white. (Old Dartmouth Historical Society, New Bedford, Mass.: Photo, Winterthur.)

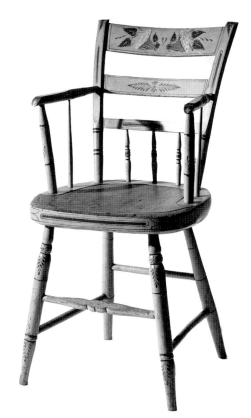

Cromwell, a New York chairmaker, and Frederick Howland formed a copartnership in 1829 with Alden S. Davis to manufacture fancy and Windsor chairs. Rufus Howland entered the picture in 1830 as a practicing chairmaker at the corner of Bridge and Market streets, where he remained about three years before cabinetmaker John Sowle took over the premises. Sowle offered his stock "at the lowest Boston and New York prices," an indication that he and his customers were familiar with the furniture trade beyond the local market. Chairmaker Walter Pancoast came to New Bedford in 1832 from New York City. He may have remained as long as two years before returning temporarily to New York. In another three years he was a furniture polisher and finally settled down to a clerkship. Short-lived business enterprises seem to have been the rule in the New Bedford furniture market as many chairmakers struggled to earn a living. An exception is the career of cabinetmaker and furniture entrepreneur William Knights, who was in business for over thirty years beginning about 1823. A letter written by Knights in 1837 to Joel Pratt, Jr., of Sterling, Massachusetts, describing an order, identifies chairmaking in the central part of the state as another substantial force in shaping the New Bedford product. Given local business conditions and the many external influences affecting the market, it is little wonder that there developed neither a local style nor a body of documented work.[183]

BARNSTABLE COUNTY AND THE ISLANDS

Fishing and coasting were prime occupations on Cape Cod, which comprises Barnstable County. Agriculture was minimal due to the barrenness of the sandy soil, but residents engaged in salt manufacture. Trade with Boston was an integral part of the local economy, so that it was relatively easy to transport seating furniture from the metropolitan center to the small towns dotting the peninsula. Undoubtedly, that situation discouraged local furniture trade. Samuel Wing of Sandwich, who constructed "green" and "great" chairs around 1800, made a set of six black chairs in 1807. If the green chairs were fan- or bow-back side chairs (fig. 6-225) and the great chairs, fan-back armchairs of the Nantucket type (figs. 6-233–6-235), then the black chairs, priced midway between the two at $1.75, could have been square-back, or bamboo, Windsors. A square-

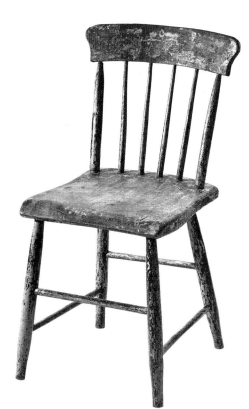

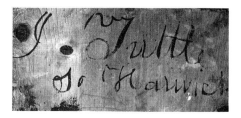

Fig. 7-54 Tablet-top Windsor side chair and detail of inscription, J. Tuttle, South Harwich, Mass., 1845–65. White pine (seat); H. 31⅜", (seat) 16¾", W. (crest) 18¼", (seat) 15¾", D. (seat) 14¾". (Carl R. Salmons collection: Photo, Winterthur.)

back child's highchair found in the Wing homestead in this century could be representative of the craftsman's later work, although the turnings exhibit strong characteristics of the Boston-Salem school. In any event, Wing's account books end in 1809, and within two years he and two of his brothers had built a dam and cotton works, which they operated for several years. That enterprise may have ended Samuel's furniture career.[184]

Calvin Stetson of Barnstable worked as a cabinetmaker and chairmaker possibly as early as 1829 when he purchased a parcel of land south of the County Road. His account book begins in 1843 and continues through the decade. William T. Haley, a Boston chair dealer, supplied most, if not all, of Stetson's seating—more than 525 chairs between 1843 and 1848. Wooden-bottom and cane-seat styles prevailed. Stetson's markup for retail sales varied from about 21 percent to 45 percent. Customers could choose from at least six different rocking chairs, probably all but one style constructed with a high back for reclining. One tall chair was armless, another had a cane seat, and two were large and small versions of the same pattern. Children's dining (high), low, and potty (hole) chairs were available. Cane-seat side chairs had "Round posts" (turned) or squared uprights (sawed) in the "Grecian" style. Some caned chairs had a banister in the back—probably the broad, unpierced vase first introduced in Boston shops in the 1830s. Wooden-bottom chairs fell into two classes, common or fancy-back. Occasional references to paint describe "dark" colors, implying that light tones prevailed in most production. On three separate occasions in 1844–45 Haley provided Stetson with "Harrison" or "Harrison Grecian" chairs, presumably a reference to seating with crests painted to suggest the 1841 "Log Cabin and Hard Cider" presidential campaign of William Henry Harrison. A scene of this type is painted in the crest of a tall, raised-seat rocking chair with an 1840s rounded-loaf top notched on the lower surface with two lunettes. A leaf-ornamented side chair of similar top without the notches is documented to Cape Cod by reason of a painted inscription on the squared plank bottom: "J Tuttle / So Harwich" (fig. **7-54**). The names of two candidates, John and Jessie Tuttle, are first found in the 1850 Harwich census.[185]

Nantucket was the place "more celebrated than any other" as a center of the whale fishery in the early nineteenth century. Out of a population of just over 9,000 in 1837, about 2,000 men and boys were employed in navigation. Eighty-eight whaling vessels

belonged to the port in 1822. Because the island was "almost entirely destitute of trees and shrubbery, and a great part of [it] . . . a naked plain," virtually all supplies had to be brought in—food and beverage; wood for building, woodworking, and fuel; and household items in great variety. By the 1830s, to meet local demand, there was daily communication with New Bedford via steamboat or packet, with stops at Falmouth and Martha's Vineyard.[186]

Evidence of island chairmaking is thin. Most painted seating was sold by dealers, and the majority of their stock appears to have been imported from centers along the Atlantic seaboard. Eighteenth-century Windsors continued in use—the high-back chair; the round, or sack-back, Windsor; and the fan- and bow-back patterns. Inventories mention green chairs most frequently, some with arms, others for table use. Mahogany-color wooden chairs also appear with some frequency. Before 1810 black and light-colored chairs, including yellow, were in use. Lydia Pinkham's "6 black strait backed table [chairs]" may have been fashionable square-back Windsors. Josiah Macy's owner's brand appears on a single-bow chair of this style. The widow Pinkham also owned other stylish seating described as "6 white gilt Table Chairs" whose $18 value indicates they were almost new. A few statistics for neighboring Martha's Vineyard, comprising Dukes County, document two one-man cabinet shops where hardwoods were the principal raw materials and the annual value of manufactured articles was only $500. Such facts suggest strongly that chair construction, if carried on at all, was limited largely to bespoke work.[187]

THE TOWN AND CITY OF WORCESTER

Pausing briefly at Worcester in 1806, John Melish remarked the town's extensive trade and reported a proposed "inland navigation between this place and Providence, distant about 40 miles." By the time Carl David Arfwedson visited in 1832, the Blackstone Canal to Providence had been in use for about four years, providing Worcester with direct communication to New York. A railroad to Boston was under construction, and the population was more than 7,000. William Chambers noted manufactories of some importance. He commented principally on the production of hardware and described the place as "a kind of American Birmingham."[188]

Evidence of chairmaking at Worcester in the early 1800s is slim. What evidence there is focuses on Thomas Atwood, who was born in Bedford, New Hampshire, and worked in Massachusetts during his early furniture-making career. After marrying in New Hampshire in 1808, Atwood and his wife moved to Worcester, where the births of four children are recorded between 1810 and 1817. Presumably, Atwood worked as a journeyman. He is thought to have returned to Bedford about 1819 and commenced business on his own. Several Windsors in the arrow-back style branded with his name appear to date from his early New Hampshire years (fig. 7-78).[189]

The "chair factory" of Henry Wilder Miller, which commenced operation in spring 1827, may have been the first large-scale chairmaking facility in Worcester. Miller (b. 1800) was a businessman. He had served an apprenticeship in the retail hardware trade with Daniel Waldo, Jr., who is said to have been "the principal importing merchant of Massachusetts west of Boston." After Waldo retired in 1821 Miller and his fellow apprentice George T. Rice succeeded to the concern under the firm name of Rice and Miller. The partnership continued until 1832, when Miller became owner and sole proprietor of the business until 1884. A newspaper sketch of "Worcester's Oldest Businessman" published at Miller's death in 1891 notes that his acquaintance with Worcester "dated back to the time when it was only a petty village on a stage route, and he lived to see it develop through railroads and manufactures into a city of 85,000 inhabitants." The chairmaking facility begun in 1827 was just one of Miller's enterprises; the accounts continue until early in 1831. Whether this record was succeeded by another or whether Miller simply closed or sold the business is not indicated; the latter date coincides with his sole proprietorship of the hardware business.[190]

Miller's factory accounts present a reasonable picture of the business. He acquired merchandise in two ways: through chair construction on the premises and through the purchase of finished and semifinished seating. His "craftsman in residence" was Smith Kendall, probably the young man of that name born in 1793 just south of Worcester in Woodstock, Connecticut. Payments to Kendall for his "Labour" or "Services" began on April 1, 1827, and ended around December 11, 1830. An early assignment carried the chairmaker to Gardner in northern Worcester County; Miller paid the expenses and provided a "Horse & Gig." The trip may have had a twofold purpose—to secure timber for the new enterprise and to contact area chairmakers as auxiliary suppliers. At the factory Kendall was responsible for chair construction and painting. Occasionally, the firm undertook special jobs, such as painting seventy-eight chairs for chairmaker Micah Holbrook or refurbishing painted furniture for private customers. There are references to gilding sconces and staining and gilding a bedstead. Once the firm painted and "figured" sixteen fire buckets for the town of Worcester. Miller provided the necessary supplies for finishing and ornamenting from his hardware store: glass paper, rottenstone, white lead, japan, turpentine, pigments, metallic powders, leaf, brushes, camel's-hair pencils (fine brushes), and the like.[191]

Apparently, Miller intended to conduct business in an extensive way. He augmented Smith Kendall's factory production with purchases of chairs and specialized seating from a wide circle of northern Worcester County suppliers, primarily in 1827 and 1828. Most frequently patronized was David Partridge of nearby Paxton, who sold Miller Windsor chairs, settees, half-size (youth's) chairs, nurse and rocking chairs, and "chair stuff." Next in number of transactions was James M. Comee of Gardner, a supplier of fancy and "Grecian Post" chairs. Nehemiah Pearson and Levi Stuart, both of Sterling, filled several orders each for chairs and rocking chairs. Miller also placed single orders with at least a dozen other craftsmen, among them three Windsor-chair makers—Stephen Taylor of South Gardner, Elijah Holman of Millbury, and Joseph F. Loring of Sterling. Jonas Childs of Gardner supplied chair timber in September 1827. Aside from minor sales to private customers, local firms, and an occasional chairmaker, Miller's accounts record no outlet for the bulk of his production. Originally, an order book and other records must have accompanied the existing accounts.[192]

Miller may have intended to pursue chair markets similar to those supplied by New York and Boston. Then there was the rural trade whose general storekeepers were the "country merchants" mentioned in chairmakers' advertisements. In summer 1827 the New York firm of Tweed and Bonnell sent unidentified chairs and Grecian posts to Miller. These may have been intended to serve as models for Miller's factory or his suppliers, a fairly common practice. During the same summer Miller paid freight for twelve chairs from Boston and in September received a "Box of Chair Stuff." A schedule of manufactures from 1832 sheds light on area distribution practice. Northern Worcester County chairmakers identified Boston as a primary outlet for their product and Providence as an occasional market. David Partridge, Miller's largest supplier, sold chairs wherever he could throughout Massachusetts. At the outset of business Miller established accounts with two newspapers to advertise his factory. He also placed a large sign on the front of the building and three smaller ones at the sides. The entrepreneur appears to have thought of everything, yet the business didn't survive or Miller thought better of his diversification. Perhaps the rising, waterpowered chairmaking industry of northern Worcester County proved too formidable a competitor.[193]

At least one Windsor side chair branded "SMITH KENDALL" is known. The pattern is a broad slat-back with five full-length, ball-turned spindles and shaved-face posts angled slightly backwards. The shovel-shaped seat with bulging serpentine sides and blunt, rounded front is a late type; typically, the simulated bamboo supports are heavy cylinders. The chair probably dates to the late 1830s when Kendall worked on his own. He died at Worcester in 1877, survived by his widow, Maria, and one daughter. Newspaper notices published at the death of Henry Miller fourteen years later describe his family as consisting of two daughters and two sisters, one sister identified as Mrs. Maria

Kendall. Thus, Henry Miller and Smith Kendall would appear to have been brothers-in-law. The close family connection coupled with Miller's exposure as a boy to cabinet-making, his father's trade, may have encouraged him to undertake the chairmaking enterprise.[194]

WORCESTER COUNTY

Chairmakers in southern and southwestern Worcester County supplied local markets and parts of neighboring Connecticut and Rhode Island. The opening of the Blackstone Canal between Worcester and Providence in 1829 probably extended their distribution territory. However, northern Worcester County had the industrial advantage, as indicated in several surveys. Although the 1820 Manufacturing Census is incomplete, listings for northern Worcester County exceed those for the southern region where activity was modest and scattered. An 1832 schedule of manufactures is more inclusive. Enumerated in northern Worcester County were fifty-two chairmakers, one turner of chair stuff, and nine cabinetmakers. By comparison only six furniture makers were recorded south of Worcester; four cabinetmakers worked in as many towns and two unnamed proprietors of chair "factories" were located in Spencer. Regional statistics compiled in 1855 are proportional; the list identifies nine furniture craftsmen in the south or southwest as compared to eighty-one in the north.[195]

Uxbridge was the home of Jerry Wheelock, a furniture maker active at the start of the century. He is said to have abandoned the trade for the textile industry following the War of 1812. Published excerpts from a daybook in private hands show that Wheelock constructed bamboo chairs, painted yellow or black, and dining chairs, possibly bow-back Windsors. Among the seating that has descended in the family, a square-back, or bamboo, armchair with double bows (rods) and rockers may have been made by Wheelock. Succeeding the craftsman in later decades was chairmaker Simon Rawson, Jr., who is listed in census records as a resident of Uxbridge and later Douglas. His brand on a ball-spindle side chair includes the Douglas placename. Rawson's product follows a pattern then current in northern Worcester County (fig. 7-62).[196]

The activity of Charlton's Chapman Lee is typical of another group of wood-workers—the part-time craftsman. Lee was principally a farmer; as occasion dictated he turned his hand to carpentry, painting, sleighmaking, odd jobs, and furniture construction for area residents. Frank O. Spinney, who saw Lee as a model country craftsman, carefully analyzed his furniture accounts for the period from 1799 to 1828. Basing his calculations on a day's labor, valued by Lee at $1, a typical average daily wage, Spinney found that the furniture maker worked at his trade as little as a single day in the years 1819 and 1827–28 and only as long as eighty-six days in 1804, his banner year. It is clear from the records that Lee's woodworking market was confined to a small geographic area and that contemporary surveyors of American industry were not likely to have considered him a "manufacturer." Further calculations by Spinney show that during the first and most active decade of Lee's woodworking career, he devoted less than 10 percent of his time to this pursuit. Only about fifty chairs are listed in the ledger, most constructed in sets of six. Kitchen chairs at 64¢ apiece probably had three-slat backs because "4 Back Chairs" cost 92¢. Presumably, the prices included the rush seats. Lee recorded the construction of only four sets of Windsors, variously called "Green" and "Fan Back" chairs, all between 1804 and 1807. The prices varied from $1 to $1.50 per chair. As the charges coincide upon occasion, it appears that Lee made only green fan-back Windsors. Spinney has pointed out that neither Major General Salem Towne, Charlton's foremost citizen, nor his family patronized Lee for furniture or services. However, at the general's death in 1825 the imposing house he had erected in 1796 held six dining chairs, an indication that he, too, followed the fashion for using painted seating at his table.[197]

A Windsor side chair with a fancy tablet top (fig. 7-55) and an old chalk inscription on the seat reading "West [Br]ookfield" seems to be associated with production in western or southern Worcester County during the 1810s. The crest is exceptional and the

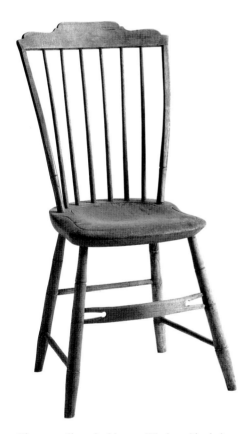

Fig. 7-55 Shaped tablet-top Windsor side chair (one of a pair), southern Worcester County, Mass., possibly West Brookfield, 1815–20. White pine (seat) with maple and other woods; H. 35¾", (seat) 17", W. (crest) 18", (seat) 14⅞", D. (seat) 15¼". (Private collection: Photo, Winterthur.)

overall design well balanced, top and bottom. The profiles of the seat, posts, front stretcher, and crest duplicate or suggest Boston work (figs. 7-32, 7-34). Indeed, the chair could pass for a metropolitan product if it were not for the existence of further information linking it to the county. In the same private collection is a tall rocking chair with an identical crest and ornamental stretcher from the Sibley family of neighboring Hardwick. A second rocking chair with minor variation in the arm posts is in the Worcester Historical Museum. A fancy-spindle variant is said to have come from a Sturbridge family.

By the start of the nineteenth century industrial growth had begun in northern Worcester County, a hilly region watered by streams, rivers, and lakes. The area was dotted with gristmills, sawmills, and fulling mills even in the mid 1790s; five forges and eighteen trip hammers were also in operation. Several decades passed before water-power served the county's chair industry, which began modestly in the early 1800s in an area bounded on the west by Athol, on the east by Lunenberg, and on the south by Paxton. In commenting on the Ashburnham chair trade, one historian noted that the early manufacturer required only a small room in a dwelling house, a few tools, and a modest outlay of money. He added, "The number who supplemented their other employment with the manufacture of chairs or chair stock, was only exceeded by the tax list," a statement applicable to other area towns.[198]

An early manufacturer was James M. Comee of Gardner, who began about 1805. In succeeding years he took into his employ several young men as apprentices, who in turn established their own businesses. Comee was a supplier of fancy and "Grecian post" chairs to Henry Miller's Worcester chair factory in 1827–28. When the federal marshals canvassed Worcester County for the 1820 Manufacturing Census, they found Comee's annual chair production to be worth $1,500; cabinetwork added another $1,000. Levi Pratt, a fancy-chair maker of Fitchburg, sold 2,000 chairs annually for $2,000. In Templeton one marshal enumerated a sizable watermill operated by Stephen Kilburn, which he estimated "annually makes more than twelve thousand chairs." For sheer numbers of manufacturers the town of Sterling may have assumed a temporary lead (or perhaps the marshal here was more thorough in the execution of his duty). The list contains twenty-three independent chairmakers, several of whom are represented today by marked furniture. Total reported production amounted to about 69,700 chairs annually.[199]

The 1832 schedule of manufactures gives statistics on employees and product value for fifty-three chairmaking establishments throughout the northern region, and no doubt some were overlooked. Employed were 244 males and 186 females, the latter probably responsible for rushing seats and doing some decorating. The total estimated value of the manufactory was $188,837. Although industrial figures collected by the state of Massachusetts in 1855 do not differentiate between chair and cabinet manufactories, ninety-seven furniture-making establishments throughout the county employed more than 1,700 individuals and grossed almost $1.6 million annually.[200]

After 1800 sawmills were almost as numerous as the streams in northern Worcester County. The erection of dams assured both mill and manufactory of reasonably steady waterpower. Gradually through the 1820s the character of the chair business began to change. Replacing the modest one-man shop were small manufactories that employed several men and used power-driven lathes. Stephen Kilburn of Templeton appears to have been one of the far-sighted individuals who early seized the opportunity to expand. Soon other area chairmakers purchased water privileges to erect a new factory or convert an older facility. Farmers and timber dealers supplied most of the turning stock, splitting and cutting sticks to length, then trimming the corners in readiness for the lathe. Many manufactories specialized in turned chair stock, leaving the framing, finishing, and merchandising to other establishments.[201]

By the 1830s the far-sighted businessmen among the chairmakers realized that maximum profit required consolidation of the entire chairmaking operation under one roof. Benjamin F. Heywood erected a sawmill fitted with "machinery for the manufac-

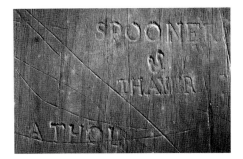

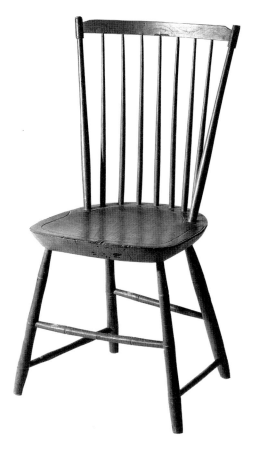

Fig. 7-56 Slat-back Windsor side chair and detail of brands, Alden Spooner and (Jesse?) Thayer, Athol, Mass. ca. 1810–16. White pine (seat); H. 34″, (seat) 15¹⁵⁄₁₆″, W. (crest) 18¼″, (seat) 15¹⁵⁄₁₆″, D. (seat) 15½″; right rear leg replaced. (David D. Draves collection: Photo, Winterthur.)

ture of . . . chairs at his dam site in 1834." As business prospered, manufactory owners enlarged their quarters, adding more water-powered lathes and, in some cases, the new circular saw. One such cutting device was already in place in the Gardner chair shop of Asa Nichols at his death in spring 1829. A few years later appraisers of Peter Peirce's Templeton estate itemized a "circular saw & Frame" with a spare "plate." Benjamin F. Heywood's water-powered mill had both three- and four-foot saws by 1843; in fact, one or both may have been in place as early as 1834. The introduction of planers, boring machines, and jointers was still several decades away, however. In the early days of mass production the chairmaker retailed his merchandise as best he could throughout the countryside and in the nearest towns and cities. As the population grew and national business expanded, demand increased, dictating the use of large wagons drawn by teams of horses destined for specific markets—Boston, Worcester, Providence, Salem, Lowell, Springfield, and a growing number of established "country merchants." Some manufacturers opened their own metropolitan chair warehouses. In time the railroad proved another boon to business expansion. Gardner, Fitchburg, and Ashburnham, in particular, became leaders in the American seating industry during the third quarter of the century. Gardner counted the chair its most important commodity, manufacturing at the quarter's close more than 1 million annually to the value of more than $1.4 million.[202]

Marked furniture and documents of several kinds help to identify northern Worcester County chairwork. Prominent is the production of Alden Spooner (1784–1877), who worked with several partners during the early 1800s in Athol, a small community with a population of about 1,000 in 1805. Stylistically, Spooner's earliest chairs probably were square-back Windsors with single bows and bent backs. One example in a private collection stands on stout, four-part bamboo legs connected by box stretchers; the knife-edge, shield-shaped seat relates to Boston work (fig. 7-34). Slim, smooth back posts approximate those shown in figure 7-29, but without the top nubs; the single top rod is similarly inset but anchors seven long, bent spindles. Stamped on the seat bottom with four separate brands is "SPOONER / & / THAYER / ATHOL."

Another Windsor similarly identified advances the style (fig. **7-56**). The seat has lost its definite shield form, and the thick, canted sides reflect Boston work of the early 1810s

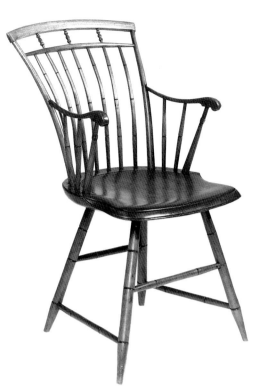

Fig. 7-57 Square-back Windsor armchair and detail of brands, Alden Spooner and George Fitts, Athol, Mass. ca. 1814–20. (Old Sturbridge Village, Sturbridge, Mass.)

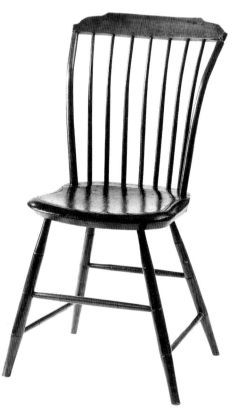

Fig. 7-58 Shaped tablet-top Windsor side chair and detail of brand, Stephen Kilburn, Baldwinville, Mass., ca. 1814–20. White pine (seat); H. 33½″, (seat) 16½″, W. (crest) 17¾″, (seat) 15¼″, D. (seat) 14⅜″. (Historic Deerfield, Inc., Deerfield, Mass.: Photo, Winterthur.)

(fig. 7-35). The back structure suggests several influences. Some contemporary Connecticut work features a narrow inset slat crest and cylinder-tipped back posts (figs. 7-7, 7-18), but the shallow depth of the crest probably relates more directly to Boston work (fig. 7-33). Altering the character somewhat are the hollow corners, a feature that is found later in northern New England work (fig. 7-85). Spooner and Thayer framed the upper structure of their Windsor with a lateral curve only, creating a straight as opposed to a bent back.

Around the time of the War of 1812 Spooner took as a new partner George Fitts. The change is recorded in the brand. The work is lighter and more delicate and features a double-bow back of sharp bend. Grooves mark the spindles, and the seat once again employs a shield shaved to knifelike edges. Slender legs have well-defined feet and rake more than formerly. A fancy Windsor of double-bow pattern exhibits special features (fig. 7-57). A thick, shallow cap replaces the top bow and encloses three short sections of ornamental beadwork, the effect not unlike that of several Boston chairs with decorative crest medallions (figs. 7-28, 7-34). The scroll arms are an adaptation of those common to bow-back production of a decade or more earlier (figs. 6-213–6-215), although the transition from front to back is somewhat uneasy. Arm posts reflect fancy chairwork (fig. 5-35). The seat is somewhat too large for the design, introducing an element of awkwardness, although the disparate elements possess visual unity. The design may be unique to this chair; certainly, it was confined to a small number of Windsors. Whether the chair represents an experimental piece or a special order may never be known.[203]

Tablet-top chairs with the crest ends stepped and rounded represent the first production Windsor of northern Worcester County during the 1810s. Some bear the brand of Stephen Kilburn (fig. 7-58), who introduced waterpower to his manufactory during this period and employed several workers. The smooth, round posts and sharply canted seat edges are those found in Spooner's double-bow, square-back chairs, but the leg tops taper sharply in the Boston manner (fig. 7-34). The crest is a variant based on a similar source (fig. 7-36). Instead of right-angle cuts defining the central tablet, the ends fall away in short ogee, or cyma, curves. Round-tenon construction secures the top to the posts.[204]

By 1832 Alden Spooner conducted business on his own account without a partner. The manufacturing survey of that year gives his trade as cabinetmaker, referring to his production as "different kinds of furniture" without mentioning chairs specifically.

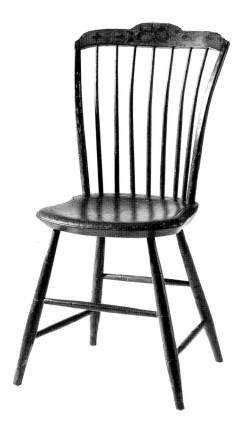

Fig. 7-59 Shaped tablet-top Windsor side chair and detail of brand, Alden Spooner, Athol, Mass., ca. 1816–22. White pine (seat); H. 35⅛", (seat) 16⅞", W. (crest) 18¾", (seat) 16¼", D. (seat) 15¼"; paint and decoration not original. (Thomas and Alice Kugelman collection: Photo, Winterthur.)

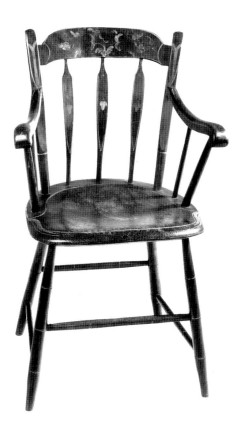

Fig. 7-60 Shaped slat-back Windsor armchair, Joel Pratt, Jr. (label), Sterling, Mass., 1820–30. White pine (seat); H. 33¾", W. 21½", D. 15¼"; dark brown and brick-red grained ground with yellow, white, and dark color. (Henry Ford Museum and Greenfield Village, Dearborn, Mich.)

Although a total of four men worked in the shop, Spooner may have given up the manufacture of chairs more than a decade earlier. The latest known Windsors marked with his identifying brand, "SPOONER / ATHOL," have tablet-type tops forming a pattern variant (fig. 7-59) of those previously illustrated (figs. 7-36, 7-58). The crest's shallow depth and subtle arches, top and bottom, introduce a bannerlike effect. These features and the lunette-shaped centerpiece herald a pattern that rose to popularity in northern Worcester County in the 1820s (fig. 7-60).[205]

Of the twenty-two Sterling chairmakers and one cabinetmaker and chairmaker listed in the 1820 manufacturing census, Joel Pratt, Jr., had the largest production at 8,000 chairs annually. His closest competitors were Joshua Reed, whose output numbered 6,000, and James Brown and Abijah Brown, who each constructed 5,000 chairs. The 1832 schedule provides only collective figures for Sterling, where fifteen chair manufactories employed a total of forty-seven men and the manufacture of furniture was a strong complementary trade. There were twenty-four establishments in 1837. By the third quarter of the century Sterling's chair business had fallen off, probably because of competition from the neighboring communities of Gardner and Fitchburg.[206]

Joel Pratt's round-top, slat-back Windsor (fig. 7-60) was one of several patterns manufactured in Sterling and northern Worcester County in the 1820s. Pratt probably did not originate the design, nor was he its sole producer. Through his use of paper labels, however, his name is one of only a few directly linked with the pattern today. Pratt probably trained as a chairmaker, although by the 1820s his association with the trade was that of entrepreneur. His book of accounts, recording transactions from 1822 through 1826, shows that he did business with more than three dozen area chairmakers. Most of the men lived within a ten-mile radius of Sterling. One, however, resided at Fitzwilliam in southwestern New Hampshire, and another was located at Winchendon, a Massachusetts town on the main route from Sterling to New Hampshire. The men supplied turned or shaved chair stuff, from rods to legs, which Pratt appears to have retailed as received or as framed and finished seating. The accounts give no indication of whether the framing was done on site or at the shops of other craftsmen. Pratt owned a lathe, the use of which he rented out at 16¢ per day. He also operated a general store.[207]

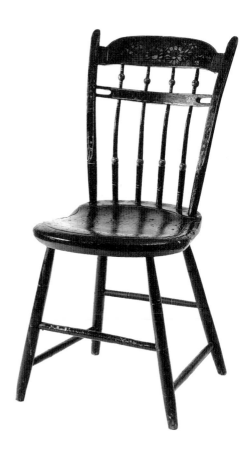

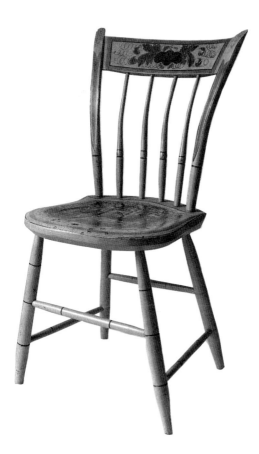

Fig. 7-61 Shaped slat-back Windsor side chair, northern Worcester County, Mass., 1820–25. White pine (seat); H. 33¾", (seat) 17⅜", W. (crest) 16⅞", (seat) 16", D. (seat) 16"; paint and decoration not original. (Private collection: Photo, Winterthur.)

Fig. 7-62 Slat-back Windsor side chair (one of a pair), John D. Pratt (stencil), Lunenburg, Mass., ca. 1821–30. Yellow ground. (Charles L. Sumners collection.)

The relationship of the rounded slat in the Pratt chair (fig. 7-60) to the tablet crest of figure 7-59 is not difficult to see. Several transitional patterns provide intermediate links. One design follows the Pratt crest, the lower edge straight and the unit framed on the post tops like the Spooner chair. Pratt-type crests of slimmer proportions are set between the posts of other Windsors, several branded by members of the Wilder family of New Ipswich, New Hampshire, to the immediate north. Pratt's heavy forward-scroll arms are typical, although the terminals are more fully developed than those of contemporary Boston work (figs. 7-38, 7-39). The arrow, or flat, spindle was only one of several sticks in use. Pratt combined the same vertical supports with a broad, inset, rectangular crest. An undocumented chair of this pattern is illustrated in plate 22.

A type of ball, or bead-defined, spindle is found in a small group of seating framed with a Pratt-type, round-top slat (fig. **7-61**). There are two patterns—that shown and a back with two short ball spindles flanking a central urn or shield just below the crest. Chairs of the latter type socket an ornamental front stretcher featuring a slim horizontal tablet; an armchair has forward-scroll arm rests. The small urn was also employed as a decorative motif in the tall back of a fancy Windsor rocker of earlier date, and a variant shield occurs in several New Hampshire chairs (figs. 7-87, 7-88). Pierced work may be noted in other Worcester County Windsors (fig. 7-55). This feature, which was probably first used in Boston Windsors (figs. 7-34, 7-35), was also copied in New Hampshire (figs. 7-74, 7-84, 7-87).

John D. Pratt, a Lunenburg chairmaker, probably was a kinsman of the Sterling chairmakers Joel Pratt, Jr., and John B. Pratt. The two Johns are first listed in the 1830 census in their respective communities. Chairs of several patterns bear the stenciled legend on the plank bottom: "J. D. PRATT. / Lunenburg Ms. / WARRANTED." Earliest in date is a slat-back Windsor of bent back and long, ball-turned spindles (fig. **7-62**). As here, the usual stick pattern is slim at the top and markedly thick in the lower half beginning just above the ball turning. The variant design, illustrated in the previous chair, extends the slender part of the stick to the ball, creating an abrupt visual transition. Modified balloon-shaped seats—either rounded and chamfered, or slightly rounded, flattened, and chamfered, as illustrated— characterize area production. Slat decoration

where intact generally consists of floral forms and/or fruit with foliage. Other area chairmakers represented by marked examples include Gilson Brown and Samuel Stuart of Sterling; S. Buss, probably of Sterling; Jonathan Whitney of Templeton; and Stephen Kilburn of Baldwinsville (township of Templeton). Stuart died before March 3, 1829, placing the pattern's introduction firmly in the 1820s. John D. Pratt must have commenced business in Lunenburg within a few years of the 1820 census and probably remained there until the late 1830s when he removed to Fitchburg, his place of residence at the 1840 census. He and Alonzo Davis built a brick chair factory there about the mid 1850s.[208]

Data in the ledgers of Luke Houghton, cabinetmaker and chairmaker of Barre, a town west of Sterling, offer insight into other aspects of chairmaking in northern Worcester County between 1816 and 1840. Rocking chairs, most with wooden seats, and fancy chairs sold well. Among prevailing finishes straw and light-colored paint were in demand, with brown, "dark color," white, and green less called for. A special item was the "imitation" chair, that is, fancy and Windsor seating painted to resemble wood, generally maple or rosewood. Specific pattern terminology is uncommon in the Houghton accounts, although the craftsman recorded "double back" chairs in 1830 and 1832 priced at about $1, which identifies Windsors with two cross slats. Seven men worked in the shop at different times.[209]

Based upon extant examples, the "double back" Windsor was considerably less common than the "triple back" pattern (fig. 7-63), a term found in Samuel Stuart's 1829 Sterling inventory, which lists a stock of "1 hundred triple back chairs." The two designs are basically similar, with short ball-turned spindles beneath the single or double midslats. The sticks in the double-back chair sometimes are longer than those illustrated. The usual seat plank is balloon-shaped with canted, flat/chamfered, or straight sides. Chairs of modified shovel-shaped seat with serpentine sides and rolled fronts document the pattern's currency into the late 1830s, a circumstance borne out by the presence of slat-type front stretchers in some examples. Patterns with the slat crest are also referred to as "mortised top." The illustrated triple-back chair, its decoration almost pristine, is from the shop of S. Buss whose name stamp is enclosed within a serrated border. The chairmaker in question may be Silas Buss, Jr., of Sterling. Certainly, an origin in northern Worcester County is indicated. Buss's stamp, although atypical in design, duplicates or resembles those of Samuel Stuart and Gilson Brown of Sterling. Buss combined a flat-edge balloon seat with the banded turnings that are found toward the end of the pattern period.[210]

"Turned tops," making up part of the extensive assortment of chair parts enumerated in 1843 in the Sterling estate of Peter A. Willard provided a pattern variant for double- and triple-back seating (fig. 7-64). John B. Pratt of Sterling was the purchaser of this lot at the estate sale. By that date the turned, or roll-top, chair had been current for some time, since at least two examples bear the brand of Gilson Brown, who died in 1834. A marked chair that originated in the Ashburnham shop of Joseph Wetherbee, Jr., is inscribed in pencil: "Sarah McIntire / Fitchburg / April 30th—1845 Mass." Unlike the illustrated chair, which bears the name stencil of John D. Pratt of Lunenburg, the Brown and Wetherbee Windsors feature single, broad midslats of flat, slightly arched, or pointed top profile. Roll-top turnings vary, and there are planks of both balloon and shovel form, the latter with an applied roll at the front edge. The illustrated chair advances the shovel pattern by adding a third piece of wood at the plank back, creating the "raised" seat of the period. Legs alternate between the bamboo style and the illustrated fancy supports, probably the "Turkey legs" itemized in the Willard inventory. The ball-and-multiple-ring pattern of the front stretcher complements the legs, posts, and crest and serves to integrate the upper and lower structures.[211]

A parallel development of the 1830s placed a rounded-end tablet on the post faces (fig. 7-65) where screws hold it fast in the manner of a fancy chair. Likely, the profile imitates a pattern introduced in the Boston market about this time. A brand on the seat bottom identifies the illustrated chair as a product of Jonathan Whitney's Templeton

Fig. 7-63 Slat-back Windsor side chair (one of four) and detail of brand, S. Buss, northern Worcester County, Mass., possibly Sterling, 1825–35. White pine (seat); H. 34⅞″, (seat) 17⅜″, W. (crest) 16½″, (seat) 16¼″, D. (seat) 15¾″; straw-yellow ground with black, bronze, light and dark gold, and transparent gray. (Marblehead Historical Society, Marblehead, Mass.: Photo, Winterthur.)

Fig. 7-64 Roll-top Windsor side chair with scroll seat, John D. Pratt (stencil), Lunenburg, Mass., 1835–40. White pine (seat); H. 34⅝″, (seat) 17¼–17⅞″, W. (crest) 16⅞″, (seat) 16⅜″, D. (seat) 15½″; medium mustard-yellow ground with black, bronze, dull gold, and dark red, and brown spongework. (Private collection: Photo, Winterthur.)

Fig. 7-65 Rounded tablet-top Windsor side chair, Jonathan Whitney (brand "J-WHITNEY"), Templeton, Mass., ca. 1828–35. White pine (seat); H. 33⅝", (seat) 17⅝", W. (crest) 17⅜", (seat) 16⅜", D. (seat) 15⅛"; dark brown and brick-red grained ground with yellow and white. (Henry Ford Museum and Greenfield Village, Dearborn, Mich.)

shop. Whitney bought the chair shop owned by [Charles] Newell Day at the west side of the reservoir pond in 1825. The craftsman styled his chair spindles with a great deal more verve than is common in ball-spindle work. Like the single-slat Windsor (fig. 7-62), four or five sticks were the rule. Levi Stuart of Sterling, another known producer of the rounded-tablet Windsor, was a supplier of Henry Miller's Worcester factory in 1827–28. The Sterling production of Gilson Brown (d. 1834) also encompassed this design; thus, a date of the late 1820s to early 1830s may be established for its introduction. Perhaps this is the crest identified in Luke Houghton's Barre accounts of about 1834 as a "round top" chair. The pattern is one of several rounded-end tablet tops in the furniture market of the 1830s and 1840s. At the next stage craftsmen added lunette-shaped cutouts along the lower edge adjacent to the posts to form a profile that was used extensively in the Boston rocking chair. Sometimes a broad, vase-shaped central banister was substituted for the spindles of the back.[212]

Elbridge Gerry Reed of Sterling made "banister chairs" by 1844. His comprehensive daybook indicates that he also turned and framed other patterns associated with northern Worcester county chairmaking from 1829 through the 1840s: chairs with four- and five-rod backs; turned-top, mortised-top, and double-back chairs. The screwed-top Windsor, also called a screwed-back chair, produced in the shops of Reed and others by 1829, probably was that described by Luke Houghton as a round-top chair (fig. 7-65). Reed's principal occupation was that of supplier. He turned hundreds of thousands of chair parts for distribution to shops throughout northern Worcester County. He also framed prepared stock, producing a variety of seating: side chairs and armchairs; children's and youth's chairs; rocking, nursing, and barber's chairs. Reed's interaction with several dozen chairmakers during his career speaks to the extensive and complex network of relationships that existed in northern Worcester County during the second quarter of the nineteenth century as the region rose to national prominence as a center of the furniture trade.[213]

The nineteenth-century traveler heading north toward Springfield along the Connecticut River would have noted a change from "the arable plains of Connecticut" to the "rugged and pastoral hills of Massachusetts." Like William Chambers, strangers found a region where "an intense spirit of manufacturing industry" prevailed. Life in Springfield near the Connecticut border revolved around the U.S. Armory established there in the late eighteenth century. By the mid 1820s the facility employed 250 or more workmen. Broadening the area's manufacturing interests were flour mills and a paper manufactory, all based on waterpower. A large cotton mill was in production by the 1830s, and river commerce was brisk. The town with its elm-lined main street and handsome buildings displayed all the marks of prosperity, yet there is only minimal evidence of vernacular chair production in the federal period. Perhaps the merchants who "imported" furniture for sale from the surrounding regions engrossed the trade. Erastus Grant, a cabinet-maker of neighboring Westfield who advertised cabinetwork in 1826, suggests as much: "ALSO between three and four hundred CHAIRS from Hitchcock's Factory and elsewhere of elegant patterns and . . . offered very cheap." Six years earlier the 1820 Census of Manufactures had reported that Grant ran a one-man operation with the assistance of five "boys," or apprentices. The opening of the New Haven and Northampton Canal (also called the Farmington Canal), which passed through Westfield, stimulated the local furniture trade after 1835. Statistics for 1837 list an annual township production of 16,000 chairs, but even at midcentury there were just seven cabinet and chair manufactories in all of Hampden County. The northern river counties of Hampshire and Franklin accounted for only another nine establishments apiece.[214]

Viewing the town and countryside around Northampton from the top of Mount Holyoke, Mrs. Basil Hall wrote with enthusiasm, "I am looking down upon one of the most beautiful prospects I ever saw. . . . In the Northampton plains . . . very picturesque trees are scattered. . . . On every side there are hills at a little distance, and the Connecticut winds . . . like a serpent." The flurry of furniture-making activity that characterized Northampton around the turn of the century appears to have died down by the time these words were written in 1827. The town had already attracted a variety of light and heavy industry and even before completion of the canal carried on "a considerable trade with the neighbouring country."[215]

By the end of the War of 1812 many furniture craftsmen at work during the 1790s had either died or left Northampton. In the early 1800s Harris Beckwith sold fan-back and dining chairs acquired from Ansel Goodrich's estate. Dining chairs, probably bow-backs, were still part of Lewis Sage's production in 1807, and the following year Luther Davis advertised both dining and fancy chairs. Sage was located in the Tontine Building, a three-story wooden structure near the town center "occupied mainly by mechanics and traders." The eight-unit building housed five furniture craftsmen at various times between 1795 and 1813, all of whom constructed or sold Windsor chairs. The woodworking tenants stored their lumber in the surrounding lots. The Tontine remained a center of craft activity until it burned in October 1813, destroying the shops of chairmakers Oliver Pomeroy and Asa Jones. Upon moving to the Tontine in 1809 Jones advertised "Bamboo, fancy, and all other kinds of CHAIRS." After the fire he continued to produce similar seating in his new quarters "at the south end of Lickingwater Bridge." Upon Jones's removal in the mid 1810s, the shop was occupied by David Judd, cabinetmaker, and later, in the 1820s, by Judd and his son-in-law Daniel J. Cook.[216]

Asa Jones's bamboo chairs probably had double- and single-bow tops, like the seating advertised at auction in November 1815 at Orange Wright's inn. Chamber (fancy), rocking, and "plain dining" chairs (Windsor) made up the stock advertised by Benjamin H. Henshaw between June 1819 and January 1823. Henshaw also repainted and regilded old fancy chairs. Judd and Cook offered competition, although they produced cabinet-ware as well. Beginning in September 1822 Daniel Pomeroy and Horace Barns, joint operators of a cabinet manufactory, offered "chairs of all kinds." Elsewhere in the vicinity

Justin Parsons of Westhampton left unfinished dining chairs at his death in 1807. Elias White of Goshen appears to have been gearing up for large-scale production in March 1812 when he advertised for "one thousand Chair Seats 17½ inches wide, and 2 inches thick, for which good pay will be made, and a generous price given." By the late 1810s or early 1820s he had removed temporarily to Bennington, Vermont, where he advertised in 1825 as a manufacturer of all kinds of chairs. He evidently returned to Massachusetts, since his estate records are on file there.[217]

Although Deerfield and Greenfield were of almost equal size in the early nineteenth century, the latter enjoyed the advantage of being the Franklin County seat. By the 1830s Greenfield, located at the convergence of the Connecticut, Green, and Deerfield rivers, had a population of slightly more than 1,800 and contained about 100 dwellings, four churches, public buildings, and a number of stores and "mechanic shops." This is the rising community where Daniel Clay had set up shop as a cabinetmaker in the early 1790s and added Windsor-chair making to his line of business by November 1797. The new venture must have been well received, since by 1800 Clay advertised for "a JOURNEY MAN Windsor Chair Maker." Fashionable Windsor and fancy chairs of "all kinds" were available "on the shortest notice" through the succeeding decade. By 1808 Clay had branched into the retail sale of looking glasses, picture frames, hardware, and ceramic goods. His 1810 notice for "Fancy, Dining and Cottage Chairs, with good materials and hands to make more on short notice" speaks of his success in vernacular chairmaking as well as merchandising. Allen Holcomb offered brief competition when he arrived in town about August 1808 to make furniture and "all kinds of Dining, Common & Fancy Chairs." Within less than a year, however, he announced the sale of "a large number of new CHAIRS" at auction before removing to Troy, New York. Holcomb was engaged in varied activity during his last months in Greenfield: furniture repairs, chairmaking and cabinetry, and the sale of wood-finishing materials.[218]

Within a few years new competition arose as local shopkeepers offered furniture acquired outside the community. On January 25, 1814, Calvin Munn announced the receipt of "a lot of elegant CHAIRS, for sale remarkably low for cash in hand." A year later Nathan Pierce advertised warranted chairs for cash, produce, or approved credit. He expanded his retail territory by transporting "one hundred good dining Chairs" eight miles to Colrain for an auction "at the house of Charles Thompson, Inn Holder." In 1824 Daniel Clay rented part of his shop to Daniel Munger who took over the painted seating business, offering "Chairs of every description, such as Fancy, Grecian, Dining & Rocking." Munger's stay lasted about two years, at which time Clay took Richard E. Field as a partner and recommenced the chairmaking business. When Clay's shop burned to the ground late in 1826, the partners moved to Field's old chaise-making shop where they continued together until 1828. The following year both left Greenfield for Algiers, Vermont, where they started a short-lived pail factory.[219]

Other furniture craftsmen filled the gap within a few years. Francis A. Birge established a sizable chairmaking operation in Greenfield by 1835, and in 1839 Joel Lyons and Isaac Miles joined forces to produce cabinetware and chairs. Birge's trade was brisk in 1835 when he supplied Philemon Robbins of Hartford with 846 chairs. Wooden-bottom seating made up the bulk of his Hartford sales, supplemented by a few rocking, fancy, and Grecian chairs. No doubt Birge shipped his product via the Connecticut River or the New Haven and Northampton Canal, which passed through Farmington west of Hartford. Birge's fortunes rose and fell, and in 1837 he was declared an insolvent debtor. Before this William Birge (probably Edward W.), who had been a member of the firm, went to Troy, New York, where directories show that he and Calvin Stebbins ran a chair store in 1837 and 1838.[220]

Edward probably returned to Greenfield in 1839, where at the end of the year Francis Birge's trustees transferred a portion of the real estate to him, probably after he had satisfied part of the debt. The Birges recommenced the manufacture of chairs, and after the operation was running smoothly, Edward returned to Troy. In February 1842 through his Greenfield "agent," Francis Birge, Edward sold part of the land purchased

in 1839. He completed the divestiture the following July with the sale to Francis of two pieces of property: a three-quarter-acre lot bordering the "highway," which contained a building, and a tract running northerly on School Street "with the buildings thereon situate being the shop now occupied by me the sd Edward W. Birge as a Chair Factory." Francis was again proprietor of the chairworks, although not for long. On June 12, 1845, the firm of Miles and Lyons "bought Birge out of business, that is they [took] all of his stock & 3 benches," according to a journal entry made by Edward Jenner Carpenter, apprentice to the purchasers. Carpenter continued, "I guess Birge thought he had more irons in the fire than he could tend upon." Francis Birge may have left for Troy soon after the sale. The following February he and Edward contracted to lease a lot in that city on the east side of River Street near Adams upon which the owner was to erect a brick building. The Birges expanded their operation in spring 1848. Four years later Francis Birge, acting alone, added more leased space to his manufacturing site. Again, he may have overextended himself because within a year and a half he transferred the unexpired portion of the lease to a group of businessmen.[221]

Meanwhile, shortly after acquiring Francis Birge's stock and equipment, Lyons began "tearing out to make room for more hands." As Carpenter concluded, "It makes a pretty good shop full, 4 jours [journeymen], 2 apprentices & 2 bosses, & they have advertised for another apprentice." During the mid 1840s a Mr. Wilson of nearby Colrain came periodically to the shop "to paint" chairs; he probably ornamented them, as well. From time to time young Carpenter recorded shop sales. Once he mentioned a load of furniture sent to North Adams, including a set of chairs and a rocker. Another time he noted that "Russel Warren the tinpeddler was here today & bought a Butternut table & a couple of rocking chairs."[222]

A stepped tablet-top side chair, its crest more closely approximating the angular profile of the Boston design (fig. 7-36) than the ogee curves of Stephen Kilburn's chair (fig. 7-58), is stamped "J GRISWOLD" on the plank bottom. The chair is a product of the Joseph Griswold shop at Buckland, a town located west of Greenfield. Four of the craftsman's account books survive. They cover the period between 1798 and Griswold's death in 1844 and detail his full career as a furniture maker, housewright, storekeeper, and general handyman. Griswold's production of Windsor seating was limited and concentrated between 1801 and 1809. He recorded only two sets of fan-back chairs, priced at 7s. apiece, and three groups of dining, or bow-back, chairs at a shilling less. His six sets of "Windsors," which sold for 9s. the chair, were probably bamboo, or square-back, seating; the price increase reflects the chair's fashionable status. Griswold advanced the price by 1s.6d. when he added rockers. The only seats that met the Windsor side chair in retail price were the rush-bottom rocking and great chairs constructed occasionally from 1801 to 1834. Griswold's primary product was the side chair frame, usually sold without the rush seat at between 3s. and 4s. The addition of a "bottom" increased the price by about 1s.6d., or 25¢. Most chairs are unidentified further, except on one occasion when Griswold specified "3 backt" seating; he also made periodic use of the term "common chair."[223]

The 1832 survey of manufactures reported two chairmakers working east of the Connecticut River at Shutesbury and Wendell. Nathan Macomber of Shutesbury established his shop in 1825 and by 1832 was constructing 500 seating pieces annually on a half-time basis. No doubt, he farmed the rest of the time. For Emeriah Sawyer at Wendell chairmaking was a full-time occupation, and he employed a journeyman as well. His annual production of 2,000 chairs realized $1,200, or 60¢ the chair. Viewed in terms of price and quantity, both men appear to have manufactured cheap plank-seat chairs, a conclusion that appears to be confirmed by the presence of paint among the shop materials.[224]

Western Massachusetts, comprising Berkshire County, is rough, hilly, and in some parts mountainous. In the early nineteenth century the land was generally unproductive, except in the valley of the Housatonic, lending itself to little more than cattle grazing. The natural resources—iron, marble, and lime—also figured as articles of

commerce, and light manufacturing became an important pursuit. John Warner Barber noted of the county that "its wood and water power are sufficient to enable it to fit them for useful purposes." Most towns of any size had cotton and woolen mills. The population grew slowly, rising from 33,835 in 1800 to 39,101 in 1837, although many small settlements dotted the landscape. A Philadelphian traveling through western Massachusetts in 1825 said of the villages, "You rarely pass thro one too diminuitive to have a church and a steeple; in them are generally combined neatness, cheerfulness, & Beauty."[225]

Scattered records indicate that the area supported a furniture trade of moderate size and scope. This thriving industry took two forms—the production of completed articles of furniture, and the manufacture of furniture parts. At Lee, south of Pittsfield, Abner Taylor, cabinetmaker and woodworker, made a few chair sets during the 1810s, all probably of the "kitchen" variety, as specified from time to time. Taylor's memorandum book, dating to the early 1820s, lists the names of several men who boarded with him, among them a Mr. Bedortha, possibly Calvin the chairmaker of West Springfield. The men appear to have been engaged in joinery "at the Powder Mill." In September 1824 a tremendous explosion leveled the works, killing four workmen and damaging many neighborhood buildings. Town sentiment induced the owners to sell out, and a papermill rose on the site, one of twelve reported in the town in 1837. One furniture entry in Taylor's accounts dated November 2, 1822, credits a Timothy Thatcher with "1 Sett Windsor Chares" at $9. As there is no inventory with Thatcher's estate papers of 1833–34, he cannot be identified positively as a chairmaker; however, the will mentions his part ownership of a "sawmill and yard."[226]

Amos Barns and James Gardner combined skills to open a cabinet warehouse at Pittsfield about 1827, where they offered "ELEGANT & PLAIN FURNITURE . . . FANCY AND PLAIN CHAIRS" to the "fair daughters of Berkshire." Their solicitation for materials to construct a brick building in exchange for cabinetwork and chairwork reveals their plans and prospects. The partners were still going strong five years later when they manufactured furniture worth $4,500 and employed eight workmen. John Ayres, a contemporary, actively pursued fancy- and Windsor-chair making "at his shop, a few rods south of the Female Academy." He sought one or two journeymen and an apprentice. In the northern part of the county Ira Sheldon operated a cabinet and chair warehouse at North Adams; his probate inventory of 1830 contains a long list of woodworking tools. Daniel Churchill may have already opened his chair factory at Stockbridge. His annual production in 1832 numbered 14,000 painted and cane-seat chairs valued at $17,500. He employed twenty-five men and twenty-five women or girls, the latter probably to weave cane and rush bottoms and possibly to assist with ornamentation. Gold leaf and gold bronze were among the materials consumed. Churchill reported his distribution area as New York state.[227]

Thomas Bassett had commenced the manufacture of "all kinds" of fancy and Windsor chairs at Lee when listed in the *American Advertising Directory* of 1831. He produced sets of stock to build 45,000 chairs annually. Likely his was one of the two local turning and chair factories reported the following year in a national manufacturing survey. Since the collective annual production of the two establishments was reported as 90,000 sets of chair stuff, the factories were of about equal size. The total labor force numbered forty-five men, four boys, and eight women or girls, the latter probably employed to weave seats for the 18,300 cane chairs constructed each year. Again, New York state was the principal distribution area. At his death in 1847 Bassett's home was comfortably furnished with cane, flag, and rocking chairs. Further production of parts is reported in 1832 at Becket and Otis, towns near the county's eastern border. An anonymous craftsman in Becket manufactured $800 worth of "chair stuff" annually. At Otis two turning factories employed four men who produced $4,000 worth of chair stuff sent to New York state.[228]

It is important to note the shift in distribution that took place in Berkshire County in the 1820s and 1830s. New York state now was its leading consumer of chairs and chair

Fig. 7-66 *Mr. Goodrich of Hancock, Massachusetts*, attributed to Ammi Phillips, Massachusetts, ca. 1820. Oil on canvas; H. 34¾", w. 28¼". (Art Museum, Princeton University, Princeton, N.J., gift of Edward Duff Balken.)

parts as opposed to Connecticut, which had figured prominently in distribution during the 1810s, as detailed in Silas Cheney's Litchfield accounts. West and Hatch of Lee had carted a variety of chair stuff to Cheney, including Windsor (fancy bamboo), plain Windsor, bamboo ball-back, kitchen, and sprung-back patterns. Later, Daniel Foot supplied more of the same material, along with "fancy benders" for backs. West and Hatch also sold chair parts in Hartford. Ammi Phillips's portrait of Mr. Goodrich of Hancock, Massachusetts (fig. 7-66), painted about 1815, pictures a plain slat-back, plank-seat chair, a pattern that became popular following the War of 1812. The bold decoration lends itself to the gold leaf and bronze techniques employed by contemporary chairmakers like Daniel Churchill. Berkshire maintained its lead as a furniture manufacturer among the state's western counties, and by 1855 housed twenty-one cabinetmaking and chairmaking establishments within its borders, as compared to nine each for Franklin and Hampshire counties and seven for Hampden.[229]

Northern New England

The northern New England states concentrated on three areas of development from 1800 through midcentury—New Hampshire on manufacturing, Vermont on agriculture, and Maine on commerce. During this period New Hampshire's population rose from 184,000 to 318,000. Vermont accelerated the pace with an increase from 154,500 to 314,000. But Maine's population grew the most, rising from 152,000 inhabitants in 1800, when Maine was still a district of Massachusetts, to 583,000 in 1850 after thirty years of statehood.

With only eighteen miles of seacoast and a single port of entry at Portsmouth, New Hampshire was not a commercial giant. Farming was the leading occupation, although the seeds of industrial growth were planted with the erection of the state's first textile mill at New Ipswich in 1803–4. By 1820 the number of mills had risen to fifty-one. Waterpower, canals, and railroads facilitated industrial expansion. With the further addition of money and expertise from Lowell, Massachusetts, in the late 1830s, the village of Manchester at the falls of the Merrimack became a city of 10,000 inhabitants in less than a decade.

Vermont was an agricultural state. Cultivating the land and raising livestock were the main occupations. There was no access to the sea, and the textile manufactory achieved only limited success, even by midcentury. Inland commerce was facilitated by the presence of the Connecticut River on the east and Lake Champlain on the west; both bodies also served to conduct vast quantities of lumber out of the state.

Maine achieved separation from Massachusetts and national statehood in 1820. In a state with 278 miles of seacoast, commerce ranked first. Maine led New England in shipbuilding and ranked second only to Massachusetts in the fisheries. The lumber trade began there as early as 1621, but agriculture was slow to gain a foothold. Before 1820 only nine cotton and woolen manufactories operated in the state, but with the achievement of statehood basic industry began to flourish. The momentum of expansion led to an extremely rapid population growth between 1830 and 1850.[230]

NEW HAMPSHIRE

Portsmouth

Despite several disastrous fires in the early nineteenth century, Portsmouth with its "secure and commodious" harbor was able to hold its own as a trading center of second rank. Through the port, New Hampshire maintained its maritime contacts with other American coastal centers. About 1806 when the population stood at around 5,500, John Melish noted that "a great part of the surplus produce of this state is carried to Boston." Contact with that city and New York also enabled local furniture makers to monitor

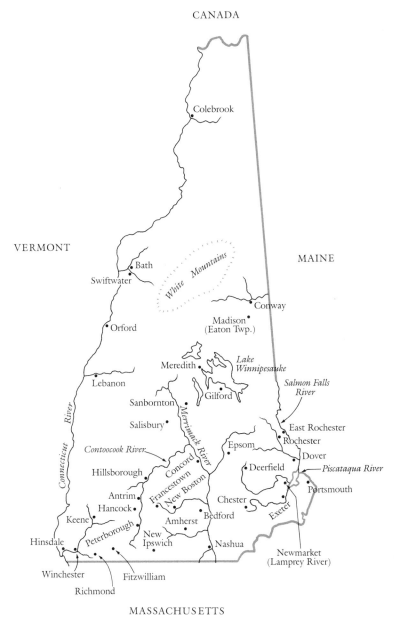

CANADA

Colebrook

VERMONT

MAINE

Bath

Swiftwater

White Mountains

Conway

Orford

Madison
(Eaton Twp.)

Lake
Winnipesauke

Meredith

Salmon Falls
River

Lebanon

Sanbornton

Gilford

Merrimack River

Salisbury

East Rochester

Rochester

Contoocook River

Epsom

Dover

Connecticut River

Hillsborough

Concord

Deerfield

Piscataqua River

Francestown

New Boston

Portsmouth

Antrim

Chester

Hancock

Bedford

Exeter

Keene

Amherst

Hinsdale

Peterborough

New
Ipswich

Nashua

Newmarket
(Lamprey River)

Winchester

Fitzwilliam

Richmond

MASSACHUSETTS

1 inch = 32.7 miles

developments in the domestic market and keep abreast of changes in the fashion centers of western Europe.[231]

Portsmouth chairmakers and cabinetmakers alike engaged in the sale of painted seating. Henry Beck opened shop in Congress Street in 1805 and offered fancy, bamboo, and Windsor chairs. An advertisement of three years later is more explicit: fancy chairs were gilt, bamboo seating was either straight-backed or "swelled" (bent), and the Windsors had fan backs. Supplementing this list were settees, armchairs, and kitchen seating. By 1806 Beck had joined the Associated Mechanics and Manufacturers of New Hampshire. Cabinetmaker and entrepreneur Langley Boardman, a fellow member, leased to Beck the two shop sites Beck occupied at different times between 1805 and 1809. Meanwhile, Jonathan Judkins and William Senter had arrived in Portsmouth where they maintained a cabinetmaking partnership until 1826, just before Senter's death. They sold

a "Small Chair" in 1809 to Captain Reuben Randall. The shop was destroyed in a fire of December 1813 but immediately rebuilt. Likely burned out at the same time was the adjacent turner's shop of John T. Senter, probably a brother to William. When John left Portsmouth to join the army in 1815, Henry Beck moved into the Judkins and Senter building and remained there until his retirement in 1828. The location may have been advantageous, affording Beck an opportunity to retail some production to and through his cabinetmaking landlords. In the years following the fire George W. Walker probably provided competition. A cabinetmaker, Walker also constructed chairs and supplied turned work for the furniture and ship-building trades on his water-powered lathe. Samuel M. Dockum commenced the cabinetmaking and chairmaking business about this time as well.[232]

When Dockum concentrated on cabinetware in the 1820s, he turned to outside sources for seating furniture. By the mid 1830s his stock of cabinetware and seating furniture filled the twelve rooms of his merchandising facility. Chairs "of various kinds" in the "newest fashions" arrived by the dozens from Boston and New York, often unpainted. By decorating the merchandise in Portsmouth, dealers could assure customers of fresh, undamaged surfaces. John Grant, Jr., met the competition by offering thirty dozen chairs for sale "as low as can be bought in town of the same quality." He also supplemented new chair sales with repair and refinishing work. Jacob Wendell, a steady customer, purchased chairs and "crickets" (footstools) between 1817 and 1823.[233]

Edmund M. Brown, a former partner of Samuel Dockum, flourished in an independent business by 1834. His large stock included "chairs of Grecian patterns, cane and flag Seats; Fancy d[itt]o; Imitation Fancy, Dark, and dark with light bottoms, painted to order; Common chairs in abundance, of the first quality; Children's chairs of various kinds, [and] Nursery d[itt]o a very convenient article in sickness." The following year he challenged the competition in "locally decorated" and low-priced chairs by stating that he had "Chairs from one of the best Paint Shops in Boston, which he will warrant better Furniture than those botched up by some others." Brown had formed a partnership with Alfred T. Joy by 1837, and together they advertised a selection of seating including "upwards of forty different kinds or finish[es of] CHAIRS."[234]

Currently, Windsor furniture documented to or associated with Portsmouth dates after 1810 and represents a two-decade span. Unusual among Windsor seating anywhere is a group of chairs with pierced and veneered, slat-type crests (fig. 7-67), which exhibits strong characteristics of Boston work but is ascribed by circumstantial evidence to Portsmouth. The illustrated example represents a set of six chairs that furnished a Portsmouth nursing home during recent decades. Legs, seat, bent back posts, and flared-base spindles follow Boston patterns (figs. 7-28, 7-33). Pierced slats are found in that city and elsewhere in Massachusetts (figs. 7-35, 7-61), although they also appear in New Hampshire work (figs. 7-84, 7-87). Long elliptical, light-colored, figured veneers within mahogany panels are features in the cabinetwork of both eastern Massachusetts and Portsmouth. The light wood frequently is birch; occasionally it is maple, as here. An armchair of variant pattern has a similar understructure and a bent back; the post tips are accented by small raised nubs, the slat is similarly pierced, and the figured birch veneer forms a long rectangle. Arms and short posts follow closely a Boston pattern of about 1800 (fig. 6-215), with the rests scrolling forward and the posts forming a strong S curve. The seat is a larger version of the shield pattern in the side chair. The presence of eighteenth-century-style arms on a nineteenth-century pattern dating well past the transitional period suggests a provincial orientation on the part of the chairmaker that one would not expect in Boston work, yet the chair is decidedly sophisticated, befitting a city of second rank.[235]

A delicate pattern (fig. 7-68), possibly evolving from a Boston design such as that illustrated in figure 7-32, places a narrow serpentine crest on top of a bent back. The illustrated chairs are part of a set of seven. Spindles and posts are incised with a single groove below the midpoint, which in the side chair marks the base of the shaved post faces. The flat surface of the armchair posts begins only above the rests, whose unusual

Fig. 7-67 Pierced slat-back Windsor side chair (one of six), Portsmouth, N.H., 1812–20. Mahogany and maple veneers with other woods; H. 35¼", (seat) 18¼", W. (crest) 18¾", (seat) 18¼", D. (seat) 15¾"; paint not original. (Strawbery Banke, Inc., Portsmouth, N.H.: Photo, Winterthur.)

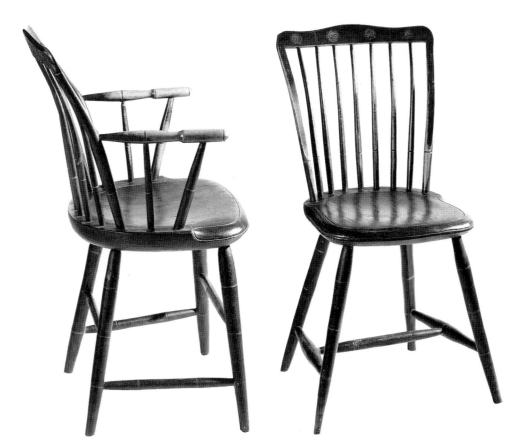

Fig. 7-68 Wavy tablet-top Windsor side chair and armchair (two of seven), Portsmouth, N.H., area, 1818–25. White pine (seats, microanalysis); (*left to right*) H. 34¾", 33⅝", (seat) 18⅜", 18⅛", W. (crest) 19", 17½", (arms) 19¾", (seat) 18⅜", 15⅝", D. (seat) 17¼", 15¾". (Strawbery Banke, Inc., Portsmouth, N.H.: Photo, Winterthur.)

turned form is a northeastern regional pattern that may have originated in Boston (fig. 7-35). The design is found again in the Canadian maritime provinces (figs. 8-39, 8-40). The seats still retain a good squared-shield form, and the tapered legs are noticeably stocky at the top. The side chairs are unusual in retaining H-plan stretchers. A written inscription on the bottom of one pine plank tells of the chairs' purchase at an auction held at the Preble Young homestead in York Corner, Maine, a site just across the Piscataqua from Portsmouth.

There is a decided relationship between the serpentine top pieces of figure 7-68 and the crest that caps the four side chairs in a set formerly owned in a Portsmouth family (fig. **7-69**). The pattern is altered by the addition of a center extension which forms a small crown with scrolled ends. There is little doubt that the chairmaker was inspired by the scrolled backboards of contemporary washstands (fig. 7-75), dressing tables, and the like. Other differences between the illustrated chair and the previous seating group include the use of almost straight backs, token shaving on the posts, and a more uniform leg diameter from top to bottom. A second set of Windsors and several individual chairs, all with similar top pieces mounted between the posts in the alternative slat style, introduce arrow (flat) spindles to the backs. The five side chairs and rocking armchair that make up this set of slat-backs employ a narrow ball fret as a front stretcher. The flat-shaved posts and spindles are broad and spatulate with cylindrical "stems" at the base. Another set of six side chairs with similar slat-style crests but plain front stretchers descended in the Demeritt family of Madbury, near Portsmouth. The chairs retain their original salmon pink surface color and delicate, handpainted foliate decoration.[236]

According to tradition, a group of twelve Windsor armchairs in two distinct patterns was purchased by the directors of the First National Bank of Portsmouth at its founding in 1824. The bank owned the Windsors until recent years. All the chairs are similar in size, and the seats and arm posts share the same profiles, but other features vary (fig. 7-70). There are nine examples of one design and three of the other. The top piece of the chair on the left is nothing more than the stepped tablet first introduced in Massachusetts in the 1810s. Here it has been adapted for framing between the bent back posts

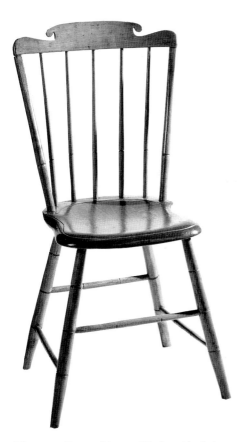

Fig. 7-69 Fancy tablet-top Windsor side chair (one of four), Portsmouth, N.H., area, 1818–30. Basswood (seat, microanalysis); H. 35⅞", (seat) 17¾", W. (crest) 18¾", (seat) 17¾", D. (seat) 15⅞". (Strawbery Banke, Inc., Portsmouth, N.H.: Photo, Winterthur.)

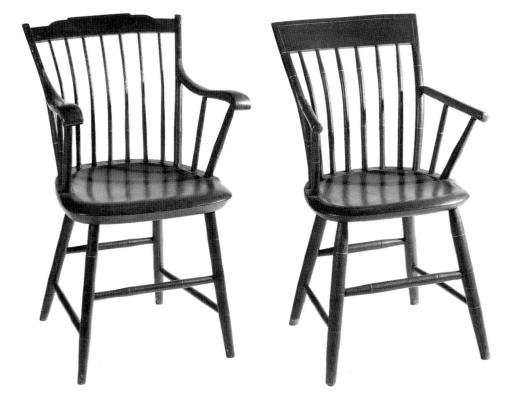

Fig. 7-70 Shaped slat-back (one of nine) and tablet-top (one of three) Windsor armchairs, Portsmouth, N.H., ca. 1824. White pine (seats, microanalysis); *(left to right)* H. 34⅜″, 36¼″, (seat) 18⅛″, 18¾″, W. (crest) 20½″, 19¾″, (arms) 22″, (seat) 19⅜″, 19″, D. (seat) 18″, 17¼″. (Strawbery Banke, Inc., Portsmouth, N.H.: Photo, Winterthur.)

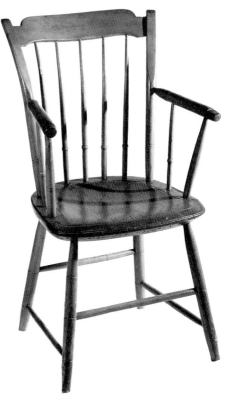

Fig. 7-71 Shaped slat-back Windsor armchair (one of a pair) and detail of brand, John G. Brown, Portsmouth, N.H., ca. 1822–30. White pine (seat, microanalysis); H. 34½″, (seat) 16″, W. (crest) 19″, (arms) 20¼″, (seat) 18″, D. (seat) 16½″; front stretcher replaced. (Strawbery Banke, Inc., Portsmouth, N.H.: Photo, Winterthur.)

as a slat. The relatively light, cylindrical character of the bamboowork again suggests a Massachusetts prototype. A similar broad-scroll arm was in use in Boston by 1820. Crest pieces in the smaller group, represented by the chair at the right, are framed directly on the posts and fit closely at the ends without an overhang, like chairs documented to neighboring Maine (fig. 7-107). Except for the arm supports, all turned work is substantially heavier than in the companion design. The leg profile is similar to that of figure 7-68; the cylindrical arms approximate those of figure 7-71. The bent back posts are flattened in token fashion at the front adjacent to the crest, better integrating the round and flat surfaces. Seats in both patterns are made of northeastern white pine.

Another Windsor crest associated with Portsmouth (fig. **7-71**) is found in a small group of armchairs whose size and plank shape approximate those of the First National Bank chairs. All are branded "JO G BROWN" in two sizes of uppercase letters within a rectangle. The leg tops exhibit a sharp, slim taper in the manner of Boston work (fig. 7-34); the back posts are shaved above the arms as in figure 7-68. Small buttons replace a groove in the lower sticks and posts, a feature found, in part, in another New Hampshire chair (fig. 7-78). The crest is a modification of one used by Joel Pratt, Jr., of Sterling, Massachusetts (fig. 7-60). Here the upper arch is slightly flatter and the lower edge forms an inverted serpentine profile comparable to that in a Boston chair (fig. 7-36). If not for the presence of a supplementary stencil on one chair bottom, it would be difficult to assign this pattern variation to New Hampshire, let alone to Portsmouth where several John Browns are listed in census records between 1830 and 1850. The stencil reads: "G. N. PORTER. / FURNITURE / PAINTER. / N° 4 LADD. ST / PORTSMOUTH. N.H." Although Porter's name first appears in Portsmouth city directories in 1856 and 1860 as a chair store proprietor and then a painter, the chairs are not of that date. Chances are a local resident took them to Porter for new paint and ornament about thirty years after their purchase. A restorer's identifying mark, while rare on Windsor chairs, is not unknown (figs. 6-72, 7-34). Two of John Brown's chairs form a pair in the collection of Strawbery Banke. The third, which is privately owned, is embellished with bands of ring turnings on the arms and a diamond-centered stretcher between the front legs (fig. 7-88).

The Southeastern and Southern Regions

Furniture making in Portsmouth had a direct influence on activity in the surrounding towns. At Exeter in 1809 Samuel Hatch sold the Widow Cram a set of eight black chairs, two with arms, and another set painted yellow. Although they are not identified by type, both groups could have been Windsors. Eight years later Hatch advertised dining and common (kitchen) chairs. The craftsman's own set of eight green chairs in his south front room was further identified as "6 Dining and two Arm Chairs." Hatch's annual furniture sales amounted to $600 in 1820, a modest figure when compared with the $2,700 reported for the shop of competitor James Bailey. For several decades beginning in 1817 the production of True Currier in Deerfield centered on rush-bottom seating. Some chair frames were bottomed when sold, others were not; the selection included kitchen, rocking, children's, and wagon chairs. Seats with arms were usually described as great or large. Barter was still an integral part of the rural economy. When Currier needed two thousand bricks in April 1827 he struck a bargain with one John Fisk to acquire them for "six kitchen chair frames painted and five dollars in money." Currier's accounts contain only two references to bamboo chairs, one in 1816 and another two years later, totaling fifteen chairs. A misspelled word in one account, possibly reading "bartard [bartered]," may identify the seating as the work of another craftsman acquired by exchange.[237]

At Lamprey River, or Newmarket, located west of Portsmouth on the opposite shore of Great Bay, Thomas Brown, cabinetmaker, operated a commission warehouse from the 1830s until around 1850. He advertised in both Exeter and Portsmouth newspapers. His label dated 1831 announces that he had "established a CHAIR FACTORY in connection with his Cabinet Shop." Four years later he continued to stock "about 400 Superior CHAIRS *of various patterns and prices.*" A tall rocking chair branded "T.Brown." within a small, serrated rectangle (fig. **7-72**) is framed with a hollow-cornered, tablet-style crest, which was available in the Boston market by the early 1820s, although *documented* metropolitan examples are unknown. The chair attributed to Boston (fig. 7-38) employs the hollow-cornered tablet as the top piece of a back extension. Brown's single-back chair is in the style of two other tall chairs with Boston associations. One in a private collection came from an "old" Boston house; another is in the Jeremiah Lee Mansion at Marblehead. The conical leg tops and short scroll arms of Brown's chair are also typical of Boston work. The craftsman's employment of a Boston workman reinforces the metropolitan connection. Hollow-cornered tablet chairs, from tall rockers to side chairs, were a popular product in neighboring Hillsborough County, where members of the Wilder family, who had many Boston contacts, operated a water-powered chair manufactory. Both the Wilders and Brown also made a standard-size Windsor with a rounded loaf-shaped tablet similar to one produced in Worcester County, Massachusetts (fig. 7-65), and probably Boston as well.[238]

Dover, the Strafford County seat, is located on the Cocheco above its fork with the Salmon Falls River where the two waterways join to form one leg of the Piscataqua. Although Dover was first settled in the early seventeenth century, its population still numbered only about 2,000 in 1800 when the inhabitants engaged principally in farming and shipbuilding. After erection of the first cotton mill in 1821, however, life changed considerably in the small community located in a country laced with winding streams. At midcentury the Cocheco Manufacturing Company alone employed 500 men and 1,000 women. In addition, local waterpower supplied smaller textile factories, a paper mill, a cotton machinery works, a sawmill, a gristmill, and several shoe manufactories. In short, the local population was sufficient to support several furniture establishments.[239]

A square-back chair with double bows, pencil-slim bamboo legs, and cylindrical swells at the ends of overhanging turned arms may be an area product, since it has a local history. Another pattern, dating a decade or more later, seems associated with the same general region (fig. **7-73**). The reverse-scallop crest probably is a variation of the stepped-tablet top. Most examples frame the top piece within the posts, suggesting an early 1820s

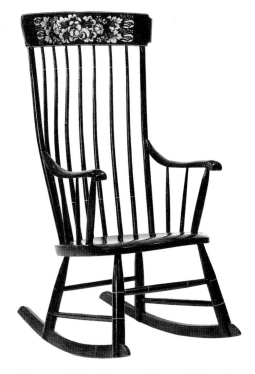

Fig. 7-72 Tall tablet-top rocking armchair and detail of brand, Thomas Brown, Lamprey River (Newmarket), N.H., 1831–35. H. 42⅝″, W. (arms) 21¼″; paint and decoration not original. (Paul Koda collection: Photo, Stowe-Day Foundation, Hartford, Conn.)

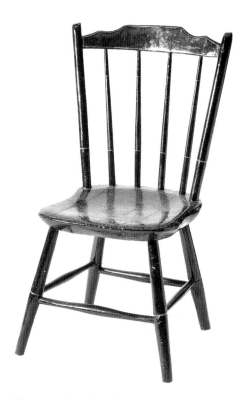

Fig. 7-73 Shaped slat-back child's side chair, southeastern New Hampshire, 1818–25. H. 26¼", (seat) 12", W. (crest) 16⅜", (seat) 12¾", D. (seat) 13"; paint and decoration not original. (Historical Society of Early American Decoration, Inc., Albany, N.Y.: Photo, Winterthur.)

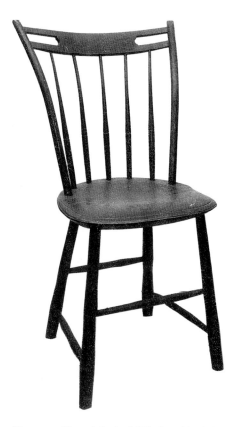

Fig. 7-74 Pierced slat-back Windsor side chair, J. B. Varney (owner brand), southeastern New Hampshire, 1820–25. H. 34³⁄₁₆", (seat) 17½", W. (crest) 18½", (seat) 15½", D. (seat) 15½". (Private collection: Photo, Winterthur.)

date when such construction became common at the introduction of the broad slat back (fig. 7-62). Most posts are cylindrical without a shaved surface; the tips of many are sawed off at a slight cant not unlike that in Samuel Gragg's ogee-back chair (fig. 7-33), which also may have influenced some Portsmouth work (fig. 7-70, left). A notable exception is a set of six side chairs with shaved-face posts and arrow spindles of spatulate form. Most reverse-scallop examples have squared-shield seats, usually shaved thin at the edges and sometimes grooved on the top surface. Aside from a selection of side chairs, the group contains an armchair, rocking chair, and child's high and low chair. The tall rocker with its crest framed on the post tops has an exaggerated back bend somewhat akin to a Massachusetts Windsor (fig. 7-57). Background information is available for several examples. One owner purchased a set of three six-spindle chairs at auction in Chester, Rockingham County, in 1935. A chair in another set of four bears the name "S. F. SEAVEY" on the seat bottom. The surname is common in Maine and New Hampshire, but only one candidate with the proper first initials emerges from public records. The New Hampshire census for 1840 and 1850 lists a Samuel F. Seavey as a resident of Rochester, a town within a few miles of Dover. Research in land records has produced a deed of 1839 in which Jonathan T. Seavey conveyed to Samuel F. the right and title to "our homestead farm" located on the banks of the Cocheco River. Unless Samuel F. Seavey pursued the chairmaking trade earlier in life, his relationship to the marked chair at this late date was that of an owner. The small size and particular style of the serif letters in the brand seem to confirm this.[240]

A parallel case of regional identification through an apparent owner's brand is encountered in another rare crest pattern (fig. **7-74**). Deriving generally from Boston design (figs. 7-34, 7-35), the pierced slat as interpreted here has a direct local prototype in an astragal-pierced front stretcher in seating constructed for the New Hampshire State House in 1819 by Low and Damon of Concord (fig. 7-87). The astragal profile is seen at the inner end of each slot. The delicate cylindrical posts with their back bends and slightly canted tips spring from Boston (fig. 7-33) or local interpretations (fig. 7-70, left). Grooved spindles, which thicken noticeably in the lower back, seem on the verge of becoming ball-turned sticks. Stamped into the seat in thin serif letters is the name "J B VARNEY," a surname common in northern New England, particularly in New Hampshire and Maine. Of the thirty-two candidates with the given initial *J* in the New Hampshire censuses for 1810 and 1830 (the 1820 records seem incomplete), all but one was a resident of Strafford County. Of this group a James B. resided in Dover (1810–30); a Joseph B. was in Middleton Corners (1830) or Newington, Rockingham County (1840); and a John B. was a resident of Rochester (1850). In plotting locations on a map, all fall along the southern New Hampshire–Maine border.[241]

Evidence of a significant level of furniture production in Strafford County is found only in the mid 1820s. Andrew L. Haskell opened a furniture warehouse in Dover where he sold formal furniture and painted seating described as "New-York & Boston Fancy & common Chairs." The inference is that Haskell sold seating imported from the metropolitan centers rather than his own chairs manufactured after metropolitan patterns. Stephen Toppan, who was open for business by 1826, illustrated his 1830 directory advertisement with furniture that, presumably, represented merchandise available at his "manufactory" in Central Street (fig. **7-75**). The ball-spindle, plank-seat chair at the left almost duplicates a pattern documented to the chair mill of Stephen Shorey, located in neighboring East Rochester on the Maine border (fig. **7-76**). The difference lies in the seat, which is balloon-shaped in the advertisement and squared in Shorey's chair. Toppan continued to use the same pictorial advertisement until at least 1848, giving currency to the ball-spindle pattern at midcentury. Indeed, Shorey himself seems to have acquired his chair mill only about 1845. A native of Lebanon, Maine, a town adjacent to Rochester on the Salmon Falls River, he is said to have been an early settler of East Rochester where he owned a sawmill and gristmill in the 1820s. A local history states that Shorey's production reached 3,000 to 4,000 chairs annually. In addition, he owned a general store. Later the entrepreneur turned to merchandising lumber.[242]

Fig. 7-75 Advertisement of Stephen Toppan. From the *Dover Directory* (Dover, N.H.: Samuel C. Stevens, 1830), p. 94. (Photo, New Hampshire Historical Society, Concord.)

Fig. 7-76 Slat-back Windsor side chair (one of a pair), Stephen Shorey (stencil), Rochester, N.H., 1845–50. White pine (seat) with birch and other woods; H. 33½", W. 17⅞", D. 17"; black and dark red grained ground with yellow and gilt. (New Hampshire Historical Society, Concord.)

The serpentine-sided plank featured in Shorey's side chair is a variation of the shovel seat documented to Worcester County, Massachusetts, by 1834. The ball-spindle, slat-back pattern was first current in Massachusetts in the 1820s (figs. 7-38, 7-62). A set of six side chairs, the back and support structures identical to the Shorey Windsor but the seat less vigorous, is stamped "G. P. FOLSOM, / DOVER, N. H. / WARRANTED." George Perry Folsom (b. 1812) worked for a while in Massachusetts. His name first occurs in the New Hampshire census for 1850, indicating that he too was a chair manufacturer at a relatively late date. By 1834 Folsom's brother Abraham, (b. 1805) probably occupied the water-powered chair mill at East Rochester later owned by Stephen Shorey. Abraham Folsom advertised a furniture and ornamental painting business in Dover two years later. He and brother George Perry may have shared manufacturing facilities sometime after 1840.[243]

A chair stylistically later than those produced by Shorey and George P. Folsom is branded "A. FOLSOM & CO DOVER N. H / WARRANTED" (fig. 7-77), identifying a family partnership that existed between 1845 and 1847. The large, eighteenth-century-type baluster splat, which returned to use in the 1830s, filtered down to painted seating during the 1840s. Often complementing the upright banister is a rounded-end crest. The early pattern is straight along the bottom edge, and later variations are cut with two small lunettes or arches. Some chairs are framed with the fancy legs and stretcher found

Fig. 7-77 Rounded tablet-top, splat-back Windsor side chair (one of six), Abraham Folsom (brand "A.FOLSOM & CO DOVER NH. / WARRANTED"), Dover, N.H., ca. 1845–47. White pine (seat) with birch and other woods; H. 33⅜", W. 17¼", D. 16½"; rosewood grained ground. (New Hampshire Historical Society, Concord.)

here. Advancing the plank design is the applied roll at the front edge. Sometime before 1856 Abraham Folsom began the manufacture of oilcloth in Dover, and George Perry Folsom followed suit by 1859. Abraham later transferred his business to Boston.[244]

No Windsors of early nineteenth-century date are firmly identified with the settled region between Rockingham County and the Connecticut River adjacent to Massachusetts. An initial brand on a bent square-back chair with double bows is attributed to Moses Hazen of Weare, although to date there is no solid evidence linking the cabinetmaker with chairmaking. Dating from the 1810s is a group of tablet-top, bent-back Windsors with an unusual outward bow in the back posts, as in figure 7-89, creating a kind of bow-legged effect above the seats. The crests of three chairs have long, low, squared-tablet centers flanked by short, rounded steps and reasonably long straight ends. One chair bears an old handwritten label with the legend "James M Laws / Milford / New Hampshire." A James Law was a resident of nearby Sharon between 1810 and 1830, but James M. probably belonged to a generation postdating the 1850 census. A small initial stamp "C.A.W." on the second chair is of sans serif style and late date, but the seating piece was inherited from a New Hampshire estate. A similar armchair sold at auction in New Hampshire in 1982. The crests of other chairs in the group exhibit several subtle variations.[245]

On firmer ground is the identification of a stepped-tablet-top armchair penciled with the name "Daniel Bixby" under the seat. Bixby (b. 1791) was a cabinetmaker and chairmaker. The 1810 census places him in northwestern Hillsborough County at Windsor, but by 1820 he had established his business in Francestown where he remained. Parts of Bixby's tablet-top armchair are reminiscent of Portsmouth work of the 1820s, namely the bamboo-turned legs, the seat, and the arms. The crest is quite stylish in its long, flowing lines. While the top profile bears a close relationship to Boston work, the bottom edge lacks the low arch often found in the metropolitan chair (fig. 7-36). Covering the wood is the popular light yellow paint of the period. Bixby's accounts for 1839 and later describe wooden-, flag-, and cane-seat chairs. Special forms include children's, rocking, and closestool chairs, rocking settees, and stools. The Francestown directory for 1849 refers to Bixby as a manufacturer of furniture and chairs. By 1853 fancy box production augmented chairmaking, and sons Daniel P. and James T. had joined Bixby in business. Francestown at that date had a population of 1,114; located within the town limits were 241 houses and 128 farms.[246]

An indenture dated August 1, 1795, documents David Atwood's apprenticeship of about four and a half years with David McAfee of Bedford where he learned the trades of "Cabinet Joiner & Windsor-Chair-maker." David's brother Thomas (b. 1785/86) presumably trained in the same shop. Two early nineteenth-century Windsor side chairs in private hands are attributed to David Atwood by reason of direct family descent. One is a square-back chair with double bows, straight back, and four-section bamboo spindles. The other has a tablet top with long, vigorously curved ogee steps at the ends, bent back, and shaved posts. Both seats are squared shields; the four-section bamboo legs relate to Daniel Bixby's work.[247]

Thomas Atwood has left marked examples of his chairwork in the slat-back, flat-spindle style (fig. 7-78, pl. 23). The young man probably completed his apprenticeship about 1806–7. He married in 1808 and removed shortly thereafter to Worcester, Massachusetts, where he remained until about 1819. The craftsman returned with his family to Bedford and bought a water-powered mill to manufacture furniture. It is of interest that Thomas named his eighth child Catherine McAfee—perhaps in honor of the man who had taught him his trade. The arrow-spindle style was just coming into fashion in New England when the craftsman set up in Bedford. From his recent residency in Massachusetts Atwood was familiar with current developments in the rising centers of northern Worcester County (figs. 7-60, 7-62), as reflected in his chairs. A design subtlety—perhaps of New Hampshire origin since it also appears in a Portsmouth chair (fig. 7-71)—is the disk below the shaved posts of both figure 7-78 and plate 23. The chairs also have similar painted design motifs, although the ornament is executed in different

Fig. 7-78 Slat-back Windsor armchair and detail of brand, Thomas Atwood, Bedford, N.H., 1820–25. White pine (seat); H. 34⅛", (seat) 17¾", W. (crest) 18", (arms) 20¾", (seat) 19", D. (seat) 16⅞"; pinkish coral ground with yellow, green, and black (some restoration). (Hitchcock Museum, Riverton, Conn.: Photo, Winterthur.)

colors on different grounds. Atwood opened a furniture warehouse in Nashua with his son Albert in 1832, the year a manufacturing survey valued at $800 his annual output produced by three workmen. Atwood's timing was good, since the Nashua Manufacturing Company had incorporated in 1823 to produce cotton cloth, and the village was fast becoming "the centre of a large trade and the seat of important manufactures." The craftsman formed another partnership in May 1837; however, his New Hampshire career soon ended, possibly hastened by the financial panic of 1837. Over the next few years he disposed of his real estate and in 1840 removed to New York state where he died in 1865.[248]

With a population numbering fewer than 1,500 in the 1820s, the small town of Antrim was about the size of Bedford. John Dunlap II (b. 1784), son of Major John Dunlap, settled there about 1805. Young Dunlap would have just completed his apprenticeship, which by tradition was served with a Mr. McAfee of Bedford beginning about 1800. Presumably, his master was David McAfee; in view of the date, Thomas Atwood would have been training in the shop at the same time. John Dunlap II built his shop in 1806 and married the following year. During the summer of 1815 he acquainted himself with knitting loom construction in the Mohawk Valley and was engaged in that business along with cabinetmaking for several decades. In 1830, or earlier, Dunlap began to construct wooden-bottom seating. Several patterns bear the brand "JOHN / DUNLAP / 1830" marked with three separate stamps, the first two enclosed within rectangles. Dunlap's known Windsors employ some form of ball spindle. The bent-back, slat-type side chairs are relatively broad and somewhat flat across their four-spindle upper structure. The forward-scroll arms in a tall slat-back rocking chair are supported on thick, S-scroll posts whose design is a heavier version of the Boston work current about 1800 (fig. 6-215). A chair of close-fitting rectangular tablet (fig. 7-79) seems the least provincial of all the designs. The crest almost duplicates that of a chair acquired in 1824 at the founding of Portsmouth's First National Bank (fig. 7-70, right), and close counterparts are found in Wilder family seating. Dunlap's bamboowork is of good quality for this late date.[249]

The Wilder Family and Neighbors

Just as one Wilder family group dominated the chairmaking and woodworking trades in Keene for several decades from the late eighteenth century, so another part of the clan monopolized chairmaking at New Ipswich for more than half a century beginning about 1810. The patriarch of the enterprise at New Ipswich was Peter Wilder (b. 1761), brother of Abijah, Sr., who headed the Keene group. Peter himself had worked at Keene for about a decade early in his career before moving to Brattleboro, Vermont, where he remained until the late 1790s. In the period when round-back chairs gave way to square-back seating, Wilder worked in Boston. Then in 1807 he and his eldest son, Joseph (b. 1786/87), purchased land "in the dense woods" along the new turnpike at the northwest corner of New Ipswich, a "region long known under the name of 'Tophet Swamp.'" The deed identifies the men as "of Boston, traders."[250]

The New Ipswich chairworks probably was in place around 1810 when the local population stood at about 1,400. Meanwhile, Peter's second daughter, Elizabeth, had married chairmaker Abijah Wetherbee at Boston in 1805, and a child was born there two years later. By 1810 Wetherbee was in New Ipswich where he is said to have been closely associated with the family enterprise, possibly as a partner. In the second quarter of the century the one-and-a-half-story building also housed some of Peter's younger sons and kin. A freshet in 1869 damaged the waterpower source, bringing the business to a speedy end.[251]

Probably of Boston origin are two Wilder square-back chairs with double bows, one containing a central, clipped-corner medallion (fig. 7-80). Unlike Samuel Horton's work (fig. 7-27), the posts are bent and marked by a single groove, thus advancing the date slightly. The seat is a grooved shield like that in Amos Hagget's Windsor (fig. 7-28); the legs are typical of Boston bamboowork. Branded on the plank is the surname

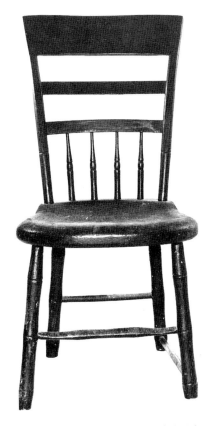

Fig. 7-79 Tablet-top Windsor side chair, John Dunlap II (stamp "JOHN / DUNLAP / 1830"), Antrim, N.H., 1830–35. H. 33¾", W. 16¾", D. 15¾". (Private collection: Photo, Winterthur.)

Fig. 7-80 Square-back Windsor side chair, Peter or Joseph Wilder (brand "WILDER"), Boston, or New Ipswich, N.H., ca. 1803–12. (Private collection: Photo, Winterthur.)

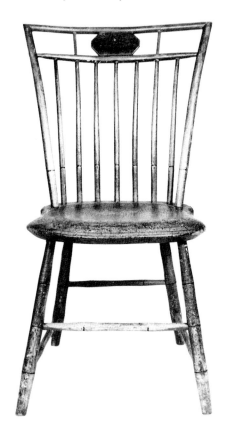

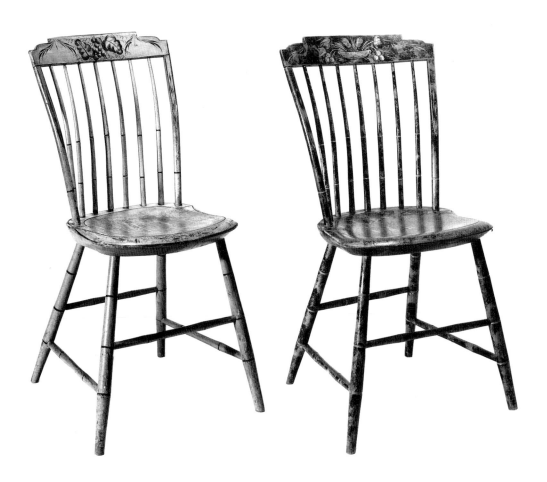

Fig. 7-81 Shaped tablet-top Windsor side chairs (one of two, and one of six), Peter and/or Joseph Wilder (brand "WILDER"), New Ipswich, N.H., 1815–25. Yellow grounds with brown, black, and gilt (*left*) and brown. (Abby Aldrich Rockefeller Folk Art Center, Williamsburg, Va.)

"WILDER," a stamp probably used by both Peter and Joseph. In one instance the mark has been found in conjunction with a Joseph Wilder label; here the work is early enough to be that of Peter. Two single-bow chairs of the Wilder family have rockers, broad backs slightly higher than those of an armchair, and forward-scroll "elbows" deeply shaped at the front. Both have a small top extension. One chair is marked "WILDER" in 7/16-inch letters, the other, "J. WILDER" in smaller italic capitals. Forming the back of the second chair are S-contoured spindles and posts, a feature whose date bridges the transition from Boston to New Ipswich and thus may be linked with either place.[252]

Following closely are several chairs with stepped tablet tops that seem more firmly associated with the Wilders' New Hampshire period. One pair has biblical decoration in the crest and a tradition of ownership by a New Hampshire church from about 1821; the planks bear Joseph Wilder's italic stamp. A slim, rectangular medallion in the front stretcher and an arch along the lower edge of the crest are features brought from Boston. A second chair is supported on three-part bamboo legs thickened at the bottom to accommodate rockers. From a slightly modified crest rises a comparable extension piece supported on six independent spindles. The chair is branded "WILDER." Two bent-back side chairs similarly marked share a crest-top profile with the church-associated Windsors, but a straight lower edge creates a thicker slat and alters the appearance of the top piece significantly (fig. **7-81**). The seats and support structures are those found in the previous double-bow Windsor, although flat-shaved forward surfaces are introduced to the back posts. The original chair decoration introduces striking contrasts and suggests the potential for variation even within a single pattern group.[253]

The Wilder family introduced both square (fig. **7-82**) and hollow-cornered (fig. 7-72) tablet-top Windsors to their line before 1825, the year of Joseph's death. The seats and turnings are typical of family production (figs. 7-80, 7-81). Accenting the back of figure 7-82 are bold roundels that rival even the original crest decoration. The short overhang of the top piece bears comparison with similar work of Maine origin (fig. 7-108). Remnants of Joseph Wilder's label remain on the mate to this chair. Although the

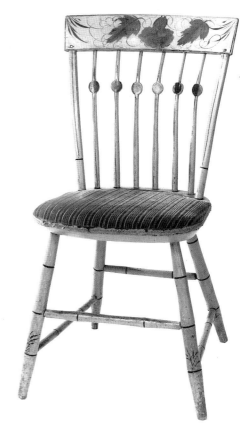

Fig. 7-82 Tablet-top Windsor side chair (one of a pair), Joseph Wilder (label), New Ipswich, N.H., 1820–25. White pine (seat) with birch and other woods; H. 34″, W. 18¾″, D. 15¼″; yellow ground with gilt. (New Hampshire Historical Society, Concord.)

seat cover appears to have been renewed at least once, it is doubtful that the plank was padded originally, since the chair postdates the 1790s when Windsors with stuffed seats were a fashionable option. Here the narrow, flattened seat edge (fig. 7-78) provided an ideal surface to anchor a cover and stuffing added in the Victorian period.

The "WILDER" stamp is impressed on a set of six hollow-cornered, tablet-top side chairs with plain shield seats and spindles. The chairs bear a second stamp beneath the plank consisting of the letters "S:I" (or "I:S"). A similar brand, although not from the same iron, appears on Vermont plank-seat chairs and is identified as that of chairmaker Samuel Ingalls of Danville, Caledonia County (fig. 7-104); the name and location are confirmed in Vermont census records for 1820, 1840, and 1850, but not for 1830. A comparable check of New Hampshire records identifies a Samuel Ingalls in Peterborough, near New Ipswich, in 1830 but neither earlier nor later. Ingalls could have worked both independently and for members of the Wilder family during his New Hampshire residency. He may have bought Wilder merchandise and restamped it with his own name during Joseph Wilder's lifetime and at the dispersal of his estate.

The hollow-cornered crest also became the focal point of a group of tall rocking chairs manufactured by Abijah Wetherbee, Joseph Wilder's brother-in-law. The design is that of Thomas Brown's chair (fig. 7-72) with modifications in several individual features. The Wilder arm has a greater front roll, and the bamboo-turned legs are proportioned differently with a more gradual taper at the top. Marked production employs the squared-oval plank with a flat-chamfered front edge. The chair was introduced probably as much as a decade before Wetherbee's death in 1835. An identical chair, except for the substitution of a rectangular crest with squared corners, is labeled by Minot Carter (b. 1812), brother-in-law to J. P. Wilder, one of Peter's younger sons. Carter may not have made chairs under his own name before 1837, although this design had been in the market for some time. The same crest is used in a commode armchair with a low back and boxlike compartment beneath the seat. The maker was Josiah Prescott Wilder (b. 1801), whose woodworking career began in the mid 1820s, although he probably did not mark his own production until well into the 1830s. The commode chair likely dates from the end of that decade. An 1842 reference in Josiah's records, begun in 1837, refers to the form as a "Cabinet Chair" priced at $3; the chairmaker also used the term "Night Chair."[254]

A tall rocking chair branded "WILDER" varies the rectangular crest by substituting rounded top corners. On aesthetic grounds, the design is less successful than the other two. The same pattern is seen in a child's armchair made by Josiah Prescott Wilder. The final phase of the rectangular tablet introduced a slight arc to the upper and lower edges in combination with square corners (fig. **7-83**). The design was produced by J. P. Wilder in several forms—as a tall rocking armchair, as a rocking side chair of moderate height (this was either Wilder's "sewing" or "nurse" chair), and as a plain side chair. Other common features are a large, three-piece, raised seat; fancy front legs; and a small cylinder-centered front stretcher.

Josiah Prescott Wilder was the sixth son of Peter. His chairmaking career probably began only in 1825, the year his eldest brother, Joseph, died. A family history states that Josiah was a student at the New Ipswich Academy from 1822 to 1825. He married Amanda, sister of Minot Carter, the following year before his twenty-fifth birthday. Josiah probably received his training in woodworking from his father before entering the academy. In 1822 elder brother Joseph was active in the firm, three other brothers were dead, and a fifth seems to have pursued another occupation; the younger brothers,

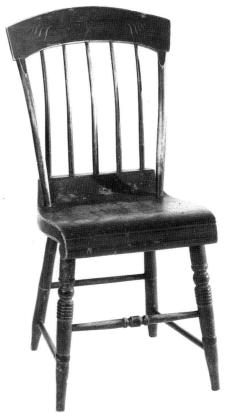

Fig. 7-83 Tablet-top Windsor side chair with scroll seat, Josiah Prescott Wilder (brand "J.P.WILDER / WARRANTED"), New Ipswich, N.H., 1835–45. White pine (seat) with birch and other woods; H. 34¼″, W. 17⅝″, D. 18⅝″; black ground with gilt. (New Hampshire Historical Society, Concord.)

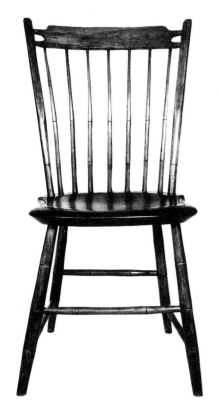

Fig. 7-84 Pierced slat-back Windsor side chair, Peter and/or Joseph Wilder (brand "WILDER"), New Ipswich, N.H., 1820–25. (Private collection: Photo, Winterthur.)

Fig. 7-85 Shaped slat-back Windsor side chair with scroll seat, Minot Carter (label), New Ipswich, N.H., 1837–41. H. 32¾″, (seat) 16⅛″, w. (crest) 17⅛″. (Private collection: Photo, Winterthur.)

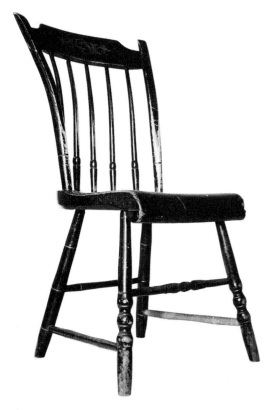

John B. and Calvin R., were likely training with their father. No doubt, Joseph's death in 1825 was a serious blow to the family enterprise, but Josiah Prescott was there to step in. The young man probably worked as one of several members of the firm until 1837, the year his business accounts begin. That date probably marks the point at which Josiah Prescott Wilder took over the family business and operated the manufactory with the assistance of his brother John B. and various temporary workmen. Calvin had removed to New York City by 1833 where he remained until 1844 or later, and brother-in-law Abijah Wetherbee had died in 1835. Peter Wilder reached the age of seventy-six in 1837 and probably retired from active business. Josiah's brother-in-law Minot Carter joined the firm in 1837, probably working in part as an independent craftsman. He withdrew from the firm in 1841, as recorded in Wilder's accounts for September 15, 1841: "Cr[edit] By Chairs Left in my possession when you left the business." The firm continued under the guidance of Josiah P., assisted by John B. until his death in 1852. A spring freshet of 1869 seriously damaged the facility and brought about its demise; Josiah died four years later at age seventy-one. At least three of his sons constructed chairs at various times during their working lives. One assisted his father in New Ipswich in 1847, another worked in the Midwest, and the third made chairs for a time in Ashburnham, Massachusetts.[255]

Charles S. Parsons, who extensively researched the Wilder craftsmen, estimated after careful analysis of Josiah P. Wilder's accounts that production at the manufactory in the twenty-two years between 1837 and 1859 totaled more than 25,000 chairs and other seating forms. At least 2,000 units represent sets of chair parts shipped to Wilder (Calvin R.) and Stewart (Edwin) at 64 Gold Street, New York, between 1840 and 1842. One of the largest outlets for chairs from 1842 to 1859 was the rapidly growing mill city of Lowell, where at least six furnishing stores sold Wilder's seating. There were sales to private individuals, small businesses, peddlers, and institutions, as well. Wilder's chair descriptions are at best general, denoting function or place of use more often than an identifiable pattern. The terms *parlor, sewing, chamber, nurse, dining, bar-room, office,* and *barber* chair occur with frequency. There are also references to large and small rocking chairs and seats for children. The more than 15,000 "common" chairs recorded by Wilder were the cheapest of pine seating, since they usually retailed for less than 25¢ apiece. Only two terms for patterns appear in the accounts—"double back" and "fancy back." The former identifies chairs with one centered cross slat below the crest. The terms *double back* and *triple back* were in contemporary use just across the Massachusetts border in Worcester County. Fancy-back chairs will be discussed shortly.[256]

Seating produced by the Wilders beginning in the 1820s comprised both tablet-top and slat-back Windsors. The spindle count dropped from seven to four within less than two decades. Six- and seven-spindle side chairs were branded by Joseph Wilder before 1825. Other datable chairs bear impressions of the "WILDER" stamp, apparently used at times by Joseph but employed more regularly by his father, Peter, probably right up to his retirement in 1837. Among other new patterns is one featuring a slat with an arch, top and bottom (fig. 7-71). A straight lower edge was introduced to a variant. Springing from that design is the arched and pierced slat illustrated in figure **7-84**, a pattern that seems to have been uncommon in Wilder work. A variant of higher crown, larger piercings, and fewer spindles bears the stamp of Thomas Wilder, a family member not thought to have worked at the trade. Either his chairmaking career was brief or he marked chairs in his capacity as a sometime ornamental painter.[257]

When Josiah Prescott Wilder took over the family business in 1837, he continued to manufacture some patterns that bear the stamps of his predecessors; Minot Carter, his brother-in-law, followed suit. New patterns current during Carter's residency at the manufactory between 1837 and 1841 include a rectangular tablet curving in a shallow arc, top and bottom (fig. 7-83). Carter's output is represented by a tall rocker. Chairs with slat-type crests cut away at the upper corners and supported by four or five spindles bear the brand of either man. Carter produced an elaborate design (fig. **7-85**), with ball-accented spindles, scrolled seat, and an ornamental front stretcher and legs. A crest

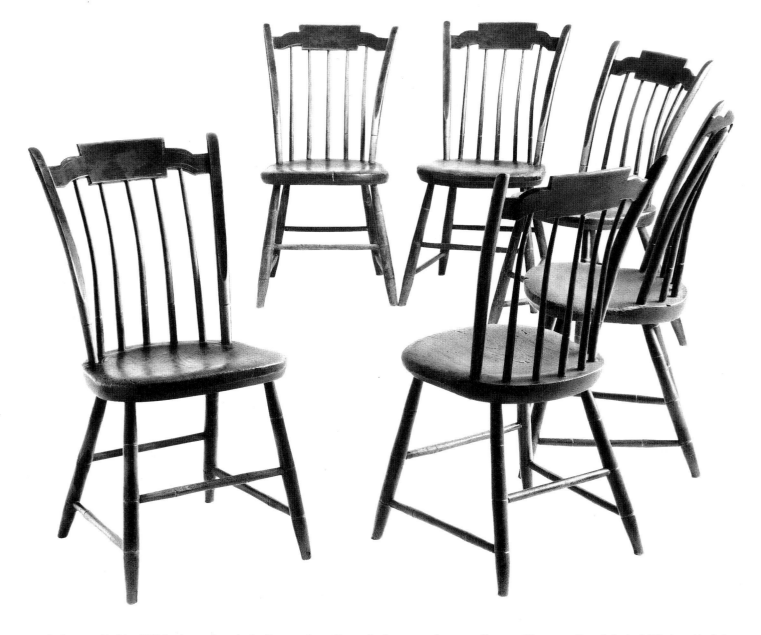

variation retailed by Wilder introduced a hollow-end profile to the bottom edge as well. The hollow-cornered slat is also an occasional back feature in southern New Hampshire splint-bottom seating.[258]

The crest pattern likely referred to as a "fancy back" by J. P. Wilder is one that both he and Minot Carter manufactured (fig. 7-86). Each chair in Carter's illustrated set of five-spindle Windsors with black and dark red painted "rosewood" grounds is labeled; the printed identification gives his location as "WILDER'S CHAIR FACTORY." Chairs documented in this manner were constructed on Carter's own account rather than for factory profit. The illustrated key border occurs on half the labels; a second design features a continuous border of lunettes with radiants. The text is the same. The fancy-back probably was popular in parts of northeastern New England for more than a decade. A chair of similar crest is pictured at the right in Stephen Toppan's Dover directory advertisement of 1830 (fig. 7-75). Minot Carter sometimes added arms to chairs of this pattern. When he fitted side or armchairs with rockers, the lower legs were swelled and slotted to receive the curved pieces of wood. J. P. Wilder made a group of tall rocking chairs with the same crest framed on top of the contoured cylindrical posts and spindles. A roll at the back of the tablet produced still another variant. The pattern provided an alternative to the fully developed crown top with downturned scroll ends (fig. 7-104), although Wilder manufactured that pattern as well. Presumably he continued production begun by his father, since at least one crown-top rocker bears the "WILDER" brand.

Fig. 7-86 Shaped slat-back Windsor side chairs (set) and detail of label, Minot Carter, New Ipswich, N.H., 1837–41. White pine (seats) with maple and beech (microanalysis); H. 31¾", (seat) 16¾", W. (crest) 17½", (seat) 16¼", D. (seat) 15⅝"; black and brick red grained ground with bright yellow and possibly white. (Winterthur 73.292.1-.6.)

A late Wilder pattern, probably postdating Carter's departure from the manufactory, introduced a loaf-shaped tablet to both a straight-back, four-spindle Windsor (fig. 7-54) and a "double back" chair. A child's highchair has a similar top. A variant of still later date added shallow curves and a flattened peak to the center top of the crest and a similar contour along the bottom edge, with backs as described. Special forms include an armless, scroll-seat rocker.

Note should be taken of two Hillsborough County men who specialized in furniture decoration, although they were not chairmakers. From 1840 until his death in 1906 Zophar Willard Brooks (b. 1812) was a resident of Hancock. As late as 1936 his stencil kit and several decorated chairs were still in the hands of descendants. Brooks purchased unpainted chairs from area craftsmen and embellished the surfaces with paint and ornament. A large armchair crowned by a Worcester County type of rounded tablet (fig. 7-65) supported on ball spindles similar to those in a Strafford County chair (fig. 7-76) bears his decoration featuring a stenciled compote.[259]

William Page Eaton (b. 1819) of Salem, Massachusetts, began his career as a painter and decorator in Boston where directory listings place him through the year 1861. He then moved to a New Hampshire farm located between New Boston and South Weare from which he led a semi-itinerant life. Account books and stencils exist, and a few chairs still bear his name integrated into the decoration of the stenciled patterns.[260]

Keene was the chairmaking center of Cheshire County in the early 1800s. The Wilder family, which had gained a foothold in the local furniture and woodworking trades late in the previous century, was still active. Abijah, Sr., brother of Peter of New Ipswich, headed the family at Keene. As a cabinetmaker and sleighmaker who made cheese presses and spinning wheels, he may never have constructed chairs. His sons Azel and Abijah, Jr., added chairmaking to the same business. Another town resident in the early 1800s was Abel Wilder, a kinsman of unknown family connection. He formed a partnership with Luther Holbrook before March 16, 1804, when the men sought workers for their business. The following year the partners advertised their furniture warehouse where they also sold plows and spinning wheels; a double-bow Windsor illustrates the text. The association continued until about August 1807 when Abel Wilder advertised alone as a cabinetmaker, chairmaker, and wheelwright; he offered among other seating bamboo, fan-back, and kitchen chairs. In 1808 Abel sold his "Turning Works and Tools" to Wilder (John), Rugg (Elisha) and Company; the business continued for two years before John Wilder became sole proprietor. From 1812 to 1815 the brothers Abijah Wilder, Jr., and Azel combined skills to manufacture sleighs, cabinet furniture, and chairs similar to those mentioned. Azel, described as an inventor, patented a double-geared wheelhead for spinning wool. The brothers may have known competition from a local turning mill operated by Smith and Briggs. This building burned in May 1812, but the following February the firm advertised briefly for apprentices to the cabinetmaking and chairmaking trades.[261]

A double-bow, bent-back armchair branded "A. WILDER" is designed as proficiently as any contemporary metropolitan chair; its grooved, knife-edge plank is typical of early nineteenth-century production. The arms, which cap the supports, may be unusual for southern New Hampshire where projecting turned rests or forward-scroll arms seem more common. As discussed earlier, identification of the "A. WILDER" brand favors Abel, based on the existence of earlier marked seating and the emphasis given by Azel and Abijah, Jr., to the wheel- and sleighmaking business.

During the mid 1820s as Abijah Wilder, Jr., advertised his cabinet and sleigh business, Charles Ingalls announced that he had taken a room at the manufactory to carry on the "Art of Painting." By the close of 1825 Ingalls retailed chairs on his own account:

CHAIRS, Charles Ingalls, (At A. WILDER JR'S CABINET MANUFACTORY) Has on hand an assortment of FANCY and DINING CHAIRS, of a superior quality, which he is disposed to sell low for Cash, or most kinds of Produce, at cash prices.

The earliest Keene directories, dating to 1827 and 1830, list Ingalls under the dual headings of "Painters and Glaziers" and "Sign Painters"; the 1831 entry reads, "Ingalls, Charles, painter, in rear of Wilders' Building." The decorator appears to have acquired his seating in the wood from Abijah or another local woodworker. By 1832 Ingalls had moved to Vermont. What kinship existed between him and Samuel Ingalls, a resident of neighboring Peterborough who may have affixed his brand to Wilder chairs made in New Ipswich, is yet to be determined.[262]

A few miles south of Keene at Fitzwilliam Jacob Felton (b. 1787) commenced chairmaking as the younger Wilder family members launched their careers. He was master of his own shop between 1836 and 1838, and likely earlier. About 1840 the chair manufacturer moved to Quincy, Illinois, finding it "difficult to compete . . . with such places as Ashburnham and Gardner, Mass., with their vastly better waterpower." Felton's existing record details a sizable enterprise; his contacts extended over a substantial territory lying west, south, and southeast of Fitzwilliam. He was a manufacturer as well as a consumer of woven and wooden-bottom chair parts purchased from suppliers. His sales outlets varied. There were a limited number of private customers, several of whom were handy enough to frame their own seating, as in the case of Edward Cook who purchased "stock for [a] large R[ocking] Chair." Some women who wove cane or flag seats for Felton's chairs took their pay in chair frames rather than cash. The craftsman sold chair parts to manufacturers and framed seating to retailers. He shipped large numbers of chairs "in the wood" to Boston painter George L. Miller in 1836. Aside from Boston, Felton's market included towns in northern Worcester County, such as Gardner, Sterling, Phillipston, and Ashburnham. To the west Anthony Van Doorn of Brattleboro, Vermont, and the New Hampshire firms of William Woodbury and Sargent and Priest at Hinsdale received Felton seating. Closer to home there were contacts at Winchester, Richmond, Hillsborough, and Amherst.[263]

Felton offered a variety of seating. Among the rocking chairs were armless "nurse" and single- and double-scroll styles. The term *scroll* describes the seat; the single scroll comes at the front (fig. 7-85) and the double scroll adds a raised back (fig. 7-83). Fancy seating included the Grecian-style saber, or curved, support and the turkey leg, a pattern popular at Lambert Hitchcock's Connecticut manufactory (fig. 7-22). The crests probably consisted of rectangular tablets, some squared on the top edge (flat-top) and others finished with a small backward roll or scrolling ends (scroll-top). The imitation chair referred to by Felton was painted to resemble curled maple or some other well-figured wood. The chairmaker described Windsor plank shapes as round (fig. 7-86) or "square front." The backs featured four or five spindles mounted beneath a scroll top, or a stay rail below a slat-type crest. Probably all the children's seating had wooden bottoms: there were dining chairs, or highchairs; low seats imitating adult styles; and "hole," or potty, chairs.[264]

Concord and the Central Region

Concord occupied a pleasant location along the Merrimack River "upon a single street, near two miles in length." The population in 1810 stood at around 2,400. The state legislature held frequent sessions there, but the town had not yet been selected as the seat of government. When construction of the Middlesex Canal linked the Merrimack with Boston in 1808, Concord became "the deposite of an extensive inland trade."[265]

Before the canal opening Levi Bartlett took over the cabinet and chair shop of the late Hubbard C. Gale; in September 1805 he offered mahogany, birch, and cherry furniture supplemented by "Windsor and Bamboo chairs." Bartlett's business appears to have prospered, and within a year he had opened a branch store sixteen miles north in Salisbury. The canal had been open only a year, however, when Bartlett sold his business to Porter Blanchard; perhaps he already saw greener pastures elsewhere. In 1811 he offered his building for sale and sold or auctioned the remainder of his furniture stock at Concord. Bartlett was a resident of Boston by 1814 when he married. Within two years he was selling iron hollow ware, West India goods, and a miscellany of items at his store

Fig. 7-87 Tablet-top Windsor armchair (one of five) with upholstered seat, William Low and Benjamin Damon (bill of sale), Concord, N.H., 1819. Mahogany (arms) with birch and chestnut; H. 36¼″, W. 23½″, D. 21¼″; off-white ground with black, yellow, and shades of brown. (New Hampshire Historical Society, Concord.)

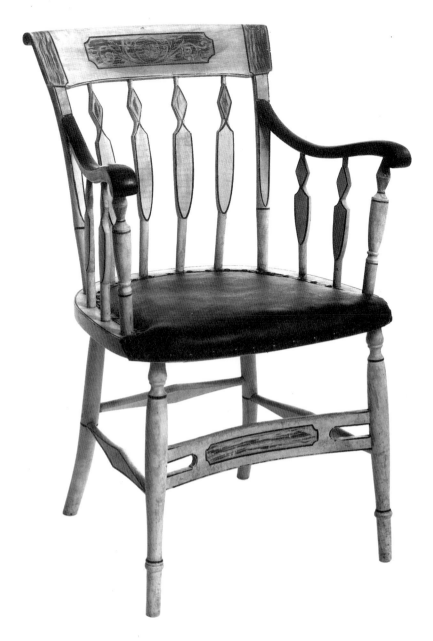

on Long Wharf. Bartlett achieved some stature as a merchant and was named among the wealthy men of Massachusetts in an 1852 publication.[266]

As Bartlett's career began so did that of the partners William Low and Benjamin Damon. The craftsmen arrived in Concord from Amherst, New Hampshire, in 1806 and maintained a business relation for two decades. An advertisement of February 6, 1816, publicizing their shop at the sign of the eagle offered "Elegantly Gilt . . . SETTEES, and CHAIRS of every description, ornamented & varnished in superior style." Local residents must have recognized a quality product in Low and Damon's chairs, since during construction of the new Statehouse between 1816 and 1819 the firm received contracts both for painting the building and for supplying the seating furniture. Low's membership on the building committee undoubtedly had something to do with the choice as well. A traveler reported on the appearance and structure of the Statehouse a few years later: "THE STATE HOUSE occupies a conspicuous situation near the middle of the town, a little removed from the street, and surrounded by a handsome stone wall. . . . It is built of hewn granite . . . and is a neat edifice, 100 feet long, with a large hall on the first floor, and on the second the Senate and Representatives' Chambers, with the committee rooms, state offices, &c."[267]

The bill rendered by Low and Damon to "The state of New Hampshire" is dated 1819. In all, the partners provided 182 chairs, 11 settees, and 3 cushions for use in various rooms and chambers throughout the building. Porter Blanchard supplied the case

furniture. The illustrated armchair (fig. 7-87) is one of five that survive from the original seating. The off-white ground is highlighted in black and yellow and embellished with decorative panels shaded in brown. The state seal, consisting of a rising sun and a ship on the stocks, is centered in the top panel. The close-fitting crest with back scroll almost duplicates a Boston top piece (fig. 7-39). There the similarity ends, however, because the Massachusetts chair is obviously a hastily constructed production piece, while the Low and Damon chair represents custom work of a superior type. The front legs follow a pattern that appears in Boston fancy seating (fig. 7-30). The pierced slat bracing the supports generally follows other Boston work (figs. 7-34, 7-35), but the astragal-end slots may be a regional interpretation, since they embellish another New Hampshire Windsor (fig. 7-74). Above the seat the urn-and-diamond profile of the turned front posts repeats that of the flat sticks; the diamond motif is echoed again in the side and rear stretchers. Urn-style arm supports occur both in Boston and New York seating (fig. 5-25) and must have been known locally well before the Statehouse commission. As early as 1808 Levi Bartlett advertised his close connections with furniture warehouses in those cities. The dark mahogany arms and dark painted accents of the Low and Damon chair suggest the probable color of the original seat covering. The seat itself is unusual in Windsor construction, since it is framed at the four corners and open at the center to receive the webbing that supports the stuffing and cover.[268]

The features of a stepped tablet-top chair suggest a Concord provenance, possibly the shop of Low and Damon (fig. 7-88). Close comparison with the Statehouse chair reveals similarities: the flat sticks consist of bold shapes stacked one upon the other, the urn profiles are identical, the back posts are shaved and grooved in like fashion, and a related diamond-shaped stretcher braces the front legs. Somewhat out of the ordinary is the stepped crest profile; the tiny corners of the central projection are hollow instead of squared, and the flanking, rounded shoulders are decidedly humped. Other stepped-tablet chairs, forming two sets labeled by Low and Damon, have similar hollow-cornered projections at the crest center, although the flanking rounded shoulders are low and the bottom edge is arched slightly in the manner of Samuel Gragg's Boston work (fig. 7-36). The knife-edge shield-shaped seats appear to duplicate the plank in figure 7-88. The bamboowork of the legs is not as well executed as that in the attributed chair, however, and the front stretchers differ in profile. The stretcher design in the labeled chairs closely resembles that in a New Bedford, Massachusetts, Windsor (fig. 7-53), except for the central element, which is considerably larger and completely oval.[269]

After January 14, 1826, Low and Damon pursued separate careers. Low, a painting specialist, continued awhile at the trade but eventually became postmaster of Concord (1829–39). By 1844 the local directory listed him as a farmer. Damon pursued the painting and chairmaking trades until at least 1834 when he advertised "Chairs in good style of my own manufacturing in the good old way for strength." By 1844 he specialized only in house and sign painting, which trade he continued into the 1860s. Damon was a founding member in 1828 of the Concord Mechanics' Association.[270]

Providing competition in the painting business for both Low and Damon was Henry Farley, who is identified by trade in a local deed of 1826. In a lengthy notice of 1831 Farley advertised his "NEW PAINT STORE" and offered "a superior assortment of Fancy and Windsor CHAIRS, at low prices." The craftsman's emphasis on the painting trade suggests that he was not a manufacturer but simply finished and decorated chairs purchased elsewhere. Farley met an untimely death through a fall in 1838. George D. Abbot, a contemporary, pursued the dual trades of painter and chairmaker until 1834 when he concentrated on painting. He sustained a considerable loss in the great Concord fire of 1851.[271]

For want of a precise geographic location the unusual stepped-tablet chair of figure 7-89, one of a pair, is logically placed in the current discussion because its crest relates to that of the previous chair. More exaggerated in curve, the profile repeats the basic plan, comprising a low central tablet flanked by notched, ogee-profile shoulders and pointed tips. Bowed posts are sometimes noted in New Hampshire work. There is other

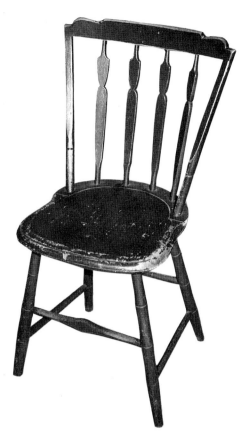

Fig. 7-88 Shaped tablet-top Windsor side chair (one of six), possibly William Low and Benjamin Damon, Concord, N.H., 1815–25. White pine (seat); H. 34¼″, (seat) 18″, W. 16″, D. 15¾″. (Private collection: Photo, Winterthur.)

Fig. 7-89 Shaped tablet-top Windsor side chair (one of a pair), southern New Hampshire, 1820–30. Basswood (seat, microanalysis); H. 37″, (seat) 18¼″, W. (crest) 19½″, (seat) 16¼″, D. (seat) 15⅛″; paint and decoration not original. (Mary Lou and Robert Sutter collection: Photo, Winterthur.)

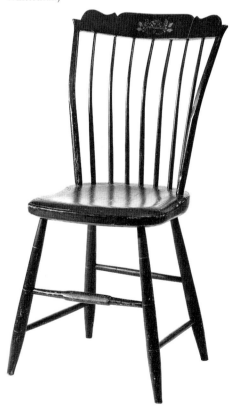

influence here as well. Boston and eastern Massachusetts design is prominent in the flat-edged seat (figs. 7-27, 7-62), the smooth styling and bend of the posts (fig. 7-28), and the use of a medallion, or small tablet, in the front stretcher (fig. 7-33). Both this and the previous chair also owe a considerable debt to the Worcester County crest illustrated in figure 7-55. The chair legs with their tapers above and below the point of the lowest groove are strongly associated with Maine work (figs. 7-108, 7-110). The sharply peaked crest corners can be compared with the work of Daniel Stewart (fig. 7-117). Purchased from a Maine dealer, the chairs are said to have come from New Hampshire. A Maine-New Hampshire border provenance is probably correct and is reinforced by the presence of basswood in the seat.

In opening a branch store at Salisbury, Levi Bartlett of Concord may have been prompted by knowledge of the recent departure of Theodore Cushing to Vermont. Cushing (b. 1780) advertised for an apprentice to the Windsor-chair making business on September 1, 1803, and less than a year later in June 1804 formed a partnership with John W. Cushing (possibly from Goffstown). They offered a good range of vernacular seating to area residents: "ON HAND AND READY FOR SALE, Dining Chairs of various prices; Bamboo, Easy and Kitchen Chairs." The terminology is straightforward, excepting the word "Easy," which is mentioned in other early nineteenth-century New Hampshire records. Abel Wilder of Keene, for instance, named this form in an advertisement of 1807. In its close association with vernacular seating the reference appears to identify a rocking chair. The "ease" enjoyed by the body in rocking is comparable to the comfort found in sinking into a well-stuffed upholstered chair, and certainly overstuffed, expensive seating is out of place in this context. When Cushing removed from Salisbury to Thetford, Vermont, in 1806, he left a vacancy filled temporarily by Levi Bartlett's retail furniture store. Shortly after Bartlett's sale of the business in 1809 to Porter Blanchard, Stephen Ross advertised as a cabinetmaker and chairmaker in Salisbury, but his tenure was short and by 1815 he offered his property for sale. The farm on the turnpike road consisted of a house, barn, and "shop [with] stock suitable for the cabinet and chair manufacturing business."[272]

East of Concord at Epsom, Simon Sanborn sought the services of a journeyman chairmaker in 1818, an indication of the general prosperity of his businesss. Although Sanborn's name is absent from the 1832 manufacturing survey for New Hampshire, the enumeration contains that of William S. Cilley, a chairmaker located at Pittsfield. Cilley reported that he produced 1,500 unpainted chairs annually at his manufactory where each of three men earned 75¢ a day and chairs sold for 62½¢. At that rate daily production per man had to average at least a chair and a half to clear expenses.[273]

Belknap County in central New Hampshire was described at midcentury as rough and uneven in its terrain, yet productive agriculturally. The area's great claim then, as today, was its variety of picturesque scenery, which includes Lake Winnipesaukee. John Avery worked there by the month in 1811 for cabinetmaker James Chase of Gilford (formerly part of Gilmanton). The following year he purchased chair stuff from Chase, presumably to frame and finish seating on his own account. Land records dating from 1815 to 1830 refer to Avery as a cabinetmaker of Meredith. Daybook entries kept in the early 1830s by John Cate, a jack-of-all-trades who worked at Wolfeboro across the lake, show exchanges with John Avery. The cabinetmaker provided a set of bedstead posts and a wagon spring and in return received 500 feet of birch and maple timber and 1,744 feet of basswood boards.[274]

John Commerford settled in Sanbornton in 1813 to carry on the trades of painter and chairmaker; later he pursued only the former of these. By 1825 Ira Elliott, a storekeeper of Sanbornton Bridge, advertised "a lot of good Dining Chairs, elegantly ornamented, at the small sum of seventy-five cents pr. chair." Presumably, he obtained the seating locally, since he was able to retail the merchandise at this modest figure. Not to be outdone, perhaps, Lewis, Lane and Company at Sanbornton countered in 1827 with a notice: "HAVE for sale good substantial DINING CHAIRS, elegantly painted and ornamented with gold leaf, at the very low price of 62½ cents each."[275]

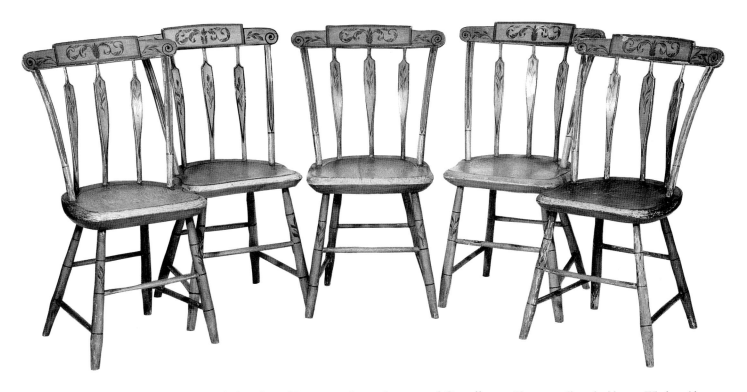

Fig. 7-90 Shaped tablet-top Windsor side chairs (set), Joseph Ruggles Hunt (brand "J.R.HUNT / MAKER."), Madison, Carroll County, N.H., 1825–35. Ocher-yellow ground with red, blue, and black (possibly not original). (Photo, Elizabeth S. Mankin Antiques.)

Joseph Ruggles Hunt (b. 1781), a chairmaker of Boston, migrated to central Carroll County north of Lake Winnipesaukee before 1813 when his name first appears in the Eaton tax records. Born in Boston, Hunt probably also trained there. He married in 1803 and advertised his chair factory the following year; his name continued in local directories only through 1807. Other records suggest that Hunt remained in the area until at least 1811 when he was a creditor of the estate of cabinetmaker Ebenezer Knowlton, Sr. The substantial sum of money due to Hunt—$451.95—suggests strongly that the chairmaker supplied Knowlton with wooden-bottom chairs and parts or worked as a shop journeyman. Knowlton's inventory itemizes both chairs and stock on hand to the value of about $185, and the two craftsmen occupied shops and residences in the same neighborhood. Upon removing to New Hampshire Hunt settled in the western part of Eaton Township, Carroll County, now incorporated as Madison. He purchased land in 1815 and a mill site within three years. In later life Hunt served two years in the state legislature and was postmaster of Eaton from 1841 to 1852, all the while continuing to operate his manufactory. As late as 1859 "one cabinet and chair manufactory" was part of the local industry of Eaton.[276]

Several wooden-bottom chairs are branded "J. R. HUNT / MAKER," the last word only in italic letters. The seating ranges from single- and double-bow styles to tablet-top patterns. Although Hunt's cross-bow chairs are appropriate in style to his metropolitan period, they cannot be ascribed with certainty since they share several characteristics with his later work (fig. 7-90). The seat planks all form squared shields marked by a thick front edge rounding to a deep chamfer. Early and late bamboo profiles are comparable. The bent-back chairs of the illustration have an unusual crest that may represent a "personal" design developed by Hunt. The profile springs from English cabinetwork transmitted through regional sources: the stepped tablet-top Windsor popular in the 1810s, a Boston fancy crest (fig. 7-30) modified to a tablet mounted above the posts, or a sabre-leg formal chair of tablet top current to the Boston market of the 1820s. The broad, flat spindles may represent the influence of Maine work (fig. 7-107); indeed, Carroll County forms part of the great Saco Valley with its outlet on the southern Maine coast. Another documented chair of similar crest has plain sticks. Hunt also produced double-bow and stepped tablet-top rocking chairs and other seating with an inset, slat-type crest.[277]

Located close to Hunt, in Conway, Elijah Stanton began his furniture-making career in the early 1840s. He practiced cabinetry as well as chairmaking, since the former is the

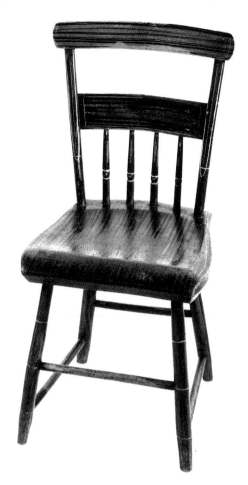

Fig. 7-91 Tablet-top Windsor side chair (one of six), Elijah Stanton (stencil), Conway, N.H., ca. 1842–50. White pine (seat) with maple and other woods; H. 33¼″, W. 17⅛″, D. 16¾″; rosewood-grained ground with yellow. (New Hampshire Historical Society, Concord.)

trade given in a land record of 1842. By 1849 a New England business directory called him a furniture manufacturer. There is no mistaking the Boston influence in the crest of Stanton's double-back chair (fig. **7-91**), one of a set of six. The straight board with arc-type ends was introduced in the city about 1840 (fig. 7-40), but the slim styling relates to Hunt's work. An ogee-, or shovel-, shaped plank made its appearance in New England in the 1830s; however, Stanton's interpretation is unusually thick. Perhaps the intent was to achieve the depth of a rolled front while sidestepping the extra work of applying a shaped piece of wood to the forward edge. The rosewood graining is enhanced with yellow penciling.²⁷⁸

At midcentury light industry, such as the manufacture of chairs, was gaining ground in the still thinly settled areas of northern New Hampshire where the economic impact of metropolitan centers and large, flourishing inland towns was less direct and forceful than in the southern part of the state. At 20,000 or less the population of Belknap and Carroll counties was approximately half that of Merrimack and Rockingham. Grafton County, thanks to its substantial size and location on the Connecticut River, equaled Merrimack at 40,000 inhabitants, while Coos in the far north still numbered less than 12,000. In plotting by map the locations of northern New Hampshire chair manufactories listed in a directory of 1849, it may be observed that aside from two in the Winnipesaukee region, all fall along the Connecticut River from Lebanon near White River Junction to Colebrook adjacent to the Canadian border. The river and its tributaries provided both a power source and a limited means of local distribution.²⁷⁹

VERMONT

Bennington

The story of early nineteenth-century Vermont seating begins only after the War of 1812. The Bennington chairmakers of the 1790s seem to have faded shortly after 1800. Ralph Pomeroy resettled at Troy, New York, and Amasa Elwell probably "declined" in business, settling into the life of a full-time farmer. At his death in 1814 his shop building, "large turning lathe," and "Set of makin Chairs" (hand tools) constituted the last remnants of his former occupation. There is no evidence in the form of stock or timber indicating that he still actively pursued his trade.²⁸⁰

While much of Bennington County is mountainous, the western part around the county center and northward was generally suited to raising grain and cattle. Industrial development beyond simple milling activity began only after the war but by midcentury it included several pottery and textile works, a number of metalware manufactories, a papermill, and miscellaneous small enterprises. At that date, too, a good, macadamized road permitted direct and convenient communication with Troy, the head of steamboat navigation on the Hudson River only thirty miles to the west. The first solid evidence of chairmaking in the postwar period is a notice published in January 1825 by Elias White, who called himself a chair manufacturer. White had been in business earlier in Hampshire County, Massachusetts, and died there in 1845. His venture at Bennington probably was short-lived. At Bennington East Village, Buckley Squires was established in a manufactory of fancy and Windsor chairs before his newspaper advertisement of June 5, 1832. Although he employed "the best of workmen" and did "his work in the most fashionable modern style," Squires seems to have been an entrepreneur rather than a craftsman. Supplementary information indicates that he had operated a tannery in the late 1810s, a fact supported by his purchases of land and water rights in 1818–19. At his death in 1860 Squires was identified as a traveling salesman.²⁸¹

Meanwhile, the young partners Henry Freeman Dewey and Heman Woodworth pooled their resources and talents and opened a chair manufactory in East Village in autumn 1827. In two transactions on September 8 they purchased a water site comprising 2¾ acres bounded on the south by the "highway leading from Bennington Meeting House to Safford's mill." Their advertisement of November 12, repeated the following year, is identical to the notice published in 1832 by Buckley Squires. There are no further

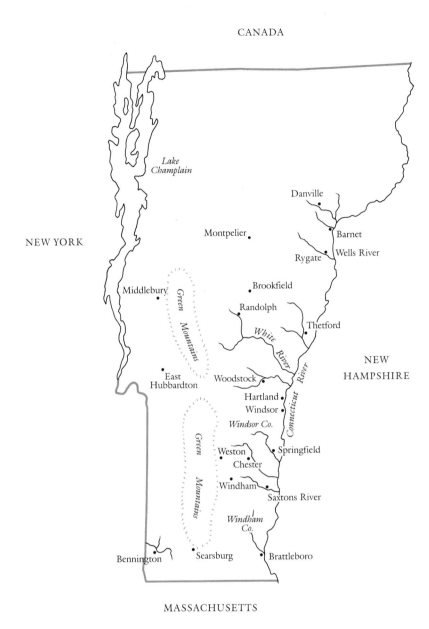

CANADA

Lake
Champlain

NEW YORK

Danville

Montpelier

Barnet

Rygate
Wells River

Middlebury

Brookfield

Randolph

Green Mountains

Thetford

White River

NEW
HAMPSHIRE

East
Hubbardton

Woodstock

Connecticut River

Hartland
Windsor

Windsor Co.

Green Mountains

Weston
Chester

Springfield

Windham

Saxtons River

Windham
Co.

Bennington

Searsburg

Brattleboro

MASSACHUSETTS

1 inch = 31.4 miles

references to the concern. It seems entirely possible that the Dewey and Woodworth manufactory was the same property occupied by Buckley Squires a few years later and that one or both men stayed on as workmen. Henry F. Dewey (b. 1800) reappears in records and documents of the late 1830s. His book of accounts for chairwork and related activity commences only in 1837, although there is evidence that there was an earlier volume. Land purchases beginning in the following year reveal that Dewey was a near neighbor of Buckley Squires.[282]

Production in the Dewey shop centered on three kinds of seating—Windsor, maple, and cottage (or common cottage) chairs. Specific descriptions are almost nonexistent, so that prices and knowledge of the 1830s furniture market are about the only guides. Maple chairs at $1.75 were the most expensive. They probably were available in several patterns

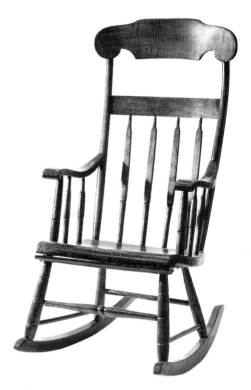

Fig. 7-92 Crown-top (Boston) rocking chair and detail of stamp, Henry F. Dewey, Bennington, Vt., ca. 1837–45. Basswood (seat, microanalysis) with maple and other woods; H. 43¼″, (seat) 15½″, W. (crest) 22″, (arms) 21″, (seat) 19″, D. (seat) 19″. (Bennington Museum, Bennington, Vt.: Photo, Winterthur.)

with plain or ornamental slats, possibly an occasional roll top, and either turned or sabre legs. Both plain and curled maple construction was available; the wood was finished and varnished and the seats probably caned rather than rushed. The customer who ordered "maple green Chairs" for a few cents more in 1839 probably had them stained, painted, or trimmed to color. The references to fancy painted chairs at $1.50 each are not common. The more favored painted chair was the cottage piece. At $1.25 it was simple in design, perhaps a plain slat pattern framed between or above the posts. An 1841 reference to a set of "slat" chairs priced individually at $1.25 seems to confirm this. Modest decoration and a rush seat completed the work. Almost without exception the Windsors sold for 83½¢ apiece. A few priced at 50¢ may have been sold without paint, as there are occasional references to chairs purchased "in the white." But, again, there is little indication of pattern; the price suggests a simple contemporary style. Dewey's receipt of spindles from suppliers of turned work documents his production of plank-seat patterns with sticks; references to slats (tops) and banisters (midrails) further describe the appearance of the back structure.[283]

There was a steady, though limited, demand for rocking chairs in the Dewey shop. The simple, rush-seat cottage piece was at times fitted with rockers, and there is mention of a roll-top rocker priced at $1.75. This may have been a special-order item since turned top pieces do not appear to have been part of Dewey's regular production. Most in demand were his "large" rocking chairs, made, no doubt, with wooden seats and ranging in price from $3 to $5. One that sold without paint in 1842 cost the purchaser $2.50. The only documented Dewey chairs known are tall rockers with scroll-front seats and crown tops (fig. **7-92**). With its fancy "front round" (stretcher), flat spindles, and crest sawed to a stylish pattern, this chair likely was one originally priced in the $4 to $5 range. Other Dewey rockers have a slat-type front stretcher. Arrow spindles are not particularly common in rocking chairs, especially the tall models. Here, the top piece with its lower central projection seems more a type made to receive full-length cylindrical sticks—four at the bottom edge of the tablet and one each in the triangular void adjacent to the scroll. The narrow cross slat and sizable void between the slat and crest introduce some awkwardness to the design. Rather provincial, too, is the use of deep grooving on all the spindles, posts, and legs, which makes for a segmented quality that detracts from the overall smooth effect of the surfaces. The chair has lost its paint, however, and individual features may have been less conspicuous when ornamented. Dewey impressed his small name stamp several times on the back seat edge.[284]

References to exchanges, purchases of chair stock, and commission sales are frequent in the Dewey accounts. Erastus Y. Clark obtained both maple plank and completed maple chairs from the craftsman in 1839 and paid in part with an unfinished washstand. Clark had advertised only a year earlier as a fancy-chair maker. Westel Rose framed chairs in the shop from time to time. Since his account was transferred from another book, he probably worked before 1837 as well. Alvin Bates, Solomon Rich, and Richard Smith, the latter two from Searsburg in the Green Mountains, supplied turned or shaped parts—posts, spindles, rounds, legs, slats, and banisters—between 1839 and 1845. Bates owned a shop in Bennington. Solomon Rich, described in records as a farmer and lumberman, met an untimely death in 1848 when he was thrown from a heavy wagon and run over. His holdings in addition to the homestead consisted of various lots and tracts of land, one "with a saw mill thereon." Among his tools and machinery were two lathes and circular and mill saws.[285]

Once in 1842 a D. Burton painted cottage chairs for H. F. Dewey to the equal value of a large rocking chair "in the white." Credits for "cut cane" and several dozen cane seats occur in Dewey's account for Jacob Batchelor in 1839. Batchelor advertised from his own chair shop at East Arlington the same year, announcing that he "Wanted Immediately, Two men . . . that have the use of Joiner's tools, to work on . . . Tops and Slats, and tend the Shop." Probably both wooden and woven-bottom seating were in production. The framing Batchelor described called for mortising cross pieces between the posts, that is, "the use of Joiner's tools." In 1841–42 Dewey accepted chairs on commission from

Lysander M. Ward and Company of Heath, Massachusetts, and George Boardman, probably a resident of the same area. Dewey charged the latter for delivering merchandise when sold. Beyond the flurry of shop activity, Dewey found time to serve as sexton of the local Second Congregational Society for several years from 1839.[286]

Windham and Windsor Counties

Chairmaking in Windham County, which is bounded by Massachusetts and the Connecticut River, appears to have been modest. Peter Wilder, who began his trade at Keene, New Hampshire, and later established a family chairmaking business at New Ipswich, resided in Brattleboro during the 1790s. Although a "substantial bridge" connected the town with New Hampshire across the river in 1804, the place was still just a village in 1826. Visitors noted the presence of "several manufactories" and a "large and comfortable stage house." Anthony Van Doorn (b. 1792), who migrated from Bristol, Rhode Island, in 1815, was established in the furniture-making business at West Brattleboro. Around 1830 he formed an association with William Conant and opened a sales outlet in East Village, Brattleboro, where in April the partners announced receipt of "a complete assortment of CHAIRS" from their "Chair Shop" for "QUICK SALES & SMALL PROFITS." In the same vein they noted that "as it is cheaper sitting than standing, people are invited to call and select Chairs for themselves, as well as Cabinet work." Later, Van Doorn had dealings with chairmaker Jacob Felton of Fitzwilliam, New Hampshire, from whom he purchased rocking and children's chairs, Grecian and cane seating, "square front" and common chairs—215 in all. A copy of his pictorial billhead inscribed for January 4, 1839, illustrates a scroll-back, cane-seat chair and a chest of drawers. Enumerated in the bill are "kitchen chairs" sold for 50¢ apiece. About 1847 Van Doorn turned the business over to his sons. To date no chairs from this manufactory have come to light.[287]

The itinerant artist Asahel Powers has left a visual record of the painted seating in use during the 1830s in communities north of Brattleboro, such as Windham, Springfield, Windsor, and Chester. Powers painted at least twelve subjects seated in tall, contoured-back rocking chairs with stepped-tablet tops and scroll arms. A low tablet-type extension further heightens several chairs. The rocker shown in the Springfield portrait of Jonathan Chase painted in 1832 is representative of the group (fig. 7-93). Although the slightly outdated crest appears to have been especially popular locally, and possibly throughout the state, the number of extant examples is remarkably small. A tall chair in a regional museum has related features (fig. 7-94). Some of its imitation rosewood ground and cream-colored ornament remain. The Chase portrait pictures an alternative scheme with bright yellow and green decoration enhancing a cream-colored ground. Another portrait dating a few years later and attributed to the artist Aaron Dean Fletcher pictures Benjamin Smith, a successful soapstone merchant of Saxtons River, seated in a large rocker with a crown top of the type made by H. F. Dewey (fig. 7-92). Seated in a decorated rocking chair of similar crest is Mrs. Jessie Stedman of Chester, painted in 1833 by Asahel Powers.[288]

Following his departure from Northampton, Massachusetts, in 1802 and his brief sojourn in New Hampshire, Julius Barnard pursued the trade of cabinetmaker and chairmaker for a short period at Windsor, Vermont. He remained there until 1809 when he moved on to Montreal. The cabinetmaker pinpointed the location of his "stand" in Windsor as "next door south of PETTES' Tavern," an inn described by a later traveler as "a good stage house." The town also contained "a number of stores, some elegant houses, two or three handsome churches, and the State Prison" erected of stone in 1808–9. Windsor's well-watered, fertile terrain and its "favorable position for trade" along the Connecticut River contributed to its "flourishing" state.[289]

Little is known of Barnard's Vermont career. Windsor would seem to have been an ideal location, although the craftsman's residence there coincided with the period of Jefferson's embargo. Barnard is identified as a cabinetmaker; when he ventured into popular seating, he appears to have employed specialized assistance. A letter of Windsor

Fig. 7-93 Asahel Powers, *Jonathan Chase*, Springfield, Vt., 1832. Oil on wood panel; H. 37¼", W. 24⅞". (Springfield Art and Historical Society, Springfield, Vt.: Photo, Winterthur.)

Fig. 7-94 High shaped-tablet rocking chair, Vermont, 1820–30. White pine (seat) with maple; H. 41", (seat) 16⅞", W. (crest) 21⅜", (arms) 21½", (seat) 18⅞", D. (seat) 17¼"; dark brown and brick-red grained ground with pale yellow. (Orleans County Historical Society, Old Stone House Museum, Brownington, Vt.: Photo, Winterthur.)

origin identifies the chairmaker who worked for Barnard about 1804 and describes the day-to-day difficulties that were part of conducting business, then as now. In addressing the Windsor Congregational Church concerning one Captain Skinner who, Barnard said, had not kept his word, the cabinetmaker wrote: "Capt. Skinner came to my shop and requested the privilege of getting chair timber of different kinds mentioning . . . that he had a . . . large birch tree which he said . . . split like an acorn. . . . He agreed with Mr. Wilder who was then my chairmaker to fetch the above timber and to take his pay in cabinet work or chairs . . . told regularly that I would . . . [not] pay cash for it." Skinner, it seems, demanded cash after delivering the wood. The chairmaker Wilder, mentioned by Barnard, probably was not an immediate member of either New Hampshire branch of the chairmaking family. The Vermont census for 1800 lists three Wilders as residents of Plymouth and another, Joseph, as a resident of Hartland, both Windsor County towns, the latter only five miles away.[290]

Within a few years of Barnard's departure from Windsor, Thomas Boynton (b. 1786) removed from Boston to Hartland where he built a manufactory. The Boston entries in his account book end in July-August 1811. The record commences again only in February 1812 with the beginning of a debit account for his new "Manufactory," which itemizes building supplies, labor, and board for workmen. Business at the new site began several months later when the "manufacturer" started a new page in the accounts headed: "Thomas Boynton / Hartland, Vt. / July 1st 1812." By May 1813 Boynton had purchased timber to build another lathe. He added two similar machines in June 1814 along with five more "work Benches." The entrepreneur, a native of Lunenburg, Massachusetts, was a single man at the time, as indicated by the frequent references to his expenses for board, including one at Pettes Tavern in Windsor for thirteen weeks from October to December 1813. By the following March he had secured the services of a housekeeper and was setting up a household. The sewing chair for house use undoubtedly came from his own manufactory. The craftsman married a Hartland girl several years later.[291]

Boynton's accounts contain references to the manufacture of furniture as well as chairs. Tables, bedsteads, bureaus, clockcases, boxes, and the like were part of his regular production. Painting and ornamenting were important activities as well; the work included furniture, wagons and chaises, doors and fireboards, and building interiors. On one occasion Boynton painted "a State Prison Sign" and on another "a Sign Stage House" for Frederick Pettes. He provided the innkeeper with several sets of chairs, some described as "gilt fancy bamboo" and others as "rush Bottom elegant f[an]cy." References to work in and around Windsor and book entries for a horse and sleigh to Hartland suggest that Boynton's manufactory site in Hartland Township was close to the Windsor town line. His place of residence, as reported at his marriage in 1817, was Windsor. The manufactory primarily served the local region, but on one occasion Boynton boxed furniture for shipment to Montreal. While engaged in woodworking and painting, Boynton also opened a general store. Most merchandise came from Boston, but there are entries for Cambridge and Hartford suppliers as well. In later life Boynton appears to have given up the furniture business in favor of painting. He developed a technique he called "stamp painting" for decorating interior rooms. He also wrote fire policies for the Vermont Insurance Company and was active in town government.[292]

Certain parallels can be observed in the lives of Thomas Boynton and Joseph Wilder of New Hampshire. Both men were born in the late 1780s in rural New England, Thomas in northern Worcester County, Massachusetts, and Joseph in neighboring Keene, New Hampshire. As young men both were chairmakers in Boston, where they had business contacts, then left the city in 1811 to become successful manufacturers in areas where their families had resettled. The distance between Thomas Boynton's manufactory at Hartland and that of the Wilders at New Ipswich was about seventy miles, far enough that each could operate successfully without competing for the same markets. Indeed, there appear to be no references in the Boynton accounts to the Wilder

family after the Boston period, although Boynton had a wide circle of business and labor contacts.

Both John Patterson and John Parker became journeymen in Boynton's manufactory at an early date. Patterson and possibly Parker assisted in erecting the works. The two men were full-time workers from the manufactory's opening in 1812 until summer 1813. Thereafter, Patterson worked extensively as an ornamental painter during the following two years and Parker made chairs intermittently from 1814 to 1816. During the manufactory's construction Boynton provided both wages and board for his workmen. An account for "board myself and J P. at D B" is of note. "D B" probably was Thomas's father, David Boynton, who had removed to Hartland at the beginning of the century. Living at home with his parents would have been convenient for Thomas during the building and early business periods. Young Boynton also paid board for his apprentices, Ammi White and Zadock Spaulding. A factory account of 1814 refers to the "expense of 2 Boys from April 1st to Augt 16th." White completed his service in 1817, which was followed by a partnership with Boynton. Zadock Spaulding's term had ended a year earlier on November 7, 1816, when Boynton recorded: "for his time from June 22d 1813 to the present time 3 years and 4½ months at 30 Dollars pr year."[293]

The accounts reveal other business arrangements. William Ayres, an independent worker, purchased turned parts between 1814 and 1816; he also acquired bent "stuff" and used a shop lathe on one occasion. J. W. Barber began at piecework and then labored continuously from January to May 1814. Boynton exchanged products and services with Rufus Norton, who acquired finished seating and varnish and provided chair seats and legs in return. Boynton made a good start in business, as indicated by his personal reckoning of accounts for 1816:

amount of income for the year 1816	$1234.23
amount of expense for the same	806.14
nominal net gain for the same time which is supposed to be appropriated partially as follows Viz	$ 428.09
for interest on debts	100.00
" my own Clothing	100.00
" Contingent expenses	50.00
" losses discounts &c.	50.00

The manufacturer's clear profit was something more than $100.[294]

During the 1820s Boynton consolidated his business by limiting his associations to just a few craftsmen. Moses F. Weld agreed to work at the manufactory for two years beginning May 17, 1824, but he "[quit] before his time was out" and actually put in only a year after lost days were reckoned. Between 1828 and 1833 William Colston borrowed equipment, including chair tenoners, spoke shaves, pod bits, and an "old Bench," although there is no indication that he constructed chairs for Boynton.[295]

Charles Ingalls's account with Boynton began in September 1832. Ingalls appears to be the person who advertised fancy and dining chairs for sale in 1824–25 at the cabinet manufactory of Abijah Wilder, Jr., in Keene. He was still a resident of that community as late as 1831 when the local directory gave his occupation as "painter." Apparently, within a year Ingalls moved on and negotiated a similar arrangement with Boynton, since several entries for a "years rent" occur in the manufacturer's accounts. The men appear to have shared certain work and collaborated on a few large jobs, such as "painting at Pette's house," "Striping Torreys Gig," "3 evenings work at E. H & D s store," and "a job of papering at Claremont," New Hampshire. The business arrangement lasted for a decade. Meanwhile, Ingalls formed an association with chairmaker Franklin Howe, possibly the man listed in the 1830 census at neighboring Grafton, to act as his furniture agent at Windsor. On hand in 1835 at Ingalls's "Furniture Ware House . . . one door east

Fig. 7-96 Asahel Powers, *Hannah Fisher Stedman,* Chester, Vt., 1833. Oil on wood panel; H. 36″, W. 24⅞″. (National Gallery of Art, Washington, D.C., gift of Edgar William and Bernice Chrysler Garbisch.)

Fig. 7-95 Slat-back Windsor side chair (one of three), probably south-central Vermont, 1825–35. White pine (seat); H. 34″, (seat) 17⅞″, W. (crest) 16″, (seat) 16½″, D. (seat) 15⅛″; mustard-yellow ground with black, wine-red, and pale and bronze gold. (State of Vermont, Division for Historic Preservation, Old Constitution House, Windsor: Photo, Winterthur.)

of P. Merrifield's Book-Store" was a selection of Howe's seating furniture, including "Raised seat, Rocking, Cane seat, Fancy, Flag-bottomed, . . . Common, . . . [and] Nursing Chairs." Most, if not all, of Howe's seating arrived at Windsor in the wood. Through 1836 Boynton assisted with the work of painting, ornamenting, and varnishing and debited Howe's account directly. The following year he charged Charles Ingalls with "2 days work varnishing Howes Chairs."[296]

Chair production at Boynton's manufactory was greatest during the 1810s. In the 1820s the craftsman devoted increasing attention to his work as an ornamental painter and gilder. This high level of specialization, rare for a rural craftsman, became possible in the urban atmosphere that developed in Windsor as the community became a center of trade and style in the upper Connecticut Valley. A note on the town's flourishing prospect during the prime of Boynton's career describes "about eighty dwelling houses, mostly well built and commodious; . . . shops, stores, . . . many of them brick, and large, so that the business part of town has an air of dignity rarely met with in the country." The community was large enough to support three physicians, eight attorneys, two printers, and several merchants, along with a full range of craftsmen from a jeweler to coopers. Representing the furniture trades were three cabinetmakers and "one chair-maker and painter." Light industry included a gristmill and a woolen manufactory.[297]

Boynton's trade terminology of the 1810s permits reasonable identification of the seating patterns then fashionable. Bent-back styling prevailed, since there are few references to straight-back chairs. A new term is the "bell" back, which in Boynton's vocabulary referred to something other than a crest. A review of period seating presents two possibilities, both centering on the curve of the back posts. A bell back either flares from bottom to top in an exaggerated outward curve (fig. 7-98) or has posts that "belly" outward along their length (fig. 7-93).[298]

Chair "tops," or crests, were of several forms. Boynton was familiar with "single"- and "double"-bow (rod) chairs from his Boston days. Another pattern made and sold before his departure from the city in 1811 was the "fancy top," which in date and numbers identifies a stepped-tablet crest. Production continued at least until 1818. Boynton's broad- and narrow-top (fig. 7-33) chairs, their slats framed between the posts, are straightforward types; bamboo-grooved spindles would have been the rule rather than the flattened arrow, which emerged slightly later in New England work. The round-top chair current in accounts between 1814 and 1816 is not as obvious; a Boston candidate (fig. 7-32) may describe the general type.[299]

Seating depicted in portraits executed by Asahel Powers reflects in some measure the chair production of the Windsor area. The stepped-tablet crest, or Boynton's "fancy" top, is seen on tall rocking chairs depicted by Powers (fig. 7-93). Stylistically, the next pattern in the limner's work is the triple-back Windsor with short spindles. A set of three fancy-painted, triple-back chairs in the possession of Old Constitution House, Windsor, formerly owned by the Ascutney Chapter, Daughters of the American Revolution, may be a local product (fig. **7-95**). The quality of construction and decoration is that expected of a Thomas Boynton or Charles Ingalls. The half-spindle pattern describes the over-whelming influence of northern Worcester County styles on the work of adjacent regions (fig. 7-63), if, indeed, the chair is not of Massachusetts origin. Another crest, pictured in the likeness of Hannah Stedman (fig. **7-96**), springs from a similar source (fig. 7-65). Hannah and her brother John Quincy Adams Stedman are both seated in side chairs with rounded-end tablet tops fitted on the back posts without an overhang.

Another painting of a woman recovered in the region illustrates a rocking chair with the popular crown top dating from the 1830s. The enlarged, tablet-centered crest has a scrolled lip at the top and slim, rounded, tab-shaped ends (fig. 7-104).[300]

Through the years a disparate group of stepped-tablet and other Windsor patterns has been ascribed to the chairmaker or painter John N. White of Woodstock, Windsor County. The number is sufficient to raise serious question about the legitimacy of any attribution. Signed Windsors by this man are unknown. Among stepped-tablet chairs designated as White products are at least seven variants. To this may be added inconsistencies in seat shape, leg splay, post styling, back bend, and spindle shape—too many variables to expect within a single pattern group from a man who appears to have supplied only a limited local clientele.

John White (b. 1803) was the son of Francis White, who is said to have operated a chair shop on Happy Valley Creek between Taftsville and Hartland from the 1790s. John likely worked with his father and completed his training in the mid 1820s. Published sketches of the younger man's life place him in Woodstock only in 1838, an undocumented statement but one seemingly confirmed by Henry Swan Dana in a local history. Speaking of High Street, which he notes was opened and laid out in 1825, Dana mentions a brick house built by one Thomas McLaughlin in 1824 who "resided here for some years, then John N. White, painter, occupied it." The 1830s decade is much too late for production of the stepped-tablet chairs attributed to the craftsman. Thomas Boynton was making this pattern twenty years earlier in neighboring Hartland, and by the time White resided in Woodstock there would have been no market for this old-fashioned chair. White could have specialized in ornamental painting, however, and redecorated locally owned chairs that already had seen a generation of use. Before his residency in Woodstock, White may have worked with his father at the shop on Happy Valley Creek, the ruins of which were still to be seen in the middle of the twentieth century. The elder White died in 1839, the year following John's supposed removal to Woodstock.[301]

A child's rocking chair at the Woodstock Historical Society stands a reasonable chance of being a White family Windsor (fig. **7-97**). Its precisely stepped profile is that found in two highchairs in the society's collection and in a set of six side chairs owned in the Williams family of Woodstock and said, by tradition, to have been purchased from John White. Other central Vermont chairs employ the same crest (fig. 7-99), however, and the pattern has been noted in several chairs with southern New Hampshire histories. Spindles in the present chair thicken in a manner suggestive of pre-ball-spindle styling, of which examples also occur in New Hampshire (fig. 7-73). The posts not only bend to the rear but belly outward forming what may be the "bell back" referred to in Thomas Boynton's accounts. Another chair ascribed to John White without basis in fact has a pierced-slat crest with a raised tablet center; the profile generally relates to Wilder family work (fig. 7-84). On much safer ground is the attribution of a group of long benches to White's shop. Late in style, they feature overhanging, rectangular tablet tops, squared planks, and under supports framed "chairwise," that is, with groups of four legs—two front and two back—spaced below the seat and socketed in complementary angles, as if supporting individual chairs. White is credited with having made thirty-eight such seats for the Woodstock Town Hall and County Courthouse. The original bill of sale is said to exist. At the time of his death of typhoid fever in 1865, White was still active in business. His inventory contains materials for painting and ornamenting and a few hand tools. No lathe is listed; the "lot of chair stuff" on hand valued at $5 could have been useful in making repairs to damaged seating prior to repainting.[302]

Elsewhere in southwestern Windsor County a chair with a Weston history appears to be the work of a rural chairmaker who interpreted the stepped-tablet crest in a highly individual manner (fig. **7-98**). Even at midcentury the area around Weston, which is situated along the margin of the West River, was described as "very rough and mountainous." By that date there were ten sawmills, a gristmill and turning mill, and other light industry in the region. The village was the sort of semi-isolated agricultural community where an independent chairmaker could adapt a commercial pattern to his

Fig. 7-97 Shaped tablet-top child's rocking chair, south-central Vermont, 1820–30. Maple and other woods; H. 25½", (seat) 12¼", W. (crest) 15½", (arms) 16¼", (seat) 14½", D. (seat) 14¾"; dark brown ground with yellow and white (probably some repainting). (Woodstock Historical Society, Woodstock, Vt.: Photo, Winterthur.)

Fig. 7-98 Shaped tablet-top Windsor side chair, south-central Vermont, ca. 1814–20. White pine (seat, microanalysis); H. 35½", (seat) 17⅞", W. (crest) 20¹³⁄₁₆", (seat) 16", D. (seat) 15⅜". (Weston Community Club, Inc., Farrar-Mansur House, Weston, Vt.: Photo, Winterthur.)

personal design. The "creases" that mark the central tablet "steps" lend something of an architectural character to the top piece. The extreme flare of the posts produces another pattern that could qualify as an inverted "bell back." The chair is said to have been part of Hannah Dow's "setting out" when she married a Spaulding in 1814. No Dow family members appear in the 1810 or 1820 census for Weston, but by 1820 both a Jessie and a Simeon Spaulding were town residents.[303]

The Central Region

Less provincial than the Weston chair, though still suggestive of a rural orientation, is a Windsor that could be a product of central Vermont fig. **7-99**). Examples fitted as rocking chairs are associated by recovery area with the region extending north from Windsor County to Montpelier. One chair has been ascribed without foundation to John White, and although the crest relates to that of figure 7-97, the arms differ substantially. The typical chair has plain spindles in a bent back; the one illustrated can be considered a fancy example whose broad, flat sticks provided a suitable surface for ornamentation. With their extra long "pipestem" tops, the spindles introduce a note of provincialism. Other rural features are the extended arm reach and exaggerated forward angles of the supports. The stepped-tablet profile is close to work executed by the Wilder family (fig. 7-81). The hollow-contoured extension, above, features either a tipped rail, as illustrated, or a flat-arched slat with rounded ends. The bamboo legs, tapered top and bottom, are designed specifically to tenon into rockers. Plain-spindle chairs have a tablet-centered front stretcher of the Boston type (fig. 7-33).

The counties of Rutland and Addison in western Vermont provide evidence of early nineteenth-century chairmaking. In East Hubbardton, a village northwest of Rutland, Norman Jones (1790–1874) worked as a cabinetmaker. His father, a chairmaker of Raynham, Massachusetts, had resettled in Vermont before Norman's birth. Attesting to

Fig. 7-99 Shaped tablet-top rocking chair with top extension, central Vermont, 1820–30. Maple and other woods; H. 43⅛″, (seat) 15⅞″, W. (main crest) 18″, (arms) 22⅛″, (seat) 19¼″, D. (seat) 19⅜″. (Williams College Museum of Art, Williamstown, Mass., bequest of Charles M. Davenport: Photo, Winterthur.)

Norman's productivity is a body of family furniture, miscellaneous documents, a manuscript price book, and a notebook containing drawings, specifications, paint recipes, and the like. In the hands of descendants is a set of six plank-seat chairs dating no earlier than the 1840s. Rectangular seats are rounded at the front above a short chamfer and form a serpentine curve along the sides. In the backs are broad, vertical, vase-shaped splats flanked by cylindrical posts with one large ball turning near the bottom. Crowning all are deep rectangular tablets with concave ends.[304]

Norman Jones's price book describes his dealings with the furniture craftsman Hastings Warren of Middlebury. Jones carefully recorded prices agreed upon by him and Warren in the late 1820s or 1830s for furniture to be supplied to the Middlebury shop. Warren, who had been in business for more than two decades at this time, began as a partner to his father-in-law, William Young, about 1801 or 1802. The younger man launched out on his own late in 1805. In a November advertisement he offered cabinet-ware and chairs described as "Cottage, Bamboo, Dining, and Common." A fire in 1814 consumed the shop and also destroyed a stock of raw materials and the tools of "10 or 12 Workmen, which were constantly employed." Fortunately, Warren's warehouse containing finished furniture was located elsewhere in town. Furniture sales enabled the craftsman to rebuild and recover his financial losses. By the time of his association with Norman Jones, Warren was an entrepreneur engaged in many activities. Shop management and production were in the hands of others.[305]

Written and visual evidence illuminate Orange County chairmaking north of Woodstock and Hartland. Theodore Cushing, who advertised as a Windsor-chair maker at Salisbury, New Hampshire, in 1803–4, removed with his family to Thetford along the Connecticut River in 1806. His young son Samuel evidently followed the same trade. Both men resettled in New York state in the 1830s. In western Orange County at Randolph one M. Church pursued the chairmaking trade for a time following the War of 1812. A hollow-cornered, slat-top side chair bears his name and location stencil on the plank (fig. 7-100). The pattern has its parallel in eastern New England work. Minot Carter of New Ipswich produced a larger version of this top piece at the close of the 1830s in combination with obvious late features (fig. 7-85). A more emphatic interpretation is found in the Farmington, Maine, work of Daniel Stewart, who died in 1829. But the particular silhouette of this chair identifies Church's background as northern Worcester County, Massachusetts, a center of major influence throughout most of northern New England from the 1820s on. In the shallow top piece and cylinder-capped back posts the chair relates to a Windsor constructed by Spooner and Thayer at Athol, Massachusetts (fig. 7-56). Church is something of an enigma in Vermont records, since his name is missing from the census lists. He appears to have drifted into Orange County from the southeast, worked for a time, and moved on.[306]

Charles C. Cotton emigrated to Brookfield, Vermont, just north of Randolph, between 1810 and 1820. A native of Pomfret, Connecticut, he is known to have practiced Windsor-chair making there at the start of the century (fig. 6-127), several years after his first cousin, chairmaker Thomas Cotton Hayward, emigrated from Pomfret to Charlestown, Massachusetts. The census places Cotton in Brookfield through 1830, and after his first wife's death he remarried there on January 12, 1832. Existing records do not indicate whether he continued to practice his trade in northern New England. Ara Howe (b. ca. 1798) was, perhaps, just establishing himself in the area at this time. Several chairs of late style bear his paper label or stamp (fig. 7-101). All feature a loaf-type tablet top cut with two small ogee arches along the lower edge. One is a Boston rocker with a spindle back, raised seat, and fancy-turned front legs and stretchers; the others are as illustrated. A loaf-shaped top cut with round arches seems to have preceded the ogee top, since one such crest is painted with a scene representing William Henry Harrison's "Log Cabin and Hard Cider" campaign of 1841. The vase-style banister presented an alternative to spindles during the 1840s; the model occurs in cabinetwork of the 1830s. The introduction of the squared plank, or shovel-shaped seat, to New England chairmaking is another development of the 1830s. The front supports are a modified version of the turkey leg

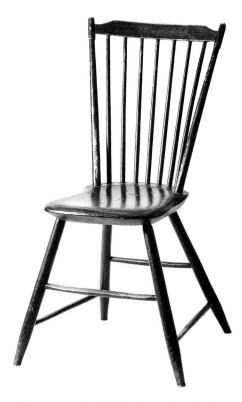

Fig. 7-100 Shaped slat-back Windsor side chair, M. Church (stencil), Randolph, Vt., 1815–20. Basswood (seat, microanalysis); H. 33¼″, (seat) 16⅝″, W. (crest) 17¼″, (seat) 13½″, D. (seat) 15³⁄₁₆″. (Bennington Museum, Bennington, Vt.: Photo, Winterthur.)

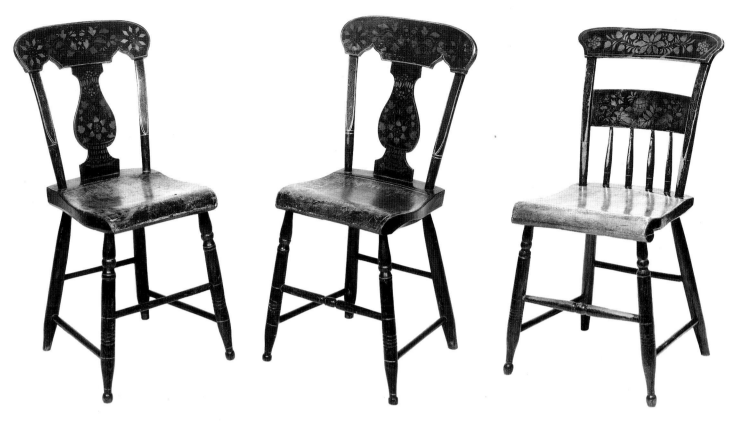

Fig. 7-101 Rounded tablet-top, splat-back side chairs (two of six), Ara Howe (stamp "A R A HOWE"), Brookfield, Vt., 1840–50. (*Left*) front stretcher replaced. (Photo, Sotheby's.)

Fig. 7-102 Rounded tablet-top side chair (one of five), central Vermont, 1840–50. White pine (seat); H. 33″, (seat) 17¼″, W. (crest) 17⅞″, (seat) 15½″, D. (seat) 14⁹⁄₁₆″; dark and light brown grained ground with yellow and gilt, seat pale yellow mottled with green. (State of Vermont, Division for Historic Preservation, Old Constitution House, Windsor: Photo, Winterthur.)

popular from the late 1820s (fig. 7-22). The same supports and front stretcher are seen on a set of unmarked side chairs (fig. **7-102**). Here, the smaller loaf-shaped tablet is without cutouts and the ends are patterned in distinctive points. The broad, slightly arched cross slat at midback anchors short, exceptionally thick spindles of a kind that usually have a ball turning. Seats with an applied front roll date somewhat earlier than the elliptical-front plank of the Howe chairs.[307]

The Northern Region

Both chairs and documents confirm the manufacture of Windsor furniture in Caledonia County. Dining chairs are listed in several Barnet household inventories before 1820. A dining Windsor of single-bow, square-back form is described through an inscription under the seat as originating in Danville to the north in 1815 (fig. **7-103**). The craftsman introduced fairly individual styling to both the turned and hand-shaped elements. The provincial overtones of the seat are expressed in its shallow, saucerlike quality heightened by a deep chamfer and sharply defined edges. The choice of a support structure of earlier style, comprising three-part bamboo legs and H-plan braces, does not seem out of character here. The selection suggests that the chairmaker had previous trade experience. As in the Church Windsor (fig. 7-100), some features illuminate the maker's origin. Here, eastern Connecticut or the Rhode Island border are likely possibilities. The seat compares favorably with figure 6-87; related supports emphasizing swells and hollows are seen in the work of Tracy family members and others (figs. 6-114, right, 6-119, 7-9). A Tracy square-back chair has cylindrical post tops, a form simplified here.[308]

Before 1820 chairmaker Samuel Ingalls settled at Danville. He had been a resident of Ryegate, a village south of Barnet, where he was enumerated in both the 1800 and 1810

census. In 1805–6 his name was recorded in the accounts of Robert Whitelaw, a local resident. Whitelaw owned a large, productive farm, kept a tavern, and manufactured spinning wheels. Ingalls made purchases of rum, which he paid for with various crafted products, including a "little Chair" and "nine Small Buttons . . . turned." The chairmaker removed to Danville, a good farming country well watered by streams, before 1820 when he operated a two-man chair factory equipped with a lathe and paint mill. The annual market value of Ingalls's "Chairs of *the best quality*" was $1,000, and he commented that business was "better than it has ever been heretofore—Demand increasing." That statement is in marked contrast to most others in the manufacturing census, but eventually the hard times caught up with Ingalls, too.[309]

Sometime during the 1820s the chairmaker apparently left Danville temporarily, since his name does not appear there in the 1830 census. At this date a Samuel Ingalls was a resident of Peterborough, New Hampshire, near New Ipswich, where he had business connections with the chairmaking Wilder family. Ingalls returned to Vermont before 1840. Dating to this general period is a chair that bears his initial brand (fig. **7-104**). The stamp is slightly smaller than that used on the Wilder chairs, although the crude character of the letters is similar. Ingalls's crown top is cut to the same narrow-ended pattern seen in an Asahel Powers portrait of the early 1830s. Here, other features indicate a later period. The raised seat probably was first used only about the mid 1830s, although the large size and thickness of the present plank advance the date. The chair back of four as opposed to five spindles reinforces this line of thinking.[310]

Montpelier, twenty-eight miles southwest of Danville, became the Vermont capital in 1805. During the next quarter century the town commanded an extensive trade, although its inland site was removed from water transportation. The community also functioned as the seat of Washington County, the hub of several stage lines, a center of local light industry, and, in time, a station along the Vermont Central Railroad.[311]

The 1820 manufacturing census lists only one chair and cabinet manufactory in Montpelier, that of John and Cyrus Wood. The brothers were natives of Leominster, Massachusetts, where, presumably, they received their training. Based upon their ages at death, the men appear to have been twins (b. 1788). With their brother Zenas (b. 1793) they are said to have left Leominster about 1809 to settle in Lebanon, New Hampshire, where the names of John and Cyrus are recorded in the 1810 census. About 1814 the

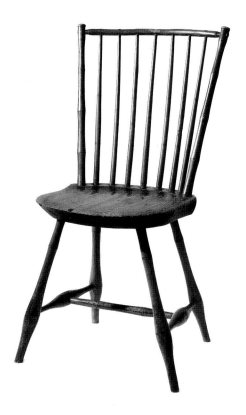

Fig. 7-103 Square-back Windsor side chair, attributed to Danville, Vt., ca. 1815. White pine (seat) with maple and other woods; H. 36″, (seat) 17⁹⁄₁₆″, W. (crest) 19³⁄₈″, (seat) 16³⁄₈″, D. (seat) 15¼″. (Mr. and Mrs. John H. Hodgson collection: Photo, Winterthur.)

Fig. 7-104 Low crown-top rocking side chair with scroll seat and detail of brand, Samuel Ingalls, Danville, Vt., 1840–50. H. 32″, (seat) 15″, W. (crest) 19¾″, (seat) 16½″, D. (seat) 17″; dark brown and brick-red grained ground with yellow, gilt, and other colors. (Vermont Historical Society, Montpelier: Photo, Winterthur.)

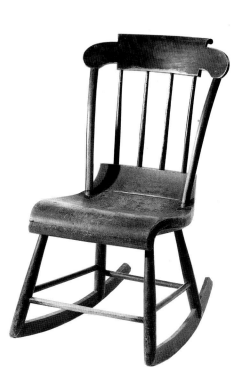

Fig. 7-105 Rounded tablet-top side chair and detail of stencil and label, Lyman N. Howe, Montpelier, Vt., retailed by E. D. Carpenter, Wells River, Vt., 1855–70. H. 31½", (seat) 17⅜", W. (crest) 17½", (seat) 14¾", D. (seat) 15"; dark and reddish brown grained ground with yellow, white, black, green, pinkish red, gilt, and bronze gilt; seat mustard-orange with swirled orange-brown. (Hitchcock Museum, Riverton, Conn.: Photo, Winterthur.)

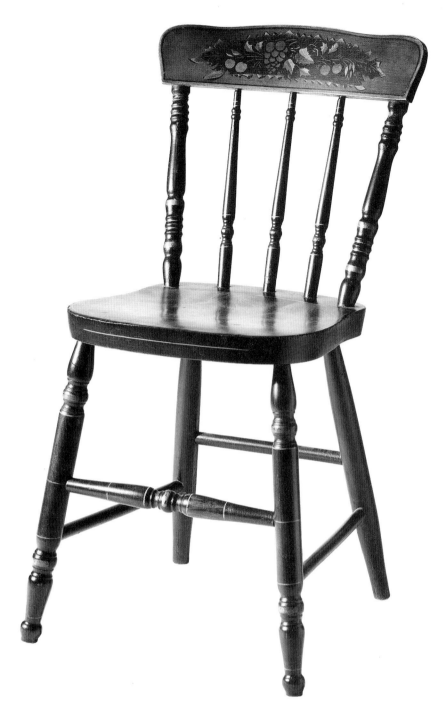

brothers moved to Montpelier, where the industrial survey of 1820 reports the employment of three men in their manufactory, none of whom received wages as such, suggesting that all three were family members. Although Zenas was later the proprietor of a stove and tinware business, he may have spent his early manhood in the woodworking trade with his brothers. The factory products were cabinetware and Windsor chairs; unfortunately, no chairwork documented to the Wood brothers is known. Their earliest seating probably had a stepped-tablet crest. The elder brothers supposedly maintained their business association until Cyrus's death in 1840. His identification as a merchant indicates that the basic business structure had changed or at least diversified.[312]

Lyman N. Howe commenced chairmaking at the state capital some years later; perhaps he filled a vacancy left by the Wood brothers. His marriage in 1852 may signal the beginning of his career. Several chairs of late design (fig. **7-105**) are documented to his establishment. The label on the illustrated chair reads: "Made and Warranted by L. N. HOWE, MONTPELIER, VT." The chair is further stenciled with the name and

address of its retailer, E. D. Carpenter of Wells River, a town situated along the Connecticut River just south of Ryegate. The stencil is placed over the label. Howe's chair, which is typical of the post-1850 period, retains the loaf-shaped tablet introduced prior to midcentury but adds a low serpentine curve to the top edge. Turned work of the period exhibits an increasing use of small round shapes reintroduced only sparingly to plank seating before midcentury. There is no mistaking these turnings for eighteenth-century work. Both delicacy of design and deftness of execution are missing; the machine, not the craftsman, was master.[313]

MAINE

Commerce and waterpower were significant in the development of Maine. Observations by an early nineteenth-century traveler tell the story:

The objects of first importance . . . are *mills*. If farms are cultivated, then mills are wanted, to make flour of the grain; but if . . . the *lumber-trade* precedes farming, . . . then mills are indispensable, for sawing boards and plank. The place, therefore, at which a village begins, is either a sea-harbour or other *landing*, where country-produce is exchanged for foreign merchandise, or it is a cataract on a river, or some situation capable of affording a *mill-seat*. . . . To this mill, the surrounding *lumberers* . . . bring their logs. . . . The owner of the saw-mill becomes a rich man; builds a large wooden house, opens a shop, denominated a *store*, erects a still, and exchanges rum, molasses, flour and pork, for logs. . . . A flour-mill is erected near the saw-mill. Sheep being brought upon the farms, a carding machine and fulling-mill follow. . . . The *mills* becoming every day . . . a point of attraction, a blacksmith, a shoemaker, a taylor, and various other artisans . . . assemble. . . . [Thus,] a settlement . . . is progressively formed . . . [which] constitutes itself a socity or parish; and, a church being erected, the village, larger or smaller, is complete.[314]

Some artisans drawn to or born in Maine villages of this description were workers in wood. The life of Benjamin Webber, possibly the maker of a bow-back Windsor side chair stamped with an initial and surname, seems typical. Estate records of 1826 show that he owned and farmed a homestead of 125 acres in Shapleigh, York County. His shop contained a set of basic woodworking tools augmented by various kinds of saws, augers, drilling tools, an adz, and turning lathe. No doubt Webber regularly exercised his right to "2½ days in 24 in the sawmill called Morrisons mill" located just to the south in Sanford. By 1823 regular steam navigation had begun between Boston and Maine's commercial centers of Portland and Bath; the water routes soon extended up the Kennebec to Augusta and along the coast to Eastport bordering New Brunswick. In 1820 Maine achieved statehood, and the stage was set for substantial, steady growth. With expansion came a fast rising market for household furnishings that offered encouragement to old and new generations of cabinetmakers and chairmakers.[315]

York and Cumberland Counties and Portland

Although southern Maine was lightly settled as early as the seventeenth century, there is little evidence of furniture making before the nineteenth century. Except for basic furnishings, most casework and seating probably originated in other areas. Many busy little ports dotted the seaboard—York, Kennebunk, Saco—and the coasting trade flourished. Close ties were maintained with Portsmouth and Boston. Even in the early nineteenth century chairmaking evidence is scant. Limited information indicates that craftsmen were more occupied with repairing old seating than in making new. Nathaniel Knowlton, an apparently successful cabinetmaker at Eliot on the Piscataqua River, made a few popularly priced chairs now and again during the 1810s and 1820s, although his primary work centered in such tasks as making chair rockers, painting, and varnishing. Upon occasion he turned his hand to odd jobs, including mold construction for a local brickworks, one of Maine's important industries.[316]

At Alfred, the county seat, George W. Rogers operated a four-man shop in 1832 to supply local demand for "furniture of various kinds"; the output was valued at $1,000

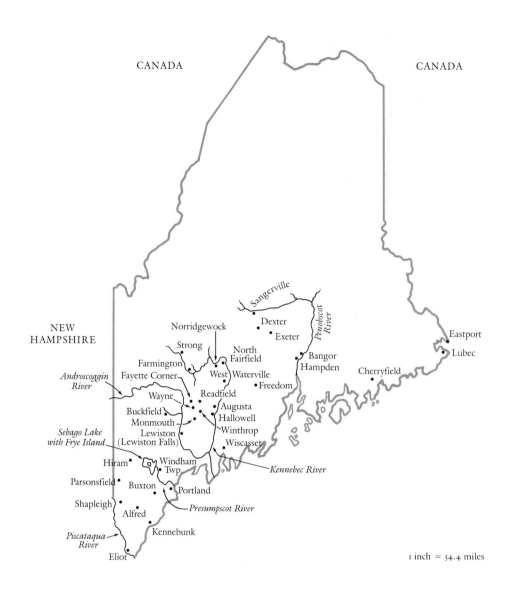

1 inch = 54.4 miles

annually. On the coast at Kennebunk Paul Jenkins's work appears to have paralleled that of Nathaniel Knowlton. In 1837 he constructed a set of "kitchen" chairs, but otherwise his activity in this line consisted almost entirely of repairs—new rockers, a replacement arm for a rocking chair, a "new Stick" in a chair back, and painting. Like Rogers, he employed several hands. A late Windsor bench from a church in Kennebunk branded "I B WOOD" on the pine plank has cylindrical bamboo turnings, heavy scroll arms, and a rectangular, board-style tablet top. The only reasonable candidate in York County is a John B. Wood who was a resident of Lebanon, near the New Hampshire border, in 1830, although the bench dates closer to 1840. Oliver Allen came to Maine as a semimigratory furniture maker from Utica, New York. He was in Hiram briefly around 1844 before moving on to Parsonsfield in 1845 where he constructed tables, bedsteads, and fancy and rocking chairs in limited number. A year later he moved to Massachusetts.[317]

Portland was the coastal center for furniture making in nineteenth-century Maine, and following statehood the craft began to flourish there. The location of "old" Portland is a peninsula flanked on one side by Casco Bay and on the other by a good, landlocked harbor. Henry Tudor reported a population of about 9,000 in 1831. Trade was considerable, reaching to Boston, the West Indies, and Europe; the principal occupation was shipbuilding. The community's prosperity was reflected in its buildings. In viewing Congress Street, which follows an elevated ridge along the peninsula, one traveler noted "a number of very elegant private houses," among them a three-story brick dwelling built in 1785, known today as the Wadsworth-Longfellow House. Visitors remarked the quality of the public buildings; however, all was not entirely neat and orderly. Carl David Arfwedson noted in 1832 that the streets were "neither paved nor Macadamized . . . [and] in such bad condition, that passengers ran the risk of being every minute engulphed in a mud-hole." By 1842 railroads linked Portland with Portsmouth and the latter with Boston; other lines followed.[318]

Within this setting Windsor-chair making in Maine came into its own in the 1820s. Already at the beginning of the century Portland was influenced by Philadelphia painted seating. The firm of John Warder and Sons sent "One Settee & Six Bundles of Chairs" to a local consignee in August 1804; other shipments followed during the next several years. Even as late as 1825 chairs from Philadelphia found a city market. By that date Portland businessmen themselves had ventured an occasional chair shipment to the West Indies.[319]

The inventories of several local residents, compiled to satisfy court suits in 1808, document the presence of black fan-back Windsors in the city. Square-back patterns soon followed, although to date only a pair of double-bow chairs is actually documented locally (fig. 7-106). The brand "ELI WEBB" is found on the plank bottoms, but whether he was the maker or owner is unknown. Until 1956 the chairs were in the possession of a Portland resident. That fact and data from New England census records confirm the local origin. Between 1800 and 1820 Webb's name appears only in Maine listings for Cumberland County or Portland. Comparison of the chair with square-back seating from other areas reveals a close affinity to Boston work (figs. 7-27, 7-28). Of course, the chair could have been imported and then stamped; however, the leg turnings bear a marked relationship to later Maine seating (figs. 7-107, 7-111).[320]

Fashions had changed measurably by the 1820s, and seating of totally different patterns was current. The flat-spindle Windsor is known in several crest variations. One group has a close-fitting rectangular tablet (fig. 7-107). Characteristically, the spindles are especially broad for their type, the flat part confined to the top half. A pair of grooved rings marks the post bases below the shaved faces. Typically, seats are rounded at top and bottom to form knifelike edges at the front and sides. Legs taper markedly both above and below the lower groove, forming delicate feet at the base. The illustrated chairs are branded with the name "HAGGET" preceded by a symbol. John Hagget and Joseph Very announced a Portland partnership on August 25, 1818, which continued somewhat more than a year before Hagget advertised on November 16, 1819, that he was continuing the business alone. These facts explain the presence of the symbol—the remnant of an ampersand—in the Hagget brand. With the partnership dissolved Hagget altered an existing iron by removing Very's name. Whether John Hagget was related to Amos Hagget, the chairmaker of Charlestown, Massachusetts (fig. 7-28), who migrated to New Brunswick in 1817, is unknown. Maine census records from 1820 through 1850 list an Amos at Edgecomb, a coastal town of Lincoln County.[321]

A single chair of identical pattern was branded by "BENJ.N NEWMAN" of Gloucester, Massachusetts. The chairmaker is identified in Massachusetts records at various periods; his name is absent from the 1820 census, however. At that time he was a resident of Portland. A third name, M. Rounds, was reported on each of six Windsors making up a set thought to have originated in Portsmouth, New Hampshire, when auctioned in 1961. Between 1810 and 1850 Mark and Moses Rounds were residents of Buxton, a community about ten miles west of Portland.[322]

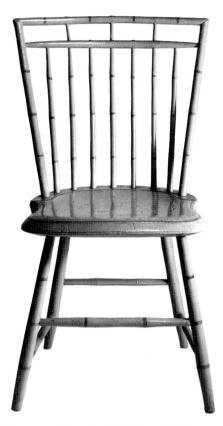

Fig. 7-106 Square-back Windsor side chair (one of a pair), Eli Webb (brand "ELI WEBB"), Portland, Me., 1805–15. H. 31¼", W. 19¾", D. 17½". (Photo, New Hampshire Historical Society, Concord.)

Fig. 7-107 Tablet-top Windsor side chairs (pair) and detail of brand, John Hagget, Portland, Me., 1819–30. White pine (seat) with beech and birch (microanalysis); H. 36¾″, (seat) 17¼″, W. (crest) 19⅜″, (seat) 17¾″, D. (seat) 16⅛″. (Winterthur 70.437.1,.2.)

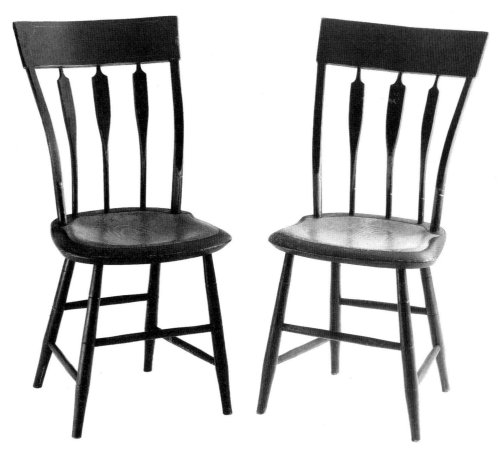

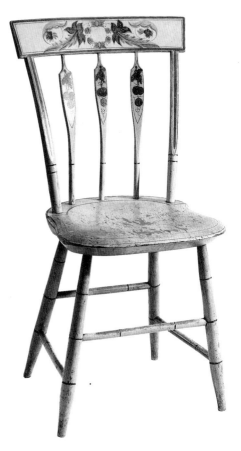

Fig. 7-108 Tablet-top Windsor side chair (one of six in mixed set), Elisha Trowbridge (stencil and crayon inscription), Portland, Me., 1822 (dated). White pine (seat); H. 35″, (seat) 17¹¹⁄₁₆″, W. (crest) 19¼″, (seat) 16⅝″, D. (seat) 15⅞″; light mustard-yellow ground with olive-green, dark brown, light orange, and medium-light gray. (Private collection: Photo, Winterthur.)

There is a close relationship between the pair of Hagget arrow-back chairs and other work associated with Portland. Five side chairs (fig. **7-108**) en suite with a rocker bear the stenciled name "E. TROWBRIDGE," with further documentation in pencil reading "E. Trowbridge / Portland / 1822." That date probably marks closely the chairmaker's entry into the Maine furniture trade, since census records list him first in 1830. The Trowbridge tablet varies and improves upon the Hagget crest pattern by introducing a pronounced overhang and reducing the height. The double post grooves remain, and the seats and support structures are comparable. The hand-painted, symmetrical crest decoration on a pale mustard ground is particularly delicate in form and color—light orange edged with gray. The accents are dark brown, the color of the penciling; the banding is olive green. The pendent grapes of the spindles are a recurring feature in Portland work (figs. 7-110, 7-111).[323]

Still another variation introduces a slat-style crest to the Portland chair. A particularly ornamental interpretation substitutes an urn-shaped spindle at the center (fig. **7-109**), a motif probably based directly on an ornamental element in Boston fancy rush-bottom seating. The double grooves that mark the lower back posts are filled with color to simulate a ring turning. The rocker forms a set with several side chairs, all part of the family furnishings at the Wadsworth-Longfellow House on Congress Street. Other Portland rocking chairs constructed with low backs are heightened by an extension piece providing support for the sitter's head.

An angular crown is used as a slat-type crest mounted between the posts in a small group of distinctive side chairs with particularly large arrow spindles of the long-stemmed type under discussion. Representative of the pattern is a side chair with painted decoration that can only be described as spectacular (fig. **7-110**). Long called a Rhode Island chair, the Windsor is more logically attributed to Maine, where it probably originated in the vicinity of Portland in the late 1820s or 1830s. While the decoration is not as sophisticated in subject as that of the Wadsworth-Longfellow or Trowbridge chairs, it is a competent and imaginative performance by a craftsman trained in the ornamental and sign-painting tradition. The grape clusters are a variant of the

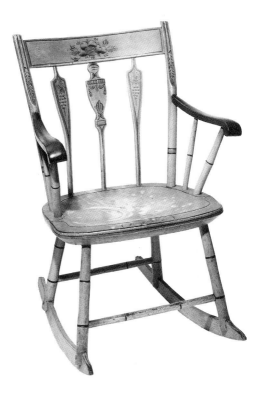

Fig. 7-109 Low slat-back rocking chair (one of five in mixed set), Portland, Me., 1820–30. White pine (seat) with beech and birch (microanalysis) and mahogany (arms); H. 32¼″, (seat) 15″, W. (crest) 19⅜″, (arms) 21¾″, (seat) 18¾″, D. (seat) 17″; pale yellow-beige ground with dark brown, light mustard-yellow, and gilt. (Maine Historical Society, Wadsworth-Longfellow House, Portland: Photo, Winterthur.)

Fig. 7-110 Shaped slat-back Windsor side chair (one of a pair), southern Maine, ca. 1828–35. White pine (seat); H. 36¼″, (seat) 16⅝″, W. (crest) 16¼″, (seat) 16¼″, D. (seat) 15⅜″; dark brown ground with bright and mustard-yellow, brown, wine-red, and naturalistic landscape browns and greens. (New York State Historical Association, Cooperstown: Photo, Winterthur.)

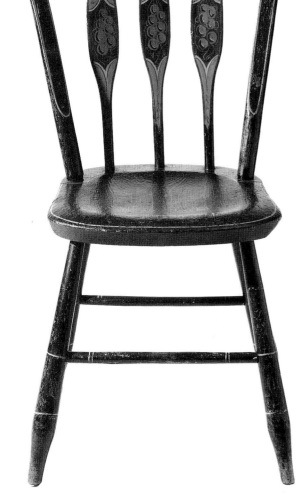

Fig. 7-111 Shaped tablet-top Windsor side chair (one of six), William Capen (label), Portland, Me., 1828–40. White pine (seat); H. 34¼″, (seat) 17⅜″, W. (crest) 19⅝″, (seat) 17½″, D. (seat) 15¹³⁄₁₆″; original decoration restored. (The late Lowell Innes collection: Photo, Winterthur.)

popular local motif. Another side chair of the same crest profile was recovered in a farmhouse near Limerick, just west of Portland. The decoration consists of fanciful seashells on the crest and pendent acorns on the spindles. The crest profile owes much to the stepped tablet developed earlier in Boston (fig. 7-36), but there may also be a kinship with the Massachusetts arch-top slat (figs. 7-60, 7-61).[324]

Several side chairs with the same crest elevated to the post tops can be ascribed to local craftsmen. Representative of the group is a rare example of the work of William Capen, Jr. (fig. 7-111); its original, retouched decoration again features grapes and leaves

New England, 1800 to 1850 539

on the flat spindles. The strong compartmental crest banding imparts a bannerlike quality to the ends. Between 1824 and 1827 Capen (b. ca. 1801) occasionally patronized the Portland shop of turner Increase Pote, as noted in Pote's accounts. By 1830 city directories indicate that Capen had given up chairmaking in favor of sign and chair painting, suggesting perhaps that he only decorated the illustrated Windsor. Another chair, its tablet of trapezoidal rather than rectangular form, bears the brand "E. MARCH" on the plank. Edward March, a cabinetmaker, is listed in the Portland directories of 1830–31, but there are no entries for him in the 1827 and 1834 volumes. The branded chair possesses a family history in nearby Yarmouth. Its dark-painted ground features large gilt grape leaves in the crest. The seashell motif noted previously occurs on an angular-crown chair of intense blue-green ground. There another motif, the pendent bellflower, is featured in the flat spindles. In less capable hands that decoration some-times takes on the character of a suspended peapod. Spring and Haskell, partners at Hiram about thirty miles northwest of Portland, branded another example. The circle of documented angular-crown seating widens with the appearance of a side chair signed by W. J. Berry, an owner or maker of Fayette Corner, a village some distance north of Portland in Kennebec County. The Berry chair crest is mounted between the posts flush with the top. One extra-embellished set of four side chairs with crest pieces overhanging the back posts has small cutout scrolls at the upper corners of the central rectangular tablet. The scrolls, which are incorporated into the banded and penciled borders outlining the top piece and its central decoration of grapes and leaves, are painted with tiny faces that speak to the subtle humor of the decorator.[325]

Increase Pote's Portland account book includes a brief record of business dealings with two chairmaking firms besides that of William Capen. In May 1828 J. and D. Mountfort acquired "Stock for 1250 common [Windsor] chairs" and "100 Fancy D[itt]o" from the turner. A notation by Pote in the margin next to the first entry reads: "18,750 Peases Com[mon]." Each arrow-spindle side chair illustrated, including that documented to Capen's shop, contains fifteen individual parts. Simple arithmetic indicates that the Mountforts framed and painted "common" chairs of this general form, perhaps substituting plain rectangular crests. Less than a year later Abiel Somerby bought selected chair parts from Pote, comprising 248 chair backs (crests) at 2¢ apiece and 3,849 sticks at 81¢ per hundred. There follows in local records a hiatus of several years when Portland chairwork cannot be documented, although the 1831 directory lists six chairmakers or turners at work. The 1834 volume lists several fewer. In 1836, however, there arrived in Portland a man whose name was to become and remain synonymous with cabinetmaking and chairmaking in the city.[326]

Walter Corey was born in 1809 at Ashburnham, Massachusetts, where he likely learned the woodworking trade along with Jonathan O. Bancroft, his future brother-in-law and business associate. After leaving Ashburnham both men worked briefly in Boston before relocating in Portland. Boston directories list Bancroft as a chair *dealer* between 1833 and 1835. He acquired his stock at Ashburnham from Woods, Stevens and Company and possibly from John C. Glazier, his brother-in-law, both of whom he had associations with before removing to Boston. In 1830 Bancroft married Lucinda Corey, sister to Walter. A set of four slat-back, ball-spindle side chairs branded with Bancroft's name probably dates to his Massachusetts period, based on the style. Walter Corey's name is found in Boston directories only in 1835, both alone and as an agent for J. C. Glazier. In their study of Corey's business career, Shettleworth and Barry state that the entrepreneur arrived in Portland in 1836. Bancroft appears to have left Boston at or about the same time. The furniture enterprise built by the two men, under Corey's name, flourished until the early decades of the twentieth century in the hands of successors. Shettleworth and Barry write that Corey "bought out the cabinetmaker Nathaniel Ellsworth on Exchange Street, and opened a 'cabinet warehouse.'" The concern grew rapidly. Corey handled business affairs and dealt with customers, and Bancroft super-vised the manufacturing process. The *Eastern Argus* reported on June 2, 1840, that chair production alone numbered 300 to 500 items per week. Corey's advertisement in the

Portland directory the following year lists the output of the "Chair Factory": "Curled Maple, and common cane seat CHAIRS; Fancy and common wood seat d[itt]o.; Cane Seat, common Rocking and Nurse Chairs." The heading for the same notice, "FURNI-TURE, CHAIRS, FEATHERS, &C.," describes the business scope. (Feathers were an essential component of mattresses, called beds, and of pillows and cushions added to seating furniture for comfort.)[327]

Corey's progress as a businessman is chronicled succinctly in the Cumberland County land records where he is called a trader in 1843, a merchant in 1850, and a gentleman in 1852. The rapid success of the enterprise dictated an expansion of facilities and close control over sources of raw material. In 1842–43 Corey purchased water rights and land in Windham at the "Great Falls" of the Presumpscot River, a stream that afforded "excellent water power for mills and manufactories, seldom affected by freshets or drought." According to Shettleworth and Barry, Corey constructed a large building at the falls where he employed about twenty-five men to saw timber and turn heavy work. Corey added a house lot to his buildings in 1850, but whether for his own use or a site supervisor is unknown. As early as 1846 the furniture manufacturer began acquiring land at Sebago Pond (Lake) to procure timber. He purchased a series of lots on Frye Island, where one of the grantors reserved the right to continue removing wood, timber, and bark—a provision that later caused some little controversy. The matter was settled with Corey paying $100 and obtaining the complete privilege for himself. Many of the notes passed in the transactions were secured by Jonathan Bancroft. The Sebago purchases continued through the mid 1850s. An occasional deed gives some idea of the timber range: hardwood growth, red oak, pine, hemlock, and spruce. Presumably, Corey's men were able to float the timber cut on Frye Island to the head of the Presumpscot and downstream to the mill.[328]

The *Portland Transcript* for April 27, 1850, reported that Corey's Portland works contained an acre of floor space devoted solely to furniture framing, finishing processes, and retail activities. In addition, there were specialized departments for carving, uphol-stery work, and the like. The same publication valued the annual output at $75,000 and noted that Corey's markets were mainly in Maine and the West Indies. According to city directories, Increase Pote had become a turner at Corey's by 1847. When the manufac-turer enlarged and improved his establishment on Exchange Street in 1859, William Capen painted "the beautiful signs that ornament[ed] the building." The following year the community mourned the death of Jonathan Bancroft. In 1866 disaster struck twice in rapid succession. On June 16 fire destroyed the machine shop, and less than a month later Corey lost his entire business in a conflagration that began in a boatyard and leveled a large section of the city. Thereafter, the businessman became a furniture distributor rather than a manufacturer.[329]

As expected, Walter Corey's early Portland chairwork reflects his previous associa-tions with Boston and Worcester County (fig. 7-64). First in production was a roll-top side chair with short spindles and fancy front legs and stretcher. The squared, serpentine plank forms a thick, blunt ellipse at the front. The stenciled identification on the bottom includes Corey's address at 19 Exchange Street, a site occupied between 1836 and 1841. Of identical back is an undocumented Windsor (pl. 24), one of a set of six, retaining extraordinary painted decoration and several structural embellishments that mark it as a top-of-the-line product that must originally have commanded a premium price. The front supports are a variation of Corey's usual fancy work (fig. 7-112), introducing two squared ball turnings and a carefully delineated intervening spool. The feature is reversed in the stretcher. A shaped piece of wood attached to the seat front produces a full roll. The carefully executed grained, stenciled, and penciled ornament forms a vocabulary of the best contemporary decoration. The compote featured in the cross slat appears identical to one in a documented Corey fancy chair with a cane seat.[330]

During the 1840s a loaf-shaped tablet became one of the factory's standard crests (fig. **7-112**). The illustrated example probably represents the "fancy" model. A stenciled address on the seat bottom for Nos. 52 and 54 Exchange Street dates the chair, at the

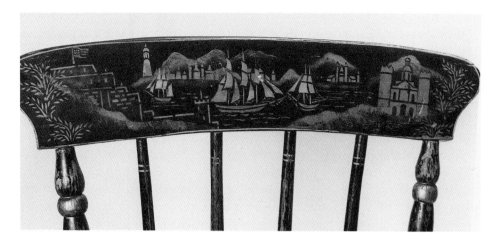

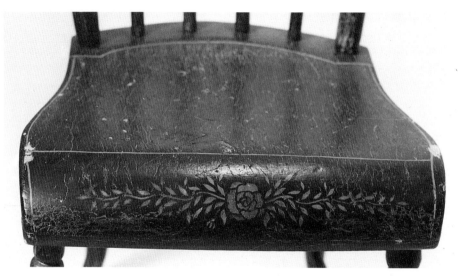

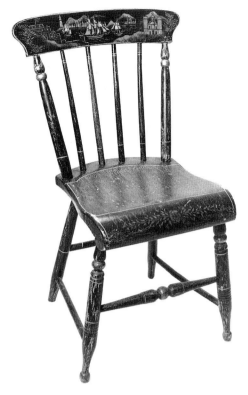

Fig. 7-112 Rounded tablet-top Windsor side chair, and details of crest and seat front, Walter Corey (stencil), Portland, Me., ca. 1844–55. Basswood (seat) with beech and birch; H. 33″, W. 19¾″, D. 18⅛″; black and dark red grained ground with gilt, bronze, silver, gold, and copper. (Earle G. Shettleworth, Jr., collection: Photo, Maine State Museum, Augusta.)

earliest, to 1842 when Corey first occupied this site. When merchandising the same chair at a cheaper price, the manufacturer reduced the depth of the crest, eliminated fancy turnings from the posts, legs, and front stretcher, and used a plain shovel seat without a front roll. Painted ornament was probably kept to a minimum as well. Perhaps that was his "substantial chair" priced as low as 37½¢, as reported by the *Argus* in 1843. The stenciled scene of Portland Harbor across the illustrated crest is one of several views used by the firm in its "top line" Windsors. Corey's directory advertisement of 1850 describes "Rich Chamber Sets—landscape and flowers," a reference, no doubt, to seating as well as cabinet furniture. Floral and fruit forms are also found among documented work. Somewhat less ambitious in decoration, these chairs may represent Corey's middle-priced Windsor. Loaf-pattern chairs were also offered for sale at the Portland furniture rooms maintained by Todd and Beckett between 1844 and 1849. Primarily looking-glass makers, the partners could have bought their seating furniture from Corey. A rocking side chair with their identification has all the earmarks of Corey work. At West Waterville, north of Augusta, Joseph Bachelder made chairs of similar pattern, although subtle variations distinguish his work from the Portland Windsors.[331]

Concurrent with his production of plank, or common, chairs Walter Corey manufactured cane seating. Some examples have a late tablet-style crest with full rounded ends and small angular or rounded arches along the bottom. The central back support is a large, rounded or angular, baluster-shaped splat. Some front legs are turned; others are sawed to saber form. Many surfaces are covered with a simulated rosewood finish sometimes accented with penciling. A rounded-end tablet of modified pattern appears on still another plank-seat chair marked with a Corey stencil. The roll-front seat, spindle back, and support structure are close in pattern to figure 7-112.[332]

Only scattered chairmaking activity is known for the counties immediately north of Cumberland. Jonathan Raynes manufactured painted chairs and furniture at Lewiston Falls at midcentury with the aid of steam-powered machinery and six men. The 1850 census pegged his annual chair production at several thousand. Because of its excellent waterpower the area had a heavy concentration of textile mills, an economic condition that probably offered encouragement to the furniture manufacturer. Also located within the town boundaries were a manufactory to produce steam engines and a sawmill capable of cutting 5 million feet of lumber annually, facilities important to the success of Raynes's enterprise.[333]

Bath, located on the Kennebec twelve miles north of the river's mouth, was a noted center of commerce and shipbuilding by 1800. Beginning in the early 1820s the community enjoyed steamboat communication with Portland and Boston, a service that soon extended upriver to Augusta. At midcentury Bath became the seat of Sagadahoc County. Richard R. Smith advertised his cabinet warehouse there in 1828, offering a complete range of cabinet furniture along with "an assortment [of] FANCY CHAIRS, of BATH manufacture" and "common Chairs, of various prices." He challenged local consumers to compare his chairs "with any made in this country, New-York and Philadelphia not excepted." The vulnerable state of this and other businesses is underscored in Smith's closing note, warning persons with unpaid accounts of more than eighteen months' standing to settle immediately or answer to a collection agent. The commercial climate at Bath must have seemed sufficiently attractive in the 1840s to woo John B. Hudson, formerly of Hudson and Brooks, away from Portland. Hudson was a Portland resident until at least 1844; deeds dated 1849–50 call him a cabinetmaker of Bath.[334]

The 1820 Manufacturing Census gives only passing notice to Maine and overlooks Portland altogether to concentrate on Lincoln County where six woodworking craftsmen are listed by name, one identified as a chairmaker, the others as cabinetmakers. Most shops appear to have been small, one-man businesses. Francis Chapman and Edwin Smith, both cabinetmakers, were residents of Jefferson, a small agricultural community at the head of Damariscotta Lake. There were several good water privileges in the area and some sawmills in operation. The men probably served only the local region. The other four craftsmen worked farther south near the mouth of Sheepscott River at Wiscasset, a town "directed to ship-building and maritime pursuits" and thus adversely affected by the embargo of 1807 and the ensuing war. But the harbor was excellent, and trade continued to some degree. The census identifies Henry Weed as a chairmaker but does not elaborate on his production. David Owen and Joshua Damon were cabinetmakers. Damon trained two apprentices and seems to have had the most extensive trade of any in the group. Although the census refers to Daniel Carr as a cabinetmaker, he is likely the "D. CARR." who branded a tall, contoured-back, rocking chair with a crown-top crest of the general type shown in figure 7-104. The Maine census places Carr in Wiscasset again in 1830 and 1850 but omits a listing for the decade between. A Daniel Carr "chairmaker" is listed in the Boston directory of 1840, but not earlier or later. Of the others, Damon and Owen were still in Wiscasset in 1830.[335]

A short section in the same industrial census titled "Tabulation of exportation goods" lists three towns in Kennebec County next to an entry reading "900 Dining Chairs." Named are Readfield, Winthrop, and Monmouth, which are credited with 100, 300, and 500 chairs, respectively. Unfortunately, the craftsmen are unnamed, and the three individuals presently associated with county chairmaking were residents of other communities. The earliest identifiable work is that of Dean M. Smiley, who practiced his trade in Hallowell (fig. 7-113). An advertisement of 1823 may mark his entry into business. When Smiley purchased land on the south side of Academy Street two years later, the deed referred to him as a "painter." The seat in Smiley's chair is similar to that found in Portland work of about 1820 (figs. 7-107, 7-111) although the crest suggests a date later in the decade. This is reinforced by the presence of a similar slat with deeply

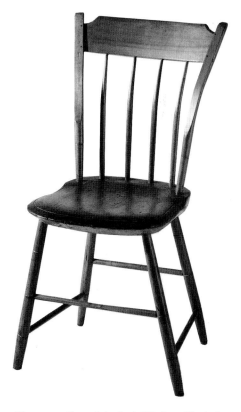

Fig. 7-113 Shaped slat-back Windsor side chair and detail of label, Dean M. Smiley, Hallowell, Me., ca. 1822–30. H. 34⅜", (seat) 17¼", W. (crest) 18¼", (seat) 15⅝", D. (seat) 15¾". (Private collection: Photo, Winterthur.)

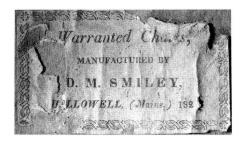

hollowed top corners in a chair of obviously later date exhibited at the Maine State Museum in 1979. The seat is a broad shovel with serpentine sides and a simulated front roll; the forward-scroll arms are heavy, and the bamboowork of the legs is a late type tapering in both directions from the center. The chair was found in North Fairfield, located upriver along the Kennebec. Another late use of the crest is seen in a New Hampshire chair made by Minot Carter of New Ipswich (fig. 7-85).[336]

Augusta, a few miles north of Hallowell and the seat of Kennebec County, became the center of state government in 1831. Joshua D. Pierce pursued his trade there a decade later, offering a varied selection of seating that included "Common Cane Seat Chairs; Flag seat d[itt]o; Cane and Wood Rocking Chairs of all kinds; common and fancy back Chairs made with Basswood seats, and warranted." The previous year Pierce and a J. G. Holcomb, both described as "traders," had purchased a sixty-acre tract of land located a dozen or more miles north in Belgrave, presumably as a timber site. A large dam with locks built across the Kennebec above the town became by midcentury an important power source for varied manufacturing activity, while lumber for industrial use and exportation was a primary local commodity. Granite for building purposes was abundant, and the surrounding country was rich and fertile.[337]

Joseph Bachelder commenced business at West Waterville on the Kennebec, possibly during the late 1820s. A deed of 1835 refers to him as a "painter." The craftsman apparently enjoyed early success; his son Abram joined him in business by 1849. The estate inventory of the elder man drawn in 1881 details the contents of a flourishing furniture factory equipped with all the latest power machinery—lathes, a jig saw, boring and planing machines, a jointer, a dowel machine, and a "Swing Sawing machine & Saw." The factory complex consisted of a warehouse, chair shop, paint shop, "Dry House," "Bending house," and shed. Stock on hand covered a range of seating, including office and camp chairs, patent rockers, children's high and low seats, and cane chairs. There were finished parts in abundance. A marked settee dating to this general period has a rectangular tablet top. The legs are turned to a fancy pattern and are connected front and back by flat stretchers; heavy forward-scroll arms cap short posts. Bachelder's earliest known work includes rounded tablet-top, plank-seat chairs of the general pattern constructed at Portland by Corey in the 1840s (fig. 7-112).[338]

Although the population of Freedom, Waldo County, stood at less than 1,000 in the 1850s, the community was "one of the most thriving inland villages in the country." Lumbering and tanning were encouraged by the presence of good mill sites. Joseph Hockey located in the town at Hussey Mills sometime before 1840, possibly from the neighboring village of Unity. Hockey's large rocking chair contains an usual amalgam of features (fig. **7-114**). The tall, hollow-bowed back with its slim tablet top resembles Boston and southern New Hampshire work (fig. 7-72), a comparison strengthened by painted decoration in the crests of some chairs that forms several panels with hollow corners. The ball spindles are somewhat out of place in the tall back and appear overwhelmed by the chair's substantial proportions, pointing up the provincial, though original, quality of Hockey's design. Again rooted in Boston-area work are the blunt-edge seat and oval-centered stretcher (figs. 7-48, 7-35). A similar medallion appears in Vermont work and probably derives from the same source. The legs exhibit a hint of the triangularity found in the supports of rocking chairs made in Boston and New Hampshire in the 1820s and 1830s.[339]

Overlapping Joseph Hockey's working dates in Freedom are those of William H. Cunningham and Benjamin F. Cunningham. Deeds of 1841–42 provide an initial working date for Benjamin F., who is designated a "chairmaker of Freedom." The two apparently united in partnership on March 14, 1844, when William purchased a half interest in Benjamin's property; together they acquired by mortgage another village lot of fifty-eight rods lying on the east side of a stream. The men next bought a small lot on a stream in East Freedom, which they held jointly for only several months in 1845 before Benjamin F., "chairmaker," bought out the interest of William H., "painter," exclusive of William's right "to flow water and affix dams to the same." That transaction apparently

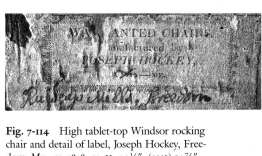

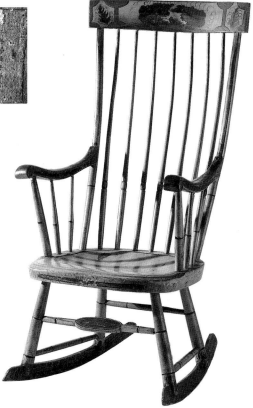

Fig. 7-114 High tablet-top Windsor rocking chair and detail of label, Joseph Hockey, Freedom, Me., ca. 1828–35. H. 44½", (seat) 14⅞", w. (crest) 22½", (arms) 22", (seat) 19⅞", D. (seat) 18⅛". Probably basswood (seat); medium bright yellow ground with mottled brown graining, black, medium light olive-green, and bronze. (Arlie R. Porath collection: Photo, Winterthur.)

marked the end of the partnership. Benjamin made further land purchases, including one lot with a water privilege in 1847 and another containing a "two story shop" in 1854. Meanwhile, William had discharged the mortgage for the 1844 joint land purchase in his own name and was designated a chairmaker in the 1850 transaction. At least two Windsors are documented to the Cunningham partnership, one bearing a label. The crests of the side chair and Boston-style rocking chair are rounded, slightly bulging tablets with two small lunettes cut along the lower edge.[340]

The North-Central Region

Hiram, located at the southern tip of Oxford County near the New Hampshire border, was not as far removed from mainstream life in the early nineteenth century as its geographic location might imply. Coolidge and Mansfield reported that town women made a large amount of "sale-work" for the clothing merchants of Boston, and several shops manufactured shoes for merchandising interests in Lynn, Massachusetts, and elsewhere. The town was well watered by the Saco and Ossipee rivers and numerous ponds, providing sites for a variety of mills. Chairmakers Spring and Haskell were in business by 1830 when they placed their brand on the plank of a crown-top, arrow-spindle side chair identical in form and banded decoration to William Capen's Portland chair (fig. 7-111). Of two contemporary Windsors manufactured by the firm, one is a half-spindle, slat-back chair with a medallion-type front stretcher and ball tips in the front legs. The more pedestrian second pattern is a slat-back, ball-spindle design with a balloon-shaped seat and late bamboo-style legs.[341]

Near the county's eastern boundary at Buckfield, Lloyd Cole constructed ball-spindle chairs of much the same pattern. One example has a shovel-shaped plank in place of Spring and Haskell's balloon seat. Both manufacturers included their location as part of the brand. Cole may not have entered business before the 1840s. In an October 1841 land transaction with James Jewett, formerly a cabinetmaker of Portland, Cole acquired village property bounded by several highways and the Twenty Mile (now Nezinscot) River for $700. Jewett described the property as "the land on which my Cabinet Shop,

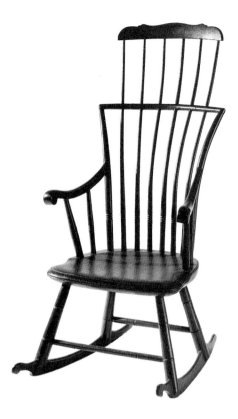

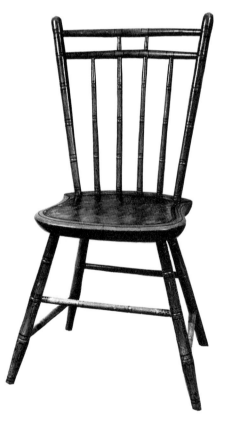

Fig. 7-116 Square-back Windsor side chair (one of six), Daniel Stewart (label), Farmington, Me., ca. 1812–20. Golden yellow ground with black, graining on seats (paint old or original). (Photo, Pam Boynton.)

Fig. 7-115 Square-back Windsor rocking chair with top extension and detail of label, Daniel Stewart, Farmington, Me., ca. 1820–27. H. 39⅝″, w. (main crest) 18⅛″, (arms) 19″. (Betty Berdan collection: Photo, Winterthur.)

which is herewith conveyed, and lumber is situated." The location appears to have been advantageous for business. A town history indicates that Cole was still working in 1847.[342]

Farmington, situated in the fertile Sandy River valley, was part of Kennebec County when it was incorporated as a town in 1794; with the establishment of Franklin County in 1838 it became the county seat. The area was highly suitable for grazing and fruit cultivation. The Stewart family arrived in Farmington in the year of its incorporation. The father, Hugh, was a housewright and chairmaker; two of his sons, Henry (b. 1779) and Daniel (b. 1786), followed in his footsteps. A Windsor labeled by Henry is said to be extant; several chairs are documented to the hand of his brother. Collectively, Daniel Stewart's work represents the largest surviving body of early nineteenth-century Windsor furniture made by a Maine craftsman. From the standpoint of style, Stewart's earliest Windsors are those with single- and double-bow backs, although variation from chair to chair indicates that he employed these patterns over a period of some years. As Edwin A. Churchill has observed, Stewart's work seems characterized by extremes in quality— from the exceptional to the ordinary. Some chairs appear to have been made to special order, or at least as first-quality seating; others represent mass production. Stewart used a label to identify his work.[343]

Documented single-bow Windsors by Stewart may be limited to rocking armchairs. There are two types. One has a straight back with stout bamboowork in the posts tapering sharply from top to bottom. The crossbow is inset more than an inch from the top (fig. 7-116). Arms are forward scrolls or turned cylinders tapered sharply at the back; some legs are heavy and exhibit a pronounced triangularity in the upper section. Extension headpieces are supported on continuous spindles more often than not; the crest is a narrow, low-arched tablet angular on the top surface and rather discordant in profile. Seat planks often are large and without much shaping. The adult rocking chair of the second type (fig. **7-115**) is of lighter form and more delicate feature. The grooved seat is well shaped; the scroll arms are those noted previously. The slim back posts are deeply bent and flared and the spindles are contoured, indications that Stewart was familiar with Boston work either directly or through a secondary source. The cross rod caps the posts, and the delicately contoured extension is better integrated into the design. The pairs of beads in the roundwork just above the seat may be influenced by the ball spindle that became popular in the 1820s.[344]

A double-bow, square-back chair by Daniel Stewart, one of a set of six, represents another high point in the craftsman's work (fig. **7-116**). The post taper relates to that of the straight-back rocker, but the overall design is lighter. Thin, painted bands flanking the grooves of the bamboo work lend a special character. The effect is not unlike the double beads of the rocking Windsor, though flat. Next in stylistic sequence is Stewart's stepped-tablet, bent-back chair (fig. **7-117**). The seat is comparable to that of the rocking chair. Boston influence in the crest profile and single groove of the back posts is pronounced (fig. 7-36); however, Stewart's delicate abstract decoration, executed in colors of dark green and brick red on a pale salmon ground, is an unusual departure from contemporary furniture motifs. The ornament relates closely to that found on painted tinware. Several other stepped-tablet chairs that appear to have originated in the

Stewart shop have equally distinctive ornament. Stewart died in 1827, apparently quite suddenly. He and John R. Cong (Corey?) of Augusta, both described as "painters," purchased land together in Farmington on the east side of the Sandy River contiguous with Stewart's own property on August 27, 1827. Apparently, they intended to expand production and tap more of the potential area market, including Augusta and points south and north on the Kennebec River. Stewart's probate inventory drawn in January 1829 shows that he also owned 200 acres of "wild land" in northern Oxford County, a district laced with lakes. The list of cabinetmaker's and chairmaker's tools itemizes a good selection of equipment, and among the lumber is basswood and pine plank.[345]

A distinctive side chair pattern featuring a crown top may be a Maine product (fig. 7-118). As in the tall, contoured rocking chair (fig. 7-92), the crest follows one of two patterns. One centers a precisely formed rectangular panel with squared corners; the other, commoner pattern has a hollow-cornered midsection. Painted fruits and leaves are the usual decoration. Roundels are well suited to the scroll ends, the dark ones having the power of two piercing eyes. Seats are shaped to two patterns, a squared shield, as shown, or a scroll. Crest pieces in late chairs usually have stenciled decoration, and the legs are sometimes fancy-turned. As illustrated, even the bamboowork varies. One pattern has sections of nearly equal size, while the divisions of the other are irregular. There are also differences in the spindles; ball turnings are only simulated with paint at the left. The ground color of both chairs is pale yellow; later chairs generally are painted in dark colors.

Information of several kinds suggests that production of the crown-top side chair may have covered a sizable area. The chair at the right with dark roundels, one of a set of six, is branded "H.S.NICKERSON," a common Maine surname in the early nineteenth century. The chairs were found in Franklin County near Farmington. A man identified by those initials in the 1840 census was a resident of Strong, a community just north of Farmington on the Sandy River. A decade later the name Hiram S. Nickerson is recorded in Wayne, Kennebec County. A tall crown-top rocking chair was also recov-

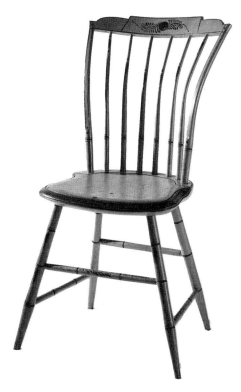

Fig. 7-117 Shaped tablet-top Windsor side chair (one of six), Daniel Stewart (label), Farmington, Me., 1815–25. Basswood (seat); H. 35¾", (seat) 17¾", W. (crest) 19⅜", (seat) 16¾", D. (seat) 16⅟₁₆"; salmon ground with green, wine-red, and black. (Formerly Burton and Helaine Fendelman collection: Photo, Winterthur.)

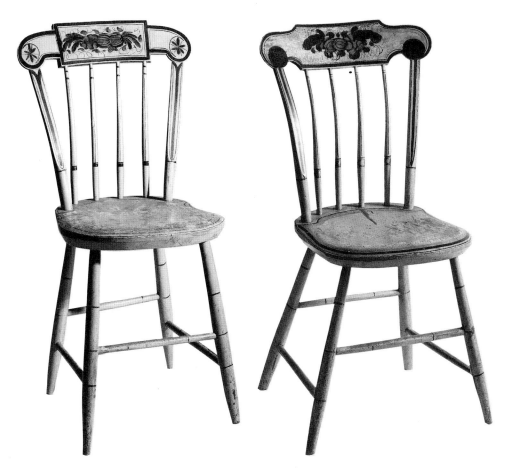

Fig. 7-118 Crown-top Windsor side chairs (one of two and one of six), H. B. Nickerson (brand, *right*), (*left to right*) central interior Maine and Franklin County, Me., possibly Strong, 1830–40. H. 34⅝", 34¼", (seat) 18⅜", 17", W. (crest) 18⁵⁄₁₆", 18½", (seat) 15½", D. (seat) 15¹³⁄₁₆", 15¾". (Private collection: Photo, Winterthur.)

Fig. 7-119 Slat-back Windsor side chair (one of four), central interior Maine, 1825–40. White pine (seat) with maple, poplar, beech, and birch; H. 32⅞″, (seat) 16⅞″, W. (crest) 16¼″, (seat) 15¼″, D. (seat) 15″; dark brown and dark red grained ground with bright yellow, medium green, and silvery to light gold. (Maine State Museum, Augusta: Photo, Winterthur.)

ered in the Farmington area. Another crown-top rocker, one with a low back and extension headpiece, has four broad, arrow spindles of the kind common in Portland work. The pattern may have been developed during the early 1830s in the coastal city and then carried inland in a northerly direction.

Common to central interior Maine are chairs of varied pattern that are grained or daubed in black or brown and dark red paint, highlighted by dark green and yellow banding, and frequently stenciled. The first exhibition of Maine furniture held at the Maine State Museum, in Augusta, in 1979 focused attention on this generally unrecognized characteristic of painted furniture from the inland regions, particularly the upper Kennebec and Androscoggin river valleys; subsequent discoveries have confirmed the widespread popularity of this decorative scheme in Maine furniture. Figure **7-119** illustrates a typical example. The half-spindle back and flat-sided balloon plank were first introduced in Boston and Worcester County a few years earlier. There yellow grounds and handpainted decoration were common choices. Here, a slightly later dark ground sets off stenciled ornament that deliberately spills over its boundaries and uses border bands for emphasis rather than containment. The feature may be a regional characteristic.³⁴⁶

The migratory career of cabinetmaker Samuel K. White is typical of a sizable segment of the American woodworking community in the early nineteenth century. During his adult years White lived and worked in perhaps as many as four communities in Somerset and Penobscot counties, where he marked his product with a label rather than a brand or stencil. The census places White in Fairfield in 1830, although a decade earlier a Samuel K. is listed at Norridgewock, about ten miles distant. Both communities are located on the Kennebec River. White left the Fairfield area for Dexter before 1840, where he remained only briefly. Labels on several chairs have had the placename "Fairfield" lined through and "Dexter" inscribed in ink to one side. The 1840 census locates White in neighboring Exeter, where he had new labels printed. Both Dexter and Exeter were agricultural towns, although by midcentury Dexter with its excellent waterpower had become a small center for the manufacture of woolen goods and offered encouragement to other industrial enterprises. White died at Exeter in 1849.³⁴⁷

White constructed Windsor chairs in at least two patterns. One example is a tall, contoured-back rocking chair of the crown-top type illustrated in figure 7-111; the heavy bamboo legs have sharply tapered tops. The chair bears White's Exeter label and dates from about 1835 to 1845. The second pattern is a slat-back, plain-spindle Windsor made with and without arms (fig. **7-120**). The earliest side chairs, constructed in Fairfield and Dexter in the 1830s, have balloon-style seats with rounded-canted edges. The bamboo turnings are relatively slim. Unlike the sticks in chairs of related pattern made by Dean Smiley farther south on the Kennebec at Hallowell (fig. 7-113), White's slat-back spindles thicken appreciably only near the bottom. The armchair, which bears a printed Exeter label, dates from the chairmaker's early years in that community. The arms appear identical to those used in his high rocking chair. A slat-back side chair of slightly later date, again with an Exeter label, substitutes a shovel-shaped plank and bamboowork of large diameter.

Aside from Samuel K. White's work at Dexter and Exeter, known evidence of chairmaking in Penobscot County centers in the Bangor area on the Penobscot River. William H. Reed had practiced the dual trades of cabinetmaker and chairmaker at Hampden for barely a decade when a British force of several vessels and 700 regulars

Fig. 7-120 Slat-back Windsor armchair, Samuel K. White (label), Exeter, Me., ca. 1835–45. Probably basswood (seat) with birch. (Ruth Coan Fulton collection: Photo, Maine State Museum.)

sailed up the Penobscot in 1814 for the express purpose of seizing the U.S. corvette *Adams* laid up for repairs at Hampden. When the American captain blew up his ship and the prize was lost, British troops took their revenge on the town in plunder and destruction. "The furniture in nearly all of the houses in the village was entirely destroyed, and the cattle and hogs belonging to the farmers were killed." Although this event is not noted in Reed's account book, his record of local furniture repairs and sales identifies household furnishings common to the area. There are many references to bottoming chairs before the war, at a time when Reed constructed great and small, rocking and kitchen chairs. There is tentative record of "3 fanbacks" sold for $5 in 1803, presumably Windsor seating. After the war there are no further entries for great chairs, and the work of reseating chair frames falls off substantially. Reed continued to make rocking chairs, and he constructed an occasional kitchen set. The sale of six green chairs in 1818 at $2 apiece may identify fancy seating; whether Reed was the maker or simply a retailer of exchange merchandise is not indicated. Aside from chairs, Reed's primary trade appears to have been in tables and bedsteads. The craftsman spent all his adult years in Hampden. In his will he described himself as a cabinetmaker; his estate was probated in 1858.[348]

Two documented chairs of about midcentury represent the work of Bangor craftsmen. Henry S. Brown used black paint to sign the bottom of an armchair constructed in a tablet-top pattern with long, rounded, projecting ends. The chair is a less skilled copy of a Boston pattern popular at this date. A pivoting, or office, chair of similar pattern was sold at auction in recent years. The seat is mounted on a stoollike base with simple turned legs, but elements from the plank upward duplicate those in the Bangor chair line for line. Another Bangor seating piece with a Boston orientation is a child's armless rocking chair, its rounded-arch tablet top cut with two small lunette-sawed hollows along the lower edge. On the tablet face is a stenciled floral vine. The chair is from the shop of John Meservy.

Bangor was a good location for an enterprising chairmaker in the mid nineteenth century. The community grew rapidly after receiving its city charter in 1833. Shipbuilding and lumbering were important pursuits, and the town's location on the navigable Penobscot encouraged the coasting trade and communication with southern and West Indian ports. In spite of the hardships caused by the Panic of 1837, a disastrous flood in 1846, and a cholera epidemic in 1849, the population doubled between 1840 and the mid 1850s.[349]

Sangerville in the valley of the Piscataquis was described at midcentury as "a beautiful township . . . in a thriving condition." The sparsely populated area was one of only twenty-three townships out of a hundred in Piscataquis County that were settled and incorporated. Much of the region still consisted of "wild land." It is not surprising, therefore, that a tall, crown-top chair made by A. J. Stephenson in the village of Sangerville reveals its provincial origin in the wide, slightly awkward, splay of its legs. Otherwise, the plank, upper structure, and crest present a fairly straightforward example of the chairmaker's art of about 1835 to 1840.[350]

Cherryfield in coastal Washington County was a community where direct outside influence from cities such as Portland, Boston, and Portsmouth probably was the rule rather than the exception. A scroll-seat rocking side chair with a rounded, lunette-sawed crest made by Lewis and Godfrey follows standard production of the 1840s. Lumbering was the principal business in Cherryfield, and the coasting trade was brisk. Eastport, near the Canadian border, also was home to a group of trading vessels, including the schooner *Splendid,* which made regular trips to Boston. In January 1836 Hiram Balch of neighboring Lubec paid freight on a varied cargo, including a bedstead and "3 Bundles [of] Chairs." A rocking chair was also an 1836 purchase. Balch's records indicate that he patronized the Boston furniture stores of Kittredge and Blakes and P. F. Packard.[351]

Notes

1. Samuel Eliot Morison and Henry Steele Commager, *The Growth of the American Republic*, 2 vols. (4th ed.; New York: Oxford University Press, 1950), vol. 1, p. 502.

2. General introductory references include Morison and Commager, *Growth of the American Republic*; Marcus Cunliffe, *The Nation Takes Shape: 1789–1837*, Chicago History of American Civilization (Chicago: University of Chicago Press, 1959); Marshall B. Davidson, *Life in America*, 2 vols. (Boston: Houghton Mifflin, 1951). Records of the 1820 Census of Manufactures, State of Connecticut, National Archives, Washington, D.C. (hereafter cited as NA) (microfilm, Joseph Downs Collection of Manuscripts and Printed Ephemera, Winterthur Library [hereafter cited as DCM]).

3. John Melish, *Travels through the United States of America*, 2 vols. (Philadelphia: By the author, 1815), vol. 1, p. 73; [Gideon Miner Davison], *Traveller's Guide* (6th ed; Saratoga Springs, N.Y.: G. M. Davison, 1834), pp. 409–10.

4. Melish, *Travels*, 1:78, 83; Henry Bradshaw Fearon, *Sketches of America* (2d ed.; London: Longman et al., 1818), p. 99; [Anne Newport Royall], *Sketches of History, Life, and Manners in the United States* (New Haven, Conn: By the author, 1826), pp. 368–69; Carl David Arfwedson, *The United States and Canada*, 2 vols. (1834; reprint, New York: Johnson Reprint Corp., 1969), vol. 1, p. 225.

5. William, Daniel, and Samuel Proud, ledger, 1782–1825, Rhode Island Historical Society, Providence (hereafter cited as RIHS); William Mitchell Pillsbury, "The Providence Furniture Making Trade, 1772–1834" (Master's thesis, University of Delaware, 1975), appendix B, table 4.

6. Proud, ledger; Pillsbury, "Providence Furniture Making," p. 48.

7. Proud, ledger; Daniel and Samuel Proud, daybook and ledger, 1810–34, RIHS; Pillsbury, "Providence Furniture Making," appendix B, table 4.

8. Job Danforth, Sr., ledger, 1788–1818, RIHS.

9. *Providence Gazette* (Providence, R.I.), October 3, 1801, as quoted in Wendell D. Garrett, "Providence Cabinetmakers, Chairmakers, Upholsterers, and Allied Craftsmen, 1756–1838," *Antiques* 90, no. 4 (October 1966): 516; Cyrus Cleaveland, property and estate records, 1803–12 and 1837, Providence, R.I., Registries of Deeds and Probate.

10. *Providence Gazette*, January 8 and 11, 1823, and Howard biographical data in Eleanore Bradford Monahon, "Providence Cabinetmakers," *Rhode Island History* 23, no. 1 (January 1964): 6–22; *Providence Gazette*, March 7, 1812, and April 3, 1813, as quoted in Garrett, "Providence Cabinetmakers," p. 517; Proud, daybook and ledger.

11. Joseph K. Ott, "Recent Discoveries among Rhode Island Cabinetmakers and Their Work," *Rhode Island History* 28, no. 1 (February 1969): 23; Joseph Vickary, property and estate records, 1815–18, Newport, R.I., Registries of Deeds and Probate; George H. Richardson, scrapbook, n.d., Newport Historical Society, Newport, R.I. (photocopy, RIHS).

12. Christian M. Nestell, drawing book, 1811–12, DCM; Henry W. Rugg, *History of Freemasonry in Rhode Island* (Providence, R.I.: E. L. Freeman and Son, 1895), pp. 371–73; Proud, daybook and ledger.

13. *Providence Patriot* (Providence, R.I.), August 28, 1822 (reference courtesy of Robert P. Emlen).

14. Christian M. Nestell, estate records, 1880, Providence, R.I., Registry of Probate; Joseph K. Ott, "Still More Notes on Rhode Island Cabinetmakers and Allied Craftsmen," *Rhode Island History* 28, no. 4 (November 1969): 118; Jane L. Cayford, "The Sullivan Dorr House in Providence, Rhode Island" (Master's thesis, University of Delaware, 1961), p. 141; Christian M. Nestell, bill to Richard W. Greene, April 3, 1827, A. C. and R. W. Greene Collection, RIHS.

15. *The London Chair-Makers' and Carvers' Book of Prices for Workmanship* (London: T. Sorrell, 1802), pl. 5, no. 13, and p. 26; *Supplement to the London Chair-Makers' and Carvers' Book of Prices for Workmanship* (London: T. Sorrell, 1808), pl. 4, fig. 4, and pp. 21, 34.

16. A check for the Sarle name in the 1820 New England census provides evidence only for Rhode Island. Two family members resided in Providence and six in Cranston, now a suburb. Given names beginning with *R* occur in one or the other location for 1810, 1830, and 1840.

17. *Providence Gazette*, April 26, 1823, as quoted in Garrett, "Providence Cabinetmakers," pp. 514–15; *Providence Directory* (Providence, R.I.: Brown and Danforth, 1824), p. 33; *Providence Directory* (Providence: Carlile and Brown, 1826), p. 4.

18. Ott, "Recent Discoveries," p. 22; *Providence Gazette*, August 28, 1822, as quoted in Garrett, "Providence Cabinetmakers," pp. 518–19; Robert P. Emlen and Sara Steiner, "The Short-Lived Partnership of Adrian Webb and Charles Scott," *Antiques* 127, no. 5 (May 1985): 1141–43; *Mercury* (Charleston, S.C.), December 8, 1831 (reference courtesy of Wendell Hilt); Joseph K. Ott, "Lesser-Known Rhode Island Cabinetmakers," *Antiques* 121, no. 5 (May 1982): 1159–60, fig. 7, pl. 4.

19. *Providence Gazette*, May 4, 1816, as quoted in Garrett, "Providence Cabinetmakers," p. 517; *Clarion, or Bristol County Advertiser* (Warren, R.I.), January 10, 1824, as quoted in Ethel Hall Bjerkoe, *The Cabinetmakers of America* (Garden City, N.Y.: Doubleday, 1957), p. 132; *Providence Directory* (Providence, R.I.: H[ugh] H. Brown, 1838), p. 156; Amasa Humphreys, property records, 1845, Providence, R.I., Registry of Deeds.

20. Ezekiel Adams, property records, 1832, Providence, R.I., Registry of Deeds; Ezekiel Adams, bill to Perez Peck, November 16, 1840, Papers of Perez Peck, Old Sturbridge Village, Sturbridge, Mass. (hereafter cited as OSV); W. A. and D. M. Coggeshall, advertisement in *Rhode Island Republican* (Newport, R.I.), July 15, 1835 (reference courtesy of Wendell Hilt); Wendell D. Garrett, "The Newport Cabinetmakers: A Corrected Check List," *Antiques* 73, no. 6 (June 1958): 559.

21. Melish, *Travels*, 1:125; J. Hammond Trumbull, ed., *The Memorial History of Hartford County, Connecticut, 1633–1884*, 2 vols. (Boston: Edward L. Osgood, 1886), vol. 1, pp. 553–54; Timothy Dwight, *Travels in New England and New York*, 4 vols.; ed. Barbara Miller Solomon (Cambridge, Mass.: Belknap Press, 1969), vol. 3, pp. 275, 365; [Theodore Dwight], *The Northern Traveller* (2d ed.; New York: A. T. Goodrich, 1826), pp. 238, 246; John Lambert, *Travels through Canada and the United States of North America*, 2 vols. (London: C. Cradock and W. Joy, 1813), vol. 2, p. 305; Albert E. Van Dusen, *Connecticut* (New York: Random House, 1961), p. 187.

22. Connecticut estate records: Daniel Huntington, Jr. (1806, Norwich), Elisha Swan (1807, Preston), Nathan Smith (1809, Stonington), Capt. William Harris (1809, New London), and Isaac Treby (1809, New London), Genealogical Section, Connecticut State Library, Hartford (hereafter cited as CSL).

23. *Courier* (Norwich, Conn.), July 7, 1802, and July 18, 1804, as excerpted in Phyllis Kihn, comp., "Connecticut Cabinetmakers, Part I," *Connecticut Historical Society Bulletin* 32, no. 4 (October 1967): 106.

24. Kihn, "Connecticut Cabinetmakers, Part I," p. 107; index, Barbour Collection of Connecticut Vital Records, Genealogical Section, CSL; *Courier*, February 26, 1806, and November 16, 1808; *Norwich Courier* (Norwich, Conn.), April 11, 1810 (some references courtesy of Wendell Hilt).

25. Manifest of ship *Dispatch*, January 24, 1804, Shipping Returns: Barbados, 1781–1806, Colonial Office, Public Record Office, London (hereafter cited as PRO); New London, Conn., Outward Coastwise and Foreign Entries, 1801–21, Federal Archives and Records Center, Waltham, Mass. (hereafter cited as FRC-Waltham); John French II and Samuel H. P. Lee, advertisements in *Connecticut Gazette* (New London, Conn.), February 18, 1807, and June 5, 1808 (second reference courtesy of Wendell Hilt); James Gere, ledgers, 4 vols., 1809–29, 1809–39, 1822–52, 1836–55, CSL.

26. Gere, ledgers; Isaac Allyn, shop sale notice in *Connecticut Gazette*, July 7, 1813, as noted in Bjerkoe, *Cabinetmakers of America*, p. 27.

27. Gere, ledgers, 1809–29, 1809–39, and 1822–52; Kihn, "Connecticut Cabinetmakers, Part I," p. 104; Stephen B. Allyn, estate records, 1822, Norwich, Conn., Genealogical Section, CSL.

28. Gere, ledgers, 1809–29, 1809–39, and 1822–52.

29. Gere, ledgers, 1809–29, 1809–39, and 1822–52; index, Hale Collection of Newspaper Death Notices, Genealogical Section, CSL.

30. *Norwich Courier*, August 19, 1819, and other data in Kihn, "Connecticut Cabinetmakers, Part I," p. 117; *Norwich Courier*, October 21, 1812, May 22, 1816, March 26, 1834, and January 8, 1840 (some references courtesy of Wendell Hilt); Gere, ledger, 1809–29.

31. *Connecticut Gazette*, April 22, 1807, as quoted in Bjerkoe, *Cabinetmakers of America*, p. 232; *Connecticut Gazette*, February 10, 1810; index, Barbour Collection; Timothy Swayne, advertisement in *Connecticut Gazette*, April 1, 1812, as excerpted in Phyllis Kihn, comp., "Connecticut Cabinetmakers, Part II," *Connecticut Historical Society Bulletin* 33, no. 1 (January 1968): 23.

32. *Connecticut Gazette*, April 26, 1815, and October 8, 1828, as excerpted in Kihn, "Connecticut Cabinetmakers, Part II," pp. 31–32; *Republican Advocate* (New London, Conn.), April 28, 1824 (reference courtesy of Wendell Hilt); *Connecticut Gazette*, February 27, 1828; Thomas West, estate records, 1828, New London, Conn., Genealogical Section, CSL; Minor Myers, Jr., and Edgar deN. Mayhew, *New London County Furniture, 1640–1840* (New London, Conn.: Lyman Allyn Museum, 1974), p. 129. An Abby West is listed as a resident of Colchester in the 1830 census.

33. Gere, ledger, 1809–39.

34. Gere, ledgers, 1809–39, 1822–52; Isaac S. Sizer, advertisement in *Republican Advocate*, May 7, 1823 (reference courtesy of Wendell Hilt).

35. Gere, ledgers; Francis W. Bushnell, advertisement in *Norwich Courier*, October 2, 1822, and January 28, 1823 (references courtesy of Wendell Hilt); William L. Cheney, advertisement in *Courier*, September 17, 1828 (reference courtesy of Wendell Hilt).

36. J. W. Coyle, advertisement in *Norwich Courier*, December 18, 1822 (reference courtesy of Wendell Hilt); B. F. Sisson, advertisement in *New London Gazette and General Advertiser* (New London, Conn.), March 25, 1840 (reference courtesy of Wendell Hilt).

37. Amos Denison Allen, memorandum book, 1796–1803, Connecticut Historical Society, Hartford (hereafter cited as CHS); Andrew Frink and Jonathan Chester, ledger, 1806–17, Windham Historical Society, Willimantic, Conn.

38. Stephen Tracy, property records, 1807, Genealogical Section, CSL; Amos Denison Allen and Frederick Tracy, indenture of apprenticeship with Elisha Harlow Holmes, 1819, Antiquarian and Landmarks Society, Hartford, Conn.

39. Manifest of sloop *Candidate*, October 25, 1817, New London, Conn., Outward Coastwise Entries, FRC-Waltham; 1820 Census of Manufactures, State of Connecticut; Frederick Tracy, estate records, 1822, Windham, Conn., Genealogical Section, CSL.

40. 1820 Census of Manufactures, State of Connecticut; Frederick Allen, advertisement in *Norwich Courier*, July 22, 1829 (reference courtesy of Wendell Hilt); Elisha Harlow Holmes, daybook, 1825–50, CSL; Richard M. Bayles, ed., *History of Windham County, Connecticut* (New York: W. W. Preston, 1889), p. 301; Elisha Harlow Holmes, property attachment, 1843, Windham, Conn., Genealogical Section, CSL.

41. Stephen Payne and Dr. Samuel Lee, estate records, 1815, Lebanon and Windham, Conn., Genealogical Section, CSL; Allen, memorandum book.

42. Jabez Gilbert, estate records, 1828, Windham, Conn., Genealogical Section, CSL.

43. Thomas Safford, ledgers, 2 vols., 1807–35 and 1808–48, CSL.

44. Perez Austin, account book, 1811–1832, CHS.

45. Marvin Clayton Hutchins, comp., *Our Ancestral Heritage: The Ancestors and Descendants of Cicero Mordecai Hutchins* (Hilton, N.Y.: By the author, 1961), p. 38 (reference courtesy of Carroll Alton Means); Zadock Hutchins, Jr., property records, 1818–39, Pomfret, Conn., Genealogical Section, CSL.

46. Benjamin H. Grosvenor, ledger, 1802–36, Mystic Seaport Museum, Mystic, Conn.; Zadock Hutchins, Jr., estate records, 1830, Pomfret, Conn., Genealogical Section, CSL.

47. Seymour Watrous, advertisement in *Connecticut Courant* (Hartford, Conn.), March 2, 1824, as illustrated in John Tarrant Kenney, *The Hitchcock Chair* (New York: Clarkson N. Potter, 1971), p. 56; Hutchins, Jr., estate records, 1830.

48. Thomas Walter Ward II, inventory book, ca. 1838–45, DCM; Hutchins, Jr., property records, 1826.

49. Ward, inventory book.

50. William Rawson, account book, 1835–53, OSV; Ward, inventory book.

51. Jeduthern Avery, account book, 1811–55, CHS. Badger was born in Coventry in 1779; he died at Bolton in 1847. Census records from 1820 to 1840 list him as a resident of Bolton, although Coventry church records suggest that his home was near the town line. Connecticut census records first carry Badger's name only in 1820; Coventry church records list him as joining in 1814. It appears that the chairmaker worked elsewhere in his early career before returning to the area of his birth. Indexes, Barbour Collection of Connecticut Vital Records and Connecticut Church Records, Genealogical Section, CSL.

52. Avery, account book; Daniel W. Badger, estate records, 1847–48, Bolton, Conn., Genealogical Section, CSL.

53. Israel Balch, estate records, 1828, Mansfield, Conn., Genealogical Section, CSL.

54. Index, Barbour Collection; Samuel Silliman, account books, 2 vols., 1804–7 and 1806–16, New York State Historical Association, Cooperstown, N.Y. (microfilm, DCM), and DCM; *Connecticut Courant*, January 7, 1807, as quoted in Bjerkoe, *Cabinetmakers of America*, p. 124.

55. Melish, *Travels*, 1:125; Josiah Powers, advertisement in *Middlesex Gazette* (Middletown, Conn.), August 8, 1806, as quoted in Kihn, "Connecticut Cabinetmakers, Part II," p. 8; Powers and Ward, Powers and Badger, advertisements in *Middlesex Gazette*, July 20 and October 19, 1809, and November 28, 1810 (references courtesy of Wendell Hilt); Josiah Powers, estate records, 1827, Middletown, Conn., Genealogical Section, CSL.

56. Samuel R. Dickinson, bill to Hezekiah Carpenter, September 25, 1810, Hurd Collection, Sterling Memorial Library, Yale University, New Haven, Conn. (hereafter cited as Yale); [Dwight], *Northern Traveller*, p. 239; *Middlesex Gazette*, January 2, 1817.

57. Edmond Bowles, account of estate of Jesse Hurd, 1817–18, Hurd Collection, Yale; Edmond Bowles, account of estate of John Shepard, 1819–25, Shepard Family Papers, CSL; Edmond Bowles, estate records, 1846, Chatham, Conn., Genealogical Section, CSL.

58. Hinsdale and Cotton, advertisements in *Middlesex Gazette*, February 3 and December 28, 1820 (references courtesy of Wendell Hilt); Giles S. Cotton, guardianship, 1817, Middletown, Conn., Genealogical Section, CSL.

59. Perkins, and Pendleton and Perkins, advertisements in *Middlesex Gazette*, December 8, 1824, August 3, 1825, and April 19, 1826 (references courtesy of Wendell Hilt); 1820 Census of Manufactures, State of Connecticut; Pendleton in index, Hale Collection.

60. Thomas Sill in index, Hale Collection; Thomas H. Sill, advertisements in *Middlesex Gazette*, December 15, 1825, and June 6, 1827 (references courtesy of Wendell Hilt); Thomas Sill, estate records, 1826, Middletown, Conn., Genealogical Section, CSL.

61. [Dwight], *Northern Traveller*, p. 238; Holmes, daybook; Frederick Allen, estate records, 1830, Windham, Conn., Genealogical Section, CSL.

62. Holmes, daybook; Ely and Hull in index, Barbour Collection; Ward, inventory book.

63. Lambert, *Travels*, 2:302–3; *Connecticut Courant*, August 17, 1801, and December 9, 1807; manifest of schooner *Antelope*, December, 28, 1805, New London, Conn., Outward Coastwise Entries, FRC-Waltham.

64. Kihn, "Connecticut Cabinetmakers, Part II," pp. 28–31; *Connecticut Courant*, January 13 and October 20, 1800, August 22, 1804, May 8, 1805, and March 19, 1806 (one reference courtesy Wendell Hilt); *American Mercury* (Hartford, Conn.), May 1, 1806; Wells and Flint, advertisement in *Connecticut Courant*, March 25, July 1, and September 2, 1807.

65. *Litchfield Gazette* (Litchfield, Conn.), August 10, 1808 (reference courtesy of Wendell Hilt); *Connecticut Courant*, March 29, 1809 (dissolution of partnership), May 31, 1809, and April 11, 1810; *American Mercury*, November 2, 1809, as quoted in Kihn, "Connecticut Cabinetmakers, Part II," pp. 30–31; Houghton Bulkeley, "John I. Wells, Cabinetmaker-Inventor," *Connecticut Historical Society Bulletin* 26, no. 3 (July 1961): 65–75; John I. Wells, estate records, 1832, Hartford, Conn., Genealogical Section, CSL.

66. 1820 Census of Manufactures, State of Connecticut.

67. *Connecticut Courant and Weekly Intelligencer* (Hartford, Conn.), May 3, 1790, and other data, in Kihn, "Connecticut Cabinetmakers, Part II," p. 32; estate of John Porter II, administrator's account, 1802–6, DCM.

68. Jane Sykes Hageman and Edward M. Hageman, *Ohio Furniture Makers*, 2 vols. ([Cincinnati, Ohio]: By the authors, 1989), vol. 2, pp. 213–17.

69. Reubin Loomis, account book, 1796–1836, CHS; indexes, Barbour and Hale Collections.

70. Oliver Moore, account book, 1808–21, CHS.

71. Watrous's pictorial advertisements are illustrated in Esther Stevens Fraser, "Random Notes on Hitchcock and His Competitors," *Antiques* 30, no. 2 (August 1936): 63. Alvin F. Alpress, advertisement of "common" and other chairs, *Jeffersonian* (Hartford, Conn.), September 21, 1832 (reference courtesy of Wendell Hilt); Daniel Dewey, advertisement in *Patriot and Democrat* (Hartford, Conn.), March 14, 1835 (reference courtesy of Wendell Hilt).

72. Isaac Wright, account book, 1834–37, CSL; William N. Hosley, Jr., "Wright, Robbins and Winship and the Industrialization of the Furniture Industry in Hartford, Connecticut," *Connecticut Antiquarian* 35, no. 2 (December 1983): 12–19.

73. Philemon Robbins, account book, 1833–36, CHS.

74. Robbins, account book.

75. Robbins, account book.

76. Robbins, account book.

77. Robbins, account book.

78. Robbins, account book.

79. The Robbins and Winship continuity is found in Joseph S. Van Why and Anne S. MacFarland, *A Selection of 19th Century American Chairs* (Hartford, Conn.: Stowe-Day Foundation, 1973), pp. 112–13. *Gardner's Hartford City Directory for 1840* (Hartford, Conn.: Case, Tiffany, 1840), p. 43.

80. Joel Pratt, Jr., and Joel Pratt III, broadside, July 1, 1840, Henry Ford Museum, Dearborn, Mich. (photocopy, OSV); Pratt and Buckingham, advertisement in *New Directory and Guide Book for the City of Hartford for 1841* (Hartford, Conn.:

C. Martinson, 1841), p. 94; Joel Pratt III, estate records, 1843, Hartford, Conn., Genealogical Section, CSL.

81. Van Dusen, *Connecticut,* p. 188; Lambert, *Travels,* 2:297; Titus Preston, ledgers, 2 vols., 1795–42 and 1811–42, Yale.

82. Preston, ledgers; Titus Preston, estate records, 1842, Wallingford, Conn., Genealogical Section, CSL.

83. Index, Connecticut Church Records; Stillman and Bliss, bill to Mr. Eastman, Benjamin Trumbull Collection, Yale; Kihn, "Connecticut Cabinetmakers, Part II," pp. 22–23; Edward E. Atwater, ed, *History of the City of New Haven* (New York: W. W. Munsell, 1887), p. 587.

84. Levi Stillman, account book, 1815–34, Yale; 1820 Census of Manufactures, State of Connecticut.

85. Stillman, account book.

86. Stillman, account book.

87. Stillman, account book.

88. Stillman, account book; Connecticut State Prison Records, 1827–42, CSL; index, Hale Collection.

89. 1820 Census of Manufactures, State of Connecticut; index, Hale Collection.

90. John Doolittle II, account book, 1816–47, DCM; index, Connecticut Church Records.

91. Stillman, account book; *New Haven Palladium* (New Haven, Conn.), March 30, 1830 (reference courtesy of Wendell Hilt).

92. Edward Bulkley, assignment of estate, 1839, New Haven, Conn., Genealogical Section, CSL; *Benham's New Haven Directory and Annual Advertiser, 1853–54* (New Haven, Conn.: J[ohn] H. Benham, 1853), p. 282.

93. Henry Tudor, *Narrative of a Tour in North America,* 2 vols. (London: James Duncan, 1834), vol. 2, p. 521; *New Haven Palladium,* March 30, 1830 (reference courtesy of Wendell Hilt); *American Advertising Directory, Manufacturers and Dealers in American Goods for the Year 1831* (New York: Joceylyn, Darling, 1831), p. 76; Harrison and Smith, advertisement in *Patten's New Haven Directory for 1841–42* (New Haven, Conn.: James M. Patten, 1841), p. 130.

94. *Palladium and Republican* (New Haven, Conn.), June 13, 1835, and *New Haven Palladium,* October 31, 1846 (references courtesy of Wendell Hilt); *Patten's New Haven Directory for 1840* (New Haven, Conn.: James M. Patten, 1840), p. 115; *Sanger's New Haven Business Directory and Advertising Circular for 1850* (New Haven, Conn.: Storer and Stone, 1850), p. 23.

95. For the Lines and Augur "establishment," see *New Haven Directory for 1840,* p. 114. For burial cases, see A. C. Chamberlain, advertisement in *Journal and Chronicle* (New Britain, Conn.), June 7, 1851 (reference courtesy of Wendell Hilt). Atwater, *History of New Haven,* p. 587.

96. Daniel S. Redfield, account book, 1829–43, DCM. T. Brooks, advertisement in *Evening Palladium* (New Haven, Conn.), December 4, 1830; Albert J. Steele, advertisement in *New Haven Palladium,* October 9, 1841 (references courtesy of Wendell Hilt).

97. Index, Barbour Collection; Lemuel Porter, property records, 1807–16, Waterbury, Conn., Genealogical Section, CSL; Henry F. Withey and Elsie Rathburn Withey, *Biographical Dictionary of American Architects* (Los Angeles: New Age Publishing, 1956), p. 482; Walter C. Kidney, *Historic*

Buildings of Ohio (Pittsburgh, Pa: Ober Park Associates, 1972), pp. 30, 38–39; Thomas L. Vince, "History in Towns: Hudson, Ohio," *Antiques* 114, no. 6 (December 1978): 1309, pl. 4.

98. Family history was provided by Kingsbury descendants; the dates were confirmed in vital records, including John Kingsbury, estate records, 1844, Waterbury, Conn., Genealogical Section, CSL.

99. David Pritchard, Jr., account book, 1816–26, Pritchard Collection, Mattatuck Museum, Waterbury, Conn. (hereafter cited as Mattatuck).

100. *Connecticut Herald* (New Haven, Conn.), April 18, 1809 (reference courtesy of Wendell Hilt).

101. Thomas Hawley Rockwell, advertisement in *Republican Journal* (Danbury, Conn.), December 30, 1799, as quoted in Kihn, "Connecticut Cabinetmakers, Part II," p. 11; index, Barbour and Hale collections; Elisha Hawley, account book, 1781–1805, CHS; Silvio A. Bedini, *Ridgefield in Review* (Ridgefield, Conn: Ridgefield Anniversary Committee, 1958), p. 165; Thomas H. Rockwell, account book, 1820–59, Yale.

102. George L. Rockwell, *The History of Ridgefield, Connecticut* (Ridgefield, Conn.: By the author, 1927), p. 387; 1820 Census of Manufactures, State of Connecticut.

103. *Norwalk Gazette* (Norwalk, Conn.), February 5, April 8, and September 2, 1823 (references courtesy of Wendell Hilt).

104. Dwight, *Travels,* 3:364; 1820 Census of Manufactures, State of Connecticut; *Connecticut Courier* (Bridgeport, Conn.), April 9, 1823 (reference courtesy of Wendell Hilt).

105. William Chappel, advertisement in *Connecticut Courier,* March 22, 1815 (reference courtesy of Wendell Hilt); David Finch, advertisement in *Danbury Recorder* (Danbury, Conn.), June 13, 1826 (reference courtesy of Wendell Hilt).

106. Frederick W. Parrott, advertisement in *Bridgeport Messenger* (Bridgeport, Conn.), January 7, 1832 (reference courtesy of Wendell Hilt); Frederick W. Parrott, and Booth and Porters, advertisements in *Carolina Sentinel* (New Bern, N.C.), December 6, 1833, and November 4, 1835, and *North Carolina Star* (Raleigh, N.C.), November 13, 1834, as quoted in James H. Craig, *The Arts and Crafts in North Carolina, 1699–1840* (Winston-Salem, N.C.: Old Salem, 1965), pp. 232–33, 235, 238; Parrott and Hubbell, insolvency records, 1835, Bridgeport, Conn., Genealogical Section, CSL; Sterling and Hubbell, advertisement in *Bridgeport Standard* (Bridgeport, Conn.), July 25, 1843 (reference courtesy of Wendell Hilt). Parrott's death is recorded in index, Connecticut Church Records.

107. F. Lockwood, Edwin Wood, and D. D. Lockwood, advertisements in *Bridgeport Standard,* March 14 and July 25, 1843, March 21, 1843, and December 31, 1844 (references courtesy of Wendell Hilt); Lockwood and Waite, insolvency records, 1847, Bridgeport, Conn., Genealogical Section, CSL.

108. Melish, *Travels,* 1:125; [Davison], *Traveller's Guide,* p. 438; Silas Cheney, deeds from Ebenezer Plumb, Jr., and Joseph Adams, April 30, 1800, and March 29, 1802, and discharge of mortgages with Moses Symonds, Jr., and Timothy and Virgil Peck, May 1, 1800, CHS; *Monitor* (Litchfield, Conn.), September 29, 1802, as illustrated in John F. Page, *Litchfield County Furniture, 1730–1850* (Litchfield, Conn.: Litchfield Historical Society, 1969), p. 119.

Data on Plumb are found in Kihn, "Connecticut Cabinetmakers, Part II," p. 7.

109. Silas E. Cheney, account books, 5 vols., 1799–1846, Litchfield Historical Society, Litchfield Co., Conn. (microfilm, DCM); Silas E. Cheney, Superior Court, Miscellaneous Papers, 1807–19, Litchfield Co., Conn., CSL.

110. Cheney, account books; Cheney, court papers.

111. Cheney, account books; Cheney, court papers.

112. Cheney, account books; Cheney, court papers; Stillman, account book.

113. Cheney, account books; Cheney, court papers.

114. Cheney, account books; Cheney, court papers.

115. Cheney, account books; Cheney, court papers.

116. Cheney, account books; Cheney, court papers.

117. Cheney, account books; Cheney, court papers; Daniel Foot, estate records, 1840, Berkshire Co. Mass., Registry of Probate.

118. Cheney, account books; Nathaniel Brown, advertisement in *Monitor,* April 3, 1799, as excerpted in Kihn, "Connecticut Cabinetmakers, Part I," p. 110; Cheney, court papers; Miles Hart, estate records, 1862, Goshen, Conn., Genealogical Section, CSL.

119. Cheney, account books; Silas E. Cheney, estate records, 1821, Litchfield, Conn., Genealogical Section, CSL.

120. David Pritchard, Jr., estate records, 1839, Waterbury, Conn., Genealogical Section, CSL; Kenney, *Hitchcock Chair,* p. 19; David Pritchard, Jr., ledger, 1800–1810, Mattatuck.

121. Cheney, account books; Kenney, *Hitchcock Chair,* pp. 18–21; David Pritchard, Jr., family papers, Mattatuck.

122. Cheney, account books; Kenney, *Hitchcock Chair,* pp. 18–21; Cheney, estate records.

123. Data on Doolittle and Sanford are found in Page, *Litchfield County Furniture,* pp. 121, 124. See Doolittle in index, Hale Collection; Cheney, account books.

124. Excerpts are drawn from *Connecticut Courant,* April 19, 1815; *Litchfield Journal* (Litchfield, Conn.), April 8, May 6, and June 3, 1818; and *Litchfield Enquirer,* December 30, 1830. Other data are found in Page, *Litchfield County Furniture,* pp. 50–51, 100–103, 119–20.

125. Photocopy of chair and bill are found in the Visual Resources Collection, Winterthur Library (hereafter cited as VRC).

126. Philemon Hinman, account book, 1804–17, CHS; Philemon Hinman, estate records, 1835, Harwinton, Conn., Genealogical Section, CSL.

127. Wait Garret, and Samuel Douglas and Son, account book, 1810–58, CSL.

128. Wood and Watson data are found in Kihn, "Connecticut Cabinetmakers, Part II," pp. 28, 33. Eli Wood, estate records, 1818, Barkhamstead, Conn., Genealogical Section, CSL; Cheney, account books; Cheney, court papers.

129. Kenney, *Hitchcock Chair,* pp. 17, 20–21, 42–43, 45, 54; Cheney, account books; Pritchard, family papers.

130. *Connecticut Courant,* March 18, 1822, and other data are found in Kenney, *Hitchcock Chair,* pp. 52–55. West and Hatch, letter to Silas Cheney,

May [11], 1814, in Cheney, court papers; Cheney, account books; Mrs. Guion Thompson, "Hitchcock of Hitchcocks-ville," *Antiques* 4, no. 2 (August 1923): 74.

131. Barzillai Hudson, advertisements in *Connecticut Courant,* July 18, 1825, August 25, 1827, and April 13, 1829, and illustration of page and village statistics, from John Warner Barber, *Connecticut Historical Collections* (New Haven, Conn., 1836), as found in Kenney, *Hitchcock Chair,* pp. 8, 91–94, 101–2; George Dewey, John Dewey, and Bulkley and Cooke, advertisements in *Litchfield County Post* (Litchfield, Conn.), January 22, 1829, and *Litchfield Enquirer,* December 30, 1830, and June 6, 1839, as given in Page, *Litchfield County Furniture,* pp. 118, 120–21.

132. Unidentified New Haven newspaper, July 2, 1828, and other data, as found in Kenney, *Hitchcock Chair,* pp. 38, 95–97, 100, 102–14; William Moore, Jr., insolvency records, 1830, Barkhamsted, Conn., Genealogical Section, CSL.

133. *Hartford Times* (Hartford, Conn.), August 14, 1830, *Connecticut Courant,* November 17, 1832, and other data, as found in Kenney, *Hitchcock Chair,* pp. 115–20; *American Advertising Directory,* p. 56; *Documents Relative to the Manufactures in the United States Collected and Transmitted to the House of Representatives in Compliance with a Resolution of January 19, 1832, by the Secretary of the Treasury,* 2 vols. (Washington, D.C.: Duff Green, 1833), vol. 1, p. 1019.

134. *Connecticut Courant,* September 29, 1834, and other data, as given in Kenney, *Hitchcock Chair,* pp. 128–29, 132–35; Wright, account book; Robbins, account book.

135. Kenney, *Hitchcock Chair,* pp. 140–45, 148–51, 153–56, 160–63; Lambert Hitchcock, estate records, 1852, Farmington, Conn., Genealogical Section, CSL.

136. Wright, account book; Robbins, account book; Pritchard, account book, ledger, and family papers; David Pritchard, Jr., account book, 1827–38, Mattatuck; Parrott and Hubbell, and Lockwood and Waite, insolvency records; Kenney, *Hitchcock Chair,* pp. 56–134, 143–44, facing p. 148; Charles F. Montgomery, *American Furniture: The Federal Period* (New York: Viking Press, 1966), pp. 90–92.

137. Pritchard, account book, 1827–38; Robbins, account book; Parrott and Hubbell, insolvency records; Kenney, *Hitchcock Chair,* pp. 211–16.

138. Robbins, account book; Pritchard, estate records; Parrott and Hubbell, insolvency records. The rocking chair is illustrated in Zilla Rider Lea, ed., *The Ornamented Chair* (Rutland, Vt.: Charles E. Tuttle, 1960), p. 131, figs. 38, 38a.

139. Samuel Eliot Morison, *The Maritime History of Massachusetts, 1783–1860* (London: William Heinemann, 1923), pp. 187–89, 191, 193–94, 213–15, 230; Richard D. Brown, *Massachusetts, a Bicentennial History* (New York: W. W. Norton, 1978), pp. 129–49.

140. Joshua Shaw, comp., *United States Directory* (Philadelphia: James Maxwell, 1822), pp. 55–56; Morison, *Maritime History,* pp. 124, 225, 229, 237; *The Diary of William Bentley,* 4 vols. (Salem, Mass.: Essex Institute, 1905), vol. 3, pp. 50, 109; Lambert, *Travels,* 2:331–32; Robert Donald Crompton, ed., "A Philadelphian Looks at New England—1820," *Old-Time New England* 50, no. 3 (January–March 1960): 68; [Royall], *Sketches,* pp.

320, 338, 345–46; John Warner Barber, *Historical Collections . . . of . . . Massachusetts* (Worcester, Mass.: Dorr, Howland, 1839), p. 534; *Lippincott's Gazetteer of the World* (2d ed.; Philadelphia: J. B. Lippincott, 1888), p. 272.

141. Reuben Sanborn, bill to Nathaniel Treadwell, June 13, 1801, Papers of Capts. John and Jonathan Lovett, Essex Institute, Salem, Mass., (hereafter cited as EI); John Doggett, account book, 1802–9, DCM; Reuben Sanborn, advertisement in *Columbian Centinel* (Boston, Mass.), February 10, 1808; Thomas C. Hayward, advertisement in *Columbian Centinel,* June 22, 1811 (reference courtesy of Donald Fennimore); Ebenezer Knowlton, estate records, 1811, Suffolk Co., Mass., Registry of Probate (microfilm, DCM). The Knowlton documents were brought to the author's attention by Page Talbott.

142. Doggett, account book; *Columbian Centinel,* June 22, 1811; Thomas C. Hayward, property records, 1803–14, Middlesex Co., Mass., Registry of Deeds.

143. Eliza Susan Quincy, memorandum of furniture, 1879, private collection; Doggett, account book; William Fisk, indenture of lease with Samuel Payson, September 1, 1809, DCM.

144. David Tilden, lawsuit vs. William Seaver, 1804, Colonial Court Records, Social Law Library, Boston, Mass. (reference courtesy of Charles A. Hammond and John T. Kirk); Knowlton, estate records.

145. Manifests of sloop *Alert,* August 8, 1804, schooner *Virginia,* September 27, 1804, schooner *Sally,* April 4 and 23, 1805, schooner *Mount Hope,* May 14, 1806, brig *Cyrus,* May 28 and July 17, 1806, schooner *Packet,* September 3, 1806, schooner *Industry,* March 14, 1807, schooner *Retaliation,* May 15 and September 21, 1807, brig *Charlotte,* September 28, 1807, schooner *Nancy,* October 20, 1807, schooner *President,* November 4, 1807, brig *William and Martha,* November 27, 1807, brig *Fox,* May 28 and July 9, 1811, all in Philadelphia Outward Coastwise Entries, U.S. Custom House Records, NA. *Columbian Centinel,* March 19, 1808; George Miles, Jr., bill to John Hancock, September 8, 1809, Hancock Collection, Baker Library, Harvard University, Cambridge, Mass. (hereafter cited as BL).

146. Bass, Barker and Co., advertisement in *Boston Patriot* (Boston, Mass.), October 1, 1814 (reference courtesy of Wendell Hilt); Benjamin Bass, estate records, 1819, Suffolk Co., Mass., Registry of Probate (microfilm, DCM). The Bass documents were brought to the author's attention by Page Talbott.

147. Bass, estate records. An identical notation on the second chair of the pair bears the heading "Elsie." A second label reads "Miss E. B. Tower / Dimond Hill / Concord / N.H. / (Care of Hopkinton Stage-driver)." Such information documents how routinely some furniture left its area of manufacture within only a few generations of purchase and suggests how easily objects came to possess "an old family history" in their new location.

148. Patricia E. Kane, "Samuel Gragg: His Bentwood Fancy Chairs," *Yale University Art Gallery Bulletin* 33, no. 2 (Autumn 1971): 27–37; Thomas Hope, *Household Furniture and Interior Decoration* (1807; reprint, New York: Dover, 1971). The portrait of Mme. Récamier is illustrated in Robert Bishop, *The American Chair* (1972; reprint, New York: Bonanza, 1983), fig. 453.

From a letter of 1803, it is obvious that the imported English chair was a commodity of some consequence in this country. The writer speaks of bundles and boxes of chairs received from Gabriel and Sons to be assembled for sale. He also notes a special order for Dr. John Warren, who requested a dozen English drawing room armchairs. Standfast Smith, letter to John R. Parker, June 2, 1803, DCM.

149. Kane, "Samuel Gragg"; *Columbian Centinal,* February 27, 1808, May 27, 1809 (as quoted in "Clues and Footnotes," *Antiques* 107, no. 5 [May 1975]: 939).

150. Bass, estate records. A plugged hole that once socketed a side stretcher is visible on the left rear leg adjacent to the rocker. The chair has been subjected to other depredations, as well. Tack holes puncture the face of the back frame and the under edges of the seat, indicating that someone added a covering of stuffed work, probably at the time the rockers were installed. Strong evidence in the form of a label establishes a time frame for the alterations. On the plank bottom are remnants of a small paper advertisement placed there between 1835 and 1850 by Henry Lawson and Francis Harrington, upholsterers in Washington Street, Boston. The chair has a tradition of ownership in the local Fuller and Higginson families, who established a summer home in Deerfield, Massachusetts, in the nineteenth century. Fuller-Higginson family history supplied by Historic Deerfield, Deerfield, Mass. (hereafter cited as HD).

151. The fancy chair dated 1808 was owned by the Historical Society of Early American Decoration but was probably transferred in 1991 with other collection objects to the Museum of American Folk Art, New York. The Boston fancy chair with finials and the alternate Gragg elastic chair pattern are illustrated in Elizabeth Bidwell Bates and Jonathan Fairbanks, *American Furniture, 1620 to the Present* (New York: Richard Marek, 1981), p. 222.

152. Bass, estate records; Rodolphus Dickinson, *Geographical and Statistical View of Massachusetts Proper* (Greenfield, Mass.: Denio and Phelps, 1813), p. 68.

153. The second side chair is illustrated in Penny J. Sander, ed., *Elegant Embellishments* (Boston: Society for the Preservation of New England Antiquities, 1982), fig. 119.

154. Montgomery, *Federal Furniture,* p. 83. The Gragg tablet-crest elastic chair is illustrated in Dean A. Fales, Jr., *American Painted Furniture, 1660–1880* (New York: E. P. Dutton, 1972), fig. 187.

155. 1820 Census of Manufactures, State of Massachusetts; Samuel Beal, bill to H. and L. Reid, September 12, 1822, BL; Samuel Beal, bill to Capt. Nathaniel Kinsman, May 5, 1824, EI; Israel Lombard, cash book, furniture account with Samuel Beal, probably January 27, 1826, American Antiquarian Society, Worcester, Mass. (hereafter cited as AAS); Samuel Beal, advertisement in *Daily Evening Transcript* (Boston, Mass.), July 24, 1830, DCM. The yellow chairs are itemized in Blake and Kittredge, bill to Miss F. A. Whitman, September 28, 1831, DCM. John Doggett, letter book, letter to Broome Sons and Horne, November 22, 1828, DCM.

156. *Catalogue of . . . Furniture,* August 28, 1829 (Boston: Dorr and Allen, 1829), lots 12–14, 27–28; *Catalogue of . . . Cabinet Furniture,* March 10, 1831 (Boston: New-England Society, 1831), lots 66, 118, 204, 282, 399; Samuel Gragg, bill to Boston

Athenaeum, July 1, 1822, Boston Athenaeum, Boston, Mass. (reference courtesy of Joyce Hill); J. C. Hubbard, advertisement in *Boston Directory* (Boston: Adams, Sampson, 1860), p. 80; Woods, Stevens and Co., advertisement in *Stimpson's Boston Directory* (Boston: Charles Stimpson, Jr., 1833), p. 17.

157. David and Abner Haven, joint account book, 1785–1800 and 1809–30, DCM.

158. Isaac Jones, estate records, 1813, Middlesex Co., Mass., Registry of Probate (reference courtesy of Richard Nylander); family data courtesy of Howard Gambrill, Jr.

159. Samuel Dakin, Samuel Barrett, and Humphrey Barrett, estate records, 1818, 1825, and 1827, Samuel Barrett property description from Edward Jarvis, "Houses and People in Concord 1810 to 1820" (manuscript, 1882; annotated typescript, Adams Tolman, 1915), items 225, 456, Concord Free Public Library, Concord, Mass.

160. Barber, *Historical Collections*, pp. 404–5; Louis C. Hunter, *Waterpower in the Century of the Steam Engine*, vol. 1 of *A History of Industrial Power in the United States, 1780–1930* (Charlottesville, Va.: University Press of Virginia, 1979), pp. 211–17; William Wilson, account book, 1837–38, DCM.

161. "Remarks on Merchandize usually shipd . . . [to] St. Salvador or Bahia Brazils," ca. 1822–25, and sloop *Common Chance*, bill to Joseph Waters, December 6, 1825, Waters Family Papers, EI; manifest of brig *Welcome Return*, September 15, 1807, Philadelphia Outward Coastwise Entries, U.S. Custom House Records, NA; Tuttle and Manning, advertisements in *Salem Gazette* (Salem, Mass.), September 29, 1801, May 2, 1806 (references courtesy of Susan B. Swan); Fales, *Painted Furniture*, p. 168; William Parkhurst, bill to Ebenezer Fox, December 19, 1806, Papers of Ebenezer Fox and Family, EI; Gridley, Blake, and Co., Hatch and McCarty, Dorr and Allen, J. L. Cunningham, and Whitney and Brown, bills to Daniel W. Rogers, July 6, 1827, June 6, 1829, August 26, 1828, ca. 1829, April 25, 1829, May 27, 1829, June 16, 1830, and November 27, 1830, Papers of Daniel Rogers, Jr., EI.

162. Burpee Ames, advertisement in *Salem Gazette*, September 28, 1810 (reference courtesy of Susan B. Swan); Mabel M. Swan, *Samuel McIntire, Carver, and the Sandersons, Early Salem Cabinet Makers* (Salem, Mass.: Essex Institute, 1934), pp. 28, 37. Fan-back chair sales: William Luther, bill to Benjamin Goodhue, June 8, 1804, Papers of Benjamin and Stephen Goodhue and Family, EI; Edmund Johnson, bill to Capt. Benjamin Pickman, March 30, 1807, Papers of Benjamin Pickman, Jr., EI; Edmund Johnson, bill to Samuel Holton, n.d. (before 1811), Papers of Samuel Holton, Library of Congress, Washington, D.C.

163. Swan, *Samuel McIntire*, pp. 27–29, 37; Burpee Ames, bill to Mr. Hathorne, November 16, 1814, Hathorne Family Manuscripts, EI; John Farrington, bill to Capt. Joseph Waters, September 23, 1804, and Nathan Luther, bill to Capt. Devereux, January 8, 1810, Waters Family Papers, EI; Isaac Stone, bill to Miss Lidia Barton, November 1, 1806, Papers of Samuel and John Barton, box 6, EI; Richard Austin, bill to Estate of Jacob Sanderson, May 6, 1810, Sanderson Family Manuscripts, EI; Bernard Foot, bill to Ebenezer Pearson, September 24, 1813, Pearson Family Papers, EI (photostat, DCM); Isaac Stone, bill to Jacob Sanderson, May

11, 1808, Papers of Elijah Sanderson, EI; Abbot and McAllaster, bill to Capt. Edmund Kimball, October 6, 1808, Kimball Family Papers, EI.

164. Montgomery, *Federal Furniture*, figs. 19, 22; Farrington, bill to Capt. Joseph Waters; James C. Tuttle, bill to Benjamin H. Hathorne, August 7, 1807, Ward Family Manuscripts, EI; brig *Massafeuro*, invoice of goods, May 4, 1805, DCM; Alva M. Tuttle, comp., *Tuttle, Tuthill Lines in America* (Columbus, Ohio: By the compiler, 1968), p. 281; Tuttle, memorandum to author, August 17, 1968.

165. Jacob Sanderson, estate records, 1810, Sanderson Family Manuscripts, EI; Bentley, *Diary*, 3:499, 4:43, 51–52; Johnson data in Henry Wyckoff Belknap, *Artists and Craftsmen of Essex County, Massachusetts* (Salem, Mass.: Essex Institute, 1927), p. 50; Edmund Johnson, estate records, 1811, Essex Co., Mass., Registry of Probate.

166. Jedidiah Johnson, estate records, 1821, Essex Co., Mass., Registry of Probate; Thomas Needham, accounts of Robert Manning, 1824–25, 1833, Papers of Robert Manning, EI; Thomas Perkins, bill to Benjamin H. Hathorne, December 4, 1822, Hathorne Family Manuscripts, EI.

167. Ebenezer Smith, Jr., accounts of Robert Rantoul, 1805–7, Papers of Robert Rantoul, Beverly Historical Society, Beverly, Mass. (hereafter cited as BHS); Ebenezer Smith, Jr., bill to Robert Rantoul, December 17, 1803, Cabinetmaker Notebook, BHS; Samuel Stickney, Jr., bill to Mrs. Elizabeth Lovett, December 9, 1801, Papers of Capts. John and Jonathan Lovett, EI; John Redfield, "A Windsor Chair by Samuel Stickney," *Spinning Wheel* 28, no. 4 (May 1972): 42–43.

168. Stephen Whipple, account book, 1803–11, Ipswich Historical Society, Ipswich, Mass. (document brought to author's attention by Michael Dunbar).

169. Whipple, account book.

170. Dwight, *Travels*, 1:317–19; Sarah Anna Emery, *Reminiscences of a Nonagenarian* (Newburyport, Mass.: William H. Huse, 1879), pp. 256, 261–65.

171. Emery, *Reminiscences*, pp. 231, 263; Dean A. Fales, Jr., *Essex County Furniture* (Salem, Mass.: Essex Institute, 1965), fig. 1; Revs. Abiel Abbot and Ephraim Abbot, comps., *A Genealogical Register of the Descendants of . . . Abbot* (Boston: James Munroe, 1847), p. 169; Abbot and McAllaster, and Samuel Dole, bills to Capt. Edmund Kimball, October 6, 1808, and November 1810, Kimball Family Papers, EI. The Eli Robbins chair is at the Lexington, Massachusetts, Historical Society (Buckman Tavern).

172. Emery, *Reminiscences*, p. 269; Bernard Foot, bill to Ebenezer Pearson, September 24, 1813, EI (photostat, DCM); Bernard Foot, bill to Mr. Adams, November 12, 1818, Adams Family Manuscripts, EI; Fales, *Essex County Furniture*, fig. 29.

173. Loring data supplied by OSV.

174. Barber, *Historical Collections*, pp. 450, 493–94; Eleazer Daniels, estate records, 1858–59, Norfolk Co., Mass., Registry of Probate.

175. John Sprague II and Rebecca Sprague, estate records, 1812 and 1813, John Sprague Papers, AAS.

176. Caleb Hobart, Jr., bill to Hingham Building Committee for Schoolhouses, March 3, 1830, DCM; Caleb Hobart, Jr., and Sr., wills and estate records, 1830, 1838, 1841, 1846–47, 1853, and 1865,

Plymouth and Norfolk Cos., Mass., Registries of Probate.

177. Barber, *Historical Collections*, pp. 110, 142–43.

178. Isaac Washburn, property and estate records, 1808–11 and 1832, Bristol Co., Mass., Registry of Deeds and Probate; Barber, *Historical Collections*, p. 143; Isaac Washburn, bill to Sylvanus Smith, October 28, 1828, as illustrated in Carl W. Drepperd, *First Reader for Antique Collectors* (Garden City, N.Y.: Doubleday, 1946), p. 20.

179. Joseph Dean, account book, 1804–39, OSV.

180. Barber, *Historical Collections*, p. 127.

181. Abraham Russell and William Russell, Jr., data in Elton W. Hall, "New Bedford Furniture," *Antiques* 113, no. 5 (May 1978): 1108, 1124–25; manifest of ship *Elizabeth*, November 7, 1804, Philadelphia Outward Coastwise Entries, U.S. Custom House Records, NA; Reynolds listed in New York City Jury List, 1819, Historical Documents Collection, Queens College, Flushing, N.Y.; William Russell, Jr., estate records, 1833, Bristol Co., Mass., Registry of Probate.

182. Hall, "New Bedford Furniture," pp. 1117–18: an interior view of Abraham Russell's dining room is illustrated on p. 1109. Thomas Allen II, property records, 1824 and 1836, Bristol Co., Mass., Registry of Deeds.

183. Hall, "New Bedford Furniture," pp. 1119–26; Thomas Ellis, advertisement in *New Bedford Courier* (New Bedford, Mass.), September 4, 1827, and *New-Bedford Mercury* (New Bedford, Mass.), June 28, 1833, the latter as quoted in Hall, "New Bedford Furniture," p. 1121; John Sowle, advertisement in *New-Bedford Mercury*, May 7, 1841, as quoted in Hall, "New Bedford Furniture," p. 1125; Joel Pratt, Jr., account book and loose papers, 1822–37, privately owned (OSV, microfilm).

184. Barber, *Historical Collections*, pp. 32–33; Samuel Wing, account books, 1800–1808, OSV. The highchair is illustrated in Henry J. Harlow, "The Shop of Samuel Wing, Craftsman of Sandwich, Massachusetts," *Antiques* 93, no. 3 (March 1968): 373. Wing's later career is noted in *The Owl* 18, no. 3 (June 1917): 1664.

185. Calvin Stetson, account book, 1843–57, DCM; Calvin Stetson, property records, 1829, 1838, Barnstable Co., Mass., Registry of Deeds. The "Harrison" chair is illustrated in Lea, *Ornamented Chair*, p. 131.

186. Barber, *Historical Collections*, pp. 445–46, 448–49; William Oliver Stevens, *Nantucket, The Far-Away Island* (New York: Dodd, Mead, 1936), p. 4.

187. Early nineteenth-century Nantucket inventories, including that of Lydia Pinkham, May 31, 1810, Nantucket Co., Mass., Registry of Probate; 1820 Census of Manufactures, State of Massachusetts.

188. Melish, *Travels*, 1:109; Arfwedson, *United States and Canada*, 1:127; W[illiam] Chambers, *Things as They Are in America* (Philadelphia: Lippincott, Grambo, 1854), pp. 251–52.

189. Charles S. Parsons, New Hampshire Notes, VRC; Donna-Belle Garvin, James L. Garvin, and John F. Page, *Plain and Elegant, Rich and Common: Documented New Hampshire Furniture, 1750–1850* (Concord, N.H.: New Hampshire Historical Society, 1979), pp. 78–79, 140.

190. Henry Wilder Miller, account book, 1827–31, Worcester Historical Museum, Worcester, Mass. (hereafter cited as WHM); Miller biographical data from various unidentified newspaper clippings, 1886–91, WHM.

191. Miller, account book; Kendall Payne Hayward, comp., *The Kendalls of Connecticut* (West Hartford, Conn: Chedwato Service, 1956), p. 23.

192. Miller, account book.

193. Miller, account book; *Documents Relative to Manufactures,* 1:292–93, 498–99, 532–33, 552–53.

194. Miller, newspaper clippings; Smith Kendall, estate records, 1877, Worcester Co., Mass., Registry of Probate.

195. 1820 Census of Manufactures, State of Massachusetts; *Documents Relative to Manufactures,* 1:292–93, 474–77, 488–89, 492–93, 498–501, 508–9, 528–29, 532–35, 546–53, 564–65; Francis De Witt, comp., *Statistical Information Relative to Certain Branches of Industry in Massachusetts for the Year Ending June 1, 1855* (Boston: William White, 1856), pp. 466, 468, 481, 485, 489, 491, 500, 505, 510, 518, 525, 527, 529, 537–38, 545, 549, 553, 558–59, 562.

196. Virginia Milnes Wheelock, "Jerry Wheelock, Joiner," in *The Decorator Digest,* ed. Natalie Allen Ramsey (Rutland, Vt.: Charles E. Tuttle, 1965), pp. 49–51.

197. Chapman Lee, ledger, 1799–1850, OSV; Frank O. Spinney, "Country Furniture," *Antiques* 64, no. 2 (August 1953): 114–15; Spinney, "Chapman Lee, Country Cabinetmaker," *New-England Galaxy* 1, no. 3 (Winter 1960): 34–38.

198. Dwight, *Travels,* 1:275; Ezra S. Stearns, *History of Ashburnham, Massachusetts* (Ashburnham, Mass: By the town, 1887), p. 408.

199. Rev. William D. Herrick, *History of the Town of Gardner . . . Massachusetts* (Gardner, Mass.: By the committee, 1878), p. 166; Miller, account book; 1820 Census of Manufactures, State of Massachusetts.

200. *Documents Relative to Manufactures,* 1:292–93, 492–93, 498–99, 528–29, 532–33, 546–49, 552–53, 564–65; De Witt, *Statistical Information,* p. 601.

201. Herrick, *History of Gardner,* pp. 167–68, 172; Duane Hamilton Hurd, ed., *History of Worcester County, Massachusetts,* 2 vols. (Philadelphia: J. W. Lewis, 1889), vol. 1, pp. 828–30, 837, 841; Stearns, *History of Ashburnham,* pp. 409–10; *History of Worcester County, Massachusetts,* 2 vols. (Boston: C. F. Jewett, 1879), vol. 2, p. 403; 1820 Census of Manufactures, State of Massachusetts.

202. *History of Worcester County,* 1:509, 2:403; Stearns, *History of Ashburnham,* pp. 411–12; Walter G. Lord, comp., *History of Athol, Massachusetts* (Athol, Mass.: By the compiler, 1953), p. 281; Hurd, *History of Worcester County,* 1:827–30, 836, 841; Herrick, *History of Gardner,* pp. 166–67, 170, 174; Asa Nichols, Peter Peirce, and Benjamin F. Heywood, estate records, 1829, 1836, and 1843, Worcester Co., Mass., Registry of Probate.

203. The Spooner and Fitts partnership is mentioned in Lord, *History of Athol,* p. 282.

204. 1820 Census of Manufactures, State of Massachusetts.

205. *Documents Relative to Manufactures,* 1:474–75.

206. 1820 Census of Manufactures, State of Massachusetts; *Documents Relative to Manufactures,* 1:548–49; *History of Worcester County,* 2:349.

207. Pratt, account book.

208. 1820 Census of Manufactures, State of Massachusetts; Samuel Stuart, estate records, 1829, Worcester Co., Mass., Registry of Probate; *History of Worcester County,* 1:489.

209. Luke Houghton, ledgers A-C, 3 vols., 1816–27, 1825–50, and 1834–76, Barre Historical Society, Barre, Mass.; *Documents Relative to Manufactures,* 1:476–77.

210. Samuel Stuart and Peter A. Willard, estate records, 1829 and 1842–43, Worcester Co., Mass., Registry of Probate.

211. Peter A. Willard, estate records.

212. *History of Worcester Co.,* 2:402–3; Miller, account book; Houghton, ledgers.

213. Elbridge Gerry Reed, daybook, 1829–51, privately owned (OSV, photocopy).

214. Chambers, *Things as They Are,* pp. 210–11; [Royall], *Sketches,* pp. 290–91; [Dwight], *Northern Traveller,* pp. 250–51; Barber, *Historical Collections,* pp. 295–96, 301.
A recent publication (Gail Nessell Colglazier, *Springfield Furniture, 1700–1850* [Springfield, Mass.: Connecticut Valley Historical Museum, 1990]) confirms the observation that little vernacular seating furniture can be documented to or associated with Springfield. Erastus Grant, advertisement in *Hampden Register* (Westfield, Mass.), May 17, 1826, as quoted in Florence Thompson Howe, "Look for Labels and Documentation on Your Antique Furniture," *Spinning Wheel* 25, no. 9 (November 1969): 27; 1820 Census of Manufactures, State of Massachusetts; De Witt, *Statistical Information,* p. 601.

215. *The Aristocratic Journey: Being the Outspoken Letters of Mrs. Basil Hall,* ed. Una Pope-Hennessy (New York: G. P. Putnam's Sons, 1931), p. 80; Barber, *Historical Collections,* pp. 330–31; Arfwedson, *United States and Canada,* 1:112.

216. Harris Beckwith, ledger, 1803–7; Sage account in William Collson, account book, 1763–1816, DCM; Luther Davis and Asa Jones, advertisements in *Hampshire Gazette* (Northampton, Mass.), March 23, 1808, September 6, 1809; Leigh Keno, "The Windsor Chair Makers of Northampton, Massachusetts, 1790–1820" (Historic Deerfield Summer Fellowship Program Paper, August 1979), pp. 21–25, 50–51. The Pomeroy-built shop is mentioned in Luther Davis, property record, 1812, Hampshire Co., Mass., Registry of Deeds.

217. Benjamin H. Henshaw, and Pomeroy and Barns, advertisements in *Hampshire Gazette,* June 1, 1819, September 18, 1822, and other data, in Keno, "Windsor Chair Makers of Northampton" (paper), pp. 44, 49–51, 121, 130–31; Justin Parsons and Elias White, estate records, 1807 and 1845, Hampshire Co., Mass., Registry of Probate; Elias White, advertisement in *Hampshire Gazette,* March 18, 1812, and *Vermont Gazette* (Bennington, Vt.), January 25, 1825.

218. Barber, *Historical Collections,* pp. 256–57; Daniel Clay, advertisements in *Greenfield Gazette* (Greenfield, Mass.), July 26, 1800, September 5, 1808, November 20, 1820, as quoted in Peter Rippe, "Daniel Clay of Greenfield, 'Cabinetmaker'" (Master's thesis, University of Delaware, 1962), pp. 12, 29, 33–34; Allen Holcomb, advertisement in *Greenfield Gazette,* August 15, 1808, May 15, 1809, as quoted in Rippe, "Daniel Clay," pp. 28–29, 30–31;

Allen Holcomb, account book, 1809–28, Metropolitan Museum of Art, New York.

219. Calvin Munn and Nathan Pierce, advertisements in *Franklin Herald* (Greenfield, Mass.), January 25, 1814, January 10 and October 3, 1815, as quoted in Rippe, "Daniel Clay," p. 46; Daniel Munger, advertisement in *Franklin Herald and Public Advertiser* (Greenfield, Mass.), September 28, 1824, as quoted in Rippe, "Daniel Clay," p. 47; Rippe, "Daniel Clay," pp. 48–49.

220. Robbins, account book; Francis A. Birge, property records, 1836–37, Franklin Co., Mass., Registry of Deeds.

221. Birge, property records, 1839–42; Edward Jenner Carpenter, journal, 1844–45, as quoted in Winifred C. Gates, "Journal of a Cabinet Maker's Apprentice," *Chronicle* (Early American Industries Assn.) 15, no. 3 (September 1962): 35–36; Edward W. and Francis A. Birge, property records, 1846–53, Rensselaer Co., N.Y., Registry of Deeds.

222. Carpenter, journal, as quoted in Gates, "Journal of a Cabinet Maker's Apprentice," pp. 35–36.

223. Joseph Griswold, ledgers, 3 vols., 1798–1844, and daybook, 1816–43, privately owned and DCM.

224. *Documents Relative to Manufactures,* 1:274–75, 282–83.

225. Barber, *Historical Collections,* pp. 60–61, 78, 88, 99; S. Schulling, diary, 1824–25, Historical Society of Pennsylvania, Philadelphia.

226. Abner Taylor, account book, 1806–32, and memorandum book, 1821–28, DCM; Barber, *Historical Collections,* pp. 78–79; Timothy Thatcher, estate records, 1833–34, Berkshire Co., Mass., Registry of Probate.

227. Barns and Gardner, John Ayres, and Ira Sheldon, advertisements in *Berkshire American* (North Adams, Mass.), June 6, 1827 (references courtesy of Wendell Hilt); *Documents Relative to Manufactures,* 1:132–33, 136–37; Ira Sheldon, estate records, 1830, Berkshire Co., Mass., Registry of Probate.

228. *American Advertising Directory,* p. 62; *Documents Relative to Manufactures,* 1:130–31, 146–47; Thomas Bassett, estate records, 1847, Berkshire Co., Mass., Registry of Probate; Barber, *Historical Documents,* pp. 66, 86.

229. Cheney, account books; Cheney, court papers; De Witt, *Statistical Information,* p. 601.

230. A. J. Coolidge and J. B. Mansfield, *A History and Description of New England,* 2 vols. (Boston: Austin J. Coolidge, 1859), 1:18, 396–97, 567–69, 727–29; Elizabeth Forbes Morison and Elting E. Morison, *New Hampshire: A Bicentennial History* (New York: W. W. Norton, 1976), pp. 92, 128–29, 132–34; Federal Writers' Project of the Works Projects Administration, *Vermont: A Guide to the Green Mountain State,* American Guide Series (Boston: Houghton, Mifflin, 1937), pp. 38–40, 43; Louis Clinton Hatch, ed., *Maine: A History* (1919; reprint, Somersworth, N.H.: New Hampshire Publishing, 1974), pp. 141, 169, 666–67, 676–78, 680–81, 689–91.

231. John Hayward, *A Gazetteer of New Hampshire* (Boston: John P. Jewett, 1849), pp. 116–17; Melish, *Travels,* 1:99–100.

232. Henry Beck, advertisement in *Portsmouth Oracle* (Portsmouth, N.H.), November 30, 1805, as quoted in Jane C. Giffen, "New Hampshire Cabi-

netmakers and Allied Craftsmen, 1790–1850," *Antiques* 94, no. 1 (July 1968): 79; Henry Beck, advertisement in *New Hampshire Gazette* (Portsmouth, N.H.), September 20, 1801 (reference courtesy of Joseph Hammond); Beck and Boardman as listed in *Constitution of the Associated Mechanics and Manufacturers of the State of New-Hampshire* (Portsmouth, N.H.: Miller and Brewster, 1832); Brock Jobe, ed., *Portsmouth Furniture: Masterworks from the New Hampshire Seacoast* (Boston: Society for the Preservation of New England Antiquities, 1993), pp. 62–63, 70, 71 n. 23. Judkins and Senter sketch in Garvin, Garvin, and Page, *Plain and Elegant*, p. 147; Judkins and Senter, bill to Capt. Reuben Randall, August 4, 1809, Wendell Papers, BL; Walker sketch in Charles S. Parsons, New Hampshire Notes, VRC.

233. Samuel Dockum, advertisements in *New Hampshire Gazette*, April 5 and November 25, 1825, September 26, 1826, January 9 and December 4, 1827 (references courtesy of Joseph Hammond); Jobe, *Portsmouth Furniture*, pp. 65– 68; John Grant, Jr., advertisement in *New Hampshire Gazette*, September 7, 1824, as quoted in Parsons, New Hampshire Notes; John Grant, Jr., bills to Jacob Wendell, June 22, 1817, November 20, 1818, April 21, 1823, Wendell Papers.

234. Brown, and Brown and Joy, advertisements in Parsons, Wilder Family Notes, VRC, without identification.

235. Portsmouth case furniture with light-colored, figured veneers forming oval and rectangular panels is illustrated in Sander, *Elegant Embellishments*, figs. 56, 57.

236. A chair from the Demeritt set is illustrated in Jobe, *Portsmouth Furniture*, p. 387.

237. The Hatch furniture sale is documented in Giffen, "New Hampshire Cabinetmakers," p. 83. Samuel Hatch, advertisement in *The Watchman* (Exeter, N.H.), February 14, 1817, as quoted in Parsons, New Hampshire Notes; Samuel Hatch, estate records, 1861–63, Rockingham, Co., N.H., Registry of Probate; Hatch and Bailey sales figures in 1820 Census of Manufactures, State of New Hampshire; True Carrier, account book, 1815–38, DCM.

238. Thomas Brown, advertisement in *Exeter Newsletter* (Exeter, N.H.), March 10, 1835, and data, as found in Giffen, "New Hampshire Cabinetmakers," pp. 79, 82. Brown's loaf-shaped-tablet chair and label are illustrated in Jobe, *Portsmouth Furniture*, pp. 389–90.

239. Hayward, *Gazetteer of New Hampshire*, pp. 61–62; Coolidge and Mansfield, *History of New England*, 1:473–74.

240. Chester auction chairs are found in Esther Gebelein Swain, "Three Ornamented 'Step-Up' Windsors," *The Decorator* 15, no. 2 (Spring 1961): 8–11. Jonathan T. and Samuel F. Seavey, property records, 1839, Strafford Co., N.H., Registry of Deeds.

241. The James Varney working as a chairmaker in Dover, New Hampshire, from 1807 to 1814, as listed in Jobe, *Portsmouth Furniture*, p. 423, would seem to be a different person, given the discrepancy of dates and the lack of a middle initial.

242. Andrew L. Haskell, advertisement in *Dover Gazette* (Dover, N.H.), December 1, 1827, as quoted in Parsons, New Hampshire Notes; Toppan sketch in Giffen, "New Hampshire Cabinet-

makers," p. 86; Shorey data in Garvin, Garvin, and Page, *Plain and Elegant*, pp. 44, 151.

243. Elizabeth Knowles Folsom, *Genealogy of the Folsom Family*, 2 vols. (Rutland, Vt.: Tuttle Publishing, 1938), vol. 1, pp. 340–42, 534–37; A. Folsom data in Garvin, Garvin, and Page, *Plain and Elegant*, pp. 42, 144–45.

244. Folsom, *Genealogy*, 1:534–37; A. Folsom data in Garvin, Garvin, and Page, *Plain and Elegant*, pp. 144–45.

245. Hazen data in Garvin, Garvin, and Page, *Plain and Elegant*, pp. 86–146.

246. Bixby sketch in Giffen, "New Hampshire Cabinetmakers," p. 79; Daniel Bixby, account book, 1839–49, DCM; J. R. Dodge, *Hillsborough County Records* (Nashua, N.H.: Dodge and Noyes, 1853), pp. 37–38; Daniel Bixby, estate records, 1870, Hillsborough Co., N.H., Registry of Probate.

247. David Atwood, indenture of apprenticeship with David McAfee, August 1, 1795 (reference courtesy of Charles H. Vilas).

248. T. Atwood data in Garvin, Garvin, and Page, *Plain and Elegant*, pp. 70, 140; Atwood genealogical data in *History of Bedford, New Hampshire, from 1737* (Concord, N.H.: By the town, 1903), pp. 856–59; *Documents Relative to Manufactures*, 1:826–27; Hayward, *Gazetteer of New Hampshire*, p. 102.

249. Charles S. Parsons, *The Dunlaps and Their Furniture* (Manchester, N.H.: Currier Gallery of Art, 1970), pp. 4,7, 9, 33, 35, 55, figs. 79–81.

250. Parsons, Wilder Family Notes; Rev. Moses H. Wilder, comp., *Book of the Wilders* (New York: Edward O. Jenkins, 1878), pp. 39, 181; Edwin M. Wilder, comp., *A Further Contribution to the . . . Book of the Wilders* (Sacramento, Calif.: Edwin M. Wilder, 1963), p. 128. Whether the Wilders occupied their land immediately is unclear. Some sources give 1810 as the date for erection of the chairworks. Peter's name is found in Boston directories only between 1803 and 1807; Joseph is listed in 1810 as well. The Boston accounts of Thomas Boynton list Joseph as a debtor for purchases and services during 1810–11. Boynton and Wilder further shared "a varnish pot copper owned between us," suggesting that Wilder rented shop space and bought supplies from Boynton to make chairs on his own account. Wilder's credit for his half pot in August 1811 marked the end of the business association and his departure for New Ipswich. Thomas Boynton, ledger, 1810–17, Dartmouth College, Hanover, N.H. (hereafter cited as DC) (microfilm, DCM).

251. Parsons, Wilder Family Notes; M. H. Wilder, *Book of Wilders*, p. 39; E. M. Wilder, *Contribution to Book of Wilders*, p. 132; Garvin, Garvin, and Page, *Plain and Elegant*, pp. 116–17, 152.

252. The *"WILDER"* brand is discussed in Garvin, Garvin, and Page, *Plain and Elegant*, p. 102.

253. Information on the "biblical" chairs can be found in Garvin, Garvin, and Page, *Plain and Elegant*, p. 102.

254. The Wetherbee and Carter rocking chairs are illustrated in Garvin, Garvin, and Page, *Plain and Elegant*, figs. 48, 50. Josiah P. Wilder, daybook and ledger, 1837–61, privately owned, as transcribed in Parsons, Wilder Family Notes.

255. Parsons, Wilder Family Notes; Wilder, daybook and ledger; E. M. Wilder, *Contribution to Book of Wilders*, p. 132.

256. Parsons, Wilder Family Notes; Wilder, daybook and ledger.

257. Parsons, Wilder Family Notes.

258. Parsons, *The Dunlaps*, figs. 83–84.

259. Esther Stevens Fraser, "Random Notes on Hitchcock and His Competitors," *Antiques* 30, no. 2 (August 1936): 67, figs. 6, 13.

260. Olive Crittenden Robinson, "Signed Stenciled Chairs of W. P. Eaton," *Antiques* 56, no. 2 (August 1949): 112–13.

261. Excerpts from *New Hampshire Sentinel* (Keene, N.H.): Wilder and Holbrook, March 9, 1805; Abel Wilder, August 7, 1807; Wilder, Rugg and Co., March 7, 1808; Smith and Briggs, May 23, 1812; February 19 and October 2, 1813. Excerpts and other data are from Parsons, Wilder Family Notes.

262. Excerpts from *New Hampshire Sentinel*: Abijah Wilder, Jr., January 16, 1823, March 30, 1824, April 20, 1825; Charles Ingalls, March 20, 1824, November 22, 1825; Azel and Abijah Wilder, Jr., July 4, 1812. These and other data are from Parsons, New Hampshire Notes, and Parsons, Wilder Family Notes. The Keene directories for 1827 and 1830 were printed in *New Hampshire Sentinel*, January 5, 1827, January 1, 1830. *Keene Directory and Register for 1831* (Keene, N.H., 1831), p. 10.

263. Jacob Felton, daybook, 1836–38, OSV; John Foote Norton, *History of Fitzwilliam, New Hampshire, from 1752 to 1887* (New York: Burr, 1888), as given in Parsons, New Hampshire Notes.

264. Felton, daybook; Parsons, New Hampshire Notes.

265. Dwight, *Travels*, 4:96–97; Hayward, *Gazetteer of New Hampshire*, p. 52.

266. Bartlett sketches are in Giffen, "New Hampshire Cabinetmakers," p. 79, and in Garvin, Garvin, and Page, *Plain and Elegant*, p. 140. Levi Bartlett, advertisements in *Courier of New Hampshire* (Concord, N.H.), September 18, 1805; *New Hampshire Gazette*, September 5, 1806; *New-Hampshire Patriot* (Concord, N.H.), October 3, 1809, September 10 and December 31, 1811, November 19, 1816 (references courtesy of Charles S. Parsons).

267. Parsons, New Hampshire Notes; Low and Damon, advertisement in *New-Hampshire Patriot*, February 6, 1816, and other data, in Garvin, Garvin, and Page, *Plain and Elegant*, pp. 143, 148–49; [Dwight], *Northern Traveller*, p. 298.

268. Garvin, Garvin, and Page, *Plain and Elegant*, pp. 70–75; Levi Bartlett, advertisement in *Concord Gazette* (Concord, N.H.), November 8, 1808 (reference courtesy of Charles S. Parsons).

269. The two sets of labeled Low and Damon chairs are illustrated in an advertisement of John L. Nichols in *Arts and the Antiques Weekly*, October 4, 1991; and in Donna-Belle Garvin, "Concord, New Hampshire: A Furniture-Making Capital," *Historical New Hampshire* 45, no. 1 (Spring 1990): 77.

270. Garvin, Garvin, and Page, *Plain and Elegant*, pp. 143–49; Damon advertisement of 1834 in Parsons, New Hampshire Notes, without identification.

271. Henry Farley, advertisement in *New-Hampshire Patriot*, May 14, 1831, and other data in Parsons, New Hampshire Notes; Abbot information in Giffen, "New Hampshire Cabinetmakers," p. 78; Henry Farley, property record, 1826, Merrimack Co., N.H., Registry of Deeds.

272. Cushing sketches in Giffen, "New Hampshire Cabinetmakers," p. 81; Cushing and Cushing, advertisement in *Courier of New Hampshire*, July 4,

1804 (reference courtesy of Jane Giffen [Nylander]); Abel Wilder, advertisement in *New Hampshire Sentinel*, August 7, 1807, and Stephen Ross, advertisement in *Concord Gazette*, November 16, 1815, in Parsons, Wilder Family Notes, and Parsons, New Hampshire Notes.

273. Simon Sanborn, advertisement in *New-Hampshire Patriot*, March 31, 1818, in Parsons, New Hampshire Notes; *Documents Relative to Manufactures*, 1:754–55.

274. Hayward, *Gazetteer of New Hampshire*, p. 34; James Chase, account books, 2 vols., 1797–1812, as transcribed in Parsons, New Hampshire Notes; John Avery, property records, 1815–30, Belknap Co., N.H., Registry of Deeds; John Cate, daybook, 1833–42, DCM.

275. Lewis, Lane and Co., advertisement in *New-Hampshire Patriot*, June 4, 1827, and Commerford note, in Parsons, New Hampshire Notes; Elliot excerpt in Giffen, "New Hampshire Cabinetmakers," p. 81, without identification.

276. Garvin, Garvin and Page, *Plain and Elegant*, p. 147; Joseph Ruggles Hunt, advertisement in *Columbian Centinel*, May 2 and June 9, 1804; Ebenezer Knowlton, estate records, 1811, Suffolk Co., Mass., Registry of Probate (microfilm, DCM); Hayward, *Gazetteer of New Hampshire*, p. 65; Giffen, "New Hampshire Cabinetmakers," p. 83; Coolidge and Mansfield, *History of New England*, 1:483.

277. The Hunt single-bow chair is illustrated in Garvin, Garvin, and Page, *Plain and Elegant*, p. 137.

278. Garvin, Garvin, and Page, *Plain and Elegant*, pp. 138, 151.

279. Giffen, "New Hampshire Cabinetmakers," pp. 79, 81, 85–86; Coolidge and Mansfield, *History of New England*, 1:421, 436, 460, 508, 580, 636.

280. Amasa Elwell, estate records, 1814, Bennington Co., Vt., Registry of Probate.

281. Coolidge and Mansfield, *History of New England*, 1:746–47; Elias White and Buckley Squires, advertisements in *Vermont Gazette* (Bennington, Vt.), January 25, 1825, and *Bennington Banner* (Bennington, Vt.), June 5, 1832, Bennington Museum, Bennington, Vt. (hereafter cited as BM). White's death is reported in Keno, "Windsor Chair Makers of Northampton" (paper), p. 603. Abby Maria Hemenway, ed., *Vermont Historical Gazetteer*, 5 vols. (Burlington, Vt.: A. M. Hemenway, 1868–91), vol. 1, p. 138; Buckley Squires, vital records, State of Vermont, Division of Vital Records, Montpelier, Vt. (hereafter cited as VVR); Buckley Squires, property records, 1818–19, Bennington Town Clerk's Office, Deeds.

282. Dewey and Woodworth, property records, 1827, Bennington Town Clerk's Office, Deeds; *Vermont Gazette*, November 12, 1827, BM; Henry F. Dewey, account book, 1837–64, Shelburne Museum, Shelburne, Vt. (microfilm, DCM); Henry F. Dewey, property record, 1843, Bennington Town Clerk's Office, Deeds.

283. Dewey, account book.

284. Dewey, account book.

285. Dewey, account book; Erastus Y. Clark, advertisement in *Vermont Gazette*, July 17, 1838, BM; Alvin Bates, property records, 1833–51, Bennington Town Clerk's Office, Deeds; Solomon Rich information in Hemenway, *Vermont Historical Gazetteer*, 1:232; Solomon Rich, estate records, 1848, Bennington Co., Vt., Registry of Probate.

286. Dewey, account book; *Vermont Gazette*, June 6, 1839, BM.

287. E. M. Wilder, *Contribution to Book of Wilders*, p. 128; Coolidge and Mansfield, *History of New England*, 1:757; [Dwight], *Northern Traveller*, p. 262; Van Doorn vital statistics and business history in "Collectors' Notes," *Antiques* 106, no. 4 (October 1974): 602; Van Doorn and Conant, advertisement in *Brattleboro Messenger* (Brattleboro, Vt.), April 23, 1830 (reference courtesy of Wendell Hilt); Felton, daybook; Anthony Van Doorn, bill to Joel Noyes, January 4, 1839, OSV.

288. Nina Fletcher Little, *Asahel Powers, Painter of Vermont Faces* (Williamsburg, Va.: Colonial Williamsburg Foundation, 1973). The portrait of Benjamin Smith is illustrated in Virginia M. Burdick and Nancy C. Muller, "Aaron Dean Fletcher, Portrait Painter," *Antiques* 115, no. 1 (January 1979): 187, pl. 3.

289. Julius Barnard, advertisements in *New Hampshire Gazette* (Portsmouth, N.H.), June 12, 1801, June 30, 1802; and *Spooner's Vermont Journal* (Windsor, Vt.), July 13, 1802; as quoted or excerpted in Leigh Keno, "The Windsor-Chair Makers of Northampton, Massachusetts, 1790–1820," *Antiques* 117, no. 5 (May 1980): 1104. Elizabeth Collard, "Montreal Cabinetmakers and Chairmakers: 1800–1850," *Antiques* 105, no. 5 (May 1974): 1137; [Dwight], *Northern Traveller*, pp. 264–65; Coolidge and Mansfield, *History of New England*, 1:953–54.

290. Letter, as quoted in Keno, "Windsor Chair Makers of Northampton" (paper), p. 37.

291. Boynton, ledger, 1810–17; John Farnham Boynton and Caroline Boynton, comps., *The Boynton Family* (n.p., 1897), p. 154.

292. Boynton, ledger, 1810–17; Thomas Boynton, ledger, 1817–47, invoice book, 1815–25, and shop account, 1817–35, DC (microfilm, DCM); Windsor Town Records, vol. 3, Town Clerk's Office, Windsor, Vt.

293. Boynton, ledger, 1810–17; William N. Hosley, Jr., "Vermont Furniture, 1790–1830," in *Old-Time New England: New England Furniture*, ed. Brock W. Jobe (Boston: Society for the Preservation of New England Antiquities, 1987), pp. 250–51.

294. Boynton, ledger, 1810–17.

295. Boynton, ledger, 1817–47.

296. Boynton, ledger, 1817–47; *Democratic Statesman* (Windsor, Vt.), November 12, 1835 (reference courtesy of Wendell Hilt).

297. William N. Hosley, Jr., "Architecture and Society of the Urban Frontier: Windsor, Vermont, in 1800," in *The Bay and the River: 1600–1900*, Dublin Seminar for New England Folklife: Annual Proceedings, 1981, ed. Peter Benes (Boston: Boston University, 1982), pp. 74–76; *Vermont Journal* (Windsor, Vt.), March 17, 1823, as quoted in Lewis Cass Aldrich and Frank R. Holmes, eds., *History of Windsor County, Vermont* (Syracuse, N.Y.: D. Mason, 1891), p. 314; Boynton, ledger, 1810–17.

298. Boynton, ledger, 1810–17.

299. Boynton, ledger, 1810–17.

300. Little, *Asahal Powers*, figs. 6, 23, 25–27.

301. N. Grier Parke, "John White, Chairmaker and Decorator," *The Decorator* 6, no. 1 (1952): 14–16; Lea, *Ornamented Chair*, pp. 61, 63–65, 68–69, 71–72, 120; Henry Swan Dana, *History of Woodstock, Vermont* (Boston: Houghton, Mifflin, 1889), pp. 165–66.

302. Lea, *Ornamented Chair*, pp. 64, 71 (Williams family chair).

303. Coolidge and Mansfield, *History of New England*, 1:944.

304. N. D. Jones, "Norman Jones, Vermont Cabinetmaker," *Antiques* 111, no. 5 (May 1977): 1028–31.

305. Jones, "Norman Jones," pp. 1029, 1031; Hastings Warren, advertisement in *Middlebury Mercury* (Middlebury, Vt.), January 8, 1806, and biographical data, in Peter M. Deveikis, "Hastings Warren: Vermont Cabinetmaker," *Antiques* 101, no. 6 (June 1972): 1037–39.

306. Cushing data in Giffen, "New Hampshire Cabinetmakers," p. 81, and New Hampshire Notes.

307. Laverne C. Cooley, comp., *A Cotton Genealogy* (Batavia, N.Y.: Privately printed, 1945), pp. 32, 40, 51; Ara Howe, vital records, VVR. The "Harrison" chair is illustrated in Lea, *Ornamented Chair*, p. 131.

308. Enos Stevens and James McIndoe, estate records, 1812 and 1820, Stevens Family Papers, Bailey Library, University of Vermont, Burlington, Vt. The dining chair inscription reads: "Bought at / Danville Green / Vermont the winter / of 1815 my father / moved to Rumney / in the Spring of the / same year David W. / Webster Received Oct / 15 1890 / Salamy Webster / Dowe Waltham / Mass" and "Bought at Danville Green Vt / The Winter of 1815 by David Webster / moved to Rumney N.H. in the / Spring of 1815. / I have just received / this chair at my rooms at Waltham / Mass. Oct the 15 1890 / S. W. Dowe."

309. Robert Whitelaw, ledger, 1804–31, Vermont Historical Society, Montpelier, Vt.; Coolidge and Mansfield, *History of New England*, 1:790; 1820 Census of Manufactures, State of Vermont.

310. Little, *Asahel Powers*, fig. 6.

311. Coolidge and Mansfield, *History of New England*, 1:850–51; [Dwight], *Northern Traveller*, p. 266.

312. 1820 Census of Manufactures, State of Vermont; Hemenway, *Vermont Historical Gazetteer*, 4:519–20.

313. Lyman Howe, vital records, VVR.

314. Edward A. Kendall, *Travels through the Northern Parts of the United States in the Years 1808 and 1809*, 3 vols. (New York, 1809), 3:33–34, as quoted in Hunter, *Waterpower*, pp. 174–75.

315. Benjamin Webber, estate records, 1826, York Co., Me., Registry of Probate; [Dwight], *Northern Traveller*, p. 318.

316. Richard C. Nylander, "The Jonathan Sayward House, York, Maine," *Antiques* 114, no. 3 (September 1979): 567–77; Nathaniel Knowlton, account books, 2 vols., 1812–59, Maine Historical Society, Portland, Me. (hereafter cited as MeHS).

317. Rogers information in *Documents Relative to Manufactures*, 1:50–51; Paul Jenkins, daybook, 1836–41, DCM; Oliver Allen, account book, 1831–77, OSV.

318. Tudor, *Narrative*, 1:395; [Dwight], *Northern Traveller*, p. 325; Arfwedson, *United States and Canada*, 1:195; Coolidge and Mansfield, *History of New England*, 1:276.

319. Manifests of brig *Comet*, August 17, 1804, schooner *Beaver*, June 12, 1806, sloop *Hannah*, June 6, 1807, and schooner *Areta*, April 23, 1825, Phila-

delphia Outward Coastwise Entries, U.S. Custom House Records, NA; manifests of anonymous ship, February 6, 1805, and brig *Venus*, July 6, 1809, from Portland, Shipping Returns: Barbados, 1781–1810, Colonial Office, PRO.

320. Thomas Beck and William Freeman, inventories, 1808, DCM.

321. Very and Hagget, advertisement in *Portland Gazette* (Portland, Me.), September 1, 1818, November 16, 1819 (reference courtesy of Edwin A. Churchill); A. Hagget advertisement in Huia G. Ryder, *Antique Furniture by New Brunswick Craftsmen* (Toronto: Ryerson Press, 1965), p. 98, without identification.

322. The Newman sketch is in Fales, *Essex County Furniture*, fig. 30. The Rounds chair(s) are illustrated and described in *George and Mildred Samaha Collection*, July 22, 1961 (Reading, Pa.: James G. Pennypacker, 1961), pp. 12, 13.

323. Elisha Trowbridge, extract from will, 1880, Cumberland Co., Me., Registry of Deeds.

324. The Limerick chair is illustrated in Lea, *Ornamented Chair*, p. 74, fig. 25.

325. Note on Capen in Earle G. Shettleworth, Jr., and William D. Barry, "Walter Corey's Furniture Manufactory in Portland, Maine," *Antiques* 121, no. 5 (May 1982): 1201–2; Increase Pote, account book, 1824–30, MeHS.

326. Pote, account book.

327. Stearns, *History of Ashburnham*, pp. 598–99, 652, 654–655. Excerpts from *Eastern Argus* (Portland, Me.), June 2, 1840, general data, and advertisement illustration in Harlowe Harris, comp., *Portland Directory for 1841* (Portland, Me: Arthur Shirley and Son, 1841), p. 158, all in Shettleworth and Barry, "Walter Corey's Furniture Manufactory," pp. 1199–1205.

328. Walter Corey, property records, 1843–55, Cumberland Co., Me., Registry of Deeds; Coolidge and Mansfield, *History of New England*, 1:359; Shettleworth and Barry, "Walter Corey's Furniture Manufactory," pp. 1200–1201.

329. Excerpts from *Portland Transcript* (Portland, Me.), April 27, 1850, and other data, in Shettleworth and Barry, "Walter Corey's Furniture Manufactory," pp. 1201–4.

330. The Corey fancy chair with compote is illustrated in Edwin A. Churchill, *Simple Forms and Vivid Colors* (Augusta, Me.: Maine State Museum, 1983), pp. 88–89.

331. Illustration of half-spindle plank chair, identification of loaf-top chair decoration, and excerpts from *Eastern Argus*, November 20, 1843, in Shettleworth and Barry, "Walter Corey's Furniture Manufactory," pp. 1201, 1203; S[ylvester] B. Beckett, comp., *Portland Reference Book and City Directory for 1850–51* (Portland, Me.: Thurston, 1850), p. 286.

332. A Corey cane-seat chair is illustrated in Fales, *Painted Furniture*, fig. 325. A plank-seat settee is illustrated in Kenney, *Hitchcock Chair*, p. 207. A Corey plank-seat chair is illustrated in Shettleworth and Barry, "Walter Corey's Furniture Manufactory," p. 1203, fig. 8.

333. Raynes data from Edwin A. Churchill, *To Sit On or Set On, Phase II: Maine-Made Chairs and Tables, Featuring Shaker Items* (Augusta, Me.: Maine State Museum, 1980), no. 36; Coolidge and Mansfield, *History of New England*, 1:189–91.

334. Coolidge and Mansfield, *History of New England*, 1:48–50; *Maine Inquirer* (Bath, Me.), May 13, 1828 (reference courtesy of Wendell Hilt); John B. Hudson, property records, 1849–50, Cumberland Co., Me., Registry of Deeds.

335. 1820 Census of Manufactures, State of Maine; Coolidge and Mansfield, *History of New England*, 1:165, 366.

336. 1820 Census of Manufactures, State of Maine; reference to unidentified Smiley advertisement, and other data, in Edwin A. Churchill, "Maine Furniture and Its Makers," *Maine Antique Digest* (November 1978): B-2; Dean M. Smiley, property record, 1825, Kennebec Co., Me., Registry of Deeds.

337. Coolidge and Mansfield, *History of New England*, 1:39, 41–42; reference to unidentified Pierce advertisement in Churchill, "Maine Furniture and Its Makers," p. B-2; Joshua D. Pierce, property records, 1840–47, Kennebec Co., Me., Registry of Deeds.

338. Joseph Bachelder, property and estate records, 1835–47 and 1881, Kennebec Co., Me., Registries of Deeds and Probate. Abram Bachelder is listed in Hildreth G. Hawes, *Maine Furniture Makers*, Maine State Museum Checklist Series (Augusta, Me.: Maine State Museum Commission, 1976), n.p.

339. Coolidge and Mansfield, *History of New England*, 1:130–31; Hockey identification in Churchill, *To Sit On or Set On, Phase II*, no. 26.

340. Benjamin F. Cunningham and William H. Cunningham, property records, 1841–57, Waldo Co., Me., Registry of Deeds.

341. Coolidge and Mansfield, *History of New England*, 1:158.

342. Lloyd Cole, property record, 1841, Oxford Co., Me., Registry of Deeds; A. Cole and C. F. Whitman, *History of Buckfield, Oxford County, Maine* (Buckfield, Me.: Journal Printshop, 1915), p. 495, as noted in Hawes, *Maine Furniture Makers*, n.p.

343. Coolidge and Mansfield, *History of New England*, 1:124–25; Francis Gould Butler, *History of Farmington, Franklin County, Maine, 1776–1895* (Farmington, Me.: Knowlton, McLeary, 1885), pp. 576, 578, as noted in Hawes, *Maine Furniture Makers*, n.p.; Churchill, *To Sit On or Set On, Phase II*, no. 37.

344. A Stewart rocking chair of the first type is illustrated in Hawes, *Maine Furniture Makers*, n.p.

345. Churchill, *Simple Forms and Vivid Colors*, p. 17; Daniel Stewart, property and estate records, 1827 and 1829, Kennebec and Franklin cos., Me., Registries of Deeds and Probate.

346. Edwin A. Churchill, *To Sit On or Set On: Maine-Made Chairs and Tables, 1790s–1920s* (Augusta, Me.: Maine State Museum, 1979); Churchill, *Simple Forms and Vivid Colors*, pp. 15, 84.

347. White sketch in Churchill, *Simple Forms and Vivid Colors*, p. 86; Coolidge and Mansfield, *History of New England*, 1:106–7, 123.

348. Coolidge and Mansfield, *History of New England*, 1:149–50; William H. Reed, account book, 1803–48, DCM; William H. Reed, estate records, 1854 and 1858, Penobscot Co., Me., Registry of Probate.

349. Coolidge and Mansfield, *History of New England*, 1:44–47.

350. Coolidge and Mansfield, *History of New England*, 1:291–92.

351. Coolidge and Mansfield, *History of New England*, 1:91, 114, 342; schooner *Splendid* and owners, Kittredge and Blakes, and P. F. Packard, bills to Hiram A. Balch, January 7 and November 15, 1836, March 27, 1833, Papers of Hiram A. Balch, Mystic Seaport Museum, Mystic, Conn.

Chair Production in Other Regions

The South, Midwest, and British Canada

The South

For purposes of this study, the South consists of Virginia, West Virginia, the District of Columbia, North and South Carolina, Georgia, Louisiana, Mississippi, and Alabama; Maryland has been treated in an earlier chapter because of its cultural interaction with Pennsylvania. The coastal, or tidewater, region from Maryland to Georgia was settled and cultivated first. Tobacco became the chief export crop in the greater Chesapeake area; farther south, rice and indigo were better suited to the terrain and climate, and naval stores was a substantial business. By the mid nineteenth century, cotton was a prominent crop, linked closely with New England's industrial prosperity. Southerners were principally people of British stock—English, Scotch, Scotch-Irish, and some Welsh and Irish. Small numbers of French Huguenots and refugees from the French-speaking Caribbean islands resided in the coastal metropolitan centers. The Germans formed a larger minority. They migrated south from Pennsylvania into the Shenandoah Valley and to the Wachovia tract in North Carolina, where the Moravian sect founded several religious-oriented communities; some emigrated directly from Europe to establish settlements on the frontier. Among these people few were of aristocratic origin. Some had been members of the merchant community or the European squirearchy; many were middle-class citizens or individuals pursuing skilled trades. A considerable number came as redemptioneers and, before the Revolution, even as banished felons. There was, of course, a sizable slave population, mostly of African origin. As the coastal plain filled with people and as the land gave out from poor agricultural practice, particularly in the tobacco-growing regions, the Piedmont became increasingly attractive. This back country stretched all the way to the Appalachian foothills. There the river valley tracts of the "gentry" intermingled with the small plots of yeomen farmers.

Before the Revolution the principal commercial centers of the South had been those with direct shipping access and commodities to exchange for imported goods. Georgetown and Alexandria were small centers on the Potomac. Hampton-Norfolk controlled traffic on the James and York rivers. Charleston was "the city" of the South because of its size and its cosmopolitan nature. Williamsburg enjoyed considerable status as the seat of the colonial Virginia government, but when the capital moved to Richmond after the Revolution the community reverted to a country town. Edenton and Wilmington on the North Carolina coast were never more than small trading centers. National growth brought substantial change in the nineteenth century. The establishment of the federal capital at Washington encouraged a boom along the Potomac. As new commercial centers, Savannah and New Orleans served the inland territories made accessible by improvements in navigation.[1]

Early Evidence

The earliest evidence of Windsor-chair making in America occurs in a notice placed in the *Virginia Gazette* in November 1745 by upholsterer Richard Caulton of Williamsburg, formerly of London, who made and mended Windsor chairs. Since Caulton had no formal shop, it is doubtful that he realized much trade; he was not heard from again. Until the 1790s Windsor furniture was primarily an imported commodity in Virginia, although it is tempting to think that James Wray, a carpenter of Williamsburg who bought the "Timson House" in 1745, acquired the two Windsor chairs listed in his probate inventory of 1750 from Richard Caulton. In 1767, a dozen "old Windsor Chairs" were at "Green Spring," a property of Philip Ludwell, Esq., on the James River near Williamsburg. The Windsors were listed near the end of the inventory and valued at only 1s. apiece, suggesting outdoor use. The chairs could have been fabricated in England or America. Only a year later the sloop *John* arrived in Virginia from Philadelphia with a dozen Windsor chairs. Another twelve Windsors formed part of the schooner *Peggy's* Philadelphia cargo in 1774. Doubtless there were earlier shipments from the Delaware River port for which records are missing, since Philadelphia vessels carried Windsor chairs to other Atlantic ports as early as 1752.[2]

Evidence of the importation of English Windsors into Virginia occurs in an order of goods dated February 22, 1770, from Mann Page of near Fredericksburg to his London factors John Norton and Sons, who received payment from tobacco receipts. Page listed for his own use "1 dozn Windsor Chairs for a Passage" (hall). Two years later an appraisal of Thomas Thompson's Norfolk estate listed seven chairs along with a "Passage" cloth (painted floorcloth), suggesting their area of use. A *Virginia Gazette* notice of 1777 speaks of "green Passage Chairs" for sale with the contents of a house located on Williamsburg's "Market Square." Contemporary documents expand on the use of Windsor seating in Virginia households. William Pearson's York County estate, probated in 1777, included six Windsors valued at 12s. each, a high figure that indicates they were armchairs and relatively new. Landon Carter, Esq., owner of Sabine Hall on the Rappahannock in Virginia's Northern Neck, placed a Windsor in a downstairs bedroom. There was probably similar seating about the plantation, since Carter hosted large entertainments. In the vicinity of Fredericksburg, Thomas Davis made careful note of the acquisition of twelve Windsors and two leather armchairs shortly after his marriage in May 1783. Since Davis purchased his wedding clothes in Fredericksburg, his furnishings could have come from town suppliers. George Johnston of Alexandria possessed Windsor chairs at his death in February 1767.[3]

Shipping records of the 1780s show considerable activity in the Windsor trade between Philadelphia and Virginia. Harrold E. Gillingham found that "the Southern states were good patrons of the Philadelphia Windsor chair-makers." Between March 1784 and August 1786, 1,734 Windsors entered Virginia ports, and Gillingham recorded another 454 chairs in 1789–90. The principal ports of entry were Alexandria, Richmond, Norfolk, and Petersburg. Individual shipments ranged from fewer than twelve chairs to several dozen. Settees augmented a shipment in 1789. By the 1790s some Philadelphia chairmakers were shipping Windsors on consignment or order on their own accounts rather than through intermediaries. Lawrence Allwine sent seven dozen Windsors to Robert Farmer of Norfolk in 1797, the year that Joseph Burr shipped chairs to Petersburg. Upon reaching their destination some orders were forwarded to specific customers. Stephen Cocke of the Woodlands, an Amelia County plantation west of Petersburg, had dealings with merchants William and James Douglas of that river town; he exchanged wheat for many purchases. In 1791 the Douglases forwarded four high-post bedsteads and "2 doz Green 11 Stick Windsor Chairs" shipped from Philadelphia by Cocke's order. The spindle count and the modest individual price of 7s.6d. identify the seating as sack- or bow-back armchairs. Philadelphia artisans were not the only ones who reaped benefits from the lucrative southern trade. St. George Tucker of Wil-

Locations of Craftsmen and Product Destinations
Virginia, West Virginia, and District of Columbia,
1745–1850s

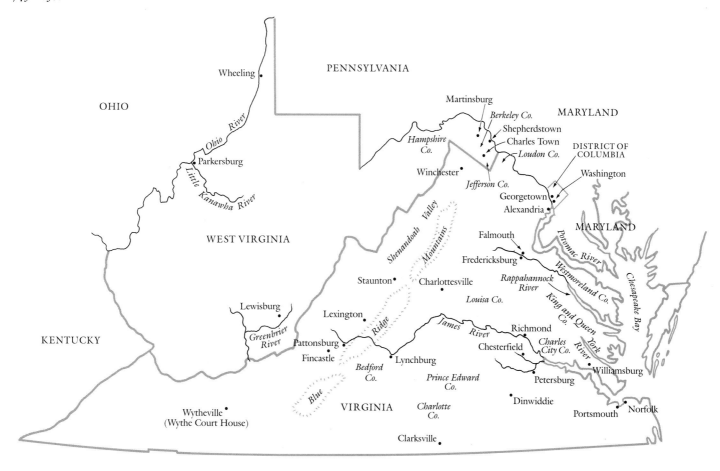

1 inch = 61.4 miles

liamsburg placed his order for adult and children's Windsor seating with Thomas and William Ash of New York City; their receipted bill survives (fig. 5-5).[4]

Although most Windsor seating found in Virginia homes into the 1780s was imported, there was some local chair construction. The earliest evidence is a record kept by Francis Jerdone of Louisa County, northwest of Richmond, noting a payment of 30s. to John Richardson, "Carpenter," for "2 Windsor Elbow [arm] Chairs made for me" on August 12, 1769. Richardson may have been the same man who at age twenty left London for Virginia as a "farmer" under an indenture term of five years. To furnish Nomini Hall in Westmoreland County, Robert Carter, Esq., purchased a dozen Windsor chairs from local "ship carpenter" John Attwell in 1770. The price of 11s. apiece probably identifies armchairs and exceeds by 1s. the cost of each of three tables Attwell also supplied. The account book of an anonymous Fredericksburg-Falmouth cabinetmaker records the sale of a dozen Windsors to Captain Lawrence Taliaferro on October 5, 1774. The craftsman obviously was a competent workman, since he also produced such sophisticated furniture as walnut Marlboro chairs, cherrywood clockcases, and a walnut bookcase.[5]

Northern Virginia

The 1780s mark the start of Windsor-chair making in Virginia by known craftsmen, some of whose work is identifiable. Both chairmakers and dealers were found in Alexandria, a Potomac community near the future site of the nation's capital. By the

Revolution wheat, flour, and tobacco were the chief trading items at Alexandria. The town plan was similar to that of Philadelphia, and there were "excellent warehouses and wharfs." Concerning commerce J. F. D. Smyth remarked; "Besides a great many ships for Europe, the West Indies, and other places, several vessels [sail] from this port annually for New Orleans with flour." At the end of the century the population stood at 4,000 or 5,000; many houses were "handsomely built." Olney Winsor of Providence, who managed a shipping business in Alexandria from 1786 to 1788—at a time when Rhode Island was beset by financial problems—wrote to his wife in Providence that the town flourished, with "manny new Buildings going up—Wharves filling out, & other marks of profitable Business." He continued in the same vein when describing the region generally, which "tho' the first settled, may be truly said to be fifty years behind the New England states in literary and mechanic improvements, and fully that period advanced of them in the destructive vices of Mankind.—the deficiency in the former may be principally attributed to the custom of importing all articles of manufactory and Husbandry, which discourages the few Mechanics here."[6]

In spite of Winsor's assessment of area crafts, in 1785 Philadelphia chairmaker Ephraim Evans ventured to resettle in Alexandria, where he advertised for "yellow poplar" chair plank. The chairmaker enjoyed steady trade in his new location. Perhaps it was he who through the firm of Reynolds and Barclay supplied a dozen chairs the following year to Fielding Lewis, Jr., nephew of George Washington and son of the builder of Kenmore, a Fredericksburg mansion. Evans was master to several young apprentices at Alexandria, although that role had its trials. For example, twice in 1802 apprentice Thomas Mathews ran away, once along with the apprentice of a local plasterer. Similar cases occurred in 1807 and 1808. The craftsman seems to have been a good teacher, but he may also have been a stern taskmaster. Hector Sanford, who spent five years in the Evans shop in the 1790s, later opened a business in Georgetown, and George Grymes, another of Evans's apprentices, later worked at various southern locations. Orphan George Wakefield was apprenticed to Evans in June 1804, and at the same time another orphan was bound to the Windsor-chair maker Joseph Emmit.[7]

Ephraim Evans's known Windsor work consists of two branded sack-back armchairs of slightly different pattern. One of the two also bears a label, although the paper is deteriorated and only a few words are decipherable (fig. 8-1). This chair appears to be the later of the two and seems to represent a pattern produced both in Philadelphia and Alexandria. The chair's actual origin probably was Philadelphia, based on label remnants that appear to identify a 1785 directory address at Front Street between Callowhill and Vine. The bulbous terminal at the post bases rather than the more usual cone was first used in Philadelphia work during the early 1780s (figs. 3-40, right, 3-48). Otherwise, the turnings of the two Windsors are close in character. The first chair, which is at Independence National Historical Park, has flat arms; here, the terminals are detailed in a scroll. An undocumented fan-back side chair acquired by its owner from an Alexandria bank and painted on the plank bottom with the surname "Hooff," a known family of bankers, may also be the work of Evans (fig. 8-2). The back posts have a Philadelphia-style bulbous base and capped spools, along with other elements that resemble the arm posts of the sack-back chair. The thick side stretchers are also comparable, although the heavy character of the legs suggests Baltimore influence (fig. 4-2).

Evidence of another kind points to Evans's manufacture of a third type of Windsor, the bow-back chair. On June 12, 1802, he advertised: "STOLEN from the shop of the subscriber . . . Six round back Chairs, painted yellow, tip'd with black; the seats painted mahogany colour." Other notices shed light on Evans's later Alexandria career. In 1817 Horner and McDennick, wheelwrights and blacksmiths, identified their location on Royal Duke Street "opposite Evan's chair manufactory." By 1820 Daniel Evans had commenced coach painting "at the shop of E. Evans, Royal street." Meanwhile, N. Blasdel, a competitor, employed a "most skillful work[man]" at his chair manufactory who specialized in painting and glazing, carving and gilding. Customers could choose from chair stock on hand or purchase seating "made agreeably to order."[8]

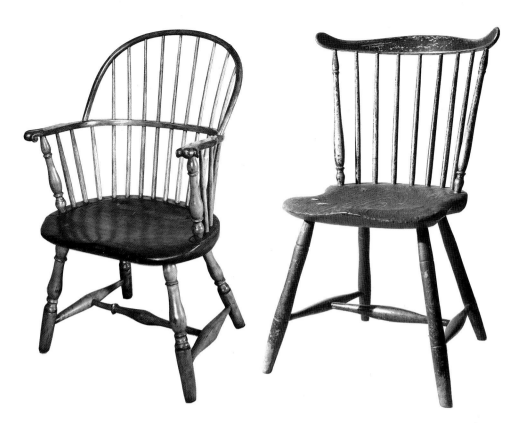

Fig. 8-1 Sack-back Windsor armchair, Ephraim Evans (brand "EVANS" and label), Philadelphia or Alexandria, Va., 1782–92. Maple and other woods; H. 35¾", W. 24½", D. 16½". (Photo, Bernard and S. Dean Levy, Inc.)

Fig. 8-2 Fan-back Windsor side chair, L. Hooff (owner, painted), Alexandria, Va., 1790–1800. H. 32¾", (seat) 17". (Private collection: Photo, Museum of Early Southern Decorative Arts, Winston-Salem, N.C.)

Dealers in chairs and furnishings shared the Alexandria market. Robert Miller sold various household goods, including two Windsor chairs, to Charles(?) Young in 1797. When Young died a few years later, his inventory itemized six Windsors painted brown; another dozen in green paint were "up the Country." South of Alexandria the estate left in 1815 by Sarah, second wife of George Mason, builder of Gunston Hall in Prince William County, contained thirty Windsor chairs. A dozen were described as "old"; the rest were mahogany color to harmonize with the formal house furnishings.[9]

By the 1820s Alexandria's future was not as promising as it once had been. The town had suffered a severe economic blow during the War of 1812 from which it did not recover, and already Baltimore overshadowed the Potomac port. Later evidence of the chair trade in Alexandria is thin. Levi Hurdle advertised in 1834 that his brother Thomas T. was newly associated with him in the manufacture of Grecian, fancy, and Windsor chairs; they also executed orders for sign and ornamental painting and gilding. Hurdle had learned his trade with Thomas Adams in Georgetown. As an added inducement he announced that "Chairs purchased at this manufactory will be sent, free of expense, to any part of the District." Perhaps competition from outside suppliers had already eroded the local market. Within a decade or so William H. Muir stocked his warerooms with chairs made at South Gardner, Massachusetts, by Samuel S. Howe (fig. 8-3). Both Howe's brand and Muir's stencil are found on the seat bottom of the illustrated example. The latter reads: "From / WILLIAM H. MUIR'S / Cabinet / Upholstery Chair / WARE ROOMS / Cor King & Asaph Sts / ALEXANDRIA Va." The leg turnings provide a new and unusual profile for a chair of this period; the ball spindles are enlarged versions of those found earlier in the half-spindle, slat-back Windsor. The plank shape with its flat-canted forward edge resembles earlier Worcester County work (fig. 7-62). Howe's career began in the 1820s and presumably continued until his death in 1864. Muir is listed in the Virginia directory of 1852 and probably worked earlier.[10]

An anonymous notice for an apprentice "TO THE Windsor Chair-Making Business" was printed in the *Mercury* on December 31, 1788, at Winchester, a town which eight years earlier Lieutenant Thomas Anburey had described as "irregular built . . . containing between three and four hundred houses." Perhaps the advertiser was William King, who in 1790 pursued concurrently the trades of turner, Windsor-chair maker, and

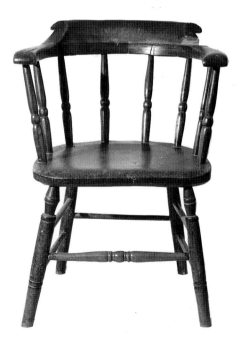

Fig. 8-3 Low-back Windsor armchair, Samuel S. Howe (brand "S.S. HOWE"), South Gardner, Mass., retailed by William H. Muir (stencil), Alexandria, Va., 1842–52. H. 30½", W. (arms) 23". (Private collection: Photo, Museum of Early Southern Decorative Arts, Winston-Salem, N.C.)

cabinetmaker and employed "well experienced hands from the city of Philadelphia." But neither diversification nor the promise of fashionable merchandise could turn the trick, and by 1797 King had left northern Virginia for Frederick, Maryland, some forty miles distant. He was in Baltimore in 1804.[11]

After William King left Winchester David Russell apparently took his place. Accounts from a small record book dating between 1796 and 1806 describe some of Russell's Windsor-chair making activity. Seating made for one L. Lewis in 1800 carried fashionable paint of a bright palette—mazarine blue with mahogany-colored bottoms, cream color with mahogany seats, and pale blue with yellow seats. Edward B. Jones of Bottle Town preferred "plain" seating; he purchased a set of six side chairs and two armchairs in 1802. Plain black or green chairs were also the choice of General Stevens Thomson Mason of neighboring Loudon County. As business increased at the Russell shop, the chairmaker contracted in 1803 with Isaac Smith to construct plank seating at agreed prices. Included on the list are "Bamboo" and "Fanback" chairs, armchairs, and settees.[12]

During a journey from Alexandria to Williamsburg in December 1786, Olney Winsor passed through Fredericksburg, which he described as "one of the largest Towns in Virginia, situate on the . . . Rappahannock, to which small Craft can come, it lies principally on one Street, which is broad and straight—the buildings in general are good, many large stores of Goods, & large & extensive Tobacco houses proclaim it a place of considerable business." To this place Alexander Walker removed in 1798 from nearby Falmouth, "a small village" with "large Tobacco houses." The craftsman took over the shop and cabinet business of John Alcock, purchasing "his stock and materials of every description." It was not until February of the following year, however, that Walker began to supplement his cabinet production in "Mahogany, Cherry Tree, and Walnut" with the sale of Windsor chairs. In a July notice Walker described his Windsor stock as being of "good quality" and "different colours."[13]

On July 13, 1802, the craftsman joined forces with James Beck. The partners offered "FANCY CHAIRS—Stuff bottoms, Settees, and common [Windsor] Chairs of the newest fashions, and at the northern prices—when the quality is equal, if not superior, risk and freight saved." Before the July notice Walker had stocked the requisite materials—maple, ash, hickory, and white oak by the cord. During the partnership he continued to pursue the cabinet business as usual. By August of the following year the partners felt secure enough in their new venture to stock a large quantity of chairs and settees described as "equal if not superior to any manufactured in Baltimore, and at the same prices." That rising Chesapeake metropolis was already making its presence felt in furniture production and design. Walker also added another service: "Funerals discharged at the shortest notice, and on the most reasonable terms." The woodworker served as undertaker and probably supplied the coffin as well.[14]

On April 26, 1805, Walker described a stock of 400 "double and single square Back" chairs and "round ditto." The references identify Windsors with one or two cross rods in the upper back and seating in the bow-back style. The chairs sold for the "moderate price" of 7s.6d. ($1.25) each; settees could be ordered to match. Walker also exchanged new chairs for old, presumably to clean and repaint for recycling. By this time he and Beck had parted company, "the Copartnership . . . having expired." Walker obtained the services of a journeyman or two, since he offered "one hundred dozen Windsor Chairs of every description" less than a year later. Sometime after 1808, however, the entrepreneur scaled down this part of his business; Windsor chairs are next mentioned only in an 1816 list of mixed furniture forms. By then Walker also dabbled in the coal business, to which he gave prominence in 1822 when he established a coal yard to supply fuel to householders and blacksmiths. The 1820 industrial census records a substantial production of "Cabinet furniture of nearly every description" at Walker's "Manufactory," where he employed six men and two boys. When asked for comment the craftsman reported "the demand limited, and Sale dull at present—(formerly in good demand & brisk sale)," a reflection of the recession that gripped the country from the late 1810s into the 1820s.

Walker's statements about former business conditions and the size of his labor force indicate that he supplied more than just the local market. Towns along the Rappahannock and beyond probably contributed to his prosperity.[15]

James Beck launched his independent career on March 19, 1805. He took a house on Williams Street adjoining the "Market-House Lot," where he commenced to "manufacture *Windsor-Chairs & Settees*, With plain or stuffed bottoms, agreeable to any pattern and [to] finish them in the neatest style, painted in different colours, gilt and jappaned." To supplement this line Beck offered mahogany or painted bedsteads, window cornices, and Venetian blinds; he also pursued the "Turning-Business." Dating from this early period of his career is a bow-back Windsor armchair stamped "J BECK" on the seat bottom (fig. **8-4**). In basic design and proportions the chair follows Philadelphia work (fig. 3-51); however, several details reflect Baltimore chairmaking (fig. 4-2). Associated with the latter city are bamboo-style turnings of stout quality, flaring spindle bases, and deeply rolled arm terminals. The chamfered seat front differs from Philadelphia and Baltimore models, but the chair may well have been designed for a "stuffed bottom," as advertised by Beck. In that case shaving and saddling the plank edges would have been unnecessary and undesirable, since flat surfaces ensured a smooth fit and provided a tacking face.[16]

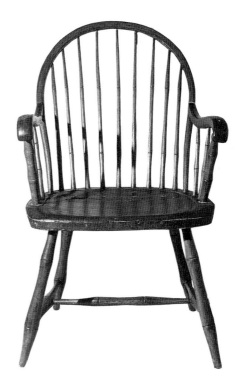

Fig. 8-4 Bow-back Windsor armchair, James Beck (brand "J • BECK"), Fredericksburg, Va., 1805–10. Yellow poplar (seat); H. 36″, (seat) 17¼″, W. 20¾″; left arm support replaced. (Private collection: Photo, Museum of Early Southern Decorative Arts, Winston-Salem, N.C.)

Some years passed before Beck advertised again. A notice of 1815 tells of his removal to Commerce Street, where he continued to manufacture Windsor chairs but offered a more complete line of cabinetwork as well. Special seating still included settees, children's Windsors, and writing chairs. Beck, too, is listed in the 1820 manufacturing census, although his operation was modest compared to that of Alexander Walker; he and two men made up the workforce. Like Walker, Beck noted the dull market at that time. The last reference to the craftsman occurs in an 1822 notice of a fire in a vacant house that he had previously occupied. When Anne Newport Royall visited Fredericksburg two years later she observed that "every thing wears a gloomy aspect, very little business doing in any part of the town." Only later did Fredericksburg enjoy renewed prosperity, when its water resources were developed for industrial use.[17]

South and west of Fredericksburg in the Piedmont and Shenandoah Valley, Charlottesville and Staunton were small centers of sporadic chairmaking activity. Charlottesville consisted of a courthouse, a tavern, and a dozen houses surrounded by "an immense forest, interspersed with various plantations, four or five miles distant from each other," each plantation effectively a small village in itself. Tobacco was the primary crop. This is where Thomas Jefferson built his home, Monticello (1769–1809), and later planned the campus of the University of Virginia. Jefferson ordered "stick chairs" (his words) from Philadelphia for his Charlottesville plantation house in 1800 and 1801 and later for his country seat, Poplar Forest near Lynchburg. Given the difficulty of overland transportation, this speaks to the problems of finding suitable local craftsmen. The situation appears to have changed by the time J. B. Dodd advertised his cabinetmaking services in autumn 1835. Dodd took "old furniture . . . in part payment for new" and sought two boys as apprentices. The small furniture cuts accompanying the notice depict a chest of drawers, bedpost, and Windsor tablet-top side chair with fancy spindles, the style suggestive of Baltimore work.[18]

Across the Blue Ridge Mountains from Charlottesville lay the valley of the Shenandoah River, inhabited largely by Scotch-Irish and German immigrants who had migrated from Pennsylvania. The town of Staunton was the center of "a brisk inland trade," and it was there that Jacob Kurtz first advertised in 1804. From his Main Street location Kurtz offered "Windsor and Writing Chairs, &c. and all kinds of Spinning Wheels, which he will warrant to be of the first quality." By 1807 he referred to the establishment as a "Windsor Chair & Spinning Wheel MANUFACTORY." Turning of all kinds was a specialty, and Kurtz prudently accepted "country produce . . . at cash price in payment for work." The craftsman's production of spinning apparatus points up the continuing importance of home crafts in the region.[19]

Norfolk and Vicinity

Isaac Weld stated in the mid 1790s that "the principal place of trade in Virginia is Norfolk." The city held this position even before the Revolution but lost it temporarily when the British burned and destroyed the city in 1776. Rebuilding was accomplished quickly after the war but with little plan or regularity. One visitor pronounced the place "one of the ugliest, most irregular, and most filthy towns that can any-where be found." The thoroughfares were unpaved, making them "unpleasantly dusty or muddy, according to whether it is dry or rainy." The land surrounding the town was swampy. New wharves and warehouses completely filled the riverfront, rising like the houses without general plan. The principal landing place was the dock area at the foot of an open square lined with shops and taverns. Neighboring Portsmouth was also advantageously located along deep water but was little more than a Norfolk suburb.[20]

Up to 300 vessels could anchor at Norfolk. The city commanded the trade of southeastern Virginia and eastern North Carolina whose coast was dotted with shoals and sandbars. A flourishing commerce existed with the northern ports and the Caribbean islands. To the latter Portsmouth shipped quantities of lumber brought out of the Dismal Swamp. In the north regional produce was exchanged for European dry goods, particularly in the commercial centers of Baltimore, Philadelphia, and New York. Local merchants without factors traveled north once or twice a year to purchase a stock of goods. As Moreau de St. Méry noted, "In Norfolk, as elsewhere in America, everything is sold in the same store, and the townspeople gladly follow this custom because farmers who bring their products to Norfolk generally sell them to merchants at whose stores they can find everything they need." Direct trade with England consisted mainly of tobacco exports.[21]

Before the Norfolk fire Windsor chairs were imported from Philadelphia and New York. The trade continued following the war when merchant Richard Blow of neighboring Portsmouth received at least two Philadelphia cargos containing Windsors. By the 1790s he had relocated across the Elizabeth River in prospering Norfolk and on two occasions bought bow-back Windsors from other importers; one group was painted mahogany color. Vessels from Philadelphia and New York continued to sail into Hampton Roads with cargoes of Windsors, some destined for local businesses, others for reshipment up the James River to Richmond or Petersburg. An occasional settee was included. In 1795 the woodworkers David Martin and John Jefferson of Norfolk formed a partnership to conduct business as cabinetmakers, turners, upholsterers, and Windsor-chair makers "on a more extensive scale." Other craftsmen followed suit as the bustling entrepôt grew.[22]

In 1799 Michael Murphy removed from Philadelphia to Norfolk, where he announced the start of his Windsor chair manufactory on October 29. He sought two apprentices "of good character." The craftsman was already familiar with the local commercial scene, having previously made shipments of chairs to city consignees. After resettling Murphy received chair parts from Philadelphia in 1800 and 1804. He agreed with the Norfolk County Overseers of the Poor in 1802 to take an orphan, Samuel Chilton, as an apprentice. However, the master chairmaker's career in Norfolk was short-lived; he died within a month of writing his will on April 26, 1804. Murphy stipulated that his eldest son, Thomas, be sent to his Philadelphia friend Michael Magrath, one of his suppliers of parts, "in order to be bound to a trade." A witness to the will was Windsor-chair maker Joshua Moore. The following year Richard Bailey, cabinetmaker, announced his expansion: "He has purchased the whole stock of the late Mr. *Michael Murphy*, deceased, Windsor-Chair Maker and has also employed his principal Workmen, and Intends carrying on the *Windsor Chair Manufactory*." Michael Murphy's work is known by one branded bow-back side chair typical of the best Philadelphia Windsor work of the 1790s. Like the work of Philadelphian Ephraim Evans, who migrated to Alexandria, Murphy's work probably showed little if any alteration in style immediately following his move.[23]

Another craftsman who migrated to Norfolk for a brief residency was Lemuel Adams of Hartford, Connecticut. He advertised the "best warranted" Windsor chairs and a selection of cabinetwork on July 11, 1801. Known as an "ingenius mechanic" in Hartford, Adams leased his shop there to another on June 30, 1800, possibly because of financial difficulties. The following May 28 when he sold the property, the deed referred to his place of residence as "since of Norwich and now of no certain address." Adams and his family had been in Norfolk only a short time when his wife died on August 16. This is the last word of him until the 1820s, when he appears to have been a resident of New Hampshire.[24]

Richard Bailey had worked in Norfolk as a cabinetmaker for at least a decade when he bought the chair stock from Michael Murphy's estate in 1805. He shortly added undertaking to his specialties. Public records do not disclose how long Bailey continued the Windsor-chair making business, but he still conducted funerals as late as 1819 when he submitted a bill to the estate of Philip Collins. Regular turnover in the Norfolk chairmaking business may have been due in large part to the continued importation of northern chairs. John Tunis, merchant and storekeeper, announced in June 1812 the arrival from New York of the schooner *Washington*, which carried a "large assortment" of both fancy and Windsor chairs. Richard Blow purchased "1 set chairs" from Tunis for $18 two weeks later. Perhaps the eight Windsor chairs in the Portsmouth, Virginia, estate of Lucy Hall, widow of Dr. Lee Hall, administered by executor George Blow in 1809, were also of New York or Philadelphia origin. George Blow himself had recently acquired Windsor chairs at sheriff's sale; he had them painted before he took them home.[25]

Although Joshua Moore witnessed Michael Murphy's will in 1804, his name does not appear in the Norfolk directories for 1801 and 1806. Perhaps he was a journeyman, or he may have been the Moore of Johnson and Moore, Windsor-chair makers, listed in the 1806 volume. The next definite evidence of the man dates to 1811 when the *Norfolk Herald* announced the death of his wife and identified him as a Windsor-chair maker. A deed, the death of his daughter, and his remarriage account for Moore through 1818. Records of the Skipwith family describe several chair purchases from Moore in 1819. In July Humberston Skipwith bought "12 Broad top Chairs," a crest pattern that identifies the heavy influence of Baltimore design on Norfolk work (figs. 4-11, 4-12) and recalls the portrait of Henrietta Frances Cuthbert who stands beside a "broad top" child's Windsor (fig. 4-10). Mrs. Skipwith bought a rocking chair from Moore later that year, and there is record of still another chair purchase. Skipwith also acquired furniture from Hugh Finlay and Company of Baltimore. The family plantation, Prestwould, was located in Mecklenburg County near Clarksville and the North Carolina border. After Moore had shipped the chairs up the James River to a Petersburg merchant, Skipwith dispatched his wagons to fetch the freight.[26]

The woodworking career of John Widgen began when he was apprenticed at Norfolk in 1802 to Richard Raley "to learn the Occupation of a Cabinet Maker." A decade later Widgen himself took Tully Johnson as an apprentice to the Windsor chair trade, followed by James Braithwaite in July 1815. Within three months Widgen was at the expense of advertising for his runaway apprentice James Pallett, whom he described as "slim made, of light complexion; eyes and hair dark. Had on when he went away, a homespun jacket and nankeen pantaloons—and carried off with him a bundle of cloaths, and a copy of his *Indenture*, which, he no doubt, took for the original." Widgen married in 1820. Later he sold two groups of Windsors (twenty-four chairs) to "Judg Tucker" (St. George Tucker) of Williamsburg. At the death of Tucker's widow three years later the estate inventory identified sixty Windsors in the household.[27]

Richmond

"Richmond . . . stands on the north side of James river, just at the foot of the falls, and contains about 300 houses, part of which are built upon the margin of the river . . . the

Fig. 8-5 Staircase balustrade, Marshall House, Richmond, Va., 1789. (Photo, Museum of Early Southern Decorative Arts, Winston-Salem, N.C.)

rest are upon a hill. . . . A large and elegant state-house or capitol, has lately been erected on the hill. . . . A canal is cutting on the north side of the river, which is to terminate in a basin of about two acres, in the town of Richmond. From this basin to the wharves in the river, will be a land carriage of about 400 yards. . . . The opening of this canal promises the addition of much wealth to Richmond." With these words Jedidiah Morse described the Virginia capital in 1789, shortly after the manufacture of Windsor chairs had been introduced in the community. Above the city a rapids, or "falls," impeded further direct navigation on the James; near the falls were several fisheries, numerous mills, and an ironworks. The surrounding land was rich and fertile, producing wheat, corn, and tobacco. The population in the mid 1790s was about 6,000, of which one-third or more was black. Rather than a major port, Richmond was "an intermediate place for the deposit of goods passing to and from the back country." The canal, built to circumvent the impediment of the falls, was a boon to this trade and set the stage for future development and expansion. By the end of the decade Richmond extended nearly a mile and a half along the banks of the James. The lower, or business, part of town was built close to the river near the shipping.[28]

During the 1780s imported Windsor furniture must have been a fairly common commodity in the Richmond market. An item in a 1784 notice of merchants Hollingsworth, Johnson and Company probably is typical: "Likewise a few Philadelphia made Windsor chairs." Within less than a decade, Andrew and Robert McKim, probably brothers, began to make Windsor chairs. Both likely came to the chair business via the turning trade. Andrew is recorded as having provided turned ornament for the capitol building and a balustrade for the staircase of the John Marshall House (fig. **8-5**) in 1789, the year that he supplied a dozen sack-back chairs for the state auditor's office. He, Robert, and a William McKim, carpenter (relationship unknown), jointly purchased a lot in 1792 on an important thoroughfare through the center of town at an intersection leading directly to the James River Canal basin eighty yards away. Robert McKim was paid for a stool that year by the auditor's office. The first mention of a joint chair shop, which probably was established in 1795, appears in a notice of October 1796, although in this and other advertisements partners Andrew and Robert identified the chair business only in passing. The principal focus was an apparently lucrative sideline, the sale of milling items—"GERMAN BOULTING-CLOTHS," Oliver Evans's *Young Mill-Wright and Miller's Guide*, and "buckets for wheat and flour elevators in mills." Nevertheless, in 1796 the partners were favored with a substantial order for six dozen chairs for the state Capitol. In 1798 the McKims erected two adjoining brick tenements of two apartments each on their shop lot; Robert and his family occupied one. Several young men must have been serving apprenticeships in the shop, since the partners paid head taxes on five white and one black male over sixteen years of age.[29]

A small but varied group of Windsors documented to the McKim craftsmen provides a close look at patterns produced in a single shop within the ten-year period between 1795 and Andrew's death in 1805. Earliest in date is a fan-back side chair (fig. **8-6**) whose baluster turnings, particularly those in the back posts, bear a striking resemblance to the same elements in Andrew's staircase baluster, allowing for necessary variation in length and proportion. The overall model for the chair is the Philadelphia fan-back Windsor with its low, broad back, long, slim crest, thick spindles, and wide plank (figs. 3-48, 3-49). The paper label on the seat bottom, which reads, "Andrew & Robt McKim, / makes every kind of / WINDSOR CHAIRS, / In the neatest and best manner at their / Chair Shop near the Post Office / RICHMOND," within a guilloche border, is the same as that found on the McKims' first bow-back design.

The spindles of the McKims' early bow-back chair are again plain, but the leg balusters are more rounded in profile. The next development introduced "creased" spindles to the round back (fig. **8-7**). The grooved pattern is more accentuated than in Philadelphia work (fig. 3-51) although it bears some resemblance to Maryland examples (fig. 4-2). As turning specialists the McKims likely took particular pride in this part of their work. The bow face is molded with a low, rounded crown flanked by scratch beads,

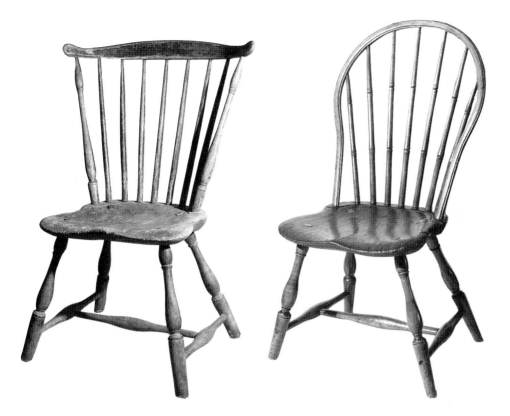

Fig. 8-6 Fan-back Windsor side chair, Andrew and Robert McKim (label), Richmond, Va., ca. 1795–1800. Yellow poplar (seat); H. 32¾″, (seat) 15½″, W. (seat) 16½″. (Private collection: Photo, Museum of Early Southern Decorative Arts, Winston-Salem, N.C.)

Fig. 8-7 Bow-back Windsor side chair, Andrew and Robert McKim (label), Richmond, Va., ca. 1798–1805. Yellow poplar (seat) with maple and other woods; H. 35¾″, (seat) 14½″. (Private collection: Photo, Museum of Early Southern Decorative Arts, Winston-Salem, N.C.)

again copying the Philadelphia style. Angular bends mark the points where the loop bellies outward, a characteristic that seems consistent in the McKims' round-back work. Another feature raises speculation as to its source: the unusual, close placement of the spindles at seat level creates an awkward gap at either end between the last stick and the bow. This mannerism is present in bow-back work executed by craftsmen of German background (fig. 3-74). The feature could easily have been transmitted from southern Pennsylvania to Virginia, since the work of Pennsylvania fraktur artists has been identified as far south as the Carolinas. German American Windsors from Maryland (figs. 3-87, 3-88) may be part of a general group that influenced the McKims in choosing a slim elongated baluster. In Philadelphia design only the turned work of Joseph Henzey provides a reasonable prototype (figs. 2-6, 3-47).[30]

The third bow-back pattern manufactured by the McKims introduced bamboo leg turnings. The work is somewhat heavier than that found in Philadelphia; stouter supports are used in the partners' labeled writing chair. With the side chair of figure 8-7 the brothers introduced a new label containing a shortened text. Still another variation appears in the writing chair label, which describes the shop site as "just below the Capitol," although the location was the same. The last line provides space for a handwritten date, there inscribed "May 31 1802." The use of a square back with flared posts in the writing chair demonstrates again the influence of Philadelphia on Virginia chairmaking (fig. 3-112). During the three years between construction of the writing chair and Andrew's death, the brothers may also have produced the more common *bamboo* square-back pattern (fig. 3-114), although no examples are known.[31]

In 1802 the McKims supplied turned work for the Virginia Manufactory of Arms, which was just completing construction, and provided Windsor chairs and tall stools for the superintendent's office. At Andrew's death in 1805 Robert and Alexander McKim were estate administrators; Windsor-chair maker William Pointer and another McKim family member were appraisers. Robert continued the chair business alone for fifteen years or more, gaining the necessary help from the steady stream of apprentices who passed through the shop. The chairmaker served in various public offices and was chosen a trade representative in 1814 to assist in preparing a constitution for the new Benevolent Mechanical Society. Disaster struck early in March 1816 when fire consumed McKim's shop and the two tenement buildings next door, one of which was the chairmaker's

residence. McKim's "loss in manufactured articles peculiar to his trade, as well as furniture [was] considerable." The fire was judged to have been set by an incendiary. McKim had recently lost a lumber house and two stables in other fires of suspicious origin.[32]

Within a year the craftsman had erected four brick buildings with slate roofs on his property at Main and Tenth streets. On May 17, 1817, he announced "*An elegant assortment of* MAHOGANY FURNITURE" for sale at his new establishment. This appears to have been a line of furniture that he retailed along with seating of his own manufacture. Probably in the same year, McKim formed a partnership with chairmaker Samuel Beach; the firm was dissolved on November 12, 1818. At that time the craftsman noted he had "just received, in addition to the former Stock of McKim & Beach, some of the most elegant Fancy and Curled Maple Chairs, Ever offered in this market, at New York prices"—a statement that reveals another source of competition for Richmond craftsmen. The notice suggests that McKim had substantially reduced or given up manufacturing. He augmented his income by taking in boarders "by the week, month or year, with or without Lodging." The craftsman died about 1822.[33]

Competition in the Windsor-chair trade surfaced within a few months of the McKims' entry into business. As announced in the *Virginia Gazette*, William Pointer and Joseph Childres opened a manufactory on Shockoe Hill in January 1797 at a location between Crouch's Tavern and the Governor's House. The partnership was still in force in March 1799 when John Kearnes of Portsmouth drew his will leaving to his sisters a Richmond property "now occupied by Pointer and Childers [*sic*]." The following January, however, the overseers of the poor bound out an orphan boy to Pointer alone. Childres moved to Chesterfield in adjacent Chesterfield County, where in 1803 his personal property was seized "to satisfy several attachments for rent, &c." Included in the sale were a lathe, poplar plank, seasoned timber, several dozen chairs, and "a vast quantity of Rounds, Sticks, &c. ready prepared for putting together." After losing the materials of his trade, the chairmaker moved to Edenton, North Carolina, but continuing litigation forced him to return.[34]

William Pointer fared somewhat better, although he died early. He may have come to Richmond from Chesterfield County, where a man of that name is listed in the 1790 federal census. On January 13, 1800, Pointer accepted as an apprentice Leonard Seaton, an orphan aged seventeen who later produced Windsor furniture on his own, some of it identified. Other young men began shop training in 1802 and 1805, and in the latter year Pointer helped to appraise the estate of Andrew McKim. Pointer, too, was involved in several court actions either as plaintiff or defendant. When the chairmaker died on February 26, 1808, the *Virginia Gazette* reported that he had borne a "long lingering illness."[35]

There is a close relationship between the work of Pointer and Childres and that of the McKims. Pointer and Childres labeled chairs made in the baluster fan-back style and the bow-back bamboo pattern. Pointer's individual work, which also includes both leg styles, shows greater range and suggests that he worked independently before the partnership with Childres. Records indicate that in 1796 he was a member of the McKims' household, possibly in the capacity of a boarding journeyman. In a set of four bamboo-turned, bow-back chairs, Pointer employed the angular bow featured in the McKims' work, although the loop is fuller. The distinctive bamboowork of the legs has its counterpart in the McKim writing chair and is found again in a pair of continuous-bow armchairs (fig. 8-8) forming a suite with the side chairs. Comparison of the spindles with those in figure 8-7 reveals another point of similarity; underarm balusters also are virtually identical to the leg turnings. Pointer's basic design likely was influenced by imported work from New York, since the continuous bow was not a Philadelphia pattern. An earlier documented Pointer armchair is in the full baluster style rather than the hybrid pattern illustrated.[36]

Samuel Parsons and Son (Samuel P.), Richmond entrepreneurs in the early nineteenth century, centered their basic activity on a lumber yard and a flour and grain

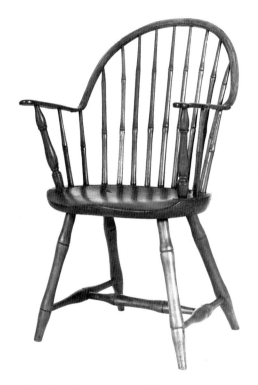

Fig. 8-8 Continuous-bow Windsor armchair (one of a pair), William Pointer (label), Richmond, Va., 1800–1805. Yellow poplar (seat) with maple (microanalysis) and other woods; H. 35⅝″, (seat) 16½″, W. (arms) 22¾″, (seat) 20″, D. (seat) 15⅛″. (Museum of Early Southern Decorative Arts, Winston-Salem, N.C.)

warehouse, although they had many irons in the fire. The men had sizable real estate holdings, and at one point Samuel P. Parsons ran a wheelwright and wheat-fan business, although neither man was a "mechanic." The rising popularity of Windsor furniture caught their attention, and on February 3, 1801, Samuel the elder advertised "to employ a person (of good moral character) acquainted with the business of making WINDSOR CHAIRS, &c. to whom he will give extraordinary wages." By October father and son could announce that they had "set up the WINDSOR CHAIR making business in all its different branches, on the South side of the Bason, . . . where any person may be supplied with Settees, Cribs, Cradles, &c. of any fashion wanted, on short notice. The work done at their shop, will be warranted to be good." Since nothing more is heard of the business, it likely was abandoned early. Lack of notices concerning the sale of stock or equipment may indicate that shop materials were disposed of privately, possibly to the McKims. The Parsonses' dabblings finally got them into trouble, and in 1809 the elder Samuel was forced to sell many holdings to meet creditors' demands. No doubt family finances were aggravated by the embargo.[37]

Richmond's overseers of the poor apprenticed Leonard H. Seaton, an orphan of seventeen years, to William Pointer on January 13, 1800. After Seaton was freed of his bonds four years later, he probably worked for a time as a journeyman, possibly with William Pointer. About November 1808 he joined forces with John Hobday in the "FANCY & WINDSOR CHAIR-MAKING, TURNING, SIGN-PAINTING, [and] GILDING" business. The partners wisely located at a center of activity "adjoining the City Hotel" near the Governor's House. This was the area where Pointer had practiced his trade until his untimely death, and one that Seaton would have known well from his apprentice days. The partners took Fleming Moseley, an orphan, as an apprentice in 1811. When the business affiliation was dissolved, Seaton continued to make chairs "at the old stand" and presumably retained the apprentice. The chairmaker sold a dozen gilt chairs, probably fancy seating, to William Randolph in 1814. The purchaser may have been the contemporary proprietor of Tuckahoe, a plantation overlooking the James River in neighboring Goochland County. Randolph is known to have made other purchases in Richmond. Hobday formed a new partnership with James Barnes in October 1816 to pursue the business of sign painting and *fancy* chairmaking "OPPOSITE the Virginia Inn, on Governor's Hill." The men offered rush- and cane-seat chairs and settees. At the printing of the Richmond directory for 1819, both Hobday and Seaton were independent chairmakers.[38]

Listed in the same Richmond directory with Leonard H. Seaton is a William Seaton, also a chairmaker. The entries, which follow one another, are unclear but seem to indicate that both men resided/worked at the same address. In 1814 Leonard had been a partner in the Petersburg firm of Seaton and Matthews. By 1818 he had formed another local business relationship with James Barnes, which according to Petersburg newspaper notices continued at least until March 1820. It is during this period that Seaton was inexplicably listed in the Richmond directory for 1819. The work of both Hobday and Seaton and Seaton and Matthews can be identified (fig. 8-11).[39]

As the local Windsor trade increased during the early nineteenth century, the city of Richmond grew to become the largest city in the state. It had one-third more inhabitants than Norfolk, which it also outdistanced in trade. Thus, it is surprising that other documented Windsor production is of considerably later date. The label on a tablet-top side chair by J. T. Woodson of 150 Main Street indicates that he was "SUCCESSOR TO LEANDER WOODSON" and manufactured "plain and fancy CHAIRS of different patterns" (fig. 8-9). Leander Woodson was a Richmond resident in 1840, as documented by the federal census and city directory, and the latter source carried his name in 1845 at the address given on the chair label. Listings for 1850 name John T. Woodson, but there is no mention of Leander. The directory gives a general Main Street address without a number, and the census places John T. outside the city in the Western District of Hanover County. The chair, then, probably dates from 1846 and 1850. The stylistic impulses that directed the hand of the maker are clear: the shovel-shaped seat with its rolled and

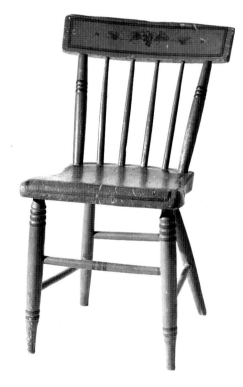

Fig. 8-9 Tablet-top Windsor side chair, J. T. Woodson (label), Richmond, Va., ca. 1846–50. Yellow poplar (seat); H. 30″, W. 15¼″; paint and decoration not original. (Private collection: Photo, Museum of Early Southern Decorative Arts, Winston-Salem, N.C.)

abruptly terminated front edge and ogee sides has a Pennsylvania orientation, while the remaining elements are designed after Baltimore prototypes (figs. 4-19, 4-20), including the back posts, tablet top, multiringed front legs, and plain, well-splayed back legs. The present paint is not original.

Petersburg and Vicinity

The tobacco trade was centered in Petersburg, and receipts given by the tobacco warehouses for hogsheads of merchantable leaf circulated as specie throughout the state. The town was located just below the falls of the Appomattox, which powered "some of the best flour mills in the state." The river, which communicates with the James, was sufficiently deep to float vessels of fifty or sixty tons. The town itself was "built along the river-side, only two streets deep, and a mile and a half in extent, on a hill of pretty rapid elevation." There were about 300 houses in the mid 1790s.[40]

Joel Brown, the most successful Windsor chairmaker in early nineteenth-century Petersburg, was established in Old Street by 1804 at the sign of the Figure of Hope, although he had worked in the town from 1796, when he first paid local taxes. Stock for sale in late September included about fifteen dozen Windsor chairs exchangeable "for cash or produce." Brown also offered riding-chair bodies over a period of several years and in 1806–7 stocked an unusually large assortment of Windsors, described as "elegant gilt, striped, and plain." He was "daily finishing chairs of every description, priced from one to three dollars each" and prided himself that he had "the newest and neatest fashions ever offered in Petersburg at reduced prices." Brown moved to new quarters in autumn 1807, and in 1811 he advertised for three apprentices. At the outbreak of hostilities with Britain he felt compelled to enter "the service of my country" and so employed Elijah Crages of Georgetown, District of Columbia, possibly already a shop journeyman, to supervise the operation of his "Windsor Chair Manufactory." Brown was back in Petersburg well before May 1814, when he again offered his "elegant finished" Windsor chairs. But the war appears to have changed the area's business prospects, an economic situation further aggravated by the destruction of a large part of the town center in a fire in 1815. By late spring 1816 Brown had moved to Raleigh, North Carolina, a distance of about 125 miles. Alexander Brown took over the Petersburg shop but stayed only a short time before he advertised the establishment for rent. He further offered to "furnish timber for 200 chairs complete, at a liberal price" and was willing to "rent the tools . . . required."[41]

A labeled Windsor that Joel Brown constructed in Petersburg at the Old Street shop is illustrated in figure **8-10**. The bamboowork is bold. Comparison with the Richmond writing-arm chair of the McKims and the work of William Pointer (fig. 8-8) reveals appreciable differences. Clearly that work was not Brown's basic source. Further search discloses striking similarities between Brown's chair and the work of certain Pennsylvania German craftsmen. The same swelled and flaring sticks are prominent in figure 3-88, while legs of angular definition near the top with a full swell below appear in such examples as figures 3-73 and 3-94. This second link between southern Virginia and distinctly mannered German work suggests the presence of rural-trained Pennsylvania craftsmen or their products within the area. Brown's label fixed to the chair bottom lists several services not itemized in his advertisements: "Columns turned for Porticos and Porches: Cabinet turning executed in the neatest manner."[42]

Concurrent with Joel Brown's first Petersburg years were the early careers of several other men who made or sold Windsor furniture. In 1805 Archer Brown, who like Joel Brown began as a coachmaker, advertised "a large and complete assortment" of Windsor chairs supplemented by writing chairs, settees, and cradles. A year later George Dillworth and John Priest formed a partnership and opened a shop in Old Street to manufacture wheat fans and wirework, Windsor chairs and settees, and riding-chair bodies. Diversity and an eye to country custom from rural residents and storekeepers were prominent aspects of the Petersburg woodworking trades. George W. Grimes arrived in town in 1812 and announced as a painter of coaches and signs. Two years later

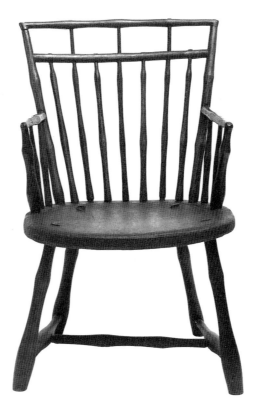

Fig. 8-10 Square-back Windsor armchair, Joel Brown (label), Petersburg, Va., ca. 1804–7. Yellow poplar (seat); H. 30¾", (seat) 14¼", W. (crest) 19". (National Society of the Colonial Dames of America in the State of North Carolina, Joel Lane House, Raleigh, N.C.: Photo, Museum of Early Southern Decorative Arts, Winston-Salem, N.C.)

he, too, stocked "a handsome assortment of Fancy and Windsor CHAIRS" to which he added a supply of prints in gilt frames. Like Joel Brown, he removed to Raleigh, North Carolina, arriving there about 1815.[43]

Leonard H. Seaton and Graves Matthews also had their turn in the Petersburg Windsor market. They set up shop in 1814 and advertised Windsor-chair making and "TURNING executed in all its various branches." This is the firm's only public notice, and the business association was over by 1818, thus it is rather surprising that several labeled chairs still exist (fig. 8-11). The basic pattern originated in Pennsylvania (fig. 3-132), but the seat front projection is a Baltimore innovation (figs. 4-3, 4-11). With its original paint and decoration this probably was a stylish chair (fig. 4-13). In 1818 Leonard Seaton formed another Petersburg partnership with James Barnes. Their specialty was fancy- and Windsor-chair making, although they also "understood" sign painting. They located in a house next to Redmond's Tavern, possibly a site formerly occupied by Seaton and Matthews. The partners were still there in February 1820, when a disastrous fire swept away the wooden tavern buildings and destroyed most of the furnishings. Perhaps Seaton and/or Barnes assisted in refurnishing a new building. Seaton is named in a newspaper notice of March 3, 1820, which relates how cabinetmaker William H. Russell lost a pair of boots placed "under a work bench in the back yard of Mr. Leonard Seaton's house" while "repairing to the fire." This same William H. Russell had taken over the cabinet shop of his deceased brother-in-law, George Mason, in 1813 and between May 26, 1815, and September 17, 1816, retailed "elegant" Windsor and fancy chairs "MADE in the state of New-York, of the best quality" in addition to cabinet furniture.[44]

Rural and semirural areas peripheral to Richmond and Petersburg account for a share of chairmaking and provide evidence of Windsor use in southern and southeastern Virginia from the 1790s and later. The Honorable John Tyler of Charles City County made his will in January 1813; by June appraisers had inventoried the household, where they found mahogany and rush-bottom chairs and thirty Windsors. The plantation was of moderate size, numbering among the hands thirty-nine slaves. William Minor, who trained in Richmond in the 1790s, eventually settled in King and Queen County, where he manufactured twenty dozen Windsor chairs annually in 1820. Robert McKeen was a relative newcomer to Dinwiddie, located southwest of Petersburg, in May 1793, when

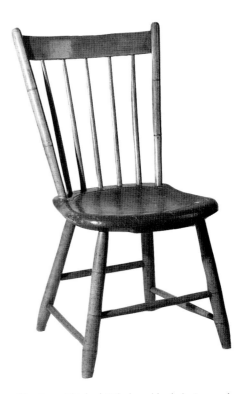

Fig. 8-11 Slat-back Windsor side chair, Leonard H. Seaton and Graves Matthews (label), Petersburg, Va., ca. 1814–18. H. 31⅝", (seat) 15". (Private collection: Photo, Museum of Early Southern Decorative Arts, Winston-Salem, N.C.)

he advertised his Windsor-seating business in a Petersburg newspaper and sought an apprentice. By 1795 he had moved to Petersburg, where he remained until 1800. He changed occupations in 1801 and became the proprietor of an inn in Warrenton, North Carolina. This was likely the same Robert McKeen who as a Boston journeyman under the age of twenty-one sued chairmaker Joseph Adams in 1790 for nonpayment of services. The South was beginning to "open up" to craftsmen at the close of the eighteenth century and, from a distance at least, appeared attractive as a trade opportunity.[45]

The wide circulation of the Petersburg *Republican* induced Sterling H. Woodward to appeal "to the Citizens of the states of Virginia & N. Carolina" in March 1807. He supplemented coachmaking at Dinwiddie by employing "a young man . . . well acquainted with the Windsor Chair making business." Nathaniel Lilly of adjacent Brunswick County pursued business in much the same manner in 1820; he manufactured gigs that cost from $75 to $150, cart wheels and spinning wheels, and "sitting chairs" priced at $1 to $1.50. The shop was of good size, employing besides the proprietor two men and an apprentice. The census reported: "The . . . manufactory . . . is in good condition and articles manufactured very saleable on a credit. Collection bad."[46]

Peyton Skipwith erected a new house during the 1790s at Prestwould, his plantation near Clarksville in southern Mecklenburg County close to the North Carolina border. By 1797 he was ready to purchase a large order of Windsor seating to meet the needs of a household that included four young children. He sought the services of David Ruth, a carriagemaker and chairmaker of adjacent Granville County, North Carolina:

1797 November 6th Dr Sr Peyton Skipwith to David Ruth	
To 2 Doz: of Fan-backed Scrowled	
chairs at 10/	£12.. 0..0
D[itt]o 2 Portico Settees at 42/	4.. 4..0
D[itt]o 1 Settee at 48/	2.. 8..0
D[itt]o 6 small Chairs at 6/	1..16..0
D[itt]o 1 Child's chair at 12/	0..12..0
	£21 — —

The fan-back chairs had volute-carved ("Scrowled") crests. At 10*s.* each they could have been armchairs, especially since the half dozen "small" chairs at 6*s.* apiece were priced within the range for adult-size side chairs. The substantial cost of the child's seat probably indicates it was a highchair, which as a special order required custom work to produce the extra-long legs. In ordinary circumstances such parts would not have been stocked in a rural shop. The single settee, unlike the portico seats, probably was for indoor use; the increased cost may indicate that it was of larger size.[47]

About fifty miles northwest of Prestwould at Red Hill, the Charlotte County home of Patrick Henry, an inventory of the statesman's £6,000 estate taken at his death in 1799 itemizes "2 green winsor chairs." Information for adjoining Prince Edward County identifies the Windsor workshop of John Marshall, where in 1820 production amounted to twenty-nine dozen chairs annually, valued at $680. The output suggests that Marshall farmed or pursued other work part time.[48]

The Southwestern Region

Lynchburg in the southwestern part of the state can account for a great deal of woodworking. The area was settled in the mid eighteenth century, and by 1757 a family-operated facility known as Lynch's Ferry served the James River; the site grew into Lynchburg. The James River above the falls at Richmond was navigable all the way to Lynchburg, an important factor in the town's growth and development. In 1816 when the population stood at about 3,100, three cabinet shops were reported in operation. The earliest known chairmaker is William Dicks, who announced on July 28, 1795, that he pursued the "Winsor Chair making Business At his shop in Amherst county on the main

road about ½ a mile from Lynche's Ferry." The location was calculated to capitalize on commercial traffic passing to and from the town and river. A notice inserted two years later in the *Lynchburg Weekly Museum* offered "One Dozen New WINDSOR CHAIRS" for sale. The seating probably was "imported" from one of the state's eastern centers. Furniture brought into the community from outside likely represented a considerable source of competition for local woodworkers. A public auction of 1814, for instance, disposed of mahogany furniture and "fashionable Windsor Chairs," the whole lot "executed in Richmond." A fan-back side chair with an area history appears to be the work of either the McKims or Pointer and Childres of Richmond.[49]

Two types of craftsmen operated in the community: those who were long-term residents and those who remained for only a short period. Chester Sully and Archer Brown belong to the latter group. Sully arrived in 1814 and left the following year. When located in Norfolk in 1805, he had made Windsor chairs, but in Lynchburg his activity appears to have been confined solely to *selling* furniture, and likely the furnishings were "imported" from the coast. Archer Brown had sold Windsor chairs in Petersburg before his departure about 1812. He arrived in Lynchburg in 1816 and two years later joined forces briefly with John Hockaday, a cabinetmaker from Williamsburg. Among the long-term residents were Alanson Winston and Sampson Diuguid, partners from 1818 to 1820. They settled in Lynchburg following the War of 1812 and remained community residents until their deaths after midcentury. Their advertisement of December 1818 while promoting the cabinet, upholstery, and undertaking businesses, also mentions "Windsor Chairs, Of good materials and workmanship." Winston continued to retail or manufacture Windsors during his later career. A printed label of 1841 for the firm of Winston and Calwell offers Windsor and fancy chairs "of their own manufacture." There is no further established link between Diuguid and Windsor-chair making, except for a writing-arm chair that has descended in the family. However, that chair has strong overtones of Richmond work, particularly where the seat front breaks forward across the center in the manner of the McKim writing chair.[50]

Chairmakers George T. Johnson and Chesley Hardy shared a partnership between 1819 and 1821, although the association may have existed earlier and/or later. A Lynchburg chair with a damaged label is possibly a product of the firm. The words "Johnson &" are clear, but little remains of the second name. The chair appears later in style than the firm's known working dates, and the Market Street address on the label does not agree with known locations for either man. A later Windsor bears a Johnson label with a Main Street address. Both locations were within a few steps of the markethouse. The Johnson and Hardy(?) slat-back chair relates to the Petersburg Windsor made by Seaton and Matthews (fig. 8-11) and shows the same Baltimore influence in the seat-front projection. By contrast, the bamboowork of the Lynchburg chair legs bears little modeling, and the back posts are shaved on the face above a band of triple rings. The labeled Johnson chair, which has similar back posts angled sharply to the rear, frames a deeper slat and is centered by an ornamental arrow spindle. The front stretcher consists of double balusters flanking a ball turning, and the forward legs are turned to a fancy pattern, ringed top and bottom. New York seating may have provided the model for the turnings. Jacob Fetter III of Lancaster, Pennsylvania, used a similar arrow spindle in the back of one of his Windsors (fig. 3-154), and that silhouette is also seen in Baltimore work. There was good custom for New York, Philadelphia, and Baltimore chairs in early nineteenth-century southern markets. All provided local craftsmen with design sources for updating their production.[51]

Northwest of Lynchburg there is evidence that Windsor seating was looked upon with favor in the Lexington area, and no doubt intensive study would confirm this. An inventory of George Mason's plantation house in 1797 itemizes an extensive and imposing group of seating, some of it obviously imported. Eighteen Windsor side chairs and two armchairs, the seats covered in green moreen (wool), appear to have stood in a parlor, which also contained two sofas with similar upholstery. These were accompanied in part by gilt-framed looking glasses and a mahogany tea table. Another large suite of

Windsor furniture, consisting of two settees, thirteen armchairs, and twenty-three side chairs, was painted green. Just a few years later, William Keys and James Dickson collaborated at Lexington as Windsor-chair makers and house painters, as described in an October 1801 advertisement.[52]

South of Lexington in the great valley of Virginia the town of Fincastle, seat of Botetourt County, was founded in 1772 and settled from eastern and northern Virginia and Pennsylvania. The principal occupations were farming and stock raising. By 1820, the earliest recorded date for chairmaking, the community was still small. Within a decade, however, the place had grown to 260 houses and 703 inhabitants. Among the craftsmen were wheelwrights and wagonmakers, house joiners and cabinetmakers, and a chairmaker. An advertisement of the local dry-goods firm of Shanks and Anderson displays the cosmopolitan influence that was becoming common even in the inland towns: "New York and Philadelphia at Your Door!"[53]

The Fincastle chairmaking shop probably was that of Samuel Fizer. The craftsman's earliest known advertisement, of September 4, 1820, reminded the "Citizens of Fincastle" that his chairmaking business "continued at his old stand." Fizer stated emphatically that his work was executed in a style to "rival any of the Northern Cities." To supplement orders for chairs he offered his services as a painter of houses and signs and as an ornamental painter. He assured potential customers of "reasonable ... terms to suit the present oppressive and difficult times." Planning for further diversification to counter the depressed economy, within six months Fizer advertised for a journeyman wheelwright, "sober and industrious." Wheels for spinning and wagon use filled a critical need in a region devoted to farming. Fizer was still a county resident in 1830.[54]

Two documented Windsors by Fizer are in the Philadelphia style. Both appear close in date and copy work that became current in the Delaware Valley in the 1810s. One chair is similar to the Seaton and Matthews pattern (fig. 8-11) with minor modifications: there is no seat-front extension, the slat is slimmer, the back posts have three bamboo grooves instead of two, and the legs are plain. Fizer's second chair alters the back posts and crest by introducing flat, shaved surfaces to the roundwork and a tablet to the slat (fig. 8-12). The tablet-centered slat pattern had a short life even in Philadelphia where it originated around the War of 1812 (figs. 3-125, 3-126). The late, squared-shield seat resembles an interior Pennsylvania type (fig. 3-154).

Among the several cabinetmaking shops in Fincastle, one was operated by Adam Fizer (relationship unknown), whose inventory was probated in 1838. Adam Fizer died suddenly, as indicated by the several hundred feet of board and plank on hand and the unfinished work in the shop, which included "100 table legs 1 Cut per piece Rough" and "86 D[itt]o D[itt]o dressed 3 Cuts per piece." Fizer's equipment consisted of a full range of planes, a variety of saws, and miscellaneous hand tools. He owned a lathe and chisels, and his stock included yellow poplar plank, a wood often used in Virginia for Windsor seats. Fizer's modest household contained six Windsor chairs. The craftsman worked in Botetourt County by 1810, when his name first occurs in the census.[55]

In the same area J. and P. Trovillo set up a chair business opposite the Valley Hotel in Pattonsburg on the James River in November 1820. Like Samuel Fizer they painted houses and signs, and served as ornamental painters. How long the men remained before moving on is unknown. Their names do not appear in Virginia or North Carolina census records from 1810 to 1830. Given the informality of spelling common to this period, it is possible that one of the firm members was the John Travilitt, who at age eleven in 1807 was apprenticed to the Baltimore Windsor-chair maker William Snuggrass.[56]

Across the mountain in Bedford County Jessie Spiner made his living farming and raising livestock with the help of about thirteen slaves. His household furnishings, while not extensive, were comfortable. In 1836 he owned half a dozen Windsor side chairs valued at $1 apiece and an armchair worth $1.50. Another half-dozen "Round Top" (bow-back) chairs had been in the house for many years; accordingly, appraisers valued them at 50¢ apiece. South along the mountains in Wythe County near the North

Fig. 8-12 Slat-back Windsor side chair and detail of label, Samuel Fizer, Fincastle, Va., 1820–25. H. 33", (seat) 15", W. 17½". (Old Salem, Inc., Winston-Salem, N.C.: Photo, Museum of Early Southern Decorative Arts, Winston-Salem, N.C.)

Carolina border, Lacker Smith turned out Windsor chairs in the latest patterns. He and a workman used 1,000 feet of yellow poplar and oak a year. The establishment was reported as new in 1820, and the annual value of the products was estimated at $600.[57]

Thomas J. Moyers and Fleming K. Rich worked at Wythe Court House (Wytheville) in the 1830s. Although the men were cabinetmakers, customers called upon them for routine repairs to seating furniture, such as fixing an arm, making new rockers, or replacing a chair plank. The partners executed miscellaneous turned work from time to time, a skill of some consequence in Wythe County. Samuel H. Wills specialized in cabinetwork and turned work and with five workmen produced merchandise worth $4,000 annually. The manufacturing census of 1820 also lists six wheel- and reel- making establishments. In a county located at a considerable distance from either the seacoast or the regular paths of commerce, home industries were crucial.[58]

WEST VIRGINIA

Although West Virginia did not become a state until 1863, a natural and political division between eastern and western Virginia existed long before that date. The Appalachian Mountains effectively cut off easy direct communication, except in the panhandle that contains Martinsburg and Harper's Ferry. Opening of the Mississippi and Ohio rivers further directed western Virginia interests away from the east. The population of the western region, which stood at almost 56,000 in 1790, had risen to well over 78,000 by 1800. Lewisburg, Morgantown, and Charles Town (Charleston) were among the first communities founded and incorporated. Agriculture was the main pursuit, but the irregular land surface with its narrow valleys precluded any but small farms, even though the land was fertile. Livestock raising became an important occupation. Conditions and resources made the area ripe for industrial development. These included the commercial production of salt on the Great Kanawha, the establishment of boat yards and ropewalks at Wheeling on the Ohio, coal mining after discovery of the mineral in 1817, wool processing to utilize an important livestock product, the erection of iron furnaces, and lumber production. Development of railroad transportation toward midcentury acceler- ated industrialization but aided agriculture as well.[59]

The Panhandle and Hampshire County

Early evidence of Windsor furniture in western Virginia centers in the panhandle, where Horatio Gates settled in 1772 on a plantation in Berkeley County called Traveller's Rest. In 1775 Gates entered the Continental Army where he achieved the rank of major- general. At the war's end he resumed life as a planter and in 1786 married as his second wife a Maryland woman with a handsome fortune. In 1788 the general redecorated part of his home. He paid one William Anson for painting "the Large Dining Room" and "the Chairs for Ditto." It is unlikely that Gates used common rush-bottom seating for this room, and the only painted alternative at that date was the Windsor. A high-back, ball-foot Pennsylvania Windsor branded three times on the seat with the name "H. GATES" was perhaps once used at Traveller's Rest.[60]

Some years after Gates had left Virginia for a new residence in New York, Robert Philips opened shop in Martinsburg, the seat of Berkeley County. Here in November 1799 he advertised his spinning-wheel and Windsor-chair-making business and sought an apprentice and a journeyman. This was not the first time Philips had worked in town, since he clearly stated he had "returned to Martinsburg." Between August 1808 and January 1814 Michael Kearns advertised his "Wheel-Right" business on Burke Street near James Faulkner's store, a location he apparently had occupied for some time. Production included spinning wheels, reels, and Windsor chairs, the latter "of the newest fashions," all sold for cash or "country produce." The text of Kearns's notice remained practically unchanged during six years of advertising; once he offered to do house painting. George Kearns, cabinetmaker, painter, and turner, announced on April 15, 1811, that he had commenced business "in the Yellow House, in the Main Street." He offered

chairs and settees, plain or elegantly decorated. The craftsman enjoyed good public response, since within a week he found he needed the services of an apprentice. On April 7, 1814, less than three months after Michael Kearns's last advertisement, George Kearns announced that he had "removed his shop to the red House in Burke Street, near Maj. Faulkner's Store," and added wheelmaking to his business. Clearly, George had taken over the shop of Michael Kearns, which strongly suggests a close relationship between the two, possibly that of father and son.[61]

Ten miles away at Shepherdstown William Kain advertised his spinning-wheel and Windsor-chair making business little more than a month after George Kearns opened shop. Perhaps responding to the pressures of rising competition, Kain advised customers that he would "carry on his business far more extensively than ever" and added lettering, house painting, and glazing to his services. A year later, in April 1812, he further expanded by providing residents of neighboring Charles Town village an opportunity to purchase his chairs locally from "Mr. Gibbs." But such business maneuvers were in vain. On March 31, 1814, Kain announced a public sale to dispose of household goods, a cow, "a stock of excellent seasoned Wheel stuff," and the house and lot where he resided. Since Kain made no mention of tools or other stock, it may have been his intention to relocate elsewhere.[62]

Windsor seating produced by chairmakers in Berkeley and Jefferson counties was up to date, as indicated in a notice placed in 1810 by a Charles Town resident attempting to recover lost property: "Some person, (I presume thro' mistake) took from the grove where preaching was on Sunday last, a Windsor chair, of mine. It was made by Mr. Brown, of this place, is painted black, and has a square back. I will thank the person who has it in possession, to return it." Several Browns are enumerated in the Jefferson County census of 1810. A few years later Matthew Wilson offered his chairmaking services at Charles Town. His first advertisement, of February 1813, states his intention to expand into the "*Wheel-Wright* business in the spring." Wilson probably cut into William Kain's local consignment sales through Mr. Gibbs and possibly contributed to Kain's quitting the area altogether. Prospects were bright in August when Wilson advertised for a journeyman wheelwright and a chairmaker, a notice repeated the following spring. By October 1814 the picture had changed. At public sale on October 22 he offered wheels and chairs, "a quantity of 2 inch Poplar Plank," and other articles. Adverse economic conditions precipitated by the embargo and the war seem to have taken their toll. Thomas Cope, a Philadelphian, gave some impression of the general area several years later, commenting in his diary that "Charleston, a handsome town of 150 dwellings . . . is the seat of justice for Jefferson & a lively looking place. . . . We saw many fine farms, but still it is a slave country."[63]

The manufacturing census of 1820 identifies a later chairmaking site in Hampshire County adjacent to the panhandle. John Thearns and Peter Murray operated independent chair "manufactories." The production of the former was small, only four dozen chairs a year, valued at $20; almost certainly Thearns made common slat-back, rush-bottom seating. Data for Murray clearly indicate that his production consisted of Windsor chairs—eighteen dozen a year priced at $16 a dozen. He had a hired hand to help him. Another census entry identifies John Barrett of Parkersburg on the Ohio River as a manufacturer. He and another man produced chairs and settees to the value of $2,500 annually; the wood alone cost $1,000.[64]

Wheeling and Lewisburg

Wheeling, located north of Parkersburg on a high bank of the Ohio, was first laid out in town lots in 1793 along a creek that empties into the river. The town was "one of the most considerable places of embarkation to traders and emigrants, on the western waters," and "quantities of merchandise designed for the Ohio country, and the upper Louisiana, [were] brought in waggons during the dry seasons." Growth was rapid. From 1810 to 1836 the population increased tenfold to about 10,000. Many substantial warehouses stood along the waterfront; the retail center was up the hill on Main Street and beyond.

South Wheeling below the creek developed as a residential area, where brick structures were intermixed with wooden ones. Transportation statistics gauge the city's commercial traffic with the western regions in the mid 1830s: annual wagoners' fees ranged between $265,000 and $285,000, irrespective of charges for waterborne freight; steamboat arrivals numbered about 800; and 228 flat and keel boats operated out of the port. The major local industries were glassmaking and metal manufactures. Coal from the newly developing mines provided fuel for industrial development; the surplus was exported. Widespread use of the mineral prompted Carl David Arfwedson to comment in 1833, "The town appeared so sooty and unpleasant, that it was with very little regret I left it." The previous year a severe flood in Wheeling had carried away many buildings standing on the low lands.[65]

As expected, recorded chairmaking in Wheeling begins only with the industrial period. Both William Cunningham and Robb and Morrison were early advertisers; they offered fancy and Windsor chairs in 1828. Cunningham added rockers, settees, and writing chairs to the list. Robb and Morrison dissolved their partnership sometime after their April advertisement, since James W. Robb advertised alone by September. The names of both Robb and Cunningham are found in two directories published in the 1830s. A national advertising volume of 1831 calls the former a fancy-chair manufacturer and Cunningham a fancy-chair and cabinet manufacturer. Both names appear again in the first Wheeling directory of 1839; there Cunningham identified his products as mahogany, Grecian, and Windsor chairs. He died in 1851, and his widow managed the business until 1868. Other Windsor-chair makers identified in 1839 are James Davis and Jonas Thatcher. The men called simply chairmakers probably produced Windsor seating as well. In addition, two men were identified as fancy-chair makers. The next directory of 1851 repeats Robb's name and adds those of William H. Seaman, William Riheldaffer, and E. L. Pratt. Neither list contains the names of J. Connelly and Sons or William Graham, or the partnerships of Thatcher and Smith, and Thatcher and Connelly, all of whom are known to have worked in Wheeling around this time.[66]

Wheeling is the only West Virginia site associated with identifiable Windsor furniture. Documented examples represent the work of five firms: William Cunningham, Jonas Thatcher, Thatcher and Smith, Thatcher and Connelly, and William Graham. Patterns vary, and features are sufficiently intermixed to make dating difficult, but all probably are later than the basic designs would indicate. As might be expected, chair patterns draw mainly on features of Baltimore and Pennsylvania origin. Wheeling in its situation southwest of Pittsburgh received overland influences from both sources. A chair by Cunningham could pass for a Baltimore Windsor, if it were not for the chairmaker's label on the bottom. The tapered rectangular seat has raised, platform-style side pieces supporting a back structure in the style of figure 4-16; the posts are turned to a fancy pattern with a "beehive" base, like the front legs of figure 4-18 (inverted). Replacing the beehive at the top of the front legs is another fancy turning (fig. 8-15).

Stylistically, an "early" design is a slat-back, bamboo-turned chair branded "THATCHER & SMITH / WHEELING / WARRENTED." The same basic pattern is also found in Virginia (fig. 8-11). The Thatcher and Smith chair has four-section posts and legs, and a balloon seat with flat edges. It probably dates to the years immediately preceding Jonas Thatcher's independent listing in the 1839 directory. A chair of the same general description bears Thatcher's brand alone (fig. **8-13**). Modifications include shaved posts and arrow spindles of a Pennsylvania pattern (fig. 3-137, left). The legs, with

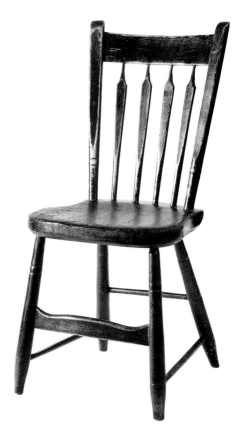

Fig. 8-13 Slat-back Windsor side chair and detail of brand, Jonas Thatcher, Wheeling, W. Va., ca. 1839–45. Yellow poplar (seat); H. 35¼″, (seat) 17⅛″, W. (crest) 16⅞″, (seat) 16¼″, D. (seat) 15″. (Oglebay Institute Mansion Museum, Wheeling, W. Va.: Photo, Winterthur.)

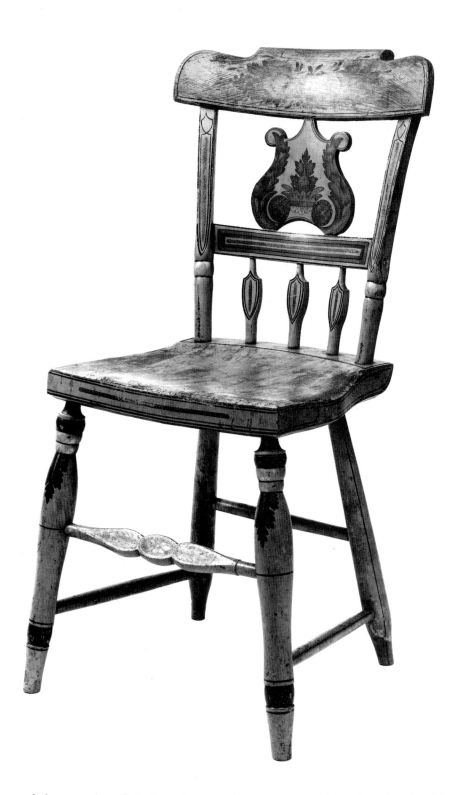

Fig. 8-14 Rounded tablet-top Windsor side chair (one of a pair), attributed to Wheeling, W. Va., 1840–50. H. 34″, (seat) 17⅞″, W. (crest) 18¼″, (seat) 16½″, D. (seat) 15⅜″; light mustard yellow ground with black, dark wine red, light and dark bronze, and gilt. (Marian V. Dock collection: Photo, Winterthur.)

their suggestion of a ball turning near the top, seem an adaptation of a related feature as seen in rural Pennsylvania-Maryland border work (fig. 3-161). The slat-style front stretcher is generally of late date when found in Windsors; it was developed from earlier Baltimore fancy work (figs. 4-16, 4-17). The top curvature probably is due to wear. A settee by William Graham of Wheeling with narrow slats for stretchers, front and back, has similar legs somewhat better defined.[67]

A fancy Windsor pattern that may be peculiar to the Wheeling area is illustrated in figure **8-14**. One of a pair, the chair is not marked, but another of almost identical design bears Jonas Thatcher's brand. Minor differences can be seen in the shouldered crests and short arrow spindles. Both front and back legs derive from Baltimore work (figs. 4-18, 4-19). The seat is a Pennsylvania plank with the front sliced off vertically (fig. 3-144); the crest is of similar origin (fig. 3-146). A pair of chairs made by William Graham has the

Fig. 8-15 Fancy side chair (one of twelve), Baltimore or eastern Maryland, 1830–35. H. 32″, (seat) 17½″, W. 18⅞″. (Private collection: Photo, Museum of Early Southern Decorative Arts, Winston-Salem, N.C.)

Fig. 8-16 Child's tablet-top Windsor side chair, Jonas Thatcher and J.(?) Connelly (stencil), Wheeling, W. Va., ca. 1844–51. Yellow poplar (seat); H. 28⅞″, (seat) 14″, W. (crest) 17⅛″, (seat) 14″, D. (seat) 14″; dark brown ground with bright mustard yellow and gilt. (Oglebay Institute Mansion Museum, Wheeling, W. Va.: Photo, Winterthur.)

same top piece but only a mid slat below the crest. The focal point of the Thatcher design is the large, scrolled, shieldlike ornament of the back. The feature derives from formal and fancy woven-bottom seating (fig. **8-15**), where it is defined as an openwork lyre. An elegant painted piano with similar ornament is documented to a Baltimore maker. In the Windsor chair the decorator took liberties with the original design, perhaps to coordinate the motif with the floral work of the crest.[68]

There is no indication whether Jonas Thatcher's partnership with J. Connelly occurred before or after the latter's advertisement of 1843 as J. Connelly and Sons. Thatcher died in 1851, and Connelly's name does not appear in the city directory published that year. The partners stenciled their firm name on the bottom of a tablet-top child's chair (fig. **8-16**) that has back features seen in other area work. The seat rounds somewhat at the forward edge, and the front legs are a close copy of a Pennsylvania pattern dating just before midcentury (fig. 3-147). This strongly suggests that the partnership postdates 1843. As mentioned, a tablet crest is found on a late plank-seat bench made by William Graham, who commenced work in Wheeling sometime after publication of the 1851 directory. Graham also used the flat spindles of the Thatcher chair (fig. 8-13) and legs of the same general design with a slat-type stretcher.

Manufacturing in Wheeling was highly mechanized. A publication of 1837 describes a steam sawmill and window sash manufactory fueled by coal and notes that in the sash department "the only manipulation by the operatives, was putting the joints together."[69]

Mass production had spread to other areas of West Virginia by midcentury. An example is Lewisburg in Green Briar County. Thomas Henning, Sr., was a veteran chairmaker in February 1852 when he advertised "a better supply of Chairs than he has had for some years past." Available in quantity were split- or cane-bottom chairs, Windsors, rockers, parlor, and office chairs. Henning described his shop capability: "He can furnish from 3 to 5 or 600 chairs per month, and would be glad to receive orders from gentlemen who want or will want a lot of Chairs, either now or in the Spring." The chairmaker apparently did not live to see spring, since Washington G. Henning, probably a son, advised customers on June 24 that they could view his chairwork "at the old stand of Thomas Henning, Sen." Following in the elder Henning's footsteps, Washington later announced an auction for May 1, 1853, where he would sell "the largest and best Stock . . . ever offered in Western Virginia or in any other market," the lot

"warranted equal to any, in point of Workmanship or durability, no matter where manufactured":

> 700 New style Split Bottom Chairs
> 100 Rocking d[itt]o. d[itt]o. d[itt]o.
> 25 " solid bottoms, (very superior)
> 100 Windsor Chairs, handsome pattern
> 25 Lounges, very fine
> 25 Settees, d[itt]o.
> Also, a large lot of Children's Chairs,
> all kinds, sizes, styles, and patterns.

Henning explained his purpose in selling the chairs at auction, where they would bring relatively low prices: "Having just commenced the manufacture of Chairs, &c., in Lewisburg, I feel desirous of having my present works distributed as samples of my future, pledging myself to serve you to the best of my ability."[70]

WASHINGTON AND THE DISTRICT OF COLUMBIA

Long before Washington was conceived as a capital city, Georgetown on the eastern bank of the Potomac was a port of entry. Rock Creek to the east would later serve as its boundary with the national seat of government. As early as 1769–70 shipping records detail the exportation of Philadelphia Windsor chairs to area consignees. Clement Biddle and Company sent four armchairs to T. Richardson and Company and "6 high backt Windsor Chairs" to Andrew Leitch of Bladensburg, who from the quantity of foodstuffs in his order may be identified as a country merchant. Sounding a political note were Leitch's 200 copies of the *Farmer's Letter* and six prints of "Mr Pitt." The first advertisement of record for a Georgetown retailer of Windsor chairs dates to September 1799, when John Duhy offered a quantity of seating for sale at his cabinet and chair manufactory. The following year Duhy removed from Georgetown to Washington. In 1801 Thomas Renshaw, who later found better custom in Baltimore, opened a Windsor chair manufactory "TWO DOORS BELOW THE COLUMBIAN INN." When Hector Sanford followed suit a year later he located near another center of activity, the Union Tavern. Sanford had served an apprenticeship with Ephraim Evans in Alexandria a few years earlier and may have remained with his former master for awhile as a journeyman. Even after moving to Georgetown, Sanford advertised in an Alexandria newspaper that he delivered chairs there "free from all expense of carriage." Through 1804 he continued to offer Georgetown residents "chairs handsomely finished, among which are some NEATLY GILT." Sanford attracted some local custom, since Colonel William Washington, Esq., called a judge in 1805, bought two and a half dozen Windsors in 1803. By 1805 Sanford had removed to Chillicothe, Ohio. At the end of the decade, when John Bridges and Thomas Adams located their chairmaking facilities in Georgetown, the new seat of federal government was reasonably well established in adjacent Washington City, although the business community there was still scattered.[71]

Early Washington had three distinct parts—Capitol Hill, the Navy Yard, and Pennsylvania Avenue. Pierre Charles L'Enfant's plan had the primary streets radiating as points of a compass from the Capitol and named after the older states of the Union. In 1802 Pennsylvania Avenue was the only major thoroughfare to have been "improved." Both the Capitol and the President's House were built upon eminences from which they commanded excellent views of the city and countryside. The city itself contained around 770 houses and various public offices. By 1820 the city numbered more than 13,000 inhabitants and 2,100 houses, half of them built of brick. Still in 1817 John Bristed was "forcibly struck with the contrast between the magnificence of the natural scenery of the place and the forlorn appearance of the few buildings and broad streets."[72]

District Production

There was commercial activity in and around the capital city in the early decades of the nineteenth century, and chairmaking was a part of it. In a comprehensive study of District furniture crafts by Anne Castrodale Golovin, Thomas Adams was identified as an early chairmaker. He advertised as a turner in Alexandria in 1797–98 but was working in Georgetown by 1806, when he took the first of many apprentices. In 1820 he employed 10 people and produced 160 dozen chairs annually. By 1825 Adams had moved to Washington. His first known address in the capital was Pennsylvania Avenue between Twelfth and Thirteenth streets, where he occupied a two-story brick building through 1834. Later he had a shop on D Street. Adams's frequent advertising kept his name before the public, and he may have had influential business connections as well. In November 1814 while still in Georgetown he provided "Single" and "flat" top chairs, two and a half dozen in all, for use by the U.S. War Department. Nine other chairs in the order, priced at $2 apiece, appear to have been fancy rush-bottom seating. A month later the department found it required another half dozen "Brown Flat Top Chairs." The description indicates that the seating followed either the Philadelphia slat style (fig. 3-132) or one of the Baltimore tablet patterns (figs. 4-6, 4-11). Single-top chairs had one cross rod at the upper back (fig. 3-114). Adams also enoyed a private trade. In 1822 when Robert Underwood set up housekeeping, Adams supplied a dozen fancy rush-bottom chairs priced at $3 apiece, a dozen plain Windsors, two sewing chairs, and two four-foot settees.[73]

Through the years there was a steady stream of apprentices in the Adams shop. The first young man under the chairmaker's tutelage was James Williams, who began in 1806. Much later Williams worked in the city as a chairmaker and cabinetmaker and became master to an apprentice. He may have been the man of that name who worked at Lancaster, Pennsylvania, as an ornamental painter for a while following his training. Adams's next apprentice of record, Joseph Hall, was described in 1807 as a "free person of color." At least ten young men trained between 1808 and 1825 of whom nothing at all is known; others have fuller biographies. Elijah Crager (Crages), who apprenticed with Adams between 1808 and about 1812 as a chairmaker and turner, was in Petersburg, Virginia, in 1812 in the employ of Joel Brown as shop supervisor during Brown's absence for service to his country. The brothers(?) Aloysius (apprenticed 1816) and Ignatius Noble Clements (apprenticed 1819) started their own Washington business in 1823 as makers of fancy and Windsor chairs following completion of their training with Adams. After 1826 Aloysius continued alone for a time. Levi Hurdle came from neighboring Montgomery County, Maryland, to learn ornamental painting from Adams while the craftsman was still in Georgetown. Hurdle settled in Alexandria before January 1, 1835, when he announced that he had taken his brother Thomas into partnership. John Morris began with Adams in 1822 but ran away three years later at age nineteen, possibly heading for Ohio where a brother lived.[74]

Although the District census carries John Bridges's name in 1800, there is no evidence that he had a Windsor-chair making business before 1811, when he took the first of several apprentices. Indenture records also refer to Bridges and Son. Strangely, the men did not advertise, yet the firm was sufficiently well known to supply a small group of chairs to the Library of Congress in 1815. Also working in Georgetown was Gustavus Beale, a cabinetmaker from New York who is last listed there in the 1811 directory. Beale's first District advertisement is dated September 8, 1812, the year he took an apprentice from Charles County, Maryland. In 1817 Beale offered "plain" Windsor chairs along with a complete stock of household furnishings; it is likely that he acquired his seating elsewhere.[75]

Another early immigrant to the District was Henry R. Burden of Philadelphia, who advertised his "Windsor Chair Factory" on Pennsylvania Avenue in October 1815. He was then, or would soon be, in partnership with Joseph Cassin. Burden was probably related to the well-known Philadelphia Windsor-chair maker Joseph Burden for whom he

signed a chair receipt in 1796. Burden found it rough going for his business enterprise in the capital city. The owner of the building he occupied, described as a two-story brick house, offered the property for sale, and the partnership was dissolved. On June 19, 1818, "sundry articles of household . . . furniture" were sold at auction at the "residence" of Henry R. Burden. From the silence that followed it could be presumed that Burden had quietly returned to Philadelphia, but such was not the case. On July 1, 1819, the District of Columbia circuit court inserted a notice in the *Daily National Intelligencer* stating that Henry Burden, an insolvent debtor who had been conveyed to the Washington County Prison, had petitioned to be administered the oath pursuant to "an act for the relief of insolvent debtors within the District of Columbia" under which a trustee would be appointed for the benefit of his creditors.[76]

Optimism about business conditions continued to lure men into the city's chairmaking trade during the 1820s. David Bates, an auctioneer who probably had no craft training, began to diversify in 1820. He started by advertising for a journeyman Windsor-chair maker on February 28, then added two apprentices and a painter to his shop. The new work retailed a few months later at his "Commission Store" comprised an assortment of styles, including Windsor, bamboo, fancy, Grecian, and "stump" chairs. The last, a regional term, refers to the fancy chair whose extended back legs, forming posts, are cut off at the top in blunt "stumps" rabbeted on the face to receive the tablet crest popular in Baltimore seating (fig. 4-18). Bates was careful to note that the chairs were "custom work, and not for auction." Business was looking bright as he advertised in August for raw materials: "POPLAR PLANK. THE subscriber wishes to purchase 10,000 feet of 1¾ yellow poplar plank, 17 inches wide of a good quality." By the following March the entrepreneur offered customers such enticements as "Chairs to match their drapery, carpeting, or paper . . . according to order." But within a year and a half Bates was dead, and another auctioneer sold the contents of his estate.[77]

Evidence of John White's career emerges almost entirely from District apprenticeship records, in which his specialties are identified as Windsor- and fancy-chair making and fancy-chair painting. His "factory" was located in Georgetown from about 1821 to 1826. Thomas C. Brashears, who was apprenticed to White in 1822, eventually went to Baltimore, where he worked between 1837 and 1845. Jeremiah T. Brashears, who began a chairmaking apprenticeship with White in 1825, and Henry Hasson, who started in 1826, continued their training in fancy painting with John Dickson in 1827, an indication that White had either left the area or died. Dickson had been a cabinetmaker in Georgetown only two years when he announced in 1826 an expansion into the "manufactory of Chairs of the most beautiful and durable kind." A minor setback occurred in December 1828, when "half a dozen Grecian Chairs, painted yellow, rush seats, and gilt" went astray because a carter delivered them to the wrong address. At an estimated minimum price of $2 apiece, the chairs were worth the wages of a journeyman for two weeks, and Dickson was understandably concerned about finding them. In 1833, with business apparently prospering, Dickson moved to Washington, where he continued to offer cabinetwork and chairwork, with rocking chairs as a new item.[78]

Robert Wilson began his Washington career in 1825 by selling furniture in much the same manner as David Bates, although unlike Bates he probably had trained as a cabinetmaker. In 1826 he was in partnership with William M. Morrison to manufacture and sell furniture and chairs. When the association was dissolved in January 1827, Morrison remained at the Pennsylvania Avenue site near Third Street and continued to manufacture chairs; Wilson dropped out of sight for a time. Little more than a year later Morrison "determined to relinquish the [chair] business"—probably another way of saying that he wasn't making out—and placed his entire stock in the hands of an auctioneer. Within six weeks Wilson announced his "NEW CHAIR MANUFACTORY" at the corner of Pennsylvania Avenue and Third Street, where he may have augmented his own stock with some of Morrison's. He offered free delivery within the District and like other chairmakers repaired and repainted old seating. Wilson added cabinetmaking to his business the following year, a day after dissolving a partnership with cabinetmaker

and chairmaker David Johnston. But the businessman appears to have overextended himself, and in another year his stock was on the auction block and the premises at the corner of Third and Pennsylvania were put up for rent by the owners. Within five weeks David Johnston advertised that he had taken over Wilson's "stand" and was prepared to carry on the chair and cabinet business. Johnston didn't quite make it through a full year before he too called it quits in August 1831. The commercial picture in Washington—a city in the midst of growing pains with periodic recessions and men frantically trying to make a living only one step ahead of bankruptcy most of the time—had much in common with business life in Bridgeport, Connecticut, in the 1830s.[79]

Conditions had eased by 1833, when Charles W. Boteler and John M. Donn first advertised as partners, an association that lasted seven years or more. Already in the house-furnishing business on Seventh Street, the men announced on April 10 that they had added "a CHAIR FACTORY." The selection of painted seating included "Slat Backs, Wood Seat Grecians, Cane Seat d[itt]o., Rush Seat d[itt]o., Children's of every pattern, . . . [and] Cane and Wood Seat Rocking Chairs." The business was doing so well a year later that the firm opened a second wareroom on Pennsylvania Avenue. The additional space permitted the partners to add "an assortment of Boston made spring-seat, cushioned-seat, and scroll-seat [Boston] Rocking and Nursery chairs," new forms that were sweeping the country. Sometime during the 1840s the men set up independent businesses.[80]

In spite of the substantial chairmaking activity recorded for Georgetown and Washington and the demonstrated competition among dealers and manufacturers, not a single documented example of District painted seating is known.

THE CAROLINAS

Rice and indigo were the principal products of the Carolinas, although tobacco was grown in some upland areas. Following invention of the gin in 1793, cotton took on increasing importance as a cash crop. From 73,000 bales at the beginning of the nineteenth century, production reached 4.5 million just after midcentury. The economy rode on slave labor, and in the Carolinas slaveholding was more extensive than anywhere else in the South. Grains, potatoes, peas, and fruits were the staples of human consumption. The lowlands were flat and swampy with scattered plantations. The wooded uplands were marked by enclosures made with split rails piled up in angled sections to form worm fences. John Lambert commented in 1808 on the extremes in house building. In the cities and towns and on the better plantations there were one- and two-story wood structures with a piazza, or porch, at the southern end to shade the house interior. Poorer structures were made of logs, the corners notched and the chinks filled with clay and straw. Many of these were crude and dirty. Oxcarts were common in the low country; wagons and sledges were used inland for transport and lumbering.[81]

Lowland business and society offered striking contrasts with upland life. Concerning the lowlands, J. F. D. Smyth commented in the 1760s that "all in the country, without exception, are planters, store-keepers or persons in trade, and hunters. . . . In the towns there are some few mechanics, surgeons, lawyers, store-keepers, . . . and tavern-keepers. . . . The different branches of manufactures . . . are not known here; they are all comprehended in the single name and occupation of merchant, or store-keeper." The midland and upland regions were heavily settled after 1800 as the frontier pushed rapidly westward. Here, as John Lambert observed, the inhabitants provided "for their respective wants from their own resources, in consequence of the difficulty and expense of conveying bulky articles from the seacoast to the interior." A familiar sound was "the humming music of the spinning-wheel and the loom," since most households supplied their own domestic needs for cotton and wool. Carpenters, blacksmiths, tanners, and other craftsmen settled throughout the region, and gristmills and sawmills were scattered over the country. People supported themselves with subsistence farming and livestock production, and only salt and sugar were wanted from other sources.[82]

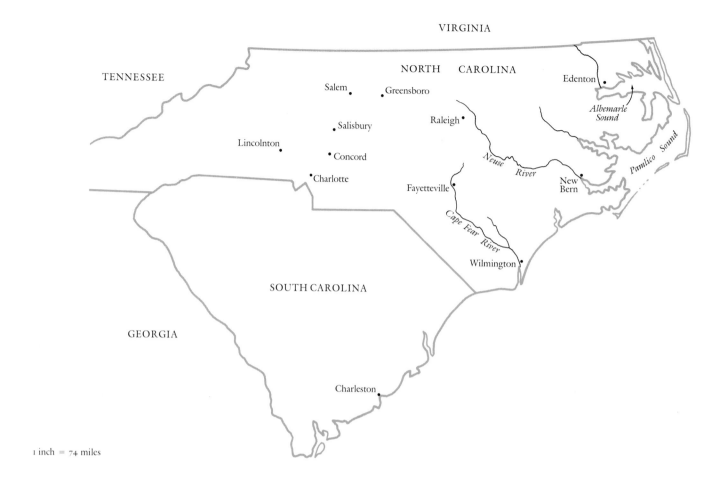

1 inch = 74 miles

North Carolina

THE COASTAL AND PIEDMONT REGIONS To fill the void in the coastal Carolina "mechanic" arts, Philadelphia chairmakers and merchants conducted a vigorous trade in seating furniture to the region. Harrold E. Gillingham, who has documented the scope of the postrevolutionary chair trade, found that from August 1783 to August 1786 at least 474 chairs in various painted styles were shipped from Philadelphia to North Carolina ports, as indicated in manifests. On August 13, 1784, the *Friendship* sailed for North Carolina with two dozen Windsors on board. Since no specific destination was indicated, the captain probably had orders to seek the best market once he reached southern waters. In an April voyage the following year the same vessel carried "one dozen Green Windsor Chairs." The three principal ports along the North Carolina coast were Edenton, New Bern, and Wilmington, none of which enjoyed anything like the trade of the Virginia seaports, due to serious obstructions in the channels and harbors and limited exportable commodities. A cargo bound for Edenton in 1783 contained thirty-six chairs, along with six tons of iron, two millstones, a phaeton, iron kettles and pots, and miscellaneous merchandise shipped in hogsheads, bales, parcels, and cases. A quantity of mahogany furniture and Windsor chairs was destined for Wilmington in October 1789, and thirty-eight "Green Chairs" were put on board the *Newbern Packet* just before it sailed the following January.[83]

In the eighteenth century, Windsor-chair making was negligible in the coastal towns, with the exception of Wilmington. When J. F. D. Smyth passed through Wilmington, he found it contained about 200 houses, "a few . . . pretty good and handsome." He noted the presence of a sandbar at the mouth of the harbor, but he reported that in spite of the obstruction Wilmington carried on "a considerable trade, especially to the West Indies, and to the northern colonies." Smyth found the surrounding land "nothing but a sand-bank covered with pines," although lumber was a significant export item of the coastal South. Cabinetmaker John Nutt removed from Charleston to Wilmington sometime before April 1786, when fire consumed his house at the North Carolina port. By 1788 he had recovered sufficiently from his losses to seek an apprentice. Perhaps the orphan John Dunbiben, bound to the cabinetmaking trade the following year, was the result of that search. Dunbiben worked in the town as a Windsor-chair maker less than a decade later, suggesting that his training was more varied than the record indicates. This seems to be confirmed in a 1798 advertisement of Nutt, who had for sale "a likely young Negro fellow" soon to finish his apprenticeship in the cabinetmaking and chairmaking business. It seems that other young black boys also trained in the shop, since a few months later Nutt threatened to take legal action against individuals who employed his black apprentices on the side. Nutt enjoyed a long and full life; when he died in 1810 the published notice gave his age as eighty-seven.[84]

Wilmington had attracted other craftsmen by the late 1790s. Two men named Vosburgh (Harmon) and Childs arrived from New York in 1796 and commenced business near the wharf. They offered Windsor chairs "highly varnished in any colour, and ornamented to any pattern," along with settees of different lengths. The partnership apparently continued until 1798; Vosburgh was joined by John Dunbiben, John Nutt's former apprentice, sometime before May 31. This connection may have continued until about 1801, when Vosburgh returned to New York to manufacture varnish and, later, paint. There is no indication whether Dunbiben remained in Wilmington or migrated elsewhere. An advertisement placed in a Wilmington newspaper the following year by one W. H. Hill to recover a runaway negro named John Johnson, alias John Hill, appears to be connected with John Nutt's 1798 notice to sell a trained black boy. Hill described his runaway as a twenty-three-year-old who had "served his time with a Cabinet-maker, and understands the business of a Windsor Chair-maker."[85]

Joseph Childres, formerly a partner in the Richmond firm of Pointer and Childres, settled briefly in the seaport town of Edenton on the northern coast. He probably came directly from Chesterfield, Virginia, where early in 1803 the deputy sheriff had seized tools and chairmaking materials to satisfy several attachments for shop rent. The chairmaker was in Edenton in March 1803, when he took an orphan as an apprentice; he followed this contract with a similar one a year later. Childres probably had left Edenton by September 1807, when William Manning, cabinetmaker, advertised his business at the shop formerly occupied by Joseph Childres. With other legal matters pending, Childres appears to have returned to Virginia by 1810.[86]

The imported seating trade still held sway at Edenton and New Bern in the early nineteenth century. In 1818 and the year following Cheshire and Cox, local merchants at Edenton, advertised an assortment of New York Windsor chairs of "superior quality." Chairs from a similar source were brought to New Bern in 1820 by Thomas Pittman, who had just been north on a buying trip. A year later a competitor offered Philadelphia Windsor chairs. There may have been little local activity in New Bern until Frederick K. Parrott's arrival from Bridgeport, Connecticut, late in 1833. The Yankee craftsman opened a "Cabinet, Chair, and Sofa Warehouse" near the State Bank and offered "chairs, of every description." Parrott likely had removed to the South temporarily for financial reasons during the troubled times preceding the panic of 1837. His brief residency in New Bern and his moves first to Raleigh in 1834 and then back to Bridgeport in 1835 initiated a chain of financial dealings in the small coastal town. The firm of Booth (Silas C.) and Porters (Edwin and James) bought Parrott's New Bern stock in November 1835. Already in the tin and sheet iron business, the partners removed the stock to their

metal goods store near the courthouse. Metalwares and cabinetwares apparently didn't mix well, since the firm soon sold the newly acquired stock to John McDonald. With the death of McDonald in mid 1840 the stock again changed hands, this time purchased by Salmon S. Backus, one-time agent of and later partner in Booth, Porter and Company. Through the entire succession of ownership, the business continued to offer "Fancy and Windsor Chairs."[87]

Removal of the capital from New Bern to Raleigh in 1794 focused attention on the state's central region, just then emerging as an area of commercial development. The city of Raleigh was in its infancy, having been founded only in 1792. Located on an elevated site, it contained an open central square from which radiated the four principal streets. In the 1830s a new, imposing state capitol was erected on part of the square. In the mid 1790s, the local craft community was only just forming. Craftsman David Ruth, at that time a resident of Granville County to the north, saw an opportunity and seized it. He secured orders to supply seating to several government offices in the relocated facility. During this period he took two apprentices to the Windsor-chair making and carriage trades and also supplied Windsor furniture for the new plantation house of Peyton Skipwith in southern Virginia. The two dozen chairs Ruth constructed in 1795 for the state treasurer's and comptroller's offices, priced at 13s.4d. apiece, appear to have been Windsor armchairs.[88]

Around 1802 Ruth removed to Raleigh, where he placed an advertisement in the *Register* on October 26, announcing the opening of his carriage and Windsor-chair making business. Almost immediately he advertised for two apprentices and a journeyman wheelwright. Ruth was favored with three more orders from the state between 1805 and 1807, and he made furniture for the local courthouse in the latter year. Then on July 4, 1810, he had an unfortunate accident. While he was engaged in firing the cannon for the celebration, his left hand suffered injuries that led to amputation. The published announcement noted that Ruth had "a large family dependent upon his labour" and reported that "a subscription was instantly opened for his relief, which was very liberally entered into." Four years later Ruth was joined in business by his son, David, Jr. By then the firm specialized in fancy- and Windsor-chair making. In the interim Ruth may have employed journeymen and functioned primarily as a shop supervisor, although he probably still could manage some jobs on his own, such as turning and painting. Father and son parted in 1818, when the elder man became "Ranger of public grounds" at the Capitol. Young David formed a partnership with Graves Matthews to pursue the business of chairmaking, sign painting, and turning. The association may have continued until David, Jr., removed to Fayetteville, where he took an apprentice and advertised his Windsor-chair making business in the spring of 1822. Apparently, young Ruth had big plans, since he searched for two or three more apprentices and employed a "first rate Ornamental Painter."[89]

Like David Ruth, Sr., Wesley Whitaker practiced both the carriage and Windsor-chair making trades in Raleigh during the early nineteenth century. He first advertised in 1805. Several young men trained in the Whitaker shop, although the craftsman's first apprentice of record, Michael Humphries, ran away in 1809 after three years' service. The relationship between master and apprentice was none too friendly: Whitaker offered a nominal reward "but no thanks" for the boy's return. Sometime after 1814 Whitaker left off chairmaking in favor of coachmaking, and in the 1820s he turned to the manufacture and repair of pianos.[90]

George W. Grimes's career began at age thirteen in 1799 as an apprentice to Ephraim Evans of Alexandria, Virginia. He was next heard from in Petersburg, where he "provided himself with a convenient apartment in Captain Thomas Claiborne's new shop" to pursue the trade of coach painter and sign painter. Grimes probably bought his fancy and Windsor chair stock "in the wood" to paint, ornament, and sell himself. His next move was to Raleigh in June 1815, where he shifted his craft emphasis to Windsor-chair making, with "Sign and Military Colour Painting" as a sideline. The changes of location and emphasis seem to have been due to the power of advertising. Grimes

evidently heard, directly or indirectly, of the sheriff's sale at Raleigh of the personal property of cabinetmaker Zenos Bronson, "an absconding debtor." Offered in addition to Bronson's tools and materials for cabinetmaking were: "a Turner's Lathe and Tools, and Materials for carrying on the business of a Chair Maker; Together with Maple stuff turned, already in preparation, as well as the bottoms gotten out, for near 200 chairs. As there is no person in Raleigh, or within 50 miles, who is exclusively engaged in Chair Making, it is thought that there are but few places which offer such superior advantages in that line." The last sentence was, of course, the real enticement. The house Grimes occupied was that formerly used by Bronson.[91]

Either Grimes's expectations exceeded custom or else he was not happy in this line of work. By the end of the year he had sold his "entire stock of Windsor Chair materials" to Thomas Cobbs and returned to his former specialty. Cobbs also took over the two-story house in Hillsborough Street. For a time Grimes located at Colonel Wiatt's carriage shop, but by May 1816 he had taken another house, apparently in Fayetteville Street. This was an ill-fated move. On the night of June 11 an incendiary set fire to a storehouse on Fayetteville Street, and the ensuing blaze consumed fifty-one buildings, including the one occupied by Grimes. Having lost his tools and supplies, Grimes may have worked for a few years as a journeyman. He was next heard from in February 1823 at Salisbury, a town about 100 miles west of Raleigh. The tone of his advertisement indicates that he had been established there as a painter for some time. On the same date Grimes and one John Cooper advertised their association for the purpose of making Windsor and fancy chairs, which they offered at $12 to $120 the set. Cooper was the chairmaker and Grimes, the decorator.[92]

The Hillsborough Street house in Raleigh—occupied first by Zenos Bronson, the absconding woodworker, then by George Grimes, followed shortly by Thomas Cobb—became the "Windsor Chair Manufactory" of Joel Brown by June 1816 upon his removal from Petersburg, Virginia, to North Carolina. Brown, like Grimes, gave preference to the trade of ornamental painting and gilding. The two men must have known each other, since their careers had overlapped earlier in Petersburg. Within the year Brown made a bold move. He acquired a lot near the markethouse where he "erected a very commodius building" to better suit his needs. To meet the "liberal encouragement" he expected, he "procured the best Workmen from the North" to provide a stock of chairs, settees, cribs, and cradles. Obviously, the word *North* was associated in the minds of southern consumers with merchandise fashioned in patterns current in the trend-setting northern centers. After only two more years in Raleigh, Brown, like others before him, found that the capital city was not nearly as attractive for business as it appeared from the outside. Beginning in January 1819 the craftsman offered his house and shop at private sale. Finding no ready buyer, he placed the sale in the hands of an auctioneer but still did not achieve his design. He continued to advertise his Windsor-chair making business and was also prepared to turn columns for porticos. A pictorial cut showing a tablet-top Windsor beneath a swag supported by columns embellishes the notice (fig. **8-17**).[93]

After meeting with little success in the sale of his property, Brown gave up his plan to leave Raleigh. In the recession of the early 1820s he experienced hard times. Some of his creditors "with leaden hand and iron grasp, exerted themselves to crush him down," while others forbore "to press him in the hour of his distress and embarrassment"—a favor for which Brown expressed his gratitude publicly. His advertisement of March 29, 1822, advised that he continued business at his old Market Street location, "through the aid of some useful friends." He offered a range of services—chairmaking, house and sign painting, column turning—and made every effort to be as accommodating as possible. He offered work executed "at short notice," country delivery to a distance of thirty or forty miles, and furniture painting and ornamenting on location to match rooms or to avoid damage during transport. In exchange, he accepted country products, such as "bacon, corn, wheat, flour, whisky or homemade cloth," in lieu of cash. Undoubtedly, some financial difficulties experienced by craftsmen like Brown stemmed from the local importation of northern chairs. Several such dealers advertised in 1819. For example, on

Fig. 8-17 Advertisement of Joel Brown. From the *Star and North-Carolina State Gazette* (Raleigh, N.C.), June 24, 1819. (Photo, Museum of Early Southern Decorative Arts, Winston-Salem, N.C.)

April 15, A. Clark offered a new assortment of fancy and Windsor chairs "of the latest patterns" from New York. There also was fierce competition for customers among local furniture craftsmen. The manufacturing census of 1820 gives an aggregate figure of fourteen cabinetmakers and ten chair manufacturers in Raleigh, and several more were located in surrounding Wake County. The population of Raleigh must have been no more than several thousand in this period, since it reached only 4,780 by 1860.[94]

Despite others' lack of success, Robert Williamson and Samuel Shelton formed a partnership to construct Windsor chairs before January 21, 1819; like other local craftsmen, they advertised for apprentices. The frequency of apprenticeship notices and the short duration of so many local chairmaking businesses suggests that the practice was abused and that the boys were regarded less as learners than as a source of cheap labor. Henry Gormon was bound to Williamson on March 15 to learn chairmaking and seating. The Williamson and Shelton association had a short run. The men went their separate ways, although Williamson continued in the Fayetteville Street shop and even advertised for a journeyman in June 1820. The assignment of his apprentice, Henry Gormon, to Elias Hales on August 19, 1822, may mark the end of his Raleigh career.[95]

A tablet-top chair with a history of descent in the family of Joel Lane, an early Raleigh settler, may be the product of a Raleigh craftsman, particularly one who migrated from or to Petersburg, Virginia (fig. 8-18). A Joel H. Lane was a contemporary Raleigh resident, occupying a house later rented by George Grimes. Joel Brown illustrated a chair of this general pattern in his June 1819 advertisement. Since he appears to have gone to the expense of having the cut made for his own use, he would hardly have selected any but a fashionable chair as a model, thereby giving currency to the tablet-top design in the Raleigh market. Rather than the New York influence suggested in A. Clark's advertisement, Baltimore design strongly dominates this chair. Tablet tops (fig. 4-11), pencil-slim legs, and ball turnings are all reminders of the Baltimore style, which exerted influence over a broad area (figs. 3-155, 3-156). The unusual arms appear to be a local or regional invention. Although the hand grips are hooflike, the effect may be unintentional and merely the result of rounding the tips to lighten their appearance. The turned ball behind each grip is an attempt to coordinate the arms and supports, but the resulting design, while novel, is awkward. The effect is not unlike that of a Massachusetts chair with late eighteenth-century scroll arms modified for use in a square-back chair (fig. 7-57). By tradition, a second tablet-top armchair with similar bowed arms terminating in hooflike grips that lack ball turnings was made for a church in Petersburg, Virginia, about 1831. Continued church ownership of the chair, which retains its original painted biblical decoration, supports the tradition.[96]

Fayetteville, at the head of navigation on the Cape Fear River northwest of Wilmington, was easily accessible from the coast by steamboat. Local chairmaking appears to have been modest. The town's location within fifty miles of the state capital with its vigorous chairmaking community may have discouraged any considerable local trade. Thomas and James Beggs, early artisans, pursued several lines of work during the 1790s. Deeds of 1793–94 refer to them as "carpenters" or "chairmakers," and apprenticeship records dating from the turn of the century mention the occupations of turner and wheelwright. The firm's one known advertisement, of January 2, 1793, enlarges the scope of activity to include the riding chair, an open two-wheeled vehicle built to hold one person. Household furnishings offered in the notice include Windsor chairs, spinning wheels, and bedsteads with short posts. The firm also engaged in repair work. Apparently custom increased sufficiently that further advertising was unnecessary. James still continued the business in 1825 when he took an apprentice to learn chairmaking.[97]

When Thomas McCrosson made Windsor chairs priced at $9 to $18 the set in 1816, he was not a newcomer to the Fayetteville trade. Fellow craftsman Duncan McNeill is identified as a cabinetmaker in records dating from 1812 through 1818. He may have left town for some time, since David Ruth, Jr., upon his arrival in 1822 advertised that he had "taken the Cabinet Shop of Duncan McNeill." McNeill later returned, but in November 1835 he again "contemplated [an] absence . . . from this place for some time." He was

Fig. 8-18 Tablet-top Windsor armchair and detail of arm terminal, area of Raleigh, N.C., 1825–35. Yellow poplar (seat); H. 34¼", (seat) 17⅝", W. 19½", D. 16½". (National Society of the Colonial Dames of America in the State of North Carolina, Joel Lane House, Raleigh, N.C.: Photo, Museum of Early Southern Decorative Arts, Winston-Salem, N.C.)

anxious to dispose of "a quantity of Mahogany and Walnut Furniture" and a variety of chairs "from the most elegant Rush Bottom to [the] common Windsor." Chances are that all the seating was of New York origin. Benjamin W. Branson's New York shop records list an outstanding account at his death for a "Dunkin McKnell." Two bills of chairs "Shiped to Order" to North Carolina involved substantial sums: $135.88 in February 1834, and $194.50 in May 1835. Seating identified specifically includes Windsors, sewing chairs, and Boston rockers. Thus, a full range of New York seating found its way to the North Carolina interior.[98]

Chairmaking continued its westward movement through North Carolina. From the mid 1820s onward, towns ranging from Greensboro southwest to Charlotte and Lincolnton provide evidence, mainly through the medium of advertising, of a rising community of woodworkers. Sometime after dissolving his Raleigh partnership with Robert Williamson in 1819, Samuel E. Shelton moved to Greensboro, where he took an apprentice in 1825 and advertised in 1828. His public notice offered a "beautiful assortment" of Windsors for cash or country produce, and he also undertook repair work. C. H. Dejernatt may have begun his cabinetmaking and chairmaking career at Greensboro in a house opposite Townsend's Hotel in 1838. By autumn 1839 he was in Salisbury, where he switched businesses temporarily to execute "cheap sign painting." He was back working at his old trade a year later at Concord. With a partner named Rainey he opened shop near the courthouse, a center of activity for Cabarrus County.[99]

Chairmaking at Salisbury in Rowan County, the state's geographic center, was more substantial than in Greensboro. John Cooper was introduced to the trade as an apprentice in 1815. By 1823 he and George Grimes from Raleigh were associated in the fancy- and Windsor-chair making business. They went their separate ways before March 1825, when Cooper advertised independently from his shop east of the courthouse. When a district court was in session the area around the courthouse was alive with activity, drawing residents from throughout the region, among them potential customers of seating furniture. Knowing this, Cooper announced that he would "attend" Davidson, Iredell, and Cabarrus courts in the surrounding counties. The chairmaker probably rented a room temporarily in the immediate vicinity of the county buildings, where he displayed and sold his merchandise. Just as Duncan McNeill introduced customers in Fayetteville to New York chairmaking, so John Cooper kept "pace with all the changes of fashion" in chairs and bedsteads imported from Philadelphia.

Cooper probably acquired Philadelphia furniture more as models to copy than as sale merchandise.[100]

Making bedsteads and chairs was the specialty of William R. Hughes at Salisbury in 1830. He stocked Windsor seating "both Gilded and Painted" at his shop near Jones's Tavern. Hughes sought and apparently found "first rate workmen." David Watson, who may have been one of them, became his partner in May 1831 and probably provided the expertise necessary to expand into the cabinet business, since several later advertisements are devoted to that trade. The joint venture may have lasted until May 1832, following which Watson took an apprentice to the cabinet trade. Hughes remained in Salisbury for several years, until William Rowzee took over his location in 1834. At the end of the decade Watson advertised for two journeymen chairmakers and reintroduced Windsor chairs to his furniture line. Rowzee supplemented his cabinet business with chairmaking and for that purpose procured a workman who, he proclaimed, could "take the Shine off any thing in these parts." Woodworking evidently was a hard-sell business. Down the line at Concord, the Cabarrus County seat, George W. Spears began to supply the local area with Windsor chairs and riding vehicles around 1827. When Dejernatt and Rainey opened a cabinet and chair manufactory in town more than a decade later, they introduced coffin work.[101]

Charlotte, the seat of Mecklenburg County in the south-central part of the state and today one of the largest cities in the Carolinas, had a brisk trade in Windsors by the mid 1820s. William Culverhouse, who served a chairmaking apprenticeship in Rowan County, went to Lincolnton following his training and then settled briefly in Charlotte, where he was offering Windsor chairs, settees, and writing chairs by February 1825. In October of the following year he announced he was selling out during the next superior court session. William Cornwell and George Nichols were already in business at Charlotte when Culverhouse arrived. Their cabinetmking and chairmaking partnership continued until spring 1825, when Cornwell announced as an independent cabinetmaker and Nichols formed a partnership with Joseph Pritchard. The Nichols-Pritchard relationship was an intermittent one. The firm advertised Windsor chairs specifically in August 1831.[102]

In 1825 Nathan Brown moved to Charlotte from Lexington, where he had followed the carriage and Windsor-chair making trades. In spring 1831 he figured in the advertisements of two other Charlotte craftsmen. John M. Jarret and Company established a cabinet and Windsor-chair manufactory on the premises of "Mr. Brown" near the courthouse in early May. Two weeks later Henry E. Spencer announced the removal of his "Painting Shop to the Coach-making establishment of Mr. Nathan Brown." By June 8 Brown could state that he had taken over the chairmaking business located on his premises and was prepared to make bedsteads as well. Presumably, the former principals stayed on as workmen.[103]

During his brief career in Lincolnton in 1823–24 before an equally short stay in Charlotte, William Culverhouse joined forces with Windsor-chair maker Martin C. Phifer. The partners supplemented their chairwork with carriage making and sign painting, and after Culverhouse left town Phifer continued alone for a while. Phifer may have been one of eight makers of Windsors and riding chairs in the county listed in the 1820 manufacturing census; six cabinetmakers were also enumerated. Lincolnton, thirty-five miles northwest of Charlotte, was a county seat and as such enjoyed some economic advantage. Following Phifer in the coachmaking and chairmaking business was Samuel Lander, who offered both Windsor and fancy seating in March 1829. Obed Parrish was working in town by January 1833, when he took an apprentice to the Windsor-chair making and painting trades. Parrish had trained in Charlotte with William Culverhouse; thus, he continued the migration cycle when he set up at Lincolnton.[104]

MORAVIAN CHAIRMAKING Well before the period of activity described for the piedmont towns, there was a thriving, highly organized settlement of craftsmen at Salem. The community was the third of three towns laid out in the Wachovia tract, a vast wilderness of about 100,000 acres purchased by the Moravian Church from Lord Granville. The first Moravians arrived in North Carolina in 1753 from the church settlements in Pennsylvania. The agricultural communities of Bethabara and Bethania were developed initially. Clearing and construction began at Salem in the mid 1760s, but the site was not inhabited as a community until 1772, when a group of skilled workers from Bethabara established the core of the craft-oriented "industrial" town. The focal point of the community was the square, with the town's principal buildings on three sides and the main street on the fourth. The church dominated the structured community life and also held all the land. Certain businesses—the mill, tavern, store, tanyard, and pottery—were owned and operated by the church. Independent craftsmen and tradesmen leased the lots on which they erected homes and shops and were free to take apprentices and journeymen from outside the community, but all were subject to community rules. Initially, there were forty-six master craftsmen and ten apprentices practicing various trades. Since development of a sound economy was an overriding consideration, there was strong emphasis on the practical and utilitarian. Given the central European background of most workmen, the arts as practiced in early Salem were strongly traditional. In time influences from other cultures played a part in shaping community products. Trade was necessary to dispose of shop and farm surpluses and to acquire commodities not otherwise available, and by this means local craftsmen were exposed to new stylistic impulses, which then reappeared in their own work.[105]

Moravian records document the use of Windsor furniture in Salem and suggest that local production took place even before it was specifically identified. The earliest reference to Windsor furniture in the community is found in an inventory of the Salem Tavern taken in 1789, the third such enumeration in a continuing series; the seating comprised forty "woven-bottomed" and six "green" chairs. The former were either common slat-back seats or else turned and framed walnut vase-back chairs, with an unusual central European splint seat woven around lists raised above the seat rails. Some of the latter survive today. The green chairs were Windsors, although they were not listed as such until 1803, when there were nine. The previous year nine "green" chairs were enumerated.[106]

By 1791 twelve green chairs were itemized in an inventory of the Gemein Haus, or congregational house, apparently for use in the Saal, or meeting hall, located in the building. A furnishing list of 1802 for Charles G. Reichel, minister of the Salem congregation from 1802 to 1811, contains the items "10 grüne Stühle" and "1 D[itt]o arm Stuhl." In translation these are "green chairs," or Windsors. Reichel probably occupied several rooms in the Gemein Haus as living quarters. When he departed Salem in 1811 he left behind "1 green armchair." Records dating two years later show that a community-owned dwelling occupied by minister-musician Jacob van Vleck contained a quantity of seating furniture, including sixteen Windsor side chairs and an armchair, and two walnut framed chairs with wooden seats. No early Windsor furniture has as yet been associated with a particular craftsman.[107]

Later Windsor work is identified in part with the cabinetmaker Karsten Petersen, who arrived in Salem in 1806 and then practiced woodworking at a Moravian mission in Georgia until 1813, when he returned to Salem. His name appears several times in community records. On October 18, 1813, it was noted that he planned to set up a turning lathe; four months later he rented his craft tools from a store of community-owned implements. On April 19, 1815, there is mention of "Br[other] Petersen's turner shop." By 1819 this man definitely was associated in Moravian records with Windsor-chair making, since the rooms in the Gemein Haus occupied that year by Christian Frederick Schaaf, associate minister, contained a dozen Windsor chairs "made by Petersen." A community cash book records that Petersen obtained raw materials for chairs under the date April 30, 1819, probably from one of the Moravian sawmills. The same day a tavern inventory

Fig. 8-19 Fan-back Windsor side chair (one of a group), Gemein Diacony (brand "GD" signifying Moravian Church ownership), Salem (Winston-Salem), N.C., ca. 1787–1805. Yellow poplar (seat) with maple and hickory; H. 34″, (seat) 17⅛″, W. 16⅛″. (Old Salem, Inc., Winston-Salem, N.C.: Photo, Museum of Early Southern Decorative Arts, Winston-Salem, N.C.)

Fig. 8-20 Slat-back Windsor side chair (one of six), Gemein Diacony (brand "GD" signifying Moravian Church ownership), Salem (Winston-Salem), N.C., ca. 1818–35. Yellow poplar (seat) with maple and hickory; H. 34″, (seat) 17″. (Old Salem, Inc., Winston-Salem, N.C.: Photo, Museum of Early Southern Decorative Arts, Winston-Salem, N.C.)

lists fifty "common" chairs, "66 new chairs by Petersen," and twenty-two Windsors. An enumeration dating three years later further identifies the "new chairs" as "66 Windsor chairs of Petersen's." The other Windsors were older chairs that had seen varying periods of service. Additional inventories of the early 1820s list ten green side chairs and two armchairs as community store property. Furnishings in Brother and Sister Andrew Benade's rooms at the start of his ministry in 1822 included sixteen green side chairs and two armchairs, none identified by maker. Petersen and a man named Siewers were named in 1839 as the makers of unidentified chairs at the tavern. John Daniel Siewers probably had just completed an apprenticeship as a Salem furniture maker, to which trade he was bound in 1832 at age fourteen.[108]

Windsors of several patterns surviving in Salem today bear community identification in the form of a brand or a local history of Moravian ownership. In part, the seating demonstrates the impact of outside influences beginning in the late eighteenth century. There is little that identifies most chairs as distinctly Moravian. One group of fan-back Windsors has long, slender baluster turnings (fig. **8-19**). The chairs generally follow Philadelphia design, but there is little specific influence from that source or from rural Pennsylvania, with one or two exceptions, although interaction between North Carolina and Pennsylvania Moravians was commonplace, and the southern communities were settled from the northern colony. Slim leg balusters terminated at the top by a tiny bulbous element surely recall early Philadelphia work, such as that executed by Thomas Gilpin (fig. 3-4), and the blunt, canted seat front could reflect a pattern such as that found in figure 3-20. Otherwise, the design is more suggestive of New England work, although it probably represents the independent development of a personal style by a local craftsman responding to influences from various sources. Perhaps, as John Bivins suggests, this was the pattern of the dozen green chairs in use at the Gemein Haus in 1791. The brand "GD" on the plank bottom reinforces the theory, since the letters are an abbreviation of the words *Gemein Diacony* and identify congregational property. Similar chairs could have furnished parts of the tavern a few years earlier. Bow-back Windsor side chairs were contemporary.[109]

A group of slat-back Windsor side chairs dating around 1820 bears the identifying congregational brand (fig. **8-20**). This pattern is distinctly influenced by Delaware Valley chairmaking (figs. 3-132, 3-133) and draws from the same sources as contemporary

work in Virginia, such as that executed by Seaton and Matthews (fig. 8-11) and Samuel Fizer (fig. 8-12). Among Windsors of this type, the Moravian chairs are more sophisticated than those of neighboring chairmakers. Following closely a rural Pennsylvania-Baltimore pattern, the seat edges are deeply rounded and then abruptly terminated near the plank base. A similar seat is found in a chair made by Jacob Fetter III of Lancaster, Pennsylvania (fig. 3-154). The stout bamboo legs of Fetter's chair also have much in common with the work shown here. A subtle touch is the wafer-thin disk that caps each back post; the feature occurs in some Pennsylvania work (figs. 3-121, 3-128). The slat-back Windsors date from about the time when Karsten Petersen was constructing Windsors for community use, but for the present there is no way to link them with his shop.[110]

Charleston, South Carolina

Evidence of the Windsor in late eighteenth-century South Carolina centers in Charleston. At that time, Charleston was a city of about 15,000 inhabitants, 1,500 houses, and a commodious harbor that accommodated ships of up to 200 tons. Its peninsular location at the confluence of the Ashley and Cooper rivers provided good access to the back country and enabled the city to control the trading market in imported and local goods throughout most of the state as well as in parts of North Carolina. As a result, Charleston ranked fourth among American commerical centers. The city plan was regular, the straight streets were airy thanks to ocean and river breezes, and many of the houses were large and handsome. Because the climate was hot, construction took every advantage of cross-ventilation, and galleries sheltered upper stories from the direct sun. Many dwellings had "office houses" and small gardens at the back. Notable families who lived on surrounding plantations generally had town residences as well. J. F. D. Smyth commented during the 1760s that the planters and merchants were rich and well bred, with many fortunes acquired through trade; he found more luxury in Charleston than elsewhere. But the town had drawbacks, too: It suffered several disastrous fires, and its low elevation subjected it to periodic flooding from high tides. A lack of available stone prevented street paving. As a result, the sandy surfaces were hot in summer, sending heat and dust into the houses.[111]

The earliest recorded use of Windsor seating in Charleston dates to the 1730s, when John Lloyd, Esq., owned what appraisers described as "3 Open Windsor [Chairs]" valued at £1 apiece. Lloyd appears to have been both a lawyer and a planter, judging by the titles in his library, his agricultural implements, and the large number of slaves. Other inventory items suggest that Lloyd had acquired many furnishings, including the Windsors, from England. Another early Windsor reference follows in 1745, when a chair in the front garret room of the James Mathewes residence was valued at £1.5.0.[112]

"Common" chairs were available locally. At his plantation on "John's-Island," Solomon Legare offered black, white, low, and children's chairs—probably rush-bottomed seating made by skilled blacks. Raw materials and supplementary seating entered the port occasionally from Philadelphia and probably from other northern ports as well. The brig *Charles Town Packet* arrived with "24 rush chairs" from the Delaware River in 1763, and as late as 1767 two ships from Philadelphia carried between them 500 bushels of "matt," or rushing, for chair seats. Although London-trained Thomas Elfe was pursuing the cabinetmaking business in Charleston by midcentury, newspaper notices and other records make clear that there remained a substantial city market for imported seating. When two men named Da Costa and Farr offered goods from the cargo of the "Prince of Orange . . . from London" in January 1759, they itemized "mahogany, walnut, and Windsor chairs, [and] neat Italian dining chairs." The firm received more Windsors from London in the spring. Philadelphia merchants and chairmakers were offering their popular new seating piece in the southern city by 1761. The brigantine *Hannah* and another vessel from the Delaware River arrived in June of that year with "neat Windsor chairs" for sale by local storekeepers. Through the 1760s the trade escalated. An occasional vessel, such as the sloop *Henry* (1762) or the brig *Harietta* (1766), carried 150 or more chairs in a single cargo. Local retailers also offered

other Windsor forms, including two-seated settees and children's furniture. A highly descriptive advertisement of the Sheed and White firm, dating to June 1766, details the range of Windsor patterns in American production as high, low, and sack-back chairs; there were also special Windsors constructed of walnut (fig. 3-9). English Windsor seating still arrived occasionally during the 1760s. Storekeeper Walter Mansell offered a quantity of "neat green Windsor chairs" from London in 1764, and three years later Mansell, Corbitt and Company imported "green Windsor chairs and stools" from the same place.[113]

John Biggard arrived from Philadelphia in 1767 and opened a "TURNER'S SHOP, on the Bay, the corner of Queen-street" where he was prepared to supply gentlemen with "Windsor and Garden Chairs, Walking-sticks, and many other kinds of Turnery ware, as neatly finished, and cheaper than can be imported." However, the competition from imported seating may have proven overwhelming, since nothing more is heard of Biggard. Turner Joshua Eden may have fared better. He was about thirty-six years of age in 1767, when he first advertised his turned work—banisters, bedposts, table frames, and straw-bottom chairs. In 1775 he also offered "some extraordinary good Spinning-Wheels."[114]

Philadelphia Windsor chairs continued to arrive at Charleston during the 1770s. The low-back pattern had already passed out of fashion, since notices speak only of high-back and, more frequently, "round top" chairs. The latter term was new, replacing *sack-back* in use. Green was still the common color. Probate records indicate how popular Windsor seating had become in and around Charleston. Among a group of eighty-four inventories from 1774, eighteen list Windsor furniture by name or by some other recognizable term. When tallied, sixty-five Windsor chairs and twenty-three "green" chairs emerge from the records, and at least two settees, or "double chairs," are recorded. The seating appears to have been well dispersed throughout the district. For the most part the owners were individuals of some means, judging by their occupations, which included "planters" (or plantation owners), doctors, an attorney, an architect, several "gentlemen," and the "surveyor general" of South Carolina, one Moses Lindo. A widow, a schoolmaster, and a minister complete the list. A newspaper notice of four years later describes "a large Windsor chair" among items "lost during the late fire" by one Elizabeth Wood."[115]

A New England businessman visiting Charleston in 1785 was visibly impressed with postwar trading conditions. On March 12 Benjamin Greene wrote to his brother-in-law Stephen Salisbury of Worcester, Massachusetts, saying, "You cannot conceive of the Vast quantities of Goods, that centers in this City." He further suggested, "I will endeavor to inclose a return from the Custom house of the Goods exported from the City in 1784 and it will be much larger this Year." Greene's observations are amply borne out in contemporary shipping records. Harrold E. Gillingham's compilation of furniture cargoes outward bound from Philadelphia between June 1783 and August 1786 records more than 2,100 "chairs" exported to Charleston; supplementary records describe still other seating cargoes. Many chairs are identified as Windsors, but even when unspecified, the vast number in some shipments (as many as eleven or twelve dozen) clearly confirms the type. The dates are still too early for the fancy chair, and there was already a local production of common rush-bottomed seating.[116]

Andrew Redmond tried his luck as a turner and chairmaker in the southern city about this time. An advertisement of October 14, 1783, describes his "Philadelphia Windsor Chairs . . . both armed and unarmed, as neat as any imported, and much better stuff." The seating likely could pass as the northern product. The notice was repeated the following January. Redmond appears to have been in the Charleston area as early as 1774, when he worked upon occasion for cabinetmaker Thomas Elfe. The craftman's will was probated on February 1, 1791. There seems little doubt that Andrew Redmond was the same individual identified as a runaway "Irish SERVANT" in September 1771 by the ironmaster at Legh Furnace in Frederick County, Maryland. The notice describes Redmond as about thirty years old, of dark complexion, and 5 foot, 10 or 11 inches

tall. The master further noted that Redmond was "by trade a turner and spinning wheel maker."[117]

Redmond would have been in the Charleston area when the city celebrated state ratification of the national Constitution with a "Federal Procession" in late May 1788. He may even have been among the estimated 2,800 participants. Preceded by a band of music and a battalion of artillery, the "Gentlemen Planters" led the march. Not far behind were other "symbols" of South Carolina's wealth in the persons of the "Inspectors of Rice, Indigo and Tobacco, with a hogshead of Tobacco, drawn by horses." A large group of craftsmen followed. Representing the furniture trades were the cabinetmakers, wheelwrights, and turners. Significantly, there was no separate group of chairmakers.[118]

The late 1780s are marked by the same brisk activity in the Windsor market that prevailed earlier in the decade. As the English Windsor faded from view, a new rival challenged Philadelphia's monopoly. Several times in 1789 vessels arrived from New York laden with Windsor chairs. Philadelphia craftsmen met the competition in part by supplementing the popular green color with painted finishes of yellow and mahogany. Harrold Gillingham's compilation for the eight months from August 1789 to March 1790 records the shipment of 617 chairs from Philadelphia to Charleston. Responsible for more than half the number was a single chairmaker, Francis Trumble, who sent his seating to consignees John Minnick and James Raggee (Raguet?) in several cargoes. It was Minnick who advertised the colorful chair selection in 1789.[119]

Minnick advertised similar merchandise during the early 1790s. "Chocolate" color supplemented the available finishes. "Dining," or bow-back, side chairs are mentioned as early as 1792. A reference in the same year to both mahogany and yellow-colored "bamboo" chairs describes the same kind of seating. Green Windsors in the same cargo had either sack or fan backs. In addition to Trumble, at least two other Philadelphia chairmakers dealt directly with Charleston retailers. Michael Murphy, Jr., sent Windsors to John Drummond aboard the *Maria* in July 1797, and Lawrence Allwine shipped seventy-two chairs to another retailer the same year. New York shippers and craftsmen were also active; records name the chairmaking firms of Thomas and William Ash and John Sprosen. Between 1789 and 1794 these two shops were responsible for shipping almost 1,200 chairs *of record* to the southern port. Other New York cargoes account for almost 2,300 chairs from 1792 to 1801.[120]

There is somewhat more local activity recorded for this period than earlier. James Norris started as a painter around 1794. After the turn of the century he concentrated on Windsor-chair making and turning; he died young in 1806. Meanwhile, Jay Humeston and Theodore Stafford pooled their talents and resources to open a chairmaking shop in November 1798. They also repaired and repainted chairs "in style and with dispatch." Anticipating good custom, the men advertised for journeymen and apprentices. However, the partners had gone their separate ways little more than a year later when Humeston advertised alone at Savannah. He returned to Charleston briefly about 1802–3 before leaving for Halifax, Nova Scotia. Stafford departed for parts unknown.[121]

Two Philadelphia craftsmen came to Charleston during the 1790s. Francis De L'Orme (also John Francis Delorme), an upholsterer "from Paris," was in Philadelphia in 1790, at which time he supplemented his regular work by stuffing the seats of Windsor chairs and settees. Perhaps he continued this activity when he removed to Charleston in 1791, where he enjoyed a long and prosperous career. William Cocks, on the other hand, stayed only briefly. The cabinetmaker came to Charleston in the summer of 1798 apparently to sell a cargo of venture furniture that comprised in part "Windsor Chairs of all colours." Cocks does not appear to have been a chairmaker.[122]

When William Thompson married a Philadelphia woman at Charleston on December 20, 1799, he may have worked as a journeyman. Shortly after his wife's death the following October, he announced his Windsor-chair making business. To supplement his new chair production and repair work, Thompson kept a constant supply of "northern made chairs of the neatest and best kind." His move to sell imported chairs along with his own speaks of the local esteem for imported Windsors. Thompson's name

turns up in local directories through 1806. Also listed as a chairmaker in 1802 is David Moon, a Philadelphian who appears to have divided his time between the two cities for several years. When the schooner *Hero* left Philadelphia on October 26, 1801, part of its cargo consisted of "Eighty five Chairs, a quantity of Chair Bottoms, & Sundry Baggage" shipped by and consigned to David Moon. Clearly, the chairmaker was on board with his baggage. The Windsors may have been framed rather than in pieces, but they probably were not painted. The chairs provided Moon's starter stock as he set about constructing more seating. During the next year or so Moon acquired a Philadelphia partner, chairmaker Joseph Burr, who on May 19, 1803, shipped six cases of chairs and "a Quantity of Chair Backs" to Moon on the schooner *Dispatch*. Moon probably returned north not long afterward, where he and Burr together consigned chair parts, probably for temporary warehousing, to one William Cotton of Charleston; the cargo left Philadelphia on August 3 on the brig *Charleston*. Moon already had plans to return south; another shipment followed in early October, when the brig *Assistance* carried "Sixty winsor Chairs" from Burr and Moon to Cotton. Acting independently, a month and a half later Moon shipped and consigned to himself "10 Doz Windsor Chairs in Bulk." He may have left Philadelphia on November 26, when the sloop *Ruby* sailed with the furniture. The partnership appears to have been over at this point, although Burr made several additional chair consignments directly to Cotton in Charleston.[123]

By the start of the new year Moon had formed a connection with Edward Prall, who shipped six dozen chairs to Charleston on January 4, 1804. After receiving the chairs Moon again wound up his immediate business in the South and left, having made arrangements with Cotton to handle further chair consignments. Between February 25 and August 28 Moon and Prall made six shipments of record to Cotton for a total of 689 chairs, two jugs of varnish, and unspecified materials contained within one barrel, one box, and two packages. Other consignments probably were made before and after the last recorded cargo of eleven and a half dozen chairs left the Delaware River in early April 1805 on the schooner *Sally*. But Moon's time was running out. He was buried at age twenty-seven on October 1, possibly a victim of the yellow fever epidemic in Philadelphia.[124]

While the Moon connection flourished in Charleston, other consignees received and sold chairs shipped by Philadelphia chairmakers, of whom at least six were active before 1810. Exports included both fancy and Windsor chairs. This small group was responsible for shipping more than 3,550 chairs to Charleston in the seven-year period from 1805 to 1811. Middlemen handled many other consignments. Charleston newspaper notices provide some insight on the appearance and range of the seating. There were surfaces to suit every taste and pocketbook—plain, gilt, and ornamented (the combination of black and gold was particularly fashionable). Augmenting standard seating were rockers and "ladies low Work Chairs." Settees could be purchased to match, and children's furniture and counting-house stools were always available. The tremendous potential of the Charleston market is illustrated in the single cargo of forty-two dozen Windsor chairs that arrived on the schooner *Industry* in June 1809. Supplementing Philadelphia imports were consignments from New York factors, who demonstrated a renewed interest in the Charleston market. A cargo of six dozen Windsors on the schooner *Lively* sailing from Marblehead in March 1806 probably represents Boston- or Salem-made seating, since there is little evidence of substantial chairmaking elsewhere on the North Shore. Even seating not destined originally for the Charleston market found an occasional sale there. On September 24, 1806, part of the *Thomas Chalkley*'s cargo, consisting of eighteen dozen green and cane-colored Windsor chairs, four settees, and "A Quantity of Mahogany Furniture," was offered at public auction. The ship had put into Charleston in distress on her passage from Philadelphia to St. Thomas.[125]

By the early nineteenth century, Charleston had about 24,000 inhabitants. John Melish's observations on general mercantile activity in 1806 were equally applicable to the Windsor trade: "There are few manufactures at Charleston, but there is a very active

commerce, particularly in the winter season; and vast quantities of shipping are constantly arriving and departing." Outside Charleston there is a contemporary chairmaking record for Joseph H. Hoell, who combined the Windsor- and riding-chair businesses at his inland shop in Camden, the seat of Kershaw County.[126]

Charleston seating importations remained about the same in the 1810s. New York sent some cargoes, but Philadelphia still dominated the scene. Five of the six chairmakers responsible for supplying a major portion of the chair market a few years earlier were still active. Imports escalated as two newcomers joined the group. One of them was William Lee. In a single year, 1816, Lee is known to have shipped no fewer than 1,410 chairs to Charleston. Some of his Windsors probably were made to the pattern illustrated in figure 3-127. A Charleston retailer, Joseph Page, improved his competitive advantage in October 1812 by hiring a Philadelphia chairmaker on site to construct forty-two dozen Windsor chairs "of a superior quality" in "fancy colours," thus saving freight charges. At a later date another retailer added writing chairs to the list of available forms. One local painter offered customers "Chairs colored and ornamented in any manner they please."[127]

Most imported chairs sold at retail and wholesale in Charleston appear to have been disposed of directly from shipboard, at auctions or warehouses, or in rooms rented on a temporary basis to sell specific cargoes. In 1822 or earlier G. C. Harriott established a "Fancy and Windsor Chair Store" where he retailed a large assortment of new chairs, sold copal and japan varnish, and refurbished old chairs. Now and again a local craftsman sought to stem the overwhelming tide of furniture importation. Cabinetmaker John J. Sheridan emphasized Charleston-made furniture and in 1825 encouraged householders to buy local products. During the 1830s he offered Windsor and "easy" (probably rocking) chairs along with cabinet furniture. However, Philadelphia furniture exportations to Charleston continued strong.[128]

GEORGIA

The Windsor-chair trade in Georgia centered primarily in Savannah. The town was the principal regional center when Windsors were first imported in the mid 1760s. Laid out in the midst of a forest on a bluff above the Savannah River, the community stood about fifteen miles from the river's mouth. Swampy tideland suitable for rice cultivation lay on both sides of the waterway. Regional exports included rice, indigo, naval stores and timber, and deerskins. Navigation was possible on the Savannah for 300 miles upriver to the town of Augusta. In the late 1780s, after the capital had been established at Milledgeville and the British occupation of the war years had ended, the town population was still less than 1,000. However, there was considerable growth during the next twenty years. Counting slaves and free persons of color, the population reached about 6,000, and the regional economy was about to be dominated by cotton. At his visit in 1808 John Lambert found a community of wide streets and spacious squares. Many houses were separated by courtyards. Bay Street, the principal thoroughfare, stood opposite a tree-lined mall. Below it along the shore, forming a "lower town," stood the "merchant's stores, warehouses, and wharfs for landing, housing, and shipping of goods."[129]

The earliest reference to Windsor furniture in Savannah is found in an advertisement of James Muter, captain of the local first troop of horse militia. His public notice of September 8, 1763, announced: "To be sold for cash, NEAT WINDSOR CHAIRS at 10s. or 12s. when painted, a chair." The announcement's brevity makes it impossible to know whether Muter was the chairmaker or whether he had obtained the seating in the import trade. Evidence of importation comes with the arrival of the schooner *Fanny* from Charleston on October 11, 1766, with a cargo of fourteen Windsor chairs likely made in Philadelphia, and the earlier arrival in June of thirty Windsor chairs in the schooner *Ogeeche(e)* direct from Philadelphia. The rapid increase in Savannah's shipping after the

1 inch = 155.6 miles

Gulf of Mexico

first wharf was constructed in 1759 is demonstrated by comparing records: 41 vessels entered the river the year after the facility opened, and by the mid 1760s 171 sailing craft were recorded during a similar period.[130]

Interest in imported seating in Savannah was renewed in the postrevolutionary years. Importations from Philadelphia were substantial. Between June 1783 and July 1786, 640 chairs, some identified specifically as Windsors, left the Delaware River for the southern port. One cargo on board the *Commerce*, which sailed June 11, 1783, was shipped directly by Richard Mason, who was well known in Philadelphia as a manufacturer of fire engines and Windsor seating. "Transient Duties" paid in June 1784 to the State of Georgia by Crookshanks and Speirs, Savannah merchants, for merchandise apparently destined for local sale included charges for 102 Windsor chairs. The firm's advertisement of October 21 lists many items found on the duty list, including the Windsor chairs, "Biscuit in kegs," and "Philadelphia Beef." The following January the partners advertised "green chairs." Other local businesses merchandised New York seating. For example, in May 1786, Thomas Cumming and Company advertised Windsor chairs and settees newly arrived on the brig *Rockahock* from the Hudson River.[131]

There is record of the local sale of imported Windsors on January 17, 1792, when William Maxwell, a general merchant, purchased two chairs from Henry Sadler. At 2s. apiece the seating was acquired at cost or less and probably was unassembled as well as unpainted. Windsors arrived in sufficient quantity that local merchants were able to transship some to other markets, including Demerara (British Guiana), St. Augustine (the Floridas), and Sunbury (Georgia). Local shippers also loaded merchantmen with cane reed, another important product in the furniture trade. Southern-owned vessels transported this commodity over a large geographic area, including the ports of Bordeaux, France; Liverpool and Lancaster, England; Newport and Providence, Rhode Island; New York City; and Philadelphia. Individual shipments varied from 3,000 to 30,000 poles. The source of the product is identified as the Malay Peninsula in one

record: "45 Bundles Malacca Canes." There is no indication whether local merchants acquired the merchandise directly from the Far East or through another source.[132]

During the 1790s and later southern imports of painted seating reached unprecedented levels. New York shippers often sent chairs in lots of 100 or more units. Like many Philadelphia chairmakers, Thomas and William Ash sometimes shipped work on their own account; they consigned fifty Windsors to the ship *Jenny*'s captain in February 1794. A visitor to the New York, Philadelphia, Savannah, or other southern waterfronts in this period would have seen chairs piled in every direction. In what at best are scattered records for the 1790s through 1806, documents account for 2,200 chairs, both Windsor and fancy rush-bottom styles, entering Savannah from Philadelphia, and seven Philadelphia chairmakers are specifically identified with the trade. In 1803–4 shipments of twenty and twenty-six dozen chairs are listed for James Whitaker and John Wall, respectively. Some documents distinguish between side chairs and armchairs, and in one case the finish is described. William Mitchell's shipment on the schooner *John and Ely* in November 1801 contained a dozen each of yellow, black, and green Windsor side chairs, the first two groups complemented by pairs of armchairs.[133]

Imported cabinetware from London and the eastern seaboard was as important a business at Savannah as painted seating. Arrivals are recorded by the 1760s, and following a community fire in 1796 activity increased. Several prominent northern craftsmen are associated with the trade. Joseph Meeks of New York accompanied his "handsome assortment of elegant Mahogany Furniture" to Savannah in March 1798 and personally sold the merchandise on Morel's Wharf. He was followed in October by Joseph B. Barry of Philadelphia, who arrived with a cargo ranging from bookcase desks to wine coolers. Barry had come in part to escape one of many yellow fever epidemics that raged through Philadelphia in the late eighteenth century. About 1800 a new face appeared in Savannah. John Hewitt, later a cabinetmaker of New York, tried his hand at merchandising and cabinetwork in the South for several years. A series of letters from Hewitt to Matthias Bruen of Newark and New York, his principal supplier of cabinetware and goods, describes business after the turn of the century as generally dull and money as scarce. A few items sold reasonably well, particularly dining tables and mahogany bedsteads. Hewitt requested mahogany boards to make coffins, veneers for general furniture repair, and sideboard tops to replace some that had cracked on a passage from New York. In 1800 as he had prepared to head south Hewitt had purchased chairs on credit from David Alling, but upon his arrival at Savannah he found the Newark-made seating was "finished in a shamefull manner," lacking a coat of varnish. For his part, Alling, whom Hewitt called "that fearful man," was inordinately concerned about being paid. By March 1802, Hewitt found it necessary to diversify further. As he explained to middleman Bruen, "I cannot Continue in the same way with you, for this reason Meeks can under sell me, because they make their furniture." Later that year Hewitt formed a partnership with Benjamin Ainsley of Savannah, a relationship that continued until 1806. In the meantime, the craftsman returned to New York to continue as a cabinetmaker in Water Street.[134]

References to Windsor furniture are found in Savannah estates probated after the revolutionary war, a period when it is possible to identify local chairmaking activity as well. Nathaniel Brown, who is said to have migrated from Philadelphia about 1777, appears to have enjoyed reasonable success; he was still an active Windsor-chair maker at his death in 1803. The shop contained "a lot of chair bottoms, bows, etc." sufficient to make about 125 chairs. There were also finishing supplies—paint, oil, varnish, and brushes—in addition to the craftsman's tools. Competition from imported seating remained keen. Moses Nichols advertised in November 1800: "WINDSOR CHAIRS of the newest fashion, different from what has ever been offered for sale, in this city." The wording suggests these were single-bow, square-back chairs (fig. 3-114). The next year Dennis and Williams advertised a large assortment of Philadelphia Windsors; chairs sold by G. and F. Penny in 1808 were imported from New York. For a decade or more

beginning in 1801 Silas Cooper specialized in painting and ornamenting chairs in an "elegant" style, some gilt; he also executed custom work. The painter left the state temporarily about August 1811 but had "returned from the north" by November 9, when he again offered fashionable seating "finished on the spot," so as to avoid paint loss during water transport. Cooper gave no indication of the source of his stock, but he may have undertaken the northern trip to establish contact with a suitable supplier of unpainted chairs. A probate inventory of 1813 sheds additional light on the trade. Mrs. Jane Villepontoux, who died that year, owned half a dozen "yew chairs," probably Windsors of English origin. She may have ordered the chairs directly or acquired them after they entered the Savannah market as venture cargo.[135]

Chairmaking in other parts of Georgia may have commenced only after 1810. About 1811 John Furlow secured the contract to construct Windsor chairs for the chambers of the senate and house of representatives in the new statehouse at Milledgeville. He filled two large orders and was paid for the second in 1812. At Augusta John Pew advertised the following year for an apprentice to the fancy- and Windsor-chair making trade. He found young Charles Martin Gray in neighboring Edgefield County, South Carolina. Pew may be the same man listed in Jackson County, northwest of Athens, in the 1820 manufacturing census. Enoch Floyd also worked in Jackson County. He sold "chairs to set in" at $9 per dozen.[136]

Other names in the 1820 compilation extend the craft throughout the eastern central region. Considerable recorded activity centered at local seats of government. Around Athens, Thomas Mehathy manufactured spinning wheels in Gwinnett County, two chairmakers worked in Morgan County, and Henry W. Wilcox made Windsor chairs at Lexington, Oglethorpe County, to the value of $600 annually. Located across the center of the state in towns east and west of Milledgeville were several more craftsmen. Benjamin Merrett made spinning wheels and chairs in Jones County from a stock of ash, hickory, and red oak; chairs and spinning wheels were produced in Washington County; and three men practiced turnery at Waynesboro, Burke County. With the assistance of three men and three boys, Jesse Dimond manufactured chairs and bedsteads in Richmond County (probably at Augusta) and grossed $1,600 a year. Both Dimond and Enoch Floyd of Jackson County commented that business was very good in spite of the recession that gripped most of the nation.[137]

Right up to midcentury, local craftsmen had to contend with a tremendous influx of imported seating. The competition did not come solely from Philadelphia and New York. The eastern Connecticut records of the Tracy family (see chapter 7) describe their participation in the export trade from the late eighteenth century through the early 1820s. One of their identified markets was Georgia; in fact, Frederick Tracy, youngest son of Ebenezer Tracy, Sr., died in Milledgeville, Georgia, in 1821. A square-back side chair with a single-rod top (probably replaced), illustrated in an exhibition catalogue of Georgia furniture, probably is a Tracy chair (or a near copy), dating to the early years of the nineteenth century. Found at Eatonton, about thirty-five miles from Milledgeville, the turnings and plank are typical of eastern Connecticut work (figs. 6-105 [medial stretcher], 6-114, right [turnings], 7-5).[138]

THE GULF COAST

New Orleans

Before its acquisition by the United States in 1803 as part of the Louisiana Purchase, New Orleans had been both a French and a Spanish possession, so it is not surprising that the city wore an "old Continental aspect." Built in a semicircle, or crescent, fronting the Mississippi River, the city had a street plan in the form of a regular grid. A levee, or embankment, extended many miles above and below the city to protect the low-lying community from the "huge and turbid river." Since the swiftness of the watercourse precluded the erection of wharves, ships tied up along the levee, sometimes three deep. In 1817 Samuel Brown found the levee "crowded with vessels from every part of the

world; and with boats from a thousand different places in the 'upper country.'" The population of New Orleans at its acquisition in 1803 was 8,000; in less than a decade it had doubled.[139]

New Orleans commerce underwent a dramatic change when the city passed from French to American hands. Business went from being controlled by a few powerful interests to being open to many aspirants. After several years, however, the market settled down to its natural level. Trade continued to blossom after the War of 1812, when 300 to 400 seagoing vessels entered port annually. The leading regional commodities were cotton and sugar, but equally important were the products of the western states and territories drained by the Mississippi. Foodstuffs, pelts and hides, tobacco, whiskey, and dozens of other items were floated down the Mississippi in vast quantities. The *Western Gazetteer* reported that 594 flat-bottom boats and 300 barges had arrived at New Orleans in 1816 and commented, "The receipts of this city from the upper country is beyond conception." Within a few years steamboats also carried processed goods in the opposite direction. New Orleans was a boom town, with public facilities and amusements open seven days a week.[140]

During a visit to New Orleans in 1801, John Pintard of New York found house furnishings "very plain" but noted that "American manufactured Chairs and tea tables [are] getting into vogue." A mere fifteen years later Henry Fearon could remark, "The general style of living is luxurious." There is little documented record of chairmaking in New Orleans during the early nineteenth century. The city directory of 1811 lists Peter Ructiarra as a turner and Windsor-chair maker. Thomas Magarey sold cabinet furniture in 1819, which he supplemented with "Chairs painted and ornamented." W. R. Carnes, a dealer in furniture, chairs, looking glasses, and bedding, sold a rocking chair for $3 in 1839. Most of the painted seating sold in New Orleans was imported. Pre-Purchase shipping records document some American export interest in the gulf port. For example, a cargo of mahogany cabinetware left Philadelphia in December 1794 with New Orleans as its destination. A ship carrying nineteen chairs of unknown type sailed from New York for the city in October 1796; twenty-four chairs and two settees with plank or rush bottoms were shipped two years later. Meanwhile, two dozen chairs valued at $40 had left Baltimore on August 11, 1797, for New Orleans. Two shipments of armchairs and settees valued at $3 and $10 apiece followed in 1798. New York and Baltimore appear to have jumped the gun on Philadelphia as far as the New Orleans market was concerned.[141]

The first recorded shipment of Philadelphia Windsor seating to New Orleans dates from November 26, 1799, when the brig *Amazon* carried twelve dozen chairs valued at $1.92 apiece into the southern waters. Similar cargoes followed during the next two years: nine dozen chairs in December 1799 (at $1.66 apiece); ten dozen on April 25, 1801 ($1.33 apiece); eight dozen on June 19, 1801. Entrepreneurs at Salem, Massachusetts, shipped a large cargo of mahogany furniture to New Orleans in October 1799 and repeated the venture four months later. The manifest of furniture shipped on February 1, 1800, details merchandise worth more than $8,000 and identifies the shippers by initials in the margin. Sixteen Windsor chairs, four with arms, were part of a consignment consisting of "Circular Bureaus," "Swell'd Desks," and other items whose shipping cases bore the initials "IA," probably identifying Josiah Austin. The craftsman valued the side chairs at $1 each and the armchairs at $3 apiece. Boston records show the exportation of sixty dozen chairs of unknown type to New Orleans on January 23, 1801; the shipper valued them at a little more than $23 per dozen. Two shipments from New York in September and October 1801 totaled fifteen dozen chairs. The assimilation of Windsor furniture into New Orleans life in the 1790s is illustrated in a portrait of Doctor Joseph Montegut and family, who enjoy a musical interlude in their home (fig. **8-21**). The artist has suggested baluster turnings through the use of a bulbous element at the leg and post tops, although he has taken some license in introducing box stretchers to the fan-back seating. No doubt fancy chairs with similar braces were known in the city. Since the doctor as well as the young pianist sit on Windsor chairs, it may be presumed that the doctor's wife, seated next to him, her aunt, and the eldest daughter are likewise

accommodated. The little girl at the left of the piano is thought to have been born about 1790–91.[142]

Chair shipments from Philadelphia to New Orleans had escalated by 1804, and Philadelphia soon came to dominate the market as it did at Charleston and Savannah. Records for that year, which appear reasonably complete, identify 1,608 "chairs" and "Windsor chairs" exported from the Delaware River to the gulf, accompanied by 19 settees and 12 rush-bottom chairs identified by name. In all, six Philadelphia chairmakers and various middlemen participated. Three chairmakers and one merchant house were responsible for a furniture venture on the brig *Eliza*, which sailed in July 1804. Through 1807 annual shipments continued at a brisk pace, with another chairmaker joining the roster of craft entrepreneurs. One shipment made by Joseph Burden on the brig *Union* in December 1805 is itemized:

> 5 dozen yellow oval Back Chairs
> 2 dozen Black double bow Chairs
> 1 doz & four Bamboo Chairs
> 1 dozen Bamboo Chairs
> 2 dz Green Oval back Chairs
> 2 doz & Six Black oval back Chairs
> 2 dz Cane coloured double bow Chairs

Shipments were thin during the war years, since businessmen preferred to concentrate on markets closer to home, particularly that at Charleston. Exportation resumed by the 1820s and continued into the 1830s, but the trade lacked the vigor of earlier years.[143]

Natchez and Mobile

Before and after the War of 1812 Natchez represented a small pocket of activity in painted seating. The town stood on a "considerable eminance" overlooking the Mississippi northwest of New Orleans. Cotton culture dominated the economy and was so profitable that many planters lived in considerable luxury. In 1806 the population comprised

about 2,500 people of several races. During a sojourn Thomas Ashe noted, "There is a great number of mechanics in this city, whose wages are very high, as is labour of every kind. The market is proportionally extravagant.... The citizens, however, are enabled to endure the high price of provisions, by their trade between New Orleans and the back and upper country."[144]

No doubt the area's agricultural prosperity encouraged Sterling B. Mangum to anticipate reasonable success when he opened shop about fifty miles away at Gibson Port (now Port Gibson) in 1808 to make Windsor chairs, wheels, and reels. His name is listed in the Claiborne County census for 1820, suggesting that his hopes had been realized. Bracken and Smith, who operated a store at Natchez in 1810, found it expedient to augment their regular merchandise with a selection of tools, painter's oil, and Windsor chairs, which they sold only "by the dozen." The firm probably acquired its chair stock through a wholesaler in New Orleans, with Philadelphia the likely place of origin. After the war James Turnbull arrived from Philadelphia "with a quantity of Cabinet Furniture," which he offered for sale in rented quarters; the selection included fancy chairs. On February 2, 1819, J. D. Cochran advertised fancy chairs and a general assortment of Windsors received from New York. Previously Cochran had been a chair dealer in Chillicothe, Ohio. In the same issue of the *Mississippi Republican* an unnamed craftsman sought a journeyman turner for employment at the "Turning establishment two doors above Henry Postlethwaite's Auction and Commission Store, Mako street."[145]

Little more than a month passed before Thomas Bislep (also Heslip) arrived in Natchez "from Pittsburgh," having pursued the trade of fancy- and Windsor-chair maker for four years or longer. In Mississippi Bislep supplemented chairwork with ornamental painting and gilding, as formerly. The chairmaker's journey from Pittsburgh to Natchez would have been a relatively straightforward though tedious one by boat down the Ohio and the Mississippi. Since Bislep (as Heslip) had probably begun his career in Chester County, Pennsylvania, migration was not new to him. His stay in Natchez may have been brief, as nothing further is heard of him. Almost a decade later Obadiah Conger set up in town as a dealer in furniture and chairs. Before his January 1828 advertisement, he received cabinetware from New York, which he offered along with a large assortment of rocking and children's chairs. Although Conger referred by name only to fancy rush-bottom seating, he may also have had Windsors in stock, since he carried sewing chairs and children's highchairs. Such seating was more likely to have plank bottoms than rush or cane seats.[146]

By the 1820s and 1830s Mobile shared in the trading activity of the gulf. Standing near the mouth of two rivers that afforded transportation for the produce of the hinterlands, it was surrounded by rich cotton-growing land. However, the port suffered from the presence of sandbars at the harbor entrance, preventing access by large vessels. Carl David Arfwedson found the town "small but ... comfortable" in 1833. Several fires had swept the city in previous years, but this circumstance had been turned to advantage. Replacing the former log huts were "rows of fine brick houses." The waterfront was the scene of "continual bustle," and "pyramids of cotton-bales" stood before most buildings.[147]

Records of chair exports to Mobile date between 1820 and 1837. In 1820 George Murray, a Philadelphia merchant, shipped a quantity of merchandise, comprising curled maple and mahogany bedposts, casks of nails, and chair parts, to C. and A. Batré. The number of loose "bottoms," "backs," and "feet" was sufficient to make about six dozen Windsors. Clearly, someone in town possessed the skill to assemble the materials. That person or another would have painted, ornamented, and varnished the seating prior to sale. New York documents record a large chair shipment in 1832. Three consignments placed on board the ship *Catharine* by as many individuals left for the gulf port on September 26. The chairs were framed and, for the most part, packaged. One lot from chairmaker Benjamin Newhouse numbered 116 bundles; each package probably contained two chairs. An 1837 Philadelphia shipment on the brig *Virginia* was wrapped in a similar manner.[148]

The Midwest

In 1817 Henry Fearon, an Englishman touring the American Midwest, commented, "The tide of emigration . . . is eternally changing its course." Just as the quest for property and new roots, and the promise of a brighter future had led individuals, families, and even community groups to seek a new life in the sparsely settled lands of northern and western New England and New York state after the Revolution, so similar forces and aspirations drove many more to the western territories in the 1800s, creating a giant melting pot of eastern American and European stock. The western trek began in earnest after 1795 when the Treaty of Greenville provided reasonable safety from Indian depredations; an even greater push occurred after the War of 1812. More than a quarter of the national population resided west of the Appalachians by 1830, and at that date the inhabitants of Ohio exceeded in number those of Connecticut and Massachusetts combined. By actual count the western population rose from 150,000 in 1795 to more than 1 million in 1810; the greatest settlement took place along the waterways. Pittsburgh on the Ohio River was the great gateway to the West for emigrants from New England, the Middle Atlantic states, and the northern sections of the South. Mountain passes in Virginia and North Carolina afforded access, and New Orleans and other gulf ports provided an approach from the south. The heterogeneous character of the western population is revealed in the Cincinnati directory of 1840, which lists place of birth along with occupation and address. Among the chairmakers, turners, and ornamental painters listed, nine eastern states are represented, including Connecticut, Maine, Virginia, Vermont, Massachusetts, New Jersey, New York, Pennsylvania, and Maryland, the last four supplying the most emigrants. Other woodworkers were Ohio natives, and one hailed from neighboring Kentucky. Represented among foreign nations were Germany, England, Ireland, Scotland, and Austria, in that order. Land companies and speculators helped to promote the migration.

The western economy was both agrarian and mercantile. Emigrants from the South were basically farmers and planters. Hemp was an early commercial crop south of the Ohio River, but after the Revolution tobacco cultivation spread rapidly. North of the Ohio subsistence farming prevailed. New Englanders in particular were village people, used to mixing trade with agricultural pursuit. In time a modest agricultural surplus provided a much needed economic leverage. The Ohio, Missouri, and Mississippi river systems were the vehicles of trade; they permitted broad distribution of the manufactured and imported goods shipped from the East through Pittsburgh and drained off the surplus produce of the region for transport downriver to New Orleans by flatboat or keelboat. Urban areas increased in number and size and attracted traders, merchants, skilled "mechanics," and professional men. Manufacturing was on the rise by 1815, in the form of lumbering, milling and distilling, salt processing, tanning, and shipbuilding. As trade expanded the middleman became a more important figure. By 1832 it could be stated that most young men "of enterprise and standing" in the region had made the flatboat trip to New Orleans at least once and thus had been exposed to the cosmopolitan impulses of that urban center. Steamboat navigation became part of the western commercial scene after the War of 1812. Seventeen vessels were engaged in commerce in 1817, and the number increased yearly. The same goods formerly brought overland to Pittsburgh for western markets at freight charges of $5 to $8 could now be shipped for $1 from Philadelphia to New Orleans for steamboat distribution. With the transportation boom came new workers: boat builders, pilots, and ship and dock hands. A few years more, and the Erie Canal opened direct intercourse between New York City and the Midwest.

Regulatory instruments, such as the Northwest Ordinance, provided an outline for government in the new settlements; a body of laws and a system of courts followed. Lawyers found good custom in the complexities and problems of land claims and of commercial activity built upon long credit. Chartered banks began to emerge in the early 1800s and proliferated rapidly in the speculative period that followed the war—a

1 inch = 68 miles

circumstance that eventually proved disastrous in the recession that began around 1819 and continued into the early 1820s. Georgian architecture and, later, the revival styles traveled west to maintain a fashionable pace with the goods and household furnishings that were streaming in.[149]

OHIO

Cleveland and the Western Reserve

A half century ago Rhea Mansfield Knittle compiled introductory lists of early Ohio furniture craftsmen and allied artisans. More recently Jane Sikes Hageman published three volumes of information on Ohio furniture makers, based on a statewide canvass of public records. Included in this work are listings for three Windsor-chair makers who began their woodworking careers in Cleveland in the 1830s. Although the city was settled in 1796 at a harbor site bordering Lake Erie, growth was slow. Shortly after the War of 1812 the population was sufficient to support a Windsor-chair maker and a cabinetmaker. The unnamed men were surveyed in the 1820 manufacturing census, and each stated that he had been in business for four years. The Windsor-chair maker reported annual sales to the value of $600 but noted that demand had declined due to

the depressed economy. His raw materials consisted of maple and yellow poplar timber. Opening of the Erie Canal in 1825 provided new access to New York City and state and spurred community growth. The population had climbed to 5,080 by 1835. During the following years the annual tally of sailing vessels and steamboats in the harbor was nearly 2,000, and Frederick Marryat found city stores "better furnished . . . than any shops in Norwich, in England." In March 1835 Daniel A. Shepard advertised a variety of Windsor, fancy, and cottage chairs, supplemented by formal seating executed in mahogany, black walnut, and curled maple. Many styles were offered at New York City prices. Shortly thereafter, Shepard's manufactory was heavily damaged by fire, but he was back in business by mid July. Throughout a career that extended into the 1850s, Shepard also constructed special seating, such as Boston rockers, Windsor sewing and nursing chairs, boat stools, settees, and office chairs. His contemporaries, Elijah Bradley and William Hart, supplemented the production of cabinetware with Windsor and other chairs. Hart's operation was assisted in 1848 by the installation of a steam engine to supply power for turning and sawing. Late in style and dating to the Civil War at the earliest is a plank-seat chair at the Henry Ford Museum made by Park and Company. The chair is similar to those made by William Stoner in Fulton County, Pennsylvania (fig. 3-148), and, like those Windsors, the design was influenced by both Pennsylvania and Baltimore work.[150]

Chairmaking in areas surrounding Cleveland may date earlier. At Painesville, east of Cleveland near the lake shore, Christopher Crafts (or Croft) occupied a chair factory in 1820, where two men achieved an annual production of 500 Windsor and fancy chairs. In commenting on business, Crafts noted that sales were "dull," except as bartered for produce, a common medium of exchange. Aside from the lake traffic at Fairport three miles away, Painesville's economy probably centered around the local Geauga furnace. Residing in the same area were Ebenezer Williams and Grandison Newell, both natives of Connecticut. Williams had been a Windsor-chair maker in East Windsor but turned to innkeeping in Ohio. Newell, an entrepreneur, installed a lathe and operated a chair factory from 1829 to 1841, when he sold the business. In the meantime, Orrin Judson Lines set up as a cabinetmaker in 1839. Chances are that he, too, emigrated from Connecticut, where the Lines and Judson families were prominent in the New Haven-Stratford area. Apparently, Lines first sold chairs obtained from Grandison Newell's Kirtland Factory. By 1844 Lines had teamed up with Dwight Donaldson, a cabinetmaker who also once stocked Kirtland Factory chairs. The association lasted nine years, unusually long for a furniture-making partnership.[151]

Parkman, an inland town twenty-five miles from Painesville, was far enough from Crafts that Barton F. Avery pursued the Windsor-chair making business there in 1820. With production standing at 300 chairs a year, the one-man shop could hold its own. Seating sold for $1.50 a chair, providing a gross annual income of $450. The business was relatively new, and the product must have filled a local need, as the census taker recorded that demand was good and the manufactory increasing. Parkman stands on the Grand River, where eventually three dams furnished waterpower. Perhaps even in the 1820s Avery was able to take advantage of these improvements. He had emigrated from Cayuga, New York, in 1816. In later life he held several public posts, including postmaster and justice of the peace.[152]

In Portage County immediately south there was a flurry of activity. The firm of Belding and Collins made Windsor and fancy chairs in the village of Randolph in 1828–29. A contemporary named Ladd made and stenciled Windsor chairs at Mantua, another small settlement. Chairmaker Nelson Talcott of Nelson, a hamlet thirty miles northeast of Akron, left comprehensive accounts, which began on October 19, 1839, and continued until 1848. Talcott documented the production of various seating forms, including "Dining," or side, chairs, priced at 75¢ apiece or slightly less. Customers frequently purchased them by the "set" or half set, a set comprising six chairs. One group sold in 1840 was painted green; others were described as "Light colered." Armchairs, priced from 83¢ to $1 each, usually were sold in sets as well. There was a good

market for Talcott's rockers, some of which were described as "small" or sewing chairs; the $1.00 price reflects their size and lack of arms. Talcott's most expensive chair was a "Boston" rocker priced at $3.50. Children's chairs were high or low, the latter occasionally fitted with rockers. Fancy seating suited some Talcott customers at $2 each; settees cost $4.50 to $6.00.[153]

Nelson Talcott became an independent chairmaker before the start of his daybook in 1839, when he was about thirty-five years old. The entrepreneur also operated a prosperous general store. Clouding the picture is an October 1838 advertisement from the local firm of Sylvester Taylor, Jr., and Edward Z. Brown, stating that the partners had just "purchased the Factory formerly owned by Nelson Talcott and more recently by Edwin Caldwell [sic]." Since Talcott's accounts indicate that he retained a chairmaking capability, the so-called "factory" must have proven unsuitable. Either Talcott had used the facility for another purpose, or he had set up shop in new quarters. Talcott's continued receipt of quantities of seat plank and turned stock and the sale of framed seating to Edwin Cadwell testify to his status as a chairmaker.[154]

In February 1842 Talcott began storekeeping in neighboring Garrettsville. Chairmaking continued, but whether in the new location or the old is not clear. During the early years of the accounts, Talcott employed several men to make chairs or to perform special services. From September 1839 to November 1840, Edwin Cadwell supplied 180 chairs and 3,025 feet of plank. The following year he painted chairs, "as per contract," renting space within the Talcott shop. William B. Paine (also Payne) agreed with Talcott on February 1, 1841, to paint the "ground work" of chairs; piecework payment was based upon seating size and Paine's boarding arrangement with Talcott. The men settled their accounts on September 20. Two months after Edwin Cadwell commenced work, Edwin Whiting, Talcott's brother-in-law, began a three-month stint; another eight-month period followed in January 1841. Basically, Whiting was a chair framer, although he also performed other work, such as hauling plank, furnishing general shop labor, bending wood, and roughing out stock for turning. According to the record, he framed about 1,458 dining and Windsor chairs during the first eight months of 1841.[155]

Like Edwin Cadwell and Edwin Whiting, Sylvester Taylor, Jr., was a chairmaker. His working dates overlap and extend beyond those of the other two men. Taylor painted some of Cadwell's chairs in June 1840; the following November he bought "rattan" from him for caned work after Cadwell had contracted with Talcott as a painter. Taylor appears to have left the Talcott shop in mid 1840, but he returned several years later. Beginning in September 1843, he concentrated on chair painting, ornamenting, and seat caning. He may have worked on his own account in the Talcott shop, since Talcott recorded his purchase of painting supplies and a variety of chairs, probably "in the wood" (unpainted). The association continued until about January 1844, when Taylor borrowed Talcott's horses and wagon to haul two loads of wood. Earlier he had used the vehicle to fetch rattan in Cleveland.[156]

At the back of his accounts Talcott kept a record of chair production. The first entry, dated November 15, 1839, tabulates 359 "chairs Framed up to this date." The notations continued through January 1841 for a grand total of 2,924 chairs identified as Windsor, dining, rocking, and little chairs, and highchairs. Sales records kept by Talcott indicate that merchandising kept pace with construction. Some customers paid for their purchases by exchanging lumber; others, like Pliny Allen and R. Mumford, provided chair parts in 1840–41. Among Allen's credits are "Rocking chair Slats" for backs. Mumford supplied stuff for both rocking and children's chairs, along with turned "Rolls" for top pieces and "Fancy chair Rounds," or ornamental front stretchers. Part of Mumford's pay was in chairs.[157]

Lemuel Porter removed from Waterbury, Connecticut, to the Western Reserve at Tallmadge, Summit County, about 1817–18. Northeastern Ohio, which made up the Western Reserve, had been a Connecticut territory before its formal opening to settlement in the 1790s. The area attracted many New Englanders, who brought with them the customs, traditions, and place-names of their native region. Thus, when furniture

Fig. 8-22 Slat-back Windsor side chair (one of four), attributed to William Tygart, North Bloomfield, Oh., ca. 1829–30. Maple and other woods; H. 34″, W. 16″, D. 15″. (Western Reserve Historical Society, Cleveland, Oh.)

maker Porter migrated and became an architect-builder, it was no surprise that his buildings retained a strong New England character. His clapboarded First Congregational Church with columns and spire, built in Tallmadge in 1825, remains every inch a New England meetinghouse. Porter continued his new vocation, probably to the exclusion of furniture making, until his death at Hudson in 1829 at age fifty-five.[158]

As Porter's Ohio career began, Joseph Musser and James Goldsburg advertised as chairmakers and ornamental painters at Canton, Stark County, which lies just outside the Western Reserve. The community was not very old in 1818, but it may already have shown signs of being the "compact town, with many brick dwellings" it was described as two decades later. Canton's rising state also seems confirmed by the presence in town of a second manufactory, owned by the Dunbar family. By 1823 George Dunbar and his son George, Jr., operated separate facilities, the latter with and without a partner. Both men remained in business into the following decade. By the 1840s Canton had become a substantial flour-milling center. Booze and Wertenberger set up shop at the sign of the "Big Red Chair," and George B. Haas, former partner of George Dunbar, Jr., located at the "Big Black Chair"; William Prince advertised for "10,000 feet of Poplar plank suitable for Chairs."[159]

Near the Pennsylvania border at Warren, Trumbull County, about fifty miles northeast of Canton, Jedidiah Darrow practiced chairmaking and ornamental painting. Knittle suggests he was working there by 1822, and several advertisements date to the 1830s. In 1838 Darrow's "chair factory" was located nearly opposite the Hope Tavern, a location that probably encouraged patronage. Today Warren is part of a large urban area contiguous with Youngstown, Mahoning County, where John Laughridge advertised for an apprentice in 1824. Elsewhere in Trumbull County, Ephraim Brown, a New Hampshire craftsman and merchant who migrated to the Western Reserve in 1815, had erected a fine federal-style house at North Bloomfield by 1822 with the assistance of a New Hampshire builder. In 1829 he rented a shop to cabinetmaker William Tygart (or Taggart), whom he also employed to supplement his household furnishings. The house and furniture remained intact until 1969. An itemized account of Tygart's furniture and a signed dressing table identify his work.[160]

Among furnishings supplied by Tygart was "1 set maple Windsor Chairs with dart backs" priced at $5.50. Four chairs answering this description survive from what may have been a six-chair set (fig. **8-22**). These Windsors are of particular interest in two

respects. First, Tygart refers to them as "dart backs," the first and only use of this descriptive word known to the author. The usual term among craftsmen was *flat stick*. (The term *arrow-back* does not occur in the period.) Second, Tygart drew on various sources for his design. The upper structure is a fairly typical pattern of the 1820s (figs. 3-134, 7-3), although Tygart managed to include more flat spindles than usual. The pronounced cant of the seat edges in a typically squared-shield plank reflects either southeastern New England or central Pennsylvania influence. The lower structure is strongly provincial; here the craftsman innovated. The leg pattern may spring from earlier New England or rural Pennsylvania work, where turners placed strong emphasis on the "bamboo" quality of the turnings (figs. 7-2, 3-123). The slim button-toe supports are analogous to those in rush- and cane-bottom seating popular in Connecticut and New York during the 1820s and later (figs. 7-22, 5-56). Tygart's double rod-and-medallion front stretcher appears to have come from Pennsylvania work popular from about 1800 to 1815 (figs. 3-120, 3-122), although the craftsman shifted its function from crest to brace. In 1831 at North Bloomfield Tygart married the daughter of a family that had migrated from Hartford, Connecticut. An advertisement for a journeyman cabinetmaker two years later rounds out information on his career. The 1820 census lists no appropriate Tygart in Ohio or Connecticut. Eastern Pennsylvania records, however, identify "Taggart" family members as cabinetmakers in Chester County beginning in the eighteenth century.[161]

West of Cleveland in the farthest part of the Western Reserve, known as the Firelands, William Gallup was active from the late 1820s as a chairmaker at Norwalk, the seat of Huron County. He may have had no formal training in woodworking, since he was a town resident long before he offered Windsor chairs and cabinetwork for sale in 1829. Within the same month he advertised for two journeyman cabinetmakers and a journeyman chairmaker. The date corresponds to Gallup's disposition of his deceased brother Caleb's estate, which included Windsor chairs, finished and unfinished. By the following January Gallup had set up woodworking quarters in the "upper part" of a local steam mill and soon offered cabinetware and chairs at "Buffalo and Rochester prices." Providing competition during the 1830s was Douglas Squires, who by 1842 was located on Mechanic Street. Neighboring New London was the location chosen in the 1840s by Stephen Kilburn, a Worcester County, Massachusetts, native, to establish a chair factory with the assistance of his grown sons. To the north on Lake Erie, Henry Moore advertised Windsor and fancy chairs at Sandusky in 1825, only eight years after the town was laid out.[162]

Eastern Central Ohio and Columbus

The early settlers of Harrison County came mainly from western Pennsylvania. Cadiz, the county seat, was laid out as a community in 1803–4, but even in 1840 the population stood at just slightly more than 1,000. The location marked a junction of roads from Wheeling, Pittsburgh, and Zanesville. William D. Geddes, assisted by two men, made Windsor chairs at Cadiz in 1820 to the market value of $875 annually. His product likely was indistinguishable from seating made in Pennsylvania. Later, G. E. Bushnell manufactured fancy, Windsor, and Grecian chairs there. When the census taker queried James Smith, spinning-wheel and reel maker, in 1820, he replied there was more demand for his product than two years earlier. Either the recession had encouraged renewed interest in home cloth manufactures or there was considerable migration into the area. An unnamed wheelwright and chairmaker in neighboring Morgan County said just the opposite: his business was dull. But local prospects had brightened when, several years later, Nathaniel Sprague removed from Zanesville to a farm near McConnelsville. Records identify him as a wheelwright, chairmaker, and painter. He is said to have hung a chair above his shop entrance as a sign. W. Williams worked northwest of Cadiz at New Philadelphia, the seat of Tuscarawas County. Business was dull there, too, in 1820, although the chair and "patent" wheel manufacturer kept his establishment in good repair.[163]

A highly successful business enterprise was launched several decades later in adjoining Carroll County by German-born George Deckman, who spent his youth in Philadelphia and served an apprenticeship there at midcentury. As expected, his product (fig. 8-23) closely follows Pennsylvania work (fig. 3-149). In the late 1850s Deckman opened a furniture manufactory in Minerva, but by 1862 he had relocated in the neighboring village of Malvern where, under his son, the business continued into the twentieth century. Deckman chose his site wisely on a branch of the Cleveland and Pittsburgh Railroad, assuring easy access to raw materials and markets. His balloon-back chair has grained decoration and simple penciled flourishes typical of late nineteenth-century work. The front legs represent a last interpretation of the ball-turned, fancy Pennsylvania support seen in figure 8-24; here the ball is merely suggested by a gilded band. The pierced crest with its centered serpentine crown has long been associated with Ohio chairmaking, although the pattern is not correctly ascribed to the Zoarites.[164]

Zanesville in Muskingum County was an active chairmaking center from the early nineteenth century. When the county was established in 1804, the town on the Muskingum River became the seat; it also served as the temporary state capital from 1810 to 1812 before Columbus became the permanent site in 1816. Wheat and salt production were economically important. Waterpower for manufacturing developed gradually, along with the use of local bituminous coal for steam power. By the 1840s the combination of steam navigation and a system of locks and canals gave Zanesville communication with the Ohio River to the south and Lake Erie and the canal to the north. Daniel Stickney is said to have made Windsor chairs and settees in 1815. He advertised for a journeyman from his location across the river in Putnam a year later and was still a county resident at the 1820 census. Abraham Sells, who manufactured Windsor and rush-bottom chairs in 1814, may have provided some competition. John Alter, a native of western Pennsylvania, enjoyed a long career in Zanesville. Perhaps beginning modestly as a maker of chairs and spinning wheels before the War of 1812, he later supplied cabinetware as well. His chair stock of 1841 included sophisticated styles in the French and Grecian taste along with the ubiquitous Boston rocking chair.[165]

A branch of the Pennsylvania Allwine family moved to Zanesville before the War of 1812. Lawrence, the father, was a practicing Philadelphia chairmaker in 1785, when he advertised for a runaway apprentice. Directories for that city identify him as a Windsor-chair maker through 1800 and then list him as an oil and color man until 1809. His son Westley (Westle) may have begun his career when he took an apprentice in 1805. Within four years Westley was in the Zanesville area, where he married on October 7, 1809. He may have concentrated on house painting and ornamental painting until he began to make chairs after the war. Lawrence Allwine was an innkeeper at Zanesville by 1811. He later joined his son Barnhart to manufacture Windsor chairs and settees until February 1827, when the two sold their entire stock of seating, yellow poplar plank, and miscellaneous materials. The men appear to have relocated in adjacent Perry County, where Lawrence was enumerated in the 1830 census; Barnhart was still there in 1850. A plain-spindle, slat-back Windsor settee, the slat tapered at the ends where the back corners "wrap around" in a style associated with Philadelphia, is branded "L.ALLWINE / PHILADᴬ." Despite the mark, the seat is likely an Ohio product of the late 1810s or 1820s. A similar documented settee has arrow-type spindles. Neither the flat spindle nor the slat back were known in Philadelphia work before Allwine migrated to Ohio. The curved form appears to be a later update of a rod-back pattern familiar to him when he left the city.[166]

The opening left by the removal of the Allwines from Zanesville likely was filled by James Huey, another Pennsylvanian who migrated west. Huey advertised his "Chair Factory," where he sold fancy, Windsor, and common seating and "a variety of settees," from August 1828. His success is attested by the longevity of his business and by statistics from the 1850 industrial census that describe a steam-powered cabinet and chair factory employing twenty men and producing furniture worth $8,000 annually. Unlike the

Fig. 8-23 Balloon-back Windsor side chair (one of six), George Deckman (stencil), Malvern, Oh., ca. 1862–80. Maple and other woods; H. 33⅞″, W. 16½″, D. 18½″; dark brown and brick red grained ground. (Henry Ford Museum and Greenfield Village, Dearborn, Mich.)

majority of Ohio chairmakers, Huey has left marked examples of his work, which bear his name and location stenciled in large letters on the plank bottoms. In common with other midwestern Windsor work, there is no so-called "Huey style" or "Ohio style"; rather, the patterns are amalgams of designs drawn from many sources. Stylistically, the earliest Huey Windsor is a straight-back, slat-crested side chair with grooved bamboo turnings and sharply pointed feet. The general prototype is a Pennsylvania chair of the 1820s (fig. 3-132) with a seat in the flat-edge balloon style (fig. 3-131). Huey's chair dates no earlier than the 1830s, however. Another side chair introduced shaved and bent back posts, a roll-top crest, and a shovel-shaped seat. The legs are late Pennsylvania-type supports (fig. 8-24); the front stretcher duplicates one found in a Wheeling chair (fig. 8-14). Both features place the pattern firmly in the 1840s.[167]

Fig. 8-24 Tablet-top Windsor settee, James Huey (stencil), Zanesville, Oh., 1845–55. White pine (seat) with maple; H. 35½", W. 72½", D. 22½"; dark brown ground with yellow and shaded gold. (Private collection: Photo, Columbus Museum of Art, Columbus, Oh.)

Huey's work shows considerable competence in design and proportion. His settee is a tour de force for its place and time (fig. 8-24). Use of slat-style stretchers and a late Pennsylvania leg (fig. 3-147) reinforces the midcentury date. Several parallels exist between this long seat and a Baltimore settee: an overhanging tablet crest, bold forward scroll arms, shieldlike flat spindles, and tapered supports with conelike tops. Huey's vigorously shaped back slats, complemented by well-executed painted ornament, come from fancy chairwork, especially that executed in and around New York City (figs. 5-52, 5-56). A forward scroll arm, or "elbow," of similar pattern is illustrated in the New York chairmakers' price book for 1817 (fig. 5-48).

Lancaster, seat of Fairfield County to the west, was the location of several chair shops between 1818 and the early 1830s. The community, laid out as a town in 1800 along the Hocking River, was so named because many early settlers emigrated from Lancaster County, Pennsylvania. First to advertise was Walter MacDonald, whose notice of April 9, 1818, identified production of high and low post bedsteads as a supplement to his fancy- and Windsor-chair business. His work was warranted and "in case of any failure in the first twelve months [was] made good, free of charge." Joseph Grubb was assisted in his chairmaking business by one or more shop apprentices during the 1820s and later. After Grubb's 1831 search for "three boys of good moral character . . . from the country," E. R. and S. Lewis began to offer competition at their Windsor-, fancy-, and rocking-chair manufactory, where they also produced settees and cradles.[168]

Athens County, with only a toehold along the Ohio, had its greatest commercial activity in the valley of the Hocking River, where salt manufacture and coal mining predominated. At the center was Athens, the seat of government and a town of 710 inhabitants in 1840. Patrick Develling and Matthew Patrick sold "Chairs, Chairs! . . . lots of them" at this location in 1838–39. In neighboring Washington County activity was more substantial by reason of its long border on the Ohio. As the local seat of government and the oldest town in Ohio, Marietta was well located at the confluence of the Muskingum and Ohio rivers. At the 1840 census the township was the county's largest, with almost 2,700 inhabitants. The location proved attractive to craftsmen, but prosperity was still just around the corner when Windsor-chair maker Nathaniel Smith solicited payment of outstanding debts in December 1815. Prospects were brighter when W. S. Clark set up shop in the mid 1820s after the recession. As advertised, local chairmakers supplemented their regular production by producing bedsteads and writing and rocking chairs, and by offering sign and ornamental painting.[169]

The 1820 manufacturing census identifies several active woodworkers in the central Ohio counties of Knox and Richland. William McFarland, who constructed Windsor chairs and spinning wheels at Mount Vernon, Knox County, reported that there was "great demand for the . . . articles." McFarland, who pursued his trade with the help of four men, priced his wheels at $4 apiece and chairs at $10 to $12 the dozen. He continued in business for several decades. The Vernon River afforded good waterpower, and the bottom lands bordering the waterway were rich and agriculturally productive; both factors contributed to the area's generally flourishing state. The census also lists three cabinetmakers, a wheelwright, and two wheel and chair manufacturers in Richland County north of Mount Vernon. Organized in 1813, the county was named for the "character of its soil," where grains, hay, and potatoes were "raised in great abundance." Original settlement was largely from Pennsylvania. At Mansfield two boys assisted Clement B. Pollock in the wheel and chair business; demand was "increasing," although payment was poor. David Shankland, assisted by one man, produced similar work in another part of the county and reported a "ready sale" for his wares. The spinning-wheel maker is unnamed, although his production realized $200 annually. Perhaps this was J. Laughridge, Sr., and his son, who were living on a farm one mile south of Mansfield in 1825 when they advertised their "wheelwright," chairmaking, and ornamental painting business.[170]

Columbus, the seat of Franklin County, became the state capital in 1816. Like Zanesville, the town enjoyed access to the Ohio River and Lake Erie through the Scioto River and a series of canals by the 1840s. Knittle reported that chairmaker Henry Rigour (published as Harry Riggor) worked in Columbus in 1807, but since the town was laid out only in 1812, that information is in error. Rigour is accounted for in the 1820 manufacturing census at a location in neighboring Delaware County, an offshoot of Franklin organized in 1808. Rigour's business in Delaware Township was prospering; he and another man manufactured chairs, signs, showboards, and bedsteads to the value of $2,700 annually.[171]

Adin G. Hibbs came to Columbus from Pennsylvania in 1832. He was well established the following year when he advertised his "Manufactory, sign of the Golden Chair," where customers could view and purchase from "a large and handsome assortment of Windsor and Fancy chairs of every description." Columbus prospered due in part to the location of a national road through the community. The population more than doubled between 1830 and 1840, reaching 6,048. The high quality of Hibbs's Windsor production is indicated in a bent-post, slat-back side chair featuring long arrow spindles, a shovel-shape seat, Maryland-type legs (fig. 4-13), and a front stretcher centered with a slim rectangular medallion. The chair can be dated to the 1830s, since sometime after 1837 Hibbs left the chair business to become a sawmill partner in neighboring Shadeville. There, with other business interests, he eventually made a fortune. Perhaps Hibbs's retirement from chairmaking offered encouragement to Hiram Hanes, who by 1843 had established himself at Columbus in the manufacture of Windsor, cottage, and fancy chairs, supplemented by the production of settees, cradles, rockers, and children's seating.[172]

Circleville, the seat of neighboring Pickaway County, was a small, active center of chairmaking from the 1820s. The local economy was based upon agriculture. As was typical of area communities, the town increased rapidly. About 1821 James McCrum made chairs for a new octagonal courthouse. He maintained a diversified business as a chairmaker, painter, and glazier for many years. George Wildbahn and John Carolus commenced business in 1824 to produce cabinetware and "Plain and fancy Windsors." Recognizing the problems of merchandising in a society where circulating currency was limited, they willingly exchanged their products for "wheat, whiskey, oats, or any other thing." Michael Pontius from Pennsylvania had already set up "opposite Hedges Hotel." He pursued a successful career, offering chairs and bedsteads initially, then adding painting and gilding services, and finally introducing cabinetmaking through a business association.[173]

The South, Midwest, and British Canada 617

Cincinnati

Within a short time of its founding Cincinnati dominated southern Ohio and, eventually, a substantial territory beyond. It was early dubbed the "Queen City of the West." Located in a part of the Miami Purchase, the future city occupied an elevated bank on the north side of the Ohio River. Until the Treaty of Greenville secured peace with the Indians in 1795, Cincinnati was a small community of rude and temporary structures, comprising private dwellings, a military facility, and a few public buildings. Two armed keelboats made regular monthly trips to Pittsburgh beginning in 1794. The following year John Humes, the first identified Windsor-chair maker in Cincinnati, advertised his spinning-wheel and chair business. Jane E. Sikes found that Humes led an active business life before his removal in 1805 to another part of Hamilton County. His Sycamore Street building was described as a two-story frame house with a stable and smokehouse adjoining.[174]

In 1801 the territorial government moved temporarily to Cincinnati. This event, coupled with the town's advantageous situation on a major navigable river, no doubt contributed substantially to its early progress. Ohio was admitted to the Union as the seventeenth state in 1803. When Christian Schultz visited Cincinnati in 1807, he found about 300 houses and several new public facilities. The local stores were "well stocked with every kind of merchandise in demand." The population of Cincinnati in 1800 stood at 750; by 1810 it had risen to 2,540.[175]

Offering competition to John Humes in the Windsor-chair making business in 1803, and possibly the reason for his removal from town two years later, were the partners Jacob Cotts and Andrew Glass. They too located on Sycamore Street and could not have been very far from Humes. They offered Windsor chairs, settees, cradles, repair services, and painting "on more reasonable terms than any in the place." David Kautz, who had migrated from Maryland to Cincinnati in 1798, may not have had his own business until a few years later. A notice of December 23, 1806, reported that his "log" chairmaker's shop had been destroyed by fire. He formed a business association with kinsman Daniel Kautz by 1811. The firm offered "Fashionable & Common Chairs" of varied color, supplemented in part by settees and rocking chairs, large and small. By 1820 David had given up chairmaking to become proprietor of the City Hotel.[176]

Burrows Smith first announced his Windsor-chair making services in 1807, the year Christian Schultz visited Cincinnati. He appears to have prospered and four years later was prepared to expand his work force by taking both an apprentice and a journeyman. James Ayres, who had come to Cincinnati from New Jersey, probably was already in town; he may be the person who married Abigail Roll in 1815. She, no doubt, was a close connection of Jacob C. Roll with whom the couple was living in 1819, the date of the first city directory. Ayres's residence is listed as No. 7 East Fourth Street, the same home address given for Roll, who had his shop next door at No. 9. Presumably, Ayres worked as a journeyman for Roll and may have continued in this capacity until he became a grocer in the mid 1820s. By 1829 Ayres was back at chairmaking, and his woodworking career continued at least until 1853.[177]

Cincinnati's location on the Ohio River was crucial to its commercial vitality as it pushed toward prominence among western settlements. Already in 1812 it was reported that the community carried on a considerable trade with New Orleans "in keel boats, which return laden with foreign goods." A forty-ton boat required twenty-five days to reach New Orleans. The return trip consumed about sixty-five days. Steam navigation was still several years away. By 1820 the population stood at 9,602. A major burst of activity followed the War of 1812, when there was a considerable influx of eastern craftsmen, particularly from New Jersey and New York. One of the first to arrive was Samuel P. Stibbs, a New Jersey native who had worked in New York City between 1802 and 1814 as a chairmaker and painter. He and Jonathan Stout, probably also from New Jersey, formed a partnership in 1816 to manufacture "fancy flag bottom" and Windsor chairs. The seating was painted and ornamented to the fashion of the day. The Stibbs-Stout relationship was short-lived, terminated within a year by the untimely death of

Jonathan Stout at New Brunswick, New Jersey. Stibbs continued in business and in 1818 numbered among his customers two prominent Cincinnati citizens.[178]

Jacob C. Roll of New Jersey came to Cincinnati in 1813 to join established family members. The chairmaker was in business by December 1814 when he advertised "Setting Chairs and Settees" in the *Western Spy*. Since he noted that he had been "at a very considerable expense, to procure good workmen," James Ayres may already have begun employment with him. Figures reported in a tax evaluation of 1817 suggest that Roll met with considerable success, possibly due to diversification. An advertisement of May 1815 seeking chairmaking apprentices was followed by one in December announcing that Roll had "recommenced the Tin business at his old stand." The entrepreneur probably hired a trained metalworker to manufacture the basic product; shop personnel familiar with furniture ornamentation could have assisted with the decoration. In August 1818 Roll formed a partnership with Isaac Deeds to make fancy and Windsor chairs. Deeds had arrived in Cincinnati in 1817 from New York, where he is listed in an 1816 city jury list as a chairmaker, age twenty-four. The partners advertised to contract with turners for a regular supply "of chair stuffs for fancy and Windsor chairs," for which they were ready to supply "patterns" to the applicants. By jobbing out the parts production, Roll and Deeds could concentrate on framing and finishing in the shop and in that way maintain high volume production in limited quarters. The business appears to have had a successful beginning, based upon several receipts for local sales. Fancy chairs, Windsors painted yellow or brown, sewing and rocking chairs, stools, and settees were all part of the output. Then on October 17 the men announced the dissolution of their association. It is tempting to speculate that incompatibility was at the heart of the matter.[179]

Deeds went on to form a partnership the following January with another newcomer from New Jersey, Jonathan Young, but this connection, too, was short-lived, lasting only about five months. Deeds moved north to Butler County. Meanwhile, Jacob Roll continued on his own in Cincinnati and in 1820–21 made furniture repairs for General William Lytle. Something of the geographic scope of Roll's activity is documented in a Louisville, Kentucky, advertisement of February 1820 sponsored by McSwiney and Barnes, proprietors of a cabinet and chair warehouse. They announced receipt of an initial stock of fancy and Windsor chairs made by "Mr. Jacob Roll, of Cincinnati," which they pronounced "equal to any manufactured in the western country." It was a simple matter for the manufacturer to ship the chairs down the Ohio to their Kentucky destination either by steam or keelboat. Then on March 16, 1822, a victim of the recession, Roll sold his business to Moses P. Clark and Nathan Crowell. Roll may have worked in other local shops for several years until 1825, when he removed temporarily to Sangamond County, Illinois. He is listed again in the Cincinnati directory for 1829. James Ayres, likely a Roll employee, turned to the sale of groceries about the time Roll sold his chairmaking business.[180]

The manufacturing census of 1820 provides an almost unparalleled view of the effects of the 1820 recession on chairmaking and other businesses in America. Jacob C. Roll's personal statement about economic conditions as recorded by the Cincinnati census taker is particularly cogent because it tells how a successful, flourishing business that was obviously well managed was virtually destroyed within a few months. Roll's shop, established with a capital investment of $6,300, was of considerable size; he employed three men and four boys. Material consumed on an annual basis was substantial: 12,000 feet of yellow poplar plank for seats, 2,500 feet of poplar and "sugartree" (maple) boards; 300 bundles of flag for rush seats; "turned stuff" for 3,500 chairs; 40 gallons of oil; 150 gallons of turpentine; paints; and 10 packages of gold leaf. The estimated total cost was $1,990. Shop equipment included one lathe used "for turning odd pieces." The absence of other machines was explained by Roll: "I purchase my Turned Stuff from Persons that live and do their Turning in the Country." Roll paid annual wages of $1,400, with contingency costs beyond materials adding almost $1,000. He estimated the 1820 market value of his products, which included chairs, settees, cradles, lounges (rocking chairs),

and stools, at $5,720, which probably was a lower figure than usual in view of his statement about business conditions:

The foregoing estimate is made for 1820, the first six months of which, my business was nearly as good as it had been for Several years preceding—The last Six months it has been extremely bad, & continues so. The chair business has been very good (if well followed) for Six years past, untill about within seven or eight months past, during the latter period the demand has been considerable but the Sales quite limited, owing to persons wanting to purchase, not having cash to pay, or else wishing to pay in Barter—the laws are so unfavorable to the collecting of debts, that I dare not credit much, for out of about $4000 which I now have owing to me, I have not, for Several months past, been able to collect as much as would pay one half of the expenses of my establishment—I have already curtailed my business as much as I could without discontinuing of it altogether, but I am apprehensive that I shall soon be under the necessity of discontinuing and winding up my business for the want of funds to purchase stock—So much for having Speculating Bankrupts to legislate for us.

February 9, 1821 Jacob C. Roll[181]

Cincinnati directories do not list James Theadore, although the chairmaker is enumerated in the 1820 manufacturing census; his products are identified as fancy and Windsor chairs. Theadore's shop was sizable, but the enterprise was apparently brief. His operation was comparable to those of Jacob C. Roll and Jonathan Young. Theadore, like Roll, found business dull in 1820. Young, on the other hand, *said* that demand was brisk. When on March 16, 1822, Moses P. Clark and Nathan Crowell took over Jacob Roll's business and premises, Clark had been in town for a number of years and may have been in Roll's employ. Crowell, a chairmaker in New York City in 1817–18, is said to have come from New Jersey sometime in the early 1820s. The partnership lasted just two months, after which Clark was in and out of town. Crowell had a long career in Cincinnati.[182]

After Isaac Deeds and Jonathan Young terminated their five-month association in 1819, Young went on to form another partnership of a year's duration with Isaac M. Lee. This had ended by mid 1820. Lee next joined with Philip Skinner in May 1822 to open a "Chair Factory." A published notice indicates that their chairs were available in Louisville at the wareroom of Jeremiah Diehr; the partners also solicited the patronage of steamboat owners in furnishing their vessels. The partnership lasted three years, until mid 1825, when John Lee, younger brother to Isaac, arrived from New Jersey. On January 13, 1826, Isaac announced the new business association, commenting, "From the knowledge of the senior partner in the business, they have no hesitation in warranting their work equal to any in their line in the Western Country." By 1829 Isaac was on his own again; he probably remained in Cincinnati for a while following the disastrous flood of 1832.[183]

Like Lee, Philip Skinner formed a partnership with a brother, Corson C., in 1826. With the possible exception of a short break in 1828, the brothers appear to have remained together until 1832. A notice of May 1, 1828, refers in passing to another business arrangement while concentrating on recovering the cost of two purloined chairs:

THE person I saw, on the evening of the 28th April, going down Columbia street, opposite the theatre, dressed in blue clothes, umbrella under his arm, carrying two green windsors chairs, is requested to call at *Skinner & Stewarts* ware room, where they were taken from, and settle for them, to save himself from being exposed to the public. Let him take this as a warning.

 PHILIP SKINNER.

By August the brothers had introduced fancy Grecian pier tables and sofas to their line. Their fancy chairs were cane- or rush-bottomed, some constructed of curled maple. The next year the firm added "Stuffed"-seat chairs. The establishment was near the "Public Landing," where the brothers could take full advantage of the river trade to supply

steamboats, hotels, private customers, and warerooms in other communities. The flood of 1832, the worst in memory on the Ohio, apparently ruined their chair factory, although the building still stood. That disaster and the ensuing cholera epidemic completely disrupted Cincinnati's trade. Corson Skinner left the city; Philip continued more modestly as a materials supplier at locations away from the waterfront before also departing.[184]

After terminating his partnership with Isaac Lee in 1820, Jonathan Young probably worked alone for a while. Sometime between publication of the 1825 directory and July 18, 1828, Young and Nicholas Lanning, chairmaker from New Jersey, were business associates. A termination notice was published on the last-named date. Lanning went on to Kentucky, and Young stayed in Cincinnati several years longer. By the early 1830s much of the local chairmaking workforce, including the turners and ornamental painters, was concentrated in a few large shops. This was in contrast to the small two-partner establishments that had flourished earlier. Two-fifths of the men listed in the 1831 directory can be identified as workers rather than masters, through their place of employment or boardinghouse addresses. Four men worked at the fancy- and Windsor-chair manufactory of Charles W. James.[185]

James, who came to Cincinnati from Philadelphia, appears to have maintained connections with the East. In May 1828 he took over Nathan Crowell's site at Fourth and Sycamore streets as a "Chair Factory." From that year until 1830 James advertised "extensively," offering "Grecian, Fancy and Windsor Chairs, all warranted good, and of the most modern Eastern and Western Patterns." A receipt for fancy chairs purchased from James by a private customer at Cincinnati is dated December 31, 1831. After the disastrous years of the early 1830s, James sold his Cincinnati business to Jonathan Mullen, a former employee, and went to work as agent and collector for a Cincinnati publishing house.[186]

Transfer of the James chair factory at the corner of Fourth and Sycamore streets to Jonathan Mullen and William Cowperthwaite occurred sometime during final preparation of the 1834 directory. That volume contains a listing for James but none for the purchasers; however, the new owners were able to insert a full-page pictorial advertisement at the front of the directory. The cuts, used by others in the city, were standard throughout the trade: a Grecian side chair with roll top, cane seat, and sabre legs; and a fancy slat-top, ball-back, rush-seat side chair. Mullen was born in Pennsylvania, possibly at Philadelphia; Cowperthwaite is an old New York name. In the 1831 directory Mullen is called a chairmaker, and Cowperthwaite, a chair painter. At the printing of the 1836 volume, Mullen conducted the business alone, and Cowperthwaite appears to have left town. A local historian has written that the industrious Mullen developed his business into one of the foremost establishments in the city despite the natural disasters of the early 1830s—and, presumably, the chaos created by the Panic of 1837. The fancy- and Windsor-chair making business had become a family affair by 1840, when the directory lists three others of the Mullen surname at the factory or at the same residential address: Mrs. Ann Mullen, chair caner; James, chair painter; and William, chairmaker.[187]

The same volume contains the names of eight other workmen identified as Mullen employees. These are John T. Goodrich, chairmaker from Connecticut; Joseph Harrison, a native-born chair painter, John Muller, chair ornamenter from Pennsylvania; Robert Pette and Benjamin G. Thomas, chairmakers from New Jersey and Vermont, respectively; William Wales, a chairmaker from England; and Robert Zebold, a chairmaker from Maryland. The last-named man may be the P. Zebold who made chairs in Washington from about 1828 to 1834. Also working at Mullen's factory as a chairmaker was James Ayres, former employee and kinsman of Jacob Roll. Mullen's advertisement in the 1840 directory is a cooperative promotional piece sponsored jointly by all three occupants of the building at Fourth and Sycamore streets; the other two proprietors were a cabinetmaker and a mattressmaker (fig. 8-25). Located only a few blocks from the public landing on the Ohio River, the complex was convenient for private and commercial customers alike. During the 1840s or earlier the Mullen factory began to supplement

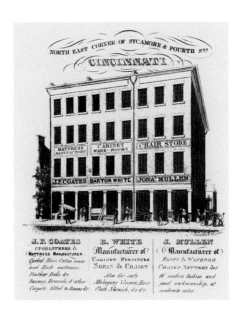

Fig. 8-25 Advertisement of Jonathan Mullen. From David Henry Shaffer, *Cincinnati, Covington, Newport, and Fulton Directory for 1840* (Cincinnati, Oh.: J. B. and R. P. Donogh, 1839), facing p. 297. (Photo, American Antiquarian Society, Worcester, Mass.)

its Windsor- and fancy-chair production with mahogany, black walnut, cherry, and curled maple seating. By 1853 Mullen had added cabinetware. At the chairmaker's death in 1856 no less a figure than Frederick Rammelsberg, a leading Cincinnati cabinetmaker, was one of the sureties for the administration bond.[188]

Craft life in Cincinnati was in a state of continual flux as the commercially prominent city attracted a host of hopeful entrepeneurs. Some artisans had a run of bad luck and moved on; others, like Mullen, enjoyed success. Representative of the first group are David Gordon and William Matthews, who are listed independently in the 1831 directory. The flood of 1832 may have encouraged both to leave Cincinnati, since their names are not listed in the 1834 directory. Gordon worked in St. Louis in 1836 and was in Louisville by 1838. Matthews moved on to Richmond, Indiana, where he had formed a partnership by 1834. The successful ones included Robert Moore and Robert Mitchell, who both emigrated to Cincinnati from Ireland, the first via Canada, the second from Indiana. Both, apparently, were cabinetmakers by trade, gaining or completing their training in Cincinnati during the 1830s. Mitchell worked on his own between 1836 and 1840 before forming a partnership with Moore. Their first advertisement, of November 1840, identifies them as furniture and chair manufacturers; a notice the following year features their Windsor- and fancy-chair production. The business association was dissolved in February 1844, and a few years later Mitchell joined forces with Frederick Rammelsberg. The Mitchell and Rammelsberg firm achieved some prominence before Rammelsberg's death in 1863. John Mitchell's stenciled name and address have been found on the bottom of a late, low-back Windsor armchair dating well into the 1840s or 1850s; the chair has turned members centered by ball-shaped elements. Mitchell operated a wholesale chair manufactory during the third quarter of the century, if not earlier. Meanwhile, Robert Moore served in the Mexican War and achieved the rank of lieutenant colonel in the Civil War. He married well and eventually became mayor of the city of Cincinnati (1877).[189]

Cincinnati became a great and thriving city during the 1830s. The flood and cholera epidemic were only temporary setbacks. The population grew from about 25,000 in 1830 to more than 46,000 in 1840; by 1847 it had doubled again. In 1833 Carl David Arfwedson was amazed to find that in just twenty-five years Cincinnati had "sprung up from nothing to be a place of great consequence." He marveled as he looked around him at the city's "three thousand houses, gardens and hills, churches and public buildings, its smoking manufactories and numerous wharfs, its active trade and [the] bustle of hundreds of waggons and carts." During a residence in Cincinnati between 1828 and 1830, Mrs. Frances Trollope often saw fifty steamboats at the landing at one time "and still half the wharf was unoccupied." By 1836, the year Enoch V. Kerr and David J. Westerfield formed a partnership, the annual value of chairs manufactured in the city was $94,300. The cabinetmakers were doing a $294,000 business.[190]

Kerr, a native of Pennsylvania, was in Cincinnati by 1830; Westerfield arrived sometime in 1834–35, following a two-year stint as a chairmaker in New York City. Kerr was first associated with William Ross and John Geyer from February 1830 in a concern called the Western Chair Manufactory. A manuscript bill for a "Table Chair," possibly a child's highchair, exists for this firm. Kerr withdrew from the business about October 1833, at which time Ross and Geyer announced that they had "purchased the entire stock in the . . . establishment." Following the partnership with Westerfield, Kerr went into the grocery business.[191]

Both Ross and Geyer were Maryland natives. Their business relationship was productive and lasted until 1845. The establishment was similar to that of Jonathan Mullen although probably more extensive. The 1840 directory identifies a dozen employees, eight of them chairmakers, and four, chair ornamenters. The group represented natives of Ohio, Pennsylvania, Maryland, New Jersey, and New York. Three individuals in particular bear mentioning. One is Jacob Roll, who had begun many years earlier in his own business but was ruined by the depression of 1820–22 and forced to sell out; he died in 1849. The other two individuals are of interest because of actual or presumed

family ties with better known chairmakers. Samuel Geyer from Maryland was brother to one of the proprietors, and Abraham Rose from New Jersey may have been a kinsman of Ebenezer P. Rose, a Windsor-chair maker of Trenton. Ross and Geyer bought out the cabinetmaking firm of Andrew McAlpin in 1841 and thereafter produced cabinetwork as well. Ross left the firm in 1845, and Geyer continued until 1866 when he removed to St. Louis, Missouri, where he spent the last twelve years of his life.[192]

Both the Ross and Geyer and the Mullen manufactories were of substantial size, but they were not the only large chairmaking establishments that flourished in Cincinnati during the 1840s. John Pfaff, a Philadelphia native who arrived in the city in 1839, was involved in business by 1840; he introduced steam power in 1844. Pfaff eventually headed the Great Western Varnish Company. Another manufacturer who introduced steam power was George W. Coddington. His chair factory, established in 1843, was located in a six-story building by 1851 and fitted with a full range of machinery for completing all mechanical processes preliminary to framing. Charles Cist, a local historian, credited the firm with an annual production of 180,000 chairs in 1851. He noted that mechanization generally had reduced the average local price of a dozen chairs by two-thirds over a period of twelve to fifteen years. At peak times Coddington's factory employed as many as 180 workers. Large markets existed in the South, Southwest, and Northwest. As Cist reported, Coddington's chairs "have entirely driven out the eastern article, their quality and price rendering them more acceptable."[193]

Southwestern Ohio

From the 1820s on residents of southwestern Ohio felt the increasing influence of Cincinnati in their economic lives; to some it was a benefit, to others, a disadvantage. Chairmakers were cognizant of the patterns, decoration, and prices at this rising center. Ideas and information were transmitted in the normal course of trade and business and by the resettling of city craftsmen elsewhere in the area. For example, Jacob Roll furnished country turners with patterns, or models, to copy, as indicated in his statement for the 1820 manufacturing census.

The manufacturing census of 1820 identifies three members of the Ross family as woodworkers in Saint Clair Township, Butler County, near Cincinnati. One was a chairmaker who had one apprentice and sold fancy and Windsor chairs to the value of $1,000 annually. Demand was good, but money scarce. At Eaton, Preble County, the firm of Sayres and Donohoe established a chairmaking shop in 1839. The advertisement describes an up-to-date facility where a horse-powered lathe was in operation. Knowledge of popular decoration is demonstrated in their promotion of painted imitations of both wood and marble.[194]

Clark County was the origin of documented seating made by William Coles of Springfield. As a county seat, the village offered an excellent business opportunity for an energetic craftsman in the postrecession years of the 1820s. It was advantageously situated west of Columbus on the National Road in a region well watered by the Mad River and its tributaries. Surrounding the community were more than twenty mill seats. Coles came to Springfield from New York City at about age thirty and in July 1833 formed a partnership with J. Francis Spencer. The two men produced chairs and cabinetwork for about a year, possibly with the help of "Two Smart, Active Boys, as apprentices," for whom they advertised. Coles continued a productive career, adding undertaking to the business in 1839. Area facilities, such as the Mad River Mills, provided a convenient source of raw materials. Here, Coles purchased lumber and on one occasion "625 chair legs." When his sons joined the firm in the 1850s there were about eight workmen employed in the business.[195]

Three chairs, two with plank seats (figs. **8-26, 8-27**) and one with caning, are documented to the Coles shop. The fancy chair has a New England-type back; the crest is similar to figure 7-22, with a variant midslat of peaked rectangular form attached to the posts by circular "buttons." The leg pattern follows that of figures 8-26 and 8-27 and may have continued in use for as long as fifteen years, as suggested by the Windsor-chair

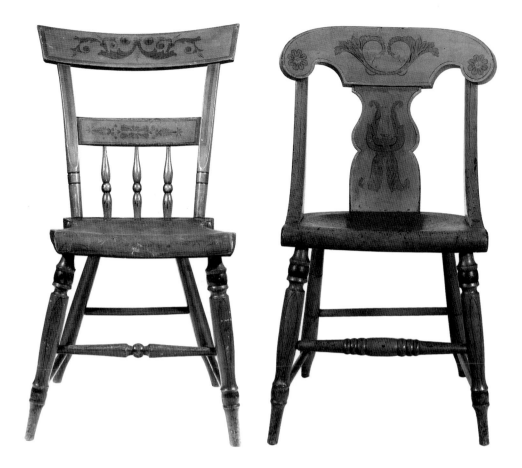

Fig. 8-26 Tablet-top Windsor side chair, William Coles (stencil), Springfield, Oh., 1840–50. Yellow poplar (seat) with maple; H. 32″, W. 17″, D. 15″; dark tan ground with medium and dark brown. (Shari Knight collection: Photo, Columbus Museum of Art, Columbus, Oh.)

Fig. 8-27 Crown-top, splat-back Windsor side chair, William Coles (stencil), Springfield, Oh., 1845–55. H. 31¾″, W. 20½″, D. 23″; greenish-tan ground with light and dark brown and gilt. (Miami Purchase Association for Historic Preservation, Cincinnati, Oh.: Photo, Columbus Museum of Art, Columbus, Oh.)

backs (fig. 8-27 the later of the two) and reinforced by the presence of name stencils of different format on the seats. The heavy character of the short spindles and front stretcher in the Windsor of figure 8-26 places the chair in the 1840s. The broad, tablet top is one first popularized in Baltimore chairmaking (figs. 4-14, 4-16); the turned front legs derive from the same source (figs. 4-19, 4-20), possibly by way of Pennsylvania (figs. 3-158, 3-159). Coles's second design is less successful aesthetically because of its extreme breadth and particular combination of elements (fig. 8-27). The thick front stretcher, the back features, and the use of a different name stencil all suggest a later date. Again Maryland influence is prominent. Forward-sweeping back posts attached to the plank sides were popular in Baltimore chairmaking by the late 1820s (figs. 4-16, 4-17); even closer models are seen in central Pennsylvania work (pl. 16). The pattern is based loosely on a classical revival design known in Europe from the beginning of the century (fig. 3-164). The top piece is that which evolved in later interpretations of the Boston rocking chair (fig. 7-92) and may owe as much to New England work as to that of the Middle Atlantic region.

South of Springfield, Dayton and Xenia, the seats of Montgomery and Greene counties, had resident chairmakers from the 1810s. Dayton was a community of almost 3,000 in 1830, and its population had more than doubled by 1840. Encouraging regional growth were local deposits of limestone, an abundance of streams to supply waterpower, and the development of a good system of turnpike roads.[196]

John Mitton advertised from Dayton for a runaway apprentice in 1813. Perhaps impatient with the early pace of business, he removed to Xenia sometime before 1820. A Dayton contemporary, Aaron Richardson, likely began as a wheelwright but by June 1818 announced as a chairmaker. He was still manufacturing fancy and Windsor seating at his shop a few doors from the courthouse in 1829, taking barter in payment when necessary but advising that cash was "always acceptable." Moses Hatfield came to Ohio from western (West) Virginia; his Dayton advertisements commenced in 1817. Hatfield was a man of enterprise and by 1827 had established two branch locations northwest of Dayton at Union and Greenville. Hatfield died in 1835 at age fifty-five, probably sud-

denly, since his inventory describes a shop in active production. Appraisers found almost 11,000 chair parts. Framed rush- and plank-bottom chais were in several states of completion, ranging from "in the white" to "primed" and "finished." Both straight and bent backs were in production, with "scroll top" and "slat back" patterns prevailing. The shop also produced other forms, including writing and rocking chairs, settees, children's seating, stools, and spinning wheels. Five workbenches and three grindstones for sharpening tools speak to the establishment's capabilities. Hatfield likely engrossed most of the local chair trade, making it difficult for outsiders to gain or maintain a foothold.[197]

Xenia, equidistant from Cincinnati and Columbus, had its start with Dayton. By comparison, growth was moderate, and the population stood at only 1,400 in 1840. Consequently, local chairmaking may have been sporadic. Daniel Day began in 1825, when he announced prices for sets of seating, probably comprising six chairs each: "fancy chairs $20.00; half-fancy $12; mock-fancy $9; and common chairs $6.00." The first two groups likely had rush seats, the latter two, plank bottoms. Samuel Binckley followed in 1829 and also practiced house painting. George Monroe, a native of Scotland, likely trained in the Xenia furniture shop of his father, David Monroe. He married in 1829, although the first evidence of his independent woodworking occurs only in 1850, when he operated a small chair factory. His younger brother James may have worked with him.[198]

The county seats of Lebanon and Wilmington in Warren and Clinton counties south of Xenia were closer to Cincinnati. Lebanon, only twenty-eight miles from the river city, was connected to it by a turnpike road, while other thoroughfares extended to Dayton and Columbus. In time railroad and canal transportation was available. Light industry was established early. Edmund Geoghagen first advertised as a Windsor-chair maker in 1823; in the summer of 1829, he announced his partnership with Samuel F. Yeoman. At that time he occupied a Mulberry Street shop "opposite Mr. Wood and Boyd's wollen factory." By the time Yeoman sold chairs "at Cincinnati prices" in 1830, the business association had already been terminated. George B. Moore, who pursued business some twenty-odd miles to the east at Wilmington in the mid 1820s, offered "a bargain" to "those who will pay cash in hand."[199]

Chillicothe and South

Portsmouth, the seat of Scioto County, enjoyed an advantageous situation for trade at the juncture of the Scioto and Ohio rivers. The furniture business of Levi McDougle reflects local prerecession prosperity in 1820 when the craftsman gave employ to four journeymen and an apprentice. He constructed wheels and reels, chairs and cabinetwork to the value of $1,700 annually. But within six years McDougle had relocated in Indiana. Knittle reports that two men named Cook and Barbee opened shop in town as fancy- and Windsor-chair makers after the recession in 1829.[200]

Chillicothe, situated on an elevated plain above the Scioto River forty-five miles north of the Ohio, was the seat of Ross County and a business center from an early date. The government for the Northwest Territory located there briefly in the early nineteenth century. The state constitutional convention met there in 1802, and the state legislature convened there on and off until Columbus became the permanent state capital in 1816. The population was about 1,200 in 1807. James Phillips settled in Chillicothe in 1798. Two years later he advertised for a journeyman Windsor-chair maker "or a Lad who understands turning and can produce good recommendations." When the new statehouse was ready for occupancy in 1802, the purchasing agents knew where to turn for furnishings. The legislature ordered three dozen chairs from Phillips, and the county court of quarter sessions, which met in the same building, purchased twenty-four Windsors at $2 apiece. Phillips's business must have flourished for years, with public officials and other individuals frequently in town. Phillips took George Hoffman as an apprentice in 1812; three years later the chairmaker formed a partnership with John D. Cochran. On November 30, 1815, the men advertised "Windsor and Spindle Chairs"

available for cash or country produce. The partners may have worked together until Hoffman completed his training in 1818 and Phillips gave up chairmaking in favor of tavernkeeping. Cochran, if he had not already left the area, then moved to Natchez, Mississippi, where he advertised in 1819. By that time Chillicothe was no longer the state capital, and the chair business may no longer have offered a steady livelihood. Phillips continued in his new business until it failed in 1829. Hoffman established a chair business in 1824 and continued for forty years.[201]

Hector H. Sanford emigrated from the District of Columbia to Chillicothe at age twenty-five. In 1805 he advertised his "CHAIR MANUFACTORY" at the sign of the Windsor chair, where he offered bow-back and square-back Windsors along with "gilt ornamented" fancy seating. Settees, rocking chairs, and children's seating rounded out production. Sanford was also prepared to refurbish old chairs and to paint and letter signs. The craftsman apparently remained in the area until his death in 1837, but at some point he gave up chairmaking for the ministry.[202]

Another chairmaker who came to Chillicothe from the East was Thomas Renshaw. He had worked at Georgetown on the Potomac in 1801 and at Baltimore a decade later. In 1816 Renshaw formed a business connection with Henry May, who eight years earlier had advertised in Chillicothe as a wheelwright. The partners' chairmaking notice of 1816 provides insights into available patterns and hints at the influences shaping chair production in Chillicothe. As expected, Renshaw's background figured prominently in the announcement: "From the experience of the latter partner in the City of Baltimore, they flatter themselves they can furnish Work in a stile equal to any imported." Here, too, is evidence that merchant traffic on the Ohio and Scioto was already supplying the town with chairs from the East. The partners went on to itemize "an extensive variety of Bend Backs, Broad Tops with landscapes, and plain chairs of every description." Their potential audience would have understood the terms. The broad-top pattern came out of Baltimore (fig. 4-12); construction of the bend-back probably demonstrates Renshaw's familiarity with New York chairmaking (fig. 5-37). The partners solicited country trade and promised that chairs sent any distance would be "put up so as to receive no injury from carriage."[203]

The same year two brothers from Maine introduced New England influence into the local chair trade—if it was not already present. Joseph T. and Samuel Moore of North Yarmouth opened a Chillicothe chairmaking shop in 1816, which they continued to operate together until 1823. When the brothers dissolved their partnership, Joseph constructed fancy and Windsor chairs on his own and executed ornamental painting and gilding. The local population at that time stood at about 2,500. In May 1824 Joseph Moore announced that he had "formed a connection" with William Y. Emmett. The partners worked together for three years, possibly intermittently, until June 1827 when Emmett continued alone. At one point Emmett supplemented his income by providing instruction in vocal music, renting a room in the courthouse for this activity. Meanwhile, Joseph Moore, who had advertised independently as a "Portrait Painter" as early as 1826, devoted himself to this pursuit full time. Many portraits dating from the 1820s remain in the Chillicothe area.[204]

William Emmett made Windsor and fancy chairs in his shop "Opposite the Public Buildings" in Chillicothe until September 1835, when he and John E. Mills joined forces. Their services ranged from chairmaking and cabinetmaking to house painting, sign painting, paperhanging, and glazing. Within the year Emmett's property was offered at sheriff's sale to satisfy several outstanding debts; the event may have prompted his removal to Circleville. In later years Emmett was a Universalist minister. For his part, Mills formed another partnership about January 1838 with Joshua Seney to manufacture cabinetwork and chairs in the shop formerly occupied by Emmett. Mills was on his own again in September 1844, when he illustrated his chair manufactory notice with a balloon-style, splat-back joined chair, a type that later influenced the development of a related Windsor (fig. 3-149). Mills enjoyed an advantageous location, "opposite the Market-house," a regular rendezvous of householders in this growing city, which now

had a population of about 5,000. With their marketing completed, shoppers could drop by for a "look" at his stock, which he priced "to suit the times."[205]

Henry Shepherd set up in Chillicothe as a cabinetmaker in May 1833. The business must have struggled from the first, a situation that prompted Shepherd to enter a partnership with Nathan Durfee. That relationship ended in March 1834, and Shepherd continued alone, augmenting his cabinet production with the manufacture of fancy and Windsor chairs. He spoke of "experienced workmen," an indication that his operation was of some size. Shepherd continued to advertise until July 25, 1835, one week before the publication of a notice identifying him as an "absconding debtor" whose property was being seized by writ of attachment. By the end of August a William Shepherd (relationship unknown) had taken over the shop, presumably after satisfying the terms of the writ.[206]

Northwestern Ohio

East Liberty, Logan County, was just a small village in 1831 when Thomas F. McAden sold bent-back chairs to a local resident. Subsequent accounts record the production of companion settees and other seating in ball-back and common styles. Posts in the common chairs, although canted backward in the sockets, were straight rather than bent. In Seneca County in the north, William Campbell, a Pennsylvanian, settled at the village of Tiffin in the 1830s. He pursued the dual trades of cabinetmaker and chairmaker and offered ornamental painting as a sideline. Frederick Kridler, who provided local competition during the 1840s, supplemented his chair production with settees and rockers.[207]

Toledo, on the Maumee River at the western end of Lake Erie, had been incorporated for only a year in 1837 when William R. Hoyt advertised in this community of about 1,000 inhabitants. His warerooms were located near the corner of Summit and Locust streets, an area marked by "stores, warehouses and dwellings . . . densely packed together." Hoyt retailed cabinetware and chairs at prices comparable to those at Cleveland and Buffalo, lake cities accessible to Toledo via steamboat. In the same year Maumee, the seat of Lucas County, located fifteen miles up the Maumee River at the head of navigation, was the site of James Creed and Henry Hale's cabinetmaking and chairmaking business. From their shop in Mechanic's Row the partners sold Grecian, fancy, Windsor, and common chairs supplemented by settees, rockers, and children's furniture. Perhaps even then one of the two sawmills known to be standing in the community a decade later supplied the partners with the raw materials of their trade.[208]

INDIANA

In many ways the developing chair industry in Indiana paralleled that of Ohio, aside from Cincinnati, although production did not reach its stride until a decade or more later than in Ohio. Betty Lawson Walters has identified some 2,000 woodworking craftsmen who produced furniture between 1793 and 1850. The 1820 manufacturing census provides a comprehensive first listing of state chairmakers, but major production was still a decade away. Information pinpoints principal activity in four areas: the southeastern border adjacent to Ohio, where influence flowed from Cincinnati; the south-central Ohio River region opposite Louisville, Kentucky, extending north toward the state center; the capital at Indianapolis north to the Michigan border; and the western boundary with Illinois along the Wabash River. Indiana was set off from the Northwest Territory in 1800 but achieved statehood only in 1816, thirteen years after Ohio joined the Union. In 1820 the state's population stood at 147,000, far short of Ohio's 581,000. Many areas were removed from the avenues of commerce. The well-being of the family group and the development of a basic means of subsistence were of prime importance to most settlers during the early 1800s. Walters surveyed probate inventories for Fayette County, which lies east of Indianapolis and fifty miles northwest of Cincinnati, and found that before 1833 household furnishings on the average were

quite sparse. The popularly priced, durable plank-seat Windsor proved ideal for the frontier in transition.[209]

The Southeastern Border Region

Rising Sun, located on the Ohio River only thirty-six miles below Cincinnati, was part of a prosperous area by the mid 1830s. Included among the town's manufacturing establishments were two stoneware potteries, four cabinet shops, and a chair factory— the last of these apparently under the direction of William H. Mapes. Although the chairmaker's earliest known advertisement dates to September 1838, he began his notice by thanking customers for their "past favors," thereby documenting his earlier entry into business. At his "old stand" on Main Street Mapes was prepared to make "Family Chairs in all their variety," that is, fancy, Windsor, and common slat-back seating. As requested, he supplied settees, sewing chairs, and writing chairs. Assuring customers that he used only the "best kind of stock" and employed none but "first class . . . workmen," he offered "accommodating" terms. In 1841 Mapes advertised several new products, including Boston rocking chairs and sewing chairs with drawers. There were also "children's chairs of all description," although these probably were available earlier as "bespoke" work. There is no hint of Mapes's birthplace, but the surname occurs earlier among chair-makers in Monmouth County, New Jersey, New York City, and Long Island. Sometime between 1833 and 1838 Mapes was partner to a man named Armstrong, possibly Cyrus, who by 1839 was a chair and cabinet manufacturer in Lawrenceburg, fourteen miles east of Rising Sun on the river. Armstrong was producing 3,000 chairs annually by 1850, as well as cabinetware.[210]

Chairmaking in Lawrenceburg is documented from January 30, 1830, when Lucius Taylor advertised the opening of his cabinet and chair shop. His seating selection included Windsor, fancy, and "Split Bottom" chairs, the latter a common utilitarian slat-back type that was often unpainted and unstained. Taylor probably was the same chairmaker who worked at midcentury in Howard County, north of Indianapolis. The 1850 census gives his birthplace as Massachusetts. The year following Taylor's start in business, Nelson Rogers opened a chair manufactory at Lawrenceburg to produce fancy and Windsor seating. Heading his notice was a familiar cut illustrating Grecian and fancy ball-back chairs. William Davidson and Thomas Duffy constructed seating furni-ture in town a few years later; they terminated their partnership on April 9, 1835. Davidson continued alone, producing a general assortment of painted seating, aug-mented by settees and rocking chairs. His shop was opposite Jesse Hunt's Hotel, a good location to catch merchants and river captains coming and going. When business was slow Davidson supplemented his income by house painting. By the early 1840s both Davidson and Duffy had removed to Louisville, Kentucky. William Brown, a cabinet-maker and joiner who had been in Lawrenceburg since 1836, seized the opportunity and stocked his warerooms with a selection of seating furniture. Whether the furniture was of his own construction or imported is unclear.[211]

Brookville, twenty miles from the Ohio River in Franklin County, was a settlement consisting only of a few cabins in 1808. By May 1820, when Edward H. Hudson announced the removal of his chair shop to the public square, the town had made considerable progress. *The Western Gazetteer* of 1817 noted that already a silversmith, two cabinetmakers, and a chairmaker (Hudson) were at work. Soon to join the woodwork-ing force was Joseph Meeks of the New York family of cabinetmakers. He arrived in Brookville in 1818 and first advertised as a newcomer in February 1819. By 1822 Hudson had augmented his Windsor chair and ornamental sign-painting business with the manufacture of spinning wheels. It may have been in his shop that Seth Sumpter was temporarily employed when he left town in 1824 with bills unpaid:

LOOK OUT FOR WOLVES IN SHEEP'S CLOTHING. . . . Seth Sumpter, A chairmaker by trade, boarded with me for five weeks past, and promised that I should have my demand for . . . expenses, knowing his employers to be men of stability, every attention was rendered unto him: Notwithstanding the aforesaid Seth, has absconded and to my loss ten dollars.[212]

After Hudson left Brookville for a new location in Wayne County, several chair-makers took up the slack. Franklin McGinnis continued to produce fancy and common chairs at his manufactory. He may have left town by September 14, 1838, when William Hartley and James E. Wheat first advertised their Brookville Chair Manufactory near the courthouse, where they offered painted seating "of the latest Cincinnati fashions." The partners executed all kinds of painting, including imitation wood graining. When the advertisement was repeated the following January, Wheat had a new partner, Jasper Longe. This association was no more successful than the first, and Wheat was conduct-ing business alone by July. He had come to Brookville from previous working experience in Indianapolis.[213]

There was considerable activity in Richmond from the 1820s on. Area residents enjoyed the services of a full range of craftsmen, including several cabinetmakers. Of the two local chairmakers in 1833, one may have been William Matthews, who entered a partnership with I. L. Johnston the following year. Matthews may have worked in Cincinnati at the time of the flood. The brothers Elijah and Griffith D. Githens, natives of New Jersey, arrived in 1834 and announced that they had "permanently established themselves" locally in the Windsor- and fancy-chair making business. Elijah had pre-vious working experience in Dayton, Ohio. As partnerships went, the brothers' associa-tion survived a long time. Elijah withdrew in 1848 for health reasons and opened a grocery store. Griffith continued chairmaking into the second half of the century; his production reached 100 sets in 1850.[214]

The South-Central Region

The 1820 manufacturing census reported on several woodworking facilities in Clark County about fifteen miles above Louisville, Kentucky, along the Ohio River. Two men and a pair of apprentices labored in a Charlestown establishment, where they produced finished chair stock on two shop lathes. General painting was a sideline. The town also supported another chairmaker, a turner, and several cabinetmakers. Levi McDougle, a Maryland native, worked in neighboring New Albany as early as January 1826 and may have come directly to the river town from Portsmouth, Ohio, where a sizable manufac-tory had been under his direction in 1820. The depression probably forced him out of business. In New Albany McDougle constructed Windsor chairs not "inferior to any made in Louisville." During the next decade the chairmaker led a semi-itinerant life. He announced his return to New Albany in June 1828, and an 1838 advertisement from Corydon, fifteen miles away, suggests he also had worked there once before. McDougle may have had serious competition from Levi Cobb, who opened a Windsor-chair manufactory at New Albany in December 1826 and accepted "Country produce . . . at market prices, in payment for Chairs." The following March the craftsman announced an auction of "Several Sets of New Plain and Fancy Windsor Chairs" at the markethouse. Rather than disposing of surplus stock, Cobb likely was deliberately exposing his products to public view in the hope of gaining new customers.[215]

John Rice of Corydon may have produced cabinetwork for almost two years before advertising on June 7, 1838, that he had branched into chairmaking and was ready to supply the community with Windsor, rocking, and sewing chairs. This was only three months after Levi McDougle had revived a similar business in town. It is likely that neither man fared well. Although Corydon had been the state capital briefly before the seat of government moved to Indianapolis in the early 1820s, the community was still not much more than a village in the late 1830s. The town of Salem, seat of Washington County, twenty-five miles to the north, may have shared in the area's prosperity before the 1820 depression. John McCoullouch (McCullouch) constructed Windsor chairs and painted signs and houses in a one-man shop. He reported good sales and a ready market in 1820. A similar establishment owned by James Kennedy was temporarily or perma-nently closed when the census was made, and the two local cabinetmakers were making few sales. However, the presence of four woodworking shops speaks of the former prosperity of the place. In time McCoullouch himself was forced to close and go

elsewhere, but an advertisement of 1824 tells of his return to Salem and the revival of his old business. He may have made Salem his "permanent residence," as stated in the notice. Perhaps with tongue in cheek, he spoke of "long experience . . . in the East and Western country," a statement used frequently by chairmakers in the West to enhance their image in the local market.[216]

Indianapolis and the North-Central Region

Indianapolis has been called "the most successful of the government towns in the Old Northwest." The state legislature chose the central location in 1820; the following year commissioners laid out the town "on an expanse of trees and underbrush." Among settlers' cabins in 1822 there was only one two-story house. In 1823 about ninety families were in residence, and already the town had four furniture makers. A local editor optimistically described the capital as being "in a rapid state of improvements." In 1828 the population stood above 1,000—greater after only eight years of growth than those of some county seats and villages established several decades earlier. At that date the town contained "25 brick, 60 frame, and about 80 hewn log houses and cabins" and several public and commercial buildings, although "stumps still dotted the streets."[217]

Samuel S. Rooker, a chairmaker and painter from Tennessee, arrived in 1822 among the first settlers in Indianapolis. In 1828 he and Jesse Grace teamed temporarily as partners and solicited orders for "Windsor Chairs and turning of every description." Within two years Rooker had met with sufficient success to venture a turning lathe "at Gen. [John] Tipton's Mill" in Logansport sixty miles to the north. He appears to have operated that facility only part time or with the assistance of hired help. Grace was doing well in Indianapolis, where he offered Windsor chairs, settees, and "Cradle Settees" while searching for an apprentice and journeyman. Rooker continued to gear his primary business to the expanding needs of the developing capital. By July 1835 he occupied a new wareroom and chair manufactory, where he imported a supply of materials from New York that permitted him "to execute fancy work in a style superior to any before offered" in town.[218]

Other furniture makers also tapped the local market. Andrew McClure opened his Indianapolis Chair Manufactory in spring 1834, and before the following January he had added cabinet furniture to his stock and taken James E. Wheat as a partner. But the firm of A. McClure and Company had a short life; it was dissolved in June, and Wheat, not McClure, took over "sole management." Wheat offered "parlor sets of every kind . . . CHAIRS, SETTEES, &c. at short notice." McClure probably moved north, and Wheat himself had resettled in Brookville by 1838. Joseph I. Stretcher opened a chair manufactory near the bank in December 1836, when he advertised for two apprentices. By autumn 1841 he had occupied a two-story building on Washington Street almost opposite the post office and had named his establishment the Eagle Chair Factory. He enlarged and varied his stock: black walnut chairs, with or without upholstery; caned, "Boston," Windsor, and upholstered rocking chairs; caned maple stools "for Hotels or Canal Boats"; large writing chairs; cane and flag-seat Grecian chairs; scroll-top or slat-back Windsors; children's chairs; and settees to suit any pattern. In January 1842 Stretcher searched for a journeyman cabinetmaker and a turner.[219]

Areas west and north of Indianapolis developed as the frontier pushed forward. Lucius Taylor, who in 1830 was located at Lawrenceburg near Cincinnati, pursued the chairmaking trade at midcentury in Center Township, Howard County, about fifty miles north of Indianapolis. Still farther north Corson Skinner eventually settled in Peru after fleeing flood-torn Cincinnati about 1832. He is named in the 1850 census. Logansport, fifteen miles due west and on the fringes of settlement when founded in 1828, became the seat of Cass County a year later. During the first twelve months forty buildings were erected in the new town, four of them, including a Masonic Hall, constructed of brick. Logansport was the site chosen by Samuel Rooker of Indianapolis for his frontier turning service at Tipton's Mill in 1830. In advertising to perform "any kind of turning from one to twelve inches," Rooker advised "Persons wishing work . . . to

call on Wednesdays and Saturdays." Leaving no stone unturned, he concluded: "He is also prepared to furnish those who wish to set comfortable with Chairs of a superior quality. House and Sign painting done on moderate terms."[220]

The state legislature established Tippecanoe County northwest of Indianapolis in 1826, and Lafayette on the Wabash became the seat. The first steamboat arrived in town the same year. Like Logansport, the community developed rapidly. Benjamin Beckner's January 1839 advertisement for a Windsor chair shop is the first evidence of town chairmaking, but there probably were earlier practitioners. Within a month William Bullock had taken over the premises formerly occupied by a cabinetmaker and opened a chair and spinning-wheel manufactory. This appears to be the same William Bullock who had worked in Carlisle, Pennsylvania, in the 1820s and was still practicing his trade in the Cumberland Valley at Shippensburg in 1837. Bullock's Indiana production likely reflected his training in central Pennsylvania, where there was strong influence from Baltimore design (fig. 3-157). The Pennsylvania chairmaker stood ready to finish his chairs with "gold and bronze, in the best manner." James Wallace also began his Lafayette career as a chairmaker and painter in 1839. At midcentury, with a staff of two, he produced 1,300 chairs annually.[221]

Mathias Stover established his cabinet and chair factory in 1832 at South Bend, which later became an important center of the U.S. furniture industry. Business at his "well known stand opposite the printing office, on Michigan Street" was "extensive." Beginning in November 1839 Leonard Haines conducted the chair factory at "Stover's Cabinet Shop"; he produced Windsor and flag-bottomed chairs and supplemented this work with paperhanging, sign painting, and house painting. Stover, a trained surveyor as well as a woodworker, also held the post of city engineer.[222]

George Stephens practiced chairmaking at Mishawaka, east of South Bend, beginning in June 1838. Like Stover, he operated a full-service furniture business that included upholstery work. His seating ranged from mahogany to plank-bottom patterns. At Niles, Michigan, only twelve miles north, two chairmakers advertised as that region achieved statehood (January 1837). R. Wilson at the Eagle Chair Shop on Front Street manufactured "the best chairs in the country," according to his July 1836 notice. Competitors Leonard Whitney and William P. Derby had just taken over the Niles Chair Factory when they advertised the next July. Not to be outdone by Wilson, they warranted their chairs "to be equal to any made in Michigan." Both firms undertook house painting and sign painting "on the shortest notice," and provided glazing and paperhanging services as well. Passing through Niles late in 1835, Lambert Hitchcock, the Connecticut chair manufacturer, noted that the community stood at the head of steamboat navigation on the St. Joseph River. This gave local entrepreneurs access to Lake Michigan and the lakeside market. West of South Bend at LaPorte, E. B. Strong from New York City opened a chair warehouse in early summer 1838. There is little doubt that he brought fashionable urban designs to the frontier, since as late as 1837 a New York directory listed an Ellsworth B. Strong, chairmaker. Apparently, there was a good local market for chairs, and Strong's work was well received. By 1850 he and five factory workmen were constructing 1,000 chairs a year, along with cabinet work valued at $3,000.[223]

Wabash Country

The Wabash was an important commercial tributary of the Ohio well before it served to float produce of the Indiana and Illinois territories to southern markets in keelboats. The French had actively pursued the fur trade all through the region. Vincennes in Knox County was a French river post as early as the seventeenth century and had permanent settlers from Canada by 1735. It was an old town compared to the surrounding communities. Vincennes was the capital of the Northwest Territory before that seat moved to Cincinnati in 1790; from 1800 to 1813 it served as the capital of the Indiana Territory. In 1816, the year Indiana entered the Union, the community offered a full range of skilled services, including silversmithing, cabinetry, and chairmaking. The chairmaker probably was Daniel (or David) Moore, who also advertised as a painter. In a notice of July 2,

1814, the artisan announced his start in a house below Graeter's Inn. By October and November he was seeking "a smart active lad between the age of 14 & 16 as an apprentice." Joseph Roseman is documented as being in Vincennes by 1819. There seems little doubt that this is the same individual listed in the 1815 Pittsburgh directory as a chairmaker. Roseman had several interests. He referred to himself as a "WINDSOR and FANCY Chair MAKER" in a December 11, 1819, advertisement, although the purpose of the notice was to obtain "Clean Flax Seed" for which he paid $1 a bushel. The population census of 1820 called him a "manufacturer," perhaps identifying an oilmill where Roseman ground the flaxseed to produce linseed oil.[224]

The names of several Knox County woodworkers are found in the 1820 industrial census, among them that of William McCracken who manufactured Windsor chairs and spinning wheels at his log shop in Washington Township. Late in the 1820s J. Jones established himself in Vincennes to construct chairs and settees "of all sizes," which he sold for cash or "such articles of produce as may suit." Jonathan Smiley followed in 1837. Customers selected from Windsor chairs and settees on hand; rocking chairs were made to order. Production included a great variety of colors and patterns "in the very best style of workmanship."[225]

Steamboats chugged their way up the Wabash to Terre Haute, sixty miles above Vincennes, as early as 1823. The community, built on elevated ground above the river, boasted "about fifty buildings" in addition to stores and craft shops. Enoch Dole probably had just entered business in July 1826, when he advertised his manufactory of fancy and Windsor chairs and settees. Chances are he continued this trade even in 1829–30, when he received a license to operate a tavern; one occupation could supplement the other very nicely. The partners Jamison and Lawrence, who announced the opening of their chair "Factory" on November 2, 1842, were latecomers to Terre Haute. By 1850 Jamison, a native Pennsylvanian, was working in Harrison Township, where he and three men made 1,200 chairs a year valued at $2 apiece.[226]

KENTUCKY

Kentucky entered the union as the first trans-Appalachian state. From the seventeenth century English settlers had viewed the area with a curious eye. Finally, through the provisions of the Treaty of Paris (1763), which terminated the French and Indian War, England came into possession of the frontier regions east of the Mississippi. But settlement did not begin until the immediate prerevolutionary years. Kentucky achieved statehood in 1792, and in the same year Frankfort was selected as the site of the capital. Hemp, grain, and livestock were early regional products; tobacco and cotton culture came later. Several communities along the Ohio River developed as commercial centers, and Lexington, not Frankfort, became the important interior town. Louisville, south of Cincinnati, was the site of the Ohio Falls, where within a distance of a mile and a half the waterway dropped thirty feet, dividing the river into its upper and lower sections. There was sufficient water during all seasons for a light boat to pass with the aid of a pilot; cargo from other vessels required a short portage. A canal bypassing the falls finally opened in 1829. Settlers to Kentucky who arrived by way of the river generally landed at Maysville and from there traveled overland. Log construction prevailed in the early decades of statehood, but by 1817 the *Western Gazetteer* could observe: "In the old settlements of the rich counties, *log houses* have nearly disappeared, and stone, brick, or frame houses of good size and appearance have arisen in their places." By then both commerce and banking had greatly expanded; the latter, however, was unfortunately caught up in the general financial confusion that reigned at the decade's end.[227]

Lexington and the Bluegrass Country
Industry was in a rising state at Lexington by 1800, when local facilities were producing a range of essential products from nails to rope. Thomas Ashe visited a few years later and found 300 houses, many constructed of brick and well furnished, standing on streets that

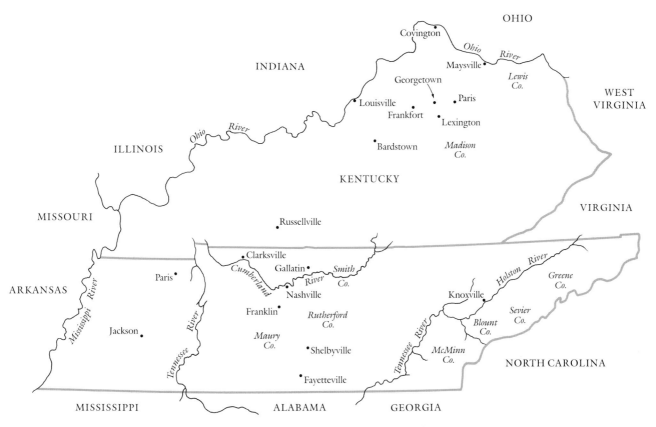

1 inch = 74.9 miles

formed a regular intersecting pattern. The public buildings included a bank, a court-house, and a university. Large-scale merchandising distributed European, eastern, and local manufactured goods throughout a region encompassing Tennessee and the territory north of Kentucky. Merchants received in exchange produce and livestock, which they shipped south to New Orleans.[228]

A visitor to Lexington in 1816 was amazed to discover "as much wealth, and more beauty than can be found in most of the atlantic cities." "Costly brick mansions" were complemented by fifty to sixty "*villas,* or handsome country residences," in the immediate vicinity. These included Ashland, the home of Henry Clay. The city appeared as a thriving cultural center, an "Athens of the West." The population stood at just over 5,000 in 1820. Small manufactories abounded, among them five cabinet shops, as many chairmaking establishments, and facilities for painters. But the cosmopolitan face of Lexington was a sharp contrast to the frontier society of much of the rest of Kentucky.[229]

Robert Holmes is said to have come to Lexington from New Hampshire before 1788, when he became a member of the local militia at the age of twenty-four. His early activity is confirmed in an advertisement of William Ross, boot and shoemaker, who stated in 1792 that he had opened shop "in the house of Robert Holmes, Chairmaker." Three years later Holmes sought an apprentice to the wheel- and chairmaking business; other young men followed in 1803 and 1810. In 1803 the Windsor-chair maker introduced the manufacture of brushes. He paid 1s.3p. per pound for clean hog's bristles and guaranteed better quality products and lower prices than comparable Philadelphia

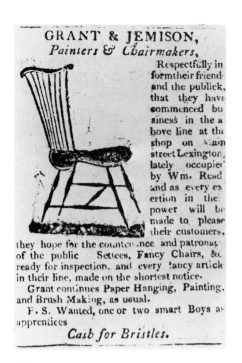

GRANT & JEMISON,
Painters & Chairmakers,

Respectfully inform their friends and the publick, that they have commenced business in the above line at the shop on Main street Lexington, lately occupied by Wm. Read and as every exertion in their power will be made to please their customers, they hope for the countenance and patronage of the public Settees, Fancy Chairs, &c ready for inspection, and every fancy article in their line, made on the shortest notice.

Grant continues Paper Hanging, Painting, and Brush Making, as usual.

F . S. Wanted, one or two smart Boys as apprentices

Cash for Bristles.

Fig. 8-28 Advertisement of (Thomas?) Grant and (?) Jemison. From the *Kentucky Gazette and General Advertiser* (Lexington, Ky.), December 1, 1807. (Photo, Museum of Early Southern Decorative Arts, Winston-Salem, N.C.)

merchandise. Similar advertisements followed in 1805 and 1806. Holmes remained in Lexington until about 1817, when he retired to a farm in Scott County.[230]

William Reed (Reid), a Scotsman, advertised as a chairmaker in 1793; he is listed in the first two city directories of 1806 and 1818. In the latter volume he is designated a Windsor-chair maker. James Har(d)wick advertised in 1794 as a Windsor-chair maker, stating that he gave "full satisfaction" in his work. His career appears to have been short, since he is not listed in the early directories. A published list of Lexington market prices for 1797 indicates that Windsor chairs sold for about $1.67.[231]

Two men named Grant and Jemison first advertised their painting and chairmaking business in 1807 and illustrated the notice with a cut of a bamboo fan-back Windsor (fig. 8-28). This was a pattern that remained popular in many regions into the early nineteenth century. The men were still relative newcomers to the business. First mention of the firm is made in the Lexington directory of 1806. Since the illustrated notice adds paperhanging and brushmaking to Grant's skills, Jemison may have supplied the chair expertise of the firm. Jemison is not recorded individually in the 1806 directory, nor are first names given. A Thomas Grant is called a painter and glazier. Grant married in 1811 and is identified as a painter only in the next published directory, that of 1818.[232]

Windsor-chair maker Isaac Holmes, probably a kinsman of Robert Holmes, worked in Lexington in 1805 and 1806. By January 1807 he was advertising with a partner in Frankfort, the state capital. Holmes probably moved to Frankfort because so many chairmakers were already working in Lexington when he entered business. Perhaps it was Holmes's pending move that encouraged Francis Downing, Jr., to announce as a Windsor-chair maker. Downing also was a house painter and sign painter and offered other services, such as papering, gilding and japanning, looking-glass repair, and profile cutting. Beginning in March 1806, he was prepared to supply Lexington householders with Windsor chairs "of every description and color, painted, japanned and gilt, which has never yet been done in the country." Curiously, in advertisements dating at the year's end, Downing mentioned only his painting business and miscellaneous pursuits. His excursion into Windsor-chair making appears to have been brief and dependent upon the services of a journeyman chairmaker.[233]

A single-bow (rod), square-back Windsor attributed through family descent to Matthias Shryock dates to the same general period. Although the pattern was first introduced around 1800, the thick, squared plank suggests a date closer to 1810. It is possible that the chair was of local manufacture; however the whole question of Shryock's craftsmanship is in doubt, since Lexington directories for 1806 and 1818 list him only as a house carpenter or joiner. The New York style in chairmaking was introduced to the local market by William Challon, who had worked in the eastern metropolis from about 1796 until 1809, following his arrival "from London." By May 1809 Challon was in Lexington, where he advertised his fancy- and Windsor-chair making business and illustrated the notice with a cut of a rush-seat fancy chair. Challon offered a selection of colors—black, white, brown, green, and coquelicot (poppy red)—in combination with gold decoration. For durability his chairs were "highly varnished." By 1818 Challon had formed a partnership with Anthony Gaunt, and together they pursued the chairmaking and painting trades.[234]

Earlier Gaunt had been in partnership with John H. Vos, a painter. Their fancy- and Windsor-chair manufactory had a short life, beginning after November 10, 1812, and closing before May 11, 1813, when Vos advertised alone. Thereafter Vos apparently pursued only the ornamental painter's trade, which he had followed earlier, although he offered the usual fringe services of paperhanging and glazing. Some years after his collaboration with William Challen, Anthony Gaunt formed an association with Jones March, who advertised as a fancy- and Windsor-chair maker. He probably is the same individual as James March, cabinetmaker, whose public notice of 1834 speaks of his fancy- and Windsor-chair manufactory, where mahogany chairs and Boston cane-seat rockers were also available. Contemporary with the Vos and Gaunt partnership was Elijah Warner's wooden clockmaking and cabinetmaking business. Warner died in

comfortable circumstances in 1829; his extensive inventory shows that he either made or dealt in painted seating. Plank-seat, rush, and cane-bottom chairs are enumerated in the inventory, the former including half a dozen each of green chairs and gilt chairs along with "1 Doz yellow Windsor Chairs" and a rocker.[235]

Ringing the city of Lexington are several smaller communities where Windsor-chair making was contemporary with activities in Lexington. Directly south in Madison County, Henry D. Cock is identified as a Windsor-chair maker in 1820. The prosperity of this bluegrass region was remarked on by one traveler who observed the well-cultivated farms and "rich and opulent" farmers. To the north at Paris, seat of Bourbon County, there were several chairmakers in the early nineteenth century. John Curry began as a wheelwright, taking apprentices to this trade as early as 1803. His advertisement of 1818 reveals the growing affluence of local society in retailing "Japanned Windsors with gilded initials on [the] back." A contemporary notice by William A. Dickson offered a large selection of fancy and Windsor chairs, the latter further differentiated between fancy and common types. Dickson exchanged chairs for cash or selected commodities, among them flour and grains, whiskey, animal products, sugar, and linen. He announced that he was accepting such barter until August and willingly gave good market prices. The reasonable conclusion is that Dickson was collecting a shipment of produce for exportation down the Ohio from which he expected to realize even greater profit. The chairmaker was still working at his trade in 1828, when he advertised for an apprentice.[236]

West of Paris at Georgetown, seat of Scott County, English-born Thomas Trador Burns was in the chairmaking, painting, and papering business in 1824. A decade earlier he had focused on house painting, paperhanging, and glazing at Lexington in a building near Robert Holmes's chair shop. One item in Burns's Georgetown advertisement is unusual, considering he did not reside in Frankfort: "Orders for sign painting for the state will be particularly attended to."[237]

Frankfort, the state capital, lies on the Kentucky River, which provided access to the Ohio. Here Isaac Holmes, fresh from Lexington, and a man named Shaw opened a Windsor-chair shop on Main Street in January 1807. Holmes, who was working on his own by May, was still a county resident in 1810. Bardstown, the seat of Nelson County, rivaled Lexington and Louisville as a cultural center. Several academies and a college were located there. John Richey apparently did a reasonable country business in spinning wheels, manufacturing $500 worth annually with the assistance of his great wheel and spring pole lathes. The 1820 manufacturing census reported that while sales were good the establishment was in bad repair. Lewis Evans made chairs in Bardstown a few years later at a shop previously occupied by another chairmaker and wheelmaker. One retailer of Evans's chairs in 1826 advertised his intent to sell them for cash or whiskey, the latter already an important product in the state's economy.[238]

The Ohio River to Louisville, and the Southern Border Region

In Lewis County along the Ohio east of Maysville, Evan Henry served a local rural market. His production of common flag-seat chairs, probably with two-slat backs, was valued at $100 a year. Sales were dull and dwindling at the time of the 1820 manufacturing census. In the town of Maysville, which served to funnel emigrant traffic overland to the West, Henry Cropper and his partner, one Moss, advertised Windsor chairs in July 1828. By the following January Cropper was working alone. Westward along the Ohio at the mouth of Licking River, the town of Covington stood in the shadow of Cincinnati on the opposite shore and even in 1830 numbered only about 700 people. Seneca Jones of Cincinnati appears to have operated a sales outlet there. At his Market Street store he offered a complete line of popular seating—rocking, Grecian, and Windsor chairs, fancy ottomans, and stools—as well as some cabinetware.[239]

Just as Maysville was the principal port on the Ohio River in eastern Kentucky, so Louisville served a similar function in the southwest. The town stood on a seventy-foot eminence one-quarter of a mile above the falls of the Ohio at a distance of 706 miles from

Pittsburgh. Henry Bradshaw Fearon reported a population of between 4,000 and 5,000 in 1817 and noted that building in brick was on the rise. He further commented that while inland Lexington formerly was "the general magnet," property there had become "stationary in value" while at Louisville it was "rising prodigiously." In the fast growing commercial centers of the West the price of labor was high, the banks numerous, and the amount of circulating paper currency "immense." By 1833 Carl David Arfwedson could state emphatically that "Louisville is unquestionably the most flourishing town in Kentucky." The population had risen to more than 10,000.[240]

J. Shallcross, a fancy- and Windsor-chair maker, is the earliest recorded manufacturer of seating furniture in Louisville. He had just purchased a business when he advertised in November 1819 and gave notice that he wanted to employ a journeyman. His acceptance of notes issued by western banks may have been his undoing. G. W. McSwiney and E. Barnes chose 1820 to open a warehouse for the sale of cabinet furniture and chairs. Their seating supplier was Jacob Roll of Cincinnati. All three men were soon caught in the economic upheaval that shook the country beginning later in the year. That calamity may have caused a hiatus in local chairmaking during the 1820s.[241]

Several establishments are identified in the first city directory, published in 1832. James Ward and John M. Stokes jointly operated a cabinet manufactory opposite the post office, where they produced mahogany, Grecian, and Windsor chairs sold at "CINCINNATI CASH PRICES." Although the partners geared their advertisement and trade to the private sector, they also supplied furniture for steamboats and hotels on short notice. Stokes, who was born in New York, continued the business alone beginning in 1836. A plank-seat bench, or settee, in the slat-back pattern bears fragments of a Ward and Stokes label (fig. 8-29). Some of its elements are plain, but original painted and decorated surfaces would have provided visual enrichment. Primary pattern influence stems from Pennsylvania, although overtones of Baltimore style are present. A Pennsylvania slat-back armchair (fig. 3-137, left) has many features that occur in coarser form in the Kentucky piece: shaved back posts, outward-scrolling arms, ball- (or ring-) turned arm supports and legs, and a flat-edge, rounded-rectangular plank. Through figure 3-160 the introduction of Baltimore features can be observed in the rear leg profiles and the use of narrow slat-type stretchers.[242]

Chairmaker David Gordon can be traced to three cities. He probably was a newcomer when he started at Cincinnati in 1831, but with the disastrous flood early the

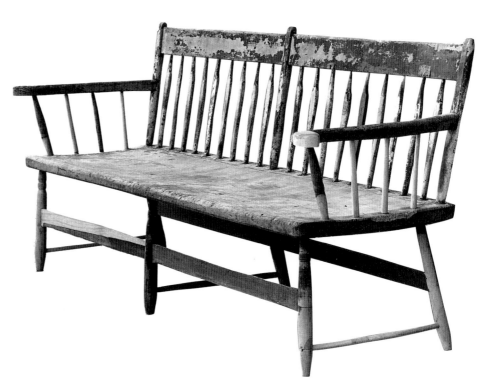

Fig. 8-29 Slat-back Windsor settee, James Ward and John M. Stokes (label), Louisville, Ky., ca. 1832–36. (Robert B. DeBlieux collection: Photo, Winterthur.)

following year, he had picked the wrong time and place. He next surfaced at St. Louis in 1836 and by 1838 was in Louisville. Gordon may have remained in Kentucky no longer than he stayed anywhere else. Many, though not all, chairmakers who practiced in Kentucky during the 1840s had begun their careers elsewhere. William H. Davidson worked in Lawrenceburg, Indiana, near Cincinnati, during the mid 1830s; in the mid 1840s he made fancy and Windsor chairs in Louisville. Davidson's Indiana partner, Thomas M. Duffy, appears to have arrived in Kentucky before him; he manufactured chairs for a decade beginning in 1841. The heading of his card in the advertising section of the 1850 directory reads "OLD KENTUCKY CHEAP CHAIR MANUFACTORY," a comment on the state of the "art" at midcentury. Nicholas E. Lanning may have come to Louisville from Cincinnati, where he is known to have worked in 1828–29. The 1850 federal census gives his age as forty-nine and his birthplace as New Jersey. The craftsman may have been a migrant journeyman during the 1830s and 1840s. John E. Scott, listed as a cabinetmaker in city directories from 1843 through the 1850s, mentions Windsor chairs in several advertisements, leading to speculation that painted seating was a regular part of his production.[243]

Writing from Monroe County in 1820, U.S. marshal Samuel Marrs, Esq., who was charged with compiling the manufacturing census for the region, commented on the nature of crafts in the area and undoubtedly also addressed conditions that were common in other parts of Kentucky: "There are Several Handicraftsmen who follow their farming Business Such as Chair makers, Powder makers, . . . Shoe and Boot makers, Carpenters, [and] Cabinet workmen that only Occasionally work at such Business that I thought did not fil the word of the law, by Reson have not tools Compleatly for such Business." Subsistence farming was an integral part of the rural family economy, although most areas still had full-time craftsmen like Jeremiah Lewis, who "commenced the [Windsor] Chair and Settee making business" in Russellville, Logan County, in 1808. Customers at Lewis's shop would have found "neat, well-made chairs, elegantly painted of different fashions and colours." North of town the land was timbered; in the surrounding area were many gristmills and sawmills and "fine sites for the erection of water-works" to secure power. In the 1810s Russellville contained 150 houses and a few public buildings.[244]

TENNESSEE

Tennessee, like other territories along the Mississippi, was a fur-trading country before the settlers came. The first permanent settlement was established in eastern Tennessee in the late 1760s. In spite of the threat of Indian attack and repercussions from the eastern seaboard during the uncertain times of the Revolution, settlers continued to find their way to eastern and middle Tennessee, which led to the incorporation of Nashville by 1784. The territory achieved statehood in 1796. Knoxville, in the more heavily settled upland region of eastern Tennessee, became the first capital, but a population shift to the rolling bluegrass country of middle Tennessee eventually caused the state center to be relocated at Nashville. Western Tennessee between the Tennessee and Mississippi rivers was settled last; like the central region, it focused primarily on agriculture. So swift was Tennessee's rise in population that it ranked seventh in the 1830 census. Water and overland access helped both Knoxville and Nashville become trading centers. Distribution of goods to the Indians and marketing of major crops, such as cotton, tobacco, and flour, brought prosperity to the state. Steamboat navigation provided Nashville with easy access to the Ohio before 1820. The outstanding political figure of the region was Andrew Jackson—lawyer, congressman, jurist, soldier, and president.[245]

Eastern Tennessee
Advertising notices, supplemented by data from the 1820 manufacturing census, provide the best information on chairmaking in Tennessee through the early nineteenth century. Five of seven furniture makers listed in the census for Greene County on the North

Carolina border were wheelwrights. Their shops were one- or two-man operations, where from $12 to $30 worth of timber was consumed annually. A "common" manual lathe furnished turning power in most establishments, although a tub waterwheel activated Joseph Gaston's lathe. This small horizontal machine was easily powered with no more than a swift mountain stream. Shop products were flax and cotton wheels, which retailed at $2.50 to $3.50 each. All proprietors reported a good market for their wares, and several could not keep up with the demand. The border counties of Sevier and Blount accounted for six more wheelmakers. Those in Sevier County identified their raw materials as oak, ash, and sugar maple. One man, John Williams, employed another workman and did a substantial business of $1,400 annually. Obviously, family self-sufficiency was a primary consideration in this area.[246]

Blount County residents could call upon at least two Windsor-chair makers in 1820. George Hicks employed two hands, and together the three men constructed 600 chairs selling at $2 apiece. The establishment of Edmund Hunt was larger, the workforce comprising the owner and five workmen. Chair production was slightly less than at Hicks's establishment, but the work was diversified. The owner reported that he and his men also painted ten houses at $200 each and made ten carriages and twenty wagons. Hunt probably got his start in the chairmaking trade at Baltimore, where a man by that name receipted a bill on behalf of chairmaker John Oldham in 1803, probably while serving as a journeyman or shop apprentice.[247]

Other chairmakers were based in Knoxville. Anne Newport Royall described the town in July 1823: "It contains four churches, . . . a court-house, . . . a prison, two printing offices, a bank . . . and several schools. It has twelve stores and 300 houses, several . . . of brick, besides barracks for 500 men." James Bridges, who was born in England, established himself in Knoxville in 1819. His advertisement of August 24 lists a varied selection of seating, including "Stump Back" chairs with rush or plank bottoms and large tablet-style crests framed in rabbets on the faces of the back posts. Bridges "spared no pains or expense in procuring from New York, Philadelphia, Baltimore and Washington city Workmen of the first description." Three months later the chairmaker advertised for apprentices, an indication that business was prospering. His statement for the 1820 census is comprehensive. There were three men working in the shop. Sales during the first year of business produced an income of $2,572, of which $800 was paid in wages and $400 expended for raw materials. Sales were reported as follows:

6½ Doz. Rush Seats @ $72/doz. Fancy	$468
13 Doz. Stump Bk Winsor Chears @ 56/doz.	728
18 d[itt]o Winsor Chears @ $36/doz.	648
20 d[itt]o d[itt]o @ $24/doz.	480
Righting Chears @ $6	12
. .	
2 Rush Settees Fancy @ $36	72
1 Wood d[itt]o @ $14	14
2 Rush Rockg Chears Fancy @ $7	14
1 Wood d[itt]o d[itt]o @ $4	4[248]

Bridges had moved southwest of Knoxville to McMinn County by 1830. At the 1850 census he was fifty-five years of age, so he must have been a very young man when he commenced business at Knoxville. When Bridges left town in 1824 his shop site was taken over before August 24 by William Moffat, who had advertised variously as a carpenter, joiner, glazier, and Windsor-chair maker. Moffat's tenure was short, however, since he died by drowning on November 20. John C. Hopkins was a latecomer to Knoxville. In 1839 he set up shop at the busy corner of Gay and Church streets and offered ornamental painting and gilding as a complement to chairwork. He manufactured fancy chairs and Boston rockers in addition to Windsor seating. Sometime before 1850 the chairmaker moved to the Cumberland River in middle Tennessee. Because of its location on a steep, confined plateau, Knoxville grew slowly. Even in 1850 the population

stood at just above 2,000; however, the community enjoyed good trade. From the late eighteenth century goods came through Virginia (probably up the James River to Lynchburg) and down the Holston from East Coast centers. Steamboat navigation with New Orleans was opened in 1828 via the Tennessee and Ohio rivers, although shoals in the Tennessee were a problem.[249]

Middle and Western Tennessee

As Christian Schultz, Jr., toured the West in 1807, he noted that the Cumberland River, which flows into the Ohio not far from its juncture with the Mississippi, was navigable "for loaded boats of sixty barrels" to Nashville, a distance of sixty miles. Smaller craft could travel farther on the waterway. When Nashville was chartered as a city in 1806, it was already well developed as a trade and manufacturing center. The state legislature sat in Nashville from 1812 to 1817 and again from 1827 to 1843, when the site became the permanent capital. Steamboat navigation was achieved in 1818, and by 1825, the year Lafayette visited Andrew Jackson at the Hermitage, the population was close to 3,500. Cotton was becoming an important cash crop.[250]

The first evidence of Windsor-chair making in Nashville coincides with the community's achievement of city status. William Bakem and John Russell dissolved a partnership, presumably as chairmakers, on November 30, 1805. Russell disappeared, but Bakem advertised as an independent chairmaker between 1808 and 1811. In autumn 1808 he searched for a journeyman Windsor-chair maker and less than a year later was ready to employ either a chairmaker or spinning-wheel maker. Within two years a wagonmaker occupied the site. Robert G. Simpson may have had something of an edge on Bakem in 1808, since his chair and spinning-wheel shop was readily identified by the "sign of the Windsor Chair."[251]

John Priest commenced business independently the same year. The chairmaker remained in Nashville eight years before removing to Columbia in 1816. In what may have been his initial Nashville announcement, Priest headed his notice with a crude woodcut of a Windsor side chair (fig. 8-30). Although the crest is imperfectly printed, enough detail remains to determine that the pattern with its central projection and sweeping ends reflects Baltimore chairwork (figs. 4-7, 4-8). The craftsman was well acquainted with contemporary Baltimore design, having just migrated from Petersburg, Virginia. Possibly Priest himself cut the woodblock, since his initials appear on the chair seat. In 1812 he and Windsor-chair maker Charles McKarahan were involved in an altercation concerning a debt, which finally was settled in court in Priest's favor. McKarahan appears to have had a more legitimate complaint the following year, when he warned the public to "Beware of the Swindler." He identified twenty-five-year-old Joseph Kerm, who posed as "a man of business," as a Windsor-chair maker by trade and a former apprentice of "Mr. Burden [Joseph or Henry] in Philadelphia." His knowledge of Kerm's true identity suggests that McKarahan was no stranger to the eastern city. The chairmaker went on to describe the deception perpetrated by Kerm, who, he said, "has travelled very much, and is quite talkative":

He came to Nashville, and became acquainted with the names of a number of persons, which he took the liberty of affixing without their knowledge to pieces of paper containing promises to pay money, which he also took the liberty to convert into ready rhino [money]. Among the number I understand he had one of mine, but as I have not seen it, I cannot tell to what amount or in whose favor it suited his pleasure to draw it. I forbid all persons trading for it.

Another local citizen who was bilked offered a reward to see Kerm incarcerated, but by then Kerm was already "traveling" again. McKarahan remained in Nashville until 1817, when he sold out to another chairmaker.[252]

The man who took over McKarahan's stock and shop was Samuel Williams. To boost his craft standing, he announced that he had "lately arrived from the eastern states and [was] in possession of the newest fashions." In January 1818 the craftsman again acquainted the public with the superiority of his establishment in stating that he

Fig. 8-30 Advertisement of John Priest. From the *Impartial Review and Cumberland Repository* (Nashville, Tenn.), March 24, 1808. (Photo, Tennessee State Library and Archives, Nashville.)

employed "several of the best workmen from . . . shops in New-York and Philadelphia." During his initial career in Nashville Williams was in partnership with one E. P. Sumner, possibly an outsider to the trade. This association was dissolved on March 3, 1818, and Williams continued the "plain and fancy chair" business on his own.[253]

Meanwhile, the Wood brothers, Alexander H. and William R., had come from Richmond, Virginia, and set up as chairmakers in Nashville. Both had been apprentices of Robert McKim. Alexander must have preceded William to the city, since upon announcing the partnership on October 7, 1817, he also thanked "the citizens of Nashville" for the "liberal encouragement" he had received. The following year the brothers felt sufficiently secure to advertise for two apprentices. A notice of 1819 promoted their sign-painting and ornamental painting business in addition to the Windsor work. The brothers bought a ground lot in Nashville in 1820, the same year Alexander was elected an officer in the Grand Lodge of Tennessee. An arrow-spindle, slat-crested side chair bearing the Wood brothers' label relates closely to West Virginia work (fig. 8-13), which is later in date. The Woods' chair has plain, slim, tapered legs and cylindrical stretchers all around and an upper structure that angles sharply in a back bend.[254]

The partners B. Sherwood and B. Dodd advertised to employ "a good WINDSOR CHAIR MAKER" in January 1823, and five months later they promoted their products, ranging from fancy and Windsor chairs to settees and children's furniture. When the partnership was dissolved on May 7, 1824, Dodd continued alone, supplementing those forms with "Gentlemen's Writing CHAIRS." A few years later partners named Thompson and Drennen dealt in cabinetware and rush- and plank-bottom seating, which they purchased at Cincinnati. The merchandise was easily shipped via steamboat down the Ohio and up the Cumberland River to its destination. Unfortunately the firm, like others before it, enjoyed but a short life in Nashville.[255]

The local records of Judge John Overton, builder of Travellers' Rest and a friend of Andrew Jackson, amplify the use of painted seating in Nashville households. In 1828 when a rear house wing was nearing completion, the judge purchased a selection of new furniture, including a dozen each of Windsor and fancy chairs and a flag-bottom settee. The seating may have come from Louisville, since drayage was paid there. Overton's estate inventory of 1833 provides a more complete description of the household seating. The dozen white, flag-bottom chairs and one of two rush-seat settees probably were those purchased in 1828. Two sets of brown Windsors, numbering a dozen chairs each, are described as "fancy" and "common." Ten other Windsors were painted yellow. The single Windsor settee likely matched one of the chair sets.[256]

Working in the communities surrounding Nashville or lying south toward the Alabama border were a dozen or more chairmakers and related craftsmen. Two men worked in Clarksville, northeast of Nashville. Advantageously situated at the town center "on the public square, next door to the Eagle Tavern," Josiah Emmit, Jr., combined house painting and sign painting with chairmaking in 1819, hoping "by a neat execution of his work, and by a strict attention to business, to merit public patronage." When J. McCullouch announced for the same business three years later, he was already an old hand at the trade. He spoke of "his experience for twenty-seven years in many of the principle [sic] towns in the East and Western count[r]y." Hugh Evans moved to Gallatin, Sumner County, in 1820 after a Nashville stint where he was first established in 1811 as a painter of houses, signs, and ornament in the shop of Charles McKarahan. His Windsor-chair manufactory in Gallatin stood near the courthouse. Annual production was calculated at 600 chairs retailing for $2 apiece.[257]

Immediately south of Nashville in Williamson County and its seat at Franklin, the woodworking trade was brisk, as partially recorded in the 1820 manufacturing census. The enumeration lists ten cabinetmakers, three turners, two wheelwrights, a chairmaker, and a clockmaker-wheelwright. One of the turners made both wheels and chairs. Judging by the market value of his products and those of the wheelwright-chairmaker, the two must have constructed slat-back, rush-bottom seating. Timothy Swayne of

Franklin was the chairmaker-painter of the group. His products, along with his background, were reasonably sophisticated. He and another man produced forty-two dozen painted chairs a year, which sold for $24 to $80 a dozen. The range indicates that the craftsmen made several qualities of Windsor and fancy seating. Swayne began his career in New London, Connecticut, when he took over the shop of Thomas West in 1812. He had located in New York City by 1816, when he was twenty-five years old. The chairmaker may have worked at several western locations between 1817 and 1825. His 1822 advertisement at Franklin states that he had "returned" to town, where he supplemented chairmaking with house and sign painting, glazing, and paperhanging. By 1826 Swayne had returned to New York, where he remained until 1831. The craftsman may have died at Norwich, Connecticut, in the late 1830s.[258]

In 1823 William D. Taylor, who remained in Franklin for a long period, was faced with the problem of a runaway apprentice. It seems that his young ward had also stolen his indenture from the drawer where it was stored. By 1831 Taylor and Jacob Everly were partners; the two advertised their "splendid assortment of *Windsor, Fancy, and Common Chairs.*" Everly was in the "tinning" business (probably as a decorator) with Charles Merrill two years later, although he continued to make chairs. When he died of cholera in July 1835, his death notice gave his place of birth as Hagerstown, Maryland. A few months later the estate administratrix, Louisa Everly, offered for sale "SEVERAL DOZEN CHAIRS, Not entirely Finished." Taylor continued working in the city. His name is present in population censuses from 1830 to 1850, when his age was given as fifty-three and his birthplace as Virginia. Charles A. Merrill was a New Englander. The first mention of him in Franklin was in 1829, when he worked for chairmaker O. S. Perry. Perry, although not identified as a Windsor-chair maker, probably constructed painted seating generally. Perry was pleased to announce the services of two chairmakers: "He will be assisted by Mr. M'Curdy of Baltimore, who will be able to execute his work in the latest fashions of the Eastern Cities, and who has the most fashionable and approved patterns for ornamental painting. He has also engaged the services of Mr. Merrill of Portland, Me. who is a firstrate workman." The following year McCurdy and Merrill opened their own shop "on the south west side of the square."[259]

Woodworking south of Franklin in Maury County was almost as extensive as in Franklin itself. In 1820 three cabinetmakers were in business, and two men made spinning wheels, one the part owner of a cotton gin. Three craftsmen made common rush-seat chairs and a few wheels. In neighboring Rutherford County another wheelwright added reels, swifts, and bedsteads to his production and reported a greater demand for his work than ever before. The more southerly seats of Shelbyville and Fayetteville were supplied by two chairmakers a decade later. Richard Davis, a cabinetmaker, added Windsor-chair making to his line in 1828, apparently to meet local demand in Shelbyville. Isaac Barton's Fayetteville chair factory was easily recognized at the sign of the "*large chair.*" Windsors of "various descriptions" were on hand in 1830.[260]

At Jackson, Madison County, the chair business flourished in the late 1820s. Stephen Sypert and Josiah Strange combined carriage making with Windsor- and fancy-chair making in 1825. By appealing to a dual market they obtained good custom and by March 1827 had built "a large shop," which enabled them to do "any kind of work in their line." The partnership was dissolved in 1829, and Sybert continued the business alone. Storekeepers John and J. C. Rudisill sold furniture and chairs along with groceries and "seasonable Goods" in their brick building at Jackson. On May 15, 1830, John Rudisill identified one of their supply sources: "Just received . . . a large assortment of WINDSOR CHAIRS, manufactured at Pittsburgh, of various patterns and colors."[261]

The firm of Jackson, Elliott, and Boden was formed at Paris, Henry County, when the partners bought out the cabinet business of Charles M. White in October 1837 and introduced "the Windsor Chair business in the same shop." The association lasted slightly more than a year before White returned to carry on the business and wind up partnership affairs. R. J. Elliott may then have become part of the firm of Hosea L. Jackson and Company. A North Carolina native, Jackson was thirty years old in 1840.

J. B. Boden from New York had just attained his majority and struck out on his own as a house painter and sign painter.[262]

OTHER MIDWESTERN CITIES: ST. LOUIS, DETROIT, CHICAGO, AND POINTS NORTH AND WEST

A *Digest of Accounts* (1823) based upon data in the 1820 manufacturing census identifies the construction of spinning wheels and Windsor chairs in the Missouri counties of Madison and St. Genevieve, respectively. Similar production took place in Howard County and its center at Fayette. Of six shops, two made chairs. Before 1820 several chairmakers worked in St. Louis. In July 1810 two men named Heslep and Taylor, fresh from Pennsylvania, announced the opening of their chair store. They had brought a quantity of chair parts to be assembled, painted, and decorated to suit the customer's taste. Philadelphia was their announced design focus, suggesting that they offered square-back chairs with double bows (figs. 3-116, 3-119) and possibly even the new slat-back design with a central tablet (fig. 3-125). Chairmaker Heslep may be the Thomas Heslip (also Bislep) who worked in Pittsburgh between 1815 and 1819 and then migrated south to Natchez, Mississippi. By 1815 J. Russell had opened a fancy- and Windsor-chair business in St. Louis; he also offered gilding and painting. Probably he is the John S. Russell who pursued the same trades between 1819 and 1821, as cited by Charles van Ravenswaay in his checklist of St. Louis furniture makers. Although the name is a fairly common one, especially without the middle initial, this may also be the same John Russell who was a partner of William Bakem at Nashville in 1805. Another chairmaker of probable eastern connections was Isaac Allyn, who worked at St. Louis in 1818. A man of this name was in business at Preston, Connecticut, from 1809 until 1813, when he sold his chair shop. The interruption of trade in the eastern states during the War of 1812 may have encouraged Allyn to try his luck in the West. Samuel Williams had worked in the city just two years earlier. He may be the craftsman who purchased the Windsor- and fancy-chair stock of Charles McKarahan at Nashville in 1817 and continued in business at that location for two years or more.[263]

St. Louis directories published between 1836 and 1841 list William Adams Lynch and George Trask as cabinetmakers and chairmakers. Van Ravenswaay pushes the date of their collaboration back to 1831 and also cites another St. Louis partnership for Lynch between 1829 and 1831 and an independent cabinet business in St. Charles from as early as 1821. Lynch and Trask developed a considerable reputation in the trade. In 1839 the Iowa Territory legislature ordered more than $200 worth of seating furniture from them, including cane, flag, Windsor, and mahogany chairs, complemented by a rocking chair and a settee. Although Lynch was a New Yorker by birth and training, his work at that date would have reflected any number of eastern influences, as was typical of western production. David Gordon, who had worked in Cincinnati in 1831, was closely associated with the Lynch and Trask firm in 1836. As advertised, his Vine Street chair manufactory was "in the same rooms occupied by Lynch & Trask, as a Cabinet Establishment." Gordon had moved to Louisville by 1838. His removal may have prompted Lynch and Trask to pursue or renew the chair manufactory on their own account. Possibly providing competition was the firm of Colburn and Coolidge, which commenced business in 1840. A bill dated in 1841 documents the sale of cane-seat and children's chairs.[264]

St. Louis was a flourishing place in the late 1830s. Frederick Marryat's view of the city in 1837–38 was that of a bustling center of commerce "situated on a hill shelving down to the river." The wharves on the Mississippi were "crowded with steam-boats, lying in two or three tiers." These vessels, ranging from 150 to 300 tons, operated as "regular traders" on the Mississippi and its tributaries, the Ohio and the Missouri. The population of the city and its environs seems to have kept pace with the rise of commerce; the number of residents was estimated at 6,000 in 1831. By the mid 1830s that figure had doubled and was still increasing. The cost of labor, rent, fuel, and building materials was high. Boards and shingles, for instance, were brought to St. Louis from western New York state.[265]

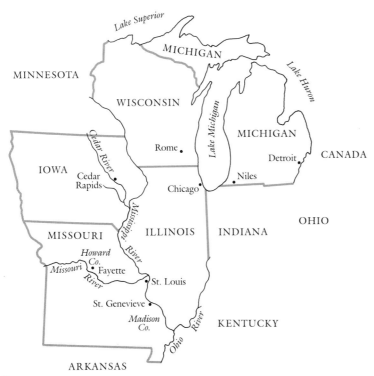

1 inch = 217.9 miles

During a trip to explore the western chair market in autumn 1835, Lambert Hitch-cock of Connecticut passed through Detroit on his way to Chicago. In writing to his brother-in-law he provided some description of the region: "So far as I have seen it is remarkably level, nothing like what we in New England should call a hill is to be seen." Hitchcock made no note of local chairmaking, although only two years later the first Detroit directory listed eight craftsmen closely associated with the trade: four turners, two ornamental painters, and two chairmakers. Fisher and Marshall, owners of one of the two furniture warehouses, manufactured both cabinetware and seating, the latter consisting of mahogany, curled maple, fancy, and Windsor chairs. The community had long since passed from the status of a small trading post on the frontier to a rising city; within a year it became the first capital of the state of Michigan, and its population approached 9,000. Buildings in brick and stone were fast replacing the old wooden structures, and businesses, banks, and hotels met "the eye at every turning."266

Arriving at Chicago, his principal destination, Hitchcock remarked the appearance and "considerable business" of the city, dubbed by some "the London of the West": "Chicago stands on Ground verry level and rather low—handsomely laid out. There are more buildings here than I expected but not as good. They are for the most part cheap wood Buildings." Hitchcock estimated the population at 4,000 to 5,000 and noted among the "mechanics" three chairmakers. It is unclear whether he included in this number William V. Smith, a former chairmaker of Brooklyn (working 1826) and a man whom Hitchcock apparently knew. The Connecticut chairmaker wrote to his brother-in-law Arba Alford saying, "Willian V. Smith is here in the grocery business and I think doing verry well." Included among local furniture prices published in *Norris' Business Directory* of 1846 were: "Common Windsor Chairs $5.50 to 6.00 per dozen." At Rome, Wisconsin, to the north, Josiah P. Wilder, Jr., son of the New Hampshire chairmaker of that name, worked briefly in a furniture store "making chairs of several different kinds"

for which he prepared patterns and bending racks. His production included Boston rocking chairs, which, he noted, sold for much more than in the East. In 1855 young Wilder was making slat-back chairs in Cedar Rapids, Iowa.[267]

American Influence on the Windsor Furniture of Upper and Lower Canada

"In travelling through Canada and the adjacent states, nothing is more satisfactory than to find that there prevails the best mutual understanding between the British and American people." So wrote William Chambers after completing an extensive tour of northeastern America in 1853. Communication and commercial exchange between the two countries was a natural and mutually advantageous consequence of their sharing a long boundary and having many common ties. Interaction had long been commonplace. Enterprising New Englanders found a market for furniture in the maritime provinces even before the Revolution. One such cargo left Massachusetts for Halifax, Nova Scotia, in 1762. Custom and excise records dating between January 1768 and January 1773 further document small but steady importations of household seating into the Canadian ports of Halifax and Quebec and the island of Newfoundland. The furniture probably represented both English and American products. The revolutionary war years saw the influx of crown sympathizers, or loyalists, into the maritime provinces from New England and the Middle Atlantic colonies. Some stayed or removed to England, others eventually returned to the United States. Immediately following the war migration expanded into the lands along the northern shore of the St. Lawrence River and westward into the Niagara peninsula. Furniture craftsmen were among the emigrants, although an identifiable period of Canadian Windsor- and fancy-chair production was yet to come. Documented importations of Windsor furniture began with the 1790s, just as local and immigrant craftsmen launched small-scale production. The first identified American Windsor-chair maker arrived at Halifax about 1804; a few anonymous craftsmen had preceded him, and others followed. From this point on, the American stamp was placed firmly on the Canadian product.[268]

The first half of the nineteenth century was a period of tremendous growth in Canada. From the eastern provinces, or Lower Canada, where many areas still remained rural and conservative, settlement pushed westward into what was called "Western," or "Upper," Canada, comprising most of present-day Ontario. Somewhat akin to observations made by travelers to the American West from early in the century, Chambers noted the "remarkable advances" in Canada during his visit of 1853 by quoting a few statistics. From a population of about 65,000 in 1763, the combined figures for Upper and Lower Canada then stood at 2 million. Assessable property in Upper Canada, which had amounted to less than $2 million in 1825, had leaped to $37.5 million by 1852. Agricultural increase and the importation of British goods kept pace. But what Chambers felt was the prime example of social progress was the opening of 250 new post offices in 1852 alone. Upon reaching Western Canada (Ontario) he remarked that from the point of general business, the area was little distinguishable "from the neighbouring parts of the states of New York, Pennsylvania, and Ohio."[269]

NOVA SCOTIA

In the 1790s Nova Scotia formed the easternmost portion of Canada. Lying in part off the Maine coast, the area is readily accessible by sea and was a place of commerce with the northeastern states. Incomplete American shipping records for the late 1700s document the exportation of Windsor seating to Nova Scotia ports. Shippers in New York City and the Boston area were particularly active, and a few voyages are recorded from New London, Connecticut. From 1791, the earliest document date, until 1801 chairs and other furnishings formed part of cargoes bound for Liverpool, Cape Breton, Digby,

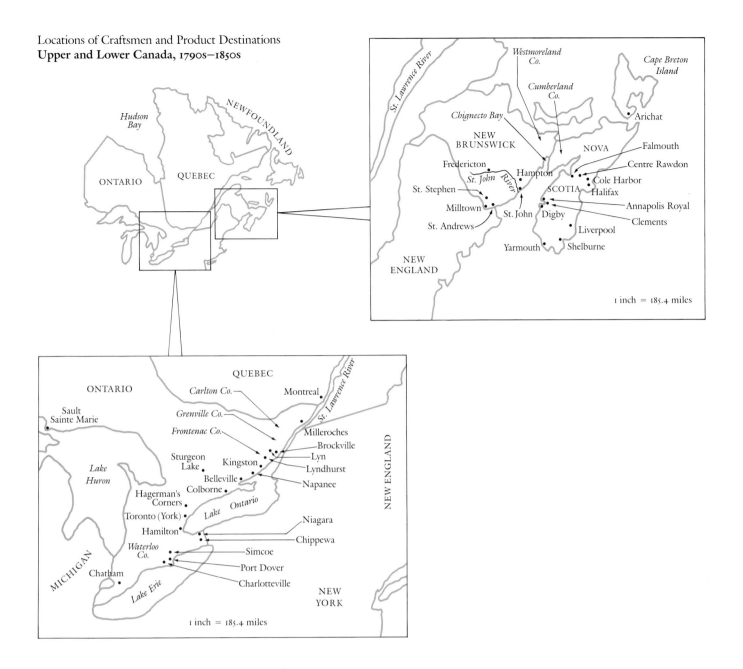

Locations of Craftsmen and Product Destinations
Upper and Lower Canada, 1790s–1850s

1 inch = 185.4 miles

1 inch = 185.4 miles

Halifax, Shelburne, Annapolis Royal, and Cumberland (County). The most common destination was Liverpool on the southeastern coast, although some of those cargoes may have found their way to other area ports. Even when Windsor chairs are not specifically mentioned, internal evidence in shipping documents sometimes provides clues for identification. For example, three dozen chairs priced at $30 imported into Liverpool from Boston on the Nova Scotia schooner *Betsey* in October 1791 probably were Windsor side chairs, based upon unit cost. Another dozen chairs valued at $15 and shipped aboard the same vessel almost two years later could have been Windsor sack-back armchairs. Eighteen Boston chairs sent to Halifax on the schooner *Defiance* in 1795 were valued at $1.17 apiece, a unit figure that compares well with the "Twelve Windsor Chairs" worth $16 that Captain Job Harrington took to Liverpool from New London, Connecticut, aboard the schooner *Eliza* in 1799. That date is correct for an American Windsor of braced bow-back pattern with baluster turnings found in modern times near Liverpool. Other Connecticut chairs were carried to "Arrphat" (Arichat), Cape Breton. Earlier, in September 1794, an unidentified New York chairmaker had supplied "six Winsor Chears" shipped to Digby on board the sloop *Delight*. New York Windsors must have been popular at Digby, since other shipments are recorded. By the 1810s the

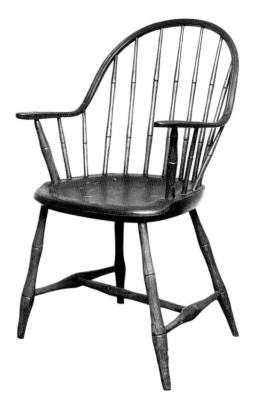

Fig. 8-31 Continuous-bow Windsor armchair, George Gammon (brand "G·GAMMON / HALI-FAX / WARRANTED"), Halifax, Nova Scotia, ca. 1800–1810. Ash and other woods. (Photo, James R. Bakker.)

provincial center at Halifax maintained a substantial seating trade with Newfoundland, although the chairs are not identified by type.[270]

Other kinds of evidence confirm the ownership of Windsor chairs in Nova Scotia before and after the busy importation period of the 1790s. A merchant of southern coastal Shelburne purchased a dozen Windsors at auction in 1788 for £3. Ten "old" Windsor chairs in Loyalist James Delancey's inventory drawn at Annapolis Royal in 1804 could well have been brought with other household furnishings when he relocated there. At Falmouth, north of Annapolis, Peter Shaw's 1817 estate included a dozen Windsor chairs; their valuation at about 6½s. apiece suggests they were still relatively new. By 1831 5s. was the usual price of new "Common Windsor Chairs," as reported by traveler Adam Fergusson.[271]

In his studies of Nova Scotia chairmaking, George MacLaren named two craftsmen said to be working in the 1790s. He identified John Brittain as advertising in Halifax in 1790 or 1792, although another source suggests that documented work by this man dates from the early nineteenth century. Similarly, Joseph(?) Degant is credited with an advertisement of 1790, although the notice is not quoted. Currently, only George Gammon, identified by MacLaren as a late workman based upon an 1838 notice, comes closest to qualifying as an eighteenth-century Canadian Windsor-chair maker. Actually, his earliest work, a continuous-bow armchair, probably dates after 1800 (fig. **8-31**). The design is notable for its low, broad back and strong overtones of Boston and Connecticut work. Specifically, the arm bend and the character of the bamboo sticks relate to the work of Thomas Cotton Hayward, who settled in Charlestown from Connecticut (fig. 6-217), although the present posts are stouter. The bow face has a Boston-style midgroove (figs. 6-209, 6-213). The stretchers form an H-plan brace, and the seat with its double-grooved front without a centered pommel follows early nineteenth-century work (fig. 7-28). Three separate irons created the brand "G·GAMMON / HAL-IFAX / WARRANTED." Gammon's location in or near the port permitted him to profit by the coastal trade.[272]

A bow-back chair branded in the same manner is grooved on the bow face like the armchair and is comparable to the marked work of Jay Humeston (fig. 8-34). Gammon next turned to the new square-back form. First to be constructed were side chairs and armchairs of single-bow (rod) pattern with six and seven spindles, respectively. The armchair shares several features with the illustrated continuous-bow chair: the same

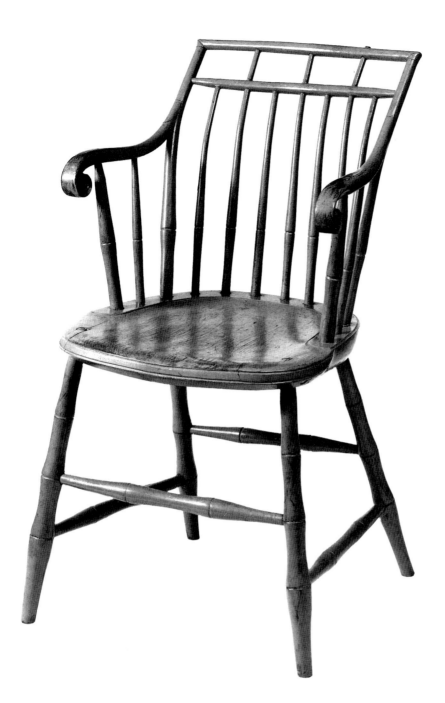

Fig. 8-32 Square-back Windsor armchair and detail of brand, George Gammon, Halifax, Nova Scotia, ca. 1812–20. H. 33¾″, (seat) 17¼″, W. (crest) 18⅛″, (arms) 20⅛″, (seat) 18⅛″, D. (seat) 17″. (Private collection: Photo, Winterthur.)

base and seat; a comparable, though longer, arm support with back posts to suit; and spindles of similar shape, although thicker. Straight, bamboo-turned arms mounted high on the posts extend beyond the front support in rounded protuberances.

From the single bow Gammon progressed to the double-bow style (fig. **8-32**), although the two probably overlapped in period. While some chairs adopted the new box stretcher and four-section leg, the plank remained the same. More obvious in this chair than the first is the manner in which the chairmaker positioned the legs close to the plank edges. His guide appears to have been the English Windsor, of which examples would have been owned locally. The backs bend to the rear, while early square examples simply cant backward in a straight plane from base to top. Even with the bend, the chairmaker's back posts retain their vigorous bamboo character. Gammon's new arm features full, heavy scrolls, carved inside and out with volutes that resemble the crest terminals of early Pennsylvania high-back chairs, a form probably known in Nova Scotia through trade or the household baggage of migrant Loyalists. Some of Gammon's square-back production is stamped as illustrated; other examples drop the place-name "Halifax."

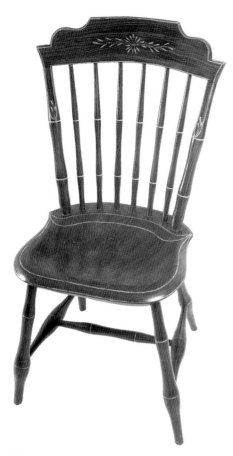

Fig. 8-33 Shaped tablet-top Windsor side chair, George Gammon (brand "G·GAMMON / WARRANTED"), Halifax, Nova Scotia, ca. 1815–25. Dark brown grained ground with yellow and green. (Photo, Henry Dobson.)

Perhaps even while producing his single- and double-bow styles, Gammon integrated another crest into his work. The profile of his "stepped" tablet is exaggerated but well conceived (fig. **8-33**). The deep ogee curves may copy New England work (fig. 7-89). Strangely, this group exhibits features from both of the chairmaker's square-back styles. The side chairs have H-plan stretchers and canted posts, now partially shaved to integrate the crests, while the one known armchair duplicates features in the illustrated scroll-arm example. The armchair crest is a modified tablet of half the depth found in the side chairs; several inches below, a thickened cross rod is set between the posts. The intervening space contains the extended tips of single long spindles at either side of a small central heart-shaped medallion with a long, pointed base. Gammon is said to have worked near Dartmouth on the road to Lawrencetown, across the harbor from Halifax; between 1839 and 1859 he was at Cole Harbor. Whether this is the same man seems in question; perhaps it was a son, especially since MacLaren records a William Gammon also working in the mid 1830s.[273]

In terms of visual evidence, Jay Humeston and not Joseph (?) Degant was the earliest contemporary of George Gammon in Halifax. Humeston is known by several stamped chairs in the bow-back style (fig. **8-34**), including one made for a child, and a continuous-bow armchair. The work of Humeston and Gammon is close in detail; the greatest difference lies in the seat front. Humeston followed late eighteenth-century practice and finished his planks to a high sharp edge deeply rounded below. Turnings with well-defined swells and hollows are typical of the same period; bow faces cut with a deep central groove are inspired by Boston work. Humeston constructed Windsor chairs in the American South before migrating to Halifax. He advertised in Savannah, Georgia, in 1800, and his name is listed in the Charleston, South Carolina, directory for 1802. His first Nova Scotia notice dates from November 23, 1804, when he stated that he made Windsor chairs and settees "equal to the best British manufacture." That statement is unusual in view of the American focus present both in Humeston's product and the import trade. On the other hand, "British manufacture" may have referred to local production, whatever the influence; the stigma Humeston attempted to overcome may have been of a personal nature, since he was not native to the area. Humeston's American experience probably accounted for his also suggesting that sea captains could be supplied with his chairs by the dozen or gross for the West Indian market. The chairmaker is said to have been in Halifax until about 1815.[274]

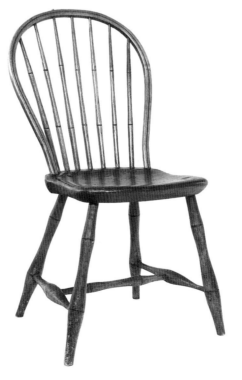

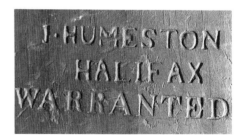

Fig. 8-34 Bow-back Windsor side chair and detail of brand, Jay Humeston, Halifax, Nova Scotia, ca. 1804–10. White pine (seat) with hickory (microanalysis); H. 34¼", (seat) 16½", W. (seat) 15¼", D. (seat) 15¼". (Photo, Museum of Early Southern Decorative Arts, Winston-Salem, N.C.)

648 *American Windsor Chairs*

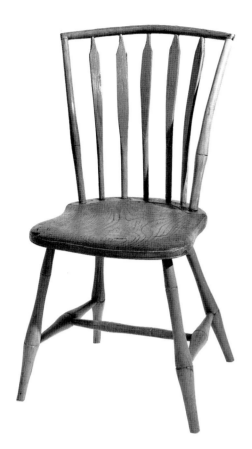

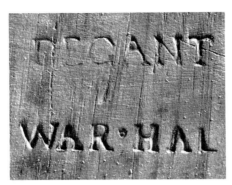

Fig. 8-35 Square-back Windsor side chair and detail of brand, Joseph(?) Degant, Halifax, Nova Scotia, ca. 1815–20. H. 33″, (seat) 16½″, W. (front legs) 18″. (Nova Scotia Museum, Halifax.)

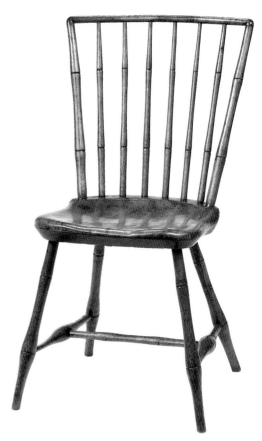

Fig. 8-36 Square-back Windsor side chair, James Cole (brand "J. COLE"), Halifax or Centre Rawdon, Nova Scotia, ca. 1812–20. White pine (seat) with beech and maple; H. 32½″, (seat) 17⅜″, W. 18¼″, D. 18½″. (Baltimore Museum of Art, Baltimore, Md.)

Two side chairs and an armchair, variants of a basic square-back style, represent the work of Joseph(?) Degant, who stamped part of his production with his surname and the contraction "WAR HAL" for "Warranted Halifax." A side chair and the armchair have single top rods and cylindrical bamboo sticks similar to work described for Gammon. The third chair substitutes later flat spindles (fig. **8-35**). Here, the base structure follows that of Gammon's side chair (fig. 8-33) and the back posts of his square-back armchair (fig. 8-32). The seat is a copy of a Boston pattern (fig. 7-27), one based upon Philadelphia prototypes (fig. 3-55). The arrow spindles are an unusual, awkward substitution for bamboo sticks. The juxtaposition of the broad spindle surfaces and the slender cross rod gives the chair an unfinished look. Improvising on standard patterns had pitfalls, since flat spindles require a heavy crest for balance. The existence of a rod-back chair branded by Cutter and Power, who in 1814 "continued" business in Halifax opposite Abraham Cunard's lumber wharf, serves further to reinforce the currency of this pattern in Nova Scotia in the 1810s when it was already out of fashion in most American centers. The Cutter and Power crest is double-bowed, similar to that in Gammon's scroll-arm chair, but it has H-plan stretchers. The seat, notable for the substitution of a rounded square with blunt edges for the squared shield, serves to date both the chair and the entry of its makers into the seating business.[275]

The J. Cole who advertised at Halifax in October 1816 probably was the James Cole who within a year resided west of the county line at Centre Rawdon. Cole's Halifax notice reveals the scope of the local chairmaking trade in addressing both the "Inhabitants of Nova-Scotia" and those of "Neighbouring Provinces." A single-bow, square-back side chair that bears Cole's brand also reinforces the impact of the import trade on local artisans (fig. **8-36**). In its upper structure Cole's Windsor is a New York chair (fig. 5-31). The seat, too, may be a mannered version of a New York plank. Below the seat the support structure follows local practice (figs. 8-33, 8-35). The combination of a white pine seat with beech and maple is typical of northern work.

MacLaren states that James Cole had a son George who was a chairmaker. George married in 1832 and is listed in the census of 1838 at Centre Rawdon. The Provincial Museum at Halifax owns this man's brand. Two writing-arm chairs stamped "G. COLE"

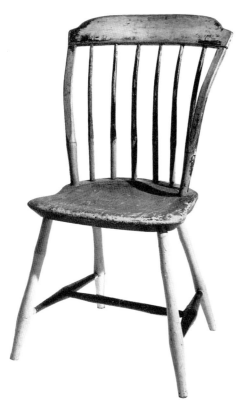

Fig. 8-37 Shaped tablet-top Windsor side chair, Joseph Vinecove (brand "HALIFAX / J. VINE-COVE / WARRANTED"), Halifax, Nova Scotia, ca. 1817–25. H. 34", (seat) 16¾", W. (front legs) 19¼". (Nova Scotia Museum, Halifax.)

presumably were marked with this iron. The chairs exhibit an unusual mixture of features for the 1830s or 1840s. Like earlier Nova Scotia Windsors, they have slim bamboo legs with exaggerated swellings; the H-plan braces have bamboo medial stretchers. The seats are large, rounded-square planks with long, single, tablike extensions at one side to support the writing leaf. The free arm in each chair undulates forward and rolls over in a moderate front scroll; the back spindles are slim, flattened, dartlike sticks. One chair has a shallow rectangular tablet with hollow top corners, fitted closely at the posts. The other tablet is large and extends beyond the post in rounded ends, combining two Boston crest patterns of the 1840s. The question raised by the designs is why the craftsman deliberately chose to use vigorously turned bamboo supports and H-plan underbraces that were twenty and thirty years out of date even in other areas of Nova Scotia. This appears to be another expression of the conservatism that ran through Nova Scotia culture.[276]

Joseph Vinecove, who MacLaren says first advertised at Halifax in 1817, introduced to his later work an arched tablet and shaved-face back posts (fig. 8-37). He apparently constructed chairs of this pattern over a period of years. Starting with an H-plan support structure, he moved on to box stretchers and four-part bamboo legs, the latter more successful in terms of balance. Vinecove's crest seems based on eastern Massachusetts work (figs. 7-58, 7-60), although the design leaves something to be desired when compared with the prototypes. In 1820 the local cabinetmaker William Gordon, whose formal furniture included pillar-and-claw tables, carved sideboards, and mahogany seating, offered Windsor chairs, presumably of his own manufacture. He may have produced some of the Windsors stamped "Halifax / Warranted," which have slat-type inset crests, arrow spindles, and bases supported by box stretchers.[277]

Several later Halifax County chairmakers are said to have produced documented work. Lewis Debol was active in 1825 in the port city; J. Beck was located at Cole Harbor. When Charles P. Allen settled at Halifax about 1832, he had had working experience in Boston, where he and a Silas Allen were called chair dealers in the 1828 directory. Identified chairmakers working outside Halifax in the 1830s and later reflect both the conservative and progressive elements found at the capital city. For example, J. Balcom of Clements, Annapolis County, made half-spindle, slat-back chairs with shaved-face posts that are barely distinguishable from American production. Other craftsmen who made chairs were located from Yarmouth in the south to Minas Basin up the western coast.[278]

NEW BRUNSWICK

Recorded Windsor-chair making in New Brunswick is confined mainly to the southwestern region encompassing the major commercial center of St. John, the capital at Fredericton, and several minor ports. Scattered records of the 1790s describe coastal activity by vessels sailing from Boston. The schooner *Nancy* carried spinning wheels to Westmoreland County via Chignecto Bay in 1791. Later the sloops *Betsey* and *Mary and Sally* unloaded several dozen chairs priced about $1 each at the port of St. Andrews, a shipbuilding center on the Maine border. Ship construction was also an important industry at St. John and in many of the coves and small harbors that dotted the Bay of Fundy. The harbor at St. John was described in the nineteenth century as "capacious, safe, and never obstructed by ice." The St. John River entered through a rocky gorge; but beyond that obstruction and throughout the province, the land was watered by navigable rivers. Complementing the shipbuilding industry was an extensive and profitable lumbering business that provided "immense" quantities of timber for exportation from the dense forests that covered much of the flat and undulating terrain of the province. The fisheries were profitable. New Brunswick also contained some good farming land, although agriculture did not keep pace with needs.[279]

Principal activity centered in St. John. After its incorporation in 1785 the city required each business person to register and become a "Freeman" of the city. These lists, which give names, dates, and occupations, provide considerable information, along with

Loyalist records. The first identified Windsor-chair maker of St. John was Nathan Oaks, who became a freeman in 1795. His career was short; within two years he was dead of smallpox. Perhaps this was the same Nathan Oaks who made chairs at 9s. apiece for Doctor Thomas Williams at Deerfield, Massachusetts, in 1786. Robert Blackwood was a contemporary who announced a shop relocation in 1796. He specialized in turning and the construction of Windsor chairs and spinning wheels. Blackwood acquired a partner, William Chapple, but the association was anything but profitable; Chapple purloined company funds and left St. John. Blackwood apparently worked on until his death in 1807.[280]

There may have been a hiatus of several years between Blackwood's death and the entry of Daniel Green into the fancy- and Windsor-chair making business in St. John. A notice of 1813 speaks of continuing production, an indication that he was not a newcomer. Green stated that he affixed his name to his product, although he did not specify the method. He left St. John in 1821. By that time Thomas Nisbet from Scotland was the proprietor of a prosperous cabinetmaking business, which had opened in 1813 or 1814. Around 1820 Nisbet began to manufacture fancy and Windsor chairs as a supplemental activity, probably with the assistance of hired specialists. How long production continued is unknown, but Nisbet enjoyed a long and productive business life, retiring in 1848. He added undertaking services early in his career; in the 1830s he owned a considerable interest in a whale fishing company.[281]

Sometime before Nisbet commenced business, Thomas Hutchings Lewis, Jr., began to make Windsor chairs in St. John. Chairs branded "T. H. LEWIS" are known in American collections. Earliest is a bow-back Windsor with several features that suggest a Boston origin (fig. 8-38). These include the leg profile and blocked swell of the side stretchers (fig. 6-205), the high rise of the front plank corners (fig. 6-202) and the prominent flare at the spindle bases (fig. 6-209). But the thinness and pronounced tilt of the plank belie a metropolitan origin, and Lewis's name is not listed in Boston directories. Appropriately, a deed from 1800 for a chairmaker of this name has been located by staff at the Maine State Museum in land records for Kittery, Maine, a small coastal community across the Piscataqua River from Portsmouth, New Hampshire. The resemblance of the bow-back chair to Boston work is no accident, considering what is known of that city's export trade with coastal New England and the maritime provinces. The bow-back Windsor could just as well be a St. John chair as a Kittery chair, even though Lewis did not migrate to New Brunswick until after his enumeration in the 1810 Maine census. If Windsor styles in New Brunswick lagged as much behind American production as they did in Nova Scotia, it would have been appropriate for Lewis to produce this pattern at St. John in the early 1810s.[282]

A side chair and armchair (fig. 8-39) made by Lewis in the single-bow, square-back pattern share several basic features, although their modest differences suggest a time lapse between construction of the two. Stylistically, the armchair is earlier. Common to both chairs are single-groove spindles and back posts and a tapered cross bow set between the post tips. Not surprisingly, the long posts relate to those of earlier Boston work (fig. 7-29). The uprights of the side chair are slimmer and cant in a straight plane without a bend. Both chairs retain comparable H-plan braces scaled to size, but the legs of the side chair are turned in four bamboo segments instead of three, thus pointing to a later date. The smaller seat retains the general squared-shield form found in the armchair. Even though Lewis's distinctively styled arms are somewhat provincial, the design is well conceived, providing a good grip for the hands and a suitable thickness to safely

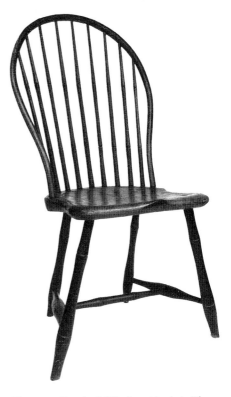

Fig. 8-38 Bow-back Windsor side chair, Thomas Hutchings Lewis, Jr. (brand "T.H. LEWIS"), St. John, New Brunswick, or Kittery, Me., 1800–1812. (Private collection: Photo, Roger Gonzales.)

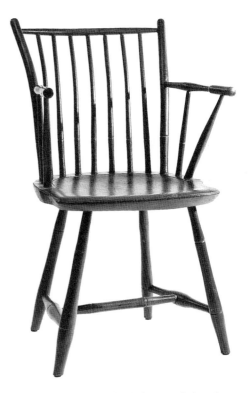

Fig. 8-39 Square-back Windsor armchair and detail of brand, Thomas Hutchings Lewis, Jr., St. John, New Brunswick, or Kittery, Me., 1810–20. White pine (seat); H. 33⅝″, (seat) 17½″, W. (crest) 19¼″, (arms) 21⅝″, (seat) 18¾″, D. (seat) 17″. (Dr. Melvyn D. and Bette Wolf collection: Photo, Winterthur.)

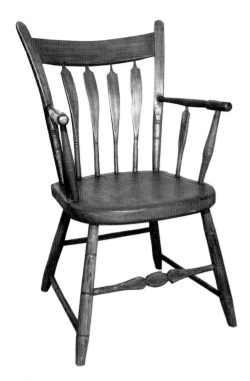

Fig. 8-40 Slat-back Windsor armchair, St. John, New Brunswick, 1820–30. H. 32½″, W. (seat) 17″, D. (seat) 17″. (Upper Canada Village, Morrisburg, Ont.)

accommodate a short spindle. This feature, too, reflects the outside influences that shaped Lewis's work. An armchair with similar rests originated in the vicinity of Portsmouth, New Hampshire (fig. 7-68, left), but again Boston chairwork probably provided the basic model (fig. 7-35).

The basis for attributing a second square-back Windsor of slat pattern to the St. John region (fig. **8-40**) lies in the similarity of the arms to those in the Lewis chair. The arrow-spindle Windsor updates the Lewis design by introducing box stretchers, four-part bamboo legs, a blunt-edge plank, and broad sticks below an inset slat crest. The features suggest a period not earlier than the 1820s. American influence again dominates the design. Shaved-face back posts are common in New England and New York City Windsors dating to the 1810s and later (figs. 7-34, 5-37). The front stretcher profile comes directly from New York work (figs. 5-39, 5-40), and the high, broad spindle silhouette derives from a style popular in and around Portland, Maine, beginning about 1820 (figs. 7-107, 7-110).

As Thomas H. Lewis, Jr., practiced his trade, Thomas Hay launched a fancy- and Windsor-chair making career in St. John that continued for more than a quarter century. Commencing as a freeman in 1819, Hay worked until his death in 1845. His father had been a Loyalist emigrant from New Jersey. Like many other chairmakers, Hay undertook painting and glazing as a sideline. His stenciled name is said to appear on the bottoms of chairs with arrow spindles or stepped-tablet crests. Jacob Townsend, a chair "manufacturer," was perhaps in business as early as Hay. In 1821, Townsend thanked area customers "for past favours" and identified his new chairmaking location. Whether he actually made the cabinet furniture and spinning wheels he offered "at considerably better prices than formerly" is unclear. He was prepared, however, to execute "Turning in all its various branches . . . at the shortest notice." The last notice of Townsend appeared in 1829.[283]

Amos Hagget, an American emigrant, settled in the provincial capital at Fredericton, an inland city on the St. John River, sometime before he announced as a Windsor-chair maker on September 30, 1817. This appears to be the only evidence of his residency in Canada. During the first decade of the century Hagget had practiced his trade in Charlestown, Massachusetts. He knew and probably was working for Thomas Cotton Hayward when he witnessed a land transaction involving Hayward in 1803; he married in Charlestown in 1806. The chairmaker's stay in Canada appears to have been short. Census listings identify a man of this name at Edgecomb, Lincoln County, Maine, from 1820 through 1850. While in Fredericton Hagget probably worked with patterns familiar to him during his previous career. Although he may have modified his work to suit local taste, there was little reason for him to introduce the provincial features characteristic of New Brunswick and Nova Scotia work.[284]

Other river towns furnish evidence of Windsor-chair makers. William Mark of Hampton, the seat of Kings County, was an enterprising individual. He became a freeman of St. John in 1812 in order to retail his merchandise there and in 1813–14 advertised in city newspapers, stating that orders for "Windsor and other Chairs" and turned work could be forwarded through designated agents. The city was readily accessible, since Hampton lies on a tributary of the St. John River only some twenty miles from the seaport. To the south along the St. Croix River bordering Maine, Thomas Jefferson Caswell worked at St. Stephen near his home in Milltown, Charlotte County. His was a long career, probably beginning by 1830 and continuing well into the latter part of the century. He identified the scope of his business in an 1865 notice, calling himself a "Manufacturer and Dealer in Furniture and Chairs."[285]

Windsors with pierced and stepped crests appear in both Canadian and American antiques markets. A side chair is in the New Brunswick Museum, St. John; an armchair without a provenance is at the Henry Ford Museum and Greenfield Village, Dearborn, Michigan (fig. **8-41**). With its lefthand writing leaf, the chair was surely made to special order, and the customer appears to have deliberately chosen a top-line pattern for the crest and extra embellishment for the front stretcher. The unusual stretcher tablet with

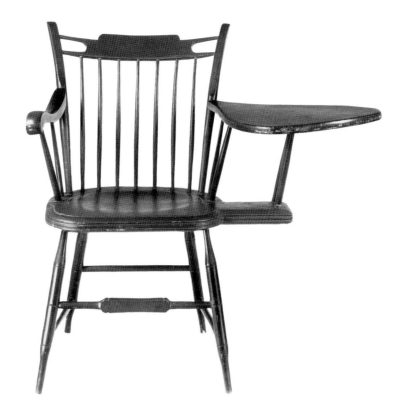

its notched, rounded ends appears identical to that of the New Brunswick Museum chair. The individual leg turnings and molded seat edges may be embellishments unique to this chair, or at best to a small seating group. To some extent the lower back posts conform to the sharp taper of the legs. The crest varies slightly from other examples in introducing rounded rather than squared or notched corners to the low projection above typically long end slots. An armchair without a writing leaf employs five long arrow spindles and forward-scroll arms that terminate in deep, hooklike rolls. The back posts are similar to those illustrated, but the seat resembles George Gammon's Nova Scotia plank (fig. 8-32). In general, the pierced crests appear to spring from earlier Boston and New Hampshire work (figs. 7-34, 7-35, 7-74, 7-87), which in turn was influenced by fancy-chair making. A particularly close, though less flamboyant, model exists in the work of the Wilder family (fig. 7-84). Chairs of variant crest also appear in Maine and Vermont, although no positive evidence as yet links them with those areas.[286]

QUEBEC

Quebec furniture making in the Anglo-American tradition centered in Montreal. Elizabeth Collard's checklist serves as a comprehensive base for interpretation. The island city located in the St. Lawrence was already more than two centuries old when it was ceded by the French to the English at the close of the Seven Years' War in 1763. The population in 1800 stood around 11,000, and within the next forty years the figure quadrupled. Mud banks still substituted for wharves at the beginning of the nineteenth century, but in time local limestone was used to correct that situation; it also supplied the material for many buildings. English-speaking entrepreneurs soon controlled city business, although the surrounding countryside with its scattered villages retained its French provincial character for more than a century.[287]

Collard has identified Samuel Park as the earliest Windsor-chair maker in Montreal. A prominent city cabinetmaker, he is said to have come from New England and appears to have been established for some time when he advertised in 1797. Although Park gave prominence to his cabinetwork, painted seating formed no small part of his stock, and presumably he was the manufacturer. On hand in 1797 was "a large and elegant assortment of Windsor Chairs neatly painted." Park's 1812 stock of "600 Windsor and

fancy Chairs" probably contained such special seating as the "Elegant Gilt parlour Bamboo" chairs with black and yellow grounds that he had advertised in 1810. In American chairmaking circles these chairs were available with rush or wooden bottoms. Park died in 1818, although it is possible that he was already in ill health three years earlier, when he sold half of his business stock to chairmaker Benjamin Whitney. Whitney, like Park, was a New Englander and a member of the local St. Gabriel Street Presbyterian Church, which could explain the acquaintance or friendship that led to the business transaction.[288]

Another New Englander, Thomas Read "from Boston," advertised Windsor chairs in 1803. Since he is not listed in Boston directories, he may have worked there only as a journeyman. His residency in Montreal appears to have been short. The year of Read's arrival Henry Corse began business as an ornamental painter. He had branched into chairmaking by 1806, when he offered a first-class selection of painted seating furniture appropriate to the period: "japann'd, gilt, cane bottomed drawing room chairs; japann'd gilt and painted bamboo chairs and sofas; [and] dining [Windsor] chairs of every description." Corse's career was long and productive, extending until midcentury.[289]

Cabinetmaker Samuel Frost, who was in business by 1811, recognized that there was a profit to be made in the manufacture and/or retail of painted seating furniture in a rising commercial community. He first advertised this branch of business in October 1815, when he offered "Spring Back, Windsor, Children's and other CHAIRS." U.S. chairmakers sometimes used the term *spring back* to identify bent-back seating. In an advertisement of February 1817, Frost further described his seating as "Rush bottomed, Fancy, Bamboo and Windsor Chairs." The bamboo chairs had either rush or wooden bottoms and turned work of segmental form (fig. 7-43). Frost, who worked in Montreal at least until 1820, may have come to the city from Connecticut. A man of that name, who worked in or near New Haven, sold chairs in 1803 to Reverend Benjamin Trumbull.[290]

Following Samuel Frost in business by 1822 was J. Andrews, a paintseller and chairmaker, who advertised "a Fashionable Variety of FANCY RUSH SEATED, & WINDSOR CHAIRS." Andrews offered his seating at low prices by reason of its manufacture on the premises, suggesting perhaps that much stock available elsewhere was not produced locally. Beginning in 1825–26 N. W. Burpee manufactured chairs and settees finished with stain or paint. At his death in 1832 his widow attempted to continue the business but found the going difficult. In three months she gave up and disposed of the shop contents. Her advertisement of October 4 itemizes stock that may be typical of the average Montreal chairmaking shop of the 1830s: "70 painted Windsor Chairs, 36 Windsor Chairs, unpainted, 120 painted and unpainted Rush Bottomed d[itt]o., Turned Wood fit for 100 Chairs, 1300 Chair Bottoms, 2400 feet half-inch Boards." After the sale Luther Temple, a city chairmaker, took over the premises. On or before his removal to a new location in 1842, Temple added cabinetmaking and upholstery services. The scope of his business was no longer that of a one-man shop.[291]

Peter Miler further described the market in painted seating when he advertised "Fancy Rush bottom Ball Backs, Spring Back and Windsor Chairs" in 1825. The ball-back chair was a popular American product by this date (figs. 5-43, 7-13, 7-14). Since it also has a "spring back," Miler's use of that term identified still another bent-back pattern. The chairmaker continued to advertise until his death in 1832, when Michael Miler and Charles J. Andrews announced their purchase of "the extensive STOCK IN TRADE of the late PETER MILER & BROTHER, consisting of a variety of Fancy Chairs, Fancy Windsor, and Windsor d[itt]o Settees, Bedsteads, Wash-hand Stands, &c." Michael Miler was perhaps the "brother" of the original firm. At the same date John Griffith entered business on his own after working as a journeyman for possibly as long as seven years. His manufactory in the northeastern "Quebec suburbs" appears to have prospered. An 1843 advertisement in a French-language newspaper announced the availability of 2,000 rush-seat and Windsor chairs.[292]

By the late 1830s the furniture business was moving from small shop production to large-scale manufacturing. N. Bethune and W. H. Kittson opened a "FURNISHING

WAREHOUSE" in 1838, where they sold the work of other craftsmen along with their own; they supplied both private and business premises, such as hotels. As advertised in April 1843, they offered seating of "neat patterns [and] good style." Chairmakers T. M. Redhead and William Allen also dealt in furniture during their partnership from 1843 to 1849. Their chair selection in 1847 probably included seating of their own manufacture along with purchased stock: "Grecian, Maple, Baltimore, and Fancy Cane-seat Chairs, Boston Rocking, Office and Windsor Chairs." Baltimore-style chairs likely had overhanging tablet tops (fig. 4-16). Office chairs were available in U.S. cities and towns in several designs (figs. 3-151, 3-152). Other specific patterns offered in the 1840s include "Windsor Roll-Top" and "Double-Backed" chairs, as advertised in 1845 by Owen McGarvey (figs. 7-64, 7-49, 7-91), whose business became the city's foremost furniture establishment during the second half of the century. McGarvey's pictorial advertisement in the Montreal directory of 1858 (dated 1857) illustrating the facade of his establishment probably is a reasonably true representation of the "clutter" common to metropolitan store exteriors from midcentury on (fig. 8-42). The upright and inverted sample chairs, including the large Boston rocker at second-story level, seem suspended in air but were actually attached in some manner to the building facade.[293]

Of the eighteenth-century Windsors that have been found in the Canadian provinces, some have long histories of family ownership or other local associations. Although most chairs were carried there with the furnishings of migrating Loyalists, as early exportation goods, or through international family ties of a later date, a few appear to have been made there. One such Windsor (fig. 8-43) is typical of a group comprising more than two dozen examples (some representing sets). Almost all are in the continuous-bow style, but one group of six has sack backs. Four chairs (one representing a set) were recovered in Canada—two in Ontario and two in Quebec. The sack-back chairs and the illustrated continuous-bow Windsor fall into the latter group.[294]

Figure 8-43 bears an old gummed label on the seat bottom telling of its ownership by Archbishop Plessis of Canada, a grandson of Mary Catlin, one of the Deerfield, Massachusetts, captives taken to French Canada by Indians in the early eighteenth century. The nuns of the Ursuline Convent in Quebec gave the chair to an American descendant of Mary Catlin. Other background and peripheral information reinforces

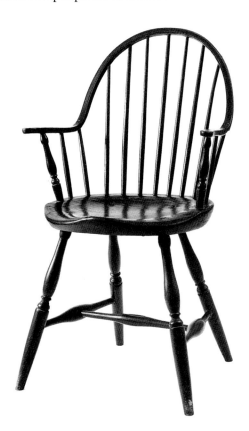

Fig. 8-43 Continuous-bow Windsor armchair, probably Montreal, Quebec, ca. 1795–1805. White pine (seat) with maple and other woods; H. 34⅜", (seat) 18", W. (arms) 21¾", (seat) 18⅜", D. (seat) 14". (Memorial Hall Museum, Pocumtuck Valley Memorial Association, Deerfield, Mass.: Photo, Winterthur.)

the plausibility of a Canadian origin for this group, and Montreal seems a logical place of manufacture. The city was accessible to migrating craftsmen, it had land and sea communication with the United States, it was an important trading center, and the English language was introduced after the cession of 1763. By contrast, in that era Toronto was still only a small settlement.

The chair is strikingly American in design and strongly suggests that its maker emigrated from somewhere in the Rhode Island-Connecticut border region during the 1790s: the broad, low arch is found in Rhode Island chairmaking (fig. 6-82); the sculpted plank is a classic pattern of that area (figs. 6-28, 6-50, 6-84); and the turned elements have counterparts in Rhode Island and northern coastal Connecticut work. The principal features of the turnings are the elongated balusters and their collarless articulations with the elements above them. Figure 6-31 provides a close prototype for both. The tiny spool and ring turnings of the arm posts share profiles with the same elements in figure 6-83. Forward of the moderate arm bends in the flat-faced bow of beaded edge are small, rounded arm pads without accompanying side pieces or projections. The arms of several continuous-bow chairs of Rhode Island origin are comparable (figs. 6-77, 6-80). There are several spindle forms. Most common is the stick that tapers top and bottom, as shown. The same feature, somewhat exaggerated, occurs in two border-region chairs (figs. 6-139, 6-140). Other spindles bulge slightly below their midpoints and then taper sharply toward the base. A chair at the Senate House in Kingston, New York, falls into this group, although its sticks also have tiny, inverted spool-and-ring turnings immediately above the bulge. Both the broad back and oval seat are atypical of continuous-bow design, although the plank is common to sack-back seating.

ONTARIO

The St. Lawrence River Region

American settlement along the north shore of the St. Lawrence River below Montreal and south to Kingston at the river's connection with Lake Ontario began in 1784. Simultaneously, other American emigrants pushed west from New York state into the narrow neck of land beyond Niagara. Some were merchants, more were farmers, but all faced the challenges of frontier life. A few entrepreneurs who came with a little cash were able to develop sizable businesses. During the mid 1790s the duc de La Rochefoucauld Liancourt described a flourishing mill of thirteen saws on the St. Lawrence, belonging to a Connecticut native and captain of the Upper Canada militia who had received a grant of 700 acres. In response to the postwar influx of thousands of American Loyalists who supplemented a small resident population of French Canadians, Indians, fur traders, and military personnel, the British Parliament created the province of Upper Canada in 1791 (titled Canada West in 1841, Ontario in 1867).

Considerable progress had been made by the time of the War of 1812. Settlements ranged across the fertile, forested land bordering Lake Ontario to join those in the Niagara region. Kingston and York (Toronto) were the principal towns, but other small centers arose where rivers flowed into the lake, much as they did in the U.S. Midwest at tributaries along the major waterways. Immigration following the War of 1812 came primarily from Great Britain. With the arrival of new waves of settlers, trade in the established towns prospered, and skilled craftsmen and professional men found an increasing demand for their services. In 1821 J. Howison advised prospective settlers traveling from a distance to leave household furnishings behind, noting that "everything . . . necessary for the interior of a log hut can be procured in the settlements. Good furniture is not at all fit for the rude abodes that must first be occupied." Building and business reflected both regional permanency and continuing expansion. The population was a mixture of British and American peoples with scattered pockets of German American settlers.

The pioneering years ended in the lake settlements and some inland areas during the 1830s. A rising middle class could now afford to focus more attention on home and

household. Anne Langton described the seating furniture in 1837: "Painted wooden chairs are the most frequent, rush-bottomed ones being in the most elegant drawing-rooms." International trade with U.S. towns and cities on the opposite lakeshore had begun, although not always to the advantage of Canadian craftsmen. A small elite society of merchants, lumber and fur dealers, and military personnel of rank was in a position to import furniture directly from England. After traversing the region in 1853, William Chambers was convinced that Ontario was "destined to be a Mediterranean around which a great people [would] cluster and flourish."[295]

Based upon her study of life in early Ontario, Jeanne Minhinnick stated that *English* Windsors were not encountered in the old farmhouses of the province and thought that few were imported or made by immigrant English artisans. The Canadian-American Windsor is another matter; it is one of the popular seating forms still found in the province. Among early patterns with Ontario histories are a few chairs carried to Canada by early immigrants; others were made by skilled artisans once they had resettled. But the majority of Ontario Windsors reflect styles popular in U.S. chairmaking only from the 1820s and later. Some were made by Canadian-born and/or -trained craftsmen, others by American-trained immigrant or migratory workmen, and still others by local artisans using chair parts purchased from U.S. suppliers.[296]

Among early examples of Windsor seating is a group from eastern Ontario made by a skilled American craftsman. The name of the maker is unknown, but there is little doubt that he emigrated from Rhode Island. Judging by the amount of surviving work from his hand—two settees, a high-back chair, a fan-back chair, and several sack-back Windsors—the chairmaker appears to have enjoyed good custom in his new home. His best-known piece of furniture is a settee in the collection of Upper Canada Village, of which a similar example is in a private American collection (fig. **8-44**). Most characteristic of the work is the leg profile. This is the shape that identifies other Windsors from the same shop and forges the Rhode Island link. The arm supports in the settees and sack-back chairs are shorter versions of the same turnings. The thick-necked baluster with its compressed, rounded base resting on a bold, flared-head spool and fitted with a large crownlike collar at the top is part of the vocabulary of postwar Rhode Island Windsor design. The collar is repeated in the medial stretchers. Comparison of the settee posts with the leg tops of figures 6-18 and 6-19 reveals that they are virtually identical. Also noteworthy is the similarity of the large-headed spool turning of the legs to those in the early work of Ebenezer Tracy, who practiced his craft in New London County, Connecticut, adjacent to Rhode Island, beginning about the mid 1780s (figs. 6-98, right, 6-101).[297]

Flat-canted seat edges are another consistent feature in the work of the anonymous chairmaker that reaffirm his Rhode Island origin. The profile, which visually lightens the plank, originated in early English Windsor work and was transmitted to Pennsylvania and Rhode Island chairmaking about the mid eighteenth century. The feature vanished from Philadelphia work before the Revolution but remained a staple of Rhode Island Windsor design until the turn of the nineteenth century. Found only in Rhode Island work is the notched oval pad forming the arm terminals of the settees and the sack-back chairs. This profile was first used in an early postrevolutionary sack-back design of Providence origin (fig. 6-16). Perhaps intended as a complement are the small, subtle decorative beads cut into the upper corners of the settee back rail. Beneath the rail, the spindles taper noticeably top and bottom.

The most unusual feature of both settees is the ornamental splat set into the center back, although its inspirational source is less than obvious. Splats found in English Windsors differ significantly in shape (figs. 1-24, 1-26, 1-32, 1-33), while the vasiform profile of the Queen Anne style that lingered on in the rush-bottom yoke chair of New York and southern New England (fig. 5-8) positions the full part of the baluster at the top. The present compressed form, dictated by the settee height, is comparable to corner-chair splats, of which some share a similar thick-necked baluster, though inverted. The settee balusters, which vary slightly, may derive from another Rhode Island

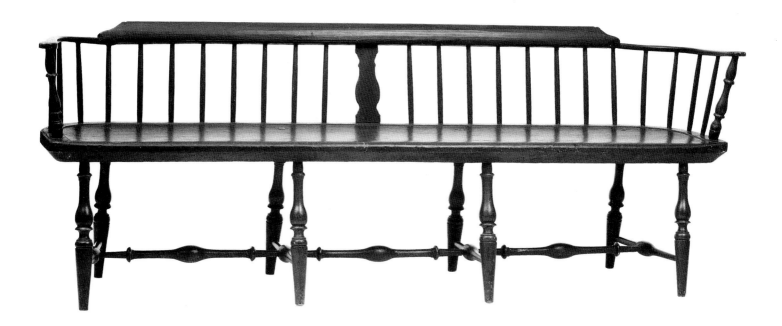

Fig. 8-44 Low-back Windsor settee with splat, eastern Ontario, 1785–1800. White pine (seat) with maple, basswood (microanalysis), and other woods; H. 28½″, (seat) 17¼″, W. (arms) 82″, (seat) 79¼″, D. (seat) 16⅞″. (Private collection: Photo, Winterthur.)

profile. Based upon his prewar or immediate postwar training, the chairmaker would have been familiar with the ornamental spindle of the cross-stretcher Windsor that derives from the banister-back chair (figs. 6-1, 6-2, 6-5). That tiny, thick-necked baluster closely resembles the splat in the Ontario settees, especially the one at Upper Canada Village. The work would have been reasonably fresh in the chairmaker's memory, since he did not remain in Rhode Island long enough to update his style in the late 1780s or 1790s.

The settee at Upper Canada Village was recovered from an "old home" in Prescott, Grenville County. Three related chairs have location histories in the same general area: one in Grenville County, one to the north in Carlton County, and the third just south at Kingston, Frontenac County. The known recovery region, then, encompasses an area of not more than sixty-five miles along the St. Lawrence River. The fan-back Windsor in the group, which is from Carlton County, has a braced back. The plank is of the general type found in figure 6-27 and has a tablike projection behind a squared shield with little side curve. The front edge cants sharply and is centered by a ridge below the pommel. Back posts employ an inverted bulbous turning at the base. The loss of the top part of the crest prevents comparison of that feature with Rhode Island fan-back work. Of five known sack-back armchairs, two have provincial histories, and another is in the collection of Upper Canada Village. All are alike in featuring a low, flattened, round-arch bow, the tips flaring outward slightly and terminating in a stumpy "toe," or foot, that rests on the arm rail (a tenon beneath it). The New York sack-back Windsor of the 1780s (fig. 5-7) provided the design source. The transplanted Rhode Island craftsman would have known this feature, since the two areas engaged in active commerce. The sack-back chair seats are large ovals with a projecting, center-front pommel; the side and back edges flatten, then cant. Spindles and arm terminals compare with those in the settees.[298]

The last chair identified as part of this group is a high-back Windsor of unusual design (fig. **8-45**). The legs are identical to those in the settee, down to the subtle hollow taper of the lower feet. The design of the seat and the arm structure, which lacks supporting spindles, is provincial in concept, but invites explanation. The craftsman received a commission for a "large" chair with a tall, reclining back. The customer may have envisioned something like an early Pennsylvania high-back chair (fig. 3-11), of which some descended in Loyalist families. But the immigrant craftsman would hardly have constructed a chair thirty or more years out of date, so he improvised. He took a shield pattern for a side-chair seat and expanded it to the proper width. This explains the unusually deep indentations at the sides. The choice was a poor one, however, because the sides cut in too deeply to permit the use of short spindles beneath the arms. The

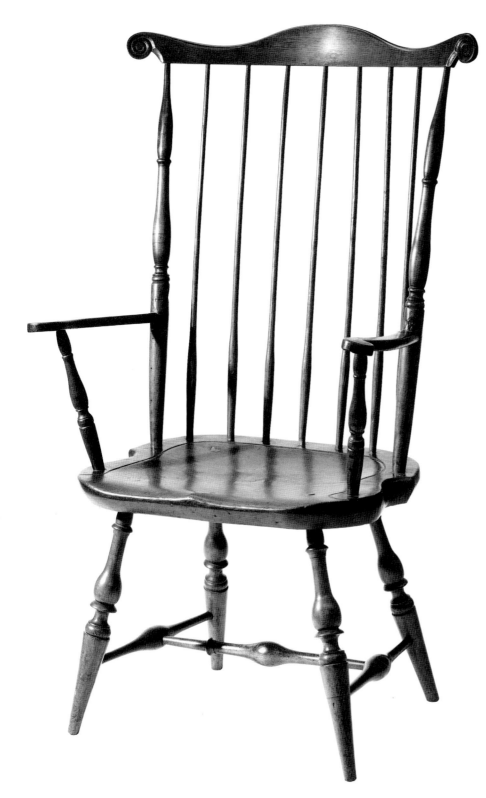

Fig. 8-45 High fan-back Windsor armchair, eastern Ontario, 1790–1805. White pine (seat, microanalysis) with maple and oak; H. 47⅜″, (seat) 17½″, W. (crest) 30″, (arms) 27⅞″, (seat) 23¾″, D. (seat) 16⅞″. (Mystic Seaport Museum, Inc., Mystic, Conn.: Photo, Winterthur.)

groove as it serpentines forward from the back posts only emphasizes the awkwardness of the design. Part of the way through construction the chairmaker may have realized that an oval plank, such as that used in his sack-back chairs, would have been a better choice. The flat arm rest probably is a modification of one in an earlier Rhode Island low-back chair, which the craftsman would have known (fig. 6-2). Although the long and short posts supporting the arms resemble each other, they do not coordinate with the legs. This is not surprising, since the chairmaker was working outside his range of experience. The spindles taper sharply at the base, duplicating those in other examples. The precise modeling of the crest suggests that the craftsman had firsthand knowledge of this carved form or possessed an example to copy or adapt. Based on this interpretation, the product, the craftsman, and the society he served can be seen in a new light.

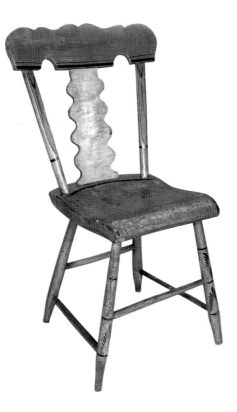

Fig. 8-46 Rounded tablet-top, splat-back Windsor side chair, S. Haskin (brand), Lyn, Ontario, 1845–60. H. 33¼″, W. (seat) 18¾″, D. 15″; light and medium yellow-brown grained ground with black. (Upper Canada Village, Morrisburg, Ont.)

Little else is identifiable in early Windsor work of the St. Lawrence region. However, there is record of production from the 1830s and 1840s. Leeds County dealers H. Billings and Company and W. Curtis and Company kept "superfine" and "first quality, assorted pattern" Windsors "constantly on hand" at their shops in riverside Brockville in 1832 and 1834. The former may be the Henry Billings who pursued the cabinet trade across Lake Ontario in Rochester, New York, from at least 1838 to 1846. Canadian authors have commented on the frequent exchange of craftsmen and products across national boundaries in the lake region. A decade or so after Billings left Brockville a Colonel E. Buell manufactured cabinetwork and chairwork there. A label identifies one of his Boston-style rocking chairs. A similar chair of midcentury date bears the name of chairmakers W. D. and L. J. Brooks, who worked at Milleroches, near Cornwall.[299]

Two other Leeds County chairmakers are known by their documented side chairs featuring back splats, shouldered tablet crests, and rectangular planks with ogee-contoured surfaces. A chair made by N. Patterson at Lyndhurst has a baluster-shaped splat. Another from the Lyn shop of S. Haskin is of individual form, with projections that ripple down the splat sides (fig. **8-46**). The crest has extra scrollwork, and the seat is branded. Both chairs owe considerable debts to Pennsylvania and New England Windsors of the second quarter of the century, especially in the crest and seat (figs. 3-138, 3-146, 3-147, 7-77, 7-101), although Pennsylvania design appears to prevail. German American immigration to Ontario, which began in the late eighteenth century, still continued to a minor degree after the mid nineteenth century. There was heavy settlement in the St. Lawrence region in areas flanking Leeds County.[300]

Kingston and the Northern Lakeshore

Kingston, on the north shore of Lake Ontario near the head of the St. Lawrence River, was the largest community in Ontario (Upper Canada) during the early nineteenth century. It was the site of a military garrison and a transfer point for goods going west along the lake. Isaac Weld commented on the "very considerable trade" of the place during his visit in the late 1790s and noted that "the principal merchants resident in Kingston are partners of old established houses at Montreal and Quebec." The British government erected a large naval facility at this location during the War of 1812. The combined presence of military personnel and mercantile interests made Kingston the

center of cultural, social, and economic life in Upper Canada for many years. The town was in a flourishing state as several furniture makers pursued their careers just before the war. Although military officers brought many furnishings with them, and merchants easily acquired furniture elsewhere, local craftsmen did well. There also were special commissions, such as that for the Barracks Department of the local garrison, which in 1814 required 200 tables for officer and barrack use and "200 cane or rush bottomed Chairs, painted black."[301]

Partners named Greno and Sawyer opened shop in 1811. As sign painters and gilders they offered professionally decorated seating furniture. Within a few years American-born Chester Hatch began a long Kingston career as a cabinetmaker and chairmaker, offering "Elegant Fancy CHAIRS" for sale about 1815. In public notices the following year he itemized a stock of "Waterloo [fancy], Windsor, Rock[ing] and Children's chairs," supplemented by settees; he also offered painting services. Custom was sufficiently good for the craftsman to introduce several new patterns by 1817. His "Broadtop Ball back" chair had a rectangular crest overhanging the back posts, a ball fret at midback, and probably a rush seat. "Bamboo" chairs were framed in fancy or Windsor styles. Other seating featured "real cane" seats, suggesting that even then there were less satisfactory imitations. Hatch's slat-back production could have included Windsor, fancy rush-bottom, and common rush-bottom seating. In 1823 the craftsman took a bold step. He opened a branch business down the lake at York (Toronto), where he offered similar merchandise and services. Joan Mackinnon in her studies of furniture makers at Kingston and Toronto was unable to determine whether this was an outlet for Kingston-made chairs or a separate manufacturing operation. Hatch located the Toronto business on the Market Square next door to a busy inn.[302]

In the mid 1830s Chester Hatch secured a land grant at Fenelon, Victoria County, and gave up the furniture business for a while. He probably intended to develop his lot; however, a prior claim eventually nullified his title. Fenelon Falls, on a short river between Cameron and Sturgeon lakes, was an excellent mill site, the falls being 20 feet high and 300 feet wide. It is possible that Hatch planned to develop a chair manufactory or sawmill there, but his scheme was thwarted, and he was back in Kingston by 1839. Unfortunately, the timing was poor. Formidable competition from U.S. chair factories in the newly developing urban and rural centers along the Erie Canal and the lakeshore was taking its toll on Canadian production. Cheap American chairs and chair parts entered Ontario in large numbers. An 1840 advertisement of E. Brown and Company, a Rochester, New York, firm with an outlet in Kingston, indicates the scope of competition: "A general assortment of chairs . . . consisting of curled maple, cane seats, scroll top with either plain or banister backs; also imitation rosewood cane bottom, gilded and bronzed with either slat or roll tops, together with Boston rocking, sewing, nurse and a superior article of office arm chairs." For some time Hatch circumvented the intrusion by ordering chair parts from a supplier in Oswego, New York, to assemble and paint. He probably was able to undersell the competition slightly, but it was not enough; eventually he had to declare bankruptcy. Understandably, many Canadian craftsmen were bitter that the government offered so little protection. Hatch's son Wilson, a chairmaker himself, was among them. The problem was not new. In 1827 "A British Mechanic" at York published a letter sharply critical of local citizens, who bought merchandise outside the country rather than supporting "domestic manufacturers." The rebuke ended with the statement: "It is a well known fact . . . that a large proportion of the articles of mechanism required by the officials of this town, are purchased in New York, Buffalo, and Rochester."[303]

After several years of retirement, Chester Hatch joined his son in business from 1850 to 1857. Again, production made extensive use of imported chair parts. Bundles of "stuff" arrived from Clayton and Cape Vincent, New York, towns located at the entrance to the St. Lawrence River only a short water passage from Kingston. These Jefferson County locations were not far from Black River, where David Dexter manufactured cane- and wood-seat chairs from about 1840 (figs. 5-59, 5-60). Dexter's Windsor chair relates to

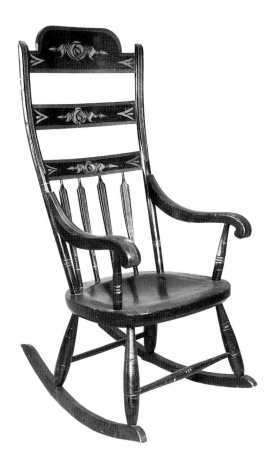

Fig. 8-47 High slat-back Windsor rocking chair, Ontario, 1835–50. Basswood (seat) with maple; H. 44″, W. (seat) 20″, D. (rocker) 28¼″; decoration not original. (Upper Canada Village, Morrisburg, Ont.)

some found in Ontario today, although the fancy legs and seat roll are uncommon. With Dexter's sizable factory operation, he too likely shipped chairs and parts to Canada. Of two patterns bearing Hatch's identifying brand, one is a half-spindle chair with a tablet top of the same general type as the Dexter chair and the other an arrow-spindle chair with an inset slat top. The latter employs a rounded rectangular plank with flat edges all around.[304]

John Duncan, a Scots cabinetmaker at Kingston, covered the bases in 1824 by hiring a chairmaker from Montreal and another from New York to make fashionable seating, but a disastrous fire wiped him out in 1832. The event coincided with a gradual decline at Kingston, which had been bypassed as the provincial capital. The frontier, too, had pushed westward, and York had grown to twice the size of Kingston by 1834. Opening of the Erie Canal altered prevailing trade routes to the west, and Kingston frequently was ignored by shippers.[305]

Few dwellings located outside the established communities bordering the lake were distinguished by sophisticated furnishings before the mid nineteenth century. Captain John W. Meyers's lakeside home in Belleville, possibly erected in 1794, contained ten Windsor chairs at his death in 1821, supplemented by a cherry table, a desk, a clock valued at £10, four looking glasses, and the like. At Colborne, several miles away, the firm of Johnson and Son, proprietors of a chair manufactory that may have been in operation by the late 1830s, produced tall rocking chairs that almost duplicate the pattern illustrated in figure **8-47**. Variation is seen only in the height of the crest projection, here slightly taller, and the substitution of a slat-type front stretcher. The crest is a distinctive Canadian interpretation of an American pattern, and the bamboo legs are decidedly more robust than those encountered south of the border. Otherwise, the pattern consists of elements drawn directly from American sources (figs. 7-60, 7-63, 7-92). In neighboring Napanee several years later, J. Gibbard advertised a full line of luxury furnishings from "Sofas of the latest patterns" to "Side, Centre, Toilet, Dining, and Work tables." He also stocked painted seating, including "Rocking, Parlor, Cane, Windsor, and Children's Chairs." But

beyond these communities, furnishings usually were of the most common or make-do sort, and the setting was no more pretentious than a cabin.[306]

Susanna Moodie, a new settler in the Cobourg area in 1832, found log houses little to her liking. A large hearth and humble furnishings, including a bed, a homemade table, and a few bass-bottom (splint-seat) chairs, soon filled the single room. Mrs. David Fleming, recalling her contemporary childhood home in the same area, painted a similar picture. The twelve-by-eighteen-foot house had no interior partitions and little furniture. Two beds, two chests, and a shelf clock were located around the room; a table, three or four chairs, and some homemade stools stood at the center. Susanna Moodie's sister, Catharine Parr Traill, published a description of life on the Upper Canada frontier in 1836, and as late as 1854 her *Female Emigrants Guide* still dispensed advice for those embarking upon a frontier life. To make a "log parlour comfortable at small cost" she suggested: "A dozen of painted Canadian chairs such as are in common use here will cost you £2.10s. You can get plainer ones for 2/9 or 3 shillings a chair; . . . you may get very excellent articles if you give a higher price; but we are not going to buy drawing room furniture. You can buy rocking chairs, small, at 7/6, large, with elbows, 15/. . . . Cushion them yourself." Further advice concerned floor coverings, window curtains, tables, bookshelves, and miscellaneous items. To fill an odd angle or two in the room she suggested corner shelves "one above the other, diminishing in size," which would form "a useful receptacle for any little ornamental matters, or a few flowers in the summer" and give "a pleasant finish and air of taste to the room." Her own dwelling of the 1830s contained "Canadian painted chairs, a stained pine table, green and white curtains," and an "Indian mat" on the floor.[307]

A few families could do better. The Langtons, who built Blythe House at Sturgeon Lake, had rooms with plastered walls and wooden trim, and furniture shipped from England. By contrast, the bachelor house of Anne Langton's brother, located nearby, was of the usual log construction with simple or make-do furnishings. Sketches show homemade and "Canadian painted chairs," the latter of slat-and-spindle pattern (fig. 8-48). Shelves in another part of the room made good use of wall space; utilitarian gadgets and equipment hung from nails here and there for ready access. A table, simple window drapery, and a few pictures completed the room. In summary, regional furnishing employed a full range of painted seating from the common, plain Windsor chair "of

Fig. 8-48 *Interior of John's House*, above Sturgeon Lake, Ontario, ca. 1835–40. Pencil on paper; H. 7³⁄₁₆″, W. 9½″. (Anne Langton Collection, Archives of Ontario, Toronto.)

the cheapest sort" to the elegantly colored and decorated parlor chair with a wooden, rush, or cane bottom.[308]

Toronto and Western Ontario

Toronto was well on its way to becoming a metropolis when William Chambers viewed it in 1853. The main thoroughfare was already two miles long. From 336 inhabitants in 1801, the population had grown to 40,000 by midcentury, and as the English visitor noted, "the additions now fall little short of 10,000 a year." However, the entire population stood only at the latter figure in 1834 when York was incorporated as the city of Toronto, reassuming its original Indian name.[309]

When Daniel Tiers (Tierce) arrived in York with a group of German settlers from Pennsylvania in 1796–97, the community was little more than a village. Tiers was only twenty, although he had already served an apprenticeship as a cabinetmaker and Windsor-chair maker. He obtained a land grant and launched his career in 1798. During the next decade Tiers apparently advertised only once. A notice dated January 23, 1802, identifies his seating production: "armed Chairs, Sittees, and dining ditto, fan-back and brace-back Chairs." The dining chairs had bow backs; the braced seating, as in American production, likely comprised several patterns. Tiers stated further that he anticipated a new supply of paints for finishing chairs, which implies that the selection included the latest fashionable colors. In a postscript the craftsman noted that he also expected "a quantity of common chairs from below." Tiers's specific use of the word *common* and his own production of Windsor furniture indicates that this was rush-bottom, slat-back seating. Philip Shackleton suggests that the chairs may have come from somewhere in French-speaking Lower Canada. This is plausible, since the form is traditional in the French culture, and water transportation down the St. Lawrence and across the lake was direct. It is also possible that Tiers was referring to the Niagara peninsula, where German-American settlers had taken up land as early as 1784. Slat-back seating is part of the German culture as well. In 1808 Tiers turned to victualing and in a short time was proprietor of the Red Lion Inn, which he ran successfully for many years. With York the seat of provincial government, innkeeping was no doubt a steadier, more profitable occupation than chairmaking.[310]

From Daniel Tiers's retirement as a chairmaker until the 1820s there appears to have been a hiatus in Toronto chairmaking. Other furniture craftsmen may have made chairs as a sideline, but even in the cabinet trade there was little activity until the end of the War of 1812. Two cabinetmakers advertised in 1815, the year the Commissariat Office sought furniture for the Barracks Department: "150 chairs, 50 tables with drawers for officers [and] 20 tables without drawers for soldiers." Shackleton suggests that the furnishings replaced those lost when the Americans burned the fort and public buildings at York (Toronto) in 1813. The postwar period marked another "beginning" in the local furniture trade, although as late as 1820 a visitor noted the city's "trifling" level of trade and credited its advances "entirely to its being the seat of government." Many furniture craftsmen still found it necessary to pursue a second occupation to make a living.[311]

When Judah M. Lawrence and B. W. Smith advertised fancy, bamboo, and Windsor seating in 1828, they operated a wareroom on Yonge Street. By this time the local population was on the rise. An influx after the Napoleonic wars brought new settlers from England, among them specialists in the trades and professions. Alexander Drummond from Liverpool and London closely followed Lawrence and Smith, who parted company in 1833. He sold fancy and Windsor chairs "finished in the latest New York fashions." Since Drummond was primarily a specialist in ornamental painting, it is likely that he purchased chairs in the wood, then painted and decorated them. The "New York fashions" likely identified decorative motifs and background colors rather than structural design. Among the masses of people arriving at Toronto, many still brought common furniture from Britain, paying more for freight than it was worth in the mistaken belief that such things were unobtainable in the wilderness. Thus, George

Henry advised emigrants in 1831 that with wood so plentiful in Canada, "common articles of furniture are very cheap in most parts of the Province; very good common chairs, quite new, are to be bought for four or five shillings each, and sometimes less."[312]

Toronto was undergoing major growth by the mid 1830s, when Samuel Church was active. The chairmaker offered the usual painted seating, to which he added the new "Settee Cradle," a bench form with rockers and a removable "gate" at the seat front. Church had been in business briefly with Charles March, an ornamental painter whose father emigrated from the United States in 1813. Church himself had removed to Lockport, New York, near Buffalo by 1842. Toronto land values began to rise during the 1830s, and several cabinet factories achieved substantial size. The economic threat posed by the importation of American furniture seems to have subsided as local production blossomed. A leading business was that of John Jacques and Robert Hay. Mackinnon states that by the mid 1850s this firm was one of the largest furniture manufacturers in North America. Jacques and Hay had joined forces in 1835 to produce cabinetware; they added Windsor seating to their line before 1850. A newspaper account of 1851 comments on their production of dining and drawing room furniture of "tasteful" design. Manufacturing statistics describe an annual output of "one thousand common French bedsteads . . . and upwards of 15,000 Windsor chairs." William Chambers toured the factory two years later: "It consists of two large brick buildings, commodiously situated on the quay, and . . . gives employment to upwards of a hundred persons. . . . For the first time [I] saw in operation the remarkably ingenious machinery for planing, turning, morticing, and effecting other purposes in carpentry, for which the United States have gained such deserved celebrity, and which I subsequently saw on a vast scale at Cincinnati." The firm weathered three disastrous fires in the 1840s and 1850s to remain the leading Toronto furniture establishment in the third quarter of the century. Its owners retired in comfortable circumstances.[313]

Toronto influence pervaded the western region by midcentury. Craftsmen in the immediate area probably produced close imitations of city furniture. A late low-back chair with heavy back rail and arms is labeled by W. W. Woodale of Hagerman's Corners in Markham Township, York County. The support structure still features slim bamboo-style legs with pointed toes rather than the heavy ball-and-ring turnings found in U.S. production of the period. At Hamilton on the lakefront Thomas Bain manufactured Windsor, fancy, French, and Grecian chairs in 1850. Out on the fringes of settlement, however, the cabin still was a common sight, and furniture styles were correspondingly less sophisticated. A drawing of the kitchen in Schramm House, Waterloo County, made as late as 1862 shows only a few more furnishings than were found earlier at Sturgeon Lake (fig. 8-48). Prominent are a large cookstove, a long table, and slat-and-spindle-back Windsor chairs. A sketch of a farmhouse sitting room in the same area details similar furnishings; a small heating stove replaces the cookstove, and the room is plastered and ceiled.[314]

Below Hamilton the Niagara peninsula had organized settlements by 1783, and a comfortable style of living was not uncommon by the early nineteenth century. Documents describing personal losses sustained by Canadian citizens during the War of 1812 list household furnishings. At Niagara a Mr. Kirby claimed compensation for cherry and walnut tables and twelve Windsor chairs. William Dickson, an established area merchant, lost far more. Along with cabinet furniture made of mahogany, walnut, and cherry, he listed fancy painted seating, described as "one dozen neat gilt chairs, seven neat gilt chairs, one arm chair, [and] two fine green arm chairs." Shackleton reports that one Poucett was operating a chair factory in Niagara in 1828, when he advertised "Plain and Ornamental painting, gilding and glazing" as an accompaniment to his chairwork. Less than a decade later, during the 1837 rebellion, area resident Robert M. Roy of Chippewa sustained the loss of six black Windsor chairs valued at $5. Ralph M. Chrysler of Niagara is thought to have been the contemporary owner of a tall-back, crown-top rocking chair bearing his initials on the seat bottom. Marked on the plank along with

other initials and the place-names "Can." and "Rochester" is the maker's stamp "A. Wetherbee / Warranted." How Abijah Wetherbee of New Ipswich, New Hampshire, shipped chairs to western Ontario or New York state is difficult to say.[315]

Furniture studies for Norfolk County, located farther west in Ontario along Lake Erie, suggest that households became more comfortable from the late eighteenth century, when chests and bedsteads sometimes substituted for chairs, through the post-1812 period. The Charlotteville household of Thomas Rolph, an Englishman with training in law and medicine, was still probably several cuts above the average in 1814 with its 5 kitchen chairs and "26 green chairs." Two decades later a dozen "common" chairs helped to furnish the local dwelling of Noah Fairchild. By then several small but busy ports flourished along the shore. The region was dotted by streams, forests, productive farmlands, and sawmills, assuring a measure of prosperity. Even so, most regional evidence of furniture making is late. Franklin Mead "commenced manufacturing . . . Fancy, Cottage and Windsor Chairs, Settees and Cradle Chairs, Rocking Chairs, &c." about September 1842, when he advertised at Port Dover. He offered "a good article" for $4.50 the set. He also followed the trade of house painter and ornamental painter. Mead had emigrated from New York state, where the Buffalo directory of 1842 listed him as a chairmaker. A decade later the craftsman moved to a new town location and offered his old property for sale. He described "a Dwelling, Cabinet and Chair Factory, situated . . . a few rods from the Farmers' Hotel. . . . There is a Well of good and never failing water, with a Garden of Fruit Trees and Shrubbery." Several slat-and-spindle-back Windsors bear the "F. MEAD" brand; a marked Boston-type rocker with a cross slat at midback has half-length spindles.[316]

Henry E. Collins and Alonzo Hatch conducted the cabinetmaking and chairmaking business at Simcoe, the county seat and a busy market center. The partners were in business before a public notice of May 1841, which described the seating stocked at their furniture warehouse as Boston, rocking, cottage, fancy, Windsor, and children's chairs. Westward almost to Detroit in Chatham, Kent County, Robert Smith advertised Windsors of his own manufacture priced from $3 to $3.50 the set. He was careful to state that the seating was "not imported from Detroit." In remote provincial areas, such as Sault Sainte Marie above the Michigan peninsula, local consumption probably was almost entirely a matter of importation until a late date. In 1828 Charles Ermatinger, a fur-trading merchant, sent to Montreal for his Windsor chairs, for which he paid 4s.4d. apiece.[317]

In summation, Canadian Windsor production, which follows American styles, frequently dates later than comparable seating originating in the United States. Construction of eighteenth-century patterns was limited. Except in the maritime provinces, the real heyday of Windsor chairmaking began only in the 1810s. The most common styles were those with slat- or tablet-type crests accompanied by plain or arrow-shaped spindles and, less frequently, cross slats. Fancy embellishments, such as ball frets and turned roll tops, were uncommon. Side-chair seats were rectangular or balloon-shaped, and leg turnings commonly consisted of tapered bamboowork, sometimes modified by a ball turning near the top.

Notes

1. Marshall B. Davidson, *Life in America*, 2 vols. (Boston: Houghton Mifflin, 1951), vol. 1, pp. 68–73; Clement Eaton, *A History of the Old South* (New York: Macmillan, 1949), pp. 1–75.

2. Richard Caulton, advertisement in *Virginia Gazette* (Williamsburg, Va.), November 28–December 5, 1745 (reference courtesy of Susan B. Swan); James Wray and Philip Ludwell, estate records, 1750 and 1767, as excerpted in Mrs. Rutherfoord Goodwin, letter to Charles C. Wall, June 26, 1962, Research Files, Colonial Williamsburg, Williamsburg, Va. (hereafter cited as CW); ship arrivals, *Virginia Gazette*, March 31, 1768, and February 3, 1774.

3. Frances Norton Mason, ed., *John Norton and Sons Merchants of London and Virginia* (Richmond, Va.: Dietz Press, 1937), p. 125; *Virginia Gazette*, August 8, 1777; Thomas Thompson and William Pearson, estate records, 1772 and 1777, Inventory Transcripts, Research Files, CW; Landon Carter, estate records, 1779, Carter Papers, Swem Library, College of William and Mary, Williamsburg, Va. (hereafter cited as WM); Jane Carson, *Colonial Virginians at Play*, Williamsburg Research Studies (Williamsburg, Va.: Colonial Williamsburg, 1965), p. 11; "Extracts from Account Book of Thomas Davis, Spotsylvania County, Va.," *Virginia Magazine of History and Biography* 17, no. 1 (January 1909) (reprint, New York: Krauss Reprint Corp., 1968): 101–3; Gretchen Sullivan Sorin and Ellen Kirven Donald, *Gadsby's Tavern Museum Historic Furnishing Plan* (Alexandria, Va.: City of Alexandria, 1980), p.33.

4. Harrold E. Gillingham, "The Philadelphia Windsor Chair and Its Journeyings," *Pennsylvania Magazine of History and Biography* 55, no. 3 (October 1931): 316–18, 322, 325, 328, 331–32. At best the records are incomplete. William and James Douglas, bill to Stephen Cocke, February 17, 1791, Virginia Historical Society, Richmond, Va. (reference courtesy of Mrs. Helen T. Reed); Helen Scott Townsend Reed, "Woodlands, A Virginia Plantation House," *Antiques* 119, no. 1 (January 1981): 228–29; Thomas and William Ash, bill to St. George Tucker, St. George Tucker Accounts and Receipts, Tucker-Coleman Collection, WM.

5. Francis Jerdone, ledger, 1750–72, and Francis Jerdone II, estate records, 1841, Jerdone Papers, WM; Jack and Marion Kaminkow, *A List of Emigrants from England to America, 1718–1759* (Baltimore, Md.: Magna Charta Book Co., 1964), p. 190; Attwell information in Wallace B. Gusler, *Furniture of Williamsburg and Eastern Virginia, 1710–1790* (Richmond, Va.: Virginia Museum, 1979), p.3; Anonymous, account book, 1767–77, Joseph Downs Collection of Manuscripts and Printed Ephemera, Winterthur Library (hereafter cited as DCM).

6. Nicholas Cresswell, *The Journal of Nicholas Cresswell, 1774–1777* (New York: Dial Press, 1924), p. 27; Jedidiah Morse, *The American Geography* (Elizabethtown, N.J.: Shepard Kollock, 1789), p. 381; Eliza Cope Harrison, ed., *Philadelphia Merchant: The Diary of Thomas P. Cope, 1800–1851* (South Bend, Ind.: Gateway Editions, 1978), p. 110; Isaac Weld, *Travels through the States of North America*, 2 vols. (London: John Stockdale, 1800), vol. 1, p. 90; J. F. D. Smyth, *A Tour in the United States of America*, 2 vols. (London: G. Robinson et

al., 1784), vol. 2, p. 201; Olney Winsor, letters to wife, September 2, 1786, February 22, 1787, and February 19, 1788, State Library of Virginia, Richmond, Va. (hereafter cited as SLV).

7. Ephraim Evans, advertisement in *Virginia Journal and Alexandria Advertiser* (Alexandria, Va.), October 20, 1785 (typecard, Museum of Early Southern Decorative Arts, Winston-Salem, N.C. [hereafter cited as MESDA]); Reynolds and Barclay, bill to Fielding Lewis, November 18, 1786, Lewis Papers, Kenmore Association, Fredericksburg, Va. (reference courtesy of Betsy Connell); Russell Bastedo, "Kenmore in Fredericksburg, Virginia," *Antiques* 15, no. 3 (March 1979): 534–43. Ephraim Evans, advertisements in *Alexandria Advertiser and Commercial Intelligencer* (Alexandria, Va.), April 1 and September 18, 1802; in *Alexandria Daily Advertiser* (Alexandria, Va.), January 20, 1807; and in *Alexandria Daily Gazette* (Alexandria, Va.), July 11, 1808 (all, typecards, MESDA). Sanford apprenticeship information is contained in a letter to the author from E. Philip Sanford, Jr., March 12, 1979. Grymes apprenticeship and Evans wardenship, 1799 and 1798 (typecards, MESDA); orphan apprenticeships, 1804, Records of the Orphans Court, Alexandria Co., Va. (references courtesy of Betty Walters).

8. Ephraim Evans, advertisement in *Alexandria Advertiser and Commercial Intelligencer*, June 12, 1802. Horner and McDennick, and Daniel Evans, advertisements in *Alexandria Herald* (Alexandria, Va.), August 13, 1817, and May 19, 1820; N. Blasdell, advertisement in *Alexandrian* (Alexandria, Va.), December 12, 1820 (all, typecards, MESDA).

9. Charles Young, bill from Robert Miller and estate record, November 1797 and 1804, Mary Cam Young Papers, SLV; Sarah B. Mason, estate records, 1815, Prince William Co., Va., Registry of Probate (photostat, DCM).

10. Levi Hurdle, advertisement in *Alexandria Gazette* (Alexandria, Va.), September 26, 1834; Hurdle apprenticeship information, in Anne Castrodale Golovin, "Cabinetmakers and Chairmakers of Washington, D.C., 1791–1840," *Antiques* 107, no. 5 (May 1975): 906, 915.

11. Thomas Anburey, *Travels through the Interior Parts of America*, 2 vols. (Boston: Houghton Mifflin, 1923), vol. 2, p. 272. Anonymous and William King, advertisements in *Virginia Centinel, or Winchester Mercury* (Winchester, Va.), December 31, 1788, and January 30, 1790; King, advertisement in *Bartgis's Federal Gazette, or the Frederick-Town and County Weekly Advertiser* (Frederick, Maryland), October 25, 1797 (all, typecards, MESDA).

12. David Russell, account book, 1796–1806, Handley Library, Winchester, Va. (reference courtesy of Neville Thompson); Gen. Stevens Mason, estate records, 1803, Loudon Co., Va., Registry of Probate (photostat, DCM); Major Hite and wife, estate records, 1837 and 1851, Belle Grove Manuscripts, National Trust for Historic Preservation, Washington, D.C.

13. Winsor, letter to wife, December 5, 1786. John Alcock, advertisement in *Virginia Herald* (Fredericksburg, Va.), October 16, 1798; Alexander Walker, advertisements in *Virginia Herald,* October 16, 1798, February 15 and July 5, 1799, March 19, 1802, August 12, 1803 (all, typecards, MESDA).

14. Walker and Beck, advertisement in *Virginia Herald*, July 13, 1802; Alexander Walker, advertise-

ments in *Virginia Herald,* March 19, 1802, and August 12, 1803 (all, typecards, MESDA).

15. Alexander Walker, advertisements in *Virginia Herald,* April 26, 1805, March 14, 1806, July 22, 1808, July 10, 1816, and March 6, 1822; James Beck, advertisement in *Virginia Herald,* March 19, 1805 (all, typecards, MESDA). Records of the 1820 Census of Manufactures, State of Virginia, National Archives, Washington, D.C. (hereafter cited as NA) (microfilm, DCM).

16. James Beck, advertisement in *Virginia Herald,* March 19, 1805 (typecard, MESDA). The Beck chair was not examined for evidence of upholstery.

17. James Beck, advertisement and fire notice, *Virginia Herald,* November 3, 1815, and July 13, 1822 (typecards, MESDA); 1820 Census of Manufactures, State of Virginia; [Ann Newport Royall], *Sketches of History, Life, and Manners in the United States* (New Haven, Conn.: By the author, 1826), pp. 117–18; *Lippincott's Gazetteer* (Philadelphia: J.B. Lippincott, 1888), p. 807.

18. Anburey, *Travels,* 2:184, 187; *Lippincott's Gazetteer,* p. 441. Thomas Jefferson, letters to George Jefferson, July 19, 1800, and March 10, 1809; Adam Snyder, bill to Thomas Claxton for Thomas Jefferson, July 31, 1801; all in Papers of Thomas Jefferson, Massachusetts Historical Society, Boston, Mass. J. B. Dodd, advertisement in *Jeffersonian Republican* (Charlottesville, Va.), November 11, 1835 (reference courtesy of Wendell Hilt).

19. Smyth, *Tour,* 2:156; Jacob Kurtz, advertisements in *Phenix* (Staunton, Va.), August 22, 1804, and *Staunton Eagle* (Staunton, Va.), August 14, 1807 (typecards, MESDA).

20. Weld, *Travels,* 1:62–63, 174; Gusler, *Furniture of Williamsburg,* p. 5; "Journal of Lord Adam Gordon," in *Narratives of Colonial America,* ed. Howard H. Peckham (Chicago: R. R. Donnelley and Sons, 1971), p. 254; duc de La Rochefoucauld Liancourt, *Travels through the United States of North America,* 2 vols. (London: R. Phillips, 1799), 2:6; Kenneth Roberts and Anna M. Roberts, eds. and trans., *Moreau de St. Méry's American Journey [1793–1798]* (Garden City, N.Y.: Doubleday, 1947), pp. 46–47, 64–65.

21. Weld, *Travels,* 1:62–63; Liancourt, *Travels,* 2:7; Roberts and Roberts, *Moreau Journey,* p. 51.

22. Inward entries of sloops *Success* from Philadelphia and *Lucretia* from New York, *Virginia Gazette, or Norfolk Intelligencer* (Norfolk, Va.), June 23, 1774, and February 23, 1775 (typecards, MESDA); Richard Blow, bills of lading from sloops *Dispatch* and *Nancy,* October 23, 1784, and April 16, 1785, and bills from H. Richardson and Robert Farmer, June 2, 1794, and June 12, 1795, Richard Blow Papers, WM. Manifests of sloops *Polly,* March 5, 1789, *Katy,* March 9, 1789, and *Godfrey,* July 24, 1789, from New York; and sloops *Rebecca and Ann,* March 20, 1789, *Folly,* May 23, 1789, and *Venus,* June 1, 1789, from Philadelphia; all in Book of Inward Entries for District of Elizabeth River, Port of Norfolk, SLV. Martin and Jefferson, advertisement in *Herald and Norfolk and Portsmouth Advertiser* (Norfolk, Va.), February 7, 1795 (typecard, MESDA).

23. Michael Murphy, advertisement in *Norfolk Herald* (Norfolk, Va.), October 29, 1799; Murphy, orphan apprenticeship, 1802, and will, 1804 (all, typecards, MESDA). Michael Murphy, seating furniture consignments in manifests of schooners *Winfield Packet,* August 2, 1794, and March 8, 1800,

Joanna, September 24, 1794, and *Industry*, February 2, 1798; sloops *Betsy*, March 12 and April 7, 1799, *Nancy*, July 24, 1799, and November 7, 1800, and *Patty*, March 10, 1804; all in Philadelphia Outward Coastwise and Foreign Entries, U.S. Custom House Records, Some French Spoliation Claims, NA. Richard Bailey, advertisement in *Herald* (Norfolk, Va.), March 5, 1805 (typecard, MESDA).

24. Lemuel Adams, advertisement in *Norfolk Herald*, July 11, 1801 (typecard, MESDA); Phyllis Kihn, comp., "Connecticut Cabinetmakers, Part I," *Connecticut Historical Society Bulletin* 32, no. 4 (October 1967): 101–2.

25. Philip Collins, estate records, 1819; John Tunis, advertisement in *Norfolk Gazette and Publick Ledger* (Norfolk, Va.), June 12, 1812 (both, typecards, MESDA). John Tunis, bill to Richard Blow, June 29, 1812, Richard Blow Papers, WM; Lucy Hall, estate records, 1809, and George Blow, purchase at sheriff's sale, December 30, 1808, Blow Family Papers, WM.

26. Joshua Moore, death notice of wife, *Norfolk Herald*, April 12, 1811; Moore, death notice of daughter, *Norfolk and Portsmouth Herald* (Norfolk, Va.), October 9, 1816; and Moore, marriage notice, *American Beacon and Commercial Diary* (Norfolk, Va.), August 17, 1818 (typecards, MESDA). Joshua Moore et al., deed to Caleb Dawley, January 3, 1812 (typecard, MESDA). Joshua Moore, bills to Skipwith family, July 12, September 6, and October 15, 1819; and Hugh Finlay and Co., bill to Skipwith family, March 10, 1819; all in Peyton Skipwith Papers, WM.

27. Richard Raley, orphan apprenticeship, 1802; John Widgen, orphan apprenticeships, 1802, 1812, and 1815; Widgen, runaway apprentice notice, *American Beacon and Commercial Diary*, October 17, 1815; Widgen, marriage notice, *American Beacon and Norfolk and Portsmouth Daily Advertiser* (Norfolk, Va.), November 24, 1820 (all, typecards, MESDA). St. George Tucker, receipts to John Widgen, February 24 and 28, 1825; and Mrs. St. George Tucker, estate records, 1828; all in Tucker-Coleman Papers, WM.

28. Morse, *American Geography*, p. 382; Smyth, *Tour*, 1:57–58; Liancourt, *Travels*, 2:32; Weld, *Travels*, 1:62, 188.

29. Hollingsworth, Johnson and Co., advertisement in *Virginia Gazette, or the American Advertiser* (Richmond, Va.), October 25, 1784 (typecard, MESDA); Giles Cromwell, "Andrew and Robert McKim, Windsor Chair Makers," *Journal of Early Southern Decorative Arts* 6, no. 1 (May 1980): 1–4; Aline H. Zeno, "The Furniture Craftsmen of Richmond, Virginia, 1780–1820" (Master's thesis, University of Delaware, 1987), pp. 80, 155–56; Andrew and Robert McKim, indentures of apprenticeship, 1799 (typecards, MESDA).

30. The first McKim bow-back chair pattern is illustrated in Paul H. Burroughs, *Southern Antiques* (1931; reprint, New York: Bonanza Books, n.d), chap. 17, pl. 12. Cromwell, "Andrew and Robert McKim," p. 10.

31. The bamboo-turned bow-back chair is illustrated in Cromwell, "Andrew and Robert McKim," p. 12.

32. Cromwell, "Andrew and Robert McKim," pp. 8–9, 16. Andrew McKim, estate records, 1806; Robert McKim, orphan and other apprenticeships, and Member Visitation Committee, 1812 and 1813 (all, typecards, MESDA). Robert McKim, com-

mon councilman notice, *Virginia Argus* (Richmond, Va.), April 6, 1812; fire notices, *Richmond Enquirer* (Richmond, Va.), March 6, 1816, and *Norfolk and Portsmouth Herald*, March 11, 1816 (all, typecards, MESDA).

33. Cromwell, "Andrew and Robert McKim," pp. 17–18. Robert McKim, advertisements in *Richmond Commercial Compiler* (Richmond, Va.), May 17, 1817, June 25, 1819, and March 9, 1820; McKim, bill to Corporation of Richmond, April 20, 1820 (all, typecards, MESDA).

34. Pointer and Childres, advertisement in *Virginia Gazette and General Advertiser* (Richmond, Va.), January 11, 1797 (typecard, MESDA). The Pointer and Childres chair and label are illustrated in Burroughs, *Southern Antiques*, chap. 17, pl. 11 (backposts replaced). John Kearnes, estate records, 1799; William Pointer, orphan apprenticeship, 1800; Joseph Childres, property seizure notices, *Virginia Gazette and General Advertiser*, August 17, 1803, and *Examiner* (Richmond, Va.), May 15, 1802; Childres, court suits, 1804; and affidavit notice, *Virginia Argus*, October 26, 1810 (all, typecards, MESDA).

35. William Pointer, orphan apprenticeships, 1800, 1802, and 1805; Pointer, court suits, 1802 and 1806; Pointer, death notice, *Virginia Gazette and General Advertiser*, March 1, 1808; Robert McKim, note from William Pointer, 1809 (all, typecards, MESDA).

36. Zeno, "Furniture Craftsmen of Richmond," p. 159; Burroughs, *Southern Antiques*, chap. 17, pl. 10.

37. Samuel Parsons (and Son), advertisements in *Virginia Argus*, September 12, 1800, February 3, April 28, and October 20, 1801, and March 15, 1808, and *Enquirer*, April 7 and June 23, 1809, October 2, 1810 (typecards, MESDA).

38. William Pointer, orphan apprenticeship, 1800; Hobday and Seaton, advertisements in *Enquirer* (Richmond, Va.), November 8, 1808, and April 3, 1812; Hobday and Seaton, orphan apprenticeship, 1811 (all, typecards, MESDA). Leonard H. Seaton, bill to William Randolph, October 31, 1814, Randolph Family Accounts, Library of Congress, Washington, D.C. (hereafter cited as LC); Hobday and Barnes, advertisement in *Richmond Enquirer*, October 30, 1816 (typecard, MESDA).

39. *Richmond Directory, Register and Almanac for 1819* (Richmond, Va.: John Maddox, 1819), p. 68. Seaton and Matthews, advertisement in *Republican* (Petersburg, Va.), May 2, 1814; Seaton and Barnes, advertisement in *Petersburg Republican* (Petersburg, Va.), September 8, 1818; Matthew Maben, tenement rental, *Petersburg Republican*, August 20, 1819; Petersburg fire notice, *Virginia Herald*, March 4, 1820 (all, typecards, MESDA).

40. Anbureys, *Travels*, 2:205; Marquis de Chastellux, *Travels in North-America in the Years 1780, 1781, and 1782*, 2 vols. (London: G.G.J. and J. Robinson, 1787), vol. 2, pp. 131–32, 150; Smyth, *Tour*, 1:62; Weld, *Travels*, 1:185; Liancourt, *Travels*, 2:56.

41. Joel Brown, advertisements in *Petersburg Intelligencer* (Petersburg, Va.), September 21, 1804, September 25, 1807, March 26, 1811, and August 28, 1812; *Virginia Apollo* (Petersburg, Va.), May 30, 1807; *Republican*, October 20, 1806, and May 20, 1814; and *Star, and North-Carolina State Gazette* (Raleigh, N.C.), July 5, 1816 (typecards, MESDA). Alexander Brown, advertisement in *Richmond Commercial Compiler*, December 23, 1816 (type-

card, MESDA). Jonathan Prown, "A Cultural Analysis of Furniture-making in Petersburg, Virginia, 1760–1820," *Journal of Early Southern Decorative Arts* 18, no. 1 (May 1992): 1–173.

42. This chair has been called a Raleigh product because of its long ownership there; however, the pattern appears too early for the dates of Brown's Raleigh career. The label placename "Petersburg" would likely have been interlined and inscribed "Raleigh," as found in the documented work of several other migratory craftsmen. Michael O. Smith, "North Carolina Furniture, 1700–1900," *Antiques* 115, no. 6 (June 1979): 1275, fig. 18.

43. Archer Brown, advertisement in *Petersburg Republican*, January 22, 1805; Dillworth and Priest, advertisement in *Petersburg Intelligencer*, July 11, 1806; George W. Grimes, advertisements in *Republican*, March 26, 1812, *Petersburg Intelligencer*, July 8, 1814, and *Star* (Raleigh, N.C.), June 2, 1815 (all, typecards, MESDA).

44. Seaton and Matthews, advertisement in *Republican*, May 2, 1814; Seaton and Barnes, advertisement in *Petersburg Republican*, September 8, 1818; Petersburg fire notice, *Virginia Herald*, March 4, 1820; William H. Russell, advertisements in *Republican*, October 8, 1813, *Petersburg Intelligencer*, May 26, July 20, and September 22, 1815, September 17, 1816, and *Petersburg Republican*, March 3, 1820 (all, typecards, MESDA).

45. Tyler estate records, as quoted in *William and Mary Quarterly* 17, no. 4 (April 1909) (reprint, New York: Kraus Reprint Corp., 1966): 231–35; William Minor, apprenticeship, 1793 (typecard, MESDA); 1820 Census of Manufactures, State of Virginia; Robert McKeen, advertisement in *Virginia Gazette and Petersburg Intelligencer* (Petersburg, Va.), September 6, 1793 (typecard, MESDA); Prown, "Furniture-making in Petersburg," p. 132.

46. Sterling Woodward, advertisement in *Republican*, April 2, 1807 (typecard, MESDA); 1820 Census of Manufactures, State of Virginia.

47. David Ruth, bill to Sir Peyton Skipwith, November 6, 1797, Peyton Skipwith Papers, WM.

48. Patrick Henry, estate records, 1799, Patrick Henry Papers, LC; 1820 Census of Manufactures, State of Virginia.

49. Patricia A. Piorkowski, *Piedmont Virginia Furniture* (Lynchburg, Va.: Lynchburg Museum System, 1982), [p. 3], fig. 10; *Lippincott's Gazetteer*, pp. 1299–1300; William Dicks, advertisement in *Lynchburg and Farmer's Gazette* (Lynchburg, Va.), August 1, 1795 (reference courtesy of Catherine Lynn); John Davis and Co., advertisement in *Lynchburg Weekly Museum* (Lynchburg, Va.), November 6, 1797 (reference courtesy of Catherine Lynn); furniture auction notice, *Lynchburg Press* (Lynchburg, Va.), August 25, 1814 (typecard, MESDA).

50. Winston and Diuguid, advertisement in *Lynchburg Press*, December 10, 1818, and other data, in Piorkowski, *Piedmont Virginia Furniture*, pp. 1, 4–11, fig. 16.

51. Piorkowski, *Piedmont Virginia Furniture*, frontispiece, pp. 7–8, figs. 17, 18.

52. George Mason, estate record, 1797, Rockbridge Co., Va., Registry of Probate (reference courtesy of Margaret Beck Pritchard); Keys and Dixon, advertisement in *Rockbridge Repository* (Lexington, Va.), October 23, 1801 (typecard, MESDA).

53. Shanks and Anderson, advertisements in *Fincastle Democrat* (Fincastle, Va.), May 18 and June 20, 1846, and other data, in Frances J. Niederer, *The Town of Fincastle, Virginia* (Charlottesville: University Press of Virginia, 1965), pp. 1–35.

54. Niederer, *Town of Fincastle*, p. 34; Samuel Fizer, advertisements in *Herald of the Valley* (Fincastle, Va.), September 4, 1820, and February 19, 1821 (typecards, MESDA).

55. Niederer, *Town of Fincastle*, p. 12; Adam Fizer, estate records, 1838, Botetourt Co., Va., Registry of Probate (reference courtesy of Neville Thompson).

56. J. and P. Trovillo, advertisement in *Herald of the Valley*, November 13, 1820 (typecard, MESDA); John Henry Hill, "The Furniture Craftsmen in Baltimore, 1783–1823" (Master's thesis, University of Delaware, 1967), p. 372.

57. Jesse Spiner, estate record, 1836, Martin P. Burks Papers, WM; 1820 Census of Manufactures, State of Virginia.

58. Thomas J. Moyers and Fleming K. Rich, account book, 1834–40, DCM; 1820 Census of Manufactures, State of Virginia.

59. Federal Writers' Program of the Works Projects Administration, *West Virginia,* American Guide Series (New York: Oxford University Press, 1941), pp. 9, 30, 41–45, 49, 70, 72, 77.

60. *Dictionary of American Biography,* s.v. "Gates, Horatio"; Horatio Gates, account of William Anson, June 21, 1788, Gen. Horatio Gates Papers, New-York Historical Society, New York (hereafter cited as NYHS). The Gates chair is privately owned.

61. Robert Philips, advertisement in *Berkeley Intelligencer* (Martinsburg, W. Va.), November 27, 1799; Michael Kearns, advertisements in *Berkeley and Jefferson Intelligencer* (Martinsburg, W. Va.), August 12, 1808, and *Martinsburgh Gazette* (Martinsburg, W. Va.), November 16, 1810, and January 20, 1814; George Kearns, advertisements in *Martinsburgh Gazette,* April 5 and 11, 1811, and April 7, 1814 (all, typecards, MESDA).

62. William Kain, advertisements in *Farmer's Repository* (Charles Town, W. Va.), May 10, 1811, April 17, 1812, and March 31, 1814 (typecards, MESDA).

63. George Hite, advertisement in *Farmer's Repository,* June 29, 1810; Matthew Wilson, advertisements in *Farmer's Repository,* February 12 and August 12, 1813, and May 12 and October 20, 1814 (all, typecards, MESDA). Harrison, *Diary of Thomas P. Cope*, p. 350.

64. 1820 Census of Manufactures, State of Virginia.

65. Thomas Ashe, *Travels in America* (London and Newburyport, Mass.: William Sawyer, 1808), p. 94; William G. Lyford, *Western Address Directory* (Baltimore, Md.: J. Robinson, 1837), pp. 155, 163–66; Carl David Arfwedson, *The United States and Canada in 1832, 1833, and 1834,* 2 vols. (1834; reprint, New York: Johnson Reprint Corp., 1969), vol. 2, p. 141.

66. William Cunningham, and Robb and Morrison, advertisements in *Wheeling Gazette* (Wheeling, W. Va.), December 13 and April 12, 1828 (typecards, MESDA); Robert E. and Cherry G. Di Bartolomeo, "Wheeling's Chairs and Chairmakers, 1828–1864," *Spinning Wheel* 26, no. 4 (May 1970): 15, 50; *American Advertising Directory* (New

York: Jocelyn, Darling, 1831), pp. 143–44; J. B. Bowen, *Wheeling Directory and Advertiser* (Wheeling, W. Va.: John M. McCreary, 1839), pp. 27, 66.

67. The Thatcher and Smith chair and the Graham settee are at Ogilbay Institute Mansion Museum, Wheeling, W. Va.

68. The Graham chairs and Thatcher chairs can be found at Ogilbay Institute Mansion Museum, Wheeling, W. Va. William Voss Elder III, *Baltimore Painted Furniture, 1800–1840* (Baltimore: Baltimore Museum of Art, 1972), pp. 71, 86–87.

69. Lyford, *Western Address Directory,* p. 169.

70. Thomas Henning, Sr., advertisement in *Lewisburg Chronicle* (Lewisburg, W. Va.), February 12, 1852; Washington G. Henning, advertisements in *Lewisburg Chronicle,* June 24, 1852, and February 24, 1853 (all references courtesy of Anne C. Golovin).

71. Clement Biddle Co., letter book, 1769–70, Thomas A. Biddle Co., Business Books, Historical Society of Pennsylvania, Philadelphia, Pa. (hereafter cited as HSP). John Duhy, advertisements in *Centinel of Liberty* (Georgetown, D.C.), September 23, 1799, and June 24, 1800; Thomas Renshaw, advertisement in *Museum and Washington and George-town Advertiser* (Georgetown, D.C.), August 31, 1801; and Hector Sanford, advertisements in *Washington Federalist* (Georgetown, D.C.), November 3, 1802, and *National Intelligencer and Washington Advertiser* (Washington, D.C.), November 19, 1804; all as quoted in Golovin, "Cabinetmakers and Chairmakers of Washington," p. 912. Hector Sanford, advertisement in *Alexandria Advertiser and Commercial Intelligencer,* May 28, 1803 (typecard, MESDA); Hector Sanford and Co., bill to William Washington, September 2, 1803, DCM.

72. [Theodore Dwight], *Northern Traveller* (2d ed.; New York: A. T. Goodrich, 1826), p. 336; Harrison, *Diary of Thomas P. Cope,* pp. 116–17; S. S. Moore and T. W. Jones, *Traveller's Directory* (Philadelphia: Mathew Carey, 1802), pp. 51–52; Joshua Shaw, *United States Directory* (Philadelphia: James Maxwell, 1822), p. 79; John Bristed, *America and her Resources* (London: Henry Colburn, 1818), p. 139.

73. Alexandria data courtesy of Anne C. Golovin. Golovin, "Cabinetmakers and Chairmakers of Washington," p. 906; Thomas Adams, bills to U.S. War Department, November 9 and December 8, 1814, Miscellaneous Treasury Accounts of the First Auditor, Treasury Department Records, NA; Robert Underwood, account book, 1795–1804, and 1822, Private collection (photostat, DCM).

74. Golovin, "Cabinetmakers and Chairmakers of Washington," pp. 906, 910, 914–15, 921; Levi Hurdle, advertisement in *Alexandria Gazette,* January 1, 1835, as quoted in Ethel Hall Bjerkoe, *Cabinetmakers of America* (Garden City, N.Y.: Doubleday, 1957), p. 133.

75. Golovin, "Cabinetmakers and Chairmakers of Washington," pp. 907, 909, 916.

76. Henry R. Burden, advertisements in *Daily National Intelligencer* (Washington, D.C.), October 12, 1815, and June 19, 1818, and other data, from Golovin, "Cabinetmakers and Chairmakers of Washington," pp. 909–10. Bernard Gratz, receipt from Joseph Burden signed by Henry Burden, April 11, 1796, Society Miscellaneous Collection, HSP; William Brent, notice of Henry Burden in-

solvency petition, *Daily National Intelligencer,* July 1, 1819 (typecard, MESDA).

77. David Bates, advertisements in *Daily National Intelligencer,* June 28 and August 28, 1820, March 13, 1821, and November 18, 1822, and other data, in Golovin, "Cabinetmakers and Chairmakers of Washington," p. 906.

78. New York City jury list, 1816, Historical Documents Collection, Queens College, Flushing, N.Y. (hereafter cited as QC); John Dickson, advertisements in *Georgetown Metropolitan* (Georgetown, D.C.), September 23, 1826, and *Daily National Intelligencer,* December 5, 1828, and other data, in Golovin, "Cabinetmakers and Chairmakers of Washington," pp. 908–9, 911–12, 914, 920.

79. William M. Morrison and Robert Wilson, advertisements in *Daily National Intelligencer,* April 4 and May 22, 1828, and other data, in Golovin, "Cabinetmakers and Chairmakers of Washington," pp. 916–17, 921–22.

80. Boteler and Donn, advertisements in *Daily National Intelligencer,* April 10 and September 11, 1833, and October 28, 1834, and other data, in Golovin, "Cabinetmakers and Chairmakers of Washington," pp. 908–9.

81. Davidson, *Life in America,* 1:64, 374; John Lambert, *Travels through Canada and the United States of North America,* 2 vols. (London: C. Cradock and W. Joy, 1813), vol. 2, pp. 207–10.

82. Smyth, *Tour,* 1:98–99; Lambert, *Travels,* 2:211–12.

83. Gillingham, "Philadelphia Windsor Chair," pp. 301–31.

84. Smyth, *Tour,* 2:87; "Journal of Lord Adam Gordon," p. 247. Wilmington fire notice, *Gazette of the State of Georgia* (Savannah, Ga.), May 11, 1786; John Nutt, advertisements in *Wilmington Centinel and General Advertiser* (Wilmington, N.C.), July 23, 1788, *Hall's Wilmington Gazette* (Wilmington, N.C.), February 8 and June 21, 1798, and *Raleigh Register* (Raleigh, N.C.), August 23, 1810 (all, typecards, MESDA). John Nutt, orphan apprenticeship, 1789, as recorded in James H. Craig, *The Arts and Crafts in North Carolina, 1699–1840* (Winston-Salem, N.C.: Old Salem for the Museum of Early Southern Decorative Arts, 1965), p. 146.

85. Vosburgh and Childs, advertisements in *North-Carolina Minerva and Fayetteville Advertiser* (Fayetteville, N.C.), November 26, 1796, and *Hall's Wilmington Gazette,* February 9, 1797; Vosburgh and Dunbibben, advertisement in *Hall's Wilmington Gazette,* May 31, 1798; John Hill, advertisement in *Wilmington Gazette* (Wilmington, N.C.), May 13, 1802 (all, typecards, MESDA).

86. Joseph Childres, orphan apprenticeships, 1803 and 1804, as recorded in Craig, *Arts and Crafts,* pp. 161–62. William Manning, advertisement in *Edenton Gazette* (Edenton, N.C.), September 17, 1807; Joseph Childres, advertisement in *Virginia Argus,* October 26, 1810 (both, typecards, MESDA).

87. Cheshire and Cox, advertisements in *Edenton Gazette,* May 12, 1818, and January 12, 1819; Thomas W. Pittman, advertisement in *Carolina Sentinel* (New Bern, N.C.), November 18, 1820 (all, typecards, MESDA). Frederick K. Parrott, advertisement in *Carolina Sentinel,* December 6, 1833, and other data, as quoted in Craig, *Arts and Crafts,* pp. 121–22, 125, 127, 232–33, 235, 237–39, 247–48.

88. *Lippincott's Gazetteer,* p. 1831; David Ruth, apprenticeship records, 1793 and 1794, as recorded

in Craig, *Arts and Crafts*, pp. 149, 151; David Ruth, statehouse furnishings, 1795, Treasurer and Comptroller's Papers, State of North Carolina (typecard, MESDA).

89. David Ruth, advertisements in *Raleigh Register,* October 26, 1802, January 4, 1803, and July 12, 1810, and *North Carolina Minerva* (Raleigh, N.C.), November 2, 1802; Ruth, statehouse furnishings, November 25, 1805, December 20, 1806, and January 9, 1807, and ranger of public grounds, 1818, Treasurer and Comptroller's Papers, State of North Carolina; David Ruth and Son, advertisement in *Raleigh Minerva* (Raleigh, N.C.), February 4, 1814; Matthews, Ruth and Co., advertisements in *Raleigh Register,* January 30 and April 10, 1818 (all, typecards, MESDA). David Ruth, court minutes, 1807; David Ruth, Jr., apprenticeship record, 1822; and Ruth, Jr., advertisement in *Fayetteville Gazette* (Fayetteville, N.C.), May 15, 1822; all as recorded in Craig, *Arts and Crafts*, pp. 169–70, 203.

90. Wesley Whitaker, advertisements in *Raleigh Register,* December 23, 1805, February 23, 1809, February 18, 1814, and February 4, 1820, *Raleigh Star* (Raleigh, N.C.), September 14, 1809, and *Star and North-Carolina State Gazette,* May 7, 1819 (typecards, MESDA). Wesley Whitaker, apprenticeship records, 1806, 1814, and 1818, and advertisement in *Raleigh Register,* November 18, 1828, as recorded in Craig, *Arts and Crafts,* pp. 167, 181, 193, 369.

91. Ephraim Evans, apprenticeship record, 1799; George Grimes, advertisements in *Republican,* March 26, 1812, *Petersburg Intelligencer,* July 8, 1814, and *Raleigh Register,* June 9, 1815 (all, typecards, MESDA). Sheriff's sale, Zenos Bronson property, *North Carolina Star* (Raleigh, N.C.), March 3, 1815, as quoted in Craig, *Arts and Crafts,* pp. 183–84.

92. Thomas Cobbs, advertisement in *Raleigh Minerva,* December 22, 1815; George Grimes, advertisements in *Star and North-Carolina State Gazette,* April 12 and May 17, 1816; fire notice, *American Beacon and Commercial Diary,* June 20, 1816 (all, typecards, MESDA). George Grimes, advertisement in *Western Carolinian* (Salisbury, N.C.), February 4, 1823, and Grimes and Cooper, advertisement in *Western Carolinian,* February 4, 1823, as quoted in Craig, *Arts and Crafts,* pp. 97–98, 205–6.

93. Joel Brown, advertisements in *Star and North-Carolina State Gazette,* July 5, 1816, and March 5 and June 25, 1819, and *Raleigh Register,* May 16, 1817, and January 15, 1819 (typecards, MESDA).

94. Joel Brown, advertisement in *North Carolina Star,* March 29, 1822, as quoted in Craig, *Arts and Crafts,* p. 202; A. Clark and Richard Roberts, advertisements in *Star and North-Carolina State Gazette,* April 23 and September 3, 1819 (typecards, MESDA); 1820 Census of Manufactures, State of North Carolina.

95. Williamson and Shelton, advertisements in *Raleigh Minerva,* January 29, April 16 and October 8, 1819 (typecards, MESDA); Robert G. Williamson and Elias Hales, apprenticeship records, 1819 and 1822, as recorded in Craig, *Arts and Crafts,* pp. 194, 204; Robert G. Williamson, advertisement in *Raleigh Minerva,* May 12, 1820 (typecard, MESDA).

96. The church's chair is illustrated in Prown, "Furniture-making in Petersburg," p. 69.

97. *Lippincott's Gazetteer,* p. 754; T. and J. Beggs, property records, 1793–94, and advertisement in *Fayetteville Gazette,* January 2, 1793 (typecards, MESDA); James Beggs, apprenticeship records, 1799, 1800, and 1825, as recorded in Craig, *Arts and Crafts,* pp. 157–58, 211.

98. Thomas McCrosson, advertisement in *American* (Fayetteville, N.C.), October 10, 1816 (typecard, MESDA); Duncan McNeill, apprenticeship records, 1812, 1814, and 1817–18, and advertisement in *North-Carolina Journal* (Fayetteville, N.C.), November 11, 1835, as recorded in Craig, *Arts and Crafts,* pp. 178–79, 181, 191–92, 238; David Ruth, Jr., advertisement in *Fayetteville Gazette,* May 15, 1822, as quoted in Craig, *Arts and Crafts,* p. 203; Benjamin W. Branson, inventory and accounts, 1835 and 1831–35, DCM.

99. Samuel E. Shelton, apprenticeship record, 1825, and advertisement in *Greensboro Patriot* (Greensboro, N.C.), October 25, 1828; C. H. Dejernatt, advertisements in *Greensboro Patriot,* February 23, 1838, and *Carolina Watchman* (Salisbury, N.C.), October 11, 1839; and Dejernatt and Rainey, advertisement in *Carolina Watchman,* December 26, 1840; all as quoted in Craig, *Arts and Crafts,* pp. 105–6, 213, 217, 243, 249.

100. John Cooper, apprenticeship record, 1815, and advertisement in *Western Carolinian,* March 22, 1825; and Grimes and Cooper, advertisement in *Western Carolinian,* February 4, 1823; all as recorded in Craig, *Arts and Crafts,* pp. 186, 205–6, 211.

101. William R. Hughes, advertisements in *Western Carolinian,* April 20 and July 13, 1830, April 11, 1831, and May 27, 1833; David Watson, apprenticeship record, 1833; David Watson, advertisements in *Western Carolinian,* May 7, 1832, and *Carolina Watchman,* December 12, 1840; Hughes and Watson, advertisement in *Western Carolinian,* May 16, 1831; William Rowzee, advertisements in *Carolina Watchman,* March 29, 1834, and *Western Carolinian,* December 13, 1838; George W. Spears, advertisement in *Western Carolinian,* May 22, 1827; and Dejernatt and Rainey, advertisement in *Carolina Watchman,* December 26, 1840; all as recorded in Craig, *Arts and Crafts,* pp. 216, 221, 223, 225–27, 229–32, 234, 245, 248–49.

102. William Culverhouse, apprenticeship records, 1817 and 1825; William Culverhouse, advertisements in *Catawba Journal* (Charlotte, N.C.), February 8, 1825, and October 10, 1826; Phifer and Culverhouse (Lincolnton), advertisement in *Western Carolinian,* January 7, 1823; Cornwell and Nichols, advertisements in *Western Carolinian,* August 31, 1824, and April 26, 1825; Nichols and Pritchard, advertisements in *Catawba Journal,* April 26, 1825, and *Miners' and Farmers' Journal* (Charlotte, N.C.), August 3, 1831; all as recorded in Craig, *Arts and Crafts,* pp. 191, 204–5, 209–14, 227–28.

103. Nathan Brown, advertisements in *Western Carolinian,* March 1, 1825, and *Miners' and Farmers' Journal,* June 8, 1831; John M. Jarret and Co., advertisement in *Miners' and Farmers' Journal,* May 25, 1831; and Henry E. Spencer, advertisement in *Miners' and Farmers' Journal,* May 25, 1831; all as recorded in Craig, *Arts and Crafts,* pp. 102, 210, 226–27.

104. Culverhouse and Phifer, advertisement in *Western Carolinian,* January 7, 1823; Martin C. Phifer, advertisement in *Catawba Journal,* Novem-

ber 16, 1824; James Bivings (for Samuel Lander), advertisement in *Western Carolinian,* March 31, 1929; and Obed Parrish, apprenticeship record, 1833; all as recorded in Craig, *Arts and Crafts,* pp. 204–5, 209, 218–19, 231. 1820 Census of Manufactures, State of North Carolina.

105. John Bivins, Jr., and Paula Welshimer, *Moravian Decorative Arts in North Carolina* (Winston-Salem, N.C.: Old Salem, 1981), pp. 1–5; Mabel Munson Swan, "Moravian Cabinetmakers," *Antiques* 59, no. 6 (June 1951): 456–59.

106. Salem Diacony, tavern inventories, 1787 and later, Moravian Archives, Winston-Salem, N.C. (hereafter cited as MA-NC); Bivins and Welshimer, *Moravian Decorative Arts,* pp. 20–21, 23. Bivens has suggested that the term *green,* as used here, does not refer to paint but rather to the construction of chairs from "green" wood. This seems highly unlikely, as demonstrated elsewhere in this volume, since the color green dominated Windsor seating until the 1780s, and the term was used interchangeably with *Windsor* to designate plank seating in many eastern areas. In the eighteenth and early nineteenth centuries, uncured timber was referred to as "unseasoned" rather than "green" wood, the latter term seemingly more modern.

107. Salem Diacony, lists of furnishings, 1791 and later, MA.

108. Bivins and Welshimer, *Moravian Decorative Arts,* p. 24; Salem Diacony, miscellaneous notes, lists of furnishings, cash book, and tavern inventories, 1787 and later, MA.

109. Bivins and Welshimer, *Moravian Decorative Arts,* p. 23.

110. Jacob Fetter III of Lancaster, Pa., was a first cousin to the Jacob Fetter, joiner, who migrated in 1799 from Bethlehem, Pa., to Salem, N.C., where he remained until the end of his life. Salem Personnel File, Old Salem, Winston-Salem, N.C.

111. Morse, *American Geography,* pp. 427–28; Weld, *Travels,* 1:63–64; Smyth, *Tour,* 2:83; "Journal of Lord Adam Gordon," pp. 241, 243; Liancourt, *Travels,* 1:556.

112. John Lloyd, estate records, 1734, Charleston, S.C., Registry of Probate (microfilm, DCM); James Mathewes, estate records, 1745, Charleston, S.C., Registry of Probate.

113. Solomon Legare, Jr., advertisement in *South Carolina Gazette* (Charleston, S.C.), October 3, 1754, as quoted in Alfred Coxe Prime, comp., *The Arts and Crafts in Philadelphia, Maryland, and South Carolina, 1721–1785* (Philadelphia: Walpole Society, 1929), p. 174. Manifests of sloop *Henry,* July 30, 1762; brigs *Charles Town Packet,* December 21, 1763, *Harietta,* January 4, 1766, and *Prince of Wales,* February 19, 1767; and ship *Argo,* February 23, 1767; all in Shipping Returns: South Carolina, 1736–64, and Charleston, 1746–65, Colonial Office, Public Record Office, London (hereafter cited as PRO). DaCosta and Farr, Walter Mansell, Mansell, Corbett and Co., import notices, *South Carolina Gazette,* January 19–27 and March 31–April 7, 1759, March 31, 1764, and February 16, 1767 [supplement] (reference courtesy of Susan B. Swan). E. Milby Burton, *Charleston Furniture, 1700–1825* (Charleston, S.C.: Charleston Museum, 1955), p. 53; Siston and Benfield, import notice, *South Carolina Gazette,* June 6, 1761, as quoted in Prime Cards, Winterthur Library (hereafter cited as WL); Edward Lightwood, Jr., Sheed and White, and Thomas Shirley, import notices, *South Carolina Gazette,*

June 27, 1761, June 23 and September 22, 1766, and January 19 and March 30, 1767 (typecards, MESDA).

114. John Biggard, advertisement in *South Carolina Gazette*, March 24, 1767 (typecard, MESDA); Joshua Eden, advertisement in *South Carolina Gazette*, January 12–19, 1767 (reference courtesy of Susan B. Swan); Burton, *Charleston Furniture*, pp. 83–84; Joshua Eden, advertisement in *South Carolina Gazette*, November 7, 1775, as quoted in Prime, *Arts and Crafts, 1721–85*, pp. 165–66.

115. James McCall, John James, Sykes and Lushington, and Bentham and Co., import notices, *South Carolina Gazette*, April 24, 1770, December 7, 1771, July 2, 1772, September 12, 1774, and March 21, 1775, Prime Cards, WL; inventories recorded in Alice Hanson Jones, *American Colonial Wealth*, 3 vols. (New York: Arno Press, 1977), vol. 3, pp. 1473–74, 1487, 1492, 1496, 1500, 1502–3, 1518, 1528–32, 1535, 1539–40, 1543, 1560, 1565–66, 1571–72, 1574, 1598–99, 1606–8; Elizabeth Wood, notice of loss, *South Carolina and American General Gazette* (Charleston, S.C.), March 12, 1778.

116. Benjamin Greene, letter to Stephen Salisbury, March 12, 1785, Salisbury Papers, American Antiquarian Society, Worcester, Mass; Gillingham, "Philadelphia Windsor Chair," pp. 318–27.

117. Andrew Redmond, advertisement in *South Carolina Gazette and General Advertiser* (Charleston, S.C.), October 14, 1783, Prime Cards, WL; Burton, *Charleston Furniture*, p. 115; Legh Furnace Master, advertisement in *Pennsylvania Journal* (Philadelphia, Pa.), September 26, 1771.

118. Federal procession description, Charleston, S.C., *Pennsylvania Gazette* (Philadelphia, Pa.), June 11, 1788.

119. Sloop *Catharine* and schooner *Polly and Betsey*, import notices, *City Gazette, or the Daily Advertiser* (Charleston, S.C.), March 30, September 2, and August 7, 1789 (typecards, MESDA); Gillingham, "Philadelphia Windsor Chair," pp. 327–31; John Minnick, import notices, *City Gazette, or the Daily Advertiser*, August 15 and November 13, 1789 (typecards, MESDA).

120. John Minnick, and Jones and Clark, import notices, *Charleston City Gazette* (Charleston, S.C.), July 10, 1792, April 29, 1794, and July 28 and October 29, 1792, Prime Cards, WL; Hopkins and Charles, import notice for chocolate-colored Windsors, *City Gazette, or the Daily Advertiser*, March 7, 1798 (typecard, MESDA); Murphy and Allwine information, in Gillingham, "Philadelphia Windsor Chair," p. 332. Manifests of schooner *Columbia*, September 25, 1789; sloop *Catharine*, December 1, 1789; and ships *Charleston, South Carolina*, and *Congress*, February 13, March 15, and March 29, 1794; all in New York Outward Coastwise and Foreign Entries, U.S. Custom House Records, French Spoliation Claims, NA.

121. James Norris, directory data and death notice, *Charleston Courier* (Charleston, S.C.), July 8, 1806 (typecard, MESDA); Humeston and Stafford, advertisement in *Charleston City Gazette and Advertiser* (Charleston, S.C.), November 29, 1798, as quoted in Alfred Coxe Prime, comp., *The Arts and Crafts in Philadelphia, Maryland and South Carolina, 1786–1800* (Topsfield, Mass.: Walpole Society, 1932), p. 184; Jay Humeston, advertisement in *Columbian Museum and Savannah Advertiser* (Savannah, Ga.), January 31, 1800 (typecard, MESDA); Burton, *Charleston Furniture*, p. 97.

122. Burton, *Charleston Furniture*, pp. 79, 81; William Cocks, advertisement in *Charleston City Gazette and Advertiser*, September 14, 1798, as quoted in Prime, *Arts and Crafts, 1786–1800*, p. 173.

123. William Thompson, advertisement in *Times* (Charleston, S.C.), October 14, 1800, and data (typecards, MESDA). Manifests of schooners *Hero*, October 26, 1801, and *Dispatch*, May 19, 1803; brigs *Charleston*, August 3, 1803, and *Assistance*, October 3, 1803; sloop *Ruby*, November 26, 1803; schooner *Ann*, November 28, 1803; and ship *James*, December 6, 1803; all in Philadelphia Outward Coastwise Manifests, U.S. Custom House Records, NA.

124. Manifests of brig *Charleston*, January 4 and February 25, 1804; schooner *Liberty*, April 7 and August 28, 1804; brig *Venus*, May 11, 1804; schooner *Edward and Edmond*, June 1, 1804; ship *Fair American*, July 25, 1804; and schooner *Sally*, April 20, 1805; all in Philadelphia Outward Coastwise Entries, U.S. Custom House Records, NA. The Moon burial record is in William Wade Hinshaw and Thomas Worth Marshall, comps., *Encyclopedia of American Quaker Genealogy*, 6 vols. (Ann Arbor, Mich.: Edwards Bros., 1938), vol. 2, p. 397.

125. The Philadelphia chairmakers-shippers' group included William Haydon, James Pentland, John Meer, James Whitaker, Joseph Burden, and John Huneker. Philadelphia Outward Coastwise Entries, 1805–11, U.S. Custom House Records, NA. Import notices, *Charleston Courier*, including brigs *Enterprize*, January 15, 1803, *Consolation*, March 3, 1804, *Lioness*, April 13, 1804, and *Elizabeth*, April 16, 1804; schooner *Lively*, March 19, 1806; sloop *Industry*, August 11, 1806; ship *Thomas Chalkley*, September 24, 1806, and February 18, 1807; and anonymous vessels, January 16, November 17, December 31, 1807, February 3, 1808, and December 22, 1809 (typecards, MESDA). Import notices, *Times*, including schooners *Philip*, December 15, 1808, and *Industry*, June 7, 1809 (typecards, MESDA).

126. John Melish, *Travels through the United States of America*, 2 vols. (Philadelphia: By the author, 1815), vol. 1, p. 276; Hoell information, as recorded in Burton, *Charleston Furniture*, p. 54.

127. James Pentland migrated to Pittsburgh. Newcomers to the shipping group were William Lee and William Stewart (sometimes participating as the firm of Stewart and Hayden). Philadelphia Outward Coastwise Entries, 1811–16, U.S. Custom House Records, NA. Import notices, *Charleston Courier*, including C. and E. Gamage and Co. (New York imports), October 20, 1815; Joseph W. Page, October 28, 1812; R. W. Otis (writing chairs), June 8, 1816; and John Hills, April 11, 1816 (all, typecards, MESDA).

128. G. C. Harriott, advertisement in *Courier* (Charleston, S.C.), December 25, 1822 (typecard, MESDA); Burton, *Charleston Furniture*, p. 120; Philadelphia Outward Coastwise Entries, 1820–37, U.S. Custom House Records, NA.

129. "Journal of Lord Adam Gordon," pp. 238, 240; Morse, *American Geography*, p. 444; Lambert, *Travels*, 2:264–66; Arfwedson, *United States and Canada*, 1:408, 411; Mrs. Charlton M. Theus, *Savannah Furniture, 1735–1825* (n.p.: By the author, ca. 1967).

130. James Muter, advertisement in *Georgia Gazette* (Savannah, Ga.), September 8, 1763 (typecard, MESDA); manifests of schooners *Fanny* and *Ogeechee*, October 11 and June 19, 1766, Shipping Returns: Georgia, 1764–67, Colonial Office, PRO; Theus, *Savannah Furniture*, pp. 4–5.

131. Gillingham, "Philadelphia Windsor Chair," pp. 318, 321–26; Crookshanks and Speirs, payment of transient duties, June 26, 1784, DCM. Crookshanks and Speirs, advertisements in *Gazette of the State of Georgia*, October 21, 1784, and June 30, 1785; Thomas Cumming and Co., advertisement in *Gazette of the State of Georgia*, May 11, 1786 (all, typecards, MESDA).

132. William Maxwell, account book, 1791–93, Rutgers University Library, New Brunswick, N.J. Chair shipments: manifests of ship *Justina*, March 20, 1793; and sloops *St. Isabella*, April 2, 1793, and *Two Brothers*, October 18, 1792; all in Savannah Outward Coastwise and Foreign Entries, U.S. Custom House Records, French Spoliation Claims, NA. Cane shipments: manifests of ship *Nancy*, October 5, 1793, and May 22, 1795; brigs *Eliza*, June 9, 1792, and *Maria*, June 24, 1795; sloops *Polly*, March 6, 1792, and *Union*, April 7, 1792; and schooner *Columbia*, December 3, 1793; all in Savannah Outward Coastwise and Foreign Entries, U.S. Custom House Records, French Spoliation Claims, NA.

133. New York shipments: manifests of brigs *Lydia*, 1799, *Huntress*, March 27 and May 4, 1799, *Prudence*, February 3, 1797, *Susan and Polly*, February 6, 1795, *Ceres*, October 17, 1801, and *Caspian* (n.d.); ship *Jenny*, February 19, 1794; schooners *Hiram*, March 11, July 7, and September 29, 1795, and *Polly*, June 28, 1797; sloop *Apollo*, October 16, 1794; all in New York Outward Coastwise Entries, U.S. Custom House Records, French Spoliation Claims, NA.

Philadelphia shipments: manifests of sloops *Polly*, August 15, 1791, April 7 and May 26, 1792, and February 25, 1797, *Dolphin*, June 8, 1798, *Sally*, October 10, 1801, *Independence*, December 12, 1801, and August 28, 1802; brigs *Georgia Packet*, October 3, 1791, *Alfred*, June 3, 1790, *Freelove*, May 14, 1803, *Eliza and Sarah*, March 24, 1804, *Sally*, June 13, 1805, and *Experiment*, October 21, 1805; ship *Swift Packet*, February 26 and June 23, 1798; schooners *John and Ely*, November 19, 1801, *Sally*, March 13, 1802, *Dispatch*, May 14, 1802, *Liberty*, January 8 and August 20, 1803, *Anne*, April 1, 1803, and *Five Brothers*, September 3, 1805; all in Philadelphia Outward Coastwise Entries, U.S. Custom House Records, Some French Spoliation Claims, NA. Philadelphia chairmakers identified with this trade are James Whitaker, John Wall, William Mitchell, Lawrence Allwine, William Cox, James Pentland, and Thomas Mason.

134. Joseph Meeks, advertisement in *Columbian Museum and Savannah Advertiser*, March 20, 1798, and other data, in Theus, *Savannah Furniture*, pp. 73–87; J. B. Barry, advertisement in *Augusta Chronicle and Gazette of the State* (Augusta, Ga.), October 13, 1798 (typecard, MESDA); Marilynn A. Johnson, "John Hewitt, Cabinetmaker," in *Winterthur Portfolio 4*, ed. Richard K. Doud (Charlottesville: University Press of Virginia, 1968), pp. 185–89; John Hewitt, letters to Matthias Bruen, January 4 and June 10, 1801, and March 2, 1802, DCM.

135. Theus, *Savannah Furniture*, pp. 15, 17–18, 21, 48–49, 66, 89. Moses Nichols and Silas Cooper, advertisements in *Columbian Museum and Savannah Advertiser*, November 7, 1800, December 18,

1801, and November 11, 1811; Silas Cooper, advertisements in *Republican and Savannah Evening Ledger* (Savannah, Ga.), October 31, 1809, March 3, 1810, and July 30 and November 9, 1811 (all, typecards, MESDA).

136. Georgia Board of State Commissioners, request for warrant, September 26, 1812 (reference courtesy of J. L. Sibley Jennings, Jr.); 1820 Census of Manufactures, State of Georgia; John Pew, advertisement in *Chronicle* (Augusta, Ga.), 1813 (reference courtesy of Mrs. William W. Griffin via MESDA); Gray information in Burton, *Charleston Furniture*, p. 54.

137. 1820 Census of Manufactures, State of Georgia.

138. Manifests of schooners *Eliza*, December 3, 1811, *Betsey*, August 5, 1816, *Evelina*, December 11, 1837, and *D.M. Smith*, September 28, 1837; brigs *America*, December 9, 1811, *Hero*, October 17, 1816, *Frances*, March 5, 1831, and March 24, 1837, and *New Hanover*, November 12, 1831; all in Philadelphia Outward Coastwise Entries, U.S. Custom House Records, NA. *Neat Pieces: The Plain-Style Furniture of 19th Century Georgia* (Atlanta, Ga.: Atlanta Historical Society, 1983), fig. 17.

139. *Lippincott's Gazetteer*, pp. 1563–64; *The Aristocratic Journey: Being the Outspoken Letters of Mrs. Basil Hall*, ed. Una Pope-Hennessy (New York: G. P. Putnam's Sons, 1931), p. 252; Samuel R. Brown, *The Western Gazetteer or Emigrant's Directory* (Auburn, N.Y.: H. C. Southwick, 1817), pp. 147–48; Ashe, *Travels*, p. 341; Frances M. Trollope, *Domestic Manners of the Americans*, 2 vols. (London: Whittaker, Treacher, 1832), vol. 1, p. 7.

140. Ashe, *Travels*, pp. 339–41; Brown, *Western Gazetteer*, pp. 149–50; Arfwedson, *United States and Canada*, 2:54–55; Henry Bradshaw Fearon, *Sketches of America* (2d ed., London: Longman et al., 1818), pp. 273–74.

141. John Pintard, "Notes respecting the Mississippi and New Orleans made during a visit to that City in March, 1801," Papers of John Pintard, NYHS; Fearon, *Sketches of America*, p. 274; Thomas Magarey, advertisement in *Louisiana Gazette* (New Orleans, La.), March 16, 1819; W. R. Carnes, bill to Capt. A. Wilson(?), April 23, 1839, DCM. Manifest of anonymous vessel, December 1794, Philadelphia Outward Coastwise and Foreign Entries, U.S. Custom House Records, NA; manifests of brig *Iphigenia*, October 3, 1796, and ship *Matilda*, August 4, 1798, New York Coastwise and Foreign Entries, U.S. Custom House Records, NA; manifests of Schooner *Experiment*, August 11, 1797, and June 2 and August 8, 1798, Baltimore Coastwise and Foreign Entries, U.S. Custom House Records, French Spoliation Claims, NA.

142. Manifests of brig *Amazon*, November 26, 1799; schooner *Liberty*, December 18, 1799; brig *Fame*, April 25, 1801; and ship *Thomas Wilson*, June 19, 1801; all in Philadelphia Outward Foreign Entries, U.S. Custom House Records, French Spoliation Claims, NA. Manifests of brigs *Betsey*, October 19, 1799, and *Speedwell*, February 1, 1800, Salem-Beverly Outward Foreign Entries, U.S. Custom House Records, French Spoliation Claims, NA; manifest of brig *Eliza and Sarah*, January 23, 1801, Boston Outward Foreign Entries, U.S. Custom House Records, French Spoliation Claims, NA; manifests of brigs *Agenora*, September 18, 1801, and *Dyett*, October 14, 1801, New York

Outward Entries, U.S. Custom House Records, French Spoliation Claims, NA.

143. Manifests of brigs *Hiram*, April 19, 1804, *Hannah*, May 24, 1804, and August 23, 1805, *Eliza*, July 19, 1804, and July 20, 1805, *Newton*, December 17, 1804, *Union*, December 21, 1805, and April 18 and October 24, 1806, *Mary*, September 25, 1806, and May 12, 1807, *Minton*, December 29, 1806, *Julia*, August 22, 1807, *Feliciana*, March 12, 1811, *Independence*, May 5 and October 24, 1831, and *Ella*, September 5, 1831; schooners *Eliza Tice*, April 19, 1804, *Polly*, May 14, 1804, *Letitia*, March 30 and September 28, 1805, *Dolphin*, June 24, 1805, *Rhoda*, June 21, 1806, and *Sally*, July 28, 1806; ships *John*, January 3, 1804, *Matilda*, March 12, 1804, *Rosanna*, November 19, 1806, *Perseverance*, December 10, 1806, *Thomas Wilson*, March 16, 1807, *America*, October 17, 1807, *Tennessee*, March 23, 1811, *Ohio*, September 19, 1810, December 5, 1811, and November 27, 1820, *Lancaster*, April 26, 1825, and *John Sergeant*, November 7, 1831; and snow *Fanny*, May 7, 1806; all in Philadelphia Outward Coastwise and Foreign Entries, U.S. Custom House Records, NA. Philadelphia chairmakers who made shipments during 1804 are James Pentland, Anthony Steel, William Haydon, John B. Ackley, William Smith, and William Mitchell. Joseph Burden joined the list in 1805.

144. Ashe, *Travels*, p. 316.

145. Sterling B. Mangum, and Bracken and Smith, advertisements in *Weekly Chronicle* (Natchez, Miss.), September 28, 1808, and March 12, 1810; James Turnbull, J. D. Cochran, and journeyman turner notices, *Mississippi Republican* (Natchez, Miss.), January 26 and February 2, 1819 (references courtesy of Millie McGehee).

146. Thomas Bislep (Heslip?), advertisement in *Mississippi Republican*, March 16, 1819; and Obadiah Congar, advertisement in *Statesman and Gazette* (Natchez, Miss.), January 10, 1828 (references courtesy of Millie McGehee).

147. Arfwedson, *United States and Canada*, 2:44–47.

148. Manifests of sloop *Morning Star*, March 14, 1820, and brig *Virginia*, July 20, 1837, Philadelphia Outward Coastwise Entries, U.S. Custom House Records, NA; manifest of ship *Catharine*, September 26, 1832, New York Outward Entries, U.S. Custom House Records, French Spoliation Claims, NA.

149. Fearon, *Sketches*, p. 281; Davidson, *Life in America*, 1:157, 406; 2:234; James M. Miller, *The Genesis of Western Culture* (Columbus: Ohio State Archaeological and Historical Society, 1938), pp. 22, 24, 31, 40, 43, 45, 47; Malcolm J. Rohrbough, *The Trans-Appalachian Frontier* (New York: Oxford University Press, 1978), pp. 42–43, 53, 66–67, 81–82, 84, 89, 93, 104, 106, 113–14, 134, 159, 173, 176–77, 180.

150. Rhea Mansfield Knittle, *Early Ohio Taverns*, Ohio Frontier Series, 1767–1847 (Ashland, Ohio: By the author, 1937), p. 42; Knittle, "Ohio Chairmakers," *Antiques* 50, no. 3 (September 1946): 192; Henry Howe, *Historical Collections of Ohio* (Cincinnati: Derby, Brandley, 1847), pp. 123–25; 1820 Census of Manufactures, State of Ohio; T. V. Olsen, "The Great Lakes: Gateway to the Heartland," in The Western Writers of America, *Water Trails West* (Garden City, N.Y.: Doubleday, 1978), pp. 101–2; Frederick Marryat, *Diary*, as quoted in Davidson, *Life in America*, 2:102; Jane Sikes Hageman and Edward M. Hageman, *Ohio*

Furniture Makers, 2 vols. ([Cincinnati, Ohio]: By the authors, 1989), vol. 2, pp. 94, 132–34, 190–193. The Park chair is illustrated in Robert Bishop, *The American Chair* (1972; reprint, New York: Bonanza Books, 1983), fig. 783.

151. Rhea Mansfield Knittle, Manuscript Checklist, n.d. photocopy, DCM (original in library of Ohio Historical Society, Columbus); Knittle, "Ohio Chairmakers"; 1820 Census of Manufactures, State of Ohio; Howe, *Historical Collections of Ohio*, pp. 279–80; Hageman and Hageman, *Ohio Furniture Makers*, 2:107–9, 156–58, 173–74, 213–17.

152. Knittle, Manuscript Checklist; Knittle, *Early Ohio Taverns*, p. 38; 1820 Census of Manufactures, State of Ohio; Howe, *Historical Collections of Ohio*, p. 190; Hageman and Hageman, *Ohio Furniture Makers*, 2:81.

153. Knittle, "Ohio Chairmakers"; Knittle, Manuscript Checklist; Nelson Talcott, account book, 1839–48, DCM.

154. Hageman and Hageman, *Ohio Furniture Makers*, 2:202–3.

155. Talcott, account book.

156. Talcott, account book.

157. Talcott, account book.

158. Walter C. Kidney, *Historic Buildings of Ohio*, Historic Buildings of America (Pittsburgh, Pa.: Ober Park Assocs., 1972), pp. 30, 38; Thomas L. Vince, "History in Towns: Hudson, Ohio," *Antiques* 114, no. 6 (December 1978): 1309, pl. 4.

159. Knittle, *Early Ohio Taverns*, p. 41; Howe, *Historical Collections of Ohio*, p. 468; Hageman and Hageman, *Ohio Furniture Makers*, 2:93–94, 109–11, 125–26, 172, 183.

160. Knittle, *Early Ohio Taverns*, p. 40; Jarius B. Barnes, "William Tygart, a Western Reserve Cabinetmaker," *Antiques* 101, no. 5 (May 1972): 832–35; Hageman and Hageman, *Ohio Furniture Makers*, 2:95–97, 105–6, 152–53.

161. Barnes, "William Tygart," pp. 832, 834; Hageman and Hageman, *Ohio Furniture Makers*, 2:97, 206; Margaret Berwind Schiffer, *Furniture and Its Makers of Chester County, Pennsylvania* (Philadelphia: University of Pennsylvania Press, 1966), p. 227.

162. Knittle, *Early Ohio Taverns*, p. 42; Hageman and Hageman, *Ohio Furniture Makers*, 2:118–20, 149–50, 170–71, 198.

163. Howe, *Historical Collections of Ohio*, pp. 242–44; 1820 Census of Manufactures, State of Ohio; Knittle, "Ohio Chairmakers," p. 192; Jane Sikes Hageman, *Ohio Furniture Makers*, 2 vols. ([Cincinnati, Ohio]: By the author, 1984), vol. 1, pp. 167–68; Hageman and Hageman, *Ohio Furniture Makers*, 2:199.

164. E. Jane Connell and Charles R. Muller, *Made in Ohio: Furniture 1788–1888* (Columbus, Ohio: Columbus Museum of Art, 1984), p. 101; *Lippincott's Gazetteer*, p. 1333.

165. Howe, *Historical Collections of Ohio*, pp. 386–90; Knittle, "Ohio Chairmakers," p. 193; Hageman, *Ohio Furniture Makers*, 1:87–88, 169.

166. Lawrence Allwine, advertisement in *Pennsylvania Packet* (Philadelphia, Pa.), November 30, 1785, as noted in Prime, *Arts and Crafts, 1786–1800*, p. 165. Daniel Madder was bound to Westley Allwine April 1, 1805; Philadelphia Almshouse Indentures, Book C, 1804–12, Philadelphia Archives, Philadelphia, Pa; Hageman, *Ohio Furniture Makers*, 1:83, 86–87.

167. Hageman, *Ohio Furniture Makers,* I:64–65, 123; Connell and Muller, *Made in Ohio,* p. 107.

168. Howe, *Historical Collections of Ohio,* p. 160; Hageman, *Ohio Furniture Makers,* 1:22, 114, 129; Knittle, "Ohio Furniture Makers," p. 192.

169. Howe, *Historical Collections of Ohio,* pp. 48–50, 54, 506, 512; Hageman, *Ohio Furniture Makers,* 1:99, 104–5, 166–67.

170. 1820 Census of Manufactures, State of Ohio; Howe, *Historical Collections of Ohio,* pp. 272–76, 430–31; Hageman and Hageman, *Ohio Furniture Makers,* 2:152.

171. Howe, *Historical Collections of Ohio,* pp. 145–49, 170–72; Knittle, "Ohio Chairmakers," p. 193; 1820 Census of Manufactures, State of Ohio.

172. Hageman, *Ohio Furniture Makers,* 1:48, 120–21; Howe, *Historical Collections of Ohio,* p. 172; Knittle, "Ohio Chairmakers," p. 193.

173. Howe, *Historical Collections of Ohio,* pp. 409–10, 412; Hageman, *Ohio Furniture Makers,* 1:132–33, 153–54, 173, 176.

174. Howe, *Historical Collections of Ohio,* pp. 205, 209, 211–13, 215; John Humes, advertisements in *Centinel of the North-Western Territory* (Cincinnati, Ohio), October 10, 1795, and *Western Spy* (Cincinnati, Ohio), December 25, 1805 (typecards, MESDA); Jane E. Sikes, *The Furniture Makers of Cincinnati, 1790 to 1849* (Cincinnati, Ohio: By the author, 1976), p. 124.

175. Howe, *Historical Collections of Ohio,* pp. 215–16; Christian Schultz, Jr., *Travels on an Inland Voyage,* 2 vols. (1810; reprint, Ridgewood, N.J.: Gregg Press, 1968), 2:181.

176. Sikes, *Furniture Makers of Cincinnati,* pp. 89, 109, 133–34.

177. Sikes, *Furniture Makers of Cincinnati,* pp. 57, 221–22.

178. Howe, *Historical Collections of Ohio,* pp. 215–16; Sikes, *Furniture Makers of Cincinnati,* pp. 230–33; Donna Streifthau, "Cincinnati Cabinet- and Chairmakers, 1819–1830," *Antiques* 99, no. 6 (June 1971): 896–905.

179. I. Clifford Roll with Marie Dickoré, "The Abraham Roll Family from New Jersey, Pioneers in Hamilton County, Ohio," *Bulletin of the Historical and Philosophical Society of Ohio* 18, no. 4 (October 1960): 285; Sikes, *Furniture Makers of Cincinnati,* pp. 205–6; Streifthau, "Cincinnati Cabinet- and Chairmakers," p. 903; Jacob Roll, advertisements in *Western Spy,* May 26 and December 8, 1815 (typecards, MESDA); New York City jury list, 1816, Historical Documents Collection, QC.

180. Sikes, *Furniture Makers of Cincinnati,* pp. 57, 94, 206; McSwiney and Barnes, advertisement in *Louisville Public Advertiser* (Louisville, Ky.), February 19, 1820 (typecard, MESDA).

181. 1820 Census of Manufactures, State of Ohio.

182. Sikes, *Furniture Makers of Cincinnati,* pp. 82, 92–93, 108; 1820 Census of Manufactures, State of Ohio; Streifthau, "Cincinnati Cabinet- and Chairmakers," pp. 898–99.

183. Isaac M. Lee, advertisement in *National Crisis and Cincinnati Emporium* (Cincinnati, Ohio), January 13, 1826, and other data, in Sikes, *Furniture Makers of Cincinnati,* pp. 141–42, 258–59; Streifthau, "Cincinnati Cabinet- and Chairmakers," pp. 899–901, 905.

184. Philip Skinner, advertisement in *Cincinnati Daily Gazette* (Cincinnati, Ohio), May 1, 1828, and other data, in Sikes, *Furniture Makers of Cin-cinnati,* pp. 216–21; Streifthau, "Cincinnati Cabinet- and Chairmakers," p. 904.

185. Sikes, *Furniture Makers of Cincinnati,* pp. 113, 140, 214, 258–59; Streifthau, "Cincinnati Cabinet- and Chairmakers," pp. 900, 904–5; *Cincinnati Directory for 1831* (Cincinnati, Ohio: Robinson and Fairbank, 1831), n.p.

186. Streifthau, "Cincinnati Cabinet- and Chairmakers," p. 900; Sikes, *Furniture Makers of Cincinnati,* pp. 126–27.

187. Charles Cist, *Sketches and Statistics of Cincinnati* (Cincinnati, Ohio: W. H. Moore, 1851) and other data, in Sikes, *Furniture Makers of Cincinnati,* pp. 90, 175–77; *Cincinnati Directory for 1834* (Cincinnati, Ohio: E. Deming, 1834), n.p.

188. Sikes, *Furniture Makers of Cincinnati,* pp. 175–77; Golovin, "Cabinetmakers and Chairmakers of Washington," p. 922.

189. Matthews information, in Betty Lawson Walters, *Furniture Makers of Indiana, 1793 to 1850* (Indianapolis: Indiana Historical Society, 1972), p. 148; Sikes, *Furniture Makers of Cincinnati,* pp. 38, 165–72; Moore and Mitchell notice, in Charles Cist, *Cincinnati in 1841: Its Early Annals* (Cinncinnati, Ohio: By the author, 1841), n.p.

190. Sikes, *Furniture Makers of Cincinnati,* p. 45; Howe, *Historical Collections of Ohio,* p. 216; Arfwedson, *United States and Canada,* 2:126–27. Trollope, *Domestic Manners,* 1:48; Lyford, *Western Address Directory,* p. 294.

191. Ross and Geyer, advertisement in *Cincinnati Daily Gazette,* November 15, 1833, and other data, in Sikes, *Furniture Makers of Cincinnati,* pp. 105–6, 207–8, 250; Streifthau, "Cincinnati Cabinet- and Chairmakers," pp. 899–90, 903.

192. Sikes, *Furniture Makers of Cincinnati,* pp. 105–7, 206–8.

193. Cist, *Sketches,* and other data, in Sikes, *Furniture Makers of Cincinnati,* pp. 84–85, 92–93, 189–90.

194. 1820 Census of Manufactures, State of Ohio; Hageman, *Ohio Furniture Makers,* 1:160–61.

195. Howe, *Historical Collections of Ohio,* p. 93; Connell and Muller, *Made in Ohio,* pp. 96–97; Hageman, *Ohio Furniture Makers,* 1:99–102.

196. Howe, *Historical Collections of Ohio,* pp. 369–72.

197. Hageman, *Ohio Furniture Makers,* I:115–17, 137, 158.

198. Howe, *Historical Collections of Ohio,* pp. 197–99; Hageman, *Ohio Furniture Makers,* 1:92, 104, 138.

199. Howe, *Historical Collections of Ohio,* pp. 500–501; Hageman, *Ohio Furniture Makers,* I:111–12, 139, 181.

200. 1820 Census of Manufactures, State of Ohio; Knittle, "Ohio Chairmakers," p. 192.

201. Howe, *Historical Collections of Ohio,* pp. 435–38. Information on Phillips, Hoffman, and the firm of Phillips and Cochran is contained in a letter to the author from John R. Grabb, December 3, 1978, including notices published in the *Scioto Gazette and Chillicothe Advertiser* (Chillicothe, Ohio), November 27, 1800, and *Scioto Gazette and Fredonian Chronicle* (Chillicothe, Ohio), November 30, 1815.

202. Information on Sanford is contained in letters to the author from John R. Grabb, December 3 and 27, 1978, including notice published in *Scioto Gazette* (Chillicothe, Ohio), December 26, 1805.

203. Information on Renshaw and May is contained in a letter to the author from John R. Grabb, December 3, 1978, including notice published in *Scioto Gazette and Fredonian Chronicle,* February 29, 1816.

204. Information on the Moores, and on Moore and Emmett, is contained in letter to the author from John R. Grabb, December 27, 1978, including notices published in *Supporter and Scioto Gazette* (Chillicothe, Ohio), June 14, 1823, and *Chillicothe Times* (Chillicothe, Ohio), May 26, 1824. Howe, *Historical Collections of Ohio,* p. 438; Joseph Thoits Moore, in George C. Groce and David H. Wallace, comps., *The New-York Historical Society's Dictionary of Artists in America* (New Haven, Conn.: Yale University Press, 1957), p. 452.

205. Information on Emmett is contained in letters to the author from John R. Grabb, December 27, 1978, and March 1980. Hageman, *Ohio Furniture Makers,* 1:108–9, 136–37; John Mills, advertisement in *True Democrat* (Chillicothe, Ohio), October 23, 1844 (illustrated reference courtesy of John R. Grabb); Howe, *Historical Collections of Ohio,* p. 438.

206. Information on the Shepherds is contained in letters to the author from John R. Grabb, February 25 and August 1980, including notices published in *Chillicothe Advertiser* (Chillicothe, Ohio), May 18, 1833, April 5, 1834, and August 1 and 29, 1835. Hageman, *Ohio Furniture Makers,* 1:162–64.

207. Hageman and Hageman, *Ohio Furniture Makers,* 2:151, 163; Howe, *Historical Collections of Ohio,* pp. 153–54, 298–99, 312.

208. Hageman and Hageman, *Ohio Furniture Makers,* 2:103–4, 140; Howe, *Historical Collections of Ohio,* pp. 327–29, 331.

209. Walters, *Furniture Makers of Indiana,* pp. 31–33; Rohrbough, *Trans-Appalachian Frontier,* pp. 144–45, 234; 1820 Census of Manufactures, State of Indiana.

210. Walters, *Furniture Makers of Indiana,* pp. 15, 42, 144–46.

211. Walters, *Furniture Makers of Indiana,* pp. 57, 76–77, 184, 205–6; Arthur Whallon, "Indiana Cabinetmakers and Allied Craftsmen, 1815–1860," *Antiques* 98, no. 1 (July 1970): 122–23.

212. Rohrbough, *Trans-Appalachian Frontier,* p. 357; Walters, *Furniture Makers of Indiana,* pp. 12–13, 204, 116–17, 148–49; Whallon, "Indiana Cabinetmakers," p. 121.

213. Walters, *Furniture Makers of Indiana,* pp. 107, 141, 166, 219.

214. Walters, *Furniture Makers of Indiana,* pp. 14, 97, 148, 193; Whallon, "Indiana Cabinetmakers," p. 120.

215. 1820 Census of Manufactures, State of Indiana; Walters, *Furniture Makers of Indiana,* pp. 68, 140; Whallon, "Indiana Cabinetmakers," pp. 119, 122.

216. *Lippincott's Gazetteer,* p. 546; Walters, *Furniture Makers of Indiana,* pp. 124–25, 139, 179–81; Whallon, "Indiana Cabinetmakers," p. 122.

217. Rohrbough, *Trans-Appalachian Frontier,* pp. 361–62; Walters, *Furniture Makers of Indiana,* p. 13.

218. Walters, *Furniture Makers of Indiana,* pp. 99, 184; Whallon, "Indiana Cabinetmakers," pp. 120, 123.

219. Walters, *Furniture Makers of Indiana,* pp. 138, 202, 219.

220. Walters, *Furniture Makers of Indiana*, pp. 192, 205–6; Whallon, "Indiana Cabinetmakers," p. 123; Rohrbough, *Trans-Appalachian Frontier*, pp. 363, 388–89.

221. Rohrbough, *Trans-Appalachian Frontier*, p. 176; Walters, *Furniture Makers of Indiana*, pp. 48, 59, 215.

222. Walters, *Furniture Makers of Indiana*, pp. 102–3, 201; Whallon, "Indiana Cabinetmakers," p. 125.

223. Walters, *Furniture Makers of Indiana*, pp. 199, 203. R. Wilson, advertisement in *Niles Gazette and Advertiser* (Niles, Mich.), July 20, 1836; Whitney and Derby, advertisement in *Niles Gazette* (Niles, Mich.), July 19, 1836 (references courtesy of Wendell Hilt). John Tarrant Kenney, *The Hitchcock Chair* (New York: Clarkson N. Potter, 1971), p. 308.

224. Rohrbough, *Trans-Appalachian Frontier*, pp. 71, 77, 79, 143, 180; *Lippincott's Gazetteer*, p. 2318; Walters, *Furniture Makers of Indiana*, pp. 23–24, 155, 185; Whallon, "Indiana Cabinetmakers," p. 123.

225. 1820 Census of Manufactures, State of Indiana; Walters, *Furniture Makers of Indiana*, pp. 122, 139, 193.

226. Rohrbough, *Trans-Appalachian Frontier*, p. 176; *Lippincott's Gazetteer*, p. 2187; Walters, *Furniture Makers of Indiana*, pp. 13, 83, 120.

227. Federal Writers' Project of the Works Projects Administration, *Kentucky: A Guide to the Bluegrass State*, American Guide Series (New York: Harcourt, Brace, 1939), pp. 35–43; Miller, *Genesis of Western Culture*, pp. 34–37; Ashe, *Travels*, p. 237; Brown, *Western Gazetteer*, p. 113.

228. Miller, *Genesis of Western Culture*, pp. 63, 86; Victor S. Clark, *History of Manufactures in the United States*, 2 vols. (New York: Peter Smith, 1949), 1:340–41; Ashe, *Travels*, pp. 191, 193.

229. Brown, *Western Gazetteer*, pp. 91–94; Ashe, *Travels*, pp. 191–92; Miller, *Genesis of Western Culture*, pp. 36–37; WPA, *Kentucky*, p. 84; Mary Jane Elliott, "Lexington, Kentucky, 1792–1820: The Athens of the West" (Master's thesis, University of Delaware, 1973), p. 7.

230. Edna Talbott Whitley, *A Checklist of Kentucky Cabinetmakers from 1775 to 1859* (Paris, Ky.: By the author, 1969), p. 50. William Ross, advertisement in *Kentucky Gazette* (Lexington, Ky.), August 4, 1792; Robert Holmes, advertisement in *Kentucky Gazette*, May 2, 1795 (typecards, MESDA). Elliott, "Lexington, Kentucky," pp. 41–42, 44. Robert Holmes, advertisements in *Kentucky Gazette and General Advertiser* (Lexington, Ky.), October 18, 1803, November 21, 1805, and November 10, 1806; Robert Warden, advertisement in *Kentucky Gazette*, April 4, 1814 (typecards, MESDA).

231. Bjerkoe, *The Cabinetmakers of America*, pp. 120, 184; Whitley, *Kentucky Cabinetmakers*, pp. 44, 88–89. James Har(d)wick, advertisement in *Kentucky Gazette*, April 12, 1794; Lexington market prices, *Stewart's Kentucky Herald* (Lexington, Ky.), September 19, 1797 (typecards, MESDA).

232. Whitley, *Kentucky Cabinetmakers*, p. 39, addenda, p. 3. The author states that Grant and Jemison first advertised late in 1804 and used a cut of a fan-back chair. Apparently, this date is in error, since a check of the *Kentucky Gazette* has failed to locate the advertisement before December 1, 1807. Grant and Jemison, advertisement in *Kentucky Gazette and General Advertiser*, December 1, 1807; and Downing and Grant, advertisements in *Kentucky Gazette*, April 30, 1811, February 6, 1815, and December 2, 1816 (typecards, MESDA).

233. Elliot, "Lexington, Kentucky," p. 44; Whitley, *Kentucky Cabinetmakers*, p. 50, addenda, p. 3; Francis Downing, advertisements in *Kentucky Gazette and General Advertiser*, July 2, 1805, March 8 and December 11, 1806, and August 25, 1807 (typecards, MESDA).

234. The Shryock chair is illustrated and identified in Helen Comstock, "Country Furniture," *Antiques* 93, no. 3 (March 1968): 344. Whitley, *Kentucky Cabinetmakers*, pp. 16, 37; William Challen, advertisement in *Kentucky Gazette and General Advertiser*, May 9, 1809 (typecard, MESDA).

235. John H. Vos, advertisements in *Kentucky Gazette*, November 10, 1812, and May 11, 1813; and Vos and Gaunt, advertisements in *Kentucky Gazette*, May 4, 1813 (typecards, MESDA). Julius P. Bolivar MacCabe, *Directory of the City of Lexington and County of Fayette* (Lexington, Ky.: J. C. Noble, 1838), n.p.; Whitley, *Kentucky Cabinetmakers*, pp. 37, 70, 111–12, addenda, pp. 15–17; Elliott, "Lexington, Kentucky," pp. 70–78.

236. 1820 Census of Manufactures, State of Kentucky; J. Winston Coleman, Jr., "Lexington as Seen by Travellers, 1810–35," *The Filson Club History Quarterly* 29, no. 3 (July 1955): 271, as quoted in Elliott, "Lexington, Kentucky," p. 8; Whitley, *Kentucky Cabinetmakers*, pp. 7, 15, 17, 23, 26–27, 67.

237. Thomas T. Burns, 1824 advertisement (source unknown), and advertisement in *Kentucky Gazette*, August 29, 1814 (typecards, MESDA).

238. WPA, *Kentucky*, pp. 157–59, 380–81; Whitley, *Kentucky Cabinetmakers*, p. 32, addenda, p. 3; 1820 Census of Manufactures, State of Kentucky.

239. 1820 Census of Manufactures, State of Kentucky; Whitley, *Kentucky Cabinetmakers*, pp. 22, 56; WPA, *Kentucky*, pp. 147–48; Sikes, *Furniture Makers of Cincinnati*, pp. 131–32.

240. Brown, *Western Gazetteer*, pp. 103–4; Fearon, *Sketches*, pp. 243, 281–82; Arfwedson, *United States and Canada*, 2:124.

241. J. Shallcross, and McSwiney and Barnes, advertisements in *Louisville Public Advertiser*, November 27, 1819, and June 28, February 19, and March 1, 1820 (typecards, MESDA).

242. Ward and Stokes, 1832 advertisement (source unknown), as reproduced in Carl W. Drepperd, *Pioneer America: Its First Three Centuries* (Garden City, N.Y.: Doubleday, 1949), p. 265; Whitley, *Kentucky Cabinetmakers*, p. 104; *The Louisville Directory for 1832* (Louisville, Ky.: Richard W. Otis, 1832), p. 181.

243. Sikes, *Furniture Makers of Cincinnati*, pp. 110, 140; Walters, *Furniture Makers of Indiana*, pp. 76–77; Whitley, *Kentucky Cabinetmakers*, p. 60; Scott information, in John B. Jegli, *Louisville Directory for 1848–1849* (Louisville, Ky.: John C. Noble, 1848), p. 281, and *Louisville Merchants', Mechanics' and Manufacturers' Business Register for 1850* (Louisville, Ky.: Brennan and Smith, 1850), p. 62.

244. 1820 Census of Manufactures, State of Kentucky; Jeremiah Lewis, advertisement in *Russellville Mirror* (Russellville, Ky.), June 22, 1808, and other data, as recorded in Whitley, *Kentucky Cabinetmakers*, pp. 31, 62, 104; Brown, *Western Gazetteer*, p. 105.

245. William T. Alderson, "Tennessee, A Historical Introduction," *Antiques* 100, no. 3 (September 1971): 378–80; Federal Writers' Project of the Works Projects Administration, *Tennessee: A Guide to the State*, American Guide Series (New York: Viking Press, 1939), pp. 3–5, 48–53, 66–68, 70–71.

246. 1820 Census of Manufactures, State of Tennessee; Louis C. Hunter, *Waterpower in the Century of the Steam Engine*, vol. 1 of *A History of Industrial Power in the United States, 1780–1930* (Charlottesville: University Press of Virginia, 1979), pp. 74, 76.

247. 1820 Census of Manufactures, State of Tennessee; John Oldham, bill to Mr. Wessels, August 17, 1803, Wessels and Primavesi Papers, Maryland Historical Society, Baltimore, Md. (reference courtesy of Dwight Lanmon).

248. [Royall], *Sketches*, p. 22; James Bridges, advertisements in *Knoxville Register* (Knoxville, Tenn.), August 24 and November 23, 1819, as recorded in Ellen Beasley, "Tennessee Cabinetmakers and Chairmakers through 1840," *Antiques* 100, no. 4 (October 1971): 613; 1820 Census of Manufactures, State of Tennessee.

249. Bridges information, in advertisement of William Moffat, *Knoxville Register*, August 20, 1824, as noted in Beasley, "Tennessee Cabinetmakers," pp. 616, 618; WPA, *Tennessee*, pp. 233, 235–36.

250. Schultz, *Travels*, 1:202; WPA, *Tennessee*, p. 182.

251. Bakem and Russell, advertisement in *Clarion and Tennessee Gazette* (Nashville, Tenn.), November 30, 1805; William Bakem and Robert G. Simpson, advertisements in *Impartial Review and Cumberland Repository* (Nashville, Tenn.), October 20 and December 1, 1808 (all, typecards, MESDA). Beasley, "Tennessee Cabinetmakers," p. 612.

252. John Priest, advertisement in *Democratic Clarion and Tennessee Gazette* (Nashville, Tenn.), January 7, 1812; Charles McKarahan, advertisement in *Clarion and Tennessee Gazette*, February 23, 1813 (typecards, MESDA). Beasley, "Tennessee Cabinetmakers," pp. 617–19.

253. Samuel Williams, advertisements in *Clarion and Tennessee State Gazette* (Nashville, Tenn.), June 10, 1817, and January 6, 1818, and in *Nashville Whig and Tennessee Advertiser* (Nashville, Tenn.), March 7 and 14, 1818 (typecards, MESDA); Beasley, "Tennessee Cabinetmakers," p. 621.

254. A. H. Wood and W. R. Wood, advertisements in *Nashville Whig and Tennessee Advertiser*, October 6, 1817, January 31, 1818, and May 1, 1819, in *Nashville Gazette* (Nashville, Tenn.), June 3, 1820, and in *Clarksville Gazette* (Clarksville, Tenn.), October 21, 1820 (typecards, MESDA). For the Wood chair, see Nancy Goyne Evans, "Design Transmission in Vernacular Seating Furniture," in *American Furniture 1993*, ed. Luke Beckerdite (Hanover, N.H.: University Press of New England for the Chipstone Foundation, 1993), p. 93.

255. Beasley, "Tennessee Cabinetmakers," p. 614.

256. Judge John Overton, household accounts, July 1, 1828, and estate inventory, 1833, Claybrooke-Overton Collection, Tennessee State Library, Nashville, Tenn. (references courtesy of Mrs. Lawrence Dortch).

257. Josiah Emmit, Jr., advertisement in *Clarksville Gazette*, November 21, 1819 (typecard, MESDA); Beasley, "Tennessee Cabinetmakers," pp. 614, 618; 1820 Census of Manufactures, State of Tennessee.

258. 1820 Census of Manufactures, State of Tennessee; Swayne data, in Minor Myers, Jr., and Edgar deN. Mayhew, *New London County Furniture, 1640–1840* (New London, Conn.: Lyman Allyn Museum, 1974), p. 127, and in New York City jury list, 1816, Historical Documents Collection, QC; Beasley, "Tennessee Cabinetmakers," p. 621.

259. O. S. Perry, advertisement in *Franklin Western Balance* (Franklin, Tenn.), June 19, 1829, and other data, in Beasley, "Tennessee Cabinetmakers," pp. 614–15, 618–19, 620–21; Ellen Beasley, "Tennessee Furniture and Its Makers," *Antiques* 100, no. 3 (September 1971): 425.

260. 1820 Census of Manufactures, State of Tennessee; Beasley, "Tennessee Cabinetmakers," pp. 612, 614.

261. John Rudisill, advertisement in *Jackson Gazette* (Jackson, Tenn.), May 15, 1830, and other data, in Beasley, "Tennessee Cabinetmakers," pp. 620–21.

262. Beasley, "Tennessee Cabinetmakers," pp. 613–14, 617.

263. *Digest of Accounts of Manufacturing Establishments in the United States, and of their Manufactures* (Washington, D.C.: Gales and Seaton, 1823); Charles van Ravenswaay, *The Anglo-American Cabinetmakers of Missouri, 1800–1850* (St. Louis: Missouri Historical Society, 1958), pp. 240, 250, 252, 254–56; Allyn information in Kihn, "Connecticut Cabinetmakers, Part I," pp. 103–4.

264. Van Ravenswaay, *Anglo-American Cabinetmakers of Missouri*, pp. 253–54; Margaret N. Keyes, "Piecing Together Iowa's Old Capitol," *Historic Preservation* 26, no. 1 (January–March 1974): 40–43; Gordon information, in Charles Keemle, *St. Louis Directory for 1836–7* (St. Louis: Charles Keemle, 1836), n.p.; Colburn and Coolidge, bill to J. S. Hull, August 16, 1841, DCM.

265. Frederick Marryat, *A Diary in America*, 2 vols. (London: Longman et al., 1839), vol. 2, pt. 1, p. 135; Lyford, *Western Address Directory*, pp. 298–99, 401.

266. Kenney, *Hitchcock Chair*, p. 308; Julius P. Bolivar, *Directory of the City of Detroit* (Detroit: William Harsha, 1837), n.p.; W[illiam] Chambers, *Things as They Are in America* (Philadelphia: Lippincott, Grambo, 1854), pp. 142–43; *Lippincott's Gazetteer*, p. 618.

267. Kenney, *Hitchcock Chair*, p. 310; James Wellington Norris, *Norris' Business Directory and Statistics of the City of Chicago for 1846* (Chicago: Eastman and Davidson, 1846), pp. 21–22 (reference courtesy of Louise C. Belden); Charles E. Parsons, Wilder Family Notes, Decorative Arts Photographic Collection, WL.

268. Chambers, *Things as They Are*, p. 139; Shipping Returns: Massachusetts, 1752–65, Colonial Office, and Ledger of Imports and Exports: America, 1768–73, Board of Customs and Excise, PRO.

269. Chambers, *Things as They Are*, pp. 137, 139.

270. New London, Conn., Salem-Beverly and Boston, Mass., and New York Outward Coastwise and Foreign Entries, 1791–1801, U.S. Custom House Records, French Spoliation Claims, NA, including manifests of schooners *Betsey*, October 17, 1791, ca. April 1792, and August 28, 1793, *Defiance*, April 10, 1795, and *Eliza*, December 31, 1799, and sloop *Delight*, September 25, 1794. The American bow-back Windsor found near Liverpool, N.S., is illustrated in Henry and Barbara Dobson, *The Early Furniture of Ontario and the Atlantic Provinces* (Toronto: M. F. Feheley, 1974), fig. 82.

Shipping Returns: Nova Scotia, 1811–16, Colonial Office, PRO.

271. George G. MacLaren, "The Windsor Chair in Nova Scotia," *Antiques* 100, no. 1 (July 1971): 124; MacLaren, *Antique Furniture by Nova Scotia Craftsmen* (Toronto: Ryerson Press, 1961), p. 50; Adam Fergusson, *Practical Notes Made during a Tour in Canada* (Edinburgh: W. Blackwood, 1833), as quoted in Jeanne Minhinnick, "Canadian Furniture in the English Taste," *Antiques* 92, no. 1 (July 1967): 86.

272. MacLaren, "The Windsor Chair," pp. 124–27; MacLaren, *Antique Furniture*, pp. 52–54; George G. MacLaren, *The Chair-Makers of Nova Scotia* (Halifax: Nova Scotia Museum, 1966), n.p.; Phil Dunning, "The Evolution of the Windsor," *Canadian Antiques Collector* 9, no. 2 (March/April 1974): 14.

273. The heart-back Windsor is illustrated in MacLaren, *Antique Furniture*, p. 54. MacLaren, "The Windsor Chair," p. 126.

274. MacLaren, "The Windsor Chair," p. 124; MacLaren, *Chair-Makers of Nova Scotia*, n.p.

275. MacLaren, *Antique Furniture*, 51–53; MacLaren, "The Windsor Chair," pp. 124–26.

276. MacLaren, *Antique Furniture*, pp. 51–52.

277. MacLaren, "The Windsor Chair," p. 127; Gordon advertisement, noted in Minhinnick, "Canadian Furniture," p. 85. The "Halifax" chair is illustrated in Dunning, "Evolution of the Windsor," p. 15.

278. MacLaren, "The Windsor Chair," pp. 126–27. The Balcom chair is illustrated in Dunning, "Evolution of the Windsor," p. 15. MacLaren, *Chair-Makers of Nova Scotia*, n.p.

279. Manifests of schooner *Nancy*, August 16, 1791, and sloops *Betsey*, August 28, 1793, and *Mary and Sally*, December 4, 1798, Boston Outward Foreign Entries, U.S. Custom House Records, French Spoliation Claims, NA; *Lippincott's Gazetteer*, pp. 1933–34.

280. Huia G. Ryder, *Antique Furniture by New Brunswick Craftsmen* (Toronto: Ryerson Press, 1965), pp. 17–19, 165–66.

281. Ryder, *New Brunswick Craftsmen*, pp. 21, 23–31; New Brunswick Museum Art Department, "Thomas Nisbet, Cabinet Maker of Saint John," *Art Bulletin* 1, no. 4 (Fall 1953): 1–2.

282. Ryder, *New Brunswick Craftsmen*, p. 166.

283. Jacob Townsend, advertisement in *Courier* (St. John, N.B.), 1821, and other data, in Ryder, *New Brunswick Craftsmen*, pp. 23–24, 35–37, 166–67.

284. Ryder, *New Brunswick Craftsmen*, pp. 98, 167.

285. Ryder, *New Brunswick Craftsmen*, pp. 84–86, 111, 166, 168.

286. Ryder, *New Brunswick Craftsmen*, p. 36.

287. *Lippincott's Gazetteer*, pp. 1468–69; Elizabeth Collard, "Montreal Cabinet Makers and Chairmakers: 1800–1850," *Antiques* 105, no. 5 (May 1974): 1132–33.

288. Samuel Park, advertisements in *Montreal Gazette* (Montreal, Que.), January 1, 1798, *Canadian Courant* (Montreal, Que.), April 30, 1810, and February 10, 1812, and *Montreal Herald* (Montreal, Que.), August 5, 1815, and other data, in Collard, "Montreal Cabinetmakers," pp. 1144, 1146.

289. Henry Corse, advertisement in *Gazette* (Montreal, Que.), August 11, 1806, and other data,

in Collard, "Montreal Cabinetmakers," pp. 1138, 1144.

290. Samuel Frost, advertisements in *Canadian Courant*, October 15, 1815, and February 1, 1817, as quoted in Collard, "Montreal Cabinetmakers," p. 1140; Rev. Benjamin Trumbull, account book, 1761–1819, Benjamin Trumbull Collection, Yale University, New Haven, Conn.

291. J. Andrews, advertisement in *Montreal Herald*, August 7, 1822; N. W. Burpee, advertisement in *Canadian Courant*, December 21, 1826; Catherine Burpee, advertisement in *Montreal Gazette*, October 4, 1832; and other data; all in Collard, "Montreal Cabinetmakers," pp. 1137–38, 1146.

292. Peter Miler, and Miler and Andrews, advertisements in *Canadian Courant*, January 25, 1826, and September 12, 1832; John Griffith, advertisement in *La Minerve* (Montreal, Que.), May 29, 1843; all in Collard, "Montreal Cabinetmakers," pp. 1140, 1143.

293. Bethune and Kittson, advertisement in *Morning Courier* (Montreal, Que.), April 10, 1843; Redhead and Allen, advertisement in *Montreal Gazette*, January 4, 1847; and Owen McGarvey, advertisement in *Montreal Daily Argus* (Montreal, Que.), September 7, 1857; all in Collard, "Montreal Cabinetmakers," pp. 1137, 1142, 1144.

294. Henry Dobson, *A Provincial Elegance* (Kitchener, Ont.: Kitchener-Waterloo Art Gallery, 1982), fig. 153. A continuous-bow chair with an Ontario history is illustrated in Dunning, "Evolution of the Windsor," p. 14, fig. 2.

295. Howard Pain, *The Heritage of Country Furniture* (Toronto: Van Nostrand Reinhold, 1978), pp. 9n, 17–22, 25, 305–11; Jeanne Minhinnick, *Early Furniture in Upper Canada Village, 1800–1837* (Toronto: Ryerson Press, 1964), pp. 1–4, 6–7, 13, including information and quotations from Liancourt, Howison, and Langton; Chambers, *Things as They Are*, p. 101.

296. Jeanne Minhinnick, *At Home in Upper Canada* (Toronto: Clark, Irwin, 1970), p. 181.

297. The Upper Canada Village settee is illustrated in Pain, *Heritage of Country Furniture*, p. 134, fig. 331.

298. Sack- and fan-back chairs from this group are illustrated in Pain, *Heritage of Country Furniture*, figs. 237, 266. Other sack-back chairs are illustrated in Minhinnick, *Early Furniture*, p. 27, and Philip Shackleton, *Furniture of Old Ontario* (Toronto: Macmillan of Canada, 1973), fig. 53.

299. Minhinnick, *At Home*, p. 180; Joan Lynn Schild, "Furniture Makers of Rochester, New York," *New York History* 37, no. 1 (January 1956): 101; Shackleton, *Furniture of Old Ontario*, p. 36.

300. The Patterson chair is illustrated in Shackleton, *Furniture of Old Ontario*, fig. 84. Pain, *Heritage of Country Furniture*, pp. 19–20, 306–9.

301. Weld, *Travels*, 2:66, and other data, in Joan Mackinnon, *Kingston Cabinetmakers, 1800–1867*, National Museum of Man Mercury Series (Ottawa: National Museums of Canada, 1976), pp. 1, 6–7.

302. Mackinnon, *Kingston Cabinetmakers*, pp. 10–14.

303. E. Brown and Co., advertisement in *Upper Canada Herald* (Kingston, Ont.), July 28, 1840, and other data, in Mackinnon, *Kingston Cabinetmakers*, pp. 44–47; *Lippincott's Gazetteer*, p. 757; "British Mechanic," in *Canadian Freeman* (Toronto, Ont.), 1827, as quoted in Shackleton,

Furniture of Old Ontario, p. 27; Pain, *Heritage of Country Furniture,* p. 38.

304. Mackinnon, *Kingston Cabinetmakers,* pp. 46, 48, illustrations, pp. 75–76.

305. Mackinnon, *Kingston Cabinetmakers,* pp. 14–15, 36–39.

306. Shackleton, *Furniture of Old Ontario,* p. 29; Pain, *Heritage of Country Furniture,* pp. 25, 27, 120.

307. Shackleton, *Furniture of Old Ontario,* pp. 30–31; Minhinnick, *At Home,* pp. 63, 211–12.

308. Shackleton, *Furniture of Old Ontario,* pp. 31–33.

309. Chambers, *Things as They Are,* pp. 102, 113–14.

310. Joan Mackinnon, *A Checklist of Toronto Cabinet and Chair Makers, 1800–1865,* National Museum of Man Mercury Series (Ottawa: National Museums of Canada, 1975), pp. 159–60; Shackleton, *Furniture of Old Ontario,* p. 21; Pain, *Heritage of Country Furniture,* p. 305.

311. John Howison, *Sketches of Upper Canada* (Edinburgh: Oliver and Boyd, 1821), p. 55, and other data, in Mackinnon, *Checklist of Toronto Cabinet and Chair Makers,* pp. 2, 38, 57–58, 68; Shackleton, *Furniture of Old Ontario,* p. 22.

312. Alexander Drummond, advertisement in *Upper Canada Gazette* (Toronto, Ont.), 1829, and other data, in Mackinnon, *Checklist of Toronto Cabinet and Chair Makers,* pp. 2–3, 42–43, 105; George Henry, *The Emigrant's Guide; or, Canada as It Is* (Quebec: W. Gray, 1830), and other data, in Shackleton, *Furniture of Old Ontario,* p. 27.

313. Jacques and Hay account, *Globe* (Toronto, Ont.), 1851, and other data, in Mackinnon, *Checklist of Toronto Cabinet and Chair Makers,* pp. 3–4, 29–30, 56, 69–72, 77–97, 110; Chambers, *Things as They Are,* p. 115.

314. Shackleton, *Furniture of Old Ontario,* p. 35, fig. 115; Minhinnick, *At Home,* pp. 55, 180.

315. Shackleton, *Furniture of Old Ontario,* pp. 23, 37, fig. 86; Minhinnick, "Canadian Furniture," p. 85; Minhinnick, *At Home,* p. 181.

316. Franklin Mead, advertisements in *Long Point Advocate* (Simcoe, Ont.), September 16, 1842, and in *Norfolk Messenger* (Simcoe, Ont.), August 26, 1852, and other data, in William Yeager, ed., *The Cabinet Makers of Norfolk County* (2d ed.; Simcoe, Ont.: Norfolk Historical Society, 1977), pp. 3, 12, 14–19, 127–28, 139.

317. Yeager, *Cabinet Makers of Norfolk County,* pp. 54–55, 127; Minhinnick, *At Home,* p. 181; Shackleton, *Furniture of Old Ontario,* pp. 29–30.

Summary

The mid nineteenth-century commentator who wrote that "chairs are the most changeable of all . . . furniture" was squarely on the mark. Experimentation and timely response to new stylistic impulses are more suited to the production of chairs than to costlier, bulkier furniture. Windsor construction was a bold departure from the standard techniques of early eighteenth-century chairmaking. Contributing to the American design were more varied stylistic influences than those found in any other class of seating furniture, vernacular or formal.

Following the introduction and initial refinement of the American Windsor, a successful union of the English Windsor and design elements selected from the body of early eighteenth-century Philadelphia seating furniture, the most important influence on the form was the fancy chair. This new type of furniture introduced from England in the 1780s had simplified turnings, a box-type support structure, bright surface color, and painted decoration, features that Philadelphia chairmakers adapted to Windsor construction and design at the close of the century.

Philadelphia was the center of the Windsor-chair-making craft in North America from the late 1740s until the early nineteenth century. The coastal location of the city midway between New England and the South and within a few weeks' sail of the Caribbean islands encouraged an active waterborne trade. Merchant entrepreneurs tested the potential of the Windsor in this commerce as early as 1752. Their success and a rising demand for the new furniture in the local market encouraged the growth of a community of chairmakers that expanded and focused increasing attention on the utilitarian commodity as the century advanced.

The success of Philadelphia as a center of Windsor-chair making encouraged the establishment of small communities of Windsor-chair makers at Newport, Rhode Island, and New York before the revolutionary war. After the war, other centers sprang up in most of the important northern ports. The craft soon spread to the surrounding towns and villages and had an impact on the developing centers of northern New England and the maritime provinces of Canada. Distinctly local features became increasingly common. Today, these so-called regional characteristics assist furniture scholars in distinguishing between the products of different areas and serve to highlight the close interaction between regions.

Regional interaction became commoner after 1800 as new transportation technology, territorial expansion, and homesteading opportunities encouraged migration and commercial growth. These developments also contributed to the dilution of regional characteristics in Windsor furniture. Windsors carried in the household baggage of families to new localities often became associated with the adopted homes of their owners. Frequently, skilled chairmakers who resettled reproduced familiar patterns in their new locations. Baltimore, which attained commercial leadership in the early 1800s, began to rival Philadelphia as a regional design center. Influences from the two cities met head on in the valleys of south-central Pennsylvania. The same centers had a

profound impact on midwestern chairmaking, which is characterized by composite patterns reflecting varied impulses. New York state, where both New England and New York City designs influenced local production, enjoyed an economic boom even before completion of the Erie Canal. Along the northern boundary of the United States, lakes Champlain, Ontario, and Erie provided inland communication for further exchanges with Canada.

During the early nineteenth century the Windsor industry also began to rely heavily on supply specialists. The work of single establishments was distributed over broad areas, further blurring the regional identity of the furniture. Some chair parts were made to order, but most were produced for a general market within a limited framework of price and chair type. Crest patterns are a principal distinguishing characteristic in this period. Although chair factories were under construction everywhere at midcentury, many individual shops still existed because setting up and operating a small chairmaking business required only a modest investment and the proprietor's labor.

A sharp rise in demand for Windsor furniture during the 1790s permitted artisans in large urban areas to specialize, especially after the introduction of fancy-painted, woven-bottom seating provided increased opportunities for chair production. Small-town and rural chairmakers often pursued several trades and farmed as well. Improvements in transportation and technology during the early nineteenth century enhanced the position of the non-urban chairmaker and gave rise to the development of water-powered turning mills, local chairmaking centers, and, eventually, the steam-powered factory, as markets continued to expand. The principal product of the Windsor-chair makers was the side chair, first marketed in the late 1770s. Its modest price and dimensions encouraged the purchase of sets and, later, suites, with armchairs, settees, children's furniture, and rocking chairs all options. Chairmakers increasingly stockpiled parts, which they could quickly frame and paint for small private commissions or large orders from merchants and sea captains. By the late 1810s, warerooms offering furniture for sale "off the floor" were becoming common.

The Windsor-chair-making craft developed within the framework of the woodworking shop. The facilities, equipment, and organization were similar in many respects. Eighteenth-century Windsor-chair makers were frequently also cabinetmakers. Astute craftsmen gave particular thought to the location of their businesses: metropolitan chairmakers generally set up shop near the waterfront; non-urban craftsmen chose a recognized business center or a well-traveled rural route; seats of county government often proved good locations in the developing "West." Most chairmaking facilities were small, consisting of one room and possibly a rear lean-to or a loft. Many were staffed only by the proprietor. Generally, there was only one workbench. Chairmakers operated their turning lathes by foot- or hand-power until the second quarter of the nineteenth century when waterpower, then steam, permitted them to increase production to meet rising demands.

Wood, the chairmaker's primary raw material, was obtained from private woodlots, local sawmills or board yards, or by barter. The Windsor seat plank is often the key to identifying the regional origin of a chair, thus knowledge of timber distribution and craft preferences is an important complement to stylistic analysis. Yellow poplar (also called tulip or tulip poplar) was used in the South, the Mid-Atlantic region, and southern New England. White pine was common in eastern Massachusetts, Rhode Island, parts of Connecticut, and northern coastal New England. Chairmakers in Rhode Island and eastern Connecticut made considerable use of chestnut and occasionally maple and walnut. Basswood served in many locations, including Rhode Island, the Connecticut River valley, and the northern New England coast. Oak was a good wood for bending, and hickory was often selected for spindles because of its elasticity. Maple was the premier wood for turned work, since its close grain produced sharp, precise elements; birch and ash were alternatives. After a chair was framed, the surfaces were primed and painted. Green grounds prevailed until after the revolutionary war, when the selection ranged from pale yellow to black. Painted ornament was first used to accent

bamboowork; more surface decoration was possible only when broad, flat elements were introduced to nineteenth-century designs.

The many subtle variations in Windsor furniture, even in chairs of similar pattern from the same region, are explained by the prevalence of small, owner-operated shops. When masters engaged hired help, short-term employment was the norm. Journeymen labored for a daily wage or, more often, at piecework; apprentices assisted according to their degree of training. Before the revolutionary war, 4s. or 5s. was a good day's wages for a journeyman. After the war and into the early nineteenth century, 5s. or 6s., the common retail price of a Windsor side chair, was the average daily wage. Masters, journeymen, and apprentices, alike, usually worked six days a week, from early morning until sundown and later. When the chair factory was developed in the 1830s, specialty departments were set up to handle different tasks, and workmen frequently knew only their one assigned skill.

The Windsor chair became an important commodity in the coastal and Caribbean trades before the revolutionary war, especially at Philadelphia. During the early federal period domestic and overseas markets broadened in scope as the country struggled to develop an economic base and gain a foothold in international commerce. An index of the stature of the Windsor chair as a commercial commodity at Philadelphia is its inclusion in printed lists of local "prices current." After 1800, South America became increasingly attractive as a supplementary overseas market, and in time U.S. vessels carried chairs along the southern continental coast, from the Guianas to the Pacific ports. The domestic coastal trade remained profitable, especially to the South. Charleston was the biggest market, and Savannah ranked second by the early nineteenth century. The lower Chesapeake Bay from Norfolk to Richmond constituted another sizable outlet for northern chairs. New England craftsmen continued to pursue the Canadian chair trade.

The overland trade in Windsor furniture developed slowly. The transport of goods by wagon was cumbersome, expensive, and frequently destructive to the merchandise. Until extensive road improvement began in the early nineteenth century, water routes were preferred. From an early date, towns and landings along coastal rivers from the Hudson to the Rappahannock served as distribution points to the interior. As the western territories opened after 1800, waterways continued to serve as highways of commerce. Eastern merchandise was floated down the Ohio and the Mississippi from Pittsburgh and Wheeling to destinations as far south as New Orleans. Steamboat transportation, introduced after the War of 1812, proved a boon to eastern travel and commerce, but it revolutionized midwestern trade. By 1820, seventy-five steamboats annually plied the Mississippi. At that date the upriver journey from New Orleans to Louisville against the swift currents of the Mississippi and Ohio rivers required ninety days by poled keelboat. The steamboat completed the same journey in thirty-six days, and that time improved each year. Canal building began in the same period, and by the 1840s almost 4,000 miles of artificial waterways had been completed in the East and Midwest. In 1825 the Erie Canal provided new access to western markets and contributed to a flourishing Great Lakes' and Canadian trade. During the 1830s, steam railways began to carry merchandise overland, and for the first time year-round freight and passenger service was possible, unhampered by frozen waterways. Technological advances reduced freight costs, regularized transportation schedules, and created new jobs.

Chairmakers had to sell their products to stay in business. Successful marketing hinged in part on good business practices, which included several options. Customers occasionally paid for purchases in cash but more often bought on credit or bartered produce, merchandise, or services. Auctions were useful for disposing of stock surpluses when the market was favorable. Commission sales became common as warerooms opened and improved transportation permitted the transfer of large numbers of chairs from shops to retail facilities. As firms grew, agents were appointed to handle parts of their wholesale and retail trade. Coastal and overseas business was usually conducted by

direct sales to middlemen—merchants and sea captains—or by consignment to a firm at a cargo's destination. Advertising helped to promote business. Newspaper notices identified suppliers to domestic consumers and overseas shippers; some firms also distributed small printed or pictorial trade cards (fig. 7-26). Printed labels, with information ranging from names and locations to long descriptions of products and services, were affixed to chair bottoms, although many fell off or were destroyed within a few years. Branded names were more durable and today represent the most common form of identification on Windsor furniture. By the 1820s, stencils had begun to replace stamps and, like labels, provided more information.

Changing economic and social conditions following the revolutionary war extended economic opportunity to a large segment of the population. Increasingly, Windsor seating met the domestic furniture needs of all classes, ensuring growth of the craft to an industry. Windsor furniture answered both utilitarian and formal needs in the household. Side chairs became the common dining-room furniture of the middle classes, especially after the bow-back pattern was introduced. Windsors also served as outdoor furniture and as seating at social gatherings, from private clubs to lecture halls. Business uses of Windsor seating were varied. Low maintenance recommended the all-wood chair as furniture for America's inns and hotels and for sailing and steam vessels. Specialized forms, such as high and low stools, were useful in countinghouses and shops. Windsor seating was also in demand to furnish America's public institutions. Statehouses, courthouses, schools, and libraries from New England to the Deep South and the Midwest seated everyone, regardless of socioeconomic status, on plain, painted Windsor chairs. As aptly summarized by a Philadelphia merchant-factor when writing to a client in the 1790s: "The Windsor chairs are of the cheapest kind, yet neat and fashionable."[1]

In sum, the sizable demand for Windsor seating furniture during the initial 100 years of production from the 1740s to 1850 created a substantial legacy of design.

Note

1. Stephen Collins to Samuel Cheesman, October 27, 1792, in letterbook, 1792–1801, Stephen Collins Papers, Manuscript Division, Library of Congress, Washington, D.C.

American Windsor Craftsmen, 1745–1850

Explanation

The names on the checklist are principally those of Windsor craftsmen associated with the trade through written/printed records and documented, or occasionally firmly attributed, furniture. Many individuals were cabinetmakers as well. Also included are the names of Windsor-furniture dealers active during the 1745–1850 period, a few original and subsequent owners whose brands or signatures on furniture have been mistaken for those of Windsor craftsmen, and several individuals working in other trades or businesses whose brands were added to antique Windsor furniture in recent times to enhance the value. Although extensive, the list represents only a fraction of the Windsor-chair makers working during this 105-year period.

The identification of a craftsman as a chairmaker in period records must be interpreted with caution. At times, researchers are unable to distinguish between craftsmen who produced chairs for sitting and those who made riding chairs, or vehicles. Many other so-called Windsor-chair makers pursued the craft only part-time or sporadically, devoting the rest of their time to farming or, to a lesser extent, other trades. The cut-off date for the list coincides with the end of hand-craft production in the Windsor trade and the rise of the factory system.

Working dates given in the checklist were established using a combination of documentation from records, circumstantial evidence based on known products, and pertinent business relationships. Family connections and master-apprentice associations are noted when known.

Abbreviations

b.	= born	princ.	= principally	fr.-in-law	= father-in-law
bp.	= baptized	N, S, E, W, NE, NW, SE, SW =	cardinal directions	gr.	= grandson
d.	= died	cent.	= central	mkr.	= maker
m.	= married	mstr.	= master	chrmkr.	= chairmaker
w.	= working, worked	appr.	= apprentice	cabtmkr.	= cabinetmaker
ca.	= circa	jnyman.	= journeyman	orn. ptr.	= ornamental painter
n.d.	= no date	ptnr.	= partner	mfr.	= manufacturer
bef.	= before	br.	= brother	bus.	= business
aft.	= after	fr.	= father	assoc.	= associated with
poss.	= possibly	br.-in-law	= brother-in-law		
prob.	= probably				

Craftsmen Checklist

A., W. M. Prob. Newbury or Newburyport, Mass., w. ca. 1790–ca. 1830. Spinning-wheel mkr.

Abbot, Daniel (and Co.) 1774–1856, m. 1796. Newburyport, Mass., w. 1800–ca. 1815. *See also* Abbot and McAllaster.

Abbot, Daniel, and McAllaster, Benjamin Newburyport, Mass., w. ca. 1807–9.

Abbott, William B. ca. 1790. Baltimore, Md. Appr. to Caleb Hannah, 1801.

Abraham, George Philadelphia, Pa. Appr. to James Pentland, 1800.

Abraham, Samuel B. ca. 1781. Baltimore, Md. Appr. to Reuben League, 1800.

Ackerman, Gilbert D. ca. 1834. Albany, N.Y., w. 1798–1834.

Ackerman, John Haycock Twp., Bucks Co., Pa. Mstr. to James Watson Stogton, 1812.

Ackley, John Brientnall D. 1827. Philadelphia, Pa., w. 1786–ca. 1809.

Ackley, M(assey?) Prob. Philadelphia, Pa., ca. 1800. Poss. son of John B. Ackley.

Ackman, William B. ca. 1795. Baltimore, Md. Appr. to Matthew McColm, 1810.

Adam, D., and Adam, W. (or Adam, D. W.) Bradford, N.H., w. ca. 1855.

Adams, Ezekiel B. 1813. Providence, R.I., w. 1832–44; Gardner, Mass., w. 1850.

Adams, John, and Faries, George C. Wilmington, Del., and Savannah, Ga., w. 1815–17.

Adams, Joseph 1767–1856, m. 1792. Boston, Mass., w. 1789–90, 1796, 1798–99, 1800, 1805–9; Litchfield, Conn., w. 1790, 1792, 1797, 1799, 1800–1804, 1812–18.

Adams, Joshua Camden, Del. Appr. to David H. Stayton, 1835.

Adams, Lemuel Hartford, Conn., w. ca. 1796–1800; Norfolk, Va., w. 1801.

Adams, Moses 1759–96, m. 1784. Ipswich, Mass., w. 1785; Beverly, Mass., w. 1789–96.

Adams, Nathan S. 1806–70. Princeton, Mass., w. 1830–50.

Adams, Thomas Alexandria, Va., w. 1797–98; Georgetown, D.C., w. 1806–ca. 1825; Washington, D.C., w. 1825–55. Mstr. to Benjamin Belterton, 1813; Benjamin Boswell, 1822; George Boswell, 1808; Jesse Branan, 1813; Samuel Brunner, 1819; Aloysius Clements, 1816; Ignatius Noble Clements, 1819; Elijah Crager, 1808; Jacob Hiram Creamer, 1825; William Dalton, 1813; Joseph Hall, 1807; Levi Hurdle, 1817; William Matting, 1819; Thomas Minnis, 1821; John Morris, 1822–25; Simon Theophilus Reeder, 1816; James Williams, 1806.

Aiken, Thomas, Jr. 1747–1805, m. 1772. Antrim, N.H., w. 1772; Deering, N.H., w. 1790–1805.

Alcock, John Richmond, Va., w. 1806–11. Dealer.

Alden, Luther 1797–1870. Lebanon, N.H., w. 1827–31 and prob. earlier and later.

Alexander, Calvin Cent. Massachusetts, w. ca. 1830–50.

Alford, Arba 1807–81, m. 1836. Hitchcocksville (Riverton), Barkhamsted Twp., Litchfield Co., Conn., w. 1829–64. Br.-in-law of Lambert Hitchcock. *See also* Hitchcock, Alford and Co; Hitchcocksville Co.

Allen, Amos Denison 1774–1855, m. 1796. Windham, Conn., w. 1796–ca. 1840 and poss. later. Appr. to Ebenezer Tracy, Sr., 1790. Son-in-law of Ebenezer Tracy, Sr.; fr. of Frederick Allen; fr.-in-law of Elisha Harlow Holmes.

Allen (Allan), Charles P. Boston, Mass., w. 1825–29; Halifax, Fall River, and Waverly, Nova Scotia, Canada, w. ca. 1832–62. *See also* Silas Allen, Jr., and Charles P. Allen.

Allen, Frederick 1799–1830, m. 1828. Area Essex, Conn., w. 1828–29; S. Windham, w. 1829. Son of Amos Denison Allen; gr. of Ebenezer Tracy, Sr.; br.-in-law of Elisha Harlow Holmes.

Allen, J. C. New England, ca. 1800s–1810s.

Allen, Job A. Cambridge, Washington Co., N.Y., w. ca. 1810–50.

Allen, Joseph Boston, Mass., w. 1800–1803.

Allen, L. H. Prob. New England, w. ca. 1795–1805.

Allen, Moses. D. 1812. Uniontown, Pa., w. 1812.

Allen, Oratia P. Fitzwilliam, N.H., w. 1826. Poss. seatmaker only.

Allen, Rhodes G. Providence, R.I., w. 1815–28. Dealer.

Allen, Silas, Jr. Boston, Mass., w. 1826–34. Chair ptr. *See also* Silas Allen, Jr., and Charles P. Allen.

Allen, Silas, Jr., and Allen, Charles P. Boston, Mass., w. 1827–28. Dealers.

Allen, Thomas, II New Bedford, Mass., w. 1822–ca.1832.

Allen, William Montreal, Canada, w. 1843–66. *See also* Redhead and Allen.

Alling, David 1773–1855, m. 1802, 1817. Newark, N.J., w. ca. 1800–1855. *See also* John Hall and David Alling.

Allwine, Barnhart Zanesville, Oh., w. 1827; Perry Co., Oh., w. 1850. Son of Lawrence Allwine.

Allwine (Allvine), John, Jr. Poss. d. 1816, Zanesville, Oh. Baltimore, Md., w. 1796–1801; Philadelphia, Pa., w. 1801–9. Appr. to Lawrence Allwine, 1788. Br. of Peter Allwine.

Allwine, Lawrence (also Lewis Alwein) Philadelphia, Pa., w. 1785–1809; Zanesville, Oh., w. 1811–27; poss. Perry Co., Oh., w. 1830. Mstr. to John Allwine, Jr., 1788; Peter Allwine, 1788; John Clarkson, 1792; John Hill, 1795; Philip Karcher, 1785; Daniel Perkins, 1788; Peter Rise, 1794; Job Swim, 1793. Fr. of Barnhart Allwine and Westley Allwine.

Allwine, Peter Philadelphia, Pa. Appr. to Lawrence Allwine, 1788. Br. of John Allwine, Jr.

Allwine, Westle(y) M. 1809, d. 1842. Philadelphia, Pa., w. 1805–8; Zanesville, Oh., w. 1809–30. Mstr. to Daniel Madder, 1805. Son of Lawrence Allwine.

Allyn, Isaac 1787–1839. Preston, Conn., w. 1809–12.

Allyn, Stephen Billings 1774–1822, m. 1797. Norwich, Conn., w. 1797–1822. Poss. appr. to Lemuel Adams, ca. 1795. *See also* Stephen Billings Allyn and Daniel Huntington III.

Allyn, Stephen Billings, and Huntington, Daniel, III Norwich, Conn., w. 1797–1802.

Alter, John 1779–1850; b. Reading, Pa. Zanesville, Oh., w. 1806–ca. 1850.

Alvord, Elihu 1775–1863; b. Fairfield, Conn.; d. Davenport, Ia. Milton, N.Y., w. 1804–6; Marcellus, N.Y., w. 1810; Cayuga Co., N.Y., w. 1812; Black Rock, N.Y., w. 1818; Ellicottville, N.Y., w. 1833–37; Long Grove, Ia., w. 1837, 1855.

Always, James D. ca. 1811. New York, N.Y., w. 1794–1810.

Always, John New York, N.Y., w. ca. 1789–1801. *See also* John Always and Joseph Hampton.

Always, John, and Hampton, Joseph New York, N.Y., w. 1795–96.

Ames, Burpee D. 1824. Salem, Mass., w. 1810–24. Poss. dealer only.

Ames, Luther Guilford, Vt., w. 1797.

Amies, T. Prob. Delaware Valley, ca. 1795. Poss. owner.

Anderson, Andrew New York, N.Y., w. 1786–1809.

Anderson, James New Castle Co., Del. Appr. to George A. Richmond, 1841.

Andrews, Charles J. Montreal, Canada, w. 1832. *See also* Michael Miler and Charles J. Andrews.

Andrews, J., and Co. Montreal, Canada, w. 1822.

Andros (Andrus), Frederick Canterbury, Conn., w. 1790s; poss. Hartford, Conn., w. 1820.

Anne, Conrad, Jr. Lancaster, Pa., w. 1842–50.

Annit, John Sussex Co., Del., w. 1754. Spinning-wheel mkr.

Apple, A. H., and Thompson, (?) Indiana, Pa., w. 1864–77.

Apple, George Ca. 1799–1839. Philadelphia, Pa., w. 1823–33.

Arcularius, Philip I., II (also called Jr.) B. ca. 1785. New York, N.Y., w. ca. 1811–30; Brooklyn, N.Y., w. 1831–32. *See also* Philip I. Arcularius II and Co.

Arcularius, Philip I., II, and Co. New York, N.Y., w. 1830.

Arcularius, Philip I., III (also called Jr.) Prob. New York, N.Y., w. 1825; Brooklyn, N.Y., w. 1836–41.

Arheart, Robert Piqua, Oh., w. 1823–29.

Armstrong, Joseph Greensburg, Pa., w. 1799–1801.

Armstrong, L. E Pennsylvania or Delaware Valley, ca. 1780s. Poss. owner.

Armstrong, William B. 1803. Baltimore, Md., w. 1827–37. Appr. to Matthew McColm, 1816.

Arthur, Peter New York, N.Y., w. 1802–22.

Ash, Thomas, I M. 1763, d. 1806. New York, N.Y., w. 1774–99. Mstr. to John Vanwyck Warner, 1786. Br. of William Ash I; uncle of Thomas Ash II, William Ash II, and Gabriel Leggett, Jr. *See also* Thomas Ash I and William Ash I.

Ash, Thomas, I, and Ash, William, I New York, N.Y., w. 1783–94.

Ash, Thomas, II B. ca. 1787. New York, N.Y., w. 1815–24. Son of William Ash I; br. of William Ash II; nephew of Thomas Ash I. *See also* Thomas Ash II and Alexander Welsh.

Ash, Thomas, II, and Welsh, Alexander New York, N.Y., w. 1824.

Ash, William, I D. 1815. New York, N.Y., w. 1775–1815. Fr. of Thomas Ash II and William Ash II; br. of Thomas Ash I; uncle of Gabriel Leggett, Jr. *See also* Thomas Ash I and William Ash I.

Ash, William, II D. ca. 1845. New York, N.Y., w. 1818–44. Son of William Ash I; br. of Thomas Ash II; nephew of Thomas Ash I.

Ashburn, Humphrey Raleigh, N.C. Appr. to Joel Brown, 1819.

Ashley, (?), and Williston, (?) Syracuse, N.Y., w. ca. 1840–51.

Ashton, Thomas D. 1853. Philadelphia, Pa., w. ca. 1800–1839.

Attwell, John Prob. Westmoreland Co., Va., w. 1770–89. Windsor craftsmanship doubtful.

Atwater, M. Prob. SE New England, ca. 1780s–1790s. Poss. owner.

Atwood, David 1779–1869, m. 1802. Bedford, N.H., w. ca. 1802–21. Appr. to David McAfee, 1795. Br. of Thomas Atwood.

Atwood, Thomas Ca. 1785–1865, m. 1808. Worcester, Mass., w. 1810–ca. 1819; Bedford, N.H., w. ca. 1819–40; Nunda, N.Y., w. 1840–1860; Canaseraga, N.Y., w. 1860–65. Br. of David Atwood.

Augur, William H. 1814–98, m. 1837. New Haven, Conn., w. 1840–60. *See also* Charles B. Lines and William H. Augur.

Austin, D. B. Spurious brand on spurious continuous-bow armchair.

Austin, Josiah 1746–1825; b. Charlestown, Mass.; m. 1771, 1778. Charlestown, Mass., w. 1775; Medford, Mass., w. ca. 1775–ca. 1779; Salem, Mass., w. ca. 1779–1811 and prob. later. Br. of Richard Austin.

Austin, Perez D. 1832. Canterbury, Conn., w. 1811–32.

Austin, Richard 1744–1826; b. Charlestown, Mass.; m. 1797. Charlestown, Mass., w. 1775; Salem, Mass., w. 1775–1813. Br. of Josiah Austin.

Austin, Samuel D. 1767, m. 1723, 1748. Philadelphia, Pa., w. ca. 1723–1760s. Windsor craftsmanship doubtful.

Avery, Barton F. M. 1816. Cayuga Co., N.Y., w. bef. 1816; Parkman, Oh., w. 1816–29.

Avery, John Area Gilmanton, N.H., w. 1811–ca. 1830.

Avery, Oliver 1757–1842, m. 1802, 1806. N. Stonington, Conn., w. 1781–1831.

Avery, Park(e) 1788–1866. Preston, Conn., w. 1814–24.

Ayres, James M. 1815, d. 1862. Cincinnati, Oh., w. 1807–25, 1829–ca. 1853.

Ayres, John Pittsfield, Mass., w. 1820–27.

Ayres, William Windsor, Vt., w. 1810–16.

B., R. Philadelphia, Pa., w. late 1750s–1760s. Poss. Robert Black; poss. owner.

B. and F. Oxford, Mass., w. ca. 1850s–1860s.

Bachelder, Joseph (and Son) D. 1881. W. Waterville, Me., w. 1835–81.

Backus, Salmon S. New Bern, N.C., w. 1837–40.

Bacon, Henry Providence, R.I., w. 1768 and prob. earlier–ca. 1780 and poss. later. A Henry Bacon who died in 1797 is called a merchant in his will.

Badger, Daniel Weld 1779–1847, m. 1827 (and earlier). Bolton–Coventry, Conn., w. 1816–47.

Bailey, O., Jr. Prob. E or SE Massachusetts, 1790s. Poss. owner.

Bailey, Paul B. 1810. Sterling, Mass., w. ca. 1830s–1852.

Bailey, Richard Norfolk, Va., w. ca. 1805–10. Princ. cabtmkr.

Bailey, Shubal (Shubael) Sterling, Mass., w. 1790–1824.

Bain, Thomas Hamilton, Ont., Canada, w. 1850.

Baines (Bains), John Troy, Oh., w. 1849.

Bakem (Bakam), William Nashville, Tenn., w. 1805–11. *See also* Bakem and Russell.

Bakem, William, and Russell, John Nashville, Tenn., w. 1805.

Baker, Daniel 1780–1858. Trenton, N.J., w. ca. 1800–1812.

Baker, Ezra B. 1789. Gardner, Mass., w. 1820s–1837. Fr.-in-law of Merrick Wallace.

Baker, Thomas, III Poss. d. 1842. Sterling, Mass., w. 1833.

Balch, J., Jr. Boston, Mass., or area, late 1790s–early 1800s. Poss. owner.

Balcom, J. Clements, Nova Scotia, Canada, w. 1830.

Baldwin, Cyrus New York, N.Y., w. 1820–44, 1850–60. *See also* Cyrus Baldwin and James B. Cook; Richard Cornwell and Cyrus Baldwin; Oliver Edwards and Cyrus Baldwin.

Baldwin, Cyrus, and Cook, James B. New York, N.Y., w. 1837–42.

Baldwin, Harlan Wilmington, Del., w. 1853–57. Appr. to Jared Chesnut, 1829.

Bale, Rudolph Philadelphia, Pa. Appr. to Joseph Burden, 1806.

Ball, Aaron 1792–1856. Quakertown, Pa. Appr. to Aaron Jones, 1809.

Baltzell, L. W. Steubenville, Oh., w. 1839–44. *See also* Baltzell and Hicks.

Baltzell, L. W., and Hicks, (?) Steubenville, Oh., w. 1839.

Bancroft, Amasa, and Parker, Frederick Gardner, Mass., w. ca. mid 1830s.

Bancroft, Jonathan O. 1806–60, m. 1830. Ashburnham, Mass., w. ca. 1824–ca. 1833; Boston, Mass., w. 1833–35 (dealer); Portland, Me., w. ca. 1836–58. Br.-in-law of Walter Corey and John C. Glazier. *See also* Jonathan O. Bancroft and John C. Glazier.

Bancroft, Jonathan O., and Glazier, John C. Ashburnham, Mass., w. ca. 1824–ca. 1833.

Banker, Henry New York, N.Y., w. 1790.

Banta, Christian B. 1777. New York, N.Y. Appr. to Peter Tillou, 1793.

Barber, J. W. Windsor, Vt., w. 1814.

Barber, James N. M. 1799. Norwich, Conn., w. ca. 1799–1812.

Barber, John S. Prob. d. bef. 1853. Wilmington, Del., w. 1845. Appr. to Jared Chesnut, 1829. Widow Mary Ann operated business, ca. 1853–57.

Barclay, James New York, N.Y., w. 1784. Poss. dealer only.

Barnard, David Shelburne–Greenfield, Mass., w. ca. 1786–1806.

Barnard, Julius B. 1769. Northampton, Mass., w. 1792–1801; Hanover, N.H., w. 1801; Windsor, Vt., w. 1802–9; Montreal, Canada, w. 1809–12.

Barnes, Elizur 1780–1825, m. 1804. Middletown, Conn., w. 1802–25.

Barnes, James Richmond, Va., w. 1816–17; Petersburg, Va., w. 1818–20. *See also* Leonard H. Seaton and James Barnes; Hobday and Barnes.

Barnes, Robert New York, N.Y., w. 1811–17. *See also* Robert Barnes and William Osborn.

Barnes, Robert, and Osborn, William New York, N.Y., w. 1815–16.

Barnet (Barnit), Abraham Philadelphia, Pa., w. 1796–1801. *See also* Halberstadt and Barnet.

Barnet, Sampson M. 1776. Goshen and E. Goshen twps., Chester Co., Pa., w. 1779–81, 1814–23; Wilmington, Del., w. 1786–95, 1810; Lancaster, Pa., w. 1807. Mstr. to Abraham Hoopes, 1795.

Barney, Henry Bridgeport, Conn., w. 1823. *See also* Barney and Thomas.

Barney, Henry, and Thomas, (?) Bridgeport, Conn., w. 1820.

Barnhart, Henry Baltimore, Md. Appr. to Robert Fisher, 1807.

Barnhart, John Washington, Pa., w. 1813. Jnyman. to James Meetkerke, 1813.

Barrell, John D. 1841. Ashburnham, Mass., w. 1841.

Barrett, Oliver Bolton, Mass., w. ca. late 1790s–1800s.

Bartholf, John G. B. ca. 1794. New York, N.Y., w. 1816–24.

Bartlett, John C. Greenwich (Union Village), Washington Co., N.Y., w. ca. 1820.

Bartlett, John M. Philadelphia (Frankford section), Pa., appr. 1807; Easton, Md., w. 1810s. Appr. to Isaac Whitelock, 1807.

Bartlett, Levi 1784–1864, m. 1814. Concord, N.H., w. 1804–9; Salisbury, N.H., 1806–9 (branch shop).

Bartlett, Luther D. 1838. Leominster, Mass., w. 1826–1838. Poss. turner only.

Bartling, B., and Hall, S. New Haven, Conn., w. 1804. Orn. ptrs.

Barton, Isaac B. 1793. Baltimore, Md., appr. 1810; Fayetteville, Tenn., w. 1830. Appr. to Jacob Daley, 1810.

Barton, M(iah?, Mial?) P. Jackson Twp. and Cambridge, Washington Co., N.Y., w. ca. 1830s–ca. 1850s.

Bass, Benjamin, Jr. D. 1819. Boston, Mass., w. 1798–1819. See also Bass and Barker.

Bass, Benjamin, Jr., and Barker, James (and Co.) Boston, Mass., w. 1816.

Bassett, Thomas D. ca. 1847. Lee, Mass., w. 1822–32.

Bassford, Gassaway W. B. 1796. Baltimore, Md., w. 1827–37. Appr. to John Oldham, 1814. See also Bassford and McDonald; Markland and Bassford.

Bassford, Gassaway W., and McDonald, Charles Baltimore, Md., w. 1833.

Bates, Alvin M. 1821, 1834. Poss. Williamstown, Mass., w. 1821; Bennington, Vt., w. 1833–ca. 1851.

Bates, David D. 1822. Washington, D.C., w. 1820–21.

Bates, William Poss. 1794–1859, m. 1814. New Bedford, Mass., w. 1804–59. See also William Bates and Thomas Allen II; William Bates and Reed Haskins; William Russell, Jr., and William Bates.

Bates, William, and Allen, Thomas, II New Bedford, Mass., w. 1822.

Bates, William, and Haskins, Reed New Bedford, Mass., w. 1832–41. Prob. orn. ptrs. only.

Bates, (?), and Johnson, (?) Albany, N.Y., w. 1819.

Bayler, William B. 1801. Baltimore, Md. Appr. to James Knox, 1819.

Beach, Abraham Ca. 1791–1854, m. 1811. Newark, N.J., w. 1810s–1837.

Beach, Edward P. Poss. d. 1859, poss. m. 1822. Area Newark, N.J. (poss. Hanover, Morris Co.), w. 1832.

Beach, Miles Poss. b. 1750s, m. 1807. Ballston Spa, N.Y., w. ca. 1804–9; Saratoga, N.Y., poss. w. early 1810s. See also Miles Beach and (?) Miner.

Beach, Miles, and Miner, (?) Ballston Spa, N.Y., w. 1805.

Beach, Samuel Richmond, Va., w. 1818–19. Possibly same man who had chair store in New York City, 1817, and was a boarding chairmaker in Cincinnati, Oh., 1829–31. See also Robert McKim and Samuel Beach.

Beal, Jacob, Jr. 1774–1805. Hingham, Massachusetts, w. ca. 1790s.

Beal, Samuel (and Sons) Boston, Mass., w. 1807–40.

Beale, Horatio Augusta, Me., w. 1824–25; Bangor, Me., w. 1825–34. See also Amaziah S. Moore and Horatio Beale.

Beale, Jepheth, and Robinson, Elihu Augusta, Me., w. 1836–ca. 1839. Orn. ptrs.

Beall, Gustavus New York, N.Y., w. 1811; Georgetown, D.C., w. 1812–20. Mstr. to Edward King.

Beals, Peter B. Plainfield, Mass., w. 1802–3.

Beatty, Dempster M. 1806. Norwich, Conn., w. 1806–10. Appr. in Philadelphia.

Bechler, George Canton, Oh., w. 1823–25. See also George Dunbar, Jr., and George Bechler.

Beck, D. Prob. SE New England, w. 1790s.

Beck, Henry 1787–1837. Portsmouth, N.H., w. 1805–34. Ptnr. to Nathaniel Frost, 1810.

Beck, J. Cole Harbor, Nova Scotia, Canada, w. 1830.

Beck, James Fredericksburg, Va., w. 1805–20. See also James Beck and Alexander Walker.

Beck, James, and Walker, Alexander Fredericksburg, Va., w. ca. 1802–5.

Beckett, Samuel S. D. ca. 1848/9. Portland, Me., w. 1834–48. Also looking-glass mkr., gilder, and orn. ptr. See also James Todd and Samuel S. Beckett.

Beckner, S. H. Lafayette, Ind., w. 1839.

Beckwith, Harris Northampton, Mass., w. 1803–ca. 1810; Marlow, N.H., w. 1820. See also Beckwith and Hollman.

Beckwith, Harris, and Hollman, (?) Northampton, Mass., w. 1807.

Bedell, J. W. Prob. Hudson River valley, poss. area Esopus, N.Y., ca. 1800s–1810s. Poss. owner.

Bedortha, Calvin 1774–1853. W. Springfield (Agawam), Mass., w. 1800–1815 and poss. later.

Beecher, William Willis New York, N.Y. Appr. to Richard E. Halsey, 1832.

Beesley, William G. 1797–1842, m. 1826. Salem, N.J., w. ca. 1826–41.

Beggs, James D. 1837. Fayetteville, N.C., w. 1793–1825. Mstr. to John Gunn, 1800; John Rich, 1799; Calvin Wright, 1825. Had negro slave named Isaac to whom he taught trade of riding-chair maker. See also Beggs and Beggs.

Beggs, Thomas, and Beggs, James Fayetteville, N.C., w. 1793–94.

Belding, (?), and Collins, (?) Randolph, Oh., w. 1828–29.

Bell, John New York, N.Y., w. 1791–92.

Bell, Robert Baltimore, Md. Appr. to John Conrad, 1802.

Belterton, Benjamin Georgetown, D.C. Appr. to Thomas Adams, 1813.

Bender, Lewis Philadelphia, Pa., w. 1794.

Benjamin, C. E Massachusetts or N New England, w. ca. 1820s.

Benjamin, Miles D. 1853. Coopertown, N.Y., w. 1820–29.

Bennett, Samuel New Bedford, Mass., w. 1832–45. See also Samuel Bennett and George Piggott.

Bennett, Samuel, and Piggott, George New Bedford, Mass., w. 1832–33.

Bennett, Simeon Boylston, Mass., w. 1824–40.

Bennett, Z. Prob. E Massachusetts, w. ca. late 1790s. Poss. owner.

Bentley, George Washington B. ca. 1814. W. Edmeston, N.Y., w. 1850.

Bereman, Thomas W. Union, Oh., w. 1820–24.

Berry, W. J. NE New England, prob. Fayette, Me., w. ca. 1820s–1830s.

Berryman, John W. Kilmarnick, Bourbon Co., Ky., w. 1821–24. See also Chinn and Berryman.

Bertine, James Prob. d. 1842/3. New York, N.Y., w. 1789–97.

Bethune, N., and Kittson, W. H. Montreal, Canada, w. 1838–43.

Bheares, Henry Pittsburgh, Pa., w. 1819, 1839–41.

Bibby, John B. ca. 1785. Baltimore, Md. Appr. to Jacob Cole, 1796.

Bickford, Alfred Gardner, Mass., w. early 1830s.

Bidwell, E(rastus?) F(ranklin?) B. ca. 1816, m. 1839. Canton, Conn., prob. w. ca. 1839; Farmington, Conn., w. 1850–51; Collinsville, Conn., w. 1858. Windsor craftsmanship unconfirmed.

Bigelow, W. Brooklyn, N.Y., w. ca. 1825–ca.1835. Windsor craftsmanship unconfirmed.

Biggard, John Philadelphia, Pa., w. 1767 and earlier; Charleston, S.C., w. 1767.

Billings, Henry (and Co.) Brockville, Ont., Canada, w. 1832 (dealer); Rochester, N.Y., w. 1838–46.

Bird, Henry N. Cincinnati, Oh., w. 1853–60. See also Henry N. Bird and George Burrows.

Bird, Henry N., and Burrows, George Cincinnati, Oh., w. 1855–60.

Bird, Isaac Philadelphia, Pa., w. ca. 1810–13 and poss. later.

Bird, William Hopewell Village, Pa., w. 1812.

Birdsey, Joseph, Jr. 1769–1805; m. ca. 1790; d. Geneseo, N.Y. Ridgefield, Conn., appr. and jnyman., 1787–90; Huntington, Conn., w. 1790s; Hopewell, N.Y., w. 1800. Appr. to Elisha Hawley, 1787.

Birge, Edward W. Troy, N.Y., w. 1837–52. See also Edward W. Birge and Brother (Francis A.); Edward W. Birge and Calvin Stebbins.

Birge (Edward W.) and Brother (Francis A.) Troy, N.Y., w. 1846–52.

Birge, Edward W., and Stebbins, Calvin Troy, N.Y., w. 1837–38.

Birge, Francis A. (and Co.) Greenfield, Mass., w. 1835–45; Troy, N.Y., w. 1846–53. *See also* Edward W. Birge and Brother (Francis A.).

Bishop, G(eorge?) Prob. Cumberland Co., Me., w. 1800s. Windsor craftsmanship unconfirmed.

Bislep (Heslip?), Thomas Pittsburgh, Pa., w. bef. 1819; Natchez, Miss., w. 1819.

Bispham, J. M. Delaware Valley, w. ca. 1800s. Windsor craftsmanship unconfirmed.

Bissell, (?), and Rodgers, (?) Wolcottville (Torrington), Conn., w. 1829–30.

Bixby, Daniel 1791–1870. Francestown, N.H., w. 1817–53.

Black, Robert Prob. d. 1793–94. Philadelphia, Pa., w. 1760–93.

Blackburn, Robert B. ca. 1780. New York, N.Y., w. 1816–17; Washington, D.C., w. 1821. Mstr. to Alexander Collins and James M. Osburn, 1821.

Blackford, Thomas Philadelphia, Pa., w. bef. 1784; Boston, Mass., w. 1784–86.

Blackman, John Stoughton, Mass., w. 1796–1800.

Blackwood, Robert D. 1807. St. John, New Brunswick, Canada, w. 1796–97. *See also* Blackwood and Chapple.

Blackwood, Robert, and Chapple, William St. John, New Brunswick, Canada, w. 1796–97.

Blake, Samuel, Jr. Boston, Mass., w. 1789.

Blake, William M. 1792. Boston, Mass., w. 1789–1806.

Blakiston (Blackiston, Blackstone), Benjamin B. ca. 1789. Baltimore, Md., w. 1817–18. Appr. to Jacob Daley, 1806; mstr. to James A. Bostick, 1818; Joel B. Sparks, 1818.

Blasdell, N. Alexandria, Va., w. 1820.

Blauvelt, Richard D. New York, N.Y., w. 1824–52.

Bliss, Seth M. 1824. New Haven, Conn., w. 1816–22. *See also* Stillman and Bliss.

Bloom, J. Spurious brand.

Bloom, Matthias New York, N.Y., w. 1787–93.

Bly, J. T. New England, w. 1800s–1810s.

Boardman, Langley 1774–1833, m. 1799. Portsmouth, N.H., w. 1798–1833. Poss. dealer only.

Boden, J. B. Paris, Tenn., w. 1837–40. *See also* Hosea L. Jackson, R. J. Elliott, and J. B. Boden.

Boden, Omar Ca. 1766–1844, m. 1792. Burlington, N.J., w. bef. 1799; Cooperstown, N.Y., w. ca. 1799–ca. 1826.

Bodey, Rudolph W. Philadelphia, Pa., w. 1811–33.

Boggs, Walter Philadelphia, Pa., w. 1793–1802.

Bollinger, George 1819–83. Millheim, Centre Co., Pa., w. ca. 1840–80.

Bolton, Horatio N. Gardner, Mass., w. ca. early 1830s.

Bomer, J(ohn?) S. SE New England, ca. 1790s. Poss. owner.

Bonnell, Hezekiah W. D. 1843. New York, N.Y., w. 1824–43. *See also* Richard Tweed, Sr., and Hezekiah W. Bonnell.

Boone, John H. D. B. 1802. Baltimore, Md., w. 1829–31. Appr. to Jacob Daley, 1816.

Booth, Silas C., and Porter, Edwin, and Porter, James New Bern, N.C., w. 1835–36.

Booze, (?), and Wertenberger, (?) Canton, Oh., w. 1845. Booze called sign and orn. ptr. earlier.

Bosserman, (?) Cent. Pennsylvania, w. late 1830s–1850s.

Bostick, James B. 1805. Baltimore, Md. Appr. to Benjamin Blakiston, 1818.

Boswell, Benjamin Washington, D.C. Appr. to Thomas Adams, 1822.

Boswell, George Washington, D.C. Appr. to Thomas Adams, 1808.

Boteler, Charles W., and Donn, John M. Washington, D.C., w. 1833–40, 1846.

Boulware, Andrew D. 1875. Williamsburg, Clermont Co., Oh., w. 1820–75. *See also* Boulware and Boulware.

Boulware, Jacob, and Boulware, Andrew Jacob, d. 1842. Williamsburg, Clermont Co., Oh., w. 1820–42.

Bound, William Philadelphia, Pa., w. 1785.

Bourdett, Stephen New York, N.Y. Windsor craftsmanship unconfirmed.

Bowditch, Jonas Blair (and Son) 1804–66, m. 1826. New Haven, Conn., w. 1834–60.

Bowen, Thomas Philadelphia, Pa., w. 1791–1807. Prob. son of William Bowen.

Bowen, Warren B. 1795. Brookfield, Mass., w. 1817–20; prob. Douglas, Mass., w. 1830; Spencer, Mass., w. 1840–50.

Bowen, William Ca. 1750–1831, poss. m. 1773. Philadelphia, Pa., w. ca. 1781–ca. 1811. Prob. fr. of Thomas Bowen.

Bowles (Bolles), Edmond Ca. 1789–1846. Chatham (E. Hampton), Conn., w. 1817–ca. 1836.

Bowman (Boughman, Baughman), Aaron D. 1813. Philadelphia, Pa., w. 1809–13.

Boyce, John A. (and Son) New York, N.Y., w. 1824–60.

Boyd, George W. (and Son) M. ca. 1822–29, d. 1863. Harrisburg, Pa., w. ca. 1822–47.

Boynton, Thomas 1786–1849, m. 1817. Boston, Mass., w. 1810–11; Hartland, Vt., w. 1812–14; Windsor, Vt., w. 1814–47. *See also* Boynton and White.

Boynton, Thomas, and White, Ammi Windsor, Vt., w. 1817.

Brackett, Martin D. ca. 1840. Buckland, Mass., w. 1814–36.

Bradley, Elijah Cleveland, Oh., w. 1837.

Bradshaw, George Hagerstown, Md., w. 1815. Fr. of John Bradshaw.

Bradshaw, John Hagerstown, Md., w. 1812–1820. Mstr. to Daniel Steel, 1817–18. Son of George Bradshaw. *See also* John Bradshaw and John H. Rutter.

Bradshaw, John, and Rutter, John H. Hagerstown, Md., w. 1820.

Braithwaite, James Norfolk, Va. Appr. to John Widgen, 1815.

Branan, Jesse Washington, D.C. Appr. to Thomas Adams, 1813.

Branson, Benjamin W. D. 1835. New York, N.Y., w. 1829–35.

Brashears, Jeremiah T. Georgetown, D.C. Appr. to John White, 1825; appr. to John Dickson, 1827.

Brashears, Thomas C. Washington, D.C., appr. 1822; Baltimore, Md., w. 1837. Appr. to John White, 1822.

Bratton, David Xenia, Oh., w. 1839–44.

Breck, J. Prob. E Massachusetts or S New Hampshire, 1800s. Poss. owner.

Brewer, L. Cherry Valley, Otsego Co., N.Y., w. ca. 1840s.

Brewster, William Rochester, N.Y., w. 1827–51. *See also* Brewster and Fenn.

Brewster, William, and Fenn, Harvey Rochester, N.Y., w. 1841–51.

Briard, Oliver Portsmouth, N.H., ca. 1800. Merchant.

Brick, Elijah B. 1794. Gardner, Mass., w. 1814–50. Appr. and jnyman. to James M. Comee I, 1806–ca. 1814. Br. of Enoch Brick and Jonas Brick.

Brick, Enoch B. 1790. Gardner, Mass., w. ca. 1814–50. Appr. to James M. Comee I, bef. 1814. Br. of Elijah Brick and Jonas Brick.

Brick, Jonas Gardner, Mass., w. 1818. Appr. to James M. Comee I, bef. 1818. Br. of Elijah Brick and Enoch Brick.

Bridges, James S. B. ca. 1795, England. Knoxville, Tenn., w. 1819–24; poss. McMinn Co., Tenn., w. 1830–50.

Bridges, John (and Son) Georgetown, D.C., w. 1811–15. Mstr. to Alexander Carrico, 1811; Ananias Collins, 1811; Benedict Jackson (Johnson?), 1815; John Tenley Robey, 1815; James Spurling, 1812.

Brientnall, David New York, N.Y., w. 1805–1811. Poss. son of Joseph Brientnall. *See also* David Brientnall and Sands G. Reynolds.

Brientnall, David, and Reynolds, Sands G. New York, N.Y., w. ca. 1810.

Brientnall, John D. 1747. Philadelphia, Pa., w. bef. 1747. Windsor craftsmanship doubtful.

Brientnall, Joseph D. 1785. Philadelphia, Pa., w. 1783–ca. 1785. Poss. fr. of David Brientnall.

Briggs, Eliphalet, Jr. 1788–1853, m. 1810. Keene, N.H., w. 1812–49. Fr. of Warren S. Briggs. *See also*

Eliphalet Briggs, Jr., and John W. Briggs; Eliphalet Briggs, Jr., and Warren S. Briggs.

Briggs, Eliphalet, Jr., and Briggs, John W. Keene, N.H., w. 1824–35.

Briggs, Eliphalet, Jr., and Briggs, Warren S. Keene, N.H., w. 1839–49.

Briggs, John W. Keene, N.H., w. 1824–35. *See also* Eliphalet Briggs, Jr., and John. W. Briggs.

Briggs, Warren S. 1802–48. Keene, N.H., w. 1831–49 and prob. earlier and later. Son of Eliphalet Briggs, Jr. *See also* Eliphalet Briggs, Jr., and Warren S. Briggs.

Brigham, Asa B. 1785. Leominster, Mass., w. 1820–1830s.

Bright, Jonathan 1765–1817. Hartford, Conn., w. 1798–99; Salem, Mass., w. 1800 and later. Upholsterer-retailer.

Brittain, John B. 1785. Halifax, Nova Scotia, Canada, poss. w. bef. 1800.

Brittan, A. N. Athol, Mass., w. 1839; Black River, Jefferson Co., N.Y., w. 1839–42.

Britton, Henry Baltimore, Md. Appr. to Godfrey Cole, 1801–2.

Britton, Lewis Rochester, N.Y., w. 1821–27.

Britton, Sewell W. Area Sterling, Mass., w. 1830.

Brockway, Lebius M. 1813. Poss. New London, Conn., w. 1820; Middletown, Conn., w. 1823–24, poss. 1830.

Bromely, Robert Sussex Co., Del. Appr. to Rice Paynter, 1828.

Bronson, Zenos Raleigh, N.C., w. 1815; Lexington, Ga., w. 1820.

Brooks, F. Prob. Worcester Co., Mass., w. ca. 1820s–1830s.

Brooks, Gardiner Bangor, Me., w. 1828–29.

Brooks, John Philadelphia, Pa. Appr. to Abraham McDonough, 1831.

Brooks, John L. Portland, Me., w. 1820–31. *See also* John B. Hudson and John L. Brooks.

Brooks, Zophar Willard 1812–1906. Hancock, N.H., n.d. Ptr. and decorator.

Broomhall, Albert G. Goshen Twp., Clermont Co., Oh., w. 1809.

Brower, Samuel H. New York, N.Y., w. 1810–13, 1819–41.

Brown, A., and Brown, E. Schenectady, N.Y., w. ca. 1833–41; Rochester, N.Y., w. 1841.

Brown, A. G. Prob. New England, 1820s–1840s. Poss. owner.

Brown, Albert H. Boston, Mass., w. 1827–37. *See also* George Whitney and Albert H. Brown; Whitney, Brown and Co.

Brown, Alexander Petersburg, Va., w. ca. 1816–ca. 1819. Was in Huntsville, Ala., by 1820. Prob. related to Archer Brown and Joel Brown. *See also* Graves Matthews and Alexander Brown.

Brown, Archer 1775–1854. Petersburg, Va., w. ca. 1803–1807; Dinwiddie Co., Va., w. 1812;

Lynchburg, Va., w. 1816–18 and poss. later. Prob. related to Alexander Brown and Joel Brown.

Brown, Artemus (Artemas) Gardner, Mass. Appr. of James M. Comee I, aft. 1805.

Brown, Daniel B. Newark, N.J., w. 1834–47. *See also* Daniel B. Brown and Co.; Daniel B. Brown and Peter G. McDermit.

Brown, Daniel B. (and Co., with Samuel B. Brown, Jr.) Newark, N.J., w. 1834–38.

Brown, Daniel B., and McDermit, Peter G. Newark, N.J., w. 1842–47.

Brown, Edmund M. 1803–1883. Portsmouth, N.H., w. 1825–64. *See also* Edward M. Brown and Alfred T. Joy; Dockum and Brown.

Brown, Edmund M., and Joy, Alfred T. Portsmouth, N.H., w. 1837–43.

Brown, Gilson (also Gibson) D. 1834. Sterling, Mass., w. 1820–34.

Brown, Henry S. Bangor, Me., w. ca. 1840s–1850s.

Brown, Ira 1778–1820, m. 1807, 1810. Litchfield, Conn., w. 1802–20.

Brown, James, Jr. Richmond, Va., w. 1815. Poss. dealer.

Brown, Joel Petersburg, Va., w. 1796–1816; Raleigh, N.C., w. 1816–22. Mstr. to Humphrey Ashburn, 1819; Wayne Evans, 1805; Ransom P. Parker, 1817. Also made riding vehicles in early career; prob. related to Alexander Brown and Archer Brown.

Brown, John Augusta, Me., w. 1833.

Brown, John West Chester, Pa., w. 1829.

Brown, John G. S New Hampshire, poss. Portsmouth, w. 1820s.

Brown, J(oseph?) Prob. Boston, Mass., w. 1798–1803.

Brown, Josiah C. Princeton, Mass., w. 1835–50.

Brown, Nathan M. 1820, 1824, d. 1852. Griswold (Jewett City), Conn., w. 1823–34; New York, N.Y., aft. 1834.

Brown, Nathan Lexington, N.C., w. 1825; Charlotte, N.C., w. 1831.

Brown, Nathaniel Poss. 1769–1851. Litchfield, Conn., w. 1797–ca. 1818.

Brown, Nathaniel D. 1803. Savannah, Ga., w. ca. 1777–1803.

Brown, O. H. New England, 1820s. Poss. owner.

Brown, Richard Philadelphia, Pa. Appr. to Thomas Mason, 1773.

Brown, Robert W. Wilmington, Del., w. 1809.

Brown, Samuel B., Jr. Newark, N.J., w. 1804–40. *See also* Daniel B. Brown and Co.

Brown, Thomas D. ca. 1866. Lamprey River (Newmarket), N.H., w. 1829–66.

Brown, Thomas H. Sterling, Mass., w. 1830–31 and prob. later.

Brown, William Providence, R.I., w. ca. 1800–1810.

Brown, William Marysville, Union Co., Oh., w. 1818–19.

Brown, William, Jr. 1785–1819, m. 1813. New York, N.Y., w. 1812–19. Appr. to Duncan Phyfe, 1802.

Brown, (?) Charlestown, W. Va., w. 1810.

Bruce, George New York, N.Y., w. 1818–28. *See also* Bruce and Dean.

Bruce, George, and Dean, Henry New York, N.Y., w. 1818–19.

Brunner, Samuel Washington, D.C. Appr. to Thomas Adams, 1819.

Bryant, Ebenezer 1794–1867. Litchfield, Conn., w. 1815–17.

Buel, William Wilbraham, Mass., w. 1801.

Buell, Colonel E. Brockville, Ont., Canada, w. ca. 1840s.

Buell, Hiel, II 1764–1851, m. 1790. Killingworth–Clinton, Conn., ca. 1790s. Poss. owner.

Bulkley, Edward Ca. 1801–80, m. 1828. New Haven, Conn., w. 1830–60.

Bull, Charles B. ca. 1788. Baltimore, Md. Appr. to Absalom Chrisfield, 1805.

Bull, Russell Ca. 1772–1835, m. 1795. Litchfield, Conn., w. 1813–14.

Buller, William West Chester, Pa., w. 1834–35.

Bullock, Ezekiel M. 1819. Carlisle, Pa., w. 1819–44. Son of Moses Bullock.

Bullock, Moses Carlisle, Pa., w. ca. 1797–ca. 1832. Fr. of Ezekiel Bullock. *See also* Moses Bullock and William Bullock.

Bullock, Moses, and Bullock, William Carlisle, Pa., w. ca. 1813–ca. 1823.

Bullock, William Carlisle, Pa., w. ca. 1813–ca. 1823; Shippensburg, Pa., w. 1837; Lafayette, Ind., w. 1839. *See also* Moses Bullock and William Bullock.

Burchall, Robert, and Wickersham, William West Chester, Pa., w. 1822–24.

Burden, Alexander Philadelphia, Pa., w. 1822–31.

Burden, Henry R. (and Co.) Philadelphia, Pa., w. 1804–15; Washington, D.C., w. 1815–19. Prob. son of Joseph Burden. *See also* Henry R. Burden and Joseph Cassin.

Burden, Henry R., and Cassin, Joseph Washington, D.C., w. 1815–18.

Burden, Joseph Philadelphia, Pa., w. 1791–1837. Mstr. to Rudolph Bale, 1806; Joseph Kerm, bef. 1813. Prob. fr. of Henry R. Burden. *See also* Joseph Henzey, Sr., and Joseph Burden; Trumble and Burden.

Burkhard, Melchoir W. Philadelphia, Pa., w. 1839–55. *See also* Burkhard and Smith.

Burkhard, Melchoir W., and Smith, (?) Philadelphia, Pa., w. 1839–42.

Burnett, Gilbert D. 1855–56. Baltimore, Md., w. 1807–10; Harrisburg, Pa., w. 1812–ca. 1843.

Burnham, Daniel Litchfield, Conn., w. 1811.

Burns, Thomas Tradore Lexington, Ky., w. 1814–16; Georgetown, Ky., w. 1824.

Burpee, Abel 1795–1842. Sterling, Mass., w. 1820–28.

Burpee, Andrew 1803–27. Sterling, Mass., w. 1824.

Burpee, Dwight B. 1823. Sterling, Mass., w. 1850. Prob. a jnyman.

Burpee, Edward 1814–97. Sterling, Mass., w. 1835–ca. 1870s. *See also* Edward Burpee and Thomas Lewis II.

Burpee, Edward, and Lewis, Thomas, II Sterling, Mass., w. 1835 and poss. until 1838.

Burpee, Ephraim Sterling, Mass., w. 1810; Weathersfield, Vt., w. 1820; Springfield, Vt., w. 1820s; Moreau, Saratoga Co., N.Y., w. 1830.

Burpee, Joel Sterling, Mass., w. 1830–50. Poss. turner only.

Burpee, Nathan, Jr. Sterling, Mass., w. ca. 1810–33.

Burpee, N. W. D. 1832. Montreal, Canada, w. 1825–32.

Burr, Joseph Poss. m. 1798, poss. d. 1845. Prob. New Jersey, area Mt. Holly–Haddonfield–Burlington, w. ca. 1793, 1797, poss. ca. 1813–17; Philadelphia, Pa., w. 1803–ca. 1813, 1818–33; Newark, N.J., w. 1837–46. *See also* Burr and Moon.

Burr, Joseph, and Moon, David Philadelphia, Pa., w. 1803.

Burrows, George Cincinnati, Oh., w. 1853–60. *See also* Henry N. Bird and George Burrows.

Burt, Horace, and Harrison, W. H. Troy, Oh., w. 1848.

Bush, Charles W(ebster?) (and Co.) 1807–1872, m. 1833. Gardner, Mass., w. ca. 1833–49 and earlier and later. *See also* Edgell, Bush and Co.

Bush, Jotham (and Co.) B. 1800. Boston, Mass., w. 1821–35. Poss. also w. in Boyleston, Mass.

Bushnell, Francis Wells Ca. 1796–1859, m. 1822. Norwich, Conn., w. 1821–27 and later.

Bushnell, G. E. Cadiz, Oh., w. 1840–41.

Buss, Mason B. 1797. Sterling, Mass., w. 1820.

Buss, Silas 1799–1827. Prob. Worcester Co., Mass., poss. Sterling, w. ca. 1820s.

Bussey, John D. 1857–58. Albany, N.Y., w. 1819–57. *See also* Caleb(?) Davis and John Bussey.

Butler, William Litchfield, Conn., w. 1807–9.

Butler, William Fayetteville, N.C. Appr. to Neal Graham, 1817.

Butler, (?), and Easton, Silas, Jr. E. Hartford, Conn., w. 1795.

Button, George D. 1849. Preston and Groton, Conn., w. 1820–ca. 1840.

Buttre, William 1782–1864. New York, N.Y., w. 1805–14, 1819; Albany, N.Y., w. 1815–18; Auburn, N.Y., w. 1821–24.

Byard, Charles B. 1844. Manalapan and Allentown, N.J., w. late 1860s. Son of Zebulon Clayton Byard.

Byard, Zebulon Clayton B. 1810, prob. m. 1843. Allentown, N.J., w. 1848. Fr. of Charles Byard.

C., I. C. Prob. E Massachusetts or S New Hampshire, late 1820s–1830s. Prob. owner.

C., S. Massachusetts or N New England, 1810s. Poss. owner.

Cabot, S. Prob. New England, ca. 1780s–1790s. Poss. owner.

Cadwell (Caldwell), Edwin Nelson, Portage Co., Oh., w. 1837–41.

Cahoone, Jonathan M. 1760. Newport, R.I., w. ca. 1760–ca. 1786.

Cain, T. Prob. Delaware Valley or Charleston, S.C., w. 1790s–1810s.

Caldwell, J. M. Urbana, Oh., w. 1839.

Caldwell (Coldwell, Colwell), John Prob. Groton, Conn., w. 1786; New York, N.Y., w. 1789–ca. 1807.

Call, D. W. E Connecticut or Rhode Island, late 1780s–1790s. Owner, contemporary or later.

Campbell, John Norfolk, Va., w. 1806.

Campbell, (John?), and Johnson, (?) Norfolk, Va., w. 1804.

Campbell, William B. ca. 1807. Tiffin, Oh., w. 1839–50.

Cannon, Fergus Cincinnati, Oh., w. 1819.

Cannon, Thomas Pittsburgh, Pa., w. 1815–26.

Canon (Cannon), James Downington, Pa., w. 1832–38.

Capen, William, Jr. 1802–63. Portland, Me., w. 1823–60. Princ. orn. ptr.

Carnahan, Andrew Wilmington, Del. Appr. to Jared Chesnut, 1829.

Carnighan (Carningham), James Baltimore, Md., w. 1827. Ptr. and glazier earlier and later.

Carolus, John Circleville, Oh., w. 1824–27. *See also* Wildbahn and Carolus.

Carpenter, Kingsley Providence, R.I., w. 1793–97 and earlier and later.

Carpenter, Lemuel Broadkill Hundred, Sussex Co., Del., or Frederica, Kent Co., Del., w. 1831. Mstr. to John Hobbs and Russel Hobbs.

Carpenter, William Philadelphia, Pa., w. 1793–97.

Carr, Alexander, (Jr.?) Delaware Valley, poss. including Trenton, N.J., Wilmington, Del., and Chester Co., Pa., w. ca. 1780s–1790s.

Carr, Daniel Boston, Mass., w. 1840.

Carr, Moody 1766–1851. Fremont, N.H., w. 1800–1815.

Carrico, Alexander Georgetown, D.C. Appr. to John Bridges, 1811.

Carsillas, William Philadelphia, Pa., w. 1804–8. Prob. jnyman. to Joseph Burden, 1804, and John Hayes, 1806–8.

Carter, Horatio B. 1796. Lancaster, Mass., w. 1824.

Carter, Isaac Uniontown, Pa., w. 1815.

Carter, James Lexington, Ky. Appr. to Robert Holmes, 1803.

Carter, Jesse Baltimore, Md. Appr. to Jacob Daley, 1811.

Carter, Minot 1812–73. New Ipswich, N.H., w. 1837–41. Prob. later a ptr. Br.-in-law of Josiah Prescott Wilder.

Carter, Robert D. 1802. New York, N.Y., w. 1787–1800.

Carteret, Daniel, Jr. D. 1830. Philadelphia, Pa., w. 1786–1829.

Cary, Hugh Paris, Ky., w. 1811.

Cary, J. Nantucket, Mass., or off-island, 1790s. Prob. owner; poss. James Cary (1777–1812), sea captain and merchant.

Case, A(llen?) G. Providence, R.I., 1790s. Owner.

Case, C. R. Painesville, Oh., w. 1844–45. *See also* Donaldson, Case, and Lines.

Case, Lewis Philadelphia, Pa., w. 1810–13. Appr. to Moon and Prall, 1804.

Cassin, Joseph Washington, D.C., w. 1815–18. *See also* Henry R. Burden and Joseph Cassin.

Caswell, Thomas Jefferson 1806–94. Milltown and St. Stephen, New Brunswick, Canada, w. ca. 1830–65.

Cate, H. E New England from Rhode Island to Portsmouth, N.H., 1790s–1800s. Prob. owner; prob. Henry Cate, blacksmith, Portsmouth, N.H.

Caulton, Richard Williamsburg, Va., w. 1745. Princ. upholsterer.

Challen, William New York, N.Y., w. 1796–1809; Lexington, Ky., w. 1809–33. Mstr.(?) to Anthony Gaunt, 1813. From London. *See also* Challen and Gaunt.

Challen, William, and Gaunt, Anthony Lexington, Ky., w. 1818.

Chamberlain, Abel C. Ca. 1811–85, m. 1835. New Haven, Conn., w. 1840–ca. 1885.

Chambers, Alexander Delaware Valley, New Jersey, and E Pennsylvania, w. ca. 1750–1800. Windsor craftsmanship unconfirmed.

Chambers, David Philadelphia, Pa., w. 1748.

Chambers, John New Jersey, w. ca. 1790s. Windsor craftsmanship unconfirmed.

Champlin, H. P. Rhode Island, 1790s. Later owner.

Chandler, Elisha B. ca. 1782. Baltimore, Md. Appr. to Caleb Hannah, 1799. Br. of Thomas Chandler.

Chandler, Thomas Baltimore, Md., w. 1817–22. Appr. to Caleb Hannah, 1797. Br. of Elisha Chandler.

Chapin, Justin 1781–1826. Holyoke, Mass., w. 1801–26.

Chapman, James S. Redding, Conn., w. 1809–10. *See also* James S. Chapman and John B. Merrit.

Chapman, James S., and Merrit, John B. Redding, Conn., w. 1809.

Chapman, John Philadelphia, Pa., w. 1793–1811 and poss. later.

Chappel, Henry Poss. area Lima–Avon, Livingston Co., N.Y., w. 1840s–1850s.

Chappel, William M. 1793. Danbury, Conn., w. 1790–1828; Norfolk, Va., poss. w. ca. 1828 and later. Mstr. to David Finch, 1815. *See also* William Chappel and Ebenezer Booth White.

Chappel, William, and White, Ebenezer Booth Danbury, Conn., w. 1790–92.

Chapple, William St. John, New Brunswick, Canada, w. 1796–97. *See also* Blackwood and Chapple.

Chase, Charles 1731–1815, m. 1755. Nantucket, Mass., w. ca. 1776–1811.

Chase, James 1737–1812. Gilmanton–Gilford, N.H., w. 1797–1812.

Cheney, Silas E. 1776–1821. Litchfield, Conn., w. 1799–1821.

Cheney, William L. Norwich, Conn., w. 1828–29.

Cheshire, (?), and Cox, (?) Edenton, N.C., w. 1818. Dealers.

Chesney (McChesney), James D. 1862. Albany, N.Y., w. 1796–1830.

Chesnut, Jared Christiana, Del., w. 1800; Wilmington, Del., w. 1804–32; Philadelphia, Pa., w. 1837. Mstr. to Harlan Baldwin, 1829; John Barber, 1829; Andrew Carnahan, 1829; William D. Chesnut, 1829(?); Abel Dougherty, 1832; William Gray, 1829; Peter Stidham, 1831. Fr. of William D. Chesnut. *See also* Jared Chesnut and Samuel Harker; James Ross and Jared Chesnut.

Chesnut, Jared, and Harker, Samuel Wilmington, Del., w. 1814.

Chesnut, William D. Wilmington, Del., appr. 1829(?), w. 1845–57; Baltimore, Md., w. 1829–31. Son of Jared Chesnut and appr. (1829?).

Child, T. E Massachusetts or S New Hampshire, ca. 1810s. Poss. owner.

Childres, Joseph D. 1805. Richmond, Va., w. 1796–99; Chesterfield Co., Va., w. 1802–3; Edenton, N.C., w. 1803–5. Mstr. to John Love, 1803; Joseph Middleton, 1804.

Childs, Jonas Packersville (Nelson), N.H., w. 1805; Gardner, Mass., w. 1827.

Chilton, Samuel Norfolk, Va. Appr. to Michael Murphy, 1802.

Chinn, Robert Kilmarnick, Bourbon Co., Ky., w. 1821–24; Mason Co., Ky., w. 1824. *See also* Chinn and Berryman.

Chinn, Robert, and Berryman, John W. Kilmarnick, Bourbon Co., Ky., w. 1821–24.

Chrisfield, Absalom Ca. 1789–1817. Baltimore, Md., w. 1805–8. Appr. to Jacob Williams, 1800; mstr. to Charles Bull, 1805; Fletcher Gater, 1806; John Gater, 1805; Thomas Sterling, 1805.

Church, M. Randolph, Vt., w. ca. 1810–1820s.

Church, Samuel Toronto, Canada, w. 1835–37; Lockport, N.Y., w. 1842. *See also* Samuel Church and Charles March.

Church, Samuel, and March, Charles Toronto, Canada, w. ca. 1836.

Claridge, Cyrus B. 1807. Baltimore, Md. Appr. to William Keener, 1820.

Clark, A. Raleigh, N.C., w. 1819. Dealer.

Clark, David B. ca. 1821. Peterborough, N.H., w. ca. 1850–80.

Clark, George P. B. 1806. Ashburnham, Mass., w. 1829–1840s; Princeton, Mass., w. 1850.

Clark, James 1782–1858. New Braintree, Mass., w. bef. 1822; West Brookfield, Mass., w. 1824–38; New York City, w. ca. 1838 and later.

Clark, J. Connecticut–Rhode Island border region, ca. 1800. Poss. owner.

Clark, J(ames?) C(harles?) Poss. d. 1841. Newburgh, N.Y., w. 1824.

Clark, John Litchfield, Conn., w. 1814–21.

Clark, Moses P. Cincinnati, Oh., w. 1818–34. *See also* Moses P. Clark and Nathan Crowell.

Clark, Moses P., and Crowell, Nathan Cincinnati, Oh., w. 1822.

Clark, Oliver B. 1774. Litchfield, Conn., w. 1797–99. *See also* Oliver Clark and Ebenezer Plumb, Jr.

Clark, Oliver, and Plumb, Ebenezer, Jr. Litchfield, Conn., w. 1797–98.

Clark, Richard B. 1786. Baltimore, Md. Appr. to Richard Sweeney, 1797.

Clark (Clarke), Samuel B. 1785. Baltimore, Md., w. 1807–10 and prob. later. Appr. to Richard Sweeney, 1802–6; mstr. to George Cole, 1810; William Mitchell, 1810.

Clark, Samuel S. New York, N.Y., w. 1834–39.

Clark, William Baltimore, Md. Appr. to Richard Sweeney, 1797.

Clarke, Jesse Baltimore, Md., w. 1799–1801.

Clarkson, John Philadelphia, Pa. Appr. to Lawrence Allwine, 1792.

Claus, C(hristian?) E. Prob. LeRay Twp., Jefferson Co., N.Y., w. ca. 1840s–1850s.

Clay, Daniel 1770–1848, m. 1795. Greenfield, Mass., w. 1794–1832. *See also* Clay and Field.

Clay, Daniel, and Field, Richard E. Greenfield, Mass., w. 1826–28.

Cleaveland, Cyrus D. 1837. Providence, R.I., w. 1801–36. *See also* Cleaveland and Metcalf.

Cleaveland, Cyrus, and Metcalf, Luther Providence, R.I., and Medway, Mass., w. 1801.

Clements, Aloysius (Lotius) Washington, D.C., w. 1823–33. Appr. to Thomas Adams, 1816. *See also* Aloysius Clements and Ignatius Noble Clements.

Clements, Aloysius, and Clements, Ignatius Noble Washington, D.C., w. 1823–26.

Clements, Ignatius Noble Washington, D.C., w. 1823–26. Appr. to Thomas Adams, 1819. *See also* Aloysius Clements and Ignatius Noble Clements.

Cleveland, Aaron P(orter?) Ridgefield, Conn., w. 1788–89.

Cluss, Charles New York, N.Y., w. 1807–19; Newbridge (near Hackensack), N.J., w. 1828.

Coates, Albin Washington, D.C., w. 1818. Mstr. to James O'Lary, 1818; John Robertson, 1818.

Cobb, Levi New Albany, Ind., w. 1826–27.

Cobbs, Thomas Raleigh, N.C., w. 1815–21.

Cochran, John D. Chillicothe, Oh., w. 1815–ca. 1818; Natchez, Miss., w. 1819 (prob. dealer). *See also* Phillips and Cochran.

Cock, Henry D. Madison Co., Ky., w. ca. 1810–20.

Cocks, William D. 1799. Philadelphia, Pa., w. 1798–99; Charleston, S.C., w. 1798.

Coddington, George W. Cincinnati, Oh., w. 1843–55.

Coeser, A. Prob. New England, 1790s. Poss. owner.

Coffin, C. New York, N.Y., 1810s. Prob. owner.

Coffin, Job Bunker 1783–1854, m. 1805. Hudson, N.Y. Later owner.

Coggeshall, W. A., and Coggeshall, D. M. Newport, R.I., w. 1835–45.

Cohen, Mendes I. B. 1796. Baltimore, Md. Appr. to John and Hugh Finlay, 1811.

Coladay, John Cent. Pennsylvania or Maryland, w. ca. 1790s–1800s.

Colby, M. H. Painesville, Oh., w. 1853–54. *See also* Donaldson and Colby.

Cole, George 1808–59. Halifax and Centre Rawdon, Nova Scotia, Canada, w. 1832–59. Son of James Cole.

Cole, George, I Baltimore, Md., w. 1804–18. Br. of Godfrey Cole, Jacob Cole, and John Cole; uncle of George Cole II.

Cole, George, II Baltimore, Md. Appr. to Samuel Clark, 1810. Son of Godfrey Cole; nephew of George Cole I and Jacob Cole.

Cole, Godfrey (Godfred) Ca. 1756–1803. Baltimore, Md., w. 1790–1803. Mstr. to Henry Britton, 1801–2; George Riley, 1801; John Ross, ca. 1789; Michael Sebastian, 1801. Fr. of George Cole II; br. of George Cole I, Jacob Cole, and John Cole. *See also* Cole and Brothers.

Cole, Jacob D. 1801. Baltimore, Md., w. 1796–1801. Mstr. to John Bibby, 1796; James Hughes, 1794–96 (rebound to Richard Sweeney); William Ogle, 1794. Br. of George Cole I, Godfrey Cole, and John Cole; uncle of George Cole II. *See also* Cole and Brothers.

Cole, James Halifax, Nova Scotia, Canada, w. 1816; Centre Rawdon, Nova Scotia, Canada, w. 1817–27. Fr. of George Cole.

Cole, Jarret B. 1799. Baltimore, Md. Appr. to Jacob Daley, 1816.

Cole, John Baltimore, Md., w. 1796–99. Br. of George Cole I, Godfrey Cole, and Jacob Cole; uncle of George Cole II. *See also* Cole and Brothers.

Cole, John Halifax and Centre Rawdon, Nova Scotia, Canada, w. ca. 1816. Windsor craftsmanship unconfirmed.

Cole, Lloyd, and Co. Buckfield, Me., w. 1841–47.

Cole, Mathias B. ca. 1784. Baltimore, Md. Appr. to Reuben League, 1800.

Cole, Solomon 1772–1870, m. 1797, 1809. Glastonbury, Conn., w. 1794–ca. 1830.

Cole and Brothers (Godfrey, Jacob, and John) Baltimore, Md., w. 1796–99.

Coles, William 1804–62. New York, N.Y., w. bef. 1832/33; Springfield, Oh., w. 1832/33–56. Son J. W. Coles joined firm in 1852; son H. Coles joined firm in 1854. *See also* Spencer and Coles.

Colgrew (Colegrow), William Area Providence, R.I. (poss. Scituate, Mass.), w. 1799–1807. Poss. supplier of parts only.

Collins, Alexander Washington, D.C. Appr. to Robert Blackburn, 1821.

Collins, Ananias Georgetown, D.C. Appr. to John Bridges, 1811.

Collins, Henry E., and Hatch, Alonzo Simcoe, Ont., Canada, w. 1841–42.

Collins, Thomas Washington, Pa., w. 1814; Pittsburgh, Pa., w. 1816. *See also* Collins and Co.; McGrew and Collins.

Collins and Co. (Thomas Collins and Isaiah Steen) Washington, Pa., w. 1814.

Colon (Collin), David New York, N.Y., w. 1789–1806.

Colston, William Windsor, Vt., w. 1828–33.

Colt, Robert New London Twp., Chester Co., Pa., w. 1827–28.

Colton, Horace 1784–1862, m. 1817. Norwich, Conn., w. 1811–40. *See also* Horace(?) Colton and (?) Huntington.

Colton, (Horace?), and Huntington, (?) Norwich, Conn., w. 1834.

Colton, R. Spurious brand.

Comee, James M., I 1777–1832. Gardner, Mass., w. ca. 1805–32. Mstr. to Elijah Brick; Enoch Brick; Jonas Brick; Artemas Brown; Luke Fairbank; Benjamin Howe; Joseph Jackson; Isaac Jaquith; Elijah Putnam; Enoch Putnam.

Comee, James M., II B. 1811. Poss. Fitchburg, Mass., w. ca. 1850 and later.

Commerford, John New York, N.Y., w. 1828, 1831–60; Brooklyn, N.Y., w. 1829–30.

Comstock, (?) New England, ca. 1800. Poss. owner.

Conant, Samuel 1784–1824. Sterling, Mass., w. 1820.

Condit, Linus Hanover Twp., Essex Co., N.J. (near Newark), w. 1801–7. Turner and sawmill owner.

Congdon, (?), and Tracy, (?) Norwich, Conn., w. 1830–31. Dealers.

Conklinton, David Dayton, Oh. Appr. to John Mitton, 1813.

Conover, Michael F. Philadelphia, Pa., w. 1832–40.

Conrad (Conrod), John Baltimore, Md., w. 1802–16. Mstr. to Robert Bell, 1802; Robert Gravey, 1806; Gale March, 1802.

Cook, Daniel J. Northampton, Mass., w. 1819. Son-in-law of David Judd. *See also* Judd and Cook.

Cook, Edward Poss. 1793/4–1875. Waterbury, Conn., or area, w. 1827–ca. 1840. Poss. intermediary/dealer.

Cook, J., and Cook, William Norfolk, Va., w. 1807–8; Richmond, Va., w. 1808–11.

Cook, James B. New York, N.Y., w. 1837–59. *See also* Cyrus Baldwin and James B. Cook.

Cook, Ransom 1794–1881, m. 1818. Saratoga, N.Y., w. 1813–45.

Cook, Thomas, Jr. B. 1808, m. 1828. Newburyport, Mass., w. bef. 1842; Sterling, Mass., w. 1842–48.

Cook, (?), and Barbee, (?) Portsmouth, Oh., w. 1829.

Cooper, (?) New York, N.Y., w. 1794. Windsor craftsmanship unconfirmed.

Cooper, Gilbert M. Poss. New York, N.Y., w. 1825–29 (wheelwright); Saddle River, Bergen Co., N.J., w. 1828–54. Proprietor of turning mill.

Cooper, John Salisbury, N.C., w. 1823–25. Appr. to Wayne Evans, 1815; mstr. to Jacob Ghents, 1825. *See also* Grimes and Cooper.

Cooper, Silas Savannah, Ga., w. 1801–11. Prob. orn. ptr.-dealer.

Cooper, Vincent Baltimore, Md., w. 1802–3. Appr. to Caleb Hannah, 1799.

Copernaver (Copnaver), John B. ca. 1776. Baltimore, Md. Appr. to John Oldham, 1790. Br. of Michael Copernaver.

Copernaver (Copnaver), Michael B. 1775. Baltimore, Md. Appr. to John Oldham, 1790. Br. of John Copernaver.

Corey, Walter 1809–89, m. 1846. Prob. Ashburnham, Mass., w. bef. 1835; Boston, Mass., w. 1835 (dealer); Portland, Me., w. 1836–66 (dealer later); Windham, Me. (mill site, purchased 1843); Gorham, Me. (outlet, 1849). Br.-in-law of Jonathan O. Bancroft.

Cornman (Comman), Frederick R. Carlisle, Pa., w. 1849–ca. 1879.

Cornwell (Cornell), Richard B. ca. 1793. New York, N.Y., w. 1816–29, 1839, 1844–46, 1849. *See also* Richard Cornwell and Cyrus Baldwin; Richard Cornwell and Job(?) Cowperthwaite; Richard Cornwell and Jacob Smith.

Cornwell, Richard, and Baldwin, Cyrus New York, N.Y., w. 1828.

Cornwell, Richard, and Cowperthwaite, (prob. Job) New York, N.Y., w. 1820–24.

Cornwell, Richard, and Smith, Jacob New York, N.Y., w. 1817–19, 1829.

Cornwell, William Charlotte, N.C., w. 1824–25. *See also* William Cornwell and George H. Nichols.

Cornwell, William, and Nichols, George H. Charlotte, N.C., w. 1824–25.

Corse, Henry Montreal, Canada, w. 1803–50.

Cotter, S. New England, poss. E Massachusetts, n.d. Windsor craftsmanship unconfirmed.

Cottle (Cotteral, Cottrell), John New York, N.Y., w. 1787–ca. 1792. Prob. also turner and wheelwright.

Cotton, Charles C. B. 1778, m. (2) 1832. Pomfret, Conn., w. 1810 and earlier and later; Brookfield, Orange Co., Vt., w. ca. 1820–30 and later. Cousin of Thomas Cotton Hayward.

Cotton, Giles S. B. ca. 1800. Middletown, Conn., w. 1820–23.

Cotts, Jacob, and Glass, Andrew Cincinnati, Oh., w. 1803.

Coutant (Coutong), David D. ca. 1829. New York, N.Y., w. 1786–94; New Rochelle, N.Y., w. 1789–ca. 1829.

Covel, T. Poss. New England, w. ca. 1810s–1820s. Windsor craftsmanship unconfirmed.

Covert, Isaac M. 1779, d. 1792 or 1802. Philadelphia, Pa., w. 1780–86. Appr. to Joseph Henzey, 1772–74.

Cowen, Jacob Philadelphia, Pa., w. 1819–22.

Cowperthwaite, Job B. ca. 1788 or 1797, poss. d. 1831. New York, N.Y., w. 1816–30. *See also* Richard Cornwell and Job(?) Cowperthwaite.

Cowperthwaite, John Knox New York, N.Y., w. 1807–33. Fr. of Samuel N. Cowperthwaite.

Cowperthwaite, Samuel N. New York, N.Y., w. 1825–58. Son of John Knox Cowperthwaite.

Cox, William D. 1811. Philadelphia, Pa., w. 1768–1811. Prob. appr. to John Shearman, 1765; mstr. to David Booz, 1772; William Spade, 1800; William Widdifield, 1768.

Coyl, J. W. Norwich, Conn., w. 1822.

Craft, Charles B. ca. 1762. New York, N.Y., w. 1793–1801, 1819–20. *See also* Charles Craft and Thomas Craft; Charles Craft and Charles(?) Timpton (Timpson?).

Craft, Charles, and Craft, Thomas New York, N.Y., w. 1794.

Craft, Charles, and Timpton (Timpson, Charles?) New York, N.Y., w. 1797.

Crafts (Croft), Christopher Painesville, Oh., w. 1820–ca. 1830.

Crafts (Croft), William Painesville, Oh., w. ca. 1840.

Crager (Crages), Elijah Georgetown, D.C., appr. 1808; Petersburg, Va., w. 1812–ca. 1814. Appr. to Thomas Adams, 1808.

Creager, James 1817–1900. Mechanickstown (later Thurmont), Md., w. ca. 1840 and later.

Creamer, Jacob Hiram Washington, D.C. Appr. to Thomas Adams, 1825.

Creed, James, and Hale, Henry Maumee, Oh., w. 1837–40.

Cresson, C. Philadelphia, Pa., 1790s. Prob. owner.

Crissey, Charles M. Chester Depot, Orange Co., N.Y., w. ca. 1850.

Cromwell, Thomas B. New York, N.Y., w. 1822; New Bedford, Mass., w. 1829. *See also* Cromwell and Howland; Howland, Davis and Co.

Cromwell, Thomas B., and Howland, Frederick New Bedford, Mass., w. 1829.

Cropper, Henry, and Moss, (?) Maysville, Ky., w. 1828–29.

Crosby, James Wilmington, Del., w. 1814. Spinning-wheel mkr.

Cross, James Alexander Martin Baltimore, Md. Appr. to Matthew McColm, 1822.

Crow, Thomas D. 1817. Philadelphia, Pa., w. 1794–96; Baltimore, Md., w. 1802–16.

Crowell, Nathan New York, N.Y., w. 1817–18; poss. New Jersey, poss. w. 1818–ca. 1820; Cincinnati, Oh., w. ca. 1820–29, 1836–49. *See also* Moses P. Clark and Nathan Crowell; Crowell and Lewis.

Crowell, Nathan, and Lewis, (prob. Joseph) Cincinnati, Oh., w. 1839–43.

Culverhouse, William Rowan Co., N.C., appr. 1817; Charlotte, N.C., w. 1823–26. Mstr. to Obed Parrish, 1825. *See also* Phifer and Culverhouse.

Cunningham, Benjamin F. Freedom, Me., w. 1842–54. *See also* William H. Cunningham and Benjamin F. Cunningham.

Cunningham, William D. 1851. Wheeling, W. Va., w. 1828–51.

Cunningham, William H. Freedom, Me., w. 1844–50. *See also* William H. Cunningham and Benjamin F. Cunningham.

Cunningham, William H., and Cunningham, Benjamin F. Freedom, Me., w. ca. 1844–45.

Curry, John Paris, Ky., w. 1818. Wheelwright earlier.

Curtis, W., and Co. Brockville, Ont., Canada, w. 1834. Dealers.

Cushing, John W. Salisbury, N.H., w. 1804. *See also* Theodore Cushing and John W. Cushing.

Cushing, Samuel B. 1799. Thetford, Vt., w. bef. 1838; Monroe Co., N.Y., w. 1838 and later. Son of Theodore Cushing.

Cushing, Theodore 1780–1850. Salisbury, N.H., w. 1803–ca. 1806; Thetford, Vt., w. ca. 1806–31; W. Grace, N.Y. (near Rochester), w. ca. 1831 and later. Fr. of Samuel Cushing. *See also* Theodore Cushing and John W. Cushing.

Cushing, Theodore, and Cushing, John W. Salisbury, N.H., w. 1804.

Custer, Jesse Vincent Twp., Chester Co., Pa., w. 1796; Coventry Twp., Chester Co., Pa., w. 1798.

Cutler, Jarvis Beverly, Mass., w. 1796–98. Poss. dealer only.

Cutler, John H. Rutland, Mass., w. 1830–38 and prob. later.

Cutter, D. E. Prob. New England, ca. late 1790s–1800s. Poss. owner.

Cutter, N. Prob. New England or E Canada, ca. 1810s. Poss. owner.

Cutter, (?), and Power, (?) Halifax, Nova Scotia, Canada, w. 1814.

Dagget, Alis(?) B. 1826. Princeton, Mass., w. 1850. Prob. jnyman.

Daley (Dailey), Jacob Baltimore, Md., w. 1804–ca. 1847. Appr. to Richard Sweeney, 1797; mstr. to Isaac Barton, 1810; Benjamin Blakiston, 1806; John H. D. Boone, 1816; Jesse Carter, 1811; Jarret Cole, 1816; John Daley, 1806; John Henry Deppisch, 1815; Benjamin Franklin, 1813; Richard Fowler, 1815; Abel Gould, 1806; Jacob Hare, 1816; Robert Hare, 1816; Sabreeth Harryman, 1813; Job Jarmin, 1813; John Jewell, 1804; Thomas Sterling, 1805; Gustavus Thompson, 1816; Joseph L. Yales, 1811. *See also* Jacob Daley and Son.

Daley, Jacob, and Son Baltimore, Md., w. 1842.

Daley, John B. ca. 1795. Baltimore, Md. Appr. to Jacob Daley, 1806.

Dalton, William Boston, Mass., w. 1799–1800.

Dalton, William Georgetown, D.C. Appr. to Thomas Adams, 1816.

Damon, Benjamin 1783–1872, m. 1811. Amherst, N.H., w. bef. 1806; Concord, N.H., w. 1806–34 and later, 1844–60. Ptr. only, from ca. late 1830s. Br.-in-law of William Low. *See also* William Low and Benjamin Damon.

Dana, Alvan Owego, N.Y., w. 1829.

Danforth, D. Area Boston, Mass., 1790s. Owner, contemporary or later.

Daniels, Eleazer 1788–1858. Medway, Mass., w. ca. 1810s–1859. Poss. appr. to Luther Metcalf.

Dannley, George Dickerson B. 1828. Pine Grove, Centre Co., Pa., w. ca. 1850s and later.

Darrow, Ammirus Warren, Oh., w. 1839–40. Son of Jedidiah Darrow.

Darrow, Jedidiah Warren, Oh., w. ca. 1822–40. Fr. of Ammirus Darrow.

Davenport, Ebenezer Dorchester, Mass., w. ca. 1800–1810.

Davidson, George Boston, Mass., w. 1793–99; Charlestown, Mass., w. 1800 and later. Orn. ptr. and chair dealer.

Davidson, Robert, Jr. D. 1820. Baltimore, Md., w. 1796–1819.

Davidson (Davison), William H. Lawrenceburg, Ind., w. 1835–36; Louisville, Ky., w. 1843–45. *See also* William H. Davidson and Thomas M. Duffy.

Davidson, William H., and Duffy, Thomas M. Lawrenceburg, Ind., w. 1835.

Davies, Alonzo B. 1813. Fitchburg, Mass., w. 1850. Prob. jnyman.

Davis, A. J. Medina, Oh., w. 1855.

Davis, Caleb D. ca. 1821. Albany, N.Y., w. 1816–19. *See also* Caleb(?) Davis and John Bussey.

Davis, (poss. Caleb), and Bussey, John Albany, N.Y., w. 1819.

Davis, Chester C. Blairsville, Pa., w. 1850s–1870s.

Davis, Cornelius E. R. Carlisle, Pa., w. ca. 1831–49.

Davis, David Baltimore, Md., appr. 1804, w. 1819–29; poss. New York, N.Y., w. 1832 (dealer). Appr. to John Barnhart, then Matthew McColm, 1804.

Davis, H. Pennsylvania or NE New England, w. 1800s.

Davis, James B. ca. 1785. Baltimore, Md. Appr. to Jacob Williams, 1801.

Davis, James Wheeling, W. Va., w. 1839.

Davis, Luther D. ca. 1861. Northampton, Mass., w. 1808–30.

Davis, M. New England, prob. Maine, poss. Cumberland Co., w. 1820s.

Davis, Milo, and Abbott, David Painesville, Oh., w. 1841.

Davis, Richard Shelbyville, Tenn., w. 1828–ca. 1830.

Davis, W(illiam?) Pittsburgh, Pa., w. ca. late 1790s–early 1800s. *See also* Thomas(?) Ramsey and William(?) Davis.

Davis, William Philadelphia, Pa., w. 1791. Poss. same person as preceding.

Davison, Samuel Plainfield, Mass., w. 1795–1824 and poss. later.

Dawson, William T. Laurel, Del. Appr. to Jonathan Hearn, 1845.

Day, Charles (Chauncey?) N(ewell?) Templeton, Mass., w. 1820–25; Otter River, Worcester Co., Mass., w. 1825 and later.

Day, William B. 1825. Princeton, Mass., w. 1850. Prob. jnyman.

Dean, D. G. Middle Atlantic region or New England, w. 1820s. Windsor craftsmanship unconfirmed.

Dean, Henry B. ca. 1782. New York, N.Y., w. 1805–8, 1816–36. Also orn. ptr. and gilder. *See also* Bruce and Dean; Henry Dean and Charles(?) Fredericks.

Dean, Henry, and Fredericks, (Charles?) New York, N.Y., w. 1816–17.

Dearborn, Warren 1802–63. Sandwich, N.H., w. 1828–61 and prob. earlier.

Debol, Lewis Halifax, Nova Scotia, Canada, w. 1800s or 1820s.

Deckman, George 1833–1901; b. Prussia. Minerva, Carroll Co., Oh., w. ca. 1859–62; Malvern, Oh., w. 1862–ca. 1901.

Deeds, Isaac B. ca. 1792. New York, N.Y., w. 1816; Cincinnati, Oh., w. 1817–19; poss. Butler Co., Oh., poss. w. after 1819. *See also* Deeds and Roll; Deeds and Young.

Deeds, Isaac, and Roll, Jacob C. Cincinnati, Oh., w. 1818.

Deeds, Isaac, and Young, Jonathan Cincinnati, Oh., w. 1819.

Degant, Joseph(?) Halifax, Nova Scotia, Canada, w. ca. 1800s–ca. 1820s.

Degrove, John Area New Brunswick, N.J., w. 1791.

Dejernatt, C. H. Greensboro, N.C., 1838; Salisbury, N.C., 1839; Concord, N.C., w. 1840. *See also* Dejernatt and Rainey.

Dejernatt, C. H., and Rainey, (?) Concord, N.C., w. 1840.

De La Hunt, George Huntington, Long Island, N.Y. Appr. to Carman Smith, 1828.

Deland, Philip D. 1847. W. Brookfield, Mass., w. 1812–46.

De L'Orme, Francis, (Delorme, John Francis) Philadelphia, Pa., w. 1790; Charleston, S.C., w. 1791–ca. 1819. Upholsterer who stuffed Windsor-chair and settee seats.

Dempsey, John B. ca. 1782. Baltimore, Md., w. 1816. Appr. to Richard Sweeney, 1799.

Denig, John Chambersburg, Pa., w. ca. 1820–22.

Denmark, N. S. Canton, Pa., w. ca. 1830s or later.

Dennis, Joshua New York, N.Y., w. 1810–19. Worked sometimes as orn. ptr. and gilder. *See also* Patterson and Dennis.

Denoon, James Petersburg, Va. Appr. to Graves Matthews and Alexander Brown, 1817.

Denwiddie, David Cumberland, Pa., w. ca. 1829–32; Centre Twp., Wayne Co., Ind., w. 1835–50. Prob. br. of Hugh Denwiddie II.

Denwiddie (Dinwiddie, Dunwiddie), Hugh, II Cumberland, Pa., w. ca. 1829–32; Gettysburg, Pa., w. 1840; poss. Indiana, w. ca. 1840 and later. Prob. br. of David Denwiddie.

Deppisch, John Henry Baltimore, Md. Appr. to Jacob Daley, 1815.

Derby (Darby), Almond 1800–1864. Westminster, Mass., w. 1829. *See also* Edgell and Derby.

Deshar, Stephen B. ca. 1788. Baltimore, Md. Appr. to Jacob Newcomer, 1802.

Destouet, S(aturnius) Philadelphia, Pa., w. ca. 1819–ca. 1860. Merchant.

Develling, Patrick W., and Patrick, Matthew Athens, Oh., w. 1838–39.

Dewees, Jesse Philadelphia, Pa., w. 1809–17; Pittsburgh, Pa., 1819–26.

Dewey, Erastus, and Co. Poss. m. 1798. Hartford, Conn., w. 1796; poss. Bolton, Conn., w. 1798–1800.

Dewey, George 1790–1853. Litchfield, Conn., w. 1815–42. Also a dealer. Temporary partners included Amos Adams (w. 1819–20), John Dewey (w. ca. 1820–23), James H. Cooke (w. 1824–26).

Dewey, Henry Freeman 1800–1882/83. Bennington, Vt., w. 1827–64. *See also* Henry Freeman Dewey and Heman Woodworth.

Dewey, Henry Freeman, and Woodworth, Heman Bennington, Vt., w. 1827–28.

Dewey, John 1747–1807, m. 1772. Suffield, Conn., w. 1790–91.

Dewey, Josiah New London, Conn., w. 1803.

Dewitt, John Ca. 1769 or 1774–ca. 1851. New York, N.Y., w. 1794–ca. 1819.

Dexter, David D. 1880. Athol, Mass., w. bef. 1837; Black River, Jefferson Co., N.Y., w. 1837–ca. 1880.

Dibble, Noah 1771–1813. Danbury, Conn., prob. w. bef. 1812, 1813; Litchfield, Conn., w. 1812.

Dickey, (Samuel J.?), and Co. Hopewell, Chester Co., Pa., w. ca. late 1850s–1860s.

Dickinson, Samuel Redfield Bp. 1786, m. 1815, d. 1836. Chatham Twp., Middlesex Co., Conn., w. 1810; Middletown, Conn., w. ca. 1815–20; prob. Hartford, Conn., w. ca. 1836 and earlier.

Dickinson, (prob. Samuel Redfield), and Badger, (?) Middletown, Conn., w. 1815.

Dicks, William Near Lynche's Ferry, Amherst Co., Va., w. 1795.

Dickson, James L. Nashville, Tenn., w. 1818.

Dickson, John Georgetown, D.C., w. 1824–33; Washington, D.C., w. 1833–ca. 1837. Mstr. to Jeremiah T. Brashears, 1827; Henry Hasson, 1827.

Dickson, William A. Paris, Ky., w. 1819, 1828.

Dill, Alexander Camden, Del. Appr. to David A. Stayton, 1832.

Dimmits, Ezekiel Batavia, Oh., w. 1824. Dealer.

Dimock, Albert B. B. ca. 1820. Prob. Norwich, Mass., w. 1850; Croghan, N.Y., w. 1860; Harrisville, N.Y., w. 1865.

Dinsmore, James M. 1804. Hopkinton, N.H., w. 1803–9; Brunswick, Me., w. ca. 1809–ca. 1823.

Diuguid, Sampson 1794–1856, m. 1817. Lynchburg, Va., w. 1817–ca. 1850. *See also* Winston and Diuguid.

Doak(s), William Boston, Mass., w. 1787–89.

Doane, Thomas Prob. E Massachusetts or S New Hampshire, 1800s. Poss. owner.

Dockum, Samuel M. 1792–1872. Portsmouth, N.H., w. 1815–72. *See also* Dockum and Brown.

Dockum, Samuel M., and Brown, Edmund M. Portsmouth, N.H., w. 1827–29.

Dodd, B. Nashville, Tenn., w. 1823–24. *See also* Sherwood and Dodd.

Dodd, J. B. Charlottesville, Va., w. 1835.

Dodge, C(harleroy?) Montreal, Canada, w. 1819–21. Poss. orn. ptr. only.

Dodge, T. New England, w. ca. 1800. Poss. owner.

Dolby, John B. 1788. Baltimore, Md. Appr. to Caleb Hannah, 1805.

Dole, Enoch Terre Haute, Ind., w. 1826 and poss. later.

Dole, N. NE New England, prob. New Hampshire, w. 1810s.

Dole, Samuel Poss. 1765–1844, m. 1787. Poss. Windham, Me., w. ca. 1787–1830, or poss. Newburyport, Mass., w. ca. 1805–12.

Dominy, Nathaniel E. Hampton, Long Island, N.Y., w. 1794. Made special-order mahogany Windsors in 1794.

Donaldson, Dwight (and Co.) Painesville, Oh., w. 1841 and earlier–1854 and later. *See also* Donaldson, Case, and Lines; Donaldson and Colby; Orrin Judson Lines and Dwight Donaldson.

Donaldson, Dwight, Case, C. R., and Lines, Orrin Judson Painesville, Oh., w. 1844–45. Business also known as Painesville Chair Factory.

Donaldson, Dwight, and Colby, M. H. Painesville, Oh., w. 1853–54.

Donevan, Daniel B. ca. 1778. Baltimore, Md. Appr. to William Snuggrass, 1799.

Donner, Daniel 1803–81. Manheim, Pa., w. 1835–43 and earlier and later. Turner and spinning-wheel mkr.

Dooley, Hiram Jonesboro, Tenn., w. 1840.

Doolittle, Benjamin Litchfield, Conn., w. 1819–20.

Doolittle, John, II B. 1795. Wallingford, Conn., w. 1816–36.

Dougherty, Abel Wilmington, Del. Appr. to Jared Chesnut, 1832.

Douglas, Samuel (and Son) D. 1845. Area Canton, Conn., w. ca. 1810–ca. 1840 and later.

Dow, I. Rhode Island, ca. 1790s–1800s. Poss. owner.

Dow, O. New England, ca. 1820s. Poss. owner.

Downey, J. Risden, Jr. B. ca. 1801. Baltimore, Md., w. 1829–35. Appr. to John Robinson, 1813.

Downing, Francis, Jr. Lexington, Ky., w. 1805–16. Also orn. ptr.

Downing, R. H. E Pennsylvania, 1800s. Poss. owner.

Draine, George Washington Georgetown, Del. Appr. to Elias James, 1843.

Drake, T. New York, N.Y., 1790s. Prob. owner.

Drake, William Cincinnati, Oh., w. 1834–43.

Drennen, (?) Nashville, Tenn., w. 1830–31. *See also* Thompson and Drennen.

Dresser, Harvey 1789–1835. Southbridge, Mass., w. 1824–31.

Drum, Phillip Cincinnati, Oh., appr. 1799; Bethel, Oh., w. 1847. Appr. to Robert McGinnis (cabtmkr.), 1799.

Drummond, Alexander Toronto, Canada, w. 1829.

Duffy, John Pittsburgh, Pa., w. 1837–39.

Duffy, Thomas M. Lawrenceburg, Ind., w. 1835; Louisville, Ky., w. 1841–51. *See also* William H. Davidson and Thomas M. Duffy.

Duhy, John Georgetown, D.C., w. 1799–1800. Dealer.

Dulin, William Camden, Del. Appr. to David H. Stayton, 1841.

Dunbar, A., and Dunbar, G. Canton, Oh., w. 1841.

Dunbar, George, Jr. Canton, Oh., w. 1817–37. Son of George Dunbar, Sr. *See also* George Dunbar, Jr., and George Bechler; George Dunbar, Jr., and George B. Haas; George Dunbar, Sr., and Son.

Dunbar, George, Sr. Canton, Oh., w. 1817–33. Fr. of George Dunbar, Jr. *See also* George Dunbar, Sr., and Son.

Dunbar, George, Jr., and Bechler, George Canton, Oh., w. 1823–25.

Dunbar, George, Jr., and Haas, George B. Canton, Oh., w. 1835–37.

Dunbar, George, Sr., and Son (George Dunbar, Jr.) Canton, Oh., w. 1817.

Dunbiben, John B. ca. 1774. Wilmington, N.C., w. 1798. Appr. to John Nutt, 1789. *See also* Vosburgh and Dunbiben.

Dunham, Campbell D. 1837. New Brunswick, N.J., w. 1793–1812.

Dunham, James New York, N.Y., w. 1802. Poss. son of Matthew Dunham, Sr.

Dunham, Matthew Prob. Wayne Co. and (E.) Bloomfield, Ontario Co., N.Y., ca. 1795–1803; Johnson Creek (Kuckville), Carlton Twp., Orleans Co., N.Y., w. ca. 1803–16 and prob. later. Had sons James Dunham and Matthew Dunham, Jr.

Dunlap, Major John 1746–92. Bedford, N.H., w. 1791. Poss. obtained Windsor stock by trade.

Dunlap, John, II 1781–1869. Bedford, N.H., appr. 1800–1804; Antrim, N.H., w. 1830s and poss. earlier. Appr. to David McAfee, 1800–1804.

Dunlap, W. J. Prob. New Hampshire or Maine, ca. 1820s–1830s. Prob. owner.

Dunn, S. E Massachusetts or S New Hampshire, ca. 1820s. Poss. owner.

Dupignac, Ebenezer R. B. ca. 1794. New York, N.Y., w. 1818–45.

Durborow (Dunborow, Durbrow), Joseph, Jr. B. ca. 1787. New York, N.Y., w. 1807–50. *See also* Skellorn and Durborow.

Dyer, William B. 1806. Baltimore, Md., w. 1829. Appr. to Gale March, 1816.

Dyke, John Danvers, Mass., w. 1803–5.

E., P. SE coastal Connecticut, 1790s. Poss. owner.

Easton, Silas, Jr. 1771–1813. E. Hartford, Conn., w. 1793–ca. 1813. *See also* (?) Butler and Silas Easton, Jr.

Eaton, William Page 1819–1904. Boston, Mass., w. 1844–61; New Boston, N.H., w. ca. early 1860s and later. Orn. ptr.

Eden, Joshua 1731–1802. Charleston, S.C., w. 1767–1802.

Edgell, Bush and Co. (John Edgell and Charles W. Bush) Gardner, Mass., w. 1844.

Edgell, John Westminster, Mass., w. 1829; Gardner, Mass., w. 1844. *See also* Edgell, Bush and Co.; Edgell and Derby.

Edgell, John, and Derby, Almond Westminster, Mass., w. 1829.

Edgerton, Ezekiel Hawley, Mass., w. 1804–ca. 1810.

Edling, John Philadelphia, Pa., w. 1785–97.

Edmunds, David Charlestown (and poss. Boston), Mass., w. ca. 1790–ca. 1810 and later.

Edwards, Ambrose Adair Co., Ky., appr. 1819.

Edwards, Benjamin Alvord 1757–1822. Northampton, Mass., w. ca. 1788–ca. 1810. *See also* Benjamin Alvord Edwards and Simeon(?) Pomeroy.

Edwards, Benjamin Alvord, and Pomeroy (prob. Simeon) Northampton, Mass., w. 1793.

Edwards, Oliver Ca. 1788–1837. New York, N.Y., w. 1818–36. *See also* Oliver Edwards and Cyrus Baldwin; Smith Ely and Oliver Edwards.

Edwards, Oliver, and Baldwin, Cyrus New York, N.Y., w. 1833–36.

Egbert, Stephen D. ca. 1808/9. New York, N.Y., w. 1802–8.

Elliot, Ira Sanbornton (Bridge), N.H., w. 1825. Prob. dealer.

Elliott, R. J. Paris, Tenn., w. 1837–38. *See also* Hosea L. Jackson, R. J. Elliott, and J. B. Boden.

Ellis, Thomas New Bedford, Mass., w. 1815–52.

Elwell, Amasa D. 1814. Bennington, Vt., w. 1799–early 1800s; Arlington, Vt., w. late 1800s–ca. 1814.

Ely, Charles Prob. ca. 1772–1854, m. 1796. Lyme, Conn., w. 1827–29.

Ely, Smith 1800–1884. New York, N.Y., w. 1823–39. *See also* Smith Ely and Oliver Edwards; Smith Ely and George(?) Nuttman.

Ely, Smith, and Edwards, Oliver New York, N.Y., w. 1825–27.

Ely, Smith, and Nuttman (George?) New York, N.Y., w. 1828–29.

Emery, D. SE New England, ca. 1800. Poss. owner.

Emery (Embree, Embury), Peter Prob. d. 1855. New York, N.Y., w. 1789–96.

Emmett, William Y. Chillicothe, Oh., w. 1824–36; Circleville, Oh., w. 1839–40. *See also* Emmett and Mills; Joseph Thiots Moore and William Y. Emmett.

Emmett, William Y., and Mills, John E. Chillicothe, Oh., w. 1835–38.

Emmit (Emit), Joseph Alexandria, Va., w. 1804. Mstr. to Joseph Langton, 1804.

Emmit, Josiah, Jr. Clarksville, Tenn., w. 1819.

Emory, Moses W. B. 1829. Gardner, Mass., w. 1850. Prob. jnyman.

English, James Ca. 1785–1850. New Haven, Conn., w. 1819–46.

Enos, Thomas Thompson 1817–89, m. ca. 1840. Smyrna, Del., w. bef. 1840; Odessa, Del., w. 1840 and later.

Epright, R. Rhode Island, 1790s. Prob. owner.

Ermentrout, Emanuel Reading, Pa., w. 1840s–ca. 1860.

Erskine, H. Prob. New York state or New England, w. 1850s and later.

Esbin, Jesse Ca. 1793–1873. E. Goshen Twp., Chester Co., Pa., w. 1824–42.

Etling, I. (or J.) S New England, prob. Rhode Island, w. 1790s. Poss. variation of the Dutch name *Elting* associated with the Hudson River valley.

Evans, Ephraim Philadelphia, Pa., w. 1779–85; Alexandria, Va., w. 1785–ca. 1820. Mstr. to George Green, 1808; George Grimes, 1799; Thomas Mathews, 1802; Hector Sanford, 1792–ca. 1797; Samuel Tyler, 1807; George Wakefield, 1804.

Evans, Hugh Nashville, Tenn., w. 1811 and later; Gallatin, Tenn., w. 1820.

Evans, J. New England, prob. E Massachusetts or S New Hampshire, 1800s. Poss. owner.

Evans, Lewis Bardstown, Ky., w. 1826.

Evans, Wayne (Waine) Petersburg, Va., appr. 1805; Rowan Co., N.C., w. 1815. Appr. to Joel Brown, 1805; Mstr. to John Cooper, 1815.

Eveche, (?) E Massachusetts or NE New England, 1820s or later. Poss. owner.

Everly, Jacob D. 1835. Franklin, Tenn., w. 1831–35. *See also* Everly and Merrill; William D. Taylor and Jacob Everly.

Everly, Jacob, and Merrill, Charles A. Franklin, Tenn., w. 1833.

F., B. Delaware Valley, poss. Philadelphia, Pa., early 1790s. Poss. owner.

F., C., Jr. E Pennsylvania, early 1790s. Poss. owner.

F., D. A. Sans-serif brand on 1790s chair. Poss. later owner.

Fahy, (?) Prob. Rhode Island, 1790s. Poss. owner.

Fairbank, Luke Gardner, Mass. Appr. to James M. Comee I, aft. 1805.

Fairbanks, Charles L. Utica, N.Y., w. 1839–43. *See also* James C. Gilbert and Charles L. Fairbanks.

Far, R. L. E Pennsylvania, w. 1820s. Windsor craftsmanship unconfirmed.

Faries (Faris), George G. Wilmington, Del., and Savannah, Ga., w. 1815–17. *See also* John Adams and George C. Faries. Shipment of chrs. consigned to him at Savannah by James Whitaker, 1817.

Farley, Henry D. 1838. Concord, N.H., w. ca. 1826–ca. 1838. Also orn. ptr.

Farley, James A. SE New England, 1790s. Later label, prob. owner's.

Farrer (Farrar), Jacob Danvers, Mass., w. 1803–5.

Farrington, Benjamin D. ca. 1849/50. New York, N.Y., w. 1820–35. *See also* Benjamin Farrington and Elijah Farrington; Fredericks and Farrington.

Farrington, Benjamin, and Farrington, Elijah New York, N.Y., w. 1826–35.

Farrington, Elijah B. ca. 1793. New York, N.Y., w. 1816–35. *See also* Benjamin Farrington and Elijah

Farrington. Appears to have had Brooklyn, N.Y., outlet in 1834.

Fassaur, Michael D. ca. 1820/1. New York, N.Y., w. 1812–ca. 1816, 1819.

Faunce, Asa D. ca. 1824. Winslow, Me., w. 1800; Waterville, Me., w. 1803–ca. 1824.

Faxon, J. O. Prob. Rhode Island, 1790s. Poss. owner.

Faye, Obed B. 1766, m. 1787. Nantucket, Mass., w. ca. late 1790s or early 1800s.

Fell, J. Delaware Valley, 1800s. Poss. owner.

Fellows, C(harles?) H. and Co. Poss. 1819–80. New London, Conn., w. 1843. Dealers.

Felton, Jacob 1787–1864. Fitzwilliam, N.H., w. 1833, 1836–38; Quincy, Ill., poss. w. 1840 and later.

Fenn, Harvey Rochester, N.Y., w. 1834–51. *See also* Brewster and Fenn.

Ferriss, John, Sr. Wilmington, Del., w. 1775–1824.

Ferson, J. J. N New England, w. 1840s or later.

Fetter, Frederick Lancaster, Pa., w. ca. 1805–35. Son of Jacob Fetter II; br. of Jacob Fetter III. *See also* Frederick Fetter and Jacob Fetter III.

Fetter, Frederick, and Fetter, Jacob, III Lancaster, Pa., w. 1811–15.

Fetter, Jacob, II Lancaster, Pa., w. ca. 1763–ca. 1799. Fr. of Frederick Fetter and Jacob Fetter III.

Fetter, Jacob, III D. 1834. Lancaster, Pa., w. ca. 1805–34. Son of Jacob Fetter II; br. of Frederick Fetter. *See also* Frederick Fetter and Jacob Fetter III.

Fields, (?), and Brown, (?) Seneca Falls, N.Y., w. 1820.

Fillman, Jacob D. ca. 1837. Sumneytown, Pa., w. 1827.

Finch, David Ca. 1799–1855, m. 1822. Danbury, Conn., appr. 1815; Bridgeport, Conn., w. 1826–29. Appr. to William Chappel, 1815.

Finlay (Finley), Hugh (and Co.) 1781–1830. Baltimore, Md., w. 1803–1830. Br. of John Finlay. *See also* John Finlay and Hugh Finlay.

Finlay (Finley), John 1777–1851. Baltimore, Md., w. ca. 1799–1837. Br. of Hugh Finlay. Mstr. to James E. Miller, 1814; Mather Purdin, 1813; William Shield, 1815. *See also* John Finlay and Hugh Finlay.

Finlay, John, and Finlay, Hugh Baltimore, Md., w. 1803–16. Mstrs. to Mendes I. Cohen, 1811; Thomas Paul, 1812.

Fisher, Robert Baltimore, Md., w. 1796–1810 and later. Mstr. to Henry Barnhart, 1807; Peter Jackson, 1808; James Otley, 1798; John Watham Patterson, 1810.

Fisher, (?), and Marshall, (?) Detroit, Mich., w. 1837.

Fisk, John William New York, N.Y., w. 1828–32. Worked for Richard Tweed, Sr., and Hezekiah M. Bonnell, 1828.

Fitch, Bush Ticonderoga, N.Y., w. 1820.

Fizer, Adam D. 1837. Prob. Fincastle, Va., w. ca. 1820–ca. 1837.

Fizer, Samuel Fincastle, Va., w. 1820–ca. 1830s.

Flint, Erastus Hartford, Conn., w. 1806–15. *See also* John I. Wells and Erastus Flint.

Folsom, Abraham (and Co.) 1805–86, m. 1832. Dover, N.H., w. 1829–47. Br. of George Perry Folsom. Also orn. ptr. and cabtmkr.

Folsom, George Perry 1812–82, m. 1835. Dover, N.H., w. ca. 1830s–ca. 1850s. Br. of Abraham Folsom.

Folsom, Josiah 1763–1837, m. 1786, 1803. Poss. Boston, Mass., w. ca. 1786–88; Portsmouth, N.H., w. 1788–1812.

Foot, Bernard Newburyport, Mass., w. 1813–18.

Foot, Daniel D. 1840. Lee, Mass., w. 1819–40.

Fordney, John D. 1816. Lancaster, Pa., w. 1807–16.

Foresman, Robert K. D. 1823. Circleville, Oh., w. 1822.

Foster, Jesse D. 1800. Boston, Mass., w. 1795–1800.

Foster, Joseph Whitestown, Oneida Co., N.Y., w. 1798–ca. 1800.

Fowler, Abraham S. Newark, N.J., w. 1835–40.

Fowler, Richard B. 1801/2. Baltimore, Md. Appr. to Jacob Daley, 1815.

Fox, Frederick Reading, Pa., w. ca. 1840–77.

Fox, Jacob 1788–1862, poss. m. 1807. Tulpehocken Twp., Berks Co., Pa., w. ca. 1807–39 and later.

Fox, William Philadelphia, Pa., w. 1796.

Foy, Frederick B. 1805. Baltimore, Md. Appr. to James Knox, 1821.

Francis, Thomas B. ca. 1788. Richmond, Va. Appr. to William Pointer, 1805.

Francis, William D. 1802. Philadelphia, Pa., w. 1791–1800.

Franklin, Benjamin B. 1797. Baltimore, Md. Appr. to Jacob Daley, 1813.

Franklin, Thomas, and Franklin, James New York, N.Y., w. 1762. Dealers.

Frazer, (?) Prob. Delaware Valley, 1800s. Poss. owner.

Frean, Samuel Philadelphia, Pa. Appr. to James Pentland, 1799.

Frederick, Robert B. 1801. Baltimore, Md., w. 1827–43. Appr. to John Simonson, 1812.

Fredericks, Charles New York, N.Y., w. 1812–ca. 1836. *See also* Henry Dean and Charles(?) Fredericks; Fredericks and Farrington.

Fredericks, Charles, and Farrington, Benjamin New York, N.Y., w. 1818–25.

Freeland, John SE New England, prob. E Massachusetts, 1790s. Poss. owner.

Freeland, Richard Rochester, N.Y., w. 1821–27; New York, N.Y., w. 1833–37, 1843–53.

Freeman, Benjamin D. 1820. Philadelphia, Pa., w. ca. 1765–1819. *See also* Freeman and Houck.

Freeman, Benjamin, and Houck, Andrew Philadelphia, Pa., w. 1784.

French, E. E Pennsylvania or Delaware Valley, ca. 1820. Poss. owner.

French, John, II (and Son) Ca. 1783–1848, m. 1807. New London, Conn., w. 1807–29 and poss. 1848. Poss. in New York City during part of 1810s. *See also* John French II and George Griffin Jewett.

French, John, II, and Jewett, George Griffin New London, Conn., w. 1810–11.

French, Stephen B. 1825. Gardner, Mass., w. 1850. Prob. jnyman.

Fricker, Nicholas Philadelphia, Pa., w. 1807–17. *See also* William Lee and Nicholas Fricker.

Fries, J. A. Bethlehem, Pa., w. ca. 1860s.

Frost, James Boston, Mass., w. 1798–ca. 1813. Poss. cabtmkr. only. *See also* Seaver and Frost.

Frost, Nathaniel Portland, Me., w. 1803; Portsmouth, N.H., w. 1810–18. Ptnr. to Henry Beck, 1810.

Frost, Samuel Montreal, Canada, w. 1811–20.

Fry, George D. 1821. Philadelphia, Pa., w. 1809–20.

Fulton, David A. Near Renovo, Pa., w. ca. 1860s and later.

Furlow, John Georgia, area Milledgeville, w. 1812.

G, D. Prob. SE New England, ca. 1790s. Poss. owner.

Gage, Caleb Strong Essex, Mass., w. ca. 1820s–1840.

Gaines, (?), and Reed, (?) Nashville, Tenn., w. 1845. Dealers.

Galatian, William W. Ca. 1771/2–1848. New York, N.Y., w. 1796–ca. 1834.

Galer (Gayler), Adam Philadelphia, Pa., w. 1767–ca. 1773; New York, N.Y., w. 1774–75.

Galer, G. Prob. NE Pennsylvania, w. ca. late 1830s–1840s.

Galligan, William Buffalo, N.Y., w. 1838–60.

Gallup, Caleb H. D. 1827. Norwalk, Oh., w. 1827.

Gallup, William Norwalk, Oh., w. ca. 1822–34.

Gammon, George Halifax, Nova Scotia, Canada, w. ca. 1800–ca. 1820s; Dartmouth and Cole Harbour, Nova Scotia, Canada, w. ca. 1830s and later.

Gammon, William Halifax and Cole Harbour, Nova Scotia, Canada, w. 1835.

Gantz (Gants), William H. B. 1813. New York, N.Y., w. 1838–52. Appr. to Timothy Cornwell, 1832.

Gardiner (Gardner), Peter Philadelphia, Pa., w. 1802–ca. 1810, ca. 1818–22; Baltimore, Md., w. ca. 1810–ca. 1818.

Gardner, Thomas Bottle Hill, prob. Union Co., N.J., w. 1789. Spinning-wheel mkr.

Garret, Wait Ca. 1789–1885. Area Canton, Conn., w. 1810–ca. 1830s.

Gater, Fletcher Baltimore, Md. Appr. to Absalom Chrisfield, 1806. Br. of John Gater.

Gater, John Baltimore, Md. Appr. to Absalom Chrisfield, 1805. Br. of Fletcher Gater.

Gates, James W. Boston, Mass., w. 1829–60. Assoc. Benjamin Franklin Heywood and Co., 1831–33; Levi and William Heywood and Co., 1834–36; William Heywood and Co., 1837–44; with br. M. L. Gates 1845–47; with F. R. Jenkins, 1848–50. Orn. ptr. and dealer.

Gates, Luther M. 1818. Sterling, Mass., w. 1825–43. Poss. turner only.

Gaunt, Anthony Lexington, Ky., appr.(?) 1813, w. 1818–ca. 1833. *See also* Challen and Gaunt; Gaunt and March.

Gaunt, Anthony, and March, Jones Lexington, Ky., w. bef. 1833.

Gautier, Andrew 1720–84. New York, N.Y., w. 1765–67. Dealer.

Gavit, George, Jr. 1773–ca. 1855, m. 1795. Westerly, R.I., w. 1794–ca. 1840s and later.

Gaw, Gilbert Prob. m. 1795/6, d. 1824. Philadelphia, Pa., w. 1793–1824. Br. of Robert Gaw. *See also* Gaw and Gaw.

Gaw, Gilbert, and Gaw, Robert Philadelphia, Pa., w. 1793–98.

Gaw, Robert Prob. m. 1792. Philadelphia, Pa., w. 1793–ca. 1833. Br. of Gilbert Gaw; mstr. to Collin W. Pullinger, 1827. *See also* Gaw and Gaw.

Geddes, William D. Cadiz, Oh., w. 1818–20.

Geoghagen, Edmund Ca. 1799–1833. Lebanon, Oh., w. 1823–ca. 1833. *See also* Yeoman and Geoghagen.

Gere (Geer), James B. 1783, m. 1808. Groton, Conn., w. 1808–55; poss. Ledyard, Conn., w. ca. 1830 and later.

German (Jarman), Daniel Philadelphia, Pa., w. 1818–22.

Gerrish, (?) Poss. area Newburyport, Mass., n.d. Windsor craftsmanship unconfirmed; poss. owner.

Gerry, Caleb D. 1831. Sterling, Mass., w. 1826. Poss. turner only.

Gerry, Reuben W. D. 1833. Sterling, Mass., w. 1824–33.

Geyer, John 1808–78. Cincinnati, Oh., w. 1830–ca. 1866; St. Louis, Mo., poss. w. 1866 and later. *See also* Kerr, Ross, and Geyer; William H. Ross and John Geyer.

Ghents, Jacob Salisbury, N.C., w. 1825.

Gibbs, S. Prob. Rhode Island, prob. later brand on 1760s chair. Windsor craftsmanship doubtful.

Gibson, Alexander Cincinnati, Oh., w. 1793–ca. early 1820s. Became brushmkr.

Gibson, Israel Lexington, Ky. Appr. to Robert Holmes, 1810.

Gideon, George D. 1826. Philadelphia, Pa., w. 1799–1805, 1813–25.

Gilbert, Jabez Ca. 1745–1827, m. 1769. Windham, Conn., w. ca. 1790–ca. 1820s.

Gilbert, James C. Troy, N.Y., w. ca. 1827–32; Utica, N.Y., w. 1833–43. Proprietor of Utica Chair Store. *See also* James C. Gilbert and Charles L. Fairbanks.

Gilbert, James C., and Fairbanks, Charles L. Utica, N.Y., w. 1839–40.

Gilbert, John, Jr. M. ca. 1757, d. 1788. Philadelphia, Pa., w. ca. 1759–ca. 1788.

Gilbert, Thomas Philadelphia, Pa., w. 1802. Prob. jnyman. to John Letchworth, 1802.

Gill, Bryson Baltimore, Md., w. 1822–31. *See also* Gill and Guiton; Gill and Halfpenny; Gill and Ross.

Gill, Bryson, and Guiton, George Baltimore, Md., w. 1831.

Gill, Bryson, and Halfpenny, James(?) Baltimore, Md., w. 1830–31.

Gill, Bryson, and Ross, William B. Baltimore, Md., w. 1829.

Gillihen (Gilliker) William New York, N.Y., w. 1789–92. *See also* Thomas Timpson and William Gillihen.

Gillingham, Joseph New Lisbon, Oh., w. 1818–ca. 1826.

Gillingham, W(illiam?) Poss. b. 1783, poss. d. 1850. Morrisville, Bucks Co., Pa., w. 1800s–ca. 1810s.

Gilpin, Thomas Philadelphia, Pa., w. 1752–67.

Ginsburg, Andrew B. 1804. Baltimore, Md. Appr. to Matthew McColm, 1819.

Ginter, David 1809–93. Lewisburg, Pa., w. ca. 1830–early 1870s.

Githens, Elijah H. 1808–82. Dayton, Oh., w. 1828; Richmond, Ind., w. 1834–48. Br. of Griffith D. Githens. *See also* Githens and Githens.

Githens, Elijah H., and, Githens, Griffith D. Richmond, Ind., w. 1834–ca. 1848.

Githens, Griffith D. B. ca. 1810. Richmond, Ind., w. 1834–54 and poss. later. Br. of Elijah H. Githens. *See also* Githens and Githens.

Glatz, (?) Prob. E cent. Pennsylvania, ca. 1770–1780s. Poss. owner.

Glazier, John C. 1798–1860. Ashburnham, Mass., w. 1824–49. Br.-in-law of Jonathan O. Bancroft. *See also* Jonathan O. Bancroft and John C. Glazier.

Goen, Noah D. 1873. New Ipswich, N. H., w. 1837.

Golden, Edward, Jr. B. ca. 1798. Baltimore, Md. Appr. to Matthew McColm, 1814.

Goldsbury, (?), and Musser, (?) Canton, Oh., w. 1818.

Goodrich, Ansel Ca. 1773–1803. Northampton, Mass., w. ca. 1794–1803.

Goodrich, Joel 1783–1851, m. 1805. Wethersfield, Conn., w. 1821–24.

Goodridge, (?) New England, w. 1790s. Windsor craftsmanship unconfirmed.

Goodwin, William B. 1800. Baltimore, Md. Appr. to John Hiss, 1816.

Goodwin, William (and Co.) Mansfield, Oh., w. 1854–56.

Gordon, David Cincinnati, Oh., w. ca. 1830–31; St. Louis, Mo., w. 1836; Louisville, Ky., w. 1838.

Gordon, John H. Baltimore, Md., w. 1831–37.

Gordon, S. Spurious brand on 1790s bow-back side chair.

Gordon, William Halifax, Nova Scotia, Canada, w. 1820.

Gormley, John Strasburg, Lancaster Co., Pa., w. 1802–25; Lampeter Twp., Lancaster Co., Pa., w. 1828.

Gormon, Henry B. ca. 1807. Raleigh, N.C. Appr. to Robert G. Williamson, 1819; Elias Hales, 1822–23.

Gosner, David Philadelphia, Pa., appr. 1803; Easton, Pa., w. 1808 and later; prob. Philadelphia, Pa., w. 1811 as cabtmkr. Appr. to John Aitken, cabtmkr., 1803.

Gould, Able B. 1792. Baltimore, Md. Appr. to Jacob Daley, 1806.

Gould, William G. B. 1830. Princeton, Mass., w. 1850. Prob. jnyman.

Grace, Jesse B. ca. 1804. Columbus, Oh., appr. 1823; Indianapolis, Ind., w. 1828–30. Appr. to John M. Wolcott, 1823. *See also* Grace and Rooker.

Grace, Jesse, and Rooker, Samuel S. Indianapolis, Ind., w. 1828.

Gragg, Samuel S. B. 1772, m. (2) 1801; d. 1855. New York state, w. bef. 1801; Boston, Mass., w. 1801–37. Br.-in-law of William Hutchins. *See also* Gragg and Hutchins.

Gragg, Samuel S., and Hutchins, William Boston, Mass., w. ca. 1801–7.

Graham, Neal (Neil) M. 1812, 1817, d. 1820. Fayetteville, N.C., w. ca. 1790–1820. Mstr. to William Butler, 1817; Archibald Smith, 1815.

Graham, William Wheeling, W. Va., w. 1863–64.

Graham, William, Jr. D. 1853. Carlisle, Pa., w. ca. 1801–18. *See also* William Graham, Jr., and Edwin R. Mulhern.

Graham, William, Jr., and Mulhern, Edwin R. Carlisle, Pa., w. 1806.

Grant, Henry Salem, Mass., w. 1809–10.

Grant, James D. 1826. Norfolk, Conn., w. 1820–21.

Grant, John, and Very, Joseph Portland, Me., w. 1813.

Grant, John, Jr. Portsmouth, N.H., w. 1817–27; Boston, Mass., w. 1833.

Grant, M. Prob. E Massachusetts or S New Hampshire, 1810s. Poss. owner.

Grant, Thomas(?), and Jemison, (?) Lexington, Ky., w. 1807.

Gravey, Robert Baltimore, Md. Appr. to John Conrad, 1806.

Gray, I. Prob. Boston, Mass., or area, ca. 1800. Prob. owner.

Gray, William Wilmington, Del., appr. 1829; Philadelphia, Pa., w. 1835–57. Appr. to Jared Chesnut, 1829.

Great Western Chair Manufactory *See* John Butler Robinson.

Green, Beriah 1774–1863, m. 1793; d. Twinsburg, Summit Co., Oh. Preston, Conn., w. 1793–95; Lisbon Twp., New London Co., Conn., w. 1795–1805; poss. Pawlet, Vt., w. ca. 1809–20 and prob. earlier and later; Twinsburg, Summit Co., Oh., poss. w. bef. 1840.

Green, Daniel St. John, New Brunswick, Canada, w. 1815–21; St. Andrews, New Brunswick, Canada, w. 1821–25.

Green, George B. ca. 1788. Alexandria, Va. Appr. to Ephraim Evans, 1808.

Green, Jacob Philadelphia, Pa., w. 1823–24.

Green, Job B. ca. 1795. Richmond, Ind., w. 1848–51.

Green, Philo Lisle, Broome Co., N.Y., w. 1820.

Green, William Laurel, Del. Appr. to Martin Hearn, 1835.

Greenwood, Calvin S. B. 1810. Gardner, Mass., w. 1837–59. Prob. mstr. to Marcus Greenwood, 1850. *See also* Calvin S. Greenwood and David Wright.

Greenwood, Calvin S., and Wright, David Gardner, Mass., w. ca. 1837–ca. 1859.

Greenwood, Marcus B. 1833. Gardner, Mass. Prob. appr. to Calvin S. Greenwood, 1850.

Greenwood, Walter D. 1861. Gardner, Mass., w. 1827–ca. 1861. Business titled Greenwood Bros. and Co., 1827–bef. 1849.

Greider, J(acob?) Prob. Warwick Twp., Lancaster Co., Pa., w. 1828 and prob. earlier and later.

Grey, Charles Martin Atlanta, Ga. Appr. to John Pugh, 1813.

Griffith, John M. 1825, d. ca. 1847. Montreal, Canada, w. 1833–47.

Grigory, John B. ca. 1784. Baltimore, Md. Appr. to William Snuggrass, 1798.

Grimes, George W. B. 1785. Alexandria, Va., appr. 1799; Petersburg, Va., w. 1812, 1814; Raleigh, N.C., w. 1815–16; Salisbury, N.C., w. 1823. Appr. to Ephraim Evans, 1799. Also orn. ptr. *See also* Grimes and Cooper.

Grimes, George W., and Cooper, John Salisbury, N.C., w. 1823.

Griswold, Joseph 1777–ca. 1843/4. Buckland, Mass., w. 1804–44.

Gros, John Charleston, S.C., w. 1818. Dealer.

Grosvenor, H. M. Shelby Co., Tenn., w. 1849–50.

Guild, C. E Massachusetts or Rhode Island, 1790s. Poss. owner.

Guiton, George Baltimore, Md., w. 1831. *See also* Gill and Guiton.

Gullet, Isaac Milford, Del. Appr. to Purnell Hall, 1833.

Gunn, John Fayetteville, N.C. Appr. to James Beggs, 1800.

H., G. SE New England, ca. 1800. Poss. owner.

H., O. E Pennsylvania, 1790s. Poss. owner.

H., T. SE Pennsylvania, 1790s. Poss. owner.

Haas, George B. Canton, Oh., w. 1835–46. *See also* George Dunbar, Jr., and George B. Haas.

Hadley, Richard New York, N.Y., w. 1829–34, 1839. Also gilder. *See also* Elihu Rose and Richard Hadley.

Hadley, Simon Mill Creek Hundred, New Castle Co., Del., w. ca. 1790–1821. Spinning-wheel mkr. and joiner.

Hagerty, Andrew Area Philadelphia, Pa., w. 1787; Baltimore, Md., w. 1801. Prob. turner only.

Hagget, Amos M. 1806. Charlestown, Mass., w. 1803–8; Fredericton, New Brunswick, Canada, w. 1817; poss. Edgecomb, Me., w. 1820 and later.

Hagget, John Portland, Me., w. 1818–1820s. *See also* Very and Hagget.

Hains, Leonard B. ca. 1798. South Bend, Ind., w. 1839; Portage Twp., St. Joseph Co., Ind., w. 1850.

Halberstadt, George Poss. m. 1793, d. 1812. Philadelphia, Pa., w. 1793–1811. Princ. a cabtmkr. *See also* Halberstadt and Barnet.

Halberstadt, George, and Barnet (Barnit), Abraham Philadelphia, Pa. w. ca. 1796–1801.

Haley, William P. Boston, Mass., w. 1837–59. Prob. dealer and orn. ptr. only.

Halfpenny, J(ames?) Baltimore, Md., w. 1830–31. *See also* Gill and Halfpenny.

Hall, E. Poss. Longmeadow, Mass., w. ca. 1790s. Windsor craftsmanship unconfirmed.

Hall, Elias B. ca. 1798. Raleigh, N.C. Appr. to Wesley Whitaker, 1814.

Hall, John Newark, N.J., w. 1835–49. *See also* John Hall and David Alling; John Hall and Peter G. McDermit; John Hall and John R. Tillou.

Hall, John, and Alling, David Newark, N.J., w. 1837–44.

Hall, John, and McDermit, Peter G. Newark, N.J., w. 1848.

Hall, John, and Tillou, John R. Newark, N.J., w. 1845.

Hall, Joseph Georgetown, D.C. Appr. to Thomas Adams, 1807.

Hall, Purnell Milford, Del., w. 1820–48. Mstr. to Isaac Gullet, 1833; Lemuel Shockley, 1830; James Wise, 1833.

Hall, Richard Georgetown, D.C. Appr. to John White, 1822.

Hall, William B. 1778, poss. m. 1811. Poss. Lyme, Conn., w. bef. 1820; New London, Conn., w. 1820–ca. 1850.

Hall, William Sag Harbor, Long Island, N.Y., w. 1802–4.

Hallack, John Y. New York, N.Y., w. 1813.

Hallet, James, Jr. M. 1793, d. 1851. New York, N.Y., w. 1790–1811.

Halsey, Richard E. New York, N.Y., w. 1832–38. Mstr. to William Willis Beecher, 1832.

Halzel, Philip D. ca. 1866/7. Philadelphia, Pa., w. 1802–53.

Hamilton, I. E Pennsylvania outside Philadelphia, w. 1790s and poss. later.

Hamilton, Jude Farmington, Conn., w. 1800. *See also* Jude Hamilton and Nathaniel Watson.

Hamilton, Jude, and Watson, Nathaniel Farmington, Conn., w. 1800.

Hamilton, William New York, N.Y., w. 1802–3.

Hamlin, (prob. H. or S.) Prob. Rhode Island, ca. 1810. Prob. owner.

Hammond, Benjamin, and Hammond, John Poss. 1755–1806 (Benjamin). Newport, R.I., w. 1796–1800.

Hammond, Jesse B. 1802. Baltimore, Md. Appr. to John Oldham, 1818.

Hampton, Jonathan New York, N.Y., w. 1768–70. Dealer.

Hampton, Joseph Ca. 1769–1849. Rahway-Plainfield, N.J., w. bef. 1794 and aft. 1797; New York, N.Y., w. 1794–97. *See also* John Always and Joseph Hampton.

Hand, Richard Bridgton, N.J., w. 1826.

Handy, B. Area Laurens, Otsego Co., N.Y., w. 1845.

Hanes, Hiram Columbus, Oh., w. 1843.

Hanks, H. Connecticut–Rhode Island border region, w. 1790s. Windsor craftsmanship unconfirmed.

Hannah, Caleb Baltimore, Md., w. 1790, 1796–ca. 1808. Mstr. to William Abbott, 1801; Elisha Chandler, 1799; Thomas Chandler, 1797; Vincent Cooper, 1799; John Dolby, 1805; Thomas Johnson, 1800; David Mitchell, 1808; Perry Owens, 1799; William Powell, 1802; Andrew Russell, 1805; Ephraim Stevenson, 1795; Benjamin Thornburgh, 1807; Severn Watson, 1797.

Hannan, J. Marietta, Oh., w. 1832.

Hanson, Timothy D. 1798. Wilmington, Del., w. ca. 1787–98.

Harbison, William Wilmington, Del., w. 1814.

Harding, R. Yarmouth, Nova Scotia, Canada, w. 1830.

Har(d)wick, James Lexington, Ky., w. 1794.

Hardy, Chesley 1791–1880. Lynchburg, Va., w. ca. 1816–34 and poss. later. *See also* George T. Johnson and Chesley Hardy.

Hardy, William Reed 1773–1841. Portsmouth, N.H. Owner.

Hare (Harr), Jacob B. 1797. Baltimore, Md. Appr. to Jacob Daley, 1816.

Hare (Harr), Robert B. 1803. Baltimore, Md. Appr. to Jacob Daley, 1816.

Harrington, Artimus 1784–1848. Boylston, Mass., w. 1810–30.

Harker, Samuel Wilmington, Del., w. 1814 and prob. later.

Harriott, G. C. Charleston, S.C., w. 1822. Poss. dealer only.

Harris, Henry Ashtabula, Oh., w. 1838. Dealer.

Harris, S. D., and Morgan, J. J., II Warren, Oh., w. 1841–42.

Harris, William, Jr. 1742–1802, m. 1763. New London, Conn., w. 1788–98 and poss. earlier and later.

Harrison, Francis Cincinnati, Oh., w. ca. 1826–ca. 1851.

Harrison, Israel 1799–1868, m. 1825, 1841. New Haven, Conn., w. ca. late 1820s–1841. *See also* Israel Harrison and Samuel M. Smith.

Harrison, Israel and Smith, Samuel M. New Haven, Conn., w. 1840–41.

Harryman, Sabreeth B. ca. 1795. Baltimore, Md. Appr. to Jacob Daley, 1813.

Hart, Miles 1787–1862, m. 1820. Goshen, Conn., w. 1815–16.

Hart, Richard Portsmouth, N.H., 1790s. Merchant-owner.

Hart, William (and Co.) Cincinnati, Oh., w. 1837–53.

Hartley, William Brookville, Ind., w. 1838. *See also* Hartley, Wheat and Co.

Hartley, William, and Wheat, James E., and Co. Brookville, Ind., w. 1838.

Hartman, John E. Ca. 1814–61. Lionville, Chester Co., Pa., w. 1840–54.

Hasbrouck, J. M. Prob. Ulster Co., N.Y., 1790s. Poss. owner.

Haskell, Nathan B. 1805. Newburyport, Mass., w. 1829, poss. earlier and later. Agent for Newburyport Chair Factory.

Haskell, William O. (and Son) D. 1860. Boston, Mass., w. 1836–60. Also orn. ptr. *See also* William O. Haskell and George W. Haskell.

Haskell, William O., and Haskell, George W. Boston, Mass., w. 1840–42. Orn. ptrs.

Haskin, S. Lyn, Leeds Co., Ont., Canada, w. ca. late 1840s–1850s.

Haskins, Reed New Bedford, Mass., w. 1832–41. Prob. orn. ptr. only. *See also* William Bates and Reed Haskins.

Hassen, Henry Georgetown, D.C. Appr. to John White, 1826; John Dickson, 1827.

Hastey, John Poss. Philadelphia, Pa., w. bef. 1805. Carlisle, Pa., w. 1805–28.

Hastings, Levi Moore B. 1802. Boylston, Mass., w. 1825–27.

Hatch, Chester (and Co.) B. 1796, United States. Kingston, Ont., Canada, w. 1815–57; Toronto, Canada (branch), 1823 and later.

Hatch, Edward Craftsbury, Vt., w. 1849; poss. Bethel, Vt., w. 1850; poss. Wardsboro, Vt., w. 1850s.

Hatch, J. B. New England or New York state, w. 1830s.

Hatch, Samuel 1774–1861, m. 1797. Exeter, N.H., w. ca. 1800–1824.

Hatfield, Moses 1780–1835. Poss. Bowers Mills (Lanier), Preble Co., Oh., w. ca. 1811–bef. 1817; Dayton, Oh., w. 1817–35.

Hatfield, Thomas W. Broadkill Hundred, Sussex Co., Del., appr. 1830; Georgetown, Del., w. aft. 1830–49. Appr. to Perry Prettyman, 1830.

Haven, Abner Framingham, Mass., w. bef. 1801–30. Son of David Haven.

Haven, David D. 1800/1. Framingham, Mass., w. 1785–1800. Fr. of Abner Haven.

Hawkins, Samuel B. ca. 1799. Baltimore, Md. Appr. to John Simonson, 1815.

Hawley, Elisha 1759–1850, m. 1786. Ridgefield, Conn., w. 1781–1800 and prob. later.

Hawley, Samuel Ridgefield, Conn., w. 1820 and later.

Hawley, Thomas 1759–1840. Ridgefield, Conn., w. 1786–91 and later.

Hay, George York, Pa., w. ca. 1840s–1860s.

Hay, Thomas Ca. 1798–1845. St. John, New Brunswick, Canada, w. 1819–ca. early 1840s.

Hayden, Benjamin Sterling, Mass., w. 1800–1810s; Harvard, Mass., w. 1820–40. Poss. turner only.

Haydon, William Philadelphia, Pa., w. 1799–1833. *See also* Haydon and Stewart.

Haydon, William, and Stewart, William Henry Philadelphia, Pa., w. 1809–ca. 1818.

Hayes, Owen Poss. New England, w. ca. 1790s. Windsor craftsmanship unconfirmed.

Hayes, Perry, and Sherbroke, (?) New York, N.Y., w. 1763. Dealers.

Hay(e)s, John Philadelphia, Pa., w. 1803–8, 1820–22, 1828–33. Poss. same man listed as orn. ptr. in Baltimore, Md., 1796, 1824.

Hays, Thomas New York, N.Y., w. 1790–1826.

Hayward, Thomas Cotton 1774–1845, m. 1800. Pomfret, Conn., w. 1796–98; Boston, Mass., w. 1799, 1811–17, and poss. later; Charlestown, Mass., w. 1800–1810, aft. 1817–late 1820s; Ashford, Conn., w. 1830–ca. 1840. Cousin of Charles C. Cotton.

Hayworth (Haworth), Warner Upper Providence Twp., Delaware Co., Pa., w. 1810, 1819; London Grove Twp., Chester Co., Pa., w. 1814–16, 1821, 1829. Mstr. to John Raphun, 1815.

Hazelet, James Utica, N.Y., w. 1842–47.

Hazen, Moses, Jr. 1776–1837. Weare, N.H., w. 1803–5 and later.

Hazlet, James New York, N.Y., w. 1799–1811. *See also* Karnes and Hazlet.

Hearn, Jonathan Laurel, Del., w. 1830–45. Mstr. to William T. Dawson, 1845; Philip Wainwright, 1842; John Ward, 1830.

Hearn, Martin Laurel, Del., w. 1835. Mstr. to William Green, 1835. Spinning-wheel mkr.

Heaton, James R. New York, N.Y., w. 1825–37.

Heckman, Henry Baltimore, Md. Appr. to John King, 1808.

Hedge, Ek. B. Prob. SE New England, w. late 1790s–early 1800s.

Helme, James C. Plymouth, Luzerne Co., Pa., w. 1827–41.

Hemenway, Samuel 1755–1813, m. 1779. Grafton, Mass., w. 1781–ca. 1786; Shrewsbury, Mass., w. 1786–92; Shoreham, Vt., w. 1792–ca. 1813.

Henderson, Peter D. 1784. Philadelphia, Pa., w. 1766–84. Mstr. to Alexander McNeiley, 1772.

Henning, Thomas, Sr. Lewisburg, W. Va., w. 1852.

Henning, Washington G. Lewisburg, W. Va., w. 1852–53.

Henshaw, Benjamin H. Northampton, Mass., w. 1819; prob. Utica, N.Y., w. 1828.

Henzey, Joseph, Jr. M. 1804. Philadelphia, Pa., w. 1802–6.

Henzey, Joseph, Sr. 1743–96, m. 1772. Philadelphia, Pa., w. 1767–96. Mstr. to Isaac Covert, 1772; David Stackhouse, 1772; Jesse King, bef. 1778. *See also* Joseph Henzey, Sr., and Joseph Burden.

Henzey, Joseph, Sr., and Burden, Joseph Philadelphia, Pa., w. ca. 1795–96.

Herwick, Joseph Greensburg, Pa., w. 1810. Mstr. to George Sloan, 1810.

Heslip (Bislep?), Thomas Prob. Sadsbury Twp., Chester Co., Pa., w. 1800–1801; poss. St. Louis, Mo., w. 1810; Pittsburgh, Pa., w. 1815–19.

Hewes (Hews), Alpheus D. 1839. New Jersey, w. bef. 1787; New Haven, Conn., w. 1787 and later; Newark, N.J., poss. w. bef. 1793, certainly by 1818–39. Poss. discontinued chairmaking upon returning to New Jersey.

Hewes, Hezekiah M. 1786, 1794. Salem, N.J., w. ca. 1786–94.

Heywood (Hayward), Benjamin Franklin (and Co. with Walter Heywood, William Heywood, James W. Gates, Moses Wood, and Levi Heywood, 1831–37) D. 1843. Boston, Mass., w. 1831–34; Gardner, Mass., w. ca. 1827–31, 1834–43. Br. of Levi Heywood, Walter Heywood, and William Heywood. *See also* Levi Heywood and Co.

Heywood, Levi (and Co. with Benjamin Franklin Heywood, Walter Heywood, and William Heywood, ca. 1837–ca. 1843) 1800–1882. Boston, Mass., w. 1831–35; Gardner, Mass., w. ca. 1826–31, 1835–82. Br. of Benjamin Franklin Heywood, Walter Heywood, and William Heywood. *See also* Benjamin Franklin Heywood and Co.

Heywood, Walter 1804–80. Gardner, Mass., w. 1826–41; Fitchburg, Mass., w. 1844–49; Boston outlet, 1831 and poss. later. Br. of Benjamin Franklin Heywood, Levi Heywood, and William Heywood. *See also* Benjamin Franklin Heywood and Co.; Levi Heywood and Co.; Walter Heywood and Leander P. Comee.

Heywood, Walter, and Comee, Leander P. Fitchburg, Mass., w. 1844–49.

Heywood, William D. 1873. Gardner, Mass. w. ca. 1831–33, 1836–ca. 1843; Boston, Mass., w. 1834–35, poss. ca. 1843–55. *See also* Benjamin Franklin Heywood and Co.; Levi Heywood and Co.

Hibbs, Aden G. Pennsylvania, w. bef. 1832; Columbus, Oh., w. 1832–37 and later.

Hicks, George Nashville, Tenn., w. 1818; Blount Co., Tenn., w. 1820 and poss. later.

Higbee, Thomas Philadelphia, Pa., w. 1800–1801. *See also* Higbee and Wall.

Higbee, Thomas, and Wall, Richard Philadelphia, Pa., w. 1800.

Higgins, Sylvester 1776–1860, m. 1805. Duanesburgh, N.Y., w. 1804–5; E. Haddam, Conn., w. 1805–7 and later.

Hildreth, John T. Brooklyn, N.Y., w. 1831–36.

Hill, Elijah Area Canton, Conn., w. 1813.

Hill, J(?), Jr. Massachusetts or N New England, w. ca. late 1820s–1830s.

Hill, John (Johnson) Prob. b. ca. 1780. Wilmington, N.C., w. 1802–3. Poss. trained with John Nutt, 1798 and earlier. Runaway slave of W. H. Hill, 1802, 1803, and prob. of Michael Sampson, 1801; alias John Howe.

Hill, John Philadelphia, Pa. Appr. to Lawrence Allwine, 1795.

Hill, Sullivan B. 1808. Spencer, Mass., w. 1833–35.

Hill, (?), and Mead, (?) Mt. Vernon, Oh., w. 1845.

Hills, John Charleston, S.C., w. 1816. Dealer.

Hilyard, B New England or Pennsylvania, w. ca. 1810. Windsor craftsmanship unconfirmed.

Hine, Amos Litchfield, Conn., w. 1813–20.

Hines, William Philadelphia, Pa. Appr. to Thomas Mason, 1772.

Hiney, Christian Philadelphia, Pa., w. 1790–91.

Hiss, John Baltimore, Md., w. 1816. Mstr. to William Goodwin.

Hitchcock, Lambert 1795–1852, m. 1830, 1836. Waterbury, Conn., prob. appr. bef. 1814, prob. jnyman. 1814–15; Litchfield, Conn., prob. jnyman. 1815–17; Hitchcocksville (Riverton), Barkhamstead Twp., Litchfield Co., Conn., w. 1818–49; Unionville, Farmington Twp., Hartford Co., Conn., w. 1844–52. Prob. appr. to David Pritchard, bef. 1814; jnyman. to David Pritchard, 1814–15; Silas Cheney, 1815–17. Br.-in-law of Arba Alford; br.-in-law of David Pritchard. *See also* Hitchcock, Alford and Co.; Hitchcocksville Co.

Hitchcock (Lambert), Alford (Arba) and Co. Hitchcocksville (Riverton), Conn., w. 1832–41.

Hitchcocksville Co. (Arba Alford, Lambert Hitchcock, Josiah Sage) Hitchcocksville (Riverton), Conn., w. 1841–49.

Hobart, Caleb, Jr. D. 1865. Hingham, Mass., w. ca. 1810–30, ca. 1840–65; N. Yarmouth, Me., w. ca. 1830–ca. 1840.

Hobbs, John Broadkill Hundred, Sussex Co., Del., or Frederica, Kent Co., Del. Appr. to Perry Prettyman, 1827; Lemuel Carpenter, 1831.

Hobbs, Russel Sussex Co., Del., or Frederica, Kent Co., Del. Appr. to Lemuel Carpenter, 1831.

Hobbs, Thomas Broadkill Hundred, Sussex Co., Del. Appr. to Perry Prettyman, 1827.

Hobday, John Richmond, Va., w. 1808–12, 1816–17, 1819. *See also* Hobday and Barnes; Hobday and Seaton.

Hobday, John, and Barnes, James Richmond, Va., w. 1816–17.

Hobday, John, and Seaton, Leonard H. Richmond, Va., w. 1808–12. Mstrs. to Fleming Moseley, 1811.

Hockey (Hocking), Joseph Unity, Me., w. bef. 1825; Freedom, Me., w. 1825–40.

Hodges, Thomas Nelson 1818–65. Hitchcocksville (Riverton), Conn., w. 1842–43 and later. Prob. orn. ptr. only.

Hodgkinson, John (and Son) Baltimore, Md., w. 1822–56.

Hoell, Joseph H. Camden, S.C., w. 1805.

Hoffman (Huffman), George D. ca. 1884. Chillicothe, Oh., w. 1824–66. Appr. to James Phillips, 1810s.

Hogan, Ruben B. ca. 1786. Baltimore, Md. Appr. to Jacob Newcomer, 1802.

Holbrook, Luther Keene, N.H., w. 1805–7; poss. Winchester, N.H., w. 1810; poss. Utica, N.Y., w. 1832. *See also* Abel Wilder and Luther Holbrook.

Holcomb, Allen 1782–1860. Granby, Conn., poss. w. 1802–8; Greenfield, Mass., w. 1808–9; Troy, N.Y., w. 1809–10; New Lisbon, Otsego Co., N.Y., w. 1811–28 and later. Fr. of Edgar Holcomb and George Holcomb.

Holcomb, Edgar 1820–74. Area Laurens (poss. Morris), Otsego Co., N.Y., w. 1851–57. Son of Allen Holcomb; br. of George Holcomb. *See also* George Holcomb and Edgar Holcomb.

Holcomb, George 1811–68. Area Laurens (poss. Morris), Otsego Co., N.Y., w. 1851–57. Son of Allen Holcomb; br. of Edgar Holcomb. *See also* George Holcomb and Edgar Holcomb.

Holcomb, George, and Holcomb, Edgar Area Laurens (poss. Morris), Otsego Co., N.Y., w. 1851–57.

Holman, E(lijah?) R. Poss. d. 1857. Area Worcester (prob. Millbury), Mass., w. ca. 1828–45.

Holman, Jonathan B. 1790. Templeton, Mass., w. 1829–31.

Holman, Levi Prob. Vermont (poss. Salisbury) or Maine, w. ca. 1814. Windsor craftsmanship unconfirmed.

Holmes, A. Prob. N New England, poss. New Hampshire, 1810s. Poss. owner.

Holmes, Elisha Harlow B. 1799, m. 1823. Essex, Conn., w. 1825–30. Appr. of Amos Denison Allen and Frederick Tracy; mstr. to John L. Hull. Son-in-law of Amos Denison Allen.

Holmes, Isaac Lexington, Ky., w. ca. 1805–ca. 1807; Frankfort, Ky., w. 1807–8.

Holmes, Robert Lexington, Ky., w. bef. 1792–ca. 1816. Mstr. to James Carter, 1803; Israel Gibson, 1810.

Holmes, Rufus (1781–1855), **and Roberts, Samuel** Robertsville, Colebrook Twp., Litchfield Co., Conn., w. ca. 1836–39. Rufus Holmes investor only. Factory sold to Hitchcock, Alford and Co., 1839; sold to Caleb Camp and Moses Camp, 1849; thereafter known as Union Chair Co.

Holstein, William H. E Pennsylvania, poss. Montgomery Co., ca. 1805–12. Poss. owner.

Holton, Thomas Phildelphia, Pa. Appr. to William Widdifield, 1799.

Hook, W. Delaware Valley, ca. 1820. Poss. owner.

Hooper, Joseph Area Litchfield, Conn., w. 1803–6.

Hoopes, Abraham 1775–1823. Wilmington, Del., appr. 1795; Goshen Twp., Chester Co., Pa., w. ca. 1807–20.

Hopkins, John C. (and Co.) B. ca. 1813. Knoxville, Tenn., w. 1839–40; poss. Smith Co., Tenn., w. 1850.

Hopkinson, Abraham Camden, Del. Appr. to David H. Stayton, 1843.

Hopper, Nicholas D. 1802. Philadelphia, Pa., w. ca. 1789–91, 1795–1802; poss. Baltimore, Md., and vicinity, w. ca. 1791–92.

Hopson, Obediah Area Guilford, Conn., w. ca. 1780s–1790s. Windsor craftsmanship unconfirmed.

Horn, Samuel B. ca. 1801. Canton, Oh., w. 1835; Wayne Twp., Allen Co., Ind., w. 1850.

Horne, Jacob Philadelphia, Pa., w. 1797–1800, 1816–18.

Horsford, John, Jr. Poss. m. 1794. Litchfield, Conn., w. 1811–15.

Horton, Christopher Murderkill Hundred, Kent Co., Del., w. 1790–91.

Horton, Samuel H. D. 1836. Boston, Mass., w. 1804–10.

Hosbourgh, F. Windsor craftsmanship doubtful. Name appears on 1790s chair of New London Co., Conn., type.

Houck, Andrew Philadelphia, Pa., w. ca. 1781–84. *See also* Freeman and Houck.

Hough, M(atthew?) Cleveland, Oh., w. 1848–59. Poss. orn. ptr. only.

Houghton, Ezra Winchendon, Mass., w. 1822–24.

Houghton, Luke D. 1877. Barre, Mass., w. 1816–76.

Houghton, Phineas Sterling, Mass., w. 1834–50.

Hovey, Joshua Salem, Mass., w. 1807. Windsor craftsmanship unconfirmed.

Howard (Hayward, Haywood), Rial (Royal) B. 1790. Fitzwilliam, N.H., w. ca. 1820–28; Sterling, Mass., w. 1830–50.

Howard, Thomas, Jr. 1774–1833, m. 1798. Providence, R.I., w. 1812–ca. 1827. Prob. dealer only.

Howe, Ara 1798–1863. Brookfield, Vt., w. 1840s–1850s.

Howe, Benjamin Gardner, Mass., w. ca. 1820s–1830s. Appr. to James M. Comee I.

Howe, E. E Connecticut or Connecticut–Rhode Island border, ca. 1810. Poss. owner.

Howe, Franklin, and Co. Area Windsor, Vt., w. 1835–37.

Howe, Lyman N. M. 1852. Montpelier, Vt., w. ca. 1850–1860s.

Howe, Samuel S. 1809–64. S. Gardner, Mass., w. ca. 1824–ca. 1850s.

Howell, Thomas B. 1787/8. Baltimore, Md. Appr. to Matthew McColm, 1803.

Howland, Frederick New Bedford, Mass., w. 1829–31. See also Cromwell and Howland.

Howland, Rufus, II New Bedford, Mass., w. 1830.

Howland, Davis and Co. (Thomas B. Cromwell, Alden S. Davis, Frederick Howland) New Bedford, Mass., w. 1829–31.

Hoyt, William R. Toledo, Oh., w. 1837 and later; Norwalk, Oh., w. bef. 1841–49.

Hubbard, Ira 1784–1853, m. 1809. Glastonbury, Conn., w. 1806–20 and later.

Hubbard, John C. D. ca. 1877. Boston, Mass., w. 1826–60 and later. See also John C. Hubbard and William White, Jr.

Hubbard, John C., and White, William, Jr. Boston, Mass., w. 1863–76. Listed separately at same address although furniture known bearing both brands.

Hubbell, Fenelon 1810–92, m. 1833. Bridgeport, Conn., w. 1835–50. See also Parrott and Hubbell; Gasford Sterling and Fenelon Hubbell.

Huckel, Francis (and Sons) Philadelphia, Pa., w. 1814–55.

Hudson, Edward H. Brookville, Ind., w. ca. 1815–22; Centerville, Ind., w. ca. 1835.

Hudson, John B. Portland, Me., w. 1820–43; Bath, Me., w. 1849–50. See also John B. Hudson and John L. Brooks.

Hudson, John B., and Brooks, John L. Portland, Me., w. 1820–23.

Huey, James B. 1805. Zanesville, Oh., w. 1828–51 and later.

Hughes, James B. ca. 1776. Baltimore, Md. Appr. to Jacob Cole, 1794–96; Richard Sweeney, 1796.

Hughes, William R. Salisbury, N.C., w. 1830–34. Mstr. to Augustus Robinson, 1830. See also William R. Hughes and David Watson.

Hughes, William R., and Watson, David Salisbury, N.C., w. 1831.

Hull, Isaac Mechanicsburg, Cumberland Co., Pa., w. ca. 1840–60.

Hull, John L. 1808–62. Essex, Conn., appr. 1826; Killingworth, Conn., w. 1832–ca. late 1830s; Clin-

ton, Conn., w. 1840–50 and poss. later. Appr. to Elisha Harlow Holmes, 1826.

Humes, John Cincinnati, Oh., w. 1795–1805; Springfield Twp., Hamilton Co., Oh., w. 1805–6.

Humes, Samuel Ca. 1753–1836. Lancaster, Pa., w. 1779–ca. 1830.

Humeston, Jay Charleston, S.C., w. 1798, 1802; Savannah, Ga., w. 1800; Halifax, Nova Scotia, Canada, w. 1804–5 and prob. later. See also Humeston and Stafford.

Humeston, Jay, and Stafford, Theodore Charleston, S.C., w. 1798.

Hummel, P. E Pennsylvania, ca. 1795–1810. Prob. owner.

Humphreys, Amasa Pawtucket, R.I., w. 1816; Warren, R.I., w. 1824; Providence, R.I., w. 1838.

Humphreys, John B. ca. 1807. Guilford Co., N.C. Appr. to Samuel E. Shelton, 1825.

Humphreys, Michael B. ca. 1791. Raleigh, N.C. Appr. to Wesley Whitaker, 1806–9.

Humphreyville, Joseph D. 1803–54, m. 1827. Morristown, N.J., w. 1828 and later.

Huneker (Huniker, Huncker), John Philadelphia, Pa., w. 1805–25, 1830–60. House ptr. and orn. ptr. from 1842.

Hunt, Edmond B. 1787. Baltimore, Md., appr. 1802–3; Blount Co., Tenn., w. 1820; poss. Monroe Co., Tenn., w. 1830–40. Appr. to John Oldham, 1802–3.

Hunt, Joseph Ruggles 1781–1871, m. 1803. Boston, Mass., w. ca. 1803–10; Eaton, N.H., w. 1813–1830s.

Huntington, Daniel, III 1776–1805. Norwich, Ct., w. 1798–1802. See also Stephen Billings Allyn and Daniel Huntington III.

Huntington, Felix 1749–1823, m. 1773. Norwich, Conn., w. 1775–99 and prob. later.

Huntington, John F. Troy, N.Y., w. 1829–32; Catskill, N.Y., w. 1833; Newburgh, N.Y., w. 1842–43.

Hurdle, Levi Georgetown, D.C., appr. 1817; Alexandria, Va., w. 1834–35. Appr. to Thomas Adams, 1817. Br. of Thomas I. Hurdle.

Hurdle, Thomas I. Alexandria, Va., w. 1835. Br. of Levi Hurdle.

Hut, Charles Granville Co., N.C. Appr. to David Ruth, Sr., 1794.

Hutchins, William Boston, Mass., w. ca. 1801–7. Br.-in-law of Samuel Gragg. See also Gragg and Hutchins.

Hutchins (Huchens), Zadock, Jr. 1793–1830. Killingly, Conn., w. bef. 1818; Pomfret, Conn., w. 1818–ca. 1830.

Hutchinson, Storel (Storr?) Solebury Twp., Bucks Co., Pa., w. ca. 1810–20.

Ilsley, G. L. Exeter, N.H. 1800s. Later owner, repairer, or mfr.

Ingalls, Charles 1794–1878. Keene, N.H., w. 1824–31; Windsor, Vt., w. 1832–42 and prob.

later. Agent for Franklin Howe and Co., w. 1835–37. Princ. orn. ptr.

Ingalls, Samuel 1784–1854, m. 1810. Danville, Vt., w. ca. 1810s–1840s. Incorrectly identified in published works as Silas Ingalls.

Ingersoll, Lorin New York, N.Y., w. 1839–60.

Ingols, Samuel Sterling, Mass., w. 1824. Poss. turner only.

Ingram, James D. 1811. Harrisburg, Pa., w. 1799–ca. 1811.

Inman, M. L. NE New England, poss. Maine, w. ca. 1840s–1850s and poss. earlier.

Innes, John B. Canonsburg, Pa., w. 1828–42. See also Innes and Orr.

Innes, John B., and Orr, James Canonsburg, Pa., w. 1828–42.

Isaac Fayetteville, N.C., w. 1801–3. Negro slave of James Beggs; knew trade of riding-chair maker.

Jackson (Johnson?), Benedict Georgetown, D.C. Appr. to John Bridges, 1815.

Jackson, Francis Easton, Pa., w. 1820s–1830s.

Jackson, Hosea L. (and Co.) B. ca. 1810. Williamson Co., Tenn., appr. 1823; Paris, Tenn., w. 1837–50 and prob. later. See also Hosea L. Jackson, R. J. Elliott, and J. B. Boden.

Jackson, Hosea L., Elliott, R. J., and Boden, J. B. Paris, Tenn., w. 1837–38.

Jackson, Joseph D. 1837. Gardner, Mass., w. bef. 1837. Appr. to James M. Comee I, aft. 1805.

Jackson, Peter Baltimore, Md. Appr. to Robert Fisher, 1808.

Jackson, T. E Pennsylvania or Delaware Valley, w. ca. early 1810s.

Jacobs, Jacob B. 1787. Baltimore, Md. Appr. to Richard Sweeney, 1802.

Jacques, John, and Hay, Robert Toronto, Canada, w. 1835–70.

Jacques, Richard New Brunswick, N.J., or N New Jersey, w. ca. 1760s–1790s. Windsor craftsmanship unconfirmed.

Jacques, S(amuel?) New Jersey, prob. Monmouth Co., w. 1790s–1800s.

James, Charles W. B. 1798. Philadelphia, Pa., w. 1820–26, 1828–31, 1833; Cincinnati, Oh., w. 1828–31, 1834. Overlapping directory, public, and advertising records suggest either that James maintained Philadelphia ties after moving west or that he had two separate chr. manufactories in operation simultaneously. See also John A. Stewart and Charles W. James.

James, Elias Broadkill Hundred, Sussex Co., Del., appr. 1829; Georgetown, Del., w. ca. 1835–43. Appr. to Perry Prettyman, 1829; mstr. to George Washington Draine, 1843; Edward G. Pepper, 1835; Isaac Wilson, 1838.

Jameson, David W. Warren, Oh., w. 1836.

Jameson, John Greensburg, Pa., w. 1799.

Jamison, (Henry?), and Lawrence, (?) B. ca. 1816 (Jamison). Terre Haute, Ind., w. 1842.

Janvier, John, Jr. 1777–1850. Odessa (formerly Appoquinimink), Del., w. 1798–1850. Windsor craftsmanship unconfirmed.

Jaquith, Isaac B. 1797. Gardner, Mass. Appr. to James M. Comee I, aft. 1805.

Jarman, Job Baltimore, Md. Appr. to Jacob Daley, 1813.

Jarret, John M., and Co. Charlotte, N.C., w. 1831.

Jebine, Nicholas M. 1790. New Haven, Conn., w. ca. 1790–94; Woodbury, Conn., w. 1795–ca. 1819.

Jefferis, Emmor D. West Chester, Pa., w. 1830; Philadelphia, Pa., w. 1837–60. Poss. orn. ptr. only. *See also* James Jefferis and Emmor D. Jefferis.

Jefferis, James West Chester, Pa., w. 1830–ca. 1834. *See also* James Jefferis and Emmor D. Jefferis.

Jefferis, James, and Jefferis, Emmor D. West Chester, Pa., w. 1830.

Jeffers, Thomas Wilmington, Del., w. 1786.

Jenkins, Ebenezer B. ca. 1801. Richmond, Va. Appr. to Robert McKim, 1812.

Jenkins, George W. Near Honeybrook, Chester Co., Pa., w. 1834. *See also* George W. Jenkins and J. Jenkins.

Jenkins, George W., and Jenkins, J. Near Honeybrook, Chester Co., Pa., w. 1834.

Jenks, B. W., and Co. Louisville, Ky., w. 1832 and prob. later.

Jenks, Daniel Smithfield, R.I., ca. 1810s–1840s. Poss. owner.

Jewell, John Baltimore, Md., w. 1812. Appr. to Jacob Daley, 1805.

Jewett, Ebenezer Princeton, Mass., w. 1823–24. Poss. turner only.

Jewett, George Griffin 1785–1861. New London, Conn., w. 1810–11; Albany, N.Y., w. 1818–26; New York, N.Y., w. 1828 and poss. later. *See also* John French II and George Griffin Jewett.

Johnson, Edmund M. 1793, d. 1811. Salem, Mass., w. ca. 1796–1811. Br. of Jedidiah Johnson and Micaiah Johnson.

Johnson, George T. B. 1796. Lynchburg, Va., w. 1819–50. *See also* George T. Johnson and Chesley Hardy.

Johnson, George T., and Hardy, Chesley Lynchburg, Va., w. 1819–21.

Johnson, H. V. SE New England, 1790s. Poss. later owner.

Johnson, Howard Baltimore, Md., w. 1840–60.

Johnson, I. Prob. Delaware, Pennsylvania, or Maryland, w. ca. 1810–40. Prob. spinning-wheel mkr. only.

Johnson, Jedidiah 1759–1821. Salem, Mass., w. ca. 1790–ca. 1820. Br. of Edmund Johnson and Micaiah Johnson.

Johnson, John D. Philadelphia, Pa., w. ca. 1837–49 and later. *See also* John D. Johnson and John T. Sterrett.

Johnson, John D., and Sterrett, John T. Philadelphia, Pa., w. 1843–48.

Johnson, Micaiah 1767–1817. Salem, Mass., w. 1794–1816. Br. of Edmund Johnson and Jedidiah Johnson.

Johnson, Peter B. 1801. Baltimore, Md. Appr. to Gale March, 1816. From Albany, N.Y.

Johnson, Thomas B. ca. 1783. Baltimore, Md. Appr. to Caleb Hannah, 1800.

Johnson, Tully Norfolk, Va. Appr. to John Widgen, 1812.

Johnson, (?), and Son Colborne, Northumberland Co., Ont., Canada, w. ca. late 1830s–1840s.

Johnson, (?), and Moore (?) Norfolk, Va., w. 1806.

Johnston, Daniel Washington, D.C., w. 1829–31. *See also* Robert Wilson and Daniel Johnston.

Johnston, I. L. Richmond, Ind., w. 1834. *See also* I. L. Johnston and William Matthews.

Johnston, I. L., and Matthews, William Richmond, Ind., w. 1834.

Jones, Aaron Buckingham Twp., Bucks Co., Pa., w. ca. late 1800s–1820s. Mstr. to Aaron Ball, 1809.

Jones, Asa Barnstable Co., Mass., w. bef. 1809, aft. 1813 but bef. 1820; Northampton, Mass., w. 1809–13 and prob. later.

Jones, Daniel (Deacon) Ashburnham, Mass., w. 1820–40. Poss. turner only.

Jones, David Sterling, Mass., w. 1823. Poss. turner only.

Jones, Erastus 1806–50, m. 1831. New London, Conn., w. 1831–ca. 1850.

Jones, George W., and Jones, Augustus Partridgeville (near Templeton), Worcester Co., Mass., w. ca. early 1820s.

Jones, J. Vincennes, Ind., w. 1829.

Jones, John Wooster, Oh., w. 1838.

Jones, Joseph D. ca. 1868. West Chester, Pa., w. 1817–41 and prob. later.

Jones, Samuel B. ca. 1786. Baltimore, Md. Appr. to Richard Sweeney, 1801–6.

Jones, Seneca Covington, Ky., w. ca. 1836/7; Cincinnati, Oh., w. 1838–48.

Jordan, Willoughby B. ca. 1784. Cumberland Co., N.C. Appr. to Gurdon F. Saltonstall, 1799.

Joy, Alfred T. 1808–ca. 1888. Portsmouth, N.H., w. 1837–64. *See also* Edmund M. Brown and Alfred T. Joy.

Judd, David D. 1827. Northampton, Mass., w. 1799–ca. 1827. Fr.-in-law of Daniel J. Cook. *See also* Judd and Cook.

Judd, David, and Cook, Daniel J. Northampton, Mass., w. 1819.

Kain, William Shepherdstown, W. Va., w. 1811–14.

Karcher, Philip Philadelphia, Pa. Appr. to Lawrence Allwine, 1785.

Karnes, John D. 1804/5. New York, N.Y., w. 1796–1803. Mstr. to John Roach, 1799. *See also* Karnes and Hazlet.

Karnes, John, and Hazlet, James New York, N.Y., w. ca. 1796–ca. 1803.

Kautz, David Ca. 1779–ca. 1849. Cincinnati, Oh., w. ca. 1798, 1806–11 and poss. later. *See also* David Kautz and Daniel Kautz.

Kautz, David, and Kautz, Daniel Cincinnati, Oh., w. 1811.

Kay, P. M. Georgetown, Brown Co., Oh., w. 1839.

Kearns, George Martinsburg, W. Va., w. 1811–14.

Kearns, Michael Martinsburg, W. Va., w. 1810 and earlier–1814.

Keen, William Baltimore, Md., w. 1796–99.

Keener, William B. ca. 1794. Baltimore, Md., w. 1817–24. Appr. to John Simonson, 1809; mstr. to Cyrus Claridge, 1820.

Keens (Kens), Joseph Baltimore, Md., w. ca. 1798–ca. 1804. Mstr. to Philip Kiholts, ca. 1798; Michael Stietz, bef. 1804.

Keesee, Leroy Richmond, Va. Appr. to Robert McKim, 1815.

Keim, George Reading, Pa., w. 1800 and later.

Keim, William(?) Germantown (Philadelphia), Pa., w. 1803.

Keller, Samuel 1820–93. Kellersville, Juniata Co., Pa., w. 1840s and later.

Kelly, Edward Providence, R.I., w. 1789–96. Appr. to Daniel Proud and Samuel Proud, 1786–88.

Kelly, John Georgetown, D.C. Appr. to John White, 1823.

Kelso, John Philadelphia, w. bef. 1774; New York, N.Y., w. 1774–75 and poss. later.

Kendall, George Sterling, Mass., w. 1836–50. Poss. turner only.

Kendall, Smith Prob. 1793–1877. Worcester, Mass., w. 1827–31, 1845. Prob. br.-in-law of Henry Wilder Miller.

Kennedy, James M. B. 1795. Baltimore, Md. Appr. to John Oldham, 1810.

Kennedy, Samuel Muddy Creek, Green Co., Pa., w. 1814; Fallston, Beaver Co., Pa., w. 1830s.

Kent, G. W. Area Boston, Mass., 1810s. Prob. owner.

Kerm, Joseph Philadelphia, Pa., appr. ca. 1800s; Nashville, Tenn., w. 1813. Appr. to Joseph Burden, ca. 1800s.

Kerr, Enoch V. Cincinnati, Oh., w. 1830–37, 1846. *See also* Kerr, Ross, and Geyer; Kerr and Westerfield.

Kerr, Enoch V., Ross, William H. R., and Geyer, John G. Cincinnati, Oh., w. 1830–33. Business also known as Western Chair Manufactory.

Kerr, Enoch V., and Westerfield, David J. Cincinnati, Oh., w. 1836–38.

Kerr, J. Maryland, Virginia, West Virginia, or Midwest, w. ca. late 1830s–1840s.

Ketcham, Lewis N. Wilkes Barre, Pa., w. 1820–23.

Kettell, Jonathan 1759–1848. Newburyport, Mass., w. 1781–94 and later.

Keyes, Amos Princeton, Mass., w. 1820–50.

Keyes, Ephraim 1791–1867. Sterling, Mass., w. 1820–50.

Keyes (Keys), Thomas Cincinnati, Oh., w. 1836–50. Princ. orn. ptr. *See also* Philip Skinner and Thomas Keyes.

Keys, William, and Dixon, James Lexington, Va., w. 1801.

Kibling, George W. B. 1810. Ashburnham, Mass., w. 1842 and earlier.

Kiholts, Philip B. ca. 1786. Baltimore, Md. Appr. to Joseph Keens, ca. 1798.

Kilbourn, James E. Norwalk, Conn., w. 1823.

Kilburn, Stephen 1787–1867. Baldwinville, Templeton Twp., Worcester Co., Mass., w. 1810s–ca. 1825; prob. Adams, Jefferson Co., N.Y., w. ca. 1825 and later; New London, Huron Co., Oh., w. ca. 1840–1860s.

Kimball, I. Poss. Joseph Kimball, Jr. (1772–1863, m. 1795), Canterbury, N.H., w. bef. 1797–1824 and later; poss. John Kimball (1739–1817, m. 1765), Concord, N.H., w. 1764 and later; poss. owner.

Kimball, S. Poss. Shubael Kimbal (b. 1775), Preston, Conn., late 1790s–early 1800s; poss. went to New York state; poss. owner.

King, Daniel Philadelphia, Pa., w. ca. 1796–1805 and prob. later; Montgomery Twp., Montgomery Co., Pa., w. 1820 and prob. earlier and later. *See also* Robert Taylor and Daniel King.

King, Edward Georgetown, D.C. Appr. to Gustavus Beall, 1812.

King, Jesse Philadelphia, Pa. Appr. to Joseph Henzey, bef. 1778. May have left American colonies in 1778 with British.

King, John S. Baltimore, Md., w. ca. 1796–1829. Mstr. to Henry Heckman, 1808; Lawrence O'Laughlin, 1812.

King, Peleg C. Sag Harbor, Long Island, N.Y., w. 1804.

King, William Winchester, Va., w. 1790 and later; Frederick, Md., w. 1797–1802; Baltimore, Md., w. 1804, as ivory turner. *See also* William King and (?) Rice.

King, William, and Rice, (?) Frederick, Md., w. 1799-1800.

King, William Thomas Sussex Co., Del. Appr. to William H. Nichols, 1845.

Kingsley, I. New England, ca. 1800–ca. 1815. Poss. owner.

Kinsela, Thomas D. ca. 1822. Schenectady, N.Y., w. ca. 1810–22.

Kipp, Richard, Jr. M. 1776, d. 1793/4. New York, N.Y., w. 1775–93. Upholsterer who stuffed Windsor chair seats.

Kirk, George Philadelphia, Pa., w. 1792. *See also* Wire and Kirk.

Kirtland Chair Factory *See* Grandison Newell.

Kitchell (Mitchell), Isaac Poss. Elizabeth, N.J., w. bef. 1789; New York, N.Y., w. 1789–1812.

Kite, Jonathan Philadelphia, Pa., w. 1790–93.

Kitler, John L. Philadelphia, Pa., w. 1819–20.

Kittredge, F. C. Prob. Henniker, N.H., w. 1830s.

Kline, J. Eastern Pennsylvania, poss. w. ca. 1774–ca. 1810. Poss. spinning-wheel mkr. only; poss. the John Kline wkg. as spinning-wheel mkr. in Philadelphia (Germantown), 1774.

Knight, Stephanus Ca. 1772–1810, m. 1796/7, 1804. Enfield, Conn., w. 1795–1809.

Knouss, J. E Pennsylvania, 1780–1800. Poss. owner.

Knowles, Simon Prob. Connecticut–Rhode Island border region, w. 1790s. Poss. owner.

Knowlton, Ebenezer, Jr. Cazenovia, N.Y., w. 1812–1850s.

Knowlton, Ebenezer, Sr. Ca. 1769–1810. Boston, Mass., w. 1796–1810. Prob. fr. of Ebenezer Knowlton, Jr.

Knox, James (John?) Baltimore, Md., w. 1817–24. Appr. to Matthew McColm; mstr. to William Bayler, 1819; Frederick Foy, 1821.

Kratz, A. F. E Pennsylvania, 1830s. Poss. owner.

Kridler, Frederick Tiffin, Seneca Co., N.Y., w. ca. 1830–45. *See also* Kridler and Cunningham.

Kridler, Frederick, and Cunningham, Daniel Tiffin, Seneca Co., N.Y., w. 1845.

Kurtz, Jacob Staunton, Va., w. 1804–7.

Kurtz, John K. Waynesburg, Chester Co., Pa., w. 1820s.

Kurtz, Nicholas New Lisbon, Columbiana Co., Oh., w. 1826.

L., J. Prob. S New Hampshire, 1810s. Poss. owner.

Lackey, John Reading, Pa., w. late 1790s–early 1800s.

Ladd, John 1786–1824, m. 1807. Concord, N.H., w. 1808–9; Hallowell, Me., w. sometime aft. 1809.

Ladd, (?) Mantua, Portage Co., Oh., w. 1820s–1830s. Windsor craftsmanship unconfirmed.

La Forge, Benjamin Wilmington, Del., w. 1789–90.

Lake, David, Jr. Philadelphia, Pa., w. 1823–33. Employed Adam Snyder as jnyman., ca. 1824–25. *See also* Lake and Lake.

Lake, David, Jr., and Lake, Joseph E. Philadelphia, Pa., w. 1824.

Lambert, John D. 1793. Philadelphia, Pa., w. ca. 1786–93.

Lamphier, John, and Lamphier, Thomas B. ca. 1807 (John); ca. 1813 (Thomas). District of Columbia, w. bef. 1844; Memphis, Tenn., w. 1844–50.

Lander, Samuel Lincolnton, N.C., w. 1829.

Landon, George D. ca. 1834. Erie, Pa., w. 1830–32.

Landon, William Easton, Pa. Appr. to Peter G. Tilton, 1802.

Lane, M. Area Boston, Mass., 1800s–1810s. Poss. owner.

Lang, J. D. Pennsylvania or SE New England, ca. 1800. Poss. owner.

Langla (Langley?), Moses Gilmanton, N.H., w. ca. 1802–10.

Langton, Joseph Alexandria, Va. Appr. to Joseph Emmit, 1804.

Lanning, Nicholas E. B. 1801. Cincinnati, Oh., w. 1828–29; Jefferson Co., Ky., w. 1850. *See also* Lanning and Young.

Lanning, Nicholas E., and Young, Jonathan Cincinnati, Oh., w. 1828.

Lanphear, John K. Virgil, Cortland Co., N.Y., w. 1820.

Lapham, (?) Brand on several late eighteenth-century-style children's chairs, part of a larger group of children's chairs and low stools that appear to have been made after 1850.

Laughridge, J., Sr., and Laughridge, J., Jr. Mansfield, Oh., w. 1825.

Laughridge, John Youngstown, Oh., w. 1824.

Laughton, J. S New England or Middle Atlantic states, 1800s–1820s. Poss. owner.

Lawrence, Daniel Providence, R.I., w. 1787.

Lawrence, Judah Monis Toronto, Canada, w. 1828–33. *See also* Judah Monis Lawrence and B. W. Smith.

Lawrence, Judah Monis, and Smith, B. W. Toronto, Canada, w. ca. 1828–31.

Laws, James M. Area Milford, N.H., 1810s. Poss. owner.

Lawson, Henry, and Harrington, Francis Boston, Mass., w. 1835–50. Upholsterers who repaired and labeled earlier chair.

Lawson, P. C. Brooklyn, N.Y., w. 1843–45.

Lawson, William A. Cuyahoga Falls, Oh., w. 1833–34.

Laycock, Isaac H. Philadelphia, Pa., w. 1819–33. Mstr. to Collin W. Pullinger, 1826.

Lea(s), George W. Lancaster, Pa., w. 1815.

League, Reuben Baltimore, Md., w. 1796–1804. Mstr. to Samuel Abraham, 1800; Mathias Cole, 1800; Thomas March, 1803.

Lecock, (?), and Intle, (?) New York, N.Y., w. 1786.

Ledyard, W. P. Owner's brand on chairs dating to 1790s.

Lee, Chapman Charlton, Mass., w. 1800–1850.

Lee, Isaac M. Cincinnati, Oh., w. 1819–34. Br. of John Lee. *See also* Isaac M. Lee and John Lee; Isaac M. Lee and Philip Skinner; Isaac M. Lee and Jonathan Young.

Lee, Isaac M., and Lee, John Cincinnati, Oh., w. 1825–29.

Lee, Isaac M., and Skinner, Philip Cincinnati, Oh., w. 1822–25.

Lee, Isaac M., and Young, Jonathan Cincinnati, Oh., w. 1819–20.

Lee, John Cincinnati, Oh., w. 1825–29. Br. of Isaac M. Lee. See also Isaac M. Lee and John Lee.

Lee, John Newark, N.J., w. ca. 1827–54.

Lee, Richard K. New York, N.Y., w. 1829; Brooklyn, N.Y., w. 1843–49.

Lee, Samuel H. P. New London, Conn., w. 1808. Poss. dealer only.

Lee, William Philadelphia, Pa., w. 1807–24. See also William Lee and Nicholas Fricker.

Lee, William, and Fricker, Nicholas Philadelphia, Pa., w. 1807–11.

Leeds, J. C. Paris, Ky., w. 1839–51.

Lees, Samuel D. 1798. Philadelphia, Pa., w. 1795–98.

Legget, John New York, N.Y., w. 1795–96.

Leggett, Gabriel, Jr. New York, N.Y., w. 1791–1807. Nephew of Thomas Ash I and William Ash I.

Leigh, Isaiah New York, N.Y., w. 1805–11.

Leigh, John E. Later restorer's label on 1790s Philadelphia-type chair.

Lentner, George C. Philadelphia, Pa., w. 1801–24. See also Lentner and Patterson.

Lentner, George C., and Patterson, John Philadelphia, w. 1822–23.

Letchworth, John 1759–1843, m. 1783. Philadelphia, Pa., w. 1782–1807.

Leverett, William Boston, Mass., w. ca. 1798–1810.

Lewis, C. E Pennsylvania, w. 1790s–1800s.

Lewis, Edward R., and Lewis, Samuel B. ca. 1776 (Edward). Poss. Lancaster, Oh., w. 1832; Steubenville, Oh., w. 1832 and prob. later.

Lewis, Isaac Cooperstown, N.Y., w. 1823–ca. 1830. See also Isaac Lewis and Gilbert Sisson.

Lewis, Isaac, and Sisson, Gilbert Cooperstown, N.Y., w. 1823–24.

Lewis, Jeremiah Russellville, Logan Co., Ky., w. 1808.

Lewis, Nathaniel D. 1859. Sterling, Mass., w. 1820–50. Poss. turner only.

Lewis, Thomas Hutchings, Jr. Kittery, Me., w. ca. 1790–ca. 1810; St. John, New Brunswick, Canada, w. 1814.

Lewis, Thomas, II M. 1817. Sterling, Mass., w. 1829–38 and prob. earlier and later. See also Edward Burpee and Thomas Lewis II.

Lewis, (?), and Godfrey, (?) Cherryfield, Washington Co., Me., w. ca. 1850s–1860s.

Lewis (?), Lane (?), and Co. Sanbornton, N.H., w. 1827.

Lindle, D. N. Philadelphia, Pa., w. 1832.

Lines, Charles B., and Augur, William H. New Haven, Conn., w. 1840–41.

Lines, Orrin Judson Ca. 1811–90. Painesville, Oh., w. 1839–54. See also Donaldson, Case, and Lines; Orrin Judson Lines and Dwight Donaldson.

Lines, Orrin Judson, and Donaldson, Dwight Painesville, Oh., w. 1847–53.

Lloyd, Richard Cincinnati, Oh., w. 1839–41.

Lobach, Samuel D. ca. 1847. Pike Twp., Berks Co., Pa., w. ca. 1820s–1840s.

Lock, Henry Poss. Rensselaer, Albany Co., N.Y., w. 1790; New York, N.Y., w. 1796–1813.

Lockwood, David D., and Co. Ca. 1823–63. Bridgeport, Conn., w. 1844–47. See also David D. Lockwood and Thomas E. Waite.

Lockwood, David D., and Waite, Thomas E. Bridgeport, Conn., w. 1847.

Lockwood, Henry Camden, Del. Appr. to David H. Stayton, 1830.

Longe, Jasper Brookville, Ind., w. 1839. See also Wheat and Longe.

Looker, R. S. Cleveland, Oh., prob. w. 1840s or later. Windsor craftsmanship unconfirmed.

Loomis, Reubin 1773–1860. Windsor and Suffield, Conn., w. 1796–1836; poss. Wethersfield, Conn., w. 1810.

Loring, John T. Newburyport, Mass., w. ca. 1835–ca. 1845.

Loring, Joseph Flagg 1806–45. Sterling, Mass., w. 1828–45.

Love, Benjamin D. 1821. Oxford Twp., Philadelphia Co., Pa., w. 1781–1800 and later; Frankford Twp., Philadelphia Co., Pa., w. bef. 1807, 1810–ca. 1820; Trenton, N.J., w. 1807. Prob. fr. of William Love. See also Benjamin(?) Love and Isaac Whitelock.

Love, John Edenton, N.C. Appr. to Joseph Childres, 1803.

Love, William Philadelphia, Pa., w. 1791–1800, 1806. Prob. son of Benjamin Love.

Love, (prob. Benjamin), and Whitelock, Isaac Prob. Frankford Twp., Philadelphia Co., Pa., w. ca. 1800s–1810s.

Low, Henry V. New Brunswick, N.J., w. 1804.

Low, Marinus New York, N.Y., w. 1796–99; Westchester Co., N.Y., w. 1800.

Low, William 1780–1847. Amherst, N.H., w. bef. 1806; Concord, N.H., w. 1806–30. Br.-in-law of Benjamin Damon. See also William Low and Benjamin Damon.

Low William, and Damon, Benjamin Concord, N.H., w. 1806–26.

Lucas, J. C. E Massachusetts or S New Hampshire, 1820s. Poss. owner.

Lusby, Thomas Baltimore, Md. Appr. to John Simonson, 1816.

Luther, Nathan Salem, Mass., w. 1802–10.

Luther, William T. M. 1804. Salem, Mass., w. 1803–11.

Lynch, William Adams B. 1796. Poss. New York City or state, w. bef. 1821; St. Charles, Mo., w. 1821–29; St. Louis, Mo., w. 1829–44. See also Lynch and Trask.

Lynch, William Adams, and Trask, George, and Co. St. Louis, Mo., w. 1836–40.

Lyndall, James Philadelphia, Pa., w. 1837–40.

Lynds (Linds), John Sterling, Mass., w. 1830–50.

Lyon, Caleb Poss. Cayuga Co. N.Y., w. 1800; Schenectady, N.Y., w. 1818–35 and later.

Lyon, Moses Poss. 1787–1832, poss. m. 1812. Newark, N.J., w. 1815–17. Orn. ptr.

M., G. E Pennsylvania, w. 1750s–1760s. Windsor craftsmanship unconfirmed.

MacBride, Walter D. 1837. New York, N.Y., w. 1792–96 and poss. later. Mstr. to Isaac Van Dyke, 1792.

MacDonald, Walter Lancaster, Oh., w. 1818.

McAdan, Thomas F. Philadelphia, Pa., w. 1820–22; E. Liberty, Oh., w. 1831–50.

McAfee (McDuffee), David 1770–1809. Bedford, N.H., w. ca. 1786(?), 1795–ca. 1809. Mstr. to David Atwood, 1795; John Dunlap II, 1800–1804.

McAllaster, Benjamin Newburyport, Mass., w. 1807–9. See also Abbot and McAllaster; (?) Todd and Benjamin McAllaster.

McClelland, Isaac 1805–87. Richmond, Ind., w. ca. 1830 or later; Shandon, Butler Co., Oh., n.d.

McClintic, John Chambersburg, Pa., w. 1807–27.

McClure, Andrew B. ca. 1810. Indianapolis, Ind., w. 1834–35; Logansport, Ind., w. 1850. See also Andrew McClure and Co.

McClure, Andrew, and Co. (with James E. Wheat) Indianapolis, Ind., w. 1835.

McColm, Matthew Baltimore, Md., w. 1803–49. Mstr. to William Ackman, 1810; William Armstrong, 1816; James Alexander Martin Cross, 1822; David Davis, 1804; Andrew Ginsburgh, 1819; Edward Golden, Jr., 1814; Thomas Howell, 1803; James (John?) Knox, 1807; Benjamin Magness, 1822; Thomas March, 1804–6; Samuel Snyder, 1816; Thomas Steele, 1806; Thomas Jefferson Thompson, 1822; Robert Upperman, 1815; Thomas Upperman, 1815.

McConnell, M. Cadiz, Oh., w. 1845.

McCormick, S. Spurious brand.

McCracken, Henry Xenia, Oh., w. 1820–33.

McCracken, William Washington Twp., Knox Co., Ind., w. 1820.

McCrosson, Thomas Fayetteville, N.C., w. 1816; prob. Annapolis, Md., w. 1820. Also spinning-wheel mkr.

McCrum, James Circleville, Oh., w. 1821–40.

McCullouch, J. Clarksville, Tenn., w. 1822.

McCullough (McCoullouck), John Salem, Ind., w. 1820–24.

McDermit, Peter G. Newark, N.J., w. 1840–60. *See also* Daniel B. Brown and Peter G. McDermit; John Hall and Peter G. McDermit.

McDonald, John D. 1840. New Bern, N.C., w. 1836–40.

McDonough, Abraham D. 1852. Philadelphia, Pa., w. 1830–ca. 1851. Mstr. to John Brooks, 1831.

McDormick, James B. ca. 1793. Baltimore, Md. Appr. to John Simonson, 1809.

McDougle, Levi B. ca. 1798. Portsmouth, Oh., w. 1820; New Albany, Ind., w. 1826 or 1828; Coryden, Ind., w. 1838–50.

McElroy, William Area Moorestown, N.J., w. ca. mid 1790s–ca. 1820 and poss. later.

McFarland, William Mt. Vernon, Oh., w. 1820–ca. 1840.

McGarvey, Owen Montreal, Canada, w. 1843–96.

McGinnis, Casperus D. ca. 1790. New Castle Co., Del., w. 1784–90.

McGinnis, Franklin Brookville, Ind., w. 1835.

McGrew, John Pittsburgh, Pa., w. 1815–37. *See also* McGrew and Collins.

McGrew, John, and Collins, Thomas Pittsburgh, Pa., w. 1816.

McIntire, Andrew D. 1805. Lower Chichester Twp., Chester Co., Pa., w. 1773, 1775, poss. 1790; Philadelphia, Pa., w. 1785–ca. 1799; Pittsburgh, Pa., w. 1800–1805.

McKarahan, Charles Nashville, Tenn., w. 1810–17.

McKeen, Robert Boston, Mass., w. 1789–90; Dinwiddie Court House (Dinwiddie), Va., w. 1793–95; Petersburg, Va., w. 1795–ca. 1800. Was proprietor of an inn in Warrenton, N.C., by 1801.

McKelsie (McKelsey), David Troy, N.Y., w. 1818, 1829–35; Albany, N.Y., w. 1826–28, 1833–35.

McKim, Andrew D. 1805. Richmond, Va., w. 1788–1805. *See also* Andrew McKim and Robert McKim.

McKim, Andrew, and McKim, Robert Richmond, Va., w. 1795–1805. Mstrs. to Holt Pannell, 1799; Samuel Pearce, 1798; Pleasant Willis, 1804.

McKim, Robert D. ca. 1822. Richmond, Va., w. 1792–ca. 1820. Mstr. to Ebenezer Jenkins, 1812; Leroy Keesee, 1815; Edmund Redford, 1808; Harrison Redford, 1809; James Taylor, 1813; Alexander Hamilton Wood, 1812; William R. Wood, 1813. *See also* Robert McKim and Samuel Beach; Andrew McKim and Robert McKim.

McKim, Robert, and Beach, Samuel Richmond, Va., w. 1818.

McKinley, A. B. Washington, Pa., w. 1815.

McLain, Washington Circleville, Oh., w. 1840.

McNeil, (?) Litchfield, Conn., w. 1810–11.

McNeiley, Alexander Philadelphia, Pa. Appr. to Peter Henderson, 1772.

McNeill, Duncan Fayetteville, N.C., w. 1812–22, 1834–35, 1850 and earlier. Poss. dealer only during part of career.

McPherson, Alexander Philadelphia, Pa., w. 1793.

McSwiney, G. W., and Barnes, E. Louisville, Ky., w. 1820. Dealers.

Macy, G. W. Nantucket, Mass., 1810–40. Owner.

Macy, Josiah Nantucket, Mass., 1805–30. Owner.

Madder, Daniel Philadelphia, Pa. Appr. to Wesley Allwine, 1805.

Magness, Benjamin B. ca. 1806. Baltimore, Md., w. 1835–40. Appr. to Matthew McColm, 1822.

Magowin, J. E Massachusetts, S New Hampshire, or S Maine, w. ca. 1805–15.

Mahoney, H. B. United States, ca. 1800s–1820s. Poss. owner.

Major, William J. Brandywine Twp., Chester Co., Pa., w. 1829–42.

Mallard, Ephraim D. 1874. Gilford, N.H., w. 1811–50; Meredith, N.H., w. 1849 (poss. branch).

Manchester, Matthew E Connecticut or Rhode Island, w. 1800s–1810s. Windsor craftsmanship unconfirmed.

Mangum, S. B. Gibtonport (Port Gibson), Claiborne Co., Miss., w. 1808 and prob. later.

Mann, William Bloom Twp., Columbia Co., Pa., w. 1820.

Manning, Caleb D. ca. 1810. Salem, Mass., w. 1803–10 and prob. earlier.

Mansfield, I(?) Prob. Rhode Island, 1790s. Poss. owner.

Mansfield, James Prob. Gloucester, Mass., w. ca. late 1780s–1790s.

Mapes, William H. B. ca. 1815. Rising Sun, Ind., w. aft. 1833–50. Business also known as Rising Sun Chair Manufactory. *See also* Mapes and Armstrong.

Mapes, William H., and Armstrong, (?) Rising Sun, Ind., w. aft. 1833.

March, Charles Toronto, Canada, w. 1836–37. *See also* Samuel Church and Charles March.

March, Edward Portland, Me., w. 1830–31.

March, Gale Baltimore, Md., w. 1812–27. Appr. to John Conrad, 1802; mstr. to William Dyer, 1816; Peter Johnson, 1816; Thomas Mayberry, 1816; Elisha Oldham, 1810; Thomas H. Sewell, 1817; John Watson, 1816.

March, James Lexington, Ky., w. 1834–48. Mstr. to Thomas Sutton. Poss. same person as Jones March.

March, Jones Lexington, Ky., w. 1833. Poss. same person as James March. *See also* Gaunt and March.

March (Marsh), Thomas Baltimore, Md., poss. w. 1818. Appr. to Reuben League, 1803; Matthew McColm, 1804–6.

Mark, William Hampton, Kings Co., New Brunswick, Canada, w. 1812–14.

Markland, William Baltimore, Md., w. 1827. *See also* Markland and Bassford.

Markland, William, and Bassford, Gassaway W. Baltimore, Md., w. 1827.

Marsh, Charles Poss. m. 1812, poss. d. 1819. New York, N.Y., w. 1797–1811; poss. Cincinnati, Oh., w. 1812–19 (called Charles March). *See also* Sprosen and Marsh.

Marsh, Richard Poss. Staten Island, N.Y., w. 1800; New York, N.Y., w. 1805–13.

Marsh, Timothy Windsor, Conn., w. 1821.

Marshall, Andrew Baltimore, Md. Appr. to Francis Younker, 1812–13.

Marshall, John Prince Edward Co., Va., w. 1820.

Marshall, Roger B. 1763. Torrington, Conn., w. ca. 1795–1815.

Marsteller, S. A. Alexandria, Va., w. 1820. Dealer.

Martin, David, and Jefferson, John Norfolk, Va., w. 1795.

Martin, Jacob D. 1800. Philadelphia, Pa., w. 1783–1800. Directory listings for this man in 1801 may indicate that a kinsman was disposing of shop stock, which included "Windsor Chairs on hand not Finish'd" and "Stuff in Stock."

Martin, Peter D. 1867. Philadelphia, Pa., w. 1830–60 and poss. later.

Martiny, John Hagerstown, Md., w. 1814.

Mason, George Petersburg, Va., w. 1812–13. Dealer only.

Mason, H. W. Rhode Island, 1790s. Prob. owner.

Mason, I. (prob. John) Prob. m. 1785. Philadelphia, Pa., w. 1783–ca. 1800. Also cabtmkr. and upholsterer.

Mason, James Camden, Del. Appr. to David H. Stayton, 1832.

Mason, Joel W. New York, N.Y., w. 1844–60 and later.

Mason, Richard Philadelphia, Pa., w. 1764–93. Mstr. to Richard Brown, 1773; William Hines, 1772. Poss. joiner only bef. 1772.

Mason, Thomas D. 1818. Philadelphia, Pa., w. 1779–80(?), 1787–1817.

Mason, Thomas Boston, Mass., 1820s. Prob. later owner or restorer.

Mason, William Philadelphia, Pa., w. 1781(?), 1794.

Mathers, S. Ashtabula, Oh., w. 1845.

Mathews, Edward T. Sterling, Mass., w. 1830–44 and prob. earlier and later.

Mathews, Thomas Alexandria, Va. Appr. to Ephraim Evans, 1802.

Mathiot, Augustus Baltimore, Md., w. 1827–60 and poss. later. *See also* Mathiot and Mathiot.

Mathiot, Augustus, and Mathiot, John B. Baltimore, Md., w. 1840–51.

Matlock, David Wilmington, Del. Appr. to Samuel Riley, 1831.

Matthews, Graves Petersburg, Va., w. 1814–17; Raleigh, N.C., w. 1818. *See also* Graves Matthews and Alexander Brown; Graves Matthews and David Ruth, Jr.; Leonard H. Seaton and Graves Matthews.

Matthews, Graves, and Brown, Alexander Petersburg, Va., w. 1817. Mstrs. to James Denoon, 1817.

Matthews, Graves, and Ruth, David, Jr. (also Matthews, Ruth and Co.) Raleigh, N.C., w. 1818.

Matthews, William Cincinnati, Oh., w. 1831; Richmond, Ind., w. 1834–35. *See also* I. L. Johnston and William Matthews.

Matting, William Georgetown, D.C. Appr. to Thomas Adams, 1819.

Mattocks, John Litchfield, Conn., w. 1786–97.

Mauck, Jesse 1805–70, m. 1826. Millheim, Centre Co., Pa., w. 1826–62. Fr. of William Mauck.

Mauck, William 1827–95. Millheim, Centre Co., Pa., w. ca. 1850s and later.

May, Aaron Leominster, Mass., w. 1826. Poss. turner only.

May, Henry Chillicothe, Oh., w. 1798–ca. 1818; Kingston, Ross Co., Oh., w. ca. 1822 and later. *See also* Henry May and Thomas S. Renshaw.

May, Henry, and Renshaw, Thomas S. Chillicothe, Oh., w. 1816–ca. 1818.

May, James Litchfield, Conn., w. 1813–17.

May, James A. Baltimore, Md., w. 1837–51.

May, John Sterling, Mass., w. 1822–25, 1849–50.

May, Joseph Leominster, Mass., w. 1824–25. Poss. turner only.

May, Nathan Sterling, Mass., w. 1835–ca. 1850. Poss. turner only.

May, Samuel S. 1802–78. Sterling, Mass., w. 1840–1850s.

May, Stephen Sterling, Mass., w. 1825–28.

Maybury (Mayberry), Thomas B. 1798. Frederick, Md., appr. 1816; Baltimore, Md., appr. 1816–19. Appr. to Thomas Newens, 1816; Gale March, 1816–19.

Maynard, Henry B. 1834. Gardner, Mass. Prob. appr. to Joseph Maynard, 1850.

Maynard, Joseph B. 1805. Gardner, Mass., w. ca. 1827–1830s. Prob. mstr. to Henry Maynard, 1850.

Mead, Franklin Buffalo, N.Y., w. 1832; Port Dover, Norfolk Co., Ont., Canada, w. 1842–56.

Meetkerke, James Washington, Pa., w. 1811–13. Employed John Barnhart, 1813.

Mere (Meer, Mears, Myers), John (prob. Sr. and Jr.) Philadelphia, Pa., w. ca. 1788–1825. John, Jr's., career prob. began ca. 1803. Also orn. ptrs. and japanners.

Merrill, Charles A. Franklin, Tenn., w. 1829–33. *See also* Everly and Merrill.

Merrill, Jacob, Jr. 1763–1841. Plymouth, N.H., w. 1784–1812.

Merrit, John B. Redding, Conn., w. 1809–ca. 1830. *See also* James S. Chapman and John B. Merrit.

Merritt, J. and Co. Southbridge, Mass., w. 1830. Dealer.

Merritt, Uriah B. 1826. Templeton, Mass., w. 1850. Prob. w. as jnyman.

Meschoff, Clark B. ca. 1812. Harrisonville, N.Y., w. 1865.

Meservey, John Bangor, Me., w. 1832–84.

Metcalf, Luther 1756–1838. Medway, Mass., w. ca. 1778–1801 and later. Appr. of Elisha Richardson, 1770–78. *See also* Cleaveland and Metcalf.

Middleton, Joseph Edenton, N.C. Appr. to Joseph Childres, 1804.

Mifflintown Chair Works *See* William F. Snyder.

Miler, Michael Montreal, Canada, w. 1832. *See also* Michael Miler and Charles J. Andrews.

Miler, Michael, and Andrews, Charles J. Montreal, Canada, w. 1832.

Miler, Peter D. 1832. Montreal, Canada, w. 1825–32.

Millard (Miller), Thomas Prob. m. 1785, d. 1818. Philadelphia, Pa., w. ca. 1780–1817. Also made spinning wheels.

Miller, Franklin 1801–63, m. 1826. Homer, N.Y., w. 1838–61. Poss. orn. ptr. only.

Miller, Henry Wilder 1800–1891. Worcester, Mass., w. 1827–31. Prob. br.-in-law of Smith Kendall. Entrepreneur.

Miller, James Fayetteville, N.C. Appr. to Gurdon F. Saltonstall, 1801.

Miller, James E. B. 1798. Baltimore, Md. Appr. to John Finlay, 1814.

Miller, John Philadelphia, Pa., w. 1790–1800.

Miller, John Baltimore, Md., w. 1796–1800.

Miller, John New York, N.Y., w. 1836.

Miller, Nathan Lancaster, Mass., w. 1823. Poss. turner only.

Miller, Robert Alexandria, Va., w. 1797. Poss. dealer only.

Miller, Salmon Westminster, Mass., w. 1827–30; Worcester, Mass., w. 1830. *See also* Salmon Miller and Francis Wood; Peckham and Miller.

Miller, Salmon, and Wood, Francis Westminster, Mass., w. 1829–30; Worcester, Mass., w. 1830.

Miller, W. Delaware Valley, w. 1810s.

Mills, John E. Chillicothe, Oh., w. 1835–44. *See also* Emmett and Mills; Seney and Mills.

Miner, (?) Ballston Spa, N.Y., w. 1805. *See also* Beach and Miner.

Minor, William Richmond, Va., appr. 1793; Hanover, Va., w. 1805; King and Queen Co., Va., w. 1820. Appr. to Coleman Estes (trade unknown), 1793.

Minnis, Thomas Washington, D.C. Appr. to Thomas Adams, 1821.

Mitchell, B. Area Philadelphia, Pa., 1780s. Prob. owner.

Mitchell, David B. ca. 1791. Baltimore, Md. Appr. to Caleb Hannah, 1808.

Mitchell, Isaac *See* Isaac Kitchell.

Mitchell, John Poss. New Brunswick, N.J., w. 1802; Philadelphia, Pa., w. 1809–23, 1829–44. Made spinning wheels in New Jersey.

Mitchell, John 1813–95; b. Ireland. Cincinnati, Oh., w. 1839–77. Br. of Robert Mitchell and William Mitchell. *See also* Robert Mitchell and Co.

Mitchell, Robert 1811–99; b. Ireland. Cincinnati, Oh., w. 1836–80. Br. of John Mitchell and William Mitchell. *See also* Robert Mitchell and Robert Moore; Robert Mitchell and Co.; Robert Mitchell and Frederick Rammelsberg.

Mitchell, Robert, and Co. (with John Mitchell and William Mitchell) Cincinnati, Oh., w. 1844–47.

Mitchell, Robert, and Moore, Robert Cincinnati, Oh., w. 1840–44.

Mitchell, Robert (and Co.) and Rammelsberg, Frederick Cincinnati, Oh., w. ca. 1846–63 (name used until 1880).

Mitchell, William Philadelphia, Pa., w. 1799–1817, 1828(?). Poss. w. for Joseph Burden as jnyman., 1802, 1804. *See also* William Mitchell and Thomas Mitchell.

Mitchell, William B. ca. 1792. Baltimore, Md., w. 1817–24, 1829. Appr. to Samuel Clark, 1810.

Mitchell, William, and Mitchell, Thomas Philadelphia, Pa., w. 1799.

Mitton, John Dayton, Oh., w. 1813; Xenia, Oh., w. 1817. Mstr. to David Conklinton, 1813.

Moffat, William D. 1824. Knoxville, Tenn., w. 1821–24.

Montgomery, John New York, N.Y., w. 1789–93.

Montgomery, Samuel New York, N.Y., w. 1796–98.

Moon, David Ca. 1778–1805. Falls Twp., Bucks Co., Pa., w. 1798–99; Philadelphia, Pa., w. 1800–1801, 1803–5; Charleston, S.C., w. 1801–3. Poss. son of Samuel Moon. *See also* Samuel Moon and David Moon; David Moon and Edward Prall.

Moon, David, and Prall (Prahl), Edward Philadelphia, Pa., w. 1804–5. Mstrs. to Lewis Case, 1804.

Moon, Samuel, Jr. M. 1776, d. 1839. Fallsington, Bucks Co., Pa., w. 1769–ca. 1800; Philadelphia, Pa., w. 1800–1802; Downingtown, Chester Co., Pa., w. 1803–7, 1810, 1820; Morrisville, Bucks Co., Pa., w. 1808, prob. 1810s, aft. 1820. Poss. father of David Moon. *See also* Samuel Moon and David Moon.

Moon, Samuel, and Moon, David Philadelphia, Pa., w. 1801–2.

Moon, William D. Philadelphia, Pa., w. ca. 1800–1813. Kinship with Samuel Moon and David Moon unknown.

Moore, Amaziah S. Bangor, Me., w. 1825–28. *See also* Amaziah S. Moore and Horatio Beale.

Moore, Amaziah S., and Beale, Horatio Bangor, Me., w. 1825–28.

Moore, George B. Wilmington, Oh., w. 1825.

Moore, Henry Sandusky, Oh., w. 1825–27.

Moore, James B. 1798. Baltimore, Md. Appr. to Francis Younker, 1810.

Moore, Joseph Thiots 1796–1854, m. 1823. Chillicothe, Oh., w. 1816–ca. 1827. Br. of Samuel Moore. Also orn. ptr., which led to portrait painting by 1826. *See also* Joseph Thiots Moore and William Y. Emmett; Joseph Thiots Moore and Samuel Moore.

Moore, Joseph Thiots, and Emmett, William Y. Chillicothe, Oh., w. 1824–27.

Moore, Joseph Thiots, and Moore, Samuel Chillicothe, Oh., w. 1816–23.

Moore, Joshua Norfolk, Va., w. 1804–19.

Moore, Oliver E. Granby, Conn., w. 1808–21.

Moore, Robert 1816–80. Cincinnati, Oh., w. 1831–44. *See also* Robert Mitchell and Robert Moore.

Moore, Samuel Chillicothe, Oh., w. 1816–23. Br. of Joseph Thiots Moore. *See also* Joseph Thiots Moore and Samuel Moore.

Moore, William Lebanon, Oh., w. 1827–29.

Moore, William, Jr. 1764/5–1833. Barkhamsted Twp., Litchfield Co., Conn., w. ca. 1800–1830.

Morgan, Thomas Portsmouth, Oh., w. ca. 1810s–1830s.

Morrell, Thomas Albany, N.Y., w. 1830–34; New York, N.Y., w. 1839–54 (dealer).

Morris, John Washington, D.C. Appr. to Thomas Adams, 1822–25.

Morrison, Frederick S. New York, N.Y., w. 1828–40.

Morrison, William M. Washington, D.C., w. 1826–30. *See also* Robert Wilson and William M. Morrison.

Morse, Alonzo Sterling, Mass., w. 1835–42. *See also* Alonzo Morse and Francis Morse.

Morse, Alonzo, and Morse, Francis Sterling, Mass., w. 1842.

Morse, H. Warren, Oh., w. 1837.

Morse, Lemuel Poss. Worcester Co., Mass., w. ca. 1800s–1810s. Windsor craftsmanship unconfirmed.

Morse, R. E Massachusetts or S New Hampshire, 1800s. Poss. owner.

Moseley, E. SE New England, 1790s. Windsor craftsmanship unconfirmed; poss. owner.

Moseley, Fleming B. ca. 1797. Richmond, Va. Appr. to John Hobday and Leonard H. Seaton, 1811.

Mountfort, J(ames?), and Mountfort, D. Area Portland, Me., w. 1828.

Muir, William H. Alexandria, Va., w. 1852 and earlier. Dealer.

Mulhern (Mulhorn), Edwin (Erwin) R. B. ca. 1784. Carlisle, Pa., w. 1806; area New Market, Va., w. 1811. *See also* William Graham, Jr., and Edwin R. Mulhern.

Mullen, John Poss. d. 1837. Philadelphia, Pa., w. 1792–93.

Mullen, Jonathan 1800–ca. 1856. Cincinnati, Oh., w. 1828–ca. 1856. *See also* Jonathan Mullen and William S. Cowperthwaite.

Mullen, Jonathan, and Cowperthwaite, William S. Cincinnati, Oh., w. 1834.

Munger, Daniel Greenfield, Mass., w. 1824–26.

Murdick (Murdock), John Strasburg, Lancaster Co., Pa., w. ca. 1823–ca. 1860.

Murdoch, S. Middle Atlantic region, 1810s–1820s. Poss. owner.

Murphy, Michael, (Jr.?) D. 1804. Philadelphia, Pa., w. ca. 1790–99; Norfolk, Va., w. 1799–1804. Mstr. to Samuel Chilton, 1802.

Murphy, Orrell Frederick, Md. Appr. to Thomas Newens, 1809.

Murray, Peter Hampshire Co., W. Va., w. 1820.

Murrow (Morow), Peter Philadelphia, Pa., w. ca. 1817–24.

Mushett, Thomas Philadelphia, Pa., w. ca. 1790–1806. Poss. appr. to Francis Trumble, 1780.

Musser, Joseph, and Goldsbury, James B. Canton, Oh., w. 1818.

Muter, James Savannah, Ga., w. 1763. Dealer.

Myers, Joseph B. ca. 1806. Baltimore, Md. Appr. to Richard Sweeney, 1822.

Needles, Edward Baltimore, Md., w. 1827–33. House ptr. later.

Nees, George Manheim, Pa., w. 1850s and later; poss. Ephrata Twp., Lancaster Co., Pa., w. 1860.

Nelson, O. Prob. Connecticut–Rhode Island border region, 1790s. Prob. owner.

Nelson, (?), and Gates, (?) Burlington, Vt., w. 1840.

Nesbit, James Poss. d. 1858. New York, N.Y., w. 1799–1816 and poss. later.

Nesbitt, Allen Troy, Oh., w. ca. 1830–33.

Nestell, Christian 1792/3–1880. New York, N.Y., appr./student 1811–12; Providence, R.I., w. 1820–36 and poss. later. Poss. orn. ptr. and dealer only.

Newburyport Chair Factory Newburyport, Mass., w. 1829, poss. earlier and later. Nathan Haskell, agent.

Newcomer, Jacob Baltimore, Md., w. 1800–1803. Mstr. to Stephen Deshar, 1802; Ruben Hogan, 1802.

Newell, Grandison 1785–1874. Painesville, Oh., w. 1829–41. Proprietor, Kirtland Chair Factory.

Newens, Thomas Frederick, Md., w. 1809–16. Mstr. to Thomas Maybury, 1816; Orrell Murphy, 1809; Michael Rowe, 1813–14.

Newhard, J. Delaware Valley, prob. Northampton Co., Pa., w. 1800s–ca. 1810s.

Newman, Benjamin B. 1781, m. 1803 and later. Gloucester, Mass., w. ca. 1803–ca. 1816, 1824–29; Portland, Me., w. 1820.

Newton, R. SE New England, 1790s. Poss. owner.

Nice, J. Horton, Kings Co., Nova Scotia, Canada, w. 1842.

Nichols, George H. Charlotte, N.C., w. 1824–36. *See also* William Cornwell and George H. Nichols; George H. Nichols and Joseph P. Pritchard.

Nichols, George H., and Pritchard, Joseph P. Charlotte, N.C., w. 1825–32.

Nichols, Moses Savannah, Ga., w. 1800. Dealer.

Nichols, Samuel Wilmington, Del., w. 1800–1804. *See also* Samuel Nichols and George Young.

Nichols, Samuel, and Young, George Wilmington, Del., w. 1803.

Nichols, William N. Sterling, Mass., w. 1840–50.

Nichols (Nicholson), William H. Sussex Co. and Laurel, Del., w. 1830–59. Mstr. to William Thomas King, 1845; Jacob P. Ward, 1843; Joseph Parson Ward, 1848.

Nicholson, John B. 1825. Columbus, Ind., w. ca. 1845 and later.

Nickerson, H(iram?) S. Prob. Franklin Co. or Kennebec Co., Me., w. 1830s–1840s.

Nields, Daniel 1810–72. Coatesville, Pa., w. 1835–37; West Chester, Pa., w. 1837–50.

Nisbet, Thomas M. 1803, d. 1851. St. John, New Brunswick, Canada, w. 1813–48.

Noble, Matthew Chatham Twp., Middlesex Co., Conn., w. 1797.

Noone, Patrick, Jr. B. ca. 1794. Baltimore, Md. Appr. to Francis Younker, 1806.

Norris, James 1769/70–1806. Charleston, S.C., w. 1794–1806.

Norton, Ambrose 1782–1867, m. 1810. Litchfield, Conn., w. ca. 1809–21 and prob. later.

Norton, Jacob D. 1793. Hartford, Conn., w. 1787–90 and poss. later.

Norton, Rufus Windsor, Vt., w. ca. 1810–16.

Norton, (Ambrose?), and Trobridge, (?) Litchfield, Conn., w. 1818.

Norwood, Andrew S. D. 1856. New York, N.Y., w. 1793–ca. 1799. Upholsterer who sold Windsor chairs.

Nott, James T. Middletown, Pa., 1835–45. Owner.

Noyes, Henry Belfast, Me., 1836.

Noyes, S. Prob. Maine, late 1810s–1820s. Prob. owner.

Nutt, John Ca. 1723–1810. Charleston, S.C., w. 1770 and earlier; Wilmington, N.C., w. ca. 1770–98. Mstr. to John Dunbiben, 1789; prob. trained John Hill, a negro slave, 1798 and earlier.

Oakring, Frederick B. ca. 1799. Baltimore, Md. Appr. to John Oldham, 1815.

Oaks (Oakes), Nathan D. 1797. Poss. area Deerfield, Mass., w. 1786; St. John, New Brunswick, Canada, w. 1795–97.

Odell, Reuben Ca. 1776–ca. 1841/2. New York, N.Y., w. 1797–1829 and poss. later.

Oestereicher, C. F. Bethlehem, Pa., w. 1873 and prob. earlier and later.

Ogilby, J. Philadelphia, Pa., 1780s. Owner.

Ogle, William Baltimore, Md., w. 1800–1804, 1833(?). Appr. to Jacob Cole, 1794.

O'Lary, James Washington, D.C. Appr. to Albin Coates, 1818.

O'Laughlin, Lawrence B. 1798. Baltimore, Md. Appr. to John S. King, 1812.

Oldham, Elisha B. ca. 1795. Baltimore, Md. Appr. to Gale March, 1810.

Oldham, John D. 1835. Baltimore, Md., w. 1790–1835. Mstr. to Gassaway W. Bassford, 1814; John Copernaver and Michael Copernaver, 1790; Jesse Hammond, 1818; Edmund Hunt, 1802–3; Frederick Oakring, 1815; John Pawley, 1810.

Oldham, Thomas Wooster, Oh., w. 1838.

Ormond (Orman), John D. ca. 1801/2. New York, N.Y., w. 1795–1801. *See also* Joseph Riley and John Ormond.

Ormsby, Orrin B. 1766. Windham, Conn., w. ca. 1785–94 and later.

Orr, James Canonsburg, Pa., w. ca. 1828–ca. 1842. *See also* Innes and Orr.

Orr, John, Jr. M. 1824, 1830, 1837. Steubenville, Oh., w. 1826–30 and earlier and later.

Osbeck (Ossback), John Philadelphia, Pa., w. 1817–22.

Osborn, Jonathan New York, N.Y., w. 1822–48. *See also* William Osborn and Jonathan Osborn.

Osborn, William B. ca. 1789. New York, N.Y., w. 1816–33. *See also* Robert Barnes and William Osborn; William Osborn and Jonathan Osborn.

Osborn, William, and Osborn, Jonathan New York, N.Y., w. 1828–33.

Osborne, Stephen Baldwinville, Templeton Twp., Worcester Co., Mass., w. ca. 1820s.

Osburn, James M. Washington, D.C. Appr. to Robert Blackburn, 1821.

Osgood, Aaron, and Osgood, Isaac Oxford, Oh., w. ca. 1820s–ca. 1840s.

Osgood, Ephraim Lancaster, Mass., w. 1823–28. Poss. turner only.

Otley (Olley), James Baltimore, Md., w. 1803–4. Appr. to Robert Fisher, 1798.

Outwater, L. E New York state, prob. Dutchess Co. or Orange Co., w. 1838.

Overholt, Abraham Area Bedminster, Bucks Co., Pa., w. 1790–1833. Spinning-wheel mkr., turner, and cabtmkr.

Owen, Calvin Wooster Penfield, Monroe Co., N.Y., w. ca. 1820s and later.

Owens, Perry Baltimore, Md. Appr. to Caleb Hannah, 1799.

P., S. Rhode Island, 1790s. Prob. owner.

Packard, Sylvester Rochester, N.Y., w. 1819–49.

Packwood, George B. 1773, m. 1799. New London, Conn., w. 1796–1803.

Paddock, Peter Poss. b. 1774, poss. m. 1797. Nantucket, Mass., w. ca. 1800–1822. Poss. dealer only.

Page, W. H. Mid nineteenth-century (or later) owner's brand on a late eighteenth-century New England armchair.

Paine, John 1739–1815. Southold, Long Island, N.Y., w. ca. 1790–1815.

Paine, S. O. Spurious brand.

Painesville Chair Factory *See* Donaldson, Case, and Lines.

Pallett, James Norfolk, Va. Appr. to John Widgen, 1815.

Palmer, A. R. Mansfield, Oh., w. 1850–54.

Palmer, P. Brookville, Ind., w. 1837.

Palmer, William (and Son) B. ca. 1768/9 or earlier. New York, N.Y., w. 1787–1841 and poss. 1849. Princ. fancy-chair mkr. and orn. ptr.

Pancoast, Walter New York, N.Y., w. 1824, 1834–35; New Bedford, Mass., w. 1832, 1836–45.

Pannell, Holt Richmond, Va. Appr. to Andrew and Robert McKim, 1799.

Park, H. G. SE New England, 1800s. Prob. later owner.

Park, Samuel Montreal, Canada, w. 1797–1818.

Parker, C. New England, 1820s. Poss. owner.

Parker, John Windsor, Vt., w. 1812–16.

Parker, Ransom P. B. ca. 1803. Raleigh, N.C. Appr. to Joel Brown, 1817.

Parkhurst, William Area Boston, Mass., w. 1806; poss. Connecticut River valley in New Hampshire or Vermont, w. 1810s.

Parmeter (Parmenter), John D. 1855. Area Whately, Franklin Co., Mass., poss. Pelham, Hampshire Co., Mass., w. 1810–11.

Parris (Paris), Benjamin Philadelphia, Pa., w. 1820–39. Appr. to Jonathan Tyson, 1813; jnyman. to Daniel Tees, 1820. Also turner.

Parrish, Obed (Obid) Charlotte, N.C., appr. 1825; Lincoln Co., N.C., w. 1833. Appr. to William Culverhouse, 1825; mstr. to Elisha Shaw, 1833.

Parrott, Frederick Wells 1805–91, m. 1827. Bridgeport, Conn., w. 1832, 1835–55; New Bern, N.C., w. 1833–35 (poss. branch only); Raleigh, N.C., w. 1834 (poss. branch only). *See also* Parrott and Hubbell.

Parrott, Frederick Wells, and Hubbell, Fenelon Bridgeport, Conn., w. 1835.

Parsons, Justin D. 1807. Westhampton, Mass., w. 1796–1807.

Parsons, Samuel (and Son, Samuel P. Parsons) Richmond, Va., w. 1801–2. Prob. entrepreneurs only.

Parson(s), Stephen Prob. Hampshire Co., Mass., area Plainfield (or Wilbraham, Hampton Co., Mass.?), w. 1803–9.

Parsons, Theodosius Scotland, Conn., w. 1784–99.

Parsons, (?), and Hewson, (?) Area Clyde, N.Y., w. 1840.

Partridge, David D. 1850. Paxton, Mass., w. 1827–32 and later.

Partridge, L. E. Rural SE New England, ca. 1800. Poss. owner.

Patrick, Jacob Windsor, Vt., w. 1788–90.

Patterson, Alexander New York, N.Y., w. 1806–38. Princ. orn. ptr. *See also* Alexander(?) Patterson and Joshua(?) Dennis.

Patterson, John Windsor, Vt., w. 1812–20.

Patterson, John Watham Baltimore, Md., appr. 1810–ca. 1816; Philadelphia, Pa., w. 1817–ca. 1840. Appr. to Robert Fisher, 1810.

Patterson, Michael L. B. ca. 1811. Baltimore, Md. Appr. to John Simonson, 1822.

Patterson, N. Lyndhurst, Leeds Co., Ont., w. ca. 1840s.

Patterson, R. NE Massachusetts, 1800s–1810s. Prob. owner.

Patterson, (prob. Alexander), and Dennis, (prob. Joshua) New York, N.Y., w. 1806, 1809–11.

Paul, Thomas B. 1796. Baltimore, Md. Appr. to John and Hugh Finlay, 1812.

Pawley (Powley), John Baltimore, Md. Appr. to William Snuggrass, 1807; John Oldham, 1810.

Paynter, Rice Sussex Co., Del., w. 1828. Mstr. to Robert Bromely, 1828.

Peacock, William H., and Co. Pittsburgh, Pa., w. 1815.

Peale, James A. Lynchburg, Oh., w. 1842.

Peale, Samuel Lynchburg, Oh., w. 1838.

Pearce, Samuel Richmond, Va. Appr. to Andrew and Robert McKim, 1798.

Pearson, George B. 1789. West Chester, Pa., w. ca. 1810–23. *See also* Ezekiel White and George Pearson.

Pearson, Nehemiah 1789–1874. Sterling, Mass., w. 1827.

Peck, William E., and Peck, Jonathan C. Newburgh, N.Y., w. ca. 1856–61.

Peckham, Robert Westminster, Mass., w. 1827. Chr. dlr. *See also* Peckham and Miller.

Peckham, Robert, and Miller, Salmon Westminster, Mass., w. 1827.

Peirce, A. T. New England, w. 1820s–1830s. Poss. same person as (?) Peirce, below, using different marking iron at later date.

Peirce, (?) Prob. Rhode Island, 1800s. Poss. owner.

Pendleton, Prentice 1791–1869, m. 1814, 1827. Middletown, Conn., w. 1826. *See also* Pendleton and Perkins.

Pendleton, Prentice, and Perkins, Williams Middletown, Conn., w. 1826.

Pennington, James B. ca. 1792. Baltimore, Md., w. 1819–40. Appr. to Francis Younker, 1808.

Pentland (Pantlin), James Poss. m. 1785. Philadelphia, Pa., w. 1790–1806; Pittsburgh, Pa., w. 1810, 1820(?). Mstr. to George Abraham, 1800; Samuel Frean, 1799.

Pepper, Edward G. (J.?) Broadkill Hundred and Georgetown, Sussex Co., Del. Appr. to Perry Prettyman, 1831; Elias James, 1835.

Perkins, D(aniel?) Poss. Philadelphia, Pa., appr. 1788; prob. E Pennsylvania, w. 1790s. Poss. appr. to Lawrence Allwine, 1788.

Perkins, Thomas Salem, Mass., w. 1822–31; Troy, N.Y., w. 1832–39. *See also* William Perkins and Thomas Perkins.

Perkins, William (and Co.) Middletown, Conn., w. 1824–26; Troy, N.Y., w. 1829–ca. 1842, 1847–55. *See also* Pendleton and Perkins; William Perkins and Thomas Perkins.

Perkins, William, and Perkins, Thomas Troy, N.Y., w. 1836–39.

Perley, Asa B. 1798. Gardner, Mass., w. ca. 1827–49. Prob. mstr. to George A. Perley, James M. Perley, and poss. William P. Perley, 1850.

Perley, George A. B. 1832. Gardner, Mass. Prob. appr. to Asa Perley, 1850.

Perley, James M. B. 1834. Gardner, Mass. Prob. appr. to Asa Perley, 1850.

Perley, William P. Gardner, Mass. Prob. appr. or jnyman. to Asa Perley, 1850.

Perry, Charles M. Richmond, Va., w. 1808–10. Moved to Charleston, W.Va., 1811. Poss. dealer.

Perry, R. Prob. E Massachusetts, 1800s. Poss. owner.

Peter, John D. B. ca. 1814. Corydon, Ind., w. ca. 1838–50. *See also* John Rice and John D. Peter.

Petersen, Karsten 1776–1857. Salem, N.C., w. 1813–19 and later.

Pfaff, John 1816–77. Cincinnati, Oh., w. 1839–48.

Phelps, Bethuel 1747–1832. East Windsor, Conn., w. 1791–ca. 1820 and later.

Phelps, Jonas Sterling, Mass., w. 1830–40.

Phelps, William, Kingman, Henry W., and Co. New York, N.Y., w. 1841–60.

Phifer, Martin C. Lincolnton, N.C., w. 1820–24. Mstr. to Isaiah Williams, 1820. *See also* Phifer and Culverhouse.

Phifer, Martin C., and Culverhouse, William Lincolnton, N.C., w. 1823.

Philips, Robert Martinsburg, W. Va., w. 1799.

Phillips, Benjamin Baltimore, Md., w. ca. 1800–1803.

Phillips, James D. 1837. Chillicothe, Oh., w. ca. 1798–1810, 1815–18. Mstr. to George Hoffman, 1810s. *See also* Phillips and Cochran.

Phillips, James, and Cochran, John D. Chillicothe, Oh., w. 1815–ca. 1818.

Phillips, Minos Broadkill Hundred, Sussex Co., Del. Appr. to Perry Prettyman, 1831.

Phippen, Samuel 1744/5–98, m. 1782. Salem, Mass., w. 1790–98.

Pierce, Alfred Brewster M. 1831, d. 1880. Colchester, Conn., w. 1834–42.

Pierce, Amasa Boston, Mass., w. 1833–37. *See also* Whitney, Brown and Co.

Pierce, Aziel (also Peirce, Azel) 1773–1856, m. 1836. Glastonbury, Conn., w. 1796; Lebanon, Conn., w. 1813 and later.

Pierce, Joshua D. (P.?) Poss. d. 1885. Augusta, Me., w. 1841 and later.

Pierce, Nathan Greenfield, Mass., w. 1815. Dealer.

Pierce (Peirce), Peter 1790–1836. Templeton, Mass., w. 1825–36.

Pierpont, David 1764–1826, m. 1787. Litchfield, Conn., w. 1787–96, 1805–8.

Pilsbury, Benjamin Windsor, Vt., w. 1813–14.

Pilsbury, J. Prob. S New Hampshire or NE Massachusetts, w. 1790s.

Pinkerton, John Poss. m. 1762, prob. d. 1804. Philadelphia, Pa., w. 1767–83. Became ironmonger, ca. 1784.

Pitt, R. E Pennsylvania or Delaware Valley, w. 1800s.

Plumb, Ebenezer, Jr. B. 1774. Litchfield, Conn., w. 1797–1802. *See also* Oliver Clark and Ebenezer Plumb, Jr.

Pointer, William D. 1808. Richmond, Va., w. 1797–ca. 1808. Mstr. to Thomas Francis, 1805; Benjamin Reid, w. 1802; Leonard Seaton, 1800. Resided in household of Andrew McKim and Robert McKim, 1796. *See also* Pointer and Childres.

Pointer, William, and Childres, Joseph Richmond, Va., w. 1797–ca. 1799.

Pomeroy, Daniel, and Barns, Horace Northampton, Mass., w. 1822 and poss. later. Poss. dealers only.

Pomeroy, Oliver B. 1767, m. 1795. Northampton, Mass., w. 1802. Princ. cabtmkr., prob. sold only Windsors made by another.

Pomeroy, Ralph Bennington, Vt., w. 1796–1800; Troy, N.Y., w. 1802.

Poole, F. C. New England, 1800s. Prob. owner.

Porter, Lemuel 1766–1829. Farmington, Conn., w. 1790; Waterbury, Conn., w. 1800–ca. 1818; Tallmadge and Hudson, Oh., w. ca. 1818–29 (architect-builder).

Porter, William N. B. 1804, New Hartford, N.Y. Warren, Oh., w. 1832–35.

Pote, Increase Portland, Me., w. 1824–58.

Powell, William B. ca. 1785. Baltimore, Md. Appr. to Caleb Hannah, 1802.

Powers, Gilman B. 1801. Leominster, Mass., w. 1825–27. Poss. turner only.

Powers, Josiah 1780–1827, m. 1805, 1816. Middletown, Conn., w. 1806–ca. 1827. *See also* Powers and Badger; Powers and Ward.

Powers, Josiah, and Badger, Eleazer Middletown, Conn., w. 1810.

Powers, Josiah, and Ward, Eber Middletown, Conn., w. 1809.

Prall (Prahl), Edward D. 1854. New Jersey, w. 1802–ca. 1804; Philadelphia, Pa., w. 1805–40. Kinsman of Henry Prall. *See also* David Moon and Edward Prall; Edward Prall and Jacob Fritz.

Prall (Prahl), Edward, and Fritz, Jacob Philadelphia, Pa., w. 1828–35.

Prall (Prahl), Henry D. 1802. Philadelphia, Pa., w. 1798–1802. Mstr. to Elias Hewes, d. 1802. Kinsman of Edward Prall.

Pratt, A. W. New England, w. 1840s–1850s.

Pratt, E. L. Wheeling, W.Va., w. 1849–51. Poss. dealer only.

Pratt, Ezra Sterling, Mass., w. 1820–35.

Pratt, Joel, Jr. (and Son) 1789–1868. Sterling, Mass., w. 1820 and earlier–1848 and prob. later; Hartford, Conn., w. 1840 (branch). Prob. entrepreneur only.

Pratt, Joel, III D. 1843. Hartford, Conn., w. 1840–43. *See also* Joel Pratt III and Edward Doty Buckingham.

Pratt, Joel, III, and Buckingham, Edward Doty Hartford, Conn., w. 1841.

Pratt, John Ball 1791–1855. Sterling, Mass., w. 1820–ca. 1855.

Pratt, John David 1792–1863. Lunenburg, Mass., w. ca. 1820s–1834; Fitchburg, Mass., w. 1840–55 and prob. earlier and later.

Pratt, Levi B. 1797 (1791?) Fitchburg, Mass., w. ca. 1816–47.

Pratt, Samuel Prob. Sterling, Mass., w. 1823–1830s; prob. Sterling or Rutland, Mass., w. 1850. Poss. turner only.

Prescott, Levi 1777–1823, m. 1797. Boylston and prob. Berlin, Bolton, and Lancaster, Worcester Co., Mass., w. 1799–ca. 1823.

Preston, Almon 1789–1852, m. 1812. Wallingford, Conn., w. 1807–31 and prob. later. Son of Titus Preston.

Preston, J. S. New York or SE New England, 1790s. Prob. owner.

Preston, Titus 1764–1842. Wallingford, Conn., w. ca. 1790–1840. Fr. of Almon Preston.

Prettyman, Perry Broadkill Hundred, Sussex Co., Del., w. 1827–32. Mstr. to Lemuel Carpenter, 1831; Thomas Hatfield, 1830; John Hobbs, 1827; Thomas Hobbs, 1827; Elias James, 1829; Edward G. (J.?) Pepper, 1831; Minos Phillips, 1831.

Priest, Francis A. M. 1817. Steubenville, Oh., w. 1817–30 and prob. later. *See also* Francis A. Priest and William Doyle.

Priest, Francis A., and Doyle, William Steubenville, Oh., w. 1830.

Priest, John Petersburg, Va., w. 1806–7; Nashville, Tenn., w. 1808–16 and poss. ca. 1830; Columbia, Tenn., w. 1816. *See also* John Priest and George Dillworth.

Priest, John, and Dillworth, George Petersburg, Va., w. 1806.

Prince, William, and Co. Canton, Oh., w. 1847–52.

Pringle, William Georgetown, D.C. Appr. to John White, 1821.

Pritchard, David, II 1775–1838, m. 1797. Waterbury, Conn., w. ca. 1798–1838. Prob. mstr. to Lambert Hitchcock, bef. 1814. Br.-in-law of Lambert Hitchcock.

Pritchard, Joseph P. Charlotte, N.C., w. 1825–40. *See also* George H. Nichols and Joseph P. Pritchard.

Proud, Daniel 1762–1833. Providence, R.I., w. 1779–1833. Br. of Samuel Proud. *See also* Samuel Proud and Daniel Proud.

Proud, Samuel 1753–1835. Providence, R.I., w. 1779–1833. Br. of Daniel Proud. *See also* Samuel Proud and Daniel Proud.

Proud, Samuel, and Proud, Daniel Providence, R.I., w. 1779–1833.

Provoost, Robert D. ca. 1852. New York, N.Y., w. 1795, 1799–1804, 1826–ca. 1845. Princ. ptr.

Pugh (Pew), John Atlanta, Ga., w. 1813. Mstr. to Charles Martin Grey, 1813.

Pugh, S. SE Pennsylvania, w. 1800s.

Pullinger, Collin W. Philadelphia, Pa. Appr. to Isaac H. Laycock, 1826, to Robert Gaw, 1827.

Purdin, Mather B. 1800. Baltimore, Md. Appr. to John Finlay, 1813.

Putnam, Andrew Rutland, Mass., w. ca. 1810–ca. 1840.

Putnam, Elijah (Jr.?) B. 1801. Gardner, Mass., w. ca. 1825–ca. 1851; prob. Boston, Mass., w. 1831–32. Appr. to James M. Comee I, aft. 1805.

Putnam, Enoch Gardner, Mass. Appr. to James M. Comee I, aft. 1805.

Putnam, J. Prob. E Connecticut, ca. 1810. Later owner.

Quidort, C. F. E Pennsylvania or Delaware Valley, 1800s. Poss. owner.

Quinby, Moses 1759–1824. Bucks Co., Pa., w. ca. 1805–16; Wrightstown, N.J., w. 1816 and later; Essex Co., N.J., w. bef. 1824.

Quintin, Hugh Baltimore, Md., w. 1799.

R., E. G. SE New England, ca. 1825–ca. 1835. Prob. owner.

R., P. Prob. E Connecticut, 1800s. Windsor craftsmanship unconfirmed; poss. owner.

Rain, Thomas Poss. m. 1793. Philadelphia, Pa., w. 1799–1814.

Ramsey, Hugh 1754–1831. Holderness, N.H., w. ca. 1800–1831. Spinning-wheel mkr.

Ramsey, T(homas?) Pittsburgh, Pa., w. 1790s. Poss. migrated later to Ohio. *See also* T(homas?) Ramsey and W(illiam?) Davis.

Ramsey, T(homas?), and Davis, W(illiam?) Pittsburgh, Pa., w. 1790s.

Rand, Joshua Boston, Mass. Appr. to Samuel Jones Tuck, 1799.

Raphun (Raphum, Rappoon), John London Grove Twp., Chester Co., Pa., appr. 1815; Philadelphia, Pa., w. 1833–37. Appr. to Warner Hayworth, 1815.

Rasber, John Philadelphia, Pa., w. 1820–21.

Rauch, Charles William 1817–87. Bethlehem, Pa., w. ca. 1840s–ca. 1860s.

Rawlins, Thomas Philadelphia, Pa., w. 1833–41.

Rawson, Simon, Jr. Prob. d. 1888. Douglas, Mass., w. ca. 1820s–1830s, 1850; prob. Uxbridge, Mass., w. ca. 1840.

Rawson, William Killingly, Conn., w. 1835–41.

Raybold (Reybold), Thomas Philadelphia, Pa., w. 1818–24.

Raymond, F[rancis?] E Massachusetts (poss. Sterling) or S New Hampshire, w. ca. 1820s–1840s.

Raymond, Joseph F. B. 1810. Sterling, Mass., w. 1835–1850s.

Raynes, Jonathan Lewiston, Me., w. 1850 and earlier and later.

Rea (Rhea), John Philadelphia, Pa., w. 1794–1837. Upholsterer who sold Windsors.

Read, Thomas Boston, Mass., w. bef. 1803; Montreal, Canada, w. 1803.

Redford, Edmund Richmond, Va. Appr. to Robert McKim, 1808.

Redford, Harrison Richmond, Va. Appr. to Robert McKim, 1809.

Redhead, T. M. Montreal, Canada, w. 1843–54. *See also* Redhead and Allen.

Redhead, T. M., and Allen, William Montreal, Canada, w. 1843–49.

Redmond, Andrew D. 1791. Poss. Frederick Co., Md., w. 1771 (indentured servant, by trade turner and spinning-wheel mkr.); Charleston, S.C., w. 1784–90.

Reed, Elbridge Gerry 1800–1870. Sterling, Mass., w. ca. 1821–68.

Reed, H. Prob. SE New York state, ca. 1810. Poss. owner.

Reed, Joseph Prob. Rutland, Mass., w. 1830–31; prob. Sterling, Mass., w. ca. 1840–50.

Reed, Peter K. B. 1811. Sterling, Mass., w. 1829–50.

Reed (Reid), William Lexington, Ky., w. 1797–1818.

Reed, William B. 1784. Sterling, Mass., w. 1810–1830s.

Reed, William, Jr. Sterling, Mass., w. ca. 1840–50.

Reed, William H. D. 1858. Hampden, Me., w. 1803–ca. 1854.

Reeder, Simon Theophilus Georgetown, D.C. Appr. to Thomas Adams, 1816.

Rees, James Philadelphia, Pa., w. 1825; poss. Delaware Valley, w. earlier and later.

Rees, (?), and Gavin, (?) Prob. Pennsylvania, w. ca. 1850s.

Reid, Benjamin B. ca. 1788. Richmond, Va. Appr. to William Pointer, 1802.

Reinhart, George Hazleton, Pa., w. 1875–80.

Remer, R. Brand on reproduction chair.

Renshaw, James 1794–1856. Phoenixville, Pa., w. 1847–56 and earlier.

Renshaw, Thomas S. (and Co.) M. 1818, 1828. Georgetown, D.C., w. 1801; Baltimore, Md., w. 1811–15; Chillicothe, Oh., w. 1816–39. Mstr. to George Taylor, 1811. *See also* Henry May and Thomas S. Renshaw.

Reynolds, George B. ca. 1796. New York, N.Y., w. 1819; New Bedford, Mass., w. 1823. *See also* William Russell, Jr., George Reynolds, and Courtlandt Charlot.

Reynolds, Sands G. New York, N.Y., w. ca. 1809–10. *See also* David Brientnall and Sands G. Reynolds.

Rhein, H(enry?) L. Reading, Pa., ca. 1840. Poss. owner.

Rhine, Henry B. 1795. Baltimore, Md. Appr. to Jacob Williams, 1806.

Ricarts, John B. ca. 1788. Baltimore, Md. Appr. to William Snuggrass, 1807.

Rice, John B. ca. 1805. Corydon, Ind., w. 1836–ca. 1838. *See also* John Rice and John D. Peter.

Rice, John, and Peter, John D. Corydon, Ind., w. ca. 1838.

Rice, John Flavel B. 1792. Sterling, Mass., w. 1825–45.

Rice, W. Poss. New England, 1790s. Poss. owner; poss. William Rice, ship captain and merchant, Portsmouth, N.H.

Rich, John Fayetteville, N.C. Appr. to James Beggs, 1799.

Rich, Solomon M. 1828, d. 1848. Searsburg, Vt., w. 1840–45.

Richards, Samuel E Pennsylvania or Maryland, w. ca. 1805–ca. 1820.

Richardson, Elisha 1743–98. Franklin, Mass., w. 1770–ca. 1797. Mstr. to Luther Metcalf, 1770–78.

Richardson, H. Norfolk, Va., w. 1793. Dealer.

Richardson, John Louisa Co., Va., w. 1769 and poss. later.

Richmond, George A. Philadelphia, Pa., w. 1836; New Castle Co., Del., w. 1841. Mstr. to James Anderson, 1841.

Richmonde, (?) Reported as Philadelphia woodworker, 1763. Both name and Windsor craftsmanship doubtful.

Riddle, Charles Richardson B. 1786. Baltimore, Md., w. 1810. Appr. to William Snuggrass, 1803.

Rigby, Alexander D. ca. 1804–5. Baltimore, Md., w. 1802–4. Mstr. to Michael Stietz, 1804; Samuel Taskey, 1802.

Riggor (Rigour), Henry (Harry) Delaware Twp., Delaware Co., Oh., w. 1820.

Riheldaffer, William Wheeling, W. Va., w. 1851.

Riley, Charles S. D. 1842. Philadelphia, Pa., w. 1813–24, 1830–42. *See also* Josiah Sharp and Charles S. Riley.

Riley, George B. ca. 1784. Baltimore, Md. Appr. to Godfrey Cole, 1801.

Riley, Joseph B. 1770s. New York, N.Y., w. 1800–1825, 1830–55. Dealer from 1830. *See also* Joseph Riley and John Ormond.

Riley, Joseph, and Ormond, John New York, N.Y., w. 1800–1801.

Riley, Mary Wilmington, Del., w. 1832–59. Widow of Samuel Riley.

Riley, Samuel D. 1832. Wilmington, Del., w. 1811–32. Mstr. to David Matlock, 1831. Husband of Mary Riley. *See also* Samuel Riley and John Robinson.

Riley, Samuel, and Robinson, John Wilmington, Del., w. 1811.

Riley, Thomas B. 1818. Princeton, Mass., w. 1850. Prob. w. as jnyman.

Rise, Peter Philadelphia, Pa. Appr. to Lawrence Allwine, 1794.

Rising Sun Chair Manufactory *See* William H. Mapes.

Roach, John New York, N.Y. Appr. to John Karnes, 1799.

Robb, James W. Wheeling, W. Va., w. 1828–51. *See also* Robb and Morrison.

Robb, James W., and Morrison, (?) Wheeling, W. Va., w. 1828.

Robbins, Philemon F. Hartford, Conn., w. 1833–1870s. *See also* Robbins and Winship; Isaac Wright and Co.

Robbins, Philemon F., and Winship, Joseph Hartford, Conn., w. 1838–1870s.

Roberts, Richard Raleigh, N.C., w. 1819. Dealer.

Roberts, S. New Mills (now Pemberton), N.J., w. 1800s–1810s.

Roberts, Samuel. Robertsville, Colebrook Twp., Litchfield Co., Conn., w. ca. 1835–39. *See also* Rufus Holmes and Samuel Roberts.

Robertson, Elias 1819–95. Newark, N.J., w. 1838–41 and later. Jnyman. to David Alling.

Robertson, John Washington, D.C. Appr. to Albin Coates, 1818.

Robey, John Tenley Georgetown, D.C. Appr. to John Bridges, 1815.

Robinson, Augustus Salisbury, N.C. Appr. to William R. Hughes, 1830.

Robinson, Charles C. D. 1825. Philadelphia, Pa., w. 1809–25.

Robinson, Charles T. (and Co.) Ca. 1808–78, m. 1831. Rochester, N.Y., w. ca. 1831–78. Brother of Oliver H. Robinson. *See also* Oliver H. Robinson and Charles T. Robinson.

Robinson, Elihu D. 1863. Augusta, Me., w. ca. 1828–39 and later. *See also* Jepheth Beale and Elihu Robinson.

Robinson, George W. Baltimore, Md., w. 1840–43. *See also* Tucker and Robinson.

Robinson, John Wilmington, Del., w. 1811–ca. 1814; prob. Christiana Hundred, New Castle Co., Del., w. 1821. *See also* Samuel Riley and John Robinson; John(?) Robinson and (?) Gwynn.

Robinson, John Butler Philadelphia, Pa., w. 1840–42, 1849, 1853–58; prob. Earl Twp., Lancaster Co., Pa., w. 1847–49. Proprietor of Great Western Chair Manufactory, 1855 and prob. later.

Robinson, John R. (and Son) Baltimore, Md., w. 1812–45. Mstr. to J. Risden Downey, Jr., 1813; Jacob Skillman, 1819.

Robinson, Joseph Harrisburg, Pa., w. 1809–13.

Robinson, Oliver H. Rochester, N.Y., w. 1838–59. Brother of Charles T. Robinson. *See also* Oliver H. Robinson and Charles T. Robinson.

Robinson, Oliver H., and Robinson, Charles T. Rochester, N.Y., w. 1842.

Robinson, (prob. John), and Gwynn, (?) Wilmington, Del., w. 1814.

Rockwell, Thomas Hawley 1775–1865, m. 1800. Ridgefield, Conn., w. 1799–1859.

Rodgers, William Ashtabula, Oh., w. 1824.

Rogers, George Whitefield 1770–1847. Newburyport, Mass., w. bef. 1800; Concord, N.H., w. 1800–1819.

Rogers, Nelson Lawrenceburgh, Ind., w. 1831.

Rogers, William Prob. d. 1812. Hartland, Vt., w. 1802–ca. 1812.

Roll, Jacob C. 1782–1849; Essex Co., N.J., m. 1810. Cincinnati, Oh., w. ca. 1814–21, 1829–46. *See also* Deeds and Roll.

Rooker, Samuel S. B. ca. 1800. Indianapolis, Ind., w. 1821–28, 1835; Logansport, Ind., w. 1830. *See also* Grace and Rooker.

Roper, Lucien Sterling, Mass., w. 1830–40.

Rose, Ebenezer Prout 1784–1836, m. 1811. Trenton, N.J., w. 1807–19 and prob. later.

Rose, Elihu New York, N.Y., w. 1816–ca. 1832. Gilder later. *See also* Elihu Rose and Richard Hadley; Nathaniel S. Rose and Elihu Rose.

Rose, Elihu, and Hadley, Richard New York, N.Y., w. 1830.

Rose, Nathaniel S. New York, N.Y., w. 1816–29. *See also* Nathaniel S. Rose and Elihu Rose; Nathaniel S. Rose and Reuben B. Sykes.

Rose, Nathaniel S., and Rose, Elihu New York, N.Y., w. 1816–19.

Rose, Nathaniel S., and Sykes, Reuben B. New York, N.Y., w. 1827.

Rose, Westal Bennington, Vt., w. 1839–41.

Rose, William D. 1863. Ocean Co., N.J., btwn. Prospertown and Archertown, w. 1850 and prob. earlier and later.

Roseman, Joseph B. ca. 1793. Pittsburgh, Pa., w. 1815; Vincennes, Ind., w. 1819–20.

Ross, Arad Lynde B. 1800. Prob. Sterling, Mass., w. 1825. Poss. turner only.

Ross, Daniel D. 1854. Ipswich, Mass., w. 1781–1805. Made few Windsors.

Ross, James, and Chesnut, Jared Wilmington, Del., w. 1804.

Ross, John B. ca. 1776. Baltimore, Md. Appr. to Godfrey Cole, ca. 1789.

Ross, Lewis B. 1796. Sterling, Mass., w. 1821–26.

Ross, Peter B. 1783. Sterling, Mass., w. 1820–50.

Ross, William B. Baltimore, Md., w. 1829. *See also* Gill and Ross.

Ross, William H. Cincinnati, Oh., w. 1830–46. *See also* Kerr, Ross, and Geyer; William H. Ross and John Geyer.

Ross, William H., and Geyer, John Cincinnati, Oh., w. ca. 1833–ca. 1845. Successors to Kerr, Ross, and Geyer; business continued as Western Chair Manufactory.

Roswell, (?) St. Clair Twp., Butler Co., Oh., w. 1820.

Rote, George F. Lancaster, Pa., w. ca. 1836–60.

Rounds, (Moses or Mark) Buxton, Me., w. 1820s.

Rowe, A. Prob. NE New England, ca. 1800. Prob. owner.

Rowe, Michael Frederick, Md. Appr. to Thomas Newens, 1813–14.

Rowland, M. Prob. S New England, ca. 1795–1805. Poss. owner.

Rowley, Edward Area New Lisbon, Otsego Co., N.Y., w. 1821.

Rowzee, William Salisbury, N.C., w. 1834–38. Mstr. to Wilson Rowzee, 1836.

Rowzee, Wilson Salisbury, N.C. Appr. to William Rowzee, 1836.

Royster, Jethro Granville Co., N.C. Appr. to David Ruth, Sr., 1793.

Ructiarra, Peter New Orleans, La., w. 1811.

Rudisill, John Jackson, Tenn., w. 1830. Dealer.

Rudy, Henry Gottlieb 1781–1818. Area Lititz, Pa., w. 1800s–1810s. Poss. mkr. of chair branded with initials *HGR* for Moravian congregation at Lititz.

Rugg, Elisha Keene, N.H., w. 1808–10. *See also* Wilder, Rugg and Co.

Ruker (Ricker), James B. ca. 1790/1. Baltimore, Md. Appr. to Jacob Williams, 1798–1810. Br. of John Ruker, Jr.

Ruker, John, Jr. B. 1787. Baltimore, Md. Appr. to Jacob Williams, 1798–1802; William Snuggrass, 1802. Br. of James Ruker.

Russell, Andrew B. ca 1788. Baltimore, Md. Appr. to Caleb Hannah, 1805.

Russell, Barzilla (Barzillai, Brazilla) Brooklyn, N.Y., w. 1831–46, 1852–56. *See also* Barzilla Russell and Joseph S. Weeks.

Russell, Barzilla, and Weeks, Joseph S. Brooklyn, N.Y., w. 1832.

Russell, David Winchester, Va., w. 1796–1806.

Russell, John Nashville, Tenn., w. 1805. *See also* Bakem and Russell.

Russell, Jonathan D. 1800/1. Petersburg, Va., w. 1793–ca. 1800.

Russell, Joseph B. Area Laurens, Otsego Co., N.Y., w. 1841–42.

Russell, William, Jr. 1765–1833. New Bedford, Mass., w. ca. 1790–1833. Some records cannot be separated from those of William Russell, Sr. *See also* William Russell, Jr., and William Bates; William Russell, Jr., George Reynolds, and Courtlandt Charlot.

Russell, William, Jr., and Bates, William New Bedford, Mass., w. 1804.

Russell, William, Jr., Reynolds, George, and Charlot, Courtlandt New Bedford, Mass., w. 1823.

Russell, William, Sr. Prob. d. aft. 1820. New Bedford, Mass., w. ca. 1784–ca. 1820. Some records cannot be separated from those of William Russell, Jr.

Russell, William H. Petersburg, Va., w. ca. 1813–20. Cabtmkr. dealing in chairs.

Ruth, David, Jr. Raleigh, N.C., w. 1814–18 and poss. later; Fayetteville, N.C., w. 1822. Mstr. to William Wynn, 1822. *See also* Graves Matthews and David Ruth, Jr.; David Ruth, Sr., and Son.

Ruth, David, Sr. Granville Co., N.C., w. 1793–ca. 1802; Raleigh, N.C., w. 1802–ca. 1818. Mstr. to Charles Hut, 1794; Jethro Royster, 1793. Lost left hand in accident, 1810; state appointments as ranger and caretaker, 1818–20. *See also* David Ruth, Sr., and Son.

Ruth, David, Sr., and Son (David Ruth, Jr.) Raleigh, N.C., w. 1814–ca. 1818.

S., A. SE New England, ca. 1795–ca. 1805. Prob. owner.

S., C. A. Prob. SE New England, ca. 1795–1805. Prob. owner.

S., G. E Connecticut, ca. 1800. Poss. owner.

S., R. E Massachusetts or S New Hampshire, ca. 1810s. Prob. owner.

S., W. Pennsylvania or the South, 1830s or later. Poss. owner.

Safford, Thomas M. 1785–1865, m. 1806. Canterbury, Conn., w. 1807–48.

Sage, Francis Middletown, Conn., w. 1788.

Sage, Lewis Samuel 1765–1822, m. 1790. Middletown, Conn., w. 1790–91; Northampton, Mass., w. 1793–ca. 1816.

Salter, John Portsmouth, N.H., ca. late 1760s–1770s. Merchant-owner.

Saltonstall, Gurdon F. Fayetteville, N.C., w. 1790–ca. 1803; Wilmington, N.C., w. ca. 1805–21. Mstr. to Willoughby Jordan, 1799; James Miller, 1801.

Samler (Semler, Sambler), John New York, N.Y., w. 1791–94, 1800–1803, 1807–8.

Samory, Claude N. Charleston, S.C., w. 1816–17. Dealer.

Sample, J. (Joseph Sampsel?) Cent. Pennsylvania, w. ca. 1855–75.

Sanborn, Reuben Boston, Mass., w. 1796–1809.

Sanders, John Litchfield, Conn., w. 1800–1801, 1810.

Sanderson, William Philadelphia, Pa., w. 1837–39. *See also* John A. Stewart and William(?) Sanderson.

Sanford, Garwood 1793–1876, m. 1820. Litchfield, Conn., w. 1817–38 and prob. later. Also orn. ptr. *See also* Garwood Sanford and Elizur B. Smith.

Sanford, Garwood, and Smith, Elizur B. Litchfield, Conn., w. 1822.

Sanford (Sandford), Hector 1780–1837. Alexandria, Va., appr. 1792–ca. 1797; Georgetown, D.C., w. 1802–4; Chillicothe, Oh., w. 1805–ca. 1813 and poss. later. Appr. to Ephraim Evans, 1792–ca. 1797.

Sanford, (?) Branded name on Pennsylvania chair, 1790s. Prob. Nantucket, Mass., owner.

Sargent, Nathaniel M. B. ca. 1814. Sterling, Mass., w. 1840–50; Leyden Twp., Lewis Co., N.Y., w. 1855; Boonville, N.Y., w. 1860–71.

Sarle, R. Rhode Island, 1820s. Owner.

Saul, Joseph D. 1773. Philadelphia, Pa., w. 1746–67 and prob. later. Turner and spinning-wheel mkr.

Sawin, Reuben Heywood Gardner, Mass., w. 1826–ca. 1836; Fitzwilliam, N.H., w. 1836 and later. *See also* Sawin and Damon.

Sawin, Sullivan, Jr. Gardner, Mass., w. 1826–36 and later. *See also* Sawin and Damon.

Sawin, Sullivan, Sr. Gardner, Mass., w. 1826–ca. 1836; Fitzwilliam, N.H., w. 1836 and later. *See also* Sawin and Damon.

Sawin (Sullivan Sawin, Sr.; Sullivan Sawin, Jr.; Reuben Heywood Sawin) and Damon, John Gardner, Mass., w. 1826–ca. 1836; Fitzwilliam, N.H., w. 1836 and later (poss. without Sullivan Sawin, Jr.). Sullivan Sawin, Sr., fr. of Sullivan Sawin, Jr., and Reuben Heywood Sawin; fr.-in-law of John Damon. Firm produced turned "stuff" for chairs.

Sawyer, (?), or Sawyer and Brown, (?) Prob. upstate New York or N New England, ca. 1830. Windsor craftsmanship unconfirmed.

Saxton, (?) NW Vermont, w. ca. 1820s–1830s. Windsor craftsmanship unconfirmed.

Sayres, (?), and Donohoe, Joseph Eaton, Oh., w. 1839. Also orn. ptrs.

Scadin, Robert C. Cooperstown, N.Y., w. 1829–31.

Schafer, Samuel Hamilton, Oh., w. 1842.

Scherer, Samuel D. 1804. Richmond, Va., w. 1782–93. Moved to Hanover Co., Va., in 1796 or earlier.

Schroeder, Emanuel H. York, Pa., w. ca. late 1820s–1860 and prob. later. Orn. ptr.

Schroeder, John F. Lancaster, Pa., w. 1834–45 and prob. later. *See also* John F. Schroeder and (?) Widmyer.

Schroeder, John F., and Widmyer, (?) Lancaster, Pa., w. 1843.

Schroeder, Wilhelm (William) York, Pa., w. ca. late 1820s–1830s and prob. later.

Schumm (Shum), J. Berks Co., Pa., poss. Oley Valley, w. ca. 1815–25.

Schureman (Shureman), William J. D. ca. 1836. New York, N.Y., w. 1815–25.

Scibird, John S. Richmond, Ind., w. 1854 and prob. earlier.

Scott, Charles Ca. 1795–1851, m. 1819, 1843. Providence, R.I., w. 1819–30; Charleston, S.C., w. 1831, 1835–40; SE Massachusetts, w. 1840s.

Scott, Edward Boston, Mass., w. 1799–1803. *See also* Edward Scott and Josiah Willard.

Scott, Edward, and Willard, Josiah Boston, Mass., w. 1800–1803.

Scott, John D. 1808. Savannah, Ga., w. 1806–8. Dealer and cabtmkr.

Scott, John E. Louisville, Ky., w. 1843–ca. 1855.

Seal, T. C. Prob. E Pennsylvania, w. 1800s–ca. early 1810s.

Seaman, William H. Wheeling, W. Va., w. 1851.

Seaton, Leonard H. B. ca. 1783. Richmond, Va., appr. 1800, w. 1808–14, 1815–18, 1819; Petersburg, Va., w. 1814–15, 1818–20. Appr. to William Pointer, 1800. May have had shops in both places simultaneously. *See also* Hobday and Seaton; Leonard H. Seaton and James Barnes; Leonard H. Seaton and Graves Matthews.

Seaton, Leonard H., and Barnes, James Petersburg, Va., w. 1818–20.

Seaton, Leonard H., and Matthews, Graves Petersburg, Va., w. 1814–15.

Seaton, William Richmond, Va., w. 1819.

Seaver, William Boston, Mass., w. 1793–1837. *See also* Seaver and Frost.

Seaver, William, and Frost, James Boston, Mass., w. 1800–1803.

Seavey, S. F. SE New Hampshire, prob. Strafford Co., late 1810s–1820s. Prob. owner.

Sebastian, Michael B. 1782. Baltimore, Md. Appr. to Godfrey Cole, 1801.

Selden, C. Prob. New England, ca. 1800–1815. Poss. owner.

Sells, Abraham Zanesville, Oh., w. 1814.

Seney, Joshua, and Mills, John E. Chillicothe, Oh., w. 1838–ca. 1844.

Sewell, Thomas H. B. 1804. Baltimore, Md., w. 1829–37. Appr. to Gale March, 1817.

Shallcross, J. Louisville, Ky., w. 1819–20.

Sharp, Jonah Philadelphia, Pa., w. 1825–33.

Sharp, Josiah Prob. m. 1801. Philadelphia, Pa., w. 1802–5, 1811–24. *See also* Josiah Sharp and Charles S. Riley.

Sharp, Josiah, and Riley, Charles S. Philadelphia, Pa., w. 1814.

Sharpless, Abraham 1748–1835. SE Pennsylvania, ca. 1800. Owner.

Sharpless, Benjamin Poss. Bridgton, N.J., or Philadelphia, Pa., w. ca. 1760s–1770s. Windsor craftsmanship unconfirmed.

Shaw, Alexander Ca. 1780–1828, m. 1801. Philadelphia, Pa., w. 1801–14. Called cabtmkr.; Windsor craftsmanship unconfirmed.

Shaw, Elisha Lincoln Co., N.C. Appr. to Obed Parrish, 1833.

Shaw, (?), and Holmes, (?) Frankfort, Ky., w. 1807.

Sheed, John Cincinnati, Oh., w. 1829–31.

Sheldon, Ira D. 1830. North Adams, Mass., w. 1827–ca. 1830.

Shelly, D. E Pennsylvania, poss. Lehigh or Northampton cos., w. ca. 1800–1835. Spinning-wheel mkr.

Shelton, Samuel E. Raleigh, N.C., w. 1819; Greensboro, N.C., w. 1825–28. Mstr. to John Humphreys, 1825. See also Robert G. Williamson and Samuel E. Shelton.

Sheneman, Joseph 1805–75. W. Pikeland Twp., Chester Co., Pa., w. ca. 1830s. Windsor craftsmanship unconfirmed.

Shepard, Daniel A. Cleveland, Oh., w. 1835–53.

Shepard, Edward 1783–1862, m. 1807. Wethersfield, Conn., w. 1803–35 and later.

Shepherd, Henry Chillicothe, Oh., w. 1833–35.

Sheppard, C. SE Pennsylvania, 1800s–early 1810s. Poss. owner.

Sherald (Sharald), Josiah M. 1762. Philadelphia, Pa., w. 1758–ca. 1778.

Sheridan, John J. Charleston, S.C., w. 1825–32 and prob. later.

Sherwood, B. Nashville, Tenn., w. 1823–24. See also Sherwood and Dodd.

Sherwood, B., and Dodd, B. Nashville, Tenn., w. 1823–24.

Shield, William B. 1798. Baltimore, Md. Appr. to John Finlay, 1815.

Shields, A. Prob. western Virginia, 1800s. Owner; resident of Lexington, Va.

Shipman, Henry Titus 1782–1838, m. 1805; b. Saybrook, Conn. Coxsackie, N.Y., w. ca. 1805–10 and prob. later; poss. Chenango, Broome Co., N.Y., w. 1820, 1830. Nephew of William Shipman.

Shipman, William 1752–1824; b. Saybrook, Conn. Middletown, Conn., w. 1787, 1790; Hadley, Mass., w. 1788, 1794 and later. Uncle of Henry Titus Shipman.

Shockley, Lemuel Milford, Del. Appr. to Purnell Hall, 1830.

Shorey, Stephen Ca. 1808–79. Rochester, N.H., w. 1845–62.

Shove, Abraham Bristol Co., Mass., at Berkley, w. 1804; Freetown, w. ca. 1805–16 and later; Somerset, w. 1821–35.

Shove, Theophilus D. 1856. Berkley, Bristol Co., Mass., w. ca. 1790–ca. 1832.

Shreader (Schroeder), I. (prob. John) Cent. Pennsylvania, prob. York, w. 1800s.

Shryock, Matthias 1774–1833. Lexington, Ky., w. 1800s. Windsor craftsmanship unconfirmed.

Shugart, Zachariah Hagerstown, Md., w. 1812.

Shurlot (Sharlott, Charlotte), Samuel New York, N.Y., w. 1798–1817.

Shutt, Augustus P. Baltimore, Md., w. 1840–43.

Sibley, Joseph Lower Stewiacke, Nova Scotia, Canada, w. 1830.

Sibley, Solomon 1769–1856. Auburn (Ward) and Sutton, Mass., w. 1793–1840.

Sickler, W. C. Poss. Pennsylvania, ca. 1820s–1850s. Windsor craftsmanship unconfirmed.

Sieger, Reuben F. Hanover Twp., Lehigh Co., Pa., w. ca. 1850–60 and prob. later.

Sill, Thomas, Sr. 1776–1826, m. 1800. Middletown, Conn., w. 1799–1824. Fr. of Thomas Henry Sill.

Sill, Thomas Henry (Hervey?) 1801–38. Middletown, Conn., w. 1825–ca. 1838. Son of Thomas Sill, Sr.

Simmons, George W. Harrisburg, Pa., w. 1839–45.

Simms, Isaac P. Connecticut–Rhode Island border region, ca. 1800. Later owner.

Simms, John W. Franklin, Tenn. Appr. to William D. Taylor, 1823.

Simonson, John Baltimore, Md., w. 1809–49 and poss. 1860. Mstr. to Robert Frederick, 1812; Samuel Hawkins, 1815; William Keener, 1809; Thomas Lusby, 1816; James McDormick, 1809; Michael Patterson, 1822.

Simpson, Robert G. Nashville, Tenn., w. 1808.

Singer, George Pittsburgh, Pa., w. 1837–59.

Sink (Sinck), Lawrence D. 1828. Philadelphia, Pa., w. 1794–1824. Called cabtmkr.; Windsor craftsmanship unconfirmed.

Sisson, Benjamin Franklin 1811–84, m. 1838. North Stonington, Conn., w. 1834–40 and later. Son of Gilbert Sisson.

Sisson, Gilbert 1769–1840, m. 1791. Bozrah Twp., New London Co., Conn., w. 1795; North Stonington, Conn., w. ca. 1800–1823, 1825–40; Cooperstown, N.Y., w. 1823–25. Fr. of Benjamin Franklin Sisson. See also Isaac Lewis and Gilbert Sisson.

Sites, George F. D. 1858. Philadelphia, Pa., w. 1833–58.

Sizer, Isaac Sheffield B. 1801, m. 1822. New London, Conn., w. 1822–23.

Skellorn (Skilleron), George W. B. ca. 1775. New York, N.Y., w. 1796–1828. Mstr. to Richard Tweed, (Sr.), n.d.; Alexander Welsh, n.d. See also Skellorn and Durborow.

Skellorn, George, and Durborow, Joseph, Jr. New York, N.Y., w. 1812.

Skillen, John, and Skillen, Simeon, Jr. Boston, Mass., w. 1785–86. Carvers who sold Windsors.

Skillman, Jacob B. 1799. Baltimore, Md. Appr. to John R. Robinson, 1819.

Skinner, Corson C. B. ca. 1802. Cincinnati, Oh., w. ca. 1825–33; Peru, Ind., w. 1850. Br. of Philip Skinner. See also Philip Skinner and Corson C. Skinner.

Skinner, Horace Ca. 1794–1848, m. 1828. Middletown, Conn., w. 1822–23.

Skinner, Philip Cincinnati, Oh., w. 1822–37. Br. of Corson C. Skinner. See also Isaac M. Lee and Philip Skinner; Philip Skinner and Thomas Keyes; Philip Skinner and Corson C. Skinner.

Skinner, Philip, and Keyes, Thomas Cincinnati, Oh., w. 1836–37.

Skinner, Philip, and Skinner, Corson C. Cincinnati, Oh., w. 1826–32.

Slack, Joseph B. 1820–57. Franklin Twp., Hunterdon Co., N.J., w. 1850.

Slade, Frederick 1777–1800. Nantucket, Mass., w. 1799. Died at sea.

Sloan, George Greensburg, Pa. Appr. to Joseph Herwick, 1810.

Sloss, J. A. Pennsylvania or the South, w. 1850s–1870s.

Small, Isaac Newport, R.I., w. 1803.

Smedley, (?) E Pennsylvania or Delaware Valley, 1800s. Prob. owner.

Smiley, Dean M. Hallowell, Me., w. 1822–25.

Smiley, Jonathan Vincennes, Ind., w. 1837.

Smith, Archibald B. ca. 1798. Fayetteville, N.C., w. 1820–25. Appr. to Neal Graham, 1815.

Smith, Asher Litchfield, Conn., w. 1805–9.

Smith, B. W. Toronto, Canada, w. ca. 1828–31. See also Judah Monis Lawrence and B. W. Smith.

Smith, Burrows D. 1824. Cincinnati, Oh., w. 1807–24.

Smith, Carman 1801–77. Huntington, L.I., N.Y., w. 1826–28. Mstr. to George De La Hunt, 1828.

Smith, Christopher 1779–1853. Cincinnati, Oh., w. 1806–53.

Smith, Elihu B. B. 1768, m. 1788, 1798. East Haddam, Conn., w. ca. 1791–95; Lyme, Conn., w. 1798–1810 and prob. later.

Smith, Elizur B. Litchfield, Conn., w. 1822. See also Garwood Sanford and Elizur B. Smith.

Smith, G. Prob. New England or New York state, w. 1820s. Roll-top chair with this brand found in Canada.

Smith, George W. 1818–90. Norwich, Conn., w. 1837–46 and prob. later.

Smith, Hugh Mill Creek Hundred, New Castle Co., Del., w. 1806. Spinning-wheel mkr.

Smith, I. Prob. E Massachusetts or S New Hampshire, w. 1800s.

Smith, Isaac Winchester, Va., w. 1803.

Smith, Jacob New York, N.Y., w. 1817–19, 1829. Prob. not same Jacob Smith w. earlier as rush-bottom-chair mkr. *See also* Richard Cornwell and Jacob Smith.

Smith, John New York, N.Y., w. 1795–1804.

Smith, John, Jr. New York, N.Y., w. 1810–31.

Smith, John H. Cincinnati, Oh., w. 1811–12.

Smith, John N., and Brown, Archer Petersburg, Va., w. 1805.

Smith, Joseph New York, N.Y. Appr. to Thomas Timpson, 1793.

Smith, Lasker Wythe Co., Va., w. 1820.

Smith, Mial (Myles?) Providence, R.I., w. 1803–4.

Smith, Nathan Ridgefield, Conn., w. 1786–95.

Smith, Nathaniel Ca. 1792–1817. Marietta, Oh., w. 1815–17.

Smith, Richard Searsburg, Vt., w. 1841.

Smith, Richard R. Bath, Me., w. 1828. Prob. dealer.

Smith, Robert Chatham, Ont., Canada, w. 1846.

Smith, S. J. Lafayette, Ind., w. 1839–40. *See also* S. J. Smith and (?) Kelley.

Smith, S. J., and Kelley, (?) Lafayette, Ind., w. 1840.

Smith, Simon D. 1837. Troy, N.Y., w. 1809–ca. 1837 and prob. earlier. Employed Allen Holcomb 1809–10.

Smith, Thomas Philadelphia, Pa., w. 1818.

Smith, Thomas M. Philadelphia, Pa., w. 1831–40; W. Chester, Pa., w. 1842.

Smith, W. Prob. E Massachusetts or S New Hampshire, w. 1820s.

Smith, William Philadelphia, Pa., w. 1802–4.

Smith, William V. Brooklyn, N.Y., w. 1826 and prob. later. Known to Lambert Hitchcock, who during market survey of West (1835) found Smith in the grocery business in Chicago.

Smith, (prob. O. P. or W. H.), and Wilson, (prob. J. R. or William) Wooster, Oh., w. 1840.

Snowden, Benjamin D. 1869. Philadelphia, Pa., w. 1829–69.

Snowden, Jedidiah D. 1799. Philadelphia, Pa., w. 1749–ca. 1776. Returned to cabtmkg. trade sometime aft. Revolution; prob. gave up Windsor-chair mkg.

Snowden, William Philadelphia, Pa. Appr. to John Wall, 1817.

Snuggrass (Snodgrass), William Baltimore, Md., w. 1798–1807 and poss. later. Mstr. to Daniel Donevan, 1799; John Grigory, 1798; John Pawley, 1807–10; Charles Richardson Riddle, 1803; John Ruker, 1802; John Travilitt, 1807.

Snyder, Adam Philadelphia, Pa., w. 1798–ca. 1836. Jnyman. to David Lake, Jr., ca. 1824–25. *See also* John Wall and Adam(?) Snyder.

Snyder, Samuel B. 1800. Baltimore, Md. Appr. to Matthew McColm, 1816.

Snyder, William Philadelphia, Pa., w. 1793–1801.

Snyder, William F. 1845–1921. Mifflintown, Pa., w. ca. 1865 and later. Business also known as Mifflintown Chair Works from 1870s.

Solomon, John 1774–1840. New Berlin, Pa., w. ca. 1800–ca. 1840.

Somerby, Abiel Portland, Me., w. 1823–41. Princ. orn. ptr.

Soran, John Baltimore, Md., w. 1829–60.

Southmayd, John Bulkley 1794–1870, m. 1815. Middletown, Conn., w. 1821–24, 1830 and later; area Northfield, Vt., 1827–28.

Spade, William Philadelphia, Pa., appr. 1800–ca. 1806, w. 1810. Appr. to William Cox, 1800–ca. 1806. Poss. w. as jnyman. in 1810.

Spalding, J. W. Norwich, Conn., w. 1826. *See also* J. W.(?) Spalding and (?) Allen.

Spalding, (poss. J. W.), and Allen, (?) Norwich, Conn., w. 1826.

Spang, Daniel Reading, Pa., w. 1840s.

Sparks, Joel B. Baltimore, Md. Appr. to Benjamin Blakiston, 1818.

Spaulding, Phineas B., and Evans, (?) Fitchburg, Mass., w. 1839. Poss. dealers only.

Spaulding, Zadock Hartland and Windsor, Vt., w. 1813–19. Worked in shop of Thomas Boynton.

Spears, George W. Concord, Cabarrus Co., N.C., w. 1827.

Specht, Aaron 1815–75. Beavertown, Pa., w. 1830s and later.

Speers (Spearce, Speirs), John New York, N.Y., w. 1795–1800.

Spencer, J. Francis, and Coles, William Springfield, Oh., w. 1833.

Spooner, Alden 1784–1877, m. 1820. Athol, Mass., w. ca. 1807–32. Princ. cabtmkr. *See also* Spooner and Fitts; Spooner and Thayer.

Spooner, Alden, and Fitts, George (1785–1866; m. 1809, 1815). Athol, Mass., w. 1808–13. Fitts, cabtmkr. and goldsmith, probably never made Windsor chairs outside partnership.

Spooner, Alden, and Thayer, (prob. Jesse) Athol, Mass., ca. 1813–14.

Sprague, Nathaniel 1795–1845, m. ca. 1820. Zanesville, Oh., w. ca. 1820–23; McConnelsville, Oh., w. ca. 1827–1830s.

Spriner (Springer?), I. Prob. E Pennsylvania or Delaware Valley, w. 1790s.

Spring, (?), and Haskell, (?) Hiram, Me., w. ca. late 1820s–1830s.

Sprosen, John M. 1785. Philadelphia, Pa., w. 1783–86; New York, N.Y., w. 1789–98. *See also* Sprosen and Marsh.

Sprosen, John, and Marsh, (prob. Charles) New York, N.Y., w. 1798.

Spurling, James Georgetown, D.C. Appr. to John Bridges and Son, 1812.

Squires, Buckley 1791–1860, m. 1814. Bennington, Vt., w. ca 1818–32 and prob. later.

Squires, Douglas, and Co. (with L. Bradley in 1834) Norwalk, Oh., w. 1834–42.

Stackhouse, David Prob. m. 1789. Philadelphia, Pa., appr. 1772; prob. Falls Twp., Bucks Co., Pa., w. early 1780s, 1809–18; prob. Buckingham Twp., Bucks Co., Pa., w. 1787–89 and prob. earlier and later; prob. Middletown Twp., Bucks Co., Pa., w. by 1800–1809; poss. New Garden Twp., Chester Co., Pa., w. 1818 and later. Appr. to Joseph Henzey, 1772.

Stackhouse, Stacy M. 1775. New York, N.Y., w. 1775; Hartford, Conn., w. 1784–ca. 1795; Claverack, N.Y., w. 1795–1800 and poss. later.

Stafford, Theodore Charleston, S.C., w. 1798–1802. *See also* Humeston and Stafford.

Stalcup, Israel Wilmington, Del., w. 1798–1801.

Stanton, Elijah B. ca. 1820. Conway, N.H., w. 1842–52 and poss. later.

Stanyon, John Concord, N.H., and area, w. 1811–ca. 1820 and poss. later.

Starr, Frederick Rochester, N.Y., w. 1827–ca. 1854.

Starr, Samuel Middletown, Conn., w. 1821–24; Rochester, N.Y., w. 1827, 1842–46.

Stayton, David H. Camden, Del., w. 1802–59. Mstr. to Joshua Adams, 1835; Alexander Dill, 1832; William Dulin, 1841; Abraham Hopkinson, 1843; Henry Lockwood, 1830; James Mason, 1832.

Steel, Anthony D. 1817. Philadelphia, Pa., w. 1790–1817.

Steel, Daniel Hagerstown, Md. Appr. to John Bradshaw, 1817–18.

Steel, Elizabeth (Mrs.) Philadelphia, Pa., w. 1817. Sold off shop stock of deceased husband, Anthony Steel.

Steele, Albert J. B. ca. 1812. Humphreysville, near Derby, Conn., w. ca. 1840–50 and prob. earlier and later.

Steel(e), Thomas B. 1790. Baltimore, Md., appr. 1806; poss. Philadelphia, Pa., w. 1814–20. Appr. to Matthew McColm, 1806.

Steen, Isaiah W. Caln Twp., Chester Co., Pa., w. 1796; Washington, Pa., w. 1800–1820 and poss. earlier and later. *See also* Collins and Co.

Steever, Daniel, Jr. Philadelphia, Pa., w. 1810–14.

Stephens, George Mishawaka, Ind., w. 1838.

Stephenson (Stevenson), A. J. Sangerville, Me., w. 1840 and prob. earlier and later.

Sterling, Gasford Ca. 1800–1850, m. 1834, 1841. Bridgeport, Conn., w. 1843–47 and prob. earlier and later. *See also* Gasford Sterling and Fenelon Hubbell.

Sterling, Gasford, and Hubbell, Fenelon Bridgeport, Conn., w. 1843–47.

Sterling (Starling, Stirling), Thomas B. ca. 1789. Baltimore, Md., w. 1814–23. Appr. to Absalom Chrisfield, 1805.

Sterrett, John T. Philadelphia, Pa., w. 1839–48. *See also* John D. Johnson and John T. Sterrett.

Stetson, Calvin D. ca. 1860. Barnstable, Mass., w. 1843–57 and prob. earlier.

Stevenson, Ephraim B. ca. 1778. Baltimore, Md. Appr. to Caleb Hannah, 1795.

Stevenson, J. W. Fremont (Lower Sandusky), Oh., w. 1846–56. Manufacturer and dealer.

Stewart, Daniel 1786–1827. Farmington, Me., w. ca. 1812–27.

Stewart, David Philadelphia, Pa., w. 1797.

Stewart, E. C. Cadiz, Oh., w. 1845 and prob. earlier.

Stewart, Edwin R. New York, N.Y., w. 1840–49. *See also* Calvin R. Wilder and Edwin R. Stewart.

Stewart, John A. Philadelphia, Pa., w. 1816–40. *See also* John A. Stewart and Charles W. James; John A. Stewart and William(?) Sanderson.

Stewart, John A., and James, Charles W. Philadelphia, Pa., w. 1826–29.

Stewart, John A., and Sanderson, William(?) Philadelphia, Pa., w. 1835–40.

Stewart, William Henry Philadelphia, Pa., w. 1809–36. *See also* Haydon and Stewart.

Stibbs, Samuel P. New York, N.Y., w. 1802–14; Cincinnati, Oh., w. 1816–57. *See also* Stibbs and Stout.

Stibbs, Samuel P., and Stout, Jonathan Cincinnati, Oh., w. 1816–17.

Stickney, Daniel Putnam (now part of Zanesville), Oh., w. 1816–ca. 1820.

Stickney, Samuel 1771–1859, m. 1794. Beverly, Mass., w. mid 1790s–1832 and later.

Stidham, Peter Wilmington, Del. Appr. to Jared Chesnut, 1831.

Stietz, Michael B. 1787. Baltimore, Md. Appr. to Joseph Keens, bef. 1804; Alexander Rigby, 1804.

Stillman, Levi 1791–1871. Springfield, Mass., w. 1813–14; New Haven, Conn., w. 1815–34. *See also* Stillman and Bliss.

Stillman, Levi, and Bliss, Seth Springfield, Mass., w. 1813–14; New Haven, Conn., w. ca. 1815–18.

Stillman, (poss. Levi), Lines, (?), and Perry, (?) New Haven, Conn., w. 1835.

Stilwell, William Ballston Spa, N.Y., w. ca. 1800–1804 and prob. later. *See also* Stilwell and Minor.

Stilwell, William, and Minor, (?) Ballston Spa., N.Y., w. 1804.

Stimson, G. New England, 1820s. Owner.

Stocking, Anson 1786–1857, m. 1810, 1825. Waterbury, Conn., w. ca. 1808–14, 1825–ca. 1830; Litchfield, Conn., w. 1815; prob. Goshen, Conn., w. 1816–20; Torrington, Conn., poss. w. 1830s and later.

Stogton, James Watson Haycock Twp., Bucks Co., Pa. Appr. to John Ackerman, 1812.

Stokes, John M. (and Son) Louisville, Ky., w. 1832–59. *See also* James Ward and John M. Stokes.

Stone, Ebenezer 1763–1800 or earlier, m. 1795. Boston, Mass., w. 1786–87; Charlestown, Mass., w. aft. 1787–ca. late 1790s.

Stone, Isaac B. 1767, m. 1792. Rindge, N.H., w. ca. 1790–ca. 1805; Salem, Mass., w. ca. 1805–ca. 1815; Fitchburg, Mass., w. ca. 1815–20.

Stone, Joseph East Greenwich, R.I., w. 1788–98.

Stone, Nathaniel Poss. d. 1848. Prob. Watertown, Mass., w. 1800s.

Stoner (Steiner), Michael 1764–1810, m. 1791. Harrisburg, Pa., w. 1790–bef. 1798; Lancaster, Pa., w. bef. 1798–ca. 1810.

Stoner, William 1827–1919. McConnellsburg, Pa., w. ca. 1850s–1870s and prob. later.

Stout, Jonathan D. 1817. Cincinnati, Oh., w. 1816–17. *See also* Stibbs and Stout.

Stover, Mathias 1802–79. South Bend, Ind., w. 1838–ca. 1850.

Stow, John D. 1832. Philadelphia, Pa., w. 1779–1831. Princ. turner.

Strange, Josiah Jackson, Tenn., 1825–29. *See also* Sypert and Strange.

Stretcher, Joseph I. Indianapolis, Ind., w. 1836–ca. 1842.

Stripe, W(illiam?) Poss. Lake Twp., Stark Co., Oh., w. 1820; Canton, Oh., w. ca. 1820s–1830s.

Strong, Chauncey 1791–1882. Laurens, Otsego Co., N.Y., w. 1841–69.

Stuart, Benjamin (and Sons) 1793–1868. Sterling, Mass., w. ca. 1829–51 and prob. earlier and later.

Stuart (Stewart), Charles Pencader Hundred, New Castle Co., Del., w. 1789–90. Spinning-wheel mkr.

Stuart, Ebenezer B. 1825. Princeton, Mass., w. 1850. Prob. w. as jnyman.

Stuart, Joseph M. B. 1816. Princeton, Mass., w. ca. 1845–50.

Stuart, Levi D. 1875. Sterling, Mass., w. 1827–50 and prob. later.

Stuart, Ralph R. 1795–1872. Sterling, Mass., w. 1829–50 and prob. later.

Stuart, Samuel D. 1829. Sterling, Mass., w. 1820–28 and prob. earlier.

Stuber, Michael Bethlehem, Pa., and area, w. ca. 1840–1860s.

Studdart, Daniel Adair Co., Ky., w. 1817.

Sturdevant, John, Jr. M. 1782, d. 1825. New Milford, Conn., w. ca. 1782–1825 and prob. earlier. Father of John Sanford Sturdevant. Spinning-wheel mkr. and carriage mkr.

Sturdevant, John Sanford 1798–1874, m. 1824. New Milford, Conn., w. ca. 1824 and prob. earlier and later; prob. Albany, N.Y., w. 1830–32; prob.

Utica, N.Y., w. 1832. Son of John Sturdevant, Jr. Likely the purchaser at private sale of the "brand or stamp" listed in the estate of John Sturdevant, Jr., 1825; prob. also made spinning wheels.

Sturgis, James 1747–1822, m. 1765. Ridgefield, Conn., w. 1787–93 and prob. later.

Sully, Chester Norfolk, Va., w. 1805–ca. 1810, 1812, 1815–17 (lumber yard); Edenton, N.C., w. 1811; Richmond, Va., w. 1813, 1818 (lumber yard); Lynchburg, Va., w. 1814–15.

Suplee, T. E Pennsylvania, poss. Montgomery, Co., w. 1840s–1850s.

Sutton, Thomas Lexington, Ky. Appr. to James March, n.d.

Swain (Swayne), Timothy B. ca. 1791; poss. d. 1838 in Norwich, Conn. New London, Conn., w. 1812; New York, N.Y., w. 1816, 1826–31; Franklin, Tenn., w. 1820–22.

Swan, Elisha Prob. 1755–1807, m. 1778. Stonington, Conn., w. early 1790s–early 1800s.

Swan, Travers Onondaga, N.Y., w. 1820.

Swasy, William, and Dole, Henry Limerick, Me., w. 1830 and poss. earlier and later.

Sweeney, Richard Baltimore, Md., w. 1796–1837. Mstr. to Samuel Clark, 1802–6; William Clark, 1797; Jacob Daley, 1797; John Dempsey, 1799; James Hughes, 1796; Jacob Jacobs, 1802; Samuel Jones, 1801–6; Joseph Myers, 1822; John Threeby, 1799; Francis Younker, 1801.

Sweet, A. and C. Urbana, Oh., w. 1839.

Sweney, William West Chester, Pa., w. 1839–50.

Swift, R. Brand from New Bedford, Mass., area placed at later date on Delaware Valley or Philadelphia chairs of the 1800s.

Swift, R. W. Rhode Island, 1790s. Later owner.

Swift, Reuben Eldred 1780–1843, m. 1803. New Bedford, Mass., w. 1821–25. Br. of William Swift, Jr. Princ. cabtmkr.; w. earlier. *See also* Reuben Eldred Swift and William Swift, Jr.

Swift, Reuben Eldred, and Swift, William, Jr. New Bedford, Mass., w. 1821–25.

Swift, William, Jr. B. 1790. New Bedford, Mass., w. 1821–29. Br. of Reuben Eldred Swift. Dealer only, 1827–29; also cabtmkr. *See also* Reuben Eldred Swift and William Swift, Jr.; William Swift, Jr., and William Ottiwell.

Swift, William, Jr., and Ottiwell, William New Bedford, Mass., w. 1827–29. Cabtmkrs. dealing in chairs.

Swim, Job Philadelphia, Pa. Appr. to Lawrence Allwine, 1793.

Swint, John Lancaster, Pa., w. 1847–60 and poss. earlier and later.

Sypert, Stephen B. ca. 1797. Jackson, Tenn., w. 1825–29 and later, 1842–50 and prob. later. *See also* Sypert and Strange; Vick and Sypert.

Sypert, Stephen, and Strange, Josiah Jackson, Tenn., w. 1825–29.

T., R. Philadelphia, Pa., 1800s. Windsor craftsmanship doubtful; prob. owner.

Talcott, Nelson Nelson Twp. (area Nelson and Garrettsville), Portage Co., Oh., w. bef. 1837–48. Br.-in-law of Edwin Whiting. Prob. changed shop locations within area several times; also owned store.

Taskey, Samuel B. 1788. Baltimore, Md. Appr. to Alexander Rigby, 1802.

Taylor, George B. 1796. Baltimore, Md. Appr. to Thomas Renshaw, 1811.

Taylor, James Richmond, Va. Appr. to Robert McKim, 1813.

Taylor, John A. Wilmington, N.C., w. 1820. Dealer.

Taylor, Lewis B. ca. 1797. Lawrenceburg, Ind., w. 1830; Center Twp., Howard Co., Ind., w. 1850.

Taylor, N. SE New England, w. 1800s.

Taylor, Robert Philadelphia, Pa., w. ca. 1795–ca. 1821. Poss. same Robert Taylor who emigrated from England, ca. 1792; widow carried on business, 1822–23. See also Robert Taylor and Daniel King.

Taylor, Robert, and King, Daniel Philadelphia, Pa., w. 1799–1800.

Taylor, Stephen South Gardner, Mass., w. 1827–ca. 1840.

Taylor, Sylvester, Jr. Nelson Twp., Portage Co., Oh., w. 1838–44. See also Sylvester Taylor, Jr., and Edward Z. Brown.

Taylor, Sylvester, Jr., and Brown, Edward Z. Nelson Twp., Portage Co., Oh., w. 1838.

Taylor, Thomas Prob. East Greenwich, R.I., 1808–17.

Taylor, William D. B. ca. 1797. Franklin, Tenn., w. 1823–31 and prob. later. Mstr. to J. W. Simms, 1823. See also William D. Taylor and Jacob Everly.

Taylor, William D., and Everly, Jacob Franklin, Tenn., w. 1831.

Teese, Daniel D. 1836. Philadelphia, Pa., w. 1816–35. Employed Benjamin Parris as jnyman., 1820. Spinning-wheel mkr. See also Tyson and Teese.

Temple, Luther Montreal, Canada, w. 1830–49.

Terry, I. F. SE New England, 1790s. Prob. owner.

Thatcher, Jonas Wheeling, W.Va., w. 1839–bef. 1851. See also Jonas Thatcher and J.(?) Connelly; Jonas Thatcher and (?) Smith.

Thatcher, Jonas, and Connelly, (J.?) Wheeling, W.Va., w. ca. early 1840s or ca. late 1840s.

Thatcher, Jonas, and Smith, (?) Wheeling, W.Va., w. ca. late 1830s–ca. early 1840s.

Thatcher, Timothy D. 1833. Area Lee, Mass., w. 1811–22 and prob. later.

Thayer, A. SE New England, w. 1800s.

Thayer, Jesse Athol, Mass., w. 1813–14. See also Spooner and Thayer.

Thayer, Joseph Boston, Mass., w. 1833–35; Charlestown, Mass., w. 1836–38. Princ. orn. ptr.

Thayer, (?), and Jones, (?) E Massachusetts, poss. Worcester Co., w. 1810s.

Theodore, James Cincinnati, Oh., w. 1820.

Thomas, Jacob R. Uniontown, Md., w. 1814.

Thomas, John E. Uniontown, Md., w. 1814.

Thomas, Nathaniel Cummington, Mass., w. 1804 and poss. later.

Thomas, (?), and Williams, (?) Windsor craftsmanship unconfirmed.

Thompson, Gustavus B. 1800. Baltimore, Md. Appr. to Jacob Daley, 1816.

Thompson, Thomas Lancaster, Mass., w. 1820–26; poss. Sterling, Mass., w. 1810, 1830–40.

Thompson, Thomas Trumansburg, N.Y., w. 1835–37.

Thompson, Thomas Jefferson Baltimore, Md., w. 1831–40. Appr. to Matthew McColm, 1822.

Thompson, William M. 1799. Charleston, S.C., w. ca. 1799–1806. Also dealer.

Thompson, (?) Nashville, Tenn., w. 1830–31. See also (?) Thompson and (?) Drennen.

Thompson, (?), and Drennen, (?) Nashville, Tenn., w. 1830–31.

Thornburgh, Benjamin B. 1790. Baltimore, Md. Appr. to Caleb Hannah, 1807.

Thornton, William C. Urbana, Oh., w. 1818.

Threeby, John B. ca. 1783. Baltimore, Md. Appr. to Richard Sweeney, 1799.

Throop, Jonathan F. D. 1860. Norwich, Conn., w. 1823 and prob. later.

Thurston, Billie R. Area Cooperstown, N.Y., w. 1831.

Tiers (Teirs, Tierce), Daniel B. ca. 1777, Pennsylvania; m. 1801. York (now Toronto), Canada, w. ca. 1798–1808.

Tileston, William Windsor, Vt., w. 1814 and prob. earlier and later.

Tillou (Tilyou, Tillow), Peter (prob. Jr.) New York, N.Y., w. 1765–98. Mstr. to Christian Banta, 1793. Also turner.

Tillou (Tillyou, Telyan), Vincent D. 1807/8. New York, N.Y., w. 1747 (poss.), 1755–98. Also turner and rush-bottom-chair mkr. Son of Peter Tillou, Sr., who was prob. rush-bottom-chair mkr. only.

Tilton, Peter G. Easton, Pa., w. 1799–1802. Mstr. to William Landon, 1802.

Timpson, Cornelius New York, N.Y., w. 1792–1803. See also Cornelius Timpson and John Vangelder.

Timpson, Cornelius, and Vangelder, John New York, N.Y., w. sometime btwn. 1796 and 1801.

Timpson, Thomas New York, N.Y., w. 1785–1806. Mstr. to Joseph Smith, 1793. Princ. cabtmkr. See also Thomas Timpson and William Gillihen; Thomas Timpson and John(?) Gilmor.

Timpson, Thomas, and Gillihen, William New York, N.Y., w. 1785–86.

Timpson, Thomas, and Gilmor(e), (prob. John) New York, N.Y., w. 1793–94.

Tobey, D(aniel?) Poss. Frankfort, Me., 1822. Owner.

Todd, A. Middle Atlantic region, w. ca. 1780s.

Todd, James B. ca. 1795. Portland, Me., w. 1823–56. Also looking-glass mkr., gilder, and orn. ptr. See also James Todd and Samuel S. Beckett.

Todd, James, and Beckett, Samuel S. Portland, Me., w. 1834–48. Also looking-glass mkrs., gilders, and orn. ptrs.

Todd, (?), and McAllaster, Benjamin Newburyport, Mass., w. 1809.

om, Joseph Philadelphia, Pa. Appr. to Francis Trumble, 1771.

Tomlin, Enoch Philadelphia, Pa., w. 1823–43.

Tompkins, Squire (Squier) Ca. 1783–1847, m. 1808. Troy and Morristown, N.J., w. 1808–12 and prob. later.

Tooker, Benjamin J. Poss. m. 1820. Elizabeth, N.J., w. 1830–36. See also Benjamin J. Tooker and Abram Tooker.

Tooker, Benjamin J., and Tooker, Abram Elizabeth, N.J., w. 1835.

Tooker, Cornelius J. Fayetteville, N.C., w. 1820–24, poss. 1827–28; Raleigh, N.C., w. 1824–25 and poss. later. Mstr. to William Winn, 1823. Maintained ties with Fayetteville while in Raleigh.

Toppan, Stephen 1803–75. Dover, N.H., w. 1826–59 and later.

Tower, Levi D. 1869. Fitzwilliam, N.H., w. 1838–40. Windsor craftsmanship unconfirmed.

Town, S. Poss. Connecticut, w. 1790s. Windsor craftsmanship unconfirmed.

Townsend, Jacob St. John, New Brunswick, Canada, w. 1821–29.

Tracy, Ebenezer, Jr. 1780–1822. Lisbon Twp., New London Co., Conn., w. ca. 1801–ca. 1811; Windham, Conn., w. ca. 1811–22. Son of Ebenezer Tracy, Sr.; br. of Elijah Tracy and Frederick Tracy; br.-in-law of Amos Denison Allen; cousin of Stephen Tracy.

Tracy, Ebenezer, Sr. 1744–1803, m. 1765, 1792, 1800. Lisbon Twp., New London Co., Conn., w. ca. 1765–1803. Fr. of Ebenezer Tracy, Jr., Elijah Tracy, and Frederick Tracy; fr.-in-law of Amos Denison Allen; uncle of Stephen Tracy.

Tracy, Elijah 1766–bef. Feb. 1, 1807, m. 1788. Lisbon Twp., New London Co., Conn., w. ca. 1787–aft. Oct. 15, 1801; Clinton–Paris, Oneida Co., N.Y., poss. w. late 1801–ca. 1806. Son of Ebenezer Tracy, Sr.; br. of Ebenezer Tracy, Jr., and Frederick Tracy; br.-in-law of Amos Denison Allen; cousin of Stephen Tracy.

Tracy, Frederick 1792–1821, m. 1816. Windham, Conn., w. ca. 1813–21. Son of Ebenezer Tracy, Sr.; br. of Ebenezer Tracy, Jr., and Elijah Tracy; br.-in-law of Amos Denison Allen; cousin of Stephen Tracy.

Tracy, Stephen 1782–1866, m. 1804, 1817, 1830. Lisbon Twp., New London Co., Conn., w. ca. 1803–ca. 1811; Plainfield, N.H., w. ca. 1811–20; Cornish, N.H., w. 1820–poss. 1840s. Nephew of Ebenezer Tracy, Sr.; cousin of Ebenezer Tracy, Jr., Elijah Tracy, and Frederick Tracy.

Trask, George St. Louis, Mo., w. 1836–51. *See also* Lynch and Trask.

Travilitt, John B. 1796. Baltimore, Md. Appr. to William Snuggrass, 1807.

Treby, Isaac 1796–1863. New London, Conn., w. 1827. Orn. ptr.

Trigg, (?), and Chester, (?) Memphis, Tenn., w. 1838. Poss. dealers only.

Trotter, Benjamin 1699–1768, m. 1734. Philadelphia, Pa., w. ca. 1750s–1768.

Trovillo, J. and P. Pattonsburg, Botetourt Co., Va., w. 1820.

Trowbridge, Elisha Portland, Me., w. 1820s and later.

Trumble, Francis Ca. 1716–98, m. early 1740s, 1769. Philadelphia, Pa., w. ca. 1758–98. Mstr. to David Clark, 1773; John Gally, 1773; Joseph Tom, 1771; James Venall, 1773. *See also* Trumble and Burden.

Trumble, Francis, and Burden, Joseph Philadelphia, Pa., poss. w. ca. 1795–96.

Tuck(e), Joseph 1770–1800. Boston, Mass., w. 1795–98. Br.(?) of Samuel Jones Tuck.

Tuck(e), Samuel Jones 1767–1855, m. 1791. Boston, Mass., w. 1790–1805. Mstr. to Joshua Rand, 1799. Br.(?) of Joseph Tuck. Had paint store, 1806–ca. 1828; resided in Baltimore, Md., 1817–22/3.

Tucker, John H. Baltimore, Md., w. 1831–43. *See also* Tucker and Robinson.

Tucker, John H., and Robinson, George W. Baltimore, Md., w. 1840–43.

Tufts, U(riah?) E Massachusetts, prob. Boston, 1790s. Owner, contemporary or later; prob. resident of Malden or Boston, Mass. Not the Uriah Tufts, b. 1796, who practiced woodworking in Lowell, Mass.

Tunis, John Norfolk, Va., w. 1812–20. Dealer.

Tunis, (?), and Nutman, (?) Newark, N.J., w. 1813–23.

Turner, George Philadelphia, Pa., w. 1823–54.

Tuttle, George Ca. 1803–32. Salem, Mass., w. ca. 1820s–1832. Son of James Chapman Tuttle; br. of James Tuttle.

Tuttle, J. (poss. Jesse or John) South Harwich, Barnstable Co., Mass., w. 1850s.

Tuttle, James 1803–30. Salem, Mass., w. 1820s. Son of James Chapman Tuttle; br. of George Tuttle.

Tuttle, James Chapman Ca. 1772–1849, m. 1798. Salem, Mass., w. 1796–1825 and prob. later. Fr. of George Tuttle and James Tuttle.

Tweed, Richard, Sr. 1790–1862. New York, N.Y., w. 1816–60. Appr. to George Skellorn, n.d. Fr. of William Marcy Tweed. Also brushmkr. *See also* Richard Tweed, Sr., and Hezekiah M. Bonnell.

Tweed, Richard, Sr., and Bonnell, Hezekiah M. New York, N.Y., w. 1823–43.

Tweed, William Marcy 1823–78. New York, N.Y., w. 1840s and later. Son of Richard Tweed, Sr. Best known as "Boss" Tweed of Tammany Hall.

Tygart, William M. 1831. North Bloomfield, Trumbull Co., Oh., w. 1829–33.

Tyler, Samuel B. ca. 1787. Alexandria, Va. Appr. to Ephraim Evans, 1807.

Tyson, Jonathan D. 1858. Philadelphia, Pa., w. 1808–18. *See also* Tyson and Teese.

Tyson, Jonathan, and Teese, Daniel Philadelphia, Pa., w. 1817–18.

U., A. C. E Massachusetts, 1810s. Prob. owner.

Union Chair Co. Robertsville, Colebrook Twp., Litchfield Co., Conn., w. 1849–88. *See also* Holmes and Roberts.

Upperman, Robert B. 1801. Baltimore, Md. Appr. to Matthew McColm, 1815. Br. of Thomas Upperman.

Upperman, Thomas B. 1799. Baltimore, Md., w. 1833. Appr. to Matthew McColm, 1815. Br. of Robert Upperman.

Utica Chair Store Utica, N.Y., w. 1842. *See also* James C. Gilbert.

Vail (Veal), Joseph Poss. m. 1788, d. 1805. Poss. Millbrook, N.Y., w. bef. 1786; New York, N.Y., w. 1790–1805 and poss. earlier.

Vanbrunt, Elisha (and Co.) New York, N.Y., w. 1814–40.

Vanderpool, Jacob New York, N.Y., w. 1783–89.

Vandevanter, John D. 1814/5. New York, N.Y., w. 1794–96, 1814–15.

Van Dusen, Joshua Olean, N.Y., w. ca. 1821 and later. Moved on to Chautauqua, N.Y.

Van Dyke, Isaac 1777–1817/8. New York, N.Y., w. 1802–17. Appr. to Walter MacBride, 1792. Business operated by widow, 1818–20.

Vangelder, John D. ca. 1815. New York, N.Y., w. 1801–15 and earlier. *See also* Cornelius Timpson and John Vangelder.

Vanhorn, Nathaniel Philadelphia, Pa., w. 1816–24.

Vannosten (Van Nostan), Edward H. Philadelphia, Pa., w. 1823; Downingtown, Pa., w. 1830–31.

Varney, J. B. Prob. SE New Hampshire, 1810s. Prob. owner.

Venall, James Philadelphia, Pa. Appr. to Francis Trumble, 1773.

Very, Joseph Portland, Me., w. 1813–18. *See also* John Grant and Joseph Very; Very and Hagget.

Very, Joseph, and Hagget, John Portland, Me., w. 1818.

Vick, (?), and Sypert, Stephen Jackson, Tenn., w. 1842.

Vickary, Joseph Prob. m. 1756, d. 1818. Newport, R.I., w. 1758–98 and prob. later.

Vinecove (Viancough), Joseph Halifax, Nova Scotia, Canada, w. 1817.

Visscher, Gerrit B. 1771, m. 1793. Albany, N.Y., w. 1815–41. *See also* Visscher and Baker.

Visscher, Gerrit, and Baker, Ashley C. Albany, N.Y., w. 1821.

Voris, Abraham Area New Lisbon, Otsego Co., N.Y., w. 1813–14.

Vos, John H. Lexington, Ky., w. 1812–17. Princ. orn. ptr. *See also* Vos and Gaunt.

Vos, John H., and Gaunt, (?) Lexington, Ky., w. 1813.

Vosburgh, Harman (Herman) New York, N.Y., w. 1792–1801; Wilmington, N.C., 1796–98 (prob. branch). Became paint mfr. *See also* Vosburgh and Childs; Vosburgh and Dunbibin.

Vosburgh, Harman, and Childs, (?) Wilmington, N.C., w. 1796–97.

Vosburgh, Harman, and Dunbiben, John Wilmington, N.C., w. 1798.

W., A. Prob. Rhode Island, ca. 1800. Poss. owner.

W., C. A. Prob. S New Hampshire, 1810s. Later owner.

W., I. *See* Iredell White.

W., R. Windsor craftsmanship unconfirmed.

W., T. SE New England, 1790s. Later owner.

Wade, Littlebury (Littleberry) B. ca. 1788. Virginia, w. bef. 1812, aft. 1817.

Wadsworth, Horace Hartford, Conn., w. 1796–1800. *See also* Wadsworth and Wadsworth.

Wadsworth, John Hartford, Conn., w. 1793–1804, poss. 1810. *See also* Wadsworth and Wadsworth.

Wadsworth, John, and Wadsworth, Horace Hartford, Conn., w. 1796–1800.

Wagner, E. Cincinnati, Oh., w. late 1860s or later.

Waite, John Adams Co., Oh., w. 1820.

Wakefield, George Alexandria, Va. Appr. to Ephraim Evans, 1804.

Wales, Samuel, Jr. Boston, Mass., w. 1849–57. Dealer-merchant.

Walker, Alexander Fredericksburg, Va., w. 1798–1808 and poss. later. *See also* James Beck and Alexander Walker.

Walker, Charles Montreal, Canada, w. 1849.

Walker, C. B. 1790. Princeton, Mass., w. 1850. Prob. w. as jnyman.

Walker, Robert D. 1774. Philadelphia, Pa., w. 1766–ca. 1774.

Walker, S. Prob. SE New England, ca. 1800. Poss. owner.

Walker, Thomas Poss. d. 1843. Prob. Lancaster, Pa., w. 1811–12; Harrisburg, Pa., w. 1813.

Wall, John (Jonathan) Philadelphia, Pa., w. 1803–35 and poss. earlier. Mstr. to William Snowden, 1817. *See also* John Wall and Adam(?) Snyder.

Wall, John, and Snyder, (Adam?) Philadelphia, Pa., w. 1824.

Wall, Richard Philadelphia, Pa., w. 1801–29. *See also* Higbee and Wall.

Wallace, James 1804–79. Lafayette, Ind., w. 1839–50.

Wallace, Merrick Gardner, Mass., w. late 1820s–1831 and poss. later. Son-in-law of Ezra Baker.

Walton, Charles Norway, Me., w. ca. 1840s–1850s.

Ward, G. E Pennsylvania or Delaware Valley, 1790s. Poss. owner.

Ward, Jacob P. Sussex Co. and Laurel, Del. Appr. to William H. Nichols, 1843.

Ward, James Louisville, Ky., w. ca. 1830–36. *See also* James Ward and John M. Stokes.

Ward, James, and Stokes, John M. Louisville, Ky., w. 1832.

Ward, John Laurel, Del., appr. 1830; Bridgeville, Del., w. ca. 1830–59. Appr. to Jonathan Hearn, 1830.

Ward, Joseph Poss. d. 1808. New Brunswick, N.J., w. 1796–98; poss. Newark, N.J., w. bef. 1808.

Ward, Joseph Parson Sussex Co. and Laurel, Del. Appr. to William H. Nichols, 1848.

Ward, S. Wilmington, Mass. or Vt., w. 1810s. Orn. ptr.

Ware, Elijah D. 1893. Salem, N.J., w. 1834–41 and prob. later.

Warner, Elijah D. 1829. Lexington, Ky., w. 1818–ca. 1829. Cabtmkr. and clockmkr. dealing in chairs.

Warner, Everardus New York and Brooklyn, N.Y., w. 1799–1810.

Warner, John Vanwyck New York, N.Y., w. 1799–1800. Appr. to Thomas Ash I, 1786.

Warren, E. Chauncey 1808–65, m. 1831, 1832, 1839. Stamford, Conn., w. 1853 and earlier and later.

Warren, Hastings Ca. 1780–1845, m. 1803. Middlebury, Vt., w. ca. 1801–34.

Washburn, Isaac D. 1832. Taunton, Mass., w. ca. 1800s–ca. 1832.

Washburn, William 1774–1810. New Bedford, Mass., w. ca. 1795–1810.

Waterhouse, Timothy Newport, R.I., w. 1762–88.

Watson, David Salisbury, N.C., w. 1831–40. *See also* William R. Hughes and David Watson.

Watson, John B. 1801. Baltimore, Md. Appr. to Gale March, 1816.

Watson, Joshua D. ca. 1809. New York, N.Y., w. 1796.

Watson, Nathaniel Poss. ca. 1777–1859. Farmington, Conn., w. 1800; Hartford, Conn., w. 1801–21. *See also* Jude Hamilton and Nathaniel Watson; Nathaniel Watson and Eli Wood.

Watson, Nathaniel, and Wood, Eli (and Co.) Hartford, Conn., 1801–7.

Watson, Severn B. 1781. Baltimore, Md. Appr. to Caleb Hannah, 1797.

Watt, Archibald Baltimore, Md., w. 1800–1801; Hagerstown, Md., w. 1801. Son of John Watt.

Watt, John Hagerstown, Md., w. 1801–2. Fr. of Archibald Watt.

Weathersfield Windsor Manufactory Weathersfield Twp., Windsor Co., Vt., poss. 1810s. Existence unconfirmed.

Weaver, George A. Lancaster, Pa., w. 1830–49.

Weaver, Holmes 1769–1848. Newport, R.I., w. ca. 1796–ca. 1848. Spurious brand exists.

Webb, Eli Prob. Portland, Me., w. 1800s–1810s.

Webber, B. NE Massachusetts or N coastal New England, 1790s. Poss. owner.

Weber, Conrad Centerville, Wayne Co., Ind., w. 1844.

Weber (Weaver), John Lancaster, Pa., w. 1800–1819. Wife, Elizabeth Weber (Weaver), carried on bus. aft. his death, w. 1819–23.

Webster, B. F. Prob. NE New England, ca. 1810–ca. 1840s. Poss. owner.

Webster, Edmund, and Poore, Robert Richmond, Va., w. 1813–14.

Webster, Elijah W. Glastonbury, Conn., w. 1795–96.

Webster, Stephen C. Ca. 1779–1850, m. 1803. Salisbury, N.H., w. 1804–43.

Weeks, Joseph S. Brooklyn, N.Y., w. 1829–36. *See also* Barzilla Russell and Joseph S. Weeks; Weeks and Dawson.

Weeks, Joseph S., and Dawson, (?) Brooklyn, N.Y., w. 1833.

Weidler, John Lancaster, Pa., w. 1829–ca. 1860.

Weld, Moses F. Windsor, Vt., w. 1824–25; poss. Enosburg, Franklin Co., Vt., w. 1840.

Wells, Amos 1735–1801, m. 1758. Colchester, Conn., w. 1786 and later.

Wells, C. Canandaigua, N.Y., w. 1829. Princ. orn. ptr.

Wells, David Westminster, Windham Co., Vt., w. 1801.

Wells, John I. 1769–1832. Hartford, Conn., w. 1789–1816. *See also* John I. Wells and Erastus Flint.

Wells, John I., and Flint, Erastus Hartford, Conn., w. 1807–ca. 1809.

Wells, Moses Augusta, Me. w. 1825–43. Also cabtmkr.

Welsh, Alexander New York, N.Y., w. 1816, 1820–28. Appr. to George W. Skellorn, n.d. *See also* Thomas Ash II and Alexander Welsh.

Welsh, Thomas M. 1822. Bolton, Mass., w. 1820–40. Poss. turner only.

Wentz, John L. W. E Pennsylvania, ca. 1780s. Prob. owner.

West, Abby (Mrs.) New London, Conn., w. 1828. Sold off shop stock of deceased husband, Thomas West.

West, Charles T. Area Litchfield, Conn., w. 1812.

West, David S. New London, Conn., w. 1807. *See also* Thomas West and David S. West.

West, Ebenezer Lee, Mass., w. 1814 and prob. earlier and later. *See also* Timothy West, Ebenezer West, and (?) Hatch.

West, Thomas 1786–1828, m. 1811. New London, Conn., w. 1807–28. *See also* Thomas West and David S. West.

West, Thomas, and West, David S. New London, Conn., w. 1807.

West, Timothy Lee, Mass., w. 1814–ca. 1820. *See also* Timothy West, Ebenezer West, and (?) Hatch.

West, Timothy, West, Ebenezer, and Hatch, (?) Lee, Mass., w. 1814.

Westerfield, David J. Prob. New York, N.Y., w. 1831–33; Cincinnati, Oh., w. 1836–37. *See also* Kerr and Westerfield.

Western Chair Manufactory *See* Kerr, Ross, and Geyer; William H. Ross and John Geyer.

Westlake, Robert Cincinnati, Oh., w. 1814–30.

Westwood, Thomas B. 1794. Baltimore, Md. Appr. to Thomas S. Renshaw, 1811.

Wetherbee, Abijah 1781–1835. Prob. Boston, Mass., w. 1807; New Ipswich, N.H., w. 1810–ca. 1835. Son-in-law of Peter Wilder; br.-in-law of Calvin R. Wilder, John Wilder, Joseph Wilder, and Josiah Prescott Wilder.

Wetherbee, Joseph, Jr. D. 1847. Ashburnham, Mass., w. 1830s–1840s.

Wheat, James E. Indianapolis, Ind., w. ca. 1835; Brookville, Ind., w. 1838–39. *See also* Hartley, Wheat and Co.; Andrew McClure and Co.; Wheat and Longe.

Wheat, James E., and Longe, Jasper Brookville, Ind., w. 1839.

Wheelock, Jerry B. 1784. Uxbridge, Mass., w. ca. 1810.

Whipple, David C. 1817–52, m. 1845. Croyden, N.H., w. ca 1840.

Whipple, Stephen B. 1781. Danvers, Mass., w. 1803–11 and poss. later. Called housewright in deeds; also cabtmkr.

Whitaker, James B. D. 1822. Philadelphia, Pa., w. 1800–22.

Whitaker, Wesley Raleigh, N.C., w. 1805–16. Mstr. to Elias Hall, 1814; Michael Humphries, 1806–9.

White, Ammi Windsor, Vt., w. 1813–18 and prob. later. *See also* Boynton and White.

White, Ebenezer Booth Danbury, Conn., w. 1790–92. *See also* William Chappel and Ebenezer Booth White.

White, Elias D. 1845, Goshen, Mass. Goshen, Mass., w. 1812–17 and later; Bennington, Vt., w. 1825.

White, Ezekiel D. 1860. West Chester, Pa., w. 1809–14. *See also* Ezekiel White and George Pearson.

White, Ezekiel, and Pearson, George West Chester, Pa., w. 1814.

White, Iredell B. ca. 1814. Robertson Co., Tenn., w. 1850. Poss. mkr. of chairs stamped *IW*.

White, Jacob Baltimore, Md., w. 1799.

White, John Georgetown, D.C., w. 1821–26. Mstr. to Jeremiah T. Brashears, 1825; Thomas C. Brashears, 1822; Richard Hall, 1822; Henry Hassen, 1826; John Kelly, 1823; William Pringle, 1821; Nicholas White, 1822.

White, John Philadelphia, Pa., w. 1823–ca. 1840.

White, John West Chester, Pa., w. 1828–40.

White, John N. 1803–65. Woodstock, Vt., w. mid 1830s and later. Poss. orn. ptr. only.

White, Lyman 1800–1880. Boston, Mass., w. 1826–66. Orn. ptr.

White, Nehemiah Cazenovia, N.Y., w. 1806–12; Manlius, N.Y., w. 1812–20.

White, Nicholas Georgetown, D.C. Appr. to John White, 1822.

White, Samuel K. D. 1849. Prob. Noridgewock, Me., w. 1820; Fairfield, Me., w. 1820s–1830s; Dexter and Exeter, Me., w. 1830s–1840s.

White, Walter 1765–1819. Longmeadow, Mass., w. 1795–1819.

White, William Boston, Mass., w. 1857–77 and later. See also John C. Hubbard and William White, Jr.

White, William L. Ballston Spa, N.Y., w. 1814–30 and poss. later.

Whitelock, Isaac D. 1848. Philadelphia (Frankford section), Pa., w. 1807–21 and earlier and later. Mstr. to John M. Bartlett, 1807. See also Benjamin(?) Love and Isaac Whitelock.

Whiting, Edwin Nelson Twp. (area Nelson and Garrettsville), Portage Co., Oh., w. 1839–41 and prob. earlier. Br.-in-law of Nelson Talcott.

Whitney, George South Gardner, Mass., w. 1820s; Boston, Mass., w. 1827–40. See also Whitney, Brown and Co.; George Whitney and Albert H. Brown.

Whitney, George, and Brown, Albert H. Boston, Mass., w. 1827–33. Poss. dealers only.

Whitney, Brown and Co. (George Whitney, Albert H. Brown, Amasa Pierce) Boston, Mass., w. 1834–38. Poss. dealers only.

Whitney, Hezekiah B. 1829. Templeton, Mass., w. 1850. Prob. w. as jnyman.

Whitney, Jonathan B. 1803. Templeton, Mass., w. ca. 1825–ca. 1850.

Wickersham, William West Chester, Pa., w. 1822–24; Honeybrook Twp., Chester Co., Pa., w. 1842; prob. Caernarvon Twp., Lancaster Co., Pa., w. 1845–47. See also Burchall and Wickersham.

Widdifield, William Ca. 1749–1822, m. 1779. Philadelphia, Pa., w. 1780–1817. Appr. to William Cox, 1768–70; mstr. to Thomas Holton, 1799.

Widgen, John M. 1820. Norfolk, Va., w. 1812–25. Appr. to cabtmkr., 1802; mstr. to James Braithwaite, 1815; Tully Johnson, 1812; James Pallett, 1815.

Wight, Oliver 1765–1837, m. 1786. Sturbridge, Mass., w. ca. 1786–1837.

Wil, E. H. (or E.H.W. II) Area Northampton, Mass., 1790s. Prob. owner.

Wilcox, Henry W. Lexington, Ga., w. 1820.

Wilcox, Nathan Middletown, Conn., w. 1822.

Wildbahn, George Circleville, Oh., w. 1824–30. See also Wildbahn and Carolus.

Wildbahn, George, and Carolus, John Circleville, Oh., w. 1824–26.

Wilder, Abel 1771–1862. Keene, N.H., w. ca. 1800–1808 and poss. later; poss. Barre, Mass., w. 1817–20. See also Abel Wilder and Luther Holbrook.

Wilder, Abel, and Holbrook, Luther Keene, N.H., w. 1805–7.

Wilder, Abijah, Jr. 1784–1864. Keene, N.H., w. ca. 1812–38 and prob. later. Son of Abijah Wilder, Sr.; br. of Azel Wilder; nephew of Peter Wilder. See also Abijah Wilder, Jr., and Azel Wilder.

Wilder, Abijah, Jr., and Wilder, Azel Keene, N.H., w. 1812–15.

Wilder, Abijah, Sr. 1750–1835, m. (1) 1774. Keene, N.H., w. ca. 1770–1835. Fr. of Abijah Wilder, Jr., and Azel Wilder; br. of Peter Wilder; uncle of Calvin R. Wilder, John B. Wilder, Joseph Wilder, and Josiah Prescott Wilder. Cabinet, sleigh, and spinning-wheel mkr.

Wilder, Augustus B. ca. 1810. Poss. New York state, w. 1840–50; Leyden Twp., Lewis Co., N.Y., w. 1855.

Wilder, Azel 1788–1860. Keene, N.H., w. 1812–31 and prob. later. Son of Abijah Wilder, Sr.; br. of Abijah Wilder, Jr.; nephew of Peter Wilder. See also Abijah Wilder, Jr., and Azel Wilder.

Wilder, Calvin R. 1806–52. New Ipswich, N.H., w. bef. 1833; New York, N.Y., w. 1833–44. Son of Peter Wilder; br. of John B. Wilder, Joseph Wilder, and Josiah Prescott Wilder; br.-in-law of Abijah Wetherbee; nephew of Abijah Wilder, Sr. See also Calvin R. Wilder and Edwin R. Stewart.

Wilder, Calvin R., and Stewart, Edwin R. New York, N.Y., w. 1840–43.

Wilder, Ephraim 1792–1854. Poss. Barre, Mass., w. 1818–1820s; Templeton, Mass., w. 1820s–1830s, 1850; poss. Sterling, Mass., w. 1840.

Wilder, John D. 1863. Boston, Mass., w. 1807; Keene, N.H., w. 1808–10 and prob. later. See also Wilder, Rugg and Co.

Wilder, John B. 1804–52. New Ipswich, N.H., w. 1830s–ca. 1852. Son of Peter Wilder; br. of Calvin R. Wilder, Joseph Wilder, and Josiah Prescott Wilder; br.-in-law of Abijah Wetherbee; nephew of Abijah Wilder, Sr.

Wilder, Joseph 1787–1825. Boston, w. 1810–11; New Ipswich, N.H., w. 1811–25. Son of Peter Wilder; br. of Calvin R. Wilder, John B. Wilder, and Josiah Prescott Wilder; br.-in-law of Abijah Wetherbee; nephew of Abijah Wilder, Sr.

Wilder, Josiah Prescott 1801–73, m. 1826. New Ipswich, N.H., w. ca. 1825–ca. 1869. Son of Peter Wilder; br. of Calvin R. Wilder, John B. Wilder, and Joseph Wilder; br.-in-law of Minot Carter and Abijah Wetherbee; nephew of Abijah Wilder, Sr.

Wilder, Lewis B. 1810. Sterling, Mass., w. 1850.

Wilder, Merrick D. 1859, Sterling, Mass. Templeton, Mass., w. 1831–32.

Wilder, Peter 1761–1841. Keene, N.H., w. 1781–ca. 1789, 1798–ca. 1800; Brattleboro, Vt., w. ca. 1790–ca. 1797; Boston, Mass., w. ca. 1803–ca. 1807; New Ipswich, N.H., w. ca. 1807 (1810?)–1830s. Fr. of Calvin R. Wilder, John B. Wilder, Joseph Wilder, and Josiah Prescott Wilder; fr.-in-law of Abijah Wetherbee; br. of Abijah Wilder, Sr.; uncle of Abijah Wilder, Jr., and Azel Wilder.

Wilder, Rugg and Co. (John Wilder, Elisha Rugg, and Ephraim Willard of Boston) Keene, N.H., w. 1808–10.

Wiley, James L. Steubenville, Oh., w. 1820.

Wiley, Joseph Lawrence Twp., Stark Co., Oh., w. 1828.

Wilkinson, Edward Prob. d. 1840. Williamsport, Pa., w. ca. 1810–40.

Willard, Ephraim Boston, Mass., w. 1808–13. See also Wilder, Rugg and Co.

Willard, Josiah D. 1838. Boston, Mass., w. 1795–1829. See also Edward Scott and Josiah Willard.

Willard, Peter Atherton D. 1843. Sterling, Mass., w. 1824–42.

Willard, Samuel B. 1808. Sterling, Mass., w. 1820s–1850; Leyden Twp., Lewis Co., N.Y., w. 1855.

Willcox, Stephen M. 1795. Westerly, R.I., w. 1796–ca. 1810 and prob. later.

Willet, John Ashley Norwich, Conn., w. 1824–25. Prob. orn. ptr. only.

Williams, Ebenezer 1767–1844. East Windsor, Conn., w. ca. 1790–1811. Migrated to Painesville, Oh., in 1811 and may have discontinued furniture mkg.

Williams, Isaiah B. ca. 1803. Lincolnton, N.C. Appr. to Martin C. Phifer, 1820.

Williams, Jacob Baltimore, Md., w. 1799–1827. Mstr. to Absalom Chrisfield, 1800; James Davis, 1801; Henry Rhine, 1806; James Ruker, 1798–1810; John Ruker, 1798–1802.

Williams, James Washington, D.C., w. 1836–60. Appr. to Thomas Adams, 1806; mstr. to Thomas Wood, 1840.

Williams, Samuel, and Co. (with E. P. Sumner) Poss. St. Louis, Mo., w. 1816; Nashville, Tenn., w. 1817–18.

Williamson, Gideon Bloom Twp., Columbia Co., Pa., w. 1820.

Williamson, Robert G. Raleigh, N.C., w. 1819–20. Mstr. to Henry Gormon, 1819. See also Robert G. Williamson and Samuel E. Shelton.

Williamson, Robert G., and Shelton, Samuel E. Raleigh, N.C., w. 1819.

Willis, John (Jonathan?) Philadelphia, Pa., w. ca. 1783–85.

Willis, Pleasant Richmond, Va. Appr. to Andrew and Robert McKim, 1804.

Willis, William E. Philadelphia, Pa., w. 1823; Erie, Pa., w. ca. late 1820s–1833.

Wilson, Isaac Georgetown, Del. Appr. to Elias James, 1838.

Wilson, James B. 1826, m. 1855. Philadelphia, Pa., appr.(?) 1846, w. 1849–ca. 1852; Taylorstown, Washington Co., Pa., w. ca. 1852–91 and prob. later.

Wilson, John Area Eatontown, N.J., w. 1805–7. Poss. rush-bottomed-chair mkr. only.

Wilson, John R., and Wilson, William Wooster, Oh., w. 1837–47.

Wilson, John T. Area Hartwick, Otsego Co., N.Y., w. 1835–42.

Wilson, Matthew Charlestown, W. Va., w. 1813–14.

Wilson, Robert Washington, D.C., w. 1825–30. *See also* Robert Wilson and Daniel Johnston; Robert Wilson and William M. Morrison.

Wilson, Robert, and Johnston, Daniel Washington, D.C., w. 1829.

Wilson, Robert, and Morrison, William M. Washington, D.C., w. 1826–27.

Wilson, Samuel Granville, Mass., w. 1810.

Wilson, T. Prob. Halifax, Nova Scotia, Canada, w. ca. late 1810s.

Winchell, Orrin G. Wallingford, Conn., w. 1809; Litchfield, Conn., w. 1819; New Haven, Conn., w. 1825.

Wing, A. Prob. E cent. New York state, w. 1820s–1840s.

Wing, Samuel 1774–1854, m. 1799. Sandwich, Mass., w. ca. 1795–ca. 1810.

Winship, Joseph Hartford, Conn., w. 1834–1870s. *See also* Robbins and Winship; Isaac Wright and Co.

Winston, Alanson Ca. 1794–1862, m. 1816. Lynchburg, Va., w. 1816–56. *See also* Winston and Diuguid.

Winston, Alanson, and Diuguid, Sampson Lynchburg, Va., w. 1818–ca. 1820.

Wire (Ware, Wear), John Philadelphia, Pa., w. 1783–1811; poss. Germantown (Philadelphia), Pa., w. 1813–14 and poss. later. *See also* Wire and Cubbin; Wire and Kirk.

Wire, John, and Cubbin, (?) Philadelphia, Pa., w. 1785.

Wire, John, and Kirk, George Philadelphia, Pa., w. 1792.

Wise, James Milford, Del. Appr. to Purnell Hall, 1833.

Witman, Samuel Philadelphia, Pa., w. 1790. Orn. ptr.

Wolcott (Walcutt), John Columbus, Oh., w. 1823–31. Mstr. to Jesse Grace, 1823.

Woltz, George 1744–1812. Hagerstown, Md., w. ca. 1783–1812.

Wood, Alexander Hamilton Richmond, Va., appr. bef. 1813–15; Nashville, Tenn., w. 1817–20. Appr. to Robert McKim, bef. 1813–15. Br. of William R. Wood. *See also* Alexander Hamilton Wood and William R. Wood.

Wood, Alexander Hamilton, and Wood, William R. Nashville, Tenn., w. 1817–ca. 1820.

Wood, Cyrus ca. 1788(?)–1840. Newfane, Vt., w. 1810; Montpelier, Vt., w. ca. 1814–ca. 1840. *See also* John Wood and Cyrus Wood.

Wood, Edwin 1815–55, m. 1838, 1845. Bridgeport, Conn., w. 1843–ca. 1855.

Wood, Eli 1781–1818. Hartford, Conn., w. 1800–1807; Barkhamstead Twp., Litchfield Co., Conn., w. 1818 and earlier. *See also* Nathaniel Watson and Eli Wood.

Wood, Francis B. 1807. Westminster, Mass., w. 1829–30; Worcester, Mass., w. 1830–44. *See also* Salmon Miller and Francis Wood.

Wood, I. B. (poss. J. B.) Prob. York Co., Me., w. ca. late 1830s–1850s.

Wood, John 1788–1872. Newfane, Vt., w. 1810; Montpelier, Vt., w. ca. 1814–ca. 1840. *See also* John Wood and Cyrus Wood.

Wood, John, and Wood, Cyrus Newfane, Vt., w. 1810; Montpelier, Vt., w. ca. 1814–ca. 1840.

Wood, Luthan New Bedford, Mass., and area, w. 1786–1802 and later.

Wood, P(hineas?) Dover, Vt., w. ca. 1810–40; poss. w. New York state earlier or later.

Wood, William R. Richmond, Va., appr. 1813; Nashville, Tenn., w. 1817–ca. 1820. Appr. to Robert McKim, 1813. Br. of Alexander Hamilton Wood. *See also* Alexander Hamilton Wood and William R. Wood.

Woodall, W. H. Hagerman's Corners (near Toronto), Ont., Canada, w. ca. 1850s–1870s.

Woodbury, Jason H. D. 1891. Sunderland, Mass. Later owner.

Woodrow, Morgan, and Chapman, Jedidiah Warren, Oh., w. 1843–45.

Woodson, J. T. Richmond, Va., w. ca. late 1840s–early 1850s.

Woodward, Sterling H. Dinwiddie, Va., w. 1807 and earlier and later. A coachmkr. who employed a Windsor chrmkr. in 1807.

Worrell, (?), and Morris, (?) SE Pennsylvania, prob. Philadelphia, 1800s. Prob. owners.

Wright, Calvin B. ca. 1809. Fayetteville, N.C. Appr. to James Beggs, 1825.

Wright, David B. 1809. Gardner, Mass., w. ca. 1826–ca. 1859. *See also* Calvin S. Greenwood and David Wright.

Wright, Isaac 1798–1838, m. 1822. Hartford, Conn., w. ca. 1826–38. *See also* Isaac Wright and Co.

Wright, Isaac and Co. (with Philemon F. Robbins and Joseph Winship) Hartford, Conn., w. 1834–38.

Wright, Judson Peck 1810–80, m. 1838. Westport–Norwalk, Conn., w. ca. 1838–50 and prob. later.

Wright, (?), and McAllister, (?) New York City, w. 1776. Spinning-wheel mkrs. and prob. turners.

Wynn (Winn), William B. ca. 1806. Fayetteville, N.C., appr. 1822–23. Appr. to David Ruth, Jr., 1822; Cornelius J. Tooker, 1823.

Y., J. J. Rhode Island, 1790s. Later owner.

Yakel, John Hagerstown, Md., w. 1804.

Yates, Joseph New York, N.Y., w. 1789–95, 1809–11.

Yates, Joseph L. Baltimore, Md. Appr. to Jacob Daley, 1811.

Yengling, Daniel New Lisbon (now Lisbon), Columbiana Co., Oh., w. 1829.

Yeoman, Samuel F., and Geoghagan, Edmund Lebanon, Oh., w. 1829–30.

Young, George Philadelphia, Pa., w. 1786, 1792–98, poss. 1805; Wilmington, Del., w. 1798–1803. *See also* Samuel Nichols and George Young.

Young, James Ca. 1792–1865. Troy, N.Y., w. 1812, 1818.

Young, Jonathan B. 1798, New Jersey. Cincinnati, Oh., w. 1819–31. *See also* Deeds and Young; Lanning and Young; Isaac M. Lee and Jonathan Young.

Young, Lewis D. ca. 1825. Philadelphia, Pa., w. 1801–24. Also cabtmkr.

Young, Thomas New York, N.Y., w. 1790–93.

Younker (Younger), Francis B. 1784. Baltimore, Md., w. 1806–33. Appr. to Richard Sweeney, 1801; mstr. to Andrew Marshall, 1812–13; James Moore, 1810; Patrick Noone, Jr., 1806; James Pennington, 1808.

Zebold (Zeabold), P. Washington, D.C., w. 1828–34. Poss. Robert Zebold from Maryland w. in Cincinnati, Oh., 1839–40.

Zutphen (Sutphen, van Zutphen/Sutphen), W. N New Jersey, Long Island, or Hudson River valley, w. 1800s.

Glossary

N O T E : An asterisk preceding a term identifies a period term.

*__Apprentice__ A youth, usually between the ages of fourteen and twenty-one, bound by an indenture or other agreement to a craftsman to learn a trade.

*__Arch-top chair__ An alternative term for the sack-back chair in the eighteenth century.

__Arm pad__ The outer, broad flat (frequently rounded) end of an arm or arm rail.

__Arm post__ See Arm support.

__Arm rail__ A U-shaped structural element mounted horizontally about waist height, which provides a place to rest the arms.

__Arm support__ A short, upright member socketed into the seat, usually at a front corner, to support the outer end of an arm or arm rail.

__Arm terminal__ The outer end of an arm or arm rail.

__Arrow-back chair__ An early nineteenth-century chair fitted with flat, elongated triangular spindles between the back posts and beneath the crest. Armchairs may have similar, shorter spindles socketed beneath the arms. (See Arrow spindle; fig. 7-78.)

__Arrow spindle__ A flat-faced stick shaped in the frontal profile to a narrow, elongated triangular form. The shape is derived from the tapered urn found in contemporary formal seating. (See figs. 3-118, 3-154.)

*__Back__ A crosspiece, usually a slat, forming part of the upper rear structure of a chair. In the nineteenth century double backs and triple backs were common in Windsor seating. (See figs. 7-119, 7-53.)

__Back post__ A long upright member, usually turned, socketed into the seat at a rear corner and supporting the cross members of the chair back and, as appropriate, the arm structure. Eighteenth- and early nineteenth-century back posts are straight (canted in the sockets). Many nineteenth-century posts are bent backward at midheight and the faces shaved flat to accommodate decoration.

__Back rail__ The heavy center rear section of the arm rail in a sawed-rail chair. (See figs. 3-10, 6-96.)

*__Ball-back chair__ A term describing two early nineteenth-century chair types. One pattern has horizontal cross rods in the upper rear structure separated by small, turned balls. The other pattern has vertical back spindles accented by ball turnings in the lower part. (See figs. 5-41, 7-62.)

__Ball foot__ A rounded terminal at the lower tip of a leg originally turned to elongated oval form but usually worn down to a partial ball. (See figs. 3-71, 3-5.)

__Ball spindle__ A slim, tapered cylindrical stick with a small round or oval turning positioned below the midpoint. (See figs. 7-63, 7-65.)

__Balloon-back chair__ A type of bow-back chair in which the sides of the bow bulge in full, rounded swells. Also, a late nineteenth-century chair with a loop-shaped back, the loop formed of three pieces of wood sawed and joined rather than bent to form. (See figs. 6-75, 8-23.)

__Balloon seat__ A plank of rounded outline at the front and sides, curving inward slightly near the back corners. The edges are flat or flat-chamfered. (See figs. 7-63, 7-62.)

*__Baltimore chair__ A chair made with a tablet top. (See figs. 4-14, 4-16.)

__Baluster__ A vaselike turning consisting of a swelled body and a slim neck usually terminating in a small collar. (See figs. 3-46, 5-7.)

*__Bamboo chair__ A chair framed with turnings that simulate the segmental stalks of the bamboo plant. (See figs. 3-114, 7-6, 7-27.)

__Bamboo turning__ A stick of wood shaped in a lathe to simulate the slightly incurved segments and grooved swellings of the bamboo plant. (See fig. 7-43.)

__Banding__ Broad decorative stripes painted on early nineteenth-century chairs, usually outlining large areas, such as seat tops and crests, but also accenting vertical elements, including legs and back posts. (See figs. 3-140, 7-118.)

*__Banister__ A vertical element in a chair back that is wider than a spindle and made by sawing, molding, or turning wood. Banisters are found in woven-bottom seating and usually number four or five units per chair. (See Splat.)

*__Banister-back chair__ A rush-seated, painted chair identified by the row of narrow, vertical, turned or molded banisters that fills the back between the posts above the stay rail. (See fig. 6-5.)

__Beehive turning__ A nineteenth-century profile closely associated with Baltimore painted seating furniture and composed of stacked rings of diminishing size forming a cone. (See fig. 4-18.)

*__Bell-back chair__ A term of uncertain meaning that describes a nineteenth-century chair with rear posts that either flare outward from base to top or belly along the length. (See figs. 7-98, 7-89.)

__Bench__ An alternative term for a settee.

*__Bender__ In the early nineteenth century, any crosspiece, whether turned or shaved, bent to lateral form and used in a chair back. (See figs. 5-37, 7-53.)

*__Bent-back chair__ An early nineteenth-century square-back chair, in which the vertical elements of the upper rear structure—posts and spindles (when present)—are framed with a slight cant at the seat sockets and further angled backward in the upper half. The crest pieces are of varied pattern. (See figs. 7-47, 7-13.)

*__Bespoke work__ Furniture made to order, a universal practice until the early nineteenth century.

__Blind socket__ A deep cylindrical hole, frequently U-shaped, terminating within the seat plank or a turned member of a chair and securing the tip of a turning.

__Blunt-edge plank__ A seat with flat, vertical front and side edges. (See fig. 7-48.)

*__Boston rocker__ A stick-and-socket-framed rocking chair with a tall, contoured back, crown top (or later tablet-style crest), and raised, or scroll, seat.

*__Bottom__ A chair seat, made from a wooden plank, rush, cane, or other material.

*__Bow__ A long or short stick of shaved or turned wood bent in an arch, loop, or lateral curve (arc) to form a chair back or top. (See figs. 3-38, 3-55, 3-116.)

*__Bow-back chair__ A late eighteenth-century chair with a loop-shaped upper rear structure consisting of a wooden arch socketed at each end into the seat plank to enclose spindles cut to different lengths appropriate to the arch. In modern British use this term identifies a sack-back armchair. (See figs. 3-55, 3-51.)

__Box stretchers__ Braces mounted between the legs on all four sides of a chair, forming a rectangular figure. (See fig. 5-59.)

Boy An apprentice.

Brace A stretcher.

Bracing spindles Two vertical sticks mounted behind a chair back to increase structural strength. At the bottom the sticks are socketed into an extension piece projecting from the center back of the seat and at the top in a bow or a crest piece. (See figs. 5-12, 6-234.)

Brand A hand tool consisting of a long, rodlike shaft with a rectangular block, or head, at one end and a hanging ring at the opposite end. The broad bottom face of the head is cut or cast with a name, place name, initials, or word. Brands are usually made of wrought iron, sometimes of brass or copper. The tool was used on wet (green) wood in a cold or heated, although not charring, state to transfer an impression of the letters on the head to the wood.

Broad-top chair A New England term that describes either a chair with a slat-type crest of sizable depth or one with a rectangular tablet crest with ends overhanging the back posts. (See figs. 7-120, 7-114.)

Bronzing An alternative term for stenciling.

Butt joint A connection formed by two horizontal pieces of wood abutted at the ends and held together by means of a capping piece to which each end is secured by nails, screws, or pins. (See figs. 6-1, 6-2.)

Cabriole leg An upright support in the undercarriage of a chair, usually confined to the front, that forms a long, shallow S or reverse S in profile and terminates in a pad foot. (See figs. 1-24, 3-9.)

Cap The head on a baluster turning, which may be flared, domed (crowned), buttonlike, or disklike, with or without a collar. (See figs. 6-42, 6-99.)

Chair stuff Unframed, turned and shaved parts for a chair, usually exclusive of the seat.

Chairwise Said of the framing beneath the plank of a settee when the support structure forms two or more individual units of four legs each splayed as if beneath a chair.

Chamfer A broad or narrow beveled edge. (See fig. 3-5, seat edge; fig. 3-36, arm rail.)

Child's dining chair A highchair. Also referred to as a child's table chair. As required, the chair was drawn up to the family dining table, since a feeding tray was a late nineteenth-century innovation.

Child's hole chair A potty-chair. Some children's chairs were converted to hole chairs at a later date.

Close-stool chair An adult-size armchair pierced by a large hole in the seat which is covered by a lid. Beneath the seat a boxlike chamber accommodates a chamber pot or pan.

Coffin shape A diamond, truncated at one end. Coffin-shaped seat extensions anchor bracing spindles in bow-back and continuous-bow chairs made in New York City. (See figs. 5-12, 5-14.)

Collar A cuff that extends from one side of a vertical ring turning flanking the central swell of a medial stretcher or from the base of a baluster cap. Also called a sleeve. (See figs. 6-20, 6-202.)

Colt's foot A turned leg terminal consisting of a large ball and round-top cylinder and found in some eighteenth-century English Windsors. (See fig. 1-23.)

Columnar post A cylindrical, upright support tapered from bottom (or midpoint) to top and positioned beneath an arm or at a back corner of a seat. (See figs. 7-57, 3-29.)

Comb-back chair A high-back chair.

Common chair A term used in the eighteenth and early nineteenth centuries to identify a rush-bottomed, slat-back chair. By the 1820s the term was also used to describe the cheapest types of Windsor chairs. (See fig. 5-23, left; figs. 7-23, 7-54.)

Compass seat See Shield-shaped seat.

Continuous-arm chair An alternative twentieth-century term for the continuous-bow chair.

Continuous-bow chair An arched-back pattern, the bow sweeping forward at either side to form arms. The bow, which is based in profile on the French bergère chair, is completely elevated above seat level on the spindles and arm posts. Developed in New York City about 1790, the continuous-bow chair was also produced in southeastern New England. (See figs. 5-12, 6-107.)

Cottage chair An inexpensive fancy chair with a woven bottom.

Cradle-settee See Settee cradle.

Crease The groove separating one section from another in a bamboo turning. (See figs. 3-55, 3-119.)

Crest The topmost horizontal element in a chair or settee. A crest piece may be framed between the back posts, on top of the posts/spindles, or on the face of the posts. (See figs. 3-138, 3-18, 3-145.)

Cross stretchers Long, turned or turned-and-blocked braces positioned between the rear legs and the opposing front legs and crossing beneath the center of the seat. (See figs. 6-2, 6-209.)

Crown top A tablet-type chair crest mounted on the faces or tips of the back posts. The slim crest ends are rounded in flat, downturned scrolls; the center is a large rectangular panel. The crown top is more common on rocking chairs than on seating without rockers. (See figs. 7-104, 7-118.)

Cumberland spindle A short turned stick consisting of two balusters, end to end, separated by several small beads or beads and spools, positioned in the lower back beneath a cross slat. The term appears in chairmaking records associated with the New York City area in the early nineteenth century. (See figs. 5-49, 5-52, 6-12.)

Curved stretcher A bent, arc-shaped brace positioned between the front legs and further anchored by two straight spokes extending from points one-third the distance from the ends of the arc to the back legs. (See figs. 1-28, 6-207.)

Cushioned chair A chair with a stuffed seat. The Tracy family of chairmakers of eastern Connecticut and others used this term. (See figs. 6-108, 6-109.)

D-shaped seat A large plank forming a D in outline, with the flat surface at the front. (See fig. 3-11.)

Dining chair or dining Windsor chair A side chair used at the table. The term covers Windsor patterns produced from the late eighteenth century through the early nineteenth century. (See figs. 3-111, 7-65.)

Dished plank A wooden seat modeled with a large, rounded, shallow depression on the top surface. Also called a saucered plank. (See figs. 3-114, 7-69.)

Double-back chair A nineteenth-century chair framed with two crosspieces between the back posts. Spindles may be present in the lower back. (See figs. 7-49, 7-119.)

Double-bow chair An early nineteenth-century Windsor with the crest formed of two turned cross rods "bowed" in a lateral curve. (See fig. 3-123.)

Double chair A small settee contoured on the top surface of the plank to form two individual seating places. Of English origin, the form was produced briefly in Philadelphia in the early 1750s.

Double-cross-back chair An early nineteenth-century Windsor or fancy chair featuring a large X-shaped element in the back. Each arm of the cross is composed of two slim rectangular rods separated by a narrow void. (See figs. 5-38, 5-39.)

Double-ogee crest An eighteenth-century top piece sawed along the upper surface to form two S-shaped curves. (See figs. 6-133, 6-136.)

Double-tapered foot A thick cylindrical support diminishing in diameter from the top to a point above the center and there forming a second angle to the toe. (See fig. 6-75.)

Dressed plank A seat-shaped blank cut from a plank and planed on the bottom surface along the grain of the wood to remove irregularities and smooth the surface. The top surface is also dressed before the seat is shaped for sitting.

Easy chair A chair of high, reclining back, frequently fitted with rockers. (See figs. 6-234, 7-72.)

Elbow An arm. Thus, an elbow chair is an armchair.

Extension top A short crosspiece and supporting spindles that extend above the crest of a standard or slightly taller chair, usually a rocking chair, to provide a support for the sitter's head. (See figs. 7-38, 7-115.)

Fall-back chair An alternative term for a bent-back chair.

Fan-back chair A late eighteenth-century side chair with a back resembling a partially opened, upright fan capped by a serpentine-top crest. Fan-back armchairs were made in limited number. (See figs. 3-46, 3-34.)

Fancy chair A top-of-the-line vernacular chair with a rush or cane bottom, the wood painted in one of a range of colors and augmented by painted and/or stenciled decoration. The term was also used in eastern Connecticut during the late eighteenth century to identify the continuous-bow Windsor. (See figs. 5-35, 7-22.)

Fancy top A tablet-type crest piece mounted on the back posts, consisting of a low, flat, centered projection at the top edge flanked by low, shoul-

dered ends terminating in straight tips. A low arch is sometimes sawed out of the bottom edge. The pattern was developed in Boston and produced in Massachusetts and northern New England. Modern terms are *stepped-tablet* and *step-down crest*. (See Stepped-tablet chair; figs. 7-36, 7-81.)

Fancy Windsor chair A chair with extra embellishment, whether structural or painted, or both. (See figs. 6-173, 5-43.)

* **Feet** An alternative term for legs in the eighteenth and early nineteenth centuries.

* **Fiddle-back chair** A rush-bottomed turned chair, whose upper rear structure is dominated by a large, centered baluster- or inverted baluster-shaped splat supported on a stay rail. (See figs. 5-8, 6-161.)

* **Flags** The rushes used to weave a seat in a turned-chair frame.

Flare To curve outward or backward in a long sweep; a term usually applied to chair legs and backs. (See figs. 5-32, 7-57.)

Flat-chamfered edges Vertical plank sides sharply chamfered near the bottom. (See figs. 3-6, 3-71.)

* **Flat stick** A wide cylindrical spindle shaved on the forward face at the point where the support broadens to form an arrow, urn, oval, rectangle, or other profile. (See figs. 4-9, 7-109.)

* **Flat-top crest** A tablet- or slat-type crest with a straight top edge. (See figs. 7-107, 5-45.)

* **Forest chair** A term found in English records of the early 1720s, which probably identifies an early form of Windsor chair.

Formal chair A joined chair made from fine cabinet wood and usually upholstered on the seat. (See figs. 3-54, 7-37.)

* **Four-rod (and *five-rod) chair** A nineteenth-century slat-crested chair with four or five thick cylindrical spindles across the back. (See fig. 7-11.)

* **Fret** Any ornamental cross member in a chair back that is pierced, sawed to an intricate profile, or composed of several elements forming an open figure. (See figs. 5-49, 7-13.)

* **Frog fret** A large, sawed crosspiece positioned in the center back of a fancy chair, consisting of an oval tablet attached to the back posts by means of four short, thick ogee-curved connectors resembling the legs of the amphibian. (See fig. 7-22.)

* **Garden chair** Frequently, a Windsor used out of doors. The Windsor served well as a garden chair, being relatively portable, protected by paint, and constructed with a durable wooden seat instead of a fiber bottom.

* **Great chair** An armchair. The term identifies a variety of vernacular chair types with arms but is most commonly associated with woven-bottom seating.

* **Grecian chair** A rush- or cane-seat fancy chair with a slat or turned roll for a crest and back posts sawed to an S curve in the side profile above the seat. The pattern is also referred to as a scroll-back chair. (See fig. 5-47.)

* **Green chair** A term that usually identifies an eighteenth-century Windsor chair painted green, although vernacular seating with woven seats could also be painted green.

H-plan stretchers An eighteenth-century leg-bracing system comprising three turned members, one at each side from front to back and one across the center joining the side braces, together forming an H-shaped figure. (See figs. 3-10, 3-50.)

* **Half-size chair** A youth's chair. (See fig. 6-248.)

Handgrip The terminal of an arm, usually enlarged and sometimes carved in a scroll. (See figs. 3-37, 3-51, 3-121.)

* **High-back chair** A tall eighteenth-century Windsor crowned by a serpentine-top crest and usually framed with a bent, U-shaped arm rail. Fan-back armchairs are also frequently referred to by this name. *Comb-back chair* is an alternative twentieth-century term. (See figs. 3-13, 3-20, 3-29.)

* **High-top chair** A chair (usually with arms) of normal height, having a small extension mounted on the crest or above a bow to support the head when reclining. (See figs. 3-64, 7-99.) The term is also used to describe a sack-back chair with an exceptionally tall arch in the bow. (See fig. 6-37.)

* **Hollow corners (-cornered)** Quarter-circle cutouts at the angles of a rectangle. Crest pieces and other elements may be sawed or painted with hollow corners. (See figs. 7-72, 7-48.)

Hollow foot A tapered leg terminal that is slightly incurved from top to bottom. (See fig. 6-54.)

Hook-type crest terminal In the top piece of a fan-back or high-back chair, a rounded end that forms an angle at the upper corner adjacent to the serpentine curve of the top surface. (See figs. 6-27, 6-103.)

* **Horseshoe chair** A term first current in the 1840s that identifies a revival form of the eighteenth-century low-back chair. (See figs. 5-65, 8-3.)

* **Imitation** A term used to describe nineteenth-century chair surfaces painted to simulate the appearance of wood grain. Maple, rosewood, and oak are the most common imitation grounds encountered. (See fig. 7-91.)

* **In the wood** Unpainted. *In the white* is an alternative, although less common, term.

Incised Cut with a fine line or groove. (See fig. 3-71, leg balusters, stretcher centers; fig. 6-108, bow face.)

* **Japanning** A type of painting in which the wood surface is first covered with a mixture of whiting and size to produce a smooth ground. This surface is covered with several coats of hard japan varnish containing opaque color; the varnished surface is polished between coats. Decoration is applied and protected by one or more outer coats of clear varnish. Cheap imitations of japanwork often eliminated sizing and polishing. Japanned finishes, which were expensive, were more common on fancy seating than on Windsor furniture.

* **Journeyman** Technically, a workman who labors by the day for a wage, although in the eighteenth and early nineteenth centuries many more work-

men were engaged in piecework and paid accordingly.

* **Kitchen chair** A rush-bottomed, slat-back chair.

Knife-edge plank A nineteenth-century Windsor-chair seat that is rounded at the edges on the top surface and chamfered below, forming a sharp, horizontal ridge around the perimeter of the front and sides. (See figs. 7-57, 7-117.)

Knobs Large, turned protuberances flanking the central bulb in the medial stretchers of some eighteenth-century Windsors. Knobs are larger than ring turnings, which are also found in medial stretchers. (See figs. 3-21, 6-35.)

Knuckle arm A waist-height rail terminated by thick handgrips carved with broad ridges and depressions on the top and forward surfaces reminiscent of finger joints. Sometimes the side faces of the resulting scrolls are carved in small volutes. (See figs. 3-28, 3-37.)

Lap joint A connection formed by two horizontal pieces of wood that overlap and are secured by pins, nails, or screws. (See fig. 3-10.)

Loaf-shaped crest A tablet-type top piece rounded at the ends in projecting bulges in the upper half. (See figs. 7-54, 7-102.)

* **Lounge** A rocking chair.

* **Low-back chair** A Windsor chair terminating in height at arm-rail level. The rail is sawed from three thick pieces of wood secured at pinned or nailed lap or butt joints at the center or sides of the back. (See figs. 3-10, 6-2.)

* **Manufactory** In the late eighteenth and early nineteenth centuries, a shop where seating furniture (or other goods) was produced in quantity, usually through the labors of one or more workmen besides the master. This was not a factory in the modern sense of the word. (See figs. 4-45, 5-46.)

* **Marking iron** See Brand.

* **Master** An artisan who had attained a high level of proficiency in his trade, enabling him to operate his own shop and instruct others. Occasionally a master was one who supervised the shop of another in his absence or oversaw production for an entrepreneur.

Medallion An alternative term for a small tablet of varied shape forming a feature in a spindle, front stretcher, open crest, or the like. (See figs. 4-12, 3-119, 3-120.)

Medial stretcher The crosswise center brace in an H-plan stretcher system. (See fig. 3-13.)

Mid slat(s) One or more flat crosspieces at the middle back. (See figs. 4-16, 7-95.)

* **Miter top** A single- or double-bow, square-back chair, the upper cross rod grooved diagonally at the corners so as to appear mitered rather than tenoned to the back posts. (See figs. 3-114, 7-27.)

* **Mortise top** An alternative term for a slat-type crest framed between the back posts with mortise-and-tenon joints. (See figs. 7-60, 7-62.)

* **Name iron** See Brand.

***Narrow-top chair** A chair with a slat-style crest of shallow depth. (See figs. 7-7, 7-33.)

***Neat** As applied to a chair, one made (and decorated, if applicable) in a substantial, workmanlike manner, the design relatively simple rather than complex.

***Nurse (or nursing) chair** An armless chair with rockers. (See fig. 7-104.)

***Office chair** A chair with a swivel base, first produced in the 1840s and often of low-back, or horseshoe, form. The seat was also called a pivoting chair in the period.

Ogee seat See Scroll seat.

***Organ spindle** A short ornamental stick shaped like an organ pipe. Spindles of this type were used in the vicinity of New York City in the early nineteenth century for quality work. (See fig. 5-43.)

***Oval-back chair** An alternative term for the bow-back chair in late eighteenth-century Philadelphia and vicinity.

Oval seat A plank (usually for an armchair) of elongated, rounded form, sometimes a rectangle with rounded corners, broader in width than in depth. (See figs. 3-25, 3-67, 6-99.)

Oxbow A profile with convex ends and a concave center. (See fig. 5-8, crest.)

***Penciling** The application of fine, pinstripe lines as decoration on painted chairs and other furniture. The word also describes the painted decoration itself. Penciling was executed with a fine camel's-hair brush called a pencil.

***Philadelphia chair** An eighteenth-century term for a Windsor chair made at Philadelphia.

***Pillar** An arm post or back post.

Pinned Fastened together with wooden pins resembling thickened matchsticks, which serve the function of nails or screws.

***Pivoting chair** See Office chair.

***Plank** (1) A chair seat shaped and contoured to the desired form; (2) a length of lumber 2 inches (or more) thick.

Pommel A protuberance at the top center front of many eighteenth-century seat planks, resembling the ridge in a saddle. (See figs. 3-6, 3-72.)

Rabbet A lap joint.

***Raised seat** A scroll seat. The term comes from the upward sweep at the seat back, which was referred to as the *rise*.

Rake Splay.

Reed A narrow, continuous projection usually found in Windsor seating at the edges of a bow face. A few bows are reeded across the entire face. (See figs. 6-165, 6-166, 6-87.)

Ribbon-top chair A New Hampshire fan-back pattern of ca. 1800 that has a plain, shallow, scroll-end crest sawed to a serpentine line on the top and bottom edges. The resulting figure is ribbonlike. (See fig. 6-253.)

***Riding chair** An open, one-person, two-wheeled vehicle drawn by a horse. The single seat,

mounted on wrought-iron straps and fixed to the floor frame, was usually of Windsor construction from the 1750s into the early nineteenth century.

Ring turning A small, compressed circular element with bulging sides usually found in eighteenth-century chairs immediately above the tapered cylindrical feet and near the bases of the arm posts (and back posts, when applicable). In nineteenth-century chairs, ring turnings are frequently included as elements of the back posts, legs, and front stretchers, sometimes in the form of multiple-ring-turned bands. (See figs. 3-24, 7-64.)

***Rod** An alternative term for a spindle.

Rod-back chair An early nineteenth-century square-back chair with a single or double bow (turned crosspiece) forming the crest. (See figs. 3-114, 7-27.)

***Roll-top chair** A pattern of the 1820s and 1830s with a turned crest, consisting of short cylinders, rings, and a rounded, pillowlike center piece. (See figs. 3-140, 5-57.)

***Round-back chair** Any of several eighteenth-century patterns in which the spindles of the back are enclosed within an arched bow anchored in the seat or the arm rail. On occasion, the term may describe a low-back Windsor. (See figs. 3-55, 3-41, 3-14.)

Round tenon A short cylindrical protuberance at the tip(s) of a turned or shaved stick of wood, such as a leg, stretcher, or post, which fits into a comparable socket in another piece of wood to make a joint.

***Round-top chair** An eighteenth-century sack-back chair. The term as used in the 1830s probably described a tablet-type crest with rounded ends. (See figs. 3-39, 7-65.)

***Roundabout chair** A four-cornered, turned or joined chair with a square- or round-front seat woven of rush or stuffed and covered with a textile or leather. The waist-height sawed arm rail forms a half circle and sometimes accommodates a centered back extension. Also called corner chair. (See fig. 6-135.)

***Rounds (or chair rounds)** Stretchers.

Roundwork Turned work.

***Rush-bottomed chair** Any of several vernacular chair patterns with open frames to accommodate woven flag (rush) seats. Included in this category are slat-back, banister-back, fiddle-back, and fancy chairs. (See figs. 5-27, left; 6-7, 6-32, 3-139.)

S-curved post An arm support sawed to an ogee profile and sometimes further shaped by rounding the edges. (See figs. 6-28, 6-215.)

***Sack-back chair** A round-top eighteenth-century armchair framed with a bent or sawed, U-shaped arm rail to which is anchored a low-arched bow enclosing the long spindles of the rear structure. The pattern was revived in the mid nineteenth century and given heavier proportions. (See figs. 3-38, 3-152.)

Saddled seat An eighteenth-century plank contoured on the top surface to approximate a riding saddle, including the center front pommel. (See figs. 3-13, 3-45.)

Saucered plank A seat surface shaved and contoured to a shallow depression on the top surface. The front pommel is eliminated. The design was current from the late eighteenth century into the early nineteenth century. (See figs. 3-55, 3-136.)

***Scalloped-top chair** A slat-back chair framed with a crest board sawed at the upper center surface in a series of small, continuous arcs. (See fig. 3-138.)

Scratch bead A narrow, flattened or slightly rounded, continuous moldinglike band formed by incising a line parallel to and near the edge(s) of a flat-faced or slightly crowned chair bow. (See figs. 6-72, 3-55.)

***Scroll arm** A horizontal support attached to a back post or bow and sloping forward in an S curve in the vertical plane to a front attachment at an arm post. The forward tip usually is a large or small scroll, sometimes carved at the sides. (See figs. 3-105, 4-43.)

***Scroll-back chair** See Grecian chair.

***Scroll seat** A rectangular bottom with moderate or pronounced serpentine sides, forming an ogee in the side profile. The front edge terminates in an applied roll; the back forms a rise consisting of one or more pieces of wood. Alternative terms are *ogee seat* and *raised seat*. This is the common bottom of the Boston rocking chair. (See figs. 7-64, 7-104.)

***Scroll-top (dining) chair** A fan-back side chair, the serpentine-top crest carved in volutes, or scrolls, at the terminals. (See fig. 3-46.) In the nineteenth century the term described a chair with a rectangular-tablet crest having a small backward roll at the upper edge. (See fig. 7-39.)

Seat extension A small wedge-, coffin-, or tab-shaped projection at the center back of a chair plank, supporting a pair of bracing spindles. In a writing-arm chair, one or two side projections, usually tab-shaped, also support the stationary leaf. Most extensions are of one piece with the rest of the seat. (See figs. 6-107, 8-41.)

Serpentine-top chair An early square-back chair with a thin, squared crest rod of undulating line. (See figs. 3-112, 3-113.)

***Set (of chairs)** A variable number of matching chairs, most commonly six side chairs. Mixed sets of eight included two armchairs. Larger and smaller sets are recorded.

***Settee** A wide, chairlike form, in which the seat has been expanded to accommodate two or more persons.

***Settee cradle** A rocking bench of a length to seat two to four persons, fitted along part of the front with a removable, spindle-framed gate anchored in two sockets drilled in the plank.

***Sewing chair** A woman's rocking chair without arms and probably low to the floor. (See fig. 7-104.)

Shield-shaped seat A plank outline that is arc-shaped at the back, incurved at the sides, rounded at the front corners, and almost straight across the front. (See figs. 6-62, 6-69.)

Shouldered-tablet chair A nineteenth-century pattern with pronounced, rounded humps forming the upper corners of the crest. (See figs. 3-145, 3-163.)

Shovel-shaped seat A plank of deep rectangular outline, arc-shaped at the back, straight at the front, and serpentine-shaped at the sides, the width increasing from back to front. (See figs. 3-140, 7-49.)

*__Single-bow chair__ An early nineteenth-century Windsor, the crest formed of a single turned cross rod "bowed" in a lateral curve. (See figs. 3-114, 7-5.)

*__Single-cross-back chair__ An early nineteenth-century Windsor or fancy chair featuring a large X-shaped element in the back. (See figs. 5-40, 3-156.)

Slat A thin, straight-edged or fancy-sawed board of broad or narrow depth from top to bottom framed horizontally between the posts of a chair back as a crest, midbrace, or stay rail. (See figs. 7-33, 7-53, 3-138.)

Slat-back chair A square-back Windsor chair with a boardlike crest framed between the rear posts. The term also refers to a utilitarian rush-bottomed chair framed with two to six crosspieces, usually diminishing in size from bottom to top. (See figs. 7-76, 7-95; 5-23, left.)

Slat post A flat stick usually broad at the top and slim in the lower part, sometimes patterned with a bead on the forward edge. This early type of arm support was used in English Windsor seating during the second quarter of the eighteenth century and also in early Philadelphia Windsor work. (See figs. 1-15, 3-1, 3-2.)

Socket An open-ended or blind cylindrical hole, sometimes tapered, accommodating a round tenon to form a joint.

*__Spindle__ A shaped vertical stick used in a chair back or under the arms. Eighteenth-century spindles are long and slender; nineteenth-century spindles often are embellished with turned balls or flat-shaved medallions of varied profile. The term *spindle* is less common in period use than *stick*. (See figs. 3-28, 3-93, 3-120, 3-144.)

Spindle platform The flattened top surface of a chair seat adjacent to the back edge or the back and side edges, as appropriate, which sockets the uprights of the back and arms. The platform usually is further defined by a groove (or painted line) around the inside and frequently outside edges. (See figs. 3-6, 3-141.)

Splat A broad banister, usually sawed to a simple or complex baluster shape. (See figs. 3-17, 5-8.)

Splay The outward slant in one or more planes of the upright supports, particularly the legs and arm posts. (See fig. 3-39.)

Spool turning A small cylinder with incurved sides serving to connect larger elements. (See fig. 3-27, arm posts and legs.)

*__Spring- (or sprung-) back chair__ A bent-back chair.

*__Square-back chair__ A generic term describing any of several early nineteenth-century Windsor-chair patterns of angular frontal profile. (See figs. 3-114, 3-127, 3-137.)

*__Square-top chair__ Probably a chair with a rectangular-tablet crest. The crest may be close fitting at the posts without an appreciable overhang. (See figs. 7-20, 7-108.)

*__Stamp__ A kind of brand, the impressed letters of smaller size than those in a brand.

*__Standard__ An arm post or back post.

*__Stay rail__ A cross slat, usually shallow, framed at the lower back of a fancy chair above seat level and supporting an upright member or members. (See figs. 3-118, 8-15.)

Stenciling A decorative technique for painted surfaces that employs hollow-cut patterns, paint, and metallic powders to produce solid or shaded ornament.

Stepped-tablet chair A chair with a moderately deep crest that is usually flat at the center top and flanked by low, curved shoulders and straight tips. This early nineteenth-century pattern was produced in Massachusetts and northern New England; the crest is based on profiles used in formal Boston seating furniture of ca. 1800-1805. (See figs. 7-37, 7-81.)

*__Stick__ In chairmaking, a long, slender piece of wood, shaved or turned to form. Any appropriate part, whether framed vertically or horizontally, can be called a stick, but the term most commonly identifies a spindle.

Stick construction (or stick-and-socket construction) A method of framing furniture, mainly chairs and other seats, in which bored sockets and round tenons form the principal joints.

Stop A turning at the leg tops of some chairs immediately beneath the plank that impedes or prevents further penetration of the tips through the seat after the joint has been made. Types of stops include a thick tapered cone above a short baluster and a heavy ring similarly positioned. The feature is principally a product of Rhode Island chairmaking. (See figs. 6-75; 6-139, detail.)

*__Straight-back chair__ An early nineteenth-century chair with a squared upper structure, whose elements—posts and spindles (when present)—are framed with a slightly backward cant at the seat sockets. Unlike the bent-back chair, the upright units are straight and not further angled in the upper half.

*__Straw color__ A pale yellow tending toward light brown, as in the color of dried grain stalks or bamboo (an alternative term). The color was exceptionally popular for vernacular seating furniture from the 1790s until the early 1840s.

*__Stretcher__ A shaped stick of wood, thicker than a spindle, mounted horizontally in the undercarriage of a chair to brace the legs. Stretchers in eighteenth-century seating furniture are usually framed in an H-shaped figure; nineteenth-century braces are mounted around the perimeter of the base in box style. (See figs. 4-27, 4-32.)

Striping Narrow bands of color broader than penciled lines.

*__Stuffed seat__ A roughly finished plank padded with soft, resilient materials and covered with a textile or piece of leather nailed in place. Ornamental brass nails may be added for embellishment. (See figs. 6-75, 6-108.)

*__Stump chair__ A nineteenth-century Windsor or fancy chair, the back posts rabbeted at the top on the faces to receive a tablet crest of varied pattern held fast by screws inserted from the rear.

*__Sweep__ A continuous flowing line defining a curving or contoured profile.

Swelled spindle An eighteenth-century chair stick of slender proportions with a prominent bulge, either short or long, in the lower half. The feature was most common in the work of craftsmen residing in Rhode Island and the Connecticut-Rhode Island border region. (See figs. 6-128, 6-140.)

Swelled taper A cylindrical foot diminishing in diameter from top to bottom and marked by a pronounced bulge near the top. (See figs. 6-40, 6-71.)

*__Tablet__ A thin, angular or rounded element, large or small, with a flat face suitable for ornamentation. Tablets in Windsor seating may form an individual unit, such as a crest, or be part of another element, such as a spindle or stretcher. (See figs. 4-12, 7-32, 6-208.)

Tablet-centered crest A top piece framed either on the tips of the back posts or between those supports that has a low, shaped extension along the center top surface. (See figs. 3-125, 7-69.)

*__Tablet-top chair__ A Windsor or fancy chair framed with the crest tenoned to the tips of the back posts or rabbeted to the faces. The tablet, or crest, may be of angular or rounded figure. (See figs. 3-141, 3-147.)

Tapered foot A straight-sided cylindrical terminal diminishing in diameter from top to bottom. Tapered feet were produced from the 1770s through the 1790s.

*__Three-stick chair__ A fancy or Windsor chair, the back containing a cross feature at waist height composed of three slim cylindrical rods socketed close together. (See figs. 7-29, 7-30.)

*__Thumb-top back post__ So called because the shaved and rounded tip resembles an upright human thumb in profile. (See fig. 7-62.)

*__Top piece__ A crest.

Triple-back settee A long seat with three intersecting arches from end to end above the arm rail in place of one long arch.

*__Triple chair__ Similar to a double chair except designed to seat three persons. Unlike the double chair, the triple chair probably was not made in America.

*__Turkey leg__ A fancy-chair support consisting of a knob foot, slim ankle, and multiple-ring-turned shaft approximating the profile of a feather-covered, fleshy bird leg. Some Windsor chair legs approximate this shape in simplified form. (See figs. 7-22, 7-64, 7-77.)

Turtle back A twentieth-century term for a frog fret.

Undercarriage The part of a chair or settee beneath the seat, that is, the legs and stretchers.

Vase-back chair A fiddle-back chair.

Volute A scroll carved in an open or tight spiral. Volutes in Windsor chairs are most common in

crest pieces and knuckle-carved handgrips. (See figs. 3-24, 3-27.)

Waist The pinched part of a bow just above the seat in a bow-back side chair of Pennsylvania or Delaware Valley origin. The feature is also found in chairs produced in some regions of New England. (See figs. 3-55, 4-28, 6-87.)

***Wareroom** A structure attached to or separate from the chair shop in which ready-made Windsor (or other) furniture was offered for retail sale. Such facilities were uncommon until the late 1810s. Some were operated by middlemen independent of the craftsmen producers. *Warehouse* is an alternative period term.

Wedge A small, long and narrow, triangular-shaped piece of wood inserted into a stick-and-socket joint to tighten the construction.

***Whitewood** Any of several white or light-colored woods, but principally that of the so-called yellow poplar tree (*Liriodendron tulipifera*). Sometimes basswood is called whitewood.

***Windsor** A name applied to a type of stick-and-socket-framed furniture utilizing a wooden seat plank as the principal unit of construction. The name derives from the castle town of Windsor in England. Because of the numbers of visitors to the site, the castle grounds were furnished with rustic seating of stick-and-socket construction by the early eighteenth century. In addition, part of the vast quantity of timber harvested in the region and conveyed to London via the Thames River was shipped through Windsor. With the construction prototype and an important source of raw material centered in Windsor, London craftsmen soon attached the town/castle name to the new type of furniture they developed from the rustic model.

Windsor green The color of eighteenth-century Windsor chairs, including the English prototypes and American seating, until after the Revolution. The pigment was verdigris, a copper acetate, which produces a medium light, chalky blue-green.

Winged-tablet top A crest mounted on the back posts and shaped with a lunette or rectangle at the center from which horizontal wedge-shaped extensions rise gradually to their highest points above the posts. (See figs. 4-7, 3-153.)

Wooden-bottom chair An alternative term for a Windsor, although other types of chairs also have seats made of wood.

Writing-arm Windsor An armchair, usually of greater than normal breadth in the seat, fitted at one side with a large flat board, or leaf, forming a writing surface, usually for use by a right-handed person. Writing chairs were constructed in current patterns from the 1790s into the early nineteenth century. (See figs. 7-40, 8-41.)

***Yellow poplar** *Liriodendron tulipifera*, also called tulip tree or tulip poplar, although not a member of the genus *Populus*. Yellow poplar was the wood used in the seats of Windsor chairs made in the Middle Atlantic region, parts of the South, and parts of southern New England.

***York chair** A fiddle-back chair.

Select Bibliography

Books

Amman, Jost, and Hans Sachs. *The Book of Trades (Ständebuch)*. 1568. New York: Dover, 1973.

Baker, Hollis S. *Furniture in the Ancient World*. London: Connoisseur, 1966.

Belknap, Henry Wyckoff. *Artists and Craftsmen of Essex County, Massachusetts*. Salem, Mass.: Essex Institute, 1927.

Bishop, Robert. *The American Chair*. 1972. Reprint. New York: Bonanza, 1983.

Bivens, John, Jr., and Paula Welshimer. *Moravian Decorative Arts in North Carolina*. Winston-Salem, N.C.: Old Salem, 1981.

Bjerkoe, Ethel Hall. *The Cabinetmakers of America*. Garden City, N.Y.: Doubleday, 1957.

Brainard, Newton C. *The Hartford State House of 1796*. Hartford: Connecticut Historical Society, 1964.

Buckingham, Joseph T., comp. *Annals of the Massachusetts Charitable Mechanics Association*. Boston: Crocker and Brewster, 1853.

Burton, E. Milby. *Charleston Furniture, 1700–1825*. Charleston, S.C.: Charleston Museum, 1955.

Chippendale, Thomas. *The Gentleman and Cabinet-Maker's Director*. 1762. Reprint of 3d ed. New York: Dover, 1966.

Churchill, Edwin A. *Simple Forms and Vivid Colors*. Exhibition catalogue. Augusta: Maine State Museum, 1983.

Connell, E. Jane, and Charles R. Muller. *Made in Ohio: Furniture, 1788–1888*. Exhibition catalogue. Columbus, Ohio: Columbus Museum of Art, 1984.

Coolidge, A. J., and J. B. Mansfield. *A History and Description of New England*. 2 vols. Boston: Austin J. Coolidge, 1859.

Cotton, Bernard D. *Cottage and Farmhouse Furniture in East Anglia*. Exhibition catalogue. Lechlade, Gloucestershire: By the author, 1987.

———. *The English Regional Chair*. Woodbridge, Suffolk: Antique Collectors' Club, 1990.

———. *Windsor Chairs in the South West*. Exhibition catalogue. Lechlade, Gloucestershire: By the author, 1989.

Craig, James H. *The Arts and Crafts in North Carolina, 1699–1840*. Winston-Salem, N.C.: Old Salem, 1965.

De Witt, Francis, comp. *Statistical Information Relative to Certain Branches of Industry in Massachusetts for the Year Ending June 1, 1855*. Boston: William White, 1856.

Digest of Accounts of Manufacturing Establishments in the United States, and of their Manufactures. Washington, D.C.: Gales and Seaton, 1823.

Dobson, Henry. *A Provincial Elegance*. Exhibition catalogue. Kitchener, Ont.: Kitchener-Waterloo Art Gallery, 1982.

Dobson, Henry, and Barbara Dobson. *The Early Furniture of Ontario and the Atlantic Provinces*. Exhibition catalogue. Toronto: M. F. Fehely, 1974.

Documents Relative to the Manufactures in the United States Collected and Transmitted to the House of Representatives in Compliance with a Resolution of January 19, 1832, by the Secretary of the Treasury. 2 vols. Washington, D.C.: Duff Green, 1833.

D'Oench, Ellen G. *The Conversation Piece: Arthur Devis and His Contemporaries*. Exhibition catalogue. New Haven, Conn.: Yale Center for British Art, 1980.

Dorman, Charles G. *Delaware Cabinetmakers and Allied Artisans, 1655–1855*. Wilmington: Historical Society of Delaware, 1960.

Downs, Joseph. *American Furniture: Queen Anne and Chippendale Periods*. New York: Macmillan, 1952.

Drepperd, Carl W. *Handbook of Antique Chairs*. Garden City, N.Y.: Doubleday, 1948.

Earle, Alice Morse. *Customs and Fashions in Old New England*. New York: Charles Scribner's Sons, 1893.

Early Arts of New Jersey. Exhibition catalogue. Trenton: New Jersey State Museum, 1953.

Early Furniture Made in New Jersey, 1690–1870. Exhibition catalogue. Newark, N.J.: Newark Museum Association, 1958.

Elder, William Voss, III. *Baltimore Painted Furniture, 1800–1840*. Exhibition catalogue. Baltimore: Baltimore Museum of Art, 1972.

Elder, William Voss, III, and Jayne E. Stokes. *American Furniture 1680–1880 from the Collection of the Baltimore Museum of Art*. Baltimore: Baltimore Museum of Art, 1987.

Failey, Dean F. *Long Island Is My Nation*. Exhibition catalogue. Setauket, N.Y.: Society for the Preservation of Long Island Antiquities, 1976.

Fales, Dean A., Jr. *American Painted Furniture, 1660–1880*. New York: E. P. Dutton, 1972.

———. *The Furniture of Historic Deerfield*. New York: E. P. Dutton, 1976.

Garvin, Donna-Belle, James L. Garvin, and John F. Page. *Plain and Elegant, Rich and Common: Documented New Hampshire Furniture, 1750–1850*. Exhibition catalogue. Concord: New Hampshire Historical Society, 1979.

Gilbert, Christopher. *An Exhibition of Town and Country Furniture*. Exhibition catalogue. Leeds, Yorkshire: Temple Newsam, 1972.

Girouard, Mark. *Life in the English Country House*. New Haven, Conn.: Yale University Press, 1978.

Gottesman, Rita Susswein, comp. *The Arts and Crafts in New York, 1726–1776*. New York: New-York Historical Society, 1938.

———, comp. *The Arts and Crafts in New York, 1777–1799*. New York: New-York Historical Society, 1954.

———, comp. *The Arts and Crafts in New York, 1800–1804*. New York: New-York Historical Society, 1965.

Greenlaw, Barry A. *New England Furniture at Williamsburg*. Williamsburg, Va.: Colonial Williamsburg Foundation, 1974.

Hageman, Jane Sikes. *Ohio Furniture Makers*. Vol. 1. [Cincinnati, Ohio]: By the author, 1984.

Hageman, Jane Sikes, and Edward M. Hageman. *Ohio Furniture Makers*. Vol. 2. [Cincinnati, Ohio]: By the authors, 1989.

Haines, Carol L., and Lisa H. Foote. *"Forms to Set On": A Social History of Concord Seating Furniture*. Exhibition catalogue. Concord, Mass.: Concord Antiquarian Museum, n.d.

Hayward, Helena, ed. *World Furniture*. New York: McGraw-Hill, 1965.

Hazen, Edward. *The Panorama of Professions and Trades*. Philadelphia: Uriah Hunt, 1836.

Hepplewhite, [George]. *The Cabinet-Maker and Upholsterer's Guide*. 1794. Reprint of 3d ed. New York: Dover, 1969.

Herrick, Rev. William D. *History of the Town of Gardner . . . Massachusetts*. Gardner: By the committee, 1878.

History of Worcester County, Massachusetts. 2 vols. Boston: C. F. Jewett, 1879.

Holme, Randle. *The Academy of Armory; or, A Storehouse of Armory and Blazon*. 2 vols. 1688. Reprint. London: Roxburghe Club, 1905.

Hope, Thomas. *Household Furniture and Interior Decoration*. 1807. Reprint. New York: Dover, 1971.

Hornor, William MacPherson, Jr. *Blue Book: Philadelphia Furniture*. 1935. Reprint. Washington, D.C.: Highland House, 1977.

Hummel, Charles F. *With Hammer in Hand: The Dominy Craftsmen of East Hampton, New York*. Charlottesville: University Press of Virginia for the Henry Francis du Pont Winterthur Museum, 1968.

Hunt, John Dixon, and Peter Willis, eds. *The Genius of the Place*. London: Paul Elek, 1975.

Hurd, Duane Hamilton, ed. *History of Worcester County, Massachusetts*. 2 vols. Philadelphia: J. W. Lewis, 1889.

Ince, William, and John Mayhew. *The Universal System of Household Furniture*. 1759–62. Reprint. Chicago: Quadrangle, 1960.

Jobe, Brock, ed. *Portsmouth Furniture: Masterworks from the New Hampshire Seacoast*. Boston: Society for the Preservation of New England Antiquities, 1993.

Jones, Alice Hanson. *American Colonial Wealth*. 3 vols. New York: Arno, 1977.

Kane, Patricia E. *300 Years of American Seating Furniture*. Boston: New York Graphic Society, 1976.

Kenney, John Tarrant. *The Hitchcock Chair*. New York: Clarkson N. Potter, 1971.

Kirk, John T. *American Furniture and the British Tradition to 1830*. New York: Alfred A. Knopf, 1982.

Lea, Zilla Rider, ed. *The Ornamented Chair*. Rutland, Vt.: Charles E. Tuttle, 1960.

Lipman, Jean, and Tom Armstrong, eds. *American Folk Painters of Three Centuries*. Exhibition catalogue. New York: Whitney Museum, 1980.

Little, Nina Fletcher. *Asahel Powers, Painter of Vermont Faces*. Exhibition catalogue. Williamsburg, Va.: Colonial Williamsburg Foundation, 1973.

——. *Paintings by New England Provincial Artists, 1775–1800*. Exhibition catalogue. Boston: Museum of Fine Arts, 1976.

The London Chair-Makers' and Carvers' Book of Prices for Workmanship. London: T. Sorrell, 1802.

Lord, Walter G., comp. *History of Athol, Massachusetts*. Athol: By the compiler, 1953.

Loudon, John Claudius. *An Encyclopaedia of Cottage, Farm, and Villa Architecture and Furniture*. 1833. Rev. ed. London: Longman, Orme, Brown, Green, and Longmans, 1839.

Lyon, Irving Whitall. *Colonial Furniture of New England*. Boston: Houghton Mifflin, 1924.

MacKinnon, Joan. *A Checklist of Toronto Cabinet and Chair Makers, 1800–1865*. National Museum of Man Mercury Series. Ottawa: National Museums of Canada, 1975.

——. *Kingston Cabinetmakers, 1800–1867*. National Museum of Man Mercury Series. Ottawa: National Museums of Canada, 1976.

MacLaren, George G. *Antique Furniture by Nova Scotia Craftsmen*. Toronto: Ryerson Press, 1961.

——. *The Chair-Makers of Nova Scotia*. Halifax: Nova Scotia Museum, 1966.

Macquoid, Percy, and Ralph Edwards. *Dictionary of English Furniture*. 3 vols. 1924–27. Reprint of 2d rev. ed. by Ralph Edwards. Woodbridge, Suffolk: Barra Books, 1983.

Manwaring, Robert. *Cabinet and Chair-Maker's Real Friend and Companion*. London: Robert Pranker, 1765.

Mayes, L. J. *The History of Chairmaking in High Wycombe*. London: Routledge and Kegan Paul, 1960.

Miller, James M. *The Genesis of Western Culture*. Columbus: Ohio State Archaeological and Historical Society, 1938.

Minhinnick, Jeanne. *At Home in Upper Canada*. Toronto: Clark, Irwin, 1970.

——. *Early Furniture in Upper Canada Village, 1800–1837*. Toronto: Ryerson Press, 1964.

Montgomery, Charles F. *American Furniture: The Federal Period in the Henry Francis du Pont Winterthur Museum*. New York: Viking Press, A Winterthur Book, 1966.

Morison, Samuel Eliot. *The Maritime History of Massachusetts, 1783–1860*. London: William Heinemann, 1923.

Moxon, Joseph. *Mechanick Exercises*. 1703. Reprint. New York: Praeger, 1970.

Musser, Marie Purnell. *Country Chairs of Central Pennsylvania*. Mifflinburg, Pa.: By the author, 1990.

Myers, Minor, Jr., and Edgar de N. Mayhew. *New London County Furniture, 1640–1840*. Exhibition catalogue. New London, Conn.: Lyman Allyn Museum, 1974.

Neat Pieces: The Plain-Style Furniture of 19th-Century Georgia. Exhibition catalogue. Atlanta, Ga.: Atlanta Historical Society, 1983.

19th-Century America. Exhibition catalogue. New York: Metropolitan Museum of Art, 1970.

Nutting, Wallace. *Furniture Treasury*. 2 vols. 1928. Reprint. New York: Macmillan, 1966.

——. *A Windsor Handbook*. 1917. Reprint. Framingham and Boston: Old America Co., n.d.

Ormsbee, Thomas H. *The Windsor Chair*. New York: Deerfield Books, 1962.

Page, John F. *Litchfield County Furniture*. Exhibition catalogue. Litchfield, Conn.: Litchfield Historical Society, 1969.

Pain, Howard. *The Heritage of Country Furniture*. Toronto: Van Nostrand Reinhold, 1978.

Parsons, Charles S. *The Dunlaps and Their Furniture*. Exhibition catalogue. Manchester, N.H.: Currier Gallery of Art, 1970.

Piorkowski, Patricia A. *Piedmont Virginia Furniture*. Exhibition catalogue. Lynchburg, Va.: Lynchburg Museum System, 1982.

Prime, Alfred Coxe, comp. *The Arts and Crafts in Philadelphia, Maryland, and South Carolina, 1721–1785*. Philadelphia: Walpole Society, 1929.

——, comp. *The Arts and Crafts in Philadelphia, Maryland, and South Carolina, 1786–1800*. Topsfield, Mass.: Walpole Society, 1932.

Roe, F. Gordon. *Windsor Chairs*. London: Phoenix House, 1953.

Rohrbough, Malcolm J. *The Trans-Appalachian Frontier*. New York: Oxford University Press, 1978.

Ryder, Huia G. *Antique Furniture by New Brunswick Craftsmen*. Toronto: Ryerson Press, 1965.

Santore, Charles. *The Windsor Style in America*. 2 vols. Philadelphia: Running Press, 1981, 1987.

Scherer, John L. *New York Furniture at the New York State Museum*. Alexandria, Va.: Highland House Publishers, 1984.

Schiffer, Margaret Berwind. *Furniture and Its Makers of Chester County, Pennsylvania*. Philadelphia: University of Pennsylvania Press, 1966.

Shackleton, Philip. *Furniture of Old Ontario*. Toronto: Macmillan of Canada, 1973.

Sheraton, Thomas. *The Cabinet-Maker and Upholsterer's Drawing-Book*. 1793. Reprint. New York: Dover, 1972.

Sikes, Jane E. *The Furniture Makers of Cincinnati, 1790 to 1849*. Cincinnati: By the author, 1976.

Singleton, Esther. *The Furniture of Our Forefathers*. Garden City, N.Y.: Doubleday, Page, 1913.

Sparkes, Ivan G. *The Windsor Chair*. Bourne End, Buckinghamshire: Spurbooks, 1975.

Stanley-Stone, A. C. *The Worshipful Company of Turners of London*. London: Lindley-Jones and Brother, 1925.

Stearns, Ezra S. *History of Ashburnham, Massachusetts*. Ashburnham: By the town, 1887.

Steer, Francis W., ed. *Farm and Cottage Inventories of Mid-Essex, 1635–1749*. Colchester, Essex: Wiles and Son, 1950.

Supplement to the London Chair-Makers' and Carvers' Book of Prices for Workmanship. London: T. Sorrell, 1808.

Swan, Mabel M. *Samuel McIntire, Carver, and the Sandersons, Early Salem Cabinet Makers.* Salem, Mass.: Essex Institute, 1934.

Switzer, Stephen. *Ichnographia Rustica: or, The Nobleman, Gentleman, and Gardener's Recreation.* 3 vols. London: D. Browne, 1718.

Theus, Mrs. Charlton M. *Savannah Furniture, 1735–1825.* N.p.: By the author, ca. 1967.

Trent, Robert F. *Hearts and Crowns: Folk Chairs of the Connecticut Coast, 1710–1840, as Viewed in the Light of Henri Focillon's Introduction to "Art Populaire."* New Haven, Conn.: New Haven Colony Historical Society, 1977.

Van Hoesen, Walter Hamilton. *Crafts and Craftsmen of New Jersey.* Rutherford, N.J.: Fairleigh Dickinson University Press, 1973.

van Ravenswaay, Charles. *The Anglo-American Cabinetmakers of Missouri, 1800–1850.* St. Louis: Missouri Historical Society, 1958.

Walters, Betty Lawson. *Furniture Makers of Indiana, 1793 to 1850.* Indianapolis: Indiana Historical Society, 1972.

Weeden, William B. *Economic and Social History of New England, 1620–1789.* 2 vols. Boston: Houghton, Mifflin, 1891.

Weidman, Gregory R. *Furniture in Maryland, 1740–1940.* Baltimore: Maryland Historical Society, 1984.

The Western Writers of America. *Water Trails West.* Garden City, N.Y.: Doubleday, 1978.

White, Margaret E. *The Decorative Arts of Early New Jersey.* New Jersey Historical Series, 25. Princeton, N.J.: D. Van Nostrand, 1964.

Whitley, Edna Talbott. *A Checklist of Kentucky Cabinetmakers from 1775 to 1859.* Paris, Ky.: By the author, 1969.

Williams, Derita Coleman, and Nathan Harsh. *The Art and Mystery of Tennessee Furniture and Its Makers through 1850.* Nashville: Tennessee Historical Society and Tennessee State Museum Foundation, 1988.

Willis, Peter. *Charles Bridgeman and the English Country Garden.* London: A. Zwemmer, 1978.

Windsor Chairs and Pennsylvania German Painted Chests. Exhibition catalogue. Philadelphia: Pennsylvania Museum, 1925.

Woodbury, Robert S. *History of the Lathe to 1850.* Cleveland, Ohio: Society for the History of Technology, 1961.

Yeager, William, ed. *The Cabinet Makers of Norfolk County.* 2d ed. Simcoe, Ont.: Norfolk Historical Society, 1977.

Articles

Agius, Pauline. "Late Sixteenth- and Seventeenth-Century Furniture in Oxford." *Furniture History* 7 (1971): 72–86.

Barnes, Jarius B. "William Tygart, a Western Reserve Cabinetmaker." *Antiques* 101, no. 5 (May 1972): 832–35.

Baron, Donna Keith. "Furniture Makers and Retailers in Worcester County, Massachusetts, Working to 1850." *Antiques* 143, no. 5 (May 1993): 784-95.

Beasley, Ellen. "Tennessee Cabinetmakers and Chairmakers through 1840." *Antiques* 100, no. 4 (October 1971): 612–21.

Bulkeley, Houghton. "Amos Denison Allen, Cabinetmaker." *Connecticut Historical Society Bulletin* 24, no. 2 (April 1959): 60–64.

Catalano, Kathleen M. "Cabinetmaking in Philadelphia, 1820-1840." In *Winterthur Portfolio* 13, ed. Ian M. G. Quimby, pp. 81-138. Chicago: University of Chicago Press, 1979.

Chase, Ada R. "Amos D. Allen, Connecticut Cabinetmaker." *Antiques* 70, no. 2 (August 1956): 146–47.

——. "Ebenezer Tracy, Connecticut Cabinetmaker." *Antiques* 30, no. 6 (December 1936): 266–69.

Collard, Elizabeth. "Montreal Cabinetmakers and Chairmakers: 1800–1850." *Antiques* 105, no. 5 (May 1974): 1132–46.

Crispin, Thomas. "English Windsor Chairs: A Study of Known Makers and Regional Centers." *Furniture History* 14 (1978): 38–48.

——. "Richard Hewett's Windsor Chair." *Antique Collecting* 9, no. 9 (January 1975): 12–13.

Cromwell, Giles. "Andrew and Robert McKim, Windsor Chair Makers." *Journal of Early Southern Decorative Arts* 6, no. 1 (May 1980): 1–20.

Di Bartolomeo, Robert E., and Cherry G. Di Bartolomeo. "Wheeling's Chairs and Chairmakers, 1828–1864." *Spinning Wheel* 26, no. 4 (May 1970): 14–16, 50.

Ducoff-Barone, Deborah. "Philadelphia Furniture Makers, 1800–1815." *Antiques* 139, no. 5 (May 1991): 982–95.

Evans, Nancy Goyne. "American Painted Seating Furniture: Marketing the Product, 1750–1840." In *Perspectives on American Furniture*, ed. Gerald W. R. Ward, pp. 153–68. New York: W. W. Norton, 1988.

——. "Design Sources for Windsor Furniture, Part 1: The Eighteenth Century." *Antiques* 133, no. 1 (January 1988): 282–97.

——. "Design Sources for Windsor Furniture, Part 2: The Early Nineteenth Century." *Antiques* 133, no. 5 (May 1988): 1128–43.

——. "Design Transmission in Vernacular Seating Furniture: The Influence of Philadelphia and Baltimore Styles on Chairmaking from the Chesapeake Bay to the 'West'." In *American Furniture 1993*, ed. Luke Beckerdite, pp. 75-116. Hanover, N.H.: University Press of New England for the Chipstone Foundation, 1993.

——. "Fancy Windsor Chairs of the 1790s." *Antiques and the Arts Weekly* (Newtown, Conn.), November 6, 1981, pp. 66–68.

——. "A History and Background of English Windsor Furniture." *Furniture History* 15 (1979): 24–53, pls. 68a–95b.

——. "Identifying and Understanding Repairs and Structural Problems in Windsor Furniture." In *American Furniture 1994*, ed. Luke Beckerdite. Hanover, N.H.: University Press of New England for the Chipstone Foundation, 1994.

——. "The Philadelphia Windsor Chair: A Commercial and Design Success Story." In *Shaping a National Culture: The Philadelphia Experience, 1750–1800*, ed. Catherine E. Hutchins. Winterthur, Del.: Henry Francis duPont Winterthur Museum, 1994.

——. "The Sans Souci, a Fashionable Resort Hotel in Ballston Spa." In *Winterthur Portfolio 6*, ed. Richard K. Doud and Ian M. G. Quimby, pp. 111–26. Charlottesville: University Press of Virginia, 1970.

——. "The Tracy Chairmakers Identified." *Connecticut Antiquarian* 33, no. 2 (December 1981): 14–21.

Forman, Benno M. "Delaware Valley 'Crookt Foot' and Slat-Back Chairs." *Winterthur Portfolio* 15, no. 1 (Spring 1980): 41–64.

Garrett, Wendell D. "Providence Cabinetmakers, Chairmakers, Upholsterers, and Allied Craftsmen, 1756–1838." *Antiques* 90, no. 4 (October 1966): 514–19.

Giffen, Jane C. "New Hampshire Cabinetmakers and Allied Craftsmen, 1790–1850." *Antiques* 94, no. 1 (July 1968): 78–87.

Gilbert, Christopher. "Windsor Chairs from Rockley." *Antique Finder* 13, no. 2 (February 1974): 18–19.

Gillingham, Harrold E. "The Philadelphia Windsor Chair and Its Journeyings." *Pennsylvania Magazine of History and Biography* 55, no. 3 (October 1931): 301–32.

Golovin, Anne Castrodale. "Cabinetmakers and Chairmakers of Washington, D.C., 1791–1840." *Antiques* 107, no. 5 (May 1975): 898–922.

Goyne (Evans), Nancy A. "Francis Trumble of Philadelphia: Windsor Chair and Cabinetmaker." In *Winterthur Portfolio 1*, ed. Milo M. Naeve, pp.

221–41. Winterthur, Del.: Winterthur Museum, 1964.

Granquist, Charles L. "Thomas Jefferson's 'Whirligig' Chairs." *Antiques* 109, no. 5 (May 1976): 1056–60.

Hall, Elton W. "New Bedford Furniture." *Antiques* 113, no. 5 (May 1978): 1105–27.

Hancock, Harold B. "Furniture Craftsmen in Delaware Records." In *Winterthur Portfolio 9*, ed. Ian M. G. Quimby, pp. 175–212. Charlottesville: University Press of Virginia, 1974.

Harlow, Henry J. "The Shop of Samuel Wing, Craftsman of Sandwich, Massachusetts." *Antiques* 93, no. 3 (March 1968): 372–77.

Haworth-Booth, Mark. "The Dating of 18th-Century Windsor Chairs." *Antique Dealer and Collectors Guide* 27, no. 1 (January 1973): 63–69.

Hosley, William N., Jr. "Vermont Furniture, 1790–1830." In *New England Furniture*, ed. Brock W. Jobe, pp. 245–86. Boston: Society for the Preservation of New England Antiquities, 1987.

——. "Wright, Robbins and Winship and the Industrialization of the Furniture Industry in Hartford, Connecticut." *Connecticut Antiquarian* 35, no. 2 (December 1983): 12-19.

Howe, Florence Thompson. "The Brief Career of Ansel Goodrich." *Antiques* 18, no. 1 (July 1930): 38–39.

Hughes, G. Bernard. "Windsor Chairs in Palace and Cottage." *Country Life* 131, no. 3403 (May 24, 1962): 1242–43.

Inman, Pauline W. "House Furnishings of a Vermont Family." *Antiques* 96, no. 2 (August 1969): 228–33.

Jervis, Simon. "The First Century of the English Windsor Chair, 1720–1820." *Antiques* 15, no. 2 (February 1979): 360–66.

——. "Holland and Sons, and the Furnishings of the Athenaeum." *Furniture History* 6 (1970): 43–61.

Johnson, Marilynn A. "John Hewitt, Cabinetmaker." In *Winterthur Portfolio 4*, ed. Richard K. Doud, pp. 185–205. Charlottesville: University Press of Virginia, 1968.

Kane, Patricia E. "Samuel Gragg: His Bentwood Fancy Chairs." *Yale University Art Gallery Bulletin* 33, no. 2 (Autumn 1971): 27–37.

Kaye, Myrna. "Marked Portsmouth Furniture," *Antiques* 113, no. 5 (May 1978): 1098–1104.

Keno, Leigh. "The Windsor-Chair Makers of Northampton, Massachusetts, 1790–1820." *Antiques* 117, no. 5 (May 1980): 1100–1107.

[Keyes, Homer Eaton]. "The Editor's Attic." *Antiques* 30, no. 1 (July 1936): 6.

Keyes, Margaret N. "Piecing Together Iowa's Old Capitol." *Historic Preservation* 26, no. 1 (January-March 1974): 40–43.

Kihn, Phyllis, comp. "Connecticut Cabinetmakers, Parts I, II." *Connecticut Historical Society Bulletin* 32, no. 4 (October 1967): 97–144; 33, no. 1 (January 1968): 1–40.

Knittle, Rhea Mansfield. "Ohio Chairmakers." *Antiques* 50, no. 3 (September 1946): 192.

Love, W. DeLoss. "The Navigation of the Connecticut River." *Proceedings of the American Antiquarian Society,* n.s. 15, pt. 3 (April 29, 1903): 385–433.

MacLaren, George G. "The Windsor Chair in Nova Scotia." *Antiques* 100, no. 1 (July 1971): 124–27.

Mahler, Mary, and Frederick Mahler. "Beriah Green, Chair and Cabinetmaker," *Spinning Wheel* 34, no. 2 (March 1978): 32–34.

Minhinnick, Jeanne. "Canadian Furniture in the English Taste." *Antiques* 92, no. 1 (July 1967): 84–90.

Naeve, Milo M. "An Aristocratic Windsor in Eighteenth-Century Philadelphia." *American Art Journal* 11, no. 3 (July 1979): 67–74.

Ott, Joseph K. "More Notes on Rhode Island Cabinetmakers and Their Work." *Rhode Island History* 28 (May 1969): 49–52.

——. "Recent Discoveries among Rhode Island Cabinetmakers and Their Work." *Rhode Island History* 28 (February 1969): 3–25.

——. "Still More Notes on Rhode Island Cabinetmakers and Allied Craftsmen." *Rhode Island History* 28 (November 1969): 111–21.

Prown, Jonathan. "A Cultural Analysis of Furniture-making in Petersburg, Virginia, 1760–1820." *Journal of Early Southern Decorative Arts* 18, no. 1 (May 1992): 1–173.

Redfield, John. "A Windsor Chair by Samuel Stickney." *Spinning Wheel* 28, no. 4 (May 1972): 42–43.

Reveirs-Hopkins, A. E. "Eighteenth-Century Windsor Chairs." *Old Furniture* 5, no. 18 (November 1928): 148–55.

——. "The Windsor Chair in England and Its Ancestors." *Fine Arts* 19, no. 1 (June 1932): 19–21, 46–47.

Schild, Joan Lynn. "Furniture Makers of Rochester, New York." *New York History* 37, no. 1 (January 1956): 97–106.

Semowich, Charles. "The Life and Chairs of William Buttre." *Furniture History* 28 (1992): 129-36.

Shettleworth, Earle G., Jr., and William D. Barry. "Walter Corey's Furniture Manufactory in Portland, Maine." *Antiques* 121, no. 5 (May 1982): 1199–1205.

Skemer, Don C. "David Alling's Chair Manufactory: Craft Industrialization in Newark, New Jersey, 1801–1854." *Winterthur Portfolio* 22, no. 1 (Spring 1987): 1–21.

Spinney, Frank O. "Chapman Lee, Country Cabinetmaker." *New-England Galaxy* 1, no. 3 (Winter 1960): 34–38.

Stabler, John. "An Early Pair of Wheelback Windsor Chairs." *Furniture History* 9 (1973): 119–22.

——. "A New Look at the Bow-Back Windsor." *Connoisseur* 187, no. 754 (December 1974): 238–45.

——. "Two Labelled Comb-Back Windsor Chairs." *Antique Collecting* 11, no. 12 (April 1977): 12–14.

Stoddard, Henry B. "Special Windsor Style Found." *American Collector* 1, no. 9 (April 19, 1934): 1, 6.

Stokes, J. Stogdell. "The American Windsor Chair." *Pennsylvania Museum Bulletin* 21, no. 98 (December 1925): 46–58.

Streifthau, Donna. "Cincinnati Cabinet- and Chairmakers, 1819–1830." *Antiques* 99, no. 6 (June 1971): 896–905.

Swan, Mabel M. "Some Men from Medway." *Antiques* 17, no. 5 (May 1930): 417–21.

Symonds, Robert W. "The Windsor Chair." *Apollo* 22, pt. 1, no. 128 (August 1935): 67–71; pt. 2, no. 131 (November 1935): 261–67.

Torrey, Julia W. "Some Early Variants of the Windsor Chair." *Antiques* 2, no. 3 (September 1922): 106–10.

Ward, J. D. U. "A Note on English Windsors." *Antiques* 56, no. 3 (September 1949): 172–73.

Waters, Deborah Dependahl. "Wares and Chairs: A Reappraisal of the Documents." In *Winterthur Portfolio 13*, ed. Ian M. G. Quimby, pp. 161–73. Chicago: University of Chicago Press, 1979.

Weidman, Gregory R. "The Painted Furniture of John and Hugh Finlay," *Antiques* 145, no. 5 (May 1993): 744–55.

Whallon, Arthur. "Indiana Cabinetmakers and Allied Craftsmen, 1815–1860." *Antiques* 98, no. 1 (July 1970): 118–25.

Journals of Travel and Social and Economic Commentary

Anburey, Thomas. *Travels through the Interior Parts of America.* 2 vols. Boston: Houghton Mifflin, 1923.

Arfwedson, Carl David. *The United States and Canada.* 2 vols. 1834. Reprint. New York: Johnson Reprint, 1969.

Ashe, Thomas. *Travels in America.* London and Newburyport, Mass.: William Sawyer, 1808.

Benson, Adolph B., ed. *Peter Kalm's Travels in North America.* 2 vols. New York: Dover, 1966.

Brissot de Warville, J. P. *New Travels in the United States of America.* Dublin: P. Byrne, A. Grueber, and W. McKenzie, 1792.

Bristed, John. *America and her Resources.* London: Henry Colburn, 1818.

Brown, Samuel R. *The Western Gazetteer, or Emigrant's Directory.* Auburn, N.Y.: H. C. Southwick, 1817.

Burnaby's Travels through North America. 3d ed. 1798. Reprint. New York: A. Wessels, 1904.

Chambers, W[illiam]. *Things as They Are in America.* Philadelphia: Lippincott, Grambo, 1854.

Chapman, Thomas. "Journal of a Journey through the United States, 1795–6." *Historical Magazine* 2d ser., 5 (1869): 357–68.

Chastellux, marquis de. *Travels in North-America in the Years 1780, 1781, and 1782.* 2 vols. London: G. G. J. and J. Robinson, 1787.

Clark, Christopher, ed. "The Diary of an Apprentice Cabinetmaker: Edward Jenner Carpenter's 'Journal'." *Proceedings of the American Antiquarian Society* 98, pt. 2 (1988): 303–94.

Cresswell, Nicholas. *The Journal of Nicholas Cresswell, 1774–1777.* New York: Dial Press, 1924.

Coxe, Tench. *A View of the United States of America.* Philadelphia: William Hall and Wrigley and Berriman, 1794.

[Davison, Gideon Miner]. *The Traveller's Guide.* 6th ed. Saratoga Springs, N.Y.: G. M. Davison, 1834.

de Crevecoeur, Michel Guillaume St. John. *Letters from an American Farmer.* London: Thomas Davies and Lockyer Davis, 1782.

Defoe, Daniel. *A Tour Thro' the Whole Island of Great Britain.* 2 vols. 1725. Reprint. London: Peter Davies, 1927.

The Diary of William Bentley. 4 vols. Salem, Mass.: Essex Institute, 1905.

Dickinson, Rodolphus. *Geographical and Statistical View of Massachusetts Proper.* Greenfield, Mass.: Denio and Phelps, 1813.

[Dwight, Theodore, Jr.]. *The Northern Traveller.* 2d ed. New York: A. T. Goodrich, 1826.

Dwight, Timothy. *Travels in New England and New York.* Ed. Barbara Miller Soloman. 4 vols. Cambridge, Mass.: Belknap Press, 1969.

Emery, Sarah Anna. *Reminiscences of a Nonagenarian.* Newburyport, Mass.: William H. Huse, 1879.

Fearon, Henry Bradshaw. *Sketches of America.* 2d ed. London: Longman, 1818.

Fiennes, Celia. *Through England on a Side Saddle in the Time of William and Mary.* London: Field and Tuer, 1888.

Gilpin, Joshua. "Journal of a Tour from Philadelphia thro the Western Counties of Pennsylvania in the Months of September and October, 1809." *Pennsylvania Magazine of History and Biography* 50, no. 2 (April 1926): 163–78.

Hall, Mrs. Basil. *The Aristocratic Journey.* Ed. Una Pope-Hennessy. New York: G. P. Putnam's Sons, 1931.

Harpster, John W., ed. *Pen Pictures of Early Western Pennsylvania.* Pittsburgh: University of Pittsburgh Press, 1938.

Harrison, Eliza Cope, ed. *Philadelphia Merchant: The Diary of Thomas P. Cope, 1800–1851.* South Bend, Ind.: Gateway Editions, 1978.

Howe, Henry. *Historical Collections of Ohio.* Cincinnati: Derby, Brandley, 1847.

"Journal of Lord Adam Gordon." In *Narratives of Colonial America,* ed. Howard H. Peckham, pp. 232–94. Chicago: R. R. Donnelley and Sons, 1971.

Lambert, John. *Travels through Canada and the United States of North America.* 2 vols. London: C. Cradock and W. Joy, 1813.

La Rochefoucauld Liancourt, duc de. *Travels through the United States of North America.* 2 vols. London: R. Phillips, 1799.

Latrobe, Charles Joseph. *The Rambler in North America.* 2 vols. London: R. B. Seeley and W. Burnside, 1836.

Macky, John. *A Journey through England.* 1714. 2d rev. ed. London: J. Hooke, 1722.

M'Robert, Patrick. *A Tour through Part of the North Provinces of America, 1774–1775.* Edinburgh, 1776. Reprint. Historical Society of Pennsylvania, Narratives and Documents, 1. Philadelphia: Historical Society of Pennsylvania, 1935.

Melish, John. *Travels through the United States of America.* 2 vols. Philadelphia: By the author, 1815.

Michaux, François André. *Travels to the West of the Allegheny Mountains.* London: D. N. Shury, 1805.

Morse, Jedidiah. *The American Geography.* Elizabethtown, N.J.: Shephard Kollock, 1789.

The New Democracy in America: Travels of Francisco de Miranda in the United States, 1783–84. Trans. Judson P. Wood and ed. John S. Ezell. Norman: University of Oklahoma Press, 1963.

Pintard, John. "Notes respecting the Mississippi and New Orleans made during a visit to that City in March, 1801." John Pintard Papers. New-York Historical Society, New York.

Roberts, Kenneth, and Anna M. Roberts, trans. and eds. *Moreau de St. Méry's American Journey [1793–1797].* Garden City, N.Y.: Doubleday, 1947.

[Royall, Anne Newport]. *Sketches of History, Life, and Manners in the United States.* New Haven, Conn.: By the author, 1826.

Ryder, Dudley. *The Diary of Dudley Ryder, 1715–1716.* Ed. William Matthews. London: Methuen, 1939.

Schulling, S. Diary, 1824–25. Historical Society of Pennsylvania, Philadelphia.

Schultz, Christian, Jr. *Travels on an Inland Voyage.* 2 vols. 1810. Reprint. Ridgewood, N.J.: Gregg Press, 1968.

Scott, Joseph. *A Geographical Description of the States of Maryland and Delaware.* Philadelphia: Kimber, Conrad, 1807.

Scudder, H. E., ed. *Recollections of Samuel Breck.* Philadelphia: Porter and Coates, 1877.

Smyth, J. F. D. *A Tour in the United States of America.* 2 vols. London: G. Robinson, 1784.

Strickland, William. *Journal of a Tour in the United States of America, 1794–1795.* Ed. J. E. Strickland. New York: New-York Historical Society, 1971.

Thackara, William Wood. "A Philadelphian Looks at New England—1820." Excerpted and ed. Robert Donald Crompton. *Old-Time New England* 50, no. 3 (January–March 1960): 57–71.

"To the West on Business in 1804: An Account, with Excerpts from His Journal, of James Foord's Trip to Kentucky in 1804." *Pennsylvania Magazine of History and Biography* 64, no. 1 (January 1940): 1–21.

Trollope, Frances M. *Domestic Manners of the Americans.* 2 vols. London: Whittaker, Treacher, 1832.

Tudor, Henry. *Narrative of a Tour in North America.* 2 vols. London: James Duncan, 1834.

Wansey, Henry. *An Excursion to the United States of North America in the Summer of 1794.* 2d ed. Salisbury, England: J. Easton, 1798.

Weld, Isaac. *Travels through the States of North America.* 2 vols. London: John Stockdale, 1800.

Unpublished Works

Elliott, Mary Jane. "Lexington, Kentucky, 1792–1820: The Athens of the West." Master's thesis, University of Delaware, 1973.

Hill, John Henry. "The Furniture Craftsmen in Baltimore, 1783–1823." Master's thesis, University of Delaware, 1967.

Hofer, Margaret K. "The Tory Joiner of Middleborough, Massachusetts: Simeon Doggett and His Community, 1762–1792." Master's thesis, University of Delaware, 1991.

Keno, Leigh. "The Windsor Chair Makers of Northampton, Massachusetts, 1790–1820." Summer Fellowship Program paper, Historic Deerfield, Deerfield, Mass., August 1979.

Leibundguth, Arthur W. "The Furniture-Making Crafts in Philadelphia, c. 1730–c. 1760." Master's thesis, University of Delaware, 1964.

Pillsbury, William Mitchell. "The Providence Furniture Making Trade, 1772–1834." Master's thesis, University of Delaware, 1974.

Rippe, Peter. "Daniel Clay of Greenfield, 'Cabinetmaker'." Master's thesis, University of Delaware, 1962.

Zeno, Aline H. "The Furniture Craftsmen of Richmond, Virginia, 1780–1820." Master's thesis, University of Delaware, 1987.

Manuscripts

Manuscripts in private and public archives have been the most important sources of written information in the preparation of this work. The number of documents consulted is large and includes account books of woodworkers and other craftsmen; individual bills, receipts, and accounts; family business and household records; letters and letter books; probate and land records; census and vital records; court and apprenticeship records; and shipping and export papers. For brevity, the depositories whose holdings have been used are listed here in lieu of the documents, which are identified in the notes. The abbreviations are those used in the notes.

PRIVATE DEPOSITORIES

American Antiquarian Society, Worcester, Mass. (AAS); American Philosophical Society, Philadelphia, Pa. (APS); Antiquarian and Landmarks Society, Hartford, Conn. (ALS); Bailey Library, University of Vermont, Burlington (UV); Baker Library, Harvard University, Cambridge, Mass. (BL); Barre Historical Society, Barre, Mass. (Barre); Bennington Museum, Bennington, Vt. (BM); Beverly Historical Society, Beverly, Mass. (BHS); Boston Athenaeum, Boston, Mass. (BA); Colonial Court Records, Social Law Library, Boston, Mass. (SLL); Colonial Williamsburg, Williamsburg, Va. (CW); Connecticut Historical Society, Hartford (CHS); Dartmouth College, Hanover, N.H. (DC); Essex Institute, Salem, Mass. (EI); Friends Historical Library, Swarthmore College, Swarthmore, Pa. (SC); Girard College, Philadelphia, Pa. (GC); Hagley Museum and Library, Wilmington, Del. (HML); Historic Deerfield, Deerfield, Mass. (HD); Historical Documents Collection, Queens College, Flushing, N.Y. (QC); Historical Society of Pennsylvania, Philadelphia (HSP); Institute for Colonial Studies, State University of New York, Stony Brook (SUNY); Ipswich Historical Society, Ipswich, Mass. (IHS); Lancaster County Historical Society, Lancaster, Pa. (LCHS); Leffingwell Inn, Norwich, Conn. (LI); Library Company of Philadelphia, Philadelphia, Pa. (LCP); Litchfield Historical Society, Litchfield, Conn. (LHS); Maine Historical Society, Portland (MeHS); Maryland Historical Society, Baltimore (MdHS); Massachusetts Historical Society, Boston (MHS); Mattatuck Museum, Waterbury, Conn. (Mattatuck); Metropolitan Museum of Art, New York City (MMA); Moravian Archives, Winston-Salem, N.C. (MA-NC); Moravian Archives, Bethlehem, Pa. (MA-Pa); Museum of Early Southern Decorative Arts, Winston-Salem, N.C. (MESDA); Mystic Seaport Museum, Mystic, Conn. (MSM); National Trust for Historic Preservation, Washington, D.C. (NT); New Haven Colony Historical Society, New Haven, Conn. (NHCHS); New Jersey Historical Society, Newark (NJHS); Newport Historical Society, Newport, R.I. (NHS); New-York Historical Society, New York City (NYHS); New York State Historical Association, Cooperstown (NYSHA); Northampton Historical Society, Northampton, Mass. (NoHS); Old Sturbridge Village, Sturbridge, Mass. (OSV); Rhode Island Historical Society, Providence (RIHS); Rutgers University Library, New Brunswick, N.J. (RUL); Salem County Historical Society, Salem, N.J. (SCHS); Shelburne Museum, Shelburne, Vt. (SM); Society for the Preservation of New England Antiquities, Boston, Mass. (SPNEA); Society of Friends, Philadelphia, Pa. (SF); Sterling Memorial Library, Yale University, New Haven, Conn. (Yale); Swem Library, College of William and Mary, Williamsburg, Va. (WM); Talbot County Historical Society, Easton, Md. (TCHS); Van Pelt Library, University of Pennsylvania, Philadelphia (UP); Vermont Historical Society, Montpelier (VHS); Virginia Historical Society, Richmond (VaHS); Windham Historical Society, Willimantic, Conn. (WHS); Winterthur Library, Winterthur, Del. (WL), including the Joseph Downs Collection of Manuscripts and Printed Ephemera (DCM) and the Visual Resources Collection (VRC); Worcester Historical Museum, Worcester, Mass. (WHM); York County Historical Society, York, Pa. (YCHS).

PUBLIC DEPOSITORIES

County Courthouses and City/Town Halls

Albany Co., Albany, N.Y.; Barnstable Co., Barnstable, Mass.; Belknap Co., Laconia, N.H.; Bennington Co. and Bennington town hall, Bennington, Vt.; Berks Co., Reading, Pa.; Berkshire Co., Pittsfield, Mass.; Bristol Co., Taunton, Mass.; Bucks Co., Doylestown, Pa.; Cheshire Co., Keene, N.H.; Chittendon Co., Burlington, Vt.; Cumberland Co., Portland, Me.; Cumberland Co., Carlisle, Pa.; Dauphin Co., Harrisburg, Pa.; Delaware Co., Media, Pa.; East Greenwich town hall, East Greenwich, R.I.; Essex Co., Salem, Mass.; Franklin Co., Greenfield, Mass.; Hampshire Co., Northampton, Mass.; Hampton Co., Springfield, Mass.; Hillsborough Co., Nashua, N.H.; Kennebec Co., Augusta, Me.; Lancaster Co., Lancaster, Pa.; Merrimack Co., Concord, N.H.; Middlesex Co., Cambridge, Mass.; Nantucket Co. and Nantucket town hall, Nantucket, Mass.; Newport city hall, Newport, R.I.; Norfolk Co., Dedham, Mass.; Orange Co., Brookfield, Vt.; Penobscot Co., Bangor, Me.; Philadelphia Co. and Philadelphia city hall, Philadelphia, Pa.; Plymouth Co., Plymouth, Mass.; Providence city hall, Providence, R.I.; Rensselaer Co., Troy, N.Y.; Rockingham Co., Exeter, N.H.; Schenectady Co., Schenectady, N.Y.; Shelburne town hall, Shelburne, Vt.; Strafford Co., Dover, N.H.; Suffolk Co., Boston, Mass.; Sullivan Co., Newport, N.H.; Waldo Co., Belfast, Me.; Washington Co., Montpelier, Vt.; West Chester Co., White Plains, N.Y.; Westerly town hall, Westerly, R.I.; Windsor Co., Woodstock, Vt.; Worcester Co., Worcester, Mass.; York Co., Alfred (and Fryeburg), Me.; York Co., York, Pa.

Federal Archives and Libraries

Federal Archives and Records Center, Philadelphia, Pa. (FRC-Phila.); Federal Archives and Records Center, Waltham, Mass. (FRC-Waltham); Independence National Historical Park, Philadelphia, Pa. (INHP); Index of American Design, National Gallery of Art, Washington, D.C. (IAD); Library of Congress, Washington, D.C. (LC); National Archives, Washington, D.C. (NA).

State Archives, Libraries, and Other Facilities

Connecticut State Library, Hartford (CSL); State of Delaware, Division of Historical and Cultural Affairs, Dover (DDHCA); State of Delaware, Hall of Records, Dover (DHR); Maryland Hall of Records, Annapolis (MdHR); State Library of Massachusetts, Boston (SLM); New Hampshire Archives, Concord (NHA); Archives and History Bureau, New Jersey State Library, Trenton (NJSL); New York State Library, Albany (NYSL); Rhode Island State Archives, Providence (RISA); Tennessee State Library, Nashville (TSL); State of Vermont, Division of Vital Records, Montpelier

(VVR); State Library of Virginia, Richmond (SLV).

Local Libraries and Other Facilities
Boston Public Library, Boston, Mass. (BPL); Concord Free Public Library, Concord, Mass. (CFPL); Forbes Library, Northampton, Mass. (FL); Nantucket Public Library (Athenaeum), Nantucket, Mass. (NPL); New York Public Library, New York City (NYPL).

FOREIGN DEPOSITORIES

Berkshire Record Office, Reading, England (BRO); Bodleian Library, Oxford, England; British Museum Library, London; Buckinghamshire Record Office, Aylesbury, England; Durham Co. Record Office, Durham, England; Greater London Record Office, London; Guildhall Library, London (GL); Public Record Office, London (PRO); Victoria and Albert Museum Library, London; Westminster Public Library, London (WPL); Windsor Town Clerk's Office, Windsor, England.

Newspapers

Some of the newspapers listed here reflect the ongoing publication of single serials at different periods or under different publishers with varying titles. Complete chronologies for many of these newspapers are given in Clarence S. Brigham, *History and Bibliography of American Newspapers, 1690–1820*, 2 vols. (Worcester, Mass.: American Antiquarian Society, 1947).

CONNECTICUT

Hartford
American Mercury; Connecticut Courant; Connecticut Courant and Weekly Intelligencer; Hartford Gazette; Hartford Times; Jeffersonian; Patriot and Democrat.

New Haven
Connecticut Herald; Connecticut Journal and New-Haven Post-Boy; Evening Palladium; New-Haven Gazette and Connecticut Magazine; New Haven Palladium; Palladium and Republican.

Other
Antiques and the Arts Weekly (Newtown); Bridgeport Messenger (Bridgeport); Bridgeport Standard (Bridgeport); Chelsea Courier (Norwich); Connecticut Courier (Bridgeport); Connecticut Gazette (New London); Connecticut Gazette and Commercial Intelligencer (New London); Connecticut Gazette and Universal Intelligencer (New London); Courier (Norwich); Danbury Recorder (Danbury); Farmer's Journal (Danbury); Impartial Journal (Stonington); Journal and Chronicle (New Britain); Journal of the Times (Stonington); Litchfield County Post (Litchfield); Litchfield Enquirer (Litchfield); Litchfield Gazette (Litchfield); Litchfield Journal (Litchfield); Litchfield Weekly Monitor (Litchfield); Middlesex Gazette (Middletown); Monitor (Litchfield); New-London Gazette and General Advertiser (New London); Norwalk Gazette (Norwalk); Norwich Courier (Norwich); Norwich Packet (Norwich); Phenix, or Windham Herald (Windham); Republican Advocate (New London); Republican Journal (Danbury); Weekly Monitor (Litchfield).

DISTRICT OF COLUMBIA

Centinel of Liberty (Georgetown); Daily National Intelligencer (Washington); Georgetown Metropolitan (Georgetown); Museum and Washington and George-town Advertiser (Georgetown); National Intelligencer and Washington Advertiser (Washington); Washington Federalist (Georgetown).

GEORGIA

Augusta Chronicle and Gazette of the State (Augusta); *Chronicle* (Augusta); *Columbian Museum and Savannah Advertiser* (Savannah); *Gazette of the State of Georgia* (Savannah); *Georgia Gazette* (Savannah); *Republican and Savannah Evening Ledger* (Savannah).

KENTUCKY

Kentucky Gazette (Lexington); *Kentucky Gazette and General Advertiser* (Lexington); *Louisville Public Advertiser* (Louisville); *Russellville Mirror* (Russellville); *Stewart's Kentucky Herald* (Lexington).

LOUISIANA

Louisiana Gazette (New Orleans).

MAINE

Eastern Argus (Portland); *Maine Antique Digest* (Waldoboro); *Maine Inquirer* (Bath); *Portland Gazette* (Portland); *Portland Transcript* (Portland).

MARYLAND

Baltimore
American and Commercial Daily Advertiser; American Daily Advertiser; Baltimore American; Federal Gazette and Baltimore Daily Advertiser.

Other
Bartgis's Federal Gazette, or the Frederick-Town and County, Weekly Advertiser (Frederick); Engine of Liberty and Uniontown Advertiser (Uniontown); Frederick-Town Herald (Frederick); Maryland Herald, and Elizabeth-Town Weekly Advertiser (Hagerstown); Maryland Herald, and Hagerstown Weekly Advertiser (Hagerstown).

MASSACHUSETTS

Boston
Boston Gazette; Boston Patriot; Columbian Centinel; Daily Evening Transcript; Independent Chronicle; Massachusetts Centinel; Massachusetts Gazette; New-England Palladian and Commercial Advertiser.

Other
Berkshire American (North Adams); Columbian Minerva (Dedham); Franklin Herald (Greenfield); Franklin Herald and Public Advertiser (Greenfield); Greenfield Gazette (Greenfield); Hampden Register (Westfield); Hampshire Gazette (Northampton); New Bedford Courier (New Bedford); New-Bedford Mercury (New Bedford); Republican Spy (Springfield); Salem Gazette (Salem).

MICHIGAN

Niles Gazette (Niles); *Niles Gazette and Advertiser* (Niles).

MISSISSIPPI

Mississippi Republican (Natchez); *Statesman and Gazette* (Natchez); *Weekly Chronicle* (Natchez).

NEW HAMPSHIRE

Portsmouth
New-Hampshire Gazette; Portsmouth Oracle.

Other
Concord Gazette (Concord); Courier of New Hampshire (Concord); Dover Gazette (Dover); Exeter Newsletter (Exeter); Farmer's Weekly Museum (Walpole); New Hampshire Patriot (Concord); New Hampshire Sentinel (Keene); Political Observatory (Walpole); Watchman (Exeter).

NEW JERSEY

Sentinel of Freedom (Newark); *Trenton Federalist* (Trenton).

NEW YORK

New York City
Daily Advertiser; The Diary, or Loudon's Register; New-York Gazette; New-York Gazette and General Advertiser; New-York Gazette, and Weekly Mercury; New-York Gazette, or Weekly Post-Boy; New-York Journal, or General Advertiser; New-York Mercury; New-York Packet; New York Sun; Rivington's New-York Gazetteer.

Other
Albany Chronicle (Albany); Albany Register (Albany); Catskill Recorder (Catskill); Hudson Gazette (Hudson); Long Island Star (Brooklyn); Newburgh Gazette (Newburgh); Owego Gazette (Owego); Portico (Huntington); Suffolk County Herald (Sag Harbor); Syracuse Weekly Journal (Syracuse); Western Centinel (Whitestown).

NORTH CAROLINA

American (Fayetteville); *Carolina Centinel* (New Bern); *Carolina Watchman* (Salisbury); *Catawba Journal* (Charlotte); *Edenton Gazette* (Edenton); *Fayetteville Gazette* (Fayetteville); *Greensboro Patriot* (Greensboro); *Hall's Wilmington Gazette* (Wilmington); *Miners' and Farmers' Journal* (Charlotte); *North-Carolina Journal* (Fayetteville); *North-Carolina Minerva* (Raleigh); *North-Carolina Minerva and Fayetteville Advertiser* (Fayetteville); *North-Carolina Star* (Raleigh); *Raleigh Minerva* (Raleigh); *Raleigh Register* (Raleigh); *Raleigh Star* (Raleigh); *Star, and North-Carolina State Gazette* (Raleigh); *Western Carolinian* (Salisbury); *Wilmington Centinel, and General Advertiser* (Wilmington); *Wilmington Gazette* (Wilmington).

OHIO

Centinel of the North-Western Territory (Cincinnati); *Chillicothe Advertiser* (Chillicothe); *Chillicothe Times* (Chillicothe); *Cincinnati Daily Gazette* (Cincinnati); *National Crisis and Cincinnati Emporium* (Cincinnati); *Scioto Gazette* (Chillicothe); *Scioto Gazette and Chillicothe Advertiser* (Chillicothe); *Scioto Gazette, and Fredonian Chronicle* (Chillicothe); *Supporter and Scioto Gazette* (Chillicothe); *True Democrat* (Chillicothe); *Western Spy* (Cincinnati).

PENNSYLVANIA

Philadelphia
Commercial Advertiser; *Pennsylvania Gazette*; *Pennsylvania Journal*; *Pennsylvania Packet*; *Public Ledger*.

Other
American Volunteer (Carlisle); *Examiner and Herald* (Lancaster); *Farmers Register* (Greensburg); *Harrisburg Times* (Harrisburg); *Kline's Gazette* (Carlisle); *Lancaster Journal* (Lancaster); *Mercury* (Pittsburgh); *Oracle of Dauphin, and Harrisburg Advertiser* (Harrisburg); *York Gazette* (York).

RHODE ISLAND

Clarion, or Bristol Advertiser (Warren); *Providence Gazette* (Providence); *Providence Patriot* (Providence); *United States Chronicle* (Providence).

SOUTH CAROLINA

Charleston
Charleston City Gazette; *Charleston City Gazette and Advertiser*; *Charleston Courier*; *City Gazette, or Daily Advertiser*; *Courier*; *Mercury*; *South-Carolina Gazette*; *South-Carolina Gazette and General Advertiser*; *Times*.

TENNESSEE

Clarksville Gazette (Clarksville); *Clarion and Tennessee Gazette* (Nashville); *Clarion, and Tennessee State Gazette* (Nashville); *Democratic Clarion and Tennessee Gazette* (Nashville); *Franklin Western Balance* (Franklin); *Impartial Review, or Cumberland Repository* (Nashville); *Jackson Gazette* (Jackson); *Knoxville Register* (Knoxville); *Nashville Gazette* (Nashville); *Nashville Whig, and Tennessee Advertiser* (Nashville).

VERMONT

Bennington Banner (Bennington); *Brattleboro Messenger* (Brattleboro); *Democratic Statesman* (Concord); *Middlebury Mercury* (Middlebury); *Post-Boy* (Windsor); *Spooner's Vermont Journal* (Windsor); *Vermont Gazette* (Bennington); *Vermont Journal* (Windsor).

VIRGINIA

Alexandria Advertiser and Commercial Intelligencer (Alexandria); *Alexandria Daily Advertiser* (Alexandria); *Alexandria Daily Gazette* (Alexandria); *Alexandria Gazette* (Alexandria); *Alexandria Herald* (Alexandria); *Alexandrian* (Alexandria); *American Beacon and Commercial Diary* (Norfolk); *American Beacon and Norfolk and Portsmouth Daily Advertiser* (Norfolk); *Enquirer* (Richmond); *Examiner* (Richmond); *Fincastle Democrat* (Fincastle); *Herald* (Norfolk); *Herald, and Norfolk and Portsmouth Advertiser* (Norfolk); *Herald of the Valley* (Fincastle); *Jeffersonian Republican* (Charlottesville); *Lynchburg and Farmer's Gazette* (Lynchburg); *Lynchburg Press* (Lynchburg); *Lynchburg Weekly Museum* (Lynchburg); *Norfolk and Portsmouth Herald* (Norfolk); *Norfolk Gazette and Public Ledger* (Norfolk); *Norfolk Herald* (Norfolk); *Petersburg Intelligencer* (Petersburg); *Petersburg Republican* (Petersburg); *Phenix* (Staunton); *Republican* (Richmond); *Richmond Commercial Compiler* (Richmond); *Richmond Enquirer* (Richmond); *Rockbridge Repository* (Lexington); *Staunton Eagle* (Staunton); *Virginia Apollo* (Petersburg); *Virginia Argus* (Richmond); *Virginia Centinel, or Winchester Mercury* (Winchester); *Virginia Gazette* (Williamsburg); *Virginia Gazette, and General Advertiser* (Richmond); *Virginia Gazette, and Petersburg Intelligencer* (Petersburg); *Virginia Gazette, or American Advertiser* (Richmond); *Virginia Gazette, or Norfolk Intelligencer* (Norfolk); *Virginia Herald* (Fredericksburg); *Virginia Journal, and Alexandria Advertiser* (Alexandria).

WEST VIRGINIA

Berkeley and Jefferson Intelligencer (Martinsburg); *Berkeley Intelligencer* (Martinsburg); *Farmer's Repository* (Charles Town); *Lewisburg Chronicle* (Lewisburg); *Martinsburg Gazette* (Martinsburg); *Wheeling Gazette* (Wheeling).

CANADA

Canadian Courant (Montreal); *Canadian Freeman* (Toronto); *Courier* (St. John, N.B.); *Gazette* (Montreal); *Globe* (Toronto); *La Minerve* (Montreal); *Long Point Advocate* (Simcoe, Ont.); *Montreal Daily Argus* (Montreal); *Montreal Gazette* (Montreal); *Montreal Herald* (Montreal); *Morning Courier* (Montreal); *Norfolk Messenger* (Simcoe, Ont.); *Upper Canada Gazette* (Toronto); *Upper Canada Herald* (Kingston, Ont.).

ENGLAND

Bristol Journal (Bristol); *Norfolk Chronicle* (Norfolk); *Rutland, Lincoln and Stamford Mercury* (England); *York Courant* (York).

Directories

City/town directories published from the late eighteenth century through 1850 provided the core group of names for the checklist of craftsmen. These volumes were also helpful in tracking migratory routes of artisans and in identifying many of the branded, stenciled, and handwritten names found on Windsor furniture made before 1850. Besides names, the volumes provide addresses and usually occupations. Few communities were sufficiently large or prosperous before the early nineteenth century to support the publication of annual directories listing local residents. Only Charleston,

Philadelphia, New York, and Boston produced directories before 1790; Baltimore and Hartford published initial volumes during the 1790s. The following list identifies the communities (or regions) that produced directories through 1850 in which chairmakers are mentioned. Publication was frequently intermittent; starting dates are included.

Albany, N.Y. (1813); Baltimore, Md. (1796); Bangor, Me. (1834); Boston, Mass. (1789); Brooklyn, N.Y. (1822); Buffalo, N.Y. (1828); Charleston, S.C. (1782); Charlestown, Mass. (1831); Chicago, Ill. (1839); Cincinnati, Oh. (1819); Cleveland, Oh. (1837); Columbus, Oh. (1843); Concord, N.H. (1830); Detroit, Mich. (1837); Fitchburg, Mass. (1847); Harrisburg, Pa. (1839); Hartford, Conn. (1799); Jersey City, N.J. (1849); Keene, N.H. (1827); Lancaster, Pa. (1843); Lexington, Ky. (1806); Louisville, Ky. (1832); Milwaukee, Wis. (1847); Newark, N.J. (1835); New Bedford, Mass. (1836); New Haven, Conn. (1840); New Orleans, La. (1805); New York City (1786); New York State (1842); Norfolk, Va. (1801); Philadelphia, Pa. (1785); Pittsburgh, Pa. (1813); Portland, Me. (1823);

Portsmouth, N.H. (1817); Poughkeepsie, N.Y. (1843); Providence, R.I. (1824); Reading, Pa. (1806); Richmond, Va. (1819); Rochester, N.Y. (1827); Saint Louis, Mo. (1821); Schenectady, N.Y. (1841); Springfield, Mass. (1845); Trenton, N.J. (1844); Troy, N.Y. (1829); Utica, N.Y. (1817); Washington, D.C. (1822); Watertown, N.Y. (1840); Wheeling, W. Va. (1839); Wilmington, Del. (1814); Worcester, Mass. (1828).

Visual Resources

Decorative Arts Photographic Collection (DAPC), Visual Resources Collection (VRC), Winterthur Library, Winterthur, Del.

Robert W. Symonds Collection of Photographs, Visual Resources Collection, Winterthur Library.

Witt Library, Courtauld Institute of Art, London (CIA).

Yale Center for British Art, New Haven, Conn.

Index